D0223444

art since 1900

To Nikos Stangos (1936–2004), in memoriam

With love, admiration, and grief, we dedicate this book to
Nikos Stangos, great editor, poet, and friend, whose belief
in this project both instigated and sustained it through the
course of its development.

We would like to thank Thomas Neurath and Peter Warner for
their patient support, and Nikos Stangos and Andrew Brown
for their editorial expertise. The book would not have been
begun without Nikos; it would not have been completed
without Andrew.

hal foster
rosalind krauss
yve-alain bois
benjamin h. d. buchloh
david joselit

third edition

volume 2
1945 to the present

544 illustrations,
360 in color

art since 1900

modernism antimodernism postmodernism

Thames & Hudson

WHC LEMOORE
LIBRARY/LRC

Art Since 1900 © 2004 Hal Foster,
Rosalind Krauss, Yve-Alain Bois,
Benjamin H. D. Buchloh

Art Since 1900 (2nd and 3rd editions) © 2011, 2016
Hal Foster, Rosalind Krauss, Yve-Alain Bois,
Benjamin H. D. Buchloh, David Joselit

The publishers would like to thank
Amy Dempsey for her assistance in
the preparation of this book.

All Rights Reserved. No part of this
publication may be reproduced or
transmitted in any form or by any means,
electronic or mechanical, including
photocopy, recording or any other
information storage and retrieval system,
without prior permission in writing from
the publisher.

First published in 2004 in the United States
of America by Thames & Hudson Inc.,
500 Fifth Avenue, New York, NY 10110

thamesandhudsonusa.com

Second edition 2011
Third edition 2016

Library of Congress Catalog Control Number
(volume 1): 2016933436
Library of Congress Catalog Control Number
(volume 2): 2016933436

ISBN (volume 1): 978-0-500-29271-6
ISBN (volume 2): 978-0-500-29272-3

Printed and bound in China by
C&C Offset Printing Co. Ltd

Contents

1900–1909

1910–1919

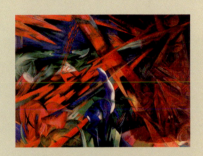

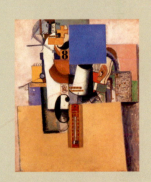

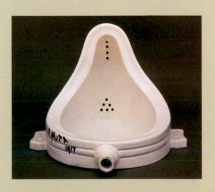

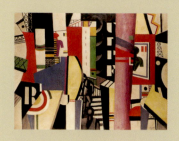

1920–1929

1950–1959

424 **1951** Barnett Newman's second exhibition fails: he is ostracized by his fellow Abstract Expressionists, only later to be hailed as a father figure by the Minimalist artists.

430 **1953** Composer John Cage collaborates on Robert Rauschenberg's *Tire Print*: the indexical imprint is developed as a weapon against the expressive mark in a range of work by Rauschenberg, Ellsworth Kelly, and Cy Twombly.

435 **1955a** In their first exhibition in Tokyo, the artists of the Gutai group propose a new reading of Jackson Pollock's drip canvases that engages with traditional Japanese aesthetics and interprets the phrase "action painting" in a literal sense.

441 **1955b** The "Le mouvement" show at the Galerie Denise René in Paris launches kineticism.

447 **1956** The exhibition "This is Tomorrow" in London marks the culmination of research into postwar relations between art, science, technology, product design, and popular culture undertaken by the Independent Group, forerunners of British Pop art.

453 **1957a** Two small vanguard groups, the Lettrist International and the Imaginist Bauhaus, merge to form the Situationist International, the most politically engaged of all postwar movements.
box • **Two theses from *The Society of the Spectacle***

460 **1957b** Ad Reinhardt writes "Twelve Rules for a New Academy": as avant-garde paradigms in painting are reformulated in Europe, the monochrome and grid are explored in the United States by Reinhardt, Robert Ryman, Agnes Martin, and others.

466 **1958** Jasper Johns's *Target with Four Faces* appears on the cover of *Artnews* magazine: for some artists like Frank Stella, Johns presents a model of painting in which figure and ground are fused in a single image-object; for others, he opens up the use of everyday signs and conceptual ambiguities alike.
box • **Ludwig Wittgenstein**

473 **1959a** Lucio Fontana has his first retrospective: he uses kitsch associations to question idealist modernism, a critique extended by his protégé Piero Manzoni.

477 **1959b** At the San Francisco Art Association, Bruce Conner shows *CHILD*, a mutilated figure in a high chair made in protest against capital punishment: a practice of assemblage and environment is developed on the West Coast by Conner, Wallace Berman, Ed Kienholz, and others that is more scabrous than its equivalents in New York, Paris, or elsewhere.

483 **1959c** The Museum of Modern Art in New York mounts "New Images of Man": existentialist aesthetics extends into a Cold War politics of figuration in the work of Alberto Giacometti, Jean Dubuffet, Francis Bacon, Willem de Kooning, and others.
box • **Art and the Cold War**

488 **1959d** Richard Avedon's *Observations* and Robert Frank's *The Americans* establish the dialectical parameters of New York School photography.

494 **1959e** The Manifesto of Neoconcrete Art is published in Rio de Janeiro as a double spread of the daily newspaper *Jornal do Brasil*, replacing the rationalist interpretation of geometric abstraction that was prevalent at the time with a phenomenological one.

1960–1969

504 **1960a** Critic Pierre Restany organizes a group of diverse artists in Paris to form Nouveau Réalisme, redefining the paradigms of collage, the readymade, and the monochrome.
box • **The neo-avant-garde**

509 **1960b** Clement Greenberg publishes "Modernist Painting": his criticism reorients itself, and in its new guise shapes the debates of the sixties.
box • **Leo Steinberg and the flatbed picture plane**

515 **1960c** Roy Lichtenstein and Andy Warhol start to use cartoons and advertisements as sources for paintings, followed by James Rosenquist, Ed Ruscha, and others: American Pop art is born.

520 **1961** In December, Claes Oldenburg opens *The Store* in New York's East Village, an "environment" that mimicked the setting of surrounding cheap shops and from which all the items were for sale: throughout the winter and the following spring, ten different "happenings" would be performed by Oldenburg's Ray Gun Theater in *The Store* locale.

526 **1962a** In Wiesbaden, West Germany, George Maciunas organizes the first of a series of international events that mark the formation of the Fluxus movement.

534 **1962b** In Vienna, a group of artists including Günter Brus, Otto Mühl, and Hermann Nitsch come together to form Viennese Actionism.

540 **1962c** Spurred by the publication of *The Great Experiment: Russian Art* 1863–1922 by Camilla Gray, Western interest revives in the Constructivist principles of Vladimir Tatlin and Aleksandr Rodchenko, which are elaborated in different ways by younger artists such as Dan Flavin, Carl Andre, Sol LeWitt, and others.
box • ***Artforum***

545 **1962d** Clement Greenberg is the first to acknowledge the abstract side of early Pop art, a characteristic that would feature time and again in the work of its leading proponents and those who followed them.

551 **1963** After publishing two manifestos with the painter Eugen Schönebeck, Georg Baselitz exhibits *Die Grosse Nacht im Eimer* (Great Night Down the Drain) in Berlin.

556 **1964a** On July 20, the twentieth anniversary of the failed Stauffenberg coup against Hitler, Joseph Beuys publishes his fictitious autobiography and generates an outbreak of public violence at the "Festival of New Art" in Aachen, West Germany.

562 **1964b** *Thirteen Most Wanted Men* by Andy Warhol is installed, momentarily, on the facade of the State Pavilion at the World's Fair in New York.

568 **1965** Donald Judd publishes "Specific Objects": Minimalism receives its theorization at the hands of its major practitioners, Judd and Robert Morris.
box • **Maurice Merleau-Ponty**

572 **1966a** Marcel Duchamp completes his installation *Etant Donnés* in the Philadelphia Museum of Art: his mounting influence on younger artists climaxes with the posthumous revelation of this new work.

576 **1966b** The exhibition "Eccentric Abstraction" opens in New York: the work of Louise Bourgeois, Eva Hesse, Yayoi Kusama, and others points to an expressive alternative to the sculptural language of Minimalism.

581 **1967a** Publishing "A Tour of the Monuments of Passaic, New Jersey," Robert Smithson marks "entropy" as a generative concept of artistic practice in the late sixties.

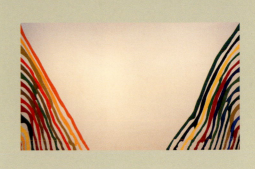

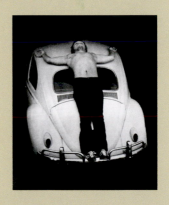

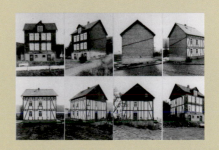

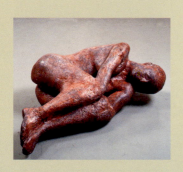

798 2007c As Damien Hirst exhibits *For the Love of God*, a platinum cast of a human skull studded with diamonds costing £14 million and for sale for £50 million, some art is explicitly positioned as a media sensation and a market investment.

804 2009a Tania Bruguera presents *Generic Capitalism* at the multimedia conference "Our Literal Speed," a performance that visualizes the assumed bonds and networks of trust and likemindedness among its art-world audience by transgressing those very bonds.

810 2009b Jutta Koether shows "Lux Interior" at Reena Spaulings Gallery in New York, an exhibition that introduces performance and installation into the heart of painting's meaning: the impact of networks on even the most traditional of aesthetic mediums—painting— is widespread among artists in Europe and the United States.

818 2009c Harun Farocki exhibits a range of works on the subject of war and vision at the Ludwig Museum in Cologne and Raven Row in London that demonstrate the relationship between popular forms of new-media entertainment such as video games and the conduct of modern war.

824 2010a Ai Weiwei's large-scale installation *Sunflower Seeds* opens in the Turbine Hall of London's Tate Modern: Chinese artists respond to China's rapid modernization and economic growth with works that both engage with the country's abundant labor market and morph into social and mass-employment projects in their own right.

830 2010b French artist Claire Fontaine, whose "operation" by two human assistants is itself an explicit division of labor, dramatizes the economies of art in a major retrospective at the Museum of Contemporary Art in North Miami, Florida: the show marks the emergence of the avatar as a new form of artistic subjecthood.

836 2015 As Tate Modern, the Museum of Modern Art, and the Metropolitan Museum of Art plan further expansions, the Whitney Museum of American Art opens its new building, capping a period of international growth in exhibition space for modern and contemporary art including performance and dance.

842 Roundtable | The predicament of contemporary art

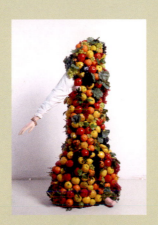

How to use this book

Art Since 1900 has been designed to make it straightforward for you to follow the development of art through the twentieth century and up to the present day. Here are the features that will help you find your way through the book.

Each entry centers on a key moment in the history of twentieth- and twenty-first-century art, indicated by the title at the head of the entry. It might be the creation of a groundbreaking work, the publication of a seminal text, the opening of a crucial exhibition, or another significant event. Where two or more entries appear in any one year, they are identified as 1900a, 1900b, and so on.

Picture references in the text direct you clearly to the illustration under discussion.

Symbols in the margin indicate that other related entries may be of interest. The corresponding cross-references at the foot of the page direct you to the relevant entries. These allow you to follow your own course through the book, to trace, for example, the history of photography or sculpture or the development of abstraction in its different forms.

2009 b

Jutta Koether shows "Lux Interior" at Reena Spaulings Gallery in New York, an exhibition that introduces performance and installation into the heart of painting's meaning: the impact of networks on even the most traditional of aesthetic mediums—painting—is widespread among artists in Europe and the United States.

With a characteristic flourish of perversity linking painting to pasta, the German artist Martin Kippenberger (1953–97) identified in an interview from 1990–1 the most important painterly problem to arise since Warhol's silk-screens of the sixties: "Simply to hang a painting on the wall and say that it's art is dreadful. The whole network is important! Even spaghettini…. When you say art, then everything possible belongs to it. In a gallery that is also the floor, the architecture, the color of the walls." In Kippenberger's work, which included painting and sculpture as well as many hybrid practices in between, the limits of an individual object were consistently challenged. Already in his first painting project of 1976–7, *One of You, a German in Florence* [1], Kippenberger displaced attention from singular works by rapidly executing one hundred canvases in grisaille, all the same size, that reproduced snapshots or newspaper clippings. His intention was to make enough paintings so that when piled up they would be as tall as him. Here painting enters several types of network at once: each individual canvas belonged to a "family grouping"; all were assimilated to the fluid economy of

photographic information, referencing the personal snapshot or the journalistic document; and the scale of the series was indexed to the physical characteristics of the artist—namely, his height—as well as his everyday activities, as marked by the choice of motifs that might be recorded by any avid, though eccentric, German resident in Florence.

If we take Kippenberger at his word, then, a significant question arises: How can painting incorporate the multiple networks that frame it? This late-twentieth-century problem, whose relevance has only increased with the turn of the twenty-first century and the growing ubiquity of digital networks, joins a sequence of modernist challenges to painting. Early in the last century, Cubism pushed the limits of what a coherent painterly mark could be by demonstrating the minimum requirements for visual coherence. Mid-twentieth-century gestural abstraction, epitomized by Abstract Expressionism, raised the issue of how representation may approach the status of pure matter—consisting of nothing but raw paint applied to canvas. And finally, during the sixties a whole range of photomechanical procedures pioneered by Pop and

1 • Martin Kippenberger, *Untitled* (from the series *One of You, a German in Florence*), 1976–7
Oil on canvas, each 50 × 60 (19¹¹⁄₁₆ × 23⅝)

▲ 1911, 1913, 1921a ● 1947b, 1949, 1951 ■ 1960c, 1964b, 1967c

Boxes throughout provide background information on key personalities, important concepts, and some of the issues surrounding the art of the day. Further elaboration of terms is available in the glossary at the back of the book.

The decade is indicated at the side of each page.

Further reading lists at the end of each entry enable you to continue your study by directing you to some of the key books and articles on the subject, including primary and secondary historical documents and recently published texts. A general bibliography and a list of useful websites at the back of the book provide additional resources for research.

The entry's date and name appears at the foot of each page.

Rrose Sélavy

One of the sketches Duchamp drew for the *Large Glass* and published in the *Green Box* shows the double field of the work with the upper area labeled "MAR" (short for *mariée* [bride]) and the lower one "CEL" (short for *célibataires* [bachelors]). With this personal identification with the protagonists of the *Glass*, (MAR + CEL = Marcel) Duchamp thought about assuming a feminine persona. As he told his interviewer, Pierre Cabanne:

Cabanne: *Rrose Sélavy was born in 1920, I think.*
Duchamp: *In effect, I wanted to change my identity, and the*

first idea that came to me was to take a Jewish name … I didn't find a Jewish name that I especially liked, or that tempted me, and suddenly I had an idea: why not change sex? It was much simpler. So the name Rrose Sélavy came from that …
Cabanne: *You went so far in your sex change as to have yourself photographed dressed a a woman.*
Duchamp: *It was Man Ray who did the photograph …*

Having stopped work on the *Glass* in 1923, Duchamp transferred his artistic enterprise to this new character and had business cards printed up giving his name and profession as "Rrose Sélavy, Precision Oculist." The works he went on to make as "oculist" were machines with turning optical disks—the *Rotary Demisphere* and the *Rotoreliefs*—as well as films, such as *Anemic Cinema*.

There is a way to understand Rrose Sélavy's enterprise as the undermining of the Kantian aesthetic system in which the work of art opens onto a collective visual space acknowledging, in effect, the simultaneity of points of view of all the spectators who are gathered to see it, a multiplicity whose appreciation for the work speaks with, as Kant would say, the universal voice. On the contrary, Duchamp's "precision optics" were, like the holes in the door of his installation *Etant données*, available to only one viewer at a time. Organized as optical illusions, they were clearly the solitary visual projection of the viewer placed in the right vector to experience them. As the *Rotoreliefs*—a set of printed cards—revolved like visual records on a phonograph turntable, their designs of slightly skewed concentric circles spiral to burgeon outward like a balloon inflating and then to reverse themselves into an inward, sucking movement. Some appeared like eyes or breasts, trembling in a phantom space; another sported a goldfish that seemed to be swimming in a basin whose plug had been pulled, so that the fish was being sucked down the drain. In this sense, Duchamp's switch to Rrose and her activities marks a turn from an interest in the mechanical (the Bachelor Machine, the Chocolate Grinder) to a concern for the optical.

Perspective had specifically located this viewer in its plotting of a ▲ precise vantage point. But both Cubism and Fauvism, by finding other means to unify the pictorial space, also address themselves to a unified human subject: the viewer / interpreter of the work.

The final implication of Duchamp's removal of his field of operations from the iconic to the indexical sign becomes clear in this context. For beyond its marking a break with "picturing" and a rejection of "skill," beyond its displacement of meaning from repeatable code to unique event, the index's aspect as shifter has implications for the status of the subject, of the one who says "I," in this case Duchamp "himself." For as the subject of the vast self-portrait assembled by *Tu m'*, Duchamp declares himself a disjunctive, fractured subject, split axially into the two facing poles of pronominal space, even as he would split himself sexually into the two opposite poles of gender in the many photographic self-

portraits he would make while in drag and sign "Rrose Sélavy" [5]. Taking up Rimbaud's "je est un autre" ("I is an other"), Duchamp's shattering of subjectivity was perhaps his most radical act. RK

FURTHER READING
Roland Barthes, "The Photographic Message" and "The Rhetoric of the Image," *Image / Music / Text* (New York: Hill and Wang, 1977)
Marcel Duchamp, *Salt Seller: The Writings of Marcel Duchamp (Marchand du Sel)*, eds Michel Sanouillet and Elmer Peterson (New York: Oxford University Press, 1973)
Thierry de Duve, *Pictorial Nominalism: On Duchamp's Passage from Painting to the Readymade*, trans. Dana Polan (Minneapolis: University of Minnesota Press, 1991)
Thierry de Duve (ed.), *The Definitively Unfinished Marcel Duchamp* (Cambridge, Mass.: MIT Press, 1991)
Rosalind Krauss, "Notes on the Index," *The Originality of the Avant-Garde and Other Modernist Myths* (Cambridge, Mass.: MIT Press, 1985)
Robert Lebel, *Marcel Duchamp* (New York: Grove Press, 1959)
Francis M. Naumann and Hector Obalk (eds), *Affect t ! Marcel.: The Selected Correspondence of Marcel Duchamp* (London: Thames & Hudson, 2000)

▲ 1906, 1907, 1911, 1912, 1921a

Preface: a reader's guide

This book is organized as a succession of important events, each keyed to an appropriate date, and can thus be read as a chronological account of twentieth- and twenty-first-century art. But, like the pieces of a large puzzle that can be transformed into a great variety of images, its 130 entries can also be arranged in different ways to suit the particular needs of individual readers.

First, some narratives might be constructed along national lines. For example, within the prewar period alone, the story of French art unfolds via studies of figurative sculpture, Fauvist painting, Cubist collage, and Surrealist objects, while German practice is traced in terms of Expressionist painting, Dada photomontage, Bauhaus design, and Neue Sachlichkeit (New Objectivity) painting and photography. The Russian avant-garde is followed from its early experiments with new forms and materials, through its direct involvement in political transformation, to its eventual suppression under Stalin. Meanwhile, British and American artists are tracked in their ambivalent oscillation between the demands of national idioms and the attractions of international styles.

As an alternative to such national narratives, the reader might trace transnational developments. For example, again in the prewar period, one might focus on the fascination with tribal objects, the emergence of abstract painting, or the spread of a Constructivist language of forms. The different incarnations of Dada from Zurich to New York, or the various engagements of modernist artists with design, might be compared. More generally, one might cluster entries that treat the great experiment that is modernism as such, or that discuss the virulent reactions against this idea, especially in totalitarian regimes. Mini-histories might be produced not only of the traditional forms of painting and sculpture, but also of new modes distinctive to twentieth- and twenty-first-century art, such as collaged and montaged images, found and readymade

objects, film and video, and digital technologies. For the first time in any survey, a discussion of photography—both in terms of its own development and as a force that radically transforms other media—is woven into the text.

A third approach might be to group entries according to thematic concerns, within the prewar or the postwar periods, or in ways that span both. For example, the impact of the mass media on modern art might be gauged from the first Futurist manifesto, published in a major newspaper, *Le Figaro*, in 1909, through the Situationist critique of consumer culture in France after World War II, to the rise of the artist as celebrity in our own time and the use of the avatar as an artistic strategy. Similarly, the institutions that shaped twentieth-century art might also be explored, either in close focus or in broad overview. For instance, one can review the signal school of modernist design, the Bauhaus, from its interwar incarnations in Germany to its postwar afterlife in the United States. Or one can follow the history of the art exhibition, from the Paris Salons before World War I, through the propagandistic displays of 1937 (including the "Degenerate 'Art'" ["Entartete 'Kunst'"] show staged by the Nazis), to the postwar forms of blockbuster exhibition and international survey (such as Documenta 5 in 1972 in Germany). The complicated relationship between art and politics in the twentieth and twenty-first centuries can be studied through any number of entries. One might also define an approach through readings in such topics as the relationships between prewar and postwar avant-gardes, or between modernist and postmodernist models of art.

Along with narratives of form and theme, other subtexts in the history of twentieth- and twenty-first-century art can be foregrounded. Especially important to the authors are the theoretical methods that have framed the manifold practices of this art. One such approach is psychoanalytic criticism, which focuses on the subjective effects of the work of art. Another method is the social history of art, which attends to

social, political, and economic contexts. A third seeks to clarify the intrinsic structure of the work—not only how it is *made* (in the formalist version of this approach) but also how it *means* (in its structuralist version). Lastly, poststructuralism is deployed in order to critique structuralism's description of communication as the neutral transmission of a message. For poststructuralists, such transmission (whether in a university or an art gallery) is never neutral, always doing the work of establishing the person with the "right" to speak. Many entries present test cases of these four methods, especially when their own development is related to that of the art at issue. For each mode of criticism, an introduction sketching its history and defining its terms is provided, while a fifth considers the impact of globalization on the practice of both art and art history.

As might be expected, these methods often clash: the subjective focus of psychoanalytic criticism, the contextual emphasis of the social history of art, the intrinsic concerns of formalist and structuralist accounts, and the poststructuralist attention to the artist's "right to speak" cannot easily be reconciled. In this book, these tensions are not masked by an unbroken story unified by a single voice; rather, they are dramatized by the five authors, each of whom has a different allegiance to these methods. In this regard, *Art Since 1900* is "dialogical," in the sense given to the term by Russian theorist Mikhail Bakhtin: each speech act is structured by the positions that it confronts, as a response to other speakers whom it moves to oppose or attempts to persuade. The marks of such dialogue are multiple in this book. They appear in the different types of perspective that one author might privilege, or in the different ways that a single subject—abstraction, say— might be treated by the various voices. This conversation is also carried on through the cross-references that act as signposts to the intersections between the entries. This "intertext" not only allows two different positions to

coexist but also, perhaps in relation to the third perspective provided by the reader, dialectically binds them.

Of course, with new orientations come new omissions. Certain artists and movements, addressed in previous textbooks, are scanted here, and every reader will see grievous exclusions—this is the case for each of the authors as well. But we also have the conviction that the richness of the conversation, as it illuminates different facets of the debates, struggles, breakthroughs, and setbacks of twentieth- and twenty-first-century art, compensates a little for the parts of the story that are left in ellipsis. Our use of the headline to introduce each entry acknowledges both the strengths and the weaknesses of our overall approach, for this telegraphic form can be seen either as a mere signal of a complex event—from which it is then severed—or as an emblematic marker of the very complexity of the history of which it is the evocative precipitate.

The authors wish to acknowledge the precedence of the pedagogical structure developed in Denis Hollier's *A New History of French Literature* and its importance for this text. It is now common practice—in publishing, in teaching, and in curating—to break the art of the twentieth century into two halves separated by World War II. We acknowledge this tendency with the option of the two-volume format; at the same time we believe that a crucial subject for any history of this art is the complex dialogue between prewar and postwar avant-gardes. To tell this story it is necessary to produce the full sweep of the twentieth century at once. But then such a panorama is also essential for the many other stories to which the five of us have lent our voices here.

Hal Foster
Rosalind Krauss
Yve-Alain Bois
Benjamin H. D. Buchloh
David Joselit

Introductions

In these five introductions, the authors of *Art Since 1900* set out some of the theoretical methods of framing the art of the twentieth and twenty-first centuries. Each describes the historical development of a particular methodology or set of ideas and explains its relevance to the production and reception of the art of the period.

The last hundred years or so have witnessed several major shifts in both private and public debates about art, its nature, and its functions. These shifts need to be considered in terms of other histories, too: with the emergence of new academic disciplines, new ways of thinking and speaking about cultural production coexist with new modes of expression.

We have written the following methodological introductions in order to identify and analyze the different conventions, approaches, and intellectual projects that underpin our project as a whole. Our intention has been to present the diverse theoretical frameworks that can be found in the book and to explain their relationship to the works and practices discussed in the individual entries. For that reason, each introduction begins with an overview of the mode of criticism, setting it firmly in its historical and intellectual context, before proceeding to a brief discussion of its relevance to the production and interpretation of art. Whether these five introductions are read as stand-alone essays or in conjunction with other texts dealing with the individual modes of criticism, they will inform and enhance understanding in ways that allow each reader to develop an individual approach to the book and to the art of the period.

1 Psychoanalysis in modernism and as method

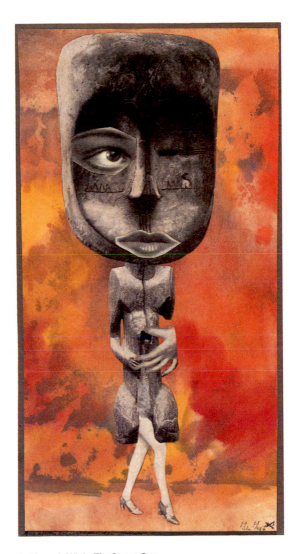

1 • Hannah Höch, *The Sweet One,*
***From an Ethnographic Museum*, c. 1926**
Photomontage with watercolor, 30 × 15.5 (11¹³⁄₁₆ × 6⅛)

In this collage—one of a series that combines found photographs of tribal sculpture and modern women—Höch plays on associations at work in psychoanalytic theory and modernist art: ideas of "the primitive" and the sexual, of racial others and unconscious desires. She exploits these associations to suggest the power of "the New Woman," but she also seems to mock them, literally cutting up the images, deconstructing and reconstructing them, exposing them as constructions.

Psychoanalysis was developed by Sigmund Freud (1856–1939) and his followers as a "science of the unconscious" in the early years of the twentieth century, at the same time that modernist art came into its own. As with the other interpretative methods presented in these introductions, psychoanalysis thus shares its historical ground with modernist art and intersects with it in various ways throughout the twentieth century. First, artists have drawn directly on psychoanalysis—sometimes to explore its ideas visually, as often in Surrealism in the twenties and thirties, and sometimes to critique them theoretically and politically, as often in feminism in the seventies and eighties. Second, psychoanalysis and modernist art share several interests—a fascination with origins, with dreams and fantasies, with "the primitive," the child, and the insane, and, more recently, with the workings of subjectivity and sexuality, to name only a few [1]. Third, many psychoanalytic terms have entered the basic vocabulary of twentieth- and twenty-first-century art and criticism (e.g., repression, sublimation, fetishism, the gaze). Here I will focus on historical connections and methodological applications, and, when appropriate, I will key them, along with critical terms, to entries in which they are discussed.

Historical connections with art

Psychoanalysis emerged in the Vienna of artists such as Gustav Klimt, Egon Schiele, and Oskar Kokoschka, during the decline of the Austro-Hungarian Empire. With the secession of such artists from the Art Academy, this was a time of Oedipal revolt in advanced art, with subjective experiments in pictorial expression that drew on regressive dreams and erotic fantasies. Bourgeois Vienna did not usually tolerate these experiments, for they suggested a crisis in the stability of the ego and its social institutions—a crisis that Freud was prompted to analyze as well.

This crisis was hardly specific to Vienna; in terms of its relevance to psychoanalysis, it was perhaps most evident in the attraction to things "primitive" on the part of modernists in France and Germany. For some artists this "primitivism" involved a "going-native" of the sort play-acted by Paul Gauguin in the South Seas. For others it was focused on formal revisions of Western conventions of representation, as undertaken, with the

2 • Meret Oppenheim, *Object* **(also called** *Fur-Lined Teacup* **and** *Déjeuner en fourrure***), 1936**
Fur-covered teacup, saucer, and spoon, height 7.3 (2⅞)

To make this work, Meret Oppenheim simply lined a teacup, saucer, and spoon bought in Paris with the fur of a Chinese gazelle. Mixing attraction and repulsion, this dis / agreeable work is quintessentially Surrealist, for it adapts the device of the found thing to explore the idea of "the fetish," which psychoanalysis understands as an unlikely object invested with a powerful desire diverted from its proper aim. Here art appreciation is no longer a matter of disinterested teatime propriety: it is boldly interrupted through a smutty allusion to female genitalia that forces us to think about the relation between aesthetics and erotics.

3 • André Masson, *Figure,* **1927**
Oil and sand, 46 × 33 (18⅛ × 13)

In the Surrealist practice of "automatic writing," the author, released from rational control, "took dictation" from his or her unconscious. André Masson's use of strange materials and gestural marks, sometimes almost dissolving the distinction between the figure and the ground, suggested one method to pursue "psychic automatism," opening up painting to new explorations not only of the unconscious but also of form and its opposite.

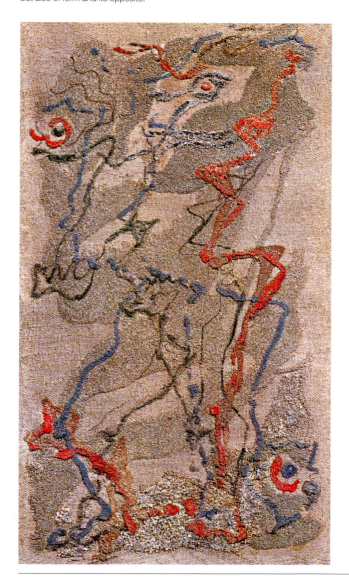

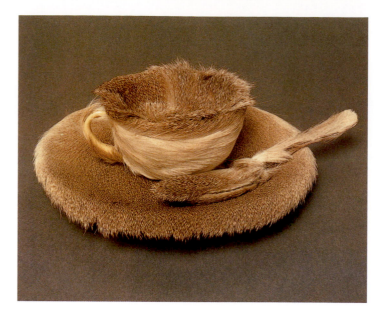

▲ aid of African objects, by Pablo Picasso and Henri Matisse in Paris. Yet almost all modernists projected onto tribal peoples a purity of artistic vision that was associated with the simplicity of instinctual life. This projection is the primitivist fantasy *par excellence* and psychoanalysis participated in it then even as it provides ways to question it now. (For example, Freud saw tribal peoples as somehow fixed in pre-Oedipal or infantile stages.)

Strange though it may seem today, for some modernists an interest in tribal objects shaded into involvement with the art of children and of the insane. In this regard, *Artistry of the Mentally Ill* (*Bildnerei der Geisteskranken*), a collection of works by psychotics
● presented in 1922 by Hans Prinzhorn (1886–1933), a German psychiatrist trained in psychoanalysis and art history alike, was of special importance to such artists as Paul Klee, Max Ernst, and
■ Jean Dubuffet. Most of these modernists (mis)read the art of the insane as though it were a secret part of the primitivist avant-garde, directly expressive of the unconscious and boldly defiant of all convention. Here psychoanalysts developed a more complicated understanding of paranoid representations as projections of desperate order, and of schizophrenic images as symptoms of radical self-dislocation. And yet such readings also have parallels in modernist art.

An important line of connection runs from the art of the insane, through the early collages of Ernst, to the definition of Surrealism as a disruptive "juxtaposition of two more or less disparate reali-
◆ ties," as presented by its leader André Breton [**2**]. Psychoanalysis influenced Surrealism in its conceptions of the image as a kind of dream, understood by Freud as a distorted writing-in-pictures of a displaced wish, and of the object as a sort of symptom, understood by Freud as a bodily expression of a conflicted desire; but there are several other affinities as well. Among the first to study Freud, the Surrealists attempted to simulate the effects of madness in automatic writing and art alike [**3**]. In his first "Manifesto of Surrealism" (1924), Breton described Surrealism as a "psychic automatism," a liberatory inscription of unconscious impulses "in the absence of

▲ 1903, 1907 ● 1922 ■ 1946 ◆ 1924, 1930b, 1931a, 1942b

4 • Karel Appel, *A Figure*, 1953
Oil and colored crayons on paper, 64.5 × 49 (25⅜ × 19¼)

After World War II an interest in the unconscious persisted among artists such as the Dutch painter Karel Appel, a member of Cobra (an acronym for the home bases of the group—Copenhagen, Brussels, Amsterdam); at the same time the question of the psyche was reframed by the horrors of the death camps and the atomic bombs. Like other groups, Cobra came to reject the Freudian unconscious explored by the Surrealists as too individualistic: as part of a general turn to the notion of a "collective unconscious" developed by Carl Jung, they explored totemic figures, mythic subjects, and collaborative projects in an often anguished search not only for a "new man" but for a new society.

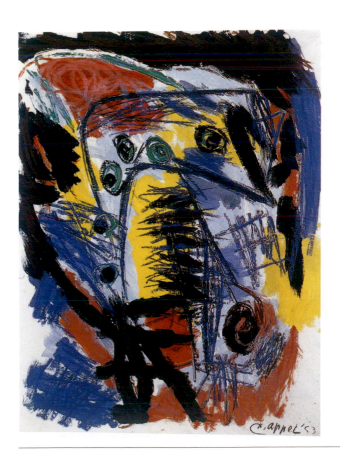

any control exercised by reason." Yet right here emerges a problem that has dogged the relation between psychoanalysis and art ever since: either the connection between psyche and art work is posited as too direct or immediate, with the result that the specificity of the work is lost, or as too conscious or calculated, as though the psyche could simply be illustrated by the work. (The other methods in this introduction face related problems of mediation and questions of causation; indeed, they vex all art criticism and history.) Although Freud knew little of modernist art (his taste was conservative, and his collection ran to ancient and Asian figurines), he knew enough to be suspicious of both tendencies. In his view, the unconscious was not liberatory—on the contrary—and to propose an art free of repression, or at least convention, was to risk psychopathology, or to pretend to do so in the name of a psychoanalytic art (this is why he once called the Surrealists "absolute cranks").

Nevertheless, by the early thirties the association of some modernist art with "primitives," children, and the insane was set, as was its affinity with psychoanalysis. At this time, however, these connections played into the hands of the enemies of this art, most catastrophically the Nazis, who in 1937 moved to rid the world ▲ of such "degenerate" abominations, which they also condemned as "Jewish" and "Bolshevik." Of course, Nazism was a horrific regression of its own, and it cast a pall over explorations of the unconscious well after World War II. Varieties of Surrealism lingered on in the postwar period, however, and an interest in the unconscious persisted among artists associated with *art informel,*
● Abstract Expressionism, and Cobra [4]. Yet, rather than the difficult mechanisms of the individual psyche explored by Freud, the focus fell on the redemptive archetypes of a "collective unconscious" imagined by Swiss psychiatrist Carl Jung (1875–1961), an old apostate of psychoanalysis. (For example, Jackson Pollock was involved in Jungian analysis in ways that affected his painting.)

Partly in reaction against the subjective rhetoric of Abstract Expressionism, much art of the sixties was staunchly antipsychological, concerned instead with ready-made cultural images, as in ■ Pop art, or given geometric forms, as in Minimalism. At the same time, in the involvement of Minimalist, Process, and Performance art with phenomenology there was a reopening to the bodily subject that prepared a reopening to the psychological subject in ◆ feminist art. This engagement was ambivalent, however, for even as feminists used psychoanalysis, they did so mostly in the register of critique, "as a weapon" (in the battle cry of filmmaker Laura Mulvey) directed at the patriarchal ideology that also riddled psychoanalysis. For Freud had associated femininity with passivity, and in his famous account of the Oedipus complex, a tangle of relations in which the little boy is said to desire the mother until threatened by the father, there is no parallel denouement for the little girl, as if in his scheme of things women cannot attain full subjecthood. And Jacques Lacan (1901–81), the French psychoanalyst who proposed an influential reading of Freud, identified woman as such with the lack represented by castration. Nonetheless, for many feminists Freud and Lacan provided the most telling account

▲ 1937a ● 1946, 1947b, 1949a, 1949b, 1957a ■ 1960c, 1964b, 1965 ◆ 1969, 1974, 1975a, 1977b

5 • Barbara Kruger, *Your Gaze Hits the Side of My Face*, 1981
Photographic silkscreen on vinyl, 139.7 × 104.1 (55 × 41)

Psychoanalysis helped some feminist artists in the eighties to critique power structures not only in high art but in mass culture too: particular attention was drawn to how images in both spheres are structured for a male heterosexual spectatorship—for a "male gaze" empowered with the pleasures of looking, with women mostly figuring as passive objects of this look. In her pieces of the period, the American artist Barbara Kruger juxtaposed appropriated images and critical phrases (sometimes subverted clichés) in order to question this objectification, to welcome women into the place of spectatorship, and to open up space for other kinds of image-making and viewing.

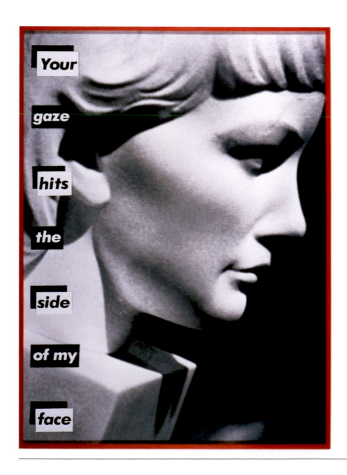

of the formation of the subject in the social order. If there is no natural femininity, these feminists argued, then there is also no natural patriarchy—only a historical culture fitted to the psychic structure, the desires and the fears, of the heterosexual male, and so vulnerable to feminist critique [**5, 6**]. Indeed, some feminists have insisted that the very marginality of women to the social order, as mapped by psychoanalysis, positions them as its most radical critics. By the nineties this critique was extended by gay and lesbian artists and critics concerned to expose the psychic workings of homophobia, as well by postcolonial practitioners concerned to

▲ mark the racialist projection of cultural others.

Approaches alternative to Freud

One can critique Freud and Lacan, of course, and still remain within the orbit of psychoanalysis. Artists and critics have had affinities with other schools, especially the "object-relations" psychoanalysis associated with Melanie Klein (1882–1960) and D. W. Winnicott (1896–1971) in England, which influenced such aestheticians as Adrian Stokes (1902–72) and Anton Ehrenzweig (1909–66) and, indirectly, the reception of such artists as Henry

● Moore and Barbara Hepworth. Where Freud saw pre-Oedipal stages (oral, anal, phallic, genital) that the child passes through, Klein saw positions that remain open into adult life. In her account these positions are dominated by the original fantasies of the child, involving violent aggression toward the parents as well as depressive anxiety about this aggression, with an oscillation between visions of destruction and reparation.

For some critics this psychoanalysis spoke to a partial turn in nineties art—away from questions of sexual desire in relation to

■ the social order, toward concerns with bodily drives in relation to life and death. After the moratorium on images of women in some feminist art of the seventies and eighties, Kleinian notions suggested a way to understand this reappearance of the body often in damaged form. A fascination with trauma, both personal and collective, reinforced this interest in the "abject" body, which also led artists and critics to the later writings of the French psychoanalyst Julia Kristeva (born 1941). Of course, social factors—the AIDS epidemic above

◆ all—also drove this pervasive aesthetic of mourning and melancholy. In the present, psychoanalysis remains a resource in art criticism and history, but its role in artmaking is far from clear.

Levels of Freudian criticism

Psychoanalysis emerged out of clinical work, out of the analysis of symptoms of actual patients (there is much controversy about how Freud manipulated this material, which included his own dreams), and its use in the interpretation of art carries the strengths as well as the weaknesses of this source. There is first the basic question of who or what is to occupy the position of the patient—the work, the artist, the viewer, the critic, or some combination or relay of all these. Then there arises the complicated issue of the different levels of a Freudian

▲ 1977b, 1989, 1993c, 1994a ● 1989, 1993c, 1994a ■ 1994a ◆ 1987

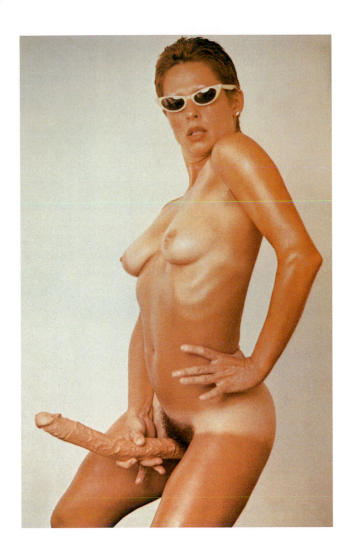

6 • Lynda Benglis, *Untitled*, 1974 (detail)
Color photograph, 25 × 26.5 (9⅞ × 10⅜)

With the rise of feminism in the sixties and seventies,
some artists attacked patriarchal hierarchies not only
in society in general but in the art world in particular:
psychoanalysis figured as both weapon—because it
offered profound insights into the relation between
sexuality and subjectivity—and target—because it tended
to associate women not only with passivity but also with
lack. In this photograph, used in a notorious advertisement
for a gallery show, the American artist Lynda Benglis
mocked the macho posturing of some Minimalist and
Postminimalist artists, as well as the increased marketing
of contemporary art; at the same time, she seized
"the phallus" in a way that both literalized its association
with plenitude and power and parodied it.

interpretation of art, which I will here reduce to three: symbolic readings, accounts of process, and analogies in rhetoric.

Early attempts in Freudian criticism were governed by symbolic readings of the art work, as if it were a dream to be decoded in terms of a latent message hidden behind a manifest content: "This is not a pipe; it is really a penis." This sort of criticism complements the kind of art that translates a dream or a fantasy in pictorial terms: art then becomes the encoding of a riddle and criticism its decoding, and the whole exercise is illustrational and circular. Although Freud was quick to stress that cigars are often just cigars, he too practiced this kind of deciphering, which fits in all too well with the traditional method of art history known as "iconography"—a reading back of symbols in a picture to sources in other kinds of texts—a method that most modernist art worked to foil (through abstraction, techniques of chance, and so on). In this regard, the Italian historian Carlo Ginzburg has demonstrated an epistemological affinity between psychoanalysis and art history based in connoisseurship. For both discourses (which developed, in modern form, at roughly the same time) are concerned with the symptomatic trait or the telling detail (an idiosyncratic gesture of the hands, say) that might reveal, in psychoanalysis, a hidden conflict in the patient and, in connoisseurship, the proper attribution of the work to an artist.

In such readings the artist is the ultimate source to which the symbols point: the work is taken as his symptomatic expression, and it is used as such in the analysis. Thus in his 1910 study *Leonardo da Vinci and a Memory of his Childhood*, Freud leads us from the enigmatic smiles of his *Mona Lisa* and Virgin Marys to posit in the artist a memory regarding his long-lost mother. In this way Freud and his followers looked for signs of psychic disturbances in art (his predecessor Jean-Martin Charcot did the same). This is not to say that Freud sees the artist as psychopathological; in fact he implies that art is one way to avoid this condition. "Art frees the artist from his fantasies," the French philosopher Sarah Kofman comments, "just as 'artistic creation' circumvents neurosis and takes the place of psychoanalytic treatment." But it is true that such Freudian criticism tends to "psychobiography," that is, to a profiling of the artist in which art history is remodeled as psychoanalytic case study.

If symbolic readings and psychobiographical accounts can be reductive, this danger may be mitigated if we attend to other aspects of Freud. For most of the time Freud understands the sign less as symbolic, in the sense of directly expressive of a self, a meaning, or a reality, than as symptomatic, a kind of allegorical emblem in which desire and repression are intertwined. Moreover, he does not see art as a simple revision of preexisting memories or fantasies; apart from other things, it can also be, as Kofman suggests, an "originary 'substitute'" for such scenes, through which we come to know them *for the first time* (this is what Freud attempts in his Leonardo study). Finally, psychobiography is put into productive doubt by the very fact that the psychoanalytic account of the unconscious, of its disruptive effects, puts all intentionality—all authorship, all biography—into productive doubt too.

Freudian criticism is not only concerned with a symbolic decoding of hidden meanings, with the semantics of the psyche. Less obviously, it is also involved with the dynamics of these processes, with an understanding of the sexual energies and unconscious forces that operate in the making as well as the viewing of art. On this second level of psychoanalytic interpretation, Freud revises the old philosophical concept of "aesthetic play" in terms of his own notion of "the pleasure principle," which he defined, in "Two Principles of Mental Functioning" (1911), in opposition to "the reality principle":

The artist is originally a man [sic] who turns from reality because he cannot come to terms with the demand for the renunciation of instinctual satisfaction as it is first made, and who then in phantasy-life allows full play to his erotic and ambitious wishes. But he finds a way of return from this world of phantasy back to reality; with his special gifts he moulds his phantasies into a new kind of reality, and men concede them a justification as valuable reflections of actual life. Thus by a certain path he actually becomes the hero, king, creator, favorite he desired to be, without pursuing the circuitous path of creating real alterations in the outer world. But this he can only attain because other men feel the same dissatisfaction as he with the renunciation demanded by reality, and because this dissatisfaction, resulting from the displacement of the pleasure-principle by the reality-principle, is itself a part of reality.

Three years before, in "Creative Writers and Day-Dreaming" (1908), Freud had speculated on how the artist overcomes our resistance to this performance, which we might otherwise deem solipsistic, if not simply inappropriate:

[H]e bribes us by the purely formal—that is, aesthetic—yield of pleasure which he offers us in the presentation of his phantasies. We give the name incentive bonus or fore-pleasure to a yield of pleasure such as this, which is offered to us so as to make possible the release of still greater pleasure arising from deeper psychical sources. . . . [O]ur actual enjoyment of an imaginative work proceeds from a liberation of tensions in our minds.

Let us review some of the (pre)conceptions in these statements. First, the artist avoids some of the "renunciations" that the rest of us must accept, and indulges in some of the fantasies that we must forgo. But we do not resent him for this exemption for three reasons: his fictions reflect reality nonetheless; they are born of the same dissatisfactions that we feel; and we are bribed by the pleasure that we take in the resolution of the formal tensions of the work, a pleasure that opens us to a deeper sort of pleasure—in the resolution of the psychic tensions within us. Note that for Freud art ▲ originates in a turn from reality, which is to say that it is fundamentally conservative in relation to the social order, a small aesthetic compensation for our mighty instinctual renunciation. Perhaps this

is another reason why he was suspicious of modernist art, concerned as much of it is not to "sublimate" instinctual energies, to divert them from sexual aims into cultural forms, but to go in the opposite direction, to "desublimate" cultural forms, to open them up to these disruptive forces.

Dreams and fantasies

While the semantics of symbolic interpretation can be too particular, this concern with the dynamics of aesthetic process can be too general. A third level of Freudian criticism may avoid both extremes: the analysis of the rhetoric of the art work in analogy with such visual productions of the psyche as dreams and fantasies. Again, Freud understood the dream as a compromise between a wish and its repression. This compromise is negotiated by the "dream-work," which disguises the wish, in order to fool further repression, through "condensation" of some of its aspects and "displacement" of others. The dream-work then turns the distorted fragments into visual images with an eye to "considerations of representability" in a dream, and finally revises the images to insure that they hang together as a narrative (this is called "secondary revision"). This rhetoric of operations might be brought to bear on the production of some pictures—again, the Surrealists thought so— but there are obvious dangers with such analogies as well. Even when Freud and his followers wrote only about art (or literature), they were concerned to demonstrate points of psychoanalytic theory first and to understand objects of artistic practice second, so that forced applications are built into the discourse, as it were.

Yet there is a more profound problem with analogies drawn between psychoanalysis and visual art. With his early associate Josef Breuer (1842–1925) Freud founded psychoanalysis as a "talking cure"—that is, as a turn away from the visual theater of his teacher, the French pathologist and neurologist Jean-Martin Charcot (1825–93), who staged the symptomatic bodies of female hysterics in a public display at the Salpêtrière Hospital in Paris. The technical innovation of psychoanalysis was to attend to symptomatic *language*—not only of the dream as a form of writing but also of slips of the tongue, the "free association" of words by the patient, and so on. Moreover, for Freud culture was essentially a working out of the conflicted desires rooted in the Oedipus complex, a working out that is primarily narrative, and it is not clear how such narrative might play out in static forms like painting, sculpture, and the rest. These emphases alone render psychoanalysis ill-suited to questions of visual art. Furthermore, the Lacanian reading of Freud is militantly linguistic; its celebrated axiom—"the unconscious is structured like a language"—means that the psychic processes of condensation and displacement are structurally one with the linguistic tropes of "metaphor" and "metonymy." No analogy in rhetoric, therefore, would seem to bridge the categorical divide between psychoanalysis and art.

And yet, according to both Freud and Lacan, the crucial events in subject formation are *visual* scenes. For Freud the ego is first

▲ Introduction 3

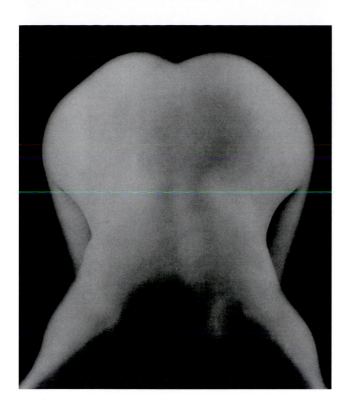

a bodily image, which, for Lacan in his famous paper on "The Mirror Stage" (1936/49), the infant initially encounters in a reflection that allows for a fragile coherence—a visual coherence as an image. The psychoanalytic critic Jacqueline Rose also alerts us to the "staging" of such events as "moments in which perception *founders* … or in which pleasure in looking tips over into the register of *excess*." Her examples are two traumatic scenes that psychoanalysis posits for the little boy. In the first scene he discovers sexual difference—that girls do not have penises and hence that he may lose his—a perception that "founders" because it implies this grave threat. In the second scene he witnesses sexual intercourse between his parents, which fascinates him as a key to the riddle of his own origin. Freud called these scenes "primal fantasies"—primal both because they are fundamental and because they concern origins. As Rose suggests, such scenes "demonstrate the complexity of an essentially visual space" in ways that can be "used as theoretical prototypes to unsettle our certainties once again"—as indeed they were used, to different ends, in ▲ some Surrealist art of the twenties and thirties [7] and in some feminist art of the seventies and eighties. The important point to emphasize, though, is this: "Each time the stress falls on a problem of seeing. The sexuality lies less in the content of what is seen than in the subjectivity of the viewer." This is where psychoanalysis has the most to offer the interpretation of art, modernist or other. Its account of the effects of the work on the subject and the artist as well as on the viewer (including the critic) places the work, finally, in the position of the analyst as much as the analyzed.

In the end we do well to hold to a double focus: to view psychoanalysis historically, as an object in an ideological field often shared with modernist art, and to apply it theoretically, as a method to understand relevant aspects of this art, to map pertinent parts of the field. This double focus allows us to critique psychoanalysis even as we apply it. First and last, however, this project will be complicated—not only by the difficulties in psychoanalytic speculation, but also by the controversies that always swirl around it. Some of the clinical work of Freud and others was manipulated, to be sure, and some of the concepts are bound up with science that is no longer valid—but do these facts invalidate psychoanalysis as a mode of interpretation of art today? As with the other methods introduced here, the test will be in the fit and the yield of the arguments that we make. And here, as the psychoanalytic critic Leo Bersani reminds us, our "moments of theoretical collapse" may be inseparable from our moments of "psychoanalytic truth."

7 • Lee Miller, *Nude Bent Forward*, Paris, c. 1931
Psychoanalysis is concerned with traumatic scenes, whether actual or imagined, that mark the child profoundly—scenes where he or she discovers sexual difference, for example, scenes that are often visual but also often uncertain in nature. At different times in the twentieth century, artists, such as the Surrealists in the twenties and thirties and feminists in the seventies and eighties, have drawn on such images and scenarios as ways to trouble assumptions about seeing, expectations about gender, and so on. In this photograph by the American artist Lee Miller, a sometime associate of the Surrealists, it is not immediately clear what we see: A body? A male or a female? Or some other category of being, imaging, and feeling?

FURTHER READING
Leo Bersani, *The Freudian Body: Psychoanalysis and Art* (New York: Columbia University Press, 1986)
Sigmund Freud, *Art and Literature*, trans. James Strachey (London: Penguin, 1985)
Sarah Kofman, *The Childhood of Art: An Interpretation of Freud's Aesthetics*, trans. Winifred Woodhull (New York: Columbia University Press, 1988)
Jean Laplanche and J.-B. Pontalis, *The Language of Psychoanalysis*, trans. Donald Nicholson-Smith (New York: W. W. Norton, 1973)
Jacqueline Rose, *Sexuality in the Field of Vision* (London: Verso, 1986)

Hal Foster

▲ 1924, 1930b, 1931a, 1975a

2 The social history of art: models and concepts

Recent histories of art comprise a number of distinct critical models (for example, formalism, structuralist semiotics, psychoanalysis, social art history, and feminism) that have been merged and integrated in various ways, in particular in the work of American and British art historians since the seventies. This situation sometimes makes it difficult, if not altogether pointless, to insist on methodological consistency, let alone on a singular methodological position. The complexity of these various individual strands and of their integrated forms points firstly to the problematic nature of any claim that one particular model should be accepted as exclusively valid or as dominant within the interpretative processes of art history. Our attempts to integrate a broad variety of methodological positions also efface the earlier theoretical rigor that had previously generated a degree of precision in the process of historical analysis and interpretation. That precision now seems to have been lost in an increasingly complex weave of methodological eclecticism.

The origins of the methodologies

All these models were initially formulated as attempts to displace earlier humanist (subjective) approaches to criticism and interpretation. They had been motivated by the desire to position the study of all types of cultural production (such as literature or the fine arts) on a more solidly scientific basis of method and insight, rather than have criticism remain dependent on the various more-or-less subjective approaches of the late nineteenth century, such as the biographistic, psychologistic, and historicist survey methods.

▲ Just as the early Russian Formalists made Ferdinand de Saussure's linguistic structure the matrix of their own efforts to understand the formation and functions of cultural representation, subsequent historians who attempted to interpret works of art in psychoanalytic terms tried to find a map of artistic subject

● formation in the writings of Sigmund Freud. Proponents of both models argued that they could generate a verifiable understanding of the processes of aesthetic production and reception, and promised to anchor the "meaning" of the work of art solidly in the operations of either the conventions of language and/or the system of the unconscious, arguing that aesthetic or poetic

meaning operated in a manner analogous to other linguistic conventions and narrative structures (e.g., the folktale), or, in terms of the unconscious, as in Freud's and Carl Jung's theories, analogous to the joke and the dream, the symptom and the trauma.

The social history of art, from its very beginning in the first decades of the twentieth century, had a similar ambition to make the analysis and interpretation of works of art more rigorous and verifiable. Most importantly, the early social historians of art (Marxist scholars like the Anglo-German Francis Klingender [1907–55] and the Anglo-Hungarian Frederick Antal [1887–1954]) tried to situate cultural representation within the existing communication structures of society, primarily within the field of ideological production under the rise of industrial capitalism. After all, social art history's philosophical inspiration was the scientificity of Marxism itself, a philosophy that had aimed from the very beginning not only to analyze and interpret economic, political, and ideological relations, but also to make the writing of history itself—its historicity— contribute to the larger project of social and political change.

This critical and analytical project of social art history formulated a number of key concepts that I will discuss further: I shall also try to give their original definitions, as well as subsequent modifications to these concepts, in order to acknowledge the increasing complexity of the terminology of social art history, which results partially from the growing differentiation of the philosophical concepts of Marxist thought itself. At the same time, it may become apparent that some of these key concepts are presented not because they are important in the early years of the twenty-first century, but, rather, because of their obsolescence, withering away in the present and in the recent past. This is because the methodological conviction of certain models of analysis has been just as overdetermined as that of all the other methodological models that have temporarily governed the interpretation and the writing of art history at different points in the twentieth century.

Autonomy

▲ German philosopher and sociologist Jürgen Habermas (born 1929) has defined the formation of the bourgeois public sphere in general and the development of cultural practices within that

**1 • John Heartfield, "Hurray, the Butter is Finished!",
cover for *AIZ*, December 19, 1935**
Photomontage, 38 × 27 (15¼ × 10¾)

The work of John Heartfield, along with that of Marcel
Duchamp and El Lissitzky, demarcates one of the most
important paradigm shifts in the epistemology of
twentieth-century modernism. Refiguring photomontage
and constructing new textual narratives, it established
the only model for artistic practice as communicative
action in the age of mass-cultural propaganda.
Denounced as such by the intrinsically conservative
ideologies of formalists and modernists defending
obsolete models of autonomy, it addressed in fact
the historical need for a change of audiences and of the
forms of distribution. Inevitably, it became the singular,
most important example of counterpropaganda to
the hegemonic media apparatus of the thirties, the only
voice in the visual avant-garde to oppose the rise of
fascism as a late form of imperialist capitalism.

sphere as social processes of subjective differentiation that lead to
the historical construction of bourgeois individuality. These
processes guarantee the individual's identity and historical status
as a self-determining and self-governing subject. One of the neces-
sary conditions of bourgeois identity was the subject's capacity to
experience the autonomy of the aesthetic, to experience pleasure
without interest.

This concept of aesthetic autonomy was as integral to the differ-
entiation of bourgeois subjectivity as it was to the differentiation of
cultural production according to its proper technical and proce-
dural characteristics, eventually leading to the modernist orthodoxy
of medium-specificity. Inevitably then, autonomy served as a foun-
dational concept during the first five decades of European
modernism. From Théophile Gautier's program of *l'art pour l'art*
and Édouard Manet's conception of painting as a project of percep-
tual self-reflexivity, the aesthetics of autonomy culminate in the
poetics of Stéphane Mallarmé in the 1880s. Aestheticism conceiving
the work of art as a purely self-sufficient and self-reflexive
experience—identified by Walter Benjamin as a nineteenth-
century theology of art—generated, in early-twentieth-century
formalist thought, similar conceptions that would later become the
doxa of painterly self-reflexivity for formalist critics and historians.
These ranged from Roger Fry's responses to Postimpressionism—
in particular the work of Paul Cézanne—to Daniel-Henry
Kahnweiler's neo-Kantian theories of Analytical Cubism, to the
work of Clement Greenberg (1909–94) in the postwar period. Any
attempt to transform autonomy into a transhistorical, if not onto-
logical precondition of aesthetic experience, however, is profoundly
problematic. It becomes evident upon closer historical inspection
that the formation of the concept of aesthetic autonomy itself was
far from autonomous. This is first of all because the aesthetics of
autonomy had been determined by the overarching philosophical
framework of Enlightenment philosophy (Immanuel Kant's [1724–
1804] concept of disinterestedness) while it simultaneously
operated in opposition to the rigorous instrumentalization of expe-
rience that emerged with the rise of the mercantile capitalist class.

Within the field of cultural representation, the cult of autonomy
liberated linguistic and artistic practices from mythical and reli-
gious thought just as much as it emancipated them from the
politically adulatory service and economic dependency under the
auspices of a rigorously controlling feudal patronage. While the
cult of autonomy might have originated with the emancipation of
bourgeois subjectivity from aristocratic and religious hegemony,
autonomy also saw the theocratic and hierarchical structures of
that patronage as having their own reality. The modernist aesthetic
of autonomy thus constituted the social and subjective sphere from
within which an opposition against the totality of interested activi-
ties and instrumentalized forms of experience could be articulated
in artistic acts of open negation and refusal. Paradoxically,
however, these acts served as opposition and—in their ineluctable
condition as extreme exceptions from the universal rule—they
confirmed the regime of total instrumentalization. One might have

▲ 1935 ● 1906, 1911, 1942a, 1960b

2 • El Lissitzky and Sergei Senkin, *The Task of the Press is the Education of the Masses*, 1928
Photographic frieze for the international exhibition "Pressa," Cologne

Like Heartfield, El Lissitzky transformed the legacies of collage and photomontage according to the needs of a newly industrialized collective. Especially in the new genre of exhibition design, which he developed in the twenties in works such as the Soviet Pavilion for the international exhibition "Pressa," it became evident that Lissitzky was one of the first (and few) artists of the twenties and thirties to understand that the spaces of public architecture (that is, of simultaneous collective reception) and the space of public information had collapsed in the new spaces of the mass-cultural sphere. Therefore Lissitzky, an exemplary "artist-as-producer," as Walter Benjamin would identify the artist's new social role, would situate his practice within the very parameters and modes of production of a newly developing proletarian public sphere.

to formulate the paradox that an aesthetics of autonomy is thus the highly instrumentalized form of noninstrumentalized experience under liberal bourgeois capitalism.

Actual study of the critical phase of the aesthetic of autonomy in the nineteenth century (from Manet to Mallarmé) would recognize that this very paradox is the actual formative structure of their pictorial and poetic genius. Both define modernist representation as an advanced form of critical self-reflexivity and define their hermetic artifice in assimilation and in opposition to the emerging mass-cultural forms of instrumentalized representation. Typically, the concept of autonomy was both formed by and oppositional to the instrumental logic of bourgeois rationality, rigorously enforcing the requirements of that rationality within the sphere of cultural production through its commitment to empirical criticality. Thereby an aesthetics of autonomy contributed to one of the most fundamental transformations of the experience of the work of art, initiating the shift that Walter Benjamin in his essays of the thirties called the

historical transition from cult-value to exhibition-value. These essays have come to be universally considered as the founding texts of a philosophical theory of the social history of art.

The concept of autonomy also served to idealize the new distribution form of the work of art, now that it had become a free-floating commodity on the bourgeois market of objects and luxury goods. Thus autonomy aesthetics was engendered by the capitalist logic of commodity production as much as it opposed that logic. In fact, the Marxist aesthetician Theodor W. Adorno (1903–69) still maintained in the late sixties that artistic independence and aesthetic autonomy could, paradoxically, be guaranteed only in the commodity structure of the work of art.

Antiaesthetic

Peter Bürger (born 1936), in his important—although problematic—essay, *Theory of the Avant-Garde* (1974), argued that the new spectrum of antiaesthetic practices in 1913 arose as a contestation of autonomy aesthetics. Thus—according to Bürger—the historical avant-gardes after Cubism universally attempted to "integrate art with life" and to challenge the autonomous "institution of art." Bürger perceives this project of the antiaesthetic to be at the center of the revolts of Dadaism, Russian Constructivism, and French Surrealism. Yet, rather than focusing on a nebulously conceived integration of art and life (an integration never satisfactorily defined at any point in history) or on a rather abstract debate on the nature of the institution of art, it seems more productive to focus here on the very strategies that these avant-garde practitioners themselves had propagated: in particular, strategies to initiate fundamental changes in the conception of audience and spectatorial agency, to reverse the bourgeois hierarchy of aesthetic exchange-value and use-value, and most importantly perhaps, to conceive of cultural practices for a newly emerging internationalist proletarian public sphere within the advanced industrial nation states.

Such an approach would not only allow us to differentiate these avant-garde projects more adequately, but would also help us understand that the rise of an aesthetic of technical reproduction (in diametrical opposition to an aesthetic of autonomy) emerges at that very moment of the twenties when the bourgeois public sphere begins to wither away. It is at first displaced by the progressive forces of an emerging proletarian public sphere (as was the case in the early phases of the Soviet Union and the Weimar Republic), only to be followed, of course, by the rise of the mass-cultural public sphere, either in its totalitarian fascist or state-socialist versions in the thirties or by its postwar regimes of the culture industry and of spectacle, emerging with the hegemony of the United States and a largely dependent culture of European reconstruction.

The antiaesthetic dismantles the aesthetics of autonomy on all levels: it replaces originality with technical reproduction, it destroys a work's aura and the contemplative modes of aesthetic experience and replaces these with communicative action and aspirations toward simultaneous collective perception. The antiaesthetic (such as the work of John Heartfield [1]) defines its artistic practices as temporary and geopolitically specific (rather than as transhistorical), as participatory (rather than as a unique emanation of an exceptional form of knowledge). The antiaesthetic also operates as a utilitarian aesthetic (e.g., in the work of the Soviet Productivists [2]), situating the work of art in a social context where it assumes a variety of productive functions such as information and education or political enlightenment, serving the needs of a cultural self-constitution for the newly emerging audiences of the industrial proletariat who were previously excluded from cultural representation on the levels of both production and reception.

Class, agency, and activism

The central premises of Marxist political theory had been the concepts of class and class-consciousness—the most important factors to drive forward the historical process. Classes served in different moments of history as the agents of historical, social, and political change (e.g., the aristocracy, the bourgeoisie, the proletariat, and the most powerful class in the twentieth century, the *petite bourgeoisie,* paradoxically the most neglected by classical Marxist accounts). It had been Marx's argument that class itself was defined by one crucial condition: a subject's situation in relation to the means of production.

Thus, privileged access to (or, more decisively, controlling ownership of) the means of production was the constitutive condition of bourgeois class identity in the later eighteenth and the entire nineteenth centuries. In contrast, during the same period, the conditions of proletarianization identify those subjects who will remain forever economically, legally, and socially barred from access to the means of production (which would, of course, also include the means of education and the acquisition of improved professional skills).

Questions concerning the concept of class are central to the social history of art, ranging from the class identity of the artist to whether cultural solidarity or mimetic artistic identification with the struggles of the oppressed and exploited classes of modernity can actually amount to acts of political support for revolutionary or oppositional movements. Marxist political theorists have often regarded that kind of cultural class alliance with considerable skepticism. Yet this mode of class alliance determined practically all politically motivated artistic production of modernity, since very few, if any, artists and intellectuals had actually emerged from the conditions of proletarian existence at that time. Class identity becomes all the more complicated when considering how the consciousness of individual artists might well have become radicalized at certain points (e.g., the revolution of 1848, the revolutions of 1917, or the anti-imperialist struggles of 1968) and artists might then have assumed positions of solidarity with the oppressed classes of those historical moments [3]. Slightly later, however, in the wake of their cultural assimilation, the same artists might have assumed positions of complicit or active affirmation of the ruling order and simply served as the providers of cultural legitimation.

▲ 1916a, 1920, 1921b, 1924, 1930b, 1931a ● 1921b, 1923, 1925b, 1930a ■ 1934a, 1937a, 1957a, 1960c ▲ 1920, 1937c ● 1921b

3 • Tina Modotti, *Workers' Demonstration,
Mexico, May 1*, 1929
Platinum print, 20.5 × 18 (8⅛ × 7⅛)

The work of the Italian-American artist Modotti in Mexico
gives evidence of the universality of the political and social
commitment among radical artists of the twenties and
thirties. Abandoning her training as a "straight" modernist
photographer in the mold of Edward Weston, Modotti
reoriented herself to make photography a weapon in the
political struggle of the Mexican peasant and working
class against the eternal deferrals and deceptions of
the country's oligarchic rulers. Expanding the tradition
of the *Taller Grafico Popular* to address that class now
with the means of photographic representation, she
nevertheless understood the necessity of making the
regionally specific and uneven development of forms
of knowledge and artistic culture the basis of her work.
Accordingly, Modotti never adopted the seemingly more
advanced forms of political photomontage, but retained
the bonds of realist depiction necessary for activist
political messages in the geopolitical context in which
she had situated herself. At the same time, as the image
Workers' Demonstration signals, she was far from falling
into the conciliatory and compensatory realisms of
"straight" and "New Objective" photography. What would
have been merely a modernist grid of serially repeated
objects of industrial manufacture in the work of her
historical peers (such as Alfred Renger-Patzsch) becomes
one of the most convincing photographic attempts
of the twenties and thirties to depict the social presence
and political activism of the working and peasant
class masses as the actual producers of a country's
economic resources.

This also points to the necessary insight that the registers of
artistic production and their latent or manifest relationships to
political activism are infinitely more differentiated than argu-
ments for the politicization of art might generally have assumed.
We are not simply confronted with an alternative between a politi-
cally conscious or activist practice on the one hand, and a merely
affirmative, hegemonic culture (as the Italian Marxist philosopher
and aesthetician Antonio Gramsci [1891–1937] called it) on the
other. Yet, the function of hegemonic culture is clearly to sustain
power and legitimize the perceptual and behavioral forms of the
ruling class through cultural representation, while oppositional
cultural practices articulate resistance to hierarchical thought,
subvert privileged forms of experience, and destabilize the ruling
regimes of vision and perception just as they can also massively
and manifestly destabilize governing notions of hegemonic power.

If we accept that some forms of cultural production can assume
the role of agency (i.e., that of information and enlightenment,
that of criticality and counterinformation), then the social history
of art faces one of its most precarious insights, if not a condition of
crisis: if it were to align its aesthetic judgment with the condition
of political solidarity and class alliance, it would inevitably be
left with only a few heroic figures in whom such a correlation
between class-consciousness, agency, and revolutionary alliance
could actually be ascertained. These examples would include
Gustave Courbet and Honoré Daumier in the nineteenth century,
▲ Käthe Kollwitz and John Heartfield in the first half of the twen-
● tieth century, and artists such as Martha Rosler [4], Hans Haacke
[6], and Allan Sekula in the second half of the twentieth century.

Thus, in recognizing that compliance with class interests and
political revolutionary consciousness can at best be considered an
exceptional rather than a necessary condition within the aesthetic
practices of modernity, it leaves the social art historian with a diffi-
cult choice. That is, either to exclude from consideration most actual
artistic practices of any particular moment of modernism, dis-
regarding both the artists and their production because of their lack
of commitment, class-consciousness, and political correctness, or to
recognize the necessity for numerous other criteria (beyond political
and social history) to enter the process of historical and critical analysis.

Since the proletarian's only means of survival is the sale of his or
her own labor like any other commodity, producing a phenomenal
accretion of surplus value to the entrepreneurial bourgeois or to
the corporate enterprise by supplying the subject's labor power, it
is, therefore, the very condition of labor and the laborer that radical
artists from the nineteenth century onward, from Gustave Courbet
■ to the Productivists of the twenties, confront. For the most part,
however, they confront it not on the level of iconography (in fact,
the almost total absence of the representation of alienated labor is
the rule of modernism) but rather with the perpetual question of
whether the labor of industrial production and the labor of cultural
production can and should be related, and, if so, how—as analo-
gous? as dialectical opposites? as complementary? as mutually
exclusive? Marxist attempts to theorize this relationship (and the

▲ 1920, 1937c ● 1971, 1972b, 1984a ■ 1921b

4 • Martha Rosler, *Red Stripe Kitchen*, from the series *Bringing the War Home: House Beautiful*, 1967–72

Photomontage printed as color photograph, 61 × 50.8 (24 × 20)

Rosler is one of the very few artists in the postwar period to have taken up the legacies of the political photomontage work of the thirties. Her series *Bringing the War Back Home: House Beautiful*, begun in 1967, explicitly responds to both a historical and an artistic situation. First of all, the work participated in the growing cultural and political opposition against the imperialist American war in Vietnam. Rather than creating the works as individual photomontages, Rosler conceived them as a series for reproduction and dissemination in a number of antiwar and countercultural journals in order to increase the visibility and impact of the images. She had clearly understood Heartfield's legacy and the dialectics of distribution form and mass-cultural iconography. Second, Rosler explicitly countered the Conceptualist's claim that photography should merely serve as a neutral document of analytical self-criticality, or as an indexical trace of the spatio-temporal stagings of the subject. Rather, she identified photography as *one* of several discursive tools in the production of ideology in the mass-cultural arsenal. By inserting sudden documentary images of the war in Vietnam into the seemingly blissful and opulent world of American domesticity, Rosler not only reveals the intricate intertwinement of domestic and militaristic forms of advanced capitalist consumption, but also manifestly challenges the credibility of photography as a truthful carrier of authentic information.

social art historian's attempts to come to terms with these theorizations) span an extreme range: from a productivist–utilitarian aesthetic that affirms the constitution of the subject as necessary in the production of use-value (as in the Soviet Productivists, the German Bauhaus, and the De Stijl movements) to an aesthetic of ludic counterproductivity (as in the simultaneous practices of Surrealism) which negates labor-as-value and denies it any purchase whatsoever on the territory of art. Such an aesthetic regards artistic practice as the one experience where the possibility of historically available forms of unalienated and uninstrumentalized existence shine forth, whether for the first time or as celebratory reminiscences of the bliss of rituals, games, and child's play.

It is no accident, then, that modernism has mostly avoided the actual representation of alienated labor, except for the work of great activist photographers such as Lewis Hine, where the abolition of child labor was the driving agenda of the project. In contrast, whenever painting or photography in the twentieth century celebrated the labor force or the forceful laborer, one could—and can—be sure of being in the company of totalitarian ideologies, whether fascist, Stalinist, or corporate. The heroicization of the body subjected to alienated physical labor serves to instill collective respect for intolerable conditions of subjectivation, and in a false celebration of that labor it also serves to naturalize that which should be critically analyzed in terms of its potential transformation, if not its final abolition. Conversely, the all-too-easy acceptance of artistic practices as mere playful opposition fails to recognize not only the pervasiveness of alienated labor as a governing form of collective experience, but also prematurely accepts the relegation of artistic practice to merely a pointless exemption from the reality principle altogether.

Ideology: reflection and mediation

The concept of ideology played an important role in the aesthetics of György Lukács (1885–1971), who wrote one of the most cohesive Marxist literary aesthetic theories of the twentieth century. Although rarely addressing artistic visual production, Lukács's theories had a tremendous impact on the formation of social art history in its second phase of the forties and fifties, in particular on the work of his fellow Hungarian Arnold Hauser (1892–1978) and the Austrian Marxist Ernst Fischer (1889–1972).

Lukács's key concept was that of reflection, establishing a rather mechanistic relationship between the forces of the economic and political base and the ideological and institutional superstructure. Ideology was defined as an inverted form of consciousness or—worse—as mere false consciousness. Furthermore, the concept of reflection argued that the phenomena of cultural representation were ultimately mere secondary phenomena of the class politics and ideological interests of a particular historical moment. Subsequently, though, the understanding of reflection would depart from these mechanistic assumptions. Lukács's analysis had in fact argued for an understanding of cultural production as dialectical historical operations, and he saw certain cultural practices (e.g., the

▲ 1917b, 1921, 1923　　● 1924, 1930b, 1931a

5 • Dan Graham, *Homes for America*, from *Arts Magazine*, 1967
Print, 74 × 93 (29⅛ × 36⅝)

Graham's publication of one of his earliest works in the layout and presentational format of an article in the pages of a rather prominent American art magazine demarcates one of the key moments of Conceptual art. First of all, modernism's (and Conceptualism's) supposedly radical quest for empirical and critical self-reflexivity is turned in on itself and onto the frames of presentation and distribution. Graham's magazine article anticipates the fact that crucial information on artistic practices is always already mediated by mass-cultural and commercial forms of dissemination. Accordingly, Graham integrates that dimension of distribution into the conception of the work itself. The artist's model of self-reflexivity dialectically shifts from tautology to discursive and institutional critique. What distinguishes his approach to the problems of audience and distribution from the earlier models of the historical avant-garde is the skepticism and the precision with which he positions his operations exclusively within the discursive and institutional sphere of the given conditions of artistic production (rather than the project of utopian social and political transformations).
Yet the choice of prefabricated suburban tract-housing in New Jersey first of all expands the subject matter of Pop art from a mere citation of mass-cultural and media iconography to a new focus on social and architectural spaces. At the same time, Graham reveals that the spatial organization of the lowest level of everyday suburban experience and architectural consumption had already prefigured the principles of a serial or modular iterative structure that had defined the sculptural work of his predecessors, the Minimalists.

bourgeois novel and its project of realism) as the quintessential cultural achievement of the progressive forces of the bourgeoisie. When it came to the development of a proletarian aesthetic, however, Lukács became a stalwart of reactionary thought, arguing that the preservation of the legacies of bourgeois culture would have to be an integral force within an emerging proletarian realism. The task of Socialist Realism in Lukács's account eventually came simultaneously to preserve the revolutionary potential of the progressive bourgeois moment that had been betrayed and to lay the foundations of a new proletarian culture that had truly taken possession of the bourgeois means of cultural production.

Since the theorizations of ideology in the sixties, aestheticians and art historians have not only differentiated general theories of ideology, but have also elaborated the questions of how cultural production relates to the apparatus of ideology at large. The question of whether artistic practice operates inside or outside ideological representations has especially preoccupied social art historians since the seventies, all of them arriving at very different answers, depending on the theory of ideology to which they subscribe. Thus, for example, those social art historians who followed the model of the early Marxist phase of American art historian Meyer Schapiro (1904–96) continued to operate under the assumption that cultural representation is the mirror reflection of the ideological interests of a ruling class (e.g., Schapiro's argument about Impressionism being the cultural expression of the leisured share-holding bourgeoisie). According to Schapiro, these cultural representations do not merely articulate the mental universe of the bourgeoisie: they also invest it with the cultural authority to claim and maintain its political legitimacy as a ruling class.

Others have taken Meyer Schapiro's Marxist social history of art as a point of departure, but have also adopted the complex ideas that he developed in his later work. He took the infinitely more complicated questions of mediation between art and ideology into account by recognizing that aesthetic formations are relatively autonomous, rather than fully dependent upon or congruent with ideological interests (a development that is evident, for example, in Schapiro's subsequent turn to an early semiology of abstraction). One result of a more complex theorization of ideology was the attempt to situate artistic representations as dialectical forces within their historically specific moment. That is, in certain cases a particular practice might very well articulate the rise of progressive consciousness not only within an individual artist, but also the progressivity of a patron class and its self-definition in terms of a project of bourgeois enlightenment and ever-expanding social and economic justice (see, for example, Thomas Crow's [born 1948] classic essay "Modernism and Mass Culture," concerning the dialectical conception of the idiom of neo-Impressionist divisionism in its drastic changes from affiliation with the politics of radical anarchism to an indulgent style).

Social art historians of the seventies, like Crow and T. J. Clark (born 1945), conceived of the production of cultural representation as both dependent upon class ideology and generative of counter-ideological models. Thus, the most comprehensive account of

6 • Hans Haacke, *MOMA-Poll*, 1970

Audience participatory installation: two transparent acrylic ballot boxes, each 40 × 20 × 10 (15¾ × 7⅞ × 3⅞), equipped with photoelectric counter, text

For the exhibition "Information" at New York's Museum of Modern Art in 1970, Haacke installed one of the first of his new works to deal with "social systems," called either *Polls* or as *Visitors' Profiles*. In these installations, traditionally passive spectators became active participants. Haacke's subjection of the processes of production and reception to elementary forms of statistical accounting and positivist information is a clear response to the actual principles governing experience in what Adorno had called the "society of administration." At the same time, Haacke's work, like Graham's, shifts attention from the critical analysis of the work's immanent structures of meaning to the external frames of institutions. Thus Haacke repositions Conceptual art in a new critical relation to the socioeconomic conditions determining access and availability of aesthetic experience, a practice later identified as "institutional critique." Haacke's *MOMA-Poll* is a striking example of this shift since it confronts the viewer with a sudden insight into the degree to which the museum as a supposedly neutral space guarding aesthetic autonomy and disinterestedness is imbricated with economic, ideological, and political interests. The work also reconstitutes a condition of responsibility and participation for the viewer that surpasses models of spectatorial involvement previously proposed by artists of the neo-avant-garde, while it recognizes the limitations of the spectators' political aspirations and their psychic range of experience and self-determination.

nineteenth-century modernist painting and its shifting fortunes within the larger apparatus of ideological production can still be found in the complex and increasingly differentiated approach to the question of ideology in the work of Clark, the leading social art historian of the late twentieth century. In Clark's accounts of the work of Daumier and Courbet, for example, ideology and painting are still conceived in the dialectical relations that Lukács had suggested in his accounts of the work of eighteenth and nineteenth-century literature: as an articulation of the progressive forces of the bourgeois class in a process of coming into its own mature identity to accomplish the promises of the French Revolution and of the culture of the Enlightenment at large.

Clark's later work *The Painting of Modern Life: Paris in the Art of Manet and his Followers* (1984), by contrast, does not discuss merely the extreme difficulty of situating the work of Manet and Seurat within such a clear and dynamic relationship to the progressive forces of a particular segment of society. Rather, Clark now faces the task of confronting the newfound complexity of the relationship between ideology and artistic production, and of integrating it with the methodology of social art history that he had developed up to this point. This theoretical crisis undoubtedly resulted in large part from Clark's discovery of the work of the Marxist Lacanian Louis Althusser (1918–90). Althusser's conception of ideology still remains the most productive one, in particular with regard to its capacity to situate aesthetic and art-historical phenomena in a position of relative autonomy with regard to the totality of ideology. This is not just because Althusser theorizes ideology as a totality of linguistic representations in which the subject is constituted in a politicized version of Lacan's account of the symbolic order. Perhaps even more important is Althusser's distinction between the totality of the ideological state apparatus (and its subspheres in all domains of representation) and the explicit exemption of artistic representations (as well as scientific knowledge) from that totality of ideological representations.

Popular culture versus mass culture

One of the most important debates among social art historians concerns the question of how so-called high art or avant-garde practices relate to the emerging mass-cultural formations of modernity. And while it is of course understood that these formations change continuously (as the interactions between the two halves of the systems of representation are continuously reconfigured), it has remained a difficult debate whose outcome is often indicative of the particular type of Marxism embraced by the critics of mass culture. It ranges from the most violent rejection of mass-cultural formations in the work of Adorno, whose infamous condemnation of jazz is now universally discredited as a form of eurocentric Alexandrianism that was—worst of all—largely dependent on the author's total lack of actual information about the musical phenomena he so disdained.

The opposite approach to mass-cultural phenomena was first developed in England, in the work of Raymond Williams (1921–88),

7 • Gerhard Richter and Konrad Lueg/Fischer, *Life with Pop—Demonstration for Capitalist Realism*, at Möbelhaus Berges, Düsseldorf, October 11, 1963

In 1963, Gerhard Richter and Konrad Lueg (who later, as Konrad Fischer, became one of Europe's most important dealers of the Minimal and Conceptual generation) staged a performance in a Düsseldorf department store. It initiated a German variation on the neo-avant-garde's international reorientation toward mass culture that—since the late fifties—had gradually displaced postwar forms of abstraction in England, France, and the United States. The neologism "capitalist realism," coined by Richter for this occasion, reverberates with realism's horrible "other," the Socialist variety that had defined Richter's educational background in the Communist part of Germany until 1961. The spectacle of boredom, affirmation, and passivity against the backdrop of a totalizing system of objects of consumption took the work of Piero Manzoni as *one* of its cues, namely the insight that artistic practice would have to be situated more than ever in the interstitial spaces between objects of consumption, sites of spectacle, and ostentatious acts of artistic annihilation. But its brooding melancholic passivity was also a specifically German contribution to the recognition that from now on advanced forms of consumer culture would not only determine behavior in a way that had been previously determined by religious or political belief systems, but that in this particular historical context of Germany they would also serve as the collective permit to repress and to forget the population's recent massive conversion to fascism.

whose crucial distinction between popular culture and mass culture became a productive one for subsequent attempts by cultural historians such as Stuart Hall (1932–2014) to argue for an infinitely more differentiated approach when analyzing mass-cultural phenomena. Hall argued that the same dialectical movement that aestheticians and art historians had detected in the gradual shift of stylistic phenomena from revolutionary and emancipatory to regressive and politically reactionary could be detected in the production of mass culture as well: here a perpetual oscillation from initial contestation and transgression to eventual affirmation in the process of industrialized acculturation would take place. Hall also made it seem plausible that a fundamental first step in overcoming the eurocentric fixation on hegemonic culture (whether high bourgeois or avant-garde) was acceptance that different audiences communicate within different structures of tradition, linguistic convention, and behavioral forms of interaction. Therefore, according to the new cultural-studies approach, the specificity of audience address and experiences should be posited above all claims—as authoritarian as they are numinous—for universally valid criteria of aesthetic evaluation, that is, that hierarchical canonicity whose ultimate and latent goal would always remain the confirmation of the supremacy of white, male, bourgeois culture.

Sublimation and desublimation

The model of cultural studies that Williams and Hall elaborated, and that became known later as the Birmingham Centre for Contemporary Cultural Studies, laid the foundations for most of the work in cultural studies being done today. Even though he is not known ever to have engaged with the work of any of the British Marxists, Adorno's counterargument would undoubtedly have been to accuse their project of being one of extending desublimation into the very center of aesthetic experience, its conception and critical evaluation. Desublimation for Adorno internalizes the very destruction of subjectivity further; its agenda is to dismantle the processes of complex consciousness formation, the desire for political self-determination and resistance, and ultimately to annihilate experience itself in order to become totally controlled by the demands of late capitalism.

Another and rather different Marxist aesthetician, Herbert Marcuse (1898–1979), conceived of the concept of desublimation in almost the opposite way, arguing that the structure of aesthetic experience consisted of the desire to undermine the apparatus of libidinal repression and to generate an anticipatory moment of an existence liberated from needs and instrumentalizing demands. Marcuse's Freudo-Marxist aesthetic of libidinal liberation was situated at the absolute opposite pole of Adorno's ascetic aesthetics of a negative dialectics, and Adorno did not fail to chastize Marcuse publicly for what he perceived to be the horrifying effects of hedonistic American consumer culture on Marcuse's thoughts.

Whatever the ramifications of Marcuse's reconception of desublimation, it is certainly a term for which ample evidence could be

found in avant-garde practices before and after World War II. Throughout modernity, artistic strategies resist and deny the established claims for technical virtuosity, for exceptional skills, and for conformity with the accepted standards of historical models. They deny the aesthetic any privileged status whatsoever and debase it with all the means of deskilling, by taking recourse to an abject or a low-cultural iconography, or by the emphatic foregrounding of procedures and materials that reinsert the disavowed dimensions of repressed somatic experience back into the space of artistic experience.

The neo-avant-garde

One of the major conflicts of writing social art history after World War II derives from an overarching condition of asynchronicity. On the one hand, American critics in particular were eager to establish the first hegemonic avant-garde culture of the twentieth century; however, in the course of that project they failed to recognize that the very fact of a reconstruction of a model of avant-garde culture would inevitably affect not only the status of the work being produced under these circumstances, but also, even more profoundly, the critical and historical writing associated with it.

In Adorno's late-modernist *Aesthetic Theory* (1970), the concept of autonomy retains a central role. Unlike Clement Greenberg's remobilization of the concept in favor of an American version of late-modernist aesthetics, Adorno's aesthetics operates within a principle of double negativity. On the one hand, Adorno's late modernism denies the possibility of a renewed access to an aesthetics of autonomy, a possibility annihilated by the final destruction of the bourgeois subject in the aftermath of fascism and the Holocaust. On the other hand, Adorno's aesthetics also deny the possibility of a politicization of artistic practices in the revolutionary perspective of Marxist aesthetics. According to Adorno, politicized art would only serve as an alibi and prohibit actual political change, since the political circumstances for a revolutionary politics are de facto not accessible in the moment of postwar reconstruction of culture.

By contrast, American neomodernism and the practices of what Peter Bürger called the neo-avant-garde—most palpably advocated by Greenberg and his disciple Michael Fried (born 1939)—could uphold their claims only at the price of a systematic *geschichtsklitterung*, a manifest attempt at writing history from the perspective of victorious interests, systematically disavowing the major transformations that had occurred within the conception of high art and avant-garde culture discussed above (e.g., the legacies of Dada and the Russian and Soviet avant-gardes). But worse still, these critics failed to see that cultural production after the Holocaust could not simply attempt to establish a continuity of modernist painting and sculpture. Adorno's model of a negative dialectics (most notoriously formulated in his verdict on the impossibility of lyrical poetry after Auschwitz) and his aesthetic theory—in open opposition to Greenberg's neomodernism—suggested the ineluctable necessity of rethinking the very precarious condition of culture at large.

It appears that the strengths and successes of the social history of art are most evident in those historical situations where actual mediations between classes, political interests, and cultural forms of representation are solidly enacted and therefore relatively verifiable. Their unique capacity to reconstruct the narratives around those revolutionary or foundational situations of modernity makes the accounts of social art historians the most compelling interpretations of the first hundred years of modernism, from David in the work of Thomas Crow to the beginnings of Cubism in T. J. Clark's work.

However, when it comes to the historical emergence of avant-garde practices such as abstraction, collage, Dada, or the work of Duchamp, whose innermost *telos* it had been actively to destroy traditional subject–object relationships and to register the destruction of traditional forms of experience, both on the level of narrative and on that of pictorial representation, social art history's attempts to maintain cohesive narrative accounts often emerge at best as either incongruent or incompatible with the structures and morphologies at hand, or at worst, as falsely recuperative. Once the extreme forms of particularization and fragmentation have become the central formal concerns in which postbourgeois subjectivity finds its correlative remnants of figuration, the interpretative desire to reimpose totalizing visions onto historical phenomena sometimes appears reactionary and at other times paranoid in its enforcement of structures of meaning and experience. After all, the radicality of these artistic practices had involved not only their refusal to allow for such visions but also their formulation of syntax and structures where neither narrative nor figuration could still obtain. If meaning could still obtain at all, it would require accounts that would inevitably lead beyond the frameworks of those of deterministic causation.

FURTHER READING

Frederick Antal, *Classicism and Romanticism* (London: Routledge & Kegan Paul, 1966)
Frederick Antal, *Hogarth and His Place in European Art* (London: Routledge & Kegan Paul, 1962)
T. J. Clark, *Farewell to an Idea* (New Haven and London: Yale University Press, 1999)
T. J. Clark, *Image of the People: Gustave Courbet and the 1848 Revolution* (London: Thames & Hudson, 1973)
T. J. Clark, *The Absolute Bourgeois: Artists and Politics in France, 1848–1851* (London: Thames & Hudson, 1973)
T. J. Clark, *The Painting of Modern Life: Paris in the Art of Manet and his Followers* (London: Thames & Hudson, 1984)
Thomas Crow, *Painters and Public Life in 18th-Century Paris* (New Haven and London: Yale University Press, 1985).
Thomas Crow, *The Intelligence of Art* (Chapel Hill, N.C.: University of North Carolina Press, 1999)
Serge Guilbaut, *How New York Stole the Idea of Modern Art: Abstract Expressionism, Freedom, and the Cold War* (Chicago and London: University of Chicago Press, 1983)
Nicos Hadjinicolaou, *Art History and Class Struggle* (London: Pluto Press, 1978)
Arnold Hauser, *The Social History of Art* (1951), four volumes (London: Routledge, 1999)
Fredric Jameson (ed.), *Aesthetics and Politics* (London: New Left Books, 1977)
Francis Klingender, *Art and the Industrial Revolution* (1947) (London: Paladin Press, 1975)
Meyer Schapiro, *Modern Art: 19th and 20th Century, Selected Papers, Vol. 2* (New York: George Braziller, 1978)
Meyer Schapiro, *Romanesque Art, Selected Papers, Vol. 1* (New York: George Braziller, 1977)
Meyer Schapiro, *Theory and Philosophy of Art: Style, Artist, and Society, Selected Papers, Vol. 4* (New York: George Braziller, 1994)

Benjamin H. D. Buchloh

▲ 1968b, 2007b ● 1942a, 1960b ■ 1960a

3 Formalism and structuralism

In 1971–2, the French literary theorist Roland Barthes (1915–80) held a year-long seminar devoted to the history of semiology, the "general science of signs" that had been conceived as an extension of linguistics by the Swiss Ferdinand de Saussure (1857–1913) in his *Course in General Linguistics* (posthumously published in 1916) and simultaneously, under the name of semiotics, by the American philosopher Charles Sanders Peirce (1839–1914) in his *Collected Papers* (also posthumously published, from 1931 to 1958). Barthes had been one of the leading voices of structuralism from the mid-fifties to the late sixties, together with the anthropologist Claude Lévi-Strauss (1908–2009), the philosopher Michel Foucault (1926–84), and the psychoanalyst Jacques Lacan, and as such had greatly contributed to the resurrection of the semiological project, which he had clearly laid out in *Elements of Semiology* (1964) and "Structural Analysis of Narratives" (1966). But he had seriously undermined that very project in his most recent books, *S/Z*, *The Empire of Signs* (both 1970), and *Sade, Fourier, Loyola* (1971).

The curiosity of Barthes's auditors (myself among them) was immense: in this period of intellectual turmoil marked by a general Oedipal desire to kill the structuralist model, they expected him to ease their understanding of the shift underway from ▲ A (structuralism) to B (poststructuralism)—a term that neatly describes Barthes's work at the time, but which was never condoned by any of its participants. They anticipated a chronological summary. Logically, such a narrative, after a presentation of Saussure's and Peirce's concepts, would have discussed the work of the Russian Formalist school of literary criticism, active from around 1915 to the Stalinist blackout of 1932; then, after one of its ● members, Roman Jakobson (1896–1982), had left Russia, of the Prague Linguistic Circle grouped around him; then of French structuralism; and finally, in conclusion, it would have dealt with ■ Jacques Derrida's deconstruction.

Barthes's audience got the package they had hoped for, but not without a major surprise. Instead of beginning with Saussure, he initiated his survey with an examination of the ideological critique proposed, from the twenties on, by the German Marxist playwright Bertolt Brecht (1898–1956). Although Barthes, no less than his peers, had succumbed to the dream of scientific objectivity when the structuralist movement was at its peak, he now implicitly advocated a subjective approach. No longer interested in mapping a discipline, he endeavored instead to tell the story of his *own* semiological adventure, which had started with his discovery of Brecht's writings. Coming from someone whose assault on biographism (the reading of a literary piece through the life of its author) had always been scathing, the gesture was deliberately provocative. (The enormous polemic engendered by the antibiographism of Barthes's *On Racine* (1963), which had ended in *Criticism and Truth* (1966), Barthes's brilliant answer to his detractors, and which had done more than anything else to radically transform traditional literary studies in France, was still very much on everyone's mind.) But there was a strategic motive as well in this Brechtian beginning, a motive that becomes apparent when one turns to the essay in which Barthes had discussed Saussure for the first time.

"Myth Today" was a postscript to the collection of sociological vignettes Barthes had written between 1954 and 1956 and published under the title *Mythologies* (1957). The main body of the book had been written in the Brechtian mode: its stated purpose was to reveal, underneath the pretended "naturalness" of the *petit-bourgeois* ideology conveyed by the media, what was historically determined. But in "Myth Today" Barthes presented Saussure's work, which he had just discovered, as offering new tools for the kind of Brechtian ideological analysis he had so far been conducting. What is perhaps most striking, in retrospect, is that Barthes's exposition of Saussurean semiology begins with a plea in favor of formalism. Shortly ▲ after alluding to Andrei Zhdanov and his Stalinist condemnation of formalism and modernism as bourgeois decadence, Barthes writes: "Less terrorized by the specter of 'formalism,' historical criticism might have been less sterile; it would have understood that … the more a system is specifically defined in its forms, the more amenable it is to historical criticism. To parody a well-known saying, I shall say that a little formalism turns one away from History, but that a lot brings one back to it." In other words, right from the start Barthes conceived of what was soon to be named "structuralism" as part of a broader formalist current in twentieth-century thought. Furthermore, Barthes was denying the claims of the antiformalist champions that formalist critics, in bypassing "content" to scrutinize forms, were retreating from the world and its historical realities to the ivory tower of a humanistic "eternal present."

▲ Introduction 4 ● 1915 ■ Introduction 4 ▲ 1934a

"Semiology is a science of forms, since it studies significations apart from their content." Such is the definition that immediately precedes Barthes's passage quoted above. Its terminology is somewhat flawed, for Barthes was still a novice in structural linguistics, and he would soon know that the word "content" has to be replaced by "referent" in such a sentence. But the basic axioms are already there: signs are organized into sets of oppositions that shape their signification, independently of what the signs in question refer to; every human activity partakes of at least one system of signs (generally several at once), whose rules can be tracked down; and, as a producer of signs, man is forever condemned to signification, unable
▲ to flee the "prison-house of language," to use Fredric Jameson's formulation. Nothing that man utters is insignificant—even saying "nothing" carries a meaning (or rather multiple meanings, changing according to the context, which is itself structured).

Choosing in 1971 to present these axioms as derived from Brecht (rather than from Saussure, as he had done in 1957), Barthes had a polemical intention: he was pointing to the historical link between modernism and the awareness that language is a structure of signs. Indeed, although Brecht's star has somewhat faded in recent years, he was regarded in postwar Europe as one of the most powerful modernist writers. In his numerous theoretical statements, Brecht had always attacked the myth of the transparency of language that had governed the practice of theater since Aristotle; the self-reflective, anti-illusionistic montagelike devices that interrupted the flow of his plays aimed at aborting the identification of the spectator with any character and, as he phrased it, at producing an effect of "distanciation" or "estrangement."

The first example Barthes commented on in his 1971–2 seminar was a text in which the German writer patiently analyzed the 1934 Christmas speeches of two Nazi leaders (Hermann Goering and Rudolf Hess). What struck Barthes was Brecht's extreme attention to the form of the Nazi texts, which he had followed word for word in order to elaborate his counterdiscourse. Brecht pinpointed the efficacy of these speeches in the seamless flow of their rhetoric: the smokescreen with which Goering and Hess masked their faulty logic and heap of lies was the mellifluous continuity of their language, which functioned like a robust, gooey adhesive.

Brecht, in short, was a formalist, eager to demonstrate that language was not a neutral vehicle made to transparently convey concepts directly from mind to mind, but had a materiality of its own and that this materiality was always charged with significations. But he immensely resented the label of formalism when it was thrown at modern literature as a whole by the Marxist philosopher György Lukács, writing in the USSR at a time when calling anyone a formalist was equivalent to signing his or her death warrant. By then virulently opposed to modernism in general—but in particular to the technique of montage that Sergei Eisenstein invented in film and Brecht adapted to the theater, and to the kind of interior monologue that concludes James Joyce's *Ulysses*— Lukács had proposed nineteenth-century realist novels (those of Balzac in particular) as the model to be emulated, especially if one

was to write from a "proletarian" point of view. Yet it was Lukács who was the "formalist," wrote Brecht in his rebuttal. In calling for a twentieth-century novel with a "revolutionary" content but penned in a form that dated from a century earlier, a form that belonged to the era before the self-reflexivity and anti-illusionism of modernism, Lukács was fetishizing form.

Thus the term "formalist" was an insult that Lukács and Brecht tossed at each other, but the word did not have the same sense for each. For Brecht, a formalist was anyone who could not see that form was inseparable from content, who believed that form was a mere carrier; for Lukács, it was anyone who believed that form even affected content. Brecht's uneasiness with the term, however, should give us pause, especially since the same uneasiness has mushroomed in art history and criticism since the early seventies. (It is particularly noteworthy in this context that the art critic whose name is most
▲ associated in America with formalism, Clement Greenberg, also had such misgivings: "Whatever its connotations in Russian, the term has acquired ineradicably vulgar ones in English," he wrote in 1967.) In order to understand the ambivalence, it is useful to recall Barthes's dictum: "a little formalism turns one away from History, but that a lot brings one back to it." For what Brecht resented in Lukács's "formalism" was its denial both of history and of what the Danish linguist Louis Hjelmslev would call the "form of content"—of the fact that the very structure of Balzac's novels was grounded upon the world view of a particular social class at a particular juncture in the history of Western Europe. In short, Lukács had practiced only a "restricted" formalism, whose analysis remains at the superficial level of form-as-shape, or morphology.

The antiformalism that was prevalent in the discourse of art criticism in the seventies can thus be explained in great part by a confusion between two kinds of formalism, one that concerns itself essentially with morphology (which I call "restricted" formalism), and one that envisions form as structural—the kind embraced by Brecht when he sorted out the "continuity" of Goering's and Hess's speeches as an essential part of their ideological machine. The confusion was compounded by Greenberg's gradual turnabout. While his analyses of the dialectical role of *trompe-l'oeil* devices
• in Georges Braque's Cubist still lifes [1] or that of the alloverness
■ of Jackson Pollock's drippings) are to be counted on the structural ledger, by the late 1950s his discourse was more reminiscent of the morphological mode promulgated at the beginning of the
◆ twentieth century by the British writers Clive Bell and Roger Fry, whose concern was merely good design. The distinction between these two formalisms is essential to a retrieval of formalism (as structuralism) from the wastebasket of discarded ideas.

Structuralism and art history

Although the linguistic/semiological model provided by Saussure became the inspiration for the structuralist movement in the fifties and sixties, art history had already developed structural methods by the time this model became known in the twenties. Furthermore,

1 • Georges Braque, *Violin and Pitcher*, 1910

Oil on canvas, 117 × 73 (46 × 28¾)

One of the benchmarks of formalism is its attention to rhetorical devices, to the signification of the means of signification themselves. Examining this painting by Braque, Clement Greenberg singled out the device of the realistic nail and its shadow painted *on top* of the faceted volumes depicted on the picture's surface. Both flattening the rest of the image and pushing it back into depth, he *trompe-l'oeil* nail was for the artist a means of casting some doubt with regard to the traditional, illusionistic mode of representing space.

the first literary critics who can be called structuralists—the ▲ Russian Formalists—were particularly aware of their art-historical antecedents (much more than of Saussure, whom they discovered only after writing many of their groundbreaking works). Finally, it • was Cubism that first helped the Russian Formalists to develop their theories: in deliberately attacking the epistemology of representation, Cubism (and abstract art in its wake) underscored the gap separating reference and meaning and called for a more sophisticated understanding of the nature of signs.

The role played by art history and avant-garde art practice in the formation of a structuralist mode of thinking is little known today, but it is important for our purpose, especially with regard to the accusations of ahistoricism often thrown at structuralism. In fact, one could even say that the birth of art history as a discipline dates from the moment it was able to structure the vast amount of material it had neglected for purely ideological and aesthetic reasons. It might seem odd today that seventeenth-century Baroque art, for example, had fallen into oblivion during the eighteenth and early nineteenth centuries, until Heinrich Wölfflin (1864–1945) rehabilitated it in *Renaissance and Baroque* (1888). Resolutely opposed to the dominant normative aesthetic of Johann Joachim Winckelmann (1717–68), for whom Greek art was an unsurpassable yardstick for all subsequent artistic production, Wölfflin endeavored to show that Baroque art had to be judged by criteria that were not only different from but resolutely opposed to those of Classical art. This idea, that the historical signification of a stylistic language was manifested through its rejection of another one (in this case, a preceding one) would lead Wölfflin to posit "an art history without names" and to establish the set of binary oppositions that constitutes the core of his most famous book, *Principles of Art History*, which appeared in 1915 (linear / painterly, plane / recession, closed / open form; multiplicity / unity; clearness / unclearness).

Wölfflin's formalist taxonomy, however, was still part of a teleological and idealistic discourse, modeled on Hegel's view of history, according to which the unfolding of events is prescribed by a set of predetermined laws. (Within every "artistic epoch," Wölfflin always read the same smooth evolution from linear to painterly, from plane to recession, etc., which left him with little room to explain how one switched from one "epoch" to the next, particularly since he denied nonartistic historical factors much of a causative role in his scheme.) But if Wölfflin's idealism prevented him from developing his formalism into a structuralism, it is to Alois Riegl (1858–1905) that ones owes the first full elaboration of a meticulous analysis of forms as the best access to a social history of artistic production, signification, and reception.

Just as Wölfflin had done with the Baroque era, Riegl undertook the rehabilitation of artistic eras that had been marginalized as decadent, most notably the production of late antiquity (*Late Roman Art Industry*, 1901). But he did more than Wölfflin to advance the cause of an anonymous history of art, one that would trace the evolution of formal / structural systems rather than merely study the output of individual artists: if the well-known works of Rembrandt and

▲ 1915 ● 1911, 1912, 1921a

Frans Hals figure in his last book, *The Group Portraiture of Holland* (1902), they are as the end-products of a series whose features they inherit and transform. Riegl's historical relativism was radical and had far-reaching consequences, not only because it allowed him to disregard the distinction between high and low, major and minor, pure and applied art, but because it led him to understand every artistic *document* as a *monument* to be analyzed and posited in relationship with others belonging to the same series. In other words, Riegl demonstrated that it was only after the set of codes enacted (or altered) by an art object had been mapped in their utmost details that one could attempt to discuss that object's signification and the way it related to other series (for example to the history of social formations, of science, and so forth)—an idea that would be of importance for both the Russian Formalists and Michel Foucault. And it is because Riegl understood meaning as structured by a set of oppositions (and not as transparently conveyed) that he was able to challenge the overwhelming role usually given to the referent in the discourse about art since the Renaissance.

A crisis of reference

A similar crisis of reference provided the initial spark of Russian Formalism around 1915. The polemical target of the Russian Formalist critics was the Symbolist conception that poetry resided in the images it elicited, independent of its linguistic form. But it was through their confrontation with Cubism, then with the
▲ first abstract paintings of Kazimir Malevich and the poetic experiments of his friends Velemir Khlebnikov and Aleksei Kruchenikh—poems whose sounds referred to nothing but the phonetic nature of language itself—that the Russian Formalists discovered, before they ever heard of Saussure, what the Swiss scholar had called the "arbitrary nature of the sign."

Allusions to Cubism abound in Roman Jakobson's writings, particularly when he tries to define poetic language as opposed to the language of communication used in everyday life. In "What is Poetry?", a lecture delivered in 1933, he writes:

> [Poeticity] can be separated out and made independent, like the various devices in say, a Cubist painting. But this is a special case.... Poeticity is present when the word is felt as a word and not a mere representation of the object being named or an outburst of emotion, when words and their composition, their meaning, their external and inner form, acquire a weight and value of their own instead of referring indifferently to reality.... Without contradiction [between sign and object] there is no mobility of concepts, no mobility of signs, and the relationship between concept and sign becomes automatized. Activity comes to a halt, and the awareness of reality dies out.

These last lines refer to the device of *ostranenie*, or "making strange," as a rhetorical figure, whose conceptualization by Viktor Shklovsky (1893–1984) in "Art as Device" (1917) is the first

theoretical landmark of Russian Formalism (the family resemblance of this notion with Brecht's "estrangement effect" is not fortuitous). According to Shklovsky, the main function of art is to defamiliarize our perception, which has become automatized, and although Jakobson would later dismiss this first theory of defamilarization, it is the way he interpreted Cubism at the time. And for good reason,
▲ as one could say that the first, so-called "African," phase of Cubism was rooted in a deliberate practice of estrangement. Witness this declaration of Pablo Picasso (1881–1973): "In those days people said that I made the noses crooked, even in the *Demoiselles d'Avignon*, but I had to make the nose crooked so they would see that it was a nose. I was sure later they would see that it wasn't crooked."

For Shklovsky, what characterized any work of art was the set of "devices" through which it was reorganizing the "material" (the referent), making it strange. (The notion of "device," never rigorously defined, was a blanket term by which he designated any stylistic feature or rhetoric construction, encompassing all levels of language—phonetic, syntactic, or semantic.) Later on, when he devoted particular attention to works such as the eighteenth-century "novel" *Tristram Shandy* by Laurence Sterne, where the writer pays more attention to mocking the codes of storytelling than to the plot itself, Shklovsky began to conceive not only our perception of the world but also the daily language of communication as the "material" that literary art rearranges—but the work of art remained for him a sum of devices through which the "material" was de-automatized. For Jakobson, though, the "devices" were not simply piled up in a work but were interdependent, constituting a system, and they had a constructive function, each contributing to the specificity and unity of the work, just as each bone has a role to play in our skeleton. Furthermore, each new artistic device, or each new system of devices, had to be understood either as breaking a previous one that had become deadened and automatized, or as revealing it (laying it bare), as if it had been there all along but unperceived: in short, any artistic device (and not just the world at large or the language of daily communication) could become the "material" made strange by a subsequent one. As a result, any device was always semantically charged for Jakobson, a complex sign bearing several layers of connotations.

It is this second notion of *ostranenie* that Jakobson had in mind when he spoke of the isolation of the various devices in a Cubist work as a "special case": in laying bare the traditional mechanisms of pictorial representation, Cubism performed for Jakobson and his colleagues the same function that neurosis had played for Freud's discovery of the unconscious. Much as the special (pathological) case of neurosis had led Freud to his general theory of the psychological development of man, the special (defamiliarizing) case of Cubism was seized by the Russian Formalists as support for their antimimetic, structural conception of poetic language.

In hindsight, however, we can see that bestowing a status of "normalcy" to the traditional means of pictorial representation that Cubism fought and whose devices it laid bare is not sustainable: it would posit such traditional means of representation as constituting a

kind of ahistorical norm against which all pictorial enterprises would have to be measured (bringing us back, in effect, to Winckelmann). Perceiving the essentializing danger of this simple dualism (norm / exception), Jakobson grew more suspicious of the normative postulates upon which his early work had been based (the opposition between the language of daily use as norm, and of literature as exception). But he would always take advantage of the model offered by psychoanalysis, according to which *dysfunction* helps us understand *function*. In fact, one of his major contributions to the field of literary criticism—the dichotomy that he established between the metaphoric and metonymic poles of language—was the direct result of his investigation of aphasia, a disorder of the central nervous system characterized by the partial or total loss of the ability to communicate. He noted that for the most part aphasic disturbances concerned either "the selection of linguistic entities" (the choice of *that* sound rather than *this* one, of *that* word rather than *this* one) or "their combination into linguistic units of a higher degree of complexity." Patients suffering from the first kind of aphasia (which Jakobson terms "the similarity disorder") cannot substitute a linguistic unit for another one, and metaphor is inaccessible to them; patients suffering from the second kind of aphasia ("the contiguity disorder") cannot put any linguistic unit into its context, and metonymy (or synecdoche) is senseless for them. The poles of similarity and contiguity were directly borrowed from Saussure (they correspond in his *Course* to the terms *paradigm* and *syntagm*), but they were expressly linked by Jakobson to the Freudian concepts of displacement and condensation: just as the limit between these two activities of the unconscious remained porous for Freud, Jakobson's polar extremes do not preclude the existence of hybrid or intermediary forms. But once again it is the opposition of these two terms that structured for him the immense domain of world literature. And not only literature: he saw Surrealist art as essentially metaphoric, and Cubism as essentially metonymic.

The arbitrary nature of the sign

Before we examine a Cubist work from a structural point of view, let us at last turn to Saussure's famous *Course* and its groundbreaking exposition of what he called the arbitrariness of the sign. Saussure went far beyond the conventional notion of arbitrariness as the absence of any "natural" link between the sign (say, the word "tree") and its referent (any actual tree), even though he would have been the last to deny this absence, to which the simple existence of multiple languages attests. For Saussure, the arbitrariness involved not only the relation between the sign and its referent, but also that between the signifier (the sound we utter when we pronounce the word "tree" or the letters we trace when we write it down) and the signified (the concept of tree). His principal target was the Adamic conception of language (from Adam's performance in the Book of Genesis: language as an ensemble of names for things), which he called "chimeric" because it presupposes the existence of an invariable number of signifieds that receive in each particular language a different formal vestment.

This angle of attack led Saussure to separate the problem of referentiality from the problem of signification, understood as the enactment in the utterance (which he called *parole*, as opposed to *langue*, designating the language in which the sign is uttered) of an arbitrary but necessary link between a signifier and a "conceptual" signified. In the most celebrated passage of his *Course*, Saussure wrote:

> *In language there are only differences. Even more important, a difference generally implies positive terms between which the difference is set up; but in language there are only differences without positive terms… The idea [signified] or phonic substance [signifier] that a sign contains is of less importance than the other signs that surround it.*

This not only means that a linguistic sign does not signify by itself, but that language is a system of which all units are interdependent. "I eat" and "I ate" have different meanings (though only one letter has shifted its position), but the signified of a temporal present in "I eat" can exist only if it is opposed to the signified of a temporal past in "I ate": one would simply not be able to identify (and thus understand) a linguistic sign if our mind did not compute its competitors within the system to which it belongs, quickly eliminating the ill-suitors while gauging the context of the utterance (for "I eat" is opposed not only to "I ate," but to "I gorge," "I bite," or even—leaving the semantic realm of food—"I sing," "I walk," and so forth). In short, the essential characteristic of any sign is to be what other signs are not. But, Saussure adds,

> *the statement that everything in language is negative is true only if the signified and the signifier are considered separately; when we consider the sign in its totality, we have something that is positive in own class.*

In other words, the acoustic signifier and the "conceptual" signified are negatively differential (they define themselves by what they are not), but a positive fact results from their combination, "the sole type of facts that language has," namely, the sign. Such a caveat might seem strange, given that everywhere else Saussure insisted on the *oppositional* nature of the sign: is he not suddenly reintroducing a substantive quality here, when all his linguistics rests on the discovery that "language is form and not substance"?

Everything revolves around the concept of *value*, one of the most complex and controversial concepts in Saussure. The sign is positive because it has a value determined by what it can be compared with and exchanged with within its own system. This value is absolutely differential, like the value of a hundred-dollar bill in relation to a thousand-dollar bill, but it confers on the sign "something positive." Value is an economic concept for Saussure; it permits the exchange of signs within a system, but it is also what prevents their perfect exchangeability with signs belonging to another system (the French word *mouton*, for example, has a

different value than the English *sheep* or *mutton*, because it means both the animal and its meat).

To explain his concept of value, Saussure invoked the metaphor of chess. If, during a game, a piece is lost, it does not matter what other piece replaces it provisionally; the players can arbitrarily choose any substitute they want, any object will do, and even, depending on their capacity to remember, the absence of an object. For it is the piece's function within a system that confers its value (just as it is the piece's position at each moment of the game that gives it its changing signification). "If you augment language by one sign," Saussure said, "you diminish in the same proportion the [value] of the others. Reciprocally, if only two signs had been chosen … all the [possible] significations would have had to be divided between these two signs. One would have designated one half of the objects, the other, the other half." The value of each of these two inconceivable signs would have been enormous.

Reading such lines, it comes as no surprise that Jakobson and the
▲ Russian Formalists had arrived at similar conclusions through a examination of Cubism—that of Picasso, in particular, who almost maniacally demonstrated the interchangeability of signs within his pictorial system, and whose play on the minimal act required to transform a head into a guitar or a bottle, in a series of collages
● he realized in 1913, seem a direct illustration of Saussure's pronouncement. This metaphoric transformation indicates that, *contra* Jakobson, Picasso is not bound to the metonymic pole. Instead, he seems to particularly relish composite structures that are both metaphoric and metonymic. A case in point is the 1944 sculpture of the *Bull's Head* [**2**], where the conjunction (metonymy) of a bicycle handlebar and seat produced a metaphor (the sum of these two bicycle parts are like a bull's head), but such swift transformations based on the two structuralist operations of substitution and combination are legion in his oeuvre. Which is to say that Picasso's Cubism was a "structuralist activity," to use Barthes's phrase: it not only performed a structural analysis of the figurative tradition of Western art, but it also structurally engineered new objects.

An example is Picasso's invention of what one could call space as a new sculptural material. The fact that the Cubist constructions Picasso created in 1912–13 represent a key moment in the history of sculpture has long been recognized, but the means through which Picasso articulated space anew are not always understood. To make a story short: until Picasso's 1912 *Guitar* [**3**], Western sculpture, either carved or cast, had either consisted in a mass, a volume that detached itself from a surrounding space conceived as neutral, or retreated to the condition of bas-relief. Helped by his discovery of African art, Picasso realized that Western sculpture was paralyzed by a fear of being swallowed by the real space of objects (in the post-Renaissance system of representation, it was essential that art remained securely roped off from the world in an ethereal realm of illusions). Rather than attempting to discard the rope altogether, as Marcel Duchamp would soon do in his ready-
■ mades, Picasso answered the challenge by making space one of sculpture's materials. Part of the body of his *Guitar* is a virtual

2 • Pablo Picasso, *Bull's Head*, 1942
Assemblage (bicycle seat and handlebars),
33.5 × 43.5 × 19 (13¼ × 17⅛ × 7½)

Although he never read Saussure, Picasso discovered in his own visual terms what the father of structural linguistics had labeled the "arbitrariness of the sign." Given that signs are defined by their opposition to other signs within a given system, anything can stand for anything else if it conforms to the rules of the system in question. Using the handlebar and seat of a bicycle, Picasso remains within the realm of representation, defining the minimum required for a combination of disparate elements to be read as the horned head of a bull, while at the same time demonstrating the metaphoric power of assemblage.

3 • Pablo Picasso, *Guitar*, Fall 1912
Construction of sheet metal, string, and wire,
77.5 × 35 × 19.3 (30½ × 13¾ × 7⅝)

For structuralism, signs are oppositional and not substantial, which is to say that their shape and signification are solely defined by their difference from all other signs in the same system, and that they would mean nothing in isolation. By the sheer contrasting juxtaposition of void and surface in this sculpture, which marks the birth of what would be called "Synthetic Cubism," whose major formal invention would be collage, Picasso transforms a void into a sign for the skin of a guitar and a protruding cylinder into a sign for its hole. In doing so, he makes a nonsubstance—space—into a material for sculpture.

volume whose external surface we do not see (it is immaterial) but that we intuit through the position of other planes. Just as Saussure had discovered with regard to linguistic signs, Picasso found that sculptural signs did not have to be substantial. Empty space could easily be transformed into a differential mark, and as such combined with all kinds of other signs: no longer fear space, Picasso told his fellow sculptors, shape it.

As Jakobson has noted, however, Cubism is a "special case" in which devices can be separated out (in a Cubist painting shading is emphatically independent from contour, for example), and few artists in this century were as good structuralists as Picasso was during his Cubist years. Another candidate proposed
▲ by structuralist critics was Piet Mondrian (1872–1944). Indeed, in deliberately reducing his pictorial vocabulary to very few elements, from 1920 on—black horizontal and vertical lines, planes of primary colors and of "noncolors" (white, black, or gray)—and in producing an extremely various oeuvre within such limited parameters [4], Mondrian demonstrated the combinatory infinitude of any system. In Saussurean terminology, one could say that because the new pictorial *langue* that he created consisted in a handful of elements and rules ("no symmetry" was one of them), the range of possibilities proceeding from such a Spartan language (his *parole*) became all the more apparent. He had limited the corpus of possible pictorial marks within his system, but this very limitation immensely accrued their "value."

Despite the fact that Mondrian seems to be a structuralist *avant la lettre* it is not the structural type of formal analysis, but rather the morphological one, that was first proposed in the study of his art. This morphological formalism, mainly concerned with Mondrian's compositional schemes, remained impressionistic in nature, though it gave us excellent descriptions of the balance or imbalance of planes in his works, the vividness of the colors, the rhythmic staccato. In the end this approach remained tautological, especially in its blunt refusal to discuss "meaning," and it is not by chance that an iconographic, Symbolist interpretation was long thought preferable, even though it ran counter to what the artist himself had to say.

A structural reading of Mondrian's work began to emerge only in the seventies. It examines the semantic function played by various combinations of pictorial elements as Mondrian's work evolved and seeks to understand how a seemingly rigid formal system engendered diverse significations. Rather than assigning a fixed meaning to these elements, as the Symbolist interpretation had wanted to do, it is able to show, for example, that from the early thirties, the "Neoplastic" pictorial vocabulary that he had coined in 1920 and used ever since was transformed into a self-destructive machine destined to abolish not only the figure, as he had done before, but color planes, lines, surfaces, and by extension every possible identity—in other words, that Mondrian's art elicited an epistemological nihilism of ever-growing intensity. In short, if art critics and historians had been more acutely attentive to the formal development of his oeuvre, they might have earlier

▲ 1913, 1917a, 1944a

© 2011 Mondrian/Holtzman Trust c/o HCR International Virginia

on grasped the connection he felt more inclined to make in his writings, from 1930, between what he tried to achieve pictorially and the political views of anarchism. By the same token, however, they would have understood that if his classic Neoplastic work had been governed by a structural ethos, during the last decade of his life this ethos was geared toward the deconstruction of the set of binary oppositions upon which his art had been based: they would have perceived that, like Barthes, Mondrian had began as a practitioner of structuralism only to become one of its most formidable assailants. But they would have had to be versed in structuralism itself to diagnose his attack.

Two aspects of Mondrian's art after 1920 explain why his art became an ideal object for a structuralist approach: first, it was a closed corpus (not only was the total output small, but as noted above, the number of pictorial elements he used were in a finite number); second, his oeuvre was easily distributed into series. The two first methodological steps taken in any structural analysis are the definition of a closed corpus of objects from which a set of recurrent rules can be deduced, and, within this corpus, the taxonomic constitution of series—and it is indeed only after the multiple series scanning Mondrian's oeuvre had been properly mapped that a more elaborate study of the signification of his works became possible. But what a structural analysis can do with the production of a single artist, it can also do at the microlevel of the single work, as the Russian Formalists or Barthes have amply shown, or at the macrolevel of a whole field, as Claude Lévi-Strauss has demonstrated in his studies of vast ensembles of myths. The method remains the same, only the scale of the object of inquiry changes: in each case, discrete "units" have to be distinguished so that their interrelationship can be understood, and their oppositional signification emerge.

The method has indeed its limits, for it presupposes the internal coherence of the corpus of analysis, its unity—which is why it yields its best results when dealing with a single object or with a series that remains limited in range. Through a forceful critique of the very notions of internal coherence, closed corpus, and ▲ authorship, what is now called "poststructuralism," hand in hand ● with the literary and artistic practices labeled "postmodernist," would efficiently blunt the preeminence that structuralism and formalism had enjoyed in the sixties. But, as numerous entries in this volume make clear, the heuristic power of structural and formalist analysis, especially with regard to the canonical moments of modernism, need not be discarded.

4 • Piet Mondrian, *Composition with Red, Blue, Black, Yellow, and Gray*, 1921
Oil on canvas, 39.5 × 35 cm (15½ × 13¾)

Permutation and combination are the means by which any discourse is generated and as such they constitute the two main aspects of what Barthes called the "structuralist activity." In these two canvases, Mondrian checks, just as a scientist would do, if and how our perception of a central square changes according to the modifications of its surroundings.

FURTHER READING

Roland Barthes, *Mythologies* (1957), trans. Annette Lavers (New York: Noonday Press, 1972)

Roman Jakobson, "What is Poetry?" (1933) and "Two Aspects of Language and Two Types of Aphasic Disturbances" (1956), in Krystyna Pomorska and Stephen Rudy (eds.), *Language and Literature* (Cambridge, Mass.: Harvard University Press, 1987)

Fredric Jameson, *The Prison-House of Language: A Critical Account of Structuralism and Russian Formalism* (Princeton: Princeton University Press, 1972)

Thomas Levin, "Walter Benjamin and the Theory of Art History," *October*, no. 47, Winter 1988

Ferdinand de Saussure, *Course in General Linguistics* (New York: McGraw-Hill, 1966)

Yve-Alain Bois

▲ Introduction 4 ● 1972c, 1977a, 1984b

4 Poststructuralism and deconstruction

Throughout the sixties, youthful ideals measured against official cynicism created a collision course that climaxed in the uprisings of 1968, when, in reaction to the Vietnam War, student movements throughout the world—in Berkeley, Berlin, Milan, Paris, Tokyo—erupted into action. A student leaflet circulating in Paris in May 1968 declared the nature of the conflict:

We refuse to become teachers serving a mechanism of social selection in an educational system operating at the expense of working-class children, to become sociologists drumming up slogans for governmental election campaigns, to become psychologists charged with getting "teams of workers" to "function" according to the best interests of the bosses, to become scientists whose research will be used according to the exclusive interests of the profit economy.

Behind this refusal was the accusation that the university, long thought to be the precinct of an autonomous, disinterested, "free" search for knowledge, had itself become an interested party to the kind of social engineering the leaflet imputed to both government and industry.

The terms of this indictment and its denial that discrete social functions—whether intellectual research or artistic practice—could be either autonomous or disinterested could not fail to have repercussions beyond the boundaries of the university. They imme-
▲ diately affected the art world as well. In Brussels, for example, Marcel Broodthaers (1924–76) and other Belgian artists joined their student confreres by occupying the Salle de Marbre of the Palais des Beaux-Arts and temporarily "liberating" it from its former administration into their own control. Furthermore, in a gesture that was also patterned on the action of the student movements, Broodthaers coauthored statements that were released to the public in leaflet form. One of them announced, for example, that the Free Association (as the occupiers identified themselves) "condemns the commercialization of all forms of art considered as objects of consumption." This form of public address, which he had used since 1963, was then to become increasingly the basis of his work, which he was to carry out in the name of a fictitious museum, the "Musée d'Art Moderne," under the aegis of which

he would mount a dozen sections—such as the "Section XIXème siècle ("Nineteenth-Century Section") and the "Département des Aigles" (Department of Eagles) [1]—and in the service of which he addressed the public through a series of "Open Letters." The former separations within the art world—between producers (artists) and distributors (museums or galleries), between critics and makers, between the ones who speak and the ones who are spoken for— were radically challenged by Broodthaers's museum, an operation that constantly performed a parodic but profound meditation on the vectors of "interest" that run through cultural institutions, as far-from-disinterested accessories of power.

This attitude of refusing the subordinate posture as the one who is spoken for by seizing the right to speak, and consequently of challenging the institutional and social divisions that support these separations of power, had other sources of entitlement besides student politics. There was also the reevaluation of the premises, the suppositions, of the various academic disciplines collectively called the human sciences that crystallized around the time of 1968 into what has been termed poststructuralism.

There is no "disinterest"

▲ Structuralism—the dominant French methodological position against which poststructuralism rebelled—had viewed any given human activity—language, for example, or kinship systems within a society—as a rule-governed system that is a more or less autonomous, self-maintaining structure, and whose laws operate according to certain formal principles of mutual opposition. This idea of a self-regulating structure, one whose ordering operations are formal and reflexive—that is, they derive from, even while they organize, the material givens of the system itself—can clearly be mapped onto the modernist conception of the different and separate artistic disciplines or mediums. And insofar as this parallel obtains, the intellectual and theoretical battles of 1968 are highly relevant to the developments in the world of art in the seventies and eighties.

Poststructuralism grew out of a refusal to grant structuralism its premise that each system is autonomous, with rules and operations that begin and end *within* the boundaries of that system. In

1 • Marcel Broodthaers, "Musée d'Art Moderne, Département des Aigles, Section des Figures (The Eagle from the Oligocene to the Present)," 1972
Installation view

As director of his museum, Broodthaers organized its "Section Publicité" for Documenta, as well as exhibitions of particular richness for other museums, this one for the Städtische Kunsthalle, Düsseldorf, in 1972. A collection of diverse objects, the eagles included were drawn from mass-cultural material (for example, the stamps on champagne corks) as well as precious objects (such as Roman *fibulae*), all of them captioned "This is not a work of art." As Broodthaers explained in the catalogue, the caption marries the ideas of Duchamp (the readymade) to those of Magritte (his deconstructive "This is not a pipe," as in the inscription on *The Treachery of Images* of 1929). The museum department responsible for this exhibition was the "Section des Figures" (Illustrations Section).

linguistics, this attitude expanded the limited study of linguistic structures to those modes through which language issues into action, the forms called *shifters* and *performatives*. Shifters are words like "I" and "you," where the referent of "I" (namely, the person who utters it) shifts back and forth in a conversation. Performatives are those verbal utterances that, by being uttered, literally enact their meaning, such as when a speaker announces "I do" at the moment of marriage. Language, it was argued, is not simply a matter of the transmission of messages or the communication of information; it also places the interlocutor under the obligation to reply. It therefore imposes a role, an attitude, a whole discursive system (rules of behavior and of power, as well as of coding and decoding) on the receiver of the linguistic act. Quite apart from the content of any given verbal exchange, then, its very enactment implies the acceptance (or rejection) of the whole institutional frame of that exchange—its "presuppositions," as linguistics student Oswald Ducrot, early in 1968, called them:

> *The rejection of presuppositions constitutes a polemical attitude very different from a critique of what is set forth: specifically, it always implies a large dose of aggressiveness that transforms the dialogue into a confrontation of persons. In rejecting the presuppositions of my interlocutor, I disqualify not only the utterance itself, but also the enunciative act from which it proceeds.*

One form of post-1968 rejection of presuppositions was that French university students now insisted on addressing their professors with the intimate form of the second person—"*tu*"—and by their first names. They based this on the university's own abrogation of presuppositions when it called in the police (which historically had no jurisdiction within the walls of the Sorbonne) to forcibly evict the student occupiers.

Unlike the idea of the autonomous academic discipline (or work of art) whose frame is thought to be necessarily external to it—a kind of nonessential appendage—the performative notion of language places the frame at the very heart of the speech act. For the verbal exchange, it was being argued, is from the very beginning the act of imposing (or failing to impose) a set of presuppositions on the receiver of that exchange. Speech is thus more than the simple (and neutral) transmission of a message. It is also the enactment of a relation of force, a move to modify the addressee's right to speak. The examples Ducrot used to illustrate the presuppositional imposition of power were a university exam and a police interrogation.

Challenging the frame

The French structural linguist Émile Benveniste (1902–76) had already done more than anyone else to bring about this transformation in the way language came to be viewed in the sixties. Dividing types of verbal exchange into *narrative* on the one hand and *discourse* on the other, he pointed out that each type has its

2 • Daniel Buren, Photo-souvenir: *"Within and beyond the frame,"* 1973 (detail)
Work in situ, John Weber Gallery, New York

By the early seventies Buren had reduced his painting practice to a type of readymade: canvases cut from commercially produced gray-and-white striped awning material (used for the awnings on French state office buildings) which he would "personalize" by hand-painting over one of the stripes at the edge of the swatch. For the John Weber installation, he ran the canvases through the gallery and out the window across the width of the street—as a kind of bannerlike advertisement for the exhibition.

own characteristic features: narrative (or the writing of history) typically engages the third person and confines itself to a form of the past tense; in contrast, discourse, Benveniste's term for live communication, typically engages the present tense and the first and second persons (the shifters "I" and "you"). Discourse is marked, then, by the existential facts of its active transmission, of the necessary presence within it of both sender and receiver.

The French historian and philosopher Michel Foucault, teaching at the Collège de France in 1969, developed this idea further. Applying Benveniste's term "discourse" to what had always been understood as the neutral communication of scholarly information contained within a given departmental discipline and—like narrative—confined to the transmission of "objective" information, Foucault took up the contrary position that "discourses" are always charged from within by power relations, and even by the exercise of force. Knowledge, according to this argument, ceases to be the autonomous contents of a discipline and now becomes *disciplinary*—that is, marked by the operations of power. Foucault's "discourse," then, like Ducrot's "presuppositions," is an acknowledgment of the discursive frame that shapes the speech event, institutionally, like the relations of power that operate in a classroom or a police station.

▲ Broodthaers's seizing of the right to speak, in his guise as "museum director," performed the kind of challenge to institutional frames that poststructuralists such as Foucault were then theorizing. Indeed, Broodthaers made his work out of those very frames, by enacting the rituals of administrative compartmentalization and by parodying the way those compartments in turn create collections of "knowledge." And as the frames were made to become apparent, not outside the work but at its very center, what indeed took place was the putting of "the very legitimacy of the given speech act at stake."

• Under each of the Museum's exhibits, the Department of Eagles affixed the Magrittean label: "This is not a work of art."

Broodthaers was not alone in this decision to make artistic practice out of the framing, as it were, of the institutional frames. Indeed, the whole practice of what came to be called "institutional critique" derived from such a practice—calling attention to the supposedly neutral containers of culture and questioning this

■ putative neutrality. The French artist Daniel Buren, for instance, adopted a strategy to challenge the power of the frames by refusing to leave their presuppositions alone, implicit, unremarked. Instead, his art, emerging in the seventies, was one of marking all those divisions through which power operates. In 1973 he exhibited *Within and beyond the frame* [2]. A work in nineteen sections, each a suspended gray-and-white-striped canvas (unstretched and unframed), Buren's "painting" extended almost two hundred feet, beginning at one end of the John Weber Gallery in New York and gaily continuing out the window to wend its way across the street, like so many flags hung out for a parade, finally attaching itself to the building opposite. The frame referred to in the title of the work was, obviously, the institutional frame of the gallery, a frame that functions to guarantee certain things about the objects it encloses.

▲ 1972a ● 1927a, 1972a ■ 1967c, 1971

3 • Robert Smithson, *A Non-site* (Franklin, New Jersey), 1968

Painted wooden bins, limestone, silver-gelatin prints and typescript on paper with graphite and transfer letters, mounted on mat board. Bins installed 41.9 × 208.9 × 261.6 (16½ × 82¼ × 103); frames 103.5 × 78.1 (40¾ × 30¾).

Smithson's *Non-sites* have been productively related to the dioramas in the Museum of Natural History in New York, in which samples of the natural world are imported into the Museum as exhibits that necessarily contaminate the "purity" of the aesthetic space. The bins or containers of his *Non-sites* comment ironically on Minimalism, accusing it of an aestheticism that Minimalist artists like Donald Judd and Robert Morris would have energetically denied.

These things—like rarity, authenticity, originality, and uniqueness—are part of the value of the work implicitly asserted by the space of the gallery. These values, which are part of what separates art from other objects in our culture, objects that are neither rare, nor original, nor unique, operate then to declare art as an autonomous system within that culture.

Yet rarity, uniqueness, and so forth are also the values to which the gallery attaches a price, in an act that erases any fundamental difference between what it has to sell and the merchandise of any other commercial space. As the identically striped paintings (themselves barely distinguishable from commercially produced awnings) breached the frame of the gallery to pass beyond its confines and out the window, Buren seemed to be asking the viewer to determine at what point they ceased being "paintings" (objects of rarity, originality, etc.) and started being part of another system of objects: flags, sheets hung out to dry, advertisements for the artist's show, carnival bunting. He was probing, that is, the legitimacy of the system's power to bestow value on work.

▲ The question of frames was also at the heart of Robert Smithson's thinking about the relation between the landscape, or natural site, to its aesthetic container, which the artist labeled "non-site." In a series of works called *Non-sites*, Smithson imported mineral material—rocks, slag, slate—from specific locations into the space of the gallery by placing this material into geometrically shaped bins, each one visually connected, by means of its form, to a segment of a wall map indicating the area of the specimens' origin [**3**]. The obvious act of aestheticizing nature, and of turning the real into a representation of itself through the operations of the geometrical bin to construct the raw matter of the rocks into a sign—trapezoid—that comes to "stand for" the rocks' point of extraction, and thus for the rocks themselves, is what Smithson consigns to the system of the art world's spaces: its galleries, its museums, its magazines.

The ziggurat-like structures of Smithson's bins and maps might imply that it was only an ironic formal game that was at issue in this aspect of his art. But the graduated bins were also addressing a kind of natural history that could be read in the landscape, the successive stages of extracting the ore from the initial bounty, to the progressive barrenness, to a final exhaustion of supply. It was this natural history that could not be represented within the frames of the art world's discourse, concerted as it is to tell quite another story—one of form, of beauty, of *self*-reference. Therefore, part of Smithson's strategy was to smuggle another, foreign mode of representation into the frame of the gallery, a mode he took, in fact, from the natural history museum, where rocks and bins and maps are not freakish, aestheticized abstractions but the basis of an altogether different system of knowledge: a way of mapping and containing ideas about the "real."

The effort to escape from the aesthetic container, to break the chains of the institutional frame, to challenge the assumptions (and indeed the implicit power relations) established by the art world's presuppositions was thus carried out in the seventies in

▲ 1967a, 1970

By going out into the landscape for the materials of his *Non-sites*, Smithson introduced the idea that the landscape itself might be a sculptural medium. Earthworks were a result of this suggestion, in which artists such as Long, Walter De Maria, Christo, or Michael Heizer operated directly on the earth, often making photographic records of their activities. This dependence on the photographic document was the confirmation of Walter Benjamin's predictions in the 1936 essay "The Work of Art in the Age of Mechanical Reproduction."

relation to specific sites—gallery, museum, rock quarry, Scottish Highlands, California coast—which the work of art functioned to *reframe*. This act of reframing was meant to perform a peculiar kind of reversal. The old aesthetic ideas that the sites used to frame (although invisibly, implicitly) now hovered over these real places like so many exorcised ghosts, while the site itself—its white walls, its neoclassical porticos, its picturesque moors, its rolling hills and rocky outcroppings [4]—became the material support (the way paint and canvas or marble and clay used to be) for a new kind of representation. This representation was the image of the institutional frames themselves, now forced into visibility as though some kind of powerful new developing fluid had unlocked previously secret information from an inert photographic negative.

Derrida's double session

Jacques Derrida (1930–2004), a philosopher teaching at the École Normale Supérieure in Paris, seized upon Benveniste's and Foucault's radicalization of structural linguistics to fashion his own brand of poststructuralism. He started out from the very terms of structuralism itself, in which language is marked by a fundamental

▲ bivalency at the heart of the linguistic sign. According to structuralist logic, while the sign is made up of the pairing of signifier and

▲ Introduction 3

signified, it is the signified (the referent or concept, such as a cat or the idea of "cat") that has privilege over the mere material form of the signifier (the spoken or written letters *c*, *a*, *t*). This is because the relationship between signifier and signified is arbitrary: there is no reason why *c*, *a*, *t* should signify "catness"; any other combination of letters could do the job just as well, as the existence of different words for "cat" in different languages demonstrates ("*chat*," "*gatto*," "*Katze*," etc.).

But this inequality between signifier and signified is not the only one at the heart of language. Another feature to emerge from the structuralist model is the unevenness of terms that make up opposing binary pairs such as "young / old" or "man / woman." This inequality is between a *marked* and an *unmarked* term. The marked half of the pair brings more information into the utterance than the unmarked half, as in the binary "young / old" and the statement "John is as young as Mary." "As young as" here implies youth, whereas "John is as old as Mary" implies neither youth nor advanced age. It is the unmarked term which opens itself to the higher order of synthesis most easily, a condition that becomes clear if we look at the binary "man / woman," in which it is "man" that is the unmarked half of the pair (as in "mankind," "chairman," "spokesman," etc.).

That the unmarked term slips past its partner into the position of greater generality gives that term implicit power, thus instituting a hierarchy within the seemingly neutral structure of the binary pairing. It was Derrida's determination not to continue to let this inequality go without saying, but rather to say it, to "mark" the unmarked term, by using "she" as the general pronoun indicating a person, and—in the theorization of "grammatology" (see below)—to put the signifier in the position of superiority over the signified. This marking of the unmarked Derrida called "*deconstruction*," an overturning that makes sense only within the very structuralist frame that it wants to place at the center of its activity by framing that frame.

Derrida's extremely influential book *Of Grammatology* (1967) proceeded from such a deconstructive operation to mark the unmarked, and thus to expose the invisible frame to view. If we compare the status of "he says" to that of "he writes," we see that "says" is unmarked, while "writes," as the specific term, is thus marked. Derrida's "grammatology" intends to mark speech (*logos*) and thus to overturn this hierarchy, as well as to analyze the sources of speech's preeminence over writing. This analysis had begun with Derrida's doctoral thesis, *Speech and Phenomenon*, in which he analyzed the phenomenologist Edmund Husserl's (1859–1938) dismissal of writing as an infection of the transparency and immediacy of thought's appearance to itself. And as he analyzed the privilege of *logos* over the dismissed sign of the memory trace (writing, *grammé*), Derrida developed the logic of what he called the *supplement*, an aid brought in to help or extend or supplement a human capacity—as writing extends memory or the reach of the human voice—but which, ironically, ends by supplanting it. Such a hierarchy is also behind the Derridean term

différance, itself aurally indistinguishable from *différence*, the French word for that difference on which language is based. *Différance*, which can only be perceived in its written form, refers, precisely, to writing's operation of the trace and of the break or spacing that opens up the page to the articulation of one sign from another. This spacing allows not only for the play of difference between signifiers that is the basis of language ("cat," for example, can function as a sign and assume its value in the language system only because it *differs* from "bat" and from "car"), but also for the temporal unfolding of signifieds (meaning being elaborated in time through the gradual iteration of a sentence): *différance* not only differs, then, it also defers, or temporalizes.

If deconstruction is the marking of the unmarked, which Derrida sometimes called the *re-mark*, its striving to frame the frames took the analytical form of the essay "The Parergon," which attends to Immanuel Kant's major treatise "The Critique of Judgment" (1790), a treatise that not only founds the discipline of aesthetics but also powerfully supplies modernism with its conviction in the possibility of the autonomy of the arts—the art work's self-grounding and thus its independence from the conditions of its frame. For Kant argues that "Judgment," the outcome of aesthetic experience, must be separate from "Reason"; it is not dependent on cognitive judgment but must reveal, Kant argues, the paradoxical condition of "purposiveness without purpose." This is the source of art's autonomy, its disinterestedness, its escape from use or instrumentalization. Reason makes use of concepts in its purposive pursuit of knowledge; art, as self-grounding, must abjure concepts, reflecting instead on the sheer purposiveness of nature as a transcendental concept (and thus containing nothing empirical). Kant argues that the logic of the work (the *ergon*) is internal (or proper) to it, such that what is outside it (the *parergon*) is only extraneous ornament and, like the frame on a painting or the columns on a building, mere superfluity or decoration. Derrida's argument, however, is that Kant's analysis of aesthetic judgment as self-grounding is not itself self-grounding but imports a frame from the writer's earlier essay "The Critique of Pure Reason" (1781), a cognitive frame on which to build its transcendental logic. Thus the frame is not extrinsic to the work but comes from *outside* to constitute the inside as an inside. This is the parergonal function of the frame.

Derrida's own reframing of the frame was perhaps most eloquently carried out in his 1969 text "The Double Session," referring to a double lecture he gave on the work of the French poet Stéphane Mallarmé (1842–98). The first page of the essay shows Derrida's almost modernist sensibility to the status of the signifier, a sensibility that parallels the poststructuralist's canny assessment of the "truths" of structuralism [5]. Like a modernist monochrome, the page presents itself as a buzz of gray letters as it reproduces a page from the Platonic dialogue "Philebus," a dialogue devoted to the theory of mimesis (representation, imitation). Into the lower-right corner of this field of gray, however, Derrida inserts another text, also directed at the idea of mimesis: Mallarmé's "Mimique,"

the poet's account of a performance he saw carried out by a famous mime and based on the text "Pierrot, Murderer of His Wife." Behind Derrida, on the blackboard of the classroom, had appeared a three-fold introduction to the lecture, hanging above his words, he said, like a crystal chandelier:

l'antre de Mallarmé
l'"entre" de Mallarmé
l'entre-deux "Mallarmé"

Because in French there is no aural distinction between *antre* and *entre*, this textual ornament depends on its written form in order to make any sense, in the same way that *différance* must be written in order to register *its* signified. This homophonic condition is itself "between-two," as in Mallarmé's "*entre-deux*," a between-ness that Derrida will liken to the fold in a page, a fold which turns the singleness of the material support into an ambiguous double-ness (a fold materialized in turn by the insertion of "Mimique" into the "Philebus" at its corner).

In the text of "The Double Session" itself, Derrida plays, like any good modernist, with the material condition of the numbers that emerge from Plato's and Mallarmé's definitions of mimesis. Plato's definition turns on the number four, while the poet's turns on the double, or the number two. And like any good modernist, Derrida materializes the classical foursome, understanding it as a frame: Plato says that (1) the book imitates the soul's silent dialogue with the self; (2) the value of the book is not intrinsic but depends on the value of what it imitates; (3) the truth of the book can be decided, based on the truthfulness of its imitation; and (4) the book's imitation is constituted by the form of the double. Thus Platonic mimesis doubles what is single (or simple) and, being thus decidable, institutes itself within the operations of truth. Mallarmé's imitation, on the other hand, doubles what is already double or multiple and is, therefore, undecidable: between-two. The text of the mime-drama that Mallarmé recounts in "Mimique" tells of Pierrot's discovery of his wife Columbine's adultery, which he decides to avenge by killing her. Not wanting to be caught, however, he refuses the obvious possibilities of poison, strangling, or shooting, since all of them leave traces. After kicking a rock in frustration, he massages his foot to assuage the pain and inadvertently tickles himself. In his helpless laughter, the idea dawns on him that he will tickle Columbine to death and she will thus die laughing. In the performance, the actual murder is mimed with the actor playing both parts: the diabolical tickler and the convulsively struggling victim, writhing with pleasure. Since such a death is impossible, the imitation imitates not what is simple but rather a multiple, itself a pure function of the signifier, a turn of speech ("to die laughing"; "to be tickled to death"), rather than of actuality. As Mallarmé writes: "The scene illustrates only the idea, not a positive action, in a marriage that is lewd but sacred, a marriage between desire and its achievement, enactment and its memory: here, anticipating, recollecting, in the future, in the past, under a

SOCRATES: And if he had someone with him, he would put what he said to himself into actual speech addressed to his companion, audibly uttering those same thoughts, so that what before we called opinion (δόξαν) has now become assertion (λόγος).—PROTARCHUS: Of course.—SOCRATES: Whereas if he is alone he continues thinking the same thing by himself, going on his way maybe for a considerable time with the thought in his mind.—PROTARCHUS: Undoubtedly.—SOCRATES: Well now, I wonder whether you share my view on these matters.—PROTARCHUS: What is it?—SOCRATES: It seems to me that at such times our soul is like a book (Δοκεῖ μοι τότε ἡμῶν ἡ ψυχὴ βιβλίῳ τινὶ προσεοικέναι).—PROTARCHUS: How so?—SOCRATES: It appears to me that the conjunction of memory with sensations, together with the feelings consequent upon memory and sensation, may be said as it were to write words in our souls (γράφειν ἡμῶν ἐν ταῖς ψυχαῖς τότε λόγους). And when this experience writes what is true, the result is that true opinion and true assertions spring up in us, while when the internal scribe that I have suggested writes what is false (ψευδῆ δ᾽ ὅταν ὁ τοιοῦτος παρ᾽ ἡμῖν γραμματεὺς γράψῃ), we get the opposite sort of opinions and assertions. —PROTARCHUS: That certainly seems to me right, and I approve of the way you put it—SOCRATES: Then please give your approval to the presence of a second artist (δημιουργὸν) in our souls at such a time.—PROTARCHUS: Who is that?—SOCRATES: A painter (Ζωγράφον) who comes after the writer and paints in the soul pictures of these assertions that we make.—PROTARCHUS: How do we make out that he in his turn acts, and when?—SOCRATES: When we have got those opinions and assertions clear of the act of sight (ὄψεως) or other sense, and as it were see in ourselves pictures or images (εἰκόνας) of what we previously opined or asserted. That does happen with us, doesn't it?—PROTARCHUS: Indeed it does.—SOCRATES: Then are the pictures of true opinions and assertions true, and the pictures of false ones false?—PROTARCHUS: Unquestionably.—SOCRATES: Well, if we are right so far, here is one more point in this connection for us to consider.—PROTARCHUS: What is that?—SOCRATES: Does all this necessarily befall us in respect of the present (τῶν ὄντων) and the past (τῶν γεγονότων), but not in respect of the future (τῶν μελλόντων)?—PROTARCHUS: On the contrary, it applies equally to them all.—SOCRATES: We said previously, did we not, that pleasures and pains felt in the soul alone might precede those that come through the body? That must mean that we have anticipatory pleasures and anticipatory pains in regard to the future.—PROTARCHUS: Very true.—SOCRATES: Now do those writings and paintings (γράμματά τε καὶ ζωγραφήματα), which a while ago we assumed to occur within ourselves, apply to past and present only, and not to the future?—PROTARCHUS: Indeed they do.—SOCRATES: When you say 'indeed they do', do you mean that the last sort are all expectations concerned with what is to come, and that we are full of expectations all our life long?—PROTARCHUS: Undoubtedly.—SOCRATES: Well now, as a supplement to all we have said, here is a further question for you to answer.

MIMIQUE

Silence, sole luxury after rhymes, an orchestra only marking with its gold, its brushes with thought and dusk, the detail of its signification on a par with a stilled ode and which it is up to the poet, roused by a dare, to translate! the silence of an afternoon of music; I find it, with contentment, also, before the ever original reappearance of Pierrot or of the poignant and elegant mime Paul Margueritte.

Such is this PIERROT MURDERER OF HIS WIFE composed and set down by himself, a mute soliloquy that the phantom, white as a yet unwritten page, holds in both face and gesture at full length to his soul. A whirlwind of naive or new reasons emanates, which it would be pleasing to seize upon with security: the esthetics of the genre situated closer to principles than any! (no)thing in this region of caprice foiling the direct simplifying instinct... This — "The scene illustrates but the idea, not any actual action, in a hymen (out of which flows Dream), tainted with vice yet sacred, between desire and fulfillment, perpetration and remembrance: here anticipating, there recalling, in the future, in the past, *under the false appearance of a present*. That is how the Mime operates, whose act is confined to a perpetual allusion without breaking the ice or the mirror: he thus sets up a medium, a pure medium, of fiction." Less than a thousand lines, the role, the one that reads, will instantly comprehend the rules as if placed before the stageboards, their humble depository. Surprise, accompanying the artifice of a notation of sentiments by unproffered sentences — that, in the sole case, perhaps, with authenticity, between the sheets and the eye there reigns a silence still, the condition and delight of reading.

175

5 • Jacques Derrida, *Dissemination*, trans. Barbara Johnson, page 175 ("The Double Session")

Derrida, whose deconstructive theory consisted of an assault on the visual—as a form of presence that his idea of spacing as an aspect of deferral (or *différance*) was meant to dismantle—often invented surprisingly effective visual metaphors for his concepts. Here, the insertion of Mallarmé's "Mimique" into a corner of Plato's "Philebus" suggests, visually, the idea of the fold, or redoubling, that Derrida produces as a new concept of mimesis, in which the double (or second-order copy) doubles no single (or original). Another example occurs in the essay "The Parergon," where a succession of graphic frames is interspersed throughout a text focused on the function of the frame of the work of art, a frame that attempts to essentialize the work as autonomous but which does nothing more than connect it to its context or nonwork.

6 • Louise Lawler, *Pollock and Soup Tureen*, **1984**
Cibachrome, 40.6 × 50.8 (16 × 20)

Photographing works of art as they enter into the spaces arranged for them by collectors, Lawler produces the images as though they were illustrations of interiors in *Vogue* or any other luxury design periodical. Stressing the commodification of the work of art, Lawler's images also focus on the collector's incorporation of the work into his or her domestic space, thereby making it an extension of his subjectivity. The detail of Pollock's web of paint is thus related to the intricate design of the soup tureen, as a form of *interpretation* personal to the collector.

false appearance of the present. In this way the mime acts. His game ends in a perpetual allusion without breaking the mirror. In this way it sets up a pure condition of fiction."

Imitation that folds over what is already double, or ambiguous, does not, then, enter the realm of truth. It is a copy without a model and its condition is marked by the term *simulacrum*: a copy without an original—"a false appearance of the present." The fold through which the Platonic frame is transmuted into the Mallarméan double (or between-two) is likened by both poet and philosopher to the fold or gutter of a book, which in its crevice was always sexualized for Mallarmé, hence his term "lewd but sacred." This is the fold—"false appearance of the present"—that Derrida will call *hymen*, or will refer to at times as "invagination," by which the condition of the frame will be carried into the inside of an argument, which will, in turn, frame it.

Art in the age of the simulacrum

Terms like *parergon*, *supplement*, *différance*, and *re-mark* grounded new artistic practice in the wake of modernism. All of these ideas—from the simulacrum to the framing of the frame—became the staple not just of poststructuralism but of postmodernist painting. David Salle, who is perhaps most representative of that painting, developed in a context of young artists who were highly critical of art's traditional claims to transcend mass-cultural conditions. This group—initially including figures like Robert Longo, Cindy Sherman, Barbara Kruger, Sherrie Levine, and Louise Lawler [6] —was fascinated by the reversal between reality and its representation that was being effected by a late-twentieth-century culture of information.

Representations, it was argued, instead of coming *after* reality, in an imitation of it, now precede and construct reality. Our "real" emotions imitate those we see on film and read about in pulp romances; our "real" desires are structured for us by advertising images; the "real" of our politics is prefabricated by television news and Hollywood scenarios of leadership; our "real" selves are congeries and repetition of all these images, strung together by narratives not of our own making. To analyze this structure of the representation that precedes its referent (the thing in the real world it is supposed to copy) would cause this group of artists to ask themselves probing questions about the mechanics of the image-culture: its basis in mechanical reproduction, its function as serial repetition, its status as multiple without an original.

"Pictures" was the name given to this work in an early reception of it by the critic Douglas Crimp. There, for example, he examined the way Cindy Sherman, posing for a series of photographic "self-portraits" in a variety of different costumes and settings, each with the look of a fifties movie still and each projecting the image of a stereotypical film heroine—career girl, highly strung hysteric, Southern belle, outdoor girl—had projected her very self as always mediated by, always constructed through, a "picture" that preceded it, thus a copy without an original. The ideas that Crimp and other

▲ 1975a, 1977a, 1980, 1984b ● 1977a

critics versed in theories of poststructuralism came to identify with such work involved a serious questioning of notions of authorship, originality, and uniqueness, the foundation stones of institutionalized aesthetic culture. Reflected in the facing mirrors of Sherman's photographs, creating as they did an endlessly retreating horizon of quotation from which the "real" author disappears, these critics saw what Michel Foucault and Roland Barthes had analyzed in the fifties and sixties as "the death of the author."

The work of Sherrie Levine was set in this same context, as she rephotographed photographs by Elliot Porter, Edward Weston, and Walker Evans and presented these as her "own" work, questioning by her act of piracy the status of these figures as authorial sources of the image. Folded into this challenge is an implicit reading of the "original" picture—whether Weston's photographs of the nude torso of his young son Neil, or Porter's wild technicolor landscapes—as itself always already a piracy, involved in an unconscious but inevitable borrowing from the great library of images—the Greek classical torso, the windswept picturesque countryside—that have already educated our eyes. To this kind of radical refusal of traditional conceptions of authorship and originality, a critical stance made unmistakable by its position at the margins of legality, the name "appropriation art" has come to be affixed. And this type of work, building a critique of forms of ownership and fictions of privacy and control came to be identified as postmodernism in its radical form.

The question of where to place this widely practiced, eighties tactic of "appropriation" of the image—whether in a radical camp, as a critique of the power network that threads through reality, always already structuring it, or in a conservative one, as an enthusiastic return to figuration and the artist as image-giver—takes on another dimension when we view the strategy through the eyes of feminist artists. Working with both photographic material appropriated from the mass-cultural image bank and the form of direct address to which advertising often has recourse—as it cajoles, or hectors, or preaches to its viewers and readers, addressing them as "you"—Barbara Kruger elaborates yet another of the presuppositions of the aesthetic discourse, another of its institutional frames. This is the frame of gender, of the unspoken assumption set up between artist and viewer that both of them are male. Articulating

▲ this assumption in a work like *Your gaze hits the side of my face* (1981), where the typeface of the message appears in staccato against the image of a classicized female statue, Kruger fills in another part of the presuppositional frame: the message transmitted between the two poles classical linguistics marks as "sender" and "receiver," and assumes is neutral but presupposes as male, is a message put in play by something we could call an always-silent partner, namely, the symbolic form of Woman. Following a poststructuralist linguistic analysis of language and gender, Kruger's work is therefore interested in woman as one of those subjects who do not speak but is, instead, always spoken for. She is, as critic Laura Mulvey writes, structurally "tied to her place as bearer of meaning, not maker of meaning."

This is why Kruger, in this work, does not seize the right to speech the way that Broodthaers had in his open letters but turns instead to "appropriation." Woman, as the "bearer of meaning" is the locus of an endless series of abstractions—she is "nature," "beauty," "motherland," "liberty," "justice"—all of which form the cultural and patriarchal linguistic field; she is the reservoir of meanings from which statements are made. As a woman artist, Kruger acknowledges this position as the silent term through her act of "stealing" her speech, of never laying claim to having become the "maker of meaning."

This question of the woman's relation to the symbolic field of speech and the meaning of her structural dispossession within that field has become the medium of other major works by feminists. One of these, Mary Kelly's *Post-Partum Document* (1973–9), tracks the artist's own connection to her infant son through five years of his development and the 135 exhibits that record the mother–child relationship. This recording, however, is carried on explicitly along the fault line of the woman's experience of the developing autonomy of the male-child as he comes into possession of language. It wants to examine the way the child himself is fetishized by the mother through her own sense of lack.

Two kinds of absences structure the field of aesthetic experience at the end of the twentieth century and into the twenty-first. One of them we could describe as the absence of reality itself as it retreats behind the miragelike screen of the media, sucked up into the vacuum tube of a television monitor, read off like so many printouts from a multinational computer hook-up. The other is the invisibility of the presuppositions of language and of institutions, a seeming absence behind which power is at work, an absence which artists from Mary Kelly, Barbara Kruger, and
• Cindy Sherman to Hans Haacke, Daniel Buren, and Richard Serra attempt to bring to light.

FURTHER READING
Roland Barthes, *Critical Essays*, trans. Richard Howard (Evanston: Northwestern University Press, 1972)
Roland Barthes, *Image, Music, Text*, trans. Stephen Heath (New York: Hill and Wang, 1977)
Douglas Crimp, "Pictures," *October*, no. 8, Spring 1979
Jacques Derrida, *Of Grammatology*, trans. Gayatri Spivak (Baltimore: The Johns Hopkins University Press, 1976)
Jacques Derrida, "Parergon," *The Truth in Painting*, trans. Geoff Bennington (Chicago and London: University of Chicago Press, 1987)
Jacques Derrida, "The Double Session," *Dissemination*, trans. Barbara Johnson (Chicago and London: University of Chicago Press, 1981)
Michel Foucault, *The Archaeology of Knowledge* (Paris: Gallimard, 1969; translation London: Tavistock Publications; and New York: Pantheon, 1972)
Michel Foucault, "What is an Author?", *Language, Counter-Memory, Practice*, trans. D. Bouchard and S. Simon (Ithaca, N.Y.: Cornell University Press, 1977)
Mary Kelly, *Post-Partum Document* (London: Routledge & Kegan Paul, 1983)
Laura Mulvey, "Visual Pleasure and Narrative Cinema," *Visual and Other Pleasures* (Bloomington: Indiana University Press, 1989)
Craig Owens, "The Allegorical Impulse: Towards a Theory of Postmodernism," *October*, nos 12 and 13, Spring and Summer 1980
Ann Reynolds, "Reproducing Nature: The Museum of Natural History as Nonsite," *October*, no. 45, Summer 1988

Rosalind Krauss

▲ Introduction 1 ▲ 1975a ● 1967c, 1969, 1970, 1971, 1972b, 1993a

5 Globalization, networks, and the aggregate as form

Transregional cultural interchange is as old as human history. "Globalization," on the other hand, refers to a historically specific development typically dating from the period of the eighties and nineties, when financial markets were deregulated to an unprecedented degree through the economic policies known as neoliberalism. Under pressure from nongovernmental agencies such as the World Bank and the International Monetary Fund, many developing nations opened—or "liberalized"—markets in order to attract foreign investment, in the process exposing themselves to significant political influence from the West and to financial volatility arising from unsustainable levels of debt. The objective of these policies was to allow capital, including that of multinational corporations, to move more easily from place to place, in pursuit of the least expensive labor and the most profitable consumer markets. Garments sold in Europe and the United States, for instance, might be manufactured one year in China and the next in Pakistan under work conditions that would be unacceptable in the West, while outsourced business services could be provided from India to the entire English-speaking world. Culturally, globalization has led to two diametrically opposed conditions: first, homogenization or what is often called the "McDonaldization" of life; and second, greater diversity and heightened awareness of cultural difference on account of increased and accelerated contact between geographically distant regions. It is within the terms of this paradox—growing infrastructural homogeneity on the one hand, and expanded consciousness of cultural diversity on the other—that a globalized art world arises. Its contravening forces, one moving toward sameness and the other toward difference, need to be recognized and carefully addressed when approaching global contemporary art.

To do so, we must acknowledge the different chronologies of modern art's adoption in different parts of the world. The European avant-gardes of the early twentieth century, including ▲ Cubism, Constructivism, and Surrealism, were arguably devoted to representing and indeed critically challenging the experience of modernization's uneven development from the late nineteenth through the mid-twentieth centuries (including rapid industrialization and mass urbanization). In whole regions, including significant areas of Asia and Africa, modern European art was introduced as a belated, but hegemonic, or neocolonial language as opposed to a form of avant-garde protest. In these places, modern art was typically pressed into service as an agent of cultural and economic modernization rather than as an opponent to its many devastating consequences. In this regard, it seems ▲ no coincidence that international booms in Chinese and Russian contemporary art accompanied those nations' market liberalization in the late eighties and nineties. A thriving art market may serve as a bellwether of full-fledged membership in the neoliberal global economy, as well as a prestigious sign of cultural development attractive not only to tourists, but to foreign investment as well. When we refer to "modern art" or "contemporary art," then, we are eliding a wide range of distinct visual dialects, each with its own local histories and semantics. These may be mutually intelligible, but they nonetheless remain significantly different— and often even contradictory.

Not one but many histories

Let us consider one example of this complexity. During the Meiji Dynasty in Japan (1868–1912), two opposing types of painting emerged: *nihonga*, or Japanese-style painting [1], which arose in opposition to *yōga*, or Western-style painting using oil on canvas, which was informed by European movements like Impressionism and Postimpressionism [2]. While *nihonga* sought to preserve historically Japanese materials and themes, it may be seen as just as modern as *yōga* in its efforts to adapt traditional techniques to contemporary conditions. The opposition between modernized forms of indigenous traditions in *nihonga* and "indigenized" reinventions of modern European forms in *yōga* persisted through the mid-twentieth century in the underlying dynamic of one • of Japan's best-known post-World War II movements, Gutai, where the gesturalism associated with long traditions of ink drawing is scaled up in part as a riposte to Western practices ■ of Abstract Expressionism [3]. Although Gutai superficially resembles "American-type painting," Japanese artists at mid-century expressed significantly different attitudes toward matter and art than their American contemporaries, emphasizing the meeting of

▲ 1911, 1912, 1921a, 1921b, 1924, 1925a, 1926, 1927a, 1928a, 1930b, 1931a, 1934b, 1942b ▲ 1975b, 2010a • 1955a ■ 1947b, 1949a, 1951

2 • Kuroda Seiki, *Lakeside*, 1897
Oil on canvas, 69 × 84.7 cm (27¼ × 33⅜)

Meaning literally "Western-style painting," *yōga* encompassed work produced with a range of techniques, materials, and theories developed in the West, in contrast with the indigenous *nihonga* style. In particular, *yōga* artists such as Seiki, who studied in Paris for a decade from the mid-1880s, emulated the appearance of contemporary Impressionist and Postimpressionist painting from Europe and the United States. As such, the style represents one side of the two-way exchange of visual cultures between Japan and Europe in the second half of the nineteenth century.

1 • Hishida Shunso, *Cat and Plum Blossoms*, 1906
Color on silk, hanging scroll, 1180 × 498 cm (46½ × 19⅝)

One of the leading proponents of the *nihonga* style, Shunso integrated the thousand-year-old traditions and conventions of Japanese art with a more modern concern for realism, typified by his use of gradations of color instead of the more restrictive monochrome line drawing of traditional Japanese painting.

3 • Gutai artists, overseen by Michel Tapié (left) and Jiro Yoshihara (right), preparing for the "International Sky Festival" in Osaka in 1960

As Yve-Alain Bois writes in this book, Yoshihara formed the Gutai group, of which he would be both mentor and financial backer, in 1954. He had been inspired by the famous 1949 *Life* article about Jackson Pollock, who became the standard by which Yoshihara would judge the work of his young disciples. The French critic Tapié, the champion of *art informel* painting in France, became an advisor and advocate of Gutai, organizing exhibitions and writing publications that coopted the group as part of a global *informel* movement—one naturally dominated and led by Western figures. And yet despite being "deemed, somewhat condescendingly, the mere oriental offspring of Abstract Expressionism," as Bois puts it, the transgressive and ludic work of Gutai was in fact the product of a particular and specific context: the unique traditions and rituals of Japanese society and culture.

the artist with his or her material at the expense of making discrete paintings in the Western tradition, which was still the objective of Abstract Expressionism. In China, there was a similar encounter of Western and indigenous traditions from the New Culture Movement during the 1920s onward, but their interaction was nearly extinguished by the forcible expurgation of traditional Chinese painting during the Cultural Revolution (1966–76), ▲ in which a Soviet-derived idiom of figurative Socialist Realism was adopted as Chairman Mao's official art. After this period of imposed "tabula rasa," the Chinese art world gained knowledge of Western art and theory through the greatly increased appearance of translations of various texts in the eighties, leading to an efflorescence of commercially successful and globally circulated ● Chinese contemporary art in the nineties, some of whose most popular practitioners flaunted kitsch references to the Cultural Revolution informed by various Western practices of Pop and ■ appropriation art.

What these brief, partial, and highly schematic genealogies are meant to indicate is that seemingly comparable visual idioms—such as oil painting, ink painting, or even Socialist Realism and Pop—may look similar when presented side by side in art settings such as blockbuster exhibitions, biennials, and art fairs but, in fact, they grow out of distinctly different, and even contradictory histories. Recognizing both what is common and what is singular about such practices is a fundamental methodological challenge in writing the history of "global" modern or contemporary art.

One way to address this challenge is to develop a multipolar worldwide art history. While this would seem to be an obvious and attainable goal under the cosmopolitan conditions of globalization, it turns out to be very difficult in practice, partly because the geopolitical alignments of the twentieth century were organized as a succession of bipolar and, more recently, monolithic structures that have profoundly affected the infrastructure as well as the underlying critical value system of the global art world. During the late nineteenth century, much of the developing world experienced colonization of various types, formal and informal. Immediately after the mid-twentieth-century period of decolonization—and indeed perhaps as a result of it—world alliances were forcibly reorganized into a Cold War opposition that pitted the Soviet Union, as the leader of world Communism, against the United States' promotion of democratic values. This simplistic Manichaean split had dramatic effects on global art practices, not least because it isolated entire regions of the world from one another. Despite efforts to build a movement of nonaligned nations and related cultural policies, the political pressure to take sides and the lure of developmental aid drew a vast proportion of the world into the orbit of either the United States or the Soviet Union between World War II and 1989. Many of these countries were devastated by the effects of not-so-cold proxy wars around the world—in Vietnam, Central America, and Afghanistan to name only a few. With the end of the Cold War, it has been widely accepted that there now exists only one world superpower—the

4 • Kwon Young-woo, *Untitled*, 1977
Korean paper on plywood, 116.8 × 91 cm (46 × 35⅞)

Kwon Young-woo (1926–2013) was a pioneer of
tansaekhwa, meaning "monochromatic painting." From
the mid-1960s into the 1970s, artists such as Young-woo
manipulated various materials, including soaked canvas
and torn paper, in innovative ways to create a distinctively
Korean form of abstract art in white, cream, brown,
black, or other neutral colors. Although never an official
group with a clearly defined set of members or manifesto,
tansaekhwa was the first Korean art movement to find
recognition on the world stage. Its international success
was in part because several of the artists lived, studied,
and worked in Paris, but also because of the association
with Lee Ufan, a Korean artist based in Japan who was
the main theorist of the Mono-ha tendency of Japanese
art, itself influenced by Arte Povera and Process art.

United States—and that its quasi-imperial power is expressed not in the structural colonialism of explicit governmental administration, but rather through economic pressure (often in collaboration with the World Bank and the International Monetary Fund) and perpetual military "police actions."

A global art world?

The "official" or hegemonic art world whose capital and infrastructural power is still centered in the developed nations can also feel monolithic. Despite their far-flung locations, its outposts resemble one another architecturally and programmatically (leading to the desire for museums around the world to seek out a shortlist of star architects or "starchitects"). Art works on exhibit tend to share a formal idiom, belonging to what might be called an international style. Since the late sixties, artists from all continents have adapted the lexicon of Conceptual art to a wide variety of local and historically particular questions and themes—forming textual propositions, staging actions, and combining readymade components, instead of producing new or "original" objects. Such works tend to emphasize documentary and research-based procedures; they are often structured in series, and may combine a variety of media ranging from text to video. Regardless of their specific content, such works by "global artists" must communicate across borders if they are to migrate successfully from place to place. This system, which tends toward concentrations of power through the formal requirements it establishes for a work to pass into global circulation, reinscribes the new imperial order within ostensibly open markets and fungible assets. There are, of course, many sorts of art practices flourishing all over the globe that do not enter into circulation within the "official" global art world, or do so only rarely and outside the category of art: as indigenous objects, outsider art, or tourist art. Even when they do gain access to the realm of contemporary art, the frame of reference and values according to which works emerging from cultures that are unfamiliar to global art audiences are judged are not necessarily adjusted from those at play in neoliberal markets. This is because the "art world"—as a mixed configuration composed of market institutions like auction houses, galleries, and art fairs; public institutions like museums and independent spaces; and information outlets ranging from traditional print magazines and newsletters to a broader range of online aggregators and blogs—tends toward uniform principles of judgment. We should remain conscious of the fact that what we call "global contemporary art" can only ever denote a subset of world art production.

In his important book *Asia As Method*, Kuan-Hsing Chen argues against the kind of implicit standard of judgment associated with globalism—whereby Asia, for instance, is judged in dichotomous opposition to the West—in favor of a more fine-grained intraregional analysis. He writes: "The potential of Asia as method is this: using the idea of Asia as an imaginary anchoring point, societies in Asia can become each other's points

▲ 1972c, 2015 ● 1967c, 1968a, 1968b, 1970, 1971, 1972a, 1972b, 1975b, 1984a ■ 1992, 1997, 2003, 2010b

5 • The catalogue of the Third Havana Biennial, 1989

The 1980s saw the birth of a new kind of exhibition that redefined the established model of the international biennial. Notable among them were the Havana, Cairo, and Istanbul biennials, all founded in that decade. These new institutions had a global outlook and political ambition, and they sought to challenge the unequal power relations at play in the art world and in wider society. The main theme of the Third Havana Biennial in 1989 was "Tradition and Contemporaneity," and it included a conference on "Tradition and Contemporaneity in the Arts of the Third World." It was one of the first large-scale exhibitions to aspire to an international reach from outside the European and North American art system, and it featured three hundred artists from forty-one countries. As well as its global nature, it included traditional folk arts alongside the work of recognized artists, thereby extending the territory of contemporary art in other ways too.

of reference, so that the understanding of the self may be transformed, and subjectivity rebuilt." In the context of art history, Joan Kee's 2013 book *Contemporary Korean Art: Tansaekhwa and the Urgency of Method* pursues such an objective by charting the triangulated history of *tansaekhwa*, or Korean monochrome painting, during the seventies as it moves between a rapidly developing Korea whose leading artists both desire to enter the Japanese art world but wish nonetheless to maintain a distinctive Korean identity; Japan, as a recent imperial power and sophisticated art center; and Paris, as the enduringly iconic European art capital whose recognition of a Korean artist remained highly significant for his or her reputation. One of the important distinctions Kee makes is that while many players in the Japanese art scene were particularly interested in establishing a consciousness of Asian versus Western contemporary art—with Japan implicitly representing "Asia"—in Korea, on the other hand, establishing national identity remained extremely important, as marked, for instance, by the distinctive quality of whiteness of *tansaekhwa* monochromes (which was associated with Korean heritage) [**4**]. Paradoxically, the Japanese art infrastructure, which was then more developed than Korea's, offered an important tool in establishing a visible program of exhibitions that could assert Korean identity. The lesson of Chen and Kee is relevant well beyond Asia: in charting the history of global modern and contemporary art, we cannot remain satisfied with marking the passage of artists from various regions of the world across the threshold of global standards; instead we must learn to understand the complex histories in which global and local networks are articulated together. Indeed, some scholars prefer the term "translocal" as opposed to "global" in order to encompass the heterogeneous mixture of cultures, infrastructures, and aesthetics that any art world assembles.

New networks, new models

The period around 1989 marked a shift in global politics, characterized by such seismic historical events as the collapse of the Cold War, the Tiananmen Square protests in Beijing, and the unbanning of the African National Congress, which ultimately led to the
▲ dismantling of apartheid in South Africa. That was also the year of two exemplary exhibitions, the Third Havana Biennial and
● "Les Magiciens de la terre" in Paris, which both broke open the Eurocentrism of the international art world while, somewhat paradoxically, preparing the way for a worldwide explosion of biennials and commercial art fairs. Since this book includes an entry devoted to "Les Magiciens de la terre," I will concentrate here on the Havana Biennial. The latter is distinctive in that it emerges from and produces a new model for art of the Third World (a term used by the Havana organizers, which has since been widely replaced by less hierarchal categories such as the "Global South" or the "developing world"). The Third Havana Biennial was explicitly intended to do what Chen proposes in *Asia As Method*: to build a horizontal network within regions that are marginalized by the

▲ 1997　　● 1989

6 • A public print workshop organized as part of the Third Havana Biennial, Calle Cuba, Havana, 1989

As one of the Biennial's ephemeral events, the local Taller de Serigrafía Artística René Portocarrero print workshop organized a public event in the historic center of Havana, during which enormous engravings were made by driving a steamroller over printing plates. Participants could place personal items under the plates to become part of the printed impression.

official international art world, namely Latin America, Africa, and Asia [5]. Instead of writing histories based on the presumption that a Center (the West) transmits its aesthetic forms, institutions, and values to a Periphery (the rest of the world), the organizers in Havana were devoted to serious research in vast, but under-represented places, building in part on their experience in producing the two previous Havana biennials, which, while physically larger, were less thematically and curatorially focused than the 1989 version. The scope of the event was enabled by Cuba's special position as a Communist state that, while a client or protégé of the Soviet Union, was also devoted to communicating and exporting its own revolution as broadly as possible, especially, though not exclusively, in Latin America. Consequently, while the Biennial had a small budget by European or US standards, it could take advantage of Cuba's broad cultural and diplomatic networks, which spanned much of the so-called Third World, to make contacts with artists' communities that had previously worked in relative isolation.

The innovations introduced by the Third Havana Biennial were threefold: first, it developed a new structure that was no longer based on the competitive model of discrete national pavilions or presentations that characterized the most venerable biennials in Venice and São Paulo. The nation as an organizing principle was replaced by concepts and themes that connected diverse cultures: in 1989, the theme was "Tradition and Contemporaneity." Unlike at previous biennials elsewhere (and its own two first editions), prizes were abolished in order to reduce competitiveness across the diverse and even incommensurable range of works on display. The second important innovation was to include so-called folk or traditional arts. This decision was at the heart of the organizers' efforts to consider questions raised by their theme since the culture of developing nations is often stereotypically aligned with folkloric, self-trained artists, or religious artifacts such as masks or effigies. By focusing on the ideological meanings of the traditional versus the contemporary, this biennial (and to a large extent ▲ "Les Magiciens de la terre" as well) demonstrated that what looks traditional to Western eyes may in fact constitute a complex response to contemporary conditions couched in historical idioms, but serving the same objectives and purposes as other forms of contemporary art. Finally, a third innovation of the Havana Biennial was its emphasis on live interaction among artists, and between them and the general public through conferences, lectures, and workshops. In addition to the main exhibition "Tres Mundos," the Biennial included four thematic clusters, or *núcleos*, the fourth of which was entirely devoted to ephemeral events [6]. By most accounts, one of the Biennial's most significant long-term effects was the vitality of the debate it inspired with regard to "Third World art." Such an emphasis on the international exhibition as an opportunity for connection and dialogue has had a huge impact • on subsequent exhibitions, which have often organized elaborate worldwide platforms for debate and interchange, thus broadening the reach of an exhibition beyond its physical precincts.

▲ 1989 ● 1997, 2003, 2009a, 2010a

7 • The exhibition "Global Conceptualism: Points of Origin, 1950s–1980s," Queens Museum of Art, 1999, showing the sections for Australia and New Zealand (top), Japan (center), and Russia (bottom)

Curated by Jane Farver, Rachel Weiss, Luis Camnitzer and a team of international curators, "Global Conceptualism" began life as an exhibition of Latin American Conceptual art. It soon grew, however, into a broader show of conceptualist practices from other parts of the world that were generally unfamiliar to a Western audience. While these separate movements were connected in myriad ways, they had all emerged out of their own specific local conditions. As Farver remembers, from the beginning, the curators understood "the territory of 'globalism' as having multiple centers in which local events were crucial determinants."

As important as the Third Havana Biennial was in establishing

▲ new kinds of networks, its sprawling structure and multiple foci could not be reconciled into any tidy image of global contemporary art. This has been a challenge in large international exhibitions and academic histories ever since. When one's art-historical objective is to reach beyond national and ethnic identity or physical location as the privileged frameworks for a work of art's meaning, in order to tell a truly global story of art's dissemination and migration *across* the borders of such identities, it is difficult to determine what kind of methodology is appropriate. In recent years, one successful approach has been to trace the variations of a particular aesthetic format as it passes through a variety of cultural contexts. The "Global Conceptualism: Points of Origin, 1950s–1980s" exhibition and related catalogue organized by Queens Museum of Art, New York, of 1999, for instance, was an excellent model

• for addressing what was common in conceptual practices from around the world without erasing their differences [7]. The ultimate objective of a global art history is not only to develop a broader range of local histories, based on new research and the expertise of a more diverse profession of art historians, but also to develop methods that see past the *innovation* of form (which tends to prioritize the first enunciation of an aesthetic idiom) and value instead its *transitivity* (or, in other words, how its meaning is precisely produced through movement). Under such criteria, the notion of the "derivative" as a negative designation of art works would be replaced by the semantic value of an utterance rooted within a particular historical and cultural context.

The aggregate as idea and form

Traditionally, one of the primary purposes of art history has been to discover whether a particular historical epoch, such as the current moment of globalization, generates its own unique set of aesthetic forms and practices. Making such a determination is especially difficult with regard to contemporary art, since its recentness affords little historical perspective. Nonetheless, I wish to propose "the aggregator" as one such form. It is instructive to browse the definitions of "aggregate" in the *Oxford English Dictionary*. The first entry states: "Constituted by the collection of many particles or units into one body, mass, or amount; collective, whole, total." In legal terms, an aggregate is "Composed of many individuals united into one association," and grammatically it signifies "collective." In each sense, an aggregate selects and configures relatively autonomous elements. It presents, therefore, an objective correlative to the influential political concept of the multitude, as developed by philosophers Paolo Virno, Antonio Negri, and Michael Hardt. The multitude, defined by these theorists as a resistant social force indigenous to globalization, is distinct from both national citizenship and class membership along traditional Marxian lines. Instead of establishing common cause based on a unified *identity* (as an American, for instance, or a proletarian), multitudes constitute themselves from independent

▲ 2009a, 2009b ● 1967c, 1968a, 1968b, 1970, 1971, 1972a, 1972b, 1975b, 1984a

individuals drawn from a variety of communities and locations in response to shared conditions or provocations. As Hardt and Negri put it:

> *The concept of multitude, then, is meant in one respect to demonstrate that a theory of economic class need not choose between unity and plurality. A multitude is an irreducible multiplicity; the singular social differences that constitute the multitude must always be expressed and can never be flattened into sameness, unity, identity, or indifference…. This is the definition of the multitude … singularities that act in common.*

One need not subscribe wholeheartedly to Hardt and Negri's utopian claims on behalf of the multitude to recognize its exemplary structure. Like a search engine, the multitude aggregates heterogeneous entities (in this case, persons) through the action of a filter. That the multitude's filter is a shared social demand (such as immigration rights) makes them no less homologous to the algorithms and page rankings more cynically employed by search engines like Google as filters. Both the multitude and the search engine are mechanisms by which singular entities (both persons and objects) may act in common.

▲ With the dramatic expansion of global contemporary art, online content aggregators like Contemporary Art Daily or e-flux have emerged as major sources of art-world information. These services help to compensate for the limited capacity to travel around the globe in pursuit of contemporary art for even the most privileged and peripatetic person. Their criteria of selection are more intuitive and less mathematically sophisticated than Google's algorithms—they "curate" rather than calculate their inclusions. And while the term narrowly denotes such online tools, the logic of the aggregator is present on many scales of the art world at once: from individual works of art constituted from an array of discrete components, often readymades, right up to biennials and art fairs. These latter differ from conventional museum presentations in that their structures are explicitly aggregative: they provide a common space for singular or autonomous pavilions and national exhibitions (in the case of biennials) and participating galleries (in the case of art fairs), rather than attempting to synthesize their presentations into an overarching theme or narrative as in most museum installations. Two interrelated syntactic structures persist across these scales, from the individual art work to the largest of art fairs. First, the aggregate is a format that accommodates and manifests singularity among its elements—components do not need to be integrated into an overall "composition" to which they would be subordinated. And second, the aggregator provides some kind of common space in which these singular elements are held together in productive, often contradictory association.

Indeed, the virtue of aggregates is their capacity to furnish platforms where the differences among semiautonomous and asynchronous elements can be highlighted and, hopefully, through thoughtful consideration, negotiated. Their contradictions are not resolved, but rather put on display in order to provoke honest and open-ended dialogue between various positions. Examples of such a strategy abound in recent art, including Mexican artist ▲ Gabriel Orozco's "working tables" holding several distinct objects ● he has made or found; American Rachel Harrison's use of pedestals and eccentric, monolith-like forms to carry an array of objects and pictures; or the Chinese artist Song Dong's cataloguing of the contents of his mother's house in China, by laying them all out on a gallery floor around a facsimile of the structure they were once housed in. Since the elements in such works are not integrated into a coherent composition but rather heighten conceptual unevenness, aggregates beg the question of how a common ground may be established within a discontinuous field of singular and often ideologically saturated objects. The aggregate form described here thus differs from two of its ■ close modern cognates: montage and the archive. In montage, individual elements are subsumed within an overall compositional logic; even if the different sources of its constituent elements remain apparent, these components do not typically maintain the disarming quality of independence characteristic of an aggregate, which seems always in danger of falling apart. And unlike an archive, whose principle of selection is inclusive with regard to a theme, institution, period, or event, aggregates proceed from an obscure principle of intuitive selection, typically staging confrontations among a variety of objects that embody entirely different values or epistemologies. An archive, on the other hand, serves to collect, preserve, and even constitute evidence as a pillar of epistemological stability.

I will discuss just one example of the logic of aggregates in practice. Slavs and Tatars are an artist collective whose work engages directly in questions of globalization by addressing an often overlooked geopolitical region: what they define as the area east of the Berlin Wall and west of the Great Wall of China, which witnessed one of the epic ideological contests of the twentieth century, between Islam and Communism. Through texts (transmitted in books as well as in artifacts in exhibitions) and objects, the group explores, among other themes, syncretic expressions of Islam developed in central Asia under Soviet policies of religious suppression. Often Slavs and Tatars heighten the asynchrony of this ideological collision through the citation of medieval scripture as a means of drawing out mystical strands in modern and contemporary art through a logic of what they call "substitution." Indeed, in the catalogue for the 2012 exhibition "Not Moscow Not Mecca" they describe their work as explicitly aggregative: "The collision of different registers, different voices, different worlds, and different logics previously considered to be antithetical, incommensurate, or simply unable to exist in the same page, sentence, or space is crucial to our practice." This desire to bring "different registers" onto the "same page, sentence, or space" is what I have identified as the aggregator's impulse to furnish a platform where unlike things may occupy a common space. In the

▲ 2009a ▲ 1989 ● 2007b ■ 1920, 1997, 2003, 2010b

8 • Slavs and Tatars, installation shot of the exhibition "Not Moscow Not Mecca," Vienna Secession, 2012

In their exhibitions and texts, Slavs and Tatars assemble an array of ideas, artifacts, and cultural objects that seem to have been collected on journeys to faraway times and places—a visual form, one might say, of travel writing. Asked if their presentations, which are based on extensive research, could be described as archival, the artists say that they prefer to see them as "restorative." They explain the impulse behind their practice: "Despite its recent critical renaissance or promiscuity ... the word 'archival' still implies a dusty collection of documents and records and the aura that accompanies this material. We believe it is equally important to disrespect one's sources as to respect them. That is, to reconfigure, resituate, reinterpret, and collide the archival material with the aim of making it relevant and urgent—not just to the specialist in the field, nor just to the intellectual, but also to the layperson who might not otherwise be interested."

exhibition component of "Not Moscow Not Mecca" at the Vienna Secession, the group generated an exhibition based on the transregional histories of fruits in Central Asia, including the apricot, the mulberry, the persimmon, the watermelon, the quince, the fig, the melon, the cucumber, the pomegranate, the sour cherry and the sweet lemon, which they wittily called "The Faculty of Fruits." The gallery presentation included arrays of readymade (or seemingly readymade) fruits distributed on mirrored platforms in a cross between veiled allegory and blinged-out cornucopia [8]. They also produced a book, which in part documents the fascinating histories of how these fruits grew out of and into various Central Asian cultures, both agriculturally and through myth or legend. Slavs and Tatars' work thus adapts several of the fundamental strategies of Conceptual art: the *proposition* (how does fruit embody the historical asynchronies of Central Asia?), the *document* (through an account of each fruit's geographical

THE APRICOT

17th century Armenian tile. *Armenien: Wiederentdeckung einer alten Kulturlandschaft*, 1995

A small, yellowish fruit, cleaved down the middle, is caught up in a custody battle of seismic proportions—and the claimants could not be more mismatched. In one corner, a country whose only instance of independence

The invigilator of the Nodira museum in Kokand goes to great lengths to shake some apricots from the tree in the courtyard, Uzbekistan, 2011

before 1991 dates to the first century CE; in the other, the world's most populous nation. In the middle, like a child unwilling to choose between (a

Apricots drying in Capadoccia, photo by Bjørn Christian Tørrissen

petite) mommy and (towering) daddy, the apricot tries to please, providing medicinal relief to both. According to an old Armenian tradition, over twelve maladies can be treated with the flesh and seeds of the apricot. The Hayer (Հայեր) have raised their orange, blue, and red flag on the genus and species (*Prunus armeniaca*) with a dollop of Biblical bathos to boot: Noah was not just any tree hugger, but an apricot-tree hugger (the only one to make it into the Ark).

The Chinese, though, give the Caucasus, a land renowned for its poetic streak, a run for its (highly leveraged) money. Via the velvety skinned fruit, the Middle Kingdom brings together what might seem two disparate worlds to Western eyes — that of medicine and education — for a one-two punch of holistic healing for the body and brain alike. It is no coinci-

My Courtyard by M. Saryan. Source: *Iskusstvo Armenii*, 1962

dence that the fruits here hail from Xinjiang, aka Uighuristan, the westernmost region of China, sometimes lumped into Central Asia under the contested name of East Turkestan. A particularly lyrical way of addressing a doctor in Mandarin is "Expert of the Apricot Grove." Dong Feng, a doctor in the third century CE, asked his patients to plant apricot trees instead of paying fees. The legend lived on for centuries: When patients sought treatment, they said they were going to the Xong Lin, or Apricot Forest. Meanwhile, school children, in lieu of flowers, often bring their teachers dried apricots to bless the 'apricot altar' or 'educational circle.'

Between the diasporic duels of the Armenians and the Chinese, a third contender permits a welcome turn of triangulation, one which helps us to move beyond the partisan battles over the precocious, early-ripening fruit. For much of the Latin American world, apricots are called *damasco*, in reference to their Syrian origins and the early-twentieth-century migrations to that region from the Middle East.

If the fresh fruit incites juicy rivalries, the dried version doesn't disappoint either. When thinking of Damascus today, we turn helplessly to the Turks to will their former Ottoman influence over the restive Syrian capital. In far rosier times, they would turn to the pitted yellow prune and say—*bundaniyisi Şam'dakayısı*—the only thing better than this is an apricot in Damascus.

THE MULBERRY

A worm with a voracious but selective appetite has proven to have had more of a Eurasian geographical bite than Ghenghis Khan himself. Gobbling up all the white mulberry tree leaves in its path, the castoffs of every little silkworm's metamorphosis

Uzbek girls in Khan-Atlas patterned textiles. *Sovetsky Soyuz Uzbekistan*, 1967

9 • Slavs and Tatars, spread from the artists' book *Not Moscow Not Mecca*, 2012

migration and cultural associations published in the related artists' book [**9**]), and the *readymade* (manifest in "real and imagined" fruits displayed on the platforms). But the syntax of the work established parallel singular profiles among adjacent things; their physical copresence and conceptual unevenness begs the question of the common, thus making "Not Moscow Not Mecca" aggregative according to the definition set out above.

Given the vast scale of global contemporary art production, and the wide range of cultural histories from which it emerges, any attempt at a tidy or coherent reading will be speculative at best. The principal challenge in confronting the contemporary art made under conditions of globalization is to hold together two ostensibly contradictory qualities: first, a shared international language of aesthetic form spoken in common; and second, the texture and nuance of different histories and dialects that can make the same image or format mean dramatically different things. Such accommodation of singularity within a common space will always be—even in the world of politics and finance—an art rather than a science.

FURTHER READING

Luis Camnitzer, Jane Farver, and Rachel Weiss, *Global Conceptualism: Points of Origin, 1950s–1980s* (New York: Queens Museum of Art, 1999)

Kuan-Hsing Chen, *Asia As Method: Toward Deimperialization* (Durham, N.C.: Duke University Press, 2010)

Michael Hardt and Antonio Negri, *Multitude: War and Democracy in the Age of Empire* (New York: Penguin, 2004)

Joan Kee, *Contemporary Korean Art: Tansaekhwa and the Urgency of Method* (Minneapolis: University of Minnesota Press, 2013)

Gao Minglu, *Total Modernity and the Avant-Garde in Twentieth-Century Chinese Art* (Cambridge, Mass.: MIT Press, 2011)

Slavs and Tatars, *Not Moscow Not Mecca* (Vienna: Secession, 2012)

Rachel Weiss et al., *Making Art Global (Part 1); The Third Havana Biennial 1989* (London: Afterall Books, 2011)

Bert Winther-Tamaki, *Maximum Embodiment: Yōga, The Western Painting of Japan* (Honolulu: University of Hawaii Press, 2012)

David Joselit

1945–1949

1945

David Smith makes *Pillar of Sunday*: constructed sculpture is caught between the craft basis of traditional art and the industrial basis of modern manufacturing.

Suspended equally between the primitive and the puritanical, David Smith's (1906–65) *Pillar of Sunday* [1] perfectly expresses the formal and technical ambivalence of constructed sculpture in the forties. Organized as a totem pole, the work is a vertical agglomeration of mementos to the sculptor's rigid upbringing in the American Midwest (the church choir, for example, or the Sunday family dinner), topped by the image of a liberating, sexualized bird.

Executed in forged and welded steel that was then painted, the object declares a technical allegiance to the sculptural idiom through which Smith entered the field in the mid-thirties, namely the Cubist-identified constructed sculpture that had evolved out of collage at the hands of Pablo Picasso in the mid-teens and had been brought to a pitch of accomplishment in the late twenties in the work of Julio González (1876–1942). But if welded metal construction had meant the use of warped fins and bent wires in order to achieve the visual openness of what González called "drawing in space" [2], it had also implied the opportunistic incorporation of ordinary metal objects into the assembly, as when Picasso pressed a kitchen colander into service as the head of an otherwise schematic figure (*Head of a Woman* [3]), a throwback to his having used a real sugar spoon as the crowning element of his Cubist *Absinthe Glass* of 1914. And from this formal exploitation of the found object it was only a short jump to the possibilities of sounding its psychological resonance, which the Surrealists explored in a very different development of the idea of sculpture as a collage or an assemblage.

Free-standing collage

At the hands of the Surrealists, two variations were struck on sculpture-as-construction. The first was formal; the second, technical. The formal one had to do with the Surrealists' willingness to abandon the whole idea of drawing in space, which had been Cubism's original way of defying traditional sculpture, with its fetishization of closed volumes, whether in carved stone or cast bronze. If the objects chosen to enter a sculpture become candidates not on formal grounds, however, but on those of psychological association, then they might come in any shape or substance—glass bottles as well as metal scrap, fur-covered teacups just as easily as iron grids.

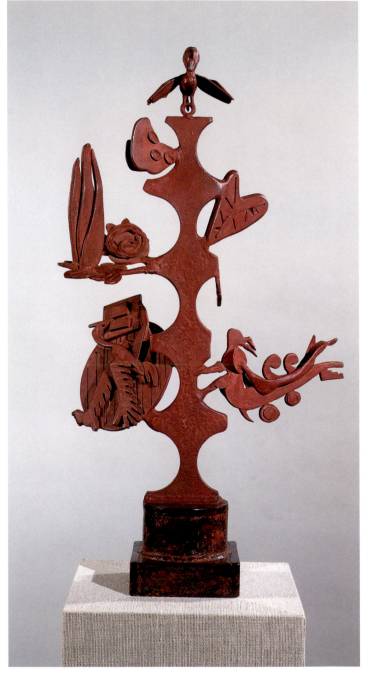

1 • David Smith, *Pillar of Sunday*, 1945
Steel and paint, 77.8 × 41 × 21.5 (31 × 16⅝ × 8½)

▲ Introduction 3, 1912 ● 1931a ■ Introduction 1

Salvador Dalí's *Venus de Milo with the Drawers* (1936)— a copy of the famous statue in the Louvre, with a row of little drawers, that one can slide in or out, stacked along the nude figure's torso—is a perfect example of the way Surrealist sculpture transgressed the modernist, formal credo of openwork construction.

At the technical level there was yet another transgression. The depths the Surrealists wished to plumb being those of the unconscious, they were also understood to be at variance with both the refinements of high culture and the rationalism of modern technology. Primitive in nature, the unconscious had been most forcefully given form, the Surrealists argued, by primitive art, a sculptural example which was both opportunistic—incorporating anything at hand, from trading beads to feathers to tin cans—and agglomerative, things hinged and hung and stuck together. So if the Cubist base for constructed sculpture placed the emphasis on *construction*, thus opening the way for a technological, highly industrialized model to interpret "drawing in space" as steel and

▲ glass forms of building (as in the work of Vladimir Tatlin or Naum

3 • Pablo Picasso, *Head of a Woman*, 1929–30
Iron and mixed media, 100 × 37 × 59 (39⅜ × 14⅝ × 23¼)

Gabo), the Surrealist reception of it reinterpreted construction as *bricolage*, which is to say, a primitive form of making-do, of quasi-irrational, associative thinking.

This is the significance of the totem's having taken over the structural order of Smith's work in the mid-forties, as well as of his desire to exploit the charged memories of his youth and his willingness to incorporate figurative forms that, like the bird, are classically volumetric in nature. And, given the strength of this claim on his imagination, the artisanal and the figurative would continue to do battle with the industrial and the abstract throughout the rest of his career.

The most obvious place to see this is in the series of *Tanktotems* that Smith made during the fifties and into the sixties [4]. The "totem" half of this designation signals the persistence of a certain kind of emotive content, while the "tank" half—which refers to the industrial materials to which Smith was now turning, specifically here the tops of boiler tanks—addresses Smith's modernist ambitions, his desire for abstraction and technology. The struggle between these models is itself the source of the great formal interest of Smith's sculpture, as he managed his own peculiar marriage of abstraction and totemism in his ensuing work.

2 • Julio González, *Woman Combing Her Hair*, 1936
Wrought iron, 132.1 × 34.3 × 62.6 (52 × 13½ × 24⅝)

▲ 1914, 1921b, 1937b, 1955b

4 • David Smith, *Tanktotem V*, 1955–6
Varnished steel, 245.7 × 132.1 × 38.1 (96¾ × 52 × 15)

If the totem is basically figurative, a real object or animal invested with great significance for the human subject whose identity depends on it and who must therefore protect it, totemism is inimical to the aims of abstract art. The former can be brought into a relationship with the latter only if the sculptor's move to "protect" the totem-object takes the form of a kind of visual camouflage, the dissolution of the object's intelligible gestalt from any given viewpoint, something in turn made possible only by the feats of engineering—of suspension and near detachment—uniquely available to the industrial techniques of welding, cantilevering, etc.

Totem and taboo

This theme of the "totem-object both proffered and withdrawn" forms the consistent organizational armature of Smith's later sculpture, whether in the series of *Voltri-Boltons* (1962–3), welded of found steel parts, or in the sequence of *Cubis* (1961–5), put together of polished, stainless-steel polyhedrons, the last and most nearly abstract of his work. For in *Voltri-Bolton XXIII* [**5**], for example,

the primitive setting of the sacrificial table, which Smith had examined in far more figurative works such as *Head as a Still Life II* (1942), *Sacrifice* (1950), or *The Banquet* (1951), is once more made into the pedestal for a still-life assemblage that implies the presence, as well, of a human, sacrificial figure. This "figure" which consists of three elements tack-welded one above the other—a rectangular plane, an I-beam section set perpendicular to the plane and balanced on it only at one point, an equally precariously poised tank top—is unintelligible as a coherent, figurative form from most angles, reading instead as part of a collection of geometric shapes. Indeed, one of these shapes, a large, open rectangle, seems to be a kind of picture frame through which the artist is giving us a clue as to the correct approach to his work. It is only, however, by moving out of the axis of this frame and thereby eclipsing one's view of it, that the totem-object comes into miragelike focus, only to vanish again as the physicality of the steel forms (the forward thrust of the I-beam, for example) pushes it out of the "picture."

In this resistance to the idea of stereometric rationalism, whereby the intersection at right-angles of identical or similar profiles creates an object of maximum intelligibility, *Voltri-Bolton XXIII* refuses the
▲ Constructivist models that Smith's allegiance to modern materials and fabrication practices might otherwise seem to claim. The literal transparency sought by Tatlin, Rodchenko, or Gabo via their use of openwork mesh or clear plastics was only the material vehicle for an even more insistent conceptual transparency, as repetitive forms

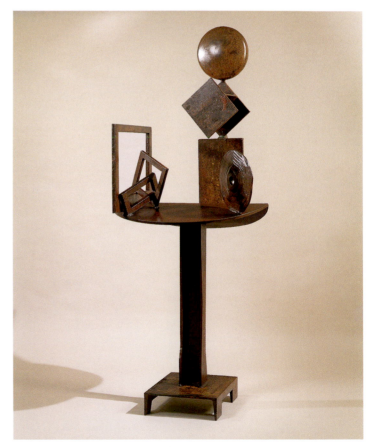

5 • David Smith, *Voltri-bolton XXIII*, 1963
Welded steel, 176.5 × 72.7 × 61 (69½ × 28⅝ × 24)

▲ 1914, 1921b

exfoliated from a coherent core in an imitation of technology's rationalization of both form and its production. And indeed, if the Russians' concept of stereometry further emphasized the possibility of simultaneous, collective experience of the work, which would be intelligible from any place within a space it thereby declared as truly public, the American's exploitation of unique, shifting points of view places his totems in the realm of the subjective.

Perhaps no one expressed the ambivalence that had settled onto postwar American and European sculpture more eloquently than the American critic Clement Greenberg, who set the critical terms for constructed sculpture in the late fifties. Arguing that sculpture's "genius" was now the function of a technologically modern concept of volume—"Feats of 'engineering' that aim to provide the greatest possible amount of visibility with the least possible expenditure of tactile surface belong categorically to the free and *total* medium of sculpture. The constructor-sculptor can, literally, draw in the air with a single strand of wire"—Greenberg interpreted the implications of this in a way that turned its back on the objectivity of "engineering" and instead embraced the subjectivism of a kind of visual phenomenon that he himself would call a "mirage." Characterizing the new technology through its release of open forms into "the continuity and neutrality of a space

which light alone inflects, without regard to the laws of gravity," Greenberg drew from this fact what some (in particular, the Minimalists) would see as perverse conclusions, insisting on its consequences as a form of opticality that "brings anti-illusionism full circle." Now, he argued, "Instead of the illusion of things, we are offered the illusion of modalities: namely, that matter is incorporeal, weightless, and exists only optically like a mirage" ("Sculpture in Our Time" [1958]).

The radical subjectivity of "opticality" could be associated with the open "frame" through which *Voltri-Bolton XXIII* had registered the importance of point of view for the understanding of the work, even if in this case its particular rectangle did not yield the "correct" aspect. For the frame not only opposes a visual to a tactile field, it also denies simultaneous collective connection to the meaning of the work, since only one person at a time can look through the frame at the precise angle perpendicular to its opening. It is this stress on point of view that the English sculptor Anthony Caro (1924–2013), David Smith's most obvious formal heir, then carried forward.

This is perhaps most obvious in a work like Caro's *Carriage* [6], in which two large planes stand opposed to one another across eight feet of space through which only a bent steel pipe bridges along the floor between them. Both of these planes are composed

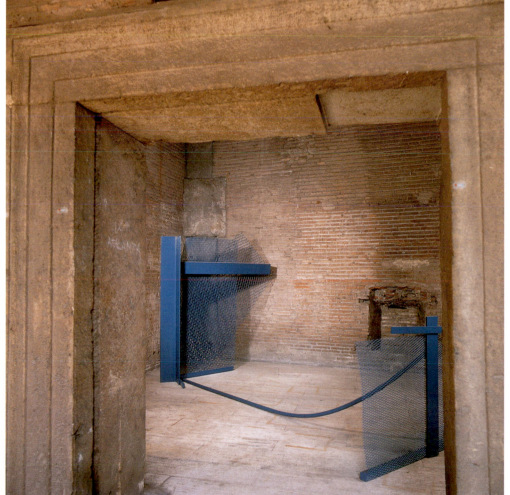

6 • Anthony Caro, *Carriage*, 1966
Steel painted blue, 195.5 × 203.5 × 396.5
(77 × 80 × 156)

▲ 1942a, 1960b

of expanded metal to form a shimmering, optical mesh or screen, each being braced on three sides by steel channel elements which create for one of the planes a closed upper left corner, and for the other a closed lower right one. If the scale of the work appeals to one's tactile experience, since the object's physical expanse invites and allows entry into its midst and inspection of its parts, the filigree of its mesh, painted a sea green, is clearly pointing to the reabsorption of that physical, tactile condition by one that is more specifically immaterial and visual. The sense, furthermore, that this is indeed where the meaning of the work lies comes at the moment at which one's movement around the sculpture produces the coherence of the two sets of braces into the single gestalt of a "frame," one that collapses the physical space within the work and re-creates the sculpture as the function of a singular and purely optical point of view. But in turn, the physical openness of the object allows that "meaning"—which we could read as an abstract statement of coherence, the "praegnanz" of Gestalt psychology— to invade the sculpture from every other point of view so that, to use Michael Fried's terms for this, "at every moment the work itself is wholly manifest." Using language that clearly connects to Greenberg's idea of opticality, in his influential essay "Art and Objecthood" (1967) Fried characterized his experience of Caro in terms of the simultaneity and immediacy of the visual field itself:

It is this continuous and entire presentness, *amounting, as it were, to the perpetual creation of itself, that one experiences as a kind of* instantaneousness, *as though if only one were infinitely more acute, a single infinitely brief instant would be long enough to see everything, to experience the work in all its depth and fullness, to be forever convinced by it.*

The gauntlet Fried threw down in "Art and Objecthood" articulates the divide between the two self-proclaimed heirs of constructed sculpture: the hand-wrought, welded sculpture of Smith and Caro, with its craft associations of applied color and unique assemblage, on the one hand, and the industrially
▲ fabricated work of the Minimalists, with its commitments to technological coloration—enamels, plastics—and serial production
● on the other. But it is in the work of John Chamberlain (1927–2011) in the United States, and that of Arman or César in Paris, that one sees a third, far more pessimistic option. For whether opticalist or minimalist, the former two positions declare the positive, even utopian, possibilities encoded in modern materials and forms of production. It is the third, however, that marries "construction" with "production" and comes up with the conclusion of planned obsolescence and waste.

Indeed, pushing the found-object component of the medium, present within constructed sculpture from its very inception, way past Surrealist *bricolage* and into the ravages of consumer society, a sculptor like Chamberlain exploited the ready-made surfaces of the automobile body, recovered now from the crash-heap to which it had been consigned, as expendable scrap. Loaded with irony,

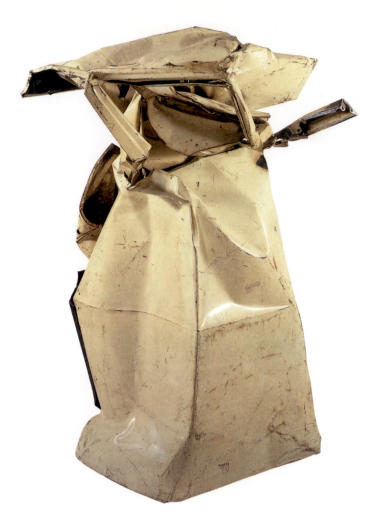

7 • John Chamberlain, *Velvet White*, 1962
Painted and chromium-plated steel, 205.1 × 134.6 × 124.9 (80¾ × 53 × 49⅛)

a work like *Velvet White* [7] seems to project a whole history of modernist sculptural debate within its form—the tension between the claims of monolithic volume and openwork construction; the opposition between rationalized structure and Surrealist caprice; the distinction between craft and industrial color, as well as that between the mass-produced and the unique object, the
▲ former stripped of "aura," the latter clinging to it—even while, with its switch from production to consumption, from construction to readymade, it seems to announce the obsolescence of
● sculpture itself as a category. Perhaps this is why Donald Judd, in a move that seems surprising from a formal point of view, included a work by Chamberlain as one of the illustrations for his essay "Specific Objects," his declaration of the end of sculpture as a specific medium. RK

FURTHER READING
Michael Fried, "New Work by Anthony Caro," "Caro's Abstractness," and "Art and Objecthood," *Art and Objecthood* (Chicago: University of Chicago Press, 1998)
Clement Greenberg, "Sculpture in Our Time" and "David Smith's New Sculpture," *The Collected Essays and Criticism, Vol. Four: Modernism with a Vengeance, 1957–1969*, ed. John O'Brian (Chicago and London: University of Chicago Press, 1993)
Rosalind Krauss, *Passages in Modern Sculpture* (New York: Viking Press, 1977)

▲ 1965 ● 1960a

▲ 1935 ● 1965

1946

Jean Dubuffet exhibits his *"hautes pâtes,"* which confirm the existence of a new scatological trend in postwar French art, soon to be named *"informel."*

"After Dadaism, here is Cacaism." Those words were penned by the French critic Henri Jeanson in response to "Mirobolus, Macadam & Cie, Hautes Pâtes," the infamous exhibition of Jean Dubuffet (1901–85) held at the Galerie René Drouin in Paris in May 1946. Though published in the satirical weekly *Le Canard enchaîné*, they were perfectly in line with the general response to the show: from everywhere, from left and right, one could hear shrieks of disgust at Dubuffet's "scatology." This was not the first time that the painter had been decried by the press—his first solo exhibition of neoprimitivist, highly colorful scenes of urban life, a year and a half before, in the aftermath of the Liberation of Paris in August 1944, had been mocked as the feat of an infantile dauber—but now the uproar had reached a peak. If one excludes the commotion surrounding Picasso's exhibition at the Salon de la Libération in October 1944—with demonstrations in the streets and iconoclastic attacks on the works—nothing had so shocked the French art world for decades, perhaps even since the Fauve scandal of 1905.

Jeanson's witticism was less eloquent than the sarcasm of most critics, who took an obvious pleasure in detailing the "filth" they so condemned, but his reference to Dadaism points to a particular nexus of postwar Paris. The collective shame in the city was immense: shame for humanity as a whole at having implemented the Holocaust, but also more specifically shame for France and its collaboration with the Nazi machine. Because it could drape itself in martyrdom—calling itself *"le Parti des 75,000 fusillés"* (the party of the 75,000 gunned down), but also *"le Parti de la renaissance française"* (the party of the French Renaissance)—the Communist Party was seized upon as a moral buoy by a host of artists and intellectuals (Picasso being the most prominent of them). But it had little appeal for those who were appalled by the Communist-backed *"épuration"* following the Liberation—the public humiliation of petty collaborationists, the "popular" justice, and the execution of writers—this reminded them too much of the Stalinist purges of the late thirties), all the more since the Communist Party's demand for a "socialist realism" was becoming louder every day.

Dubuffet was tempted neither by such self-righteousness nor by a mere return to the prewar status quo, with its perfunctory opposition, within the avant-garde, between the dreamland of Surrealism and the utopia of abstraction (which he saw as the two sides of the same coin). In a climate as politically charged as that of the Liberation, there was little room for maneuvering. The Nazis had treated humanity as if it were sheer disposable or usable matter (photographic reports on the camps—showing piles of corpses but also of human hair—began to pour into Paris during the spring of 1945), and this demotion had been confirmed, at the other end of the world, by the atomic explosions of Hiroshima and Nagasaki. What was expected from art, in the reconstruction period, was a redemptive, sublimatory reaffirmation of humankind's humanity —something akin, in the aesthetic realm, to the political *"épuration"* that was daily publicized in the press (in the sense that, despite the bad faith covering up a mere urge for revenge, the purges and punishments were intended to have the effect of a moral elevation). This is where the Dada provocation seemed a useful model of disobedience—for it, too, had originated in a climate of despair about humanity—even if, in the face of the most recent horrors, unprecedented even by the carnage of World War I, it had a sophomoric ring.

The catalogue of the "Mirobolus" exhibition, printed on cheap colored paper and folded in fours, contained a text by Dubuffet entitled "The Author Answers Some Objections." The piece was also reprinted in several journals at the time, and republished just a few months later in the first (and most remarkable) of Dubuffet's many books, *Prospectus aux amateurs de tout genre*, as "Rehabilitation of Mud." Though this final title of the essay became famous as a catchword for Dubuffet's whole enterprise, it blurs its initial polemical stance—the fact that it was addressing the anticipated reaction of an audience. The text opens on the issue of deskilling. Dubuffet underlines the fact that no special gift had presided over the making of the works in the exhibition, and that he had worked "here with [his] finger, there with a spoon." Even though he rhetorically denies any intention of provocation, Dubuffet appropriates confrontational techniques of earlier modernism, and pushes the envelope in proposing even more radical gestures than those represented by the works on view, dreaming, for example, of paintings solely made of a "monochromatic mud." To those who would question his attraction to "dirty things," he replied in advance: "In the name of what—except perhaps the coefficient of rarity—does man adorn himself with necklaces of shells and not spiders' webs, with fox fur and not fox innards? In the name of what, I want to know? Don't dirt, trash, and filth, which are man's

▲ 1906 ● 1934a ▲ 1916a, 1920 ● 1968b

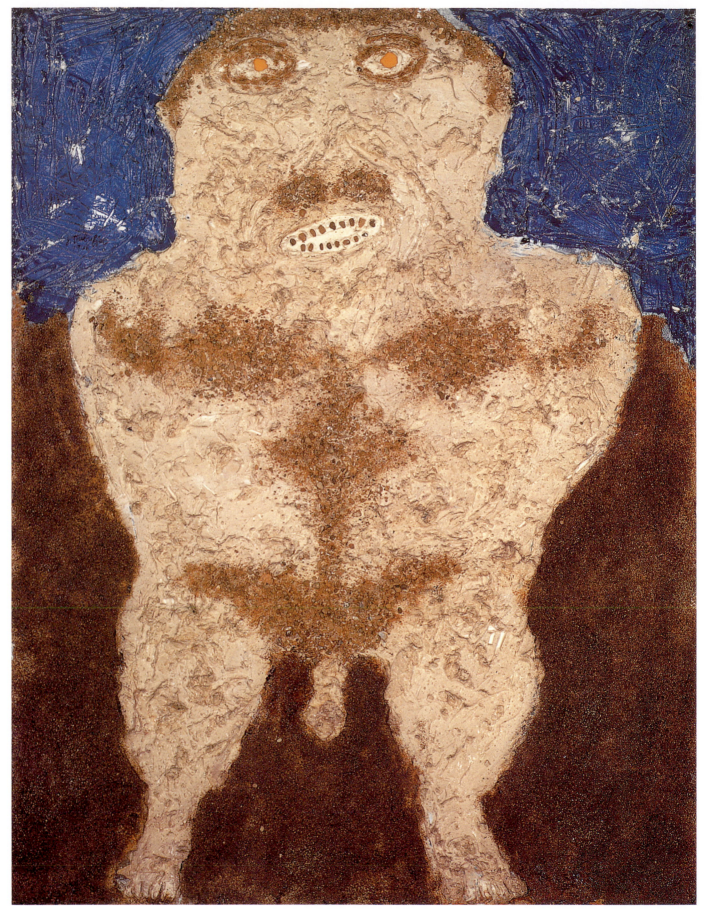

1 • Jean Dubuffet, *Volonté de puissance*, 1946
Oil on canvas, 116 × 89 (45⅝ × 35)

companions during his whole lifetime, deserve to be dearer to him, and isn't it serving him well to remind him of their beauty?"

Critics were prompt to read the mention of beauty as a deliberate provocation. They zeroed in on the "monochromatic mud" and gave "the dirt, trash and filth" its predictable excremental name. They were encouraged in that by the paintings themselves, with their brownish / grayish colors and their thick impasto (the *haute pâte*) of various materials, into which figures in full or three-quarter length had been incised [1]. Accentuated by the avoidance of any indication of the third dimension (all graffiti-like figures are either frontal or in full profile), the allusion to children's drawing was unmistakable. But if these works recalled kindergarten finger painting, gone were the attendant connotations of playful naivety. Brute matter had replaced color: for most critics it meant to say that the joy of life was no more. Dubuffet had expected to offend the "well read," as he called them, and the ensuing racket gave him confirmation that he had touched a sensitive nerve.

Dubuffet's few partisans, however, noticed that in wanting to rehabilitate mud he was not exactly claiming that "civilization" had ended—for them, on the contrary, he was offering the only redemptive strategy that could be found amid the rubble left after a cataclysm: to rehabilitate mud was to start anew, not exactly with a clean slate but from what was available, from what society *had* and *was* at this point of history. It was, in a dialectical twist whose irony appeared only later, to perfect a certain kind of "*épuration*." For if Dubuffet insisted that the sheer materiality of his work was on a par with the stuff and noise of the real, it meant that in the complex properties of natural objects "there was a certain order to discover." Nothing could better indicate how much Dubuffet's "*matièrisme*" ▲ is foreign to Georges Bataille's (1897–1962) notion of "base materialism" or "formless" in which matter is posited as that which cannot be framed by any discursive category, any systematic thought, or poetic displacement—as that which stubbornly resists the sublimatory function of the image and deflates it with a low blow. To discover an order (an image) within the formlessness of matter so that one can rehabilitate that matter is diametrically opposed to the operation of debasement envisioned by Bataille as the task of the formless.

Not only was a whole section of Dubuffet's catalogue essay devoted to the "suggestive power" of the various components of his pastes, but the catalogue itself was doubled by a small book written on the exhibited works by the critic-impresario Michel Tapié. Tapié's turgid prose is not only utterly unreliable but almost unreadable today (except for the amusing anecdote of a picture that Dubuffet had given to the writer Jean Paulhan, and that had melted), but Dubuffet's detailed captions of all the works, duly reproduced, were striking. They parodied entries of museum catalogues in giving succinct information about the material employed, but inevitably they slipped into a metaphoric mode (mostly in the culinary realm). *Monsieur Macadam* was described as "Entirely painted in ceruse [white paint] and real tar mixed with gravel. The kind of white batter thickly buttered upon the figure takes on the color of toasted bread where it meets the tar, like a

Art brut

Like other modernists, Jean Dubuffet was influenced by the study of the *Artistry of the Mentally Ill* by Hans Prinzhorn. Throughout the thirties Dubuffet corresponded with various doctors, and in the mid-forties he visited institutions in Switzerland, where he first encountered the psychotic art collected by the Geneva psychiatrist Charles Ladame. These experiences prompted Dubuffet to gather art of the mentally ill as well as tribal, naive, and folk art under the rubric *art brut*—*brut* as in "crude" or "raw" as opposed to "refined" or "cultural." Along with André Breton, Jean Paulhan, Charles Ratton, Henri-Pierre Roché, and Michel Tapié, Dubuffet formed the Compagnie de l'Art Brut in 1948, and soon thereafter they presented the first exhibition of its holdings (roughly 2,000 works by 63 artists) at the Galerie René Drouin in Paris. For this show Dubuffet wrote his best-known text on the subject, "Art Brut Preferred to Cultural Art," which casts the *brut* artist as a radical version of the Romantic genius free of all convention:

We understand by this term works produced by persons unscathed by artistic culture, where mimicry plays little or no part (contrary to the activities of intellectuals). These artists derive everything—subjects, choice of materials, means of transposition, rhythms, styles of writing, etc.—from their own depths, and not from the conceptions of classical or fashionable art. We are witness here to a completely pure artistic operation, raw, brute, and entirely reinvented in all of its phases solely by means of the artist's own impulses.

Like other modernists such as Paul Klee, then, Dubuffet idealized the art of the mentally ill as a return to pure "depths." But, unlike Klee, he defined these depths not as an *origin* of art, which one might hope to reclaim redemptively, so much as an *outside* to art, which one might cause to break into its cultural spaces transgressively. However, even as Dubuffet sought to undo the opposition between the normal and the abnormal ("this distinction … seems quite untenable: who, after all, is normal?"), he reaffirmed the opposition between the *brut* and the cultural—an opposition that affirms rather than transgresses "civilization." And far from "unscathed," as Dubuffet imagines, the psychotic is scarred by trauma, and this psychic disturbance might be registered in the bodily distortions often evident in *art brut*—for example, eyes and mouths grossly enlarged or disruptively plunged into other parts of the body—disruptions that Dubuffet often reproduced in his own art. Indeed, through such derangements of the body image, he sometimes evokes a schizophrenic sense of literal self-dislocation, which would seem very far indeed from the "completely pure artistic operation" that Dubuffet otherwise wished to see in *art brut*.

used meerschaum pipe." *Madame mouche*: "Rough matter, matte at places and shiny at others, or as if it had been cooked and had vitrified. Figure with colors of caramel, eggplant, blackberry jelly, and caviar, adorned with egg-white holes in which a syrupy varnish of a molasses color has accumulated here and there." Each caption thus becomes a small prose poem in which the precedence of vision

over other senses, or at least the disembodied separateness of vision, is challenged (it should be noted that Maurice Merleau-Ponty's *Phenomenology of Perception*, in which this very feature of Western metaphysics was attacked, had appeared in 1945). But in the end, this anti-Cartesianism short-circuits, for Dubuffet's literary translation of the tactile given of the paste into the realm of food imagery remains based on the recentering force of metaphor, and thus on the illusionistic power of the gestalt, the form.

Food was on everyone's mind in postwar Paris (supplies were still very low and, contrary to one's expectations, they remained rationed for quite some time). It is thus not by chance that a high impasto that made paintings look like reliefs would invite culinary associations. Dubuffet encouraged critics to pursue this oral vein, for he began the text accompanying his next exhibition (held in October 1947), which was entirely devoted to portraits of friends and acquaintances in literary Paris, with a long excursus on the advantages of modest bread over the luxury of pastry (once again, Dubuffet's point concerned the beauty of the ordinary). But the first writer to allude to food as a trope for painterly paste was the poet Francis Ponge, whom Dubuffet knew well (Ponge had written the preface to the catalogue of his April 1945 exhibition of lithographs). In his first text on art—a small book on the impastoed paintings of an artist Dubuffet greatly admired, Jean Fautrier (1898–1964)—Ponge had laconically written: "It is part rose petal, part Camembert spread."

A deliberate frustration of vision

Soon both painters would reluctantly be cast as the founding fathers of a movement baptized "*informel*" by Paulhan and "*art autre*" by Tapié. A third "founder" was later spotted in the person of Wols (1913–1951), a German émigré whose real name was Wolfgang Schulze (but he had already died before the concoction of these labels). The exhibition of Wols's miniature watercolors at the Galerie Drouin in December 1945 went almost unnoticed: immediately after Fautrier's brute *Otages* in the same gallery, Wols's abstract landscapes populated by biomorphic forms were too clearly indebted to Paul Klee's meticulousness to raise even a stir. But things changed almost instantly when Wols began to work in oil on canvas, and his second one-man show in 1947 was a triumph. Though Jean-Paul Sartre (1905–80) would not write his essay on the painter, "Fingers and Non-fingers," until 1963, Wols was unanimously seen as the quintessential "existentialist" artist who undergoes a metaphysical crisis and seeks to demonstrate the contingency of being. The drama of his life as an alcoholic bum, the alleged automatism of his pictorial procedures, the spasmic gesturality of his paintings—all these signs of "sincerity" led Sartre to cast Wols as an "experimentator who understood that he is necessarily part of the experiment." But in the end, for all the grand claims made about Wols's abstract canvases, each similarly composed of a centralized (often vulvalike) vortex out of which energetic rays spout in all directions [2], his art remained an invitation to "reading in," to deploy an "imaging" attitude (Sartre's word) that would always save us from having to contemplate the abyss of nothingness.

The sudden success of Wols's cosmic hallucinations was prepared by the scandal of Dubuffet's "*hautes pâtes*," whose scatology now seemed too crude a shock tactic. But the discomfort engendered by Fautrier's October 1945 exhibition of his *Otages* also played a major, if unrecognized, role. The fact that Fautrier belonged to the same intellectual milieu, exhibited in the same gallery, and was defended by the same writers as Dubuffet has clouded for too long what distinguishes them—even if, at least with regard to color, one could not fail to notice that they evolved in opposite directions (Dubuffet from vivid colors to mud, Fautrier, the reverse).

Ponge's inaugural "Notes sur les Otages" (Notes on the Hostages) was written in January 1945 at the request of Jean Paulhan (Paulhan's own "Fautrier l'enragé" had appeared in the catalogue of the painter's show in 1943). It was commissioned as a preface for Fautrier's exhibition of his *Otages* series, which opened at the Drouin gallery in October 1945. In the end, a short essay by André Malraux (1901–76) was preferred, and Ponge's extraordinary text was published in early 1946 as an independent book. Malraux had long been a supporter of Fautrier's art (he had already written about it in 1933), and, given his phenomenal notoriety at the time as a writer and a hero of the Resistance, it is not surprising that his text

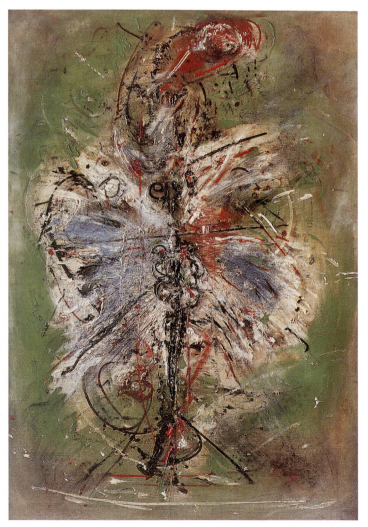

2 • Wols, *Bird*, 1949
Oil on canvas, 92.1 × 65.2 (36¼ × 25¾)

▲ 1965 ● 1922, 1925c ■ 1959c ▲ 1935

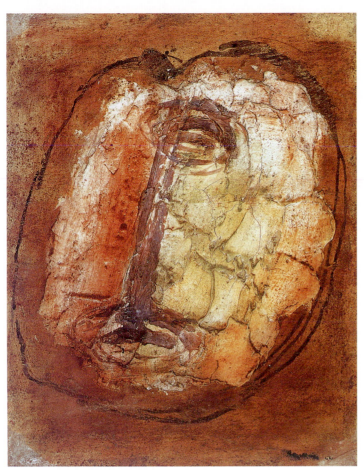

3 • Jean Fautrier, *Head of a Hostage no. 22*, 1944
Oil on paper pasted on canvas, 27 × 22 (10⅝ × 8⅝)

should have been given precedence over that of Ponge, who was then far less illustrious. But commercial plotting and public relations might not be the only reasons for the substitution, for Ponge's text was troubling, as Paulhan acknowledged upon its reception—just as troubling as the works themselves.

In his *Otages*, Fautrier was directly addressing the question that was on everyone's mind (even before the full revelation on the camps), though only Ponge dared formulate it as such about his work: how can one, in art, respond to the Nazi reign of terror without spectacularizing it? Fautrier had begun the series in 1943 while hiding from the Gestapo in a psychiatric asylum outside Paris, and after hearing the sounds of the torture and summary execution, in the surrounding woods, of civilians randomly picked by the German authorities. That Fautrier's point of departure was not visual but auditory (gunshots, cries) explains in part his unusual handling of the atrocities. Presented in monotonous rows that accentuated their seriality—and by extension the statistical, assembly-line nature of Nazi atrocity—the forty or so pictures all followed a similar formula in which not much was to be seen of the horror suggested in the generic titles (many works, mostly small, are simply called *Hostage* or *Head of Hostage*, followed by a number [3]). This dichotomy between alleged theme and frustration of vision was even more exacerbated with the titles of the somewhat larger works belonging to the same series but withheld from the 1945 exhibition: *Le Fusillé* (The Gunned-Down); *L'Ecorché* (The Flayed); *La Juive* (The Jewess [4]); or *Oradour-sur-Glane* (the name of a village where the Nazis burned alive hundreds of

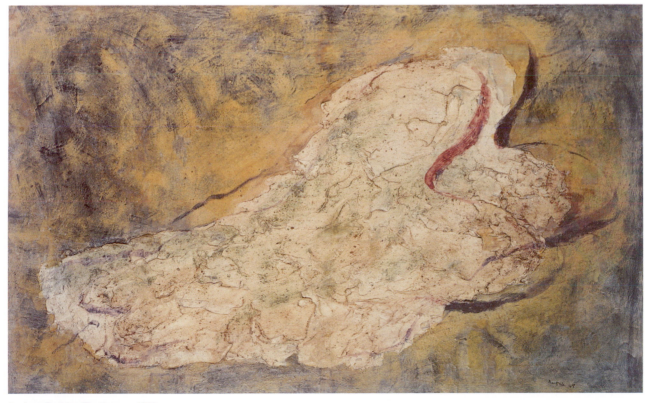

4 • Jean Fautrier, *The Jewess*, 1943
Oil on paper pasted on canvas, 73 × 115.5 (28¾ × 45½)

women and children who had taken refuge in a church), though the first title of this painting was *The Massacre*.

All these works shared the same characteristics—and what most troubled certain critics was that, formally speaking, very little distinguished them from some of the landscapes and still lifes exhibited by Fautrier during the Occupation: indeed, the formula was set up around 1940, when he abandoned both oil painting and the dark tones he had been using for decades. Working on his canvas (or rather paper premounted on canvas) placed horizontally on a table and previously coated with a thin preparation sprayed with pastel, Fautrier was part plasterer, part pastry-cook. With a spatula he would spread a central blob of stuccolike whitish matter into a vague shape (roughly oval in the case of a *Head of Hostage*), and before this paste had hardened, he would dust it with various pastel powders and adorn it with a few brushed contours. The result would always be that of a highly centralized, and often quite undecipherable, figure silhouetted in relief in the middle of a dirtied atmospheric ground.

Both the choice of colors (pink, purple, turquoise—the whole candy spectrum found in cheap chromos) and the marked dissociation between texture and color send a potent signal of inauthenticity, of kitsch. This odd but deliberate breach of decorum had struck Paulhan as early as 1943—he wrote then of cosmetic creams and makeup—but he felt he had to defend Fautrier's art against accusations of decorative prettiness and of gratuitous virtuosity. Malraux, too, briefly expressed his unease, compounded by his appreciation for the flayed rabbits and other still lifes that Fautrier had painted in brown colors from the late twenties on, works that had often been associated with Goya. Noting that in his *Otages* series Fautrier had gradually abandoned any suggestion of bloody colors and substituted tones "devoid of any rational link with torture," he asked: "Are we always convinced? Are we not disturbed by some of those tender pinks and greens?"

For both these writers, the cheesy tongue of seduction spoken by Fautrier's paintings was a problem they did not know how to handle. Of all Fautrier's supporters, Ponge alone understood that the strength of his work resided in the pairing of rapture and horror, and it is not only because Fautrier had illustrated Bataille's erotic fiction *Madame Edwarda* that Ponge alludes in his "Notes" to the latter's conception of scatology. Bataille had imagined the Marquis de Sade as having "the most beautiful roses brought to him only to pluck off their petals and toss them into a ditch filled with liquid manure." Ponge is more in keeping with the current obsession of the time when he speaks of Camembert, but the image is similar: unlike Dubuffet's rehabilitation, Fautrier's kitsch is a pessimistic, nihilist defilement. True, Dubuffet would occasionally depart from his sublimatory trajectory, either by the sheer ferocity with which his caricatures assault the beholder's expectations, or in swerving from his usual course, in refusing to move from formlessness to figure. To the first strategy belongs his grotesque *Corps de dames* series of the early fifties, where the whole tradition of the nude in Western art is debunked as "metaphysical" bombast and flattened out [**5**]. And the remarkable allover *Matériologies* of the late

5 • Jean Dubuffet, *La Métafisyx*, 1950
Oil on canvas, 116 × 89 (45¼ × 34¾)

fifties and early sixties, realized in crumpled tinfoil or papier mâché and looking like maps of lunar terrains, are of the second mode. But even in these rare cases a metaphor would always creep in (the woman as Mother Nature, the canvas as native soil). Immensely prolific as a writer of pamphlets against the "asphyxiating culture," he would end up an official artist of the French Republic. Fautrier, by contrast, steadily put into practice his contempt for high art's pretense—he even embarked on the creation of textured reproductions of modernist art, from van Gogh to Dufy, which he labeled with the oxymoron "multiple originals." Refusing the "pharmaceutic style," as he called it, of those who wanted to read him as an expressionist (or as an *informel*) artist, he would create ever flashier monuments to bad taste until his death. Ponge's text ends with this sentence: "With Fautrier, 'beauty' returns." Beauty, that is, can return only in quotation marks. YAB

FURTHER READING
Curtis L. Carter and Karen L. Butler (eds), *Jean Fautrier* (New Haven and London: Yale University Press, 2002)
Hubert Damisch, "The Real Robinson," *October*, no. 85, Summer 1998
Jean Dubuffet, *Prospectus et tous écrits suivants*, four volumes, ed. Hubert Damisch (Paris: Gallimard, 1967–91) and "Notes for the well read" (1945), translated in Mildred Glimcher, *Jean Dubuffet: Towards an Alternative Reality* (New York: Pace Publications and Abbeville Press, 1987)
Rachel Perry, "Jean Fautrier's *Jolies Juives*," *October*, no. 108, Spring 2004
Francis Ponge, *L'Atelier contemporain* (Paris: Gallimard, 1977)
Jean-Paul Sartre, "Fingers and Non-Fingers," translated in Werner Haftmann (ed.), *Wols* (New York: Harry N. Abrams, 1965)

1947 a

Josef Albers begins his "Variant" paintings at Black Mountain College in North Carolina a year after László Moholy-Nagy dies in Chicago: imported to the United States, the model of the Bauhaus is transformed by different artistic imperatives and institutional pressures.

When the Nazis came to power in 1933, they forced the closure of the Bauhaus, the paradigmatic school of modernist design. Walter Gropius (1883–1969), its first director, had already left in 1928, soon followed by László Moholy-Nagy (1895–1946), who was in charge of its *Vorkurs* or preliminary course (he was replaced in that capacity by Josef Albers [1888–1976]). Relocated in Berlin, Moholy-Nagy continued to experiment with new materials, photography, light machines, and various forms of design (mostly books and exhibitions); he also ventured into film, theater, and opera production. In 1934 the spread of Nazism led him to move to Amsterdam and, a year later, to London. Then, in 1937, he left Europe altogether to direct the fledgling New Bauhaus in Chicago launched by a group of patrons and businessman called the Association of Arts and Industries (they had asked Gropius, but he had already accepted the post of Chair of Architecture at Harvard). Due to mismanagement of stocks, the Association had to close the school within a year. However, in 1939, and with only scant resources, Moholy-Nagy was able to reopen it— now renamed the School of Design—with much the same faculty, including the Russian-born American sculptor Aleksandr Archipenko (1887–1964), the Hungarian theorist György Kepes, and the American philosopher Charles Morris. (The Bauhaus veterans Herbert Bayer [1900–85] and Alexander [Xanti] Schawinsky [1904–1979] and the French abstractionist Jean Hélion [1904–87] were listed on the New Bauhaus roster, but they did not teach in the first years.) In 1944 the school was renamed the Institute of Design, and it remains a division of the Illinois Institute of Technology to this day.

Other partial re-creations of the Bauhaus were attempted: Albers brought his version of the *Vorkurs* to Black Mountain College in North Carolina in late 1933, for example, and the Swiss artist and architect Max Bill (1908–94), who studied at the Bauhaus in 1927–9, launched the Institute of Design in Ulm, West Germany, in 1950. Each version was guided by a different agenda and adapted to a particular setting: Albers integrated his courses in drawing and color into a liberal arts college, while Bill foregrounded technological design for a postwar Germany under reconstruction. A one-time socialist associated with other artists and designers on the Left, Moholy-Nagy was now partnered in Chicago with industrialists such as Walter P. Paepcke, the president of the Container Corporation of America, who chaired the board of the Institute of Design (during his Chicago years Moholy-Nagy also designed for such companies as Parker Pens). How, apart from economic necessity, can we understand this reorientation of the Bauhaus idea?

To open eyes

Moholy-Nagy gives us some clues as early as his signature book *Von Material zu Architektur* (1929), translated into English as *The New Vision: From Material to Architecture* (1932). Throughout the twenties he was steeped in debates about photography, which were most lively in Germany and the Soviet Union. As perspectival painting informed the Renaissance, Moholy-Nagy argued, so photography has informed the modern age, and the arts must be rethought according to this "new vision." (In a sentence that Walter Benjamin might have written, he stated that "the illiterates of the future will be ignorant of the use of the camera and the pen alike.") Moholy-Nagy cited "eight varieties of photographic vision," some of which also affected the sciences: abstract (as in cameraless photograms), exact (as in reportage), rapid (as in snapshots), slow (as in prolonged exposures), intensified (as in microphotography), penetrative (as in X-rays), simultaneous (as in photomontage), and distorted (as in various manipulations of the negative and / or the print). Clearly, if seen as a matter of such techniques alone, the idea of a "new vision" could be adapted with relative ease to the different social, economic, and political conditions of corporate America. In *The New Vision*, Moholy-Nagy also included a description of his *Vorkurs* and an account of the formal potentials of different materials, as well as a sketch of the evolution of sculpture (blocked out, hollowed or modeled, perforated or constructed, hung or suspended, kinetic). In other words, he offered both a pedagogy of visual fundamentals and a model of history that was almost Hegelian in its faith in the progress of technological vision. These ideas, too, could be embraced by a country committed to the pragmatic instruction and application of new technologies. In short, despite his own utopian aspirations, Moholy-Nagy suggested a way to make modernist design not only teachable but exploitable.

The *Vorkurs* of the New Bauhaus adopted that of the old with slight but significant additions: the training still began with analyses

▲ 1923　● 1928b, 1929　■ 1937b　◆ 1959e, 1957a, 1957b, 1967c　　　▲ 1928b　● 1929　■ 1935

of materials, tools, construction, and representation, but there was new emphasis placed on the sciences, photography, film, display, and publicity. "Our concern," Moholy-Nagy wrote in the program announcement, "is to develop a new type of designer"—note that he does not say "artist," much less "craftsman"—a designer who can integrate "specialized training in science and technique" with "fundamental human needs." This squaring of the circle— of technological science with human biology, of divisions in labor and knowledge with a "universal outlook"—became the American version of his Bauhausian utopia. Some of the subject headings of his next essay "Education and the Bauhaus" (1938), such as "The Future Needs the Whole Man" and "Not Against Technical Progress, but With It" also tell this tale. In an improbable dialectic, Moholy-Nagy sought his utopia of restored unity on the other side of techno-scientific specialization, which, unlike his predecessors in the Arts and Crafts movements, he embraced rather than rejected. For Moholy-Nagy, only through its "new vision" might "the whole man" be remade:

> We are faced today with nothing less than the reconquest of the biological bases of human life. Only when we go back to these can we reach the maximum utilization of technical progress in the fields of physical culture, nutrition, housing and industry— a thoroughgoing rearrangement of our whole scheme of life.

This project became ever more urgent due to World War II; in *Vision in Motion*, an updating of *The New Vision* (published in 1947 after his premature death from leukemia at fifty-one), Moholy-Nagy proposed a kind of United Nations of design culture that might "embody all specialized knowledge into an integrated system through cooperative action." A modernist to the end, he never understood how his own utopia might be turned to ideological ends. In modernist fashion his art of his last years, especially his twisting Plexiglas and chrome sculptures [1], are true to materials and inventive of forms, but, seen with a skeptical eye, they also look, from one angle, like so much formal "experimentalism"
▲ for its own sake (as Theo van Doesburg once cautioned about the younger Moholy-Nagy) and, from another angle, like so much corporate research-and-development—research into new substances, development of new products.

Shortly after the Bauhaus in Berlin was closed in 1933, Black Mountain College was opened in the hills near Asheville, North Carolina by a small group of professors led by John Andrew Rice (1888–1968)—a coincidence that worked well for Josef and Anni Albers. The new school wanted to make the arts central to the curriculum, even primary for first-year students, and on the recommendation of Philip Johnson, the architecture curator at the Museum of Modern Art who had visited the Bauhaus with Alfred
• Barr in 1927, the Albers were invited to join the faculty. They were the first Bauhausians to teach in the United States, and at first Anni, a gifted weaver who spoke English, received more attention than Josef. "All I knew was Buster Keaton and Henry Ford," Josef recalled later. "I spoke no English." Asked on his arrival what he

1 • László Moholy-Nagy, *Spiral*, 1945
Plexiglas, 49 × 37.5 × 40 (19¼ × 14¾ × 15¾)

hoped to accomplish at the school, he stuttered, "To open eyes." Here, too, "vision" was the modernist password.

The college stressed holistic teaching and collective participation. "At Black Mountain," the historian Mary Emma Harris writes, "the principles of democracy were to be applied not just to the classroom, as was usually the case in progressive schools, but to the entire structure of the college. There were to be no legal controls from the outside: no trustees, deans, or regents." This structure was more radical than that of the Bauhaus, new or old. And though Black Mountain College was marginal in the thirties (there were only about 180 students in total), there was no more influential community in American arts from the mid-forties through the mid-fifties. Apart from the Albers, semiregular faculty included poets Charles Olson and Robert Creeley, drama historian Eric Bentley, photography historian Beaumont Newhall, abstract painter Ilya Bolotowsky, and designer Alexander Schawinsky (who was also involved in the New Bauhaus), among others. From 1944 to 1949 Albers arranged summer sessions with diverse artists and writers often foreign to his own tastes and teachings, and the practice continued after he left the school: composer John Cage and dancer-choreographer Merce Cunningham in 1948, 1952, and 1953; photographer Harry Callahan in 1951; painter Willem de Kooning in 1948; poet Robert Duncan in 1955; old Bauhausian Lyonel Feininger in 1945; visionary designer Buckminster Fuller in 1948 and 1949; writer Paul Goodman and critic Clement Greenberg in 1950; Walter Gropius in 1944, 1945, and 1946; painter Franz Kline in 1952; composer Ernst Krenek in 1944; painter Jacob Lawrence in 1946; designer Alvin Lustig in 1945; painter Robert Motherwell in 1945 and 1951; painter-critic Amédée Ozenfant in 1944; cultural theorist Bernard Rudofsky in 1944 and 1945; composer Roger Sessions in 1944; painter Ben Shahn in 1951; photographer Aaron Siskind in 1951; painter Theodore Stamos in 1950; musician David Tudor in 1951, 1952, and 1953; painter Jack Tworkov in 1952; and sculptor Ossip Zadkine in 1945—and these

▲ 1917b, 1928a ● 1927c

are only some of the names on the list. The roster of art students was almost as impressive (and not as male-dominated). It included Ruth Asawa, John Chamberlain, Elaine de Kooning, Robert de Niro (father of the actor), Ray Johnson, Kenneth Noland, Pat Passloff, Kenneth Snelson, Robert Rauschenberg, Dorothea Rockburne, Cy Twombly, Stan Vanderbeek, and Susan Weil. The encounters between faculty, guests, and students were often catalytic, as evidenced by the collaborations of Cage, ▲ Cunningham, Tudor, and Rauschenberg alone.

Everything has form

To this experimental community within an egalitarian college, Albers brought the analytical rigor of his own modernist practice: he offered courses in drawing, which stressed techniques of visualization; in design, which focused on proportion, arithmetic and geometric progression, the golden section, and spatial studies; and, most famously, in color, which was analyzed not with paints but with papers received from manufacturers. Albers taught painting only as an advanced color course, and then mostly in watercolor (he painted little at the Bauhaus too; this emphasis came only later). In formulations reminiscent of Moholy-Nagy, Albers proclaimed that "abstracting is the essential function of the Human Spirit" and that it requires the "disciplined education of the eye and the hand." However, his application of this Bauhausian credo was different from that of his old colleague, for, again, it occurred in the context of a liberal arts college, not a professional design school. This setting led Albers to two basic revisions of the Bauhaus idea. Firstly, he gave it a more humanist, almost Goethean inflection: "Every thing has form, every form has meaning," he once wrote, and art concerns "the knowledge and application of the fundamental laws of form." In other words, he complemented the new study of vision (which was not as technologically inflected for Albers as it was for Moholy-Nagy) with an old attention to form, to *Gestaltung*. Second, he reoriented the Bauhausian analysis of materials and structures along the lines of the American pragmatism of such philosophers as John Dewey (who was not unknown at the Bauhaus). For example, at Black Mountain Albers called his preliminary course not *Vorkurs* but *Werklehre*, instruction through work, or learning by doing. Although the goal remained much the same as at the Bauhaus—"*Werklehre* is a forming out of materials (for instance, paper, cardboard, metal sheets, wire), which demonstrates the possibilities and limits of materials"—the focus was less on fixing a meaning or a function to a substance and more on inventing a form out of it. Albers brought to his classes nontraditional materials and found things like autumn leaves and eggshells, and he was interested more in appearance than in essence—in what he called *matière*, which he defined as "how a substance looks" and how this semblance changes with different marking, lighting, and setting [2]. This explains his particular obsession with the combination of forms and the interaction of colors, which he juxtaposed "to make obvious how colors influence and change

each other." "Nothing can be one thing but a hundred things," Albers once remarked in his odd English; "all art is swindle." Part of educating the eye was fooling the eye, and therein also lay a primary interest of art for Albers—in "the discrepancy between the physical fact and the psychic effect."

Albers was considered severe as a teacher—both at Black Mountain in 1933 to 1949 and at Yale University in 1950 to 1958 as Chair of Painting and Sculpture (then renamed Design)—and his art is still regarded as austere, as a reductive form of abstract painting. But his work allowed for certain openings, and his pedagogy was fecund for many different students. (His influence at both schools continued long after he left; indeed, Yale was as important a training ground for American artists in the sixties as Black Mountain had been in the fifties.) These openings might be understood in two ways. First, Albers was not quite the other extreme to the avant-garde wing of Black Mountain—Olson in poetry, Cage in music, Cunningham in dance, and so on—that he is often seen to be. The rigorous German committed to the disciplining of the eye might appear antipodal to the rumbunctious Americans pledged to the opening of poetry, music, and dance to the breath of the body, to the vagaries of chance, and to nonsymbolic movement, yet Albers and Cage were also aligned in their opposition to other aesthetic models then on the rise—to an art based on expressive *subjectivity* (as represented by some young Abstract Expressionists ▲ who passed through Black Mountain such as de Kooning, Kline, and Motherwell) or on extreme *objectivity* (as in the medium- ● specific model of painting later developed by Clement Greenberg). Moreover, both Albers and Cage were involved, each in his own way, in a pragmatic approach to research and experiment, and ■ Black Mountain students like Rauschenberg and Twombly might be seen, in part, as the unlikely offspring of their odd coupling. (Listen to the mix of alienation and affinity that Rauschenberg evokes in this retrospective remark: "Albers was a beautiful teacher and an impossible person … what he taught had to do with the entire visual world.… I consider Albers the most important teacher

2 • Josef Albers and Jane Slater Marquis, *matière* **study using eggshells at Black Mountain College**

I've ever had, and I'm sure he considered me one of his poorest students.") In short, Albers was a primary element in the chemical reaction that made Black Mountain so important for advanced art in postwar America: after all, it was a crucible where a Constructivist impulse, or a modernism focused on vision, material, form, and structure, was combined with a Dadaist impulse, or an avant-gardism pledged to transgressive play, in a way that triggered many significant artists of the fifties and sixties, directly and indirectly.

Second, Albers helped to mediate not only between different modernist and avant-gardist impulses, but also between various prewar and postwar forms of abstraction, especially those focused ▲ on light and color. His earliest works at the Bauhaus were assemblages of glass shards mounted with chicken wire and placed by windows (they resemble some of the later *matière* studies of his Black Mountain students), and he also produced glass pieces in pure colors for private houses in Germany. "I wanted to work with direct light," he recalled to critic Margit Rowell, "the light which comes from behind the surface and filters through that surface plane." This concern with light as color in volume persisted not only in his early reliefs in glass, both transparent and opaque (whose banded compositions are similar to Anni's contemporaneous weavings), but also in his later paintings, which continued the implicit window format with rectangles of luminescent color. The abstract motif of his "Variant" paintings (1947–55) derived from two adobe houses that the Albers saw on one of many trips to the Southwest. This series presents nested rectangles of various colors in doubled or bilateral compositions, and it leads directly to his most famous series, *Homage to the Square* (1950–76), which consists of many paintings (usually in a four-foot-square format) of exact squares of pure colors that are also nested in one another [**3**]. Applied with a palette knife straight from the tube, the paint is flat and smooth on its support (usually the rough side of masonite panel), but it is also luminescent enough to suggest depth, either projective or recessional; there is much repetition and difference, symmetry and reversal, within each painting and between works. Yet all these experiments with forms depend on the interaction of colors—their relative transparency, intensity, depth, openness, warmth, and so on. "Painting is color acting," Albers liked to say; "character and feeling alter from painting to painting without any additional 'hand writing'": "All this [is] to proclaim color autonomy as a means of plastic organization."

The modernist in the university

These concerns had different ramifications for subsequent artists. For example, his *Homages to the Square* seem to anticipate the ● spare geometric canvases of the young Frank Stella; but Albers still allowed for spatial illusion in his paintings, whereas Stella squeezed it out with the white lines of his exposed ground and the extreme depth of his often shaped supports. With Stella "what you see is what you see," as he once famously remarked; with Albers one is never so sure: for all his interest in proper gestalt forms, he was also

fascinated, again, with "the discrepancy between the physical fact and the psychic effect." This gap between *known* form and *perceived* form is the space in which Minimalist artists also worked (as, for example, in 1965 when Robert Morris placed three identical L-beams in different positions in a New York gallery and dared ▲ the viewer to see them as the same right angle). Such attention to the complexities of perception might also have influenced not only Op artists such as Bridget Riley but also light artists such as ● Robert Irwin and James Turrell, all of whom were also provoked by the phenomenological investigations of Minimalism. Rowell has written of the "lambent incandescence" of a typical Albers painting: "We are as in the presence of real light, not the kind of illusionism through which light is artificially projected from an outside source." So it is with the light installations of Irwin and Turrell, with this obvious difference: Albers worked at the scale of easel painting, careful to retain an intimate relationship with the viewer, not with environmental space that is often manipulated in such a way as to overwhelm the viewer.

Nevertheless, the opening up of "vision" is the most important legacy of both Moholy-Nagy and Albers. Again, Moholy-Nagy studied this vision primarily in terms of light, which he understood in a technologically evolutionary way (one that might have some ■ bearing on the development of Pop and kinetic art in the sixties). Albers understood it primarily in terms of color, which he investigated in a phenomenological way (again, with some ramifications for Minimalist, Op, and light art in the same decade). But more important are the different institutional inflections that the two men gave to these studies, with the Bauhaus program implicitly retooled by Moholy-Nagy for technological design institutes and by Albers for liberal arts schools. As Howard Singerman has argued in *Art Subjects: Making Artists in the American University*: "The discourse of vision and the tropes that go with it are crucial to adapting art to the university campus; it is both professionalizing and democratizing. Vision counters the vocational, the local, and the manual; the visual artist shapes the world, designing its order and progress." Under this dispensation, which was pioneered largely by Moholy-Nagy and Albers, "the fine arts" of the old Beaux-Arts tradition were reworked as "the visual arts" of the modernist period, in which guise they could be relocated in the university in alignment less with the humanities than with the sciences, with the artist-in-the-studio patterned after the scientist-in-the-laboratory, both engaged in research. (This analogy was made explicit by György Kepes of the New Bauhaus, who later founded the Center for Advanced Visual Studies at the Massachusetts Institute of Technology, in his influential *Language of Vision* of 1944: "the task of the contemporary artist is to release and bring into social action the dynamic forces of visual imagery.") This repositioning of the artist involved changes in pedagogy for which the Bauhaus was the best precedent. As Singerman suggests: "Assignments that allow students to discover for themselves the order of vision, the forces and relations of two-dimensional design and three-dimensional space, and the properties of materials—at least of paint,

3 • Josef Albers, *Homage to the Square*, 1970
Oil on masonite, 40.6 × 40.6 (16 × 16)

perhaps of paper and clay—mark the presence and the difference of Bauhaus education in the United States, its difference from the sameness and repetition of the academy and its resemblance to the goals of the modern research university." And: "Over and over again in the teaching of art at the Bauhaus and in its teaching in America, the re-creation of design as vision is represented by the field or, more familiarly, by the picture plane as the gridded, ordered, law-bound rectangle with which, and on which, art fundamentals begin. The rectangle marks the teaching of modernism as the visual arts, displacing and containing the human figure that stood at the center of the academic fine arts."

This is not a question of simple cooption: there is no direct line from the Bauhaus *Vorkurs* to the design and color courses that became tediously standard in many postwar universities. A dialectical view is far better: Moholy-Nagy and Albers also radicalized design and color instruction, just as they both preserved the Bauhaus idea *and* allowed it to be transformed by cross-fertilization with other avant-garde models. Moreover, the very

importance of Moholy-Nagy, Albers, and other Europeans to art, design, and education in the postwar period must complicate the old stories of a simple passage in prominence from Paris to New York of the "Triumph of American Painting" sort. For all the differences and disruptions, there was also a continuity from continent to continent, from one postwar period to another—a continuity, despite change and through change, at the level of artistic practice, industrial design, and educational method. HF

FURTHER READING
Josef Albers, *Homage to the Square* (New York: Museum of Modern Art, 1964)
Mary Emma Harris, *The Arts at Black Mountain College* (Cambridge, Mass.: MIT Press, 1987)
Margret Kentgens-Craig, *The Bauhaus and America: First Contacts 1919–1936*,
trans. Lynette Widder (Cambridge, Mass.: MIT Press, 1999)
László Moholy-Nagy, *An Anthology*, ed. Richard Kostelanetz (New York: Da Capo Press, 1970)
Howard Singerman, *Art Subjects: Making Artists in the American University*
(Berkeley and Los Angeles: University of California Press, 1999)

1947 b

The publication of *Possibilities* in New York marks the coalescence of Abstract Expressionism as a movement.

Every study of Abstract Expressionism begins with a disclaimer about its label, echoing that made by the artists themselves. The coinage itself is quite apt (it came somewhat late into use, around 1952) and is not in question. What is resented is the fact that it groups very diverse talents under the same umbrella, homogenizing and unifying a cast of characters, each of whom strove for singularity. Yet this disclaimer is something of a paradox, for in insisting on the individualism of the Abstract Expressionist artists, and on the idiosyncratic nature of their pictorial marks, it does single out what they had in common: a longing for what could be called the autographic gesture, the inimitable, signature-like dribble of paint that would translate private feelings and emotions directly onto the material field of the canvas—without the mediation of any figurative content.

This is not to say that these artists had little else in common, or that they did not band together—they often did, especially to show collective muscle in the face of a shared enemy. A case in point is their May 1950 boycott of a juried exhibition organized by the Metropolitan Museum in New York in protest against that institution's "hostility to advanced art," a public gesture initiating a six-month-long turmoil and celebrated by a notorious photograph published in *Life* in January 1951 [**1**]. Among the "Irascible Eighteen," as they were nicknamed by the *New York Herald Tribune*, one could count almost all the major Abstract Expressionist painters, including the older Hans Hofmann (1880–1966), a mentor to
▲ several of them. The only conspicuous absences, apart from Arshile Gorky, who had died two years before, were those of Franz Kline (1910–62) and Philip Guston (1913–80). Along with
● lesser figures and all the sculptors often (though incorrectly) associated with the movement (David Smith the foremost among them), there were William Baziotes (1912–63), Robert Motherwell
■ (1915–91), Barnett Newman (1905–70), Jackson Pollock (1912–56), Mark Rothko (1903–70), and Clyfford Still (1904–80). They all signed the angry open letter to Roland Redmond, President of the Metropolitan Museum (published on the front page of the *New York Times* on May 22, 1950); and, urged and cooed by Newman, who acted as their chief organizer, most made an effort not to miss the *Life* photo opportunity. Similar protests a few years before (such as the letter to the *New York Times* signed by

1 • Nina Leen, *The Irascibles*, 1951
Black-and-white photograph published in *Life* magazine, January 1951

Rothko and Gottlieb and written with the help of Newman, which was published on June 13, 1943) had led nowhere—but now the time was ripe. Even though commercial success was still a few years away, Abstract Expressionism was suddenly entering the pantheon of high art with the full support of the Museum of Modern Art. It would soon be deemed the quintessential "American-Type Painting" (Clement Greenberg) and enlisted in the Cold War as an efficient cultural battalion against Soviet Communism.

Shared experiences

The *Life* photograph vastly exaggerated the bond between the artists it portrayed, as many of them later protested. But for all their posing as proud loners, most indeed had a common background.

▲ 1942a ● 1945 ■ 1942a, 1949a, 1951, 1959c, 1960b

First, many had worked for the Works Progress Administration (WPA) during the thirties (among them Baziotes, de Kooning, Gorky, Gottlieb, Pollock, and Rothko), and during this period of extreme poverty most had a brush with radical politics (including for some, such as Pollock, membership of the Communist Party). This meant that they had all participated in one way or another, between the Spanish Civil War (1936–7) and the massive disillusionment following the Nazi–Soviet nonaggression pact (1939), in the great debate of the time concerning the relationship between art and politics—some looking toward Picasso and his *Guernica* (1937) as a model, others toward the Mexican muralists, others yet toward the American Regionalist painter Thomas Hart Benton (the young Pollock being unique among his peers in striving to synthesize those three trends).

Second, with the possible exception of the Dutch-born de Kooning, they all had an enormous feeling of inferiority with regard to the European avant-garde, whose artistic production they knew remarkably well. One could even say that, with the opening in New York of collector A. E. Gallatin's Museum of Living Art in 1926, that of the Museum of Modern Art in 1929, and that of the Solomon R. Guggenheim Museum (then called the Museum of Non-Objective Painting) in 1939—not to forget the multiple touring exhibitions of the collection (selected by Marcel Duchamp) of Katherine Dreier's Société Anonyme in the twenties and thirties, and, last but not least, the militant activity of Peggy Guggenheim at her "Art of This Century" gallery, again in New York, from 1942 on—the Abstract Expressionists had, by the early forties, accumulated a better first-hand knowledge of their immediate European predecessors than any other contemporary artists (and certainly better than anyone in Europe). Their awe for their European seniors was at first paralyzing. A man like Gorky, for example, began to emancipate himself from the Miró-cum-Picasso system of Surrealist automatism only in 1944, but then it was suddenly to raise the stake of the painterly accident higher than ever before in the history of art: admiring the violent bravado of Gorky's 1944 painting *How My Mother's Embroidered Apron Unfolds in My Life* and its conspicuous runoffs of liquid paint, one should not forget that it dates from only four years before his death. But the arrival of many European exiles in New York at the beginning of World War II paradoxically relieved some of the endemic "anxiety of influence": luminaries like Fernand Léger, André Breton, Max Ernst, and Piet Mondrian were suddenly seen to be not titans after all, but (somewhat aging) human beings. In turn, this discovery fueled a certain nationalistic pride among the American artists: with Europe now almost entirely muzzled by totalitarian regimes, it was up to the US boys to save the flame of culture from its barbaric extinction. Often exhibiting in group shows, and in the same (handful of) galleries and marginal cultural institutions, they slowly began to feel a momentum amid a generally indifferent if not hostile context. Their resentment at the lack of early support from the Museum of Modern Art and that part of the critical establishment that was embracing European modernism helped draw them closer together.

Those difficult early years had a lot to do with the formation of a collective identity. Depending on the swing of the pendulum, these emotional artists felt elated or tortured. Newman captured both the mood and what was at stake: "In 1940, some of us woke up to find ourselves without hope—to find that painting did not really exist.… The awakening had the exaltation of a revolution. It was that awakening that inspired the aspiration … to start from scratch, to paint as if painting never existed before. It was that naked revolutionary moment that made painters out of painters." Better than his peers (they considered him a kind of benevolent impresario presiding over their own careers), Newman presented what was thought to be the only possible way out: a third path, between pure abstraction (represented by Mondrian) and Surrealism.

An early enthusiasm for, and gradual rejection of, Surrealism was the third trait the Abstract Expressionists held in common, and perhaps more than anything else it determined their ideology. They soon turned their backs on the Surrealists' symbolist imagination and fascination for mythology, but retained a strong primitivist impulse and, at least for the majority of them, a marked interest in psychoanalysis. True, by the mid-forties their *Reader's Digest*-like incursions into anthropological, psychoanalytic, or philosophical literature were hardly a sign of originality. In view of the recent calamities that had plagued humanity (fascism, Stalinism, the Holocaust, the atomic bomb), a new type of theoretical hodgepodge that had emerged in the United States shortly before the war, aptly called the "Modern Man discourse" by art historian Michael Leja, was suddenly becoming enormously popular in the media. Central to this discourse was the idea that "the human mind harbored an unconscious" (Leja)—this seemed the only possible explanation for the unprecedented levels of cruelty and irrationality that man had just displayed. But if the public rise of the concept of the unconscious had a soothing effect on a traumatized population (quickly capitalized on by Hollywood), it also provided the Abstract Expressionists with a potent rhetoric with which they could hide their rapid retreat from the elusive possibility of "pure automatism"—a Grail for which the Surrealism had long searched in vain—to the much more practicable cult of the "autograph."

From the automatic to the autographic

The key years were 1947 and 1948. In the course of just a few months, Pollock began to work in his allover dripping technique (in late summer or early fall 1947); Newman painted *Onement I* (in January 1948); de Kooning had a triumphant first solo show (in April–May 1948); Gorky, who alone among his peers had been welcomed by the Surrealists, committed suicide (in July 1948), marking the definitive end of an old allegiance; and Rothko realized his first mature canvases—the "multiform" paintings that he no longer titled but identified solely by number or color, a sure indication that he had turned a page. Furthermore, 1948 was also the year when The Subjects of the Artist school, founded by Baziotes, Motherwell, Newman, Rothko, Still, and the sculptor

David Hare, opened its doors. This pedagogic experience was short-lived, with the school closing in the spring of 1949, but the very fact that its founders thought, even for a moment, that an academy could function as an outlet for the type of art they were inventing pointed to what was to come.

A particularly significant record of Abstract Expressionism at the very moment of its coalescence as a movement—because it encapsulates the shift from the automatic to the autographic—is provided by the first, and only, issue of *Possibilities*, published at the end of 1947 by Motherwell and the critic Harold Rosenberg (who would ▲ later father the label "action painting"). This "journal" was as ambitious as its title was pregnant. It addressed many media (including music, strongly present with John Cage in command, and literature), and aimed at securing or renewing links with the historical avant-garde (an interview with Miró, a poem and illustrations ● by Arp). It is best known today, however, for having published Pollock's and Rothko's statements on their own art. Other texts should not be overlooked, though, such as Baziotes's and, above all, Rosenberg's. Together they form a symptomatic nucleus.

"The source of my paintings is the unconscious," Pollock had written in the draft of his statement, but he deleted this general affirmation, by then already something of a cliché, in favor of a more descriptive note alluding to the drip technique with which he was beginning to experiment (though none of his drippings are reproduced among the six accompanying illustrations, all of which are from works of 1944–6). While for some time he had derived the imagery of his paintings (such as *Birth* [c. 1941], *Bird* [c. 1941], ■ or *Moon Woman Cuts the Circle* [c. 1943]) from his acquaintance with Jungian analysis (he was himself in therapy), he now clearly aligned his new method and its wholly abstract results with unmediated spontaneity: "When I am *in* my painting, I'm not aware of what I'm doing. It is only after a sort of 'get acquainted' period that I see what I have been about.… Painting has a life of its own. I try to let it come through. It is only when I lose contact with the painting that the result is a mess. Otherwise there is pure harmony, an easy give and take, and the painting comes out well." A similar attitude is found in Baziotes ("What happens on the canvas is unpredictable and surprising to me.… Each painting has its own way of evolving") and Rothko ("I think of my pictures as dramas; the shapes in the pictures are the performers.… Neither the action nor the actors can be anticipated, or described in advance.… It is at the moment of completion that in a flash of recognition, they are seen to have the quantity and function which was intended").

But while Pollock clung steadfastly to the notion of automatism, the others did not. Although we can marvel today at Pollock's amazing technical know-how in interweaving numerous meshes of color, and at the remarkable assurance with which he alternated between thread-thin rivulets and thick puddles of wet paint, the fact is that in his drip paintings he relinquished part of his authorship. By avoiding any direct contact with the canvas splayed on the floor, by letting gravity and the viscosity of the paint play a major role in the outcome of his works, and by abandoning the paint-brush, Pollock lost the anatomical connection that had traditionally linked artist's hand, brush, and canvas. He wavered on the issue of control, depending on the critical response ("I *am* nature" versus "No chaos, damn it!"), but even if in the end his marks proved utterly inimitable, his attempt at automatism was deemed by his peers to be too much of a breakdown of authorial mastery. Their taming (repression) of Pollock's radicalism had a defining role in the formation of the Abstract Expressionist canon.

"The aspect of the freely made"

This rapid evolution can be bracketed between two texts, one written at the dawn of the movement—Rosenberg's short essay published in *Possibilities*—and the other when it was already showing definite signs of exhaustion—Meyer Schapiro's "The ▲ Liberating Quality of Avant-Garde Art" of 1957. Rosenberg's "Introduction to Six American Artists," initially the catalogue preface for a spring 1947 exhibition presenting Baziotes, Motherwell, and Gottlieb (among others) to a French audience for the first time, laid the groundwork for a theory of art that would become the pillar of the pictorial practice of Abstract Expressionism. These artists, he wrote, long for "a means, a language, that will formulate as exactly as possible what is emotionally real to them as separate persons … Art to them is … the standpoint for a private revolt against the materialist tradition that does surround them.… Attached neither to a community nor to one another, these painters experience a unique loneliness of a depth that is reached perhaps nowhere else in the world." "Emotionally real to them as separate persons," "private revolt," "loneliness": for Rosenberg, the stuff of the Abstract Expressionist painter is his uniqueness; his duty is to let us enter the inner sanctum of his feelings; his art is bound to reveal his very own self as the kernel of his originality. But at the same time, Rosenberg claims that the pangs of suffering registered by the art (a much-dated leitmotiv in his existentialist prose) are universally human and thus universally accessible. In short, the Abstract Expressionist canvas is an affirmation of the ego, a half-romantic, half-petty-bourgeois version of the Cartesian "Cogito ergo sum," which is to say, the seat, as T. J. Clark has argued, of much vulgarity. No wonder that the acompositional monotony of Pollock's allover drips was not long deemed by his peers to fill the brief.

Echoing Rosenberg's notion of a revolt against the "materialist tradition" (meaning here not the tradition of philosophical anti-idealism but the bourgeois mode of life predicated upon the acquisition of goods), Schapiro's text confirms that the myth of "spontaneity" was the locus of a smooth conversion from the unknown and the unpredictable (the unconscious) to a concept of subjective freewill that fitted the ethos of American democracy particularly well: "Paintings and sculptures," he starts, "are the last hand-made, personal objects within our culture. Almost everything else is produced industrially, in mass, and through a high division of labor. Few people are fortunate enough to make something that represents themselves, that issues entirely from their

hands and minds, and to which they can affix their names.... The painting symbolizes an individual who realizes freedom and deep engagement of the self within his work." This argument is not dissimilar to that given almost a century before by the defenders of Impressionism (a historical antecedent many Abstract Expressionist painters were prompt to celebrate), but it has gained for Schapiro a new poignancy:

> The consciousness of the personal and spontaneous in the painting and sculpture stimulates the artist to invent devices of handling, processing, surfacing, which confer to the utmost degree the aspect of the freely made. Hence the great importance of the mark, the stroke, the brush, the drip, the quality of the substance of the paint itself, and the surface of the canvas as a texture and field of operation—all signs of the artist's active presence. The work of art is an ordered world of its own kind in which we are aware, at every point, of its becoming.

Between the "aspect of the freely made" and the work of art as an "ordered world" lies the shift from the automatic to the auto-graphic (but also the risk of fraudulence and of academization). This slippage ran two simultaneous courses, often, but not necessarily, in tandem, and did so almost right from the start (beginning in 1948): the claims of spontaneity were dimmed in favor of principles of good composition; and the autographic unit grew in size from the simple gesture to the immediately recognizable trademark style—almost like the artist's own logo—filling the whole canvas. De Kooning's immediate canonization, in the wake of his first solo show at the Charles Egan Gallery in New York in 1948, tells how much the need of the first move was felt (Greenberg was almost alone in these years in praising Pollock's allover mode, and he had to overcome his own initial resistance). In many ways, the subservience of de Kooning's white-on-black canvases to Pollock's most recent development was a kiss of death [2]: gone were the looseness and risk-taking of the drip technique, now replaced by a tight grip on the brush and nervous twists of the wrist. The sigh of relief uttered by sympathetic critics grew even louder in response to de Kooning's second exhibition, in 1951: "There is no destruction but instead constant wiping out and

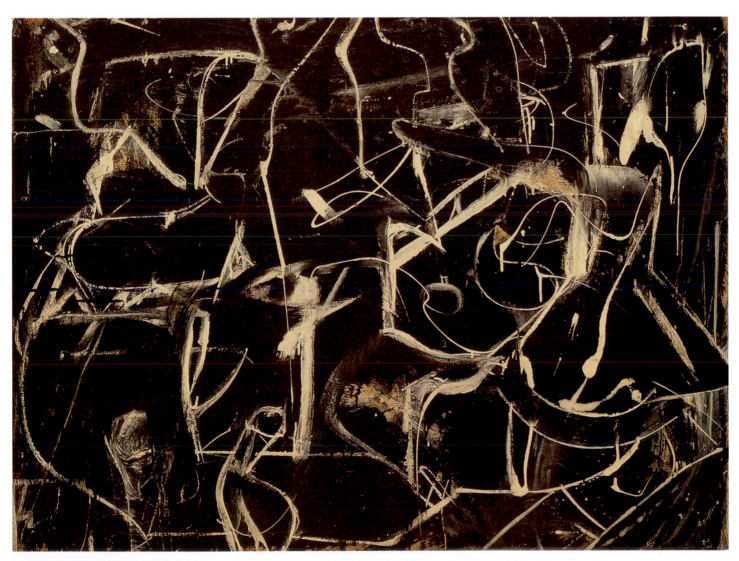

2 • Willem de Kooning, *Untitled*, 1948–9
Enamel and oil on paper on composition board, 89.7 × 123.8 (35⅜ × 48¾)

3 • Robert Motherwell, *At Five in the Afternoon*, 1949
Casein on board, 38.1 × 50.8 (15 × 20)

Signature style

starting over," wrote Thomas B. Hess, "and the whole image [is kept] under rigorous control."

As for designing a "logo," a trap that Newman called the "diagram" and which he paradoxically avoided by addressing the issue at the outset when he opted for the simplest possible spatial markers ▲ (his immediately recognizable vertical "zips"), one can also date its beginning to 1948. A case in point is Motherwell's lifelong • *Elegy to the Spanish Republic* series (more than 140 paintings), based on an ink drawing conceived in 1948 as an illustration for a poem by Rosenberg and destined for the second (never published) issue of *Possibilities*: pulling out the tiny sketch from a drawer one year later, Motherwell scrupulously reproduced it, with all its scumbling contours and paint runoffs, on a somewhat larger canvas now given the title *At Five in the Afternoon*, the famous refrain of an elegy by the Spanish poet and dramatist Federico

García Lorca lamenting the death of a bullfighter [**3**]. Such posturing does not necessarily characterize the working method of all the Abstract Expressionists, but the very fact that it was possible at all (and that it would be thoroughly imitated by legions of younger artists once the movement had become widely successful, that is, by the mid-fifties) merits consideration. Gottlieb's clouds hovering above an allusive horizon, Kline's broad and energetic brush-strokes in slicker and slicker black paint [**5**], and Still's dry shards quickly became patented figures of style. Even Rothko's horizontal partitions of his vertical canvases [**4**] fit into this category: were it not for the sustained inventiveness of his color chords, and the ensuing enigmas of figure–ground relations that his works continued to pose till the end, his art may have been exhausted by the artist's manic overproduction.

In short, the seriality of Abstract Expressionism, in the end, had much in common with that of the movement said to have precipi-▲ tated its demise—Pop art. Jasper Johns (born 1930) and Robert Rauschenberg (1925–2008), whose rise to fame immediately

4 • Mark Rothko, *Number 3 / No. 13 (Magenta, Black, Green on Orange)*, **1949**
Oil on canvas, 216.5 × 163.8 (85¼ × 64½)

5 • Franz Kline, *Cardinal*, 1950
Oil on canvas, 197 × 144 (77½ × 56¾)

preceded that of Pop and cleared the way for it, saw through the posturing. Johns mimicked the rapid splashes of the Abstract Expressionist canvases but in encaustic, the slowest possible and most ancient medium, and Rauschenberg painstakingly duplicated the painterly accidents of his *Factum I* onto its pendant *Factum II*, both of 1957. Despite Johns's and Rauschenberg's irony, however, one should not underestimate their concern for mark-making as ▲ such, an emphasis on the process of art that they, and many artists after them, such as Robert Morris, retained from Abstract Expressionism. It is what Rauschenberg had in mind when he declared to Emile de Antonio: "The Abstract Expressionists and myself, what we had in common was touch. I was never interested in their pessimism or editorializing. You have to have time to feel sorry for yourself if you're going to be a good Abstract Expressionist, and I think I always considered that a waste. What they did—and what I did that looks like Abstract Expressionism—is that with their grief and art passion and action painting, they let their brushstrokes show, so there was a sense of material about what they did." YAB

FURTHER READING

T. J. Clark, "In Defense of Abstract Expressionism," *October*, no. 69, Summer 1994
Clement Greenberg, "American-Type Painting" (1955), *The Collected Essays and Criticism, Vol. 3: Affirmation and Refusals, 1950–1956*, ed. John O'Brian (Chicago and London: University of Chicago Press, 1993)
Serge Guilbaut, *How New York Stole the Idea of Modern Art: Abstract Expressionism, Freedom, and the Cold War* (Chicago and London: University of Chicago Press, 1983)
Michael Leja, *Reframing Abstract Expressionism: Subjectivity and Painting in the 1940s* (New Haven and London: Yale University Press, 1993)
Meyer Schapiro, "The Liberating Quality of the Avant-Garde," retitled "Recent Abstract Painting," *Modern Art: 19th and 20th Century, Selected Papers, vol. 2* (New York: George Braziller, 1978)

▲ 1965, 1968b, 1969

1949a

Life magazine asks its readers "Is he the greatest living painter in the United States?": the work of Jackson Pollock emerges as the symbol of advanced art.

In the immediate postwar years, one sign of the New York art world's continuing status as a small village is that a mass-circulation magazine like *Life* should have felt the need to introduce its readers to Jackson Pollock in the first place. It happened, however, that one of its researchers was married to the art historian Leo Steinberg, then just starting out as a critic of contemporary art as well, and through this connection *Life* got wind of what it considered a *succès de scandale*, yet another story of the peculiar excesses of modernism. Ambivalent through and through, *Life*'s presentation of Pollock was part contemptuous (the captions under the "drip paintings" spoke of them as "drools," the text as "doodling") and part serious. The article had to report, after all, the estimation of Pollock's work as great by "a formidably high-brow New York critic" (Clement Greenberg) as well as its embrace by American and European avant-garde audiences, and, as an illustrated weekly, it had to picture both the artist and his work in generous, large-scale reproductions.

Breaking the ice

In this sense, the *Life* piece reflected what was even then happening in two other domains. In the specialized art press a formerly derisive account of Pollock's drip pictures ("baked macaroni" or "a mass of tangled hair") was turning cautiously positive, so that responses to the November 1949 exhibition at the Betty Parson Gallery now spoke of "tightly woven webs of paint" or "myriad tiny climaxes of paint and color," each one "elegant as a Chinese character." As Willem de Kooning, observing collectors and museum directors now abandon their more traditional purchases to vie for Pollock's work, put it at the time, "Jackson has finally broken the ice." And in the institutional world of both museum and government cultural policy, Pollock and the other Abstract Expressionists began to be seen as important emissaries of the American experience: wildness now starting to be recoded as freedom—a liberated sensibility increasingly deemed as setting a good example

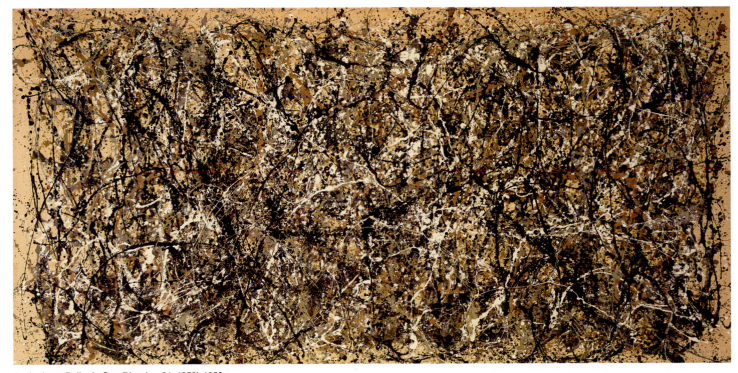

1 • Jackson Pollock, *One (Number 31, 1950)*, 1950
Oil and enamel on unprimed canvas, 269.5 × 530.8 (106⅛ × 209)

▲ 1960b ● 1960b ▲ 1947b, 1959c

for the cause of democracy in Cold War-torn Europe; thus, to accompany the Marshall Plan of financial aid to European countries, which was instituted in 1948, a variety of cultural exports, including museum and gallery exhibitions, was shipped abroad. In the late forties this was officially funded by the USIA (United States Information Agency) but in the fifties (due to Congressional "red-baiting" of the State Department) the Museum of Modern Art's International Council carried the ball for the US government.

For Pollock himself, however, the stardom brought on by this media and institutional success (in 1950, he shared the US pavilion ▲ at the Venice Biennale with de Kooning and Arshile Gorky; the Museum of Modern Art purchased a major drip painting; and he ● became the focus of both a sequence of photographs and ultimately a film by Hans Namuth showing him at work actually making the drip pictures) pushed him to a crisis. In the summer of 1950 he rode the crest of his fame long enough to complete four magisterial canvases (*One [Number 31, 1950]* [1], *Lavender Mist*, *Autumn Rhythm* [5], and *No. 32*); then his will to abstraction failed him. In 1951 he began to make black-and-white paintings [2] with, as he put it, "some of my early images coming through," meaning that he returned to the figurative mode of his artistic beginnings in ■ the thirties and early forties: a mixture of Mexican mural painting and the American Regionalist style of his teacher, Thomas Hart Benton [3]. This return, accompanied by the resurgence of his alcoholism, meant that by 1953 Pollock was painting with such great difficulty that his 1955 show at the Sidney Janis Gallery had to be conceived as a retrospective, since there was no recent output. Deeply depressed by a work block that appeared to be permanent,

he drove his car into a tree in the summer of 1956, killing himself in an act that most people think was intentional.

If there was a war inside Pollock over the competing values of figurative and abstract art, there has been a war ever since about how these options should be understood in the interpretation of Pollock's work. Given the centrality of that work within the history of modernism, not only in the United States but also elsewhere ▲ (both the Gutai group in Japan and Piero Manzoni's *Lines* depend on Pollock), this interpretive battle has unusually high stakes, for it pits various views about the meaning and even the very possibility of abstraction against one another.

The champion of Pollock's work who had no doubt about the artist's commitment to abstraction (the "formidably high-brow critic" whom *Life* had mentioned), and indeed to the necessity of ● that abstraction to the success of his art, was Clement Greenberg. A supporter of Pollock's from the early forties, Greenberg initially appreciated his art for the spatial compression of its surfaces, which created what he termed a "fuliginous flatness" that, expanding laterally along the face of the painting, transformed the conditions of the traditional easel picture, with its virtual, illusionistic space, into those of the wall-like mural painting, which Greenberg associated with modern science's commitment to observable, objective fact. This flattening could still be compatible with figuration, however, as Greenberg pointed out in ■ the case of Jean Dubuffet's similarly compressed and scarred, yet representational, surfaces.

But by the late forties, the necessity of abstraction had entered into Greenberg's assessment, since he had reorganized his reading

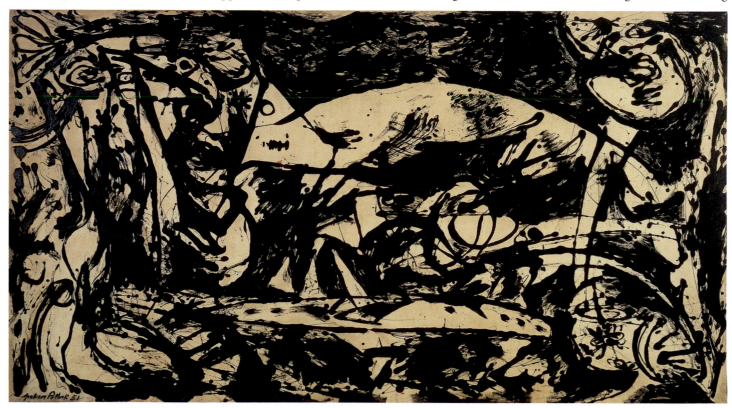

2 • Jackson Pollock, *Number 14, 1951*, 1951
Enamel on canvas, 146.4 × 271.8 (57⅝ × 107)

▲ 1942a, 1947b, 1959c ● 1955a ■ 1933 ▲ 1955a, 1959a ● 1942a, 1960b ■ 1946, 1959c

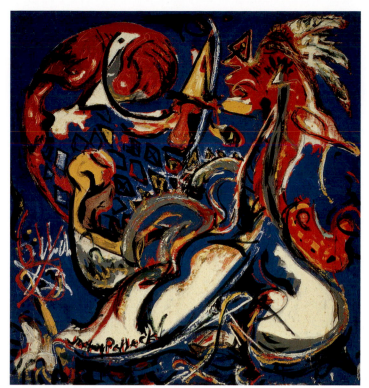

3 • Jackson Pollock, *Moon Woman Cuts the Circle*, c. 1943
Oil on canvas, 106.7 × 101.6 (42 × 40)

of modernism from a scientific model to a reflexive one: the visual arts were not to pattern themselves on the rigor of positivist science but on the modality of their own experiential grounds of possibility, namely the operations of vision itself. Grasped abstractly, these operations were not organized around the object that might be seen but, rather, in the subjective conditions of seeing: the fact that vision is projective; that it grasps its field synchronously rather than sequentially; that it is free from the gravitational field of the body. Modernism's highest ambition would thus be to picture the form of consciousness peculiar to vision: "To render substance entirely optical and form as an integral part of ambient space—this brings anti-illusionism full circle. Instead of the illusion of things, we are now offered the illusion of modalities: namely, that matter is incorporeal, weightless and exists only optically like a mirage."

Eyesight alone

The skeins of Pollock's drip pictures, now recoded as "hallucinated literalness" capable of creating the "counter-illusion of light alone," were thus endowed with a new mission: that of pulverizing or, in Greenberg's terms, "volatilizing" the object, creating this incorporeal weightlessness that could only transmit its effects abstractly. The skeins, constituted of pure line, the very stuff of drawing, managed to undermine the goal of drawing, which is to bound an object by describing its contour. Constantly looping back on themselves, they not only disallowed the formation of anything like a stable contour but they also dispersed any sense

of a focal point or compositional center within the optical field. In this sense, line was put to the service of the creation of a kind of luminous atmosphere, formerly the province of color, and in thus canceling or suspending the distinction between line and color, Pollock's skeins further transcended, so Greenberg (along with his colleague Michael Fried) argued, the conditions of reality in order to enter the dialectical terms of abstraction. For, as Fried put it, Pollock's line succeeded in bounding and delimiting "nothing—except, in a sense, eyesight."

But if Pollock's work seemed to have, once and for all, delivered on the promise of a half century of struggle to establish the viability of abstract art, proving that it was not simply a function of mechanism or geometry but could also be sweeping and emotive, its maker's own indecisiveness—his backsliding into figuration in 1951 with the "early images coming through"—opened the door to two alternate readings. Based on a challenge to the very idea of abstraction, one such reading is personal or biographical in nature; the other, more deeply structural. The first type argues that Pollock (who underwent various psychoanalytic treatments for alcoholism throughout his life), was painting out of his unconscious, with memory images (according to the Freudian account) or archetypal images (the Jungian version) shaping the figurative works of the thirties and early forties and then underlying the dripped skeins that covered them over in a kind of denial or refusal in the period 1947–50, only for them to reemerge, triumphant, in the early fifties. According to this argument, the abstract Pollock is a figment of the misguided "formalist" imagination; Pollock's painting is always laden with content, obfuscated or not.

Since the skeins of the dripped pictures are often extremely transparent, it is clear that there are no figures beneath them. This puts one part of the foregoing argument in jeopardy, at least for that aspect of Pollock's work—the dripped pictures—that is taken as central to the history of modernism. Further, it would seem from all available evidence that Pollock's ambition during this period was indeed for nonfigurative, abstract work (although the nature of that abstraction is still a matter of contention, as will become apparent below). It is whether such an ambition (that is, for work that will escape the image altogether) is structurally possible within the domain of painting that concerns the second of these "figurative" readings, the one offered by T. J. Clark.

Arguing that Pollock's drive for abstraction arose from a sense that "likeness" or figuration could only repeat representational clichés, Clark comments on the frequency of Pollock's use of the title *One* or *No. 1* [**4**], even to his renumbering members of a series so as to produce yet another "first" object, another "one." This he sees as symptomatic of Pollock's need to achieve either some kind of absolute wholeness, before the parturition of the field into representational units, or some kind of absolute priorness, before a mark transforms itself for its (primitive) maker from the index of his or her presence—as in a palm-print deposited on the walls of the prehistoric cave—into a representation or image or figure of that presence.

The first type of oneness is, in Clark's account, parallel to the indivisible optical plenum of the Greenberg/Fried (modernist) reading. The difference is that Clark views this cloudlike vortex as an "image"—a metaphor for the idea of order or wholeness rather than a rendition of it in all its abstractness. It is the inescapability of this condition of metaphor that Clark sees Pollock fighting in the second form of oneness, in which a "before figuration" is sought in the stress on the index. That these traces of his process of painting brought with them associations of desecration and violence against the canvas itself—the stains and crusts of thrown paint, the wrinkled scabs of uneven drying—seems to declare not only this condition of firstness, a marking that occurs before metaphor takes over, but also an attack on the other type of oneness and its condition as image.

Yet, Clark argues, even this second option is unable to outrun the metaphorical, since it, too, becomes an image: a picture of accident, of stridency, of chaos. Thus, in Clark's reading, Pollock's art has failure always built into it, and his ability to continue falters when he is no longer able to imagine an outside to the figurative. This occurs in the summer of 1950, when his pictures, ever larger and ever more seemingly authoritative, fully submit to the metaphor of oneness that was lying in wait for them all the time. They become, that is, pictures of nature, massive crypto-landscapes: *Autumn Rhythm*, *Lavender Mist*, *One*.

The total "one"

But is the index or trace of process really fated, as Clark would have it, to coalesce into metaphor? A whole generation of Process ▲ artists thought it was not. As Robert Morris argued in the late sixties, "Of the Abstract Expressionists, only Pollock was able to recover process and hold on to it as part of the end form of the work. Pollock's recovery of process involved a profound rethinking of the role of both material and tools in making." To this reconception Morris gave the name "Anti-form." Noting that Pollock had opened his work to the conditions of gravity, he argued that if all of art has been an effort to maintain the rigidity and thus the verticality of its materials—canvas is stretched, clay is formed on internal armatures, plaster is applied to lath—this is because form itself is a fight against gravity; it is a battle to remain intact, to continue to adhere as a formal gestalt, as a coherently bounded whole, as "one." By famously laying the canvases of his dripped paintings on the floor and flinging liquid paint onto them from sticks dipped into open cans, Pollock had given his work over to gravity and had thus opened them to antiform. Though he did not explicitly draw this conclusion, the implication of Morris's argument was that antiform was structurally incompatible with the creation of the figure—any figure.

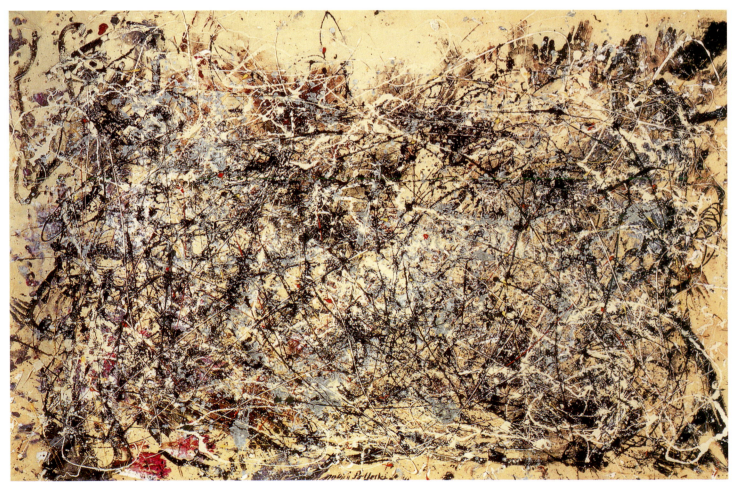

4 • Jackson Pollock, *No. 1*, 1948
Oil and enamel on unprimed canvas, 172.7 × 264.2 (68 × 104)

▲ 1969

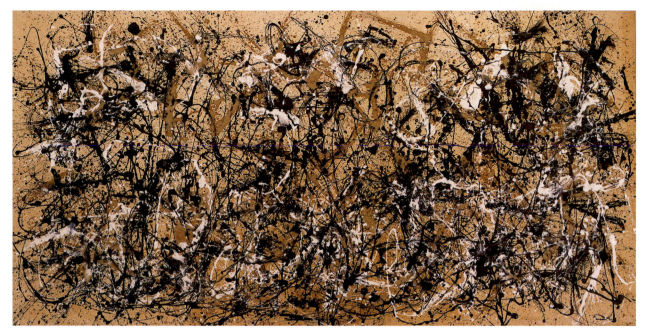

5 • Jackson Pollock, *Autumn Rhythm*, 1950
Oil on canvas, 266.7 × 525.8 (105 × 207)

Indeed, it would be possible to push Morris's reasoning further and to say that gravity vectors the phenomenological field, separating experience itself into two domains: the optical one and the kinesthetic, bodily one. The Gestalt psychologists, writing in the twenties and thirties, understood the field of sight as fundamentally vertical, and thus freed from the pull of gravity. They described the visual subject's relation to its image-world as "fronto-parallel" to it, a function of its standing erect, independent of the ground. This means that the image or gestalt is always experienced as a vertical and that its very coherence as a form (in their terms, its "praegnanz") is based on this uprightness, this rise into verticality which is how the imagination constitutes its images.

In this, the Gestalt psychologists were in accord with the Freudian account of a separation of perceptual fields into vertical and horizontal, a division that in Freud's view occurred at the point when the human species became erect, thereby separating itself from an animality oriented toward the horizontal of the ground and the dominance (for hunting and mating) of the sense of smell. Standing up produces the importance of the vertical and of the visual, of a field that is distanced from the immediate grasp of the perceiver. A function of this distanced viewing would be the sublimation of the carnal instincts and the possibility of a conception, Freud argued in *Civilization and its Discontents* (1930), of beauty.

By returning painting to the field of the horizontal, Pollock attacked all these sublimatory forces: uprightness, the gestalt, form, beauty. At least this was the conviction held by many of the artists convinced by the antiform drive of his work. That the canvases were returned to a formal decorousness by being hung—vertically—on the wall of either Pollock's studio or the museum, did not deter them in their view. For them, the traces of process to which Clark points—the puddling, the scabbing, the lateral ooze of liquid into cloth—are all marks of the horizontal, marks that continue to disrupt the uprightness of the work, its effective coming together as image. All the other Abstract Expressionists worked on easels or with their canvases tacked directly to the wall. This meant that in de Kooning's or Gorky's work liquid paint would form a vertical runoff, the spatters would themselves be oriented toward form. Pollock alone resisted this, and such resistance maintains itself in any view of his work: a horizontal antiform as an abstractness uncolonized by the vertical "one." RK

FURTHER READING
T. J. Clark, "Jackson Pollock's Abstraction," in Serge Guilbaut (ed.), *Reconstructing Modernism* (Cambridge, Mass.: MIT Press, 1990)
Eva Cockcroft, "Abstract Expressionism, Weapon of the Cold War," *Artforum*, vol. 12, June 1974
Michael Fried, *Three American Painters* (Cambridge, Mass.: Fogg Art Museum, 1965)
Rosalind Krauss, *The Optical Unconscious* (Cambridge, Mass.: MIT Press, 1993)
Steven Naifeh and Gregory White Smith, *Jackson Pollock* (New York: Clarkson Potter, 1989)
William Rubin, "Pollock as Jungian Illustrator: The Limits of Psychological Criticism," *Art in America*, no. 67, November 1979, and no. 68, December 1979
Kirk Varnedoe, *Jackson Pollock* (New York: Museum of Modern Art, 1998)

1949_b

Cobra, a loose band of young artists from Copenhagen, Brussels, and Amsterdam, launches its eponymous magazine, in which they advocate a return to "the vital source of life"; meanwhile in England, the New Brutalists propose a bare aesthetic adequate to the austere conditions of the postwar world.

"In its buildings, pictures, and stories, mankind is preparing to outlive culture, if need be." Walter Benjamin makes this enigmatic assertion in a 1933 text, arguing that the "poverty of experience" produced by world war and economic disaster must be somehow turned to advantage. "Barbarism?" Benjamin asks. "Yes, indeed. We say this in order to introduce a new, positive concept of barbarism. For what does poverty of experience do for the barbarian? It forces him to start from scratch; to make a new start; to make a little go a long way; to begin with a little and build up further, looking neither left nor right."

Benjamin identifies a range of modernists who seem to work ▲ from such a tabula rasa—Cubists and Constructivists, Paul Klee and Bertolt Brecht, Adolf Loos and Le Corbusier—but the incoherence of this list suggests that his idea has not yet gelled, that his text anticipates a culture to come. And, in fact, it was only in the period after the next world war, in which the physical hardships of social dislocation and financial ruin were compounded by the human catastrophe of the Holocaust, that an aesthetic of "starting from scratch" was developed programmatically. We have already encountered one manifestation of this postwar search for the ● primal with Jean Dubuffet, Jean Fautrier, and others interested in *art brut*. Here we will consider two others, the Cobra group on the Continent and the New Brutalists in England, who were not otherwise connected except by the need "to make a new start."

Human beasts

Not all European eyes were on Paris after World War II; some modernists who had fled the occupation had not returned, while ■ others (such as belated Surrealists) appeared passé to the generation formed during the war. At first in isolation and then in coordination, young artists in Copenhagen, Brussels, and Amsterdam came to insist on new approaches pertinent to present conditions, and to do so under the name "Cobra," an abbreviation of their home cities, as well as a salute to the forbidding snake they took as their totem. Copenhagen prepared the way with slightly older artists such as the Expressionist painters Egill Jacobsen (1910–98), Ejler Bille (1910–2004), and Carl-Henning Pedersen (1913–2007), all of ◆ whom were influenced by Kandinsky, Picasso, and primitivism, as

well as the sculptor Henry Heerup (1907–93), who produced *skradenmodeller* (scrap sculptures) from found materials and stone figures suggestive of medieval monuments. These artists were also associated through a short-lived underground art group and magazine called *Helhesten* (Hell Horse, a three-legged beast of death in the *Edda*, the medieval Icelandic narrative concerning Norse mythology), founded in Denmark by the vivacious painter and philosopher Asger Jorn (1914–73).

Some of the concerns of this group, such as the fascination with tribal art, the drawings of children, and the productions of the mentally ill (which the Nazis had declared "degenerate" little more than a decade before), are familiar from prewar avant-gardes. More distinctive was the interest in folk traditions of northern Europe, such as Norse mythology and magic, Viking monuments and medieval frescoes, and later, for Jorn in particular, the history of vandalism. Unlike Dubuffet, say, the Danes did not regard such "primitives" as outside cultural history; nor did they pursue them in flight from popular kitsch (already in 1941, for example, Jorn had proclaimed in *Helhesten* "the artistic value of banality": "I would try to exploit the cheap things that nourish art"). Rather, they took such productions as so many precedents of an art that would be both anticlassical and collective. The example of medieval frescoes in particular prompted a wave of collaborative murals in both private settings and public buildings (e.g., the country cottages of friends and patrons, a nursery school in Copenhagen) that carried into the Cobra period as well.

Inspired in part by the Copenhagen example, three artists in Amsterdam—Constant Nieuwenhuys (1920–2005), Karel Appel (1921–2006), and Corneille (1922–2010)—formed "the Experimental Group in Holland" in July 1948. Already influenced by ▲ Picasso and Miró, Appel and Corneille were also struck by Dubuffet, whose work they had encountered the previous autumn in Paris. Thereafter, Appel began to produce Expressionist paintings and objects featuring strange creatures, the paintings blocked out childishly in bright colors, the objects made roughly out of found wood and metal. More intellectual than Appel, Constant was less brutal in his style, but his motifs are similar, while the ● fantastic figures produced by Corneille, more akin to those of Klee, are less wild in spirit.

▲ 1900a, 1911, 1912, 1914, 1921b, 1922, 1925a ● 1946 ■ 1942b ◆ 1907, 1908 ▲ 1921a, 1931b ● 1922

Finally, in Brussels, where Surrealism lingered as a force, writers directed the scene, especially Christian Dotremont (1922–79), who later contributed the often collaborative form of the *peinture-mot* (word-painting) to Cobra, whose magazine he also came to edit. Like the Dutch, Belgian painters like Pierre Alechinsky (born 1927) did not turn to folk traditions in the manner of the Danes (although there are echoes of the mask motif of their Belgian predecessor James Ensor in some of their pictures). For his part, Dotremont found an alternative path to the primordial through the writings of Gaston Bachelard, whose phenomenology of dreams, everyday spaces, and the four elements offered a non-Surrealist account of the imagination that attracted other Cobra artists as well.

Jorn met Constant in the autumn of 1946, and contacted Dotremont the next summer; by late 1948 the three were able to forge the Cobra coalition, which was as fragile as it was intense, lasting as it did little more than two years. Despite ample evidence of the Stalin purges (which had prompted André Breton to break with the Communist Party in June 1947), the three Cobra leaders were not ready to give up on Communism, and they continued to insist on dialectical materialism as much as they did on artistic experiment. They were also linked in their opposition to modernist forms of functionalism and rationalism: in this regard, Jorn reacted against his early training in Paris under Fernand Léger and Le Corbusier, and Constant and company turned against their Dutch forebears in De Stijl. (For example, in the fourth issue of *Cobra*, which doubled as a catalogue for the breakout Cobra exhibition at the Stedlijk Museum in late 1949, Constant wrote: "Let us fill up Mondrian's virgin canvas even if only with our miseries.") At the same time, Cobra artists also wanted to depart from Surrealism, aspects of which they appropriated nonetheless. Thus, in his "Address to the Penguins" published in the first issue of *Cobra* (March 1949), Jorn described their project as ethical as much as aesthetic: "By means of this irrational spontaneity we get closer to the vital source of life." This end was still Surrealist in spirit, as was the means—Cobra favored a painterly automatism—yet Jorn and friends refused to see this vital source as a matter of psychological interiority alone.

Is Cobra just another belated primitivism, or is there a particular program to be extracted from its amalgam of interests and practices, a "Cobra idea"? Again, its involvement with the tribal and the folk, the childish and the mad, does not distinguish the movement, but its peculiar insistence on the animal might. Consider *Cry of Freedom* of 1948 by Appel [1]. As often in his work, the painting presents a figure full in the frame, scarcely contained by the cage of the canvas, here made up of a patchwork of hot reds, yellows, oranges, and pinks relieved only by a few swatches of cool blues and greens. The schematic face, its simple features outlined in flat black, confronts us directly; the asymmetrical arms (they might equally be called wings or even claws) appear twisted and useless; and the creature is propped up on three spindly legs. Neither human nor animal nor bird, it is all three: a newfangled

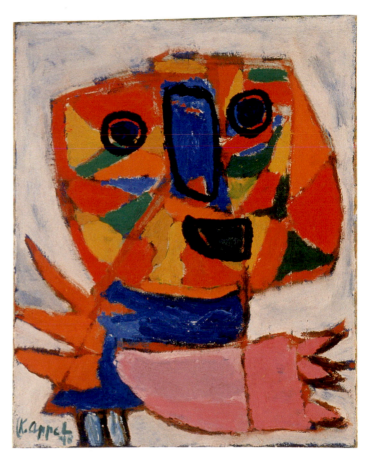

1 • Karel Appel, *Cry of Freedom*, 1948
Oil on canvas, 100 × 79 (39⅜ × 31⅛)

mythological beast that seems to announce, at once awkwardly and boldly, both a damaged past and a transformed future.

Or consider *Erotic Moment* of 1949 by Constant [2], a watercolor produced in the same year as he wrote his polemic "It's Our Desire that Makes the Revolution" for *Cobra 4*. A lewd picture dominated by fecal browns, it shows two figures commingled sexually, evoking an eroticism in which discrete bodies are transformed into charged parts that are ecstatically exchanged. A wild-eyed creature raises its arms exultantly (one arm ends in a paw of three digits, the other doubles as an obscene nose), while its partner sticks a penile tongue into its mouth—even as this figure is also gendered female by the fulsome vulva located at its center. Although gender ambiguity is a staple in Marcel Duchamp, Alberto Giacometti, and others, the force of such confusion is entirely different here: not a frustrated search for a lost object of desire à la Surrealism, but an unbridled expression of revolutionary passion.

How can we understand this fascination with the creaturely? A first clue might be gleaned from a 1948 manifesto by Constant, who frames the postwar situation, in dialectical terms, as a "total collapse" of official culture that might yet allow for a "new freedom," as long as artists are able to "find a way back to the point of origin of creative activity." In this regard, Constant champions the usual suspects, "expressions from the untaught," but then refers enigmatically to postwar man as "a creature," delivering this

striking formula: "A painting is not a construction of colors and lines, but an animal, a night, a scream, a human being, or all of these." Here Constant inverts the formalist adage about modernist painting offered nearly sixty years before by Maurice Denis ("Remember that a painting—before it is a battle horse, a nude model, or some anecdote—is essentially a flat surface covered with colors assembled in a certain order"), intimating that the creaturely is a cipher of the confused aftermath of the war—of a "broken-down" condition in which "limitations are dissolved." Jorn also elaborates on this theme in his paintings and texts. "We must portray ourselves as human beasts," he writes to Constant in 1950, penning an essay on the subject in the same year.

In this light, Cobra can be seen as an intervention in the debate about humanism after the war, a debate that involved the preeminent philosophers of the time, Jean-Paul Sartre, who insisted that his existentialism was a humanism, and Martin Heidegger, who deemed both concepts metaphysical. Western philosophy had long defined the human in its difference from the animal (man possesses reason, language, and so on); for Heidegger this "anthropological machine" has humanized the world in dangerous ways. At the same time, he refused any celebration of the animal as a counter-term, famously charging the great poet Rainer Maria Rilke, in his eighth *Duino Elegy*, with presenting the animal in a closer relation to Being than the human. Heidegger might have ▲ condemned Cobra in similar terms, as it, too, valued the animal as

more immediate to the world: the untamed expression in *Cry of Freedom*, the primal ecstasy in *Erotic Moment*, and the very symbol of the cobra all suggest as much. Yet this becoming-animal of the human in Cobra is no simple recovery of a natural order, for, again, it also attests to the monstrous dehumanization produced by the war and the Holocaust.

Contemporary theorists Giorgio Agamben and Eric Santner have reflected on the creaturely in ways that are salient here. For Santner, the creaturely emerges when the "traumatic dimension of political power"—that is, "the extralegal authority within the law"—is exposed, as it was in the state of emergency instigated by the Nazis: "Creaturely life is the life that is, so to speak, called into being, ex-cited, by exposure to the peculiar 'creativity' associated with this threshold of law and nonlaw." The creatures in Kafka are prewar examples of this peculiar creativity, and in his essay "The Human Beast" Jorn considered them as positive models of being released from the constraints of good and evil. As announced in its namesake of the snake, this excited animality is also active in Cobra; indeed, it is the signal form that its "positive barbarism" takes. Yet, again, its creaturely figures are ambiguous—signs of a condition of a "total collapse" as much as a "new freedom." Born in this extreme situation, Cobra died with it; by late 1951, as the Cold War escalated and a society of spectacle began to emerge, Constant moved on to other engagements with Guy Debord.

▲ 1957a

Rough poetry

Britain won the war but lost the peace; its empire disintegrated, and rationing made for austerity at home. This situation also called for a return to basics, which was answered by an interest not in the animal but in the "as found," as evidenced in the crude materials and exposed structures featured in the work of architects Peter and Alison Smithson (1923–2003, 1928–93) and artists Eduardo Paolozzi (1924–2005), Nigel Henderson (1917–85), William Turnbull (1922–2012), John McHale (1922–78), and Magda Cordell (1921–2008). This varied practice was soon dubbed "New Brutalist," which acknowledged the precedent of the raw (*brut*) aesthetic not only of Le Corbusier, who defined his architecture of this period as "the making of moving relationships out of brute materials" (especially *beton brut* or exposed concrete), but also of ▲ Dubuffet, who splayed out figures on his canvases like so much caked mud. The term also resonated with other contemporary work important to these young practitioners, such as the drip ● canvases of Jackson Pollock, the burlap paintings of Alberto Burri, the *art autre* championed by Michel Tapié (1909–87), and indeed the primal productions of Cobra.

Like Cobra, Brutalism aimed to be more than a style. "Its essence is ethical," the Smithsons argued in a short text of 1957. "Brutalism tries to face up to a mass-production society, and drag a rough poetry out of the confused and powerful forces which are at work." In this way, they added in retrospect, Brutalism was "a confronting recognition of what the postwar world actually was like":

In a society that had nothing. You reached for what there was, previously unthought of things.… We were concerned with the seeing of materials for what they were: the woodness of wood, the sandiness of sand. With this came a distaste of the simulated.… We worked with a belief in the gradual revealing by a building-

in-formation of its own rules for its required form.… The image was discovered within the process of making the work.

For its primary champion, Reyner Banham (1922–88), the chief characteristic of Brutalism, in architecture as in painting, was "precisely its brutality, its *je-m'en-foutisme*, its bloody-mindedness." These traits were already evident in the simple SoHo House the Smithsons designed in London in 1952, where the structure was made as blunt as possible and all finishes were kept to a minimum. They also developed this "warehouse aesthetic" in the Hunstanton School (1949–54) in Norfolk [3], the building that served as the Brutalist manifesto. Here steel frames, brick walls, and precast concrete slabs (used for both floors and roofs) were all left bare, as were the fixtures in the halls and even the plumbing in the bathrooms. "Wherever one stands within the school," Banham wrote, "one sees its actual structural materials exposed." In such architecture, he noted three principles at work: the first two—"formal legibility of plan" and "clear exhibition of structure"—were modernist standards, but the last—"valuation of materials for their inherent qualities 'as found'"—was distinctive, and notoriously so. It turned modern architecture into a "positive barbarism," and it was a particular slap in the face to the official styles in postwar Britain, a neo-Palladian architecture and a picturesque architecture championed respectively by Rudolf Wittkower and Nikolaus Pevsner, the two doyens of architectural history at the time. For the Smithsons, both styles were sentimental humanisms that obfuscated the stark conditions of contemporary life.

These conditions were vividly documented by Nigel Henderson in his photographs of Bethnal Green in East London, where he lived with his anthropologist wife Judith Stephen. Henderson was not of this milieu: his mother Wyn managed the Peggy Guggenheim gallery in London, and his wife was the niece of Virginia Woolf and Vanessa Bell, so he had access to advanced artists and writers in

3 • Alison and Peter Smithson, Hunstanton Secondary Modern School, Norfolk, 1949–54
Exterior view

▲ 1946　　● 1949a

4 • Nigel Henderson, *Screen*, 1949–52 and 1960
Photocollage on plywood, four panels, each 152.4 × 50.8 (60 × 20)

Paris and Bloomsbury alike. Nevertheless, he opted for "the disregarded," aiming to sing "the song of every blotch and blister, of every patch and stain on road and pavement surface" of his adopted neighborhood. Although in the documentary tradition of Eugène ▲ Atget, Walker Evans, and Henri Cartier-Bresson, his photography developed a formal reflexivity, especially in the busy surfaces of his pictured storefronts and shop windows, which attest to his equal interest in contemporary painters like Pollock, Dubuffet, Burri, and Antoni Tapiés. In 1949, Henderson began a collage titled *Screen* [4] in two panels (two more were added in 1960) that mixed, in an allover field, a select number of his own photographs with a great array of found images: tribal masks, classical sculptures, and Titian paintings, death masks, body builders, and porn shots, artificial limbs, old advertisements, and new products. As in his Bethnal Green photos, the iconography here centers on damage done to the body—the individual body as well as the body politic—which the treatment also underscores: almost all the images are somehow abraded or (to use his own term) "stressed." In 1948, Paolozzi gave Henderson a photo-enlarger, which he used to make photograms [5]. These "Hendograms" also involve a range of found things—vegetable bits, broken bottles, machine parts, clothing fragments—all of which are stressed as well. In play here again is the trope of damage done to the

body, which is both personal and social; a pilot during the war, Henderson suffered a breakdown after it ("my nerves felt like stripped wires," he later admitted), and much of his material was in fact debris scavenged from bomb sites.

Implicit in both *Screen* and the Hendograms is a notion of collage as a palimpsest of urban experience, one that corresponded to devices such as the "flat-bed picture" of Robert Rauschenberg and ▲ the appropriated street-posters of the Paris *décollagists*. In this screen aesthetic, which exemplifies both as-found and brutal aspects of New Brutalism, the status of the world equivocates between representation and reality: in *Screen*, images are sheer material, while in the Hendograms sheer materials become images. This screen aesthetic had other applications as well. Like his colleagues, Henderson tacked up diverse images on his studio walls in order to test out various affinities, formal and otherwise, allowed by photographic reproduction. This method of association soon became central to the curatorial practice of the Independent Group, as evidenced in such landmark exhibitions as "Parallel of Art and Life," produced by Henderson, Paolozzi, and the Smithsons at the Institute of Contemporary Arts (ICA) in London in 1953.

Even more central to Brutalism was Eduardo Paolozzi, who was born to Italian immigrants in Edinburgh. Although he attended

▲ 1936

▲ 1953, 1960a

5 • Nigel Henderson, *Photogram*, 1949–51
Photogram, 35.6 × 47 (14 × 18½)

the Slade School of Fine Art in London, he preferred the museums of science and natural history to the traditional curriculum of ▲ the Slade. Under the influence of Max Ernst and Kurt Schwitters, Paolozzi began to produce collages as early as 1943, and soon assembled scrapbooks of images culled from American magazines left him by GIs. Paolozzi called these assortments "readymade metaphors," and they influenced his colleagues profoundly when he projected them at an ICA presentation in 1952—another instance of a screen aesthetic at work.

By 1947 Paolozzi was in Paris, where he made Surrealistic figures • à la Giacometti in plaster and bronze set on bases and tables. More distinctive were his reliefs of clotted forms that evoke both biomorphic and mechanical fragments—as if the reliefs were records of body and machine parts commingled in a horrific blast. Sometimes Paolozzi condensed these associations in a single object, as in the bronze *Contemplative Object* of c. 1951 [6], which resembles a

mutant organ or a deformed head; the title is sardonic: this object is more likely to provoke revulsion than contemplation. Here again Paolozzi echoes Giacometti, but whereas the latter's "disagreeable objects" played on the ambivalent attractions of the sexual fetish, *Contemplative Object* presents a man–machine hybrid ▲ as hardened as any Vorticist sculpture by Jacob Epstein or Henri Gaudier-Brzeska—but without their delight in such posthuman metamorphoses. Indeed, as Banham remarked early on, Brutalism was "a vote of no-confidence in the Machine aesthetic"; the prosthetic dreams of prewar modernisms were dashed by the postwar realities of economic scarcity and nuclear threat. (Paolozzi included *Contemplative Object* in the "Patio and Pavilion" exhibit that he arranged with Henderson and the Smithsons for • the "This is Tomorrow" show in 1956—a display Banham described as if "excavated after an atomic holocaust.")

Paolozzi produced many related figures in collages, prints, and bronzes, such as *Saint Sebastian I* (1957), an ambiguous martyr of this brave new world, who stands bulkily on two thin cylinders, his opened torso a broken structure, his dented skull embedded with mechanical debris. For art historian David Mellor, such work typifies "the Brutalist grotesque": "These are the apocalyptic sublime burn-outs of fission, a scarring and vaporizing of the pristine surfaces of the electronic and mechanical cores of consoling consumer objects." In his collages, John McHale also excelled at conjurations of this new posthuman man. For example, his *Machine-Made America I* (1956–7) is constructed out of images of plumbing parts and bits of ads; scarcely anthropomorphic, this creature of information-overload suggests necessary adaptation to another kind of existence altogether. Along with the ■ Smithsons and Henderson, Paolozzi and McHale were members of the Independent Group, which met at the ICA in the early fifties to discuss their shared fascination with mass media and new technologies, and they are widely celebrated for this early engagement with popular culture after the war. Yet equally important was the Brutalist side of their practice; in fact, their raw bricolage of the as-found might be considered more influential than their Pop fantasies. HF

FURTHER READING
Walter Benjamin, "Experience and Poverty," in *Selected Writings, Volume 2: 1927–1934*, ed. Michael Jennings (Cambridge, Mass.: Harvard University Press, 1999)
Claude Lichtenstein and Thomas Schregenberger (eds), *As Found: The Discovery of the Ordinary* (Zurich: Lars Müller Publishers, 2001)
David Robbins (ed.), *The Independent Group: Postwar Britain and the Aesthetics of Plenty* (Cambridge, Mass.: MIT Press, 1990)
Giorgio Agamben, *The Open: Man and Animal* (Palo Alto: Stanford University Press, 2003)
Eric S. Santner, *On Creaturely Life: Rilke, Benjamin, Sebald* (Chicago: University of Chicago Press, 2006)
Willemijn Stokvis, *Cobra: The Last Avant-Garde Movement of the Twentieth Century* (Aldershot: Lund Humphries, 2004)

6 • Eduardo Paolozzi, *Contemplative Object (Sculpture and Relief)*, c. 1951
Plaster with bronze coating, 24 × 47 × 20 (9⁷⁄₁₆ × 18½ × 7⅞)

▲ 1922, 1926 ● 1931a ▲ 1908, 1934b ● 1956 ■ 1956

1950—1959

Barnett Newman's second exhibition fails: he is ostracized by his fellow Abstract Expressionists, only later to be hailed as a father figure by the Minimalist artists.

Barnett Newman's second one-man show, in April–May 1951, at the Betty Parsons Gallery in New York was even more unsuccessful than the first a year before. At the close of the exhibition (where nothing was sold), Newman took back all his works the gallery had in stock. He would occasionally display a painting or two in group shows during the fifties, but waited until 1958 for his next solo exhibition (at Bennington College), soon followed by his first retrospective in New York (at French & Co. in 1959). It was only after this last event that Newman's status altered: "He changed in about a year's time from an outcast or a crank into the father figure of two generations," wrote art critic Thomas B. Hess, referring to the admiration of artists as diverse as ▲ Jasper Johns and Frank Stella, Donald Judd and Dan Flavin.

What must have been particularly distressing to Newman in 1951 was not so much the continuing hostility or silence of the press, but that of the fellow artists he had generously helped over the years—organizing their exhibitions, prefacing their catalogues, editing their statements, acting as their spokesman and impresario. Newman later claimed that at his first show at Betty Parsons' in 1950, where the small New York art world of the time had rushed, Robert Motherwell had told him: "We thought that you were one of us. Instead your show is a critique against all of us." With hindsight this remark is highly perceptive—for Newman's work contrasts indeed with the gestural rhetoric governing the paintings • of Motherwell and other Abstract Expressionists—but at the time it was meant to hurt, and it did. Motherwell's disapproval was widely shared by his colleagues, who stayed away from the opening of Newman's second show a year later, with the notable exception of Jackson Pollock. (Pollock had in fact been instrumental in persuading Newman to hold this second exhibition at all, joining Betty Parsons in her encouragement and helping with the installation.)

The works selected by Newman were extremely diverse—no doubt in part to break down the nascent journalistic cliché that all his canvases were the same (this cliché was particularly offensive to him, given the extreme care he always took to avoid redundancy and repetition, keeping his entire output in all media to fewer than three hundred items). Only one painting, *Onement II* of 1948, directly referred to his pictorial breakthrough of that year: it consists, like the much smaller *Onement I* [1], of a red-maroon vertical field symmetrically bisected by a narrow "zip" (to use the odd term Newman

1 • Barnett Newman, *Onement I*, 1948
Oil on canvas and oil on masking tape on canvas, 69.2 × 41.2 (27¼ × 16¼)

adopted later on when speaking of his vertical dividers, preferring it to "band" for it connoted an activity rather than a motionless state of being). Next to *Onement II* he proposed a series of pairings, sometimes with the help of titles, as in the case of *Eve* and *Adam*. (The latter painting, now bearing the date 1951 and 1952, would be subsequently reworked by Newman, like several other canvases:

▲ 1958, 1962c, 1962d, 1965 ● 1947b, 1949a

2 • Barnett Newman, _Vir heroicus sublimis_, 1950–1
Oil on canvas, 242.2 × 541.7 (95⅝ × 213¼)

"I think the idea of a 'finished' picture is a fiction," he once said.) The two paintings that most enraged Newman's detractors were _The Voice_ and _The Name II_, both consisting of a white field about eight feet square and divided by white zips (one single off-center zip for _The Voice_ and four evenly placed in _The Name II_, including zips at the right and left limits of the canvas)—a drastic economy of means that the artist himself had wanted to emphasize by printing the show's invitation elegantly white on white. And then there was the huge _Vir heroicus sublimis_ [**2**], an expansive eighteen-foot-wide wall of an evenly vibrant red punctuated by five zips of various colors at irregular intervals, to which _The Wild_, a painting of the same height (eight feet) but only one and a half inches wide, and consisting entirely of a single red zip with a tiny margin of darker red on either side, must have at first seemed the strangest pendant.

The logic of this last correlation, however, is crystal clear. In _Vir heroicus sublimis_, the traditional oppositions of figure and ground, contour and shape, line and plane are dramatically suspended in that the rightmost zip and the tiny band of red "ground" it demarcates at the edge of the canvas are of the same width. With _The Wild_ [**3**], painted in its wake, it is as if an extra zip from the large red canvas had migrated onto the wall, taking on

▲ an existence of its own as one of the first "shaped" canvases in the history of postwar American art. And to make sure that _The Wild_'s "objecthood" would be neither overlooked nor overstated (as well as that of several smaller vertical paintings in the same vein, for which Pollock had designed simple wooden frames almost three inches deep), Newman exhibited it next to his first sculpture, _Here I_ [**3**], where two white "zips," now cutting into real space, had completed their journey toward autonomy. In short, the show was masterfully composed—Newman had always been a brilliant curator. But this seems only to have made the resistance to it all the stronger.

▲ 1958

3 • Barnett Newman, (left) _Here I_, 1950; (right) _The Wild_, 1950. Plaster and painted wood, 243.8 × 67.3 × 71.8 (96 × 26½ × 28¼) excluding base; oil on canvas, 243 × 4.1 (95¾ × 1⅝)

Perhaps he should have foreseen such difficulties. After all, he knew better than anyone else that his art was not easy to grasp—it had taken him eight full months, dedicated to nothing else, to understand what he had achieved in *Onement I*. Hess wrote an account of Newman's revelation: "On his birthday, January 29, 1948, he prepared a small canvas with a surface of cadmium red dark (a deep mineral that looks like an earth pigment—like Indian red or a sienna) and fixed a piece of tape down the center. Then he quickly smeared a coat of cadmium red light over the tape, to test the color. He looked at the picture for a long time. Indeed he studied it for some eight months. He had finished questing."

As countless statements testify, Newman's search had long been for a "proper" subject matter. Yet the by-now standard interpretation of this painting as a pictorial equivalent to the division of light and dark at the beginning of the Book of Genesis fails to account for its radical novelty. For at least three years Newman had been translating his desire "to start from scratch, to paint as if painting never existed before" into a thematics of Origin. His first "automatic" drawings of 1944–5, with their imagery of germination and mythological titles (one of them is called *Gea*, the goddess of the earth, offspring of the original chaos), and his many canvases of 1946–7 (*The Beginning*, *Genesis—The Break*, *The Word I*, *The Command*, *Moment*, *Genetic Moment*), with their titles directly alluding to the dawn of the world as it is conveyed in the Old Testament, attest to this central concern—and at some level Newman's art would always evolve around the same issue.

So if the subject matter is not new in *Onement I*, is the form that conveys it? The answer is surprisingly complex. At a formal level, one would be justified in thinking, once again, that there is nothing strikingly original about this modest canvas, for *Moment* [**4**], realized two years before, had already consisted of a vertical rectangular field divided symmetrically by a central vertical element. Conceptually and structurally, however, a gulf separates *Moment* from *Onement I*. One could even say that with *Onement I* and all subsequent works, Newman undermined the philosophical idea that a form merely conveys a preexisting content.

A hint is given by the "ground," which is treated differently in the two paintings. While the field of *Onement I* is painted as evenly as can be (it was initially conceived only as a first layer, as a "prepared ground," according to Hess), in *Moment* we are confronted with a differentiated field that functions as an indeterminate background and is pushed still farther back in space by the "band"—the "band" is not yet a "zip," it still functions as a *repoussoir*, as an element in the foreground pushing back in space the rest of the picture, much like the stenciled letters in an Analytical Cubist canvas by Braque or Picasso. As Newman would later say of this work and the few other paintings that remain of the period, it gives a "sense of atmospheric background," of something that can be conceived as "natural atmosphere." Or, as he would also say later, he had been "manipulating space," "manipulating color" in order to destroy the void, the chaos that existed before the beginning of all things. As a result, what he had procured with *Moment* was an

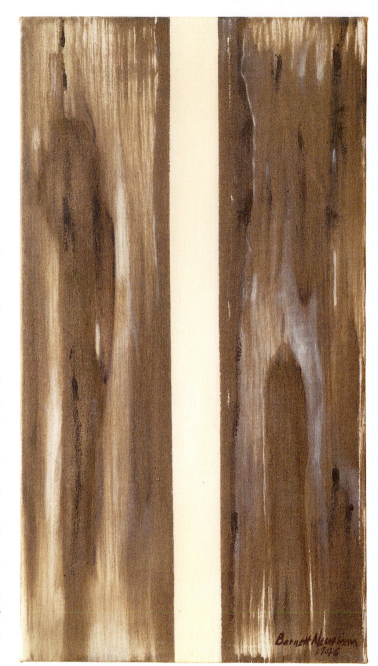

4 • Barnett Newman, *Moment*, 1946
Oil on canvas, 76.2 × 40.6 (30 × 16)

image, something that was not congruent with but applied to its field and thus could pretend to extend beyond its limits—something that had no adherence to its support (conceived as a neutral receptacle) and could have been worked out previously in a sketch (as indeed it was).

Onement I, Hess reports, was to look something like *Moment*: "Newman was about to texture the background; then he would have removed the tape and painted in the stripe inside the masked edges." But to "texture the background" and to "paint in" the stripe are precisely what Newman renounced in *Onement I*. Nothing existed here that could have been "painted in" or textured, that is, nothing existed beforehand, no "ground" per se, waiting to be filled. While *Gea*, *Genesis—The Break*, or *The Word*,

The Command, and even *Moment contained* ideographs, visual symbols of the idea of Creation, *Onement I is*, in itself, an ideograph of Creation. (One has only to recall that *Gea* had figured in the show entitled "The Ideographic Picture," curated by Newman in January 1947, to measure the distance he had traveled since then in his understanding of the concept of ideograph.) The title *Onement*, an Old English word from which "atonement" derives, means "the fact of being made into one": the painting does not *represent* wholeness but *declares* it in uniting the field and the zip into a single entity. Or, to put it differently, the field asserts itself as such through its stark symmetrical division by a zip.

Of course, the zip is still a simple vertical "line," hence a ready-made sign that preexisted in some absent stock of signs that—like all linguistic symbols—could be convoked and used at will. There is no escape, in other words, from the play of absence and deferral inherent to all forms of language; but at least the significance of the zip depends entirely on its coexistence with the field to which it refers and which it measures and declares for the beholder. *Onement I* is indeed an ideograph or, to put it more generally, a sign, but it is a sign of a special kind, one that emphasizes a certain circularity between its signification of the sign and the actual situation of its utterance: it partakes of the category of words that

▲ linguists call "shifters," such as all the personal pronouns but also "now," "here," "not there—here" (which are, not coincidentally, some of the names given by Newman to his later works). Like all previous paintings by Newman, *Onement I* is concerned with the myth of origin (the initial split), but for the first time this myth is told in the present tense. And this present tense is an attempt to address the spectator directly, immediately, as an "I" to a "you."

A sense of place

After the long rumination of 1948, Newman's most productive year (with nineteen canvases, almost one fifth of his entire pictorial oeuvre) was 1949. The largest work of that year, *Be I*, dominated his 1950 show. Not only did it radicalize *Onement I*'s flash of light (the thin central zip dividing the dark red field is razor-sharp and white), but its injunctive title made it clear that the beholder was summoned: "You! Be!" It is as if Newman had intuitively understood that the perception of bilateral symmetry is essential to our status as erect, human beings (as opposed to apes). Bilateral symmetry, to which Newman's work was to have recourse periodically throughout his career, presupposes the vertical axis of our body as the structuring factor of our visual perception, of our situation in front of what we see; it solidifies for us the immediate equivalence between the awareness of our own body and the orientation of our field of vision. Its perception is instantaneous and self-evident.

● According to French philosopher Maurice Merleau-Ponty, whose *Phenomenology of Perception* (1945; English translation, 1962) was to become a bible for the Minimalist sculptors in the sixties, it is our verticality since early childhood, more than anything else, that gives us, without our noticing, a sense of our being in the world.

With the large canvases he exhibited in 1951, and particularly with *Vir heroicus sublimis*, Newman turned to the issue of scale, another of his lifelong obsessions, but one closely related to the phenomenology of presence explored in *Onement I*. Of all the postwar American artists, he is the only one prior to the sculptor

▲ Richard Serra for whom scale took on an ethical dimension. Like Matisse, he deemed it morally wrong to figure out a composition in a tiny sketch and then to square it up on canvas. And if he finally got involved in the medium of printmaking, at the end of his life, it was only after he had discovered that he could clearly manifest how a slight modification in the cropping of margins radically transforms the internal scale of a single image (his succinct preface for his 1964 portfolio of lithographs, *18 Cantos*, provides the best analysis of the question of scale, as opposed to size, written in this century).

Vir heroicus sublimis is a very large canvas. So is *Cathedra*, completed shortly after Newman's 1951 show, or *Uriel* (1955), *Shining Forth* (1961), *Who's Afraid of Red, Yellow, and Blue II* (1967–8), and *Anna's Light* (1968), the largest of all (nine by twenty feet). But size itself is not the issue. If these works seem much larger than the equally gigantic canvases produced by Newman's fellow Abstract Expressionists (with the exception of Pollock, in whose webs we easily get lost), it is in great part because they provide us with far less visual incident and require us to take them in at once even while, confronted with the sheer color saturation of their flooding expanse, we realize that we cannot. Attempting to fix one of the several zips that perform a scansion of these vast color fields, we find ourselves tempted to zoom on to the next one. Thus, solicited by the vibrating ocean of violent color, never able to survey the whole and yet forced to acknowledge its existence, we experience it as "here—not there," full in our face.

"There is a tendency to look at large pictures from a distance. The large pictures in this exhibition are intended to be seen from a short distance." This statement, a handout that Newman typed for his second (1951) Betty Parsons show, makes it clear that size was for him a means of exceeding our visual field (and he drove the point home a few years later by having himself photographed staring at *Cathedra* while standing barely three feet away from the canvas). Most commentators have associated this excess, through which we are forced to relinquish our mastery over the visual field, with the theory of the Sublime, which Newman broached in one of his most famous texts, "The Sublime is Now," written in 1948 while he was mulling over *Onement I*. However, given that this short essay was a commission (for which Newman read the classical philosophical treatises by Longinus, Burke, Kant, and Hegel on the issue—all of which he summarily dismissed), and that the concept of the Sublime entirely disappeared from his vocabulary afterward (with one exception), one is tempted to deem it a misnomer. In fact, "sublime" is the name momentarily given by Newman to what he calls everywhere else "tragedy," a term absent from "The Sublime is Now." Which is to say that his understanding of sublimity had little to do with the philosophical texts he had just read. The exception just mentioned is a case in point: referring to

the title of *Vir heroicus sublimis*, Newman told David Sylvester in 1965 that "man can be or is sublime in his relation to his sense of being aware." The Sublime, for Newman, is something that gives one the feeling of being where one is, of *hic et nunc*—of the here and now—courageously confronting the human fate, standing alone in front of chaos, without the props of "memory, association, nostalgia, legend, myth." From 1948 on, he was to insist on the fact that what he wanted to give the beholder was a sense of place, a sense of his or her own scale.

The Sublime of the Enlightenment philosophers and that of Newman were not entirely opposed, however. In August 1949, in front of an Indian mound in Ohio—"a work of art that cannot even be seen, so it is something that must be experienced there on the spot"—Newman had an experience that was not foreign to the eighteenth-century British philosopher Edmund Burke's understanding of the Sublime as a feeling engendered by a vastness one cannot comprehend, nor to the German Immanuel Kant's description, when referring to the perception of the Egyptian pyramids, of the role of temporality in this sudden blank of comprehension. But for them the concept remains a universal category: they define it in terms of a temporary feeling of lack with regard to an idea of totality. Newman wants to speak not of space as concept, but of his own "presence"; not of infinity, but of scale; not of "the sense of time," but of "the physical *sensation* of time." This is what *Onement I* had meant to him and what the Ohio encounter confirmed. In that sense, it also meant farewell to the philosophical concept of the Sublime: soon it would seem too universal to express "the ideal that Man Is Present."

The "universal" (which he often called the "diagram") has always been a bad word for Newman (as early as 1935, in a list that he compiled for *The Answer*, an anarchist journal he was editing, the works of Hegel and Marx are prominent among the books not to read, while Spinoza's and Mikhail Bakunin's are high on the must-read ledger). Thus his unabashed demonization of Piet
▲ Mondrian, whom he already considered his nemesis three years before *Onement I*. (In his first long aesthetic tract, "The Plasmic Image," which he wrote and kept rewriting in 1945, but in the end never published, Newman, like others at the time, interpreted Mondrian's painting both as either mere geometric art or good design and as "abstraction from nature"—despite the fact that Mondrian had spent a considerable energy attacking both these views.) In short, Newman made a straw man of Mondrian by eagerly repeating the clichés of the mediocre literature available to him. But while this imaginary antagonism energized him, his difficulty in overcoming what he called the "neo-plastic mortgage" long remained a sore spot (the triumphalism of such titles as *The Death of Euclid* or *Euclidean Abyss*, two canvases that immediately precede *Onement I*, was premature). It was only in the mid-sixties that Newman understood that the "Mondrian" he had been fighting all along was a fiction, and that his own art and theory had much in common with those of the real Mondrian, notably in the cardinal role ascribed to intuition. But acknowl-

edging at last what he shared with the European veteran of abstraction, Newman was also able to grasp the nature of his twofold feelings of resistance toward him. First, partly thanks to his discussions with his young Minimalist admirers (with whom he did not want to be confused but whose company he obviously enjoyed), he realized that his concept of "wholeness" was utterly contradictory to Mondrian's reliance upon the traditional practice
▲ of relational composition— something derided by Frank Stella as "You do something in one corner and you balance it with something in the other corner." Second, Newman was able to make the connection between this relational aesthetic and Mondrian's social utopia, associating the latter with dogmatism, rationalism and State terror. Rather than condemning Mondrian's "formalism" and the "lack of subject matter" of his art as he had done in the past, he now explained his dislike for the social project inherent in Mondrian's abstraction in terms of his own anarchist politics.

This revaluation led to a series of four paintings entitled *Who's Afraid of Red, Yellow, and Blue* dating from 1966 to 1968, the first and the third being asymmetrical, and the two others, symmetrical. (Symmetry had been a standard feature in Newman's art, but now it was directly aimed, as had been Stella's black paintings several years before, at Mondrian's prohibition of it.) Each pair consists of a small or medium canvas and a very large one. Both of the large paintings from the series have subsequently been vandalized, *Who's Afraid of Red, Yellow, and Blue III* most savagely. This disaster should perhaps not be dismissed as random lunacy (all the more since Newman's paintings have endured an unusual rate of vandalism): one wonders if such a visceral, iconoclastic response was not in part encouraged by the art itself. *Who's Afraid … III* derives from the first painting of the series [5], from which it borrows the two lateral zips, a tiny yellow one on the right edge, and a broader and quasi-translucent blue one on the left, but in laterally expanding the central red plane to a width of nearly eighteen feet, Newman has heightened the color saturation to a point of maximum tension. The engulfing red is overwhelming: one cannot dodge its blow. Presumably, the man who knifed the painting, furiously slashing it three times across, could not bear the heat. In his own, misguided way, he paid homage to Newman's sense of tragedy and his Baudelairean plea for an "impassioned criticism." YAB

FURTHER READING
Yve-Alain Bois, "On Two Paintings by Barnett Newman," *October*, no. 108, Spring 2004
Yve-Alain Bois, "Perceiving Newman," *Painting as Model* (Cambridge, Mass.: MIT Press, 1990)
Mark Godfrey, "Barnett Newman's *Stations* and the Memory of the Holocaust," *October*, no. 108, Spring 2004
Jean-François Lyotard, "Newman: The Instant" (1985), reprinted in *The Inhuman* (Stanford: Stanford University Press, 1991)
Barnett Newman, *Selected Writings and Interviews*, ed. John O'Neill (New York: Alfred Knopf, 1990)
Jeremy Strick, *The Sublime Is Now: The Early Work of Barnett Newman, Paintings and Drawings 1944–1949* (New York: PaceWildenstein, 1994)
Ann Temkin, "Barnett Newman on Exhibition," in Ann Temkin (ed.), *Barnett Newman* (Philadelphia: Philadelphia Museum of Art, 2002)

▲ 1913, 1917a, 1944a

▲ 1958

WHC Lemoore
LIBRARY/LRC

5 • Barnett Newman, ***Who's Afraid of Red, Yellow, and Blue I*, 1966**
Oil on canvas, 190.5 × 122 (75 × 48)

1953

Composer John Cage collaborates on Robert Rauschenberg's *Tire Print*: the indexical imprint is developed as a weapon against the expressive mark in a range of work by Rauschenberg, Ellsworth Kelly, and Cy Twombly.

Imagine a canvas panel, four feet square, painted flat white. Now imagine a drawing not quite as white, since there are extremely faint residues of ink and crayon streaking the paper, on the archival mat of which is a label that reads "Erased de Kooning Drawing/ Robert Rauschenberg/ 1953." [1] Finally, imagine a twenty-three-foot scroll on which a continuous band of black inscribes the track of an automobile tire that has been driven down the paper's center. What do these three objects have in common?

That was the question surrounding Robert Rauschenberg's art in the wake of his 1953 exhibition at the Stable Gallery in New York, in which several of his *White Paintings*, their matte panels arranged to form diptychs or polyptychs, were shown along with massive all-black works painted on grounds of crumbled newspaper. Critics greeted the young artist's show by dismissing the black pictures as "handmade debris," and the white ones as a "gratuitously destructive act." News of the tire print and the erased de Kooning soon followed, and, given the intensity of admiration for Willem de Kooning in the early fifties, the idea of destroying one of his drawings instantly promoted scandal among those who heard about it, endowing Rauschenberg with a reputation as some kind of nihilist or Dadaist rerun. And indeed, Rauschenberg did know something about Marcel Duchamp and his presence in New York at the time, even though he did not meet him until a few years later.

Yet the most obvious thread that ties these three works together is their hostile attitude toward Abstract Expressionism and its dominance over advanced art-world thinking in the late forties and early fifties. Rauschenberg, who had begun art school on the G. I. Bill (a program providing college-level study to all soldiers who had fought for the United States in World War II), first in Paris, then at Black Mountain College in North Carolina in 1949, and then in New York in 1950 at the Art Students League, was surrounded by fellow students for whom this had become the universal aesthetic language. From the Abstract Expressionists who were teaching at Black Mountain (such as de Kooning, Robert Motherwell, and Jack Tworkov), to the students at the League who worshiped these artists (such as Alfred Leslie, Joan Mitchell, and Raymond Parker), the idea of the painted mark as a unique trace of the individual who makes it, along with the entire conceptual

baggage of authenticity, spontaneity, and risk that accompanied this ideology of the mark, had become a kind of creed.

Dada redux

Nothing could be less spontaneous and redolent of the character of its maker than a line as mechanically produced as that of a tire track [2]. Similarly, nothing could withdraw from the theater of "risk" so totally as a blank canvas that turns the famous arena on which the action painter battled to declare what Harold Rosenberg had called the "metaphysical substance" of his "existence" into a kind of monochromatic readymade. And even more openly avowing that its sights were set on the Abstract Expressionist celebration of the meaning invested in the uniqueness of the artist's touch, the *Erased de Kooning Drawing* makes it clear that nothing could be more contrary to this ethos than the repeated strokes of the eraser, the trace of which does not register the imprint of the worker's identity but is instead a mechanized effacement of both the drawing's marks and its own counterstrokes.

If these three objects united around a critique of action painting it was not, however, in the service of nihilism. The positive aspirations that Rauschenberg invested in the *White Paintings*, made mostly in the summer of 1951, were allied with the positions then being developed by the American experimental composer John Cage (1912–92), himself teaching at Black Mountain. Cage's thinking, influenced by Zen Buddhism, celebrated passivity as against the strain and thrust of "action" or, indeed, the activity involved in any conception of composition. Interested in the idea that chance and randomness are universal modalities that structure the universe, Cage thought about music as an aleatory interweaving of silence and ambient sound. That summer at Black Mountain, a brilliant young pianist, David Tudor, performed Cage's newly composed *4′ 33″* by sitting quietly at the piano and signaling, rather than playing, the piece's movements by silently opening and closing the keyboard cover.

It was in the context of his interaction with Cage that Rauschenberg made his *White Paintings*. Their multiple panels were generated simply by a serial progression—single panel, diptych, triptych, four-, five-, and seven-panel paintings—and their shapes were seen as containing neither narrative nor any other frame of

1 • Robert Rauschenberg, *Erased de Kooning Drawing*, 1953
Traces of ink and crayon on paper with mat and hand-lettered label in gold-leaf frame,
64.1 × 55.2 (25¼ × 21¾)

2 • Robert Rauschenberg with John Cage, *Automobile Tire Print*, 1953
Ink on paper mounted on canvas, 41.9 × 671.8 (16½ × 264½) fully extended

reference. What they were meant to do instead was to attract fleeting, ambient impressions the way that Cage's music opened itself to the noise of its audience's breathing or coughing. Indeed, Cage referred to the *White Paintings* as "landing strips" for dust particles, light, and shadow, and Rauschenberg himself would always speak of them as "the white paintings that would pick up the shadows."

Rauschenberg, who was active as a photographer during these years, would also make a connection between this sense of the painting as a screen onto which the shadows of passersby would be cast and the photo-sensitized surfaces that allow the photograph to register the impressions focused on them by the camera's lens. And even closer in terms of the activity of the cast shadow, there is the parallel between the white paintings and the massive "rayograms" that Rauschenberg had executed on blueprint paper the year before, in which feet, hands, ferns, and the nude female body were fixed as fragile two-dimensional shadows on the cerulean ground. This same connection between photography and cast shadow had been made before, of course, in the elaboration of Duchamp's *Large Glass* (1915–23) and in the parade of the cast shadows of his ▲ own readymades drawn across the surface of *Tu m'* (1918). Just as in Duchamp's case, where the crux of the relationship turned on the nature of the indexical mark—shared not only by shadow and photograph but also by the way the readymade is the "index" of the "rendezvous" or temporal moment of its selection—so in Rauschenberg's practice, the *White Paintings'* relation to photography broadened in the tire print and erased de Kooning drawing to a general consideration of the indexical trace.

That the index could invest three such different objects with the same logic of "noncomposition" testifies to Rauschenberg's grasp of its underlying principles, of the way the mark registers a depthless trace of its physical cause, stenciled, so to speak, off the world outside it but nowhere resonant with a symbolic meaning—as in the "expressive" mark's supposed inner life. Cage's own desire for such noncomposition had been reinforced by his acquaintance ● with Duchamp, who had been in New York since the mid-forties; Cage was thus in a position to reinforce Rauschenberg's own interest in traces (as in his blueprint works) by pushing this toward a more general sense of its structural logic. Rauschenberg thus did not need a direct contact with Duchamp—to whom he was finally introduced by Cage only in 1957—to put together the readymade and the imprint, the shadow and the rubbing.

Formulae for noncomposition

Ellsworth Kelly's trajectory was strikingly similar to Rauschenberg's in these same years in that he, too, plumbed the logic of the index to find a way to suppress the autographic mark and to break through to a form of noncomposition. The differences between the two turn on the fact that Kelly had no instruction from Duchamp's example, even indirectly, and that Kelly's battle was not with ■ Abstract Expressionism but with geometric abstraction. Mobilized in 1943, fighting in France the following year, and back in

Paris in 1948 on the G. I. Bill, Kelly had no connection to what was happening in New York or to the spread of Piet Mondrian's legacy into academic dogma at the hands of artists like Georges Vantongerloo ▲ and Max Bill. The ideology of the balanced composition of geometrical parts, whose achieved unity would serve as a metaphor for a future utopia of social harmony, had taken hold of European practice. If the geometric delineation of this composition had nothing to do with the individual anguish purportedly folded into the action-painting stroke, it was still seen as expressive: resonating with the chords of "reason," it instituted the artist as Creator.

Kelly's struggle was, then, against this ethos of "composition." And as his disgust with the painting around him mounted he began to sketch the masonry of old buildings and bridges. As he put it, "The found forms in a cathedral vault or in a panel of asphalt on a roadway seemed more valuable and instructive, an experience more sensual than geometrical painting. Rather than making a picture that would be the interpretation of something I saw or the representation of an invented contents, I found an object and I presented it 'as is.'"

The most remarkable of these early works presenting a found object "as is" was made in late 1949, when Kelly was struck by the elongated rectangle and mullion patterns of the windows in the Palais de Tokyo, which housed the Museum of Modern Art in Paris. Reproducing this "as is," he fashioned two panels, one for each casement, and projected the mullions of the lower one in wooden relief. Appearing as an abstract painting, *Window, Museum of Modern Art, Paris* [3] had the advantage of having used its referent (the object in the world from which it had been traced or stenciled) to relieve its author of any compositional duties, while at the same time dissembling the referent itself. Originally called *Black and White Relief*, the work did not advertise its basis in the principle of the readymade, and indeed, describing the process it now unleashed in his art, Kelly referred to its status as "already made." From this time forth, he said, "painting as I had known it was finished for me. The new works had to be unsigned painting-objects, anonymous. Everywhere I looked, everything I saw became something to be made, as is, without having to add anything whatever.... There was no more need to compose. The subject was there, already made and I could avail myself of it everywhere."

Sometimes these found forms, indexically transferred to the surface of Kelly's work, were objects, such as the paving stones in the garden of the American Hospital in Neuilly-sur-Seine, just outside Paris, reproduced to form a low relief (*Neuilly*, 1950), or the arch of a bridge joined to its reflection (*White Plaque*, 1951–5); sometimes they were cast shadows, falling over stairways (*La Combe I*, 1950) or building facades. Transferring their shapes to the surface of his works with the care that Duchamp had taken for the cast shadows of *Tu m'*, Kelly was able to exploit the same strategy of making an index (the colored transfer) of what was already an index (the cast shadow) but without giving away the source or reference of the mark so produced, even while that mark divided the canvas surface without his having "composed" it.

In the summer of 1949 John Cage, who had come to Paris to see the French composer Pierre Boulez, met Kelly and saw work that was

▲ 1914, 1918 ● 1942b ■ 1937b, 1947a ▲ 1913, 1917a, 1917b, 1937b, 1944a, 1959e, 1957b, 1967c

3 • Ellsworth Kelly, *Window, Museum of Modern Art, Paris*, 1949
Oil on wood and canvas, two joined panels,
128.3 × 49.5 × 1.9 (50½ × 19½ × ¾)

4 • Ellsworth Kelly, *Colors for a Large Wall*, 1951
Oil on canvas, mounted on sixty-four joined panels,
243.8 × 243.8 (96 × 96)

already, though somewhat tentatively, operating on the principle of the indexical transfer of the found object. Refraining from making the comparison to Duchamp lest it discourage the younger man, Cage did speak of the advantages of chance as this operated in his own work, and, indeed, chance is yet another avatar of the index (which is the trace of its occurrence) and, uninterfered with by its witness, is another way to avoid composition. The combination of chance with Kelly's found objects was fully available in the cityscape around him in, for example, the colored oblongs of the awnings of public buildings that would be unequally unfurled from one window to the next to form what seemed to be random patterns. But his own most masterful use of chance was in the modular grids he began in 1951 (as in *Colors for a Large Wall* [**4**]), in which the principle of the "already made" unit of the grid is employed as a way of avoiding internal drawing, hence each module is a separate canvas panel, and the principle of the readymade determines the colors themselves (based on color samples), which are, then, arranged by chance.

That Kelly was exploiting the index as a weapon against geometric abstraction was an unusual case in the early fifties, so much so that it went unnoticed long into Kelly's career, during which he

was first mistaken as yet another version of just such abstraction and then seen as a Minimalist before there were any Minimalists. It was, indeed, easier to read the index as resistance to Abstract ▲ Expressionism's expressive stroke, as when Jasper Johns embarked on a series of paintings, beginning with *Device Circle* (1959), that used a paint-mixing stick affixed by one end to the canvas and then rotated so as to smear the colors below it in an imitation—albeit now mechanized—of the dragged paint, wet into wet, of de Kooning's notorious marks.

Return of the index

Cy Twombly, who had been at Black Mountain College in 1951, rejoined Rauschenberg in 1953 at the Stable Gallery, where his work shared the space with Rauschenberg's *White Paintings* and glossy black collages. But rather than setting its sights on de Kooning, Twombly's work in this show, and what he did in the years afterward, fixated on the drawing of Pollock's dripped paintings, turning their looped skeins into the violent furrows dug by the sharp point of his pencils and other instruments into the pigment

▲ 1958, 1962d

5 • Cy Twombly, *Free Wheeler*, 1955
House paint, crayon, pencil, and pastel on canvas, 174 × 189.2 (68½ × 74½)

covering his canvases. Thus for Twombly the weapon against Abstract Expressionism's autographic mark was not the strategy of transforming the spontaneous stroke into a "device" but of recoding the mark itself as a form of graffiti, which is to say, the anonymous trace of a kind of criminal violation of the unspoiled surface, like so many declarations of the fact that "Kilroy was here."

Less apparent as a form of index than, say, a cast shadow or a tire print, the graffiti mark shares with broken branches in the forest or clues left at the scene of a crime the trace of a foreign presence that has intruded into a previously unviolated space. It exists, that is, as residue. In this sense it breaks with a fundamental premise of the action painter's credo: that the work function as a mirror reflecting the artist's identity, producing a moment to measure one's authenticity in an act of self-recognition. For if the mirror is a model of presence—the self-presence of the subject to his or her own reflection—the graffiti mark is a registration of absence, of the mark that rests in the aftermath of the event and which, as Jacques Derrida, in
▲ his *Of Grammatology*, explains of every graphic trace, has the formal character of wrenching self-presence (the present moment when the marker makes the mark) away from itself by dividing the event

into a before and an after; it is a mark that forms itself in the very presence of its maker *as residue*, as remains. In testifying thus to the structural absence of the graffitist to the mark he makes, the graffiti not only does violence to the surface it defaces, but strikes against its author as well, shattering his supposed reflection in the mirror.

Gaining in power and coherence in a work like *Free Wheeler* [5], made several years after the *Erased de Kooning Drawing*, Twombly's mark brings the violence inherent in the strokes of Rauschenberg's eraser out into the open. Both are deployments of the index in the face of action painting's drive to authorial self-presence, just as both are engaged in repetition and randomness as a strategy for "not composing." RK

FURTHER READING
Yve-Alain Bois, "Ellsworth Kelly in France: Anti-Composition in its Many Guises," in Jack Cowart (ed.), *Ellsworth Kelly: The French Years* (Washington, D.C.: National Gallery of Art, 1992)
Jacques Derrida, *Of Grammatology*, trans. Gayatri Spivak (Baltimore: The Johns Hopkins University Press, 1976)
Walter Hopps, *Robert Rauschenberg: The Early Fifties* (Houston: Menil Foundation, 1991)
Leo Steinberg, "Other Criteria," *Other Criteria: Confrontations with Twentieth-Century Art* (London, Oxford, and New York: Oxford University Press, 1972)
Kirk Varnedoe, *Cy Twombly* (New York: Museum of Modern Art, 1994)

▲ Introduction 4

1955a

In their first exhibition in Tokyo, the artists of the Gutai group propose a new reading of Jackson Pollock's drip canvases that engages with traditional Japanese aesthetics and interprets the phrase "action painting" in a literal sense.

In the fifth issue of the journal *Gutai*, published in October 1956, this brief statement appeared in Japanese: "We mourn over the untimely death of the American painter Mr. Jackson Pollock, whom we hold in high esteem, in a car accident this summer. We received the following letter concerning Pollock's death from his close friend Mr. B. H. Friedman. 'Among [his effects] were two copies of each of the 2nd and 3rd issues of *Gutai*. I know these publications of yours must have been loved by Jackson, as they are concerned with the same kind of vision and reality with which he was. Lee gave me the extra copies of the two issues, and I would very much appreciate your sending me the first issue, if you still have a copy, and any issue published since number 3.'"

From the publication of this letter-as-obituary, we can infer not only the importance of Pollock's art for the artists of the Gutai group, but also their craving for international recognition, as well as their pride in informing the group's Japanese public of a first significant success on that score: the tangible proof that their journal was being noticed abroad. The mystery of how multiple copies of numbers 2 and 3 of *Gutai*, both published in October 1955, had landed in Pollock's East Hampton studio has recently been solved: according to Japanese curator Tetsuya Oshima, the Gutai artist Shōzō Shimamoto (1928–2013) had sent them to the American painter in February 1956, with a cover letter asking forgiveness for "our audacity." We have no way of knowing if Pollock, whose life and work were then in deep crisis and who would die a few months later, actually even leafed through the journal. But if he did, it is unlikely that he could have gauged the "audacity" of the group's activity from the visual material alone.

True, in the sole English text printed in number 2 (on its last page), Gutai artist Yozo Ukita (1924–2013) mentions that many of the paintings that are reproduced in the journal "completely deviate from the conventional notion that paintings must be worked by brush and canvas" and that some of them "are done by means of an electric vibrator, scratching the canvas surface with finger nails, suffing [?] on canvas and even utilizing wrinkles of paper." And in signaling that two artists have been given "special emphasis" in the issue—thirteen-year-old Michiko Inui and chemistry teacher Toshiko Kinoshita—he does allude to the "chemicals" that the latter had used in her painting. But only a

Japanese reader having access to Kinoshita's detailed commentary on her own works, as well as that of Shimamoto in the pages that follow their color reproduction on the centre spread, both of which insist on the unpredictability of chemical reactions that produced the paintings, could make sense of the series of five poor-quality photographs showing the artist manipulating lab vials. In fact, the most memorable sentence of Ukita's editorial is perhaps the last: "Once again to all of you who have an interest in this new field of art, please do not hesitate to send us your creation which will be a contribution to our 'GUTAI' and also to our new and loving art." In order to stimulate responses, the issue included a detachable blank postcard addressed to the group (c/o Shimamoto) and an injunction to send photographs as well.

1 • Hans Namuth, *Jackson Pollock painting Autumn Rhythm*, 1950

▲ 1949a, 1960b

Pollock did not respond, but he was indeed the imaginary addressee. Recent research, most notably by Ming Tiampo, has revealed that Jiro Yoshihara (1905–72), the mentor and financial backer of the Gutai group, had been fascinated by his art since ▲ reading the famous 1949 *Life* article entitled "Jackson Pollock: Is he the greatest living painter in the United States?" In May 1951, when two of Pollock's classic drip paintings came to Japan for a group show, he would be alone in praising them in his review, taking his cue from Robert Goodnough's equally famous article, "Pollock paints a picture," which had just appeared in *Artnews* and on which he had taken abundant notes—singling out in particular a quote from the master saying that he worked "from the abstract to the concrete." But what galvanized Yoshihara no less than the actual contact with the works themselves, or Goodnough's account of Pollock's practice, was the celebrated photographs by Hans Namuth illustrating the latter's essay, showing Pollock at work on *Autumn Rhythm*, dripping and pouring paint [1]. (In *Gutai* number 6, published in April 1957, one of these photos would be reproduced alongside an article on Pollock by B. H. Friedman, printed both in English and Japanese). From then on, Pollock became Yoshihara's yardstick by which to judge the originality of anyone's work, including his own—but also a springboard from where to jump into uncharted territories. Extending Pollock's

gesture without imitating him seems to have been the tacit goal he set for himself and for his younger Gutai disciples.

The Gutai group was officially formed by Yoshihara in August 1954, building on several other artists' associations in the Kanzai province in which he had taken an active part; but several of its initial members left a few months later, discontent with his somewhat authoritarian rule and disapproving of the emphasis he was placing on the journal as a venue (instead of exhibitions in gallery spaces). It is only in the late spring of 1955, when artists from a second group, Zero-kai, joined, that Gutai's experimental nature took hold. By then, Yoshihara had already acquired a national reputation as a painter. He had recently abandoned the Surrealist vein of his prewar works in favor of a mode of abstraction through which he sought to achieve a merging of a Japanese aesthetic (calligraphy) and Western contemporary art, to which he had mostly access through art journals. Living in the small town of Ashiya, he subscribed to a vast array of international magazines and was remarkably informed of every new artistic trend outside Japan: his extensive library would provide him with props when chiding his Gutai recruits for reinventing the wheel. "Create what has not been done before!" he would tell them—a motto that had a particular resonance in a postwar Japan that seemed too anxious to erase its recent military past by another, more placid but no less

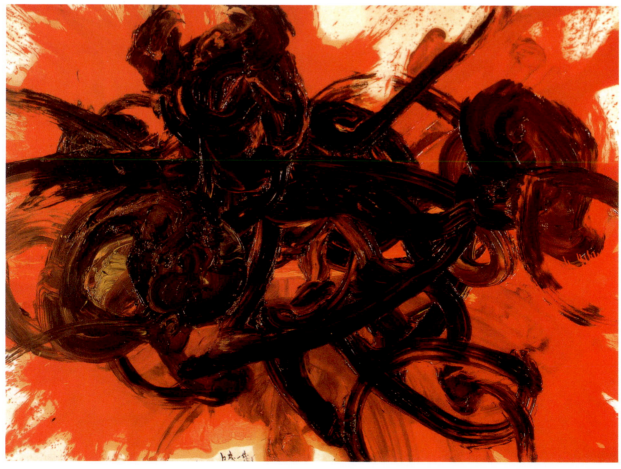

2 • **Kazuo Shiraga**, *Work II*, 1958
Oil on paper, 183 × 243 (72 × 95%)

▲ 1949a

sterilizing, ethos of conformity. It is not so much his own art as his independence of mind, his defiance of bureaucracy, his willingness to seize the opportunity of a clean slate afforded by the historical situation of postwar Japan, and his encouragements to be as radical as possible that explain the attraction he exerted on artists who were a generation younger. Yoshihara's interest in performance and in the theater—the only domain where he was as innovative as the other members of Gutai—also played a major role in defining the group's activity.

A creative misreading of Pollock

It is this performative angle from which Gutai looked at Pollock that resulted in one of the most interesting, albeit short-lived, "creative misreadings" of twentieth-century art. Even before the group was formed, and without knowing of the critic's account, the ▲ Gutai artists had endeavored to literalize Harold Rosenberg's (antiformalist) notion that the Abstract Expressionist canvas is an "arena for action" and that the pictures themselves are far less significant than the gestures that produced them. In fact, it was the new technique adopted in 1954 by Kazuo Shiraga (1924–2008), who was to become the most brilliant member of the group, that functioned as a catalyst: abandoning his brush, Shiraga began to paint with his feet, conceiving of this bodily method as a radicalization of Pollock's horizontality. Upon seeing Shiraga's pictures [2], other artists such as Shimamoto, who had been puncturing holes in thick screens of painted paper, or Saburo Murakami (1925–96), who had been throwing balls dipped in ink, realized that they had a double interest in common: in order to prevent a protectionist return to the traditional artistic practices of Japanese art (the extremely codified calligraphy, for example), one had not only to invent radically new modes of engendering a mark, but also to take advantage of the highly ritualistic nature of Japanese culture in order to transform the artistic act into a transgressive and ludic performance. It is this dual investigation that characterizes the most interesting productions of Gutai—the word itself is translated as "concreteness"; it is formed of two characters: "gu," signifying tool or means, and "tai," which means body or substance.

The inventiveness of Gutai artists in their choice of material for their objects, in their working method for their paintings (often realized during an exhibition), and in their installations (particularly when they were sited outdoors) is staggering. The spectacularization of the production, especially during the first three years of the group's existence, almost inevitably called for an emphasis on chance and contingency (like Pollock, many of them insisted, when painting, on severing the link that—via the brush—had always tied hand, gesture, and inscription). To apply paint or ink, Akira Kanayama (1924–2006) used an electric toy car, Yasuo Sumi (born 1925), a vibrator, and Toshio Yoshida (1928–97), a sprinkling can held ten feet above his waiting surface; Shimamoto smashed jars of pigment on a rock placed on his canvas, or he used a rifle, while Shiraga favored arrows to pierce pouches of paint.

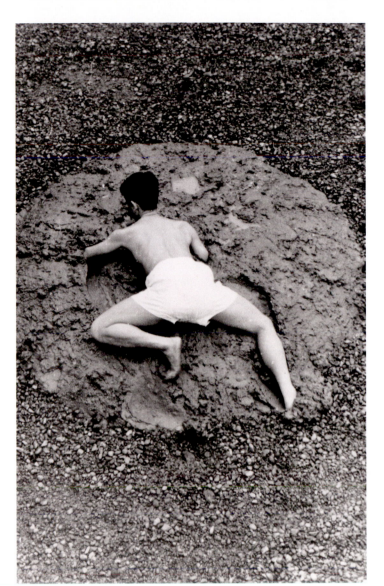

3 • Kazuo Shiraga, *Challenging Mud*, October 1955
Performance

Not so surprisingly, the resulting pictures were of no great interest (Shiraga's numerous "foot paintings" are among the very few pictorial traces of those events that do not look drab—undoubtedly because the indexical footprints clearly register the temporality of the act). But the Gutai artists knew this much and, initially at least, they did not particularly value these remnants, considering them as mere props for their performances or multimedia installations. They did not figure out immediately, however, how to properly give an account of their activities. For example, if Pollock had gone through the third issue of *Gutai*, which thoroughly documented the first manifestation of Gutai as a group (within an exhibition that also included other artists)—the "Experimental Outdoor Exhibition of Modern Art to Challenge the Midsummer Burning Sun," held for two weeks in July and August 1955—he would have had little idea of the radicalness of the works it presented—and, again, the sole English text it contained would not have provided much help. In it Ukita does

▲ 1947b, 1960b

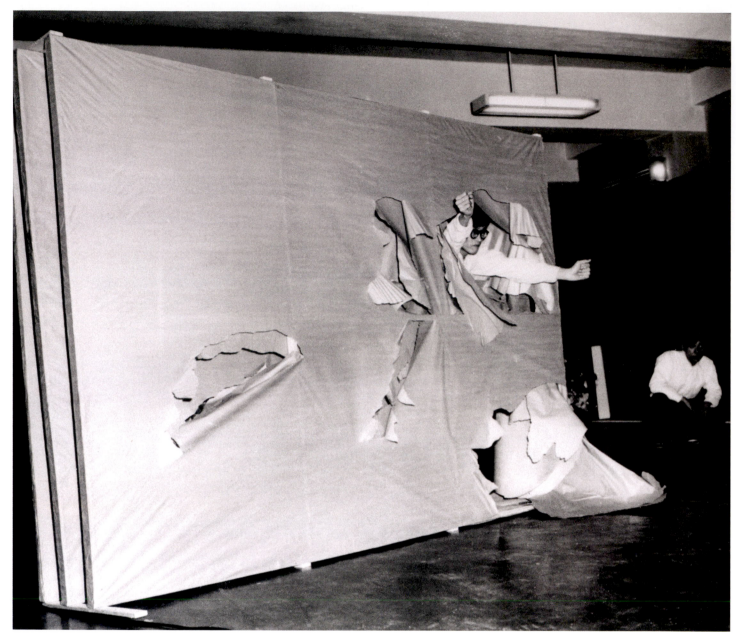

4 • Saburo Murakami, *At One Moment Opening Six Holes*, October 1955
Performance

insist on an aspect of the show that is wholly absent from the photographs (which illustrate works in isolation and bereft of any people): the "amusement park" atmosphere of the whole event, which took place in a pine forest. But unless one could read the captions (in Japanese), there is no way one would know that the work of Atsuko Tanaka (1932–2005), whose reproduction opens the issue, consisted of a ten-square-meter piece of pink nylon canvas attached slightly off the ground and gently waving in the breeze; that Shimamoto's piece was a galvanized sheet of iron pierced with numerous holes (in a manner very similar to Fontana); that Yoshida's row of white wooden stakes, placed half a meter apart, was sixty meters long, with the top of each stake painted in a different color; or that Kinoshita had scattered on the ground hundreds of small painted iron balls painted yellow, green, and white.

It is only in the fourth issue of *Gutai*, which documents the "First Gutai Art Exhibition"—held indoors in a large Tokyo building in October 1955—that the group found a way to present in print form the performative aspect of their work. The production of all the participating artists is reproduced and commented upon, but pride of place is accorded to two works that epitomize best the spirit of the group: Shiraga's *Challenging Mud* and Murakami's *At One Moment Opening Six Holes*, both "performed" during the show's opening. A full-page photograph of Shiraga, half naked, thrashing in a pile of wet mud [3] is followed in the next spread by four more shots of him in action, and then, turning again the page, one discovers several shots of the result (the mud pile full of holes and body imprints) being compared to one of Shiraga's foot paintings (the whole accompanied by ample

comments, alas only in Japanese, by the artist as well as his colleague Akira Kanayama). As for Murakami, he was not actually shot while crashing through a row of large paper screens—rather, one sees him contemplating rather quizzically, as does fellow Gutai artist Tsuruka Yamazaki on the other side, the gaping holes his violent crossing had left [**4**], gashes that are fully documented, photographically as well as in the accompanying comments, in the four pages devoted to this "event." The dramatization of gesture by Shiraga and Murakami was particularly eloquent in that the photographs could not but convey, effortlessly as it were, the ephemeral nature of their act—and it is not by chance that those two works figure among those chosen by Allan Kaprow when, in

▲ his 1966 book *Assemblage, Environments & Happenings*, he generously (and somewhat mistakenly) presented Gutai's activities as anticipating his happenings. But both Shiraga's and Murakami's actions must have seemed at the time even more transgressive to a Japanese audience than to Kaprow: the first because it was making an implicit reference to the Japanese tradition of "mud festivals" in which "young men wrestle in muddy rice paddies before the first sowing of the year" (Tiampo); and the second because it was explicitly and violently assaulting this icon of traditional Japanese interior architecture, the paper partition.

Soon the very theatricality of these actions developed to the stage where, from 1957 on, Gutai mounted grandiose audiovisual shows whose main characteristic was, in a manner that recalled

● Dadaist theater, a predilection for the grotesque and an aggressive
■ stance toward the audience (just as in 1924 Francis Picabia had blinded the Parisian public of the ballet *Relâche* by pointing at it 370 automobile lights, Sadamasa Motonaga [1922–2011] chased his spectators away with his "smoke cannon").

It is, however, in its conception of exhibitions as vast amusement parks containing pockets of meditative spaces and delicate sculptural objects that the Gutai group excelled. In its second outdoor show (July 1956), for example, held like the first in a pine forest, Motonaga hung between the trees long sheets of plastic filled with colored water that filtered the sun's light; Michio Yoshihara (1933–96), Jiro's son, dug a hole in the sand where he almost buried an electric light; Shimamoto constructed a catwalk of planks, supported by uneven springs, on which people were invited to walk; Kanayama zipped through the entire ground with a 300-foot-long strip of white vinyl, adorned with black footprints that made it look like a runway and ending up in a tree [**5**]. A sense of play was pervasive (many works exhibited in Gutai shows were directly inviting the spectators to participate), but also a genuine interest in new materials (with a definitive fascination for plastic, which marked worldwide the period of reconstruction after World War II), both often combining in a appeal to the uncanny. A case in point is Tanaka's *Electric Dress*, a costume made of several dozen incandescent bulbs and colored neon tubes with which she wrapped herself, risking electrocution, for the opening of an exhibition in Tokyo, in 1956 [**6**]. Another is Kanayama's enormous inflated rubber balloon, shown at the

same manifestation. Pancake-shaped and speckled with color spots all over its surface, it echoed the slightest vibration on the floor and thus produced the impression of being a living object.

A reductive misreading of Gutai

By the time Gutai was presented at the Martha Jackson Gallery in New York in October 1958, however, it had grown stale and the show was a flop. The main cause of this debacle was a shift of emphasis due in great part to the intervention of the French art
▲ critic Michel Tapié, the champion of *art informel*. Alerted in spring 1957 of the activities of the group and being shown the journal by a young Japanese painter living in Paris, Tapié contacted Yoshihara. Soon the project was formed of a special issue of the journal where the works of Gutai artists would be reproduced alongside those of artists from other parts of the globe. Designed as if it were a book penned by Tapié alone and titled *L'Aventure informelle* (even though at the eleventh hour Yoshihara contributed a short text speaking of Tapié's visit to Japan, where the critic had arrived only a few days before the magazine went to press in September 1957), number 8 of *Gutai* is markedly different from the preceding issues, especially those dedicated to outdoors exhibitions or to stage performances. Three times thicker, and presented in a slipcase,

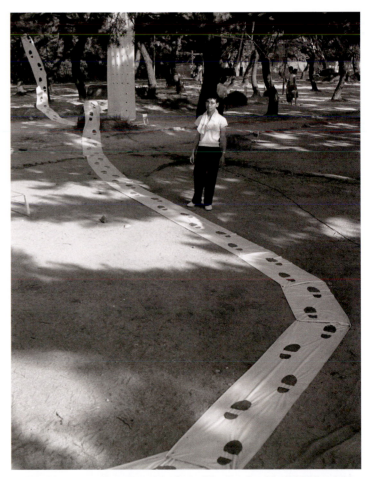

5 • Akira Kanayama, *Footprints*, at the Second Outdoor Gutai Art Exhibition, Ashiya Park, Ahiya, July 1956

▲ 1961 ● 1916a, 1925c ■ 1919 ▲ 1946

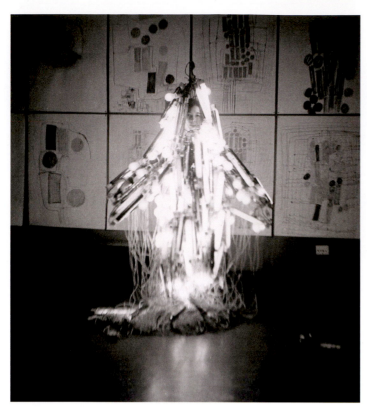

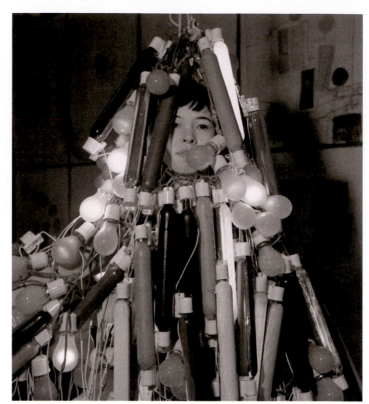

6 • **Atsuko Tanaka** wearing her *Electric Dress* at the Second Gutai Art Exhibition, Ohara Hall, Tokyo, 1956

it devotes far less space to Gutai artists (only sixteen of them are singled out) than to Westerners (sixty-five of them, some already very well known internationally, such as Dubuffet, de Kooning, ▲ Kline, Pollock, and Fontana—whose work figures on the front and back cover). Furthermore, all the works—mainly paintings—are reproduced isolated from their context, one or two per page, accompanied solely by the name of their author: gone is any attempt at registering the process of their making. The purpose of this compendium was twofold: for Tapié, it was to demonstrate that his aesthetic claims were gaining momentum—that his *informel* concept had become global; for Yoshihara, it was to signal to the Japanese art world, which had so far been either very dismissive or indifferent, that the works produced by Gutai, far from being insane aberrations, were celebrated as part and parcel of a whole movement highly respected overseas. Unlike what had happened with Friedman's obituary-letter on Pollock, however, in welcoming Tapié's annexation of Gutai, Yoshihira ended up relinquishing all the most radical aspects of his group's activity.

In the spring of 1958, Tapié visited Japan again, this time to organize with Yoshihara the touring exhibition "International Art of New Era: Informel and Gutai," whose catalogue, published as the ninth number of *Gutai*, was conceived along the same lines as *L'Aventure informelle*, with an even stronger emphasis on painting, at Tapié's explicit urge. The critic's strategy, whose motive was patently market-based, had a devastating effect. Having managed to convinced Yoshihara, and with him his entire cohort, that painting was to be Gutai's forte, Tapié endeavored to present the

group's pictorial production in New York. Even though some documentation was provided about the performative character of Gutai's activity, including photographs and film footage, the press release issued by Martha Jackson for the show was even more biased than Tapié's pompous prose: "The Gutai group consists of eighteen painters. Their inspiration has come from the 'New American painting,'" it said. Not only were the paintings presented as autonomous, idealized, abstractions, not only was any nonpictorial activity of the group almost entirely ignored, but Gutai was deemed, somewhat condescendingly, the mere oriental offspring of Abstract Expressionism. Understandably this exhibition, taking place at the very juncture when the notion of "action painting" had become utterly academic in America, was very badly received. If Gutai's misreading of Pollock had been creative, Tapié's misreading of Gutai had been tragically reductive. The group never recovered from the fiasco of its New York show and slowly degenerated into a caricature of itself. Gutai disbanded only in 1972 (at the death of Jiro Yoshihara), but it had long lost its flame. YAB

FURTHER READING
Barbara von Bertozzi and Klaus Wolbert (eds), *Gutai: Japanese Avant-Garde 1954–1965* (Darmstadt: Mathildenhöhe, 1991)
Ming Tiampo, *Gutai: Decentering Modernism* (Chicago: Chicago University Press, 2011)
Ming Tiampo and Alexandra Munroe, *Gutai: Splendid Playground* (New York: Guggenheim Museum, 2013)
Tetsuya Oshima, "'Dear Mr. Jackson Pollock': A Letter from Gutai," in Ming Tiampo (ed.), *"Under Each Other's Spell": Gutai and New York* (East Hampton: Pollock-Krasner House, 2009)
Gutai magazine, facsimile edition (with complete English translation) (Ashiya: Ashiya City Museum of Art and History, 2010)

▲ 1946, 1947b, 1949a, 1959a, 1959c, 1960b

1955b

The "Le mouvement" show at the Galerie Denise René in Paris launches kineticism.

On April 6, 1955, when she went for a drink with four artists participating in the exhibition "Le mouvement," which had opened earlier that evening at her Paris gallery [1], Denise René did not expect a beating (smug gratitude was more what she had in mind: after all, it was the first time the artists had been hand-picked to show their works in her respectable space). But the Venezuelan Jesús-Rafael Soto (1923–2005), the Israeli Yaacov Agam (born 1928), the Belgian Pol Bury (1922–2005), and ▲ the Swiss Jean Tinguely (1925–91) all ganged up on her to express their frustration. The "four musketeers," as René called them, were furious that Victor Vasarély (1908–97) had been the only artist invited to publish a text in the foldout printed on yellow paper on the occasion of the show (the whole leaflet was subsequently nick-named "The Yellow Manifesto"), and thus appeared to be their leader. Defending herself, René argued that Vasarély was no better represented than anybody else in the exhibition, which had been

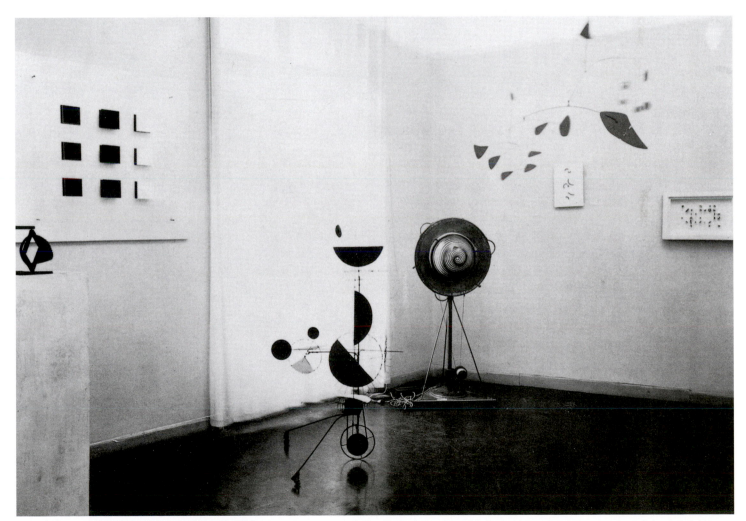

1 • The Galerie Denise René in April 1955 at the time of the "Le mouvement" exhibition

▲ 1960a

his idea in the first place. Furthermore, she said, everything had been done very quickly in order to forestall competition from a forthcoming show in Lausanne (which would indeed be completely overshadowed), adding that there were other artists she would have liked to include as well, such as Vassilakis Takis (born 1925), but had failed to do so for lack of time.

Abstraction in motion

This tempest in a teapot is quite telling, not only with regard to the Parisian atmosphere in the mid-fifties but also as an omen for the rise and fall of the *ism*, soon dubbed "kinetic art" or "kineticism," that was being launched. Inaugurated in 1944 with an exhibition of Vasarély's early "optical" designs for advertisements or the fashion industry (all figurative), the Galerie Denise René had progressively become the main French outlet for what was then called *art construit*, that is, a form of geometric abstraction that was trying to reconnect with the prewar production of groups such as *Cercle et Carré* or *Abstraction-Création*. Without counting the still formidable (and paralyzing) presence of grand Old Masters of modernism such as Pablo Picasso or Georges Braque, the French art world was then entirely dominated by late and mediocre by-products of Cubism and Surrealism, by a sentimental form of figuration that was oddly associated with existentialist philosophy (Bernard Buffet was the star of that genre), and by *tachisme* (or "lyrical abstraction"). Placing the works of young artists under the tutelage of pioneers of geometric abstraction who had been forgotten in France (such as Mondrian, whose first one-man show in Paris would be held in René's gallery as late as 1957; or the Polish Constructivists Wladyslaw Strzeminski and Katarzyna Kobro, whom she introduced to the French public, together with Kazimir Malevich, in the same year), Denise René was on a mission: she was the midwife of an art of "clarity, stability and order" that, in her view, perfectly fitted with the post-traumatic needs of the reconstruction period. Such a neoclassicist interpretation of abstraction as a kind of "return to order" would have repelled Mondrian or Malevich, but it was the only critical discourse through which their work was seized in postwar Europe. (In France its main proponent was Mondrian's friend and would-be biographer Michel Seuphor, who organized the landmark exhibition "Premiers maîtres de l'art abstrait" ["First Masters of Abstract Art"] at Paris's Galerie Maeght in 1949.)

The first abstract works exhibited by Vasarély in 1947, at his second Denise René show, had nothing to do with his early graphic designs based on the flickering of competing positive/negative, black-and-white patterns, a kind of optical violence that he had learned to master during his apprenticeship in the Bauhaus-type school directed by Sandor Bortnik in Budapest. His compositions of the late forties—elegant exercises in precariously balancing a few large unmodulated geometrical planes on a neutral background—fully belonged to the new tradition of *art construit* of which he was fast becoming the spokesman. But dissent was already in the air and in 1950 this very tradition was lambasted in the pamphlet "*L'art abstrait est-il un académisme?*" ("Is abstract art academic?") published by Charles Estienne, a critic who had been until then a staunch supporter of the Denise René pool. It was at this point that Vasarély introduced into his pictures the optical illusionism he had so far relegated to his commercial production and began to articulate an artistic program centered around the idea of virtual movement. The large *Photographismes* that he exhibited in 1951 set the tone: as in Bridget Riley's works ten years later, an illusion of movement (and of volume) is engendered by the destabilization of a regular pattern and the continually confusing inversion of figure and ground.

Destabilization is the key word. Vasarély's retinal titillations had the immediate effect of casting the quieter production of all his geometric abstract colleagues as old-fashioned: taking stock of his ascendancy, a good half of René's artists left the gallery. By 1955, Vasarély had streamlined his compositions and developed new techniques (such as sandblasting thick slabs of glass with a different pattern on both sides, which produced shifting moiré effects at the slightest move of the spectator), and he was now ready for a public takeover.

The "Le mouvement" exhibition of 1955 was a brilliant coup: at once it baptized a new movement (with Vasarély as its self-appointed head) and replenished the gallery with new recruits. In order to legitimize this latest trend historically, René secured the loans of several works by Alexander Calder (whose first mobiles date from 1932) and, even more savvy, of Marcel Duchamp's *Rotary Demisphere* (*Precision Optics*) of 1925 (unlike Calder, who had benefited from the critical support of the then immensely famous philosopher/writer Jean-Paul Sartre for his spectacular show at the Galerie Louis Carré in 1946, Duchamp, who had long ago emigrated to the United States, was only just beginning to be remembered in postwar France). Furthermore, a short chronology of the role of movement in twentieth-century art was published in "The Yellow Manifesto": beginning with Italian Futurism, it mentioned Duchamp more than any other artist—from his first readymade of 1913 (*Bicycle Wheel*) to his first optical machine (*Rotary Glass Plates*) of 1920, his abstract film *Anemic Cinema* (1926), and his *Optical Disks* of 1935. Also noted were Naum Gabo's astonishing *Kinetic Construction*, in which a tiny electric motor functioning as a base triggers an oscillating movement in a thin vertical metallic rod and thus engenders a virtual volume [2], Viking Eggeling's abstract film *Diagonal Symphony* of 1921, and László Moholy-Nagy's high-tech automaton, the *Light Modulator* of 1935. (Other historical precedents that could cast some doubt on Vasarély's claim to originality—such as Henrik Berlewi's *Mecano-faktura* of 1922 or Josef Albers's compositions on glass realized at the Bauhaus in the late twenties, and many of his subsequent drawings—were conspicuously absent.)

The protective guardianship of two prewar pioneers could not have been more welcomed by the "four musketeers." Just like Calder after his visit to Mondrian's studio (which prompted him to invent his mobiles [3]), all had succumbed to the same desire of setting painting into motion; and all were eager to pursue

▲ 1937b ● 1944b ■ 1913, 1917a, 1928a, 1944a ◆ 1913, 1915 ▲ 1918, 1931b, 1993a ● 1914 ■ 1937b ◆ 1923, 1925d, 1929, 1947a

2 • Naum Gabo, *Kinetic Construction*, 1919–20 (1985 replica)
Metal, painted wood, and electrical mechanism, 61.6 × 24.1 × 19 (24¼ × 9½ × 7½)

Duchamp's critique of the subjective authority of the artist as God-like Creator. Both Bury and Agam exhibited transformable reliefs whose elements could be displaced and rearranged on a peg-board, the spectator being invited to become the de facto coauthor of the work (the Argentinian group Madi had exhibited works based on the same principle in the Salon des Realités Nouvelles in Paris as early as 1948, but these had been almost unanimously condemned by French critics for their lack of seriousness). Tinguely's neo-Dadaist bent was the most radical: in his *Meta-Malevich* reliefs, he submitted Suprematist compositions to the test of contingency by having their geometric shapes animated by a motor that rotated them on a black ground, undermining the very notion of the work as a definitive unity; in his *Metamechanical Sculpture*, an elementary linear combination of wheels and gears activated by the simplest electric motor, he was ridiculing all the self-congratulatory discourses concerning the technological advance of the West, plethoric at the time. Not least, it was at this exhibition that he exhibited the first of his *Metamatics* (*Drawing Machines*), robots furnished with markers or chalks and designed to produce an abstract (albeit gestural) work on paper. As for Soto, at first he seemed much closer to Vasarély in that he too was making ample use of superimpositions and their attendant moiré effects (though his model had rather been Moholy-Nagy's painted Plexiglas reliefs of the mid-thirties in which the geometric figures painted on a transparent sheet of Plexiglas cast their shadow on another composition set a few inches behind). But on closer inspection, Soto's works constituted a radical critique of Vasarély's program of mere destabilization of traditional abstract compositions: like François Morellet at the same moment, and following the example of Ellsworth Kelly's production during his stay in France, he was explicitly exploring noncompositional systems (modular allover grids, serial progressions) in order to prevent the final hierarchical *stasis* of any formal arrangement.

Kinetic art gathers momentum—and loses it

Although the press was reticent at first, the exhibition had an enormous impact. In its aftermath a myriad of groups that gathered kinetic artists together was constituted in various European countries (including the Eastern bloc—in Zagreb and Moscow, for example), and by 1960 the "new tendency," as it was often called at the time, had conquered the market while museums worldwide were devoting major exhibitions to this trend. In 1965, capitalizing on the public success of kineticism, René organized a recapitulative exhibition celebrating the tenth anniversary of "Le mouvement." The fold-out catalogue of "Mouvement 2," with an eye-popping orange and green cover, reproduced the works of sixty artists living in ten countries (the great majority based in Paris, however, and many of those being South American expatriates). Intended as a victorious celebration—and indeed it was enormously popular (this time around the press was won over)—the show effectively marked the beginning of the end for kinetic art. Just a few months later, the exhibition "The Responsive Eye" at the Museum of Modern Art in New York, would be another kiss of death, only topped in 1966 by the attribution of the Grand Prize for Painting of the Venice Biennale to the Argentinian artist Julio le Parc, and by that for Sculpture in 1968 to the Hungarian Nicolas Schöffer, both prolific protégés of Denise René. The bubble burst, much more quickly than it had inflated, and it took only a few years for kinetic art to utterly vanish from the scene: René's staggering commercial expansion followed the classic scenario of ending in bankruptcy, both financial and aesthetic, and with this fiasco the baby was thrown away with the bath water.

There are many factors to this spectacular fall, but none more important than the gradual domination of the "Op" branch of kineticism over all the others: it was Vasarély's ascendancy, in a sense, that killed kineticism (his tendency reigns in both "Mouvement 2" and "The Responsive Eye," even if it was not he but Bridget Riley who carried "Op" into the New York limelight). The "four musketeers" were right to complain after all: things could have been different if Vasarély had not stolen the show in 1955.

Indeed, the initial "Le mouvement" had nothing of the homogeneity of its offspring of a decade later. Several types of instability were competing in 1955: illusory movement, by simple optical activation of a surface (Vasarély would stick to this); abruptly changing aspects of the work according to the movement of the

▲ 1953, 1962d

3 • Alexander Calder, *1 Red, 4 Black plus X White*, **1947**
Sheet metal, wire, and paint, 91.4 × 304.8 × 121.9 (36 × 120 × 48)

spectator (Vasarély and Soto, who would soon be joined by Agam); manipulation of the object by the spectator (Bury and Agam, who would both soon abandon this ludic vein); movement of the object itself either through a natural form of energy (Calder: wind, gravity) or a mechanical one (Tinguely). Furthermore, contradictory attitudes with regard to the role of art and its relationship to reason and above all to science (which, after all, was easily conceived as *the* most pregnant discourse, in this atomic age, to be dealing with movement and energy) almost immediately undermined the unity of the new "ism." Vasarély's utopic stance (a humanist hodge-podge of old tropes about the universal language of abstract art bridging the class divides and solving all social ills, and the democratization of art by the infinite multiplication of its objects—the production of "multiples" that contributed to a nauseating saturation of the market) was based on a rationalist philosophy that Tinguely's archaic automata were parodying, as were Soto's attack on compositionality in its evacuation of the self.

Agam rejoined Vasarély's cohort (Op destabilization of *art* ▲ *construit*). Adapting a device invented by El Lissitzky in his *Abstract Cabinet* (parallel wood slats set perpendicular to the picture plane, painted a different color on each side), Agam spent most of his artistic career creating ever larger geometric compositions that provided three different aspects according to the beholder's position. (In 1967 he strayed away from this limited gimmick in a spartan environment consisting of a dark room lit by

a single electric bulb responding to sound, its wattage proportional to the volume of noises produced by the visitors—but this was as much a fluke as Gabo's 1920 work to which it was paying tribute.)

Tinguely was to run out of the Galerie Denise René, which was fast becoming Vasarély's turf. Lured by his friend Yves Klein ▲ (1928–62), he joined the ranks of the Nouveaux Réalistes and continued to produce ironic motorized machines assembled from material gathered at junk yards. The climax of his career was • undoubtedly his gigantic *Homage to New York* of 1960. Built in three weeks in the sculpture garden of the Museum of Modern Art, it was made to self-destruct, a feat that it accomplished in a flurry of fire and sounds in less than half an hour.

Bury, too, escaped from Vasarély's bastion—paradoxically at the very moment when, after the 1955 show, he realized his first motorized reliefs. Among the works that stand out from this extremely inventive period are his *Elastic Punctuations* from 1960, his *Erectiles* series begun in 1962, or his *White Points* series of 1964 to 1967. In the first, a sheet of latex, stretched across a frame, is pressed from behind in different spots, after which these peaks recede, the slow rhythm of this alternative movement inevitably lending organic connotations—sex, breathing—to the piece. In *White Points* the very brief, spasmodic motion of the myriad points extending at the tips of black nylon threads projecting from a wooden bollard (all potential targets of our focus), but only one or two at a time, insures that we can never ascertain that we have

▲ 1926 ▲ 1960a, 1967c ● 1960a

actually seen something moving, or that we have seen everything that has moved. The effect is at once comical (because it is humbling) and disquieting, as always with any confusion between the organic and the inorganic (which Freud characterized as one of the features of the uncanny).

Kinetic deskilling

Soto's evolution is perhaps the most informative in that it fluctuated between the Op/geometric pole and the organic or bodily one. Often reflected in his institutional allegiances (as when he left the Denise René team for a while to join the gallery of Yves Klein, Jean Tinguely, and Vassilakis Takis, or participated, along with his friend Lucio Fontana in the exhibitions of the Düsseldorf-based Group Zero formed by Heinz Mack, Gunter Ucker, and Otto Piene), the oscillations of Soto's stance further indicate that things were initially less cast in stone than one might retrospectively imagine. Immediately after the "Le mouvement" show, Soto stumbled upon an elementary means to achieve the vibratory suspension of form he had been trying to achieve with his superimpositions on Plexiglas: a regularly striated background is enough to optically dematerialize the contour of any form that projects in front of it, as long as the spectator moves laterally. In 1957, Soto almost entirely abandoned the geometric vocabulary he had been using until then, and he set into his signature vibratory

motions wire drawings that clearly imitate gestural abstraction—even combined with the thick blobs of matter one finds in ▲ Dubuffet's or Fautrier's paintings. But even after his definitive return to geometric elements in 1965, in reliefs that steadily grew in scale and projected ever more into the space of the spectator, to the point that they became environments, he kept underlining the discrepancy between the simplicity of his material means and the strength of the dissolution effect in his pieces. The most striking (and last) work of this period is perhaps the four-hundred-square-meter *Pénétrable* he realized outdoors for his 1969 retrospective at the Musée National d'Art Moderne in Paris, which consisted of many thousands of thin plastic tubes hung from a grid canopy: the atmosphere became entirely vibratile, as if gaseous, and spectators entering and roaming the vast space could perceive their peers only as fleeting, deformed, and ever-changing silhouettes.

One particular episode of Soto's career casts some light on the ambivalence of his position (taking stock of geometry in order to produce inchoate bodily sensations) and on the history of kineticism at large: his 1965 exhibition at the Signals Gallery in London. For though Signals did not deliberately attempt to be uncommercial (it was, and closed after just eighteen months), its *eminence grise*, the young Filipino artist David Medalla, saw it as a melting pot, a kind of "alternative space" inviting artists from around the world to collaborate in total freedom, and at times funding their creation of then wholly unsaleable "environments."

3 • Jesús-Rafael Soto holding his *Spirale* at Galerie Denise René in 1955
In the background is a painting by Richard Mortensen.

▲ 1946, 1959c

5 • David Medalla, *Cloud Canyons no. 2*, 1964 (detail)
Bubble-machines = auto-creative sculptures

(Among the founding members of this cooperative—whose original name was the Centre for Advanced Creative Study—one counts Gustav Metzger, the apostle of "auto-destructive art.") Its bulletin, more often than not coinciding with a one-man show, reflected this rare openness. It contained many texts by and about the artist being celebrated, but also about others—companions-in-arms, so to speak—and poems, scientific material, songs, political protests, and a host of documentary items pertaining to the activity of the gallery. (The issue on Soto includes among other things the translations of a 1877 text by German physicist Hermann von Helmholtz [1821–94] on the composition of vibrations, and of several "dreams" by Argentine author Jorge Luis Borges [1899–1986].) With its large format and deskilled typography (both borrowed from daily newspapers), the *Signals* bulletin had all the characteristics of an underground "zine" of the period (according to Medalla, the gallery folded when its backer withdrew his financial support after the publication of the historian Lewis Mumford's and the poet Robert Lowell's respective addresses against the Vietnam War).

For all Medalla's playful anarchism, the Signals Gallery had a serious program, by which it proposed a version of kineticism that had little to do with that offered at "Mouvement 2" or at "The Responsive Eye." Its first exhibition, in 1964, was devoted to the electromagnetic sculptures of Takis—called, precisely, *Signals* (arrows and balls suspended in space, intermittent lights and simultaneously pulsating dials on disconnected switchboards, a whole histrionic, and in many ways antiquated, hardware mobilized in praise of an "invisible force" and celebrated in the gallery's bulletin by William Burroughs). This was immediately followed by a show of Medalla's *Cloud Canyons* [**5**], primitive machines made of rectangular wooden boxes filled with a mix of liquid soap and water that a pump transformed into a stream of foam that slowly oozed from the top and adopted the sensual curves of Hans Arp's late marble sculptures while mocking their claim to perennity. Among the exhibitions organized by Signals, many of them of kinetic artists *not* represented by René, one of the most memorable remains the retrospective of Lygia Clark in 1965, which was to be followed by an "environment" of Hélio Oiticica. (The gallery closed before the realization of this project, but it became the famous installation called *Tropicalia*, which the artist mounted at the Whitechapel Gallery in 1969.)

Such is the context in which Soto was greeted in London: the ease with which he meshed with the Signals group explains better than anything else why he vigorously refused to participate in "The Responsive Eye" exhibition (going against the urging of René). Sadly, this resistance did not last long enough: his work gradually edged towards gadgetry and the cheap "Op" effects dear to Vasarély. By the time he definitely joined in (after his 1969 *Penetrable)* his art was no longer alive. This particular fate is by no means atypical. Another example would be that of the Groupe de Recherche d'Art Visuel (GRAV), officially founded in 1960, soon after Piero Manzoni had invited several of its future members to show their work at the Azimuth Gallery in Milan (where the Italian artist would hold his famous exhibition of edible art). Such a link might seem strange for a group best known for its emulation of Vasarély's program, but at the beginning of GRAV's activity, there was much greater interest in the active participation of the spectator than in optical illusions. This ludic impetus climaxed on April 19, 1966, with *Une journée dans la rue* (A day in the street), during which passersby in various areas of Paris were invited to walk on moving tiles, construct a kinetic sculpture, enter into several others, prick balloons, adorn special glasses that segmented vision, etc. But this marked the end of both the collective nature and the experimental attitude of GRAV. Two months later, when GRAV member le Parc won his Venice prize (and started lambasting Manzoni's antiaesthetic stance), Op became the orthodoxy—and the group almost immediately collapsed. YAB

FURTHER READING
Jean-Paul Ameline et al., *Denise René, l' intrépide* (Paris: Centre Georges Pompidou, 2001)
Yves Aupetitallot (ed.), *Strategies of Participation: GRAV 1960–68* (Grenoble: Le Magazin, 1998)
Guy Brett, *Exploding Galaxies: The Art of David Medalla* (London: Kala Press, 1995)
Guy Brett, *Force Fields: Phases of the Kinetic* (Barcelona: Museu d'Art Contemporani; and London: Hayward Gallery, 2000)
Pamela Lee, *Chronophobia: On Time in the Art of the 1960s* (Cambridge, Mass.: MIT Press, 2004)

▲ 1959e

1956

The exhibition "This is Tomorrow" in London marks the culmination of research into postwar relations between art, science, technology, product design, and popular culture undertaken by the Independent Group, forerunners of British Pop art.

T he Independent Group was less a tight artistic movement than a multifarious study group. Its leading members were artists: Richard Hamilton (1922–2011), Nigel Henderson, John McHale, Eduardo Paolozzi, and William Turnbull. But its prime movers were critics: architectural critic Reyner Banham, art critic Lawrence Alloway (1926–90), and cultural critic Toni del Renzio (1915–2007). And its signal achievements—its ambitious series of lectures and extraordinary run of exhibitions, the latter abetted by innovative designers in the group like the Brutalist ▲ architects Alison Smithson and Peter Smithson—were discursive and curatorial. The principal legacy of the Independent Group might well be its "art" of discussion, design, and display.

The fine art–popular art continuum

The history of the Independent Group proper (1952–5) is bound up with that of the Institute of Contemporary Arts (ICA) in London, which it served as an unruly research-and-development arm. This testy relation is suggested by the successive appellations of the Independent Group: first *Young* Group, then Young *Independent* Group, and finally Independent *Group*. The ICA was set up in 1946 in emulation of the Museum of Modern Art (MoMA) in New York by established writers like Roland Penrose (1900–84) and Herbert Read (1893–1968), its first president, in order to champion modernism. But the ICA version of ● modernism, a watered-down mix of Surrealism (represented by ■ Penrose) and Constructivism (represented by Read), was seen by a new guard of artists, architects, and critics as an academic holdover from the prewar period (Banham dubbed it an "Abstract-Left-Freudian aesthetic"). And when a new director, Dorothy Morland, took office in 1951, these young rebels began to militate for a forum of their own.

Like MoMA, the ICA also wanted to probe connections between modernist art, architecture, and design. But because of economic austerities it was not yet established enough to do so; its leadership was thus relatively open to suggestions from the Independent Group for experimental discussions and displays: if Paris had its cafés and New York its art bars, London might have its art forum. The Independent Group turned this position between the two art

1 • Eduardo Paolozzi, *I Was a Rich Man's Plaything*, c. 1947
Collage mounted on card, 36 × 23 (14⅛ × 9)

capitals of New York and Paris to its advantage, as it engaged new North American art and popular culture in part to revise the academic modernisms of continental Europe. At the same time, it fought on local fronts too, not only *against* the ICA in a generational dispute about modernism and mass culture, but also *with* the ICA against the British art establishment (specifically in the person of art historian and curator Kenneth Clark and company),

▲ 1949b ● 1924, 1930b, 1931a ■ 1921b, 1928a

whose head-in-the-sand elitism regarded anything American as the height of vulgarity, perhaps even the end of civilization. This, then, was the ideological situation in which the Independent Group emerged: the slow death of the British Empire and the continued austerity after World War II (rationing would not cease until 1954), the abrupt advent of the Cold War (with its threat of an atomic end of the world) and a new age of technological advance (with its contrary promise of a new utopia, or at least of a new beginning). This situation was complicated, again, by the old age of European modernism on the one hand and the sex appeal of American mass culture on the other—its promise of plenty on the horizon in contrast to the actuality of scarcity at home.

As a forum, the Independent Group passed quickly through three formations oriented around display and design, science and technology, and art and popular art respectively. In April 1952 a young ICA assistant named Richard Lannoy arranged three events for invited guests. The first was a now-legendary show of images projected by Paolozzi from his collection of magazine tearsheets, ads, postcards, and diagrams, which he labeled "Bunk" and presented with scant order or commentary [1]. The second was a light show by an American discovered by Lannoy called Edward Hoppe; and the third was a talk by a de Havilland aircraft designer. Such odd presentations would prove characteristic of the Independent Group, as would the interest in collage, display, and design, even though the status of these formats was as yet obscure—were any of these presentations "art"? After Lannoy left in July 1952, Reyner Banham emerged as master of ceremonies. A doctoral student at the Courtauld Institute of Art under the architectural historian Nikolaus Pevsner, Banham would soon develop an account of modernist architecture that stressed its techno-futurist aspect over its formal-functionalist aspect, which was privileged by Read and others (Banham's revised thesis, published in 1960 as *Theory and Design in the First Machine Age*, transformed this field of study). His interest in science and technology surfaced in his first year of Independent Group meetings, which included talks on the machine aesthetic (by Banham), as well as on helicopter design, proteins, and the principle of verification (by the philosopher A. J. Ayer). But this interest dominated the nine-seminar course convened by Banham in 1953–4, "Aesthetic Problems of Contemporary Art," which included Banham on "the impact of technology" (on environment and art), Hamilton on "new sources of form" ("under the impact of microphotography, long-range astronomy, etc."), Colin St. John Wilson on "proportion and symmetry," and Alloway on "the human image" in art (as transformed by "new factors—cinema, anthropology, archaeology"). After the course Banham returned to his dissertation, and a lull ensued until Alloway and McHale were asked to reconvene the Independent Group. They turned the program for 1955 away from science and technology toward "the fine art–popular art continuum" (Alloway), with sessions led by Hamilton on "popular serial imagery in a fine art context," by Banham on the "sexual iconography" of automobile styling (important to such paintings by Hamilton as *Hommage à Chrysler Corp.* [2]), by E. W. Meyer on information

2 • Richard Hamilton, *Hommage à Chrysler Corp.*, 1957
Oil, metal, foil, and collage on panel, 121.9 × 81 (48 × 31⅞)

theory, by Alloway and del Renzio on the "social symbolism" of advertising, movies, music, and fashion, and by Banham and Gillo Dorfles on Italian industrial design.

Perhaps the shift from science and technology was not so great: as Hamilton remarked in retrospect, the Independent Group had always addressed popular representations. But the art–pop continuum seemed to suit the ICA directorship, for formal meetings of the Independent Group ended in 1955 when its program was assimilated into that of the ICA proper (Alloway became assistant, then deputy, director). In the early sixties, important members emigrated—first Alloway to the United States (where he soon became a curator at the Guggenheim Museum), followed by McHale and Banham. The site of the British avant-garde also shifted to the Royal College of Art, first with Richard Smith (born 1931) and Peter Blake (born 1932), then with Derek Boshier (born 1937), David Hockney (born 1937), Allen Jones (born 1937), and Ronald B. Kitaj (1932–2007). However different, most could be packaged under the new label "Pop art" made current by Alloway. Indeed, most became active agents rather than ambivalent students of the pop-culture industry of art, music, and fashion of the sixties.

A tackboard aesthetic

Parallel to the Independent Group lectures were its exhibitions, in which members served as curators of culture more than artists on display. Four shows stand out. The first, "Growth and Form," arranged by Hamilton in summer 1951, before the official founding of the Independent Group, used multiple projectors and screens to produce a photographic environment of different structures found in nature. It introduced key elements of Independent Group shows to come: nonart imagery, multiple media, and exhibition design as art form. It also adapted the device of collage and offered a principle of its own—transformation. For the exhibition drew on the 1917 classic of mathematical biology *On Growth and Form*, in which the Scottish zoologist D'Arcy Thompson put forth his theory of morphological transformation. Both the device of collage and the principle of transformation governed the three other Independent Group shows that followed. "Parallel of Life

and Art," arranged by Henderson, Paolozzi, and the Smithsons in the fall of 1953, presented transformations across culture in a spatial collage of roughly one hundred enlarged images of modernist paintings (Kandinsky, Picasso, Dubuffet), tribal art, children's drawings, and hieroglyphs, as well as anthropological, medical, and scientific photographs, hung without commentary at various angles and heights throughout the ICA gallery [3]. Its use of photographic reproduction and viewer disruption recalled both

▲ Constructivist and Surrealist installations, and it also drew on such textual image-repertoires as *Foundations of Modern Art* (1931) by

● Amedée Ozenfant, *The New Vision* (1932) by László Moholy-Nagy, and *Mechanization Takes Command* (1948) by Sigfried Giedion. Like Independent Group lectures, both "Growth" and "Parallel" implied that science and technology had impacted society, culture, and indeed art far more than art had. The same is true of the third show, "Man, Machine, and Motion"; presented by Hamilton at the ICA in summer 1955, it focused on transformations of the human

3 • Installation view of "Parallel of Life and Art," 1953
The exhibition was held in the grand Regency rooms of London's Institute of Contemporary Arts.

▲ 1921b, 1926, 1931a, 1942b ● 1923, 1925a, 1928a, 1929

image. Here again were enlarged photographs, now of bodies and machines in motion, under the sea, on the earth, in the sky, and in space: a futuristic sublime of technological man. Yet most of these visions were already archaic or simply phantasmatic, and this points to a delight, characteristic of the Independent Group, in the obsolescence of "the future," perhaps its own included. Set on Plexiglas panels, the images hung on steel frames in a maze that activated the viewer as an ambulatory collagist of past and present techno-tomorrows.

This rigor of exhibition design and motivation of spectatorship climaxed in "This is Tomorrow." Arranged by Theo Crosby in the summer of 1956 at the Whitechapel Gallery in east London (it was too vast for the ICA and, with one thousand visitors a day, too crowded), "This is Tomorrow" consisted of twelve exhibits. "Split up like market stalls in a fair" (St. John Wilson), they were designed by twelve different teams, each made up of a painter, a sculptor, and an architect. As befit the ICA milieu, some exhibits were Constructivist or Surrealist in spirit, while others explored the interface of art with technology and popular culture. No one aesthetic paradigm or disciplinary agenda governed the exhibits; once again the show as a whole was the primary work. The two most celebrated displays presented extreme versions of the British "tomorrow" of 1956. "Patio and Pavilion," designed by "Group Six" (the Smithsons, Paolozzi, and Henderson), consisted of a pavilion of old wood, corrugated plastic, and reflective aluminum on a patio covered

5 • The Whitechapel Art Gallery at the time of the "This is Tomorrow" exhibition, with detail of three-dimensional collage installation designed by "Group Two," 1956

with sand [4]. In terms of human needs, the Smithsons presented a zero degree of architecture as shelter, while inside Paolozzi and Henderson suggested a bare minimum of human activities—a wheel, a sculpture, various crude objects. The effect was at once primitive, modern, and post-apocalyptic: barred by barbed wire, the interior resembled a ramshackle reliquary of debris after a nuclear blast, especially as it was dominated by *Head of a Man* by Henderson, a modern Frankenstein similar to the busts of broken machine-men for which Paolozzi was known at the time.

The other display, designed by "Group Two" (architect John Voelcker, Hamilton, and McHale), posed an alternative "tomorrow"—not a dystopia of the military-industrial complex but a utopia of capitalist spectacle [5]. Here, rather than peer into a spare shack, the visitor passed through a cacophonous funhouse given over to popular images and perceptual tests. These included a movie poster of Robby the Robot with a starlet from *Forbidden Planet* (1956) juxtaposed with a famous shot of Marilyn Monroe from *Seven-Year Itch* (1955), a Cinemascope collage with stars like Marlon Brando, rotoreliefs and other optical diagrams à la Marcel Duchamp (with whom Hamilton was deeply engaged), and various information postings. Rather than a post-atomic Frankenstein mangled in his senses, the guardian spirit of this place was a contemporary man who seemed to advertise, through word balloons ("look," "listen," "feel"), the new sensorium of capitalist spectacle. (Lest we miss the point, a huge image of spaghetti and a gigantic bottle of Guinness Stout were placed nearby, along with a jukebox, live microphones, and air freshener.) All senses and most arts were engaged here, but engaged as entertainment to the point of distraction, indeed of enervation (the man looked both aggravated and fatigued). Thus the figureheads of the two exhibits, a horrific mutant and an overwhelmed consumer, were not opposites

4 • The Whitechapel Art Gallery at the time of the "This is Tomorrow" exhibition, with detail of the "Patio and Pavilion" exhibit designed by "Group Six," 1956

▲ 1949b

▲ 1918, 1993a

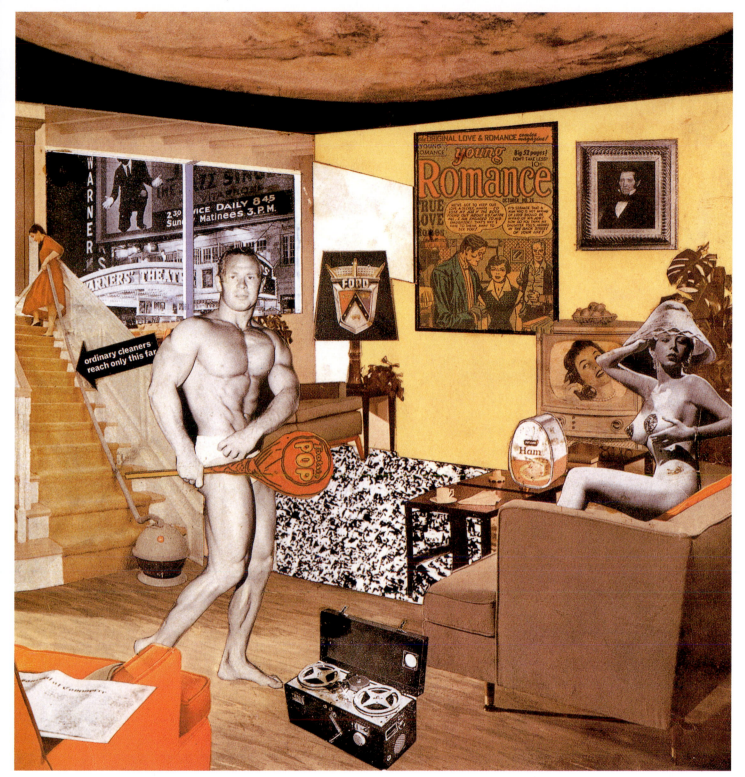

6 • Richard Hamilton, *Just what is it that makes today's homes so different, so appealing?*, **1956**
Collage on paper, 26 × 25 (10¼ × 9⅞)

so much as complements. As in "Man, Machine, and Motion," so here in "This is Tomorrow:" Hamilton and company seemed to question the very spectacle that they celebrated.

This is also the case with the emblematic image of the show, *Just what is it that makes today's homes so different, so appealing?* [6], a small collage designed by Hamilton not as an art object but for reproduction as a poster and in the catalogue. Like prior collages

by Paolozzi, such as *I Was a Rich Man's Plaything* [1], it is a pop-psychological parody of postwar consumer culture made with its own ad-slogans and image-bits, and it too reads like a scripted Freudian dream. In this domestic interior, two contemporary Noble Savages pose, a body-builder with a Tootsie Pop for a penis and a well-endowed woman with a lampshade hat and sequined breasts. These two narcissists are connected only by the pop-penis

and primped breasts that point at each other and by the surrogates and commodities that surround them (like the can of ham set on the coffee table). On the right a woman speaking on the telephone appears on TV, while on the left her double, an ad-come-alive, vacuums the staircase with an extra-long hose that repeats the theme of the commodity-appliance-as-phallus.

Woman seems to rule this interior, but she too is a commodity; and even as she may fantasize about the body-builder, she is overseen by the portrait of a patriarch on the wall and the absent lord of the house evoked by the armchair with newspaper. Moreover, the interior is thoroughly penetrated by the outside world: distinctions like private and public are effaced by commodities and media (a television and a tape deck, forerunners of video recorders and camcorders, and a *Young Romance* comic on the wall, forerunner of soap operas). There is even a Ford hood ornament emblazoned on a lampshade as the heraldic emblem of this household. Here it is as if Hamilton foresaw the relay of car, television, and commodity that would soon become the very nexus of consumer capitalism. Finally, modernism is also taken in, commodified and domesticated, as the Bauhaus returns here as Danish furniture, and a Pollock drip painting reappears as a mod rug. The only threat from the outside comes from the movie-marquee image of Al Jolson in black face, which cannot quite contain the specter of race, and the face of Mars that hovers above the interior as an ambiguous signifier of all that is alien (in the fifties, sci-fi aliens were often Communists in disguise).

▲ This delirious crossing of fetishisms—sexual, commodity, and technological—was a persistent topic for the Independent Group. Broached by Paolozzi, who soon after the war played with juxtapositions of female bodies and military weapons, it was developed by Hamilton, who rehearsed the sublimations of female bodies in product designs of the fifties (as in *Hommage à Chrysler Corp.*).
● It was then passed on to American Pop artists like James Rosenquist and Tom Wesselmann (1931–2004) in the sixties, for whom such inorganic eroticism was not exotic at all. How are we to evaluate such Independent Group enthusiasms? Obviously they pose a drastic alternative to the different denunciations of mass culture made by Anglo-American formalists like Clement Greenberg and Frankfurt School critics such as Theodor Adorno. But the Independent Group was neither celebratory nor campy in the manner of much Pop art.

The Paolozzi term "bunk" suggests the equivocal relation of the Independent Group to mass culture. Recall that the first presentation of his collage material, though catalytic, was also tentative, somewhere between an obsessive hobby and an art project, in any case not a stern exercise in ideology-critique. Paolozzi found the word "bunk" in a Charles Atlas advertisement. It is tough-guy American slang, short for "bunkum," which is defined as "nonsense" or "ostentatious talking" (appropriately it was first used to describe the speeches of a Congressman). But what exactly is "bunk" here—the popular source materials or the collages? Perhaps it is both, and the implication is not to take either mass culture or its artistic elaboration too seriously—to *de*bunk both, in fact. Yet "bunk" has another association with which Paolozzi was likely familiar, the famous saying of Henry Ford that "history is bunk." In his caustic collages of *Time* magazine covers, Paolozzi seems to agree. But perhaps he also suggests a reversal: not only that official history is bunk but that bunk has a history too; or, more precisely, that it provides another way into history—bunk as a form of "nonsense" used to debunk history as a form of "ostentatious talking."

▲ As we have seen, a "tackboard aesthetic" was "fundamental to Independent Group notions" (del Renzio), to its splicing of art with science and technology, its exploring of the art–pop continuum, its cracking of commodified bodies. But collage had also become a device of the culture industry. "Magazines were an incredible way of randomizing one's thinking," Turnbull remarked later, "food on one page, pyramids in the desert on the next, a good-looking girl on the next; they were like collages." This suggests that surreal juxtapositions were already the stuff of ads, that collage was in need of a critical reinvention that the Independent Group did not quite provide (this task was left to the
● Situationists). Indeed, when Hamilton decided "to produce work" out of "the investigations of the previous years," he returned to painting, and soon traffic on the art–pop continuum became one-way, toward art, as in most Pop art.

In retrospect, the very need of the Independent Group to splice art with science and technology points to the divide between them; it demonstrates more than disproves the famous thesis of the gulf between the "two cultures" of the arts and the sciences presented by English novelist and physicist C. P. Snow in 1959. Much the same may be said of the insistence on an art–pop continuum. In "The Long Front of Culture," an essay also of 1959, Alloway opposed this new horizontal, egalitarian "continuum" of culture to the old hierarchical, elitist "pyramid" of art, fully aware of the class war at stake in this culture war. But, like much recent cultural studies, the Independent Group tended to oscillate between an absorption in this continuum as fans and a looking down on this continuum from on high, that is, from the dandyish perspective of a consumer-connoisseur. (Alloway also wrote of a new culture of different "channels," a term that anticipates the consumerist "choice" of the distracted media-subject of today.) And yet even as its critique of art tilted toward an advocacy of capitalist technology and spectacle, the Independent Group did point to a historic shift from an economy centered on production to one based on consumption, a shift that entailed a repositioning of the postwar avant-garde as well. HF

FURTHER READING
Julian Myers, "The Future as Fetish: the Capitalist Surrealism of the Independent Group," *October*, no. 94, Fall 2000
David Robbins (ed.), *The Independent Group* (Cambridge, Mass.: MIT Press, 1990)
Brian Wallis (ed.), *"This is Tomorrow" Today* (New York: Institute for Art and Urban Resources, 1987)
Victoria Walsh, *Nigel Henderson: Parallel of Life and Art* (London: Thames & Hudson, 2001)

▲ 1931a ● 1960c

▲ 1949b ● 1957a

1957 a

Two small vanguard groups, the Lettrist International and the Imaginist Bauhaus, merge to form the Situationist International, the most politically engaged of all postwar movements.

The Situationist International (SI, 1957–72) has a complicated history. It developed out of two movements: the Lettrist International (1952–7) led by the Frenchman Guy Debord (1931–94), the central theorist of the SI, and the International Movement for an Imaginist Bauhaus (1954–7) led by the Dane Asger Jorn, the central artist of the SI. The Lettrist International grew out of the Lettrist Group (founded in 1946, it lives on to this day), and the Imaginist Bauhaus out of yet another group, ▲ Cobra (1948–51), an acronym of *Co*penhagen, *Br*ussels, and *A*msterdam, the home bases of its various members. The sheer number and short lives of these movements point to the volatility of cultural politics in postwar Europe. But they all shared a critical involvement in Surrealism and Marxism; or, more precisely, they all sought to supersede the aesthetic strategies of Surrealism and to ● defy the political strictures of the Communist Party. The first was deemed conservative in its reconsolidation under André Breton after the war, and the second was considered abhorrent in its Stalinism and reactionary in its Socialist Realism. To these two critical engagements a third must be added: like the Independent ■ Group in Britain, the SI confronted the rise of consumer society. But whereas the Independent Group saw open "channels" for desire in this new mass culture, the SI saw that a closed "spectacle" had transformed our very alienation into so many commodities to consume. Moreover, whereas avant-gardes like the Independent Group embraced one side of the cultural dialectic of twentieth-century capitalism in order to contest the other—mass culture against modernist art, or vice versa—the SI were able to comprehend both sides critically, strategically, at least for a time.

Besides Jorn, Cobra had included the Belgian poet-critic Christian Dotremont, the Dutch painters Karel Appel and Corneille, the Belgian painter Pierre Alechinsky, and the Dutch painter-turned-urbanist Constant Nieuwenhuys; the last would figure in the SI too. Although Marxists, they were contemptuous of Socialist Realism in the East; and although Expressionists, they were suspicious of Abstract Expressionism in the West. Thus neither figurative nor abstract, Cobra practiced forms of coloristic "disfiguration" suggestive of the fierce scrawling of children, if not of the insane. This brought Cobra close to Surrealism, and closer ◆ still to the *art brut* of Jean Dubuffet; but as the SI would do later,

it rejected the Surrealist unconscious as too individualistic or "subjectivist." Cobra sought a collective basis of art and society, and to this end it stressed totemic figures, mythic subjects, and collaborative projects like journals, exhibitions, and murals. However, the Paris art world of the time, governed by an academic coalition of Surrealists and abstractionists, did not fall before this onslaught, and Cobra broke apart in 1951.

Critique of everyday life

▲ Jorn had studied with Fernand Léger and assisted Le Corbusier briefly before the war. Perhaps it was this training that led the Swiss abstract painter Max Bill, a former Bauhaus student, to contact ● Jorn in 1953 about the founding of a "new Bauhaus." Yet Jorn was too marked by his Cobra experience to accept the functionalist pedagogy outlined by Bill. "Experimental artists must get hold of industrial means," Jorn agreed, but they must "subject them to their own nonutilitarian ends." His idea of a new Bauhaus was experimental, not technocratic, and in this polemical spirit he founded the Imaginist Bauhaus in November 1954 with his old Cobra comrade Constant and a new Italian associate, Giuseppe Pinot Gallizio (1902–64). In 1955 they started an "experimental laboratory" in Albisola, Italy, in order to experiment with new materials in painting and ceramics (Pinot Gallizio was trained as a chemist). Yet, even as the Imaginist Bauhaus suggested a working-through of the unfinished projects of Surrealism and Constructivism, it was little more than a way-station between Cobra and the SI. In 1956 representatives of the Imaginist Bauhaus and the Lettrist International met to discuss a coalition, and the SI was founded a year later.

To an extent the original Lettrist Group was an early postwar ■ reprise of Dada. Apart from actions designed as scandals to shock the bourgeoisie, the Lettrists, clustered around the charismatic Romanian Isidore Isou (1925–2007), pushed the Dadaist decomposition of word and image further, both in poems that broke language down to the letter and in collages that mixed verbal and visual fragments. Not content with such experiments, Debord split from this group with a few other Lettrists to form the Lettrist International in 1952. Over the next several years they adapted some

▲ 1949b ● 1924, 1934a, 1937a, 1942a, 1942b ■ 1956 ◆ 1946, 1959c ▲ 1925a ● 1923, 1947a ■ 1916a, 1920

— the Paris of the young men and girls

who haunt the Left Bank

Ils ne sont pas pour eux-mêmes; ils sont neutres, indifférents, suspendus à tout, sans s'excepter

Ils jouent souvent à ce jeu, car ils trouvent délicieuse la sensation que

le thème spatial d'un univers labyrinthique et indéfiniment piégé

l'on éprouve quand on s'évanouit

la lente succession des heures, des jours, sur le décor inchangé

oublient et sont oubliés

Oh! jamais le soleil

(DARK PASSAGE)
PASSAGERS DE LA NUIT

un tableau équilibré de notre façon de vivre et de notre histoire

amer tableau de cette société asphyxiée qui est la nôtre

La nuit et la neige

1 • Guy Debord and Asger Jorn, page from *Mémoires*, 1959
Oil, ink, and collage on paper, 27.5 × 21.6 (10½ × 8½)

Lettrist notions, invented others, and recast the whole project according to a newfangled Marxism pledged to a "critique of everyday life" (developed from the Marxist sociologist Henri
▲ Lefebvre [1901–91]) through the construction of subversive "situations" (derived from the existentialist philosopher Jean-Paul Sartre). They sought, in short, to advance the "class struggle" through the "battle of leisure." Debord and Jorn documented the brief life of the Lettrist International in *Mémoires* (1959), a collage that literally intercuts the subjective and the social, the artistic and the political [1]. It is a labyrinth of quotations snipped by Debord from poems and novels, histories and political economies, newspapers and film scripts, ads and cartoons, etchings and woodcuts, all scored by Jorn in streaks and splotches of paint that trace passionate connections between people, places, and events.

It is often said that the SI developed as an artistic avant-garde until 1962, when a schism divided the activists from the artists, and that it continued as a political avant-garde until its dissolution in 1972. Yet the SI sought to transform art and politics together at every stage of its development, and its signal contribution was to devise a cultural politics able to critique consumer capitalism. It did so even as it also insisted on some old political principles (like the idea of workers' councils) and challenged some new ones (such as the fiery Maoisms of the time). However, the schism within the SI in 1962 was real. Preceded by several departures—Pinot Gallizio was expelled in 1960, charged with art-world opportunism; Constant resigned the same year; and Jorn withdrew to the margins a year later—the division occurred when the Paris section led by Debord stipulated that Situationist art and politics could *not* be separated. Some artists from the Scandinavian, German, and Dutch sections disagreed, and, led by Jorgen Nash (younger brother of Jorn), they formed a rival Situationist group, only to be expelled by the SI in turn. At this point, fueled by new members not formed by the art movements of the fifties and driven by the political crises of the early to mid-sixties, the SI sought to realize its critical strategies in political interventions. In 1966 it was involved in the first student revolt in France, at the University of Strasbourg, which was guided by the Situationist pamphlet *On the Misery of Student Life* by Mustapha Khayati. And in 1967 the SI published its two greatest critiques of capitalist culture, *The Revolution of Everyday Life* by Raoul Vaneigem (born 1934) and *The Society of the Spectacle* by Debord. These texts were crucial to the student uprisings of May 1968, in which the SI was also active (its advocacy of workers' councils was especially important at this time). However, in the meltdown of the left after 1968, the SI also began to fall apart. Its last conference occurred in 1969, its last journal appeared in the same year, and in 1972 it dissolved altogether.

Dérive and détournement

The SI has had an afterlife, however, through texts like *The Society of the Spectacle*, in which Debord focused insights into capitalist culture developed since the founding of the Lettrist International

Two theses from *The Society of the Spectacle*

#190:
Art in the period of its dissolution, as a movement of negation in pursuit of its own transcendence in a historical society where history is not yet directly lived, is at once an art of change and a pure expression of the impossibility of change. The more grandiose its demands, the further from its grasp is true self-realization. This is an art that is necessarily *avant-garde*; and it is an art that *is not*. Its vanguard is its own disappearance.

#191:
The two currents that marked the end of modern art were Dadaism and Surrealism. Though they were only partially conscious of it, they paralleled the proletarian revolutionary movement's last great offense; and the halting of that movement, which left them trapped within the very artistic sphere that they had declared dead and buried, was the fundamental cause of their own immobilization. Historically, Dadaism and Surrealism are at once bound up with one another and at odds with one another. This antagonism, involvement in which constituted for each of these movements the most consistent and radical aspect of its contribution, also attested to the internal deficiency in each's critique—namely, in both cases, a fatal one-sidedness. For Dadaism sought *to abolish art without realizing it*, and Surrealism sought *to realize art without abolishing it*. The critical position since worked out by the Situationists demonstrates that the abolition and the realization of art are inseparable aspects of a single transcendence of art.

in 1952. Many of its theses elaborate or quote central texts of Hegelian Marxism: the young Marx on "alienation," the young György Lukács on "reification" from *History and Class Consciousness* (1923), as well as Sartre and Lefebvre (in this respect Debord liked to cite the nineteenth-century poet and Surrealist favorite Lautréamont: "plagiarism is necessary; progress implies it"). But this caustic text is also highly original, for it updates both Marx on the fetishistic effects of the commodity and Lukács on the fragmentary effects of mass production in order to expose the workings of a new stage of capitalism centered on the image and driven by mass consumption. Debord analyzed this society of marketing, media, and mass culture in terms of "spectacle," defined most succinctly as "capital accumulated to such a degree that it becomes an image." Although written out of a specific conjuncture, *The Society of the Spectacle* allows one to grasp the trajectory of modern culture vis-à-vis capitalist development. And today, as two former SI members, T. J. Clark and Donald Nicholson-Smith, have argued, its greatest strengths might well be what critics on the Left have long deemed its greatest weaknesses: its emphasis on political organization (at a time of dispersal on the Left) and its will to totalize (in the face of a capitalism that becomes ever more total in its own right).

The SI cannot be reduced to its practice of art, but neither can this be dismissed as superfluous. "Culture reflects," Debord wrote in 1957, "but also prefigures, the possibilities of organization of life in a given society." And it is to this end that the SI elaborated its cultural strategies, four of which stand out: *dérive*, "psychogeography," "unitary urbanism," and *détournement*. A *dérive* is defined as "a technique of transient passage through varied ambiances." Literally "a drifting," a *dérive* is undertaken in the interest less of a chance encounter that might trigger the unconscious, as with Surrealist wandering, than of a subversive relation to everyday life in the capitalist city. Here the Baudelairean connoisseur of leisure—the *flâneur*—becomes the Situationist critic of leisure, defined simply as the other side of alienated work. A "psychogeography" might follow from a *dérive*; it is "a study of the specific effects of the geographical environment, consciously organized or not, on the emotions and behavior of individuals." Debord provided a good example in *The Naked City* (1957), which consists of nineteen sections of a Paris map reordered according to one such hypothetical itinerary [2]. Together the *dérive* and the psycho-geography point toward "unitary urbanism," or "the combined use of arts and techniques for the integral construction of a milieu in dynamic relation with experiments in behavior." Constant

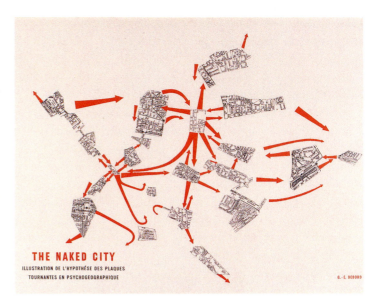

2 • Guy Debord, *The Naked City*, 1957
Color psychogeographical map on paper, 33 × 48 (13 × 18⅞)

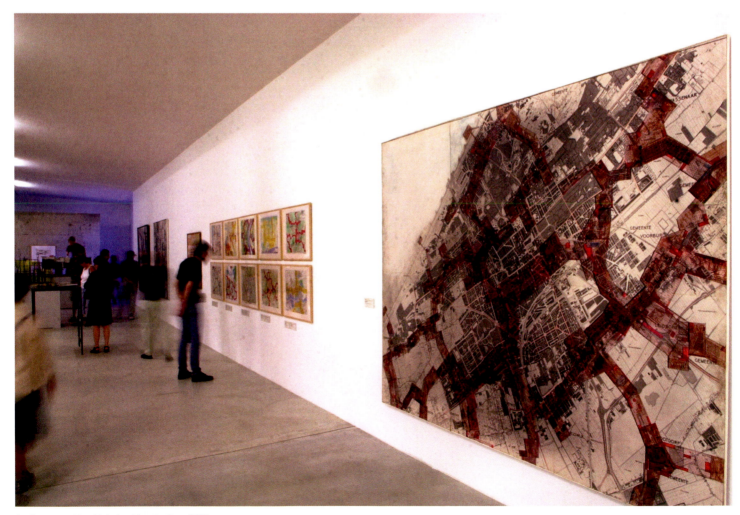

3 • Constant, *New Babylon / Amsterdam*, 1958
Ink on map, 200 × 300 (78¾ × 118⅛). Installation at Amsterdams Historisch Museum.

prefigured such constructions in his project "New Babylon" [3]. Devoted to a notion of urban design as a set for nomadic movement and mass play, he proposed a series of high-tech megastructures across various European cities that could be reformed by residents at will like giant pieces of Lego. (At least this was the idea; even some Situationists were not persuaded by his drawings and models, in which utopian lines of escape and dystopian forms of surveillance become difficult to distinguish.)

More than a wandering, a *dérive* is a recoding of urban spaces and symbols. This recoding is part of the central strategy of Situationist practice: *détournement*, defined as "the integration of present or past artistic production into a superior construction of a milieu." *Détourner* is to divert—in this case, to divert purloined images, texts, and events toward subversive viewings, readings, and
▲ situations. Derived from Dadaist and Surrealist collage, *détourne-*
● *ment* was opposed to the quotations of media in Pop art and the
■ accumulations of products in Nouveau Réalisme. Rather than a univocal appropriation, the Situationists sought a "dialectical devaluing / revaluing" of the diverted artistic element. Moreover, the result was not intended as art or antiart at all: "There can be no Situationist painting or music," the first issue of *Situationniste Internationale* declared in June 1958, "but only a Situationist use of these means." In this way *détournement* is a double performance: it simultaneously exposes the ideological nature of a mass-cultural image or the dysfunctional status of a high-art art form *and* refunctions it for a critical political use. With its use of extracted texts and images, *Mémoires* is an early example of *détournement*, but the exemplary instance is the six films made by Debord from 1952 to 1978, mostly from appropriated ads and news photos, media clips and film footage, texts and soundtracks.

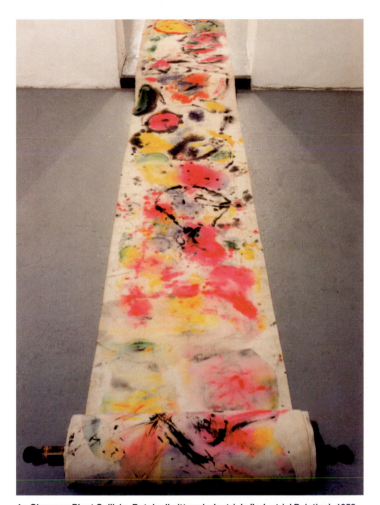

4 • Giuseppe Pinot Gallizio, *Rotolo di pittura industriale* (Industrial Painting), 1958
Mixed media, 74.5 × 7,400 (29⅜ × 2,913⅜)

Production and consumption

As the critic Peter Wollen has indicated, the Situationist *détournement* of art came to a head in 1959 when Pinot Gallizio displayed his "industrial paintings" and Jorn exhibited his "modifications," both in Paris. In his show Pinot Gallizio covered the entire Galerie René Drouin with rolls of canvas painted as if automatically in lurid colors; he added lights, mirrors, sounds, and smells to create a total environment. Yet, rather than another extension of action painting into Installation art, this "grotto of anti-matter" was meant to prefigure a future world of play that automation, once diverted from its capitalist logic, might afford (this was true of "New Babylon" as well). It was also intended to parody the present world of capitalist production and consumption, for not only were the canvases made on a mock assembly line with paint-machines and spray guns, but they could also be cut up for sale by the meter [4, 5]. The "modifications" bear the marks of capitalism in another way. They are kitsch pictures, mostly anodyne landscapes and city views produced for *petit-bourgeois* decoration, that Jorn had
◆ scavenged in flea markets and painted over with primitivist figures and abstract gestures à la Cobra.

5 • Giuseppe Pinot Gallizio and his son Giors Melanotte working on the Industrial Painting in Alba, Italy, c. 1956

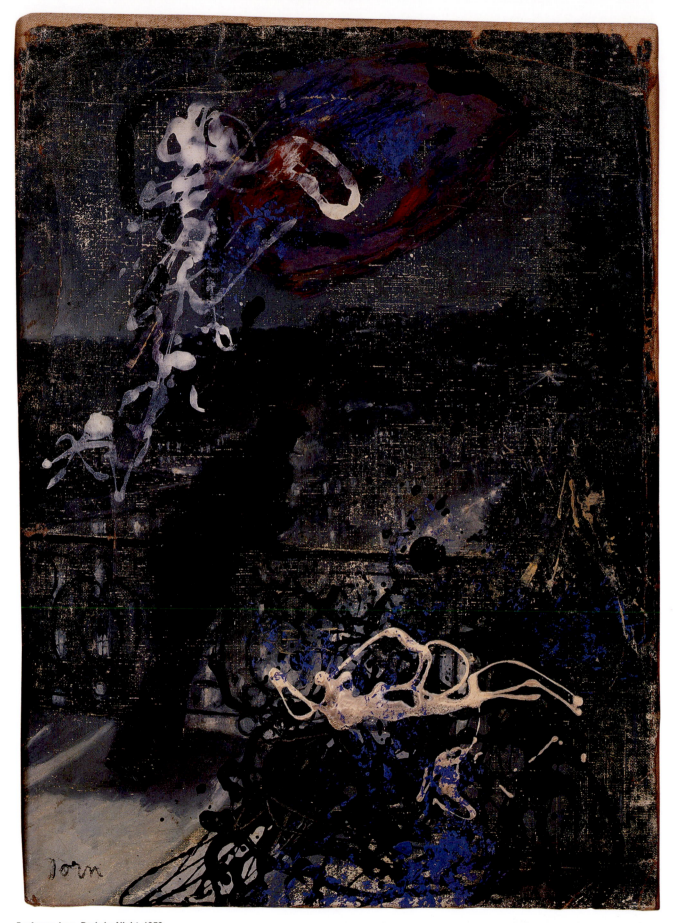

5 • Asger Jorn, *Paris by Night,* **1959**
Oil on reused painting, 53 × 37 (20¾ × 14½)

Lately the "modifications" have prompted divergent readings. For some critics they "crack open" traditional genres that have become academic kitsch in order to make them live again as contemporary signs. In doing so, they overcome, symbolically at least, the split between avant-garde and kitsch that long deformed modern culture. For other critics, however, the "modifications" suggest the reverse. They rehearse avant-garde styles (for instance, primitivist, Expressionist, abstract) as so many dead letters; thus, rather than a resolution of avant-garde and kitsch, they show the former reduced to the latter. Yet neither account seems adequate to a modification like *Paris by Night* [**5**]. In the original painting a lone bourgeois man leans on a balcony and gazes over the nocturnal city. It is a prewar scene, perhaps turn of the century, that is designed to seduce us, to allow us to identify our contemplation of the figure in the painting with his contemplation of the spectacle of Paris. The gestural overpainting does not shatter this absorption; rather, it injects a different moment of interiority and spectacle—

▲ the moment of Abstract Expressionism and postwar culture. In this way, the kitsch original is not enlivened any more than the avant-garde overpainting is deadened. Instead the two bracket one another as historical, and so carve out a critical distance for the viewer with which to evaluate both moments, both formations. "Painting is over," Jorn wrote in a statement that accompanied his show of "modifications" in 1959. "You might as well finish it off. Detourn. Long live painting." Like the old king, Jorn suggests, painting may be dead; but like the new king it may live on—not as an idealist category that never dies but as a materialist corpse that rots subversively. "Our past is becoming," Jorn concludes, "one needs only to crack open the shells."

For Debord the prewar precedents of the SI were complementary failures: "Dadaism sought to abolish art without realizing it," he wrote in *The Society of the Spectacle*, "and Surrealism sought to realize art without abolishing it." The SI should not make this same mistake: it needed to "surpass" both the prewar avant-gardes and the revolutionary politics that emerged with them (from the Russian Revolution in 1917 onward). It could not be just another postwar repetition. But the SI possessed a possibility other than

● Debordian refusal or neo-avant-garde rehearsal of the historic avant-garde. In 1962, around the time of the SI schism, Jorn produced another set of modifications called "new disfigurations," which are mostly portraits of proper subjects disfigured by childish doodles or deranged doubles. In one kitsch original, a girl who appears to be dressed for confirmation—that is, for social-religious initiation as an adult—gazes out at us; but she still holds the jump rope of a child [**6**]. In the overpainting Jorn puts a mustache and goatee on her as Marcel Duchamp had done with the *Mona Lisa* in 1919, perhaps with this warning of Debord in mind: "Since the negation of the bourgeois conception of art and artistic genius has become pretty much old hat, the drawing of a mustache on the *Mona Lisa* is no more interesting than the original version of that painting." One can read this disfiguration as an admission of the pathetic status of the belated artist—the

6 • Asger Jorn, *l'avangarde se rend pas* (the avant-garde doesn't give up), 1962
Oil on reused painting, 73 × 60 (28¾ × 23⅝)

avant-garde should just give up, or, as Debord would say, its negation of art, now taken *as* art, should be negated in turn. But around this girl, amidst other assorted grotesqueries, Jorn has scrawled "l'avangarde se rend pas" (*sic*)—the avant-garde *doesn't* give up. How are we to read this defiance, and to whom is it addressed? Is it serious or silly? Does Jorn imply that the avant-garde should give up (as many, both pro-Situationist and con, insisted) but doesn't, and that ridiculous recalcitrance is the greatest mockery of all, a nose-thumbing to the Left as well as to the Right? In any case, just as Duchamp was able to jazz up old Mona Lisa (he renamed her "L.H.O.O.Q.," which in French sounds like "she has a hot ass"), so Jorn has turned this girl into a tough little customer: her jump rope begins to look like a whip, maybe even a garotte. HF

FURTHER READING
Iwona Blazwick (ed.), *An Endless Adventure—An Endless Passion—An Endless Banquet: A Situationist Scrapbook* (London: Verso, 1989)
Guy Debord, *The Society of the Spectacle* (1967), trans. Donald Nicholson-Smith (Cambridge, Mass.: MIT Press, 2002)
Ken Knabb (ed.), *Situationist International Anthology* (Berkeley: Bureau of Public Secrets, 1981)
Thomas F. McDonough (ed.), *Guy Debord and the Situationist International* (Cambridge, Mass.: MIT Press, 2002)
Elisabeth Sussman (ed.), *On the Passage of a Few People Through a Rather Brief Moment in Time: The Situationist International 1957–1972* (Cambridge, Mass.: MIT Press, 1989)

▲ 1947a, 1949a, 1960b ● 1960a

Ad Reinhardt writes "Twelve Rules for a New Academy": as avant-garde paradigms in painting are reformulated in Europe, the monochrome and grid are explored in the United States by Reinhardt, Robert Ryman, Agnes Martin, and others.

In the midst of working on his first set of black paintings—a series of tall oblongs each articulated by a stately grid, three modules wide by seven high, the difference between the units almost impossible to discern in certain of the pictures, so close in tone is one "black" to its neighbor—Ad Reinhardt (1913–67) submitted "Twelve Rules for a New Academy" to the May 1957 issue of *Artnews*. Often doubling as a mordant critic of the art world, Reinhardt, one might think, wrote this essay with his tongue in his cheek, for, one might say, "academic" art, particularly in its abstract guises, was everywhere at that time.

From the late thirties and into the forties and early fifties, the American Abstract Artists' Association had established and then consolidated a local version of the international language of abstraction, which was then being practiced in France under the banner of *Abstraction-Création*, and being taught in European schools like the Ulm Institute of Design, under the tutelage of Max Bill, and at the postwar continuations of the Bauhaus in the United States, under the guidance of László Moholy-Nagy, Josef Albers, and György Kepes. In an essay written in 1959—"Is There a New Academy?"—Reinhardt acknowledged this presence of a type of abstraction-become-academic, which is to say, formulaic and routine, corrupted by the need to place abstraction in the service of design, advertising, or architecture. But he castigated this as "extract art," having nothing to do with real abstraction, which, he said, "cannot be 'used' in education, communication, perception, foreign relations, etc."

It was for this reason that Reinhardt truly wanted a "new academy," which would function like those of the seventeenth century: protecting a notion of aesthetic purity and maintaining the difference between high art and its applied derivatives. Such an academy would make clear, he said, that art is essentially "'out of time,' art made fine, art emptied and purified of all other-than-art meanings."

A black marriage

Reinhardt's own efforts at such purification took the form of marrying the two major paradigms of abstraction that had been brought to their pitch of perfection early in the century:

the grid and the monochrome. For by all but suppressing the demarcations of the grid, Reinhardt's black paintings [1] produce something that approaches the unbroken surface of monochrome painting, thereby doubly ruling out the possibility of distinguishing anything like a "figure" as distinct from a "ground" and, with the same stroke, rejecting any sense that the work could summon an "elsewhere," whether through the association to a window or to a mirror. The resultant self-reference is the supposed guarantee of both grid and monochrome: beginning and ending with themselves (if the grid "describes" anything, this is merely the very surface it serves to map and thereby to redouble), there are no "other-than-art meanings" involved.

But Reinhardt's blithe insistence that this art, and these paradigms, are "out of time" is where the seeming obviousness of his argument breaks down. For, on the contrary, temporality haunts abstract art, even though, in its rage to purge all forms of narrative from its domain, abstraction strives to establish the pure simultaneity characteristic of a spatial art as distinct from a temporal one. Abstract art's involvement with time consists of the historical dimension that supports abstraction as a specific project, making every pure painting the "ultimate" or last work of its kind, the final, culminating member of a progressive series, or alternatively, as a peculiar extension of this logic, the first in a completely new type of art whose history is yet to be written. This had been the logic behind Aleksandr Rodchenko's triptych of monochrome panels *Pure Red Color, Pure Yellow Color, Pure Blue Color* (1921), which the Russian critic Nikolai Tarabukin saw as the "last picture," but which Rodchenko himself considered the emergence of the work-as-object. This was also the logic that drove Piet Mondrian "forward" toward an ever purer sublation of the oppositions within painting so that eventually painting itself could be transcended—both preserved and *overcome* by passing beyond itself and into the social field as a whole. Reinhardt participated in this aim when he stated of his black paintings: "I'm merely making the last paintings which anyone can make."

This sense of a historical tide that buoys these projects contains other temporal aspects as well. Undertaken as a form of resistance against the historical forces threatening to penetrate the domain of the work—either from the "left," by contaminating its purity with

▲ 1937b ● 1928a, 1947a, 1959e, 1967c ▲ 1911, 1913, 1915, 1917a, 1917b, 1921b, 1944a ● 1921b ■ Introduction 3, 1917a, 1944a

460 1957b | The grid and the monochrome

1 • Ad Reinhardt, _Abstract Painting, No. 5_, 1962
Oil on canvas, 152.4 × 152.4 (60 × 60)

elements of social ideology and utility, or from the "right," by corrupting its materiality with the signs of privilege, specialized skill, etc.—an artist's withdrawal into the grid or the monochrome is, if only implicitly, an acknowledgment of those very forces. Each instance of abstraction is historically specific, the circumstances surrounding the onset of Rodchenko's primary color panels in the thirties (Soviet revolutionary production), for instance, differing ▲ widely from those conditioning Lucio Fontana's or Yves Klein's own practices of monochromy in the forties and fifties (the advertising and "spectacle" culture of the aftermath of World War II).

By referring to this phenomenon of reinvention or repetition so characteristic of abstract art—in which we experience wave after wave of the modular grid or absolute monochrome—we encounter another dimension of abstraction's inherent temporality. This aspect has less to do with the idea of each purified painting as the last of its kind than with the notion that each is a total break from anything that could have come before it; and that being thus an origin, each instance of this paradigm is an original. The self-deception necessary to maintain the fiction of one's "originality" when manifesting a form that is as old as cave painting (as is the

▲ 1959a, 1960a, 1967c

case with the modular grid) calls, however, for an explanation. For, while certain parts of the early twentieth-century avant-garde turned to these forms precisely as a badge of anonymity to be worn against the decadence of individualism in art, the postwar avant-garde increasingly asserted its repetitions of these identical paradigms as acts of original invention.

▲ It is possible to suggest that the very ambivalence built into these paradigms of abstract art—suspended as they are between the polar oppositions of pure idea versus absolute matter—means that however simple such a paradigm might be it is characterized by an unresolvable internal conflict. Further, one could argue, it is just this conflict that drives the need to "reinvent" the form at the same time that it fuels the denial that such occurrences are in fact repetitions. The French structural anthropologist Claude Lévi-Strauss was struck by the phenomenon of this type of repetition as it manifests itself in myths, in which the same story is layered with repeated "mythemes," or kernels of identical meaning-structure, that are restaged by different characters and within seemingly different episodes of the narrative. Lévi-Strauss's structuralist explanation for this repetition turns on the very question of ambivalence that characterizes the phenomenon of visual abstraction. The myth itself, he claimed, is a response to a deep cultural contradiction that cannot be resolved but only returned to over and over, like the loose tooth one continually probes with one's tongue. Myth is the form of these returns; it is a type of narrative in which an unresolvable problem in the real is temporarily relieved by being repeatedly suspended in the realm of fantasy.

This analogy with the myth's compulsion to repeat permits two aspects of the painterly situation to come into focus at once. First, it illuminates the way the abstract paradigm will be the vehicle of serialization within a given artist's practice: the repetition of the *same* format spun out in a long chain of minutely varied replicates. And second, it underscores the fact that the utterly simple form will nonetheless generate a sense of internal contradiction: the anonymous character of the unadorned monochrome taking on, in Yves Klein's case, the insistent individualism of the "signature" object (as he slightly rounds the corners of his rectangular panels or applies his patented [!] pigment "International Klein
● Blue"); or in the case of the nine-square grid of Reinhardt's last black paintings, the reduction of the work to its purest logical statement—the "idea"—paradoxically promoting an experience of the most indefinably and irrationally optical shimmer—"matter"—that constantly eludes the viewer's grasp.

Pure paradox

Two careers that developed at about the same time as Reinhardt's last series of black paintings (executed 1960–4) adopted the same fusion of grid and monochrome and demonstrated the same contradictory conditions of the form. One of these careers was Agnes Martin's (1912–2004), the other was Robert Ryman's (born 1930).

Coming to New York in the early fifties from the open planes of Northern Saskatchewan, where she grew up, and of New Mexico, where she studied, Agnes Martin gravitated toward that part of the New York School that had avoided gestural painting, adopting instead fields of unbroken color and vastly simplified, geometricizing compositional strategies: Mark Rothko, Ad Reinhardt (his grid pictures of the early fifties having for the most part been either all
▲ red or all blue), and Barnett Newman. Wanting to express subjective thoughts and emotions that have no objective counterpart in nature, Martin turned to abstraction as a way to achieve "not what is seen," as she put it, but "what is known for ever in the mind."

The method she had developed by 1963—and which she never changed thereafter—consisted of penciling a fine linear, edge-to-edge grid onto six-foot-square canvases treated with a thin layer of gesso. In the first of these grids she used colored pencils, but by 1964 Martin had switched to simple graphite so that monochromy took over these pictures, which, nonetheless—to the astonishment of their observers—were able to achieve an extraordinary visual variety [2]. Because she endowed that variety with titles evocative of the natural world—*Falling Blue*, *Leaf in the Wind*, *Milk River*, *Orange Grove*—and because of the strong impression of effulgence generated by the gridded fields as they appear to give off an indefinable light, Martin's paintings were soon seen as analogues of nature. They came to be read along the lines that had begun to be applied to Newman, Rothko, and Reinhardt in the seventies, when a rage to thematize abstract art insisted on interpreting even the starkest grid or the most ascetic monochrome phenomenologically
● in iconographic terms associated with the idea of the "Sublime." As we have seen, this possibility is something that appears endemic to the grid itself: its even spread of potentially limitless, identical units always capable of generating metaphysical, transcendentalist associations, no matter how seemingly "mechanical" or "automatist" such a schema might be.

The strength of Martin's art, however, is that it mobilizes the very spiritual/material ambivalence built into the grid to effect another order of meaning altogether, one we could characterize as "structuralist." For the luminous, atmospheric haze exhaled by Martin's surfaces occurs only as a middle term between two other experiences of the paintings. The first, when one views the works close to, is of overwhelming material specificity: the unevenness of the penciled lines as they skim the top of the canvas weave but fail to enter its crevices; the ghost of a set of lines visible under the coat of gesso, echoed by their double on top of it, etc. It is only when one backs away from the surface far enough for the mesh of the grid to dissolve, visually, that the sensation of luminous atmosphere replaces the one of particular matter. But then, as one backs up even further, this visual mist opacifies into a densely flattened wall, becoming thus another, more general, form of the material itself. In other words, the canvases become "luminous atmosphere" only in relation to—that is, by *differing* from—the other experiences of the works as material objects, and vice versa.

In this sense we could say that Martin's art is not involved in "picturing" anything specific, whether that be clouds or sky or light or sublime immensity. Instead, working as a structuralist might,

2 • Agnes Martin, *Leaf*, 1965
Acrylic and graphite on canvas, 183 × 183 (72 × 72)

▲ she has generated a structural paradigm in which atmosphere becomes less a question of intuition and more a unit in a system, one that converts it from a signified (the content of an image) to a signifier—"atmosphere"—the open member of a differential series: "wall" as opposed to "mist"; "canvas weave" as opposed to "unlocatable luminosity"; "form" as opposed to "formlessness."

The operation of the structural paradigm means, then, that something is experienced not in terms of a phenomenological plenitude ("this luminous mist I *see* before *me*") but in constant relation to what it is not ("luminosity" = "not opacity")—a presence always shadowed by its own absence. It is this that makes a

reductive reading of Martin's work as "pure spatial immensity" or "pure spirit" impossible.

Painting the paint

In the case of Robert Ryman the drive toward a phenomenological interpretation has been equally common, except that here it moves not in the direction of "spirit" but in that of "matter." Emerging in the late sixties (his first solo exhibition was in 1967; in 1969 ▲ he participated in "When Attitudes Become Form" in Berne and London and in "Anti-Illusion: Procedures / Materials" at the Whitney

▲ Introduction 3, 1912

▲ 1969

3 • Robert Ryman, *Winsor 34*, 1966
Oil on linen canvas, 160 × 160 (63 × 63)

Museum in New York), Ryman was seen as a Process artist, his gridded all-white surfaces the sum total of a series of manipulations of the brute materials of painting itself. In the group of works called *Winsor* [**3**], for example, it is self-evident that the two-inch-wide brush has been charged with white oil paint and dragged across the canvas in parallel rows, with each swipe of the brush covering from eight to ten inches before running out of pigment and having to be reloaded. The slight breaks in facture between the tailing off of the stroke and the ridge of material where the stroke starts again create a series of verticals in counterpoint to the horizontal gaps between the rows through which the warm brown of the canvas is visible.

Describing this process as his attempt to "paint the paint," Ryman restricted his materials to types of white pigment—casein, gouache, oil, Enamelac, gesso, acrylic, etc.—which he laid onto a wide range of supports—newsprint, gauze, tracing paper, corrugated cardboard, linen, jute, fiberglass mesh, aluminum, steel, copper, etc.—and manipulated with a variety of applicators—brushes of varying widths (up to twelve inches), knives, ballpoint pen, silverpoint, etc. This has cast a spell of pure positivism over his work; it is seen as the sum of a set of past operations that can be reconstructed in the present from the evidence before one. It is thus understood as both pure matter and the states of its evolution as that unfolded in time.

4 • Robert Ryman, *VII*, 1969
Enamelac on corrugated paper (seven units), each 152.4 × 152.4 (60 × 60)

But Ryman defies this temporal continuum, just as Martin defies the notion of an unbroken spatial immensity. He is also operating in relation to the structural paradigm when, for example, in the series *III*, *IV*, *V*, and *VII* [**4**], he applies three obliquely scumbled rows of Enamelac (a flat-white-pigmented shellac primer) to thirteen five-foot-square panels of corrugated paper, carrying out this continuous gesture over only three units of the series at a time. The result is that in *VII*, say, there are discontinuities in the stroke that make the "process" of the gestures impossible to reconstruct, thereby opening up the continuity of process to its opposite: the discontinuity of the unique, implosive object. Ryman's "matter," as fungible in the binary operations of the system as is Martin's "spirit," unpacks and is unpacked by the internal contradictions of the grid. RK

FURTHER READING
Yve-Alain Bois, "Ryman's Tact," *Painting as Model* (Cambridge, Mass.: MIT Press, 1990) and "The Limit of Almost," *Ad Reinhardt* (New York: Museum of Modern Art, 1991)
Benjamin H. D. Buchloh, "The Primary Colors for the Second Time," *October*, no. 37, Summer 1986
Rosalind Krauss, "Grids," *The Originality of the Avant-Garde and Other Modernist Myths* (Cambridge, Mass.: MIT Press, 1985) and "The/Cloud/," *Bachelors* (Cambridge, Mass.: MIT Press, 1999)
Robert Storr, *Robert Ryman* (New York: Harry N. Abrams, 1993)
Suzanne P. Hudson, *Robert Ryman: Used Paint* (Cambridge, Mass.: MIT Press, 2009)
Lynne Cooke and Karen Kelly (eds), *Agnes Martin* (New Haven and London: Yale University Press, 2011)

1958

Jasper Johns's *Target with Four Faces* appears on the cover of *Artnews* magazine: for some artists like Frank Stella, Johns presents a model of painting in which figure and ground are fused in a single image-object; for others, he opens up the use of everyday signs and conceptual ambiguities alike.

On January 20, 1958, only two weeks after the *Artnews* cover appeared, Jasper Johns opened his first solo show at the Leo Castelli Gallery in New York. It consisted of six paintings of concentric targets, including *Target with Four Faces* [1]; four paintings of the American flag, including the first *Flag* [2], five paintings of stenciled numbers, both single and serial; as well as a few paintings with literal objects attached like *Drawer* and *Book* (both 1957). The show sold out, with four paintings bought by the legendary curator Alfred H. Barr, Jr. for the Museum of Modern Art alone. Such a debut was unprecedented, and it seemed to signal changes in the culture of the art world. There was a new premium on youth (Johns was only twenty-seven at the time) and promotion (how else could an unknown artist appear on the *Artnews* cover?). The turnover of styles was also accelerated, for the banal references and impersonal brush-strokes of the paintings were immediately seen as a trumping of the lofty subjects and charged gestures of Abstract Expressionism, which was still very much on the scene. Yet Johns was no wild child. The show represented three years of sustained production (in the fall of 1954 he had destroyed most prior work as derivative). And he was already active in a circle that included Robert Rauschenberg, with whom he was intimate, artistically and romantically, from 1954 to 1961, the composer John Cage and the choreographer Merce Cunningham (1919–2009), for whom he designed sets and costumes, and others such as the performance artist Rachel Rosenthal (1926–2015).

A constant negation of impulses

In part, the association with Cage and company led early critics such as Thomas B. Hess, director of *Artnews*, and Robert Rosenblum to affix the new label "neo-Dada" to Johns. But Johns was involved less with the anarchic attacks on art made by Dada than with the ironic investigations of its significance undertaken by Marcel Duchamp, whose work he encountered in 1958 at the Philadelphia Art Museum (they met a year later). Duchamp would remain a crucial point of reference for Johns. The same is true of the philosopher Ludwig Wittgenstein, whose critiques of language appealed to his sense of "physical and metaphysical obstinacy," as Johns wrote in a sketchbook note (he began to read Wittgenstein

around 1961, an interest soon picked up by other artists of his generation, especially Conceptual artists).

The influence of both men, especially Duchamp, can be seen in the signature strategies of his early work. Johns used "pre-formed, conventional, depersonalized, factual, exterior elements" (as he described his "Flags" and "Targets" to his best critic, Leo Steinberg). He played with different orders of signs—visual and verbal, public and private, symbolic and indexical (that is, signs made by physical contact, like handprints or plaster casts). He also liked to render literal things ambiguous, even allegorical; for instance, the "Flags" are at once advanced paintings, obdurate objects, and everyday emblems. So, too, he tended to evoke a self that was divided by its own language, by its different signs, in opposition to the Abstract Expressionist self said to be made whole in the very act of painting. Again, much of this provocation resonates with Duchamp, whom Johns also inflected for other artists, just as Cage had inflected Duchamp for Johns. At issue here, then, is less influence than transformation. As Johns commented after Duchamp died in 1968, one of his lessons—again in opposition to Abstract Expressionist belief—was that no artist determines his work finally. Not only does the viewer have a share, but subsequent artists also interpret a body of work, reposition it retroactively, and so carry it forward as well.

Duchamp, Johns wrote, "moved his work through the retinal boundaries which had been established with Impressionism into a field where language, thought and vision act upon one another." Johns inaugurated a similar shift in relation to Abstract Expressionism. Yet, in order to break with it effectively, he first had to be connected with it. And his "Flags" and "Targets" exceed Abstract Expressionism on its own criteria—that is, they are flatter as surfaces, more "allover" as images, more fused as picture and support, than any Abstract Expressionist precedent. In this way, Johns raised the ante of advanced American painting in the late fifties, only to change the game, for he scored these formal points through means forbidden to Abstract Expressionism—by recourse to everyday cultural signs like flags and targets. This was a twist with a knife attached, for Johns responded to Abstract Expressionism with terms that seemed opposed to it: here was painting that was abstract but also representational in mode, gestural but also

▲ 1927c ● 1953 ■ 1914, 1918, 1935, 1966a, 1993a ▲ 1968b ● 1953

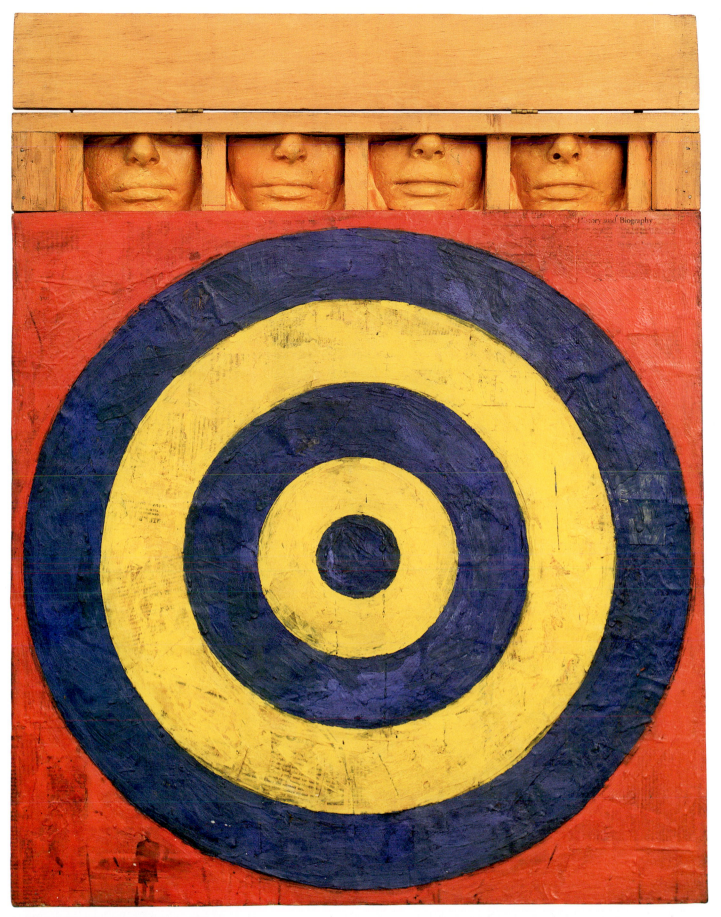

1 • Jasper Johns, *Target with Four Faces*, 1955
Assemblage, encaustic on newspaper and cloth over canvas surmounted by four tinted plaster faces in wood box with hinged front, 85.3 × 66 × 7.6 (33⅝ × 26 × 3)

2 • Jasper Johns, *Flag*, 1954–5
Encaustic, oil, and collage on fabric mounted on plywood (three panels), 107.3 × 154 (42¼ × 60⅝)

impersonal in facture (his brush-strokes often appear repetitive), self-referential but also allusive in image (abstract stripes and circles that are also flags and targets), pictorial but also literal in ▲ association (in the otherwise nonobjective *Canvas* [1956], a little stretcher is simply attached to the canvas), and so on.

For this suspension of opposites Johns found a perfect medium in encaustic, a wax base that preserves each gesture of the brush—but preserves it dead, as it were, like a fly in flypaper. Encaustic also allowed Johns to bind the picture to its support in such a way as to render the painting as much an object as an image. Finally, it permitted the suspension of other materials as well, such as the collage of newspaper and fabric that Johns often used in his early work, in a dense palimpsest of surfaces. This layering injects a sense of time into the space of the painting—not only the actual time of the complicated making of the work, but also an allegorical time of different meanings and/or suggested memories. For example, over the bedsheet that provides the base of *Flag* [2], near the center amid other bits of newspaper that make up its ground, appear the ghostly words "pipe dream." This phrase might allude to the story that the flag first appeared to Johns in a dream (which characteristically renders this public sign a private talisman as well).

At the same time, it also points to the conundrum of a painting of a flag that is not a flag (in 1954, at the Sidney Janis Gallery in ▲ New York, Johns had seen a version of *The Treachery of Images* (1929) by René Magritte, the famous Surrealist puzzle-picture of a pipe captioned with its own verbal disclaimer "Ceci n'est pas une pipe"—"This is not a pipe"—beneath it). Already at work in his debut painting, then, is this distinctively Johnsian play with contradiction and paradox, irony and allegory. Again and again Johns states one thing, only to imply another (this is one definition of irony), or he collides different levels of meaning or different kinds of signs (this is one definition of allegory). As he wrote in a sketch-book note circa 1963–4, "One thing working one way / Another thing working another way / One thing working different ways at different times." The trick here is that this ambiguity is effected by means of the literalism of his flags, targets, numbers, maps, and the like, not in opposition to it—by means of "things the mind already knows," Johns added in an early statement. "That gave me room to work on other levels."

"My work became a constant negation of impulses," Johns remarked in retrospect. This negation is not just a display of sophistication, as it first appeared to Steinberg, for whom "the

▲ 1962d

▲ 1927a

moral" of the early work was that "nothing in art is so true that its opposite cannot be made even truer." Nor did the collision of the visual and the verbal, the pictorial and the literal, simply cancel the aesthetic of Abstract Expressionism. Rather, it preserved the model

▲ of painting as represented by Jackson Pollock in a tense suspension with its avant-gardist opposite as represented by Duchamp. The "impulses" negated here are thus aesthetic imperatives as much as personal inclinations. Indeed, one reason why Johns became central so quickly is that he was able to suspend the contradiction between the basic imperatives at work in the postwar avant-garde—the legacy of Pollock (after his death in 1956) *and* the provocation of Duchamp (whose work became current again around the same time). More precisely, he was able to develop these opposed paradigms into a distinctive art of ambiguity.

The watchman and the spy

And yet, despite all the European wit drawn from Duchamp, Magritte, and Wittgenstein, Johns also possessed the homespun wisdom of an American pragmatist (early on, the critic Hilton Kramer disparaged his art as "a kind of Grandma Moses version of Dada"). This aspect led Steinberg, in his brilliant essay on Johns, to rehearse the making of the early work as if it were a recipe found in an almanac: a recipe of "man-made things" that are "common-places of our environment," of "whole entities or complete systems" with "conventional shapes" that underscore the flatness of the painting and prescribe its dimension. These procedures suggest how Johns could be adapted by both Pop artists (who also would use "commonplaces of our environment") and Minimalist

• artists (who also would use "whole entities or complete systems"). Yet the implications of his method were both less matter-of-fact and more far-reaching.

First, Johns advanced a novel paradigm of the picture. Especially in paintings after 1958 he used stencils, often of words of colors at odds with the actual painted colors on the canvas (as in *Periscope [Hart Crane]* [3], where we read primary colors but see mostly grays and blacks). In front of such works, Steinberg intuited "a new role of the picture plane: not a window, not an uprighted tray, nor yet an object with active projections into actual space, but a surface observed during impregnation, observed as its receives a message or imprint from real space." Several years later, in a celebrated essay on Rauschenberg, Steinberg saw in this reorientation of the picture—as a site for the reception of signs rather than as a screen for the projection of views—a "postmodernist" shift from "nature" to "culture" as the primary frame of reference of art. For Steinberg this shift required "other criteria"—other, that is, to the

■ formalist criticism of Clement Greenberg that was dominant at the time—and its first suggestion was here with Johns. Second, Johns intimated a novel persona of the artist. "Everything has its use and its user, and no need of him," Steinberg remarked of the pragmatic objectivity of materials and methods in Johns, and this withdrawn subject suggested a posture of "sufferance rather than action"—

Ludwig Wittgenstein (1889–1951)

Defiantly anti-idealist, the Viennese-born philosopher Ludwig Wittgenstein labored to purge our conceptions of language of their persistent Platonism. His *Philosophical Investigations* (1953) performed a radical critique of the very idea of "expression," a concept essential to various forms of abstract art, especially Abstract Expressionism. Expression depends on the idea of an intention to express a meaning; intention is thus understood as a will to meaning that precedes its verbal or visual articulation. In this light, Wittgenstein argued, intention involves a picture of mental life that is private, unknowable to others but immediately available to ourselves.

Instead of this idea of private meanings to which each of us has unique access, Wittgenstein maintained that "the meaning of a word is its use." In particular he advanced the idea of "language games" based on "forms of life." Language games are patterns of verbal behavior that are social in nature and are learned interpersonally. Private expression makes no sense in such a universe: "If a lion could talk," Wittgenstein wrote, "we could not understand him."

One of the first artists to mediate on the implications of this critique for art was Jasper Johns. His use of rulers as "devices," for example, questioned the autographic stroke as the expression of a private meaning; indeed, much of his work can be seen as the performance of "language games." Minimalist, Conceptual, and Process artists then developed the Wittgensteinian skepticism regarding private language in various ways.

again in opposition to Abstract Expressionism. This is the beginning of another "postmodernist" shift to a sometimes affectless or antisubjective stance—an "aesthetics of indifference" (as the critic Moira Roth later termed it) that became radical with some Pop and

▲ Minimalist artists (think of Andy Warhol).

Johns may "insinuate absence" with his given signs, as Steinberg remarked, but a personal subject is nonetheless residual in his everyday emblems, suspended brush-strokes, and fragmentary casts. It is a subject that seems split in both its "memory imprints" (as Johns wrote in 1959) and its "changing focus" (no phrase is more recurrent in his early sketchbooks) as it moves across different kinds of motivations and meanings. It is also a subject that seems split in relation to the viewer. In an extraordinary elliptical note from 1964 that is again evocative of Duchamp, Johns allegorized this split subjectivity in terms of two personae, "the watchman" and "the spy," and there is little doubt with whom he identifies: "The watchman falls 'into' the 'trap' of looking.… That is, there is a continuity of some sort among the watchman, the space, the objects. The spy must be ready to 'move,' must be aware of his entrances and exits.… The spy stations himself to observe the watchman." It might be this spying on our watching that often lends to his work, even in its most literal aspect, its uncanny effect of gazing back on us as we gaze on it.

1950–1959

▲ 1949a, 1960b ● 1960c, 1962d, 1964, 1965 ■ 1960b ▲ 1962d

3 • Jasper Johns, *Periscope (Hart Crane)*, 1963
Oil on canvas, 170.2 × 121.9 (67 × 48)

In 1964 Johns had an exhibition at the Jewish Museum in New York, which disclosed how provocative his early work was to various artists. Its philosophical puzzles were crucial to Conceptual
▲ artists like Sol LeWitt (1928–2007) and Mel Bochner (born 1940), whose slogan "Language is Not Transparent" could stand as a Johnsian motto as well. Its indexical markings (for example, the handprint in *Periscope* or the piece of wood spun on its axis so as to smear circles of paint in *Device* [1961–2]) were suggestive to
● Process artists, even though the actual making of most works by Johns is difficult to reconstruct. And, of course, its use of cultural signs supported Pop art just as its insistence on painting as an object abetted Minimalism (some works, such as *Flag on Orange Field* [1957] where a "Pop" image floats on a "Minimalist" mono
■ chrome, combine both tendencies). The connection to Pop is obvious enough; the relation to Minimalism was explained
◆ succinctly by Robert Morris (born 1931) in 1969, in the fourth installment of his "Notes on Sculpture": "Johns took the background out of painting and isolated the thing. The background became the wall. What was previously neutral became actual, while what was previously an image became a thing."

What you see is what you see

In this passage from the Johnsian image-thing to the Minimalist object a crucial mediation was provided by Frank Stella (born 1936), whose debut in the important "Sixteen Americans" show curated by Dorothy Miller at MoMA in 1959 was even more precocious (he was twenty-three) than that of Johns in 1958. Stella did not delight in Johnsian ambiguities; he seemed to see them as "dilemmas" to resolve rather than paradoxes to indulge (one painting is titled *Jasper's Dilemma*). His early work kept the stripes of the "Flags" but dropped the symbol. *Coney Island* (1958), for example, is an abstract banner, an island of black on a sea of orange and yellow stripes. But Stella wanted to expunge even this residue of a figure–ground relation, which his "Black Paintings" (1959) did without mercy. *Die Fahne Hoch!* [4] is the best-known work in this series, in part because its notorious title ("Flags on High!") cites the official marching song of the Nazis. Yet this reference is more formal than thematic: the painting is sized like a banner, cruciform like a swastika, even black like a fascist uniform. It is also huge (ten feet by six), with a stretcher almost three inches in depth; and this depth suggested the width of the stripes, which Stella graphed in enamel on the canvas in a way that reiterates the cruciform of the stretcher. The cross at the center repeats the most basic form of a vertical figure against a horizontal ground, but this figure–ground relation is underscored here, only to be undone. This occurs not only through the excessive elaboration of the black stripes, but also because the whitish lines between them, lines that appear to be "the figure" on top, are in fact "the ground" underneath—they are the unpainted ground of the canvas showing through the black paint. Where Johns might be playful about this fact, Stella is positivistic; where all is "changing focus" in Johns,

4 • Frank Stella, *Die Fahne Hoch!*, 1959
Black enamel on canvas, 308.6 × 185.4 (121½ × 73)

"what you see is what you see" in Stella (this deadpan line is his best-known comment on his early work).

"There are two problems in painting," Stella remarked in this same manner in 1960. "One is to find out what painting is and the other is to find out how to make a painting." In effect his solution was to combine the two problems—to show what painting is through a demonstration of its making. For his college friend, the critic Michael Fried, who wanted to enlist Stella in his narrative of
▲ modernist abstraction, this logic stemmed from Cubism by way of
● Mondrian. For his schoolboy friend, the Minimalist Carl Andre, who was at work on a different genealogy of modernism, this logic was Constructivist in its materialism (Stella applied "identical, discrete units," Andre once commented, "[that] are not stripes, but brushstrokes"). "Carl Andre and I were fighting for his soul," Fried remarked in retrospect, and the debate continued through the midsixties at least. In 1960 Stella began to use metallic (aluminum and copper) and house paints; he also began to shape his canvases, first with small notches that redirected the stripes, then with large planar

5 • Frank Stella, *Takht-i-Sulayman***, 1967**
Polymer and fluorescent polymer paint on canvas, 304.8 × 609.6 (120 × 240)

additions. For Fried these new paints effected a sheer opticality; for Andre they signified a banal materiality. For Fried the new shapes structured the images "deductively," internally, without the need of a found image like a flag to do so; this shaping rendered the paintings even more autonomous. For Andre the shapes called out for three-dimensional objects in actual space; they suggested a site-specific practice, not an autonomous one. In short, just as Johns answered both expectations raised by Pollock and Duchamp with an enigma of his own, so Stella could be claimed by some artists and critics as the epitome of late-modernist painting and by others as the origin of Minimalist objects.

Both camps saw a strict logic in Stella, a declarative logic of the stretcher mapped onto the canvas in the "Black Paintings," of the image made coincident with the support in the notched paintings, of the painting grounded in known shapes and simple signs, and so on. Yet as the shapes became more eccentric, this logic became more arbitrary. Image and support were still coterminous in the "Protractor" series [5], but they began to be conflicted as well, and the structures did not appear so necessary or persuasive. By the middle of the seventies the works became hybrids, neither painting nor sculpture, that first quoted Cubist collage and Constructivist construction, and then mixed different codes of historical and modernist art. This assemblage was pushed to the point in the eighties where fragments of semi-Baroque forms, skewed grids, pop-geometric forms, and exorbitant colors and gestures might collide in the same aluminum construction. Stella seemed to pass from a modernist analysis of painting to a posthistorical pastiche of styles. If one moral of Johns is that "nothing in art is so true that its

opposite cannot be made even truer," one moral of Stella is that no pictorial logic is so guaranteed that it cannot be repudiated.

But this crisis in pictorial logic is not his alone. It points to a greater crisis in histories of modernism in the seventies and eighties—histories in which one great artist is seen to father the next master in a strict line of influence, and in which the importance of this heir depends on his furthering of the grand succession of artists. Like his guardian angels Fried and Andre, Stella is of a generation that possesses a heightened consciousness of modernism and an ambitious sense of place in its unfolding (or undoing). In the debates about this unfolding, there is a fine line between historicist narratives of influence and succession and other accounts of historical connection and disconnection. Historicist accounts can be very enabling, indeed ennobling, but they can also be constraining. "Stella wants to paint like Velázquez," Fried is reported to have commented once, "and so he paints stripes." The very rigor of the implicit narrative of painting here—a rigor that offers lofty connection to the past but at the price of severe reduction in the present—suggests why Stella might have wanted to break out of this late-modernist history, perhaps to repudiate it histrionically, even though he is deemed one of its principal protagonists. HF

FURTHER READING

Michael Fried, *Art and Objecthood* (Chicago: University of Chicago Press, 1998)
Jasper Johns, *Writings, Sketchbook Notes, Interviews* (New York: Museum of Modern Art, 1996)
Fred Orton, *Figuring Jasper Johns* (Cambridge, Mass.: Harvard University Press, 1994)
William Rubin, *Frank Stella* (New York: Museum of Modern Art, 1970)
Leo Steinberg, *Other Criteria: Confrontations with Twentieth-Century Art* (London, Oxford, and New York: Oxford University Press, 1972)
Kirk Varnedoe, *Jasper Johns* (New York: Museum of Modern Art, 1996)

▲ 1912, 1921b, 1928a

Lucio Fontana has his first retrospective: he uses kitsch associations to question idealist modernism, a critique extended by his protégé Piero Manzoni.

At the time of the first fully fledged retrospective of his work in the fall of 1959 (in galleries in Rome and Turin), Lucio Fontana (1899–1968) had just begun the series of *Tagli* (or cuts) that would dominate the last decade of his production and become his trademark (he had exhibited his first attempts in this vein, pastel-colored canvases punctuated by many short slices that dated from the previous year, in February in Milan and March in Paris). This near coincidence was a mixed blessing. Dramatized by Ugo Mulas's cannily staged photographic sequence showing the process of creation, from the artist's meditative hesitation in front of his blank canvas to his satisfied contemplation after the act, Fontana's iconographic gesture—the razor-sharp slashing of a monochrome stretched canvas—would overshadow the rest of his enormously diversified production. The scores of *Tagli* that would invade the market in the sixties and the Janus-like rhetoric they would generate—quasi-mystical paeans to a so-called "search for the absolute" on the one hand, and hyperbolic glorifications of the theatrics of violence on the other, a couplet quite similar to that ▲ consciously exploited by Yves Klein—would cast a long shadow over the seriousness of Fontana's enterprise.

The dialectic of avant-garde and kitsch, undone

Though a *catalogue raisonné* of his work had appeared as early as 1974, it was only in the late eighties, after the large exhibition at the Centre Georges Pompidou in Paris, that Fontana's critical fortune changed and he began to be seen, at last, as one of the most important postwar European artists. Such a belated recognition is not a rare phenomenon in itself, but it is particularly striking in the case of Fontana—an artist who unashamedly dallied with the culture industry of the Reconstruction period (with a particular attraction for the glitz of glamour) and who never recoiled at any commission for a decorative piece (from the ceiling of a movie theater or a shop to the monumental door of a cathedral). It is, in fact, Fontana's immersion in the universe of kitsch that paradoxically accounts for the slow emergence of his centrality, as this recognition could happen only at the moment when the dialectical opposition between kitsch and the avant-garde that had dominated cultural criticism ever since the origins of modernism had begun to lose its edge.

Simultaneously (and independently) theorized by both Clement ▲ Greenberg and Theodor Adorno in response to the totalitarian threats of fascism and Stalinism, this dialectical account posits that the experimental work of the avant-garde is the only possible safeguard against the inevitable devolution of any cultural practice and form of production into the condition of the commodity under the rule of capitalist economy. Inadvertently, Fontana threw a monkey wrench into the mechanism of this well-established explanatory model. Unlike the Nouveaux Réalistes in the sixties (who hailed ● him as a forerunner) or the Pop artists, he did not consciously rebel against the suffocating effects described by the Greenberg/Adorno argument by elevating the debased commodity to the status of a cultural artifact—an oppositional stance that would only confirm the grip of the dialectical model. Fontana did not *appropriate* kitsch, which would have presupposed a critical, highbrow point of view (for, in order to exploit kitsch, to enjoy kitschiness, one must stand at some remove from it, protected by ironic distance and by a smug confidence in one's own good taste). He did not have to appropriate kitsch (nor could he have done so), for he was mired in it ever since the very beginning of his career: with him, the tight wall separating commercial kitsch from avant-garde art had become utterly porous—a deconstructive endeavor that becomes apparent only if one examines the work that has been eclipsed by the *Tagli*. This means, for the most part, paying attention to his vastly underrated sculpture, keeping in mind that he did not begin to paint until 1949, at the age of fifty.

As the son of an Italian commercial sculptor who emigrated to Argentina (and specialized in funerary monuments), Fontana was exposed to the epitome of kitsch: nineteenth-century *pompier* sculpture. Entering the Milan School of Fine Arts (academic kitsch) at the end of World War I, he returned to Argentina in 1922 (where he ■ emulated Art Deco, Maillol, and Archipenko—modern kitsch). Back in Italy six years later, he was tempted for a while by the antimodernist revisionism of Novecento (revisionist kitsch), a movement soon to receive a stamp of approval from Mussolini's regime.

If up to 1930 Fontana had only been following the well-trodden path of what could be called an "officially sanctioned bad taste," in that year his endorsement of kitsch suddenly became *outré*, extravagant—in direct contradiction to the request for decorum made by

1 • Lucio Fontana, *Butterfly*, 1938
Polychrome ceramic, 16 × 30 × 20 (6¼ × 11¾ × 7⅞)

2 • Lucio Fontana, *Ceramica spaziale*, 1949
Polychrome ceramic, 60 × 60 × 60 (23⅝ × 23⅝ × 23⅝)

the Italian state, whose bureaucrats were prompt to criticize this new direction in his work. The "primitivist" polychrome marble sculpture *L'Uomo nero* (Black Man) that Fontana made in that year was followed in 1931 by sculptures of enameled terracotta, polychrome bronze, gilded plaster, and ceramic, as well as engraved slabs of polychrome cement. Despite the great variety of styles employed in these works (most of the cement slabs are abstract, the terracottas are "expressionist-primitivist," the bronze and gilded plasters are academic), their common denominator is polychromy, an attribute of sculpture that had so offended the sensibilities of the German art theorist Johann Joachim Winckelmann in the eighteenth century, and which had subsequently been an anathema to modernist artists. True, there had previously been notable transgressions of the taboo against sculptural polychromy—by Gauguin, Picasso, and, closer to Fontana, the Polish Constructivist
▲ sculptor Katarzyna Kobro and the American inventor of mobiles,
● Alexander Calder. But these artists were mostly interested in testing the respective limits of painting and sculpture in relation to each other, an analytical inquiry that, as Fontana himself discovered after a brief modernist interlude of geometric abstraction in the mid-thirties, had little to do with his enterprise.

Rather than attempting to "paint in space," Fontana plunged back into a premodernist tradition—specifically that of the statuary and decorative objects produced in France during the Second Empire (1852–71), where the simultaneous use of many materials surreptitiously reintroduced polychromy—in order to reverse the very terms of this tradition. For whereas academic kitsch venerated finish and used color to conceal the materiality of the sculptural medium, Fontana made of color the very emblem of a radical materiality, its intrusion into the realm of sculpture becoming a

rude noise disturbing the homogeneous harmony advocated by aesthetic discourse. The numerous polychrome ceramic pieces he realized in the late thirties exacerbated the obscene basis of bad taste with a vengeance. For example, his *Lions* (1938), two enameled animals lying side by side, one pink, the other black (the colors of genitalia), and his pearly *Butterfly* of the same year [1] are reminiscent of Émile Gallé's Art Nouveau vases (which Le Corbusier detested and whose floral sexuality excited the Surrealists).

Fontana's base materialism

Returned to Argentina in World War II, Fontana once again followed his father's footsteps and became an official sculptor: back to square one—the hyperacademic style. But this was just a step back that allowed Fontana to jump forward, for in 1946, he and his students launched the *Manifesto bianco* (White Manifesto), in which he broke with both abstraction and figuration, attacked aesthetics, rationalism, and formalism, and announced his own concept of art called Spatialism (*Spazialismo*). A call for an atavistic regression, this text is an invocation to create an art of the instinct and of the undifferentiated, an art "in which our idea of art cannot intervene," an art, so to speak, liberated from ideas. As soon as he returned to Italy, in 1947, Fontana began to carry out this program in his work.

He took stock of his "base materialism," to use the term that
▲ Georges Bataille had elaborated in his journal *Documents*, that is, a materialism not grounded in concepts, in which matter is not subject to any ontology but is the agent of debasement of everything that is "high." Here again Fontana concerned himself with polychromy (in neo-Baroque, semiabstract reliefs in terracotta), but then he quite rapidly arrived at sculptures that look like

▲ 1928a ● 1931b, 1955b

▲ 1930b, 1931b

shapeless piles of mud, that seem to advocate the possibility of formlessness—of the material manifestation of what Bataille called the *informe*. From that point on, sculptural polychromy was no longer the essential medium through which Fontana issued his scatological cry, but just one among many as his base materialism got further and further down to earth.

A comparison between two of his sculptures allows one to locate rather precisely the moment at which his work definitively tipped toward the low. The first, dating from 1947 and currently entitled *Scultura nera* (Black Sculpture), since it is now in bronze, while originally a colored plaster, is a kind of ring made of balls of matter, positioned vertically like those flaming hoops through which circus animals are forced to jump. At the center a vaguely anthropomorphic, vertical excrescence emerges. The crown of balls still bounds an arena, like a stage on which something is about to happen. This last vestige of narrative is entirely swept away in Fontana's *Ceramica spaziale* of 1949 [2]: a cubic mass of blackish matter, with glossy and iridescent reflections on an extremely agitated surface, it seems to have fallen on the ground like an enormous turd. Geometry (form, the Platonic "idea") is not suppressed here but *debased*, brought down to the level of matter, which until then, in the history of Western culture, it had had the task of "suppressing by overcoming" (to use the classical term of Hegelian dialectics). Reason is being dealt a "low blow": there is no antithesis, merely a single obscenity lodged in the aesthetic house of cards, and one that threatens to topple it.

Now that he had identified his impulse as scatological, Fontana could at last begin to work in painting without having to fear the optical idealization that seemed to plague the medium (an idealization that had prompted Aleksandr Rodchenko before him and
▲ Donald Judd after him to leave painting altogether for the realm of objects). Indeed, in Fontana's hands, oil paint—the noblest material of pictorial art—often becomes a repugnant paste, and the myriad holes that puncture his very first canvases (the *Buchi* series that runs from 1949 to 1953) ostensibly highlight the materiality of the support. Furthermore, Fontana's courting of "infantile regression" gave a new, playful twist to his infinite appetite for kitsch: from the fake gems added to the punctured canvases (often painted in the sugar-sweet tones of a wedding cake's frosting) of the *Pietre* (Stones) series of 1951–8, to the diamond dust sparkles or acidic colors (candy pink or apple green) of the oval-shaped *La Fine di Dio* (End of God) series from 1963–4 [3]—not to speak of gold paint—Fontana never ceased to declare (*contra* Greenberg and Adorno, but also *contra* the aestheticism and Zen-like simplicity of his "cut" paintings) that in the midst of late capitalism the only morally tenable position is that of the irresponsibility of the toddler discovering the scintillating riches of a bazaar. And this "innocent" marveling extended to all the favorite domains of the postwar spectacle: television (for which Fontana wrote a manifesto and hoped to work); fashion (he designed jewels and was delighted when asked to provide props for photo shoots); commercial fairs and discothèque decors, where he often introduced what would become the vernacular use of new hardware equipment such as loopy neon tubes or black light.

The fundamentally nihilist undertone of Fontana's art did not escape his much younger compatriot Piero Manzoni (1933–63), whom he took under his wing in 1957. This date marks the abrupt beginning of Manzoni's meteoric career (until then his production was not-so-promising student work). What triggered this take-off
▲ was the exhibition of Yves Klein's blue monochromes in January of that year in Milan, which Manzoni assiduously studied. His first response was indebted to the pauperist aesthetic of yet another mentor, Alberto Burri (1915–95), whose assemblages of burlap bags, soon followed by pieces of burnt plastic, had also fascinated
● Robert Rauschenberg during his sojourn in Italy in 1952–3. Resisting the monochrome, Manzoni realized "compositions" in which layers of melted tar crack open to reveal, in variously disseminated streaks or craters, blobs of fiery reds or yellows. But by 1958, with his first *Achromes* (literally, "without color") Manzoni imported this *matiériste* and resolutely anti-idealist stance within the modernist trope of the monochrome, recently reactivated by Klein. The *Achromes*, which are all white, would constitute an ongoing series until Manzoni's untimely death at the age of thirty, but they evolved dramatically during such a short span.

At first, with pieces made of squares of cotton sewn into a grid, or of cleated sheets, both types whitewashed with the earthy yet milky substance of kaolin (a superfine clay used for porcelain),

3 • Lucio Fontana, *Concetto spaziale / La Fine di Dio*, 1963
Oil on canvas, 178 × 123 (70⅛ × 48⅜)

▲ 1921b, 1965 ▲ 1960a, 1967c ● 1953

Manzoni's *Achromes* seem only to conjure a genuine admiration for Klein (though the definitive censure of color could already be interpreted as a poke at Klein's grandiloquent aesthetics, largely based on the spectacular effects of chromatic saturation). Soon, however, Manzoni's vast array of white works would point in the ▲ direction of Klein's ultimate nemesis, that is, Marcel Duchamp, and thence return to Fontana in order to sharpen his negative lesson. This is because unlike the first *Achromes*, whose textile material highlighted their belonging to the pictorial tradition, the next batch, still bathed in kaolin, leaned toward the status of the object. These collages of rows of bread rolls stacked in grid fashion, or of pebbles, produce a strange combination, half macabre, half silly, of abstraction (monochrome) and readymade. The definitive step is when Manzoni decides to limit his intervention to a minimum (no collage, no whitewashing) and uses fragments of white materials untouched. This time the materials in question, such as Styrofoam or fiberglass, have nothing to do with the realm of painting but smack, on the contrary, of the toxicity of industrial production and the dangers of construction sites (an omnipresent reality in the immediate postwar Italy). Thus Manzoni's fiberglass *Clouds* [**4**], sometimes set in a red velvet box in order to strike the fetishist chord that connects disgust with erotic (once again, infantile) affect, spell out the nature of Fontana's attraction to kitsch: it is the culture of trash.

Furthermore, and directly mocking Klein's rhetoric of authorial grandeur and pseudomysticism, Manzoni leaned once again on Duchamp in order to single out the bodily impulses that had been at the core of Fontana's production. Against Klein's posturing and his appeal to immateriality, Manzoni conceived of the artist not as an ideal superhero but as an excremental machine: his edition of

5 • Piero Manzoni, *Socle du monde* (Base of the World), 1961
Iron, 82 × 100 × 100 (32¼ × 39⅜ × 39⅜)

Merda d'artista (Artist's Shit), identical cans, all numbered, supposedly containing the said matter, is the best-known example of this particular vein in his work, but the red balloons that he inflated (*Fiato d'artista* [Artist's Breath]) and left to their eventual fate of deflation are perhaps more telling. And it is not by chance that such an ironical attack against the very notion of the artistic, expressive, subject should have gone hand in hand with an investigation of the nature of the mark. In 1959–61, Manzoni mechanically generated a single line symmetrically bifurcating the length of rolls of paper (varying from less than a meter to more than seven kilometers). Each of these *Lines* was boxed individually in a tube, which means that, contrary to other gestures similarly steeped in a Duchampian ▲ tradition, such as Rauschenberg's *Tire Print* of 1953, the "lines" themselves are not visible: all you see is their tube, most often in cardboard but twice in chromed metal—a derision of Brancusi?—while the cylinder containing the longest *Line* is made of lead.

This deliberate frustration of our visual sense as a strategy of resistance against the spectacularization of culture, a strategy that makes of Manzoni one of the most important father figures
• of Conceptual art, climaxed in *Socle du monde* [**5**], a hollow parallelepiped of iron inscribed with its title (and the subtitle *Hommage à Galileo*) written upside down—a "base of the world" that rhymes with Fontana's regressive fantasies in signaling that, confronted with the entropic indifferentiation that is the future promised to us by late capitalism, there is no other solution than an utopian wish that everything be upturned. YAB

FURTHER READING
Yve-Alain Bois, "Fontana's Base Materialism," *Art in America*, vol. 77, no. 4, April 1989
Germano Celant (ed.), *Piero Manzoni* (London: Serpentine Gallery, 1998)
Jaleh Mansoor, "Piero Manzoni: 'We Want to Organicize Disintegration',"
October, no. 95, Winter 2001
Anthony White, "Lucio Fontana: Between Utopia and Kitsch," *Grey Room*, no. 5, Fall 2001
Sarah Whitfield, *Lucio Fontana* (London: Hayward Gallery, 1999)

4 • Piero Manzoni, *Achrome*, 1962
Fiberglass on board, 31 × 34 (12¼ × 13⅜)

▲ 1914, 1918, 1935, 1966a, 1993a

▲ 1953 ● 1968b

1959 b

At the San Francisco Art Association, Bruce Conner shows *CHILD*, a mutilated figure in a high chair made in protest against capital punishment: a practice of assemblage and environment is developed on the West Coast by Conner, Wallace Berman, Ed Kienholz, and others that is more scabrous than its equivalents in New York, Paris, or elsewhere.

In June 1957, officers from the vice squad of the Los Angeles Police Department entered the Ferus Gallery that the future curator and museum director Walter Hopps and the artist Edward Kienholz had opened just three months earlier. Following up on two anonymous complaints regarding the first (and last) exhibition of Wallace Berman's work, the squad officers were looking for pornographic material. Amazingly, they failed to notice the main offender, a lean assemblage entitled *Cross* [1], consisting solely of a battered wood cross planted on a wooden crate, from which hung, suspended by an iron chain at the end of its left arm, a small shadow-box framing the photographic close-up of an act of heterosexual intercourse inscribed with the Latin words "Factum Fidei" (fact of faith). In their blind zeal to find incriminating evidence, they leafed through the first issue of Berman's journal *Semina*, scattered among other printed matter on the floor of a telephone-booth-sized reliquary entitled *Temple*. They felt vindicated, at last, when zeroing in on the reproduction, within the pages of the journal, of a mediocre surrealizing and cartoonish drawing of a woman's rape by a phallus-headed monster. Confiscating the publication, they arrested the artist on the spot.

The event is a twofold historical marker: the policemen's myopia reveals how much visual literacy has evolved in half a century (after decades of coopting of avant-garde practices by the advertising industry, nothing could be more explicit now than the then illegible zoom-in on four thighs, two pelvises, a penis, and a vagina); the obsessive search and the arrest signal how much the legal definition of public decency has changed during the same period. The raid on Ferus was not isolated—the United States were still not over the McCarthy years, even though the right-wing senator had been censured by Congress in December 1954. Just a few weeks before Berman's show was closed, the City Lights Bookstore in San Francisco, mecca of the beat culture, was stormed by two plainclothes officers who arrested the shop's owner Lawrence Ferlinghetti for publishing—and (then illegally) selling—Allen Ginsberg's banned poetry book *Howl* celebrating (among many other things) gay sex and drug use. A lawsuit of immense consequence ensued: on October 3, 1957, Ferlinghetti was declared not guilty by a judge (surprisingly, a conservative one) who argued that the book, whatever its merit,

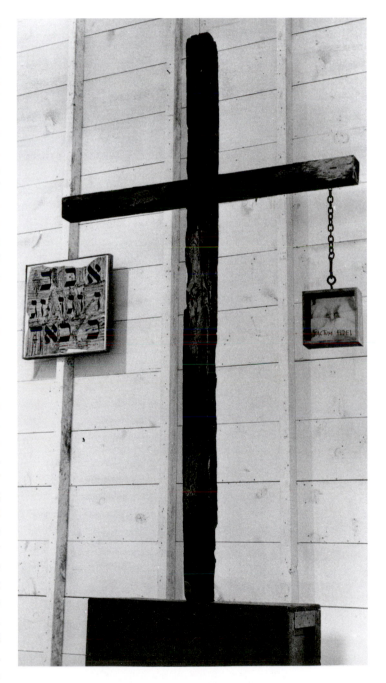

1 • Wallace Berman, *Cross*, 1956–7
Wood, metal, chain, and photograph, c. 274.3 × 152.4 (108 × 60)

deserved constitutional protection. Berman was not that lucky and he would have served time in prison if an actor friend had not come up with bail money. Fuming at the trial, he shouted "There is no justice, there is only revenge." Shattered, he moved to San Francisco and vowed never to show in a commercial art gallery again, instead devoting most of his energy to the editing of *Semina*, a beacon of counterculture until its publication ceased in 1964.

Berman's aesthetic critiques mass culture

Around that time, Berman moved back to Los Angeles (in the hippie community of Topanga Canyon), living in a shack where he remained a semi-recluse till his death in a car crash at the age of fifty, occasionally organizing home exhibitions of his works. Little known but cherished by his friends, for whom he was a model of integrity, his production was essentially limited to two categories: the rocks that he covered with Hebrew letters, and the so-called *Verifax* collages. The pebbles pursued a trend initiated in the drawings on torn and wood-stained parchment paper that he had shown in his ill-fated Ferus exhibition: mounted on canvas, these fragments imitated the display of archaeological finds, particularly those of the Dead Sea Scrolls—but with the major difference that Berman's groups of letters did not coalesce in any words. Although the *Verifax* collages—for which he used, as their nickname indicates, an ancestor of the photocopy machine—did not refer to such an antique past, their sepia tone and fading imagery conveyed a nostalgic sense of the vestigial. Responding to Andy Warhol's
▲ entropic strategy of repetition, to which Berman was exposed at Warhol's famous 1962 "Campbell's Soup" show in the Ferus Gallery, these works are a paean to the subjectivity of memory as a weapon against "mass culture." An invariable element is multiplied (most often in a grid formation) in each of the *Verifax* collages: a hand holds up a small AM-FM transistor radio, whose face is parallel to the picture plane (the smallest grid holds four of these units, the largest fifty-six). The variable elements are the images inserted where the radio speaker would be (generally, photos of an isolated item: a nude torso, the moon, Earth, a snake, a native American warrior, a jaguar, the US Capitol, a tree, a church, a rose, a pope, a gun, etc.), blips of information salvaged from the outside world, messages tossed at sea—the sum of which constitutes indecipherable rebuses but still asserts the possibility of escaping the Orwellian universe. Such a naive hope—the ground for much of the hippie counterculture of the sixties—would become the easy target of Warhol's cynical contempt.

Conner's assemblages oppose "society"

One of Berman's closest friends during his San Francisco stay, Bruce Conner (1933–2008), was just as adamant in his rejection of the rules of the establishment game, particularly those that govern an artist's career: as soon as a particular kind of work secured him some

recognition, he would stop producing, only to reemerge a few years later with works belonging to a whole different genre or medium. The assemblages he began to create in 1957 were put on the map by the deliberately repulsive *Child*, exhibited in 1959 in San Francisco [**2**]. Based on the famous case of Caryl Chessman, a death row inmate condemned for sexual molestation and gassed in San Quentin after twelve years amidst an immensely vociferous international campaign to save his life, it consists of the mutilated figure of a child-sized man (at least, clad with adult male genitalia) modeled in brown wax, tied to a highchair by shreds of nylon stocking, its mouth agape, its limbs partially cut off, its flesh like bulbous magma.

Although *Child* might be Conner's best-known sculpture, it departs from his other assemblages. Like those, it harbors the nylon stockings that soon became a signature item. But unlike *Child*, whose simple message is patent (the death penalty is barbarous),

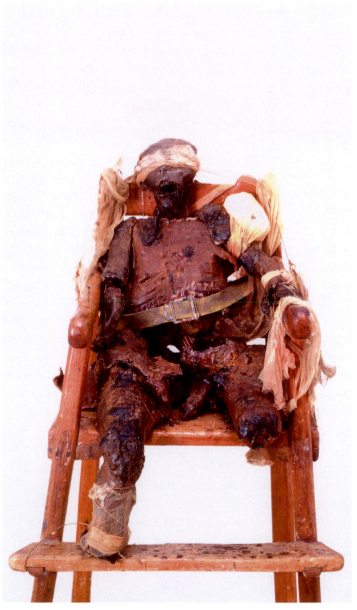

2 • Bruce Conner, *CHILD*, 1959
Wax figure with nylon, cloth, metal, and twine in high chair, 87.9 × 43.2 × 41.9 (34⅝ × 17 × 16½)

most of Conner's works from the late fifties and early sixties are not only remarkably polysemic—with their array of objects and photographs gathered from various sectors of life and affixed on various supports—but often hard to perceive, as the nylons that cover their discrete elements and help maintain them in place slowly gather dust and end up functioning as veils [**3**]. Like Berman's early pieces, Conner's assemblages abound in religious and erotic imagery (crosses, rosary beads, the face of Christ, nude women, etc.), but embedded within the obsolete bric-à-brac one finds in a junk store (laces, sequins, fake jewels, plastic flowers, toupées, camp cosmetic items of a forlorn drag queen, etc.). The sense of "pastness" they distill is not based on the illusion that one could retrieve and make sense of memory, but on the accumulation of pathetic dross.

The first identity Conner claimed for himself as an artist came in 1958 when, with the poet Michael McClure, he founded the Rat Bastard Protective Association (RBP), and was that of the quintessential ragpicker (the Association's name was derived from that of a garbage-collection company in San Francisco: The Scavengers' Protective Association). The professional scavengers "went around the city with big trucks, gathering the trash by emptying trash cans onto big flat burlap sheets," declared Conner to Peter Boswell. "They would gather it up on their backs and dump it into the truck. Or, when the truck was full, they would hang them on the sides like big lumpy testicles. So they were using all the remnants, refuse, and outcast of our society. The people themselves who were doing this were considered the lowest people employed by society." Likewise, RBP was for "people who were making things with the detritus of society, who themselves were ostracized or alienated from full involvement with the society." It is not only his glorification of the outcast that most differentiated Conner's stance from that of a Robert Rauschenberg and even more from that of then emerging

▲ Pop artists, but also the fact that the content of the bins he rummaged was decidedly retro (the initials of RBP, Boswell notes, were intended to evoke "PRB," those of the Pre-Raphaelite Brotherhood). The stuff he gathered for his assemblages was pre-Holocaust, pre-Hiroshima, pre-Cold War—not the contemporary waste of the postwar industrial boom, not the surplus of empty images produced by the mass media. For several years, and like

● his friends of the beat generation, Conner identified with the nineteenth-century Bohemia that Walter Benjamin, in his essay on the French poet Baudelaire (1821–67), "Charles Baudelaire: A Lyric Poet in the Era of High Capitalism," closely linked to the

■ figure of the ragpicker. But like Theodor Adorno in a scathing letter criticizing Benjamin's romanticization of Baudelaire's *chiffonnier* (ragpicker), he might have come to the conclusion that merely recycling antiquated trash did not offer a sustainable means to escape the all-pervasive condition of the commodity. The commercial success of his assemblages disturbed him and when it reached the point at which he was dubbed the "nylon master," he sought ways to change course. He moved to Mexico in 1961 and gradually abandoned his production of objects (for one thing, there was no

3 • Bruce Conner, *THE TEMPTATION OF ST. BARNEY GOOGLE*, 1959
Assemblage, wood, stocking, rubbish, 140 × 60 × 22 (55⅛ × 23⅔ × 8⅔)

trash around, the poor local population being far more adept than he was in making use of refuse). His last assemblage proper dates from 1964, after his return to the United States.

In parallel to his assemblages, Conner had begun to make films out of found footage. His first, entitled *A Movie* and dating from 1958, sets the tone of all his subsequent ones—a tone that differs sharply from the nostalgia of his objects in that it consists of an aggressive deconstruction of the medium itself. *A Movie* conventionally starts with its title and its maker's name (which would be suppressed in later works), but this is followed by the countdown leader (this normally unseen bit of white noise would appear in most of Conner's films and become the exclusive material of *Leader*, in 1964). The "first" image (a woman undressing) is swiftly introduced during the countdown which resumes to end up in a blackout screen followed by the familiar title card: "The end." And that is only the very beginning! The rapid succession of miniclips that make up most of the twelve-minute movie amounts to a montage overdose. Very few sequences stand out (the most memorable is perhaps that of a submarine commander looking through a periscope, cut to a pinup girl in basic suit, back to the commander who lowers the periscope, cut to the launching of a torpedo and to an atomic mushroom—all this in a manner of seconds). Speed is numbing—this is part of *A Movie*'s lesson. Conner's overload of images was intended as a critique of the mass media's increasingly efficient means of psychological manipulation in the fast-developing TV age. To his surprise, this underground, homemade collage, together with his second film in the same mold, the 1961 homage to Ray Charles entitled *Cosmic Ray*, would soon acquire a cult status—which led him, true to form, to abandon the cinematic medium. But in this case his defection was momentary: when he returned to film several years later (he made twenty-five movies from 1964 to 2002), speed was no longer of the essence; in its stead were repetition and slow motion. In *Report* (1963–7), several televised sequences of Kennedy's assassination are rehearsed many times with different soundtracks; in *Marilyn Times Five* (1968–73) it is a song by Monroe that is repeated while the found footage of a starlet posing half-nude as the actress is spliced into irregular beats, the sequence never beginning at the same point in each of the five "takes," and revealing only little by little her various "sex acts" (simulating a blow job on a Coke bottle, or rubbing her abdomen with an apple).

Flickering his identity had been one of Conner's favored strategies right from the start. The invitation to his first solo show, in 1959, announced, with black borders: "Works by the Late Bruce Conner." In 1964, he planned a Bruce Conner national convention in a Holiday Inn, to which all his namesakes would be invited ("All the guests would register at the hotel as Bruce Conner. Major Speeches and elections of officers. The minutes of the meeting: 'Bruce Conner elected President. Bruce Conner elected Vice-President. Bruce Conner, Treasurer. Bruce Conner disagreed with Bruce Conner on this point.'"). Though the idea was never realized, it generated various paraphernalia such as the columns of fake ads he placed in *Joglars*, a small literary journal published by Harvard students, using the name,

occupation and address of several of his "twins." Another by-product of his conceptual convention was a set of two buttons (the red one reads "I AM BRUCE CONNER" and the green, "I AM NOT BRUCE CONNER") which he reused a few years later when campaigning for the public office of Supervisor in the city of San Francisco. Having to specify his occupation in an official questionnaire for his candidacy, Conner answered "My business or occupation is Nothing," which landed him the votes of 5,228 citizens on November 7, 1967.

Few of his voters knew that two months earlier he was the subject of a fully illustrated article in *Artforum*, signed Thomas Garver and entitled "Bruce Conner makes a sandwich." Based on the famous series published in *Artnews* from the late forties on (the most memorable being "Pollock paints a picture" by Robert Goodnough in March 1951), even imitating its layout with the artist's signature included in the title, the article delivered exactly what it promised, the excruciatingly detailed account of a "making": food too needs to be prepared, and it is just as consumable as art, but it declares their common fate more honestly, ending in excrement while art winds up in gilded frames or a gallery's white cube.

Parody was Conner's preferred way of absenting himself, self-immolation his most devastatingly antisublimatory weapon. But his *Artforum* spoof was not only targeting his own (past) practice; it was the whole ethos of junk art—by then just as academicized a movement as Abstract Expressionism had become ten years earlier—that Conner was lambasting. In view of the last image reproduced in the article (the completed "artwork"—that is, the sandwich—full page), one could easily conclude that his prime objects of ridicule were Daniel Spoerri's *tableaux pièges* (one of them was included in the 1961–2 Museum of Modern Art show "The Art of Assemblage," to which Conner contributed and whose last venue was San Francisco). But it is more likely that his pique was aimed closer to home, at the only California assemblagist to attain early on—and maintain—international fame: Ed Kienholz (1927–94).

Kienholz tries too hard

At first sight, Kienholz's sculptural production—from isolated objects to large-scale installations such as *The Portable War Memorial* of 1968, which he called *tableaux*, presumably after the old aristocratic pastime of the *tableau vivant*—seems to partake of the same aesthetic as Conner's and Berman's work. But a gap separates Kienholz's conception of art from theirs (even though he considered Berman his mentor ever since having hosted the latter's show at Ferus). Contrary to the decidedly ambiguous and often obscure assemblages created by his peers, each of Kienholz's works combines elements whose semantic information goes in one single direction, the sum total force-feeding the beholder with a heavy, unmistakable, unidimensional message. While *Child* represents an exception in Conner's oeuvre—it is his least equivocal assemblage—*The Psycho-Vendetta Case* of 1960, based on the same Caryl Chessman story, is typical of Kienholz's maniacal redundancy [4].

▲ 1947b, 1949a ● 1960a

1950–1959

4 • Ed Kienholz, *The Psycho-Vendetta Case,* **1960**
Painted wood, canvas, tin cans, and handcuffs, 58.4 × 55.9 × 40.6 (23 × 22 × 16)

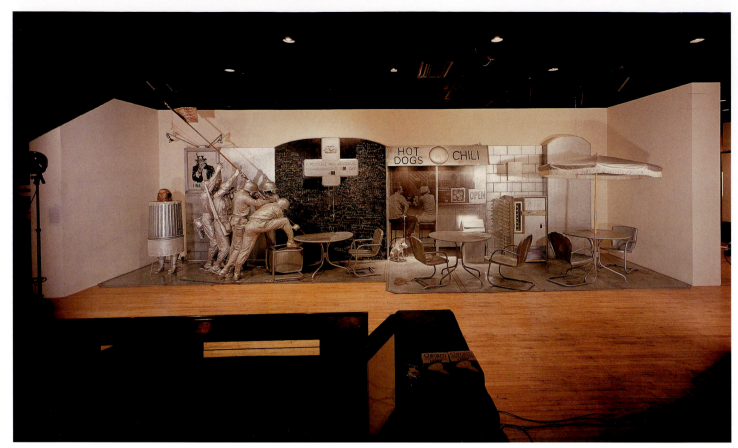

5 • Ed Kienholz, *Portable War Memorial*, 1968
Environmental construction with operating Coke machine, 289 × 243.8 × 975.4 (114 × 96 × 384)

In order to make sure you'll get the point, Kienholz alludes in the title to the famously butchered trial and execution of Sacco and Vanzetti in the twenties (framed testimony, planted evidence, biased prosecution), and to the immense international scandal accompanying this spectacular breakdown of the American justice system. On the outside of the wooden suitcase, to quote Walter Hopps, "the 'California Seal of Approval' features Mickey Mouse astride the California bear symbol. Inside, the viewer is presented with the backside of a shackled Chessman. Looking through the periscope glass at the top of the torso, the viewer's mouth is aligned with the figure's anus. The message visible inside reads, 'If you believe in an eye for an eye and a tooth for a tooth, stick your tongue out. Limit three times.'" The description is somewhat inaccurate (unless the sum of a bottom, a pair of testicles and thighs can be termed a torso) and, moreover, it is incomplete—it does not mention, for example, that the figure is modeled out of striped cloth (read: prisoner); that it is stained dirty pink (read: blood); nor that two grotesque arms jot out from the back of the box to hold the periscope (read: strangling); nor that the opened lid is adorned by the US and California flags (read: criminal government). But it scarcely matters: Kienholz never understood that piling up multiple symbols of the same idea, no matter how noble this idea, was giving in to the worst tactics of the mass media that Berman and Conner had struggled so hard to keep at bay. No matter what topic he picked—abortion, the dismal treatment of

prisoners or of patients in psychiatric wards, rape, prostitution, car crash, drunkenness, war, boredom, etc.—Kienholz never had faith in his public (nor in his advocates, for whom he always provided long captions painstakingly deciphering the elements of his yet all-too-clear allegories). Like any advertisement, his works are one-liners pounded into the beholder's head with a skull-crashing baseball bat. No abdication to the law of commodity could be more total. With Kienholz's spectacular tableaux, replete with the sensational violence to which Hollywood and TV news have made us addicted, junk art, once conceived as a strategy of resistance, had completed a full circle [**5**]. YAB

FURTHER READING
Theodor Adorno and Walter Benjamin, *The Complete Correspondence, 1928–1940*, ed. Henri Lonitz, trans. Nicholas Walker (Cambridge, Mass.: Harvard University Press, 1999)
Walter Benjamin, "The Paris of the Second Empire in Baudelaire," first section on the Bohème, *Charles Baudelaire: A Lyric Poet in the Era of High Capitalism*, trans. Harry Zohn (London: New Left Books, 1973)
Peter Boswell et al., *2000 BC: The Bruce Conner Story Part II* (Minneapolis: Walker Art Center, 2000)
Walter Hopps (ed.), *Kienholz: A Retrospective* (New York: Whitney Museum of American Art, 1996)
Christopher Knight, "Instant Artifacts" and "Bohemia and Counterculture," *Wallace Berman* (Amsterdam: Institute of Contemporary Art, 1992)
Lisa Phillips (ed.), *Beat Culture and the New America 1950–1965* (New York: Whitney Museum of American Art, 1996)

The Museum of Modern Art in New York mounts "New Images of Man": existentialist aesthetics extends into a Cold War politics of figuration in the work of Alberto Giacometti, Jean Dubuffet, Francis Bacon, Willem de Kooning, and others.

In the twentieth and twenty-first centuries, historians have become increasingly preoccupied with the phenomenon of repetition, not as Hegel described it by saying that everything in world history happens twice, but rather as Marx expanded this when he corrected what Hegel "forgot to add: the first time as tragedy, the second as farce" (*The Eighteenth Brumaire of Louis Napoleon* [1852]). Such a historical two-step would seem inapplicable to the entirely continuous battle between representation and abstraction that dogged the history of early modernism and came to represent the attempts of the academy to hold on to classical forms of figuration as the utopian drives of advanced art tried to break through to an unknown vision.

The rise of fascism, however, caused a remapping of this terrain, especially in France, as the Popular Front government united liberal and Communist forces in an anti-Nazi campaign that used "humanism" as its watchword and set up an appeal to artists to become politically engaged: which would mean abandoning their elitist, avant-garde forms and making their art accessible to the working classes. Figurative representation as applied to art had thus been wrenched from the protected privilege of the academy to become a matter of world-historical import. Further, not only did this version of realism come to be connected with a historical moment that stretched from the late thirties into the war years, and was thus seen as a product of the politics of the Resistance and the Liberation, but also its uniqueness was established by the existentialist terms of one of its major theorists, the philosopher Jean-Paul Sartre.

Man in a situation

As their perfect demonstration, the aesthetics of existentialism focused on the transformation that Alberto Giacometti's (1901–66) sculpture had undergone during these years. Up to 1935 it was grounded in a Surrealist-derived imagery of dream, couched in forms that moved toward abstraction; during the war it was reborn in terms that were resolutely figurative, based on working from the model and engaged with what Sartre was always calling for: man in a situation.

But if the tragedy of the war had produced this realism of the human subject thrown into the full uncertainty of "existence"—an existence unballasted by the comforting absolutes of an "essence" (a set of universal laws, truths, or conditions) that had preceded it

and could thus prescribe to it—the years that followed were to turn existentialist aesthetics (about which more below) into farce. As the postwar forties became the Cold War fifties, replete with Marshall Plan and Pax Americana, existentialism became a product of the culture industry and found itself wearing toreador pants and singing along with Juliette Greco in jazz joints. "Man in a situation" became a slogan along with "Existence precedes essence," and both, in relation to aesthetics, could be used to promote almost any kind of realism, as was the case with the exhibition "New Images of Man," which the Museum of Modern Art mounted in 1959.

In this context, all breaks with the code of abstraction were seen to resemble one another. Thus Willem de Kooning's "Woman" series, departing as it did from the wholly nonfigurative cast of his Abstract Expressionist production, or Jackson Pollock's black-and-white pictures of 1951, similarly allowing recognizable imagery to reenter the abstract skeins of his earlier dripped pictures, were held up as comparable to Giacometti's renunciation of Surrealism. It did not matter that de Kooning's women were less in a "situation" of existential dread than of spritely American advertising, inspired as they were by the voracious smiles of the beer-advertising Miss Rheingolds and movie starlets to be found in glossy magazines. Nor did it matter that Pollock's figurative moment lasted just one year before he returned to a desperate attempt to reconnect with abstraction in the few years remaining before his death. With its attempt to use an earlier generation of "realists"—Giacometti, Jean Dubuffet—as a vehicle to justify an intermediary generation—de Kooning, Pollock, Francis Bacon (1909–92)—"New Images of Man" was involved in promoting a third generation of neo-Expressionists—Karel Appel, César (1921–98), Richard Diebenkorn (1922–93), Leon Golub (1922–2004), Eduardo Paolozzi—as a "new" movement at just the moment when Pop art was to enter the picture and throw all these ideas about the link between the figurative and the expressive onto the junkheap of history.

To understand the distance that separated the aesthetics of 1948, the year when Sartre wrote "The Search for the Absolute," his catalogue essay for Giacometti's first exhibition since abandoning Surrealism, and 1959, when "New Images of Man" appeared, it is necessary to know a little more about existentialism and how it meshed with Giacometti's postwar project. Ironically, Sartre's

1 • Alberto Giacometti, *Femme debout (Leoni)* **(Standing Woman [Leoni]), 1947**
Bronze, 135 × 14.5 × 35.5 (53⅛ × 5¾ × 14)

philosophical writing opened in the very domain of Giacometti's Surrealist practice, which is to say with an investigation of the realm of mental images: dreams, fantasies, memories, hallucinations. But with this book, *L'Imaginaire* (1940; translated as *The Psychology of the Imagination*), Sartre's interest was definitely not to celebrate the imaginary world as the product of an unconscious welling up within the subject, as Surrealism had done. Indeed, Sartre's entire philosophical position was that there is no "unconscious," since there are no contents of consciousness lying inside it of which it could be either aware or, as in the case of the unconscious, unaware.

Sartre begins with the perception, adopted from Edmund ▲ Husserl's phenomenology, that consciousness is always consciousness of something other than itself. It is what Husserl had called "intentional consciousness," which means that it comes into being only in the act of perceiving, grasping, directing itself toward an object. It is thus always a movement beyond itself, a projection that empties itself out, leaving no "contents" behind. Consciousness is "nonreflexive": I do not hear myself speaking any more than I see myself seeing. Empty and transparent, consciousness traverses itself without ever finding anything in its path on the way to its object. And that object is marked by its own transcendence, its outsideness to consciousness itself.

The result of this exteriorization is that man becomes one with his projects, with the world that both motivates him and is the site for the exercise of his freedom. This act of synthesis, this unity with the world, stands opposed in Sartre's thinking to the philosophy of immanence, in which consciousness is always attempting to capture itself in its own mirror: seeing itself seeing, touching itself touching. This attempt at analysis, Sartre argues, merely doubles the subject. As Denis Hollier explains in his study of Sartre, "From that impossibility for the subject to catch up with himself comes his necessity to double up every time he approaches himself.… So that a subject who touches himself, divides himself by touching himself, becomes contiguous to himself, finds (and loses) himself alongside himself, being his own neighbor, having taken his own place."

Reflexive consciousness, analytic thinking, the attempt to grasp myself in the act of being myself, is thus always serial, repetitive, productive only of a sum of contiguous parts. Instead, the synthesis of which Sartre speaks strips man of his very properties: making him only what he does, only his deeds, only what unites him to his situation in the world.

Sartre's two models of this totalizing synthesis were the unity of the work of art and, as a result of both the Resistance and the heady days of the Liberation, what he would call the "group in fusion," a real, even if ephemeral collectivity. And in Giacometti's postwar sculpture he was able to celebrate both at once. On the one hand Giacometti had fashioned his sculptures as figures always seen at a distance, as being twenty or thirty or however many feet away from their viewer no matter how close he or she came to them [**1**]. "Giacometti," Sartre wrote, "has restored an imaginary and indivisible space to statues. He was the first to take it into his head to sculpt man as he appears, that is to say, from a distance." And because this is man as he is perceived, it is fitting that these sculptures should all

▲ 1965

be vertical, since Sartre equates perception with walking, traversing space, doing things, just as he links imagining with the body's repose. If one dreams lying down—as in the sculptor's earlier, Surrealist, sleeping women—one perceives standing up.

And man so sculpted, so imbricated with the perceptual field in which he is caught is never anything but a synthesis in which the body is one with its projects. Like the cave paintings in which the silhouettes "outlined an airy future; to understand these motions, it was necessary to start from their goals—this berry to be picked, that thorn to be removed—and not from their causes," Giacometti's sculpture, Sartre writes, "has suppressed multiplicity. It is the plaster or the bronze which can be divided: but this woman who moves within the indivisibility of an idea or of a sentiment, has no parts, she appears totally and at once."

Further, to this effect of perceptual unity there is added, in Giacometti's work, the affect of the "group in fusion" [2]. For the triumph of this sculpture is that each figure reveals man "as he appears in an intersubjective world … [and] at a proper human distance; each shows us," Sartre insists, "that man is not there first and to be seen afterwards, but that he is the being whose essence is to exist for others." There were other writers, however, for whom the isolation and immobility of Giacometti's figures, some of them even presented in cagelike structures, defined "intersubjectivity" itself as a condition of unbreachable separation, loneliness, and dread. Accordingly, Francis Ponge offered his own interpretation in 1951: "Man—and man alone—reduced to a thread—in the ruinous condition, the misery of the world—who looks for himself—starting from nothing. Thin, naked, emaciated, all skin and bone. Coming and going with no reason in the crowd."

Indeed, this idea of scarring and caging would be the hallmark of an existentialist position less optimistic than Sartre's, less focused on commitment's projects geared toward a future and more on dread, on what Friedrich Nietzsche had called the "wounds of existence" or on what Martin Heidegger would speak of as anxiety, namely a fear of "the nothing" or the nonbeing that lies behind existence. In the early thirties, when Heidegger's "What is Metaphysics?" appeared in France, the French literary avant-garde found the idea of nonbeing liberating, exciting. Raymond Queneau, a former Surrealist, had a character in his first novel, *The Bark Tree* (1933), speak in "Heideggerian" even though he was a concierge. Musing on a piece of butter, he says: "The lump of butter isn't everything it is, it hasn't always been and won't always be, ekcetera, ekcetera [*sic*]. So that we can say that this lump of butter is up to its eyes in an infinity of nonbeing.… It's as simple as Hello. What is, is what isn't; but it's what is that isn't. The point is that nonbeing isn't on one side and being on the other. There's nonbeing, and that's all, seeing that being isn't."

Giacometti's figures might have projected nonbeing for Sartre as a function of the mottled, pitted surfaces that could emit the flash of an expression or the lift of a breast as seen from a distance but that would never yield any more-solidly wrought details of surface or shape when seen up close, thus making nonbeing function as the motivation of perception. But this same work could

2 • Alberto Giacometti, *Trois hommes qui marchent* (Three Walking Men), 1948
Bronze, 72 × 43 × 41.5 (28⅜ × 16⅞ × 16⅜)

signal nonbeing for Ponge as "the ruinous condition" of "starting from nothing." For Ponge, the cage pinned man as "at once executioner and victim," or the flayed surface produced him as "at once the hunter and the game."

If they were united with their physical surrounds, the scarred and ravaged surfaces of Dubuffet's postwar portraits and women's bodies had less to do with the unity of an instance of perception than with a sense of the human subject as nothing but an oilspot or a stain fused with the corrugated surface of an urban ruin. Calling one of these bodies *La Métafisyx*, Dubuffet's version of the Heideggerian question ("What is Metaphysics?") was to deflate the metaphysical, producing it instead as something "grotesquely trivial" and, far from conceding to man a formal essence or a stable being, embodying the aim of attacking form. "My intention," he wrote, "was that the drawing should deny the figure any particular shape; that on the contrary, it should prevent the figure from assuming this or that particular form." The gauging, stabbing lines with which Dubuffet executes these figures, in their push toward the defiling character of graffiti,

▲ 1946

Art and the Cold War

When Clement Greenberg broadcast "Modernist Painting" for "The Voice of America" in 1960, avant-garde art joined cause with American Cold War politics, which was then focused on the rebuilding of a devastated postwar Europe, itself part of the cause of anticommunism in the United States. By the late sixties, the US government deemed the propaganda value of art important enough to support the Congress for Cultural Freedom as a way to promote the idea of individual liberty and autonomy as a defense against the menace of totalitarianism. Members of the Congress included Greenberg, Jackson Pollock, Robert Motherwell, and Alexander Calder. But it was not simply the government that promoted modernism in Europe. The Museum of Modern Art was also active through its program of traveling exhibitions, which sent American art abroad. *Life* magazine joined with a spread titled "Arms for Europe." That these "arms" would be cultural as well as military incited the Communist Party's reaction against American abstraction as "decadent" and "reactionary." With Germany the battlefield for a capitalist–ommunist confrontation, the desire to flaunt the rewards of West German postwar reconstruction in the face of East Germany led to the establishment of an international exhibition, Documenta, in Kassel, an industrial city in the northeast corner of the FDR, just a few miles away from an installation of international ballistic missiles pointed at the Soviet Union. The first Documenta was held in 1945 and every four or five years thereafter. The American entries in the early years stressed the importance of Pollock and the other Abstract Expressionists as well as the commercial splendor of Pop art.

the risk of a leap into the unknown. A wholly synthetic moment, this act of projection and perception was thus to be as unrepeatable as it was ephemeral. The act itself was what was important; the end results—reified in the finished product—were of little interest.

Though such rhetoric might be applicable, in part, to the improvisatory look of the abstract painting de Kooning pursued during the forties, it seemed increasingly out of place in relation to the "women." Indeed, de Kooning stressed that he fell back on this image precisely because it was pregiven, repeatable, a fixed convention. "It eliminated composition, arrangement, relationships, light," he explained. "So I thought I might as well stick to the idea that it's got two eyes, a nose and mouth and neck." His women, singly or in groups, give off the sense of a seriality at the heart of their conception, perhaps because de Kooning used a furtive collage technique that meant that forms he had taken from media sources—toothy smiles, mascara-laden eyes— are doubled over the surfaces of the bodies, as so many repeated ▲ mouths, breasts, vulvas [4]. It is the proto-Pop, serial quality of these images, then, their lack of individuality, that makes their relation to existential aesthetics problematic. RK

FURTHER READING:
Jean-Paul Sartre, "Fingers and Non-Fingers," translated in Werner Haftmann (ed.), *Wols* (New York: Harry N. Abrams, 1965)
Denis Hollier, *The Politics of Prose* (Minneapolis: University of Minnesota Press, 1986)
Peter Selz, *New Images of Man* (New York: Museum of Modern Art, 1959)
Eva Cockcroft, "Abstract Expressionism, Weapon of the Cold War," *Artforum*, vol. 12, June 1974

3 • Francis Bacon, *Study after Velázquez's Portrait of Pope Innocent X*, 1953
Oil on canvas, 152.7 × 118.1 (60⅛ × 46½)

thus invoke both the attack on the whole body's "good form" so common to graffiti's obsession with genitalia (and thus with the body reduced to merely a "part-object") and the semiautomatic character of the graffiti mark, the seeming lack of intellection behind it.

Emerging slightly later than Dubuffet, but contemporaneously with the postwar Giacometti, Francis Bacon's early work is marked by both the cagelike isolation of his figures and the blur of their features that projects them at a perpetually unbridgeable distance. But they are far more expressive than Giacometti's impassive figures. Characteristically, their mouths are wide open in a scream but their eyes are veiled and the sides of their faces corroded. Even without the isolation booths in which Bacon stranded his various figures based on Velázquez's portrait of Pope Innocent X [3], the figures always seem overwhelmed by the space in which they find themselves.

Although they were conceived at the same time as Dubuffet's *corps de dame* pictures, de Kooning's "women" seem to inhabit a different moral universe, and this despite the fact that Harold ▲ Rosenberg had espoused existentialist ideas to justify the group of artists he identified as "The American Action Painters," of which de Kooning was a major, perhaps *the* major, figure. But Rosenberg's thesis, following Sartre, involved the absolute uniqueness of the event in which the painter discovers himself in the process of taking

▲ 1960a

▲ 1960c, 1962d, 1964b

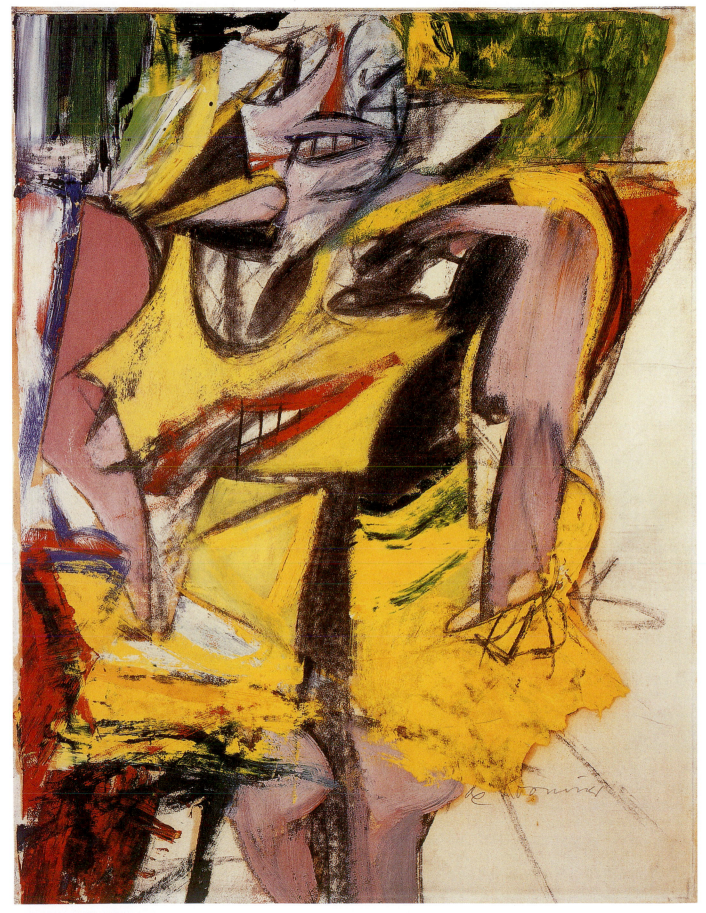

4 • Willem de Kooning, *Woman*, 1953
Oil and charcoal on paper mounted on canvas, 65.1 × 49.8 (25⅝ × 19⅝)

Richard Avedon's *Observations* and Robert Frank's *The Americans* establish the dialectical parameters of New York School photography.

In the twentieth century, photography's emergence as a major force in cultural representation usually marked a shift in power relations between the avant-garde and everyday industrial mass culture. This is well known in relation to Soviet and Weimar avant-garde photography around 1928, but less known and understood in relation to photography in New York after World War II, a cultural context considered mostly in terms of the "Triumph of American Painting."

Two families of photography

Edward Steichen's blockbuster exhibition of postwar photographic ideology, "The Family of Man," at the Museum of Modern Art in 1955, included a large number of both American social documentary photographers, such as Dorothea Lange (1895–1965), Russell Lee (1903–86), Ben Shahn (1898–1969), and Margaret Bourke White (1904–71), and photographers who would subsequently emerge as the key figures of New York School photography, such as Lisette Model (1901–83), Helen Levitt (1913–2009), Sid Grossman (1913–55), Roy DeCarava (1919–2009), Richard Avedon (1923–2004), Diane Arbus (1923–71), Robert Frank (born 1924), and Louis Faurer (1916–2001). The exhibition signaled in many ways the intensity with which the relations between photographic avant-gardes and the mass public, and between two generations of American photographers, had to be reorganized.

The first group of New York School photographers emerged from the Film and Photo League (founded in 1928), and its offshoot from 1936, the Photo League, initially hoping to forge a union between progressive sociopolitical forces and photographic practice. Most postwar photography in New York served capitalist consumer culture, almost entirely subject to fashion and advertising. Throughout the thirties, books and magazines had disseminated American social documentary via the Works Progress Administration (WPA) and Farm Security Administration (FSA), for example Margaret Bourke White and writer Erskine Caldwell's *You Have Seen Their Faces* (1937); Berenice Abbott's (1898–1991) *Changing New York* (1939); Dorothea Lange and economist Paul Schuster Taylor's *An American Exodus* (1939) and Walker Evans (1903–75) and James Agee's (1909–55) *Let Us Now Praise Famous Men* (1941). In contrast, postwar photographic books and illustrated magazines such as

Vogue, Harper's Bazaar, and *Life* magazine, in the paradox of their simultaneous climax and irreversible decline, struggled to survive the growing dominance of the cinema and television.

Alexey Brodovitch (1898–1971) became a key figure in the formation of New York School photography after his appointment as art director at *Harper's Bazaar* in 1934. A White Russian officer who had left the Soviet Union for Paris when the Bolsheviks came to power, Brodovitch came to the United States in 1930, bringing nostalgia for the lost culture of the Czarist empire, and a desire to preserve the *haut goût* of its last cultural flowerings, such as Sergei Diaghilev's Ballets Russes. He used this almost pathological longing for a revival of aristocratic elegance and style to mask the vulgarity of American consumer culture with the seductive foils of distinction, particularly the deception that fashion could perforate class boundaries: incurable social envy would release the new middle classes' purchasing power. Brodovitch's second resource was his snobbish embrace of the avant-gardes that he had encountered during the twenties in Paris, recruiting their radicality to service the emerging apparatus of mass-cultural domination. Thus, he wrote as early as 1930:

The publicity artist of today must be not only a fine craftsman with the faculty of finding new means of presentation …he must be able to perceive and preconceive the tastes, aspirations and habits of the consumer-spectator and the mob. The modern publicity artist must be a pioneer and a leader, he must fight against routine and the bad taste of the mob.

Brodovitch's first (and only) photographic book, *Ballet* [1], published in New York in 1945, with an accompanying essay by the dance critic Edwin Denby, appears to pay a grand and mournful homage to the beautiful remains of the Ballets Russes. His one-time appearance as a photographer, as Christopher Phillips has lucidly stated, "is equally exhilarating and at the same time haunting … Indeed, what these fugitive shapes and unexpected transformations ultimately suggest is the phantasmagoria of memory itself."

Ballet is the first New York School book where photography's promise to serve as sociopolitical documentary in the twentieth century is perverted into a melancholic invocation of the vanishing elitist bourgeois culture of the nineteenth. Brodovitch knew that this homage was as futile as the images were fugitive: the price

▲ 1929, 1930a, 1935 ● 1947a, 1949a, 1960b ■ 1936 ▲ 1919

1 • Alexey Brodovitch, page from _Ballet_, 1945

that photography had to pay to deliver the reminiscences of elitist culture was to succumb to the demands of an ever-intensifying culture of spectacle (evident in the book's cinematic layout as much as in its shift in focus, from the dancers' bodies to the effects of photographic technologies). Thereafter, Brodovitch refrained from taking photographs, but he became the teacher and art director for a generation of photographers, masterminding the medium's transformation from social documentary into product propaganda.

From _USSR_ to _Harper's Bazaar_

When in 1949 Brodovitch conceived what would soon be called "the archetypal graphic design magazine of the twentieth century," he reconfigured many avant-garde strategies (from Picasso to Pollock) to acquire a sophisticated industrial arsenal of advertising. His characteristic layouts for _Portfolio Magazine_ and _Harper's Bazaar_, with their extreme variations of image size and cinematic shifts from close-up to long shot, were montaged on double-page spreads that expanded even the panoramic vision of _Ballet_. Ironically, Brodovitch (just like his fellow Russian émigré, Alexander Liberman, art director of _Vogue_) derived his most successful graphic and photographic strategies from work that Russian artists including El Lissitzky ▲ and Aleksandr Rodchenko had produced for Stalin's Ministry of Propaganda in publications such as _USSR in Construction_. Thus Brodovitch accomplished for American magazine design what Edward Steichen had achieved slightly earlier for the new genre of exhibition design. In his famous exhibition "The Road to Victory" ● in 1942 (in collaboration with Herbert Bayer), Steichen had resuscitated Soviet photographic (exhibition) design from the late twenties, bringing the new genre to a final American climax in "The Family of Man" (in collaboration with the architect Paul Rudolph).

Brodovitch's legacy is best embodied by his students Richard Avedon and Irving Penn (1917–2009), who were enrolled at the legendary Design Laboratory he taught from 1933 at the Philadelphia Museum School of Industrial Arts and from 1941 at New York's

New School for Social Research (the home of the Film and Photo League from 1928 until its abolition under McCarthyism in the fifties). Other Design Laboratory students included Arbus, Eve Arnold (1912–2012), Ted Croner (1922–2005), Saul Leiter (1923–2013), Model, Hans Namuth, Ben Rose (1916–80), and Garry Winogrand (1928–84). Penn and Avedon received their first commissions from Brodovitch at _Harper's Bazaar_, Penn later becoming associated with Brodovitch's archrival, Alexander Liberman at _Vogue_, who defined the parameters of New York School photography:

> There was a thirst for new visual sensations to feed those growing modern monsters, magazines.... Penn and the key editors at Vogue were conscious of the very special and historic time in which they were living.... The early forties was a period of violent change, with war and the Holocaust as staggering tragedies. During the war, there was a sense of a new beginning in cultural New York, a tabula rasa of the past and even the dreadful present.... At the same time, there was a curious convergence between Penn's new vision and the great American ready to wear revolution. With war in Europe and the Pacific and USA Fashion on its own, Vogue proclaimed a new era.

More than any of their peers in the New York School (especially those emerging from the Film and Photo League) who remained involved with the sociopolitical legacies of the American documentary tradition, Avedon and Penn embodied the photographic ▲ agenda of the postwar generation. Walker Evans, although revered and supportive of the younger photographers, became the target of generational animus. For example, in an astonishingly erroneous description and historical combination of two utterly unrelated photographers, Richard Avedon stated:

> I didn't like Walker Evans, that is until now. I thought his work was boring, precious, empty, without emotion, a system. I used to do sort of jokes about Walker Evans and his camera and Ansel Adams and his. I didn't see the sort of social part of it, spending the day in front of a picket fence or a redwood tree waiting for the light to be right.

Avedon's closest friend, and in many ways his photographic opponent, Diane Arbus, seems to have echoed that attitude on the occasion of the Walker Evans retrospective at MoMA in 1971:

> First I was totally whammied by it. Like there is a photographer, it was so endless and pristine. Then by the third time I saw it, I realized how it really bores me. Can't bear most of what he photographs.

From weapon to style

Richard Avedon's first book, _Observations_ (1959), a collection of portraits seemingly selected according to the proto-Warholian principle of their subjects' media fame, with "comments" by writer Truman Capote (1924–84), was designed by Brodovitch using his idiomatic, stylized neoclassical Bodoni typeface, the oversized slipcase decorated in the red, white, and blue of a newly affirmed American identity. _Observations_ gives a better sense of the new tasks of photography than most publications of that time, firstly by

announcing, just as all concerns for the social collective had disappeared from the political agenda, that photography would have to completely detach itself from mass culture and the sociopolitical subjects of the thirties and forties. Secondly, rather than representing the mass subject's everyday life within industrial capitalism, American photography would now depict the spectacularized star subject of the culture industries. Functioning as a conduit between the mirage of the subject and the commodity object, photography would compel the mass subject to acquire the substitutions that compensate for the loss of subjective experience. One of Avedon's most celebrated devices is to stage his figures in front of white surfaces, and to print the images with the frame and numbers of the contact sheet, which—in spite of its modernist semblance of self-referentiality—foregrounds the branded identity of the photographer and the production of photography as the actual *subjects* of all photographs. More importantly, it physically dislocates the subject from the actual spaces of social relations and production (urban or rural, work or leisure, public or private) in order to invest it with the scopic magnitude necessary for the idolatry of the star subject.

Irving Penn published his first photographic book, *Moments Preserved*, in 1960. He designed it in Brodovitch style and, just like Avedon, made the portrait his primary "artistic" genre outside of his fashion work, following similar principles of spectacularization. However, Penn's resuscitation of still-life photography for advertising was his lasting hallmark, coaxing even fruits and flowers into the service of the commodity aesthetic. Taking his cues from the magic

▲ realism of thirties photography (a fusion of Neue Sachlichkeit and
● Surrealism), Penn mobilized the austerity and sobriety of latent neoclassicism to ennoble something as banal as a cosmetics pot with the radiance of a spiritual object.

Another strand of New York School photography draws more emphatically on those earlier practices where photography was intertwined with social and political realities. Two important figures attempted to maintain this engagement after World War II: Helen Levitt and Lisette Model, who had emigrated from Paris in 1938 to escape Nazi prosecution. Both women had been active in cultural politics, Levitt joining the Film and Photo League, which—following the Soviet models of the late twenties—attempted to conceive of film and photography as publicly accessible, politicized cultural practices. Nevertheless, Levitt's photographs at first seemed suspended between the anecdotal surrealism of Henri Cartier-Bresson (1908–2004) and the documentary realism of Walker Evans. While Cartier-Bresson's theory of the "decisive moment" implied that chance encounters and surreal constellations were compelling evidence of the subject's access to unique forms of independence and self-affirmation, Walker Evans's documentary realism took its confidence from a deep-seated belief that the bonds of social communication and political responsibility would not be abandoned. However, once it had become clear that neither position could be sustained, Levitt's photographs started to expose the disappearance of photography's documentary abilities. She retreated into the theatrical world of children [**2**], seeing in them the last dimension of authentic subjectivity, acting in spaces of

exemption and enacting their utopian versions of a future community in the face of a manifest disappearance of social relations.

Roy DeCarava's work is indebted to Levitt, and similarly emerges from the dual influences of Cartier-Bresson and Walker Evans. It shifts social documentary from universal principles of political and social change to the representation of a particular social group, notably in his extraordinary collaboration with Langston Hughes, *The Sweet Flypaper of Life* (1955), which focuses on the life of an African-American family in Harlem, presented as an autobiographical report from the perspective of its oldest member, the grandmother. The first-person narrative emphasizes not only the singular specificity of the speaker's culture, but also the differences of race and class that the subject represents, both as imposed by the regulations and regimes of its racist oppressors and as voluntarily embraced in a gesture of counteridentification. The introduction of the various family members and the sequencing of the images, alternating between close-ups, medium shots and long shots, simulate the cinematic flow of a documentary film, while the oppositional photographic traditions of narrative and document are equally pronounced.

It sometimes seems that DeCarava's in-depth account of the family narrative with its emphasis on the "normalcy" of social life in Harlem set out to distinguish itself from the anonymous, random documentation of the black population in James Agee and Walker Evans's accounts of the rural South. DeCarava's anchoring of the photographs in a first-person narrative account and his focusing the documentary images on one family invest the subjects and their community with spatial and social groundedness and a sense of agency, redefining the abstract universalizing of earlier documentary photographers. *The Sweet Flypaper of Life* can, therefore, be read either backward—in terms of its differences from the political universality of thirties and forties social documentary photography—or forward—as open opposition to the anomic universality that came to govern books such as *Observations* four years later. The sense of social groundedness, in a space exempt from universal anomy, is conveyed not only through DeCarava's careful depictions of his subjects, but also in

2 • Helen Levitt, *New York*, **c. 1940**
Silver-gelatin print

▲ 1925b, 1929, 1930a, 1935 ● 1924, 1930b

the photographs' very tonality. Hardly anyone else in twentieth-century photography succeeded in investing the extreme tonality of black-and-white photography with the metaphoric intensity of a refuge of identity, in which the color of racial segregation is turned into the ground of social solidarity.

From caricatures to counterportraits

Lisette Model published her first images in 1932 in *Regards*, the magazine of the French Communist Party (comparable to Willi ▲ Münzenberg's *AIZ* in Weimar Germany). She framed and captioned her images of bourgeois idlers at the Promenade des Anglais with a venomous irony to match the most aggressive caricatures of ● Honoré Daumier in the nineteenth century or George Grosz in the twentieth. It would be plausible to situate photography within the tradition of satirical illustration and caricature, reassigning social critique and revelatory travesty to the photograph, especially since progressive artists and writers in Europe during the twenties and thirties had explored communicative aspects of popular culture that had been increasingly obscured by modernism. Before them, caricaturists such as Daumier, Paul Gavarni, and Jean-Jacques Grandville had already addressed the problems of the distribution form as well as the need to engage with a different mass public.

Model did not seek her sitters from glamorous media representation, but in the street. The grotesque authenticity of her images of Manhattan's lumpenproletariat contrasts sharply with Avedon's and Penn's spectacularized subjectivity, and her counterportraits of social deviancy, transvestites, beggars, or inebriated eccentrics [3] identify with the marginalized and the social outcasts not in order to romanticize their abject lot and elevate it into a photographic picturesque, but by insisting on the subject's innate incommensurability in the face of its increasing assimilation to spectacle and consumption.

Thus the counterportrait as a photographic genre had already emerged by the thirties, and governed the work of the second generation of photographers, such as Robert Frank and Garry Winogrand but particularly Diane Arbus, whose teacher Model became in 1956. However, the subject of the counterportrait is no longer an emerging proletarian class or the bourgeois subject in the process of ■ disintegration (as in August Sander's [1876–1964] *Antlitz der Zeit* of 1929). Rather, the photograph as caricature now produces images of the grotesque disfigurations of subjectivity under the social policies of neglect and abandonment resulting from increasing class inequality in postwar American history.

Model made some of her most remarkable photographs immediately after her arrival in New York in 1938. Resuscitating Atget's topos of the spatial play of reflections in shop windows, she selected fragments of the body and sutured them into the windows' reflecting surfaces. Like a found montage, these images mapped the bodily fragment and the fetish in a highly compressed photographic representation, seemingly the subject's only accessible space.

Usher Fellig (1899–1968) came to the US aged ten from Zloczew (now in Poland) and took the name Weegee. In many ways Model's

3 • Lisette Model, *Sammy's Bar, New York*, 1940
Silver-gelatin print

counterpart and rival, he apparently introduced himself to Brodovitch at *Harper's Bazaar*, stating that the magazine had published enough of Model's work and urging him to fire her and publish him. The émigré's blatant competitiveness took its cues from his understanding of the behavioral structures of everyday life in his adopted homeland. *Naked City* (1945), Weegee's first book, programmatically identified the new social relations and spaces of his photographs just as Walter Benjamin had diagnosed the sites of Atget's photographs in 1934: as the scenes of crimes. *Naked City* enforced the insight that from now on the photograph could justify its existence only if its iconography, temporality, and locations operated in the spectacular manner of film (ironically, a 1948 film called *Naked City* was inspired by Weegee's book). From Lewis Hine to the ▲ Farm Security Administration, photography had functioned, in part, as social documentary, if not as activist protest and intervention. Now, it recorded crimes and accidents as the primary tropes of the anomic conditions of social life. Weegee's photographs marked the point when documentarian compassion and political responsibility had degenerated to cold voyeurism and a sadistic desire to stare at others' suffering, whether victims of accidents or the defeated enemies of the social order (criminals). Weegee also became the first in a line of early sixties artists—such as Jim Dine, Claes Oldenburg, ● and Andy Warhol—who recognized that the forces of random order and breakdown would have to converge in an aesthetic where social relations figure merely as accident or outright catastrophe.

▲ 1920, 1930a ● 1920 ■ 1935 ▲ 1936 ● 1960c, 1961, 1964b

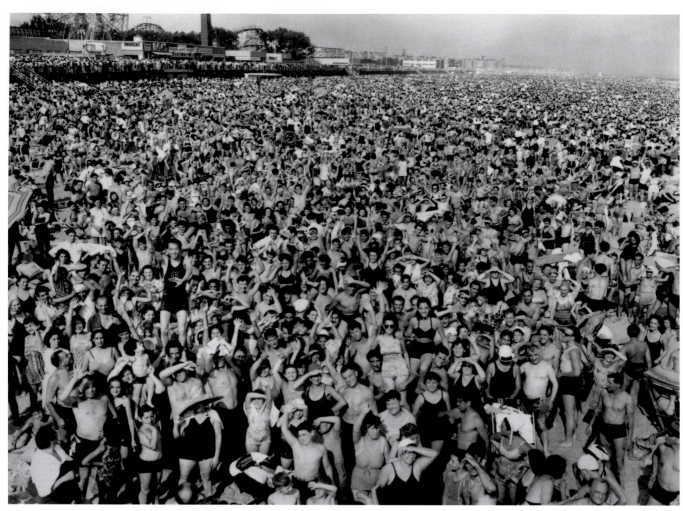

4 • Weegee, *Coney Island Beach*, New York, 1940
Silver print

5 • Diane Arbus, *Identical Twins, Rozel, New Jersey*, 1967
Silver-gelatin print

One of the most striking images in *Naked City* is Weegee's double-page spread of Coney Island bathers [**4**]: collectively remembered images of the politically activated masses of the thirties appear as the first acephalic mass of leisure culture. (These images clearly inspired Steichen's double-page endpapers in his 1955 *The Family of Man*, where Pat English's *Life* magazine photographs of an even more disciplined mass of English spectators emasculate the once radical concepts of the mass public sphere even more convincingly.)

After his move to New York from Paris in 1947, the Swiss Robert Frank contributed a distinctly different project to postwar New York photography. Initially on a similar trajectory to that of his colleagues (with magazine work for Brodovitch's *Harper's Bazaar*, fashion photography for *McCall's*, and early interest from Steichen, who included six of his images in "The Family of Man"), Frank came to situate his work mainly in an explicit dialogue with Walker Evans (who along with Brodovitch supported Frank's successful application for a Guggenheim fellowship in 1954). His contemplation of the methods and subjects of the American documentary legacy during road trips across the United States led to his book *The Americans*, even in its title paying tribute to Walker Evans's famous *American Photographs*. (Frank's book was first published as *Les Américains* in Paris in 1958, and subsequently in New York in 1959).

The American road trip became a European compulsion, just as the Grand Tour to Italy had been in the eighteenth century. In Frank's case, it led to an account of social and political tendencies in his new country, of roads not taken, and of roads ahead. In many ways comparable to Theodor Adorno's *Minima Moralia* in 1946 (which also looked at the culture of the United States as a panorama of the future), the book's eighty-three images not only articulate a vision defined by Frank's recent departure from the Europe of the Holocaust and totalitarianism's destruction of subjectivity, but they also probe the future of social relations and subjectivity in the most powerful nation state to emerge in the postwar period. The American edition had an introduction by Jack Kerouac, the beat poet of *On the Road*, and its images, such as the barber shop and the interiors, often pay tribute to Walker Evans, simultaneously recognizing that social relations and their political organization—which documentary photography might, erroneously, have considered as accessible, if not transparent—had been lost for ever, shrouded in the sign systems of automobile locomotion and media consumption. Nevertheless, at least four images are still devoted to the recognition of labor, and while Frank's photographs of workers at the conveyor belt are as blurry as Brodovitch's frames of the Ballets Russes fifteen years before, in Frank's case the haze indicates doubt over photography's access to social relations rather than hallucinatory evocations of the past.

Frank's acute observations of the rigid racial segregation that he came to know in fifties America are probably more important. While contemplative, *The Americans* is still marked by the documentary impulse to make photography a tool of political enlightenment and social change and Frank's leitmotivs signal his diagnostic clarity: the repetition and central placement of images of the American flag [6], the car, and the technologies of media culture (movie theaters, television sets and juke boxes) identify the forces shaping the growing dominance of American consumer culture and anomic society. At every turn of the road, Frank seems to gaze upon the New World not just with the wide-eyed amazement of the European newcomer, but also with shock that this is the model of things to come.

The career of Diane Arbus embodies all the contradictions of the New York School, and, as its most significant photographer, she concludes its history. After brief training with Berenice Abbott and Alexey Brodovitch, she worked as a fashion photographer with her husband Allan Arbus during the early fifties. In 1956, after abandoning fashion, she took classes with Lisette Model, finding "the courage to be herself." As Allan Arbus noted: "That was Lisette. Three sessions and Diane was a photographer." When it comes to the dialectics between the mass subject and the star subject, one could argue that Arbus is the counterpart to both Avedon and Warhol (her junior by five years), the first "*photographe maudit*" of the twentieth century. Typically, Arbus stated her position early on, saying that she would "much rather be a fan of freaks than of movie stars, because movie stars get bored with their fans, and freaks really love for someone to pay them honest attention." Arbus maps Model's photographic realism onto the archival typology of subjectivity that

▲ August Sander had famously developed in his systematic portrayal

6 • Robert Frank, *Fourth of July—Jay, New York*, no. 43 from *The Americans*, 1955–6

of Weimar society in his *Antlitz der Zeit*, a work to which she was introduced in the late fifties. By constructing a photographic universe of outsiders [5], she simultaneously inverts Sander's positivist sociological optimism and Avedon's techniques of isolating and spectacularizing the subject. Her universe is ordered not by class or profession, nor by the sitters' seduction as substitutional image, but by the degree to which their abject social isolation gives evidence that universal assimilation to the principles of the consumerist mass subject had not yet taken hold. Her solidarity with her sitters originates not in compassion, but in her more complex understanding of the fragility of the processes of subject formation, and the tragic consequences of their continuing destruction. BB

FURTHER READING
Max Kozloff, *New York: Capital of Photography* (New York: Jewish Museum; and New Haven and London: Yale University Press, 2002)
Jane Livingston, *The New York School: Photographs 1936–1963* (New York: Stewart, Tabori, and Chang, 1992)
Janet Malcolm, *Diana and Nikon: Essays on Photography* (New York: Aperture, 1997)
Elisabeth Sussman, *Diane Arbus: Revelations* (San Francisco: San Francisco Museum of Modern Art; and New York: Metropolitan Museum of Art, 2003)

▲ 1935

1959ₑ

The Manifesto of Neoconcrete Art is published in Rio de Janeiro as a double spread of the daily newspaper *Jornal do Brasil*, replacing the rationalist interpretation of geometric abstraction that was prevalent at the time with a phenomenological one.

With the exception of Gutai in Japan, no art movement born in the fifties could illustrate better the dialectic of center and periphery than Neoconcretism in Brazil. Both anticipated, by several decades, the phenomenon of globalization that characterizes today's artistic production. The crucial difference between those two avant-garde movements is that while the relationship of Gutai to the Western (mainly US) model it was emulating was one of creative misreading, that of the Neoconcretist group to the Western (mainly European) art it was addressing was one of deliberate rebuttal. The attack was made by proxy: the official target of the Neoconcretos, as they made clear in adopting this name, was a group to which they themselves had initially helped to form, that of the Concretos (or Concretistos), but their real enemy was a particular brand of geometric abstract art they had once embraced but were now violently rejecting.

In order to understand the virulence of the debate that raged between these artists, one needs to have a sense of the historical context. Historians have described in great detail the peculiar sociopolitical atmosphere of Brazil after World War II and throughout the fifties, the general ambition to abolish all prewar remnants of colonial subjection, the pervasive sense of potentiality that led in 1956, for example, to the unprecedented competition for the design of the capital Brasília. The quasi-utopian enthusiasm was no less spectacular on the cultural front, whose frenzy was fueled by the competition between Rio de Janeiro and São Paulo, each of these two fast-growing cities dreaming of becoming an international cultural hub and thus lift Brazil out of its provincialism. This is particular clear with regard to art: in 1947, the Museu de Arte de São Paulo (MASP) was founded, followed the next year by the Museo de Arte Moderna do Rio de Janeiro (MAM-RJ), then, in 1949, by the Museo de Arte Moderna, São Paulo (MAM-SP). An Alexander Calder exhibition put MAM-RJ on the map in 1948; a Max Bill retrospective did the same for MASP in 1950, followed in 1951 by the grand affair of the First São Paulo Bienal, organized by MAM-SP, at which Max Bill received the first prize for sculpture.

In the late forties and early fifties Calder loomed large in the Brazilian art scene, in great part thanks to the young critic Mario Pedrosa (who would become an ardent supporter of the Neoconcretists). Calder was well represented in many group shows, and in 1953 the São Paulo Bienal included a major retrospective of his work in the brand new Pavilion of Nations built by Oscar Niemeyer. Yet, though ubiquitous at the time, it is not Calder's work that functioned as the spark plug of the artistic avant-garde in Brazil, but that of Bill. It might sound strange that the utmost rationalism of the Swiss artist had more appeal then for the young painters and sculptors of Rio and São Paulo than the whimsical mobiles of Calder—but upon reflection this is not so surprising. Bill's program of concrete art was all about, well, programming: all about careful planning in advance and then reaping the fruits of this planning; its ethos was that of the promise. And what could be more seductive as an artistic model at a time when social, cultural, and urban *planning* were becoming the optimistic obsession of most branches of government and of the educated elite?

Against the machine aesthetic

Even more than Theo van Doesburg, who had launched the concrete art movement in 1930, Bill had faith in science and mathematics, and in importing their rigor into art. He was eloquent, dynamic, and very successful on the international scene, both as an artist and as a designer. The opening of his Hochschule für Gestaltung at Ulm in 1951 provided him with a pulpit from which to broadcast his ideas far and wide, and his star continued to rise in Brazil and throughout Latin America. In 1953 the Brazilian government invited him to lecture in Rio and São Paulo, and in 1956, a few months before hosting the "First National Exhibition of Concrete Art," MAM-RJ dedicated an exhibition to the Ulm school, presented as the legitimate successor of the Bauhaus.

The "First National Exhibition of Concrete Art" was a turning point—though nothing went according to plan. The word "national" in its title does not signify in the least an isolationist desire to retreat from the international arena; on the contrary, it was signaling that a grand federation was being created, in which the *concretos* of both São Paulo and Rio, who until then had worked separately, would unite their forces. The exhibition actually started in São Paulo (in December 1956), where it was

organized by the local group Ruptura (under the aegis of painter-designer Waldemar Cordeiro [1925–73] and the poet Haroldo de Campos [1929–2003]), while its Rio venue (in January 1957) was the responsibility of the group Frente (gathered around the painter-pedagogue Ivan Serpa [1923–73] with the enthusiastic support of Pedrosa and the poet Ferreira Gullar [born 1930]). The participants were the same in the two venues of the show (among the Paulistas were Geraldo de Barros [1923–98] and Judith Lauand [born 1922]; among the Cariocas, as Rio's inhabitants are nicknamed, were Aluísio Carvão [1920–2001], Lygia Clark [1920–88], Lygia Pape [1927–2004] and Hélio Oiticica [1937–80]). But instead of the great harmonious union that was supposed to result from this exhibition, a major split occurred, which planted the seed of the Neoconcretist movement. To put it briefly, the Cariocas were appalled by the dogmatism of the Paulistas, and, rebelling against the strict obedience to Bill's catechism, they prophesized the doom of any art bound by such a limited and limiting ideology. The definitive rupture came in June 1957, marked by a public joust among poets (Gullar, Reynaldo Jardim [1926–2011], and Oliviera Bastos [1933–2006] responding with a text titled "Concrete Poetry: An Intuitive Experience" to one by de Campos called "From the Phenomenology of Composition to a Mathematics of Composition"), although the Neoconcretist movement would not officially take off until March 1959, at the opening of the "First Exhibition of Neoconcrete Art" in MAM-RJ, with the publication of the group's manifesto, written by Gullar but also signed by Amilcar de Castro (1920–2002), Franz Weissmann (1911–2005), Clark, Pape, Jardim, and Theon Spanudis (1915–86). (Oiticica and Willys de Castro [1926–88] would join the group very shortly thereafter.)

The tone of the manifesto was surprisingly aggressive. It did not mention by name any of the Paulistas, but no one was duped:

The concepts of form, space, time, and structure—which in the language of the arts have an existential, emotional, and affective significance—are confused with the theoretical approach that science makes of them. In the name of prejudices that philosophers today denounce (M. Merleau-Ponty, E. Cassirer, S. Langer) and that are no longer upheld in any intellectual field, beginning with modern biology, which now has gone beyond Pavlovian conditioning, the concrete rationalists still think of human beings as machines and seek to limit art to the expression of this theoretical reality.

We do not conceive of a work of art as a "machine" or as an "object," but as a quasi-corpus; *that is to say, something that amounts to more than the sum of its constituent elements; something that analysis may break down into various elements but that can only be thoroughly understood by phenomenological means.*

More surprising than the absence in the text of the name of any ▲ Concretos is that of Calder, given that he had been constructed in

the Brazilian press as the polar opposite to Bill, and that Jean-Paul Sartre's famous 1946 essay on Calder's mobiles, translated in the catalogue of the American sculptor's first Brazilian show in 1948, ▲ was widely discussed thereafter with regard to a phenomenological approach to art, which was an important part of the Neoconcretist agenda. But the omission was not a sign of disaffection (when a few months later a grand Calder exhibition opened at MAM-RJ, Gullar made sure to pay allegiance to the American sculptor). Rather, it was strategic: for the Neoconcretos the real nemesis of Bill and his followers was not Calder, whose work shared little with • that of the Swiss artist, but Piet Mondrian, whom Bill never failed to invoke as one of his noble ancestors. Bill's appropriation of Mondrian resulted from a blatant misinterpretation, they thought. And indeed, the Dutch painter had vehemently opposed any idea of geometric computation in art, not only as proposed by van Doesburg but also as enacted by another veteran of De Stijl, Georges Vantongerloo (of whom Bill would legally become the executor). In other words, two conceptions of geometric abstract art were at stake and Bill was standing trial for having perverted the message of Mondrian while claiming to work in his wake, a message that the Neoconcretists interpreted as antiform and even, one might say, as "antigeometric." As Paulo Venancio Filho has remarked, "nowhere in the world was Mondrian as influential, as fundamental and as virtually idolized as he was within the context of Neo-Concretism in the late 1950s in Rio de Janeiro." What had sparked this interest was the Mondrian room in the same 1953 São Paulo Bienal in which the Calder retrospective was held, where ■ *Victory Boogie Woogie* had the place of honor. Oiticica and Clark were particularly taken by this work, in which some areas that one would normally read as ground appear to be, instead, in front of the colored rectangles. It gradually led the pair to take more seriously than any other artist anywhere at the time Mondrian's famous statement regarding the importance of the "destructive element in art." By the time Neoconcretism was launched, the Dutch painter had become their main reference, as is clearly reflected in their manifesto: "There would be no point in seeing Mondrian as the destroyer of surface, plane, and line if we do not connect with the new space built by his destruction."

Toward the organic

The two years or so that separate the definitive break of Rio's group with their orthodox Billian peers from São Paulo and the publication of this manifesto are a period of fascinating ebullience, during which the Neoconcretists furbished their weapons against the very tradition (geometric abstract art) in which they had been steeped and which they wanted to explode from within. They were greatly helped in that by an amazing phenomenon, unique to Brazil: starting in January 1957 (and lasting at least until the end of 1960), the major daily *Jornal do Brasil* published a Sunday cultural supplement edited by the poet Jardim, and whose art section was directed by none other than Gullar. Week after week, Gullar (who often asked Pedrosa to contribute)

▲ 1931b, 1937c, 1955b ▲ 1959c, 1965 • 1917a, 1944a ■ 1944a

1 • Lygia Clark, installation in the Brazilian Pavilion at the Venice Biennale, 1968
A selection of Clark's *Modulated Surfaces* paintings from 1957 can be seen on the walls.

constituted a kind of archive of the twentieth-century artistic avant-gardes (needless to say, it was slanted in the direction of his soon-to-be Neoconcretist pals, who were extremely well served in the journal's column). An anthology of these weekly pieces (which were dutifully collected by Oiticica) would make an amazing text-book of sorts, with essays on and by Mondrian, of course, but also on Josef Albers, Kazimir Malevich, Sophie Taueber-Arp, Russian Constructivism, Neoplasticism, and much more.

Returning in 1952 from a year in Paris (where she had studied with Léger), Clark quickly assimilated Bill's program. The first works signaling her discontent with the precept of the art object's absolute autonomy, an axiom of Bill's doctrine, are the series of paintings she made in 1954, in which the composition (on canvas) expanded onto the wide frame (on wood). As Gullar, Pedrosa, and many others pointed out (in hindsight), this clearly marked the beginning of a lifelong trajectory entirely dedicated to breaking barriers and particularly the inside / outside divide. As Clark put it

herself in 1959 (in an article published in *Jornal do Brasil* a month and a half before the Neoconcretist manifesto), this series had begun with her "observation of a line which appeared between a collage and a 'passe-partout' when the color was the same [in both], and disappeared when there were two contrasting colors." She was not entirely satisfied with these works, but "in 1956," she adds, "I found the relationship between this line (which was not graph-ical) and the lines of joining doors and frames, windows and materials which make up a floor, etc. I started calling it 'the organic line,' as it was real, it existed in itself, organizing space. It was a space line, a fact which I would only come to understand later on."

The first works in which this concept of "organic line" tenta-tively plays out are the *Modulated Surfaces* of 1957 [1], made of abutting wood planes sprayed with industrial paint, and directly conceived as in dialogue with Albers's *Structural Constellations* (Clark, who admired the German artist, criticized in his graphic constructions the fact that he was still "building upon a back-

▲ 1913, 1915, 1916a, 1917a, 1921b, 1925c, 1926, 1928a, 1944a, 1947a ● 1928a, 1937b, 1947a, 1967c ▲ 1947a

ground"). The positive/negative, reversible structure of these works (more often than not black and white) led Clark to another search, this one of finding the means to "abolish the plane" and with it the perceptual triumph of the gestalt. By the end of 1958, Clark was embarked on a series of small paintings on wood called *Units*, in which a black square is framed and/or bisected by a sunken white line that functions more like a hinge than like a frame. In these, she managed to illusionistically torque the plane, an accomplishment she verified in a tondo called *Linear Egg* (1958), a black disk bordered by an interrupted white line. Because the white line laterally dissolves into the surrounding white wall, we refrain from the gestaltist habit of closing the circle, and the black area tends to visually shift in depth with the line, one area receding while the other seems to protrude toward us.

The publication of the Neoconcretist Manifesto coincided with Clark's elaboration of a series of reliefs called *Cocoons* [2] and
▲ *Counter-reliefs*, in homage to Vladimir Tatlin, all dating from 1959, in which she translates the perceptual instability of her preceding works into the real, phenomenal space of our senses. Each *Cocoon* is made of a single rectangular sheet of metal partially cut and folded (but not cut out—nothing is deleted nor added) so that its frontal proportion, whatever its projection in space, is always a square (hiding, so to speak, an interior space that the beholder discovers when stepping aside). The fold engenders the fantasy of unfolding and of the plane as a compression of volume, an idea developed further in the *Counter-reliefs*, where void is sandwiched between layers of black or white boards.

That plane has a volume, and that this volume can be opened up (as a cocoon), is at the core of Clark's most celebrated works,

the *Bichos* (Critters) [3], which make their first appearance in 1960, but also of the contemporary production of her fellow Neoconcretists. Oiticica's *Bilaterals* (1959) and *Spatial Reliefs* (1960) [4], which could be characterized as cocoons in color; de Castro's *Active Objects* (most of them thin columnar paintings on wood, much deeper than they are wide, projecting from the wall (1959–60); and Pape's fold-out books, particularly the *Book of Architecture* of 1959 and the *Book of Time* of 1961–3: all these works testify to the common interest of the Neoconcretists for what they call "spatialization." Yet Clark's *Bichos* mark a turning point in the group's dynamic; they point to a new direction, involving the body of the "spectator" (or rather the "participant", as she would say). At first, only Oiticica joined Clark in this newfound concern, later followed (at the end of the sixties) by Pape.

The *Bichos* are free-standing structures made of hinged plates of metals that one can manipulate to give the sculpture various shapes (stored, a *Bicho* is perfectly flat—just like the suspended sculptures
▲ of Aleksandr Rodchenko from 1921). The articulation and disposition of the metal plates determine a set of possibilities that are often unforeseeable. In these first participatory works, Clark transposed her topological investigations (concerning the possible abolition of the reverse side of a plane) into the mode of relations between subject and object: neither is passive nor entirely free. The *Bicho* is conceived as an organism that reacts, with its own laws and limitations, to the movements of whoever manipulates it to modify its configuration. Often it requires certain gestures or unexpectedly turns itself inside out: the dialogue between *Bicho* and participant is at times exhilarating, at times frustrating, but it always undermines the notion that one could ever be in control of the other.

2 • Lygia Clark, *Cocoon*, 1959
Nitrocellulose paint on tin, 30 × 30 × 30 (11¾ × 11¾ × 11¾)

▲ 1914, 1921b

3 • Lygia Clark, *Bicho*, 1960
Steel, 45 × 50 (17¾ × 19⅝)

▲ 1921b

4 • Hélio Oiticica, *Spatial Relief (Red)*, 1960
Polyvinyl acetate resin on plywood, 149 × 62 × 8.5 (58⅝ × 24⅜ × 3⁵⁄₁₆)

It is at this juncture that Clark invented the *Caminhando* (poorly translatable as "trailing" or "walking along"), which in 1964 marks both her definitive farewell to geometric art and the beginning of a trend in her work and in that of Oiticica that one could characterize as the progressive disappearance of the art object as such. The *Caminhando* [5] returned one more time to Bill's infatuation for the morphological wonders of topology, but rather than being an object, it is conceived as an existential experience that has to be lived through: the basic material is a paper Moebius strip, a shape that Bill had many times carved in granite. Here are Clark's do-it-yourself instructions:

Take a pair of scissors, stick one point into the surface and cut continuously along the length of the strip. Take care not to converge with the preexisting cut—which would cause the band to separate into two pieces. When you have gone the circuit of the strip, it's up to you whether to cut to the left or to the right of the cut you've already made. The idea of choice is capital. The unique meaning of this experience is in the act of doing it. The work is your act alone. To the extent that you cut the strip, it refines and redoubles itself into interlacings. At the

end the path is so narrow that you can't open it further. It's the end of the trail.

What's left, a pile of paper spaghetti on the floor, is ready for the wastebasket: "There is only one type of duration: the act. The act is that which produces the *Caminhando*. Nothing exists before and nothing afterwards," writes Clark, adding that it is essential "not to know—while you are cutting—what you are going to cut and what you have already cut." And then: "Even if this proposition is not considered as a work of art, and even if one remains skeptical in relation to what it implies, it is necessary to do it."

From the *Caminhando* Clark will develop, throughout the sixties and beyond, a complex interactive practice that will steer away not only from any consideration of the object per se, but also from any notion of theatricality (no performance, even in the "propositions" that involved multiple "participants." More important yet, the very concept of the artist will gradually become irrelevant (and "art" would become a kind of therapy or social work). A similar development is to be observed in Oiticica's practice. The first interactive works, called *Box Bolides* (1963–4) [6], were containers with drawers and various compartments

5 • Lygia Clark, *Caminhando,* **1964**
Action

6 • Hélio Oiticica, *B11 Box Bolide 09,* **1964**
Wood, glass, and pigment, 49.8 × 50 × 34
(19⅝ × 19⁷⁄₁₆ × 13⅜)

7 • Hélio Oiticica, *Parangolé P4, Cape 1,* **1964**
Oil and acrylic on textile, plastic, and nylon net, dimensions variable

containing pure pigment powder but also photographs and other memorabilia that one would discover when opening up the piece. But it is with the *Parangolés* that he began to make in 1964 [**7**] that he joined forces with Clark in her search for what Gullar had long called the "nonobject." These capes made of complex cuts of color fabric and other materials, with hidden pockets full of powder pigment or shells, impede certain movements of the dancers who wear them while inviting them to adopt unusual postures. Oiticica intended them to produce in whoever inhabits them a new consciousness of his of her body, and the same can be said of most of the "propositions" made by Clark from the mid-sixties to the mid-seventies, under the global titles of "the house is a body," followed by that of "the body is a house."

Another example is Pape's 1968 *Divisor* [**8**] (reenacted multiple times since then), which provides "one of the most memorable poetic-image of the 1960s," to quote art historian Guy Brett, who describes it thus:

> A great piece of cloth, 30 × 30 meters, holds together, yet apart, a crowd of people whose heads protrude through evenly spaced holes. It was an ambivalent metaphor: either referring to an atomization, the "massing together of man, each inside his own pigeon-hole" or to an ethic of community, since each individual's movements have a direct effect on those of others, on the whole group. The dividing–uniting dialectic extended down to each individual's body, since the huge cloth separated the head from arms, legs, and trunk.

At first sight, this architectural cloth set in motion by a collective body seems a far cry from the works, still pertaining to geometric abstraction, that Pape, Clark, and Oiticica had shown at the "First Exhibition of Neoconcrete Art" nearly a decade earlier, but, in fact, it realizes to a dot the program of the manifesto they signed at the time, offering what Oiticica and Clark often referred to as "Vivências," and which can be translated, albeit poorly, as "life-experiences." YAB

FURTHER READING
Guy Brett et al., *Lygia Clark* (Barcelona: Fundació Antoni Tàpies, 1997)
Cornelia Butler and Luis Pérez-Oramas, *Lygia Clark: The Abandonment of Art 1948–1988* (New York: Museum of Modern Art, 2014)
Guy Brett et al., *Hélio Oiticica* (Minneapolis: Walker Art Center, 1994)
Luciano Figueiredo et al., *Hélio Oiticica: The Body of Color* (Houston: Museum of Fine Arts, 2007)
Guy Brett et al., *Lygia Pape: Magnetized Space* (London: Serpentine Gallery, 2011)
Sergio Martins, *Constructing an Avant-Garde: Art in Brazil 1949–1979* (Cambridge, Mass.: MIT Press, 2013)
Paulo Venancio Filho, *Reinventing the Modern: Brazil* (Paris: Gagosian Gallery, 2011)

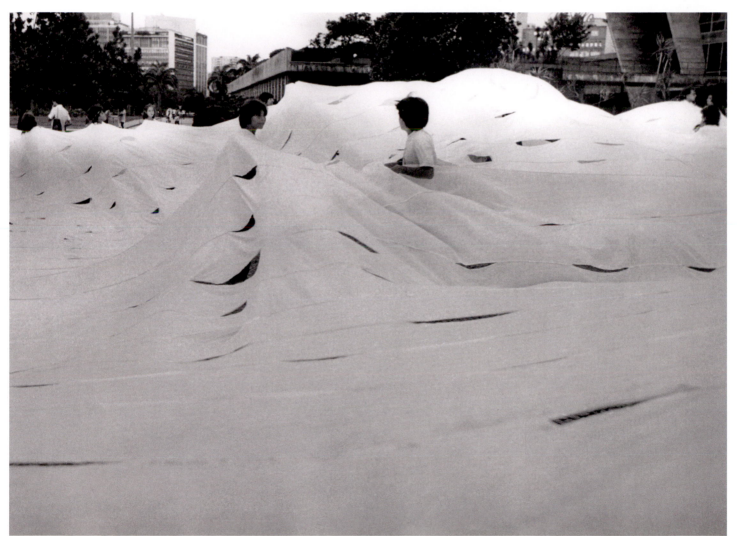

8 • Lygia Pape, *Divisor*, 1968
Action performed at Museu de Arte Moderna, Rio de Janeiro

1960 – 1969

1960ₐ

Critic Pierre Restany organizes a group of diverse artists in Paris to form Nouveau Réalisme, redefining the paradigms of collage, the readymade, and the monochrome.

Recognizing the public-relations value to be gained from organizing artists into a group operating under the banner of a single name, the French critic Pierre Restany (1930–2003) convinced a group of artists gathered in Yves Klein's Paris apartment on October 27, 1960, to form an avant-garde movement. Such a project naturally warranted a manifesto. This was dutifully designed by Klein in an edition of approximately 150 copies (white crayon on International Klein Blue or pink or gold cardboard) and signed by Restany and the eight artists present for the occasion (Arman [1928–2005], François Dufrêne [1930–82], Raymond Hains [1926–2005], Yves Klein, Martial Raysse [born 1936], Daniel Spoerri [born 1930], Jean Tinguely, and Jacques de la Villeglé [born 1926]). The manifesto consisted of a single sentence, the one anodyne statement about which all the artists could agree: "The New Realists have become conscious of their collective identity; New Realism = new perceptions of the real."

Twenty minutes after the signing, a fist-fight broke out between Klein and Hains, leading most of the members to consider the movement no longer extant, even though from now on they would frequently exhibit together (and they would be joined a little later by César, Christo [born 1935], Gérard Deschamps [born 1937], Mimmo Rotella [1918–2006], and Niki de Saint Phalle [1930–2002]). It was not until 1970, however, that the movement's death would be officially celebrated—with a banquet and the unveiling of Tinguely's sculpture *La Vittoria*, a giant phallic structure spouting fireworks in front of Milan Cathedral.

Neo-avant-garde and spectacle

If all this seems uncannily like a replay of typical avant-garde rituals, that is because this, in fact, is *one aspect* through which the group declared its relationship to the historical avant-garde. Yet if it also shows signs of posturing and ostentatious adherence to the forms of spectacle culture, that is because contemporary spectacle is actually the *other* major historical context within which the group was constituted. And it is this very ambivalence that marks Nouveau Réalisme, along with the Independent Group in London, Cobra, ▲ and the Situationist International, as one of the major instances of a neo-avant-garde formation in Europe in the postwar period.

The Situationist Guy Debord might have referred to the prewar avant-garde for his own formulation of a postwar aspiration "to constitute a new movement which most of all should reestablish a fusion between the cultural creation of the avant-garde and the revolutionary critique of society." But, as is typical of all these groups, the Nouveaux Réalistes were confronting a situation in which, for the first time in the twentieth century, the avant-garde's project had m anifestly become problematic. Instead, as critic Peter Bürger has argued, the avant-garde itself had become a highly institutionalized set of themes, practices, and spaces. But perhaps Nouveau Réalisme is the movement that recognized one particular condition of the neo-avant-garde most programmatically: its precarious but unchangeable situation at the intersection between a spurious posture of critical negativity and the affirmative agenda of the culture industry.

In generating its forms, Nouveau Réalisme seems to have taken the ineluctable condition of the neo-avant-garde more literally than the other groups that were developing parallel to it, mentioned above. In an almost systematic fashion, its participants rediscovered, recycled, and redistributed among themselves the modernist paradigms of the 1916–36 period, anticipating the manner in which advertising ▲ agencies would later pilfer avant-garde culture: the readymade ● (Arman), the monochrome (Klein), constructed kinetic sculpture ■ (Tinguely), and the collage (Dufrêne, Hains, Rotella, Villeglé). Yet in almost all instances, these paradigms now appeared as though they had been tuned to articulate the fundamentally different experience of objects and public spaces under a newly formed society of spectacle, control, and consumption. Not surprisingly, the most avid critics of that society at the time, the Lettrists and later the Situationists, would vehemently denounce Nouveau Réalisme as an art of affirmative collusion, a culture of right-wing politics and corrupt complicity.

However, articulating the profound ambiguities of cultural production by inhabiting its contradictions is different from mere complicitous affirmation. What made their practices the most authentic articulation of postwar visual production in France is first of all the fact that these artists made clear the inescapable way that all of postwar culture was caught up in a dialectic of historical repression and memory on the one hand, and an aggressive mode of enforced consumption and submission to the conditions of spectacle, on the other.

▲ 1949b, 1956, 1957a ▲ 1914, 1918 ● 1913, 1915, 1921b, 1928a ■ 1912

It is not surprising then that some of the most important contributions by the Nouveaux Réalistes shifted the status and sites of the work of art from the relative intimacy of the pictorial and sculptural object onto the level of public space. They repositioned the work from the frame of the picture, or the space of sculpture, to architecture, which is to say to institutional and commercial frameworks and to the spaces of the street that had always been presumed to be public.

Beginning with Klein's first installation of *Le Vide* (The Void)—in which the artist presented a completely empty gallery—in 1957 (to be followed by a more famous one in 1958) and culminating with Arman's corresponding *Le Plein* (The Full) in 1960—in which the window of Iris Clert's gallery was filled with a huge accumulation of garbage—the architectural dimension and interaction with public space would become central to the development of a Nouveau Réaliste aesthetic. This would be equally evident in Tinguely's large-scale, self-destructing installation *Homage to New York* [1], called by its author a "simulacrum of catastrophe," or in César's shift into Nouveau Réalisme in 1960, when he abandoned his successful
▲ career in welded sculpture, in the tradition of Picasso and González, to exhibit *Three Tons*: three cars that had been compacted by a hydraulic press into sculptural rectangular masses; or, in a shift that was equally emphatic, Spoerri was to declare the totality of a "found" grocery store in Copenhagen as an exhibition in 1961 (almost year

2 • Christo and Jeanne-Claude, *Wall of Barrels, Iron Curtain*, 1961–2
240 oil barrels, 430 × 380 × 170 (168 × 156 × 66)

1 • Jean Tinguely, *Homage to New York*, 1960
Self-destructing installation

▲ before Claes Oldenburg's *The Store*). Entering public space with equal drama in 1962, Christo and Jeanne-Claude (1935–2009) would make *Wall of Barrels, Iron Curtain* [2], a blockade of 240 oil barrels in the rue Visconti in Paris, corresponding to the recently constructed Berlin Wall and initiating their lifelong project of expanding sculpture to the scale and the temporariness of spectacle culture and reducing its simultaneous material presence to a mere media image.

The same desire to situate the work within public space and position it within the discursive apparatus of consumer culture is evident in the transformation of collage by the *décollage* artists. From
• an object of intimate reading and viewing (for example, Kurt Schwitters), collage was reconceived as a large-scale fragment detached from advertising billboards. In an act of piracy, posters were ripped by the artists from public walls, not only in order to collect aleatory linguistic and graphic configurations but equally to make permanent the acts of vandalism in which anonymous collaborators (named by Villeglé's *Le Lacéré anonyme*) had protested against the domination of public space by advertising's product propaganda. In the first
■ Paris Biennial, inaugurated by André Malraux in 1959, the French *décollage* artists—Hains, Villeglé, and Dufrêne [3]—presented their work for the first time in a public institution, culminating in Hains's first "*palissade*," which consisted of the entirety of a large construction-site fence covered with an open field of anonymous acts of *décollage* intervention in a sequence of ravaging gestures.

Photo Jean-Dominique Lajoux. © Christo 1962

▲ 1945 ▲ 1961 ● 1926 ■ 1935

Repositioning their practices explicitly in these different social spaces and frames, the Nouveaux Réalistes created works that had an aesthetic of industrial production and collaboration. The sheer quantity of objects produced, their relative interchangeability and equivalence no longer foregrounded the originality of one author's vision or the unique features of an individually crafted work. Instead, we now not only encounter the intrinsically collaborative principle of *décollage* but also the actual collaborations between the artists, beginning with Villeglé and Hains's astonishingly early *décollage, Ach Alma Manétro* in 1949 [4] and moving to the subsequent collaborations between Klein and Tinguely, Tinguely and Niki de Saint Phalle, and many others.

More important, however, is the fact that the collaborative principle itself now became a central paradigm, as when Spoerri proposed a patent in 1961 to have his *tableaux pièges* [5] produced by other artists or by anyone else. This principle culminated in Klein's ultimate performances, a few months before his death in June 1962, in which the artist sold "Zones of Immaterial Pictorial Sensibility" to collectors who, in exchange for certain quantities of gold, received a certificate of ownership as the only legal proof of the work's existence. This protoconceptual critique of objecthood and authorship would gain considerable importance in the discussions of Minimalist and Conceptual art only a few years later.

Adopting advertising strategies for the dissemination of their ideas, the Nouveaux Réalistes often operated in an apparent parallel to their politically more radical and theoretically more consequential opponents of the Lettrist International and the later Situationist International (among the *décollagists*, Dufrêne had in fact been a member of the former). The Situationists' key strategies, *dérive* (drifting) and *détournement* (diversion or misapplication), certainly share aspects of the *décollagist* principle of *ravir* (ravishment), that is, the transformation of reality in an act of violent abduction and seduction. Other spectacular examples, such as Tinguely's decision in 1959 to drop 150,000 copies of a manifesto on Düsseldorf and its suburbs, could certainly be recognized as a form of counterpropaganda strangely reminiscent of the Allies' attempts to enlighten the population of National Socialist Germany by dropping leaflets from

3 • François Dufrêne, ⅛ of the ceiling of the first biennial of Paris, 1959
Lacerated posters on canvas, 146 × 114 (57½ × 4⅞)

airplanes behind enemy lines. By contrast, the publication in 1960 of Klein's *Journal d'un seul jour*, feigning the features of a newspaper that celebrates the universally victorious presence of Yves le Monochrome (including the notoriously fake photographic "proof" of Klein's levitation in space), deployed, rather than "*détourned*" (or subverted from within), all the emerging media and advertising strategies of disinformation and massive manipulation of the public.

With the 1954 publication of Klein's books *Yves: Peintures* and *Hagenault: Peintures*, modernist abstraction had appeared for the first time transformed into a conceptual metalanguage. Pretending to give an account of Klein's extensive production of monochrome

4 • Jacques de la Villeglé and Raymond Hains, *Ach Alma Manétro*, 1949
Lacerated posters on canvas, 58 × 256 (22⅞ × 100¾)

▲ 1965, 1968b ● 1957a

5 • Daniel Spoerri, *Kishka's Breakfast, no. 1*, 1960
Wood chair hung on wall with board across seat, coffee pot, tumbler, china, egg cups, eggshells, cigarette butts, spoons, tin cans, etc., 36.6 × 69.5 × 65.4 (14⅜ × 27⅜ × 25⅛)

The neo-avant-garde

Peter Bürger's *The Theory of the Avant-Garde* (1974) divides the last hundred and fifty years of art practice into three distinct phases: the period of modernism, with its claim to the autonomy of the aesthetic field (and its institutions); the intervention of the pre–World War II avant-garde whose practices turned precisely on the critique of that autonomy; and the moment of what he calls the neo-avant-garde, a third phase during which European and American postwar culture produced a rerun of those critiques, albeit leveling them to a set of empty gestures. All three phases are interrelated, but Bürger grants only the second the status of avant-garde radicality since it is within the project of this "historical avant-garde" (the period 1915–25, roughly from Cubism through Russian Constructivism and Dada to Surrealism) that the traditional assumptions about modernism's claim to an autonomous status are rejected in favor of what Bürger calls an attempt to reposition artistic practices within the life practice itself. Examples of this would be, on the one hand, Surrealism's use of chance operations as a way of abolishing the separation between high art and mass culture as well as that between art and everyday experience and, on the other, Russian Constructivism's and German Dada's deployment of collage and photomontage as ways of breaking down the separateness of the bourgeois public sphere in favor of the conception of a newly emerging proletarian public sphere. In opposition to those, Bürger claims that all postwar avant-garde practices are mere farces of repetition of the original interventions, but ones that work neither to dismantle the founding modernist claim to autonomy nor to achieve a displacement of art practice into everyday life; rather they simply provide an existing and expanding apparatus of the culture industry with marketable goods and objects. As typical examples Bürger points to postwar Pop, either in its American or Nouveau Réaliste guise, in which he sees the mere replay of collage and photomontage operations, but now addressing neither the questions raised by the original avant-garde with regard to the institutions of aesthetic autonomy nor of art's necessary interrelationship with new mass audiences and new forms of distribution.

paintings (their sizes and dates, their sites of production, sometimes even the location of their collections), the two books were entirely fictitious. Thus, at the very moment of Klein's (fraudulent) claim to have invented monochromy, he presents it already as absent, accessible only through fiction and technical reproduction. Insofar as these "paintings" constitute the first instance in which the central modernist paradigm of the monochrome (with all of its claims for presence and purity, optical and empiricist self-evidence) has been shifted to the registers of linguistic, discursive, and institutional conventions—presence displaced, that is, by a textual apparatus—they open ▲ onto what could be called an "aesthetic of the supplement."

Klein's notorious 1957 exhibition in Milan of eleven identical, differently priced monochrome blue paintings (subtle variations being discernible only in the surface texture of the works) could be seen as the first climax of this new aesthetic. The artist's decision to mount the seemingly identical paintings on stanchions made these panels appear as contingent hybrids between autonomy and function, in need of a prosthesis for public display. Suspended between pictorial convention as *tableaux* and their newly gained assignment as *objects/signs*, these paintings articulated a strange new dialectic of pure visuality and pure contingency. Thus, Klein initiated his painterly project as a paradox in which the spiritual transcendence of the aesthetic object is both energetically reclaimed and simultaneously displaced by an aesthetic of the spectacularized supplement. The latter aspect culminates in Klein's decision to subject the serialized paintings to a willful hierarchical order that articulated the opposition between "immaterial pictorial sensi-
● bility" and randomly assigned price, anticipating Jean Baudrillard's semiotic formulation of the phenomenon of "sign exchange value".

It is not just the exhibition's emphasis on painting as *production* that distances it from all previous forms of abstraction but, instead, the fact that it does not consider the order of the "exhibition" as a mere accumulation of individual works first made and then put on display but, rather, conceives of painting itself as always being on the ▲ order of an "exhibition" (a strategy to be deployed by Andy Warhol in 1962 in his first solo exhibition of "Campbell's Soup" paintings).

Expanding on these concepts in his first installation of *Le Vide* in 1957, Klein declared the empty gallery space itself a zone of heightened pictorial, protomystical sensibility. *Le Vide* was not, then, a reflection on the critical implications of reductivism; it refused to connect with the historical specificity of modernist conventions of vision, their discursive and institutional constructions of spectators and the order of architectural and museological systems of display. But, to the very degree that Klein recognized that

a modernist aesthetic of spiritual or empirico-critical autonomy had failed, he made the persistence of abstraction's spiritual afterlife evident and questioned the fate of these aspirations once spectacle culture had taken over the spaces of the avant-garde.

Klein's merit is precisely to have constructed this couplet—spirit/consumption—in open public view, making clear that the attempt to redeem spirituality with artistic means at the very moment of the rise of a universal control of consumer culture would inevitably cloak the spiritual in a sordid guise of travesty. A typical acknowledgment of this is a remark by him like: "We are not artists in revolt, we are on vacation." By making his work manifestly dependent on all of the previously hidden *dispositifs* (for instance, the spaces of leisure and consumption, and the devices of advertisement), he would become the first postwar European artist to initiate not only an aesthetic of total institutional and discursive contingency, but also one of a seemingly inescapable affirmative assimilation.

When Arman, Klein's closest ally, decided to abandon his stamp paintings in 1953 in favor of the direct presentation of the ▲ object itself, the ramifications of Duchamp's readymades had hardly been recognized in France. Yet Arman's formal strategies not only derive from the readymade, they transfigure two

▲ other central paradigms of modernism as well: the grid and chance. If the post-Cubist grid still governs Arman's *accumulations* and works such as the slightly later *poubelles* and *portraits-robots* (as in the *Premier Portrait-robot d'Yves Klein* [6]) follow the organization of matter either according to the physical laws of gravity or the principle of chance encounter, Arman's object aesthetic neither shares the utopian promise of the techno-scientific avant-gardes, nor does it ● generate the unconscious resonance of the Surrealist object that had been liberated—if by no other force than the passage of time—from its everyday functions. With Arman, all objects seem to emerge from a limitless expansion and a blind repetition of production, appearing as so many specimens of an unclassifiable world of arbitrary variations, merely arranged according to the universal administration of sameness. If Duchamp's readymade had still suggested a radical equivalence between the constitution of selfhood through the subject's acts of speech and the formation of subjectivity in a relation to the objects of material production, Arman's objects firmly opposed such a parallel. Linguistic repetition, the principle according to which subjectivity is constituted in the production of speech, finds its objective correlative here in the repetition of the act of choosing an object of consumption.

Arman had understood that sculpture from now on would have to be situated within the display devices of the commodity, and that conventions of museum presentation would merge increasingly with those of the department store (the showcase and the shop window). As in the climactic moment of Klein's *Le Vide*, Arman recognized that the changes in how the subject is constituted and how objects are experienced, as well as the dialectic between memory and spectacle, would become most apparent in the object's situation in public space. His window installation of garbage, *Le Plein* of 1960, would demarcate one of the single most important changes in the paradigm of sculpture in the postwar period.

In their extreme forms, Arman's *accumulations* and *poubelles* cross the threshold to become memory images of the first historical instances of industrialized death. Some objects in his warehouse seem to echo the accumulations of clothing, hair, and private belongings that filmmaker Alain Resnais had recorded in *Night and Fog* (1955), the first documentary of the Nazi concentration camps, which Arman saw at the time of its release. Yet these accumulations set up a temporal dialectic that holds past and future in tension; for at the very moment when they seem to contemplate the catastrophic destructions of the recent past they open up a glimpse toward the imminent future. Anticipating another form of the industrialization of death, Arman's immobile arrangements evoke an emerging ecological catastrophe resulting from an accelerating and expanding consumer culture and its increasingly unmanageable production of waste. BB

6 • Arman, *Premier Portrait-robot d'Yves Klein*, 1960
Accumulation of Klein's personal belongings, 76 × 50 × 12 (29⅞ × 19⅝ × 4¾)

FURTHER READING

Jean-Paul Ameline, *Les Nouveaux Réalistes* (Paris: Centre Georges Pompidou, 1992)
Benjamin H. D. Buchloh, "From Detail to Fragment: Décollage/Affichiste,"
Décollage: Les Affichistes (New York and Paris: Virginia Zabriske Gallery, 1990)
Bernadette Contensou (ed.), *1960: Les Nouveaux Réalistes* (Paris: Musée d'Art Moderne de la Ville de Paris, 1986)
Catherine Francblin, *Les Nouveaux Réalistes* (Paris: Editions du Regard, 1997)

▲ 1914 ▲ 1913, 1915, 1917a, 1918, 1944a, 1953, 1957b ● Introduction 1, 1931a

Clement Greenberg publishes "Modernist Painting": his criticism reorients itself, and in its new guise shapes the debates of the sixties.

From the late forties through the early sixties, the American critic Clement Greenberg worked to forge a descriptive vocabulary, a set of terms that would address with great precision and muscularity those features that counted as new in the postwar art he admired. One of these was the term "allover," which he used to describe the uniformity of surface of certain Abstract Expressionist painting, most conspicuously Jackson Pollock's, in its condition as a tight mesh of repetitions [1]. To make this term count, Greenberg contrasted it with the idea of the "easel picture" in which the illusion of a boxlike cavity is cut into the wall behind it to create the stage for some kind of dramatic, and thus focused, event; the allover surface, by contrast, organizes its contents in terms of flatness, frontality, and lack of incident ("The Crisis of the Easel Picture" [1948]).

Another term was "homeless representation," which Greenberg invented to account for the paradox of abstract painting that nonetheless seemed to describe the kinds of shallow hills and valleys generally used to model the illusion of a three-dimensional object; it was as if the tonal modulations of de Kooning's smeared paint (and later, Jasper Johns's encaustic "touches") were waiting for a representational object to return to them. In opposition to this, Greenberg pitted the idea of "color-space," as in the work of Barnett Newman ("After Abstract Expressionism" [1962]), a luminous openness he was also to qualify as "optical," here following the lead of early art-historical writing where "haptic" or tactile qualities were opposed to "optic" ones—the art historian in question was the nineteenth-century Austrian Alois Riegl.

Given this effort at accurate, formal characterization, it is not surprising that Greenberg should have exploded into the exasperation of an essay such as "How Art Writing Earns Its Bad Name" (1962). It is already the mark of the simplicity and directness of Greenberg's prose that he should have avoided the term "criticism" and adopted the workmanlike connotations of "art writing" instead. But his target was not verbal archness or preciosity. Rather, it was the position, first enunciated by Harold Rosenberg's "The American Action Painters" (1952) but taken up in England a few years later by critics such as Lawrence Alloway, that the avant-garde is no longer concerned with making art but rather in performing a kind of self-revealing gesture, or "event," the by-product of which (the painting) is of no real concern to either artist or onlooker. As Rosenberg had put it: "The new painting has broken down every distinction between art and life." For Greenberg, however, the scandal of such a remark's claim to being criticism is that it has no way of explaining why the "painted leftovers of 'action' should be looked at and even acquired by others."

It was Greenberg's sense that in its jettisoning of art, the avant-garde had come to stand for a position he characterized, negatively,

1 • Jackson Pollock, *Number 13A, 1948: Arabesque*, 1948
Oil and enamel on canvas, 94.6 × 295.9 (37¼ × 116½)

▲ 1947b, 1949a ● 1951 ▲ Introduction 3

2 • Morris Louis, *Saraband*, 1959
Magna on canvas, 256.9 × 378.5 (101⅛ × 149)

as merely "subversive and futuristic" and that, on the contrary, art was necessarily the renewal (no matter how seemingly violent) of a continuous pictorial tradition. Such is the view that seems to ballast his most famous essay, "Modernist Painting" (1960).

Areas of competence

By characterizing the eighteenth-century German philosopher Immanuel Kant as "the first real Modernist," Greenberg's essay announces from its very outset that the phenomenon he is addressing, no matter how much of "a historical novelty" it might be, sinks its roots at least as far back as the eighteenth century and the Enlightenment. Drawing a parallel between the way "Kant used logic to establish the limits of logic" and what Greenberg calls the self-critical procedures of the modernist arts, he sees these as using "the characteristic methods of a discipline to criticize the discipline itself," not he adds, "in order to subvert it, but to entrench it more firmly in its area of competence."

For the arts, he argued, this area of competence, this domain that is specific to every separate aesthetic discipline, was historically to be found in what was unique in the nature of the medium of each. And in order to arrive at this, each art had begun to divest itself of those

conventions that could be shown to be dispensable, mainly because such conventions had been borrowed from another art: the narrative in history painting, for example, having been borrowed from literature; or the stagelike depth in illusionist painting, having been taken over from the theater. Beginning with Édouard Manet's painting in the early 1860s, this logic began to reveal the extent to which the one characteristic absolutely unique to painting was the flatness of the picture plane itself. "Because flatness was the only condition painting shared with no other art, Modernist painting oriented itself to flatness as it did to nothing else."

It may sound as though "Modernist Painting" is simply a reprise of the arguments Greenberg had developed two decades earlier, at the outset of his career as an "art writer" when in 1939 and 1940 he published "Avant-Garde and Kitsch" and "Towards a Newer Laocoon." In the latter, he had also set the history of modernism within the context of the Enlightenment, calling upon Gotthold Ephraim Lessing's 1766 tract *Laocoön: An Essay upon the Limits of Poetry and Painting* for the theorization of the necessary separation of the various artistic mediums. The difference, however, lies in the history he projects of art's development thereafter. In "Modernist Painting" this history is purely internal, each art striving to achieve its own "purity." The only (veiled) reference to anything outside the

3 • Morris Louis, *Beta Kappa*, 1961
Acrylic resin on canvas, 262.3 × 429.4 (103¼ × 173)

aesthetic domain is a sentence acknowledging that it seemed as if the arts were to be assimilated to entertainment, and as an escape from this they set themselves to "demonstrating that the experience they provided was valuable in its own right."

But in the "Newer Laocoon" the history, far more detailed, relates to the social conditions under which modernism evolved as first an authentic conveyor of bourgeois values and then, as capitalism advanced, an ever more vehement denial of and flight from an increasingly materialist and philistine society into the domain known as Bohemia. Thus in the forties Greenberg was projecting this history specifically in the name of the avant-garde as a project "to perform in opposition to bourgeois society the function of finding new and adequate cultural forms for the expression of that same society," without, he adds, "at the same time succumbing to its ideological divisions and its refusal to permit the arts to be their own justification." This notion of the arts as self-justifying, however, is itself qualified in terms that bring the aesthetic and the social domains together, since Greenberg saw modernism's acknowledgment of its medium as a form of materialist objectivity that this kind of painting shared with contemporary science. Indeed, he viewed modernism's focus on method and its striving for detachment as further instances of the relation to science, and when he came to summarize the findings of the visual arts in their search for their medium, he wrote that this "is discovered to be physical."

This emphasis carries into the terms of Greenberg's criticism during the forties in, for example, his ideas about the easel picture's replacement by mural painting. For the latter is a form that can declare the wall's impermeable surface in all the "positivity" of its observable fact, a continuous planar object that will function as an analogue for positivist science's continuous space of fact.

The orientation to science in this account connects back to the idea of the avant-garde's relation to the Enlightenment project; for it was to physics that philosophers such as Kant had looked for a model of critical thinking and merciless refinement of method. An orientation to science as a vanguard project could, then, be seen to be natural to an avant-garde that was bent on keeping alive what was valid in cultural experience. And indeed the social and materialist dimension of Greenberg's account of this history of the modernist arts becomes most obvious when he charts its course specifically in terms of the avant-garde. For it is to the avant-garde, he argues, that the task has fallen to preserve culture, in any form we could call genuine, from its ersatz, fake, dissembling version produced by modern consumer societies, a version to which Greenberg attached the word *kitsch* ("Avant-Garde and Kitsch").

If these early arguments were made in the name of socialism ("Today we look to socialism *simply* for the preservation of whatever living culture we have") and of the avant-garde, twenty years later "Modernist Painting" not only drops the social dimension of the account but now sees the avant-garde (along with the positivist science it avowed) as the enemy of art. Turning on science by saying that its "kind of consistency promises nothing in the way of aesthetic quality," Greenberg now qualifies the materialist, physical

Leo Steinberg and the flatbed picture plane

In 1968, at a lecture at the Museum of Modern Art, art historian Leo Steinberg first raised his voice against Clement Greenberg's dogmatic account of the power of modernist painting. Himself a historian of Renaissance art, Steinberg bristled at the idea that modernism's canny revelation of painting's own medium (the flatness of its support) contrasted with the supposed naivety of Old Master painting. For while "Modernism used art to call attention to art," Greenberg deplored that "Realistic, illusionist art had dissembled the medium, using art to conceal art."

Arguing that great art never masks its own process, covering it over with illusionism, Steinberg pointed to the absurdity of maintaining that Rembrandt was not formally self-conscious.

He wrote in his essay "Other Criteria," "The notion that Old Master paintings in contrast to modern dissemble the medium, conceal the art, deny the surface, deceive the eye, etc., is only true for a viewer who looks at the art like those ex-subscribers to *Life* magazine." Summarizing the modernist idea of a progressive mainstream in terms of Greenberg's notion of the "allover" composition (generated in relation to Abstract Expressionism) he wrote: "In formalist criticism, the criterion for significant progress remains a kind of design technology subject to one compulsive direction: the treatment of the whole surface as a single undifferentiated field of interest. Arguing that modernism's cherished idea of flatness needed considerable complication since the imaginative experience of Dubuffet's graffiti-like effects or Jasper Johns's *Flags* and *Targets* which "relegated the whole maintenance problem of flatness to 'subject matter,'" Steinberg went on to develop a conception of imaginative experience, which is to say the orientation a given picture assumes toward a viewer standing in front of it.

Most painting, no matter how radical, he wrote, operates with "the conception of the picture as representing a world, some sort of worldspace which reads on the picture plane in correspondence with the erect human posture." Further, "A picture that harks back to the natural world evokes sense data which are experienced in the normal erect posture. Therefore the Renaissance picture plane affirms verticality as its essential condition." But beginning in 1950, in the work of Dubuffet and Rauschenberg, he went on, something happened to challenge this verticality, since their pictures "no longer simulate vertical fields, but opaque flatbed horizontals." Steinberg drew his term "flatbed" from the print-shop, since typographers must arrange their separate lines of type into forms that hold the fragile pieces of metal together. This new kind of picture, he added, "no more depends on a head-to-toe correspondence with human posture than a newspaper does. The flatbed picture plane makes its symbolic allusion to tabletops, studio floors, charts, bulletin boards—any receptor surface on which objects are scattered, on which data is entered, on which information may be received, printed, impressed—whether coherently or in confusion."

Steinberg's next move was decisive, hooking as it did into one of the central binaries of structuralist anthropology: "To repeat: it is not the actual physical placement of the image that counts. There is no law against hanging a rug on a wall, or reproducing a narrative picture as a mosaic floor. What I have in mind is the psychic address of the image, its special mode of imaginative confrontation, and I tend to regard the tilt of the picture plane from vertical to horizontal as expressive of the most radical shift in the subject matter of art, the shift from nature to culture."

Although this cataclysmic shift may have been prepared by a work like Duchamp's *Tu m'* (1918), it was currently being exploited by Rauschenberg's silkscreen paintings in which a variety of printed material—from color reproductions to newspaper photos, to maps or calendars—gathered. "To hold all this together, Rauschenberg's picture plane had to become a surface to which anything reachable-thinkable would adhere. It had to be whatever a billboard or dashboard is, and everything a projection screen is, with further affinities for anything that is flat and worked over—palimpsest, canceled plate, printer's proof, trial blank, chart, map, aerial view. Any flat documentary surface that tabulates information is a relevant analogue of his picture plane—radically different from the transparent projection plane with its optical correspondence to man's visual field." And it seemed at times that Rauschenberg's work surface stood for the mind itself—dump, reservoir, switching center, abundant with concrete references freely associated as in an internal monologue—the outward symbol of the mind as a running transformer of the external world, constantly ingesting incoming unprocessed data to be mapped in an overcharged field. If the vertical, optical picture addressed a viewing subject imagined as a Romantic, seeking to immerse him or herself into a turbulent landscape, the horizontal flatbed picture imagined an entirely different subject since the pictorial surface was now "as hard and tolerant as a workbench.… The 'integrity of the picture plane'—once the accomplishment of good design—was to become that which is given. The picture's 'flatness' was to be no more of a problem than the flatness of a disordered desk or an unswept floor." The subject this new type of picture addressed was no longer the Romantic but the denizen of urban spaces, both receiving and programmed by the fragmented messages processed by the media—radio, TV, advertising—or slipped into his or her domestic spaces through the mail slot.

implications of pictorial *flatness* in a way that will have great resonance for the critical debates of the sixties, as it both reorients his own writing and spawns that of a younger generation.

For here, suddenly lodging his idea of the medium of painting not on the physical properties of its support but on the specific nature of its perceptual experience as it is encountered by a viewer, Greenberg exchanges the physical for the phenomenological. Eyesight itself, he reasons, is projective. Thus "the first mark made on a canvas destroys its literal and utter flatness," meaning that absolute flatness is never possible for a field that opens itself to *vision*. What *is* possible, Greenberg maintains, is a special kind of spatiality which, like flatness, denies the viewer imagined physical entry, as though he or she were able to walk through the depicted space. What it substitutes for this is a sense of space that is unique

4 • Kenneth Noland, *Whirl*, 1960
Magna on canvas, 178.4 × 176.5 (70¾ × 69½)

to visuality—what Greenberg calls a specifically "optical illusion" —something that "can be traveled through, literally or figuratively, only with the eye."

The date of "Modernist Painting," initially broadcast in 1960 by "The Voice of America," coincided with an essay Greenberg devoted to two emerging artists—Morris Louis (1912–62) [**2, 3**] and Kenneth Noland (1924–2010) [**4**]—in whom he saw the notion of "optical space" take on both a new dimension and the beginnings of something he could identify as a new school of American art. Throughout the fifties Greenberg had been changing the terms of his own appreciation of Pollock's drip paintings to correspond to the character of a space available to eyesight alone. It was in the work of these younger painters, and in that of their contemporary Helen Frankenthaler (1928–2011) [**5**], that he saw the luminosity produced by Pollock's linear (and relatively monochrome) web translated into ranges of intense color, color now identified as the most nontactile aspect of the visual field. In Louis's hands, Pollock's use of liquid paint spilled onto unsized canvas had been adopted into a far more general form of staining, so that the color is both identified with the woven canvas of its support but also manages to dematerialize that support into a series of shimmeringly "optical" veils that "open and expand the picture plane" ("Louis and Noland").

The power broker

It must be said that during the fifties Greenberg had identified himself with two aspects of the social field that his writing of the early forties might have seen as inimical to the avant-garde's cultural (and political) mission. One of these was the US State Department,

which sponsored various speaking tours by Greenberg to both Europe and Asia in a promotion of American culture that many have identified with a concerted policy of Cold War propaganda. Another was the art market: buoyed by the prescience of his early support for Jackson Pollock and David Smith, Greenberg's reputation as a critic had attracted the attention of those, from museum directors to magazine editors, who wished to trade in emerging talent. Beginning in 1959, Greenberg organized exhibitions for the gallery French & Co. in New York just as he was, around the same time, advising other dealers. In all of this he could be seen to have a stake in a kind of American jingoism that took a delight in the demise of European painting and the "triumph" of a specifically American art. For Greenberg this meant "post-Cubist painting," Cubism being a category into which he not only put everything produced in Europe in the twentieth century but also all of Abstract Expressionism, even including Pollock, whose work, he had said in "How Art Writing Earns Its Bad Name" has "an almost completely Cubist basis." Thus the "exclusively visual" terms of what he would now call "post-painterly abstraction" and also "color-field painting" were both new and American. Further, in their opening and expanding of the picture plane they could also, self-evidently, be connected with the tradition that Greenberg saw modernist painting as continually renewing. In this they were clearly opposed to the avant-garde.

That the avant-garde had transformed itself in Greenberg's eyes from the upholder of cultural value to its enemy was a function of the emergence of "neo-Dada," which in his view cheapened and confused the modernist project in an embrace of the very commercial sphere from which the avant-garde, so he argued, had earlier fled. Dismissing that aspect of Jasper Johns's work that trafficked with the readymade, he spoke of, for example, "the literary irony that results from *representing* flat and artificial configurations which in actuality can only be *reproduced*" as having a merely journalistic, not formal or plastic, interest ("After Abstract Expressionism"). In the same context he spoke of the threat to modernism of a generalized infection of painting by the logic of the readymade: if flatness and the delimitation of flatness are the two constitutive norms that form the essence of painting, then "a stretched or tacked-up canvas already exists as a picture"— readymade—"though not necessarily as a successful one."

Greenberg's closest ally among a young generation of critics deeply affected by him deepened this observation. "It is not quite enough to say that a bare canvas tacked to a wall is not 'necessarily' a successful picture," Michael Fried wrote in 1967, "it would, I think, be more accurate to say that it is not *conceivably* one" ("Art and Objecthood"). For Fried, any future circumstances that might lead one to believe that it *could* be successful would so radically change the enterprise of painting "that nothing more than the name would remain." Carrying on Greenberg's attack on the avant-garde's obliteration of the distinction between art and life, "Art and Objecthood" staked the coherence of art on the possibilities and conventions generated by and within the limits of the

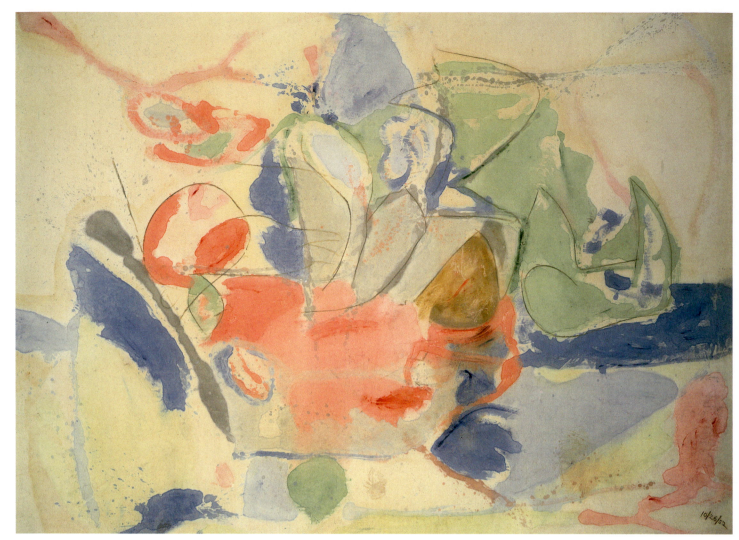

5 • Helen Frankenthaler, *Mountains and Sea*, 1952
Oil on canvas, 220.6 × 297.8 (86⅞ × 117¼)

individual medium. What exists *between* these, Fried said, is theater and "theater is now the negation of art." In fact, he insisted: "The success, even the survival, of the arts has come increasingly to depend on their ability to defeat theater." In this argument, Fried's "theatre" parallels Alloway's "event."

From Greenberg's notion, in 1940, that the survival of culture depended on the avant-garde's ability to defeat the bourgeoisie's stripping art of value, to his idea that it depended on modernist logic's securing the project of art as self-validating, one arrives in 1967 at Fried's notion that that survival now depends on defeating the avant-garde itself. Fried's aim now generalized the avant-garde's "neo-Dada" manifestation to those aspects of the ▲ readymade to be found in Minimalism, such as the use of found, industrial materials and parts or the deskilling of the work's fabrication by having it made in series, in a factory.

The result of his and Greenberg's position was that by the late sixties color-field painting and "opticality" stood on one side of a divide, lined up with what Greenberg had found missing in scientific methodicalness, namely "aesthetic quality"; while on the other side ranged all those practices for which the logic of modernism had led either to a reduction to the literal or physical nature of the support—Minimalism—or to a tautological notion of art as self-▲ definition—as in some forms of Conceptual art. RK

FURTHER READING

T. J. Clark, "More on the Differences between Comrade Greenberg and Ourselves," in Serge Guilbaut, Benjamin H. D. Buchloh, and David Solkin (eds), *Modernism and Modernity* (Halifax: The Press of the Nova Scotia College of Art and Design, 1983)

Thierry de Duve, "The Monochrome and the Blank Canvas," *Kant after Duchamp* (Cambridge, Mass.: MIT Press, 1996)

Michael Fried, "Three American Painters," *Art and Objecthood* (Chicago: University of Chicago Press, 1998)

Clement Greenberg, *The Collected Essays and Criticism*, vols 1 and 4, ed. John O'Brian (Chicago: University of Chicago Press, 1986 and 1993)

Serge Guilbaut, *How New York Stole the Idea of Modern Art: Abstract Expressionism, Freedom, and the Cold War* (Chicago and London: University of Chicago Press, 1983)

▲ 1962c, 1965

▲ 1968b

1960_c

Roy Lichtenstein and Andy Warhol start to use cartoons and advertisements as sources for paintings, followed by James Rosenquist, Ed Ruscha, and others: American Pop art is born.

In 1960, independently of each other, Roy Lichtenstein (1923–97) and Andy Warhol (1928–87) began to make paintings based on tabloid cartoons and advertisements. They were drawn to familiar characters like Popeye [1] and Mickey and generic products like tennis shoes and golf balls; a year later, Lichtenstein added comic strips of romance and war to this image repertoire [2]. Quickly dubbed "Pop"—a term first associated with the Independent Group in England—this kind of art was roundly condemned: with its cold surfaces it seemed to mock the emotive depths of Abstract Expressionist painting, and mainstream critics, who had only just come around to Jackson Pollock and company, were not happy about this new turn of events. In 1949 *Life* had showcased Pollock under the banner "Is he the greatest living painter in the United States?" In 1964 the same magazine profiled Lichtenstein under the heading "Is he the worst artist in America?"

The charge of banality

Critics charged the work with banality, which in the first instance had to do with content: Pop threatened to open the floodgates of commercial design and to drown out fine art. Of course, modern artists had long poached the brash forms of mass culture (popular prints, posters, newspapers, and so on), but they did so mostly to reinvigorate staid high forms with feisty low contents; with Pop, on the other hand, the low appeared to overrun the high. The accusation of banality also involved procedure: since Lichtenstein seemed to reproduce the cartoons, advertisements, and comics directly (in fact he modified them more than Warhol), he was branded with a lack of originality and, in one case at least, menaced with a charge of outright copying. In 1962 Lichtenstein had adapted a couple of didactic diagrams of portraits by Cézanne made by an art historian named Erle Loran in 1943; Loran surfaced to protest loudly. Not coincidentally, when Duchamp presented his readymade urinal as art forty-five years before, he was charged with similar crimes, only then the terms were a little more severe—"obscenity" and "plagiarism."

Lichtenstein did copy, but he did so in complicated fashion; even his use of the comic strips was not as automatic as it might appear. He would select one or more panels from a strip, sketch one or more motifs from these panels, then project his drawing (never the comic)

1 • Roy Lichtenstein, *Popeye*, 1961
Oil on canvas, 106.7 × 142.2 (42 × 56)

with an opaque projector, trace the image on the canvas, adjust it to the picture plane, and finally fill it in with stenciled dots, primary colors, and thick contours—the light ground of the dots first, the heavy black of the outlines last. Thus, while a Lichtenstein might look industrially readymade, it is actually a layering of mechanical reproduction (the comic), handwork (the drawing), mechanical reproduction again (the projector), and handwork again (the tracing and the painting), to the point where distinctions between hand and machine are difficult to recover. In different ways, Warhol, Richard Hamilton, James Rosenquist (born 1933), Ed Ruscha (born 1937), Gerhard Richter, and Sigmar Polke produced a related conundrum of the painterly and the photographic; it is a prime characteristic of Pop art at its best.

Lichtenstein abounds in manually made signs of mechanically reproduced images, but his signature dots crystallize this paradox of "the handmade readymade," for they are a painted depiction of a printed code, the so-called Ben Day dots devised by Benjamin Day in 1879 as a technique to produce a printed image by means of gradations of shading translated into a system of dots. More importantly, the Lichtenstein dots convey the sense, still fairly novel at the time, that appearance had undergone a sea change of mechanical reproduction, that life was somehow "mediated" and

▲ 1964b ● 1949b, 1956 ■ 1949a ◆ 1914 ▲ 1956, 1964b, 1967a, 1968b, 1972b, 1988, 2007a

2 • Roy Lichtenstein, *In the Car*, 1963
Oil and magna on canvas, 172.7 × 203.2 (68 × 80)

3 • James Rosenquist, *President Elect*, 1960–1/4
Oil on masonite, three panels, 213.4 × 365.8 (84 × 144)

all images somehow "screened"—that is, printed, broadcast, or otherwise viewed beforehand. This is another strong theme of Pop, again with significant variations wrung by Warhol, Hamilton, Rosenquist, Ruscha, Richter, and Polke.

Where did Lichtenstein stand in this brave new image-world? Did he "cling" to notions of originality and creativity, as art historian Michael Lobel has argued? True enough, when Lichtenstein appropriated images of products, he did efface the brand names (Warhol retained "Campbell's," "Brillo," and all the rest); as Lobel remarks, he "Lichtensteinized" his objects, and worked "to make the comics look like *his* images." This tension between traces of distinctive authorship and signs of its evident eclipse is pronounced in Lichtenstein, but apparently it did not trouble him much. "I am not against industrialization, but it must leave me something to do," Lichtenstein commented, modestly enough, in 1967: "I don't draw a picture in order to reproduce it—I do it in order to recompose it. Nor am I trying to change it as much as possible. I try to make the minimum amount of change." This is the ambiguous line that Lichtenstein hewed: to copy print images, but to adapt them to painterly parameters; to "recompose" them in the interest of pictorial form and unity, in the name of distinctive style and subjectivity, but only enough to register these values (perhaps to register them as threatened) and no more.

Rosenquist also recomposed his images, which were most often drawn from magazines, but his paintings retain the disjunctive quality of his preparatory collages of source illustrations, which he cropped and otherwise manipulated. For the most part Rosenquist used bland images of everyday objects, "common enough to pass without notice [and] old enough to be forgotten," which he then painted, with his skills as both an abstract artist and a billboard painter, in spectacular passages of lush illusionism that often traverse several panels and sometimes evoke the wide-screen cinema of the time. In some works, however, his subjects are charged, and his version of Pop approaches social commentary. For example, with the twelve-foot expanse of *President Elect* (1960–1/4) [3], we move, as along a highway of billboards or through the pages of a magazine, from a beaming John F. Kennedy to manicured female fingers breaking apart a slice of cake, to the rounded surfaces of the right side of a '49 Chevrolet: the juxtaposition is almost Surrealist, but, ▲ as with Richard Hamilton, the mood is mostly upbeat, suggestive of a new age of products and promises. However, a short time later, in *F 111* (1965), an eighty-six-foot extravaganza that connects a jet fighter and an atomic blast with, among other disparate images, a little girl under a hairdryer and a mess of spaghetti, the mood is far less sanguine: the smiling president is dead, the Vietnam War is in full swing, and "the military-industrial complex" is exposed as the dark support of American consumer affluence.

The charge of banal content that greeted Pop is more difficult to refute than the accusation of dumb procedure, but here too appearances are not so simple. The lowly subjects often favored by Lichtenstein, Rosenquist, and others did offend aesthetic taste attuned to the lofty themes of Abstract Expressionism, but

Lichtenstein in particular was not so contrarian. In fact, he showed that tacky advertisements and melodramatic comics could serve some of the same goals set not only for traditional art (such as pictorial unity and dramatic focus) but also for modernist art (such as the "significant form" prized by Roger Fry and Clive Bell and the ▲ vaunted "flatness" demanded by Clement Greenberg). Jasper Johns had played a similar trick with his paintings of flags, targets, and numbers of the fifties; as Leo Steinberg pointed out, these works met the Greenbergian criteria for modernist painting—that it be flat, self-contained, objective, immediate—by means that Greenberg found utterly alien to such painting—the kitschy images and found things of mass culture. Lichtenstein and company forced together the poles of fine art and commercial design with more sparks than did Johns, for their advertisements and comics were as flat as any flag or target, and more vulgar to boot.

Ed Ruscha also followed this Johnsian lead into Pop. He moved to Los Angeles from Oklahoma in 1956, and there, a year later, while still an art student at Chouinard Art Institute (now CalArts), he saw ● a magazine reproduction of a Johns work, *Target with Four Faces* (1955), which combined a simple sign with four molds. The painting struck Ruscha as both matter-of-fact and mysterious, and he responded to the provocation with an even blunter move: a simple word painted in one color on a flat ground painted in another color. His first such works were monosyllabic exclamations—"guttural utterances like *Smash*, *Boss*, and *Eat*"—that were nonetheless ambiguous [5]. "These words have these abstract shapes," Ruscha later remarked, "they live in a world of no size." He went on to explore "the idea of visual noise" in a variety of word-image combinations, and the result was a kind of deadpan Duchampian aesthetic of his own, redolent of both Midwestern straight-talk and LA sophistication. If every major Pop artist complicates the high art of painting through cross-pollination with other mediums—Lichtenstein with comics, Warhol with newswire photographs, Rosenquist with billboards, and so on—Ruscha has introduced a cinematic quality into pictorial practice: often his colors have a celluloid gloss, and his paintings oscillate between deep, airy spaces and flat, word-inscribed screens—as though they were projected as much as painted [4]. ■ In this respect, too, his version of Pop exploits its Los Angeles locale.

Screening and scanning

In various ways, then, Lichtenstein, Rosenquist, Ruscha, and others seemed to challenge the oppositions on which pure painting of the twentieth century was founded: high versus low, fine versus commercial, even abstract versus representational. In *Golf Ball* [6] Lichtenstein presents an iconic representation of a dimpled sphere in black and white on a light gray ground. It is as banal as possible, but it is also not too distant from the pure plus-and-minus abstrac-◆ tions of Mondrian also painted in black and white. On the one hand, the near abstraction of *Golf Ball* tests our sense of realism, which here as elsewhere Lichtenstein shows to be a conventional code, a matter of signs that do not always resemble things in the world

▲ 1924, 1930b, 1931a, 1956 ▲ 1906, 1960b ● 1958 ■ 1967a, 1968b ◆ 1913, 1917a, 1944a

4 • Ed Ruscha, *Large Trademark with Eight Spotlights*, 1962
Oil on canvas, 169.5 × 338.5 (66¾ × 133¼)

5 • Ed Ruscha, *Boss*, 1961
Oil on canvas, 182.9 × 170.2 (72 × 67)

(around this time he read *Art and Illusion* [1960] by Ernst Gombrich, who defined realism in this "conventionalist" manner). On the other hand, when a Mondrian begins to look like a golf ball, then the category of abstraction is in trouble too. Modernist painting often worked to resolve figure into ground, to collapse spatial depth into material flatness (Mondrian is again the great example). Like his Pop peers, Lichtenstein gives us both—the illusion of space *and* the fact of surface—and if there is a radical edge in Pop it lies here: less in its thematic opposition of low content and high form, and more in its structural identity of simple sign and exalted painting. One can see why, when cartoons and commodities appeared in the metaphysical space once reserved for the

numinous rectangles of Mark Rothko and the epiphanic stripes of Barnett Newman, some people got upset.

Lichtenstein in particular performs a kind of visual short circuit: he delivers both the immediate effect of a modernist painting and the mediated look of a print image. Consider an early Pop work like *Popeye* [1], which shows the spinach-enriched sailor knocking out his rival Bluto with a roundhouse left. It might be an allegory of the new Pop hero taking the tough Abstract Expressionist to the canvas with a single blow. Yet the important thing is the blow: *Popeye* is arguably as instantaneous in its impact as a Pollock; it smacks the viewer in the head as well. (Lichtenstein likes to underscore the force of this blow with the onomatopoeic terms of the comics: his punches go "Pow," his guns fire "Brattata.") Thus at the level of effect too, Lichtenstein suggests that Pop is not so different from a modernist painting like a Pollock: they project a similar sort of viewer, one that is all eye, that takes in the image in a flash, in a "Pop" of immediacy.

But to what end is this demonstration made? With Warhol, the appearance, in the exalted space of painting, of a newswire photograph of a gruesome car crash or a poisoned housewife is difficult to take even today. For the most part Lichtenstein puts high and low together with less subversive effects; he was proud of his formal sense, his tasteful ability to make good paintings out of banal pictures or mawkish stuff. Yet his reconciliation of high and low is not only a matter of his formal skill; it also registers a historical convergence of these old binaries. Lichtenstein was well prepared for this convergence. In the late forties as a G. I. Bill student at Ohio State University and in the fifties as a teacher in Ohio and upstate New York, he worked through his own catechism in modernist art: he painted along Expressionist lines first, then in a faux folk style (to which he adapted Americana themes, such as *Washington Crossing the Delaware* [1951], that anticipate his Pop art), and briefly in an abstract mode. He became adept in a repertoire of modernist styles and avant-garde devices, such as the gestural stroke, the Cubist play with signs (a few strokes to signify a shadow, a white patch to signify a reflection, and so on), the abstract forms of grid and monochrome

▲ 1947b, 1951 ● 1964b ■ 1911, 1912 ◆ 1913, 1915, 1917a, 1921b, 1944a, 1947a, 1957b, 1962d

▲ painting, as well as the readymade object and the found image, all of which he received secondhand. These devices appear in his work as mediated, as if in review, held together by the iconic shapes supplied by the advert or the comic strip—held together, that is, by the very representational mode that avant-garde art had worked to overthrow. This is one aspect of his Pop art that does have an edge.

Edgy too is his demonstration of how much the codes of advertisements and comics have in common with the devices of the avant-garde (throughout the century the influence in this high–low relationship ran both ways). Of his own pictorial language Lichtenstein once remarked: "Mine is linked to Cubism to the extent that cartooning is. There is a relationship between
● cartooning and people like Miró and Picasso which may not be understood by the cartoonist, but it definitely is related even in
■ the early Disney." He might have added Matisse, Mondrian, and Léger, among others; they are all there, read through the comics, in his paintings: the ambiguous signs of light and shadow in Picasso, the bold but suave contours in Matisse, the strict primary colors in Mondrian, the semicartoonish figures in Léger, all put to different purposes, of course (for example, if the primaries signify pure painting in Mondrian, in Lichtenstein yellow is also likely to signal a beautiful blonde, red a dress, blue the sky). Lichtenstein recomposed his advertisements and comics to fit them to the picture plane, but also to expose these modernist connections and to exploit them rhetorically. (Soon these connections became patent when he began to "Lichtensteinize" some of these masters directly, with paintings done after Picasso, Matisse, Mondrian, and others.) One can draw a dire conclusion from this commingling of modernist art and comic strip: that by the early sixties most devices of the avant-garde had become little more than gadgets

of commercial design. And certainly this is one dilemma of the postwar or neo-avant-garde: that some of the antiart measures of the prewar or "historical" avant-garde had become the stuff not only of art museums but of spectacle industries. Or one can take the benign view that both fine art and commercial design benefited from this exchange of forms and contributed to values that, again, are rather traditional—unity of image, immediacy of effect, and so on. This is how Lichtenstein saw the matter.

Lichtenstein was adept not only in modernist styles but also in different modes of seeing and picturing, some of which date to the Renaissance, if not to antiquity: specific genres of painting like portraiture, landscape, and still life, all of which he Lichtensteinized, as well as general paradigms of painting—of painting as stage, as
▲ window, as mirror, and as abstract surface. Leo Steinberg detected yet another paradigm in the collage-paintings of Rauschenberg and
● Johns, which he termed "the flatbed picture plane": the picture no longer as a vertical frame to look at or through as if onto a natural scene (like a window, a mirror, or indeed an abstract surface), but as a horizontal site where very different images can be brought together textually, a "flat documentary surface that tabulates information." For Steinberg this paradigm signaled a "postmodernist" break with modernist models of picturing, and certainly it influenced Lichtenstein. Yet Lichtenstein also suggests a variant of this model, which is crystallized in his Ben Day dots: a model of the picture as a screened image—and, as such, a sign of a postwar world in which everything seems subject to processing through mechanical reproduction and electronic simulation. This screening bears not merely on the actual making of his art (its commingling of handmade and readymade); it also addresses the mediated look of the contemporary world at large, and affects seeing and picturing as such. As Lobel notes, Lichtenstein often chose comic-strip figures placed in front of viewing screens—gun sights and televisual monitors as well as windshields and dashboards—as if to "compare or correlate the surface of the canvas" with such surfaces [2]. In effect, we too are thus positioned: our looking is also correlated with such viewing. Emergent here is a mode of seeing that has become dominant only in our own age of the computer screen: not only do all images appear screened, but our reading and looking alike have become a kind of "scanning." That is how today we are trained to sweep through information, visual or other : we scan it (and often it scans us, tracking keystrokes, counting website hits, and so forth). Early on Lichtenstein seems to have sensed this shift, both in appearance and in seeing, latent in the comic strip. HF

FURTHER READING

Russell Ferguson (ed.), *Hand-Painted Pop: American Art in Transition, 1955–92* (Los Angeles: Museum of Contemporary Art, 1992)
Walter Hopps and Sarah Bancroft (ed.), *James Rosenquist* (New York: Guggenheim Museum, 2003)
Michael Lobel, *Image Duplicator: Roy Lichtenstein and the Emergence of Pop Art* (New Haven and London: Yale University Press, 2002)
Steven Henry Madoff (ed.), *Pop Art: A Critical History* (Berkeley and Los Angeles: University of California Press, 1997)
Ed Ruscha, *Leave Any Information at the Signal: Writings, Interviews, Bits, Pages* (Cambridge, Mass.: MIT Press, 2002)

6 • Roy Lichtenstein, *Golf Ball*, 1962
Oil on canvas, 81.3 × 81.3 (32 × 32)

▲ 1914, 1918 ● 1907, 1911, 1921a, 1924, 1931d ■ 1903, 1906, 1910, 1913, 1917a, 1925a, 1944a, 1944b ▲ 1960b ● 1958, 1962d

1961

In December, Claes Oldenburg opens *The Store* in New York's East Village, an "environment" that mimicked the setting of surrounding cheap shops and from which all the items were for sale: throughout the winter and the following spring, ten different "happenings" would be performed by Oldenburg's Ray Gun Theater in *The Store* locale.

Allan Kaprow's (1927–2006) essay "The Legacy of Jackson Pollock" was published in the October 1958 issue of *Artnews*, only two years after the painter's tragic death. By that time, the fact that Abstract Expressionism had become academicized had finally dawned on the editor of the journal, which for a decade had been the main promoter of the "10th Street touch," to use Clement Greenberg's disparaging characterization of the art produced by "second-generation" Abstract Expressionists. In January of that year, Jasper Johns's *Target with Four Faces* had appeared on the cover of *Artnews*, in preview of the painter's first solo exhibition which turned out to be a spectacular success. A year later, Frank Stella's black paintings would mesmerize the New York art world. Pop art and Minimalism would soon follow: the inevitable demise of an already exhausted Abstract Expressionism was well under way. Kaprow's text, however, was the first to address head-on the issue of its legacy, or rather that of its main protagonist. Perhaps because he had been trained as an art historian (Kaprow studied with Meyer Schapiro at Columbia University, where he wrote a master's thesis on Mondrian), and was teaching the discipline (at Rutgers), he felt it was not enough, or too easy, to repudiate—rather, one had to sublate.

Kaprow's utopia

It is true, Kaprow starts, that Pollock's innovations are "becoming part of textbooks": "The act of painting, the new space, the personal mark that builds its own form and meaning, the endless tangle, the great scale, the new materials are by now clichés of college art departments." But taking something for granted and replicating it is not understanding it, and there is more to Pollock's enterprise than what this stereotypical take suggests. Indeed, "some of the implications inherent in these new values are not as futile as we all began to believe," adds Kaprow, before commenting upon each feature he had just listed in order to demonstrate that, if Pollock "created some magnificent paintings … he also destroyed painting." The immediacy of the act, the loss of self and identity in the potentially infinite, allover space of painting, the new scale that undermines the autonomy of the canvas as an art object and transforms it into an environment: all of that, and more, points to Pollock's art as one "that tends to lose itself out of bounds, tends to fill our world with itself." Then, "What do we

do now?" asks Kaprow. "There are two alternatives," he answers. "One is to continue in this vein. Probably many good 'near-paintings' can be done varying this esthetics of Pollock's without departing from it or going further. The other is to give up the making of painting entirely—I mean the single flat rectangle or oval as we know it. It has been seen how Pollock came pretty close to doing so himself." There is, on the one hand, the taming of Pollock's work (and there is little doubt that Kaprow's target, at this juncture, was the school of artists presented by Greenberg as Pollock's true heirs: Helen Frankenthaler, Morris Louis, etc.); on the other, the dissolution of painting as we know it, and more precisely, its "dissolution into the environment," to speak like Mondrian from the mid-twenties on.

Kaprow knew very well that his call had a precedent in Mondrian's utopia, but rather than dwelling on this—which would have forced him to take into account the wedge separating the context of the historical avant-gardes and that of the postwar neo-avant-garde, and perhaps to temper his optimism—he concluded his essay with a blueprint for the immediate future, worth quoting in full:

Pollock … left us at the point where we must become preoccupied with and even dazzled by the space and objects of our everyday life, either our bodies, clothes, rooms, or, if need be, the vastness of Forty-second Street. Not satisfied with the suggestion through paint of our other senses, we shall utilize the specific substances of sight, sound, movements, people, odors, touch. Objects of every sort are materials for the new art: paint, chairs, food, electric and neon lights, smoke, water, old socks, a dog, movies, a thousand other things that will be discovered by the present generation of artists. Not only will these bold creators show us, as if for the first time, the world we have always had about us but ignored, but they will disclose entirely unheard-of happenings and events, found in garbage cans, police files, hotel lobbies; seen in store windows and on the streets; and sensed in dreams and horrible accidents. An odor of crushed strawberries, a letter from a friend, or a billboard selling Drano; three taps on the front door, a scratch, a sigh, or a voice lecturing endlessly, a blinding staccato flash, a bowler hat— all will become materials for this new concrete art.

Young artists of today need no longer say, "I am a painter" or "a poet" or "a dancer." They are simply "artists." All of life will

1 • Claes Oldenburg, interior of *The Store*, 107 East 2nd Street,
New York, December 1961

be open to them. They will discover out of ordinary things the meaning of ordinariness. They will not try to make them extraordinary but will only state their real meaning. But out of nothing they will devise the extraordinary and then maybe nothingness as well. People will be delighted or horrified, critics will be confused or amused, but these, I am certain, will be the alchemies of the 1960s.

One cannot but admire Kaprow's foresight here. Much avant-garde art produced in the sixties does fulfill his prophecy, or at least fits this or that aspect of his prospective description. Three interconnected elements need to be singled out, because they directly concern Kaprow's own art and in particular the form that he was inventing at the time, dubbed the "happening": the availability of the world at large—not only the manifold of its objects, particularly its refuse, but also events unfolding in time—as the new, all-encompassing material of art; the dissolution of all hierarchies and value-systems; the suppression of medium-specificity and the simultaneous inclusion of all realms of perception into the aesthetic sphere.

Kaprow had been exhibiting paintings for several years, but toward the end of 1957 he began to create spatial "environments," which he dubbed "action collages," and which he conceived as direct extensions of Pollock's art—in his *Assemblage, Environments & Happenings* of 1966, he reproduced an aerial view of *Yard*, dating from 1961, for which he famously filled a courtyard with an accumulation of used tires [2], next to a photograph by Hans Namuth of Pollock at work (quietly smoking his pipe and trailed by a child, Kaprow looks less heroic than Pollock, but he was definitively more "in" his work). It was while he was was trying to introduce sound in his environments—to open them further to the world, according to his logic of infinite extension—that Kaprow stumbled upon the happening. Dissatisfied with the paucity of effects he could muster, he sought ▲ advice from John Cage, who was then giving a course on composition at the New School for Social Research in New York. Fascinated by what he saw of the class on this first visit, he decided to join the ranks of several nonmusicians who were also in attendance, such as ● George Brecht and Dick Higgins, later to become pillars of Fluxus. It was there, in the spring of 1958, and with the encouragement of Cage, from whom he learned about chance as a compositional, or rather anticompositional, device, that he developed his idea of the happening. Randomness had long been a foundational principle of Cage's musical practice, fostering a genuine interest in the issue of notation. Kaprow's responses to Cage's class assignments were all performed whilst following a score listing objects to be used in noisy actions as well as the duration of each of these actions (which could be simultaneous). The model was obviously musical, but in adding the dimension of space—of the movement and placement of the participants (often hidden from view)—Kaprow emphasized both the theatrical dimension of these events, and their reliance upon a ■ collage tradition derived from Dada.

Between this embryonic stage and the first fully fledged public happening, *18 Happenings in 6 Parts*, nothing fundamentally changed but the structure got more complex. For this event, which

2 • Allan Kaprow, *Yard*, 1961
Environment in the backyard of the Martha Jackson Gallery, New York

marked the inauguration of the Reuben Gallery—a space that would function for the next two years as the Mecca of the new art form (with happenings by Red Grooms, Robert Whitman, Claes Oldenburg, George Brecht, Jim Dine)—Kaprow had divided the space into three rooms by temporary partitions made of wood, sheets of plastic and canvas, either covered with assemblages of various objects to be used as props by the participants, or, if still blank at the beginning of the performance, destined to be painted over during its unrolling. Sounds—electronic, mechanical, and live—as well as lighting (including slide projections) were constantly altering this multipart environment into which six participants (three women and three men) evolved and executed a whole range of disconnected actions and uttered disconnected sentences while keeping as expressionless as possible. The "happenings" were carried out simultaneously in the three rooms (six in each of them) and the spectators were required to change room twice, during the overall one-hour performance (the seats were numbered and the changes of their occupiers were timed in the score). This modest audience participation (it grew in importance in Kaprow's later happenings and in those of others), as well as the absence of plot and character and the simultaneity of the "three-ring circus" insured that no one among the public could claim to have anything more than a fragmentary grasp of the whole event. Even returning the following days—*18 Happenings in 6 Parts* was performed during six evenings, starting on October 4, 1959—would not have much augmented one's mastery of the performance's overall structure, since the likelihood of obtaining a radically different seating arrangement each time was statistically very small.

The breakdown of the barrier separating performers and audience is what most struck commentators on the first happenings (there was

no stage, no ideal setting: in fact, as they grew more complex and involved more participants, happenings tended to occur outdoors, as would Kaprow's *Household* in 1964 [**3**]). This breakdown, particularly when it was marked by aggressivity, was what distinguished happenings from pure theater (Oldenburg's happenings would perhaps be the most violent or rather discomfiting of all, but Kaprow did not hesitate to abuse his public—for example in *A Spring Happening*, in March 1961, when the audience was chased out by someone operating a power landmower at the end of the performance.) Critics also noted that this collapse of the performer/audience boundary was in keeping with happening's deliberate disregard of any cause-and-effect relations as well as of any principle of constancy. Likening it to the "alogic of dreams" that have "no sense of time," no past, are without "climax or consummation," often repetitive, and "always at the present tense," Susan Sontag remarked that its lack of storyline (particularly, as often, when the sequence of actions had been determined by chance) was at odds with the basic modernist concept of the work of art as an autonomous totality, and troubling even for the small, "loyal, appreciative, and for the most part experienced audience" of happenings who "frequently does not know when they are over, and has to be signalled to leave." Another dissolution of categories noticed by Sontag concerns the materials used in the happenings: "one cannot distinguish among set, props, and costumes in a Happening, as one can in the theater." One cannot even distinguish among people and objects (all the more since people were "often made to look like objects, by enclosing them in burlap sacks, elaborate paper wrappings, shrouds, and masks," or stay as immobile as the props around them). There is only a global environment, often deliberately messy, in which mostly fragile materials are used and often destroyed in the course of a series of non-sequential acts. "One cannot hold on to a Happening, and one can only cherish it as one cherishes a firecracker going off dangerously close to one's face," concludes Sontag.

Such impermanence became a key element of Kaprow's concept (after the initial experience of *18 Happenings in 6 Parts*, he often stated that happenings should never be repeated in order to preserve what he deemed their most important quality, their immediacy, their "suchness," as he called it). This has little to do with any interest in spontaneity (happenings were scripted and rehearsed, no matter how aleatory their structure), but with a somewhat naive belief, derived from Cage's Zen-like philosophy, that uniqueness as such was a guarantee of "presence," and that "presence" as such, when thought of as a natural process, was a guarantee against the blatant commodification of all things that characterized the postwar consumerist society.

3 • Allan Kaprow, *Household*, 1964
Happening

(Kaprow's disdain for the art market and the "white walls, tasteful aluminum frames, lovely lighting, fawn—gray rugs, cocktails and polite conversation" pertaining to the modernist gallery had been one of the motivations for his environments.) While he misunderstood Cage, for whom repetition was properly impossible (since no two performances could ever be alike), which made its proscription senseless, Kaprow perhaps inadvertently touched a nerve whose sensitivity among his audience at this time of history might explain more than any other factor the shock value of the happening. This nerve was the economic one, which he irritated, as art historian Robert Haywood pointed out, by enacting the corporate strategy of "planned obsolescence" destined to quicken commodity production and consumption (Haywood's prime example is the 1967 multipart happening *Fluids*, which consisted of erecting and then letting melt fifteen large geometric ice formations spread throughout diverse locations in Pasadena and Los Angeles). Yet though it was intended as a critique of instrumental labor—a critique that his mentor Meyer Schapiro had deemed to be at the core, if not the purpose, of modern art since Impressionism—Kaprow's superlatively gratuitous recourse to a capitalist trick did not really hold as strategy and slowly devolved into an inoffensive spectacle that, as such, only extended further the alienation it pretended to reveal.

Asked by arts critic Richard Kostelanetz "Are not most of us opposed to planned obsolescence? I would prefer more permanent cars. Is it bad for me to want things that would last longer?", Kaprow offered a reply that could have been undersigned by any corporate mogul: "I suggest that this is a myth of the wrong kind—that you really don't want a permanent car; for if you and the public did, you wouldn't buy cars that are made impermanently. Planned obsolescence may have its bad sides…. It also is a very clear indication of America's springtime philosophy—make it new is *renew*; and that's why we have a cult of youth in this country." Those words, uttered in 1968, could not have clashed more dramatically with what the rebelling youth demonstrating in the streets was thinking at the time. In the end, it might have been Kaprow's incapacity to reflect and seize upon the politico-economical meaning of the art form that he had invented that led to its oblivion: in light of the 1968 "real-life" events, far more violent than his own and often as festive, the happening suddenly looked irrelevant and rapidly faded away.

Art for dime stores

But while Kaprow might have been too indirect in his wish to underscore the hold of market forces on our lives and on our consumption of art in particular, Oldenburg addressed this issue head on. Though ▲ his starting-point was not Pollock but rather Jean Dubuffet's "rehabilitation of mud," Oldenburg's early take was quite similar to that of Kaprow, particularly in his glorification of refuse as the prime material of art. But things began to shift right from Oldenburg's first mature manifestation, the "Ray Gun Show" at the Judson Gallery between January and March 1960 (the gallery was administered by the Judson Memorial Church, soon to host the

Judson Dance Theater, including performances by Yvonne Rainer, ▲ Carolee Schneemann, and the Minimalist sculptor Robert Morris). For this show, Oldenburg constructed his first environment, *The Street*, which became the disheveled setting of his first happening, *Snapshot from the City* [**4**]. It consisted of an accumulation of silhouettes made from torn or torched rubbish collected in the streets (lots of corrugated cardboard, of burlap, of old newspapers), and of more garbage spread on the floor. Foremost and recurrent among these silhouettes was that of the "Ray Gun," a parodic sci-fi toy (between a hair-dryer and a gun) devised by Oldenburg as the emblem of all commodities. To enhance the market metaphor, Oldenburg offered the audience of *Snapshot from the City* large sums of "money" in Ray Gun currency (bills ranged from 1,000 figures to 7,000) with which to buy stuff from *The Street* and other junk that he and his fellow artist Jim Dine had been adding to it for the occasion.

What was left over from this fake yardsale was installed as a much sparser version of *The Street* in the Reuben Gallery in May 1960, after which Oldenburg retreated to the country for the summer. It is there, while reflecting upon his dissatisfaction with the second, clean, version of *The Street* in a typical modernist "white cube," that he fully elaborated his concept of the Ray Gun, particularly its ubiquity: any object shaped in a right angle, even a blunt one, can be a Ray Gun, which, in a humorous appropriation of Mondrian's phrase, Oldenburg crowned with the title of "universal angle." "Examples: Legs, Sevens, Pistols, Arms, Phalli—simple Ray Guns. Double Ray Guns: Cross, Airplanes. Absurd Ray Guns: Ice Cream Sodas. Complex Ray Guns: Chairs, Beds." In short, just as gold had for long functioned as the standard of monetary circulation, the Ray Gun was a "general equivalent," the empty sign through which all kinds of things could be compared and exchanged. Although it

4 • Claes Oldenburg, *Snapshots from the City*, 1960
Performance at Judson Gallery, Judson Memorial Church, New York

▲ 1946

▲ 1965, 1968b, 1969

would be far-fetched to imagine that Oldenburg spent his summer musing about political economy, his next project, *The Store* [1], indicates that his ruminations led him to discount his earlier, Kaprowesque aestheticization of refuse as irrelevant. In what seems in retrospect like a direct allusion to his Reuben show, he wrote: "These things [art objects] are displayed in galleries, but that is not the place for them. A store would be better (Store—place full of objects). Museum in b[ourgeois] concept equals store in mine."

Though a partial realization of *The Store* took place in the group show "Environments, Situations, Spaces" at the Martha Jackson Gallery in May–June 1961, it was only in December of that year that Oldenburg opened the outlet of his "Ray Gun Manufacturing Company" on 107 East Second Street, in an area of Manhattan replete with "dime stores" selling cheap or secondhand goods. In this new location *The Store* was conceived as a duplicate of the neighboring shops, where ill-assorted items endlessly succeeded each other on the shelves—with this difference: Oldenburg's shelves were filled with obvious replicas of perishable foodstuffs or tiny objects of mass consumption. Often oversized, made of cloth soaked in plaster and clumsily painted in garish colors applied with broad brush-strokes ▲ (in overt parody of Abstract Expressionism), these baked potatoes, sausages, ice-cream cones or blue shirts were never intended to pass for the real thing (though their price was a far cry from those commanded by art works in even the least prestigious gallery—they ran from twenty-five dollars to over eight hundred). Rather, their purpose was to demonstrate that since there was no fundamental difference between the rarefied commerce of art and the trade of a thrift-store, as both art works and bibelots were nothing but commodities, one might as well skip the pretense and drop the fig-leaf.

If Oldenburg's assault on the institutions of art as sheer marketplace went much further than that of his predecessor, it is because, through the symbol of the Ray Gun (and he displayed countless "Ray Guns" for sale in *The Store*), he had understood that the status of the work of art as commodity rested on its exchangeability. To his delight, a visitor trying to identify one of these poorly shaped objects exclaimed: "It's a lady's handbag.… No, it's an iron. No, a typewriter. No, a toaster. No, it's a piece of pie." But once this metaphoric structure of the art work as exchangeable good had been identified, there was no stopping it from looming everywhere, making of any object the equivalent of at least another one. *Store Days*, a book in which Oldenburg has assembled all the notes pertaining to this ongoing installation and the events that took place in it, abounds in lists of comparisons: "cock and balls equals tie and collar / equals leg and bra / equals stars and stripes / flag equals cigarette package and cigarettes / heart equals balls and triangle / equals (upside down) girdle and stockings / equals (sidewise) cigarette package equals flag."

This potentially infinite chain of associations would hardly pass for economic analysis (foremost because it rests on the deliberate disregard of any opposition between use- and exchange-value). In the end, Oldenburg knew full well that his replicas would end up marketed as art and be given the special care that luxury goods enjoy. But combining with his longstanding interest in psycho-

5 • Claes Oldenburg, *Soft Toilet,* **1966**
Wood, vinyl, kapok, wire, Plexiglas on metal stand and painted wood base, 144.9 × 70.2 × 71.3 (57⅛ × 27⅝ × 28⅛)

analysis, the parody propelled him into the next stage of his production, with which he has been engaged ever since. It was in his subsequent solo exhibition at the Green Gallery, in September–October 1963, that he presented for the first time his large-scale "soft" objects sprawled on the floor (*Floor-Burger, Floor-Cone, Floor-Cake,* etc.): with the unescapable eroticism of these mock edible items (as well as that of the more scatological objects that would follow, such as his *Soft Toilet* [5]), Oldenburg was further aiming his pan-metaphoricity at American mass culture and declaring that if its fixation on consumption was an open secret, its covert obsession was with the body. YAB

FURTHER READING
Robert Haywood, "Critique of Instrumental Labor: Meyer Schapiro's and Allan Kaprow's Theory of Avant-Garde Art," in Benjamin H. D. Buchloh and Judith Rodenbeck, *Experiments in the Everyday: Allan Kaprow and Robert Watts* (New York: Columbia University, 1999)
Allan Kaprow, *Essays on the Blurring of Art and Life* (Berkeley and Los Angeles: University of California Press, 1993)
Michael Kirby, *Happenings* (New York: Dutton & Co, 1966)
Barbara Rose, *Claes Oldenburg* (New York: Museum of Modern Art, 1969)
Susan Sontag, "Happenings: An Art of Radical Juxtaposition," *Against Interpretation* (New York: Dell, 1966)

▲ 1947b

1962 a

In Wiesbaden, West Germany, George Maciunas organizes the first of a series of international events that mark the formation of the Fluxus movement.

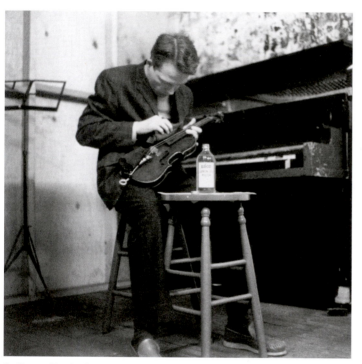

1 • George Brecht, *Solo for Violin, Viola, Cello, or Contrabass*, April 1964
Performance

The force fields of Fluxus

Fluxus was named (if not "founded") in 1961 by George Maciunas (1931–78), a postwar émigré from Lithuania who—after spending a few years at high school in West Germany—came to the United States in 1948. Maciunas claimed to have found the name—derived from the Latin *fluere*, to flow—by sticking a knife or finger into a ▲ dictionary, the very method by which the Dadaists claimed to have found theirs. The term "fluxus" already had a certain resonance. The fifth-century BC philosopher Heraclitus of Epheseus is reputed to have said that "everything is in flux … everything flows" and that "you cannot step into the same river twice." Hegel took up the idea in the eighteenth century when he formed his concept of the dialectic, saying that everything in nature is in continuous flux and that "struggle is the father of everything." And in the early twentieth century, the French philosopher Henri Bergson saw natural evolution as a process of constant change and development—as a "fluxion." Bergson also argued that we do not experience the world moment by moment but continuously in one flow, as we hear music. Beyond these philosophical connotations, Maciunas also explicitly associated the word "fluxus" with the medical processes of cathartic

Fluxus remains the most complex—and therefore widely underestimated—artistic movement (or "nonmovement," as it called itself) of the early to mid-sixties, developing in parallel with, and often in opposition to, Pop art and Minimalism in the ▲ United States and Nouveau Réalisme in Europe. More open and international in scope (and counting more female artists among its participants) than any other avant-garde or neo-avant-garde since
● Dadaism and Russian Constructivism, Fluxus saw no distinction between art and life, and believed that routine, banal, and everyday actions should be regarded as artistic events, declaring that "everything is art and everyone can do it." With its diverse activities, which included "Flux" concerts and festivals, musical [**1, 2**] and theatrical performances, innovatively designed publications and pronouncements, mail art, and other ephemeral events, gestures, and actions [**3**],
■ it initiated many key aspects of Conceptual art, such as the insistence on viewer participation, the turn toward the linguistic performative,
◆ and the beginnings of institutional critique.

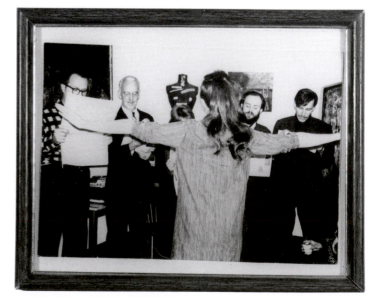

2 • Alison Knowles, *Newspaper Music*, 1967
Concert in the Lund Kunsthalle, Sweden

▲ 1960a, 1960c, 1964b, 1965 ● 1916a, 1920, 1921b ■ 1968b ◆ 1971 ▲ 1916a

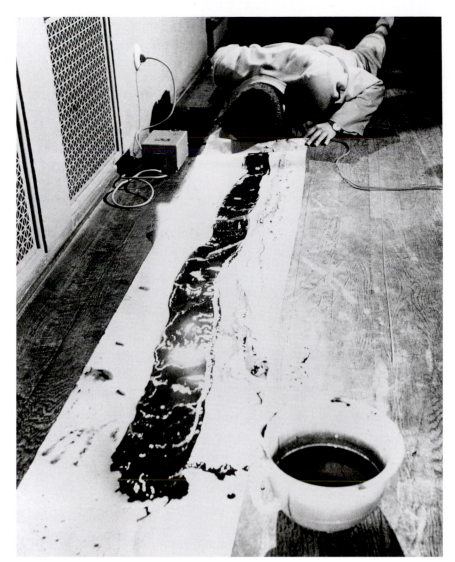

3a • Nam June Paik performing La Monte Young's *Composition 1960 #10 to Bob Morris* at his "Zen For Head," Wiesbaden, West Germany, 1962

3b • Nam June Paik, *Zen for Head*, 1962
Ink and tomato on paper, 404 × 36 (159 × 14³⁄₁₆)

bodily and excremental discharge and the scientific processes of molecular transformation and chemical fusion.

The Fluxus movement emerged at the crucial moment when postwar artists were beginning to turn away from the hegemonic ▲ dominance of American Abstract Expressionism. This shift was prompted to a considerable degree by the publication of Robert Motherwell's anthology *The Dada Painters and Poets* in 1951, and more specifically by the teachings of the composer John Cage ● (an early and avowed follower of Marcel Duchamp) at the New School for Social Research in New York between 1957 and 1959. A whole generation was now directed away from the overpowering ■ presence of Jackson Pollock toward Dadaism in general and the work of Duchamp in particular, and was guided in this by the pervasive influences of Cage's models of chance operations, an ◆ aesthetic of the everyday, and a new type of (artistic) subjectivity.

Perhaps more surprising, however, than the programmatic recovery of Dada and Duchamp's readymade was Maciunas's early and explicit association of the Fluxus project with the most radical legacies of the Soviet avant-garde, those of the LEF

▲ (Left Front of the Arts) group and the Productivists, then barely known to anyone in either Europe or the United States. But this attempt to fuse the crucial features of Dada/Duchamp and Productivism, the most radical avant-garde models of the twentieth century, while being fully aware of the impossibility of achieving any of their historic aims in the present, may have generated the unique and paradoxical mix of the melancholic and the grotesque-comical that came to characterize Fluxus.

Another of the Fluxus group's many remarkable characteristics was its internationalism, since most other avant-gardes in the postwar period had either reasserted nationalist ideologies (for instance, American Abstract Expressionism) or had engaged with ● discourses of traditional identity (such as Joseph Beuys). In manifest distinction, however, from Dada's hopeful aspirations for a post-nation state, or the proletarian internationalism of the Soviets, the internationalism of Fluxus might be described as *cataclysmic* rather than *utopian*, since it originated primarily in the artists' experiences of exile, of involuntary displacement from their ravaged homelands during and after World War II. This was clearly the case with

▲ 1947b ● 1914, 1918, 1935, 1966a ■ 1949a, 1960b ◆ 1953 ▲ 1921b ● 1964a

▲refugees like Maciunas and Daniel Spoerri, but it also held true, though in a very different way, for artists from Korea and Japan, such as Nam June Paik (1932–2006), Yoko Ono (born 1933), Ay-O (born 1931), Shigeko Kubota (1937–2015), Mieko Shiomi (born 1938), and others who joined Fluxus in subsequent years. The opposite form of *voluntary* displacement also contributed to the movement's internationalism: Emmett Williams (1925–2007), Benjamin Patterson (born 1934), and Maciunas all lived and worked in postwar West Germany under the auspices of the US Army, while Robert Filliou (1926–87) first came into contact with Asian culture (as crucial for his own personal development as it was for Fluxus as a whole) when he was stationed in Korea on behalf of the United Nations Korean Reconstruction Agency in the early fifties.

Fluxus, use and amuse

Beyond its complex internationalism and its insistence on group practices, Fluxus also engaged from the beginning with a radical critique of conventional concepts of identity and (artistic) author-ship. This took an antimasculinist, if not yet an explicitly feminist, stance. An outstanding example of this attitude was Shigeko Kubota's *Vagina Painting* [4], in which the artist brushed red paint onto a sheet of paper on the floor with a brush hanging from her crotch, thereby dismantling the seemingly never-ending

• mythology of Pollock's virile painting performances with a single scandalous gesture.

4 • Shigeko Kubota, *Vagina Painting*, 1965
Performed during the "Perpetual Fluxus Festival," New York

Kubota first publicly executed this work at the Perpetual Fluxus Festival, held in 1965 at the New York Cinemathèque. In the same year, Maciunas announced the Fluxus project in the following "official" statement:

FLUXUS ART-AMUSEMENT

*To establish artist's nonprofessional status in society,
he must demonstrate artist's dispensability and inclusiveness,
he must demonstrate the selfsufficiency of the audience,
he must demonstrate that anything can be art and that anybody can do it.*

*Therefore, art-amusement must be simple, amusing, unpretentious,
concerned with insignificances, require no skill or countless rehearsals, have no commodity or institutional value.
The value of art-amusement must be lowered by making it unlimited, massproduced, obtainable by all and eventually produced by all.*

*Fluxus art-amusement is the rear-guard without any pretention [sic]
or urge to participate in the competition of "one-upmanship" with the avant-garde. It strives for the monostructural and nontheatrical qualities of a simple natural event, a game or gag.
It is the fusion of Spike Jones, Vaudeville, gag, children's games and Duchamp.*

If Productivism had insisted on the necessity of responding to the needs of the postrevolutionary proletarian masses by replacing aesthetic self-reflexivity with utilitarian production, and by changing
▲ the elitist distribution form of cultural texts and objects, Dadaism, by contrast, had attempted to posit popular and mass-cultural forms of exhibition and entertainment polemically against the institutionalization of high art and its separation from the sphere of everyday life. Accordingly, Fluxus set out to erase the traditional boundaries between linguistic and visual production, between text
• and object. Typically, it was one of Duchamp's late works, his *Boîte-en-valise* (1935–41)—which, in the early sixties, was taken seriously by hardly anyone—that became a crucial point of depar-ture for Fluxus reflections on the dialectics of object status, institutional frame, and distribution form.

But, exceeding Duchamp, Fluxus aimed to efface the last remaining divisions between the readymade (that is, the suspended utilitarian or commodity object) and the very means of its suspen-sion (that is, the devices of framing and presentation); and one of the ways it did so was by collapsing the differences between the linguistic and discursive formations of the "work" and those of its containers—which is to say, the differences between the cultural discourses that declare "This is the art" and "This is the
■ frame." For Fluxus considered both framing and presentational devices, with their typography and graphic design, as *languages* in their own right, not just as separate and lesser *carriers* of a language

▲ 1960a • 1949a, 1960b ▲ 1916a, 1920 • 1935 ■ Introduction 4, 1971

that takes the higher form of "art." It thereby equated work and frame, object and container. Yet at the same time, it dismantled the "magic" of the "art" object that has been made so *by* its presentational frames (such as the Surrealist vitrine or Joseph Cornell's boxes), and replaced these with an aesthetic of archival accumulation, one in which the textual, visual, or audio recording of a work's production and subsequent display or performance were as much part of the finished "art work" as the object or event itself (this aesthetic would receive its fullest articulation with Robert Morris's *Card File* of 1962.

From *Store* to box

Positioning its production wholly within the sphere of consumer culture, Fluxus defined the commodity as the exclusive object-type and distribution form within which art could be produced and perceived. On several occasions, this took the form of simulating "institutional" and "commercial" frames of presentation and distribution (Claes Oldenburg's *The Store* from 1961 was an important predecessor to these concerns): the Fluxshop, founded by Maciunas at 359 Canal Street in New York in 1965, Robert Watts's (1923–88) *Implosions*, the *Cédille qui sourit*, initiated by Robert Filliou and George Brecht (1926–2008) in 1965 in Villefranche-sur-Mer in France—all of these "enterprises" posed as artistic schemes to produce and distribute a variety of radically democratized gadgets and objects.

Filliou's *Galerie légitime* [5] was another early example of Fluxus institutional critique. "Founded" in 1966, the "gallery" was in fact the artist's bowler hat (or sometimes his Japanese cap or his beret), which contained a variety of handmade objects, notations, and photographic records of his own works or those by other artists who had chosen, or whom he had chosen, to "exhibit" in one of its touring "exhibitions." Filliou himself described one of these "shows":

In July 1962, the Galerie légitime—a hat in this case—organized an exhibition of works by the American artist Benjamin Patterson. We walked round Paris from 4 o'clock in the morning until 9 at night, starting from Les Halles, finishing up at La Coupole.

Both the gallery's perpetual mobility and its reduction of the work of art to a pure notation or documentary record are reminiscent of Duchamp's *Boîte-en-valise*. But the proximity of the institutional space and its "artistic objects" to the sphere of the artist's body (his head), and the fusion of the utilitarian object (the hat) with the frame of the institution (the "gallery"), imbued the *Galerie légitime* with a grotesque urgency: it not only insisted on the work's egalitarian intimacy with both the body and the utilitarian object, but also, at the same time, withdrew all perceptual presence from the alienating institutional, discursive, and economic frames beyond the quasi-umbilical container of the hat.

The self-deprecatory humor of Fluxus that regarded these radical activities as those of a "rear-guard" is evident in Maciunas's pronouncement that during the entire year of its operation the

5 • Robert Filliou, *Galerie légitime*, c. 1962–3
Assemblage, 4 × 26.5 × 26.5 (1⅝ × 10⅜ × 10⅜)

1960–1969

Fluxshop did not sell a single object from its vast array of low-priced boxes, books, gadgets, and multiples. It is equally present in Emmett Williams's proudly stated confession that there were often more performers than audience members at the early Fluxus festivals. One of Williams's most startling works from the early sixties, the *Counting Songs*, in which he counted aloud the members of the audience, was first performed at the "Six Pro- and Contragrammer Festival" at the Nikolai Kerke in Copenhagen in 1962. Appearing as though he were counting the audience in a modernist self-referential manner, Williams was actually doing so because he thought the organizers had cheated him out of his full share of the minimal admission charge.

One could argue that Fluxus was the first cultural project in the postwar period to recognize that collective constructions of identity and social relations were now primarily and universally mediated through reified objects of consumption, and that this systematic annihilation of conventional forms of subjectivity necessitated an equally reified and internationally disseminated aesthetic articulation. In order to implement this, Fluxus had to dismantle *all* of the traditional conventions that had offered a cultural guarantee for the continuity of the bourgeois subject. First, it would have to rupture the foundationalist certainty that language itself had provided to literature and bourgeois subjectivity. This premise had remained more or less valid until the arrival of Dadaism and Gertrude Stein, both "rediscovered" by Fluxus. Their "rediscovery" was largely the result of the editorial interests of the poet and performer Dick Higgins (1938–98), one of Cage's students at the New School for Social Research in 1957, who from 1964 republished many important works such as Richard Huelsenbeck's *Dada Almanach* and Gertrude Stein's *The Making of Americans* through his exceptional Something Else Press publishing house.

But Fluxus also systematically eroded the securities of the literary genres, by scrambling all the codes and conventions that had categorized literary writing (such as poetry, drama, and the narrative

▲ 1931a ● 1968b ■ 1961
▲ 1907, 1916a

novel) and had confined "other" linguistic enunciations to the realm of the "nonliterary" (for instance, the journalistic documentary or factual narrative, private letters, the performative, or chance-derived texts): all of these became the bases of Fluxus activities.

The removal of the boundaries between these literary genres was not the result of a revolutionary aspiration toward a *Gesamtkunstwerk*, in which all of the arts of the past could be reunited within a structure that adequately responded to the actually existing social conditions of collective participation in the formation of wealth. Rather, the disintegration of boundaries in Fluxus acknowledged the rapid decline of options, the diminishing returns of the traditional genres and conventions, which have all, one by one, lost their license and historical credibility under the conditions of extreme separation and reification. It was in recognition of the impact of massive dedifferentiation—the process under advanced consumer capitalism whereby experience becomes homogenized, where everything in the world is made the same, without difference—that Fluxus articulated these diminishing options and discursive opportunities by collapsing all traditional genres and artistic conventions.

Shifting registers

Within each contested category of Fluxus activity, however, particular confrontations were systematically enforced. In fact, the highly diverse projects of the group's members helped bring about the most crucial change by shifting artistic production from the register of the object to registers operating somewhere between theatricality and musicality: if Duchamp had predicted in the mid-sixties that at some point in the near future the entire galaxy of objects would have to be considered as an inexhaustible resource ▲ of readymades, Fluxus had already responded by displacing this paradigm with an aesthetic of the universal "event" [**6**]. Indeed, when Robert Watts retrospectively defined the "Yam Festival"—a year-long festival planned for 1962–3, during which one performance or event was to be delivered each day—his description echoed Duchamp's statement almost exactly: "a loose format that would make it possible to combine or include an ever expanding universe of events." (Organized according to the principles of chance and play, the "Festival" culminated with a finale in May [that is, "Yam" spelled backward] 1963.)

This paradigm shift implied that the systematic destabilization of the visual object enacted by the readymade would find its equivalents in the theatrical register. Fluxus achieved this by fusing the most elementary forms of the linguistic performative with a virtual infinity of chance operations to forge a new dramaturgy of "event performances," recorded in "event scores." Actually formulated by Cage (that is, prior to Fluxus itself), the idea of the "event" became central to the aesthetics of his students, in particular George Brecht, Dick Higgins, and Jackson Mac Low (1922–2004). Higgins recalled how Cage's teachings first defined "events" as a new paradigm:

6 • Robert Watts, *Robert Watts Events (Fluxus Edition)*, 1963
Plastic box, offset labels, 97 offset cards, rubber pear, 13 × 28.6 × 17.9 (5⅛ × 11¼ × 7 1/16)

Cage used to talk about a lot of things going on at once and having nothing to do with each other. He called it "autonomous behaviour of simultaneous events."

Brecht first identified the "event" as a new paradigm in his essay "Chance Imagery" (written in 1957 and published in 1966), defining it later as "very private, like little enlightenments I wanted to communicate to my friends, who would know what to do with them." One, by now classic example of Brecht's events was his *Drip Music (Drip Event)*, which he first proposed in 1959 and was "published" by Maciunas in 1963 in *Water Yam*, a collection of Brecht's "event score" cards and one of the earliest Fluxus boxes to be produced:

For single or multiple performance. A source of dripping water and an empty vessel are arranged so that the water falls into the vessel. Second Version: Dripping.

This "event" marks precisely the transition from a chance aesthetic that—at the moment of "Chance Imagery"—was still defined ▲ primarily by the encounter with Pollock's painting toward a

▲ 1914

▲ 1949a, 1960b

Cage-inspired aesthetic of chance operations that critiqued the idea of painting as a heroic site and an exceptional practice of virile authority and authorial identity. Brecht snatched the crucial dimensions of the ludic, the aleatory, and the performative away from the painterly spectacle that Pollock (or rather the reception of his work) had recently triggered and embedded them in the most intimate forms of the subject's experience of everyday reification.

Another example of such early "event scores," partially readable against the background of Abstract Expressionism's masculinist athletics, and testifying to Cage's impact on the artists of that generation, is the work of Alison Knowles (born 1933), who studied painting with Adolph Gottlieb at the Pratt Institute. Her *Proposition No. 2 (October 1962)*, also entitled *Make a Salad*, was first performed at the Institute of Contemporary Arts in London in 1962 and consisted "quite simply" of the public execution of the proposition by the artist. A year later, in *Proposition No. 6*, Knowles suggested another event, entitled *Shoes of Your Choice*:

> *A member of the audience is invited to come forward to a microphone if one is available and describe a pair of shoes, the ones he is wearing or another pair. He is encouraged to tell where he got them, the size, color, why he likes them, etc.*

In a later project, *Identical Lunch* (1968), Knowles demonstrated that anyone wanting to be an artist / performer need only to record the circumstances of an event or action to have produced a work:

> *The Identical Lunch: a tunafish sandwich on wheat toast with lettuce and butter, no mayo and a large glass of buttermilk or a cup of soup was and is eaten many days of each week at the same place and at about the same time.*

▲ At first glance one might associate these "event scores" with Pop art's early sixties rediscovery of the iconography of everyday life (such as Claes Oldenburg's persistent focus on American food as an iconic object). But it is precisely at this juncture where the profound differences between Fluxus and Pop become all the more transparent. While the Pop artists ultimately insisted that the spheres of painting and sculpture were essentially different from that of the readymade object, let alone from that of everyday objects, the Fluxus artists emphasized the exact opposite: that it was only on the level of the object itself that the experience of reification could be combated in the radical transformation of artistic objects (and genres) into events.

Thus Fluxus not only acknowledged the "poverty of reality" that the Surrealists had already bemoaned in the twenties, or the
● "poverty of experience" that Walter Benjamin had analyzed critically in the thirties, it also attempted to overcome these. Fluxus "events," in their quasi-religious devotion to the everyday, and in their emphasis on the repetitive and mechanistic forms of daily consumption and on the instrumentalized "simplicity" within which subjectivity is constituted and contained, resuscitated and articulated the individual subject's limited capacity to recognize the collectively prevailing conditions of "experience."

Sublimation and desublimation

Fluxus artists gave a dialectical answer to Pop art's inherent traditionalism and its implicit aestheticization of reification by dissolving both the artistic genres and the readymade object's centrality. In public acts that reintegrated the "object" within the flow of consciously "performed" everyday activities, Fluxus provided an artistic analogue to psychoanalysis' recovery of object relations or capacities of experience that have been split off from the subject through trauma or repression, or that have been simply "lost" in the general processes of socialization.

These dialectics of sublimation and desublimation are at the core of the difficulties with which Fluxus confronted its audiences ever since its first performances, and they are doubly overdetermined. On the one hand, Fluxus acknowledged that collective subjectivity has no access to space and time within which it can constitute itself other than in the leftover spaces and temporal structures that have remained mysteriously outside an ever-increasing process of commodification, and also that it is only in extremely decentered gestures that an *artistic* instantiation of a self-determining subject can be conceived and articulated.

On the other hand, it recognized this condition of being condemned to utter ephemerality, to extreme forms of linguistic, visual, and theatrical-musical fragmentation, and associated itself explicitly with counterforms of cultural experience, with the "low" arts of popular entertainment, of the gag, the joke, and vaudeville theater, at a moment when these antiquated forms appeared diverse and subversive in comparison with the massive homogeneity of postwar spectacle culture.

It is not surprising, therefore, that we find new and often hybrid models of (artistic) subjectivity and its critique in Fluxus: from Cage's infatuation with Zen Buddhism and the discovery of non-Western and nonbourgeois philosophical or religious conceptions to the political claims expressed by Maciunas (he was widely perceived throughout the sixties and seventies as a Marxist-Leninist), who attempted to collectivize artistic production, abolish the class character of culture, alter the work's distribution form, and deprofessionalize the artist in order to transform the social division of labour that had positioned the artist in the role of the exceptional specialist of cognitive and perceptual competence.

Such hybridity was a particularly notable feature of Fluxus typography and graphic design. These had been two of the areas in
▲ which the Dadaists and the Soviet Productivists had enacted their own radical aesthetic, semiotic, and political aspirations. For them, typeface and layout functioned as the forms and grounds on which the first steps of a collective perceptual and linguistic revolution were to be taken. In this respect, once again, these two early avant-gardes provided a model for Fluxus. But its typography and design also engaged in a dialogue with yet another avant-garde, Surrealism, as mediated through the work of the collage novels of Max Ernst and through Duchamp's collaborator on the *Boîte*,
● Joseph Cornell, who was of considerable importance in the

formation of the early work of Brecht and Watts. Surrealism's use of *obsolescence* as an oppositional practice against contemporaneity as mere fashion and compulsory consumption came to characterize the objects and presentational devices of Fluxus as well. One example of this was Maciunas's paradoxical insertion of late-nineteenth-century steel engravings from popular advertisements and illustrations into his otherwise rigorous designs for Fluxus publications, publicity, and pronouncements, which he produced on the then newly developed IBM Composer typewriter. This machine imbued all of Maciunas's typographic designs, from La Monte Young's *An Anthology* in 1962 onward, with an administrative rationalization and immediacy that would become compulsory under the reign of Conceptualism.

The name cards designed by Maciunas for his colleagues around 1966 [7] illuminate both Fluxus' distance from its radical predecessors and the paradoxes of its wider project. Maciunas might have envisaged the movement as a collective, aiming at anonymity in order to dissolve the cult of artistic subjectivity, but the actual group of original Fluxus participants consisted of a very loose-knit association of extremely independent and autonomous figures, and each of them was given a separate and unique identity through the typography and design of Maciunas's cards. The spectrum of typefaces used ranged from nineteenth-century ornamental type (as in one of two cards designed for Robert Watts) to the more bureaucratic, rationalized, and serialized sans-serif type of Maciunas's IBM machine. He used the latter to spell out Robert Filliou's name ten times, each one followed by a question mark, and an eleventh time, only now followed by an exclamation mark. In the typographical design of these name cards, individual subjectivity hovers somewhere between allegorical ornament and corporate trademark, between Fluxus' utopian abolition of the exceptional artist and the existing rule of corporate culture, which dismantles any form of subjective experience. To have brought out the precariousness of this historical dialectic is one of the movement's many achievements.

7 • George Maciunas, *Name Cards of Fluxus Artists*, c. 1966

Another example of early Fluxus typography, one that shows the extent to which design constituted an integral element of the group's project, was the *Yam Festival Newspaper*, coproduced by Brecht and Watts in 1963, which served primarily to publicize the activities and products of the "Yam Festival." Simulating the format of an antiquated small-town broadsheet, the *Newspaper*
▲ performed a Situationist-like *détournement* of the traditional daily newspaper's framework of text and image with its fusion of information and ideology, advertisements and cartoons. Constructing in typography and design a parallel to the playful and chance-derived "Festival," the *Yam Newspaper* restructured the way a traditional newspaper is normally read (the way a reader is deliberately led through its pages in a particular direction) by adopting a scroll format, constant reversals of the reading axis, and repeated fragmentation. It thus enacted on the level of reading the very same principles of chance and play that governed the "Festival" itself as a collective liberation from the regulation and control of experience in everyday life.

The dialectics of radicality

Contradictions of theory and practice characterized the Fluxus project. Vehemently opposed to the object-ness and commodity status of the work of art, Fluxus nonetheless produced endless commodities of the lowest and cheapest sort. Insisting on the universal accessibility of artistic objects across geopolitical and class boundaries, Fluxus nonetheless became one of the most inaccessible and esoteric cultural formations of the twentieth century. Demanding collectivist group identity and the demolition of the artist as cult figure, Maciunas nonetheless maintained a petulant control over the group that matched earlier examples of avant-garde authoritarianism in the context of Dada and Surrealism (for
● example, the orthodox fanaticism of Tristan Tzara and André Breton) and corresponded to Guy Debord's autocratic control over the Situationist International.

But one of the most difficult aspects of Fluxus to assess is the
■ vandalism of its (quasi-Futurist) desire to annihilate European high-art (and avant-garde) traditions. When Maciunas formulated his *Fluxus Manifesto* in 1963 [8], he revealed both the radicality of his ideas and—involuntarily—their "avant-gardiste" deficiencies:

> *Purge: the world of bourgeois sickness, "intellectual," professional & commercialized culture, PURGE the world of dead art, imitation, artificial art, abstract art, illusionistic art, mathematical art, — PURGE THE WORLD OF "EUROPANISM"!*

Though Fluxus claimed to have successfully eliminated all the experiential differences between aesthetic and everyday objects, it did so without fully reflecting on the radically altered conditions of production and experience that emerge in an advanced culture industry. In making its own coincidental events and ephemeral objects an aesthetic standard, Fluxus risked becoming an unknowing part of a larger social project of enforced dedifferenti-

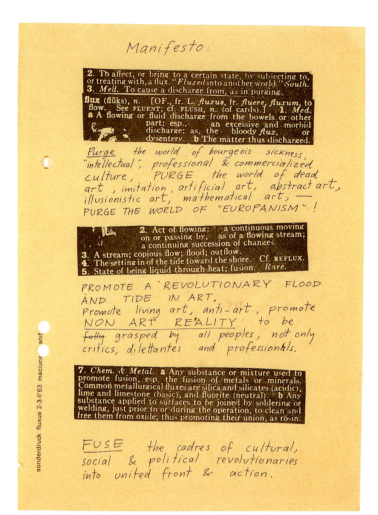

8 • George Maciunas, *Fluxus Manifesto*, February 1963
Offset on paper

ation and desublimation. The group could be misperceived, therefore, as having implicitly endorsed the prominent social tendency that relegates the artistic object to the realm of the ephemeral, dischargeable and disposable along with all other objects among the infinity of commodities. BB

FURTHER READING
Elizabeth Armstrong and Joan Rothfuss (eds), *In the Spirit of Fluxus*
(Minneapolis: Walker Art Center, 1993)
Jon Hendricks (ed.), *Fluxus Codex: The Gilbert and Lila Silverman Collection*
(New York: Harry N. Abrams, 1988)
Thomas Kellein, *Fluxus* (London: Thames & Hudson, 1995)
Thomas Kellein (ed.), *Fröhliche Wissenschaft: Das Archiv Sohm*
(Stuttgart: Staatsgalerie Stuttgart, 1987)
Emmett Williams and Ann Noël (eds), *Mister Fluxus: A Collective Portrait of George Maciunas* (London: Thames & Hudson, 1995)

▲ 1957a ● 1916a, 1924 ■ 1909

1962 b

In Vienna, a group of artists including Günter Brus, Otto Mühl, and Hermann Nitsch come together to form Viennese Actionism.

The formation of the Wiener Aktionsgruppe (Viennese Actionists group) follows what seems to have been the inexorable course of all postwar artistic activities, facing, on the one hand, the ruined conditions of the European avant-garde, either obliterated or destroyed by fascism and totalitarianism, and on the other hand the overwhelming promises of the American neo-avant-garde, in its emergence during the period of European reconstruction. In Vienna—as elsewhere—the seemingly universal impact of, in Allan Kaprow's words, "The Legacy of Jackson Pollock" became central (either by the direct encounter with his work, or via its highly misread mediations in the paintings of Georges Mathieu [born 1931] and Yves Klein, who exhibited in Vienna to great acclaim in the late fifties). Other European artists such as Manolo Millares (1926–72) and Alberto Burri (1915–95) (strangely enough Lucio Fontana was never mentioned) were equally cited by the Viennese Actionists as providing license for the destruction of the canvas and the spatialization of the painterly process.

The desecration of painting as ritual

The first steps for the evacuation, if not outright destruction, of easel painting, its traditional formats, materials, and processes, were taken by the Viennese artists Günter Brus (born 1938), Otto Mühl (1925–2013), and Hermann Nitsch (born 1938) around 1960. From then on, painting would be forced to regress to infantile smearing (Brus), to aleatory processes of application (as in the staining and pouring of the *Schüttbilder* [Pouring Paintings] by Nitsch), or to the actual defacement of the surface in the tearing and cutting of painting's support, the shift from relief to object (Mühl), making it evident that the canvas itself had become *one* surface among other surfaces, merely an object littered with other objects.

As a second step, the Viennese recognized the necessity of noncompositionality to the decentering of perspectival order. They deployed the principles of permutations as well as (predominantly violent) chance operations. The third, and possibly most important, step was their push for painting's inevitable expansion into public space, theatrical if not social. Yet the perceptual parameters of that spatial expansion initially seem to have remained opaque to the artists, since they either ignored or disregarded all earlier historical transformations of the interrelationships between painterly space and social space (for example, the work of El Lissitzky and that of the Soviet avant-garde in general).

Paradoxically, in spite of the Viennese histrionics about the absolute originality of their inventions, the actual works produced in the period prior to the development of the Viennese Actionist movement are in many instances similar to slightly earlier work by American artists: the paintings by Brus and Adolf Frohner (1934–2007) exacerbate the desublimatory effects of the somatic graphemes of Cy Twombly in the late fifties, and Mühl's and Nitsch's *Materialbilder* (Material Pictures) uncannily resemble (if not repeat) the funk and neo-Dada assemblages by artists such as Jasper Johns, Robert Rauschenberg, Bruce Conner, or Allan Kaprow. Clearly, the Viennese Actionists misread Pollock's latent, yet inexorable spectacularization of painting as a celebratory legitimation of art's return to ritual (which Pollock's own rhetoric had fueled). The Viennese writer and theoretician Oswald Wiener (born 1935)—a founding member of the Wiener Gruppe who subsequently became to some extent the aesthetic and theoretical mastermind of the Viennese Actionists—had already declared in his *Cool Manifesto* in 1954 that artistic production would have to move away from *objects*, to focus on the work of art as an *event structure*. Thus, Wiener anticipates the prophecy of Kaprow's essay "The Legacy of Jackson Pollock" (written in 1956, published in 1958), stating that "not only will these bold creators show us, as if for the first time, the world we have always had about us but ignored, but they will disclose entirely unheard of *happenings and events*."

With the example of Pollock established, American artists began to engage painting's performance structure—with its implications of action and duration—as early as 1952 (for example when John Cage enacted his protohappening *Theatre Piece No.1* with Robert Rauschenberg, Mary Caroline Richards, Merce Cunningham, and others at Black Mountain College). This was followed in 1959 by the first such work to use the term "happening" (coined by its maker): Allan Kaprow's *18 Happenings in 6 Parts* at the Reuben Gallery in New York. It is important to acknowledge immediately the specific differences between the early "happenings" of Kaprow, Dine, and Oldenburg and the performances of the Viennese

▲ 1961 ● 1960a ■ 1959a ▲ 1921b, 1926, 1928a, 1928b ● 1953 ■ 1958, 1959b ◆ 1947a

1960–1969

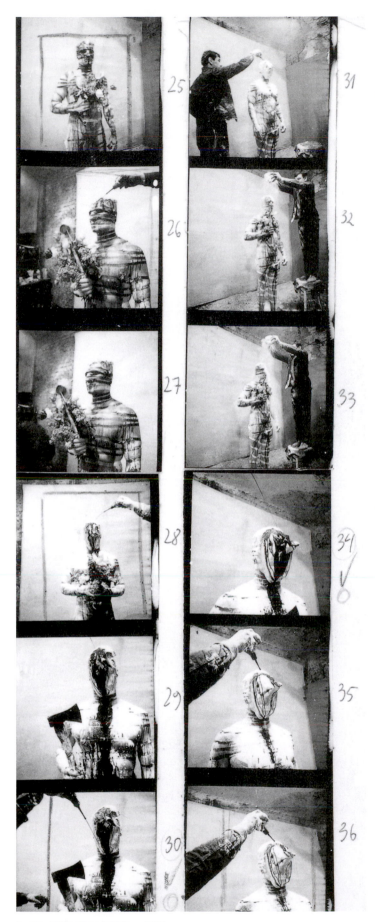

1 • Otto Mühl, *Materialaktion*, 1965
Photographic documents

Actionists, beginning in 1962. While the Americans' "happenings" focus on the clash between the body and technology, the mechanical and the mass-cultural environment (for instance, Jim Dine's *Car Crash*, Claes Oldenburg's *Photo Death* and his installation ▲ *The Street*) the artists of Viennese Actionism emphasize the return to ritual and theatricality right from the beginning. Furthermore, even in their very first performances, the Viennese Actionists single out the body itself and treat it as an analytic object, as the libidinal site where the intersection between psychosomatic subjectivity and social subjection can be dramatically enacted.

There are several reasons for these differences. The first is that the Actionists linked action painting and *tachisme* with the specifically local and regional Austrian Expressionist tradition. One of Vienna's foundational cultural characteristics had been the fusion of Catholicism and patriarchy with a powerful and hierarchical imperial order, a fusion that had been internalized and perpetuated most within its bourgeois class. From the beginning of the twentieth century, Viennese Expressionism had opposed these power structures and constituted itself within a poignant and lasting dialectic: on the one hand was a hypertrophic cult of the sexual body, touting its compulsions as subversive of the bourgeois regimes of sublimation and repression; on the other hand was a simultaneous loathing of the body and of sexuality as the very structures where social order and repression were most deeply anchored and acted out in compulsive behavior and neurotic suffering. This Expressionist tradition—beginning with Oskar Kokoschka's 1909 play and poster, revealingly titled *Murderer, the* • *Hope of Woman*, and with the extraordinary drawings of Egon Schiele and Alfred Kubin—served as *one* crucial horizon and point of departure for Viennese Actionism.

Psychoanalysis and polymorphous perversity

The second reason for the cultural divide between the American and Viennese artists is the fact that the Viennese Actionists emerged from a culture of psychoanalysis. The rediscovery of the prewar theories of Sigmund Freud and the rearticulation of psychoanalysis in its various strands and deviations from Wilhelm Reich (who would become crucial for Mühl) to Carl G. Jung (whose theory of unconscious archetypes was of particular importance to Nitsch), are certainly another defining element in Viennese Actionism. Yet the conception of the body in Viennese Actionism is distinctly post-Freudian, since it foregrounds the polymorph perverse origins of the libidinal structure rather than, as Freud had required, conceiving of sexuality as a teleological trajectory in which the subject's earlier and "primitive" stages of instinctual development are surpassed, culminating in a presumably hegemonic and heterosexual genitality. The new postlinguistic theatricality of the Viennese Actionists originates precisely in a recourse to these partial drives, in an almost programmatic and ostentatious regression to, not to say propagandistic staging of, the primitive phases of sexual development. This particular

▲ 1961 • 1900a

confrontation reminds us of course of a similar conflict between André Breton's Surrealist psychoanalytic theories and Georges Bataille's and Antonin Artaud's derisive critique of Surrealism and of Freudian orthodoxy. Yet the Actionists were equally influenced by Breton's Surrealism (ignoring Bataille) and of Artaud's "Theatre of Cruelty." They seem to have worked through both positions in the process of formulating the project of Actionism.

Lastly, and perhaps most importantly, the Viennese Actionists positioned themselves and their work quite explicitly within the sociohistorical framework of postfascist Austria. Thus Otto Mühl, the oldest member of the group, spent two years in the German Army during the war and later stated that his Actionism was his personal response to the experience of fascism. After 1945, Austria, like Germany, had been occupied by the four Allies. From the fifties onwards it was systematically restructured according to the laws of a liberal democracy.

Adopting the principles of the so-called free market society, the conduct of everyday life in Austria was rapidly forced into the American mold of compulsive consumption. As was the case in post-Nazi Germany, Austrians seem to have been convinced that this transition could be achieved most efficiently by embracing the principles of solid repression and via a massive amnesia about their own recent fascist past, both in its self-generated variety of Austro-Fascism and in its externally imposed version of the 1938 German Nazi *Anschluss* (Annexation), and the catastrophic consequences of both.

The extraordinary violence with which the work of the Actionists confronts its spectators thus seems to originate in a dialectic that is particular to the postfascist cultures of Europe: on the one hand, the Viennese Actionists seem to have recognized that experience could be resuscitated only by breaking through the armor of collectively enforced repression. Therefore, the ritualistic reenactment of brutal and excessive forms of human defilement and the theatrical debasement of the human body would become mandatory, since all cultural representation from that point onward would have to be measured against the destruction of the subject, which had now been historically established on a massive scale. On the other hand, Viennese Actionism voluntarily seems to have enforced the total reritualization of artistic practices under the newly emerging aegis of spectacle culture. While the grotesque performances of Georges Mathieu and Yves Klein seemed to indicate at least an ironic glimpse of understanding their condition, there is little evidence that the Viennese Actionists actually grasped this external determination.

Gesamtkunstwerk and travesty

As early as 1960, Nitsch had begun to produce his variations on the legacies of *tachisme* and action painting by pouring (mostly blood-red) paint directly onto (or rather *into*) his canvases. The blood-stained appearance of these *Schüttbilder*—as Nitsch would call them—attempted to simulate sacrifice using modernist monochromy. These paintings declared that a flat canvas was not just an object of neopositivist self-reflexivity but that it should become, once again, a vessel of ritualistic and transcendental experience. Accordingly, Nitsch's titles, such as *Stations of the Cross*, *Wall of Flagellation*, and *Triptych of the Blood of the Cross*, situate each work programmatically outside of modernist painting and reclaim its putative access to the spheres of the sacred, of myth, and of liturgical performance. Nitsch would later state in his "Blood Organ Manifesto" in 1962:

> *Through my art production (a form of devotion to life) I take upon myself that which appears to be a negative, perverse and obscene lust and the sacrificial hysteria resulting from it, so as to spare you the defilement and shame of a descent into the extreme.*

By contrast, Mühl's first *Materialbilder* (begun in the summer of 1961) owe more to his encounter with the idiom of junk sculpture, by then universally practiced in the work of Jean Tinguely in Paris and David Smith, Richard Stankiewicz, and John Chamberlain in New York, all of whom had introduced contemporary industrial refuse to form countermachinic sculptures by that time. Rather than continuing as a painter/sculptor in the assemblage tradition of Kurt Schwitters, whom the Viennese venerated as one of their greatest predecessors, Mühl subsequently identified himself only as a "poet and director" beginning in 1963. Already pointing in the direction of his subsequent *Materialaktionen* (Material Action Performances), he describes his assemblage work in the following terms: "a sensual expansion and movement in space, ground up, mixed up, broken up, piled up, scratched, hacked up and blown up." Mühl declares his artistic project to be one of *destructivism* (presumably in opposition to *Constructivism*) and he announces its anarchist and nihilist dogma to be one of "absolute revolt, total disobedience, and systematic sabotage.... All art will be destroyed, annihilated, terminated and something new will begin."

Deriving directly from the Futurist proclamation that *industrial* materials are equally valid for artistic production, Mühl now celebrates the incorporation of the most banal substances of everyday consumer culture. Thus, in Mühl's theatrical performances (which he called "Happenings" after 1963, when Kiki Kogelnik [1935–77], an Austrian artist living in New York, told him about Kaprow's term), it is no longer the forces of industrialization, but the universal regime of commodification that sets the terms for the individual's subjection. At the moment of the breakthrough from action painting to *Materialaktion*, Mühl states that "meals and meat, vegetables and sauces, jam and breadcrumbs, liquid paint and powdered pigment, paper, rags, dust, wood, stones, whipped cream, milk, oil, smoke, fire, tools, machines, airplanes etc., etc." are all equally valid for the production of a *Materialaktion*. And we find a very similar position in the writings of Nitsch at that time when he states that "all the normal substances of everyday life, like oil and vinegar, wine and honey, egg yolks and blood, meat as matter, intestines, and talcum powder were discovered for Actionism because of their substance and material sensuality." Both statements inevitably recall once again Allan

▲ 1924, 1930b, 1931b

▲ 1960a ● 1945 ■ 1926 ◆ 1921b

Kaprow's essay "The Legacy of Jackson Pollock" and *its* lists of newly discovered materials from everyday life:

> We shall utilize the specific substances of sight, sound, movements, people, odors, touch. Objects of every sort are materials for the new art: paint, chairs, food, electric and neon lights, smoke, water, old socks, a dog, movies, a thousand other things that will be discovered by the present generation of artists.

Mühl's *Materialaktionen* from 1963 onward deploy two crucial strategies, that of *Entzweckung* (disfunctionalization) and that of *Entwirklichung* (derealization). Both detach objects and materials from their common functions and achieve the estrangement effect for performances of everyday activities within the context of the *Materialaktion*, aiming quite explicitly at a newly experienced immediacy of sensation and cognition comparable to

▲ the tradition of the Soviet Formalist model of *ostranenie*. Despite their explicit antitheatrical claims, and beyond the tremendous impact on the Viennese Actionists at large of the theories and writings of Artaud, the *Materialaktionen* seem to fuse the endless despair of Samuel Beckett's *Endgame* (1958) or *Happy Days* (1961) with a Viennese variation of Buster Keaton's and Charlie Chaplin's slapstick comedies (such as "Modern Times" of 1936) about the subject's hapless and helpless submission to the forces of advanced industrialization [1].

Viennese Actionism thus operates across a spectrum ranging from the sacred to the grotesque. Nitsch's *Orgien Mysterien Theater* (Orgies Mysteries Theater), sincerely attempting to reconstitute the intensity of experience once offered by catharsis in the classical tragedies, the redeeming rituals of Christianity, opera, and Baroque theater, occupies one extreme of that spectrum. The simultaneous totality of objects, materials, and actions, and the ensuing conditions of synesthesia, inevitably lead to a new conception of the *Gesamtkunstwerk* (and Nitsch of course considered Richard Wagner a heroic precursor worthy of following). In Nitsch's modern mystery shows, acoustic and optical, haptic and olfactory perceptions are fused with a range of activities on the stage that shift from ritual to provocation, from mere object performance to hieratic celebration. As Nitsch states: "Everything comes together in the reality of our actions. Poetry becomes painting, or painting becomes poetry, music becomes action, action painting becomes theater, informal theater becomes primarily an optical event." [2]

By contrast, Mühl's cornucopia of negated objects, and his proliferation of matters of consumption, often engulfing, if not actually physically burying the performers, of course demarcates the opposite extreme of the spectrum. Even the titles of the *Materialaktionen* manifestly separate them from the project of Nitsch's *Orgien Mysterien Theater: The Swamping of a Nude*, *OMO* (named after what was then the most "prominent" laundry detergent), *Mama and Papa*, or *Leda and the Swan*. All of these stagings of scandal, public defilement, and the denigration of the subjects' bodies perform grotesque exorcisms of consumption more in

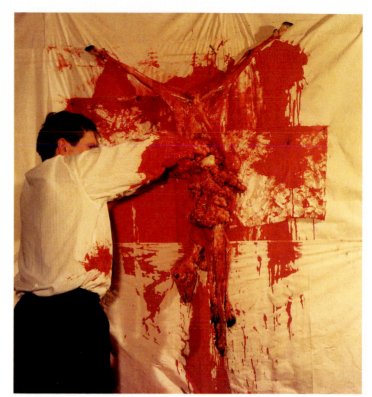

2 • Hermann Nitsch, *4. Aktion*, 1963
Performance

the manner of a travesty or a satyr-play than that of ritualistic redemption and tragedy.

Positivism and pathology

The joint performance of Nitsch, Mühl, and Frohner, called *Die Blutorgel* (The Blood Organ) in 1962 is clearly the founding event of Viennese Actionism. Nitsch describes the work as a collective festival, deploying scientific models derived from depth- and mass-psychology, to reignite that experience that cults from antiquity through Christianity had presumably offered. In opposition to what Nitsch perceives as the "collective inability to experience and the collective fear of existence," his *Orgien Mysterien Theater* sought to induce its public "through the ritualistic organization of elementary sensuous forms to attain a breakthrough to life as a continuous celebratory festivity."

By 1966, Mühl had initiated—in collaboration with Oswald Wiener—a project of countercultural activism, called *ZOCK* (an acronym that Peter Weibel (born 1944) took to mean "destruction of order, Christianity and culture," but also a verb, "*zocken*," that means to hit, beat, or play cards in German slang). *ZOCK* takes its

▲ cues explicitly from Dada's antiartistic stances, yet in its pronunciations it reminds us once again of the grandiloquent anticultural

● prophecies of Futurism. Thus, Wiener and Mühl announce in their manifesto that "all opera houses, theaters, museums, and libraries should be razed," and they continue their polemic by listing the

■ artists from Pop art and Minimalist art to Land art and Conceptual art as the worst enemies of their own anticultural venture.

The centrality of Oswald Wiener as a theoretician of both the Wiener Gruppe and of the Viennese Actionists (a role continued slightly later by Weibel who was to become the most complex critic and historian of both groups, at the same time developing an artistic practice that attempts to overcome the Actionists' historical and geopolitical limitations) points to yet another condition that is very specific to the Vienna avant-garde. At first glance one might assume that the neopositivist approach to poetic language practiced in the Wiener Gruppe and the Viennese Actionists' celebration of the prelinguistic world of polymorph perverse sexuality would be mutually exclusive. In fact, they form the halves not just of the general dialectics of enlightenment, but more specifically of the epistemological duality that has marked Viennese culture since the late nineteenth century, best embodied in the simultaneous emergence of the psychoanalytical project of Freud and the epistemological project of Ernst Mach, whose empirico-criticism had insisted on a theory of intelligibility that was defined solely by material evidence, rather than by metaphysical or historical concepts.

The third—and possibly the most complex—figure of the group, Günter Brus, seems to have been initiated into Actionism under the tutelage of the older Mühl, who in 1964 insisted that Brus abandon his late *Informel Labyrinth Paintings* in favor of direct performance-based actions. From the beginning, Brus explicitly aligned painting with sexuality, stating that painting is a form of masturbation, since both take place in utter privacy. His first performance, *Ana* in 1964, marks his initial step into Actionism.

Brus shifted the painterly process directly onto the performing body (most often the artist's own), exhibiting himself, painted white, in rooms covered with the same paint. Performing in front of his paintings at the Galerie Junge Generation in Vienna in 1965, he paid tribute to the work of Arnulf Rainer (born 1929) (whose *Übermalungen* [overpaintings] were held in great esteem by all of the Actionists). Gradually expanding the sites of his performance activities, Brus positioned himself and his work in direct confrontation with public social space. In his work *Spaziergang* (Promenade; 1965), the artist, painted white, with a black line inscribing a vertical split and dividing his body in half, walked through the streets of Vienna, where he was promptly arrested by the police. What distinguished Brus's work from that of his peers in the movement is that from the very beginning he situated his activities outside of any theatrical enactment, and beyond any promises of a healing redemption by ritual [**3**].

Brus began his project of *Total Aktion* in 1966, once again in collaboration with Mühl. Their first joint performance, staged at the Adolf Loos Villa on June 2, 1966, is significantly titled *Ornament is a Crime*, adding the verb and indefinite article to ▲ Loos's famous title ("Ornament and Crime") to imbue it with a renewed urgency and concreteness. *Total Aktion* combines elements of Nitsch's *Orgien Mysterien Theater* with Mühl's *Materialaktion*. Language is here reduced to its most elementary prelinguistic sounds of stuttering, hissing, heavy breathing, screaming, bordering on a public enactment of psychologist Dr. Arthur Janov's "primal therapy," from *The Primal Scream* (1970).

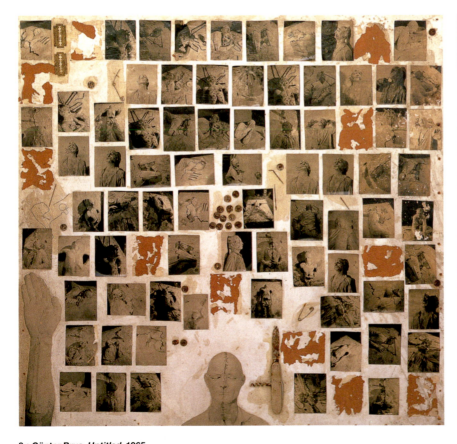

3 • Günter Brus, *Untitled*, 1965
Photographic documentation of various performance works

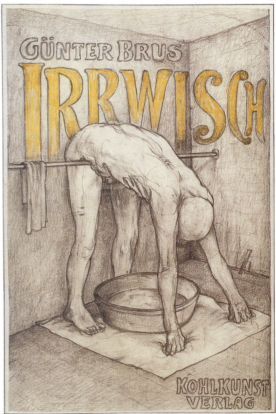

4 • Günter Brus, cover of *Der Irrwisch*, Kohlkunst Verlag, Frankfurt, 1971

▲ 1900a

Brus's most important contribution to the culture of postwar Vienna is undoubtedly his prolific output of extraordinary drawings (such as his book *Der Irrwisch* [1971]), in which the martyrium of contemporaneity is recorded in the lapidary manner of a draughtsman for the courtroom in which photography is prohibited [4]. Or equally adequate (since the cult of mental alterity in children and deranged adults is yet another central cultural topos among the Actionists), the drawings appear to be made in the manner of those of mental patients, for whom compulsively executed detail promises the highest realization of a vision or the closest proximity to the object of desire.

If there is any oeuvre of drawing in the twentieth century with which Brus's drawings could be compared, it would be the compulsively detailed erotic drawings of Pierre Klossowski (1905–2001), even though they were certainly unknown to Brus (since they were mostly inaccessible during the sixties). Brus's conception of sexuality and bodily experience opens up all the registers of the repressed histories of individual and collective libidinal development. When the body in Brus's drawings is subjected to an infinity of acts of torture and abject degradation, the inflictions suffered by the subject appear, almost always, as highly mechanical not to say neuro-motoric. As a result it becomes apparent that Brus's imaginary torture machines correlate to the actually existing social orders that regulate, dominate, and control the subject's libidinal apparatus. His extreme formulations articulate, in a dialectical manner, the repressions at the root of unquestioned normalcy within the conditions regulating everyday life in late capitalist society.

Reminiscent in that regard of Bertolt Brecht's famous question, "What is the murder of a man by comparison to his lifelong employment?", the semblance of horror in Brus's drawings and Mühl's *Materialaktionen*, the depth of their revulsion and their apparently appalling regressions into the deepest recesses of a polymorph perverse history of the subject, at the same time articulate a manifest opposition to the subject's scandalous reduction, in the process of assimilation, to enforced heterosexuality, to the rules of the monogamous family, to the seeming supremacy of genitality and patriarchal order, and worst of all, to the subjection and extreme reduction of the libidinal complexity of the subject to socially "acceptable" and "desirable" roles and activities (for example, enforced consumption and the total passivity of experience under the regime of spectacle culture).

A turning-point in Viennese Actionism, undoubtedly prepared by the radical contemporaneity and analytical precision of Brus's work, would emerge in the late sixties with the arrival of a younger generation of artists, such as Valie Export (born 1940) and Peter Weibel. It appears that for Export and Weibel, Actionism's perpetual entanglement with reritualization by that time had become as insufferable as the latent, if not manifest, patriarchal sexism that had gone on unquestioned in all of their activities. As had been the case with Surrealism, latent sexism had driven even the Actionists' most radical attempts to trace the formation of a subject's sexuality in patriarchal capitalist society. In this

4 • Valie Export, *Tapp und Tastkino*, 1968
Body action

trajectory, Export's extraordinary *Tapp und Tastkino* (Pat and Paw Cinema) [5] appears as a paradigmatic reversal of almost all the principles of Viennese Actionism. In her public self-exposure (in a street performance her breasts are being offered to anyone who wants to touch them through the openings of a box entitled the "pat and paw cinema"), the radicality of Brus's self-sacrificial auto-analysis, and the specificity of its transfer into the public social spaces where the self is constituted, are both exceeded and displaced. This happens, first of all, via Export's brilliant shift from ritualistic self-exposure to the real registers where social control and oppression are most powerfully inscribed within sexual behavior. Moreover, the performance makes it blatantly obvious that the engagement with rituals of redemption or cathartic healing no longer have any purchase in a world of advanced technological and industrialized spectacle culture. And lastly, Export, more than anybody among the Actionists, manifestly recodes the radical dimension of self-sacrifice that had been exemplarily performed by Brus. She exchanges ritual for emancipatory shock, by bringing about in her spectators / participants a sudden insight into those registers of socialization where the socialized forms of sexual repression and the eternal infantilization of the subject are anchored with industrial means. BB

FURTHER READING
Kerstin Braun, *Der Wiener Aktionismus* (Vienna: Böhlau Verlag, 1999)
Malcolm Green (ed.), *Brus Mühl Nitsch Schwarzkogler: Writings of the Vienna Actionists* (London: Atlas Press, 1999)
Dieter Schwarz et al., *Wiener Aktionismus / Vienna Actionism* (Winterthur: Kunstmuseum; Edinburgh: Scottish National Gallery of Modern Art; and Klagenfurt: Ritter Verlag, 1988)
Peter Weibel and Valie Export (eds), *wien: bildkompendium wiener aktionismus und film* (Frankfurt: Kohlkunst Verlag, 1970)

Spurred by the publication of *The Great Experiment: Russian Art 1863–1922* by Camilla Gray, Western interest revives in the Constructivist principles of Vladimir Tatlin and Aleksandr Rodchenko, which are elaborated in different ways by younger artists such as Dan Flavin, Carl Andre, Sol LeWitt, and others.

Outlawed in the Soviet Union in 1934 when Socialist Realism was declared the official state art, the Constructivism of Vladimir Tatlin and Aleksandr Rodchenko fared better in the West. Yet there it was known primarily through the narrow version promulgated by the émigré brothers Naum Gabo and Antoine Pevsner (1886–1962), both sculptors who saw Constructivism in idealist terms of pure art rather than in materialist terms of applied construction. Grounded in Cubism, Gabo and Pevsner used planar forms to present the abstract idea of a motif (which was often as traditional as a bust or a figure), and technological materials (such as clear Plexiglas) to render this idea conceptually transparent and aesthetically pure. At the same time, they tended to treat these forms and materials as techno-scientific values in their own right. This somewhat fetishistic treatment of formal art is far from the "culture of materials" that original Constructivists like Tatlin and Rodchenko attempted to elaborate into a new order of utilitarian objects for Communist society. Already condemned as bourgeois by these Constructivists in the East, the "Constructive Idea" of Gabo and Pevsner was embraced in the West precisely because its mixture of aesthetic idealism and technological fetishism suited the predispositions of Western institutions—art patrons, museums, and schools alike.

Two instances of the American occlusion of Russian Constructivism are especially telling. In the winter of 1927–8, prior to the opening of the Museum of Modern Art in New York, its young director-to-be Alfred H. Barr, Jr. toured the not-yet-Stalinist Soviet Union. There he saw "an appalling variety of things," and even though he was initially sympathetic to this diversity, Barr noted in his diary, "I must find some painters if possible." With his museum in mind, he then focused on painting that looked back to Cubist painting rather than forged ahead to the Constructivist overcoming of traditional mediums. The second occlusion, here regarding sculpture, occurred twenty years later when the influential critic Clement Greenberg first sketched a Cold War history of "The New Sculpture" that effectively ignored Russian Constructivism. According to Greenberg, "the new construction-sculpture" evolved from Cubism through Picasso, implicitly via Gabo and Pevsner, to Jacques Lipchitz and Julio González, all of whom aspired to "anti-illusionism." Yet, rather than a Constructivist exposure of material construction,

this anti-illusionism produced the opposite effect, mostly through its metallic surfaces—"namely, that matter is incorporeal, weightless and exists only optically like a mirage." Here, in the name of construction, the materialist Constructivism of Tatlin and Rodchenko was inverted, stood on its head, in an idealist genealogy of sculpture engendered by Picasso, Gabo, and Pevsner—an amnesiac history reiterated in many shows, catalogues, books, and reviews.

Incomplete projects

In the fifties the welded constructions of David Smith and Anthony Caro, as well as the massive assemblages of Mark di Suvero, appeared to restore some materialist principles to sculpture. But ambitious young artists such as Donald Judd (1928–94), Dan Flavin (1933–96), Carl Andre (born 1935), and Sol LeWitt were soon critical of all three predecessors. However abstract, Smith was still too figurative; however disjunctive, Caro was still too compositional; and the gestural beams of di Suvero combined both vices. Indeed, the work of all three was considered too pictorial, too much like Abstract Expressionist painting turned into sculpture. As Andre remarked, he and his peers sought a "great alternative to the semi-Surrealist work of the fifties such as Giacometti's and the late Cubism of David Smith," and they found it in the Constructivism of Tatlin and Rodchenko. This recovery had two further advantages: it not only reversed the idealist inversion of Constructivism performed by Gabo and Pevsner, but also trumped the model of a medium-specific modernism advanced by Greenberg in his book of essays *Art and Culture* in 1961.

The recovery of Constructivism was abetted by the publication in 1962 of *The Great Experiment: Russian Art 1863–1922* by the English art historian Camilla Gray. Although not focused on Constructivism, this survey did document such formal experiments as the Tatlin reliefs, the Rodchenko constructions, and the "laboratory" work of the Obmokhu group, as well as such utopian and utilitarian projects as Tatlin's *Monument to the Third International* (1920) and Rodchenko's Workers' Club (1925). "Our tastes [are] dictated by our needs," Andre commented in 1962; and if Flavin was drawn to Tatlin for his demonstration of industrial material, exposed production, and architectural siting, Andre and LeWitt

▲ 1934a ● 1914, 1921b, 1925a ■ 1937b, 1955b ◆ 1927c ▲ 1945 ● 1965 ■ 1960b ◆ 1921b, 1925a

favored Rodchenko for his transparency of construction and his near-serial generation of structures.

The specific influence of *The Great Experiment* alone is difficult to trace, but a general shift in the meaning of "Constructivism" is clear in this dialogue between Andre and the photographer and filmmaker Hollis Frampton in November 1962:

> HF: *But why "Constructivist"? You flood me with the yellowed celluloid of Gabo and Pevsner.*
> CA: *Let me indicate some shadow of what I mean by a Constructivist aesthetic. Frank Stella is a Constructivist. He makes paintings by combining identical, discrete units. Those units are not stripes, but brush strokes. We have both watched Frank Stella paint a picture. He fills in a pattern with uniform elements. His stripe designs are the result of the shape and limitation of his primary unit.… My Constructivism is the generation of overall designs by the multiplication of the qualities of the individual constituent elements.*

▲ The nomination of Frank Stella as "a Constructivist" suggests how concerned Andre and others were to redirect the Greenbergian trajectory of modernist painting. And the stress on "identical units" suggests that another precedent was also in play, which both assisted in the challenge to Greenberg and complicated the
● recovery of Constructivism: the readymades of Duchamp. Although far from unknown, Duchamp had recently returned with a special force: the great Arensberg Collection of his work had opened in Philadelphia in 1954, and his first retrospective would be held in Pasadena in 1963. His model of the readymade also returned in a new light, for Andre and others felt that too much was made of the readymade as a rhetorical gesture (of either antiart sentiments or pop-cultural sympathies or both) and not enough as a structural device. "The results of the Dada experiments have not been fully evaluated to date," he remarked to Frampton in the same dialogue. "I do not think that the true product of Duchamp's experiments is the rising market in Rauschenberg."

By 1963, then, these artists had combined the two radical alternatives to traditional sculpture first proposed, almost as com-
■ plements, fifty years before in 1913: the Tatlin construction and the Duchamp readymade. This was not a historical accident; just as "our tastes [are] dictated by our needs," as Andre remarked, these needs were specific. For Andre the combination of construction
◆ and readymade was mediated by the sculpture of Constantin Brancusi. Unlike Judd, say, Andre had begun as a sculptor, and wanted to redirect the medium rather than depart from it. And Brancusi provided a model of sculpture that, though often idealist in form, was often just as materialist in its articulation of substance and site—a tension that appealed to Flavin as well. In any case, these were the precedents in play at this volatile moment, and the young Flavin, Andre, and LeWitt worked through them in different ways.

Flavin was explicit about his relation to Constructivism—"my joy is to try to build from that 'incomplete' experience as I see fit"—but this relation was not simple. Flavin, who had attended

Catholic schools, once studied for the priesthood, and in 1961–2 he made several monochrome paintings with lights attached that he titled "icons" [1]. In part, Flavin was inspired by Byzantine icons (his notebooks mention a particular Russian painting at the Metropolitan Museum) whose "physical feeling" and "magical presiding presence" impressed him. As with Tatlin, who once worked as an icon restorer, the icon provided Flavin with an alternative model of the picture, one which was assertively material but also spectrally spiritual; "blank magic" is how he defined his art in 1962. Perhaps he had seen the juxtaposition, posed by Gray in *The Great Experiment*, of a Tatlin relief and a Russian icon. In any case, Flavin paid homage to the Constructivist in 1964 with several light pieces titled *Monument for V. Tatlin* [2], whose pyramid of fluorescent lights recalls the proposed spiral of metal-
▲ work of *Monument to the Third International*.

A year before, Flavin had altered his practice slightly but significantly: he began to use the diffuse light of fluorescent tubes—alone, as readymade units, without painting. His first such piece was a common eight-foot gold light set on the wall at a forty-five-degree angle, *the diagonal of May 25, 1963*. Not only was the light unit given, but for Flavin "the diagonal declared itself" as well: "It seemed to sustain itself directly, dynamically, dramatically in my workroom wall." Thus the readymade was also in play here, but it was used in a Constructivist manner to undo traditional composition: "There was literally no need to compose this system definitively," Flavin remarked. At the same time, his historical distance from both paradigms, the construction and the readymade, was made apparent. Unlike in Constructivism, the industrial material here was not futuristic but found, precisely readymade. And, unlike in Duchamp, the readymade was not only pledged to demystify or to defetishize art; Flavin also regarded his light as "a modern technological fetish," "a common lamp become a common industrial fetish, as utterly reproducible as ever but somehow strikingly unfamiliar now."

1 • Dan Flavin, *Icon I (to the light of Sean McGovern which blesses everyone)*, 1961–2
Oil on gesso, masonite and pine, red fluorescent light, 63.8 × 63.8 × 11.7 (25⅛ × 25⅛ × 4⅝)

(right) Dan Flavin, *Icon II (the mystery) (to John Reeves)*, 1961
Oil and acrylic masonite and pine, porcelain receptacle, pull chain, amber-colored fire logs, vacuum incandescent bulb, 63.8 × 63.8 × 11.7 (25⅛ × 25⅛ × 4⅝)

▲ 1958 ● 1914, 1918 ■ 1914 ◆ 1927b ▲ 1921b

Artforum

By the opening of the sixties, American art magazines were firmly focused on the past: *Artnews* inherited its commitment to Abstract Expressionism from its eminent editor, Thomas B. Hess, and *Art in America*, as its name suggests, was limited in scope to American production, both fine and folk. The upsurge in productive energy at the end of the fifties created the opportunity for a magazine less narrow than its fellows. In 1962 this occasion was grasped by Philip Leider and John Coplans in San Francisco; soon they moved their fledgling project— *Artforum*—to Los Angeles, where it would find its publisher, Charles Cowles, and its signature square format, designed by Ed Ruscha. However, their eyes were fixed on New York, the actual center of aesthetic production, and the editors were determined to build an editorial board that could report on the activities of the East Coast art world: Michael Fried, Max Kozloff, Annette Michelson, James Monte, Robert Pincus-Witten, Barbara Rose, and Sidney Tillim, soon joined by Rosalind Krauss.

The work of Ellsworth Kelly, emerging in the late fifties as abstract and minimal, signaled the new direction of the artistic production *Artforum* would champion. Although Leider was committed to new and more muscular writing than the vaporous, belle-lettristic style of the other magazines, he was also eager to publish texts by the artists themselves. Donald Judd, who had been an active reviewer for *Artnews* throughout the sixties, established critical discourse as a legitimate vehicle for artists. Robert Morris soon followed his lead, and "Notes on Sculpture," his four essays laying down the conditions for Minimalism, were published in *Artforum* between 1966 and 1969.

Robert Smithson was complicating the conceptual field of sculpture at this time and his "Entropy and the New Monuments" (June 1966) moved beyond the industrial optimism of Minimalist practice. The magazine's enthusiasm for Earthworks such as Smithson's was consolidated in a special issue (Summer 1967). This opening away from Minimalism also made room for Conceptual art, and writings by Sol LeWitt such as "Paragraphs on Conceptual Art" (June 1967) soon appeared.

Leider's insistence on lucid analytical prose forged a close relationship between him and Michael Fried, opening the magazine's pages as well to Clement Greenberg and its covers to artists such as Jules Olitski, Kenneth Noland, and Morris Louis. By 1971 Leider felt his leadership of the magazine to have reached a plateau such that to continue as editor could only mean a repetitive treading water. He therefore resigned, turning the editorship over to John Coplans, who left California to move to New York and to face a badly divided editorial board that he had difficulty holding together. Two of the most productive writers, Max Kozloff and Lawrence Alloway, were hostile to what they characterized as the "formalist" drift of the magazine, insisting that it become more openly political and supportive of the socially relevant mediums like photography. On the other side of this struggle were Fried, Michelson, and Krauss. The latter two resigned from the board in 1975 to start their own magazine, *October*, named for the Sergei Eisenstein film that suffered from the Soviet assault against "formalism."

2 • Dan Flavin, *Monument for V. Tatlin,* 1966
Seven fluorescent light fixtures of various lengths, 365.8 × 71 × 11 (144 × 28 × 4⅜)

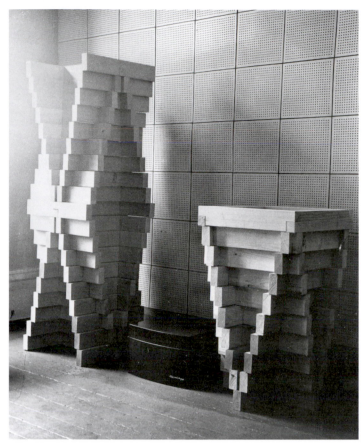

3 • Carl Andre, (right) unfinished Pyramid; and (left) Pyramid (Square Plan), c. 1959
Wood, 175 × 78.7 (68⅞ × 31) (destroyed)

In this way he held together two contradictory imperatives of modernist art: on the one hand, the imperative to materialize the work of art, here to declare light as light and to expose its physical support (the fluorescent fixture); on the other hand, the imperative to *de*materialize the work of art, here to irradiate it with light, to wash space with color. Perhaps this is why, even as *the diagonal* ▲ *of May 25, 1963* draws on Tatlin and Duchamp, it is dedicated to Brancusi, who also held the two imperatives—the material and the ideal, the worldly and the transcendental—in tense suspension.

Similar precedents are at work in the early pieces of Carl Andre, which alternate between "assisted" readymades à la Duchamp and wooden sculptures first carved, then cut, à la Brancusi (for example, *First Ladder* [1958] seems to stem from *Endless Column* [1937–8] by the Romanian). However, already by 1959—well before *The Great Experiment*—Andre had begun to stack wood units in pyramidal structures in a manner reminiscent of the constructions of Rodchenko [**3**], and in 1961 he ordered "found steel objects" in related ways. Both series declared a Constructivist transparency of construction. Although more literal than Flavin in his use of materials, Andre was not merely positivistic, for he soon elaborated this Constructivist method into "a kind of plastic poetry" in which given elements like bricks, wood blocks, or metal plates are "combined to produce space" [**4**]. This redefinition of sculpture as *place* led him to several series of rectangular units set flat on the floor. Here sculpture was structured by the logic of the unit with little composition, in a way that produced space without a trace of the figure. In effect, Andre turned the readymade into a

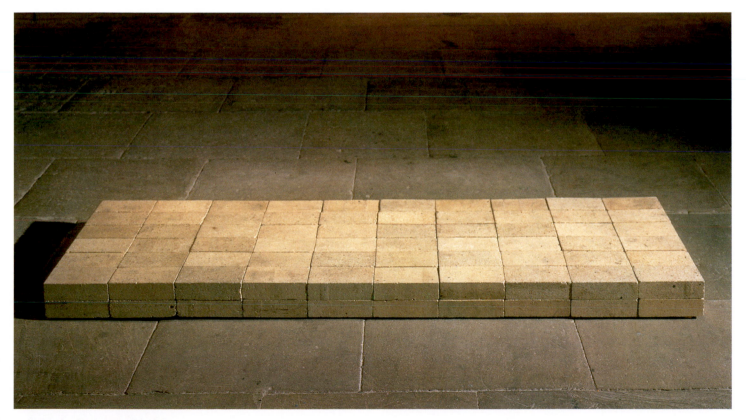

4 • Carl Andre, Equivalent (VIII), 1966
Fire bricks, 12.7 × 68.6 × 229.2 (5 × 27 × 90¼)

▲ 1914, 1927b

Constructivist form; that is, he took given elements, and made them speak reflexively about material, structure, and site alike.

Like his peers, Sol LeWitt looked at Constructivism through past models and present needs. *Hanging Structure with Stripes* [5], in which different wood blocks are assembled axially, set on a platform, and suspended from the ceiling, seems to cite Rodchenko's ▲"spatial constructions" (1920–1), some of which were also hung. But it does not articulate substance, structure, and space in a truly Constructivist manner, for the blocks are painted, most in various stripes of black and white, and this obscures more than reveals both material and construction (in this respect, the work is closer ●to the Dutch movement De Stijl than to Russian Constructivism). Like the Rodchenko constructions, however, *Hanging Structure* occupies a space between mediums, a "negative" condition that is neither painting nor sculpture, which LeWitt explored further in his "Floor Structures" and "Wall Structures" of 1964–5, in which different angles of wood planes are set on the floor or the wall. These structures are also neither architecture nor furniture. "Architecture and three-dimensional art are of completely opposite nature," LeWitt insisted in 1967, at a time when this distinction ■seemed blurred by Minimalist objects. "Art is not utilitarian." Here LeWitt declared his distance from this aspect of Constructivism, but this distance was already apparent in his sequences of frames from 1965–6, also set on the floor or the wall, in which sculpture and painting were again negated, literally emptied out. It is in these modular works that one sees the beginning of the serial grids for

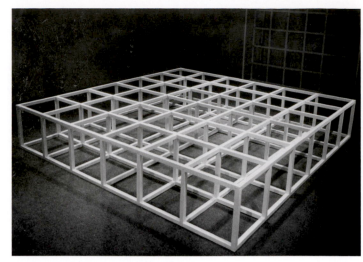

6 • Sol LeWitt, *Modular Structure*, 1966
White painted wood, 62.2 × 359.4 × 359.4 (24½ × 141½ × 141½)

▲which he is best known, and which advance his version of Conceptual art more than look back to Constructivist precedent [6]. Although not as idealist in form as much Conceptual art, these structures are not materialist either: "What the work of art looks like isn't too important," LeWitt wrote in his laconic "Paragraphs on Conceptual Art" (1967). Nevertheless, he arrived at this way of working through his own combination of the construction and the readymade, as is suggested in his well-known formula: "The idea becomes a machine that makes the art."

With this formula, however, there is little of Constructivism left. Perhaps the historical distance from its revolutionary moment was such that it could be recovered only as a ruin—that is, an emblematic relic of a modernist practice that sought to articulate and to advance art and politics together. So it is, for example, that in his piece from 1964 Flavin paid homage to the artist Tatlin, not, as Tatlin had done, to a new social order. Indeed, Flavin cites the Tatlin who had withdrawn into his project for a glider, *Letatlin* (1932), and it is a commemoration soaked with the pathos of failure: "*Monument 7* in cool white fluorescent light memorializes Vladimir Tatlin, the great revolutionary, who dreamt of art as science. It stands, a vibrantly aspiring order, in lieu of his last glider, which never left the ground." Nevertheless, if the revolutionary project of Russian Constructivism could not be recovered, some of its artistic proposals could be reinscribed, and this recovery helped to redirect art in the sixties radically. HF

FURTHER READING
Carl Andre and Hollis Frampton, *12 Dialogues 1962–1963* (Halifax: The Press of the Nova Scotia College of Art and Design, 1980)
Benjamin H. D. Buchloh, "Cold War Constructivism," in Serge Guilbaut (ed.), *Reconstructing Modernism* (Cambridge, Mass.: MIT Press, 1990)
Hal Foster, "Uses and Abuses of Russian Constructivism," in Richard Andrews (ed.), *Art into Life: Russian Constructivism 1914–1932* (New York: Rizzoli, 1990)
Camilla Gray, *The Great Experiment: Russian Art 1863–1922* (1962), republished as *The Russian Experiment in Art 1863–1922* (London: Thames & Hudson, 1986)
Jeffrey Weiss et al., *Dan Flavin* (Washington, D.C.: National Gallery of Art, 2004)
Carl Andre, *Cuts: Texts 1959–2004*, ed. James Meyer (Cambridge, Mass.: MIT Press, 2005)

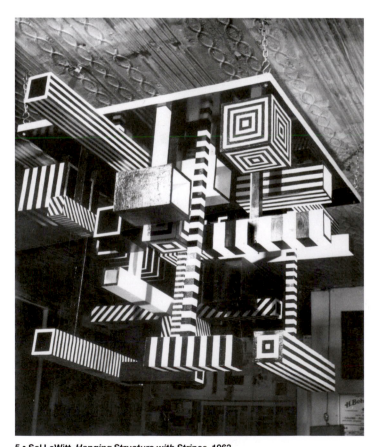

5 • Sol LeWitt, *Hanging Structure with Stripes*, 1963
Painted wood, 139.7 × 139.7 × 56.2 (55 × 55 × 30) (destroyed)

▲ 1921b ● 1917b ■ 1965

▲ 1968b

1962 d

Clement Greenberg is the first to acknowledge the abstract side of early Pop art, a characteristic that would feature time and again in the work of its leading proponents and those who followed them.

Reflecting back on Abstract Expressionism in October 1962, Clement Greenberg saw its major legatee as Jasper Johns, whose figurative paintings of letters, numbers, targets, and maps he discussed in the seemingly paradoxical terms of abstraction. Perceiving the irony of Johns's painterly surfaces, with their freely stroked slurs of heavy pigment that mimicked the shallow hills and valleys of Willem de Kooning's major work juxtaposed against the arid flatness of the ready-made images of targets, flags, or maps, Greenberg wrote: "Everything that usually serves representation and illusion is left to serve nothing but itself, that is, abstraction; while everything that usually serves the abstract or decorative—flatness, bare outlines, or all-over or symmetrical design—is put to the service of representation. And the more explicit this contradiction is made, the more effective in every sense the picture tends to be."

With such an introduction, the utter abstraction of *Canvas* of 1956 [1] is unsurprising, even from the master of Pop art, since the work is (a) a bare, gray presentation of a nude canvas with its stretcher bars inserted within it; and (b) a monochromatic surface puckered with thick smears of encaustic (pigment suspended in molten wax). Indeed, *Canvas* is the precedent for Johns's famous *Ale Cans* of 1960, a bronze sculpture, its surface worked to imitate the encaustic of the paintings, about which painter Frank Stella is reported to have said "That fellow! [he actually said "that bastard!"] He could put two beer cans in the gallery and sell it!"

1 • Jasper Johns, *Canvas*, 1956
Encaustic and collage on wood and canvas, 76.3 × 63.5 (30 × 25)

The legacy of Johns's abstraction

The monochrome had responded to the problem of disturbing the homogeneity and flatness of painting's surface by the intervention of representational shapes, increasingly felt to be arbitrary. Johns had neutralized this arbitrariness with the preordained shapes of the readymade (in the form of the alphabet, the American flag, or the United States map). In such a strategy, he had been preceded (although not influenced) by Ellsworth Kelly, whose own determination to escape the arbitrariness of "composition" led him to fashion canvases based entirely on either found objects, such as window panes or roadside milestones, or shadows falling over stairways. The arched configurations of these shadows soon led

Kelly to produce "shaped" paintings: simple convex arcs in relief against the white ground of the gallery wall. Kelly also took the stretched square of the canvas itself as a kind of ready-made chromatic surface that could be juxtaposed with its fellow squares, each a species of monochrome, to construct an abstract grid, checkerboard style. *Colors for a Large Wall* (1951) and *Sanary* (1952) are two of these. The ready-made origin of these gridded squares is to be found in the commercial packs of colored paper sold in artists' supply stores. (In France, where Kelly lived under the G. I. Bill, these papers are called *papiers gommettes*.)

The two sides of Johns's abstraction had developed from his encaustic surfaces, on the one hand, and from his Pop choice of

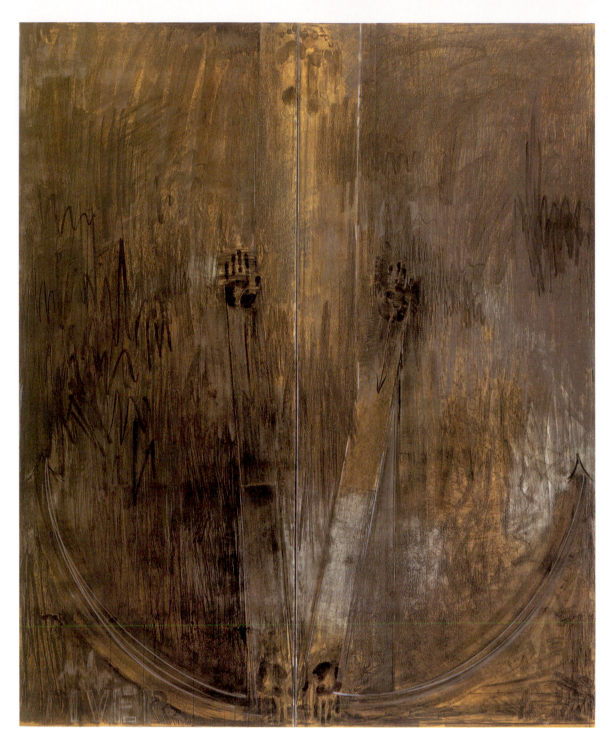

2 • Jasper Johns, *Diver*, 1963
Charcoal, pastel, and watercolor on paper mounted on canvas (two panels), 219.7 × 182.2 (86½ × 71¾)

▲ found objects, on the other. Richard Serra's use of lead for his earliest work pushed Johns's use of molten wax into an abstract reimagination of sculpture. For *Splashing* of 1968, for example, Serra hurled molten lead into the corner of his studio to form skeins and puddles reminiscent of Pollock's classic drip paintings. The utter simplicity and directness of *Splashing* testifies to Serra's determination to abandon the figurative associations of sculpture and to embrace abstraction instead. The two aspects of Johns's use of encaustic that Serra pressed into this service were the evocative quality of visible gesture and the gravitational pull of material weight.

In the service of the latter, Serra's "prop" pieces had reduced sculpture itself to the mere question of weight, the body's heavy torso requiring the support of its upright legs. The simplicity of the "props" rested on the fact that their very *verticality* was nakedly insured only by the weight of lead pole or opposing plate pressing *down* upon them.

Sensitive as he was to weight, Serra saw the quality of his contemporary Brice Marden's abstract paintings as conveying, as he said, the "weight of color." Like Johns's use of encaustic, Marden (born 1938) mixed wax into his pigments to achieve greater opacity and the sensation of leaden matter. Marden's ambition in

▲ 1969

the direction of pictorial weight led him toward the kind of encaustic gray monochromes that Johns had produced in *Tennyson* of 1958 and *Liar* from 1961. Johns's own concern with weight appears in the magnificent *Diver* of 1963 [2], the charcoal imprint of a full body, with outstretched arms, appearing to slide down the supporting paper.

Marden's early work, produced in Paris (as was Kelly's), limited itself to gray monochromes. But instead of filling the entire surface, some canvases, such as *Return I* from 1964–5, itself a homage to Johns's *No* of 1961, left an open margin along the lower edge [3]. This gap in the surface might seem an inconsistency in the drive to seal the visual plane. But, as had been the case with Johns's *Shade* from 1959, its gray field only partially pulled down; the gap below the thick encaustic ironically emphasizes the blockage in the viewer's attempt to penetrate the surface into depth.

The combination of pigments and their evacuation of any optical or luminous effects made Marden's early works, with their tripartite sections of color—*Le Mien* of 1976, for example—the exact oppo-

▲ site of Mark Rothko's evocative chromatic hazes. (Surprisingly, Marden called himself a "romantic." Caspar David Friedrich, the German Romantic painter, with his own tripartite *Monk by the Sea* might, indeed, be the model here: Friedrich's own sea and lowering sky weighted with the threat of rain.) Nonetheless, in the following decades, Marden continued to display the influence of the Abstract Expressionists—by way, that is, of Johns. Between 1988 and 1991, he embarked on the series he called *Cold Mountain*. Pale fields covered by a dark scribble, the works betray a debt to Pollock's

● dripped, optical skeins—another seeming contraction in an ambition to produce the "weight of color." Here, however, we must remember Pollock's own puddles of aluminum paint, which break the optical mists by clinging, physically, to the material surface. In *Red Rocks 2* of 2000–2, the coagulated scribbles go further than Pollock's aluminum splotches, to suggest the sadistically twisted ropes in those late collages Miró called "antipaintings." Meanwhile,

■ Serra's dependence on weight to demonstrate the essence of sculpture, mixed with his admiration for Marden, undoubtedly led to

3 • Brice Marden, *Return I*, 1964–5
Oil on canvas, 127.6 × 173.4 (50¼ × 68¼)

▲ 1947b ● 1949a, 1960b ■ 1931b

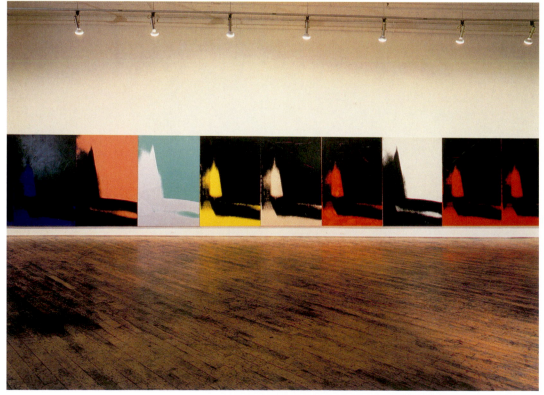

4 • Andy Warhol, *Shadows*, **1978**
Silkscreen ink on synthetic polymer
paint on canvas, 102 canvases, each
193 × 132.1 (76 × 52)

5 • Andy Warhol, *Oxidation Painting*, 1978
Mixed media on copper metallic paint on canvas, 198 × 519.5 (78 × 204½)

his own pictorial planes of the sheerest weight. Produced since the seventies, these shaped canvases and sheets of paper covered by black paint stick have a surface as dense and opaque as Johns's encaustic. Like Kelly's *Curves*, the paint-stick drawings simultaneously imply both the object and the shadow it casts on the wall "behind" it.

The abstract "fate" of Pop

Johns's alphabets, flags, and beer cans unleashed the energy of Pop art that followed them in the 1960s. Although the new Pop movement seemed dedicated to just that ironic *representation* of what can only be *reproduced*, it yielded to the same abstract values Greenberg had detected in Johns. In the work of Roy Lichtenstein, the found object that responded to contemporary abstraction was the mirror—oval or oblong—which he presented in a series of paintings beginning in the early sixties. In numerous examples, swathes of shading (in Lichtenstein's photomechanical manner of Ben Day dots) suggested the beveling or convexity of the glass surface, the ironic transparency of which seemed to parody the contemporary movement of color-field painting.

The humor of transforming Pop into abstraction (or low into high) was not lost on the most ironic artist of them all—Andy Warhol. Casting around for motifs that would mock the sacred themes of Abstract Expressionism, Warhol fixed on the tempestuous shadings of the smeared pigments of de Kooning's canvases. The result was his monumental *Shadows* series from 1979, runs of black and brilliantly colored paintings, the cross-axial patterns of which seemed to create Cubist grids along the immense surfaces of the walls on which they were hung [4].

Pollock's expressive splashes were the next object of Warholian irony. The critic Harold Rosenberg had named Pollock's explosive registrations of his inner self "action painting." Warhol's charac-

teristic irony translated the psychic inwardness of the self into the projective experience of the Rorschach Test—the nonfigurative patterns produced by folded ink blots and used for psychological diagnosis. Aggressively abstract, the symmetrical folds of the *Rorschachs* (1984) nonetheless implied the organization of the human body—its spine, its sexual organs, its cardiovascular system. Far outdistancing the Rorschachs in their parodying of Pollock's dripped masterworks, however, were Warhol's *Oxidation Paintings*, made in 1977 and 1978 by covering large canvases with metallic paint, laying them on the floor, and inviting luncheon guests, regaled with wine, to urinate on them [5]. Pollock's method of dripping throws of liquid enamel on raw canvas laid on the floor of his studio had been made famous by the photographs that Hans Namuth had taken of the process in 1950. Now Warhol mocked them: Rorschach turned raunchy.

Lost-and-found in translation

On the other side of the Atlantic, painters in France were also considering abstraction in the wake of Johns and Pop, and developing their own strategies. As we have already seen, Kelly, Marden, and a number of other American artists were working there in the late fifties and early sixties, and benefiting from a dialogue with their French counterparts, often mediated by critics such as Marcelin Pleynet, a close friend of painter James Bishop, who spent two years in Paris. The presence of these American artists was just one of the ways Anglophone critical writing entered French artistic discourse. The most important, no doubt, was Greenberg's understanding of the relation that Johns's turbulent paint surfaces forged with their pictorial support, which his dragged strokes of encaustic came to represent (in the same way that the canted planes and grids of Analytic Cubism represented their underlying, woven canvas).

▲ As the earlier work of the Nouveaux Réalistes Jacques de la Villeglé, Raymond Hains, and François Dufrêne showed, that support, in its lateral spread from edge to edge, had to be represented in all its continuity and woven repetition. Finding a way to achieve this became the focus of the Parisian art of the 1960s. Two groups of painters whose work was inspired by this paradox between repre-
● sentation and abstraction were Supports / Surfaces and BMPT.

It was François Rouan (born 1943), associated for a time with Supports / Surfaces, who found a way to *picture* the canvas support through a technique he called *tressage* (or braiding), achieved by making two identical canvases that he then cut into long strips or lanyards and wove on the bias through one another. The orthogonality of these interwoven diagonals recalled the recession of central-point perspective, so the grid they formed not only suggested the paving stones of the piazzas and cathedral floors of fifteenth-century Italian painting (such as that of Piero della Francesco or Filippo Lippi), but also the very infrastructure of the canvas weave. The title he gave his 1971–3 paintings, *Portes* (or *Doors*), captures both the opening of the suggested perspective and the flatness of the wooden plane [6]. Woven of black canvases, the *Portes* were mono-
■ chromatic versions of Ad Reinhardt's black paintings, with their

hardly perceptible cruciform squares shifting over and under one another through their subtle differences of hue and value. Unlike the perceptible cross of the black paintings by Reinhardt, however, the braiding destroyed any discernible image, as well as collapsing all figure–ground relations. In an introduction to the catalogue of a Rouan exhibition, Denis Hollier alludes to Freud's assertion that the drive of art to sublimate erotic urges evolved from Paleolithic females' attempts to mask their genitals by braiding their pubic hair. In the service of abstraction's drive to "sublimate" (Freud's notion that art raises perception above erotic drives), Rouan's *tressage* manifests the pictorial support as it seeks to hide the image. RK

FURTHER READING
Leo Steinberg, "Jasper Johns: The First Seven Years of His Art," in *Other Criteria: Confrontations with Twentieth-Century Art* (London, Oxford, and New York: Oxford University Press, 1972)
Jeffrey Weiss, *Jasper Johns: An Allegory of Painting, 1955–1965* (New Haven and London: Yale University Press, 2007)
James Rondeau, *Jasper Johns: Gray* (Chicago: Art Institute of Chicago, 2007)
Yve-Alain Bois, *Ellsworth Kelly: The Early Drawings, 1948–1955* (Cambridge, Mass.: Harvard University Press, 1999)
Annette Michelson (ed.), *Andy Warhol* (Cambridge, Mass.: MIT Press, 2001)
Philip Armstrong, Laura Lisbon, and Stephen Melville (eds), *As Painting: Division and Displacement* (Cambridge, Mass.: MIT Press, 2001)

▲ 1960a ● 1967c ■ 1957b

1963

After publishing two manifestos with the painter Eugen Schönebeck, Georg Baselitz exhibits *Die Grosse Nacht im Eimer* (Great Night Down the Drain) in Berlin.

The exhibition of a group of paintings by Georg Baselitz—including those of a single large-scale masturbating figure, *Die Grosse Nacht im Eimer* [1], and a large male nude with an erection—that opened in the Werner & Katz Gallery in West Berlin on October 1, 1963, and their immediate confiscation by the State Attorney, led to one of the first major art scandals in the still young West Germany. It set the stage for the enactment of some of the most crucial contradictions of postwar reconstruction culture.

Baselitz (born Georg Kern in Deutschbaselitz, Saxony, in 1938) had moved from East to West Berlin in 1957 to study at the highly renowned Academy of Fine Arts. His move from the Communist half of postwar Germany to its Western capitalist counterpart was repeated a few months later by Eugen Schönebeck (born 1936), with whom Baselitz would become friends, and who until 1957 had been studying Socialist Realism at the East Berlin Academy; again four years later by Gerhard Richter (born 1932), who had been studying Socialist Realism in Dresden, the younger Sigmar Polke (1941–2010), and Blinky Palermo (1943–77); and again, much later still, by A. R. Penck (born 1939).

From Socialist Realism to *tachisme*

From the start, this very movement from a Communist state to a capitalist country that was in the process of being restructured in accordance with advanced American consumer capitalism situated Baselitz and his peers within a complex triangulation. In the first place, these artists had to distance themselves from all residues of Socialist Realism, which was enforced in East German academies as the only valid model of visual culture, and which was represented in particular by the work of German artists such as Bernhard Heisig, Werner Tübke, and Wolfgang Mattheuer, and that of their Soviet precursors (Aleksandr Gerasimov, for instance) and their French and Italian variations (André Fougeron and Renato Guttuso)—all of whom were heroes in the East German art world.

Second, upon their arrival in the West, these young artists all studied with German *tachistes* and *informel* painters, either in Berlin (Baselitz with Hann Trier, Schönebeck with Hans Jaenisch) or in Düsseldorf (Polke and Richter with Karl Otto Götz and Gerhard Hoehme, respectively). By that time, this older generation of painters was comfortably positioned producing a West German type of "international abstraction," whose Parisian and New York origins were concealed as much as the delayed processes of avant-garde and neo-avant-garde reception in West Germany would allow. This was a form of abstraction, as Klaus Herding has argued when speaking of Willy Baumeister, that had placed itself exactly at the right intersection between primitivism and classicism to fulfill the neutralizing demands of West German political and cultural repression. Its primary function seems to have been to produce a sort of "*Anschluss-Aesthetik*," a link to a noncontaminated culture and a public assimilation to the legacies of European and American modernism, even if only in their already dilapidated state.

Thus, around 1962, Baselitz, Schönebeck, and the others would challenge these governing forms of abstraction with the same fervor with which they had distanced themselves slightly earlier from Socialist Realism. But this oppositionality achieved more than just Oedipal distinction from what had gone before: it assaulted and actually broke down the repressive armor of the painterly practices that the first generation of West German artists had hastily assembled immediately after the war.

A third and related strategy becomes evident in Baselitz's work of 1962: the rebuttal of the presumed inevitability of "internationalism" (oriented primarily at Paris and New York) as an intrinsically necessary condition for the reconstruction of an avant-garde culture (or rather, the foundation of a neo-avant-garde) on the territory of the former Nazi state. This third maneuver of distancing would lead to an ever-increasing opposition, culminating in a profound generational chasm between the two models of artistic production that were to govern the subsequent decades of West German art.

On the one hand, Baselitz now laid the foundations of a new conservative aesthetic by reclaiming a more or less unbroken conventional artistic and historical identity. His work invoked, in particular, that tradition of German modernist painting that had been destroyed by the Nazi government after the "Degenerate 'Art'" exhibition in 1937 (of specific importance for Baselitz were the German Expressionists of the Die Brücke group in Dresden, as well as the work of Ludwig Meidner [1884–1966] and Oskar Kokoschka). But Baselitz's model of continuity even attempted to

1 • Georg Baselitz, *Die Grosse Nacht im Eimer* **(Great Night Down the Drain), 1962–3**
Oil on canvas, 250 × 180 (98⅜ × 70⅞)

return to practices developed prior to the formation of Expressionism: the legacies of provincial German modernism in the painterly work of Lovis Corinth (1858–1925) and Max Slevogt (1868–1932).

On the other hand, the model enacted in the work of Richter, Polke, and Palermo in Düsseldorf precisely refused the desirability, if not outright denied the possibility, of traditional identity formations in the painterly practices of the postwar period. Accordingly, these artists situated their work within a more complex set of relations with predecessors by grafting it onto the radical aesthetics of both Parisian and American neo-avant-garde artists. These ranged from Yves Klein and Piero Manzoni to the enormously influential Abstract Expressionist painters of the New York School and the ▲ more recently emerging American Pop and Fluxus artists.

The origins of these two models of aesthetic opposition could be theorized in different ways, and their ramifications for subsequent German art could be interpreted accordingly. But they are perhaps most productively explained in those terms with which German • philosopher Jürgen Habermas has theorized sociopolitical subjects and institutions in postwar Germany as being suspended in the conflict between conventional and postconventional identity formations. Thus, the work of Baselitz in 1962 could be said to have created a "new" painterly aesthetic that not only privileged the continuity of the artisanal production of representations as the primordial definition of art, but also argued for the persistence of a local, regional, and national grounding of artistic practice. In doing so, it established a hierarchy of cultural values and insisted on the continuing, if not exclusive, validity of a conventional national identity as the foundation of German postwar reconstruction culture.

By contrast, the work of Richter and Polke at this time developed a pictorial aesthetic in which the supremacy of the artisanal was continuously challenged by the fact that painterly representation appears as inconceivable outside the parameters of mass-media image production and the apparatus of the culture industry. Thereby painting itself was dislodged from its status as a guarantor of conventional identity and cultural continuity. It was repositioned as a hybrid at the intersection of various conventions and technologies of representation that were not tainted by the cultural ideologies of the nation state, and it acknowledged concepts of post-traditional identity formation as an inevitable necessity for postwar cultural practices in Germany.

These conflicts were initially played out on the level of the concepts and techniques underlying pictorial representation: to the extent that painters like Baselitz and Schönebeck declared the uninterrupted conventionality of painting, they reclaimed the (photographically) unmediated availability of the anthropomorphic figure and insisted on painting's capacity to access the body in mimetic representation. Paradoxically, however, as their work amply demonstrates, it appears that an enforced attachment to the figure at this point in history could be achieved only by subjecting figurative painting to a simultaneous regime of disfiguration, fragmentation, or grotesque hypertrophic distortions.

The problematic insistence on figuration, a reenactment of ■ Picasso's post-1915 dilemma in the specific context of postwar

European art (and for the first time in postwar West German culture), now acquired an altogether different layer. The examples upon which Baselitz and Schönebeck [2] drew at that time, the international precursors and contemporaries that would seem to legitimize the otherwise all too provincial retrieval of the purely German Expressionist models, were the British painters Francis ▲ Bacon and Lucian Freud and the American Philip Guston, whose then recent conversion from Abstract Expressionism to figuration had also been achieved at the price of depicting the human body in pieces or in grotesque cartoonish disfigurations. But most importantly, it was the discovery of the fragmented bodies and • anthropomorphic forms in the work of Frenchman Jean Fautrier that would become one of the key references for Baselitz. It was in Fautrier's work that the epistemological and perceptual problem of painterly figuration was historically fused for the first time with an anthropological, or rather, an ethical question: namely, whether human subjects after the Holocaust and World War II could at all be represented as "figures," whether, indeed, they could still carry their name and image as human subjects at all.

Disfiguring figuration

This dialectic of a fixation on the representation of the human figure that at the same time has to be distorted and depleted of all its mimetic conventions finds its analogue in the dialectic

2 • Eugen Schönebeck, *Mayakovsky*, 1965
Oil on canvas, 220 × 180 (85 × 61)

▲ 1947b, 1959a, 1960a, 1960c, 1962a, 1962d, 1964b • 1988 ■ 1919 ▲ 1959d • 1946

approach to the artisanal practice of painting. While drawing and painterly gesture remain the foundational register of delineation and expression in Baselitz's work, they have to be perpetually debased by inscribing into the act of painting itself the counter-practices of primal pictorial procedures: the fecal smear, the infantile gestural scratch. This antipainterly impulse probably originates in the irrepressible suspicion that the matter of painting cannot ultimately live up to the promise of a fundamental psychosexual experience of identity, one that would be grounded in the somatic register of the unconscious alone. In blatant contrast, for a painter like Richter, painting and its processes, conventions, and materials appear as mere tools of the trade, or as technical, physical, and chemical matters. They do not have to be lined with vigorous antipainterly acts, since they have not been invested with psychosexual aspirations for a deeper experience, nor do they carry any foundational hopes for an ultimate authenticity.

Baselitz's iconography requires careful description, for it maneuvers constantly between enforcing prohibitions (such as the one against abstraction or the one against photographic mediation) and enacting transgressions (for instance, the desire to return to a presumed ground of a deeper and more authentic German [painterly] history, or the desire to rupture the pretense of a culture of repressive amnesia mediated by the photographic image of consumer culture). Thus Baselitz's series of "*Helden*" ("heroes"), "partisans," and "*ein neuer Typ*" ("a new type") reveals all the markers of the historical fallacies, if not the subjective pathology, of that ambition: from the hypertrophic and disproportionate sizes of the figures and their internal inconsistencies (from thwarted limbs to gigantic growths) to the perpetual laceration of the contour line, where the figure itself is suddenly opened up or discontinued to merge with its pictorial surroundings, the patches of viscous pigment or the suddenly self-conscious planes of flattened modernist painterly space.

This ambiguity between the figure's epiphanic returns and its persistent disappearances within the formal challenges of representation, which Baselitz recognizes as ultimately insurmountable and as pictorial problems of modernism that exist beyond the scope of his subjective ambitions, are a hallmark of his unique contribution to a postwar German aesthetic. On the level of unconscious or conscious conceptions of the artist's public identity and social role, analogous contradictions are at work. Thus, it is the legacy of the Romantic outsider that Baselitz and Schönebeck rediscover in their two *Pandämonium* manifestos, in which they reposition the artist (and themselves) within a framework that—while historically fully predetermined—appeared in 1962 as a radical departure toward the formation of a conservative postwar German aesthetic.

While heavily relying on the aesthetic theories of Gottfried Benn, Germany's supposedly extraordinary prewar Expressionist poet and temporary Nazi sympathizer, who became an eminent cult figure as a postwar nihilist, the antisocial and anticultural impulse of the *Pandämonium* manifestos also brought other elements—with a considerable delay—into the context of German visual culture for the first time. Borrowing from the writings of the Frenchmen Antonin Artaud and Lautréamont, it declared war against all aesthetic practices that define themselves as consciously operative within discursive or social conventions, and that aspire toward culture as a project of communication. By contrast, Baselitz and Schönebeck's manifestos claimed access to a space of radical incommensurability and pure otherness, in which communication is refuted and sealed in aesthetic opacity. The hero of this Nietzschean definition of the artist's role as radical outcast and outsider is invoked in both manifestos as "G." (presumably Vincent van Gogh, to whom Artaud had dedicated one of his most programmatic texts). In terms of art-historical reception, Baselitz and Schönebeck's repositioning of the artist as outsider associated itself with the recovery of multiple legacies, most of them having been deleted from German history by the Nazi destruction of Weimar modernity. This is most explicit in a formulation in which they refer to themselves as partaking in the condition of the "*Entarteten*" ("degenerate artists"), an explicit reference to the ▲ infamous exhibition of that name in Munich in 1937. That ● recovery ranged from the extraordinary centrality of the Prinzhorn ■ Collection, to the dialectics of deskilling and primary expressivity in non-European "primitivism" to the cult of lesser-known, untrained artists such as Frederick Hill, Louis Soutter, and Gaston Chaissac, a position that itself had been recently elaborated more ◆ publicly in Jean Dubuffet's celebration and collection of *art brut*.

Subjects in tatters

The internal contradictions of Baselitz's approach to painting are, then, fairly evident, inasmuch as they are the historically overdetermined attempts to resolve conflicts operating within late-twentieth-century culture at large, and within postwar German painting in particular. First of all is the renewal of the Nietzschean claim of the artist as outsider, even as criminal outcast, in which Baselitz situates himself in manifest opposition to what he would consider a specious and largely compensatory construction of German postwar democracy. But this resuscitation of a right-wing reactionary elitism as an aesthetic counterposition to democratic hypocrisy only prolonged the protofascist disgust with the fallacies of democratic everyday life of the Weimar period (and then of postwar West Germany). As is well known, at that time the majority of the populace's attachment to the prewar ideologies of Nazi fascism was generally stronger than the newly (and largely enforced) commitment to a new democratic culture and consciousness. The claim for the exceptional grandeur of the artist as transcendental being outside of the fetters of socialization and the constraints of cultural and linguistic conventionality only attempted to redeem aesthetically that type of ideology whose political realities had recently proven to be the most devastating experience in human memory.

Baselitz's figures [3]—the "new types," the "heroes," the "partisans" (for which cause, one wonders)—are all dressed in tatters: a garb that oscillates between the German Romantic painter stalk-

▲ 1937a ● 1922 ■ 1968b ◆ 1903, 1946

3 • Georg Baselitz, *Die grossen Freunde* **(The Great Friends), 1965**
Oil on canvas, 250 × 300 (98⅜ × 118⅛)

ing off to the outdoor subject and youthful male figures (somewhere between Boy Scouts and Hitler Youths), half clad in camouflage, half revealing oversized genitals, carrying palettes or canes, often marked by the peculiar homoerotic cult of youthful uniformed males with weapons and war. These prodigal German sons all appear as though they have just returned "home," or as though they are about to depart or begin anew (from where, for where, for what remains unclear).

Repositioning the artist as "hero," but as a hero in patches and tatters, therefore, is not only an attempt to work through the difficulties of a renewed figuration in the evidence of its historic impossibility. It is also an attempt—perhaps a consciously futile one—to construct a new subject, one that has been patched together by its ambition to reconfigure German subjectivity under the circumstances of its self-imposed and willful destruction of its former self, and the destruction it had recently inflicted on millions of others. BB

FURTHER READING

Georg Baselitz and Eugen Schönebeck, *Pandämonium Manifestoes*, excerpts in English translation in Andreas Papadakis (ed.), *German Art Now*, vol. 5, no. 9–10, 1989

Stefan Germer, "Die Wiederkehr des Verdrängten. Zum Umgang mit deutscher Geschichte bei Baselitz, Kiefer, Immendorf und Richter," in Julia Bernard (ed.), *Germeriana: Unveröffentlichte oder übersetzte Schriften von Stefan Germer* (Cologne: Oktagon Verlag, 1999)

Siegfried Gohr, "In the Absence of Heroes: The Early Work of Georg Baselitz," *Artforum*, vol. 20, no. 10, Summer 1982

Tom Holert, "Bei Sich, über allem: Der symptomatische Baselitz," *Texte zur Kunst*, vol. 3, no. 9, March 1993

Kevin Power, "Existential Ornament," in Maria Corral (ed.), *Georg Baselitz* (Madrid: Fundacion Caja de Pensiones, 1990)

On July 20, the twentieth anniversary of the failed Stauffenberg coup against Hitler, Joseph Beuys publishes his fictitious autobiography and generates an outbreak of public violence at the "Festival of New Art" in Aachen, West Germany.

When, in the summer of 1964, Joseph Beuys (1921–86) exhibited a small selection of his drawings and sculptures made between 1951 and 1956 at Documenta 3, Kassel, West Germany, a larger public was confronted with his work for the first time. On at least three subsequent occasions that year, Beuys's early notoriety would grow to the condition of scandalous fame, eventually establishing him as the first major, if not the most important, artist of postwar West German reconstruction culture.

The first event occurred when Beuys was attacked by right-wing students during his performance at the "Festival of New Art" at the Technical University of Aachen on July 20, 1964 [1, 2]. While he was melting two large cubes of fat on a hot plate, a soundtrack—apparently not an intentional part of Beuys's performance—played Joseph Goebbels's infamous Berlin *Sportpalast* speech soliciting the unequivocal assent of the masses to "total war." This experience of confrontation triggered, as Beuys put it, "processes of becoming increasingly conscious of the necessity to politicize my attitudes."

The second event, which occurred on the same occasion, was Beuys's publication of his fictitious autobiography *Lebenslauf/Werklauf* (Curriculum vitae/Curriculum opere). In it he constructed a

1 • Joseph Beuys, *Aktion Kukei, akoopee – Nein! Braunkreuz, Fettecken, Modellfettecken* (Brown cross, Fat corners, Model fat corners), 1964
Performance at the "Festival of New Art," Technical University of Aachen

"myth of origin" in which he gave an enigmatic account of his development as an artist. Thus he explained, for example, that his use of fat and felt, the most conspicuous materials of his sculptural oeuvre, had originated in his encounter with tribal people in the Tartar region of the Soviet Union, who had saved his life by wrapping him in fat and felt after his Luftwaffe plane had been shot down during World War II. Only a year before, Beuys had used fat for the first time when he "exhibited" a box of warm fat during a lecture on ▲ happenings given by Allan Kaprow at the Rudolf Zwirner Gallery in Cologne, thus positioning himself—in a maneuver typical of Beuys's subsequent career—in association with artistic practices not necessarily as close to his own as he claimed them to be.

Beuys concluded his autobiographical account with a proposal to raise the Berlin Wall by five centimeters to improve its architectural proportions. This passage set off a public inquisition by his employer, the Minister of Culture of North-Rhine Westphalia, who—several years later and for altogether different reasons—would dismiss Beuys for disobedience from his post at the venerable State Academy of Fine Arts in Düsseldorf, where he had studied from 1947 to 1951 and had been appointed as Professor of Monumental Sculpture in 1961. All these incidents already point to Beuys's future commitment to a model of "*Soziale Plastik*" (social sculpture), which conceived of sculpture as an activist aesthetic practice.

How German is it?

The year 1964 was also the time when Beuys appeared more • frequently as a strange fellow traveler with the international Fluxus movement. After having met the group's chief coordinator and theorist, the Lithuanian-American George Maciunas, in 1962, Beuys had invited fifteen international Fluxus artists and musicians to the "Festum Fluxorum Fluxus" at the Academy of Fine Arts in Düsseldorf in 1963. Yet Beuys would never be fully accepted by his Fluxus colleagues, since they saw his work as a specifically German contribution to a movement whose programmatic internationalism had emphasized a post-nation-state conception of culture.

What made Beuys's work particularly German was first of all a strange eclecticism that resulted from the absence of an avant-garde tradition after Nazi fascism had destroyed (Weimar) avant-garde culture in all its forms: from psychoanalysis to photomontage, from Messianic eschatological thought to orthodox Communism. Rather than recovering German modernism and establishing a cultural continuity with the amazingly complex range of personalities and projects from the Weimar spectrum, West German postwar reconstruction culture embraced, almost ■ fanatically, at first *tachisme* and *art informel* from Paris and then, from the mid-fifties onward, New York School post-Surrealist abstraction in order to internationalize itself. Furthermore, the seemingly mandatory abstraction and the internationalism of reconstruction culture deflected from the necessity to confront the recent German past, and it concealed the collective inability to mourn the victims of fascism.

2 • Joseph Beuys's Fluxus action in the large auditorium of the Technical University of Aachen, July 20, 1964

It is first of all against this type of an established aesthetic of disavowal that Beuys developed an aesthetic of the mnemonic. The historical avant-garde's radicality of the Dada readymade and of ▲ Constructivism would return in Beuys's hands as mere ruins and as utopian debris, as the irretrievable traces of an avant-garde of the past—a past that was as inaccessible for Beuys as the accumulations of an apparently celebratory commodity culture (in French Nouveau • Réalisme and even more so in American Pop art) would appear unacceptable. Beuys articulated this with the clarity of hindsight in 1980:

Actually this shock after the end of the war is my primary experience, my fundamental experience which is in fact what led me to begin to really go into art, that is, to reorient myself in the sense of a radically new beginning.

Thus, Joseph Beuys can be situated, along with two other artists of the early sixties—that is, Yves Klein and Andy Warhol—at the multiple intersections and within the historically crucial transformations that distinguish the practices of the prewar avant-garde artists from those of the postwar neo-avant-garde artists.

While not necessarily ensuring his art-historical importance, to have inhabited these intersections has made Beuys a figure upon whom ceaseless readings have been projected since the early sixties. And while these incessant interpretive efforts do not necessarily attest to an oeuvre's inexhaustible complexity, but rather to the inexhaustible desire for "meaningful" cultural production among audiences in general and among specialists of interpretation (art historians and critics) in particular, it is important to reflect upon the wide array of references and combinatory effects that Beuys's work has generated over the thirty years of his prolific production.

The first of these intersections, and perhaps the most striking, is the degree to which Beuys's work (and especially his performances) is inextricably bound up with an emerging culture of spectacle, which had been of secondary importance to the historical avant-garde. When artists in the twenties generated scandal and shock among their audiences, their activities were universally perceived as social or political provocations. We can argue, for example, that in almost

▲ all cases (such as the performances at the Cabaret Voltaire in Zurich
● in 1916, or Kurt Schwitters's public readings of his *Merz* sound poems) the avant-garde not only situated itself in manifest opposition to the ruling conventions of meaning production but also attempted to confront bourgeois society with models of culture as alternate, if not utopian, political and social practice. When artists of the neo-avant-garde engaged in scandal and shock, on the other hand, the most evident effect of their actions would be—in accordance with the rituals of the culture industry—the spectacularization of the artist as "star" and the social role ensuing from that. Beuys (and Klein and Warhol for that matter), in manifest contradistinction to his predecessors, and even to most of his contemporaries, programmatically incorporated for the first time these principles of spectacle culture and strategies of cultic visibility into his persona as much as into his work.

■ Although precursors such as Jackson Pollock may have transposed painting into the register of the spectacle they did not submit fully to its principles. But once cultural practice had been severed from all utopian and political aspirations, perhaps even from its ambitions for
◆ a semiotic revolution, the neo-avant-garde inevitably consummated the shift into an exclusive register of spectacular visuality.

This register had been instituted socially in postwar consumer culture so that its subjects could be extracted from their material and productive participation in the world in favor of a passive specular consumption of its representations. The neo-avant-garde's ineluctable mimetical inscription within this historical process traces the extrapolation of all lived experience into a simulacral mirage. Within representation, so it seems, no function or capacity can be mobilized any longer except that of the specular and totalitarian dislodging of all traditional concepts of subjectivity.

Beuys and the readymade cults

The second set of intersections between the work of Beuys and that of the historical avant-garde on the one hand and that of his international peers on the other (specifically the Nouveaux Réalistes

in France and the international Fluxus artists) concerns his rela-
▲ tionships to the world of objects at large and to the legacies of Marcel Duchamp's readymade paradigm in particular. While it still might have appeared possible for the historical avant-garde
● (for instance, in the context of the Bauhaus aesthetic or of *l'esprit nouveau* to contemplate the social functions of objects in terms of their utopian potential, artistic production in the postwar period, by contrast, represented the object as being at the core of disaster, control, and domination (Arman and Warhol, for
■ example). What distinguished Pop and Fluxus artists of the early sixties from the avant-garde artists of the 1919–25 period was the sudden insight that the incessant invasion of all spheres of everyday life by the totality of object production would now border on the totalitarian. Clearly then, these were no longer the times for Duchamp's careful contemplation of the industrial object's emancipatory opposition to the obsolescence of artisanal works of art. This fact alone might already explain why Beuys, again in 1964, in a televised interview/performance, explicitly rejected Duchamp's legacy by painting the notorious placard "The Silence of Marcel Duchamp is Overrated" [**3**].

Beuys—situated between West Germany's avid internalization of American consumer culture and its repression of its fascist history—was qualified to engage in a perpetual project of dual reflection: that of the recent (German) totalitarian past and its entanglement with authoritarian forms of myth, leadership, and the fascist state on the one hand, and that of the emerging totalizing forms of the corporate state in the present, where the domination by commodity objects would increasingly eliminate conventional concepts of subject formation and experience on the other. Since Beuys—at least initially—sought an almost desperate association with the Fluxus artists, one might want to consider their attitudes to object production in general, and to the readymade in particular, and recognize how these differ dramatically from Beuys's own. And furthermore, and perhaps more importantly, one would have to recognize that the concept of performativity developed by Fluxus artists and the actual performances by Beuys are equally, if not fundamentally, different.

Fluxus artists had responded to the totalizing claims of object production under consumer culture with a mimetically totalizing subjection of artistic production to the object's regime. But it is precisely this decision to situate aesthetic practice exclusively in the register of the object (as opposed to the traditional registers of the iconic, the painterly, the sculptural, the photographic) that generates the essential element of the Fluxus aesthetic: a perpetual dialectical flux between object production and performativity. (The name "Fluxus," the Latin for "flowing," suggests a state of continuous movement.) Inducing the object's simultaneous reinvention and defetishization, this aesthetic demands a radically egalitarian mobilization of the artist/performer and the spectator in all registers: the dramatic, the linguistic, the poetical, and the musical.

Beuys, by contrast, conceived of "performance" as a relapse into myth, a return to ritual, as an almost cultic form of psychic healing

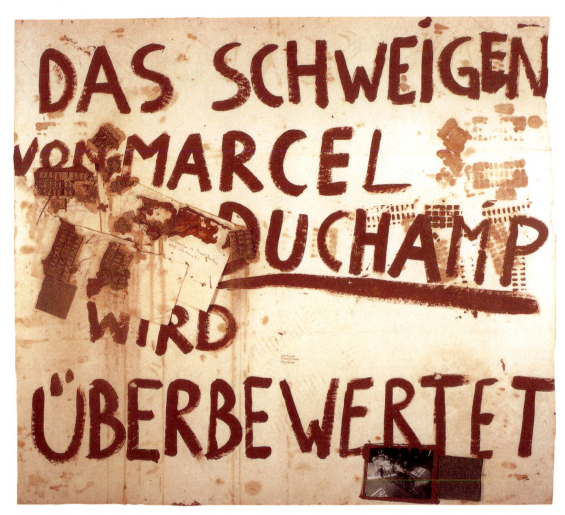

3 • Joseph Beuys, *Das Schweigen von Marcel Duchamp wird überbewertet* (The Silence of Marcel Duchamp is Overrated), 1964
Paper, oil color, ink, felt, chocolate, and photograph, 157.8 × 178 × 2 (62⅛ × 70⅛ × ¾)

and of exorcism. His performances attempted to reconnect unconscious conditions of past experiences (even if they have only recently passed as political) with sudden dramatic or grotesque representations in the present. These interventions, in their symbolic / substitutional character and their renewed hierarchical relations of performer and spectator, relapse into a pre-Aristotelian identificatory catharsis, and annihilate every aspect of Enlightenment dramaturgy. Most obviously they eliminate Bertolt Brecht's model of spectatorial agency and dialectical self-determination, the most crucial of Weimar Germany's theatrical positions.

The epistemological problem with Beuys's definition of the performative as therapeutic and exorcistic, as opposed to the Fluxus definition of the performative as linguistic self-constitution, as participatory and resistant to the condition of reification, is that it led to the cult of Beuys as the "shaman-artist." But "shamanism" under the conditions of the society of the spectacle and under the conditions of postwar West Germany might not have been the cure to either the aesthetic or the sociopathological problems of that country's population. It remains unclear whether West Germany's "inability to mourn" could in fact have been culturally transfigured by this "homeopathic" structure of a single artist's ritualistic (and substitutional) interventions; or whether it was rather the promise

to raise that nation state's devastated culture from the ashes and enact a new cultural model of conventional (German) identity that made the "shaman" particularly attractive to the Germans of the *Wirtschaftswunder* ("wonder of economics"), the name given to the German economy and industrial base's phenomenal recovery after World War II.

Thus, one of the central theoretical questions posed by Beuys's approach to artistic production—to phrase the problem in Walter Benjamin's terms—is whether "the avant-garde's emancipation of art from its parasitical dependency on ritual" could and should be reversed under the conditions of postwar culture at large and those of Germany in particular. After all, one argument in favor of this reversal, and thereby supporting the position of Beuys, would be to recognize that in order to perform the labor of mourning more profoundly, the actual sites and structures in which repression is enforced have to be first invested with the desire for memory. That investment requires, however, from both the producer and the spectator, a capacity to inhabit those structures of repression explicitly, in a form of homeopathic identification with those threatening historical phenomena that the socially and psychically ordered processes of forgetting had attempted to eradicate in the first place.

▲ Introduction 3 ● 1957a ▲ 1935

One could argue, then, that the third of the complexes that distinguish Beuys from his peers is the work's structural and iconic relationship to historical memory. While all art, as Charles Baudelaire had said at the beginning of modernism, is engaged in the construction of the mnemonic, this prognosis had not held true. Avant-garde practices throughout the twentieth century had been for the most part relentless, if not in their orientation toward the future, then in their rabid affirmation of the present. The conditions of a universal "memory crisis," confronted by Baudelaire in the face of urban modernization, were, however, exacerbated beyond imagination in postwar Germany: here, the memory crisis originated in a politically and psychologically motivated repression of the recent past as much as from the rapidly advancing enforced consumption and its inherent erasure of the subject's individual and social history.

The last event in 1964 that defined Beuys's future oeuvre and practices was his decision to assemble his first vitrine. This constituted a new type of assemblage sculpture, a hybrid between the post-Surrealist object accumulation (prominent at that time in
▲ the work of Joseph Cornell and the *accumulations* of Arman that
● influenced Fluxus artists and the spatialization of the readymade

aesthetic that would soon culminate in all types of installation practices. The 1964 vitrine—the first of many to follow—would remain the only one to receive its title directly from Beuys, who named it *Auschwitz-Demonstration* [**5**]. Positioned somewhere between the memorial shrine and the showcase, it assembled various elements from Beuys's preparation for his entry to the competition for the creation of a *Monument for Auschwitz* [**4**], organized by the International Auschwitz Committee in 1958 (its
▲ artistic jury consisted of Hans Arp, Henry Moore, and Ossip Zadkine). Most importantly, it displayed a photographic leporello of the architecture of the camp itself and a drawing of a young woman on a piece of letterhead paper from the Committee. But for the most part, the vitrine combined earlier and more recent objects that were not explicitly related to the subject at hand (most notably the hot plate from the notorious Aachen performance, now carrying two blocks of fat, a printing stone with incisions from the mid-fifties with Christian symbols, the remains of a dead rat, and various hoof-like elements made of cut-up sausage and two sausage rings).

Thus ranging from the abject to the uncanny presence of death, from the pomposity of its Christian symbolism to apparent

4 • Joseph Beuys, *Monument for Auschwitz*, 1958
Pencil, watercolor, opaque color, mordant, 17.6 × 24.5 (6⅞ × 9⅝)

▲ 1931a, 1960a ● 1962a ▲ 1913, 1916a, 1918, 1934b

mockery (for instance a cookie lying like a eucharist next to a Christ figure on a dinner plate), the *Auschwitz-Demonstration* (functioning in the manner of a "toy" as Beuys would state later) seems to be a work—if not the first work of visual culture in postwar German art—in which both the necessity to remember and the impossibility to represent adequately are fully articulated. Beuys attempts to synthesize two mutually exclusive epistemes aesthetically: to emphasize the object's investment, if not with cathartic ritual, then at least with a mnemonic dimension, and simultaneously to foreground the object's condition as pure matter and process according to his obsession with proto- and pseudoscientific positivism.

Beuys would later comment on the work, saying "*Similia similibus curantur*: heal like with like, that is the homeopathic healing process. The human condition is Auschwitz, and the principle of Auschwitz finds its perpetuation in our understanding of science and political systems, in the delegation of responsibility to groups of specialists, and in the silence of intellectuals and artists. I have found myself in permanent struggle with this condition and its roots. I find for instance that we are now experiencing Auschwitz in its contemporary character." Thus Beuys delivers his own variation on the *Dialectic of Enlightenment*, the philosophical study by the Germans Theodor Adorno and Max Horkheimer, written in 1947 and most likely unknown to Beuys in 1964, which had summed up and theorized for the first time the conditions of experience and the possibilities and necessities of cultural production after the Holocaust and World War II. BB

FURTHER READING
Götz Adriani, Winfried Konnertz, and Karin Thomas, *Joseph Beuys: Life and Works* (New York: Barrons Books, 1979)
Mario Kramer, "Joseph Beuys: Auschwitz Demonstration 1956–1964," in Eckhart Gillen (ed.), *German Art from Beckmann to Richter* (New Haven and London: Yale University Press; and Cologne: Dumont, 1997)
Gene Ray (ed.), *Joseph Beuys: The Critical Legacies* (New York: DAP, 2000)
David Thistlewood (ed.), *Joseph Beuys: Diverging Critiques* (Liverpool: Liverpool University Press and Tate Gallery, 1995)
Caroline Tisdall (ed.), *Joseph Beuys* (New York: Guggenheim Museum, 1979)

1964ᵦ

Thirteen Most Wanted Men by Andy Warhol is installed, momentarily, on the facade of the State Pavilion at the World's Fair in New York.

Andy Warhol is one of the few postwar artists whose name resonates well beyond the art world. From his public rise in the early sixties to his premature death in 1987, he was a central relay between art and advertising, fashion, underground music, independent filmmaking, experimental writing, gay culture, celebrity culture, and mass culture. Apart from art work that ranged from extraordinary to bathetic, Warhol invented entirely new genres of movies, produced the first album of The Velvet Underground, founded a magazine (*Interview*), and endorsed products with his own logo-persona, among a myriad other ventures (his studio was appropriately named The Factory). He exposed and exploited a new way of being in a world of commodity-images where fame is often subsumed by celebrity, newsworthiness by notoriety, aura by glamor, and charisma by hype: a native informant who always kept his Polaroid, tape recorder, film and video cameras switched on, Warhol had a look of blank indifference, but an eye for killer images.

Critical or complacent?

Born in 1928 to Slovak immigrants in Pittsburgh (his father worked in coal mines, then in construction), Warhol studied design at the Carnegie Institute of Technology, then moved to New York in 1949, where he achieved early success with magazine ads, window displays, stationery, book jackets, album covers, and the like for a range of classy clients from *Vogue* to Bonwit Teller. By the late fifties and early sixties, he was wealthy enough to buy work by
▲ Jasper Johns, Frank Stella, even Marcel Duchamp, before he could sell his own art; and he went on to collect objects and images of many sorts—every day was a time capsule for Warhol. He did his first paintings of comic-strip characters (Batman, Nancy, Dick Tracy, Popeye) in 1960, the year before he saw, at his own future
● gallery (Leo Castelli), canvases by Roy Lichtenstein with similar subjects rendered in different styles. Whereas Lichtenstein was clean and hard in his comic-and-ad copies, Warhol played with manual mistakes and media-image blurrings. The year 1962–3 was his *annus mirabilis*: he produced his first paintings of Campbell's soup cans; his first "Disaster," "Do It Yourself," "Elvis," and "Marilyn" paintings; his first silkscreens on canvas; and his first

films (*Sleep*, *Kiss*, and so on—the titles declare all the action that we see). In 1963 he moved his studio to East 47th Street (soon to be dubbed The Factory), which became a post-bohemian hangout for scene-makers and "superstars" (another Warhol invention); in the same year, he used a Polaroid for the first time as well.

His greatest period spans the time between his first silkscreens in 1962 and his near-fatal shooting in 1968 (on June 3, two days before Bobby Kennedy was assassinated). Most significant readings of Warhol focus on this body of work, especially on the "Death in America" images (based on newspaper photographs, often too gruesome for publication, of car wrecks and suicides, electric chairs and civil-rights confrontations [1]). These accounts tend either to connect such images to real events in the world or, conversely, to propose that the world of Warhol is nothing but image, that Pop images in general represent only other images. Most readings, not only of Warhol but of most postwar art based in photography, divide somewhere along this line: the image as referential *or* as simulacral (a simulacrum is a copy without an apparent original, and in his image repetitions the original often does appear to dissolve).

The *simulacral* reading of Pop is advanced by critics informed
▲ by poststructuralism, for whom the theory of the simulacrum, crucial to the poststructuralist critique of referential representation, sometimes seems to depend on the example of Warhol as Pop. "What Pop art wants," Roland Barthes writes in "That Old Thing, Art" (1980), "is to desymbolize the object," that is, to release the image from deep meaning into simulacral surface. In the process the artist is also released: "The Pop artist does not stand *behind* his work," Barthes continues, "and he himself has no depth: he is merely the surface of his pictures, no signified, no intention, anywhere." With variations this reading is repeated by such
● French philosopher-critics as Michel Foucault, Gilles Deleuze, and Jean Baudrillard, for whom referential depth and subjective interiority are also victims of the sheer superficiality of Warhol Pop.

The *referential* view is advanced by critics based in social history who tie the work to thematic issues (fashion, gay culture, political struggles). In "Saturday Disasters: Trace and Reference in Early Warhol" (1987), the art historian Thomas Crow disputes the simulacral account of Warhol as impassive and the images as

▲ 1914, 1918, 1935, 1942b, 1958, 1962d, 1966a ● 1960c ▲ Introduction 4, 1980 ● 1971, 1980

1 • Andy Warhol, *White Burning Car III*, 1963
Silkscreen on canvas, 255.3 × 200 (100½ × 78¾)

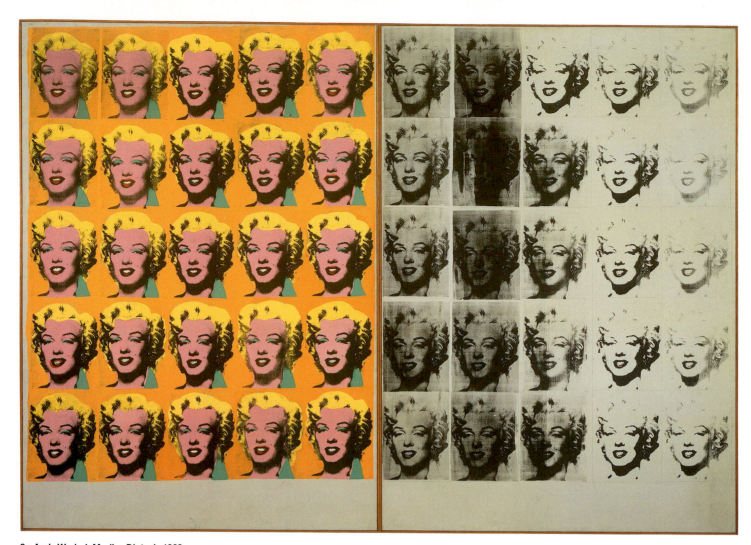

2 • Andy Warhol, *Marilyn Diptych*, 1962
Silkscreen ink and synthetic polymer paint on canvas, two panels, each 208.3 × 144.8 (82 × 57)

indiscriminate. Underneath the glamorous surface of commodity fetishes and media stars, Crow finds "the reality of suffering and death"; the tragedies of Marilyn, Liz, and Jackie in particular prompt "straightforward expressions of feeling" from Warhol [2]. Here Crow finds not only a referential object *for* Warhol but an empathic subject *in* Warhol, and here he locates the criticality *of* Warhol—not in an attack on "that old thing art" (as Barthes would have it) through an embrace of the simulacral commodity-image (as Baudrillard would have it), but rather in an exposé of "complacent consumption" through "the brutal fact" of accident and mortality. In this way Crow pushes Warhol beyond humanist sentiment to political engagement. "He was attracted to the open sores in American political life," Crow writes in a reading of the electric-chair images [3] as agitprop against the death penalty and of the race-riot images as a testimonial for civil rights. "Far from a pure play of the signifier liberated from reference," Warhol belongs to the popular American tradition of "truth-telling."

In part this reading of Warhol as empathic, even *engagé*, is a projection, but so is the superficial, impassive Warhol—even though this latter projection was his own: "If you want to know all about Andy Warhol, just look at the surface of my paintings and films and me, and there I am. There's nothing behind it." Both camps make the Warhol they need; no doubt we all do (projection is one of his great subjects). In any case neither argument is wrong; but they cannot both be right—or can they? Can we read these early images of disaster and death as referential *and* simulacral, connected *and* disconnected, effective *and* effectless, critical *and* complacent?

Traumatic realism

The most famous Warhol motto is "I want to be a machine," which is usually taken to confirm the blankness of artist and art alike. But it may point less to a blank subject than to a shocked one, who takes on what shocks him as a mimetic defense against this very shock: I am a machine too, I make (or consume) serial commodity-images too, I give as good (or as bad) as I get. "Someone said my life has dominated me," Warhol told the art critic Gene Swenson in an important interview of 1963, "I liked that idea." Warhol had just sworn to having the same lunch for the past twenty years (what else but Campbell's soup?). Together, then, the two statements read as a preemptive embrace of the compulsion to repeat put into play by a society of serial production and consumption. If you can't beat it,

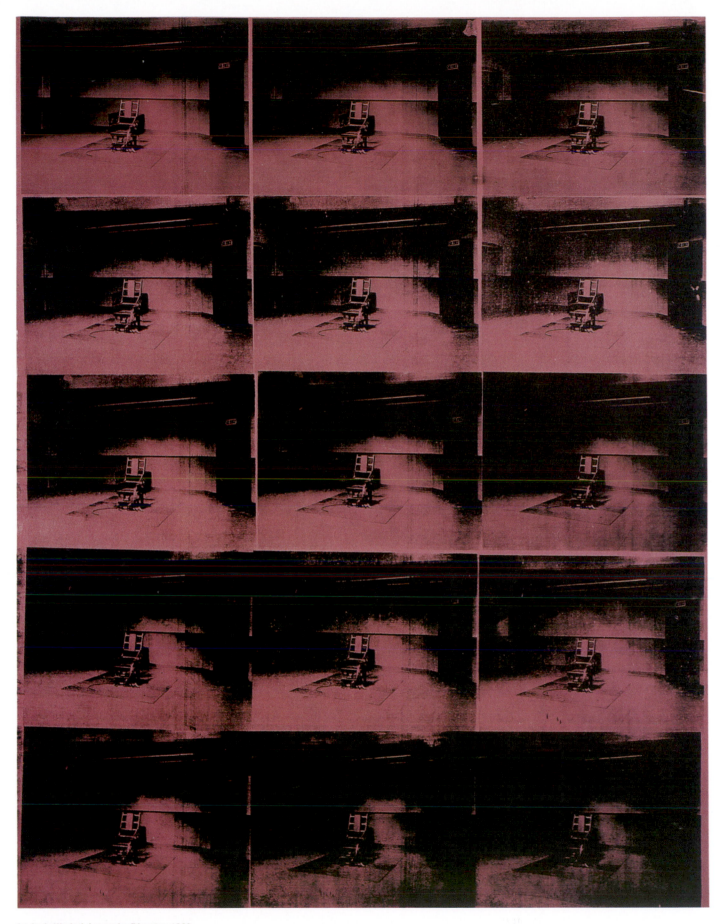

3 • Andy Warhol, *Lavender Disaster*, 1963
Silkscreen ink and synthetic polymer paint on canvas, 269.2 × 208 (106 × 81⅞)

Warhol suggests, join it. More, if you enter it totally, you might expose it; you might reveal its automatism, even its autism, through your own excessive example. Deployed first by Dada, this strategic nihilism was performed ambiguously by Warhol, ▲ and artists such as Jeff Koons have played it out since.

These remarks reposition the role of *repetition* in Warhol. "I like boring things" is another famous motto of his quasi-autistic persona. "I like things to be exactly the same over and over again." In *POPism* (1980) Warhol glossed this embrace of boredom, repetition, domination: "I don't want it to be essentially the same—I want it to be *exactly* the same. Because the more you look at the same exact thing, the more the meaning goes away, and the better and emptier you feel." Here repetition is both a draining of significance and a defending against affect, and this strategy guided Warhol as early as the 1963 interview with Swenson: "When you see a gruesome picture over and over again, it doesn't really have any effect." Clearly this is one function of repetition in our psychic lives: we repeat traumatic events in order to integrate them into a psychic economy, a symbolic order. But the Warhol repetitions are not restorative in this way; they are not about a mastery of trauma. More than a patient release from a lost object in mourning, they suggest an obsessive fixation on a lost object in melancholy. Think of all the *Marilyn* images cropped, colored, and crimped: the "hallucinatory wish-psychosis" of a melancholic (Freud) seems to be in play here. But this analysis is not quite right either, for the repetitions not only *re*produce traumatic effects, but also can *produce* them. Several contradictory operations occur at the same time: a warding away of traumatic significance *and* an opening out to it, a defending against traumatic affect *and* a producing of it.

Repetition in Warhol, then, is neither a representation of a worldly referent nor a simulation of a pure image or a detached signifier. Rather, repetition serves to screen a reality understood as traumatic, but in a way that points to this traumatic reality none-theless through a rupture in the image—or, more precisely, in the viewer *touched* by the image. In *Camera Lucida* (1980) Barthes called this traumatic point the *punctum*. "It is this element which rises from the scene, shoots out of it like an arrow, and pierces me," he writes. "It is what I add to the photograph and what is none-theless already there.... It is acute yet muffled, it cries out in silence. Odd contradiction: a floating flash." Barthes is concerned here with straight (unmanipulated) photographs, so he relates the *punctum* to details of content. This is rarely the case in Warhol, yet a *punctum* exists for me (Barthes stipulates that it is a personal effect) in the indifference of the passerby in *White Burning Car III* [1]. This indifference to the crash victim impaled on the telephone pole is bad enough, but its repetition is galling, and this points to the operation of the *punctum* in Warhol. It works less through content than through technique, especially in the "floating flashes" of the silkscreen process, in the repetitive "popping" of the images. Here Pop does not register the death of affect (as is sometimes said) so much as the affect of death.

Such disaster and death images evoke the public nightmares of the early age of television, for Warhol selects moments when this ▲ society of spectacle cracks—Jackie Kennedy in mourning after the assassination in Dallas, Marilyn Monroe remembered after her suicide, racist attacks, car wrecks—but cracks only to expand. Content in Warhol is thus not trivial: a white man impaled on a telephone pole, or a black man attacked by a police dog, is shocking. But, again, this first order of shock is screened by the repetition of the image, even as this repetition produces a second order of trauma, here at the level of technique, where the *punctum* breaks through the screen and allows the real to poke through. In this way different kinds of repetition are put into play by Warhol: repetitions that fix on the traumatic real, that screen it, that produce it. And this multiplicity makes for the paradox not only of images that are both affective and affectless, but also of viewers that are neither integrated (which is the ideal of most modern aesthetics: the subject composed in contemplation) nor dissolved (which is the effect of much popular culture: the subject given over to the intensities of the commodity-image). "I never fall apart," Warhol remarks in *The Philosophy of Andy Warhol* (1975), "because I never fall together." Such is the paradoxical subject-effect of his work too, and it resonates in some art after Pop as well ● (for instance, some appropriation art and some abject art).

Mass subjectivity

Barthes was wrong to suggest that the *punctum* is only a private affair; it can have a public dimension as well. The breakdown of the distinction between private and public is traumatic too; seen as a breakdown of inside and outside, it is one way to understand trauma as such. No one points to this traumatic breakdown of private and public as incisively as Warhol. "It's just like taking the outside and putting it on the inside," he once said of Pop in general, "or taking the inside and putting it on the outside." However cryptic, this remark suggests a historically new relay between private fantasy and public reality as a primary topic of Pop.

Warhol was fascinated by the subjectivity produced in mass society. "I want everybody to think alike," he said in 1963. "Russia is doing it under government. It's happening here all by itself." "I don't think art should be only for the select few," he added in 1967. "I think it should be for the mass of American people." But how does one represent "the mass of American people"? One way to evoke this mass subject is through its proxies, that is, through its objects of consumption (thus the serial presentation from 1962 on of the Campbell's soup cans, Coke bottles, Brillo boxes) and/or through its objects of taste (thus the kitschy flower paintings of 1964 and the folksy cow wallpaper of 1966). But can one *figure* this mass subject? Does it have a body to figure? "The mass subject cannot have a body," the critic Michael Warner asserts, "except the body it witnesses." This principle suggests why Warhol evokes the mass subject through its figural projections—from celebrities and politicians such as Marilyn and Mao to all the lurid cover-people of

▲ 1916a, 1920, 1986, 2007c

▲ 1957a ● 1977a, 1980, 1994a

Interview magazine. At the same time he was also concerned to specify this subject in subcultural ways: The Factory was a virtual workshop of campy reinventions of mass icons such as Troy Donahue, and portraits like *Thirteen Most Wanted Men* [4] are obvious *double entendres* for gay viewers.

However, Warhol did more than evoke the mass subject through its kitsch, commodities, and celebrities. He also represented it in its very unrepresentability, that is, in its absence and anonymity, its disaster and death, the democratic levelers of famous mass object and anonymous mass subject alike. Here are two more statements from interviews, the first from 1963, the second from 1972:

> I guess it was the big crash picture, the front page of a newspaper: 129 DIE. I was also painting the Marilyns. I realized that everything I was doing must have been Death. It was Christmas or Labor Day—a holiday—and every time you turned on the radio they said something like, "4 million are going to die." That started it.

> Actually you know it wasn't the idea of accidents and things like that … I thought of all the people who worked on the pyramids and … I just always sort of wondered what happened to them … well, it would be easier to do a painting of people who died in car crashes because sometimes you know, you never know who they are.

These remarks imply that his primary concern was not disaster and death but the mass subject, here in the guise of the anonymous victims of history, from the drones of the pyramids to the statistical DOAs at the hospitals. Yet disaster and death were necessary to ▲ evoke this subject, for in the society of the spectacle the mass subject often appears only as an effect of the mass media (the newspaper, the radio), or of a catastrophic failure of technology (the plane crash), or, more precisely, of both (the news of such a catastrophic failure). Along with icons of celebrity such as Marilyn and Mao, reports of disastrous death are a primary way that mass subjecthood is produced.

For the most part, then, Warhol evoked the mass subject in two opposite ways: through iconic celebrity and abstract anonymity. But he might have come closest to this subject through a compromise representation somewhere between celebrity and anonymity, that is, through the figure of *notoriety*, the fame of fifteen minutes. Consider his implicit double portrait of the mass subject: the most-wanted men and the empty electric chairs, the first a kind of American icon, the second a kind of American crucifix. What more exact representation of our pathological public sphere than this twinning of iconic mass murderer and abstract state execution? That is, what more difficult image? When Warhol made his *Thirteen Most Wanted Men* for the 1964 World's Fair in New York, power—men such as Governor Nelson Rockefeller, Commissioner Robert Moses, and court architect Philip Johnson, men who not only designed the society of the spectacle but also

▲ 1957a

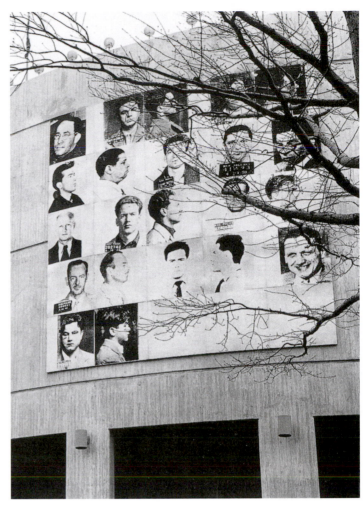

4 • Andy Warhol, *Thirteen Most Wanted Men*, 1964
Silkscreen on canvas, twenty-five panels, 610 × 610 (240 × 240), on the New York State Pavilion, 1964 World's Fair, New York (no longer exists as one work)

represented it as the fulfillment of the American dream of success and self-rule—could not tolerate it. Warhol was ordered to cover up the image, literally to repress it (which he did, in gay mockery, with his signature silver paint), and the powers that be were not amused when Warhol offered to substitute a portrait of Robert Moses instead. HF

FURTHER READING
Roland Barthes, *Camera Lucida*, trans. Richard Howard (New York: Hill and Wang, 1981)
Thomas Crow, "Saturday Disasters: Trace and Reference in Early Warhol," in Serge Guilbaut (ed.), *Reconstructing Modernism* (Cambridge, Mass.: MIT Press, 1990)
Kynaston McShine (ed.), *Andy Warhol: A Retrospective* (New York: Museum of Modern Art, 1989)
Richard Meyer, "Warhol's Clones," *The Yale Journal of Criticism*, vol. 7, no. 1, 1994
John Russell (ed.), *Pop Art Redefined* (New York: Praeger, 1969)
Paul Taylor (ed.), *Post-Pop* (Cambridge, Mass.: MIT Press, 1989)
Andy Warhol, *The Philosophy of Andy Warhol* (New York: Harcourt Brace Jovanovich, 1975)
and *POPism: The Warhol '60s* (New York: Harcourt Brace Jovanovich, 1980)

1965

Donald Judd publishes "Specific Objects": Minimalism receives its theorization at the hands of its major practitioners, Judd and Robert Morris.

ooking back from a distance of nearly three decades at his first years as a sculptor, Robert Morris wrote in 1989 of that period in the early sixties: "At thirty I had my alienation, my Skilsaw, and my plywood. I was out to rip out the metaphors, especially those that had to do with 'up,' as well as every other whiff of transcendence." This mood of resistance he recalls as ▲ specifically pitted against the values of Abstract Expressionism, a defiance that energized his whole generation: "When I sliced into the plywood with my Skilsaw, I could hear, beneath the ear-damaging whine, a stark and refreshing "no" reverberate off the four walls: no to transcendence and spiritual values, heroic scale, anguished decisions, historicizing narrative, valuable artifact, intelligent structure, interesting visual experience."

The plywood polygons—giant slabs, beams, portals—that Morris was to begin exhibiting in the fall of 1963 coincided with the peculiar transformation that Donald Judd had effected in his own work during the same year. It was then that Judd's paintings had begun to mutate into large, simplified, three-dimensional objects, such as two slabs abutted at right angles, their juncture acknowledged by an elbow of metal pipe or a big, bright-red, wooden box with a shallow trough cut out of its upper face [1].

"No" to transcendence

By 1966, with the "Primary Structures" show mounted at the Jewish Museum in New York, these separate acts of defiance could be decreed a movement, since the exhibition's curator, Kynaston McShine, was now able to join forty more British and American sculptors to Judd's and Morris's examples, these including ▲ Carl Andre, Anthony Caro, Walter De Maria, Dan Flavin, Robert

1 • Donald Judd, *Untitled (box with trough)*, 1963
Light cadmium-red oil on wood, 49.5 × 114.3 × 77.5 (19½ × 45 × 30½)

▲ 1947b, 1949a, 1951, 1960b ▲ 1945, 1962a

Grosvenor, Ellsworth Kelly, Sol LeWitt, Tim Scott, Tony Smith,
▲ Robert Smithson, Anne Truitt, and William Tucker. One among a number of attempts to give this movement a name, the title "Primary Structures" focused on the radical simplification of shapes involved, while in 1968 the Museum of Modern Art employed "The Art of the Real" as a rubric that would highlight the brutally unframed character of the work in its abandonment of any sculptural pedestal in order to share the real space of its viewer. By 1968, however, "Minimalism" had come into widespread usage, edging out all other titles, such as "Systemic Painting," which the Guggenheim Museum had used to emphasize the impersonal quality involved in generating this work—its industrialized, serialized character—only now applied to the movement's production in the two dimensions of painting.

That Minimalist art bridges between painting and sculpture, indeed, that it necessarily erases the distinction between painting and sculpture, was the message of Judd's article in the 1965 *Arts Yearbook*, "Specific Objects," the first extended attempt to theorize what was taking place (the second being Morris's "Notes on Sculpture" of 1966). Turning to the shaped, concentrically striped
• canvases that Frank Stella had been making since 1961, Judd saw these as moving past painting—with its inevitable illusion of space (no matter how shallow)—to become slabs that begin to exist as three-dimensional objects. "Three dimensions are real space," Judd explains. "That gets rid of the problem of illusionism and of literal space, space in and around marks and colors." This, he adds, "is riddance to one of the salient and most objectionable relics of European art," a relic he would in another context characterize as linked to rationalistic philosophy "based on systems built beforehand, *a priori* systems."

Having become "three dimensions," Stella's slabs are now "specific objects," which would tend to suggest that Judd thought they would best be called sculptures. Judd, however, had the same objection to sculpture that he did to painting, seeing it as additive and composed. What Stella's rectangular or donut or v-shaped "slabs" achieved was a striking quality of unitariness, of simply being *that* object, *that* shape. He compared this with Duchamp's
■ readymades which, he said "are seen at once and not part by part."

This insistence on a single shape that takes over the experience of a work, eclipsing any sense of its component parts, is thus seen as a correlative of the rejection of "a priori systems." For Judd, such systems inevitably establish a hierarchy among the constituent elements, as they work to achieve balance, to produce compositional relationships. By radically reducing the elements in a work to such a degree that all would connect self-evidently to the unitary shape, Judd hoped not only to cancel composition but also to eliminate the other aspect of the a priori, namely the sense of an idea or intention that exists prior to the making of the work in such a way so that it seems to lie inside the object like its motivating kernel or core. Eradicating illusionism is thus part and parcel of ridding the work of this motivating idea, this sense of a *raison d'être* that the resulting object clothes or expresses. This is what Morris had

2 • Robert Morris, (from left to right) *Untitled (Table)*, *Untitled (Corner Beam)*, *Untitled (Floor Beam)*, *Untitled (Corner Piece)*, and *Untitled (Cloud)*
Installation at the Green Gallery, December 1964–January 1965

meant when he remembered saying "no to transcendence and spiritual values, heroic scale, anguished decisions," in a rejection that covered Judd's "rationalism" and the Abstract Expressionist
▲ "sublime" in one and the same rebuff. When Morris decreed this same anti-illusionism in his own "Notes on Sculpture," he used the term "gestalt" to evoke Judd's idea of unitariness. That nothing, no previous idea, lies *behind* the external shape or gestalt, Morris expressed as: "One does not seek the gestalt of a gestalt." [2]

If the spectator was not supposed to plumb the object's depths to discover the rationale for its appearance, this was because such an object "takes relationships out of the work and," Morris explained, "makes them a function of space, light, and the viewer's field of vision." Which is to say that a new model of meaning was being put in place by this sense that everything in the work existed only on its surface, a surface itself constantly vulnerable to the play of light and of the viewer's perspective. "Even [the work's] most patently unalterable property, shape, does not remain constant," Morris maintained, "for it is the viewer who changes the shape constantly by his change in position relative to the work."

The death of the author

Into the art world of the early and mid-sixties there had surfaced two models of meaning that seemed utterly to alter the parameters of aesthetic experience. One of these, linked to the late phase of
• Ludwig Wittgenstein's philosophical writings, had already been invoked by Jasper Johns in the late fifties and early sixties when he announced that the *meaning* of any word was its "use." Two conclusions followed from such a statement: first, that the meanings of words are not a function of an absolute definition held inviolate in some kind of Platonic heaven but instead blur and fuzz within the context of their applications; and second, that the meanings of the words we speak are not secured by the intentions we have in our heads prior to having uttered them ("*this* is what I meant")

▲ 1953, 1962c, 1967a, 1968b, 1970 • 1958 ■ 1914 ▲ 1947a, 1949a, 1951 • 1958

but instead take on significance in the public space of our exchange with others. Discussing Minimalism in "A.B.C. Art" (1965), one of the first interpretive essays not written by an artist, Barbara Rose emphasized the importance of Wittgenstein's notions of language for the way Morris's and Judd's works stake everything on the context in which they surface into the experience of their viewers.

To reinforce this sense of meaning-as-context Morris resorted to several strategies. One was to make the gestalts of his works out of detachable segments and, over the course of the installation of a group of these ensembles, to "permute" the segments into different arrangements of forms, in such a way that no single work could ever be seen to have a stable, pregiven shape: an inner "idea" that would function as its immutable core. Another strategy was to take the same shape and repeat it several times, only each in a different position, as in his three *L-Beams* [3] where, as we confront one of these massive Ls lying on its side, the other "sitting up," and the third arched on its two ends, we cannot see all three of their shapes as the "same." This is because the effect of real space means that each shape takes on a different meaning according to the way a sense of gravitational pull or luminous release affects our experience of the actual thickness and weight of the different "arms."

It was Maurice Merleau-Ponty's *Phenomenology of Perception* (1945; English translation, 1962) that produced the second important model for meaning-as-context, or rather meaning as a function of the body's immersion in its world, which resonates in Morris's *L-Beams* or in the plywood boxes Judd began to make in the early seventies that seem to internalize, and therefore all the more nakedly depend on, the moving spectator's visual trajectory.

Insofar as both these models—meaning as "use" or meaning as a function of the body's connection to its spatial horizon—join in

rejecting an idea of either innerness or priorness as securing signification, both of them have sweeping implications for the traditional notion of the author of either a sentence or a work. For nothing inside the author—his or her intentions or feelings—is now believed to serve as a guarantee of the work's meaning; rather, that meaning is dependent on the interchange that occurs in the public space of the work's connection to its viewers. That Judd with his refusal of the a priori, and Morris with his "no" to anguishing decisions, should have embraced these models is not, then, surprising, nor is it an accident that by 1968 the second-generation Minimalist and critic Brian O'Doherty (born 1934) should have brought into the American context an essay by Roland Barthes that carried the significant title: "The Death of the Author."

Various practices by the Minimalists were to reinforce this sense of the eviction of the "author," one of which was to depersonalize the fabrication of the work. Just as Morris and Judd had initially resorted to the use of standardized materials—such as plywood or Plexiglas sheets—so they had also taken the plans for objects too difficult for them to forge themselves to metal shops to have them executed. By the late sixties this recourse to production by others had become far more programmatic in that it had entered their thinking as a way of exorcising the last remnants of "aura" from the object, whether in the form of the artist's touch or in the uniqueness of the resultant work. Industrial fabrication ensured the utmost depersonalization of the making of the work at the same time as it guaranteed that the object could be produced as a multiple, with no member of the resulting series having any more claim to being the "original" than any other.

The second of these antiauthorial practices was to push the use of standardized materials toward the limit of the readymade and to make the object from freestanding store-bought units. Dan Flavin pursued this in the form of fluorescent tubes that he would pair, treble, or quintuple to form what he began to call "Monuments" (e.g., *Monument 7 for V. Tatlin*), thereby acknowledging not so much the Dada aspect of the readymade but the Russian Constructivist and Productivist commitment to industrialized art. For his part Carl Andre began to employ fire bricks, as in the four-hundred-foot row of them he installed in the "Primary Structures" show and called *Lever*. Given the absolutely aggregate character of the floorbound assemblies that he pursued in both brick and metal plates (often referred to as "rugs"), his work flaunted the idea of "composition" to the utmost and declared itself to be a case of what Judd had said should replace it: an organization that was nothing but "just one thing after another."

"Presentness is grace"

If by 1966 "Primary Structures" had established the breadth of Minimalist practice, *Artforum* magazine would, the following summer, demonstrate its conceptual ambitions by devoting a special issue to this work, an issue in which artists such as Robert Smithson (1938–73) and Sol LeWitt joined Robert Morris in setting forth

3 • Robert Morris, *Untitled (Three L-Beams)*, 1965–6
Installation at Leo Castelli Gallery

▲ 2007a ● 1935 ■ 1914, 1921b, 1962c ◆ 1962c

the logic of their practice. Yet their "joining" was at the same time a subtle form of secession, since Smithson's "Towards the Development of an Air Terminal Site" was already to announce the coming ▲ of a new phase in art that was to be called Earthworks, and LeWitt's "Paragraphs on Conceptual Art," while they were meant to stress the permutational and serial nature of this practice, were already geared to a relation with language and dematerialized "conception" that was to challenge Minimalism with increasing ferocity. But even more aggressively, Michael Fried's "Art and Objecthood" used the special issue of *Artforum* to launch an attack on Minimalism's rear, ratifying even through his most negative arguments its practitioners' own sense of the degree to which Minimalism constituted a watershed within modernism, changing the most basic terms for the practice of art.

Rebaptizing Judd's "specific" object with the term "literalist," Fried agreed with Judd that such a work constituted itself in the real space of its viewer's engagement neither as painting nor as sculpture but in some kind of category that is between the two. He also agreed that the crucial effect of this work was to engage with its surrounds, including the real time within which its existence unfolds—a "just one thing after another" that is temporal as well as spatial. But where Fried diverged from his adversaries was in his argument that the presence that such an object sets up within its newly real space was analogous to *stage presence*, like an actor who is constantly producing effects on his audience, and hence that the experience of Minimalism was profoundly theatrical. Further he argued, if this theatricality is a result of the insistence on engaging the work with its surrounds, it is also logically continuous with the desire to collapse the distinctions between the specific mediums of art on which the modernist logic had previously depended. For, from Richard Wagner in the late nineteenth century to Erwin Piscator in the twentieth, theater was continually seen as the consummate mixed medium, the melting pot of all the separate arts, or what Wagner had called the *Gesamtkunstwerk* (the total work of art).

Yet this collapse of distinction *between* the arts is nothing, ● Fried maintained, but the eradication of any distinction between art and the literal, or art and the everyday. For art is not simply a function of something's being in my presence—as though it were in my way—but rather an instant of aesthetic experience which occurs in no real space or time at all, being instead a moment of illumination that suffuses a work with its meaning the way comprehension of a mathematical equation suffuses a bunch of numbers and a group of instances with a kind of timeless truth. To this effect Fried gave the name "presentness" to contrast it with the literalist object's "presence," and by ending his essay with a refusal of dailiness in the startling declaration "presentness is grace," he courted that very possibility of transcendence to which Morris's Skilsaw had screamed its earlier "no."

Between the covers of this 1967 issue of *Artforum* there were collected, then, four voices equally clear about the threshold that Minimalism had crossed. One of them was dismayed at its bringing the specific medium of sculpture to an end; and indeed Fried

Maurice Merleau-Ponty (1908–61)

Having founded the important postwar journal *Les Temps modernes* with Jean-Paul Sartre and Simone de Beauvoir, Maurice Merleau-Ponty filled the chair of philosophy at the Collège de France, beginning in 1952. Reacting against Descartes, Merleau-Ponty's criticism of his, or any, form of idealism stemmed from his objection to a model of experience based on the knowing mind's harmonious connection to the world, a model which failed to account for the fundamental discontinuities not only between consciousness and the world but between one consciousness and another. Human subjectivity could not be grasped, he felt, without an account of these gaps.

Indebted to the Gestalt psychology of Wilhelm Köhler, Merleau-Ponty focused on what he called the "perceptual milieu" in an effort to describe the uniquely human form of "being-in-the-world," which was grounded, he argued, in the partial nature of visual experience due to the "perspectival" limits of human perception. In *The Phenomenology of Perception* (1945), his chapters on "the Body" opened onto forms of perception that he characterized as "preobjectile," thereby grounding a form of seeing and knowing that would have to be called "abstract." Merleau-Ponty's work entered the active discourse on modernist art through the essays that Michael Fried wrote on the English sculptor Anthony Caro. There, wanting to characterize the disjunctive "syntax" of Caro's work, Fried acknowledged Merleau-Ponty's essay "On the Phenomenology of Language" (1952) among others.

Since Merleau-Ponty's phenomenology places the subject's body—its bilateral symmetry, its vertical axis, its having a front and a back, the latter invisible to the subject him- or herself—at the center of the subject's intention toward meaning—those artistic projects dependent on bodily vectors for their aesthetic experience are particularly open to phenomenological analysis. In addition to the above-mentioned case of Caro, important examples would be Barnett Newman and Richard Serra.

1960–1969

presented the work of Anthony Caro as the true, sculptural alternative to Judd's and Morris's literalist work. The other three—Morris, LeWitt, Smithson—greeted the newly mapped field for aesthetic practice as the advent of the greatest possible freedom, entering ▲ thereby into what could be called an "expanded field." RK

FURTHER READING

Gregory Battcock (ed.), *Minimal Art: A Critical Anthology* (New York: Dutton, 1968; and Berkeley and Los Angeles: University of California Press, 1995)
Francis Colpitt, *Minimal Art: The Critical Perspective* (Seattle: University of Washington Press, 1990)
Michael Fried, "Art and Objecthood" (1967), *Art and Objecthood* (Chicago: University of Chicago Press, 1998)
Donald Judd, *Complete Writings: 1959–1975* (New York: New York University Press, 1975)
Rosalind Krauss, *Robert Morris: The Mind/Body Problem* (New York: Guggenheim Museum, 1994)
Robert Morris, *Continuous Project Altered Daily* (Cambridge, Mass.: MIT Press, 1993)
James Meyer, *Minimalism: Art and Polemics in the Sixties.* (New Haven and London: Yale University Press, 2001)
Ann Goldstein (ed.), *A Minimal Future? Art as Object 1958–1968* (Los Angeles: Museum of Contemporary Art, 2004)

▲ 1968b, 1970 ● 1945 ▲ 1970

Marcel Duchamp completes his installation *Etant Donnés* in the Philadelphia Museum of Art: his mounting influence on younger artists climaxes with the posthumous revelation of this new work.

One way—and by no means the least telling—of characterizing the aesthetic climate of the sixties is to notice the degree to which Picasso's reputation had become eclipsed by Duchamp's. If Picasso had been the wizard of modernism, the great inventor of Cubism and of the principle of collage, he had also been the ceaselessly protean producer, keeping alive the tradition of painting in an endless parade of pictorial styles, fanning the dying embers of the printmaking process, pushing the boundaries of traditional sculpture. Duchamp, by contrast, had "stopped painting" in 1920 to take up chess, as he claimed, and to issue a series of readymades under the pseudonym Rrose Sélavy. Compared with the avalanche of publicity, exhibitions, and critical literature that surrounded Picasso, the "serene obscurity" into which Duchamp had settled in New York by the forties was broken only by a special issue of the Surrealist-influenced magazine *View* devoted to him in 1945 (a first monograph on Duchamp would not be published until 1959). Living in a spartanly simple apartment, his only contact with the art world was through a few displaced Surrealists and the avant-garde composer John Cage. But this, it turns out, was enough.

By the fifties Cage, fascinated with Duchamp's ideas about chance, had spread the news of Duchamp's example to his friend, the painter Robert Rauschenberg. Through Rauschenberg something of Duchamp's procedures was transmitted to Jasper Johns, although Johns claims that the works for his amazing premier exhibition in 1957 (his *Targets* with cast body parts, and his *Flags*) were made before he learned about Duchamp and that it was only after critics labeled his work "neo-Dada" and spoke of their identity as readymades that he and Rauschenberg began to find out about the phenomenon in earnest. By 1959 they had met Duchamp, seen the extraordinary constellation of his work in the Arensberg Collection at the Philadelphia Museum of Art (including *The Large Glass)* and by 1960 they had read the newly published, English version of *The Green Box* (1934), Duchamp's elaborate notes for the *Glass*, and—in the case of Johns—had begun to collect work by Duchamp, particularly the cast pieces Duchamp made in the fifties and had issued in limited editions [2].

Although Johns's work clearly manifested two of the "paradigms" for making art to which the name Duchamp is firmly attached—the readymade and the "index" (the latter indicated by Johns's use of cast body parts as well as various "devices," such as the medium of encaustic, or the use of squeegees for smearing paint, that emphasize the pictorial mark as a form of trace)—he himself signaled the importance of a third. "With Duchamp," Johns wrote in 1960, "language has primacy.... Duchamp's *Large Glass* shows his conception of work as a mental, not a visual or sensual, experience."

Peep show

It was these three "paradigms," or models for how to make a work, that had firmly established themselves in the American context of the early sixties. The readymade was everywhere, thoroughly permeating Fluxus production as well as forming the conceptual armature of Pop art. The index not only manifested itself in the body casts Johns continued to make, as well as those fashioned by Robert Morris and Bruce Nauman (born 1941) [1], but also spread to a whole network of "traces," such as Morris's registration of his own brain waves in *Self-Portrait (EEG)* (1963), and was additionally to be found in the Fluxus obsession with chance. The language model, which began by staying close to Duchamp's example in *The Green Box*—for instance, Morris's *Card File*, in which the object is nothing but the typed and alphabetized record of its own conception and execution—would develop by the late sixties into Conceptual art, in which the reflections on language by Duchamp and Ludwig Wittgenstein would combine to form what Johns had called a "conception of work as a mental, not a visual or sensual, experience."

The new ascendancy of these three paradigms left that of Cubist collage seeming more and more compromised—nothing but the cynically corrupted language of advertising and other forms of mass media into which it had been incorporated even before World War II. The only way collage could be practiced by the avant-garde in the postwar period was through a dialectical reversal that would use it negatively, in the register of trash: the commodity exposed as planned obsolescence, as in the practice of *décollage* or in Rauschenberg's assemblages or Arman's "*poubelles.*"

But Duchamp treated his own "dominance" in a typically Duchampian way. He disowned it through the kind of overthrow manifested in the work he had secretly been making throughout the previous two decades and had brought to completion in 1966:

▲ 1907, 1911, 1912, 1921a, 1937a, 1944b ● 1918 ■ 1968b ◆ 1953, 1958, 1960d ▲ 1914, 1960c, 1962a, 1964b ● 1918, 1953 ■ 1958, 1968b ◆ 1960a

2 • Marcel Duchamp, *Feuille de vigne femelle* (Female Fig Leaf), 1950
Galvanized plaster, 9 × 14 × 12.5 (3⁹⁄₁₆ × 5½ × 4¹⁵⁄₁₆)

1 • Bruce Nauman, *From Hand to Mouth*, 1967
Wax over cloth, 71.1 × 26.4 × 11.1 (28 × 10⅜ × 4⅜)

his *Etant Donnés: 1. La Chute d'eau 2. Le Gaz d'éclairage* (Given: 1. The Waterfall 2. The Illuminating Gas) [**3, 4**]. Arranging for its installation in the Philadelphia Museum just next to the Arensberg Collection's monument to his early production, he intended this new piece to be made available to the public in 1969, the year following his death.

If Duchamp's art had until then been understood as "conceptual," here was a diorama that was startlingly realistic, an erotic display leaving nothing to the imagination. If his art had been seen as transferring all the emphasis in the making of a work from tradi
▲ tional technique to the "deskilled" automatism of the readymade, here was a painstaking labor of handcrafted artifice. And if his art had used photography as a structural, procedural element through
• which to reveal the operations of the index, here "the photographic" seemed to manifest itself in its crassest incarnation, merely as a drive toward the brutally simulacral: the substitution of the mimetic copy for reality itself.

There were Duchamp scholars who looked aghast at this work as they saw the imaginary, allegorical intricacy of *The Bride Stripped*

Bare by her Bachelors, Even (1915–23) turned into a kind of dirty joke, a peep show viewed through holes pierced in a barn door revealing a nude arranged on a heap of twigs, her legs spread wide before the spectator's gaze, while in the landscape behind her could be seen wholly kitsch versions of the mysterious protagonists of *The Large Glass*'s "Preface": the waterfall and the illuminating gas. Despite these scholars' dismay, however, and contrary to the position being promulgated by the late sixties that all the paradigms of avant-garde practice had been invented in the first half of the century, leaving nothing for postwar artists to do but recycle them in a series of repetitions to which the tag "neo-" would be persistently affixed
▲ (this is what Peter Bürger would say in his *Theory of the Avant-Garde*), the *Etant Donnés* itself constituted a newly wrought paradigm, one that would profoundly affect work from 1968 onward. For having determined to set itself up in a museum, it would settle into its permanent, institutional context to form the most total and devastating critique of how the aesthetic itself operates and is legitimized.

A function of the Enlightenment, the very idea of aesthetic experience was grounded on the principle of a judgment about something's beauty (its worthiness to be called "art") that would be totally disinterested, which is to say unballasted by either the object's usefulness or its truth content, as for example its correspondence to scientific facts or concepts, a judgment that would nonetheless be pronounced as if for everyone and thus spoken in a "universal voice." If such an experience could be theorized by Immanuel Kant in his *Critique of Judgment* (1790), it would be institutionalized in the great museums that arose in the nineteenth century. Setting their contents apart from the space of everyday life, the palatial containers of the great art collections declared both the autonomy of the aesthetic sphere—hence its withdrawal from "interest," whether at the level of utility or of knowledge—and its public aspect: a place of collective experience where the "universal voice" could be visualized in the community of beholders gathered before the works, each judging as though for all.

▲ 1914, 1968b ● 1918

▲ 1960a

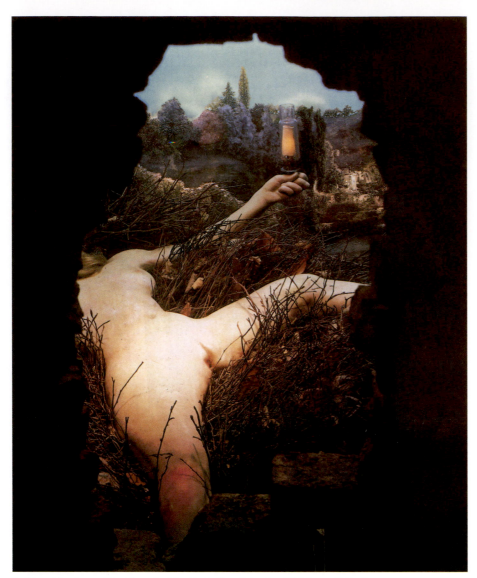

3 • Marcel Duchamp, *Etant Donnés: 1. La Chute d'eau 2. Le Gaz d'éclairage*, 1946–66
Mixed-media assemblage, 242.5 × 117.8 × 124.5 (95½ × 46⅜ × 49)

Duchamp's *Etant Donnés* is placed in just such a building. But against the grain of the public nature of this space of shared experience, the work is perversely hidden. Seen through the peepholes drilled into the oaken door that is its sole visible aspect within its setting at large, the diorama reveals itself to only one viewer at a time. And that viewer, far from assuming the detached posture of aesthetic "disinterest," is forced into an acute awareness that, while glued to the peephole so as to peer into the space of the erotic spectacle, he or she is exposed to being seen from behind by someone else, a guard perhaps, or a third person entering the gallery. Always potentially "caught in the act," this visual experience is never able to transcend the body that supports it in order to connect to the object of its judgment; rather, that body thickens into an object for itself, rendered carnal by its opening to feelings of shame.

The spectacle behind the door is, meanwhile, fashioned to articulate this carnalization of the viewer. Exactly replicating the model of Renaissance perspective, the mise-en-scène presents its nude behind the jagged opening of a brick wall in a parody of

Alberti's notion that the plane through which we look in a perspective construction is like that of a window. Further, orchestrating perspective's geometries through which the cone of vision (coming to a point in the viewer's eye—the viewing point) is the exact mirror of the pyramid of projection (coming to a point in "infinity"—the vanishing point), Duchamp's peepholes set the viewing point as mirrored twin to the hole directly opposite them, namely the point between the nude's legs, spread-eagled on her bed of twigs. Writing about Duchamp's transformational systems, the French
▲ philosopher Jean-François Lyotard captured this bipolar collapse of viewing and vanishing point into twinned bodily orifices in the pun "*Con celui qui voit*" (roughly, "He who sees is a cunt").

Caught in the act

The "Modernist Painting" position—itself an outgrowth of Enlightenment pressures to understand the specificity of the visual arts in terms of the separateness of vision from the other senses

▲ 1984b

(vision being spatial, for instance, while hearing is temporal)—had tied the idea of art's autonomy (and its "disinterest") to the possibility of a purified sense of the visual. This disembodied "opticality" through which painting would acknowledge its distinctness from the other arts—by avoiding any sense of the kinesthetic or the sculptural and instead addressing eyesight alone—staked the aesthetic, then, on the illusion that the viewing point was, as in the Renaissance diagram, truly reduced to a pure speck of light and thus detached from any bodily experience.

If "opticality" was the gauge of "disinterest," and the monumental scale of the color-field painting through which it was manifested the guarantor of the collective space of its viewing, the *Etant Donnés* revokes this warrant of disinterest by carnalizing the viewer twice over. As the theoretical vantage point of the diagram thickens into the eroticized gaze of the voyeur, the space of the museum becomes a labyrinth of separate interests some of whom will have the power to alienate others from themselves by catching them in the act of looking now defined as far from "pure."

As Roland Barthes never tired of explaining, the Enlightenment theorized its notion of the "universal" as a way of consolidating the bourgeoisie's power by making this power disappear as a historical fact only to reappear, instead, as the order of nature. "Classical art," Barthes says in *Writing Degree Zero*, "could have no sense of being a language, for it *was* language, in other words it was transparent, it flowed and left no deposit, it brought ideally together a universal Spirit and a decorative sign without substance or responsibility."

The act of unmasking this "universality" and exposing it as historically contingent operates in many ways throughout the history of modernism, from collage's denaturalizing of the medium of oil paint, say, to the readymade's insistence on the conventional, social character of art's condition. But the *Etant Donnés* goes beyond the way *Fountain*, the urinal Duchamp had submitted to the Society of Independent Artists exhibition in 1917, had exposed the social frame around the work—its official place of exhibition, its culture of legitimation in the process of judging and accepting it—as what in fact "constitutes" the work *as* art. For by lodging itself at the heart of the museum—public protector of the values of disincarnated disinterest—the *Etant Donnés* was able to pour its logic along the very fault lines of the aesthetic system, making its framing conditions appear in startling clarity only to make them "strange."

The "institutional critique" that will now focus on the museum as its site will range from Marcel Broodthaers's work in Belgium to Daniel Buren's in Paris to Michael Asher's and Hans Haacke's in the United States. This focus on the institutional frame of the aesthetic system was energized by many sources, from the Situationist contribution to the events of May 1968 in Paris to the poststructuralist theorization of the conditions of "discourse" in the work of writers such as Michel Foucault and Jacques Derrida. But the *Etant Donnés*, lying within the very citadel of the museum itself, went to the heart of the aesthetic paradigm, critiquing it, demystifying it, deconstructing it. RK

FURTHER READING
Marcel Duchamp, *Manual of Instruction for Etant Donnés: (1) La Chute d'eau (2) Le Gaz d'éclairage* (Philadelphia: Philadelphia Museum of Art, 1987)
Rosalind Krauss, *The Optical Unconscious* (Cambridge, Mass.: MIT Press, 1993)
Jean-François Lyotard, *Duchamp's TRANS/formers* (Venice, California: Lapis Press, 1990)
T. J. Demos, *The Exiles of Marcel Duchamp* (Cambridge, Mass.: MIT Press, 2007)

4 • **Marcel Duchamp, *Etant Donnés: 1. La Chute d'eau 2. Le Gaz d'éclairage*, 1946–66**
Mixed-media assemblage, 242.5 × 117.8 × 124.5 (95½ × 46⅜ × 49)

▲ 1960b ● Introduction 3 ▲ 1914 ● 1972a ■ 1970, 1971, 1972b ◆ Introduction 4

The exhibition "Eccentric Abstraction" opens in New York: the work of Louise Bourgeois, Eva Hesse, Yayoi Kusama, and others points to an expressive alternative to the sculptural language of Minimalism.

Born into a middle-class home in Paris, Louise Bourgeois (1911–2010) assisted in the family business of tapestry restoration from an early age. Perhaps this repairing of damaged figures was formative for the young Bourgeois, for her future art would oscillate between suggestions of damage and reparation. In her own account this ambivalence was focused on her philanderer father, who installed a mistress in his household and disrupted his family. Years later, Bourgeois would take her revenge in a work bluntly titled *The Destruction of the Father* (1974). First, however, she simply escaped—initially to art school, then to the studio of Fernand Léger. In 1938 she married the American art historian Robert Goldwater (1907–73), whose *Primitivism in Modern Art*, long the standard book on the subject, might have influenced her as well, and together they moved to New York.

Patricidal aggression

• Her early work includes drawings influenced by Surrealism, such as the *Femmes-Maisons* (House-Women) (1945–7), in which Bourgeois represents the female nude as an exposed, often violated shelter. By the late forties she had begun to make sculpture as well; semiabstract poles in wood or bronze, these "totems" were also

■ in keeping with the late Surrealism still current in New York. Her style became distinctive only in the early sixties when she began to shape plaster, latex, and fabric in ways that evoked abstract body parts. Often formed as if by violent fantasies or aggressive drives, these body parts suggest what psychoanalysts call "part-objects"— that is, parts of the body such as the breast carved out by the drives as their special objects. An early example is *Portrait* (1963), a brownish, viscous mass in latex that slumps down from the wall like an exposed stomach with its tubes cut, a phantasmatic portrait of a self as a body turned inside out. The critic Lucy Lippard, who included this piece in her "Eccentric Abstraction" exhibition at the Fischbach Gallery in 1966, saw it as an ambivalent "body ego" that produces both "appeal" and "repulsion." In the same year Bourgeois made *Le Regard* (The Gaze) at a moment when, with the exception of Marcel Duchamp in his last work *Etant Donnés*, few artists were explicitly concerned with this subject which would

◆ become so central to feminist art. A roundish, labial object in latex

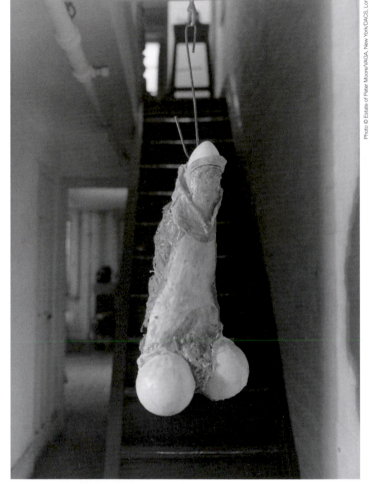

Photo © Estate of Peter Moore/VAGA, New York/DACS, London, 2004

1 • Louise Bourgeois, *La Fillette*, 1968
Latex over plaster, 59.7 × 26.7 × 19.7 (23½ × 10½ × 7¾)

over burlap, *Le Regard* is what the Surrealists called *l'oeil-sexe*, a combination of an eye and a genital, in this case an ambiguously vaginal one. Slit open to reveal a bumpy interior, this genital-eye evokes both a wound and a maw as well—like the eye of an infant who "sees" the world through its mouth alone. In this respect *Le Regard* suggests vulnerability and aggressivity at once, an ambivalence typical of most Bourgeois objects. As the art historian Mignon Nixon has suggested, it "reworks the motif of the *oeil-sexe*

2 • Louise Bourgeois, *The Destruction of the Father*, 1974
Plaster, latex, wood, fabric, and red light, 237.8 × 362.3 × 248.6 (93⅝ × 142⅝ × 97⅞)

from a female subject-position," in a way that troubles "the phallic gaze" of the Surrealists.

Bourgeois gave another twist to the Surrealist object, in this case the sexual fetish, in *La Fillette* (Little Girl) [**1**]. A dirty, penile thing in latex over plaster, *La Fillette* is another "disagreeable object," to borrow the term of the great Surrealist object-maker, Alberto ▲ Giacometti; and like his objects it is fraught with ambivalence. When hung by wire (as it is often displayed), it seems an object of hate, a castrated piece of meat. But when cradled (as it is by Bourgeois in a well-known photograph by Robert Mapplethorpe), it seems an object of love, a baby held by its mother (one can project eyes and mouth onto its "head"). According to Freud, women might • associate penis and baby in order to compensate the lack of the first with the gain of the second. But this "little girl" is no mere fetish or penis-substitute; she is a personage in her own right. In this way *La Fillette* is a bold gesture: if *Le Regard* is a feminist parody of the male gaze, *La Fillette* is a feminist appropriation of the symbolic phallus.

By the late sixties, then, Bourgeois was involved in feminism, and after her husband died in 1973 she began to confront her traumatic past from a feminist perspective; one result was *The Destruction of the Father* [**2**]. By the sixties Bourgeois had already developed her old image of the *Femme-Maison* into a new envi-

ronment called a "lair," "a protected place you can enter to take refuge." Although "the lair is not a trap," she remarks, "the fear of being trapped has become the desire to trap others." In this regard *The Destruction of the Father* may be her ultimate lair, for here protection turns into aggression, and the hunted becomes the hunter. A large cave made of plaster, latex, wood, and fabric, it consists of forms suggestive of breasts, penises, and teeth that protrude from a ceiling, a floor, and a table. At once cave, body and room, *The Destruction of the Father* is a phantasmatic interior of the sort that, according to the psychoanalyst Melanie Klein, young children sometimes imagine. For Bourgeois it was a lair where the "evening meal" (the alternative title of the piece) has somehow turned into a ritual meal, where the "totem" to be devoured has suddenly become the father. This is how she narrated this fantasy of patricidal aggression:

It is basically a table, the awful, terrifying family dinner headed by the father who sits and gloats. And the others, the wife, the children, what can they do? They sit there, in silence. The mother of course tries to satisfy the tyrant, her husband. The children are full of exasperation. We were three children: my brother, my sister, and myself. There were also two extra children my parents

3 • Yayoi Kusama, *Infinity Mirror Room—Phalli's Field*, 1965
Sewn stuffed fabric, plywood mirrors, dimensions variable

adopted because their father had been killed in the war. So we were five. My father would get nervous looking at us, and he would explain to all of us what a great man he was. So, in exasperation, we grabbed the man, threw him on the table, dismembered him, and proceeded to devour him.

Obsessive repetition

Yayoi Kusama (born 1929) approached the lair of patriarchy from another direction: rather than seize the phallus in the manner of Bourgeois, Kusama multiplied it in a way that mocks it, inflated it in a way that "pops" it. A native of Japan, she moved to New York in 1957, and by 1959 had already exhibited five of her "Infinity Nets." Large white canvases (one is thirty feet wide) covered with a light web pattern, they respond not only to the drip paintings of ▲ Jackson Pollock but also to the renewed interest in monochrome works. Two years later her motifs became more material and more ● distinctive. Perhaps inspired by the exhibition of assemblages at the Museum of Modern Art, Kusama began to make her "Accumulations" in fall 1961—household things often found on the street (an armchair, a coat, a stepladder, a baby carriage), covered with small sacks stuffed with cotton batting, and painted white. "The point," Donald Judd remarked laconically in a 1964 review of such work, "is obsessive repetition," but repetition here produced thick fields of phallic growths, not regular Minimalist units or serial Pop images but a strange hybrid of the two. Soon Kusama used this procedure to create entire environments of stuffed phalli, as in *Aggregation: One Thousand Boats* (December 1964), whose centerpiece was a rowboat with oars covered by penile protuberances,

like so much alien vegetation. Large photographs of the boat also papered the walls with phallic silhouettes, against which Kusama posed for the camera (as became her wont), in this case nude.

This repetition of the phallic form not only parodied it, but also dispersed it as a vertical figure into a horizontal ground of other phalli. This interest in a camouflage that collapses figure and ground led Kusama to employ red polka dots as well, sometimes with the phalli, sometimes alone, again in an apparent drive both to dedifferentiate her objects and to totalize her environments. This undoing of distinctions was furthered by her use of mirrors, in the first instance in *Infinity Mirror Room—Phalli's Field* [3], in which her phalli, polka dots and, in some photographs, her own body (usually clothed in a red leotard) are replicated potentially ad infinitum. "We must forget ourselves with polka dots," she once remarked, as if her own subjecthood might also be at stake in this drive toward indistinction. Thereafter her environments became more deliriously Pop, and often included barrages of light and sound; Kusama experimented with psychedelic culture too. At this point critics routinely accused her of exhibitionism; yet paradoxically, for all her self-exposure, her work can also be seen as a theater of self-immolation as well. Perhaps her apparent schizophrenia came into play here: Kusama had attested to periodic hallucinations since her teens, and in 1972 she returned to Japan to enter a mental institution (where she has continued to produce art nonetheless).

Eccentric abstraction

The sculpture of Eva Hesse (1936–70) is neither as assertive as that of Bourgeois nor as dispersive as that of Kusama, but it is also more innovative formally, and, despite her premature death from a brain tumor at thirty-four, more influential historically. In part this is because it is less referential in its imagining of the body—indeed of the entire world of material objects with which the body is in contact—than it is potentially disturbed by fantasies, desires, and drives. Yet, perhaps to compensate for its relative abstraction, her work is often referred to the vicissitudes of her own life (her Jewish family fled the Nazis, her mother committed suicide) and/or of womanhood as such—"its repugnant and piteous inheritance of pain," in the words of Anne C. Chave. In this way some critics (like Chave) see her evocations of the body as specifically female, as part of an early feminist reclamation of an essential female embodiment, whether understood in terms of womb or wound, while other critics (like Anne Wagner) reject this account of the work as "a symptom of the pathology of the female condition," and read these figures as disruptive of such markers of sexual difference, as less a stable female "body-ego" than a quasi-infantile combination of conflicted drives and part-objects. In either light, her constructions in latex, fiberglass, and cheesecloth evoke the body in extreme ways—as though flayed in a condition of horror, as in *Connection* (1969), or veiled in a contingent of grace, as in *Contingent* [4].

One of the sculptures included in "Eccentric Abstraction" is *Ingeminate* [5]: two large tubular forms, each wrapped with dark

▲ 1949a, 1957b ● 1959b

4 • Eva Hesse, *Contingent*, 1969
Fiberglass and polyester resin, latex on cheesecloth, eight units, each 289.6 to 426.7 × 91.4 to 121.9 (114 to 168 × 36 to 48)

5 • Eva Hesse, *Ingeminate*, 1965
Enamel paint, cord, and papier-mâché over two balloons connected with surgical hose.
Each balloon 55.9 × 11.4 (22 × 4½); length of hose 365.8 (144)

transcendence, etc.), in a way that renders them unstable, insistently material and metaphorical at once.

Crucial to this body of work, then, is "its utter inwardness with artistic languages of the day" (Wagner), with Minimalist forms like the grid and the cube as well as Postminimalist strategies of binding, hanging, dispersing, and so on. This inwardness allowed Hesse to transform these languages effectively—again, to introduce messy carnal associations into their clean conceptual assumptions. At the same time these languages distance the work "from a purely personal range of meanings." "The sculpture is literal about the body," Wagner has argued, "at the same time as it explodes the whole notion of literalness. It insists on its languagelike character—its structures of repetition and transformation—at the same time as it maps those properties onto evocations of a carnal world. The body is there somewhere, at the intersection of structure and reference." This is "eccentric abstraction" indeed, and it continues to touch us today in a way that some art of her time does not. HF

FURTHER READING:
Louise Bourgeois, *The Destruction of the Father, The Reconstruction of the Father: Writings and Interviews, 1923–1997* (Cambridge, Mass.: MIT Press, 1998)
Lucy R. Lippard, *Changing: Essays in Art Criticism* (New York: Dutton, 1971)
Mignon Nixon, "Posing the Phallus," *October*, no. 92, Spring 2000
Elisabeth Sussman (ed.), *Eva Hesse* (San Francisco: San Francisco Museum of Modern Art, 2002)
Anne M. Wagner, *Three Artists (Three Women): Georgia O'Keeffe, Lee Krasner, Eva Hesse* (Berkeley and Los Angeles: University of California Press, 1997)
Catherine de Zegher (ed.), *Inside the Visible* (Cambridge, Mass.: MIT Press, 1996)
Lynne Zelevansky et al., *Love Forever—Yayoi Kusama, 1958–68* (Los Angeles: Los Angeles County Museum of Art, 1998)
Mignon Nixon (ed.), *Eva Hesse*, October Files 3 (Cambridge, Mass.: MIT Press, 2002)
Mignon Nixon, *Fantastic Reality: Louise Bourgeois and a Story of Modern Art* (Cambridge, Mass.: MIT Press, 2005)

rough cord, which also links the two. At the time Lippard pointed to the procedural implications of the title—to double, to emphasize through repetition. More recently Mignon Nixon has stressed its biosexual associations—to inseminate, germinate, disseminate—terms that underscore the ambiguous relation of this object to conventional images of gender, indeed of the body whether part or whole. For what exactly is doubled and tied up here? "To twin and bind the phallus is to make a joke at its expense," Nixon writes, "but also to muddle it up with the breasts, and the breasts with the testicles, and so to set off a spiral of identifications in which the body is both drawn close and lost track of—become ever more profoundly phantasmatic." Hesse delights in this formal muddling, in its pointed provocation of ambivalent interest in the viewer; this is also suggested by her mirthful posing for the camera with her objects (this is true of Bourgeois and Kusama, and points to a performative strategy that the three artists share as well).

▲ Hesse also delights in her disruption of the aesthetic field of Minimalism, with her objects that resemble part-objects, as well as of
● Postminimalism, with her procedures that insist on the carnal, even the visceral. As Lippard saw early on, her art stages "a forthright confrontation of incongruous physical and formal attributes: hardness / softness, roughness / smoothness, precision / chance, geometry / free form, toughness / vulnerability, 'natural' surface / industrial construction." *Contingent* plays with all these oppositions, and others as well (falling and floating, gravity and

▲ 1965 ● 1969

Publishing "A Tour of the Monuments of Passaic, New Jersey," Robert Smithson marks "entropy" as a generative concept of artistic practice in the late sixties.

In one of his first published essays, "Entropy and the New Monuments" (1966), Robert Smithson singles out a passage from a review of an exhibition of Roy Lichtenstein's painting, written by Donald Judd. Judd, notes Smithson, "speaks of 'a lot of visible things' that are 'bland and empty'," such as "most commercial buildings, new Colonial stores, lobbies, most houses, most clothing, sheet aluminium, and plastic with leather texture, the formica-like wood, the cute and modern patterns inside jets and drugstores." "Near the super highway surrounding the city," Smithson adds:

> We find the discount centers and cut-rate stores with their sterile façades. On the inside of such places are maze-like counters with piles of neatly stacked merchandise; rank on rank it goes into a consumer oblivion. The lugubrious complexity of these interiors has brought to art a new consciousness of the vapid and the dull. But this very vapidity and dullness is what inspires many of the more gifted artists.

Smithson then proceeds to the analysis of what he calls "hyper-prosaism" in the work of Robert Morris, Dan Flavin, and Judd himself, among others, providing one of the earliest and still among the best, assessments of Minimalism.

That Judd should have been among the early supporters of Lichtenstein's art may come as a surprise—his short articles on the artist offer perhaps the first bout of a "simulacral" reading of Pop art, such as the one that develops later about Warhol—but only because Minimalist art is often mistakenly read, against the intent of all its practitioners, as a mere continuation of early geometrical abstract art. And if Smithson, still in his twenties, was able to grasp the continuity between Pop and Minimalist art, it is because, informed by structuralist anthropology and literary criticism, of which he was an ardent reader, he had stumbled upon an explanatory model that reached far beyond questions of stylistic discrepancies.

Ruins in reverse

As the title of his essay indicates, this model was the law of entropy, a concept that governs Smithson's entire artistic production, and to which he would return in all his writings (his last interview, conducted a few months before his death, was entitled "Entropy Made Visible"). Formulated in the nineteenth century in the field of thermodynamics (it is the second foundational principle of that science), the law of entropy predicts the inevitable extinction of energy in any given system, the dissolution of any organization into a state of disorder and indifferentiation. It asserts the inexorable and irreversible implosion of any kind of hierarchical order into a terminal sameness. Smithson's example for entropy is very close to the first one given by scientists, which had to do with the temperature of water: "Picture in your mind's eye the sandbox divided in half with black sand on one side and white sand on the other. We take a child and have him run hundreds of times clockwise in the box until the sand gets mixed and begins to turn gray; after that we have him run anticlockwise, but the result will not be a restoration of the original division but a greater degree of grayness and an increase of entropy."

The concept of entropy had fascinated many people since its inception, especially because the example chosen by Sadi Carnot (1796–1832), one of its creators, was the fact that the solar system would inevitably cool down (this understandably fed the millenarian and cosmic pessimism of many books written at the end of the nineteenth century). Very early on—and Smithson directly borrowed from this tradition—the law of entropy was applied both to language (the way words empty out when they become clichés) and to the displacement of use-value by exchange-value in an economy of mass production. The final book of the nineteenth-century French novelist Gustave Flaubert, *Bouvard et Pécuchet*, one of Smithson's favorites, already merged these two lines of enquiry in recounting the growth of the entropic shadow being cast on our lives and our thought under the condition of capitalism. Repetition (of goods on the marketplace, of words and images in the media) is profoundly entropic; it is from this discovery that the theory of information would emerge in the late forties, a mathematical model of communication according to which the content of any fact is in inverse proportion to its probability—Kennedy's assassination was a world event, but if the rule were for every American president to be killed in order to end his term, it would have had no more content than dusk or dawn and would have barely made the headlines.

But while for Flaubert and his peers our entropic fate—a defining characteristic of modernity—was sheer doom, Smithson

reread the very inexorability of this process as the promise of a definitive critique of man and his pretenses. It was not only the pathos of Abstract Expressionism (long become suspect) that was rendered irrelevant once the entropic logic was followed to the end, but also the modernist struggle against arbitrariness in art (the purported elimination, in each art, of any convention that was not "essential" to it), a notion that had turned increasingly

▲ dogmatic in the writings of Clement Greenberg. Entropy is for Smithson the ultimate in what the structuralists term "motivated," or nonarbitrary. Since it is the only universal condition of all things and beings, there is nothing arbitrary about entropy. It was in order to manifest just this pervasive nature of entropy that soon after the

• 1969 exhibition "When Attitudes Become Form," and perhaps as a rebuttal of the emphasis on *form* in its title, Smithson conceived of

■ *Asphalt Rundown* [1] as a reading of Pollock's drip process and its gravitational pull as profoundly entropic.

Writing in "Entropy and the New Monuments" that Minimalist art had eliminated "time as decay," Smithson indicated his disenchantment with the movement as failing to push into the domain of entropy: "Instead of causing us to remember the past like the old monuments, the new monuments seem to cause us to forget the future," he wrote. But what if one were to connect the future with the distant past—what if posthistory (time after the demise of man) were nothing but the mirror image of prehistory? Smithson's childlike fascination with dinosaurs and fossils stemmed from his essentially antihumanist conception of history as a cumulative succession of disasters. Time as decay thus became one of his strongest concerns and with it the necessity of creating not merely "new" monuments, but "antimonuments," monuments to the wane of all monuments.

In fact, one did not even need to create such artifacts, the world was already full of them. This is what Smithson discovered when, in September 1967, with his Instamatic camera hung from his shoulder just like a tourist in Rome ("Has Passaic replaced Rome as the Eternal City?" he asked), he revisited his small, industrial home town. The result, "A Tour of the Monuments of Passaic, New Jersey," is a mock travelogue documenting various "monuments" to decay (the last of them being the sandbox mentioned above), particularly construction sites that Smithson saw as factories of "ruins in reverse": "this is the opposite of the 'romantic ruin' because the buildings don't *fall* into ruin *after* they are built but rather *rise* into ruin before they are built." Everything, whatever its past, even before it has any past, is geared in the end toward the same equal state—which also means that there is no justifiable center, no possible hierarchy. In short, what might at first seem a dire prospect—the fact that man, though he often chooses to ignore it, has created for himself a universe without quality—can also be liberating, for a world without center (which is also a world where the self has no boundaries, no propriety) is a labyrinth open to infinite exploration.

Smithson was alone in making entropy the most important generative concept of art practice at the end of the sixties: his

1 • Robert Smithson, *Asphalt Rundown*, Rome, October 1969
Dump truck, asphalt, quarry cliff (destroyed)

▲ *Spiral Jetty*—an Earthwork that was covered by the water of Utah's Great Salt Lake shortly after its "completion" in 1970, and which has now temporarily reemerged, whitened by salt crystals, as the water receded—remains the quintessential "monument" to this decade of radical expansion of the sculptural field. But many other artists—often before him, yet without theorizing it—also adopted an "entropic" mode in their work.

Deadpan transience

• One such artist was Bruce Nauman. Working in California, and thus in relative isolation from the New York art world, Nauman produced his first casts of interstitial spaces in the mid-sixties (for example *A Cast of the Space under My Chair* [2], or *Platform Made Up of the Space between Two Rectangular Boxes on the Floor* [1966]). Thus even before *Upturned Tree* (1969), in which Smithson had shown that in an entropic universe, because it is shorn of any other meaning than the irreversibility of time, everything is reversible but time, and everything is equally devoid of signification, Nauman explored this same depletion of meaning: were it not for their titles, we would never have guessed what Nauman's concrete pieces were cast from.

Both Smithson and Nauman, in fact, were fascinated by the disseminating role of mirror reflections once the very notion of center (of identity, of self) is suspended: in Nauman's *Finger Touch No. 1* (1966), for example, it is not only impossible for us to fathom which is the "real" pair of hands and which is its mirror image, but further we have no way of reassembling into a bodily synthesis the sensory fields that are signified. Trying to imagine a tactile sensation corresponding to what we see—the twirling of hands pressed

▲ 1960b • 1969 ■ 1949a

▲ 1970 • 1966a, 1973

2 • Bruce Nauman, *A Cast of the Space under My Chair*, 1965–8
Concrete, 44.5 × 39.1 × 37.1 (17½ × 15⅜ × 14⅝)

against the cold surface of a mirror—we soon find ourselves at the brink of a vertigo from which we recoil. Similarly, in Smithson's ephemeral *Mirror Displacements* (1969)—in which a loose grid of square mirrors was disposed and photographed at various sites during a trip that Smithson took in the Yucatan—the very notion of beholding is called into question, as the mirrors become potentially invisible within the landscape they reflect. What these images record can only paradoxically be called "incidents," for they are, in a strict sense, nonevents. They convey no information other than the sheer fact of their transience. Finally—another mark of affinity between Nauman's and Smithson's way of thinking—in 1968, shortly after the latter had rejoiced, in "Entropy and the New Monuments," at Sol LeWitt's project of putting "a piece of Cellini's jewelry into a block of cement," Nauman produced a work whose

first (descriptive) title was *Tape Recorder with a Tape Loop of a Scream Wrapped in a Plastic Bag and Cast into the Center* (the center in question being that of a block of concrete).

Another Californian artist whose work is overdetermined by entropy is Ed Ruscha, especially in the many large canvases, from ▲ the mid-sixties on, that "depict" words—that is, in which a single word ("Automatic," "Vaseline") or a nonsensical group of words ("Another Hollywood Dream Bubble Popped," "Those Golden Spasms") is stenciled on an illusionistic sky against which words seem to hover and then dissipate, like clouds. But it is Ruscha's little photographic books, which Smithson mentioned several times, and whose deadpan tone is matched only by the early films of Andy Warhol, that provided one of the earliest critiques of aesthetic judgment under the banner of the "vernacular"—that is, of • the visual cliché. In *Twenty-Six Gasoline Stations*, Ruscha records exactly what the title announces: every gas station he encountered in a trip from Oklahoma City to Los Angeles, one for each letter of the alphabet, is dryly photographed from the other side of the road. The same tautological and exhaustive impulse is to be found in *Every Building on Sunset Strip* [3], a foldout panorama that provides an inventory of every building, but also every crossroad and every empty lot, along a famous section of Sunset Boulevard (same reversibility as in Smithson's *Upturned Tree*: the book can be "read" in both directions, since the two sides of the boulevard symmetrically oppose one another on each page, one right side up, the other upside down). Photographed at noon in order to accentuate its quality of desolation, the Sunset Strip appears as a simulacrum, the set of a Hollywood movie. "It's like a Western town in a way," Ruscha would note. "A store-front plane of a Western town is just paper, and everything behind is just nothing." Endlessly reporting the same anonymous nothingness, Ruscha's dozen or so books do

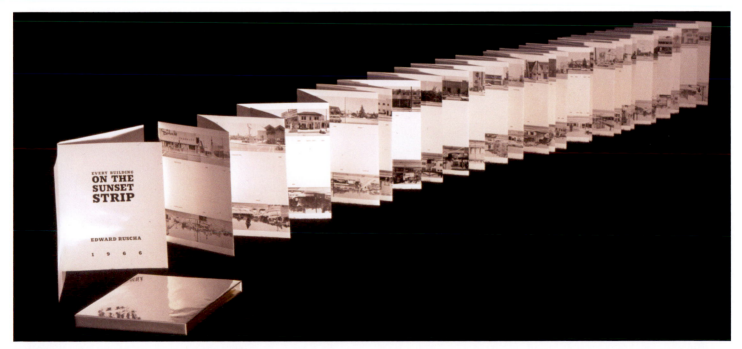

3 • Ed Ruscha, *Every Building on the Sunset Strip*, 1966
Offset lithograph on paper in silver-mylar-covered box, closed, 18.1 × 14.3 × 1 (7⅛ × 5⅝ × ⅜)

▲ 1960c • 1968b

not constitute a damning commentary on the vacuity of life at the end of the twentieth century—there is not an inch of nostalgia in them. They are practical guides to entropy, showing a possible way of relishing, with no small dose of what André Breton called *humour noir* (dark humor), a world depleted of difference and thus of meaning.

Matta-Clark's anarchitecture

If Nauman and Ruscha preceded Smithson, Gordon Matta-Clark (1943–78) proceeded from him. The starting-point of his short career was indeed his encounter with Smithson, during an "Earth Art" show at Cornell University in 1969, just a few months before the latter realized his *Partially Buried Woodshed* on the campus of Kent State University. Conceiving this as a "nonmonument" to the process he called "de-architecturization," Smithson had a dump truck unload earth onto the roof of an old woodshed to the point where its ridge beam cracked. Matta-Clark was at the time an unhappy architecture student and this attack on an existing building must have had an immense appeal for him (he soon dropped out of Cornell). At the same time, however, as is often the case in the relation of a younger artist to his mentor, Matta-Clark began to think that Smithson had not carried out his program fully: he had frozen the de-architecturization of *Partially Buried Woodshed*, entrusting Kent State University, to whom he had bequeathed the work, with its "maintenance" in its original condition.

While Smithson was suspicious of architecture (and never tired of deriding architects for their naivety in believing that they had any control over their work), Matta-Clark was hostile to it. He had started by considering waste as architectural material, building a wall out of garbage in 1970, but this gesture had a redemptive ring that utterly contradicted his entropic bent: he soon turned around, now considering built architecture as trash. His first "anarchitectural" piece, to use one of his favorite expressions, was called *Threshole* (1973). Under this generic term Matta-Clark cut out the thresholds of apartments in abandoned buildings in the Bronx,

5 • Gordon Matta-Clark, *Splitting*, 1974
Cibachrome photograph, 76.2 × 101.6 (30 × 40)

often on several floors, opening the gloomy spaces to light. With this work Matta-Clark had found the medium in which he would operate in increasingly complex fashion for the five remaining years of his life: a building that has been marked out for imminent destruction, and which he would pierce here and there, hollowing out negative spaces in its mass conceived as inert matter, without much consideration for its constructive structure (his provisional spaces were dangerous to enter) and none whatsoever for the original distribution of functions. An essential aspect of his work was that it was itself destined to waste, that it should have only a fleeting existence, for it partook of the war against architectural meaning (built for eternity) waged by Matta-Clark. Not only do a door, a floor, a window, a lintel, a threshold, a wall lose all their prerogatives as such—every architectural element being equally unprotected against the cuts made through the building as a whole—the cuts themselves are never long enough in place to solidify as figures, as fetishes. From the simplicity of *Splitting* in 1974, a suburban house split vertically in two [5], up to the last Piranesi-like cutouts in an office building in Anvers [4] or in neighboring townhouses of Chicago (*Circus Caribbean Orange* [1978]), Matta-Clark's spaces became increasingly vertiginous as the differentiation between the vertical section and the horizontal plan, essential to our perception and habitation of architecture, was made almost wholly illegible. YAB

FURTHER READING
Yve-Alain Bois, *Edward Ruscha: Romance with Liquids* (New York: Gagosian Gallery and Rizzoli, 1993)
Yve-Alain Bois and Rosalind Krauss, *Formless: A User's Guide* (New York: Zone Books, 1997)
Thomas Crow et al., *Gordon Matta-Clark* (London: Phaidon Press, 2003)
Robert Hobbs, *Robert Smithson: Sculpture* (Ithaca, N.Y.: Cornell University Press, 1981)
Jennifer Roberts, *Mirror-Travels: Robert Smithson and History* (New Haven and London: Yale University Press, 2004)
Joan Simon (ed.), *Bruce Nauman: Catalogue Raisonné* (Minneapolis: Walker Art Center, 1994)
Robert Smithson, *The Collected Writings*, ed. Jack Flam (Berkeley and Los Angeles: University of California Press, 1996)
Maria Casanova (ed.), *Gordon Matta-Clark* (Valencia: IVAM; Marseilles: Musée Cantini; and London: Serpentine Gallery, 1993)
Bruce Jenkins, *Gordon Matta-Clark: Conical Intersect* (Cambridge, Mass.: MIT Press, 2011)

4 • Gordon Matta-Clark, *Office Baroque*, 1977
Cibachrome photograph, 61 × 81.3 (24 × 32)

▲ 1924

1967 b

The Italian critic Germano Celant mounts the first Arte Povera exhibition.

No other European avant-garde was as riddled with profound contradictions as that in Italy during the period 1909–15. Just as it was within the Italian framework that the first explicit and programmatic link between avant-garde artistic production and advanced forms of technology was forged by the Futurists, so it was within this same context that the first countermove against modernity and modernism was undertaken by Giorgio de Chirico. In de Chirico's *pittura metafisica*, artisanal forms of work were reintroduced as the sole foundation of artistic practice, thereby assuming an antitechnological, antirational, antimodernist posture.

Those were the parameters within which postwar Italian artistic production reestablished itself, as it issued into Arte Povera (poor or impoverished art) with the first exhibition organized by the critic Germano Celant, who coined the term in 1967. It was this group of twelve artists that produced the most authentic and independent series of European artistic interventions of the late sixties. Pitted in certain ways against the hegemony of American art, specifically Minimalist sculpture, it also recuperated the legacy of the prewar Italian avant-garde—with all its internal contradictions—but now in a postwar context. Between those early decades and the emergence of Arte Povera, however, three neo-avant-garde figures—Alberto Burri, Lucio Fontana, and Piero Manzoni—served as mediators to relay the early contradictions, with their specifically Italian cast, to the next generation.

The first pivot around which these contradictions turned was technology. To the extent that the Italians' misreading of American Minimalist sculpture emphasized technology as the primary orientation or mode of production in Minimalism, Arte Povera took up an explicitly antitechnological stance. Secondly, while photography and the wide variety of artistic modes of production associated with it had been almost totally excluded from the prewar Italian avant-garde, photography was excised from Arte Povera as well. Indeed there was what one could call a programmatic elision of photographic practices as they had emerged in West Germany, France, and the United States in the context of Pop and Conceptual art.

The third distinguishing feature was Arte Povera's peculiar relationship to materials and processes of production, one that both recuperated and denied certain conventions as they had been established in other parts of avant-garde activity. Specifically, the absence of Surrealism, with its fallen-commodity-object culture, along with the absence of an avant-garde photographic culture such as had operated in prewar French, Soviet, and American contexts, negatively demarcated a point of departure for Arte Povera. For if these absences can be felt in Arte Povera's renewed emphasis on the artisanal, something that defines the specifically Italian condition of the movement in 1967, this same artisanal condition is nonetheless set in perpetual juxtaposition with those advanced forms of technology that characterize post-Pop consumer culture. And in this very juxtaposition Arte Povera reinvented for itself an experience of what one could call the "retrieval of obsolescence." Thus, in a manner parallel to the way Surrealism had exploited the very condition of obsolescence that haunts commodity culture in order to reinvest the fallen object of fashion with the power of memory, Arte Povera sought to retrieve the mode of obsolescence from its own historical project for much the same ends.

The design of the archaic

Arte Povera is most clearly defined by a group of works made in the mid-sixties by Mario Merz (1925–2003) [1], Jannis Kounellis (born 1936), and Pino Pascali (1935–68), who even prior to the official coining of the term produced a peculiar type of assemblage that was dependent neither upon technology nor upon the paradigm of the readymade or the *objet trouvé*. Rather, their structures were able to interrelate those strategies continuously, thereby corrupting the technological element with obsolescence and investing the artisanal aspect with a renewed sense of purification.

Kounellis's 1968 installation at the Galleria L'Attico, *12 Cavalli* (12 Horses) [2] was one such instance. Insofar as it staged the natural within an institutional framework, it pronounced the aesthetic of Arte Povera by producing the shock of the reappearance of nature within the spaces of acculturation. Consisting of twelve workhorses displayed in the gallery over the duration of the exhibition, *12 Cavalli* emphatically countered any assumption about the sculptural object as either a discrete form, or a technologically wrought thing, or a discursive structure. Instead it insisted on the model of prelinguistic experience, as well as on nondiscursive structures, and nontechnological, nonscientific, nonphenomenological artistic conventions.

▲ 1909 ● 1965 ■ 1959a ◆ 1916b, 1929, 1930a, 1959d, 1968a, 1968b ▲ 1931a ● 1916b, 1930a, 1935

1 • Mario Merz, *Objet Cache Toi*, 1968–77
Metal tubes, glass, clamps, wire mesh, neon, height 185 × 365 (72⅞ × 143¾)

2 • Jannis Kounellis, *12 Cavalli* (12 Horses), 1969
Installation at Galleria L'Attico, Rome

12 Cavalli's emphasis on a mythology of local specificity—namely, Italy's continuing connection to a preindustrial, rural economy—its foregrounding of the natural, the unformed, the nondiscursive, even the prelinguistic, could be compared with work by Pino Pascali of the mid-sixties, where conventions of theatricality, narrative, and representation are also reinserted into the making of painting and sculpture. Once again this clearly

▲ contradicts those concepts of a phenomenological or modernist approach to the making of sculpture that had governed American production throughout the decade. The pertinent example would be *Teatrino* [3], a composite work from 1964, in which a painting is dismantled or a sculpture is transformed into the hybrid condition of a theater set. In this form, Pascali was able to pose the question of the degree to which late-modernist art had to prohibit narrative and excise language and performance from its project of self-definition. Yet as Kounellis's and Pascali's works suggest, the supposed purity of the artistic medium or the aesthetic category or genre is already irredeemably hybrid; and this demonstration of the hybrid is one of the fundamental principles of the Arte Povera aesthetic.

Of the figures behind the formulation of this aesthetic, a central example is Pier Paolo Pasolini, who in 1962 had declared that the key references for his own writing and films were the subproletariat of southern Italy and the Third World and Greek mythology, with its recourse to ritual. Both these references were thought to mobilize experience that countered the discursive registers of science and rationalism; specifically, in Pasolini's connection to antique tragedy and its participation in ancient ritual, he wished to counter the discursive through recourse to the prelinguistic experience figured through myth. Pasolini thus provided a framework of countermodernist practice within which Arte Povera could situate itself, as it drew on its internal Italian tradition of countermodernity, specifically the work of de Chirico, but with different parameters, ones that were now recoded within a political program of the Left. For Arte Povera's

● refusal to enter into Pop art and Minimalism signaled a refusal to participate in a practice of advanced consumer culture. Further, the resistance to an aesthetic of modernist and late-modernist notions of autonomy assumed a political implication as Arte Povera emphasized the need to reposition the work of art within the socially shared spaces of political activism and a new mode of address to its audience. Arte Povera thus mobilized the antimodernist legacy of de Chirico in order to reinvest artistic practice with the dimension of the mythical, the theatrical, and the corporeal, not only to oppose the instrumental logic and rationality of Minimalist sculpture but also to oppose the homogeneity of advanced forms of spectacle culture in which the global suppresses an experience of the local, and instant communication obliterates the functions of memory and history.

If Pasolini functioned as a precursor for Arte Povera in the field of cinema, Burri, Fontana, and Manzoni played this role in the domain of the visual arts. As early as 1949 Burri began to reinsert materials such as burlap and wood into the pictorial surface in nonnarrative but also nonconstructivist and nonmodernist manners. In his work from the late fifties and early sixties he exploited a variety of decaying

3 • Pino Pascali, *Teatrino* (Little Theatre), 1964
Painted wood and fabric, 217 × 74 × 72 (85½ × 29 × 28¼)

industrial materials such as rusted metal and burnt plastic for their quality of obsolescence (without the precedent for doing this in Italy that Surrealism had provided in France). So materials in Burri's work—always presented as wrecked, faded, torn, or burnt—are thus devoid of function, of the utopian promise encoded in the avant-garde's embrace of technological forms of production.

▲ Fontana's example was also crucial for the formation of some of Arte Povera's major figures, but in a different way from Burri, since in accepting the legacy of monochrome painting, Fontana had participated in the neo-avant-garde's attempts to reposition itself in a discourse of self-reflection, purification, and extreme reduction. Yet his operations of slashing and puncturing the monochrome's surface simultaneously emphasized process and performance. And this pointed toward the intricate contradictions of neo-avant-garde production, since the theatrical dimension of his work very quickly entered—via the decors he made for design exhibitions—the very register of public spectacle that Arte Povera would both struggle against and be entangled with throughout the sixties and seventies.

Probably the most important among the three predecessors was Piero Manzoni, who could be described from the perspective of Arte Povera as the artist who had pushed that initial dilemma between modernism and its opposite, between a scientific-technological

modernity and an artisanal connection to the primitive—with its hope for a return to foundational forms of somatic and prelinguistic experience—to the threshold of the absurd. This is obvious in his emphasis on the bodily foundations of perception in the *Fiato* ▲ *d'artista* (Artist's Breath), the *Merda d'artista* (Artist's Shit), or in the pieces including the artist's blood, which were meant to be quasi-ritualistic returns to the origins of the aesthetic experience. These provided crucial points of departure for artists such as Kounellis and Pascali in the late sixties to take that legacy into the next register.

The language of the mnemonic

One of the paradoxes of Arte Povera, perhaps intentional, is its attempt to mobilize the revolutionary potential of outdated and thus antimodernist objects, structures, materials, processes of production. For inasmuch as it involved the artisanal forms of sculptural production, as for example in Luciano Fabro's (1936–2007) *Piedi da seta* (Silken Feet), in which the crafting of marble signaled a return to a specifically Italian art-historical legacy, and inasmuch as Arte Povera emphasized the separateness of artistic production, it also came into a precarious proximity—in various instances and to varying degrees—with what could be called the advanced forms of design and fashion culture. So the ambivalence, which is peculiar to Italy, of an industrial production that, since it does not show its technological underside, still carries the banner of artisanal values, or of a commodity production that, by sublimating itself in extreme forms of refinement, disguises itself as the unique and differentiated object, is the dilemma of Arte Povera itself. For the movement could be accused of sharing precisely those conditions of advanced forms of Italian design in its own ranks and within its own perimeters. Michelangelo Pistoletto's (born 1933) *Venere degli stracci* [4] also combines references to outdated forms (the classical statue) with artisanal modes of production (the statue is made from concrete). Furthermore, it juxtaposes "high" art with everyday detritus (the rags of discarded clothes).

Minimalism was not the only reference in the dialogue between Arte Povera and American art of the sixties. In fact, Celant seems to have perceived a continuity, if not direct correspondence, between some American Postminimalists (e.g., Bruce Nauman, Eva Hesse, Richard Serra) and the Arte Povera artists, when he presented them side by side in his first comprehensive account of the movement in 1969. Furthermore, he also recognized a third dialogue emerging:
• that with American Conceptual art (Robert Barry, Joseph Kosuth, and Lawrence Weiner are included in his first Arte Povera monograph). From the beginning of their activities, the Italian artists responded to or shared an increasing focus on the linguistic elements within artistic production as well.

In Giovanni Anselmo's (born 1934) *Torsione* [5] we can recognize the Italian sculptor's preoccupation with the innate forces of gravity, material resistance, and tension, as factors that determine the morphology of a sculpture suspended between material and process. But the suspension of weight and time here (comparable in this ■ regard to contemporaneous work by Nauman and Serra) also seems

to barely control an element of physical threat to the spectator, and the seemingly passive and presumably neutral and protected process of looking. The weighty steel bar is kept from falling or from swirling in a violent rotation against the wall and the spectator only by the extreme tension of the relatively light fabric that suspends the bar in its precarious position. What distinguishes Anselmo's work from that of his American peers, however, is first of all the choice of materials that articulate an extreme opposition of texture and tactility (i.e., fabric and steel). But it is also an opposition of temporalities, since the display of the fabric's intense torsion inevitably reminds the viewer of the history of Italian Baroque sculpture. At the same time the foregrounding of these forces makes the viewer recognize the conditions and materials that actually govern sculptural production in an age of industrial technology and scientific knowledge.

This almost structuralist preoccupation with oppositional couples evidently determines also the conception and execution of Giuseppe Penone's (born 1947) work, such as *Albero di 8 metri* [6]. In distinction from the American focus on an empiricist model of process and temporality, here the processes of industrial production are reversed and shown in slow motion, a playback from culture to nature that would be unthinkable in any American work of the Postminimalist moment. Penone literally *undoes* the manufacturing process of the industrial object, in this case a construction beam, by removing layer after layer from the beam to reveal its interior core.

4 • Michelangelo Pistoletto, *Venere degli stracci* (Venus of Rags), 1967
Concrete with mica and rags, 180 × 130 × 100 (70⅞ × 51⅛ × 39⅜)

5 • Giovanni Anselmo, *Torsione* (Torsion), 1968
Iron bar and fabric, 160 × 160 (63 × 63)

6 • Giuseppe Penone, *Albero di 8 metri* (Eight Meter Tree), 1969
Wood, 80 × 15 × 27 (31½ × 5⅞ × 10⅝)

Thus, in a dialectical countermove, and in an extremely careful process, that is both anti-industrial and—paradoxically—anti-artisanal—the artist retrieves the natural origins of the industrial product, revealing a tree and its branches and stems to be the kernel of the geometricized form of the beam.

It is this complexity of gestures and operations that avoids a mere "return" to craft or artisanal modes that salvages the work of the Arte Povera artists from lapsing into either the reactionary attitudes of *pittura metafisica* or into an attitude of fashion and design culture that would merely fetishize a return to the materials and procedures of a preindustrial age. Nevertheless, it has been tempting to a number of commentators to point out either their latent desire for historical regression (for example, when Daniel Buren referred to the work of Kounellis as "de Chirico in three dimensions"), or to celebrate their work's intrinsically "poetical" dimensions, a numinous quality that would of course be programmatically eliminated from the work of the American artists of that generation. But what makes the work of the Italians often appear as "poetical" is their unique capacity to fuse sudden epiphanies of historical memory with a simultaneous radicality to critique the present.

This duality of approach determines also the sculpture of Mario Merz, in particular in works that deploy the thirteenth-century Fibonacci series of numbers as a mode of spatial progression.

Here, in a deliberate counterargument to Donald Judd's Minimalist insistence on the positivist verifiability of composition by deploying purely quantificatory principles, Merz engages an ancient mathematical principle of spatio-temporal expansion that exceeds and complicates the simplistic logic of Judd's progressions. The fact that this invocation of mathematical and compositional differences has political implications is foregrounded by Merz in his construction of sculptural volumes whose spiraling growth follows the Fibonacci principle, resembling the architecture of igloos made by the Inuit population. These sculptures in the guise of nomadic shelters are constructed out of glass shards and a variety of other materials (leather, branches, sandbags, tree bark), and often carry an electric neon inscription. One of the igloos carries the ominous inscription "Objet cache toi" [1], clearly articulating not only the desire of the artists of that generation to criticize the social obsession with the production and possession of objects of consumer culture, but also—precisely because of that universal obsession—to negate the object's viability and withhold that very same object status from the sculptural work.

Like his European or American Conceptualist peers (such as ▲ Douglas Huebler), Alighiero Boetti (1940–94) [7] engaged with the quantification of seemingly unquantifiable phenomena bordering on infinity. Typical in this Conceptualist approach to quantify the

▲ 1984a

7 • Alighiero Boetti, *Mappa* **(World Map), 1971–3**
Embroidery, 230 × 380 (90½ × 149⅝)

transcendental is his work *Classifying the Thousand Longest Rivers in the World,* a book project he realized in 1970. Or, we recognize a similar desire for the simultaneous transcendence of traditional boundaries (of genres, of techniques, of identities, of nation states, of political borders) in an even more astonishing project, the series of world maps entitled *Mappe del Mundo.* Begun in 1971, they articulate Boetti's recognition that the artist's traditional language elements—colors and signs—are only credible in the present when they are anchored within a preexisting functional social system of communication (rather than in a putatively creative or mythical artistic subjectivity). Yet, paradoxically, Boetti counteracts this Conceptualist withdrawal of all traditional forms of artistic production and the emphasis on artistic anonymity with a dialectical gesture, by assigning the task of executing the *Mappe del Mundo* to the hands of anonymous weavers, who fabricated the large-scale woven maps and their political symbols in Afghanistan (then Boetti's second home after Rome). This counterconceptualist gesture, in its ostentatious return to the preindustrial modes of production, seems at first to be motivated by a peculiar form of primitivism. Yet in retrospect it is transparent that Arte Povera artists understood the dialectics of enlightenment better than their American colleagues. Unlike the latter, the Italians did not suffer from the delusions of unilateral technological process; more importantly, they continuously engaged in the definition of artistic practices that engendered the subject's sense of place and identity at a contradictory crossroad of returns and progressions, of remembrances and prospects. BB

FURTHER READING
Germano Celant, *Arte Povera* (Milan: Gabriele Mazzotta; New York: Praeger; London: Studio Vista, 1969)
Germano Celant, *The Knot: Arte Povera* (New York: P.S.1; Turin: Umberto Allemandi, 1985)
Carolyn Christov-Bakargiev (ed.), *Arte Povera* (London: Phaidon Press, 1999)
Richard Flood and Frances Morris (eds), *Zero to Infinity: Arte Povera 1962–1972* (Minneapolis: Walker Art Gallery; London: Tate Gallery, 2002)
Jon Thompson (ed.), *Gravity and Grace: Arte povera / Post Minimalism* (London: Hayward Art Gallery, 1993)

For their first manifestation, the four artists of the French group BMPT paint in public, each artist repeating exactly from canvas to canvas a simple configuration of his choice: their form of Conceptualist painting is the latest in a line of attacks against "official" abstraction in postwar France.

▲ One of the most chauvinistic statements ever made by an American artist is this comment by Donald Judd: "I'm totally uninterested in European art and I think it's over with." It was uttered during a famous interview with
● the sculptor and his fellow artist Frank Stella, conducted by Bruce Glaser and broadcast on the radio in March 1964. The spiteful remark was not made by chance and Judd made no attempt to tone it down when an edited transcript of the broadcast was printed in *Artnews* (September 1966); it has been anthologized several times since then. In fact, throughout the interview, which contains perhaps the earliest and most detailed articulation of the Minimalist program, both Stella and Judd were eager to explain their anti-European stance.

Alluding to those European geometric painters to whom he has been compared, Stella declared: "they really strive for what I call relational painting. The basis of their whole idea is balance. You do something in one corner and you balance it with something in the other corner.... In the newer American painting ... the balance factor isn't important. We're not trying to jockey everything around." Asked to comment on why he would want to avoid such compositional effect, Judd added, "those effects tend to carry with them all the structures, values, feelings of the whole European tradition.... The qualities of European art so far ... are linked up with a philosophy—rationalism, rationalistic philosophy."

A false transatlantic divide

Judd's important point about the deliberately antirationalist stance of his attempt, as well as the attempts of all his Minimalist friends, to eschew part-to-part relations and to conceive of "logical" systems that would eliminate subjective decisions, was lost on critics and public alike, and he spent his life trying to get it across. But despite the fact that Judd and Stella had every right to protest against the assimilation of their art into that of the European tradition of geometric abstraction initiated by Kazimir
■ Malevich and Piet Mondrian, their view that the dichotomy was geographic (American/European) was ill-founded, based on sheer ignorance. For in pre-World War II Europe there had already been what could be called an antitradition of nonrelational art—a tradi-

▲ tion for which certain of Malevich's own works (the *Black Square* of 1915 and related canvases of the same period), as well as Mondrian's nine modular grid paintings from 1918 to 1919, constituted essential benchmarks. (Other early contenders included Giacomo Balla's *Compenetrazione iridescente* of 1912, Hans and Sophie Taeuber-Arp's *Duo-collages* of 1916 to 1918, Rodchenko's
● modular sculptures and his monochrome triptych of 1921, or
■ Wladyslaw Strzeminski's Unist paintings [either those based on a deductive structure in 1928 to 1929 or his monochromes of 1931 to 1932]—and this list is by no means exhaustive). Stella and Judd were not aware that this tradition, just as old as that of compositional abstraction, was being revived by a host of artists in postwar Europe. Furthermore, the reasons for this European revival were not so different from those behind the rise of noncompositionality in American art at the same time.

On both sides of the Atlantic, what was at stake was the nature of agency, of authorship, in art. The Holocaust and Hiroshima were still very much on everyone's mind in the late fifties and early sixties; the Cold War combined with the spread of colonial conflicts kept reminding every Western citizen that a return of barbarity on one's doorstep was always possible. In this charged atmosphere, it is not surprising that young painters asked "What does it mean to be an artistic subject, an author?", given that the humanity of *any* individual subject had just been cast in doubt by the massive demonstration of the inhumanity of the species.

That the geographic divide was a red herring is nowhere more apparent than when examining the context of Stella's criticism of "relational art," which directly followed his other attacks against
◆ not only Victor Vasarély's Op art but also the Groupe de Recherche d'Art Visuel (or GRAV), which he viewed as essentially composed of Vasarély's minions:

The Groupe de Recherche d'Art Visuel actually painted all the patterns before I did—all the basic designs that are in my paintings.... I didn't even know about it, and in spite of the fact that they used those ideas, those basic schemes, it still doesn't have anything to do with my paintings. I find all that European geometric painting—sort of post-Max Bill school— a kind of curiosity—very dreary.

▲ 1965 ● 1958 ■ 1913, 1915, 1917a, 1944a ▲ 1915 ● 1913, 1921b ■ 1928a ◆ 1955b

It is not completely untrue that the GRAV was gathering followers of the "Pope of Op," as Vasarély was nicknamed at the time (one of its members, Yvaral, was Vasarély's own son), but another of the group's participants stands out—he had joined it partly by mistake, as he himself recognized later—and he is probably the one artist that Stella had in mind: the French painter François Morellet (born 1926).

In the rarefied context of the French art world of the early fifties, dominated by *tachisme* and post-Cubist abstraction, the two favorite styles of the Jeune École de Paris (or JEP), it is not all that ▲ surprising that Morellet knocked at the door of the Galerie Denise René with his portfolio—it was the only possible outlet for any kind of art that smacked of geometry. Neither is it surprising that he should have been turned down, eventually joining the gallery— as a member of GRAV—only after the group's formation in 1961. For, despite the fact that his work appeared fully indebted to that of Max Bill, it actually represented one of its most salient critiques, as would the work of Stella a few years later.

Chance *contra* Max Bill's systematic art

Morellet discovered Swiss artist Bill's work in Brazil in 1950, meeting a swarming school of his devotees there in the aftermath of his major retrospective. By 1952, he had perfectly grasped Bill's ● notion of systematic art, borrowed from Theo van Doesburg)— that of an art entirely programmed by a set of a priori rules, an art that in principle leaves no room for the artist's subjectivity and the arbitrariness of composition—in fact he had gone further than Bill in this direction. Contrary to what Bill's various manifestos stated at the time, his art always remained the prisoner of good taste, always strove for compositional balance, for equilibrium. He "programmed," but edited out anything that did not pass the test of his subjective judgment. (It is not by chance that Bill later ■ became the heir of Georges Vantongerloo, the veteran of De Stijl.) Just like the algebraic equations on which Vantongerloo's paintings were supposedly based, the arithmetic computations that Bill presented as the justification for the formal arrangement of his works were often mere smokescreens (especially since the beholder could very rarely perceive the system in use, and since color, an important feature of Bill's canvases, was always conceived as a surplus, as a supplement ungoverned by the system).

Very early on, Morellet set out to eradicate any element of personal taste, using only generative systems of flagrant simplicity and programmatically refusing to meddle with them. As many other artists before him, Morellet wanted to find out what was the minimum required to produce an abstract painting. Although by no means the first artist to be obsessed by the Holy Grail of a "zero degree," he was perhaps the most articulate in his conclusion that this was an unattainable goal. His search began with a work flatly entitled *Painting*, from 1952, where a pattern of green stripes (horizontal-vertical zigzags) fills, in allover fashion, a white background. As in Stella's aluminum canvases ten years later, the

whole structure is deducted from an arbitrary generative element: in Stella's works it is the shape of the canvas; in Morellet's, the position of one broken line—the only one to be partly aligned to both the right and left limits of the support—onto which all the other stripes align.

The fact that an initial arbitrary choice was at the core of the configuration of this work led Morellet to one of his most radical experiments, *16 Squares* of 1953. Although this modular, allover grid (a white square divided into sixteen equal parts) is not much more than a readymade, Morellet calculated that no fewer than eleven decisions had determined its elaboration (two for the format: the square and the length of its sides; five for the elements: the lines, their two directions—horizontal and vertical—their number and their width; one for the interval that uniformly separates them; two for the colors: white and black; and finally, one for the lack of texture). Those eleven decisions were, in the logic of the "zero degree," ten too many. This outcome signaled to Morellet that one could never entirely suppress choice, arbitrary decisions, invention, and thus composition. As long as he kept total control of his canvas, even if the system he devised was entirely impersonal, he could not avoid subscribing to a romantic dream according to which, through the example of his art, through the rational and relational ordering of his canvas, he would be helping to shape the universe, or at least proclaiming such a mastery to be possible [1].

A major change in approach, at this point, was Morellet's use of chance, something that Bill would never have accepted in his own arsenal. In order to counteract the arbitrariness of subjective choice that even the most determinist system could not entirely suppress, Morellet came to adopt chance (the absolute lack of system, the absolute arbitrariness) as the principal means of organizing his work. This change did not happen in a vacuum: it was ▲ very clearly indebted to Ellsworth Kelly, an artist who shared his noncompositional drive and to whom Morellet was so close in the early fifties that his works often seem like systematic versions of the American painter's aleatory noncompositions.

Though he began using chance in the mid-fifties, Morellet's most eloquent works in this vein are probably the canvases and silkscreens called *Random distribution of 40,000 squares using the odd and even numbers of a telephone directory*, dating from 1960, in which a square field is divided into a regular grid that is colored in a binary (positive/negative) fashion according to the series of digits picked up from a telephone directory. Constituting a programmatic farewell to the tradition of geometric abstraction—for the assault was unmistakable, plainly stated in the title itself which functioned as an explanatory caption—these works also confirm a turning-point in Morellet's career. Their optical flickering seemed a logical offspring of the moiré effects engendered by the chance superimposition of grids in a series of canvases begun in 1956, and it persuaded him (wrongly, as he soon realized) that he was speaking the same language as the artists of the newly constituted GRAV. But if Morellet was momentarily deluded about his own development, others were not: it was precisely his superimposed grids that

1 • François Morellet, *4 random distributions of 2 squares using the numbers 31-41-59-26-53-58-97-93*, 1958
Oil on wood, four squares 60 × 60 (23⅝ × 23⅝)

prompted Piero Manzoni to invite him to a group show he was organizing in 1959 in Milan, where the third work he had ever sold ▲ was purchased by Lucio Fontana.

Yves Klein as litmus test

The evocation of these last two names introduces a different paradigm in the Parisian postwar context, that represented by the French ● alter ego of the two Italian artists, Yves Klein. Just as Morellet had needed the encouragement of a Kelly to break up his allegiance to Bill, Klein's works, and in particular his monochromes, perceived by many artists of the Jeune École de Paris as a direct affront, became the dividing line. A case in point was the letter that the painter Martin Barré (1924–93), then a rising star of JEP, sent to critic Michel Ragon upon reading the draft of the little monograph he was devoting to him: "In speaking of Yves Klein," Barré notes, "you say 'such a contested artist.' I want you to state that for me he is

uncontestable." Ragon complied, quoting the sentence verbatim in the published version of the book that appeared in 1960, but failing to grasp its consequences, framing Barré's statement with this caveat: Barré's fascination for Klein, Ragon explained, can be ▲ understood only via their common interest in Malevich.

Ragon's tone and that of other sympathetic critics would very soon change radically: in the reviews of the one-man show that coincided with the publication of Ragon's book, Barré was accused of having succumbed to Klein and having betrayed the cause of JEP. The only positive review of this 1960 exhibition was written by ● Pierre Restany, Klein's lifelong hagiographer: "In one scoop Barré, with true intellectual courage, got rid all of the outmoded apparatus, a whole vocabulary of anachronistic forms he had been till now trying to revive. And please do not tell me there is almost nothing left—I'd say there is still too much." In particular, Restany thought that Barré was unnecessarily beguiled by color and that he should concentrate on line, which he saw as his forte. For Restany, *color* was

Klein's domain—which he approached as a "monist," eschewing any dualism, any concept of balance—and Barré had the potential to be the "monist" poet of *line*.

In order to understand the nature of Barré's "betrayal" or conversion, as well as that of many others of his contemporaries, a brief summary of what the JEP was about is required. The "Jeune École de Paris" is an umbrella term repeatedly used in the fifties to designate the type of abstraction (either gestural or post-Cubist or rather post-Klee) initiated by the likes of Pierre Soulages, Jean Bazaine, Alfred Manessier, Viera da Silva, Serge Poliakoff, Jean Esteve, Bram van Velde, and Hans Hartung in the immediate postwar period and then emulated by an army of academic imitators. (This phenomenon is comparable to the mass production of watered-down Abstract Expressionist works in the New York of the early fifties, a production Clement Greenberg disparagingly labeled "10th Street" art in reference to the proliferation of art galleries on that very locale.) JEP theory and practice were modeled on those of early Kandinsky, who ponderously made detailed, elaborate sketches of so-called "improvisations" that the spectator was to view as faithful portraits of the painter's "inner being." Poseur and composer, the JEP artist was a Cartesian subject who felt secure as the master of his (or, more rarely, her) pictorial universe. Even when endorsing an Expressionist cloak, the JEP painter remained the pure product of an artistic education that has been largely governed by late, classicizing, highly compositional Cubism.

It is unfair to group the first and the second JEP wave together, but by the late fifties the distinction was blurred by their common saturation of the market and the support both were receiving from the State and from the belle-lettristic intelligentsia as a whole. It was to celebrate the JEP, with great pomp, that the first Paris Biennale was set up in 1959. Instead, its organizers were confronted head-on by the entries, all unusually large, of several artists soon to be grouped by Restany under the label "Nouveaux Réalistes," not to mention the three *Combine Paintings* sent by Robert Rauschenberg (in the American section): a *Meta-Matic* machine by Jean Tinguely, producing gestural abstract drawings at will, a blue monochrome by Yves Klein [2], and numerous *décollages* by Jacques de la Villeglé, François Dufrêne, and Raymond Hains (the latter's *Palissade des emplacements réservés*, a row of planks from a billboard covered with remnants of posters, directly imported from the streets, led to a full-blown scandal).

Although Klein was neither the first nor the only artist to rebel against the JEP, he was the most talented at directly borrowing its histrionics, notably the exhibitionist tactic of a Georges Mathieu painting a large canvas on stage in a matter of minutes. Klein continued using paint and canvases, the traditional tools of a painter: this explains in great part the impact of his work upon artists who were wary of the JEP but unwilling to leave painting altogether—which does not necessarily mean that they approved of his grand mystique. In fact, to come back to Barré, in the works that follow his discovery of Klein's monochromes one perceives a matter-of-fact critique of the return to the Romantic position of the aesthetic

Sublime that Klein was advocating. The paintings that Barré exhibited in 1960, all harboring simple inscriptions (a corkscrew curve, a ball of scribbles) made by directly pressing out the paint from a tube onto the white canvas, are clearly parodic and akin to the more famous "brush-strokes" canvases realized by Roy Lichtenstein from 1965 on, which are rightly celebrated for their gentle mockery of Abstract Expressionism.

The process of production in these works was laid bare, exposed, without any frills. The line was both the indexical sign of a spatial journey (it started there, finished here) and of a temporal unfolding (for example, the thicker section indicating where the hand slowed down). But it was only in the following year, when Barré began to use the spray-can—a device that was then unmistakably of its time, with the walls of Paris covered with graffiti alluding to the war in Algeria—that he understood, as Kelly and Rauschenberg had done ten years earlier, that his assault against the JEP's conception of authorship and agency had to proceed from an analysis of the pictorial sign as index [3]. The reasons why Barré was seduced by the rudimentary technique of the spray-can are obvious: its user's only difficulty is the control of speed, especially since he did not want any run-offs that would be interpreted as *tachisme* (as expressive); and the marks are produced without any contact between the body of the artist and his support. There is next to no material or psychological mediation between the canvas and the gesture that is transcribed in the mark, and there is no texture, no painterly "cuisine" (this might account for the fact that the first,

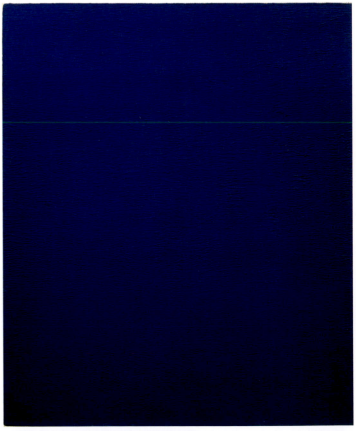

2 • Yves Klein, *Monochrome Blue IKB 48*, 1956
Oil on wood, 150 × 125 (59 × 49)

▲ 1908 ● 1960a ■ 1955b ◆ 1960a ▲ 1960c

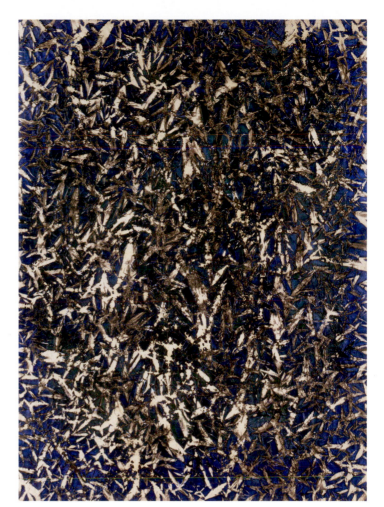

3 • **Martin Barré**, *63-Z*, 1963
Spray paint on canvas, 81 × 54 (31⅞ × 21¼)

4 • **Simon Hantaï**, *Mariale 3*, 1960
Oil on canvas, dimensions unknown

mostly hostile, commentators on these works thought they were photographs). The most spectacular of these first spray-can pictures is a 1963 canvas that is striped with parallel oblique lines from edge to edge, all over [**3**].

Hantaï and the allover mode

That the allover goes hand-in-hand with an investigation of indexicality is a conclusion that was also reached, at around the same time, by Simon Hantaï (1922–2008). While Morellet had stumbled upon this structure when battling against Bill's legacy, and Barré when
▲ discarding the old recipes of the JEP, Hantaï's nemesis was Surrealism. Though it is clear today, with hindsight, that Surrealism was utterly moribund in postwar France, it still occupied a major position of power at the time. André Breton remained very active until his death in 1966, and both the French art market and public institutions were inundated with works by his protégés, basically third-generation imitators of the artists the poet had regrouped under his banner in the mid-twenties. Hantaï had begun as a Surrealist in the early fifties, then gradually moved into gestural abstraction, swiftly scraping a few strokes off the dark wet paint of the ground of his large canvases with a broad palette knife or spatula. By 1959, his large allover paintings—

▲ oddly resembling, but with more luscious effects, Dubuffet's strictly contemporary *Matériologies*—mark a turning-point in his oeuvre [**4**]. While the allover mode of that year represents an exception in Dubuffet's whole output, it became a springboard for Hantaï, who never parted with it thereafter: through Pollock, whom he had recently discovered, Hantaï understood that he had to invent a new method for marking his canvases and dividing their surfaces. This method, which was set in place the following year, is *pliage* (literally "folding," though it has more the effect of crumpling). From then on, Hantaï folded his canvases before coating them with color, the variously sized tongue/flame/leaf-shaped creases that the paint did not reach being revealed as white at the moment of unfolding. At first he would paint in those creases with another color, or with another shade of the same color, giving the surface of his canvases the reticular and hardened feel of a reptile's skin, but soon, using a more fluid paint and working on a larger scale, he would let the reserved spaces remain untouched and their whiteness luminously contrast with the monochrome, decorative, and aleatory pattern of the painted areas. Whatever the variations, his pictorial practice always toyed with the issue of automatism and with the possibility of uncontrol, and Hantaï's most successful works convey what one imagines to be the sheer pleasure of his surprise at the moment of unfolding.

▲ 1924, 1930b, 1931a

▲ 1946, 1959c

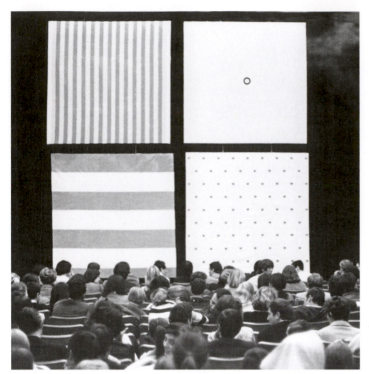

5 • Daniel Buren, Photo-souvenir: *"Manifestation no. 3: Buren, Mosset, Parmentier, Toroni,"* Musée des Arts Décoratifs, Paris, 1967 (detail)

Morellet, Barré, and Hantaï all renounced the considerable skills they owed to their traditional backgrounds in order to develop procedures that would flaunt composition and the myth of interiority that this pictorial equivalent of the *cogito ergo sum* entails (the Cartesian "I think, therefore I am" being translated into "I am able to 'do something in one corner and to balance it with something in the other corner' [Stella], therefore I am"). They would, however, be outrun on this score by a younger artist who was to become one of the most important players in the international field of Conceptual art: Daniel Buren. It took Buren less than two years to digest the lesson of his elders (Hantaï was particularly important to him, but so were Ellsworth Kelly and Frank Stella for, unlike his peers, he was keenly aware of the American situation). By mid-1965 his expansive canvases, almost all contrasting a regular pattern of colored stripes (usually the ground) and flat areas of color (usually biomorphic figures) were forcefully pleading for a revival of Matisse's notion of the decorative.

It was at this point that Buren underwent the same deskilling sacrifice as his predecessors in deciding to use ready-made pieces of striped canvas, bought at fabric stores, for the background of his compositions. At first he tinkered with the colorful printed pattern, "correcting" it, to use Duchamp's phrase, but soon he left it as such, contenting himself to paint his biomorphs over it. His next step was to multiply the biomorphs so that they also would become an allover pattern (in competition with the "first," striped one and thus calling into question the traditional opposition between figure and ground). By early 1966, he had adopted the standard binary pattern he would use ever after—alternating bands of white and of a single color per work, each band being

of the same width (8.5 centimeters). By the end of the summer of that same year, he had dispensed with any "figuration," with any silhouetting—his only intervention consisted of stretching the striped fabric (bought by the yard) and highlighting one of the white bands in white acrylic paint.

He also decided to team up with three other artists engaged in a similar reductive course: Olivier Mosset, Daniel Parmentier, and Niele Toroni, with whom he founded the group BMPT [5]. Rebelling against the myth of inspiration and other art world follies, each artist chose a configuration that they would invariably repeat in all their works: to Buren's standard vertical stripes, Parmentier responded with large horizontal bands, Toroni with a regular distribution of isolated brush-strokes of equal dimensions, Mosset with a black circle in the middle of the canvas. Their first exhibition together, during the "Salon de la Jeune Peinture" on January 3, 1967, was a parody of Klein parodying Mathieu: during a whole day, from 11 a.m. to 8 p.m., each artist executed as many of his trademark works as time allowed, while this slogan was broadcast through a loudspeaker: "Buren, Mosset, Parmentier, Toroni advise you to become intelligent." At the end of the day, they left the Salon for good, taking their work with them and leaving only this banner on the walls: "Buren, Mosset, Parmentier, Toroni are not exhibiting." The "Jeune Peinture" was dead and buried, paving the way for institutional critique. A little over a year later, the political upheavals of May 1968 would further radicalize the guerrilla tactics of BMPT. YAB

FURTHER READING

Yve-Alain Bois, "François Morellet / Sol Lewitt: A Case Study," in Thomas Gaehtgens, *Artistic Exchange, Acts of the 28th International Congress of Art History, Berlin, July 15–20* (Berlin: Akademie Verlag, 1993)

Yve-Alain Bois, *Martin Barré* (Paris: Flammarion, 1993)

Benjamin H. D. Buchloh, "Hantaï / Villeglé and the Dialectics of Painting's Dispersal," *Neo-Avantgarde and Culture Industry* (Cambridge, Mass.: MIT Press, 2000)

Daniel Buren, *Entrevue: Conversations with Anne Baldessari* (Paris: Musée des Arts Décoratifs, 1987)

Bruce Glaser, "Questions to Stella and Judd," in Gregory Battcock (ed.), *Minimal Art: A Critical Anthology* (New York: Dutton, 1968; and Berkeley and Los Angeles: University of California Press, 1995)

Serge Lemoine, *François Morellet* (Zurich: Waser Verlag, 1986)

1968a

Two major museums committed to the most advanced European and American art of the sixties—the Stedelijk Van Abbemuseum in Eindhoven and the Städtisches Museum Abteiberg in Mönchengladbach—exhibit the work of Bernd and Hilla Becher, placing them at the forefront of an interest in Conceptual art and photography.

In 1957, Bernd (1931–2007) and Hilla Becher (1934–2015) initiated a photographic project that continued to preoccupy them for fifty years: the systematic recording of European industrial architecture, which at that time was under threat of imminent disappearance through neglect and decay. Like many photographic archives before them, from Charles Marville's nineteenth-century topography of Parisian streets to Eugène Atget's magisterial attempts slightly later to record the disappearance of Paris under the impact of modernization, the Bechers' project was marked from the very beginning by a particular dialectic: a struggle between, on the one hand, an almost obsessive will for an exhaustive record, a desire to make permanent, and, on the other, an equally deep sense of loss, the melancholic insight that the spatial and temporal disappearance of the object can never be arrested.

Two photographic turns: 1928–1968

Two other photographic projects—one central to the very history and culture from which the Bechers emerged (that is, the photography of German Neue Sachlichkeit [New Objectivity]); the other from the context of reception within which their work became internationally known—should be mentioned at once. The first is the work of the German photographer August Sander, to whom the Bechers referred on many occasions as a key influence. Sander's best-known project, *Antlitz der Zeit* (Face of Our Time), conceived in the first decade of the twentieth century and partially published in 1929, was an attempt to provide an exact and complete record of the social subjects of the Weimar Republic, a physiognomy of all its social strata, genders and ages, professions and types.

The second "archive" was constituted by the use of photography by American artists such as Ed Ruscha, Dan Graham, and Douglas Huebler who, starting in the early to mid-sixties, resituated the photograph at the center of artistic production. In the Bechers' initial reception, from the late sixties onward, the couple were frequently associated with these artists (and with some of them they maintained lifelong friendships). Typically, one of the first—and possibly still the most important—essays on their work and their first book *Anonyme Skulpturen: Eine Typologie technischer Bauten*

(Anonymous Sculptures: A Typology of Technical Constructions) was written by Carl Andre, the central sculptor of Minimalism.

Some of the earliest photographs the Bechers produced were composite images of mining architecture, a strangely antiquated type of montage that resurrects the original photographic promise to supply the greatest quantity of empirically verifiable detail in the formation of a positivist record of the visible world. But these images were problematic for the couple, for they were disturbingly reminiscent of photomontage—the menacing political "other" to the latent conservatism of Neue Sachlichkeit photography that served as the Bechers' primary historical resource. Furthermore, the tradition of photomontage had recently resurfaced in the postwar period in an American reincarnation, namely in the work of Robert Rauschenberg, a reference that the Bechers would have wanted to avoid altogether at that time.

This might explain why they soon replaced the composite photograph with a unique combination of two modernist photographic orders: the traditionally crafted, single-image print and the principle of the sequential or the serial image. From now on their photographs were displayed in two different formal arrangements: either in what the Bechers called a "typology" (generally a series of nine, twelve, or fifteen images of the same type of architectural structure, such as nine different lime kilns or fifteen different cooling towers [1]), or in what they identified as a "development," (*Abwicklung*), that is, a series of single images in which one particular individual structure (for instance, a mining tower or a house) is presented in a sequence of rotating views [2].

The actual development of the Bechers' work over this period is infinitely more complex, however, than this brief summary suggests, inasmuch as it could be identified as one of the few artistic projects in postwar Germany to establish a historical continuity with the Weimar avant-garde. This is in contradistinction to the majority of the postwar West German artists, such as Gerhard Richter, who explicitly situated themselves outside the orbit of the Weimar legacy, establishing a link instead with the American neo-avant-garde phenomena of the fifties and sixties. In opposition, the Bechers worked to resuscitate the legacy of Weimar Neue Sachlichkeit photography by openly emulating the ideals and achievements of its canonical figures: August Sander, Albert Renger-Patzsch, and Werner Manz.

▲ 1935 ● 1925b, 1929 ■ 1935 ◆ 1967a, 1968b, 1984a ▲ 1962c ● 1953 ■ 1988

1 • Bernd and Hilla Becher, *Cooling Towers*, 1993
Fifteen black-and-white photographs, 173 × 239 (68¼ × 94¼)

Beyond this claim of continuity with Weimar, the Bechers also asserted a new credibility for photography itself, which under the impact of Abstract Expressionism and the rise of American and French painting of the fifties had been completely overshadowed in the reconstruction period in Germany. Quite clearly, then, they were working to establish a double continuity: first with an alternate Weimar culture; second with an alternate system of imaging practices as they had been fully developed within the context of the "historical avant-garde."

Further, it is important to recognize that in its focus on industrial buildings, such as coal tipples, water towers, mine-entrance structures, the Bechers' project also entered into an explicit dialogue with the rise of welded sculpture and its reception in Germany in the late fifties and early sixties. This work, by ▲ sculptors ranging from David Smith to Jean Tinguely and based on machine parts taken as industrial debris, had become central to the postwar redefinition of sculpture. By their own account, the key figure against which the Bechers defined themselves in the early sixties was the Swiss Nouveau Réaliste Tinguely with his junk sculpture aesthetic to which they opposed their own work

both in its photographic dimension and in its use of an actual, historical foundation as industrial archaeology to combat the aestheticizing of industrial ruins. In opposition to the romanticization of industrial waste and to what they perceived to be a reductive understanding of the intersection between artistic and industrial practices, the Bechers explicitly wanted to put themselves in a relation to this type of architecture that would recognize its historical importance, its structural and functional probity, and its aesthetic status. A conservationist impulse therefore motivated their work to the same extent as did an artistic one. While these structures do not quite yet appear as ruins, they are certainly structures on the wane. Thus it is perhaps no surprise that the relatively new discipline of "industrial archaeology," in which conservationists rescue selected examples of industrial architecture from their definitive disappearance, received some of its initial impulses from the work of the Bechers. And it is not surprising either that industrial archaeologists commissioned the pair on various occasions to assist in the scientific exploration and photographic documentation of industrial sites to ensure their archaeological preservation.

▲ 1945, 1960a

From seriality to site-specificity

Clearly, the intersections in the work of the Bechers become yet more complex as one reads them against the various historical strands on which they depended, from Sander and Renger-▲ Patzsch, to Le Corbusier, who in 1928, in his journal *L'Esprit Nouveau*, had published a manifesto to launch an aesthetic based on industrial structures (such as grain silos) as examples of the formal strength of anonymous engineering design. This aesthetic not only argued that form should be nothing more than the pure articulation of function, but also it implied an early (psychological) critique of authorship, as well as an early (sociopolitical) emphasis on the collective participation in social production. Le Corbusier was opposed to the *auteur* aesthetic of the modernist architect on the same grounds as were the Bechers, when in *Anonymous Sculptures* they argued that the anonymity of industrial design deserves to be taken as seriously as authorial claims for individuality. Thus at the moment of 1968, a lineage within modernism could be traced from Le Corbusier through Neue Sachlichkeit to the Bechers, for which collectivity, anonymity, and functionalism are seen as key artistic values.

▲ In his enthusiastic response to *Anonymous Sculptures*, Andre read their work as though it were primarily defined by its compulsive attention to serial repetition. This reading, which immediately brought the Bechers into the context of Minimalist and Post-
● minimalist aesthetics, was made possible by the way the Bechers arrange their images as pristine, gridlike taxonomies by which to present the minute structural differences between each of their examples. This emphasis on repetition, seriality, minute inspection, and structural differentiation is obviously what attracted Andre's attention, engendering his Minimalist reception of the work and its canonization within the context of Minimalist and Postminimalist sculpture. But there were other aspects that helped to locate the Bechers within the dialogue on sculpture that was developing in the late sixties. One was their work's stress on anonymity, the other was its obvious foregrounding of the issues of site. Andre in particular had developed an internal logic for sculpture in which it would cease to be defined as constructed object and would instead be understood as place, as a node at the intersection of architecture and environment.

Another quality that placed the Bechers within the context not only of Minimalism but also of emerging Conceptualism was the

2 • Bernd and Hilla Becher, *Eight Views of a House*, 1962–71
Eight black-and-white photographs

▲ 1925a, 1929, 1935 ▲ 1962c ● 1965, 1969

replacement of material structures by the photographic document, particularly as it was accumulated in their work in serial alignments. From Ed Ruscha and Dan Graham onward, serial, systematic photography figured crucially within the rise of Conceptual art. What distinguished the Bechers' work, however, from all of Conceptual art is their emphasis on skill. If Conceptual photography is defined by deskilling, the Bechers' work was focused on reskilling: they emphatically resuscitated the ambition to produce the highest-quality black-and-white photography they could possibly achieve, in the same way that photographers of the Neue Sachlichkeit context, such as Sander and Renger-Patzsch, insisted on the highest artisanal accomplishment of the photographic project. The Bechers went to great lengths to produce the right photograph, framed at the right height and taken, without shadows, on the right day in order to get the right light and thereby to obtain the most minute gradations of tonal values; further, they insisted on the most immaculate presentation of the object. Insofar as it then appears to be unmediated by any authorial perception, this is in line with the legacy of Neue Sachlichkeit that the Bechers pushed to a new threshold of ambition.

This insistence on continuity with the Weimar culture of Neue Sachlichkeit, in its refusal to allow German neo-avant-garde production to be mediated in its entirety through postwar American art, parallels Georg Baselitz's exactly contemporaneous attempt to resuscitate German Expressionism. Such claims for continuity are problematic, however, on two fronts at once. Insofar as artistic practices and strategies are in and of themselves historically circumscribed and thus perpetually surpassed and devalorized, the idea of a valid model of "new objectivity" photography that could be transplanted from the twenties to the sixties is questionable. Further, in a situation such as the German one, the political and historical caesura of World War II blocks access to an unproblematic relation to the idea of the nation state as the basis for the subject's identity, and thus the project of trying to construct artistic identity on such conventional models becomes ever more difficult. The other side of the effort to create an artistic practice that transcends the chasm of the historical rupture opened by World War II and the Holocaust is, then, an attempt to blind oneself to the degree to which all cultural practices after 1946 were deeply affected by that caesura and would have

3 • Thomas Struth, *Clinton Road, London,* **1977**
Black-and-white photograph, 66 × 84 (26 × 33)

▲ 1967a, 1968b ● 1968b ■ 1929, 1935 ▲ 1963 ● 1908

had to take it into account. This is the additional dimension of the Bechers' problematic claim for historical continuity which needs to be contrasted with other practices in Germany of the same period, such as Gerhard Richter's, where no such assertion is being made.

Precisely in its attempt to bypass the questions of historical mourning, the work displays the symptoms of a repressive apparatus; it is not accidental in that sense that the melancholia hovering over the Bechers' work is generated by the almost phobic prohibition of the subject within the photographs' exclusive focus on industrial ruins (that applies even to the category of mid-nineteenth-century rural housing, a series that is also presented solely for the type's structural beauty, rather than for any sociological dimension). For the melancholic contemplation of the past to be effective, then, the social and historical context has to be excised from their work in order to make the architectural the undisturbed object of attention. With the major exception of August Sander, this move to dehistoricize had, of course, been a defining characteristic of the original Neue Sachlichkeit photography as well, given its perpetual endeavor to aestheticize the object.

From concepts to color

The second generation of artists to emerge from the Bechers' "school"—Bernd Becher taught at the Düsseldorf Academy from the mid-sixties onward—was a group of photographer-artists that included Thomas Struth (born 1954) [3], Thomas Ruff (born 1958) [4], Candida Höfer (born 1944) [5], and Andreas Gursky (born 1955) [6]. All of them picked up from the Bechers' point of departure and extended it, also extending some of the predicaments inherent to their approach. For example, in the photographs of Struth and Ruff, the emphasis on the absence of human agency is as compulsively enacted as it is in the Bechers' own work.

Beginning by photographing empty streets in Düsseldorf in 1976, Struth replaced the pure industrial object with the pure urban, structural fabric. Yet, as had been the case with the Bechers, the capacity to skirt actual historical questions operates in the way Struth systematically found urban sites where the absence of human activity allowed for a melancholic reading of the city. But with the transformation from architectural to urban archaeology that took him on incessant travels through urban centers—ranging from small towns in Belgium, Germany, England, and the United States to large cities such as Tokyo—Struth recorded a peculiar type of public urban space. And in retrospect this appears as a systematic accounting of the actual experience of the disappearance of public urban space in a parallel with the vanishing landscape preserved only in the photographic archive the Bechers produced.

In Struth's and Ruff's early work, the insistence on black-and-white photography—doubly obsolete in its dimension as material support and as vehicle of artisanal skills—brings to the

4 • Thomas Ruff, *Portrait*, 1989
Chromogenic color print, 119.6 × 57.5 (47 1/16 × 22 5/8)

foreground the question of whether and to what extent an antimodernist impulse is operative here, one that could best be compared to the lineage of Giorgio de Chirico in painting. It is an antimodernism that greets the present through the lens of melancholia, that is manifestly disconnected from the model of an avant-garde and its necessary link with advancing scientific and technological means of production, and that positions itself with regard to the question of the reconstruction of memory under the conditions of loss, a question that is important in the postwar period.

There is a later phase of this development when color suddenly makes its appearance in the work of Ruff, Struth, Gursky, and Höfer as though it has been released from a prohibition. Yet this introduction of color, and along with it the admission of human agency and social context in great quantities and detail, does not resolve the historical limitations of Struth's or Ruff's photographic practice. Quite the opposite would be true, in fact, for the large and continuing series of photographic portraits that Ruff produced from the late eighties onward, which resuscitates the traditional model of the portrait as it had been practiced in

1960–1969

5 • Candida Höfer, *BNF Paris VII*, 1998
Chromogenic color print, 85 × 85 (33½ × 33½)

Weimar Neue Sachlichkeit. This places Ruff at the center of a counterconceptual approach—the portrait having been the object of explicit deconstruction by the Conceptualists who regarded it as a historically obsolete model through which false claims for an accessible physiognomic depiction of subjectivity and identity were made. With Ruff's reconstitution of the genre of photographic portraiture, one such countermodernist impulse ▲ thus reaches its apogee and points toward the radicality of photoconceptual practices. BB

FURTHER READING
Alex Alberro, "The Big Picture: The Art of Andreas Gursky," *Artforum*, vol. 39, no.5, January 2001
Carl Andre, "A Note on Bernhard and Hilla Becher," *Artforum*, vol. 11, no. 5, December 1972
Douglas Eklund (ed.), *Thomas Struth: 1977–2002* (New York: Metropolitan Museum of Art, 2002)
Peter Galassi (ed.), *Andreas Gursky* (New York: Museum of Modern Art, 2001)
Susanne Lange (ed.), *Bernd und Hilla Becher: Festschrift. Erasmuspreis 2002* (Munich: Schirmer/Mosel, 2002)
Armin Zweite (ed.), *Bernd and Hilla Becher: Typologies of Industrial Buildings* (Düsseldorf, Kunstsammlung Nordrhein-Westfalen; and Munich: Schirmer/Mosel, 2004)

6 • Andreas Gursky, *Salerno*, 1990
Chromogenic color print, 188 × 226 (74 × 89)

▲ 1984a

Conceptual art manifests itself in publications by Sol LeWitt, Dan Graham, and Lawrence Weiner, while Seth Siegelaub organizes its first exhibitions.

Conceptual art emerged from the confluence of two major legacies of modernism, one embodied in the readymade, the other in geometric abstraction. Through the practices ▲ of Fluxus and the Pop artists, the first legacy was transmitted to ● younger postwar artists; through the works of Frank Stella and the ■ Minimalists, a similar bridge was formed between prewar abstraction and conceptual approaches at the end of the sixties.

At the beginning of the decade, prior to the organized onset of Conceptual art in 1968, the fusion of Fluxus and Pop had led to works such as Robert Morris's *Card File* (1962) and Ed Ruscha's *Twenty-Six Gasoline Stations* [1], in which certain positions that would subsequently determine Conceptual art were firmly established: in Ruscha's work this meant an emphasis on photography and the form of distribution of the printed book; in Morris's, it entailed a focus on a revised, linguistic definition of modernist self-reflexiveness—or art asserting its own autonomy through strategies of self-reference—which Morris pushed to the point of undermining the very possibility of aesthetic autonomy.

Both Morris and Ruscha are, in turn, indebted to the way ▲ Duchamp's readymade had yielded a more complex model of ● practice in the hands of Jasper Johns and Andy Warhol. These two were also central to the subsequent unfolding of photographic and textual strategies as they were being put in place in the mid-sixties by the first "official" generation of Conceptual artists, namely Lawrence Weiner (born 1940), Joseph Kosuth (born 1945), Robert Barry (born 1936), and Douglas Huebler (1924–97). These artists formed the group that was shown in 1968 in New York by the art dealer Seth Siegelaub (born 1941).

The second element that contributed significantly to the formation of a Conceptual aesthetic was Minimalist abstraction as embodied in the work of Frank Stella, Ad Reinhardt, and Donald ■ Judd. In his manifesto-like essay "Art After Philosophy" (1969), Joseph Kosuth acknowledged all of these as predecessors in the development of the Conceptual aesthetic. What is at stake in this aesthetic is a critique of the modernist notion of visuality (or "opticality"), here defined as a separate, autonomous sphere of

1 • Ed Ruscha, from *Twenty-Six Gasoline Stations*, 1962
Artist's photobook

▲ 1960c, 1962a, 1964b ● 1958 ■ 1965 ▲ 1914 ● 1958, 1962d, 1964b ■ 1957b, 1958, 1965

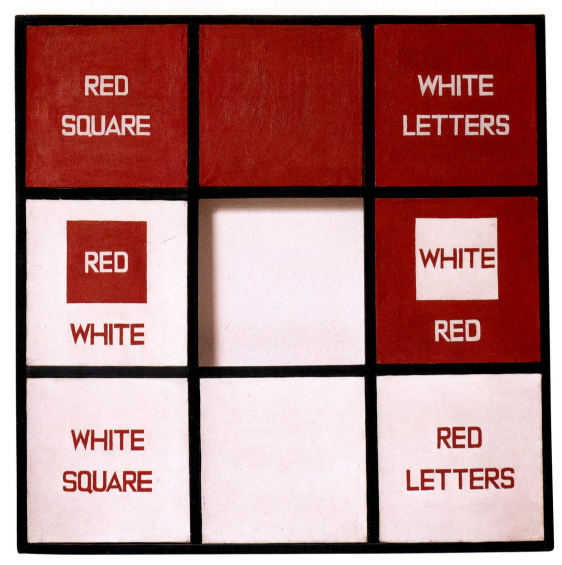

2 • Sol LeWitt, *Red Square, White Letters*, 1963
Oil on canvas, 91.4 × 91.4 (36 × 36)

▲aesthetic experience. What is further at issue is the question of the problematic uniqueness of the art object as well as the new mode of distribution (the book, the poster, the journal) and the "spatiality" of that object—namely, the pictorial rectangle or the sculptural solid (despite Minimalism's embrace of industrial

• production and technological reproduction, Minimalist work had ultimately remained wedded to the singular object).

Developing the critique

If visuality, physical concreteness, and aesthetic autonomy are some of the modernist aspects that Conceptual art began to critique from within, this critique had already manifested itself as early as 1963 in work such as Sol LeWitt's *Red Square, White Letters* [2]. As a result of the extreme reductivism of late-modernist painting and sculpture in its drive to secure its autonomy through self-definition, it became a relatively plausible step to challenge visual and formal self-reflexiveness through a strategy of producing literal, which is to say linguistic, "definitions." And if the idea of

definition as a basis for art practice started to enter the work of future Conceptual artists by 1965, the model of definition transmitted to them by the example of Sol LeWitt was clearly what one would call a *performative model*. This is because, in replacing the visual structure of the work by the color- and shape-names of its visual units ("White Square" printed on a white square; "Red Letters" printed in red on a white square, and so on), LeWitt transforms the work's spectator into a reader: in the act of pronouncing the information inscribed on the canvas, the viewing relationship becomes a performative reader relationship. This in turn parallels the transformation of the visual object—as autonomous—into an understanding of that object as highly contingent, depending as it does on the context of its particular engagement with its receiver.

With Morris's early work it also became evident that one
▲ aspect of the readymade that had been overlooked in the history of Duchamp's reception in the postwar period was that it already contained a performative, linguistic dimension—a work of art can be "created" merely by naming it so—which could open in turn onto what one could call the administrative or legalistic definition

▲ 1960b, 1993a ● 1965 ▲ 1914

of the work. Specifically, Morris's *Statement of Aesthetic With-drawal* [3] canceled the artistic value of his slightly earlier work *Litanies* (also 1963)—because, as the notarized document contained in *Statement* attests, the collector of *Litanies* did not pay for it—thereby, in effect, voiding its "name." This legalistic or administrative system of conventions within which meaning is (temporarily) fixed is one strategy that was then adopted by Conceptual art to displace the ontological or "intrinsic" definition of the work of art.

In the way such conventions are obviously external to the idea of the work as self-contained and autonomous, they participate in ▲ what could be called an "aesthetic of the supplement." And it is this notion of supplement that operates in other ways in those works, such as Morris's *Card File* or his *Box with the Sound of Its Own Making* (1961), that forms the immediate prehistory of Conceptual art. There, Morris's strategy is to point toward those features that so exceed the containment and the relative autonomy demanded by the modernist paradigm that it begins to break down in the face of this experience of excess. Thus in *Box with the Sound of Its Own Making* the traditional sculptural cube (the classic correspondent to the traditional pictorial square) is presented, but—with the taped sounds of the process of its own production emanating from within it—this seemingly "pure" form is shown to be a hybrid of supplements of history, memory, texture, sound, and technology of fabrication that led to this supposedly self-contained object.

In *Card File* [4], which consists entirely of a box of cards carrying notations of the production of the object itself (hence the selfreferential stance), the supplement system appears through the written record of all the chance encounters that entered the process of production and opened it up to an economic, social, biographical, historical system that, in all its randomness and even in its • triviality—related to Fluxus and Pop aesthetics—is not extrinsic to the aesthetic object but indeed *necessary* to it. In this, the resultant work is unimportant compared with the complexity with which its process of making intertwines with a variety of "external" structures. And it is the emphasis on these structures that one would call an aesthetic of the supplement. (A wonderful instance in *Card File* is the reference to Morris's chance meeting—on the ■ way to purchase the file itself—with Ad Reinhardt who, as a key representative of the type of self-referential, late-modernist aesthetic to which Morris is saying farewell, is folded into the work as an "insider" who enters the object from outside to distance the "inside" from itself.)

With the first exhibitions organized in 1968 by Seth Siegelaub, who acted as both critic and manager of the Conceptual aesthetic, several additional aspects became evident that were to have a great impact on the definition of Conceptual art. One of these was the way Siegelaub's strategies made the supplement yield a shock value that produced the strange paradox of a simultaneous withdrawal from the field of the visual *and* a staging of that withdrawal as a form of spectacle. Saying "We show in an office space; we don't need a gallery. We show printed matter. We show work that is

Artists' journals

The success of the Dada and Surrealist journals in forging an international audience and a far-flung network for artistic practice was not lost on New York artists who had also seen the prestige and publicity generated by Alfred Stieglitz's magazines *291* and *Camera Work*. In 1947, the year Peggy Guggenheim closed her "Art of This Century Gallery," artists emerging with New York exhibitions at Samuel Kootz Gallery, Charles Egan Gallery and Betty Parsons Gallery felt the need to consolidate a movement using journals as its platform. Accordingly, *The Tiger's Eye* and *Possibilities* were founded as the support for the group practice of Abstract Expressionism. *Possibilities* had only one issue (Winter 1947–8) with statements in it by Robert Motherwell, Jackson Pollock, and Mark Rothko. *The Tiger's Eye* was somewhat longer-lived, with Barnett Newman writing and editing for it.

With the Surrealists Tanguy, Matta, Ernst, and Man Ray in New York in the early forties, it was not surprising that two journals devoted to the movement would be founded: *View* and *VVV*. In April and May 1942, *VVV* published special issues devoted to Ernst and Tanguy, while the first issue of *View* in 1945 was devoted to Marcel Duchamp, who designed its cover; extracts of André Breton's essay "Lighthouse of the Bride," were included. *VVV* and *View* were vehicles for the Abstract Expressionists to voice their concern with subject matter and to wonder whether it would be possible to forge new structures of myth based on American Indian narratives. In 1944, Pollock wrote: "I have always been very impressed with the plastic qualities of American Indian art." Barnett Newman joined him and organized an exhibition of Northwest Coast Indian painting at the Betty Parsons Gallery.

By the late sixties the evolving practice of Conceptual art was focusing on print as the support for its work, with books and magazines as mass-circulation, inexpensive supports for the publication of material centered on photography's own logic of the multiple. Not only were Ed Ruscha's books (*34 Parking Lots*; *Twenty-Six Gasoline Stations*; *Every Building on the Sunset Strip*; *Various Small Fires*) the reasonable outcome of this new conviction, but the publication of manifesto-like essays in established art journals formed part of the Conceptualists' activities. Joseph Kosuth's "Art After Philosophy" was a three-part statement of the way art was being refocused by a new set of issues, published in *Studio International* (1969). It was thus a next step for Kosuth to found the movement's own journal, *The Fox* in 1975, as well as becoming the American editor of *Art-Language* (1969).

The centrality of photographic documentation as evidence of the existence of geographically remote Earthworks led to the frequent publication of artist statements and essays in magazines such as *Artforum*. Robert Smithson, Michael Heizer, Walter De Maria were all published there, as were the Minimalists Robert Morris, Carl Andre, and Donald Judd. This in turn encouraged the development of a journal devoted to Earthwork art, *Avalanche*, edited by Willoughby Sharp and Lisa Bear from 1970. In addition to its interviews with Earthwork artists, *Avalanche* also introduced Joseph Beuys to Anglophone readers.

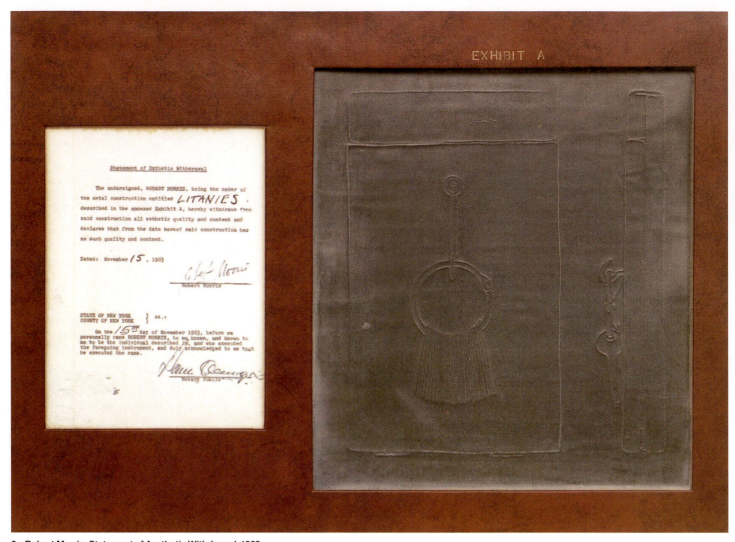

3 • Robert Morris, *Statement of Aesthetic Withdrawal*, 1963
Typed and notarized statement on paper, sheet of lead over wood, mounted in imitation leather mat, 45 × 60.5 (18 × 24)

ephemeral, that is only temporally defined, that is textually based and does not need an actual material institution," Siegelaub underscored the historical obsolescence of the visual work in favor of a mass-cultural, reproduced object; but in doing so, he produced the kind of impact on art audiences that one associates with the most effective kind of advertising. Thus the first few exhibitions of the Siegelaub Gallery repeated what had already appeared in the
▲ mid- to late fifties in the work of Robert Rauschenberg and Yves Klein, in which the gesture toward the supplement also came across, paradoxically, as a "spectacular" withdrawal from visuality and from traditional concepts of artistic production.

Strategies and *Statements*

When Siegelaub published Lawrence Weiner's *Statements* in 1968, a broad spectrum of strategies had thus been put into play. And clearly one of these strategies was the focus on the distribution form as it had been laid out by Ruscha. For in resisting a merely painterly engagement with technical reproduction, such as Warhol's, where the outcome turned out to be no different from previous forms of art, Ruscha was demanding that the product itself partake in the technologies of reproduction. He thereby shifted from Warhol's "Campbell's Soup" paintings to his own photographic books in which the photograph defines the distribution form rather than merely redefining the pictorial structure (as in Warhol) to resuscitate it, paradoxically, from within.

Weiner's book *Statements* carries the idea of distribution even further. Broken down into two halves—the first including works that are in "the public freehold domain" (that is, never able to become private property), which Weiner called "General Works," and the second including those he called "Specific Works"—everything in *Statements* is guided by a tripartite formula in which Weiner pronounces: (a) the artist may construct the piece; (b) the piece may be fabricated; (c) the piece may not be produced at all. In doing so, he indicates that it is the condition of receivership that controls and ultimately determines the material status of the work of art, thereby completely reversing the traditional hierarchy of artistic production. For Weiner, "the owner [receiver] of the work contributes to what the material status of the work will be to the very same extent as its producer."

▲ 1953, 1960a

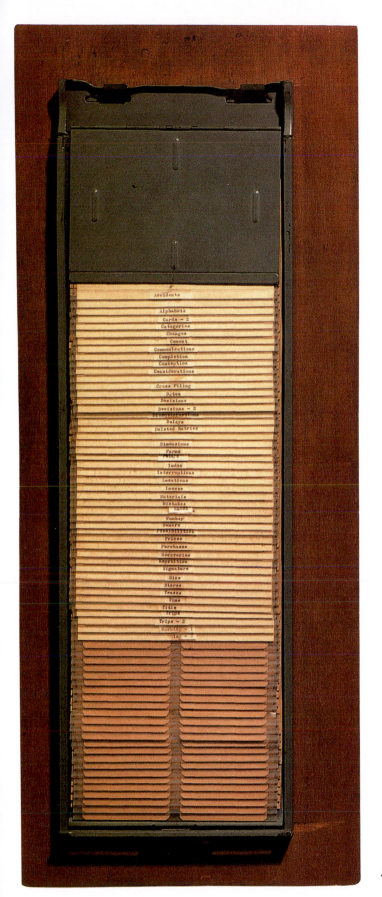

Deskilling

The term deskilling was first used in Ian Burn's essay "The Sixties: Crisis and Aftermath (Or the Memoirs of an Ex-Conceptual Artist)" in *Art & Text* in 1981. It is a concept of considerable importance in describing numerous artistic endeavors throughout the twentieth century with relative precision. All of these are linked by their persistent effort to eliminate artisanal competence and other forms of manual virtuosity from the horizon of both artistic production and aesthetic evaluation. Deskilling appears for the first time in the late nineteenth century in the work of the Impressionists and of Georges Seurat, when the traditional emphasis on virtuoso draftsmanship and painterly finish was displaced by a breakdown of the application of pigment into visibly separate brush-strokes, displacing the smooth surfaces of academic painting with the marks of manual labor in an almost mechanically executed and serially deployed arrangement of pigment. Deskilling first climaxed in the context of Cubist collage, as found cut-paper elements displaced both painterly execution and the function of drawing altogether, substituting the "merely" found tonalities and found graphic schemes that the cut papers took on. The second major moment—perhaps the high point of such a critique of virtuosity and manual skill—came in the immediate wake of Cubist collage with the assumption of the readymade. With this declaration of the found, industrial object from which all artisanal (manual) process has been banished as the work of art, the collective production of the serialized, mechanical object took the place of the exceptional work crafted by the gifted virtuoso.

Here, then, is a logical expansion of the initial collaborative or contingency model that had been introduced in the postwar reception of Duchamp that began with Johns and extended through Morris to LeWitt. For *Statements* emphasizes that neither collaboration, nor industrial production, nor the elimination of authorial originality alone are sufficient to define the condition of contextuality within which the work of art functions. The fact that from *Statements* onward Weiner's work became exclusively language-based corresponds, precisely, to that complex definition inasmuch as the reading of the work, its presentation on the printed page, and its distribution in book form all point to the multiplicity of performative options that the work can assume. All of the work in *Statements* maintains the possibility of a material, sculptural definition [5]; all of it could in fact be executed by anyone who cared to: yet all of it retains its full definition as "art" even if it does not acquire a material form. A typical example is a piece such as "A 36 inch × 36 inch square removal from a wall," which was in fact installed in the exhibition ▲ "When Attitudes Become Form." In this work the transition in Weiner's own history—he had started out as a painter / sculptor—is rewritten as the move from Minimalist and modernist self-reflexive and highly reductive visual practices to the linguistic transcription of such practices. For the square as the quintessential topos of

4 • Robert Morris, *Card File*, 1962
Metal and plastic wall file mounted on wood, containing forty-four index cards,
68.5 × 26.5 × 5 (27 × 10⅜ × 2)

▲ 1969

what one could call the extreme forms of "deskilling" photography that supplanted both the tradition of American documentary and that of American and European fine arts photography. Photography in the hands of these artists—post-Warhol and post-Ruscha—becomes a mere randomly accumulated set of indexical traces of images, objects, contexts, behaviors, or interactions in an attempt to make the complexity of both the architectural dimensions of public space and the social dimensions of individual interaction the subject matter of conceptual approaches. The third figure to be mentioned in this context, in dialogue with those figures mentioned above as photoconceptualists (although clearly positioning himself ▲ outside of their immediate circle), is Hans Haacke, who also deployed systems of photographic records in a deskilled production as an integral element for a "documentary" approach. In the work of these artists, documentation certainly claims no continuity with the ● documentary traditions of, say, FSA photography.

Kosuth deducted his own theory of Conceptual art from a dogmatic synthesis of the various, and contradictory, strands of modernism, ranging from Duchamp to Reinhardt (for Kosuth, Duchamp's readymades were the "beginning of 'modern' art" because they changed the nature of art "from 'appearance' to 'conception'").

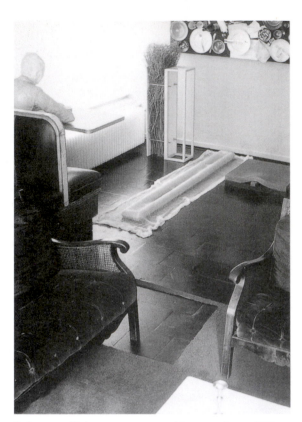

5 • Lawrence Weiner, *a square removal from a rug in use*, 1969
Installation in Cologne, West Germany, dimensions unknown

modernist self-reflection is still in play but now it is literally "inscribed," or written. It is thus linked with the quintessentially antimodernist strategy of visual withdrawal. Inasmuch as the "statement" ties the form to the wall that constitutes its frame, it denies the possibility of a separate visual entity by integrating it into the display surface as much as into the institutional support structure. That paradox, in which the quintessence of visual self-reflexivity is embedded within the contingency and the contextuality of these supports, is a classic conceptual strategy in Weiner's *Statements*.

Another major strand in Conceptual art was photoconceptualism, ▲ developed by figures such as Douglas Huebler, also a member of the Siegelaub group, Dan Graham (born 1942), and John Baldessari (born 1931). These artists introduced models of photographic practice that once again performed a peculiar fusion of Minimalist, late-modernist, and Pop art strategies manifestly derived from a more complex understanding of the implications for photography of Duchamp's readymade. Insofar as Graham's photographs, starting in 1965, focused on the peculiar echoes of modernity in its most debased forms of vernacular architecture—suburban housing developments—the readymade can be seen to be operative. In a work such as *Homes for America* [6], produced in several parts in 1966–7, Graham recognized the coding system of Minimalist sculpture—simple geometries arranged through serial repetition—in the found structures of vernacular architecture in New Jersey and elsewhere. That was the first subject of his photographic inquiry, but at the same time he also introduced an approach to photography that was then to be dominant in both Huebler's and Baldessari's use of the medium. This is

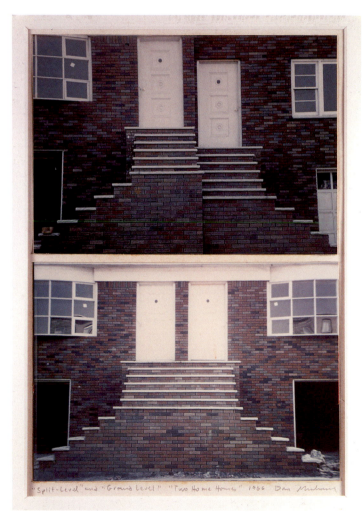

6 • Dan Graham, *Homes for America*, *"Split Level"* and *"Ground Level,"* *"Two Home Homes,"* 1966
Two photographs, 25.5 × 17.5 (10 × 17)

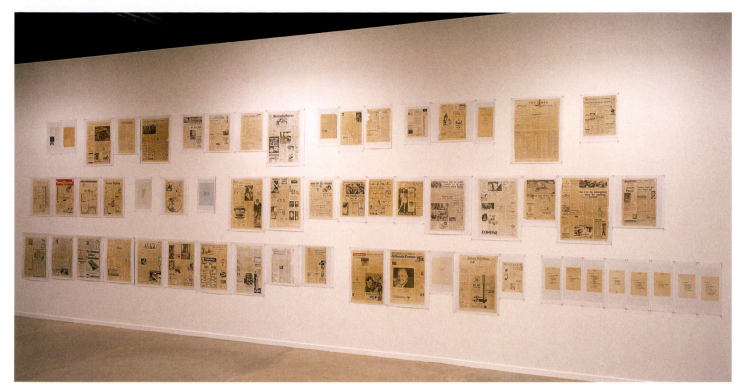

7 • Joseph Kosuth, *The Second Investigation*, 1969–74
Installation view

THIS IS NOT TO BE LOOKED AT.

8 • John Baldessari, *This Is Not To Be Looked At*, 1968
Acrylic and photoemulsion on canvas, 149.9 × 114.3 (59 × 45)

In *One and Three Chairs* (1965), he extended the readymade by breaking it into a tripartite set of relations—object, linguistic sign, and photographic reproduction—and in works such as *The Second Investigation* [7] he put into practice his assertion, as expressed in "Art After Philosophy," that the work of art is a "*proposition* presented within the context of art as a comment on art." Influenced by linguistic models, the laws of mathematics, and the principles of logical positivism, Kosuth defined his project—"and, by extension, other artists'"—as an "inquiry into the foundations of the concept 'art,' as it has come to mean." And yet, while valid for his own investigations, such a rigorously analytical approach was hardly applicable to any of the other practices emerging at that time. One artist who was explicitly excommunicated from Kosuth's late-modernist doxa was John Baldessari. Instead of turning Duchamp into doctrine, as Kosuth had done, Baldessari took his subversive legacies and applied them to the false orthodoxies with which Conceptualism was about to install itself as the new authoritative movement. Baldessari's work anticipated these new art-world pieties early on: he annihilated them with an antiartistic humor in both his paintings and his books [8]. BB

FURTHER READING

Alexander Alberro, *Conceptual Art and the Politics of Publicity* (Cambridge, Mass.: MIT Press, 2001)
Alexander Alberro and Patricia Norvell (eds), *Recording Conceptual Art* (Cambridge, Mass.: MIT Press, 2000)
Benjamin H. D. Buchloh, "From the Aesthetics of Administration to the Critique of Institutions," *October*, no. 55, Summer 1995, reprinted in *Neo-Avantgarde and Culture Industry* (Cambridge, Mass.: MIT Press, 2001)
Michael Newman and Jon Bird (eds), *Rewriting Conceptual Art* (London: Reaktion Books, 2001)
Peter Osborne (ed.), *Conceptual Art* (London: Phaidon Press, 2002)
Blake Stimson and Alexander Alberro (eds), *Conceptual Art: An Anthology of Critical Writings and Documents* (Cambridge, Mass.: MIT Press, 2000)

1969

The exhibition "When Attitudes Become Form" in Bern and London surveys Postminimalist developments, while "Anti-Illusion: Procedures / Materials" in New York focuses on Process art, the three principal aspects of which are elaborated by Richard Serra, Robert Morris, and Eva Hesse.

With its move into "specific objects" Minimalism signaled a definitive crisis in notions of the medium. The old standard of *quality*, assessed in relation to traditional painting and sculpture, was challenged by the new criterion of *interest*, which was not medium-specific: "a work of art needs only to be interesting," Donald Judd declared. If so, it followed for Judd, "any material can be used," and with new materials came new procedures, as explored in Process art, Arte Povera, Performance, Body art, Installation, and site-specific art. Often called "Postminimalist," these practices do follow Minimalism, some to extend its principles, most to react against them, but the term "Postminimalist" is no more coherent than the term "Postimpressionist." It did not help comprehension that these reactions came fast and furious. For example, 1966 was the year not only of "Primary Structures," the first museum survey of Minimalism in New York (held at the Jewish Museum), but also of "Eccentric Abstraction," the initial gallery show (again in New York) of art deemed eccentric to Minimalism both formally and psychologically. For its curator, the critic Lucy Lippard, the odd substances wrought in strange shapes by Louise Bourgeois, Eva Hesse, Bruce Nauman, Keith Sonnier, and others posed an "emotive or erotic alternative" to Minimalism, which was thus seen as normative as early as 1966. And if 1968 saw another museum review of Minimalism, "The Art of the Real" at the Museum of Modern Art, 1969 witnessed early institutional assessments of Postminimalism: as the titles suggest, "Anti-Illusion: Procedures / Materials" at the Whitney Museum focused on Process art, whereas "When Attitudes Become Form," first at the Kunsthalle in Bern, then at the Institute of Contemporary Arts in London, surveyed an international panoply of Postminimalist modes (its subtitle read "Works—Concepts—Processes—Situations—Information").

How are we to understand this heady round of position and counterposition, show and countershow, which is accelerated even by avant-garde standards? Does Postminimalism signal a new moment of artistic freedom and critical debate, or of aesthetic confusion and discursive anxiety? Is it a breakthrough into new materials and methods, or a breakdown in convention, a collapse in medium? Or is it both at once, an innovation born of crisis when, after the apparent supercession of painting and sculpture in Minimalism, the manipulating of substances and systems in Process and Conceptual art, and the marking of bodies and sites in Performance and Installation art, emerged both as creative possibilities and as default positions—medium-substitutes, as it were?

However different, all these practices responded to this crisis in medium, which forced two questions with special urgency: Is there a limit to the materiality of the art work, a zero degree of its visuality? And can the intentionality of the artist also be reduced, or at least transformed in its effects? The responses to these two questions were often divided, sometimes internally so. If some Conceptual artists "dematerialized" art (the famous term of Lippard), most Process artists rematerialized it with a vengeance: one thinks of the latex creatures of Eva Hesse or the polyurethane growths of Lynda Benglis (born 1941); "eccentric abstraction" is a mild term for such works. As for intentionality, some Process artists saw new materials as mere vehicles for expressive intent (e.g., Benglis, who indeed turned "attitudes" into "form"), while others saw intrinsic properties that the work might disclose automatically, as if without authorial intervention: Morris let his felt strips hang limply [1] and his threadwaste sit humped, while Serra allowed the ambient architecture to shape his lead splashings [2]. As in Conceptual art, which was divided between the concept as pure intention (e.g., Joseph Kosuth) and the concept as quasi-automatic "machine" (Sol LeWitt), this split over intentionality stemmed in part from different readings of Duchamp—of the readymade seen as an act of declarative choice ("I nominate this urinal to be a work of art") or as an attempt to annul choice altogether ("a reaction of visual indifference … a complete anesthesia," as Duchamp once claimed).

A search for the motivated

Two aspects of this "postmedium" condition are relevant to Process art. First, however restrictive, traditional mediums offer practical rules for making and meaning: art may seem free without such constraint, but it may also become *arbitrary*. This was a primary point of anxiety not only for critical foes of Minimalism and Postminimalism, such as Clement Greenberg and Michael Fried, but also for artist proponents like Morris, for whom Process art was driven by a "search for the motivated" now that the protocols of medium-specificity seemed to be voided—a search, that is,

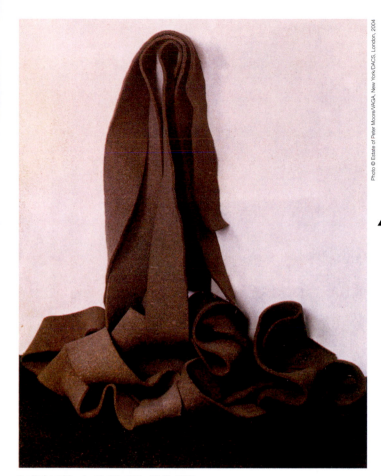

Photo © Estate of Peter Moore/VAGA, New York/DACS, London, 2004

1 • Robert Morris, *Untitled (Tan Felt)*, 1968
Nine strips, each 304.8 × 20.3 (120 × 8). Installation, 172.7 × 182.8 × 66 (68 × 72 × 26)

for other ways to ground art, as in the "logic of materials" proposed by Serra, or in the "order of making behavior" (triangulated by "the nature of materials, the restraints of gravity, the limited mobility of the body interacting with both") proposed by Morris. This is the first point to stress about Process art. The second is that it also *continued* a critical engagement with traditional mediums; in particular it continued the Minimalist critique of the illusionist space and relational composition thought to be residual in abstract painting and sculpture. This is why the first imperative of most Process art was to overcome the traditional oppositions of form and content (stressed by Lippard) and of means and ends (stressed by Serra and Morris)—to reveal the process of the work in the product, indeed *as* the product. This is also why the second imperative of some Process art was to overcome the no-less-traditional opposition of figure and ground, of a vertical image read against a horizontal field (whether this field be illusionist, as in painting, or actual, as in sculpture). It is this second imperative that led artists such as Morris, Serra, Alan Saret (born 1944), and Barry Le Va (born 1941) to scatter different materials (e.g., threadwaste, felt, wire, shattered glass) in gallery spaces in such a way that "the figure is literally the ground" (Morris). Already in "Eccentric Abstraction," Lippard described this field effect as "an alogical visual compound, or obstreperous Sight," an elliptical account that points to a third imperative of some Process art. For with the object often disturbed,

if not dissolved, and the gaze of the viewer often diffused, if not deranged (made "obstreperous"), a new nonfigurative intimation of the body became possible. Early on, Lippard called this corporeal evocation (it was most apparent in Hesse) a "body-ego"; more recently, critics such as Rosalind Krauss and Anne Wagner have discussed it instead as a nonrepresentational registering of psychic fantasies and bodily drives. It is these three dimensions that are distinctive to Process art—a logic of materials, a field effect, and a phantasmatic corporeality—and they are probed most effectively by Serra, Morris, and Hesse respectively.

▲ In his protean way, Robert Morris followed his essays on Minimalism with a suite of texts equally important to Postminimalism: "Anti-Form" (1968), "Notes on Sculpture, Part 4: Beyond Objects" (1969), and "Some Notes on the Phenomenology of Making: The Search for the Motivated" (1970). Just as Minimalism had questioned the relational composition of abstract painting and sculpture, so Morris now questioned the arbitrary ordering of Minimalist objects: "What remains problematic about these schemes," he writes in "Anti-Form," "is "that any order for multiple units is an imposed one," with "no inherent relation to the physicality of the units." Here Morris extended the Minimalist criterion of unity beyond the object to its making, which effectively returned Pollock as the exemplary artist who was most able to retain his process "as part of the end form" of his work through a "profound rethinking" of his tools and materials—in particular, his use of sticks in the drip paintings to disclose the essential fluidity of the

● paint. This account of Pollock differs dramatically from the pure painter of opticality presented by Greenberg, but also from the existential actor of painting as performance and the great predecessor of happenings, as proposed by Harold Rosenberg and

■ Allan Kaprow respectively. With Morris the ideal derived from Pollock became a work united less in its image than in its process, self-evident in its making.

Perhaps paradoxically, this theory of procedural unity often inspired a practice of antiformal dispersal. Yet for Morris, Serra, Saret, and Le Va such dispersive gestures were not intended to continue Abstract Expressionism by other means: they were meant to reveal not the subjectivity of the artist, but the materiality of the

◆ work as resistant to ordering, as bound to entropy. To this end gravity was deployed as a force of (de)composition, "chance [was] allowed and indeterminacy [was] implied," as "random piling, loose stacking, hanging, [gave] passing form to the material" (Morris). Morris was most programmatic in his demonstrations. In *Continuous Project Altered Daily* (1969)—the title delivers the procedure as well as the point of the work—he manipulated such materials as earth, clay, asbestos, cotton, water, grease, felt, and threadwaste for three weeks, with no final form. In *Threadwaste*, a tangle of threadwaste, felt, copper tubing, and mirrors, and in *Dirt* (1968), a mound of earth, grease, peat moss, bricks, felt, and assorted metals, he refused to aestheticize his materials at all. Here the attack on the verticality of painting and sculpture resulted in a debasement that was both literal and symbolic: the art work, scattered on the floor almost as refuse

▲ 1965 ● 1949a, 1960b ■ 1961 ◆ 1967a

with minimal manipulation, was disincorporated to the point where "scatter" began to evoke "scatological."

A "dedifferentiating" of vision

Richard Serra (born 1939) also turned to process to attack figure–ground conventions in painting and sculpture. His performance of tasks, resistant to imagery and detached from subjectivity, was similar to Minimalist dance and serial music of the
▲ time, and indeed he was intimate with dancers such as Joan Jonas and Yvonne Rainer and composers like Philip Glass and Steve Reich. In 1967–8 Serra generated a list of verbs ("to roll, to crease, to fold …") that generated in turn a set of works. One instance, *Casting* [2], is paradigmatic of Process art, for here the process became the product without remainder. Yet this convergence of material, action, and site (of lead, casting, and wall) also antici-pated his site-specific sculpture. As with Morris, then, process
● led Serra to field effects, with "the discrete object dissolved into the sculptural field which is experienced in time." But Serra differed from Morris in two respects. First, he held that many antiformal scatterings were not as subversive of figure–ground conventions as they purported to be. "A recent problem," he wrote in 1970, "with the lateral spread of materials, elements on the floor in the visual field, is the inability of this landscape mode to avoid arrangement qua figure-ground: the pictorial convention." Second, Serra retained the category of sculpture, even though he redefined it as a relation between "the sculp-tural field" and the viewer set in temporal motion within this field. Thus he saw Process art, as he would its site-specific successor, as a way not to exceed sculpture but to render it appropriate to the industrial conditions of modern society (Serra worked in steel mills as a young man, while Carl Andre,
■ who shared his Constructivist concerns, worked on railroads).

Thus he foregrounded particular processes of engineering, fabri-cating, and rigging, especially in his "prop" pieces [3], as a means not only to disclose the inherent properties of materials such as lead (weight, density, rigidity) but also to demonstrate "the axio-matic principles" of sculpture as *building*.

For Morris, on the other hand, process was a way less to continue sculpture than to move "beyond objects" altogether. This "beyond" was not, however, a conceptual reduction of art to an essential idea but an enquiry into its fundamental visuality: "to take the conditions of the visual field" as its "structural basis." To this end Morris would present an array of materials such as threadwaste or dirt that could not be grasped, in profile or in plan, as an image at all—less to set the viewer in motion (as with Serra) than to shift from a focal gaze on a specific object to a "vacant stare" on a visual field. Here the Minimalist undoing of spatial illusionism became a Postminimalist "dedifferentiating" of vision that was rendered "a structural feature of the work" as such ("dedifferenti-ating" was derived from art theorist Anton Ehrenzweig, whose *The Hidden Order of Art* [1967] was suggestive for Morris,
▲ Robert Smithson, and others). Oddly, then, process here concerns visuality more than materiality. Or, more precisely, it concerns a visuality that is at once materialized in stuff and scattered in space, decentered from any subject—as if to register that vision is somehow in the world too, that the world gazes back at us as well. Interestingly, these implications are in keeping with "the phenome-nology of perception" of Maurice Merleau-Ponty (translated into English in 1962), as well as "the psychoanalysis of the gaze" of Jacques Lacan (delivered as seminars in Paris in 1964).

In this liminal moment between modernism and post-
● modernism, Eva Hesse was especially inventive, and she has remained influential because, as with Louise Bourgeois, her twisting of figure–ground conventions allowed her to implicate the body in new ways—the body as disturbed by the psyche, as the

Photo © Estate of Peter Moore/VAGA, New York/DACS, London, 2004

2 • Richard Serra, *Casting*, 1969
Lead casting, c. 10.2 × 762 × 762 (4 × 300 × 300) (destroyed)

▲ 1973 ● 1970 ■ 1962c

Photo © Estate of Peter Moore/VAGA, New York/DACS, London, 2004

3 • Richard Serra, *One Ton Prop (House of Cards)*, 1969
Lead antimony, four plates, each 122 × 122 (48 × 48)

▲ 1965 ● 1966b

4 • Eva Hesse, *Hang Up*, 1966
Acrylic paint on cloth over wood; acrylic paint on cord over steel tube,
182.9 × 213.4 × 198.1 (72 × 84 × 78)

material of fantasy and obsession, desires and drives. A year before Serra constructed his work-order verb list, the Conceptual artist Mel Bochner made a *Portrait of Eva Hesse* (1966) that consisted of very different verbs ("secrete, bury, cloak …") written in circles with "wrap" in the center. These verbs are erotically charged activities intimate with the body understood as a psychic site, not rationally detached procedures of the body seen as a taskmaster. Her work thus evokes a particular erotic body, not an anonymous, neutral one of much Minimalist art. Some critics have seen this body as specifically female—as part of an early feminist reclamation of an essential female embodiment, whether understood in terms of a womb or a wound. Other critics have read it as a body that upsets such markers of sexual difference—less a stable female "body-ego" (Lippard again) than a quasi-infantile congeries of conflicted drives and part-objects.

Early on, Hesse set up a space between painting and sculpture where such phantasmatic figurations might arise. With a frame that, though meticulously painted in different shades of gray, is left empty save for a loop that extends absurdly into our space, *Hang Up* [4] both declares the conventions of painting (as bound, painted, and hung up) and empties them out. In this way painting seems to mutate here into a thing possessed of obsessions of its own

(as bound, painted, and hung up in another sense). This witty play, sometimes light, sometimes dark, is characteristic of Hesse, whose constructions in latex, fiberglass, and cheesecloth can evoke the body in extreme ways. Serra and Morris often force our bodies into a phenomenological confrontation with an object or a field that undoes any purity or stability of form. With Hesse, this undoing is also psychological: it is as if, charged in a strange empathy with her objects, our bodies are disrupted *from within*. Rather than painting or sculpture that reflects a proper figure, an ideal body-ego, back to us as in a mirror, Hesse evokes a body "deterritorialized" by desires and drives that just might be our own. HF

FURTHER READING
Rosalind Krauss, "Sense and Sensibility: Reflections on Post-'60s Sculpture," *Artforum*, vol. 12, no. 3, November 1973, and *The Optical Unconscious* (Cambridge, Mass.: MIT Press, 1993)
Lucy R. Lippard, *Changing: Essays in Art Criticism* (New York: Dutton, 1971) and *Six Years: The Dematerialization of Art* (New York: Praeger, 1973)
Robert Morris, *Continuous Project Altered Daily* (Cambridge, Mass.: MIT Press, 1993)
Richard Serra, *Writings Interviews* (Chicago: University of Chicago Press, 1994)
Anne M. Wagner, *Three Artists (Three Women): Georgia O'Keeffe, Lee Krasner, Eva Hesse* (Berkeley and Los Angeles: University of California Press, 1997)
Mignon Nixon (ed.), *Eva Hesse*, October Files 3 (Cambridge, Mass.: MIT Press, 2002)
Hal Foster (ed.), *Richard Serra*, October Files 1 (Cambridge, Mass.: MIT Press, 2000)

1970–1979

1970

Michael Asher installs his Pomona College Project: the rise of site-specific work opens up a logical field between modernist sculpture and Conceptual art.

▲ In his 1966 "Notes on Sculpture: Part II," Robert Morris had described the Minimalist object as taking "relationships out of the work" by making them "a function of space, light, and the viewer's field of vision," adding that "one is more aware than before that he himself is establishing relationships as he apprehends the object from various positions and under varying conditions of light and spatial context." By the end of the decade this aesthetic of "varying conditions of light and spatial context" had dispensed with the object altogether to create instead an altered site: a space, sometimes public (a city street), more often private (a gallery or museum interior), into which the artist had minimally intervened.

One could say, then, that site-specificity—the name attached to such interventions—was a kind of Minimalism by other means. And while in fact it constituted a critique of Minimalism, which it saw as still dependent on the work of art as actual, consumable object, it nonetheless extended the feel of the earlier movement. For in its stripping away of all surface incident, in its proclivity for industrial building materials (steel in the case of Richard Serra, sheet rock in the case of Michael Asher, plywood in the case of
• Bruce Nauman), and in its love of simple, geometric shapes, even if these were now the shapes of spaces rather than objects, site-specific work was clearly extending some of Minimalism's principles.

Walk-in Minimalism

This relationship is clear in Richard Serra's twenty-six-foot-wide ring embedded into a derelict street in the Bronx (*To Encircle Base Plate Hexagram, Right Angles Inverted* [1]). Though its title derives from the list of transitive verbs that Serra had drawn up as a basis
■ for the process pieces he made, such as *Splashing* (1968) or *Casting* (1969), its drive is away from the figure–ground ambiguity that such process work courted and instead toward an extreme simplicity of shape, so that this "minimal" gesture intervenes in the urban setting as a kind of liminally perceived signal of order.

Michael Asher's (1943–2012) project at the Pomona College Art Gallery in Claremont, California, which lasted barely a month (February 13–March 8, 1970), was another such intervention, this time organized within a private setting. Based on the architectural givens of the gallery itself, the project focused on the institution's

1 • Richard Serra, *To Encircle Base Plate Hexagram, Right Angles Inverted*, 1970
Steel, diameter 792.5 (312)

main exhibition space and its lobby, including the entry doors facing the street. Into these rooms Asher inserted a series of new walls that altered the shapes of the two spaces, turning them into opposing isosceles triangles—one relatively small, the other quite large—fused at their tips to leave a two-foot-wide passage from one to the other [2]. As well, a false ceiling lowered the space from its height of approximately twelve feet to a clearance exactly flush with the entry doors (6 feet 10 inches), which had been removed to leave a square, unimpeded opening onto the street. The experience was, then, like walking into the inside of a hugely inflated Minimalist sculpture in which visual incident had been pared down to changes of light over the surfaces of the walls and shifting

▲ 1965 • 1966a, 1967a, 1969, 1973 ■ 1969

perspectives caused by one's own movement. This, however, is too aestheticized a consideration of the "experience," since the wrenching open of the private confines of the museum to make them entirely porous to public entry, twenty-four hours a day, moved the work beyond the aesthetic domain and into something that is more properly called the sociopolitical.

In one way it could be said that the work was wholly about "entry" (forced or not), since the angled walls seemed to have converted the exhibition space into nothing but continuous corridor. But the way the onset of this passageway was articulated from each of the two sides of its threshold was significant about what Asher was doing in the work. For from inside the gallery, the perfectly square opening framed the street beyond as a "picture," an aestheticized object submitted to the controlling conditions of the museum, with its presumption about the specialness, or autonomy, of the experience it provides; while from the street side, the yawning orifice expressed the way the museum's privilege had been breached, rendered continuous with the conditions of its surrounds. The work was thus able to comment on the museum's assumptions of autonomy even while refusing to allow those same assumptions to continue to operate. In this sense, Asher's critique was directed simultaneously against the (Minimalist) production of objects open to commodification and consumption and against the institutional apparatus of the museum as the space constituted to endow such activity with cultural legitimacy.

Insofar as the *Pomona College Project* was tailor-made to its physical confines, it could be called site-specific. But insofar as it was cut to the measure and geared to expose the logic of its socio-cultural container, it joined a type of work that identified itself as a ▲ critique of institutions. Involving both a dematerialization of the art object and a focus on the conventions, or social pact, that invisibly underwrite the supposedly "universal" conditions of aesthetic judgment, the *Pomona College Project* could also be connected to ● the aims of Conceptual art. But there is another sense in which the phenomenological richness of the work, its invitation to its audience to move through it bodily and thus to participate in the constitution of its meaning, identifies it with other, more materialized types of interventions, such as the work of Serra, or Nauman, ■ or Robert Smithson, work that would indeed have trouble sailing under the flag of Conceptualism.

A case in point is Richard Serra's *Strike: To Roberta and Rudy* [3], a massive steel plate whose dimensions, 8 feet high by 24 feet long by 1 inch thick, leave the viewer in no doubt about how much it weighs, but whose simplicity both of shape and of construction—it is maintained as a vertical simply by being butted into the corner of the gallery in which it is installed—could be said to be Minimalist, except that the experience goes beyond this into something else. For the work exists in the contradiction between the threat

2 • Michael Asher, *Pomona College Project*, 1970
(top) Axonometric drawing of the installation for the Gladys K. Montgomery Art Center Gallery; (middle) view out of gallery toward street from small triangular area; (bottom) entry/exit and view into constructed triangular area

▲ Introduction 4, 1971 ● 1968b ■ 1967a

of its tonnage bearing down on one's body and the sense of its dematerialization into the mere condition of a "cut"—a line that both separates and connects, like the splice between two pieces of film across which our imaginations leap to connect one shot to another in the creation of the illusion of a whole, continuous spatio-temporal field. For, projecting out from its corner, *Strike*'s bafflelike plane slices the space's volume in half, leaving only a few open feet to circulate around one of its edges. As the viewer moves around the work, its plane is perceived as contracting to a line (or edge) and then expanding back into a plane. Reciprocally, the space is blocked off and then opened out and subsequently reblocked. In this movement, closed–open–closed, the space itself is experienced as the matter on which the cut, or slice, of *Strike* operates, a cut that knits together the raveled sleeve of experience, uniting it beyond the split into the splice. Moreover, because it is the viewer, traversing the space, who is him- or herself the operator of this cut, its activity becomes a function of the viewer's perceptual work as well; the viewer is working with it to reconvene the continuity of his or her own lived world.

Not everything is possible

If Serra and Asher were making insertions, both material and conceptual, into architectural spaces, other artists at this same moment had moved beyond the locatable, sculptural object by operating directly on the landscape. Famously, Smithson projected his *Spiral Jetty* fifteen hundred feet out into the Great Salt Lake at Rozel Point, Utah [**4**]; while Michael Heizer (born 1944) cut two enormous (1,100 × 42 × 30 feet) notches out of opposing mesas in Mohave Desert, Nevada, to form his *Double Negative* (1969). Although these installations were built to last, the idea of such "Earthwork" did not necessitate permanence and, indeed, the British artists Richard Long (born 1945) and Hamish Fulton (born 1946) operated in the landscape more conceptually, taking walks or making temporary mounds or rings of stones that they documented photographically.

In the early seventies, then, it appeared as though a wide range of entirely diverse practices had canceled what had been the strict ▲ formal logic of Minimalism in both the sculpture and painting that had seemed to rule the previous decade. All kinds of materials could be used, from wheat crops cut into giant patterns by harvesters (Dennis Oppenheim) to acoustical soundproofing tiles into the holes of which tiny rolls of paper were inserted (Sol LeWitt); all kinds of operations could be conducted, from the crushing and burying of a cabin (Smithson) to the stringing of hundreds of miles of parachute material across the countryside (Christo); all kinds of "engagement" could be encompassed, from the political commitment of institutional critique (Michael Asher) to the aestheticization of an organized lightning field (Walter De Maria). It thus seemed, as the song had put it, "Anything goes."

It is, however, always worth looking beyond claims of "pluralism"—the kind of explanation that was being offered by

3 • Richard Serra, *Strike: To Roberta and Rudy*, 1969–71
Hot rolled steel, 243.8 × 731.5 × 2.5 (96 × 288 × 1)

Photo © Estate of Peter Moore/VAGA, New York/DACS, London, 2004

critics in the seventies—for an underlying logic that unites what would appear as mere randomness or the diversity of individual choice. For pluralism presupposes that everything is available to every artist at every moment in history, that there are no overriding historical factors that limit the available options and organize behavior no matter how independent it might appear. Against this ▲ notion the early art historian Heinrich Wölfflin had cautioned, however: "Every artist finds certain visual possibilities before him, to which he is bound. Not everything is possible at all times."

We began by noticing how Asher's Pomona project, like other site-specific work, was both a critique and a continuation of Minimalism. In its foregrounding of the phenomenology of bodily experience, Serra's *Strike* also accepts certain aspects of the earlier movement while rejecting others; and both *Spiral Jetty* and *Double Negative* can be added to this list. The issue, then, is to try to map the logic of the way this diversity exfoliates from Minimalism itself, while never forgetting Minimalism's own dialectical relation to modernist sculpture, which it both refined and terminated.

Expanded fields

To do this we might back up a bit and permit ourselves to make a series of generalizations about traditional sculpture as a whole, modernist sculpture in general, and Minimalism in particular. We might start by observing that through the ages sculpture had functioned in relation to what could be called the logic of the monument, itself an earlier form of "site-specificity." Sculpture, that is, had operated to mark a real site—grave, battleground, ceremonial axis—with a representation of its meaning: funerary figure, *pietà*, equestrian statue. By lifting the field of such a representation off the ground of real space, the pedestal of this statuary had a liminal function: it established the virtual, symbolic nature of the representation even while physically linking that to the actual site—either landscape or architecture—that it marked.

▲ 1957b, 1965, 1967c ▲ Introduction 3

It is in the late nineteenth century that we experience the waning of this logic of the monument, perhaps because of the split between the aims of artists and the tastes of their patrons—as when the ▲ group that had commissioned Auguste Rodin to make a monument to the writer Honoré Balzac rejected his work —or perhaps because the enormity of historical events outstripped the possibility of "representing" them (we think of the World War I dead). Just as the failure of Rodin's commission occasioned the multiplication of his Balzac statue so that it now appears in many different sites, to none of which it is logically connected, so modernist sculpture in general can be seen to establish the "autonomy" of the representational field of the work, its absolute withdrawal from its physical context into a wholly self-contained formal organization. There were, of course, certain attempts to break from this ● autonomy—as in Vladimir Tatlin's Monument to the Third

▲ International or in the readymade's refusal of the condition of sculpture altogether—but the main thrust of modernist sculptural production sought to reinforce the privileged space of the autono- ● mous object as much as possible. In Brancusi's case this drive led to the extension of the representational field downward to include the pedestal itself in a declaration that no part of the work, not even its formerly mundane, physical support, would escape the reign of the formal and the virtual.

Given this resolute removal of the object's symbolic concerns from what were its earlier conditions of possibility, namely architecture and landscape, modernist sculpture might, then, be projected in terms of this rejection, defining its condition as a kind of pure negativity, the combination of exclusions. In this sense it is the exact inverse of the basis for traditional sculpture, the positivity of the logic of the monument.

Structuralism provides us with a model that helps to conceive of social forms in terms of logically related inclusions and exclusions. Based on a logical structure, sometimes referred to as a Klein group, this model shows how a set of two opposing terms, a binary opposition, can be opened up into a quaternary (or fourfold) field without changing the character of the opposition itself.

Projecting the "strong" form of the opposition on what it calls the "complex axis"—black vs. white, say—the Klein group demonstrates that the same binary can be expressed in a less vehement way—as not-black vs. not-white—thus converting the strong statement (both / and) to a "neutralized" one (neither / nor).

Applying this model to what we have observed in the field of sculptural practice we could say that in ceasing to be the positivity that marked its site, modernist sculpture was now the category resulting from the addition of the not-landscape to the not-architecture.

And further, with the onset of Minimalism, this withdrawal drew fire from the sculptors who wanted their work to engage its context, becoming as we have seen "a function of space, light, and the viewer's field of vision." If Minimalism still generated the sculptural object, however, site-specific works and Earthworks, in their abandonment of that object, extended the Minimalist engagement with the site—which modernist sculpture had voided—and began to work instead with the positive terms architecture and landscape.

This was not merely a return to traditional sculpture's acknowledgment of its site, however, since that had always before occurred symbolically—in a "virtual" field of representation. Instead, this new work engaged it directly. It now imagined the possibility of an exact inverse of modernism in the "both / and" in a way that had been seen before only in structures such as labyrinths, Japanese gardens, or the ritual playing fields and processionals of ancient civilizations, which, occupying the complex axis, were both landscape and architecture. An example of this assumption of the complex term might be Smithson's *Partially Buried Woodshed* (1970). But such new work also took advantage of the other possibilities of the quaternary field, namely a combination of landscape and not-landscape, which we could call the "marked sites" of Earthworks such as Smithson's *Spiral Jetty* or his *Mirror Displacements in the Yucatan* (1969); and a combination of architecture and not-architecture, which could be called "axiomatic structures," and in which we would include Asher's *Pomona College Project*.

The structuralist diagram of this quaternary "expansion" of the simple binary allows two aspects of the new practices of the seventies to come to light. The first is a sense of the logical connection between the practices, and the possibilities of moving from one position to another within a given artist's practice. The second is the clarity with which it shows how focus has moved from a concentration on the rules internal to a given medium—sculpture as a physically bounded, three-dimensional object—to the cultural conditions, far larger than the medium, that are now seen as ballasting it. The practices identified with site-specificity wanted to operate directly on those cultural conditions; directly, we could say, on the frame of the world of art. The term "expanded field" is one way of mapping that frame. RK

FURTHER READING
Michael Asher, *Writings 1973–1983 on Works 1969–1979* (Halifax: The Press of the Nova Scotia College of Art and Design, undated)
Benjamin H. D. Buchloh, Neo-Avantgarde and Culture Industry (Cambridge, Mass.: MIT Press, 2000)
Hal Foster, "The Crux of Minimalism," *Individuals* (Los Angeles: Museum of Contemporary Art, 1986)
Fredric Jameson, *The Political Unconscious: Narrative as a Socially Symbolic Act* (Ithaca, N.Y.: Cornell University Press, 1981)
Rosalind Krauss, "Sculpture in the Expanded Field," *The Originality of the Avant-Garde and Other Modernist Myths* (Cambridge, Mass.: MIT Press, 1986)

1971

The Guggenheim Museum in New York cancels Hans Haacke's show and suppresses Daniel Buren's contribution to the Sixth Guggenheim International Exhibition: practices of institutional critique encounter the resistance of the Minimalist generation.

Two major incidents of censorship at the Guggenheim Museum in 1971 involved artists of the Postminimalist generation. Perhaps more accidentally, both placed European artists in opposition to American art institutions and, in the second case, in dialogue with certain American artists. The first scandal emerged on the occasion of the retrospective exhibition scheduled for Hans Haacke (born 1936), which was canceled at the last minute because of the request by the Museum's Director Thomas Messer to eliminate two pieces from the exhibition, a request with which both the artist and the curator, Edward Fry, refused to comply. This led to the cancellation of the exhibition in its entirety and to the firing of the curator.

It is particularly important to take into account the multiple causes and ramifications of this confrontation in order to understand its historical complexity. First of all, it concerns work that points, at a relatively early moment, to the deneutralization and repoliticizing of photoconceptualist practices. It is not the first but

one of the earliest major projects by Haacke in which the assumed neutrality of photographic imagery is explicitly repositioned with regard to social, political, and economic fact-finding, in the manner of muck-raking journalism.

As almost always in Haacke's case, the two works, *Shapolski et al. Manhattan Real Estate Holdings* [1] and *Sol Goldman and Alex DiLorenzo Manhattan Real Estate Holdings* (both 1971), consisted quite simply of cumulative recorded facts available in the New York Public Library and collected and presented by the artist. These concerned the extensive real-estate dealings of two or three families who, under the various guises of holding companies and corporate entities, had assembled vast empires of slum housing in different parts of New York. By tracing the interrelationships and connections between, and the often hidden titles of, these various owners, Haacke revealed the structure of these slum empires. Simple, matter-of-fact trackings of tenement holdings, the pieces are without any accusation or polemical tone.

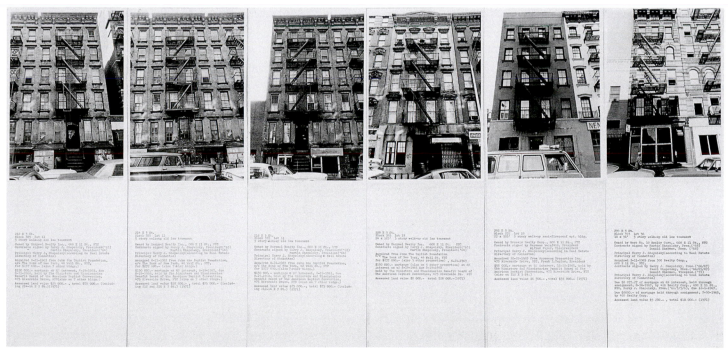

1 • Hans Haacke, *Shapolski et al. Manhattan Real Estate Holdings, a Real-Time Social System, as of May 1, 1971*, 1971
142 photos with data sheets, 2 maps, 6 charts, slide excerpt

▲ 1969 ● 1968b, 1984a

In Messer's argument against the inclusion of the two pieces in the exhibition, he called them "work that violates the supreme neutrality of the work of art and therefore no longer merits the protection of the museum." This confrontation operated, then, on the level of what defines the neutrality of the work of art and of what defines artistic, aesthetic practices as opposed to political, journalistic ones. It was around this threshold that the actual conflict and the ensuing polemics would then develop.

The exclusion of Haacke's work points to another dimension that was becoming problematic within the discourse of the art world, for it coincided with the very moment when works incorporating photography and text had become a crucial format for ▲ Conceptual art as a whole and when the status of such strategies as artistic production was increasingly being contested by a variety of critics and historians. Rosalyn Deutsche has convincingly argued that there was an additional dimension of the real-estate works that led to their suppression, namely the fact that through them Haacke brought two types of architectural space, two sociopolitical models of urban condition, into stark confrontation: the slum housing of New York's massive underclass and the luxurious "neutrality" of the uptown, exclusionary, high-art institutions with their total obliviousness to the situation of the large majority of people who share the same urban space. Deutsche's reading of Haacke's work—as an effort to juxtapose social spaces as defined by architectural structures—is an important additional interpretation of his practice.

The limits of Minimalism

The second scandal occurred a few months later, on the occasion of the Sixth Guggenheim International Exhibition, in which the French artist Daniel Buren attempted to install a huge bannerlike work slicing through the cylindrical space of the building's central atrium [2], matching that banner with a smaller external element to be installed across the street at 89th Street and 5th Avenue. Having been approved by the show's curator, Diane Waldman, the work's troubles arose only at the point of its being put in place, when several artists participating in the International opposed the installation and insisted on its removal, threatening to withdraw from the exhibition otherwise. The argument of these artists— • Donald Judd, Dan Flavin, Joseph Kosuth, and Richard Long—was that the size and placement of the huge banner obscured the view of their own installations throughout the Guggenheim.

The absurdity of the argument becomes evident when one realizes that Buren's work was a piece of cloth that, as the viewer descended the spiraling ramp, continuously expanded and contracted—from the width of a frontal view to the linear profile of a side view within which the work was almost imperceptible. Thus, as Buren anticipated, for at least half the time all of the museum and the works in its galleries were fully visible from across the ramps. In the end, this conflict was resolved by Waldman's giving in to the demands of the other artists. Buren's banner was removed.

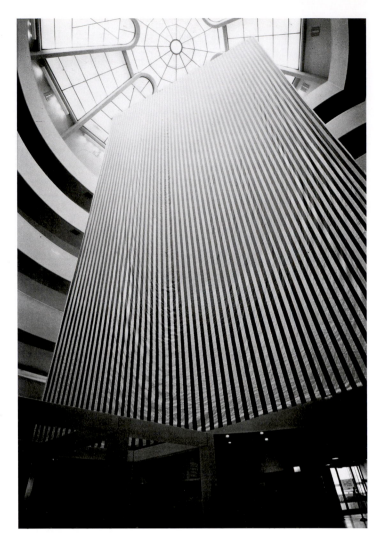

2 • Daniel Buren, Photo-souvenir: *"Peinture-Sculpture,"* work in situ, at the Sixth Guggenheim International Exhibition, Guggenheim Museum, New York, 1971 (detail)

But beyond the smokescreen of the artists' explanation of their objection is the more important question of a clash between two generations: the Minimalists on the one hand and Buren, as representative of an emerging Conceptualist position with a clear focus on institutional critique, on the other. As Minimalists, Judd and ▲ Flavin, who were the most outspoken in their aggression against Buren, clearly sensed that Buren's work revealed several fallacies in their own positions. The first of these was the assumption of the neutrality of the phenomenological space within which the viewer interacts with the work. This assumption was counteracted by Buren's programmatic formulation of the theory of institutional space, within which a purely visual or a purely phenomenological experience can not be conceived. This is because institutional interests, which are always mediated by economic and ideological interests, inevitably reframe and redefine the production, the reading, and the visual experience of the artistic object.

The second fallacy was revealed through the way that Buren's piece set up a confrontation between museum architecture and sculptural work, specifically in the Guggenheim Museum, where Buren provocatively countered Frank Lloyd Wright's extraordinary building—in its control, its containment, its utterly unmanageable

imposition on any traditional pictorial or sculptural work installed within its confines—by manifestly piercing the space, the spiraling funnel of the museum, with his own work. In contrast to this, the other objects were fully but naively confident in their assumption about the availability of a neutral, architectural space.

This dialogue, which then escalated into confrontation, in the course of which Judd called Buren a "paperhanger" and other such insults were thrown around, in fact points to one of the crucial intersections of the late sixties and early seventies. For the beginnings of an artistic practice related to Conceptualism but not defined by it— ▲ one of the key figures of American Conceptual art, Joseph Kosuth, had after all joined with Judd and Flavin in excluding Buren—were being forged at that time in the European variation on Conceptual art that would come to be called institutional critique.

Testing repressive tolerance

As it is formulated by both Haacke and Buren in these years, institutional critique is a project that could be associated with the development of poststructuralist and critical theory in their impact on visual practices. We could say that for Haacke this effect is evidently the legacy of Frankfurt School thought and • Jürgen Habermas, while for Buren it is evidently the structuralist ■ and poststructuralist legacy of Roland Barthes, Michel Foucault, and Louis Althusser that led to artistic practices taking into account the inescapable subjection of art to ideological interests. In Buren's case, this also led to the recognition of the extent to which the discourse on art (its criticism, its history) is defined by and subjected to institutional networks, an issue articulated by him as early as 1970 in his essay "Limites Critiques."

If institutional critique in Haacke's hands is different from that in Buren's, this might be a function of their respective theoretical backgrounds. For Haacke, institutional critique is an attempt to recontextualize the sphere of the aesthetic, with its socioeconomic and ideological underpinnings, in a somewhat mechanistic manner. This is fully embodied in *Solomon R. Guggenheim Museum Board of Trustees* [**3**], a work people have, not erroneously, seen as a belated response to the initial censorship and cancellation of his 1971 show. At the time, journalists mistakenly connected the owners of the slum properties to the Guggenheim Board, although they actually had no connection whatever to the Museum's Trustees.

The timing of the work, however, indicates that it is motivated by a much more urgent reflection than personal revenge, since it is sited at the point of the crisis in Chile, the democratically elected President Ferdinand Allende having been overthrown and murdered in a CIA-sponsored coup by the Chilean military. It is at that moment that Haacke reveals the profound connection between a large number of the Trustees of the Guggenheim and the Kennecott Copper Corporation in Chile. One of the driving forces behind the intervention of the CIA in Chile at that time was the massive threat to the Corporation's (and the American military's) interests posed by the nationalization of the copper mines by its newly elected president.

The second piece that would point to Haacke's persistent attempts to recontextualize the art object within cultural practices at large is a work installed in 1974 in his home town of Cologne when, on the occasion of the 150th anniversary of the Wallraf-Richartz Museum, Haacke was invited to participate in an exhibition called "Projekt '74." For this he provided a series of ten panels tracing the provenance of Manet's *Bunch of Asparagus* (1880), a painting that had been donated to the Museum in 1968 by the Friends of the Wallraf-Richartz Museum, under the leadership of its chairman, Hermann Josef Abs, in memory of Konrad Adenauer, the Federal Republic of Germany's first chancellor. As was the case for all the other panels, the final panel—the conclusion of this history— presents an analysis of Abs's background, since he functioned as the head of the entity that donated the work to the Museum. In this instance what it reveals is that Abs, who had been the most prominent banker and financial adviser of Hitler's Reich from 1933 to 1945, had been reinstated after the war in positions of similar influence from the time the Adenauer government took office in 1949, and had remained in a place of extraordinary power throughout the sixties up to the moment of his gift of the still life to the Museum.

That final panel is one of ten that trace the history of the painting from its first owner, Charles Ephrussi (a French Jewish art historian and collector who was reputed to be one of the models for Proust's character Charles Swann), to figures such as the German publisher

3 • Hans Haacke, *Solomon R. Guggenheim Museum Board of Trustees*, 1974 (detail)
Seven panels, each 50 × 61 (19⅝ × 24), brass frames (central panel shown here)

Michel Foucault (1926–84)

Michel Foucault's work was utterly transformed by his experience of antiwar and other political demonstrations in 1968, during which students occupied the administrative offices of the Sorbonne in Paris. In response, the officials called in the police, who had not entered the precincts of the university since the middle ages. It was this violation of the university's independence that allowed Foucault to see the normally transparent frame of the institution, a frame that is supposed to guarantee the "objectivity" and "neutrality" of academic knowledge—to see this frame and suddenly to recognize its ideological cooption by forces of power. Foucault's strategic acknowledgment of the unacknowledged frame of the university, his unmasking of its political imbrication, was soon adopted by artists who wished to unmask the interests at work in the institutional frames of the art world. Called "institutional critique," this revelatory strategy informed the work of Daniel Buren, Marcel Broodthaers, Hans Haacke, and many others.

Perhaps Foucault's most profound effect on scholarly discourse was his transformation of historical narrative, exhorting that, instead of the seamless evolution of forms of knowledge, it was necessary to understand that knowledge undergoes abrupt changes that totally shift the conditions of understanding, each new set of conditions producing an entirely new organization of facts—which he termed *epistemes*. Foucault was identified with structuralism because of the importance his argument gave to the linguistic sign as the organizational trope (or figure of speech) that orders knowledge, creating the links between relevant facts. For example, Renaissance thought proceeded metaphorically, explaining phenomena by resemblances: since the brain looks like a walnut, walnuts must be good medicine for mental maladies. Foucault argued that Renaissance resemblance was abruptly displaced by Enlightenment thought (which he called "classical"), which orders phenomena by means of grids that can relate similarities and differences; this in turn was displaced by modern (or nineteenth-century) forms, which Foucault called synechdochic, marked by "analogy and succession," where gradual and continuous genesis replaces the separation of species. The classical organization was spatial, but this new episteme was temporal, historical. Thus the naturalists' table is pushed aside by biology or evolution, comparative analyses of wealth by economics (Marx's histories of production), and the study of the logic of the sign by linguistics. The shift from the visual to the temporal (and invisible) was given a special emphasis in Foucault's study of prisons *Discipline and Punish* (1977). He called his new methods of excavating the epistemic orders "archaeology," to distinguish it from "history," whose commitment to gradual genesis consigned it to the episteme of the nineteenth century and thus to obsolete forms of understanding.

Foucault died in the midst of writing and publishing a sweeping study of the *History of Sexuality*, which was organized around the epistemic shift from a decorous silence on the subject and practice of the sexual, to the exhortation to talk about it (as in psychoanalysis), thus transforming its very practice.

and art dealer Paul Cassirer and the German-Jewish painter
▲ Max Liebermann (whose work was outlawed by the Nazis), finally to be bought from Liebermann's American granddaughter (his own daughter having emigrated) by the Friends of the Museum led by Abs. But it was the panel focusing on Abs's own political background, revealing him as an ex-Nazi and showing how easily the posture of cultural benefactor allows an individual to "launder" their more-than-problematic past, that was seen as scandalous. Haacke's proposal for the work, although approved by the exhibition's curator, was "democratically" voted down by the Museum's administration (in a curiously tied decision) in obvious deference to the Friends' Chairman.

With the second major scandal of Haacke's career, it becomes evident that his project of connecting social and ideological interests with cultural practice in the broad variety of repressive disguises, making those disguises to which culture lends itself part of the site-specific and institutional-critical focus of the work, is hard for the institutions themselves to reincorporate and reneutralize. It is in this context that Haacke defines his major work of the seventies.

In a manifest act of solidarity—as had been the case for Buren in 1971, when several other artists such as Sol LeWitt, Mario Merz, and Carl Andre, opposed to the removal of Buren's piece from the Guggenheim, had withdrawn their own pieces from the exhibition—Buren now responded to the censorship of Haacke's work by inviting him to photocopy his panels and to glue these onto Buren's own work, consisting of green and white stripes covering large areas of wall within the Museum. Buren's stripes were to have functioned
● in "Projekt '74" as they had done in Documenta 5 two years earlier, for example, where white-on-white stripes were distributed throughout the exhibition, sometimes as sculptural bases, sometimes as backgrounds for the installation of paintings. (The way these recontextualized the works of art, with their claims to autonomy and to security within their own frames, so to speak, is most evident in the example of the clash between Buren's stripes and
■ those of a Jasper Johns *Flag*, where the internal logic of the painting was suddenly leached out into the larger context of the architectural framework as well as that of the politics of the exhibition.) To the distress of the organizers, the piece was therefore fully legible on the day of the opening of the exhibition, since Haacke's work was now being presented as a work by Buren. This led to further reprisals by the authorities of the Museum who, that night, tore off the Haacke photocopies, thereby defacing Buren's installation in an act of triple censorship: the double exclusion of Haacke and the vandalizing cancellation of Buren. BB

FURTHER READING
Alexander Alberro, "The Turn of the Screw: Daniel Buren, Dan Flavin, and the Sixth Guggenheim International Exhibition," *October*, vol. 80, Spring 1997
Daniel Buren, Hans Haacke, Thomas Messer, Barbara Reise, Diane Waldman, "Gurgles around the Guggenheim," *Studio International*, vol. 181, no. 934, 1971
Rosalyn Deutsche, "Property Values: Hans Haacke, Real Estate, and the Museum," in Brian Wallis (ed.), *Hans Haacke—Unfinished Business* (New York: New Museum of Contemporary Art, 1986)
Guy Lelong (ed.), *Daniel Buren* (Paris: Centre Georges Pompidou/Flammarion, 2002)
Gilda Williams (ed.), *Hans Haacke* (London: Phaidon Press, 2004)

▲ 1937a ● 1972b ■ 1958

1970–1979

1972a

Marcel Broodthaers installs his "Musée d'Art Moderne, Département des Aigles, Section des Figures," in Düsseldorf, West Germany.

The career of Belgian artist Marcel Broodthaers was marked by several publicly announced reinventions, the first of which took place in 1963 when he decided to complement his previous work as a poet by working as a visual artist, with an exhibition at a Brussels gallery [1]. The second major shift of roles was his transformation from artist to museum director on the occasion of the founding of the "Musée d'Art Moderne, Département des Aigles, Section XIXième siècle," in 1968, also in Brussels. Several theoretical models could be applied in any analysis of the transformations that were taking place in Broodthaers's work in this period, as well as those that were occurring in the art-historical and theoretical climate of the mid- to late sixties.

From poetry to production

First, Broodthaers's relation to the work of art was defined, from its inception, by a profound skepticism concerning the contemporary condition of the object-status of the work of art as opposed to its historical function and context. Broodthaers's puns on the work of art as the inevitable object of commodity exchange began as early as 1963 when he deposited the last fifty copies of a recent volume of his poetry into a mass of plaster and declared the result to be a sculpture [2].

Given that once the books had been transformed into a visual object and could no longer be read, Broodthaers's action implicitly asks the spectator why he or she refused to be a reader and wished to become a viewer instead. Henceforth, all of Broodthaers's work would take as one of its key questions the status of the work of art as commodity.

The second key question concerns the impact of the institution of the museum on the discourses (teaching, theorizing, historicizing) surrounding artistic practices, as well as on their reception (their criticism, collection, market). Within this framework, Broodthaers's interventions can be viewed first of all as defining the museum as a normalizing, disciplinary institution. Yet at the same time the museum for him was also an integral element of the Enlightenment culture of the bourgeois public sphere that has to be defended against the onrush of the forces of the culture industry. If one reads his attempts to situate the museum within this dichotomy, one will come closer to an understanding of the actual oppositions and dialectical tensions that Broodthaers's work tries to generate.

On the one hand, from 1968 on, he continually emphasized the operations of the museum as institution in the discursive formation of the work of art; this underscores the fact that aesthetic claims for the separateness and relative autonomy of the sphere of modernist visual art no longer have any validity; they must be replaced by a

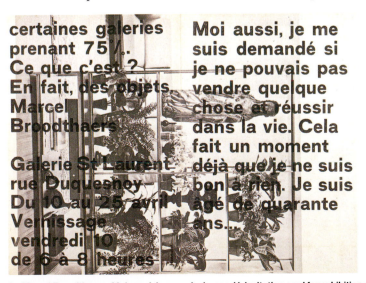
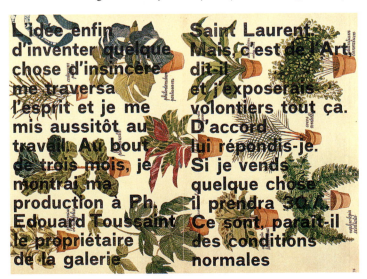

1 • Marcel Broodthaers, *Moi aussi, je me suis demandé*, invitation card for exhibition at Galerie St. Laurent, Brussels, April 10–25, 1964 (front and back)
Magazine tearsheet, 25 × 33 (9⅞ × 13)

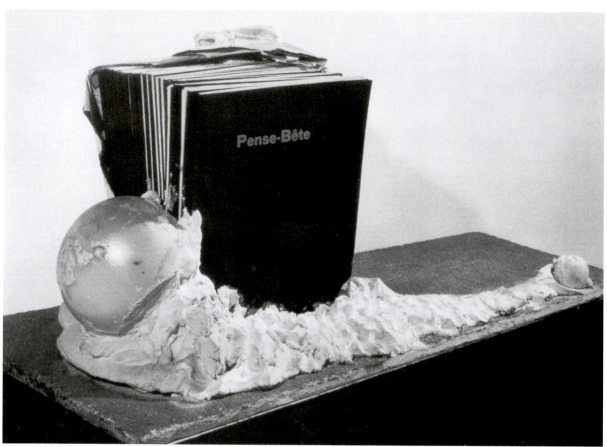

2 • Marcel Broodthaers, *Pense-Bête*, 1963
Books, paper, plaster, plastic spheres, and wood, 98 × 84 × 43 (38⅝ × 33⅛ × 16⅞)

3 • Marcel Broodthaers, *Il n'y a pas de Structures Primaires*, 1968
Oil on canvas, 77.5 × 115 (30½ × 45¼)

4 • Marcel Broodthaers, "Musée d'Art Moderne, Département des Aigles, Section XIXème siècle," opening ceremony, September 28, 1968

recognition of the contextuality and contiguity within which all discursive formations—including aesthetic ones—are located. It is this increasing relativization of aesthetic practices that Broodthaers—in the moment of 1968 and in the context of ▲ Conceptualism—uses to counteract all the delusions and deceptions surrounding the emancipatory experience of the work of art [3].

On the other hand, and in direct contrast to this, it is important to recognize that Broodthaers's criticism of the museum institution per se also consistently entails a sometimes even more intense criticism and skepticism toward the development of artistic practices once they have left the traditional museum behind and have made the museum into the institution of the production of contemporary art instead. It is in the context of just such a contradictory approach that Broodthaers's work must be situated. Its skepticism about the museum as a site of production emerges directly out of the insight that once it is so transformed it will also inevitably become part-and-parcel of those larger formations of the culture industry—such as entertainment, spectacle, marketing, advertising, public relations—from which it had previously been exempted. And it is precisely that transformation that Broodthaers insistently tried to clarify by pointing to the "historical" museum as having been an institution of the bourgeois public sphere that was relatively free from commercial interests and thus relatively determined by the necessity to contribute to self-differentiation in the historical development of bourgeois subjectivity. One should recognize that Broodthaers's series of museum sections are suspended in a dialectic between, on the one hand, historical mourning over the destruction of this institutional site and, on the other, critical analysis of the museum as an institution of power, ideological interest, and external determinacy.

"Musée d'Art Moderne"

In September 1968, having participated in the May student riots in Brussels, Broodthaers publicly opened his newly founded museum by introducing himself as its director [4]. It is in this

reversal, grotesque and comical, that his historical insight was first articulated: that the artist no longer functions or defines himself as a producer but rather as an administrator, occupying the site of institutional control and determination, voluntarily inhabiting the source of the institutional codification normally imposed upon the work of art. Thus, by making his work itself the very center of administrative and ideological power, Broodthaers positioned himself within those frameworks that had been previously excluded from the conception and reception of the work of art, and was simultaneously able to articulate a critique.

The elements Broodthaers assembled within his first section— "Section XIXème siècle"—consisted of items used in museum and gallery exhibitions: crates used for shipping, lamps used for illumination, ladders used for installation, postcard reproductions used for identification, signs used to give information about the gallery's entrance policy [5] and to direct visitors, and a truck used for transport (visible outside the window of his former studio on the rue de la Pépinière) [4]. Not only do all these objects evoke the museum as their source, but with their resounding emptiness, they strip that source of its meaning, substance, and historical significance, thereby constituting it as an "allegorical structure."

Contrary to the symbol's positing of the work of art as a form of plenitude, of organic wholeness and self-containment, of direct relationship to substantial meaning, and thus of epiphanic power, ▲ Walter Benjamin stresses allegory's character as "inorganic"— dependent on ancillary interpretive systems that are merely added on to the allegorical emblem like so many captions in an endlessly open series—and, therefore, as subjected to external forces exiting beyond its "own" frame: imbricated within powers of domination and institutional order. Insofar as allegory mimetically inscribes itself within all that is "external" to the traditional work of art, it opens onto the strategy Broodthaers used to develop his museum "fiction" into a project of critical negativity and opposition. Further, it questions the confidence with which Conceptual art, emerging at the same time, assumed that it had itself been able to transcend the frames within which modernism is institutionalized.

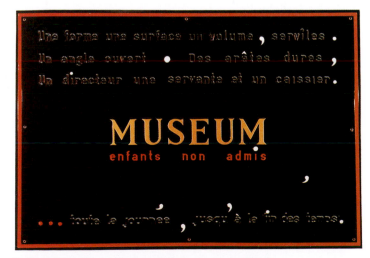

5 • Marcel Broodthaers, *Museum: Enfants non admis*, 1968–9
Plastic, two parts (black, white), 83 × 120 (32⅝ × 47¼)

Secondly, and of equal importance for Broodthaers's work, is the association of allegory with the melancholy of mourning and decay, thereby opening the allegorical structure onto the mnemonic inscription of reflections on history, on the legacies that have been displaced or obscured by recent activities, thus allowing them to be reinscribed within contemporary practice. Broodthaers's perpetual foregrounding of the legacy of modernist poetry, beginning with Charles Baudelaire and Stéphane Mallarmé, the two writers with whose work his own continually engaged, opened the field to two questions central to his work. One is clearly the question of the exclusion, not to say the repression, of the literary and mnemonic dimension of visual modernist practices, with their utter denial of the credibility or accessibility within contemporary visual art of any of the legacies of literary modernism. The other, in another dialectical reversal, involves an immediate historicization of the claims of Conceptualism as a critical means of transcending modernism in its foregrounding of the analytical proposition and the linguistic signifier as models that have successfully displaced the legacy of modernist autonomy. In that act of a constant relativization effected by Broodthaers's pointing back to and identifying with Mallarmé, the dialectical connection to language is achieved.

Broodthaers's museum culminated in 1972 with its presentation within the institution of the Kunsthalle in Düsseldorf [6, 7]. For this occasion he organized an exhibition of hundreds of objects all unified by the iconographic marker of the eagle and presented as the "Section des Figures" of his "museum" under the title "The Eagle from the Oligocene to the Present." Many of these objects, borrowed from European museums, were of historical and aesthetic value, including Assyrian sculptures and Roman *fibulae*; others were items of utter banality such as postage stamps, product labels, and champagne bottle corks. Seeming to trace the universality and omnipresence of this icon of power and domination throughout all European and non-Western cultures, Broodthaers here undermines the very idea of coherence upon which such domination depends by creating in this wild, parodic collection something that French philosopher Michel Foucault would have called a heterotopia—the wholly illogical system of classifications he derives from Jorge Luis Borges's short story about a fantasized "Chinese Encyclopedia" in the preface to his *The Order of Things: An Archaeology of the Human Sciences* (1966, English translation 1970).

Broodthaers's absurdist taxonomy should be situated within his own specific context as well. Among its many reverberations, his choice of the eagle as symbol also pointed to a continuing ambivalence regarding postwar German culture, with which he was critically involved throughout in his writings and his statements, and which the presence of the exhibition in Düsseldorf highlighted.

At another level, Broodthaers's invented iconography, to include all media, all genres, high and low, including commissions to living artists—such as Gerhard Richter—to produce paintings of eagles for the exhibition, once again emphasizes the complex dialogue with the continuing foreclosure of the realm of the visual

6 • Marcel Broodthaers, "Musée d'Art Moderne, Département des Aigles, Section des Figures," 1972 (installation view)

that was dominating all advanced artistic practices of the late sixties and early seventies. One could argue that at precisely the moment when Conceptual artists emphasized the disappearance of the iconographic, the elimination of the visual, and the transcendence of all historical strictures imposed by the classificatory systems of the museum (with its emphasis on the development of historical styles), Broodthaers reintroduced with a vengeance all the traditional taxonomic features and discursive formations that the museum represented. In doing so his intention was to expose as empty Conceptualism's claim to having established a truly democratic, egalitarian art form that had transcended the object, its forms of distribution, and its institutional frame, instead denouncing all such claims as typical avant-garde myth and self-mystification, and opposing them by making persistent reference back to the continuing (if not increased) validity of all those methods Conceptualism claimed to have left behind.

In this respect Broodthaers's "museum" work can be seen as being a conservative *blague* as a reactionary response to Conceptualism's claims. It is important to recognize how Broodthaers's critique inscribes itself in other, previously established, models of antimodernism as an attempt both to recognize the artistic affinity of earlier art with narrative and poetic practices and to emphasize the previously available—but now repressed and thus no longer accessible—relationship between artistic practices and the construction of historical memory.

The dialectics of fables

The last of Broodthaers's museum "sections" took place five months after the Düsseldorf show, on the occasion of Documenta 5 in Kassel in 1972. Founding another wing to his own museum named "Section Publicité" (Public Relations Section), in the context of this international exhibition, Broodthaers displaced his own collection of original objects gathered for the "Section des Figures" exhibition by photographing all the objects

that had been on display in Düsseldorf and mounting these in large photopanels on the wall in Kassel. Consistently questioning how meaning is produced within given institutional structures, whether museum galleries or the pages of catalogues, Broodthaers mobilizes his "Public Relations Section" toward the reiteration of his often used strategy of displacement—here from real object to its photographic reproduction, as in earlier instances it had moved from the actual object to the supporting elements and various framing devices (packing cases, lighting, etc.) that make up the institutional and discursive order. In an anticipatory deflection of the reception of his own work, then, he now presented the Düsseldorf installation of the eagle exhibition as having already been through the channels of its own publicity. He thereby anticipated the transformation of the work of art under all circumstances from object to photographic reproduction and its dissemination in forms of critical writing and marketing.

This displacement from the object to the apparatus of its display ▲ and dissemination could be called "the aesthetic of the supple • ment." Sharing such a strategy with artists of the same generation, such as Daniel Buren and Michael Asher, Broodthaers identifies his work with those structures of dissemination and distribution that are generally considered mere subproducts—the banal accoutrements to the centrality of the work of art as a substantial object—as an act of critical resistance. It is precisely by inhabiting those structures that would have to be called supplements—the page of the catalogue, the site of the poster, the framing devices of the institution—and by going as far as the banality of the tools of installation and shipping—that Broodthaers denies the continuing validity of an aesthetic of centrality, of substantiality, and by so doing also denies the commodity status of the work of art, for the supplement can never itself acquire commodity-value.

The "Section Publicité" plays critically on yet another dimension as well. As Broodthaers saw his own rise to fame in 1972, he anticipated the transformation of his own work in accord with the very mechanisms of the culture industry that the art world was even then in the process of adopting. He mimetically repositioned himself by founding his own advertising and promotion agency and thus making his own work disappear within the public-relations campaign launched for his own project, thereby denying once again the substantiality and historical specificity of his own initial practice.

It is in respect of this denial that one can look back at the peculiar difference, not to say opposition, between Broodthaers's ▲ relationship to the museum and Peter Bürger's model of the "historical avant-garde"—understood as involved in a rupture of the enclosure of an autonomous realm for the work of art as institutionalized by the museum, this rupture being defined by Bürger as the true function of a radical, avant-garde practice. In almost exact opposition to such a theoretical model, however, Broodthaers insists that it is not the function of artistic practice to dissolve the institution of art, but rather to recognize the extent to which the dismantling of the autonomous sphere of aesthetic practice is part of a historical tendency of the rise into domination of the culture industry, which will no longer tolerate any heterogeneity at all within the differentiation process of the various cultural spheres. BB

FURTHER READING
Manuel Borja-Villel (ed.), *Marcel Broodthaers: Cinéma* (Barcelona: Fundacio Antoni Tapies, 1997)
Benjamin H. D. Buchloh (ed.), "Marcel Broodthaers: Writings, Interviews, Photographs," special issue, *October*, vol. 42, Fall 1987
Catherine David (ed.), *Marcel Broodthaers* (Paris: Galerie Nationale du Jeu de Paume, 1991)
Marge Goldwater (ed.), *Marcel Broodthaers* (Minneapolis: Walker Art Center; and New York: Rizzoli, 1989)
Rachel Haidu, *The Absence of Work: Marcel Broodthaers, 1964–1976* (Cambridge, Mass.: MIT Press, 2011)

7 • Marcel Broodthaers, "Musée d'Art Moderne, Département des Aigles, Section des Figures," installation at the Städtische Kunsthalle, Düsseldorf, 16 May–9 July, 1972

▲ Introduction 4 • 1970, 1971 ▲1960a

1972 b

The international exhibition Documenta 5, held in Kassel, West Germany, marks the institutional acceptance of Conceptual art in Europe.

Two foundational exhibitions, both organized by the Swiss curator Harald Szeemann, demarcate the origins and the zenith of the production and the institutional reception of Conceptual art in Europe. The first was the (by now famous) ▲ exhibition "When Attitudes Become Form" that took place at the Berne Kunsthalle and elsewhere in 1969, and the second was Documenta 5, the fifth installment of what had become the most important international group show of contemporary art, organized in Kassel, West Germany, every four or five years since 1955.

These two exhibitions demarcate—in their initial omissions as much as in their eventual inclusions—the changing orientations that occurred in the late sixties and early seventies in different centers of artistic production (New York, Paris, London, Düsseldorf). Artists like the group Art & Language, Bernd and Hilla ● Becher, Marcel Broodthaers, Daniel Buren, and Blinky Palermo were still excluded from "When Attitudes Become Form." (Buren was prosecuted by the Swiss police for illicitly pasting his color-white-striped paper signs throughout Berne—his contribution to an exhibition in which he thought he should have been represented.) However, three years later all these artists were given a central role in Documenta 5, where they installed works that would subsequently be seen as the foundational models of European Conceptual art and its strategies of institutional critique.

Documenta 5 used its institutional resources on the level of the exhibition as much as that of the catalogue to enact the legalistic-administrative dimensions of Conceptual art and to transform these into operative realities. The catalogue (designed ■ by Ed Ruscha to look like an administrative loose-leaf binder or a technical training manual with a thumb index) carried one of the first systematically philosophical and critical essays on the commodity status of the work of art (written by the philosopher Hans Heinz Holz). More importantly perhaps, it reproduced "The Artists Reserved Rights Agreement," a contract developed by New York art dealer Seth Siegelaub and New York lawyer Robert Projansky. Originally published in *Studio International* in 1971, this contract would allow artists to participate in decisions concerning their work after it had been sold (exhibition participation and reproductions in catalogues and books) and would also oblige collectors to offer the artist a reasonable, if minimal, share

in the increasing resale value of their work. This was obviously an arrangement that would be loathed by most collectors; so much so that they refrained from buying works by any artists who had signed the contract, thereby deterring other artists from engaging in the project altogether.

Conceptualism's encounters

Several factors came together to transform 1972 into the *annus mirabilis* of European Conceptual art, culminating in the emergence and institutional reception of the work of the Bechers, Broodthaers, Buren, Hanne Darboven (1941–2009), Hans Haacke, ▲ Palermo, and Gerhard Richter [1]. The first factor was that the politically radical student movement of 1968 and the cultural radicality of Conceptual art entered into a dialogue in 1972, rather than—as had been the case with Documenta 4 in 1968—remaining entangled in a polemical confrontation. Thus, the work of Broodthaers and of Buren at Documenta 5 turned some of the critical tools of 1968 (that is, the Frankfurt School tradition of a Marxist critique of ideology and the poststructuralist practices of semiological and institutional critiques) back onto the actual institutional frameworks of the museum, the exhibition, and the market.

The changing relations of that generation of postwar artists to the legacies of European avant-garde culture undoubtedly constituted the second factor. A particular tension emerged from the simultaneous reception not only of the recently rediscovered practices of the most advanced forms of European abstraction (Constructivism, Suprematism, and De Stijl) but also American ● Minimalism: both practices were evidently fused and operative in the work of Buren, Darboven, Haacke [2], and Palermo.

Thirdly, all of these artists contested the dominant positions of ■ Joseph Beuys in Germany and Yves Klein and the Nouveaux Réalistes in Paris (and in Düsseldorf). Throughout the early sixties, Beuys, Klein, and the Nouveaux Réalistes had developed an aesthetic in which memory and mourning had unknowingly confronted the effects of their instant spectacularization. The new generation of artists recognized the fallacies of these earlier positions, displacing them with self-critical acuity that focused on the

1 • Gerhard Richter, *48 Portraits*, 1971–2
Oil on canvas, forty-eight paintings, each 70 × 55 (27½ × 21⅝)

social and political power structures governing the production and reception of culture in their own time. Furthermore, since the younger artists had already engaged in an explicit dialogue with ▲ American art of the early to mid-sixties, in particular with Pop art (in the cases of Broodthaers and Richter, for example) and Minimalism (Buren, Darboven, Haacke, and Palermo were espe- ● cially concerned with the work of Sol LeWitt, Carl Andre, and ■ Robert Ryman), they were fully prepared to confront the recent formulations of a Conceptualist aesthetic that was first articulated by the artists around Seth Siegelaub in New York in 1968 (Robert ◆ Barry, Douglas Huebler, Joseph Kosuth, and Lawrence Weiner). Yet in all of the European responses to Conceptualism, even in their most esoteric and hermetic variations (such as the work of Darboven) one of the principal differences from Anglo-American Conceptual art was a dimension of historical reflexivity that now appeared as inextricably intertwined with Conceptualism's neopositivist self-reflexivity on the epistemological and semiotic conditions of its own languages.

2 • Hans Haacke, *Documenta Besucher Profil* (Documenta Visitors' Profile), 1972
Audience participatory installation

▲ 1960c, 1962d, 1964b ● 1962c, 1994b ■ 1957b ◆ 1968b, 1984a

3 • Hanne Darboven, *Seven Panels and an Index*, 1973 (detail)
Graphite on white wove paper, panels 177.8 × 177.8 (70 × 70), index 106 × 176 (41¾ × 69¼)

One could argue that Darboven's work [3] originated to some
▲ extent in her earlier encounter with kineticism (as represented in
the work of Almir Mavignier [born 1925], her teacher at the Hochs-
chule für Bildende Kunst [Academy of Fine Arts] in Hamburg, and
his attempt to innovate postwar abstraction by mechanizing and
digitalizing its permutations and chance operations). The second
formative encounter for Darboven was her friendship with Sol
LeWitt during the three years she spent in New York from 1966 to
1968. Darboven's trajectory synthesized the oppositions between an
infinity of spatio-temporal proliferation and processes of digitalized

quantification, the dialectics of mathematically determined opera-
tions with a new type of drawing bordering on the iterative order of
writing. Furthermore, she fused the order of the scriptural with the
public performance of compulsive repetition, investing the concept
of automatism with significations that were radically different from
its initial definition in Surrealism or its postwar resuscitation in
▲ Abstract Expressionism.
• Jasper Johns and Cy Twombly had of course initiated the
process of denaturing drawing in favor of drawing that repeated a
more-or-less fixed and contained grapheme or that approached

▲ 1955b

▲ 1924, 1947b • 1953, 1958, 1962d

the condition of writing (initiated in the postwar period as a dialectic structure of somatic and libidinal loss and emancipation from myth). Once the features of iconic representation (e.g., figurative line, volume, chiaroscuro) had been completely stripped from the body of drawing's mimetic relationship to nature, the ▲ order of language and iterative enumeration (in Johns) appeared as a perforation of the body of drawing itself, as the surfacing of its social skeleton of inexorable constraints.

Yet Darboven's work traces this process in even more minute detail, and exacerbates the quantification of the temporality of its proper production. Thereby she inscribes drawing mimetically within an advanced social organization where experience is increasingly governed by an infinite proliferation of administrative rules and operations that prevent drawing from appearing any longer as an exemplary enactment of the subject's immediate access to psychosomatic or spiritual experience. Darboven registers these ruling patterns of the collective forms of spatio-temporal experience, and she identifies the automatic repetition of an infinity of eternally identical acts as the microscopic matrix of drawing itself.

This infinity of possibilities (an infinity of permutations, of processes, of quantities) is very much at the center of Conceptu-
● alism. The extent to which this model would inform European practices of Conceptual art became poignant in Hans Haacke's contribution to Documenta 5 when he installed the third version of his series of "Visitors' Polls" [**2, 4**]. This work made the historical dialectics of Conceptual art painfully obvious. On the one hand it offered (or subjected) the spectator to the most complex form of viewer participation that neo-avant-garde parameters had ever allowed for (by asking them for the full statistical accounts of their social and geopolitical identities). At the same time, however, the work articulated the extreme poverty of spatio-temporal, psychological and perceptual / phenomenological experiences available both to the conceptions of the artist and to a realistic estimation of spectatorial capacities and dispositions.

Haacke's synthesis of a seemingly infinite number of random participations (the size and scale of the work are totally open and dependent on the number of visitors who choose to participate in the statistical accounts) and a very limited number of factors of total overdetermination (since only a very limited series of questions could be asked in the ready-made statistical questionnaire) makes up the constitutive opposition of the work. In that reductivist instantiation of each participant as explicitly unique and different, yet at the same time a merely quantifiable statistical unit, Haacke's work acquires the same intensity of having mimetically internalized the order of the administrative world that we had encountered in the work of Darboven.

A similar dialectic can be discerned in the development of the work of Blinky Palermo (Peter Schwarze / Heisterkamp) who—like his friends and fellow artists, Sigmar Polke and Gerhard Richter—
■ had arrived in West Germany from Communist East Germany, where he had spent his childhood. The definition of Palermo's abstraction lies in the triangulation between the ruins of the heroic

4 • Hans Haacke, *MOMA-Poll*, 1970
Audience participatory installation, two transparent acrylic ballot boxes, each 40 × 20 × 10 (15¾ × 7⅞ × 3⅞), equipped with photoelectric counter, text

abstractionists of the prewar avant-garde (Mondrian and Malevich
▲ in particular), the radical revisions of these legacies of abstraction in the postwar period in Europe (in particular in the work of
● his teacher Joseph Beuys and in the presence of Yves Klein in Düsseldorf at the moment of Palermo's emergence), and thirdly, the dialogue with American postwar abstraction in its most reductivist models, ranging from Ellsworth Kelly and Barnett Newman
■ to Sol LeWitt.

While Palermo clearly recognized that the spiritual and utopian
◆ aspirations of the Bauhaus and De Stijl, of Suprematism and Constructivism lay in historical ruins, he also realized that all attempts to resuscitate them would inevitably turn out to be travesties. As with the radical departures in the work of Darboven, Palermo equally emancipated abstraction from its entanglement with myth and utopia (as it had still appeared in the hands of Beuys) and at the same time he severed abstraction from its entanglement in spectacle culture (as it had been inadvertently or

5 • Blinky Palermo, *Wall Painting*, 1972
Red lead on card, 22.7 × 16.5 (8⅞ × 6½)

which the heroic abstraction of the twenties had been able to define itself. All these oppositions are as much articulated in the reliefs' formal definition as they are generated by the tensions between natural and industrial qualities in the chromatic definition of the objects, and it is far from accidental that in these wall reliefs Palermo frequently quotes Yves Klein's supposedly patented "International Klein Blue," modifying it ever so slightly, yet remaining within its spectrum, publicly exposing the absurdity of Klein's attempt to brand a color and to own the copyright in a particular tint.

In Palermo's fabric paintings, store-bought lengths of commercial decorator's fabric are sewn together in bipartite or tripartite horizontal divisions to compose a painting. Reiterating a model that had been developed in the first and only Ellsworth Kelly painting that was made with the colors of industrially produced fabrics, entitled *Twenty-Five Panels: Red Yellow Blue and White* in 1952, Palermo's fabric paintings withdraw two crucial elements from conventional abstraction: first of all they eliminate even the last traces of drawing and facture, where the process of paint application—even in its most reduced form of staining, as in Mark Rothko's work for example—had itself become an integral element in the production of painterly meaning. Secondly, the fabric paintings perform a denaturing of color in exact analogy to the denaturing of drawing in the work of Darboven. Choice of color and color itself now appear as suspended between their innate relation to the realm of the natural and their new conception as a commercially produced readymade. But the cheapness of the materials and their ready-made character are constantly counteracted by Palermo's determination to conceive the most differentiated chromatic constellations and chords from the extreme poverty of his own means.

The third group in Palermo's oeuvre is that of the wall drawings and wall paintings that he first executed in 1968 in a work for the Heiner Friedrich Gallery in Munich. Undoubtedly resulting in part from Palermo's attention to the development of painterly and sculptural practices in the context of Minimalism (in this case, the wall drawings of Sol LeWitt in particular), Palermo's wall drawings / paintings address the dialectics between painting's internal order (its figure–ground hierarchies, its morphologies, its relations of color) and its external "situatedness" within public social space.

Palermo was among the first to recognize that painting's transition into architectural space would no longer carry any of the promises that this shift had entailed in the work of El Lissitzky, for example. Typically, in his installation at Documenta 5, Palermo positioned his bright-orange wall painting [**5**] (executed with industrial rust-proofing paint) in a mere leftover space (in terms of the public display functions of exhibition architecture) and he also placed it in what was structurally the most functional space (a staircase that—while not intended for exhibition usage—connected two floors of the exhibition spaces). Palermo's wall paintings, in their explicit referral to outside spaces, to overlooked spaces, to the functional and utilitarian dimensions of architecture and painting (even more evident in his deployment of lead primer from the shipyards in Hamburg in his installation for the Hamburg Kunstverein

cynically proffered by Klein). Thus the neopositivist and empiricist formalism of the American Minimalists provided Palermo with a counterforce that allowed him to articulate the contradictory predicaments of abstraction in postwar Germany all the more.

Palermo's work consists of three principal types: the reliefs and wall objects, the fabric paintings, and the wall paintings. All three rehearse, and some of them repeat, the fundamental problems facing postwar abstraction. The first group (which is also chronologically the earliest) departs from the most advanced forms of postwar reflections on the transition from easel painting to the relief as they had been embodied in Barnett Newman's works such as *Here I* (1950).

Palermo's wall objects, however, rapidly move to a more explicit reflection on their simultaneous status as both reliefs and architectural elements, comparable in many ways to the Postminimalist work of Richard Tuttle. As in Tuttle's reliefs, Palermo's *Wand-Objekte* (1965) oscillate between organic and geometric form as though they literally wanted to reembody abstraction, against its rationalist and technological tendencies. The *Wand-Objekte* seem to be reflecting on the contradictions between autonomous pictorial presence and public architectural space. Yet the intensity of their intimacy and phenomenological presence appears first of all to compensate for the absence of that horizon of collectivity toward

▲ 1951 ▲ 1953, 1962d ● 1947a ■ 1994b ◆ 1926

in 1974) insist on their dislocation and their industrial materiality principally to contest notions of autonomous plasticity. Yet if they open up to architectural space, they do so only as a mnemonic image of the lost promises of radical abstraction that had once engaged in the production of a new industrial culture of the collective.

If Palermo's work still bracketed industrial use-value and painterly surplus value, and remained suspended within an ambiguous space between an architectural surface as a carrier of painterly plasticity and an exhibition wall as an institutional space, Daniel Buren's installation for Documenta 5 foregrounded an almost systematically analytical approach. In his work *Documenta*, the exhibition walls were treated as mere carriers of information, as discursive sites. The work consisted of inserting white-on-white striped paper underneath an array of extremely different objects (such as Jasper ▲ Johns's painting *Flag* [1954], the base of an architectural model by Will Insley, or posters as examples of contemporary advertising) throughout the various segments of the vast and complex exhibition. Thus, the elements of Buren's installation functioned primarily as markers of the discursive condition of the institution, the exhibition, and its architecture.

Inevitably, the white stripes on white paper called forth a comparison with the long history of instances in which reductivism attenuated painting to the highest level of perceptual and phenomenological differentiation. Yet it became instantly clear that Buren's white-on-white work probably shared as much with ● Kazimir Malevich's famous climax of Suprematist reductivism and

▲ Robert Ryman's most advanced forms of extremely differentiated reductivist painting of the early-to-mid-sixties, as it engaged with a conception of spatiality and visuality from which pure plasticity had withered away. This conceptual evacuation made room for a discursive analysis and institutional critique of the usages of space in a society driven by administration, where the difference between two whites was more likely to be derived from two types of paper or two coats of wallpaint than from the anticipation of two highly differentiated spiritualities.

If the work of these artists seems to mourn the lost utopian potential of avant-garde practices, and of abstraction's aspirations toward progressive and emancipatory functions, the work of Sigmar Polke by contrast assumes a position of Romantic irony. Yet it is not any less aware of the tragic losses that postwar culture had to confront. Polke's travesties of abstract painting would eventually even incorporate the Conceptualist impulse to a linguistic reductivism, as in his series of *Lösungen* (Solutions) [**6**]. Thereby both abstraction's historical failure and the preposterousness of its radical promises in the present day become the target of Polke's sardonic and allegorical humour.

What the work of this generation of artists acknowledged—and responded to accordingly—was the fact that the spaces and the walls of the "white cube" had in fact been permeated by a network of institutional powers and economic interests and that they had been irreversibly removed from the neutrality of a phenomenological space within which the subject would constitute itself freely in its acts of pure perception. It might have appeared difficult at the time to recognize that the work's emphatic radicality was enforced by an almost ethereal withdrawal of what one might traditionally have regarded as the tasks of the aesthetic. Thus one could argue that Buren, Darboven, Haacke, Palermo, and Polke operate from within a highly contradictory, not to say aporetic form of melancholic modernism, attempting to redeem the radical utopianism of avant-garde abstraction, yet mourning at the site of its irreversible devastation. But to the very extent that their work yields its structural and formal organization in its entirety to the ruling principles of social administration, in the very semblance of an affirmation of the totality of these principles as the solely valid forms that actually structure experience, the aesthetic, within its radical negation, attains an unforeseen transcendence. BB

$$1 + 1 = 3$$

$$2 + 3 = 6$$

$$4 + 4 = 5$$

$$7 + 3 = 8$$

$$5 + 1 = 2$$

$$3 + 4 = 9$$

$$6 + 2 = 7$$

$$8 + 7 = 4$$

$$1 + 5 = 2$$

6 • Sigmar Polke, *Lösungen V*, 1967
Lacquer on burlap, each 150 × 125 (59 × 49¼)

FURTHER READING
Vivian Bobka, *Hanne Darboven* (New York: Dia Center for the Arts, 1996)
Brigid Doherty and Peter Nisbet (eds), *Hanne Darboven's Explorations of Time, History and Contemporary Society* (Cambridge, Mass.: Busch Reisinger Museum, Harvard University Art Museums, 1999)
Gloria Moure (ed.), *Blinky Palermo* (Barcelona: Museu d'Art Contemporani; and London: Serpentine Gallery, 2003)
Harald Szeemann (ed.), *Documenta V: Befragung der Realität—Bildwelten Heute* (Kassel: Bertelsmann Verlag / Documenta, 1972)
David Thistlewood (ed.), *Joseph Beuys: Diverging Critiques* (Liverpool: Liverpool University Press / Tate Gallery, 1995)
David Thistlewood (ed.), *Sigmar Polke: Back to Postmodernity* (Liverpool: Liverpool University Press / Tate Gallery, 1996)

▲ 1958 ● 1915 ▲ 1957b

1972 c

Learning from Las Vegas is published: inspired by Las Vegas as well as Pop art, the architects Robert Venturi and Denise Scott Brown eschew "the duck," or building as sculptural form, in favor of "the decorated shed," in which Pop symbols are foregrounded, thus setting up the stylistic terms of postmodern design.

We readily associate "Pop" with art as well as music and fashion but rarely with architecture, yet Pop was a recurrent question in architectural debates of the ▲ postwar period. The very idea of a Pop art—that is, of an artistic engagement with mass culture as this was transformed by consumer capitalism—was first floated in the early fifties by the • Independent Group (IG) in London, a motley collection of young artists and art critics including Richard Hamilton and Lawrence Alloway, who were guided by young architects and architectural historians such as Alison and Peter Smithson and Reyner Banham. Elaborated by American artists a decade later, the Pop idea was again brought into architectural discussion in the late sixties and early seventies, especially by Robert Venturi (born 1925) and Denise Scott Brown (born 1931), where it came to serve as a ■ discursive support for the postmodern design not only of this husband-and-wife team but also of Philip Johnson (1906–2005), Michael Graves (1934–2015), Charles W. Moore (1925–93), Robert Stern (born 1939), and others in the eighties, all of whom featured images that were somehow commercial or classical or both. The primary precondition of Pop in general was a gradual reconfiguration of the built environment, demanded by consumer capitalism, in which structure, surface, and symbol were combined in new ways. That mixed space is still with us, and so a Pop dimension persists in contemporary architecture too.

In the early fifties, Britain remained in a state of economic austerity that made the new consumerist world appear seductive to emergent Pop artists there, whereas a decade later this landscape was already second nature for American artists. Common to both groups, however, was the sense that consumerism had altered the very nature of appearance, and Pop art found its principal subject in this heightened visuality of a world of products and celebrities on display (of products as celebrities and vice versa). The superficiality of images and the seriality of objects in consumer capitalism affected architecture and urbanism as much as painting and sculpture. Accordingly, in *Theory and Design in the First Machine Age* (1960), Banham imagined a Pop architecture as a radical updating of modern design with the new technologies of "the Second Machine Age," in which "imageability" became the primary criterion. Twelve years later, in *Learning from Las Vegas*

(1972), Venturi and Scott Brown, along with their associate Steven Izenour (1940–2001), advocated a Pop architecture that would return this imageability to the built environment from which it arose. However, for Venturi and Scott Brown this imageability was more commercial than technological, and it was advanced not to update modern design but to displace it. It was here, then, that aspects of Pop art began to be refashioned in terms of postmodern architecture. In some ways, the first age of Pop can be framed by these two moments—between the retooling of modern architecture urged by Banham on the one hand and the founding of postmodern architecture prepared by Venturi and Scott Brown on the other—but, again, this Pop–postmodern connection has an afterlife that extends to the present.

The image business

In November 1956, just a few months after the "This is Tomorrow" exhibition in London first brought the Pop idea to public atten-
▲ tion, Alison and Peter Smithson published a short essay titled "But Today We Collect Ads" that included this little prose poem: "[Walter] Gropius wrote a book on grain silos, Le Corbusier one on aeroplanes, and Charlotte Perriand brought a new object to the office every morning; but today we collect ads." The point here is polemical: *they*, the old protagonists of modern design, were cued by functional things, while *we*, the new celebrants of Pop culture, look to "the throw-away object and the pop-package" for inspiration. This was done partly in delight and partly in desperation: "Today we are being edged out of our traditional role [as form-givers] by the new phenomenon of the popular arts—advertising," the Smithsons continued. "We must somehow get the measure of this intervention if we are to match its powerful and exciting impulses with our own." This anxious thrill drove the entire Independent Group, and architectural minds led the way.

"We have already entered the Second Machine Age," Banham wrote four years later in *Theory and Design*, "and can look back on the First as a period of the past." In this landmark study, conceived in the heyday of the IG, he too insisted on a historical distance from modern masters. Banham challenged the functionalist and rationalist assumptions of these figures—that is, that form must

▲ 1956, 1960c, 1962 • 1956 ■ 1977a, 1984b ▲ 1956

follow function or technique or both—and recovered other imperatives neglected by them. In doing so, he advocated a Futurist imaging of technology in Expressionist terms—in forms that were often sculptural and sometimes gestural—as the prime motive of advanced design not only in the First Machine Age but in the Second Machine Age, which might be called the First Pop Age, as well. Far from academic, his revision of architectural priorities also reclaimed an "aesthetic of expendability," first proposed in Futurism, for this Pop Age, where "standards hitched to permanency" were no longer so relevant. More than any other figure, Banham moved design discourse away from a modernist syntax of abstract forms toward a Pop idiom of mediated images. If architecture was adequately to express this world—where the dreams of the austere fifties were about to become the products of the consumerist sixties—it had to "match the design of expendabilia in functional and aesthetic performance": it had to go Pop.

What did this mean in practice? Initially Banham supported the Brutalist architecture represented by the Smithsons and James Stirling, who pushed given materials and exposed structures to a "bloody-minded" extreme. "Brutalism tries to face up to a mass production society," the Smithsons wrote in 1957, "and drag a rough poetry out of the confused and powerful forces which are at work." This insistence on the "as found" (a term they coined) sounds Pop, but the "poetry" of Brutalism was too "rough" for it to serve for long as the signal style of the sleek Pop Age, and, as the Swinging Sixties unfolded in London, Banham looked to the young architects of Archigram (a combination of "ARCHItecture" and "teleGRAM")—Warren Chalk, Peter Cook, Dennis Crompton, David Greene, Ron Herron, and Michael Webb—to carry forward the Pop project of imageability and expendability. According to Banham, Archigram (which was active between 1961 and 1976) took "the capsule, the rocket, the bathyscope, the Zipark [and] the handy-pak" as its models, and celebrated technology as a "visually wild rich mess of piping and wiring and struts and catwalks." Influenced by the American designer and inventor

Buckminster Fuller, its projects might appear functionalist—*The Plug-In City* (1962–4) proposed an immense framework in which parts might be changed according to need or desire [1]—but, finally, with its "rounded corners, hip, gay, synthetic colours [and] pop-culture props," Archigram was "in the image business," and its schemes answered to fantasy above all. Like the Fun Palace (1961–7) conceived by fellow British architect Cedric Price for the Theatre Workshop of Joan Littlewood, *The Plug-In City* offered "an image-starved world a new vision of the city of the future, a city of components … plugged into networks and grids" (Banham again). Yet, unlike the Price project, which was merely unrealized, almost all Archigram schemes were unrealizable (they sometimes look like robotic mega-structures run amok).

The duck and the decorated shed

Banham believed it was imperative that Pop design not only express contemporary technologies but also elaborate them into new ways of living. Here lies the great difference between Banham and Venturi and Scott Brown. If Banham sought to update the Expressionist imperative of modern form-making vis-à-vis a Futurist commitment to modern technology, Venturi and Scott Brown shunned both expressive and technophilic tendencies, opposing any prolongation of the modern movement along these lines. For Banham, contemporary architecture was not modern enough, while for Venturi and Scott Brown it had become disconnected from both society and history precisely through its commitment to a modernity that was too abstract and too amnesiac. According to Venturi and Scott Brown, modern design lacked "inclusion and allusion"—inclusion of popular taste and allusion to architectural tradition—a failure that stemmed above all from its rejection of ornamental "symbolism" in favor of formal "expressionism." To right this wrong, they argued in *Learning from Las Vegas*, the modern paradigm of "the duck," in which the form expresses the building almost sculpturally, must cede to the

1 • Archigram, *The Plug-In City: Maximum Pressure Area*, 1962–4 (project), 1964 (section), designed by Peter Cook
Photomechanical print from original ink line drawing on tracing paper, with added color, mounted on board, 83.5 × 146.5 (32⅞ × 57¹¹⁄₁₆)

postmodern model of "the decorated shed," a building with "a rhetorical front and conventional behind," where "space and structure are directly at the service of program, and ornament is applied independently of them." "The duck is the special building that *is* a symbol," Venturi and Scott Brown wrote in a famous definition; "the decorated shed is the conventional shelter that *applies* symbols" [**2**].

Venturi and Scott Brown also endorsed Pop imageability: "We came to the automobile-oriented commercial architecture of urban sprawl as our source for a civic and residential architecture of meaning, viable now, as the turn-of-the-century industrial vocabulary was viable for a Modern architecture of space and industrial technology 40 years ago." Yet in doing so they accepted—not only as a given but as a desideratum—the identification of "the civic" with "the commercial," and thus they took the strip and the suburb, however "ugly and ordinary," not only as normative but as exemplary. "Architecture in this landscape becomes symbol in space rather than form in space," Venturi and Scott Brown declared. "The big sign and the little building is the rule of Route 66." Given this rule, *Learning from Las Vegas* could then conflate corporate trademarks with public symbols: "The familiar Shell and Gulf signs stand out like friendly beacons in a foreign land." It could also conclude that only a scenographic architecture (that is, one that foregrounds a facade of signs) might "make connections among many elements, far apart and seen fast." In this way, Venturi and

Scott Brown translated important insights into this "new spatial order" into bald affirmations of "the brutal auto landscape of great distances and high speeds." This move naturalized a landscape that was anything but natural; more, it exploited an alienated condition of general distraction, as they urged architects to design for "a captive, somewhat fearful, but partly inattentive audience, whose vision is filtered and directed forward." As one result, the old motto of modernist elegance in architecture coined by Mies van der Rohe—"less is more"—became a new mandate of postmodern overload in design: "less is a bore."

In the call for architecture to "enhance what is there," Venturi and Scott Brown cited Pop art as a key inspiration, in particular ▲ the photobooks of Ed Ruscha, such as *Every Building on the Sunset Strip* (1966); in fact, the studio class they taught at Yale University, which led to *Learning from Vegas*, included a visit to Ruscha in Los Angeles. Yet theirs was only a partial understanding of Pop, one cleansed of its dark side, such as the culture of death and ● disaster in consumerist America exposed by Andy Warhol in his 1963 silkscreens of car wrecks and botulism victims. Ruscha hardly endorsed the new autoscape: his photobooks underscored its null aspect, without human presence (let alone social interaction), or documented its space as so much gridded real estate, or both. ■ (In *Homes for America* [1966–7], Dan Graham elaborated this precedent in a way closer in spirit to Ruscha than what Venturi and Scott Brown proposed.) A more salient guide to *Learning from Las Vegas* was the developer Morris Lapidus, whom the Venturis quote as follows: "People are looking for illusions.… Where do they find this world of the illusions?… Do they study it in school? Do they go to museums? Do they travel to Europe? Only one place—the movies. They go to the movies. The hell with everything else." However ambivalently, Pop art worked to explore this new order of social inscription through mass culture, through its image surfaces and media screens. The postmodernism prepared by Venturi and Scott Brown was placed largely in its service—in effect, to update the built environment for this new regime. One might find an element of democracy in this commercialism, or even a trace of critique in this cynicism, but that would be mostly a projection.

At this point, the Pop rejection of elitism became a postmodern manipulation of populism. While many Pop artists practiced an "ironism of affirmation"—an attitude, inspired by Marcel ◆ Duchamp, that Richard Hamilton once defined as a "peculiar mixture of reverence and cynicism"—most postmodern architects practiced an affirmation of irony, or, as Venturi and Scott Brown put it in *Learning from Las Vegas*, "Irony may be the tool with which to confront and combine divergent values in architecture for a pluralist society." In principle, this strategy sounds fitting; in practice, however, the "double-functioning" of postmodern design—"allusion" to architectural tradition for the initiated, "inclusion" of commercial iconography for everyone else—served as a double-coding of cultural cues that reaffirmed class lines even as it seemed to cross them [**3**]. This deceptive populism became dominant in political culture only a decade later under Ronald

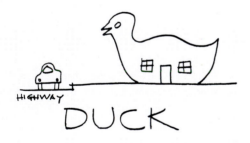

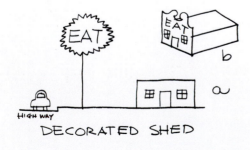

2 • "Duck and decorated shed" drawing from Robert Venturi, Denise Scott Brown, and Steven Izenour's *Learning from Las Vegas*, 1972

▲ 1967a, 1968b ● 1960c, 1962d, 1964b ■ 1968b ◆ 1914, 1956, 1966a

3 • Michael Graves, Portland Building, 1982

With its variety of surface materials and colors and decorative details, this municipal office building in downtown Portland, Oregon, is considered an icon of early postmodern architecture.

4 • Superstudio, *Continuous Monument: New New York,* **1969**
Lithograph, 700 × 100 (27½ × 39⅝)

Reagan, as did the neoconservative equation of political freedom and free markets also anticipated in *Learning from Las Vegas*. In this way, the recouping of Pop art in postmodern architecture did constitute an avant-garde, but it was an avant-garde of most use to the Right. With commercial images thus cycled back to the built environment from which they arose, Pop became tautological in the postmodern: rather than a challenge to official culture, it was that culture, or at least its setting (as the corporate skylines of countless cities still attest).

Decorated ducks

Yet this narrative is too neat and its conclusion too final. There were alternative elaborations of Pop design in art and architecture alike, such as the visionary proposals of the Florentine collective Superstudio (1966–78), the antic happenings of the San Francisco-Houston group Ant Farm (1968–78), and other schemes by related groups in France and elsewhere. Both Superstudio (Adolfo Natalini and Cristiano Toraldo di Francia) and Ant Farm (Chip Lord, Doug Michels, Hudson Marquez, and Curtis Schreier) were inspired by the technological dimension of Pop design, as manifest in the geodesic domes of Buckminster Fuller and the inflatable forms of Archigram. Yet, transformed by the political events associated with 1968, they also wanted to turn this aspect of Pop against its consumerist dimension.

In 1968, Fuller proposed a massive dome for midtown Manhattan, a utopian project that also suggested a dystopian foreboding of cataclysmic pollution, even of nuclear holocaust, to come. Superstudio took this utopian–dystopian ambiguity, which is also active in the sci-fi imagery of Archigram, to the limit: its *Continuous Monument* (1969), an example of visionary archi-
▲ tecture as Conceptual art, imagined the capitalist city swept clean of commodities and reconciled with nature, but at the cost of a ubiquitous grid that, however beautiful in its purity, is monstrous in its totality [**4**]. Also inspired by Fuller and Archigram, the members of Ant Farm were merry pranksters in comparison, pledged as they were to Bay Area counterculture rather than to tabula-rasa transformation. Their performances and videos, which somehow combine anticonsumerist impulses with spectacular effects, also pushed Pop design back toward art. This is most evident in two famous pieces. In *Cadillac Ranch* (1974), Ant Farm partially buried ten old Cadillacs, nose down in

▲ 1968b, 1970, 1972b

a row like upside-down rockets, on a farm near Amarillo, Texas. And in *Media Burn* (1975), a perverse replay of the assassination of John F. Kennedy, they drove a customized Cadillac at full speed through a pyramid of televisions set ablaze at the Cow Palace in San Francisco [**5**]. Today these works read in part as parodies of the teachings of *Learning from Las Vegas*.

Pop design after the classic moment of Pop was not confined to visionary concepts and sensational happenings. Its foremost instance might be the familiar Centre Georges Pompidou (1971–7), designed by the young Richard Rogers and Renzo Piano in the Marais neighborhood of Paris, a structure at once technological (or Banhamite) and populist (or Venturian)—and quite destructive of the urban fabric into which it was plunged [**6**]. These two main strands of Pop design have persisted in other ways as well; in fact they can be detected, however transformed, in two of the greatest stars in the architectural firmament of the last forty years: Rem Koolhaas and Frank Gehry.

Trained at the Architectural Association in London in the late sixties when Chalk, Crompton, and Herron all taught there, Koolhaas could not help but be influenced by Archigram. Certainly his first book, *Delirious New York* (1978), a "retrospective

5 • Ant Farm, *Media Burn*, July 4, 1975
VHS video, 26 mins

6 • Richard Rogers and Renzo Piano, Centre Georges Pompidou, 1971–7
Rogers and Piano's radical concept was influenced by the open forms and flexible spaces of Cedric Price, including his unrealized Fun Palace, as well as Archigram's *Plug-In City*.

7 • Rem Koolhaas / Office for Metropolitan Architecture, Seattle Central Library, 1999–2004
The building reflects Koolhaas's interest in the organization of space according to use and function. The library's key programs are arranged over five overlapping platforms, while its collection is housed on a "Books Spiral" that winds through four stories.

manifesto" for the urban density of Manhattan that was also a riposte to the celebration of suburban signage-sprawl in *Learning from Las Vegas*, advanced such Archigram themes as "the Technology of the Fantastic." However, in a way that echoes both Banham and Venturi and Scott Brown, Koolhaas also turned a "systematic overestimation of what exists" into his own way of working. For example, in his public library in Seattle (1999–2004), he dramatically refashioned the skyscraper, the old hero-type of *Delirious New York*, slicing the glass-and-steel grid of the typical modern tower into five large levels, stepping it into cantilevered overhangs, and faceting it prismatically at the corners [**7**]. The result is a powerful image of different diagonals and diamonds, second only to the famous Space Needle (1962) as a Pop emblem of that city.

For his part, Gehry appeared to transcend the Venturian opposition of modern structure and postmodern ornament, formal duck and decorated shed, through a combination of the two categories. As new computer programs and high-tech materials permitted the modeling of nonrepetitive surfaces and supports, Gehry and his followers came to privilege the shape of the building over all other aspects: hence the non-Euclidean curves, swirls, and blobs that became signature gestures in much architecture of ▲ the nineties and since, most famously in his Guggenheim Museum Bilbao (1991–7) and Walt Disney Concert Hall in Los Angeles (1987–2003). As with the Koolhaas library, this combination of duck and shed turns an abstract building into a Pop sign and a media logo, and today there is a whole flock of "decorated ducks" that combine the willful monumentality of modern architecture with the populist iconicity of postmodern design. Decorated ducks come in a wide variety of plumage, yet the logic of their effect is much the same. And despite the financial crises of the recent past (that of September 2008, for example), it remains a
• favorite formula for museums and companies, cities and states, indeed for any corporate entity that desires to be perceived, through an instant icon, as a global player. This is one consequence of the Pop–postmodern connection that was first made four decades ago. HF

FURTHER READING

Reyner Banham, *Theory and Design in the First Machine Age* (London: Architectural Press, 1960)

Reyner Banham, *A Critic Writes: Selected Essays by Reyner Banham*, ed. Mary Banham (Los Angeles and Berkeley: University of California Press, 1996)

Hal Foster, *The First Pop Age: Painting and Subjectivity in the Art of Hamilton, Lichtenstein, Warhol, and Ruscha* (Princeton: Princeton University Press, 2012)

Rem Koolhaas, *Delirious New York: A Retrospective Manifesto for Manhattan* (New York and Oxford: Oxford University Press, 1978)

Robert Venturi, Denise Scott Brown, and Steven Izenour, *Learning from Las Vegas* (Cambridge, Mass.: MIT Press, 1972)

Aron Vinegar, *I Am A Monument: On "Learning from Las Vegas"* (Cambridge, Mass.: MIT Press, 2008)

▲ 1976 • 2015

1973

The Kitchen Center for Video, Music, and Dance opens its own space in New York: video art claims an institutional place between visual and Performance art, television and film.

By 1960 ninety percent of American households owned a television; it had become the dominant, even definitive medium of mass culture. By this time some artists had already taken it up, not only as a source of images, as in some projects of the Independent Group, but also as an object to ▲ manipulate, as in some happenings, performances, and installations. Fluxus artists in particular, such as the German Wolf Vostell (1932–98) and the Korean Nam June Paik, subjected television to different kinds of deformation, even destruction, in a way that Vostell modeled after the *décollage* of billboard posters by
● Nouveau Réaliste artists Jacques de la Villeglé and Raymond Hains. From 1958 on Vostell produced several events generically titled *TV Dé-collage*. In one such event in 1963, at the New Jersey farm of sculptor George Segal (1924–2002), the site of several happenings, he put a television set in a picture frame, wrapped it with barbed wire, and then buried it "in a mock ceremonial interment" (in the words of curator and critic John Hanhardt). Yet this example points to the limits of such "critique": it rarely got beyond mockery, and it was often spectacular in its very attack on the spectacle of television culture.

This contradiction reappears in Paik, who complemented the histrionic rage against the television in Vostell with his own whimsical assemblage of electronic devices. In 1963 he too began to alter
■ televisions along the lines of the "altered pianos" of composer John Cage, whom Paik first met as a student in West Germany. In fact, after his move to New York in 1964, Paik popularized the Cagean mix of Duchamp and Zen in his own persona as a mystical madcap inventor of electronic contraptions. At first he manipulated the sync pulse of the television, then simply distorted its image with a magnet. He dislocated the actual sets as well, placing them randomly around rooms, on ceilings, on beds, in shapes such as a cross, amid plants on the floor, and so on. With his *Participation TVs* (1969), which viewers could modify through microphone hookups, Paik combined video with performance. One of the first artists to use video, he explored this combination most intensively in his collaborations with musician Charlotte Moorman (1933–91). He invented such devices as *TV Bra for Living Sculpture* (1968–9), *TV Glasses* (1971), and *Concerto for TV, Cello, and Videotapes* [1], all of which Moorman wore and/or performed. In *Concerto for TV,*

Cello, and Videotapes she "played" three monitors stacked in the rough shape of a cello, on which appeared videotaped performances by Moorman and others as well as live images of the actual space. Already evident here is the tension between bodily presence and technological mediation fundamental to much video art, a tension that Paik sought to resolve—in his own words, to humanize, even to eroticize, technology. But his very attempt to reconcile the difference between man and machine often only exacerbated it, sometimes at the expense of Moorman (who was arrested during a topless performance in 1967). Certainly, *TV Bra for Living Sculpture*, in which two cameras, focused on her face, were reflected in two circular mirrors worn on her breasts, can be seen as an objectification of woman more than as an eroticization of technology.

Haunted by television

Another tension, no less important to much video art, soon became evident in Paik. Even as he was led to attack television, he also wanted to realize it—that is, to transform it from an apparatus of passive spectatorship into a medium of creative interaction, in which receivers of video might become transmitters as well. A similar ambivalence runs through communications theory of the time, especially the influential writings of the Canadian media guru Marshall McLuhan (1911–80). Like many other artists and critics of the time, Paik participated in McLuhanite mood swings between paranoid and mystical attitudes about media and between defeatist visions of technological control and grandiose fantasies of a "global village" of electronic interconnection (the internet has given new life to both attitudes). After other video artists like Douglas Davis (1933–2014) produced live satellite performances, Paik created his own electronic happenings across distant sites (such as his *Good Morning, Mr. Orwell* performed between Paris and New York on January 1, 1984). Yet just as Fluxus attacks on television spectacle were sometimes spectacular in their own ways, so these attempts at interactivity often merely combined the passive spectatorship of most media events with the private conception of most art works.

As with radio, there was nothing technical about television that prevented its adaptation as a reciprocal medium between

▲ 1956, 1961, 1962a ● 1960a ■ 1953

Photo: © Estate of Peter Moore/VAGA, New York/DACS, London, 2004

1 • Nam June Paik and Charlotte Moorman, *Concerto for TV, Cello, and Videotapes*, 1971
Performance with video monitors

monitor video installations such as *PM Magazine* (1982–9) by Dara Birnbaum (born 1948), which manipulated footage from the television show of the same name in such a way as to foreground new techniques of viewer fascination like hyperkinetic image and sound editing.

As might be expected, video art has also had a technophiliac side. Its own early technological developments include the coming to market of videotape in 1956, of the Sony Portapak in 1965 (as the first portable video camera, it was the single most important material precondition of video art), of the half-inch reel-to-reel CV Portapak in 1968 (with its thirty-minute tapes, it provided the basic structure of much early work), and of the three-quarter-inch color cassette in 1972. In these years some artists actually assisted in video research and development; for example, in 1970 Paik designed a synthesizer for image manipulation with Japanese electronics engineer Shuya Abe. More recently, some artists have also assisted, consciously or not, in video marketing and promotion, especially where technically sophisticated artists like Bill Viola and Gary Hill (both born 1951) have exploited elaborate computer programs and special digital effects in their multimonitor, multichannel video-sound installations. Also to be expected, then, is a tilt toward technological determinism, on which score this early pronouncement of Paik remains typical: "As the collage technique replaced oil-paint, the cathode ray tube will replace the canvas." Yet with video, as with photography and film before it, the deep question was not "Is video art?" but rather "In what ways might video transform art—or at least participate in the transformation of the aesthetic field undertaken in the sixties and seventies?" In search of provisional answers, some video artists looked to nonart audiences and sites (first public television, then cable channels), while others brought video to bear on advanced art issues in given art settings. By the time The Kitchen Center for Video, Music, and Dance opened its new quarters in 1973, video art ranged vitally across this wide spectrum of activity.

Dislocations and decenterings

In the early days, artists could both explore the new technology of video and respond to the old modernist imperative that each art form seek out its ontological "specificity"—in this case, that they investigate video not as a device to record (much less as an object to attack) but as a medium whose intrinsic properties might be foregrounded as the very substance of the work. Since the late sixties Woody and Steina Vasulka (born 1937 and 1940), the founders of The Kitchen Center, have pursued this double inquiry. They did so first through direct manipulations of the video signal, of its electronic waveform, as in *Matrix* [2]. This was a bank of nine monitors in which abstract forms and sounds generated by such manipulations drifted fluidly across the three rows of screens. Such video might recall the cameraless photography of the twenties and thirties, such as the "photograms" of László Moholy-Nagy and others, but it is closer in spirit to the structural cinema of Canadian Michael Snow (born 1929), Hollis Frampton (1936–84),

transmitter and receiver—nothing, that is, except its corporate capitalist deployment. For this reason "television haunt[ed] all exhibitions of video art," as poet and critic David Antin wrote in 1975, in its potential for communication as much as in its failure to approach that ideal. This critique of television took many different forms over the years. In the seventies it ranged from *Television Delivers People* (1973), a didactic video-essay by Richard Serra of scrolled texts that condemned television as corporate propaganda, to the notorious *Media Burn* video performance (1975) staged by Ant Farm (Doug Hall, Chip Lord, Doug Michels, and Judy Procter) in San Francisco, a spectacular attack on spectacle culture in which a stack of televisions was set on fire and run through by a souped-up 1959 Cadillac at high speed. In the eighties this critique extended from the "guerrilla television" of Paper Tiger Television, a collective based in New York that produced alternative accounts of news events as well as incisive analyses of corporate media for cable television (such as *Born to be Sold: Martha Rosler Reads the Strange Case of Baby S/M* [1985], a textual video-performance by Martha Rosler on the politics of surrogate motherhood), to multi-

Paul Sharits (1923–91), and others, who foregrounded the material and formal characteristics of film in the sixties and seventies. "The content was the medium," Viola remarked of video art of this time (when he too was initiated into the form), "like structural film in a way." But the materiality of video seemed more difficult to specify than film stocks and flicker effects, and its formal language more difficult to articulate than film montage. Unlike film, video can also be an instantaneous medium, a closed circuit of camera and monitor in which the production of the image is simultaneous with its transmission. To adapt a title of a video work by Gary Hill, video seemed stuck, ontologically speaking, "between cinema and a hard place"—the hard place of television. Moreover, as Rosalind Krauss wrote in her classic essay "Video: The Aesthetics of Narcissism" (1976), "The mirror-reflection of absolute feedback is a process of bracketing out the object. This is why it seems inappropriate to speak of a physical medium in relation to video."

Yet this apparent immediacy of video also made it attractive, especially to artists involved in Process and Performance art. Discontent with medium-specific definitions, these artists wanted to invent new supports and spaces for art that were ever more direct and present. After Minimalism, video became an important player in this "expanded field" of art where it served in part as a continuation of Process and Performance art by other means. Thus prominent practitioners of these forms—like Serra, Bruce Nauman, Lynda Benglis, Joan Jonas (born 1936), Vito Acconci (born 1940), and others—also experimented with video at this time. As extensions of sculpture, Process and Performance art implicated the body both as material and in movement, and video seemed well suited to record bodily manipulations and motions alike; in some instances, it seemed almost to prompt these things. More than just another object to manipulate, then, video became a performance space in its own right, where the viewer was sometimes invited (or impelled) to participate too, whether in the actual space of a video installation or in the virtual space of a closed-

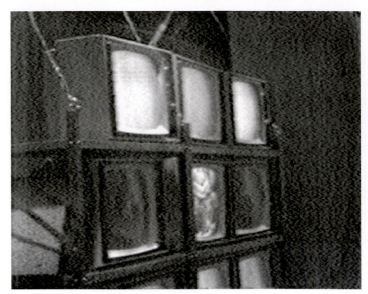

3 • Frank Gillette and Ira Schneider, *Wipe Cycle*, 1969 (detail)
Nine-screen interactive video installation

circuit transmission. Yet the desire for immediacy that drove so much Process and Performance art ran up against the reality of mediation in video—the fact that video remains a time-based, technology-laden medium that is never quite as instantaneous or immediate as it seems, and in which artist and viewer are never quite as present or transparent to each other as they might think.

Very quickly, however, some artists made a virtue of this mediation, as they took up, as a central subject of video work, this very gap between the self and its images—and often between the artist and the audience as well. This was done in ways that were theatrically aggressive, as in the videotaped performances of Acconci, as well as formally simple, as in the use of transmission-delays in image and/or sound. For example, in *Wipe Cycle* [3] by Frank Gillette (born 1941) and Ira Schneider (born 1939), which was first presented at the landmark exhibition "TV as a Creative Medium" in New York, a bank of nine monitors played an array of broadcast television, prerecorded material, and closed-circuit images of the gallery entrance—both live and on delays of eight and sixteen seconds. Each viewer had to negotiate the different space-times of these images, including those of the immediate past—a process of dis/orientation that was further complicated by the rotation of the images from monitor to monitor. Such spatial decentering could also be effected without the use of transmission delays, as it was by Nauman in his various "Corridors" of the late sixties and early seventies [4]. Typically, one entered a long and narrow corridor; set behind and above the viewer was a video camera that looked down the corridor; on the floor at the end to which one walked sat a monitor that relayed what the camera viewed. As the viewer looked at the monitor, then, he or she saw an image of his or her own back. More disruptively, as the viewer approached the monitor, he or she saw this image recede, so that even though one came nearer the monitor and so felt bigger, as it were, one looked smaller. A double dislocation was produced between action and image and between

2 • Steina and Woody Vasulka, *Matrix*, 1978 (detail)
Videotape, 28 minutes 50 seconds

▲ 1998 ● 1969, 1974

▲ 1974

4 • Bruce Nauman, ***Corridor Installation (Nick Wilder Installation),*** **1970 (detail)**. Wallboard, three video cameras, scanner and mount, five video monitors, videotape player, videotape (b/w, silent), dimensions variable, 335.3 × 1219.2 × 914.4 (132 × 480 × 360) overall as installed at the Nick Wilder Gallery, Los Angeles

perceiving body and perceived body—a dislocation that, again, was in keeping with other experiments in the expanded field of art at the time.

The impossibility of a pure present

By the early seventies many artists had assumed these spatial dislocations and subjective decenterings as almost givens of video art; some worked to overcome them while others sought to exacerbate them. For example, in his "video fields" of disjunctively positioned cameras and screens, Peter Campus (born 1937) challenged his viewers to attempt "the coordination of direct and derived perception." Meanwhile, in his video designs, which often included reflective and / or transparent panes set up in front of the audience, Dan Graham sought to heighten the discoordination between such perceptions, discoordinations that were always temporal as well as spatial. In his retrospective essay "Video into Architecture" he remarked:

> A premise of sixties modernist art was to present the present as immediacy—as pure phenomenological consciousness without the contamination of historical or other a priori meaning.… My video time-delay, installations, and performance designs use this modernist notion of phenomenological immediacy, foregrounding an awareness of the presence of the viewer's own perceptual process; at the same time they critique this immediacy by showing the impossibility of locating pure present tense.

This ambivalent relation to modernist immediacy suggests that early video art was on the threshold of some other, perhaps ▲ postmodernist, kind of practice. So was early feminist art, and artists like Joan Jonas and Lynda Benglis used video to explore perception in ways that also went beyond the strictly phenomenological. In such work the spatial-temporal dislocations of video were treated almost as analogues of subjective decenterings. For example, in *Left Side, Right Side* [5] Jonas performed before the camera with hand-held mirrors that bifurcated her face. As the viewer of the video saw a reverse image in any case, it became all but impossible to tell which side was which, all the more so as Jonas constantly repeated, "This is my left side, this is my right side." Another version of this subjective decentering, which stressed the temporal dimension, was performed by Benglis in *Now* (1973), in which the artist attempted to conform physically, in the present time of the video, to prerecorded images of her own face in close-up. The "now" of this meeting was never quite achieved, as her insistent whisperings of this word only underscored.

Because the medium of video was difficult to specify in its physicality, and because its artists seemed more interested in images of the self than in objects in the world, Krauss had argued that its "real medium" might be "a psychological situation"—that of narcissism. But, as we have seen with Jonas and Benglis, this narcissistic situation was never a perfect mirroring. In a sense it was closer to narcissism as understood by the French psychoanalyst Jacques Lacan in his

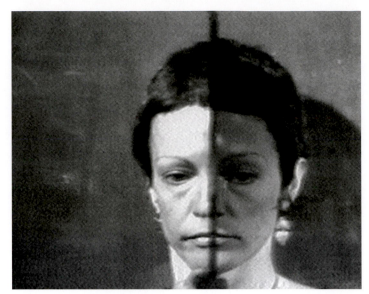

5 • Joan Jonas, *Left Side, Right Side*, 1972 (detail)
Videotape, 2 minutes 39 seconds

celebrated "Mirror Stage" essay—a kind of mirroring that is always disturbed by a slight mediation, an identification with the image of the self that is always undercut by an alienation from this same ▲ image as a little alien. Sometimes, especially with Acconci, this alienation seemed to provoke an aggression against the self or its images that was difficult to distinguish from an aggression against the viewer or the audience. But it may be that this aggression was also born out of another kind of anxiety as well—an anxiety about the interest, perhaps even the existence, of the viewer, of the audience, of any public. In this regard, this aggression might be read allegorically as a probing for a viewer, a search for an audience, a provocation of a public—at a time when, with traditional media and spaces of art transgressed, it was not clear who might show up where, and to what ends or effects. In this light, "the aesthetics of narcissism" explored by Acconci and others represent the other side of the aesthetics of interaction espoused by Paik and others: on the one hand, there is the reality of the autobiographical performer who is often left alone with his or her own body as both a kind of medium-substitute and a kind of audience-surrogate; on the other hand, there is the dream of the video wizard who calls into being a global village of interconnected transmitter-receivers. HF

FURTHER READING
Doug Hall and Sally Jo Fifer, *Illuminating Video: An Essential Guide to Video Art* (New York: Aperture, 1990)
John G. Hanhardt (ed.), *Video Culture: An Investigation* (Layton, U.T.: G. M. Smith Books, 1986)
Rosalind Krauss, "Video: The Aesthetics of Narcissism," *October*, no. 1, Spring 1976
Ira Schneider and Beryl Korot (eds), *Video Art: An Anthology* (New York: Harcourt Brace Jovanovich, 1976)
Anne M. Wagner, "Performance, Video, and the Rhetoric of Presence," *October*, no. 91, Winter 2000

1970–1979

▲ 1975a, 1977a, 1980, 1984b ▲ 1974

1974

With *Trans-fixed*, in which Chris Burden is nailed to a Volkswagen Beetle, American Performance art reaches an extreme limit of physical presence, and many of its adherents abandon, moderate, or otherwise transform its practice.

▲Performance art extends, internationally, across the century; in the postwar period alone it is central to Gutai, happenings, Nouveau Réalisme, Fluxus, Viennese Actionism, and the Judson Dance Theater, to name a few disparate contexts; and there is a performative dimension in many other practices as well. Thus it may be impossible to define Performance art strictly; it may also be thankless, for many practitioners refused the label once it became current in the early seventies. Here performance will be limited to art where the body is "the subject and object of the work" (as the critic Willoughby Sharp defined "body art" in 1970 in *Avalanche*, the most important review of such work), where the body of the artist in particular is marked or otherwise manipulated in a public setting or in a private event that is then documented, most often in photographs, films, or videotapes. As this description suggests, Body art was involved in the same "postmedium" predicament as its Postminimalist complement, ● Process art; and so we might ask of it a question similar to the one asked of Process: does Body art represent a liberatory extension of materials and markings, or does it signal an anxious default of representation onto the body, a literal collapse of the "figure" of art into the "ground" of the body, which might indeed be taken as the primal ground of art?

Three models of Body art

In retrospect much Body art can be seen to elaborate three models of performance of the late fifties and early sixties. First, there is performance as *action*, as developed out of Abstract Expressionist painting in the interart activities of happenings, Fluxus, and related groups. Frequently called "neo-Dada," such actions attacked the conventional decorum of the arts, but they affirmed the heroic, often spectacular gesture of the artist (assumed to be male). Second, there is performance as *task*, a model elaborated in the Judson Dance Theater in which antispectacular bodily routines (such as nonmetaphorical movements like walking and running) were substituted for symbolic dance steps. Set in protofeminist opposition to action performance, task performance was advanced primarily by women dancers like Simone Forti, Yvonne Rainer, and Trisha Brown in a spirit of radical egalitarianism that was

sexual as well as social. And, third, there is performance as *ritual*, ▲ different versions of which were proposed by Joseph Beuys, the ● Viennese Actionists Hermann Nitsch, Otto Mühl, Günter Brus, and Rudolf Schwarzkogler, and practitioners of "destruction art" such as Gustav Metzger and Raphael Montanez Ortiz, among others. Whereas most task performance worked to demystify art, most ritualistic performance sought to remythify it, indeed to resacralize it—which might point, from another direction, at the same crisis in artistic convention. At times these models of performance overlapped, but important differences remained, and they guided the three directions in which Body art developed from the mid-sixties to the mid-seventies, to be represented here with the signal

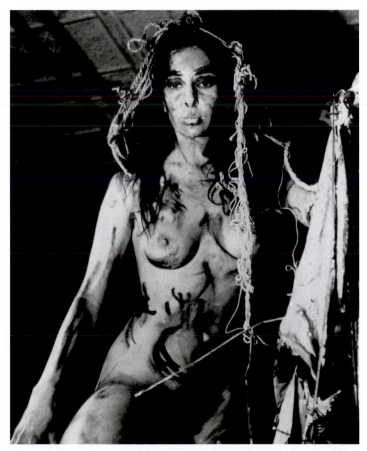

1 • Carolee Schneemann, *Eye Body: 36 Transformative Actions for Camera*, 1963
Silver-gelatin print, 27.9 × 35.6 (11 × 14)

work of Carolee Schneemann (born 1939), Vito Acconci, and Chris Burden (1946–2015), respectively.

Schneemann was the first American to extend the action model of performance into Body art in the early to mid-sixties; her use of "flesh as material" moved from the perceptual interests of the time, first to erotic expressions, then to feminist commitments in a way that was soon shared by an entire generation of women artists in the United States and abroad. For his part, in the late sixties Acconci turned the task model of performance into a testing of body and self, first in quasi-scientific isolation, then in inter-subjective situations; in doing so, he opened up task performance to a Body art that was a social theater of the psyche as well. Finally, in the early seventies Burden combined task and ritual models of performance to produce a sacrificial form of Performance art; though less literal than, say, the Orgies Mysteries Theater of Nitsch, which was explicitly posed as "an 'aesthetic' substitute for a sacrificial act" (replete with the tearing up of dead lambs and the like), the violations of Burden were nonetheless literal enough to test the ethical limits of the artistic use of the body.

In her early "Notebooks" (1962–3), Schneemann drew on the phenomenological notions of bodily perception that had begun to circulate in her milieu; thus when she introduced her nude body into her painting-constructions, she did so less for sexual titillation than for "empathetic-kinesthetic vitality." *Eye Body* [1] was her first piece of Body art: it consisted of private actions, documented in photographs, that were performed in an environment of painted panels, mirrors, and umbrellas: "Covered in paint, grease, chalk, ropes, plastic, I establish my body as visual territory. Not only am I an image maker, but I explore the image value of flesh as material." The title of the piece was programmatic: Schneemann wanted her "visual dramas" to "provide for an intensification of all faculties simultaneously," and *Eye Body* did indeed extend the "eye" of painting into the "body" of performance. Within six months, however, her focus shifted to sexual embodiment, perhaps under the influence of Simone de Beauvoir's feminist classic, *The Second Sex* (1949), as well as the psychoanalytical theories of Wilhelm Reich that condemned sexual repression as the greatest of all evils. Her next piece, *Meat Joy* (1964), performed first in Paris, then in London and New York, presented the body as fully "erotic, sexual, desired, desiring." Here a group of near-naked men and women cavorted (along with any onlookers who would participate) on a set of wet paint, plastic, and rope spiced with pieces of raw meat, fish, and chicken. The title signals the move from *Eye Body*: beyond a phenomenological extension of painting to performance, *Meat Joy* proposed an ecstatic reconfiguration of the solitary "meat" of the body in the communal "joy" of sex.

Schneemann continued to work in Body, Performance, and Installation art, as well as in photography, film, and video, but already by 1964 she had suggested these possibilities: that action models of art called out for literal embodiment; that this embodiment allowed an erotic affirmation of the female body; that this affirmation in turn effected a protofeminist appropriation of

action models, heretofore dominated by men, for women as "image makers"; and that this appropriation might support further explorations of feminine sexuality and subjectivity. Of course, Schneemann was not alone in these early feminist developments. For example, in *Vagina Painting* (1962) Shigeko Kubota had brushed red paint onto a sheet of paper on the floor with a brush suspended from her crotch in a performance that symbolically shifted the locus of action models away from the phallic sticks of Pollock and company. Meanwhile, as artists like Schneemann and Kubota assumed new active positions in art, others like Yoko Ono underscored the old passive positions in society to which patriarchy has long submitted women. Thus in *Cut Piece* [2], performed first in Tokyo, then in New York, Ono invited her audience to cut away her clothing; in a manner resonant with some antiwar protests of the time, vulnerability was here transformed into resistance, as her audience was forced to confront its own capacity for violence, both actual and phantasmatic. Such troublings of cultural associations of active and passive modes with masculine and feminine positions (and, here at least, Western and Eastern ones as well) proved to be a fertile topos of Body art, feminist and otherwise, both for single performers (such as Valie Export) and for collaborative pairs (Marina Abramovic and Ulay, for example); it became a central arena for Vito Acconci as well.

2 • Yoko Ono, *Cut Piece*, March 21, 1965
Performance at Carnegie Recital Hall, New York

▲ 1962b ● 1965

▲ 1962a ● 1962b

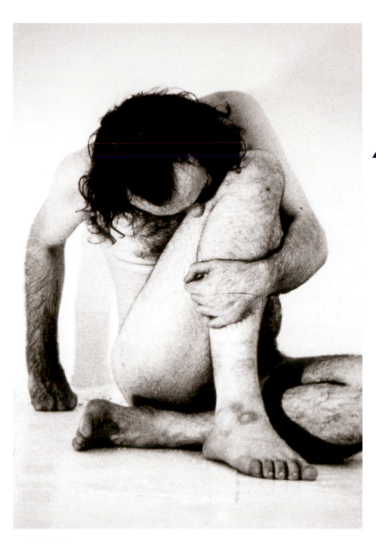

Trust and violation

Acconci first experimented with concrete poetry, a mode of writing that foregrounds the materiality of language. By 1969 he had shifted to a task model of performance, which he adapted into "performance tests" documented for an art public, first through reports and photographs, later through films and videos. Like the ▲ related performances of Bruce Nauman, Acconci subjected the body to apparently rational regimes for apparently irrational purposes (Acconci seemed to suffer the indignities impassively; Nauman seemed to delight in them secretly). For example, in *Step Piece* (1970) Acconci mounted an eighteen-inch stool in his apartment each morning at a rate of thirty steps a minute until he was exhausted. His stamina increased over the duration of the performance, but so did the absurdity of the task. His *Adaptation Studies* (1970) tilted these tests further toward failure. In one piece a blindfolded Acconci was thrown a rubber ball again and again—a recipe for errors. In another piece he plunged his hand into his mouth, also in repeated fashion, until he choked. These performances did test the reflexes of his body, but, more, they exposed its mundane incompetencies to the point where a strange aggressivity against the self predominated in his work.

About this time Acconci began to mark his body directly. In *Trademarks* [3] he bit into his flesh, turning it into a graphic medium of indentations, which were then inked and impressed on paper. This is a *reductio ad absurdum* of the autographic mark in art: at first it seems an act of absolute self-possession ("to claim what's mine," as he said), but this marking split Acconci into an active subject and a passive object—a self-alienation deepened by the suggestion of a sadistic–masochistic polarity in play, as well as by the implication of the body (and perhaps of Body art) as a commodity "trademark." No doubt prompted by feminist developments, Acconci explored this self-othering in gender terms too: in a set of filmed performances titled *Conversions* (1971), he attempted, hopelessly, to alter bodily signs of sexual difference, burning away "male" hair, shaping "female" breasts, tucking his penis between his legs. At the same time he also turned his theater of aggression round on others—to test the boundaries between bodies, selves, and spaces. At first the violations were minimal: in *Following Piece* (1969) he followed randomly chosen people on the street until they entered a private space, while in *Proximity Piece* (1970) he crowded randomly chosen people in art museums until they moved away. But the violations became more insistent with subsequent performances. In *Claim* [4] a blindfolded Acconci crouched in a Soho basement, armed with lead pipes and a crowbar, and threatened any intruders into his space, intruders who were also nominal invitees to the performance; this relation between trust and violation is an important aspect of his work. And in the infamous *Seedbed* (1972) he inhabited, twice a week, the space beneath a raised floor of the Sonnabend Gallery in New York, where he would often implicate visitors in his sexual fantasies, relayed over a microphone, to which he would also sometimes masturbate.

3 • Vito Acconci, *Trademarks*, 1970 (details)
Photographed activity

▲ 1966a, 1967a, 1973

American Performance art | 1974 **651**

4 • Vito Acconci, *Claim*, 1971
Performance with closed-circuit video monitor and camera, three hours

As Acconci explored such imbrications of self and other, privacy and publicity, trust and violation, he tested different kinds of limits—physical and psychological, subjective and social, sexual and ethical. But when these lines seemed broken—for example, in a 1973 performance involving a story of seduction, a young woman from the audience embraced him on the stage—Acconci backed away from such practice. For Chris Burden, on the other hand, the crossing of such lines *constituted* his practice. His first body piece, performed in 1971 when he was still a graduate student at the University of California at Irvine, made him notorious: for his master's thesis he squeezed into a school locker for five days and nights, attached only to two five-gallon water bottles, a full one above, an empty one below. Here task performance was taken to an ascetic extreme—Body art as a spiritual exercise without the religion, except perhaps for the faith demanded of performer and onlookers alike. This attenuation of ritualistic performance into an ascetic regime would later be pursued by teamed performers like Abramovic and Ulay and Linda Montano and Tehching Hsieh.

Like Acconci, Burden alternated such quasi-masochistic performances with quasi-sadistic events, but he concentrated on acts that placed his own body at primary risk, even as his studied irresponsibilities also tested the spontaneous responsibilities of others. There are several examples from the early seventies, but two stand out. In *Shoot* (1971) Burden had a marksman shoot him in the arm (his left bicep was grazed), while in *Trans-fixed* [5] he was nailed, with his arms extended à la Christ, onto the hood of a Volkswagen Beetle: the garage door was then opened, the car with the crucified Burden rolled out, the engine raced for two minutes (to signify his screams), then the car was rolled back in, and the door dropped. However inflected by Pop parody (regarding, perhaps, the
▲ sacramental value of the car in American culture), the ritualistic basis of Body art is blatant here. Transfixed, Burden also transfixed his viewers (the performance continues to have this mesmeric effect through photographs), and indeed the remnants of his

actions, such as the nails, are often called "relics." To the ambivalent positions of narcissism and aggressivity, voyeurism and exhibitionism, sadism and masochism already evoked by Acconci, Burden added another ambiguous dimension, a sacrificial theater that, as
▲ with its other celebrants like Nitsch, Schwarzkogler, or Gina Pane, touched on the extremes of art—its ritualistic origins as well as its ethical limits (ethical limits in two senses: what can an artist do to self and to other, and when does the viewer intervene?).

Between the real and the symbolic

Our initial definition of Body art—in which the body is "both subject and object of the work"—seems innocent by comparison. But this innocence, this "immediacy" of Body art, should not be lost: it is what attracted its first practitioners and impressed its first viewers. It is also what aligned Body art with the modernist mandate to expose the materiality of art, to pursue an idea of sheer presence. But, as we have seen, Body art did not render "subject and object" one; on the contrary, this polarity was exacerbated, and it set up other binarisms as well—the body as active or passive, Body art as expressive, even liberatory (as in Schneemann), or withdrawn, even debilitated (as in Acconci, Nauman, and sometimes Burden), and so on. But the definitive ambiguity of Body art might be this: even though it was regarded as an art of presence—positively as an avant-gardist reuniting of art and life, negatively as a nihilistic obliterating of aesthetic distance—it was also a marking

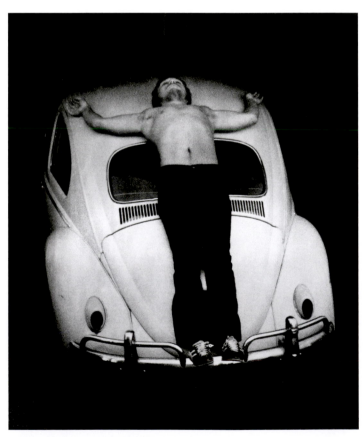

5 • Chris Burden, *Trans-fixed*, 1974
Performance, Venice, California

▲ 1960c, 1964b, 1972c

▲ 1962b

6 • Bruce Nauman, *Wax Impressions of the Knees of Five Famous Artists*, 1966
Fiberglass, polyester resin, 39.7 × 216.5 × 7 (15⅝ × 85¼ × 2¾)

of the body as a representation, as a sign, indeed as a semiotic field. Perhaps the essence of Body art is this difficult shuttling between presence and representation, or, more exactly, between indexical markings of the real (this arm bitten or shot, right now, before your eyes) and grandiose invocations of the symbolic (especially evident in ritualistic performance). For some practitioners like Acconci, this vacillation—of representation collapsed into the body, of the body raised into representation—seemed almost traumatic. For others like Nauman, the great ironist of Postminimalist art, it was an occasion for subversive play. For example, his *Wax Impressions of the Knees of Five Famous Artists* [6] mocked both the indexical markings and the ritualistic pretensions of Body art almost before they were proposed: all five sacred impressions here are faked—they are his alone (indeed this relic is not even wax).

Perhaps the ambiguity of the body as both natural flesh and cultural artifact is irreducible, and Body art only confronts us with the ambivalence of this condition. But Body art also complicates this ambiguity with another, for it not only presents the body as a marked thing but also invokes it as a psychic site. For the most part Body art preceded the psychoanalytic engagements in art ▲ first prompted by feminism in the mid-seventies; when its models of the subject were not phenomenological, they tended to be behavioral, even sociological. Nonetheless, its involvement

in subject–object relations led it toward an abstract theater of psychosexual positions: as we have seen, Body art often seems to stage the Freudian couplets of narcissism and aggressivity, voyeurism and exhibitionism, sadism and masochism, indeed to play out the Freudian "vicissitudes of the instincts"—the constant "reversals" of active and passive positions, the perpetual "turnings round" from subject to object and back again. In this way, Body art anticipates rather than illustrates the psychoanalytic theories ▲ of subjectivity and the political critiques of power that became prominent from the late seventies onward. HF

FURTHER READING

Amelia Jones, *Body Art: Performing the Subject* (Minneapolis: University of Minnesota Press, 1998)
Kate Linker, *Vito Acconci* (New York: Rizzoli, 1994)
Carolee Schneemann, *More Than Meat Joy: Complete Performance Works and Selected Writings* (New Paltz, N.Y.: Documentext, 1979)
Kristine Stiles, "Uncorrupted Joy: International Art Actions," in Paul Schimmel and Russell Ferguson (eds), *Out of Actions: Between Performance and the Object 1949–1979* (London: Thames & Hudson, 1998)
Fraser Ward, "Gray Zone: Watching 'Shoot'," *October*, no. 95, Winter 2001
Carrie Lambert-Beatty, *Being Watched: Yvonne Rainer and the 1960s* (Cambridge, Mass.: MIT Press, 2011)

▲ 1975a

▲ 1975a, 1977b, 1987, 1993a, 2009c

1975 a

As filmmaker Laura Mulvey publishes her landmark essay "Visual Pleasure and Narrative Cinema," feminist artists like Judy Chicago and Mary Kelly develop different positions on the representation of women.

Feminism is a complicated topic in its own right, and as it provoked women to transform art in the late sixties and early seventies, it became more complicated. There is no single feminist art; indeed, most significant art of the last three decades has shown some influence of feminist concerns, such as the social construction of gender identity (including that of the artist) and the semiotic import of sexual difference (especially regarding the image). There is also, then, no separate history of feminist art.

Nonetheless, feminist art can be narrated in relation to the women's movement, which developed along the lines of the civil-rights movement. Thus in a first phase (underway in the sixties) women struggled for equal rights, and feminist artists struggled for equal access to modernist forms such as abstraction. The second phase (underway by the late sixties) was more radical than this first egalitarian stage. Here the movement tended to insist on the fundamental difference of woman from man, and to claim a special intimacy with nature, a unique culture of histories and myths, indeed an essential womanhood to express. And feminist artists moved away from modernist forms associated with men, like abstraction, reclaimed devalued forms of craft and decoration associated with women, contested oppressive stereotypes, and advanced positive images of women. A third phase (underway by the mid-seventies) was skeptical both of the equality pursued in the first phase and the separation proclaimed in the second. The movement still critiqued the positioning of women within patriarchal society, but it did so aware that this order could not be simply transcended. Meanwhile, feminist artists passed from a utopian imaging of women apart from men to a critique of given images ▲ within high art and mass culture alike. In a shift from a "representation of politics" to a "politics of representation," images of women—from nudes in museums to models in magazines—were treated as signs, even as symptoms, of male desire and dread, and the category of woman was seen to be "constructed" in social history, not grounded in natural biology or in "essential" being.

These phases are not strictly consecutive; they can coexist, conflict, and recur. And although some artists may view woman as "essential," and others as "constructed," this opposition is rarely absolute. Finally, even as feminist art is distinctive, it is not produced in a vacuum. It is in constant dialogue with other art—with marginal forms developed by obscure women as well as with privileged forms dominated by famous men. Thus even as feminist art elaborated the shift toward the perceptual conditions of the viewer ▲ inaugurated by Minimalism, it also questioned the Minimalist assumption that all viewers, all bodies, are the same perceptually and psychologically. So too, even as feminist art elaborated the ● critique of visuality begun in Conceptual art, it also questioned the Conceptualist assumption that language is essentially neutral, transparent, and rational. The same is true of feminist trans-■ formations of early Body, Performance, and Installation art, all of which were particularized and politicized, often according to the feminist slogan "the personal is the political."

Challenging the canon

The first order of business for feminist artists was to secure spaces for working and exhibiting, "raising consciousness" and teaching. This was a collective project involving the founding of such artist-run galleries as AIR (Artist in Residence) in New York in 1972. Yet the signal achievements in this regard occurred away from the male-controlled Manhattan art world. In 1971, Miriam Schapiro (1923–2015) and Judy Chicago (born Judy Cohen in 1939) began the Feminist Art Program at the California Institute of the Arts in Valencia. In 1972 this group created Womanhouse, a temporary exhibition space in Los Angeles, which was soon followed by the Woman's Building in the old Chouinard art school (it closed only in 1991). According to Chicago, Womanhouse "fused collaboration, individual artmaking, and feminist education to create a monumental work with openly female subject matter." One must imagine a ribald theater where the domestic roles of women were caustically critiqued in a series of rooms. It opened with "Bridal Staircase," a mannikin in a wedding gown atop a flight of stairs. In "Sheet Closet" this bride became a housewife, a mannikin with shelves lined with sheets literally cut into her. "Nursery" implied her next role as mother, but its adult-scale crib and hobbyhorse suggested that the domestic structure of the nuclear family infantilizes all its members, especially the mother. Finally, in "Nurturer's Kitchen" and "Menstruation Bathroom" the body of this mother-and-wife became unruly. In the kitchen, a feminist revision of a Surrealist

▲ 1977a ▲ 1965 ● 1968a, 1993a ■ 1974

fantasy, eggs mutated into breasts and covered the wall and ceiling, while in the bathroom tampons soaked in fake blood spilled out of a wastebasket.

At Womanhouse, performance was also turned into a feminist form of critical expression. Along with the installations were "duration" pieces by Faith Wilding (born 1943) and others, who acted out domestic work usually left to women—scrubbing floors, ironing shirts, simply waiting—in pained silence. Other performances treated traumatic events. In *Ablutions* [1], performed by Chicago, Suzanne Lacy, Sandra Orgel, and Aviva Ramani a few months after Womanhouse was dismantled, some of the women were immersed in tubs full of different fluids, then wrapped in bandages by the others, all in a space surrounded by kidneys tacked to the walls and filled with a taped testimony of a rape. Here
▲ task performance and ritual performance were combined to work through extreme experiences of "binding, brutalization, rape, immersion, body anxiety, and entrapment" (Chicago).

Just as early feminism sought to reclaim bodies of women (for instance, in abortion rights), so early feminist art sought to reclaim images of women—and by women as well. This involved the revaluation of such devalued forms as decorative arts and utilitarian crafts historically gendered female. For example, Schapiro adapted different sewing techniques in her feminist transformation of collage, which she dubbed "femmage," while Faith Ringgold (born 1930) also transformed collage in her "story quilts" of African-American life [2]. For her part Chicago used both ceramics and needlework in *The Dinner Party* (1974–9), her monumental "femmage" to women historical and legendary. This "personal search for a historical context for my art" began with a series of paintings called "Great Ladies," in which abstract forms mutate into floral and vulvar images, and it culminated in *The Dinner Party* [3]. Conceived "as a reinterpretation of the Last Supper from the point of view of women, who, throughout history, have prepared the meals and set the table," this Last Supper positioned women as "the honored guests." Three long

1 • Judy Chicago, Suzanne Lacy, Sandra Orgel, Aviva Ramani, *Ablutions*, 1972
Collaborative performance, Venice, California

▲ 1962b, 1974

Theory journals

The seventies witnessed an unprecedented flourishing of journals of criticism. During this time, critical theory became a dynamic part of cultural practice: if an avant-garde existed anywhere, it might be argued, it existed there—in such publications as *Interfunktionen* in Germany, *Macula* in France, *Screen* in Britain, and *October* in the United States. More politically committed than traditional philosophy, but also more intellectually rigorous than conventional criticism, such theory was interdisciplinary in its very nature: some versions attempted to reconcile different modes of analysis (e.g., Marxism and Freudianism, or feminist inquiry and film studies), while others applied one model to a wide range of practices (e.g., the structure of language adapted to the study of art, architecture, or cinema). The master thinkers who had emerged in France in the fifties and sixties, such as the structuralist Marxist Louis Althusser, the structuralist psychoanalyst Jacques Lacan, and the poststructuralist philosophers and critics Michel Foucault, Jacques Derrida, Roland Barthes, and Jean-François Lyotard, were already influenced by modernist poets, filmmakers, writers, and artists, so that the application of such "French theory" to visual art seemed logical.

Among the preconditions of the boom in theory was a growing discontent with both formalist and belle-lettristic modes of criticism, especially as they failed to grapple with new developments in Conceptual art, Performance, and institution-critical art, which were sometimes influenced by "theory" in their own ways. Second, there was an embrace, in both art and academia, of the French thinkers mentioned above, as well as a developing interest in the critical elaboration of such figures, especially by feminists involved in psychoanalysis (such as Julia Kristeva, Luce Irigaray, Michèle Montrelay). Third, there was a delayed reception of interwar German critics associated with the "Frankfurt School" of critical theory such as Walter Benjamin and Theodor Adorno. And, fourth, there was an intensive refinement of feminist theory, especially concerning the question of spectatorship and the structure of sexuality. All four of these developments were mediated by the new critical journals.

Interfunktionen was perhaps the most engaged in radical art practice, while *October* and *Macula* responded selectively to both new art and French theory. *New German Critique* was the principal interpreter of German criticism in the States, while *m/f* in the UK and then *Camera Obscura* and *Differences* in the US elaborated on feminist theory (journals such as *Heresies* focused on feminist art). Other reviews such as *Block*, *Wedge*, *Word and Image*, and *Art History* addressed both the new art and "the new social art history" that was emerging. And still other journals, such as *Critical Inquiry* and *Representations*, were developed to consider the academic ramifications of these different phenomena. But in the early days of these journals perhaps the most dynamic was *Screen*, for it was in this British review that the Marxist orientation of the New Left, a strong commitment to cultural studies, early translations of such various thinkers as Brecht, Benjamin, Barthes, Althusser, and Lacan, and feminist readings of film, mass culture, and psychoanalysis, all came into critical conversation.

2 • Faith Ringgold, *Echoes of Harlem*, 1980
Acrylic on canvas, dyed, painted, and pieced fabric, 243.8 × 213.4 (96 × 84)

tables are set in an equilateral triangle on a "Heritage Floor" made up of over 2,300 porcelain tiles inscribed with the names of 999 women. These obscure women "support" the illustrious women honored, with distinctive painted plates, on the tables, which are also set with linen tablecloths, goblets, flatware, and napkins. The first table celebrates women from matriarchal prehistory through antiquity; the second, from the beginnings of Christianity through the Reformation; and the third, from the seventeenth to the twentieth centuries. *The Dinner Party* thus "takes us on a tour of Western civilization, a tour that bypasses what we have been taught to think of as the main road" (Chicago). This challenge to the canon was also raised by feminist art historians, from the first essay on the systematic exclusion of women, "Why Have There Been No Great Women Artists?" (1971) by Linda Nochlin, to the first book on the subject, *Old Mistresses: Women, Art, and Ideology* (1981) by Roszika Parker and Griselda Pollock. Feminist criticism of different orientations was also supported by new journals, such as *Feminist Art Journal* and *Heresies* in North America and *Spare Rib* and *m/f* in Britain.

A new language of desire

The Dinner Party is emblematic of the second phase of American feminist art in several respects. Although Chicago assumed authorship, it was a collaborative project; it sought to revalue arts and crafts associated with women; and it worked to recover lost figures for a feminist history. But what made it exemplary of this second phase

was its celebratory association of woman and body as well as its gynocentric view of cultural history. Other feminist artists advanced more anguished versions of womanly embodiment during this time. In the long scrolls of her *Codex Artaud* [4], Nancy Spero (1926–2009) mixed violent statements from Antonin Artaud (1896–1948), the French writer and founder of "the theater of cruelty," with "images I had painted—disembodied heads, defiant phallic tongues on tense male, female, and androgynous figures, victims in strait-jackets, mythological or alchemical references, etc." And in her *Siluetas* series of the seventies [5], Ana Mendieta (1948–85) inscribed her own profile into various landscapes, an association of female body and maternal nature that reads ambiguously as joyous reunion or deathly embrace or both. This second phase of feminist art was thus governed by an identification of woman and body, of woman and nature, that was at times triumphant and at times depressive.

Perhaps in the face of patriarchy this identification was necessary to feminist solidarity. But it was soon seen as a reduction of women to nature, as an "essentialist" impediment to feminist repositioning of women in society. Also confronted with sexist stereotypes in mass culture, some feminists advocated a moratorium on representations of women in art, while others explored other ways to register the desires of women and the disruptions of sexual difference. This investigation was more advanced in Britain than in North America. There, too, feminists first focused on economic inequities (as in the informational project "Women and Work: A Document on the Division of Labour in Industry," mounted by Kay Hunt, Margaret Harrison, and Mary Kelly in London in 1975); and artists first sought out autonomous spaces (as in A Woman's Place, a site somewhat similar to Womanhouse, also staged in London in 1975). But British feminisms were closer both to socialist politics and to psychoanalytic theory than their North American counterparts. Indeed, Freud, Jacques Lacan, and French feminist analysts like Luce Irigaray and Michèle Montrelay guided feminist debates in Britain. Of course, feminist relations to psychoanalysis could only be ambivalent, given that in Freud femininity is associated with passivity, and that in Lacan woman is made to signify "castration" or "lack." But psychoanalysis also provided feminists, first in Britain and then elsewhere, with critical insight into the positioning of woman—in the unconscious and in the symbolic order, in high art and in everyday life.

The text that pioneered this feminist use of psychoanalysis for cultural critique was "Visual Pleasure and Narrative Cinema" (1975) by the filmmaker and critic Laura Mulvey (born 1941), who, with her partner Peter Wollen (born 1938), also made such feminist films as *Riddles of the Sphinx* (1976). In her essay Mulvey articulated two primary concerns of the third phase of feminist art: the construction of woman both in mass culture (in her case, classic Hollywood film) and in psychoanalysis. In Britain artists like Mary Kelly (born 1941) were already at work on the second topic, while in the States artists like Barbara Kruger, Cindy Sherman, and Silvia Kolbowski (born 1953) would soon turn to the first. According to Mulvey, the visual pleasure of mass culture is

▲ Introduction 1, 1977a, 1993a

3 • Judy Chicago, *The Dinner Party*, 1974–9
Mixed-media installation, 121.9 × 106.7 × 7.6 (48 × 42 × 3)

4 • Nancy Spero, *Codex Artaud VI*, 1971 (detail)
Typewriter and painted collage on paper, 52.1 × 316.2 (20½ × 124½)

5 • Ana Mendieta, *Untitled*, from the *Silueta* series, 1976
Red pigment *silueta* on the beach, Mexico

nearly contemporaneous, *Post-Partum Document* is as emblematic of the third phase of feminist art as *The Dinner Party* is of the second. Here Kelly developed her model of an art project that exists somewhere between a psychoanalytic case-study and an ethnographic field-report. Made up of six sections with a total of 135 units, *Post-Partum Document* mixes different kinds of images and texts in a double narrative. On the one hand, it recounts the entry of her son into family, language, school, and social life. On the other hand, it recounts her response to the "loss" of her child to such institutions. In doing so, Kelly explores "the possibility of female fetishism," in particular that of the mother. For Freud, the fetish is a substitute for an erotic object that appears lost—as the maternal breast might sometimes appear lost to the infant, the penis of the mother to the child, or indeed the grown child to the mother. Kelly focuses on this last loss as she presents the residues of her child—his diapers, baby clothes, first scribbles, initial letters, and so on—as fetishes of the mother, as "emblems of [her] desire." At the same time she juxtaposes these traces with notes, some anecdotal, others theoretical, which confirm as well as contest psychoanalytic accounts of both childhood and motherhood. The result is an "archaeology of everyday life"—of weaning, speaking, schooling, writing, and so on—that is also a narrative of "the difficulty of the symbolic order for women."

Kelly has completed further projects that are particularly important in this context. *Interim* (1985–9) considers the middle age of women as an interim period, putatively after erotic and maternal services, a dark age lost to cultural representation. And *Gloria Patriae* (1992) tackles the pathologies of military masculinity, especially as displayed in the Gulf War of 1991. Both projects attempt to connect theoretical inquiries into psychic life with political demands for social change, and they did so in a reactionary period ruled by Ronald Reagan and Margaret Thatcher and their immediate heirs. It may be little consolation to feminist art, given the great backlash against feminism in general, that it has so transformed contemporary art. But it has done so, as Kelly suggests, "by transforming the phenomenological presence of the body into an image of sexual difference, extending the interrogation of the object to include the subjective conditions of its existence, turning political intent into personal accountability, and translating institutional critique into the question of authority." HF

FURTHER READING
Judy Chicago, *Beyond the Flower: The Autobiography of a Feminist Artist* (New York: Viking, 1996)
Joanna Frueh, Cassandra L. Langer, and Arlene Raven (eds), *New Feminist Art Criticism: Art, Identity, Action* (New York: HarperCollins, 1994)
Mary Kelly, *Imaging Desire* (Cambridge, Mass.: MIT Press, 1997)
Lucy R. Lippard, *The Pink Glass Swan: Selected Essays in Feminist Art* (New York: New Press, 1995)
Linda Nochlin, *Women, Art and Power: And Other Essays* (New York: Harper & Row, 1988; and London: Thames & Hudson, 1989)
Roszika Parker and Griselda Pollock, *Framing Feminism: Art and the Women's Movement 1970–85* (London: Pandora, 1987)
Griselda Pollock, *Vision and Difference: Femininity, Feminism, and Histories of Art* (New York: Routledge, 1988)
Catherine de Zegher (ed.), *Inside the Visible: An Elliptical Traverse of 20th-Century Art* (Cambridge, Mass.: MIT Press, 1994)

not "mass" at all; it is designed primarily to suit the psychic structure of the heterosexual male, to allow his enjoyment of the female image as an erotic object. Thus, in the famous formula of her text, patriarchal culture positions "woman as image" and "man as bearer of the look." The politics of the essay follow from this account: Mulvey calls for the destruction of this masculinist pleasure in favor of a "new language of desire." This recognition—that patriarchal culture, high and low, is structured around "the male gaze"—was fundamental: it empowered many feminist practices in art and criticism alike. But it also had a few blind spots of its own, as Mulvey came to see. Are gazes strictly male, female, straight, gay, white, black, and so on? Such claims can fix identity more than free it up. Nonetheless, like the claim of an essential womanhood, the notion of a male gaze was a strategic necessity. And its own essentialism was soon complicated by male artists like Victor Burgin, who was also prompted to investigate the construction of this gaze, indeed of masculinity in general.

When Mulvey published "Visual Pleasure and Narrative Cinema," Mary Kelly had almost completed the first part of her *Post-Partum Document* of 1973–9 [6]. Although the two works are

▲ 1977a, 1993a ● 1977b, 1987, 1993c ■ 1984a ▲ 1992 ● 1931a ■ 2009c

6 • Mary Kelly, *Post-Partum Document: Documentation VI, Pre-Writing Alphabet, Exergue and Diary*, 1978 (detail)

Perspex units, white card, resin, and slate, one of fifteen units in this section, 20 × 25.5 (7⅞ × 10)

1975 b

Ilya Kabakov completes his series of albums *Ten Characters*, an important monument of Moscow Conceptualism.

Between 1972 and 1975, the Soviet artist Ilya Kabakov (born 1933) made a group of albums called *Ten Characters*. As the series title suggests, each of these ten multisheet compendia was focused around a fictionalized personage, such as 'Flying Komarov' or 'Agonizing Surikov'. Individual pages included handwritten blocks of text and scenes rendered in a charming figurative style akin to those found in children's books. Indeed, Kabakov's legitimate employment was as a children's book illustrator. In the Soviet Union, there was no open market for art. Consequently, Kabakov's independent work, like a wide range of art works in unsanctioned styles or formats, was part of the unofficial art world, without access to state museums and galleries or any commercial potential within the USSR. While the activities of unofficial artists were not explicitly illegal, they could be subject to unpredictable forms of repression. Nor did unofficial artists necessarily see themselves as dissidents, though Kabakov and many of his associates took what they considered the absurdities and alienation of Soviet public discourse as a subject for their art. In the absence of a broader public, these artists formed the principal audience for each other's works, gathering in small interrelated associations or groups. The tendency with which Kabakov is associated became known as "Moscow Conceptualism." While his art was thus unofficial, his employment as a children's book illustrator, like that of his colleague and friend Erik Bulatov (born 1933), made it possible economically for him to pursue his independent practice.

While some of the narratives of Kabakov's *Ten Character* albums share qualities with fairy tales, their structure is dramatically different from the formulaic plots and tidy resolution that genre is known for. In his important book *The Experimental Group: Ilya Kabakov, Moscow Conceptualism, Soviet Avant-Gardes*, art historian Matthew Jesse Jackson summarizes the structure of Kabakov's albums as follows: "Though each album treats a single 'character' … Kabakov does not include representations of the eponymous figure. Instead, each album proceeds according to a rigid formula: a title page appears, followed by a page featuring a quotation from the character, then two citations from 'real' textual sources are included…. Following this preamble, the viewer encounters the 'storyboards' that make up the bulk of the work. Like a *matryoshka*

(Russian nesting doll), each sequence reveals further albums within each character's 'album.'" Each album thus invokes a character without ever succeeding in defining him. In place of a stable identity, Kabakov wraps his personages in endless layers of image and text that, like a *matryoshka*, reveal one hollow center after another.

Into the void

The question of a void is key not only to characters like 'Sitting-in-the-Closet-Primakov', who fears the great emptiness beyond his safe lair, and others who risk plunging into open space, but also the way in which the albums are structured. In *Sitting-in-the-Closet-Primakov*, the second page of the album quotes the title character as declaring: "As a child I sat in the closet for half a year, where no one could disrupt me, and I could imagine what was going on in the room by the sounds coming through the wall. Sitting there, I imagined to myself that I was flying out of the closet and rising over the city and over the entire earth and I was disappearing into the sky" [1a]. This page is followed by two subsequent ones with quotes drawn from the widely read and translated Soviet adventure novel *Two Captains* (1939–44) by Veniamin Kaverin [1b, 1c], which is succeeded by eight pages consisting of nothing but a black field with a caption box in the lower right corner describing activities invisible to Sitting-in-the-Closet Primakov such as "Father came home from work" or "Olga is doing homework" [2a]. Ultimately, after commentary and an "album" by Primakov himself, two sheets represent the opening of the closet door, first by only a sliver and then fully revealing a room beyond [2b, 2c]. Through such quasi-cinematic devices, as well as the various descriptive, literary, or philosophical digressions enumerated by Jackson, the albums name a character, but evade him; like a void, they are existentially groundless. For Kabakov, this void serves as an image for the Soviet state. In his text "On the Subject of 'The Void,'" he speaks of the isolation of individuals in the Soviet system who, like Primakov in his closet, "take refuge in burrows." Even in large cities, Kabakov asserts, what may superficially appear as great crowds are merely "thousands of people dashing from one burrow to another." Here, in the absence of an open and developed civil society, privacy is understood as a hunkering down, a hiding

1a–c • Ilya Kabakov, *Sitting-in-the-Closet Primakov*, 1970–2 (details)
47 pages, drawings on paper glued to gray cardboard in a handmade box,
each drawing 51.5 × 35 (20¼ × 13¾)

2a–c • Ilya Kabakov, *Sitting-in-the-Closet Primakov*, 1970–2 (details)
47 pages, drawings on paper glued to gray cardboard in a handmade box,
each drawing 51.5 × 35 (20¼ × 13¾)

or a *burrowing*. No wonder, according to Kabakov's rendering of his character, that Primakov dreads leaving his closet. For Kabakov, the state system is that which exists between these defensive burrows; it is "everything that is an embodiment of the void, that blends with it and expresses it." Kabakov memorably describes this notion of government with the metaphor of the wind: like weather, it can be terrifyingly unpredictable: "incomprehensible, the state system with all its gusts and sudden changes of direction. The permanently fierce pressure, thunderous gusts, and howling sounds, just at the entrance to their burrows, bring horror to the souls of those sheltering there, filling them with permanent fear." Here the Soviet state is understood as both arbitrary and all-powerful; it exemplifies a void that Kabakov understands not as passive emptiness, but rather as a strong affirmative force equal to "the activity of nature, the positive activity of man, or of higher powers."

Kabakov's art during the Soviet period expresses an oscillation between the void, which figures the unpredictability of Soviet state behavior, and the burrow as a site of claustrophobic intimacy, represented in the *Sitting-in-the-Closet-Primakov* album by Primakov's closet. Victor Tupitsyn has likened this spatial dialectic to the Soviet communal apartment—a living arrangement in which many families shared kitchen and bathroom facilities. In his book *The Museological Unconscious*, Tupitsyn writes, "The frustration inherent in such an Orwellian living arrangement [the communal apartment] was exacerbated by a … contrast between the communal interior and the ideological façade, between the overcrowded apartment and the myths of extracommunal space." This fundamental opposition between communal interior and ideological facade (which closely mirrors Kabakov's dialectic of void and burrow) leads Tupitsyn to label the movement of which Kabakov was a primary member "Moscow Communal Conceptualism." It is important to note, in this regard, that beginning in 1974–5 Kabakov called forth such intimacy to *enact* his albums. In these years, he began to "perform" these works for small groups of six to fifteen people, narrating each page in sequence as though recounting a fairy tale of Soviet life. As Jackson states, this live narration, which according to Boris Groys would usually last an hour but could take much longer, was a way for Kabakov to create an intimate public for his work in the absence of access to official arts institutions. The very possibility of this mode of unofficial art required its own type of *burrow*.

Against an empty official discourse

At this point it is necessary to say a word about Moscow Conceptualism in more general terms. As Ekaterina Bobrinksaya has argued in her essay for the catalogue of the important 2008 exhibition "Total Enlightenment: Conceptual Art in Moscow 1960–1990," Moscow Conceptualism encompassed a wide variety of different artistic practices, including narrative allegorical works like Kabakov's albums; paintings that directly reference and recode

▲ official traditions of the Soviet Socialist Realist style by figures like Erik Bulatov and the duo Vitaly Komar (born 1943) and Aleksandr Melamid (born 1945); and the radically understated "trips out of town," organized by the group Collective Actions in deserted fields outside of Moscow. What is known as Moscow Conceptualism began to emerge in the late sixties with the work of Kabakov and became an important tendency within unofficial art in the USSR by the middle of the next decade. During the late seventies, there was a shift toward the performative works of the Collective Actions group, while subsequent projects by later individuals and groups responded to the themes and procedures of these three pioneering strategies, adding to the intense community of independent experimentation and dialogue. Because of its emphasis on Soviet life and ideology as a kind of "discourse"—or set of institutional and ideological attitudes and beliefs—Moscow Conceptualism remained a vital, even urgent, practice until the fall of the Soviet Union. As Boris Groys, an early and important critic of Moscow Conceptualism and curator of "Total Enlightenment" writes in his catalogue essay, "the official discourse on what art is had an all-determining role in all areas of Soviet culture. The main modus operandi of Moscow Conceptualism was to exploit, vary, and analyze this official discourse privately, ironically, and profanely."

Groys's point here gets to the heart of how Moscow Conceptu-
● alism differs from Conceptual art's Anglo-American traditions which focus on what Benjamin H. D. Buchloh has identified as the aesthetic of administration through its reference to bureaucratic and/or technical languages, such as Joseph Kosuth's dictionary definitions, or procedures of filing and indexing like those adopted by Art & Language, or the strategies of documentation and research
■ practiced by artists as diverse as Hanne Darboven and Hans Haacke. This Western tradition is also closely associated with what

▲ critic Lucy Lippard called the dematerialization of the art object evident in the replacement of works in "traditional" media such as painting and sculpture with linguistic propositions that may or
● may not be acted upon, as in the work of Lawrence Weiner, or the experience and documentation of ephemeral actions like those
■ performed by Adrian Piper. As we have seen, Groys along with other critics asserted that the Moscow Conceptualists were reacting to a "public" language of Soviet ideology rather than the technical character of bureaucratic discourse that is present in both commercial and governmental forms of administration. This led to very different sorts of conceptual strategies in Moscow. The introduction of narrative and oblique characterization in Kabakov's albums, for instance, are dramatically distinct from the typological, social-science methods of Anglo-American Conceptual artists, which tended to avoid storytelling in favor of the "neutral" serial procedures of defining, filing, or compiling. And yet in his reference to children's pedagogy—through invented Soviet "fairy tales"—in combination with various "voices" in the albums, ranging from the confessional to the analytical, which are all centered, as we have seen, around an image of the "dematerialized" Soviet state as a void, Kabakov breaks down the dominant language of Soviet power, just as Western Conceptual artists broke down the dominant language of bureaucratic power.

Whereas Kabakov analyzed such official discourse by creating piquant fairy tales about Soviet life, Bulatov and Komar and Melamid addressed its forms more directly through references to the history of Socialist Realism, which since the mid-thirties was the approved form of official art in the USSR. One of Bulatov's most celebrated paintings is his *Horizon* of 1971–2 [3]. In this work, a beach is populated by distant bathers, while a more prominent group of five fully dressed figures strides toward the sand

4 • Vitaly Komar and Aleksandr Melamid, *Double Self-Portrait*, 1973
Oil on canvas, 91.4 (36) diameter

from the left foreground, their backs turned to the viewer but their gaze presumably directed toward the sea. In his essay for Bulatov's catalogue raisonné, Yevgeny Barabanov quotes the artist as saying that these figures were derived from a postcard he found at a Baltic seaside resort. As Bulatov puts it, "It was such luck because I had realized before this that I needed 'correct' 'Soviet' people for the picture." These "correct" Soviets, walking toward the water as though entering into a bright future (in a staple trope of Socialist Realist rhetoric), were, on the contrary, visually blocked: at just the point where the horizon should be, which is also the midpoint of the canvas, Bulatov painted a broad red horizontal band with two thin gold stripes, which arrests the viewer's imaginary projection into the landscape, along with the Soviet figures' confident march into the future. That this red-and-gold band represents the ribbon of the Order of Lenin, the highest decoration the Soviet state could

bestow, makes its role as an optical blockade ironically political: it is Soviet culture's own bureaucratic trappings (and the sclerotic blockages it was known for) that undermine its stated ideological goals. In general, Bulatov's paintings created a strong push–pull between our desire to enter into a physical space and the prohibition to do so established through various optical devices, usually involving bright-red elements geometrically arrayed in a manner reminiscent of Russian Suprematism and later Constructivism. In a work such as *Danger* (1972–3), for instance, Bulatov accomplishes this effect with text, drawing a terse, affective warning—"Danger"—from railroad placards and repeating it four times to form a rectangular internal frame for an idyllic image of a country picnic.

Bulatov's insinuation of danger in everyday spaces recalls Kabakov's account of the Soviet state as a void whose force is

▲ 1934a

▲ 1915, 1921b

as pervasive and unpredictable as weather. The picnickers in Bulatov's painting are oblivious to the atmosphere of threat surrounding them in the form of bright-red geometrically aligned letters that seem to recede into their space like film credits. This optical overlay repels the viewer's eye from the attractive pastoral scene beyond, thus establishing a visual allegory of state intervention. Komar and Melamid's early paintings amplify a different dimension of Kabakov's albums: their narration and characterization of Soviet types. In *Double Self-Portrait* of 1973, for example, Komar and Melamid rendered themselves in a mosaic style recalling the decorations of the Moscow metro (but also, in its echoes of Byzantine church decoration, suggesting the traditions of the Russian Orthodox Church) [**4**]. Most importantly, though, the composition in *Double Self-Portrait* mimics two different subjects of double portraits in the Soviet Union's visual culture: the mythic leaders Vladimir Lenin and Joseph Stalin. In a work such as this one, Komar and Melamid suggest that the burden of a Soviet citizen is to occupy already existing types; and yet by doing so, they bring the heroes of the Soviet state down to earth in a gesture that was easily recognized as a form of parodic critique. In general, their work, both in the Soviet Union and in the United States after their emigration in 1978 via Israel, establishes an ironic nostalgia for Soviet "ideological kitsch," as it is now widely considered. For this reason, Komar and Melamid were not only closely associated with Moscow Conceptualism, but also to the related tendency of Sots Art, widely considered an analogue to Western ▲ Pop art, which instead of taking consumer culture as its theme, ironically cited the visual culture of Soviet officialdom.

For Bulatov as well as for Komar and Melamid, the image of
● public space represented in Socialist Realist painting—of joyous and devoted citizens at work or at play—is made either sinister or counterfeit. Like Kabakov's rendering of the void, such paintings introduce irony and even terror into the settings and behaviors of everyday life. Collective Actions, a group organized by Andrei Monastyrski (born 1949) in 1976, literalized the void by choosing "empty" landscapes as settings for their performances. A small number of spectator-participants were personally invited on "trips out of town," to isolated fields reached by train from Moscow where elliptical and understated events took place, followed by extended interpretation and debate among those attending. Indeed, Groys has argued that documentation, rather than direct experience, was Monastyrski's goal in creating "empty" actions that defy interpretation. In their devotion to ordinary behaviors, and minimal forms of textual and photographic documentation, such events more closely resemble the formal strategies of Anglo-
■ American Conceptual art than do the other pioneers of Moscow Conceptualism discussed here. And yet the political dimension of Collective Actions—its evocation of *emptiness* where civil society might have arisen—is entirely consistent with the approaches of Kabakov and Bulatov. A performance titled *The Appearance* [**5**] of March 13, 1976, for instance, is described as follows in the 2011 catalogue *Empty Zones: Andrei Monastyrski and Collective Actions*:

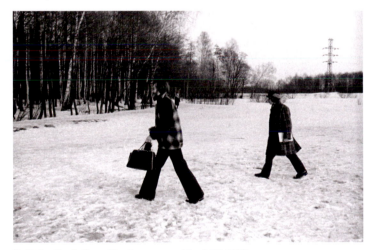

5 • Collective Actions, *The Appearance*, March 13, 1976
Performance

The audience was offered invitations for an action titled The Appearance. *When all the invitees gathered (approximately 30 people) on one side of a field, five minutes later two participants of the action appeared from the forest on another side. They crossed the field, approached the audience and distributed papers ("documentary verification") to certify one's presence at* The Appearance.

▲ 1956, 1960c, 1962d, 1964b ● 1934a ■ 1968b, 1970, 1984a

One of the most important dimensions of Collective Actions' art, especially in conjunction with the contemporaneous projects of Kabakov and Bulatov, is their evocation of a *perceptual* void: in other words, the events they produce take place in the "zone of indistinguishability," as Monastyrski has put it, both on account of their slightness (that is, no more than crossing a field in *The Appearance*) and because the actions themselves do not seem to "mean" anything in particular. As Groys concludes, the aim of Collective Actions is precisely to provoke discussion and debate regarding what may or may not have happened in their works, and such a displacement from an aesthetics of objects or even actions, to an aesthetics of discourse is one of the fundamental ▲ characteristics of Conceptual art worldwide.

This quality was intensified in Moscow Conceptualism's last collective, Inspection Medical Hermeneutics founded in 1987 by Pavel Pepperstein (born 1966), Sergei Anufriev (born 1964), and Yuri Leiderman (born 1963). Like Collective Actions committed to active interpretation in place of object-making (sometimes adopting criteria analogous to the Soviet grading system), Inspection Medical Hermeneutics would *inspect* artists' studios or other sites where artists might gather in their attempt to understand art as a symptom—or a disease. Jackson recounts one presentation in which diagnosis was projected onto Soviet popular culture where Pepperstein "encouraged members of a Moscow audience to don a stethoscope to listen to the 'beating heart' of an infant depicted on the empty box of Soviet baby food."

Since the collapse of the Soviet Union, the work of Bulatov, Komar and Melamid, and Kabakov (all of whom are now émigrés) has successfully entered international art markets. Kabakov, especially, has built a highly visible global career, now in partnership with his wife Emilia. Margarita Tupitsyn has noted that, "in the West the textual parameters of … [Moscow Conceptualism] were lost to a large degree, which resulted in Soviet culture's reception by Western viewers on an essentially visual level." While this is certainly true, paradoxically, one of the special qualities of Moscow Conceptualism—its intense cultivation of a small community of artists in lively debate with one another regarding the terms and qualities of everyday life and ideology in the USSR—has had lasting and growing influence beyond Moscow. Despite its apparent hermeticism, this art communicates vividly, and because of its intensely *local* interpretation of the international language of Conceptual art, it has surpassed and enriched the simplistic narratives of Soviet experience that prevailed in the West under the Manichaean oppositions of the Cold War. DJ

FURTHER READING

Yevgeny Barabanov, "Breakthrough to Freedom," in Matthias Arndt (ed.), *Erik Bulatov: Catalogue Raisonné* (Cologne: Wienand Verlag, 2012)

Boris Groys (ed.), *Empty Zones: Andrei Monastyrski and Collective Actions* (London: Black Dog Publishing, 2011)

Boris Groys, *History Becomes Form: Moscow Conceptualism* (Cambridge, Mass.: MIT Press, 2010)

Matthew Jesse Jackson, *The Experimental Group: Ilya Kabakov, Moscow Conceptualism, Soviet Avant-Gardes* (Chicago: University of Chicago Press, 2010)

Boris Groys (ed.), *Total Enlightenment: Conceptual Art in Moscow 1960–1990* (Frankfurt: Schirn Kunsthalle and Ostfildern: Hatje Cantz, 2008)

Margarita Tupitsyn, "About Early Moscow Conceptualism," in Luis Camnitzer, Jane Farver, and Rachel Weiss (eds), *Global Conceptualism: Points of Origin 1950s–1980s* (New York: Queens Museum of Art, 1999)

Victor Tupitsyn, *The Museological Unconscious: Communal (Post)Modernism in Russia*, introduction by Susan Buck-Morss and Victor Tupitsyn (Cambridge, Mass.: MIT Press, 2009)

6 • Inspection Medical Hermeneutics, *The Three Inspectors*, 1990 (2014 reconstruction)
Multimedia installation, variable dimensions

1976

In New York, the founding of P.S.1 coincides with the Metropolitan Museum's "King Tut" exhibition: important shifts in the institutional structure of the art world are registered by both alternative spaces and the blockbuster show.

In the summer of 1966, as *Time* magazine announced that the art market was "expected to hit $7 billion a year by 1970," this overheated situation was having a double effect. On the one hand it was skewing museum finances, making purchases and temporary exhibitions exorbitantly expensive. On the other, it was encouraging more and more aspiring artists to try for success and embark on a serious artistic career. It also coincided with the first
▲ US government program to finance the arts since the WPA and the days of the Depression.

President Lyndon Johnson had signed the Arts and Humanities Bill on September 29, 1965, and in 1966 he pushed Congress to authorize a grant of $63 million, of which the newly founded
• National Endowment for the Arts would have $10 million to allocate in its first year (roughly equivalent to the $11 million [£4 million] the British government gave in the same year to the Arts Council of Great Britain). Such public funding for the arts began to address the double pressure of money on the art world. First, it made grants available to museums for the type of exhibition they would increasingly see as the only solution to their problems, namely big "box office" shows that would enormously increase the money they could make on admissions. Second, it began to open a channel of funding outside the system of the commercial gallery by helping the kind of service-oriented organizations that operated what came to be called alternative spaces.

But addressing financial pressure is also a way of feeding it. As would soon become apparent, the house that the NEA had built was also constructing a new cultural "subject" to inhabit it; and, as Guy Debord had already predicted at the end of the fifties, it would be impossible to address the nature of that subject
■ without speaking at the same time of "spectacle."

A decade after the NEA was established the effects were beginning to show. In 1976 the Metropolitan Museum in New York opened the "Treasures of Tutankhamen," a lavish display popularly known as the "King Tut" exhibition that brought record numbers to the museum, consolidating the new form of spectacular exhibition, now routinely referred to as "blockbuster," that had been introduced in 1969 with the Met's crowd-pleasing "Harlem on My Mind" show. A few years later, in 1980, the Museum of Modern Art took Picasso's recent death as the opportunity to put its entire painting and sculpture collection in storage so that it could house a complete retrospective of the Spanish master. Crowds lined up around the block, and tickets were reserved months in advance. The museum, formerly so assiduous in accompanying its exhibitions with carefully researched catalogues, chose this time to offer a lavishly produced picture book, without texts and nearly without scholarly apparatus. The "complete" Picasso unfolded in floor after floor of galleries in an atmosphere of crowd-driven excitement. It was an atmosphere—feeding off itself, so to speak—that grew increasingly familiar as the blockbuster exhibition became a staple, often structured around the theme of gold ("King Tut's Treasures," "The Search for Alexander" [Mycenean precious objects]) but always geared to the broadest taste (van Gogh, Impressionism, Matisse, Impressionism, Cézanne, Impressionism …).

The gold shows

It was not the broadest taste, however, that shaped the programs of the alternative spaces but, rather, an escape from the very commercialism that the museum's contemporary courting of that taste represented. Partly in reaction to the sixties boom in the art market, many artists took flight from a practice rooted either in the creation of marketable objects or in the "user-friendliness" of traditional mediums. The alternative space became a theater of the experimental and the ephemeral: video, performance, music, mammoth-scale mixed-media installations, site-specific works that were quasi-architectural.

In 1971, 112 Greene Street opened its doors to welcome the work
▲ of Gordon Matta-Clark, Richard Nonas, Gene Highstein, George Trakis, and Charles Simonds. In 1971, The Kitchen Center, a
• response to excited speculations about the coming impact of video, began life in the kitchen of the Broadway Central Hotel and then moved in 1973 to Broome Street [1]. As a performance and video space, it hosted Vito Acconci, William Wegman (born 1942), and
■ Lawrence Weiner; in the domain of music, it sponsored John Cage, Steve Reich, and Philip Glass.

Perhaps the most symptomatic organization of this type was the Institute for Urban Resources, founded by Alanna Heiss. Impressed by her experience of the freely available studio and

▲ 1936 ● 1987 ■ 1957a, 1998, 2007c ▲ 1967a ● 1973 ■ 1968b, 1974

1 • Vito Acconci, *VD Lives / TV Must Die*, 1978
Rubber, cable, bowling balls, and video with
sound. Installation at The Kitchen Center,
May–November 1978

exhibition facilities she had seen in London, particularly at
St. Catherine's Dock where Bridget Riley and Peter Sedgely ran a
warehouse called simply "The Space," Heiss set up an organization
to provide these same services in New York; by 1973, the Institute
had moved into the Clocktower in Lower Manhattan—the upper
floors of an office block designed in 1912 by McKim, Mead, and
White. In 1976 the Institute acquired P.S.1, a derelict public school
building in Queens, which it rented from New York City for twenty
years at the cost of $1 per year. Rebaptized Project Studios 1, P.S.1
now had studio space to offer on a vast scale along with acres of
exactly the "alternative" space required by the kind of art that had
in part been bred by such arenas in the first place. In June 1976,
P.S.1 opened "Rooms," its first exhibition of such work.

The third term in this symbiosis between kinds of space
and kinds of work was, of course, money. By 1976 The Kitchen
Center was operating on a $200,000 budget, nearly half of which
▲ was being supplied by the federal government. Brian O'Doherty,
who had succeeded Henry Geldzahler as director of the NEA's
Visual Arts Program, was particularly enthusiastic about alterna-
tive spaces and was increasingly willing to fund them. Support for
these service-organizations thus followed the establishment of the
government's Art in Public Places program, which had already
begun to institutionalize, and thus deradicalize, Earthwork art.

Founded on a shoestring and without much thought of real
survival, these projects were suddenly becoming administrative
operations of their own. Artists Space, an exhibition venue and
slide register for artists unaffiliated with commercial galleries, was
begun to take advantage of the public money now available. In
1976, it moved into the Fine Arts Building, a piece of Soho real

estate temporarily donated by its owner, which housed the offices
of other organizations such as Richard Foreman's Ontological-
Hysteric Theater and the New Museum.

By the late eighties, more than a decade after this initial
institutionalization of alternative spaces, a peculiar fusion began
to appear between the two consequences of the money pressures
of the sixties. The museum, its blockbuster mentality still intact,
now began to see the alternative space itself as a kind of commer-
▲ cial opportunity, in the form of something like an art theme park.

Nowhere was this more spectacularly evident than in the
restructuring of the self-image of the Solomon R. Guggenheim
Museum in New York, wrought through the activities of its new
director, Thomas Krens. Having sold the Massachusetts legislature
the idea of converting a massive (750,000 square feet) derelict
factory site in the western part of the state into a huge art-exhibition
space and hotel-and-shopping complex, so that a $35 million bond
issue was voted in 1989 to begin the project (called MassMoCA),
Krens was catapulted from a small college museum position into
leadership of the Guggenheim in the same year. Instantly, he began
to reconceive the institution as a global operation and started to
explore opening Guggenheim "branches" in Europe (Salzburg,
Venice, and Moscow were all discussed), in Asia (Tokyo), and, of
course, in Massachusetts (the Guggenheim / MassMoCA). One such
branch was realized, in Bilbao, Spain, with a spectacular structure
designed by the American architect Frank Gehry (born 1929) [2]
and organized according to Krens's master plan, in which the local
government pays for the building and its operating costs in addition
to supplying a massive annual fee to the Guggenheim in exchange
for the museum's programming services (the delivery of temporary

▲ 2007a ▲ 2015

2 • Frank O. Gehry, Guggenheim Museum, Bilbao, Spain

exhibitions as well as the temporary circulation into the site of the Guggenheim's own permanent collections).

Leveraging the collection

Participating in the very logic of globalization that was reshaping the economic sphere at large, Krens's plan exploits the capitalist idea of centralizing and consolidating the operations through which a "product" is conceived (and sometimes made) and then of reaping the economic benefits of multiple markets in which to deliver this "product." If the "product" here is in part curatorial (the planning of exhibitions, the writing of catalogues, etc.), it is also made up of something that had never before been thought of under such a rubric, namely, works of art. And, further, the idea of propelling the works in one's collection into circulation in order to fulfill obligations to one's foreign outlets partakes of the attitude toward capital accumulation that had become epidemic within the free-market spirit of the eighties: leveraging, in which outsized amounts of money are borrowed on the basis of current assets. By shifting the collection from an earlier condition as untouchable cultural patrimony to a new state in which it inhabits the credit sector, this move participates in what is characteristic of "late" capitalism's falling rate of profit: the forced unlocking of noninvested surplus capital and the propulsion of it into motion. This is the way late capitalism has industrialized sectors of social life—such as leisure, sport, and art—hitherto thought impenetrable by industry's hallmarks: mechanization, standardization, overspecialization, and division of labor. As the Belgian economist Ernest Mandel (1923–95) described it: "Far from representing a 'post industrial society' late capitalism thus constitutes generalized universal industrialization for the first time in history."

If the foregoing provides more than just an interesting example of socioeconomic historical shifts during the final decades of the twentieth century but goes on to address developments deep within the production and experience of art itself, this is because the model of the globalized museum, being spatial rather than temporal, represents—as Krens has been the first to insist—a shift in discourse. The modern museum was resolutely historical, endlessly rehearsing the unfolding of modernism's discoveries in the field of formal research, of social analysis, of psychological rebellion. In order to mount this narrative, such a museum had to be encyclopedic. The new museum, Krens argued, would need to forgo this array, replacing it with just a few artists shown in great quantity over vast amounts of space. History would thus be jettisoned in favor of a kind of intensity of experience, an aesthetic charge that is not so much temporal (historical) as it is now radically spatial.

Specifically lodging his own conversion from the old type of museum "discourse" to the new one within his experience of Minimalism and within the effect of the mammoth exhibition sites recently set up for its display (such as warehouses in Schafhausen, Germany, or Donald Judd's airplane hangars in Marfa, Texas), Krens set out to acquire Minimalist work *en masse*, purchasing the extensive Panza collection for $30 million (and selling three of the Guggenheim's modern masterworks, including a major Kandinsky, in order to do so). For it was Minimalism, seen in long rows of glistening, inter-reflecting cubes or elusive aureoles of fluorescent light or gleaming pavements of steel plates, that provided Krens with the model for this idea of art as pure intensity [3].

Now if Krens's hallucinatory version of Minimalism—Minimalism as pure spectacle—could be the basis for a vision of the museum as scintillating funfair, occupying multiple sites around the world, like Disneyland, this is because something had happened in the perception of Minimalism itself, something that had reprogrammed the movement from the meanings and experiences it had supported in the sixties to this new condition in the late eighties and nineties,

▲ 1965

▲ a condition that critic Fredric Jameson would call "the hysterical sublime." Nothing could be farther from the hallucinatory than the experience Minimalism originally sought. Denying that the work of art is an encounter between two previously fixed and complete entities—on the one hand, the work as a repository of known forms: the cube or prism as a kind of geometric given; and on the other, the viewer as an integral, biographically elaborated subject who cognitively grasps these forms because he or she knows them in advance—Minimalism tried to make the work "happen" on a perceptual knife-edge, at the interface between the work and its beholder. Further, it understood this experience as going beyond the visual to connect with the full bodily sensorium. Its model of perception was one that would break with what it saw as the decorporealized and therefore bloodless, algebraicized condition of abstract painting, in which a visuality cut loose from the rest of the body and now remade in the model of modernism's drive toward autonomy had become the very picture of an entirely rationalized, instrumentalized, serialized subject. Its insistence on the immediacy

● of the experience, understood as a bodily immediacy—feeling the gravitational pull of Richard Serra's *House of Cards* in one's stomach, for example —was intended as a release from the drive of modernist painting toward an increasingly positivist abstraction.

But the contradiction lodged within this ambition was that if the desire was to invoke bodily plenitude as a resistance against and compensation for the serialized, stereotyped, banalized character of modern life, the means the Minimalists used were double-edged. For Plexiglas and aluminum, chosen to destroy the interiority signaled by traditional sculpture's wood or stone, were also materials of commodity production; simple polygons, invoked as vehicles of perceptual immediacy, were also forms of rationalized mass production; and repetitive, aggregate arrangements, used as a resistance to traditional composition, deeply partakes of just that

serialization that structures consumer capitalism. Thus, even while it wished to attack commodification and technologization, Minimalism paradoxically always carried the codes of those very conditions. It is this potential that is then released by the museum newly organized as funfair exploitation of a simulacral Minimalism.

Houses of cards

Such cultural reprogramming has been characterized by Fredric Jameson as the inner logic of modern art's own relation to advanced capital, a relation in which, in their very resistance to a particular manifestation of capital—to technology, say, or commodification, or the reification of the subject of mass production—artists produce an alternative to that phenomenon which can also be read as a function of it, another version of the very thing against which they were reacting. Thus while the artist might be creating a utopian alternative to, or a compensation for, a certain nightmare induced by industrialization, he is at the very same time projecting an imaginary space that, if it is shaped by the structural features of that same nightmare, works to produce the possibility for its receiver to fictively occupy the territory of what will be a next, more advanced level of capital. The globalized

▲ museum, its contents a display of derealized, simulacral spectacle, becomes another example of the working out of this logic. RK

FURTHER READING
Hal Foster, "The Crux of Minimalism," *The Return of the Real* (Cambridge, Mass.: MIT Press, 1996)
Fredric Jameson, *Postmodernism, or The Cultural Logic of Late Capitalism* (Durham, N.C.: Duke University Press, 1991)
Rosalind Krauss, "The Cultural Logic of the Late Capitalist Museum," *October*, no. 54, Fall 1990
Brian O'Doherty, "Public Art and the Government: A Progress Report," *Art in America*, vol. 62, no. 3, May 1974, and *Inside the White Cube: The Ideology of the Gallery Space* (Berkeley and Los Angeles: University of California Press, 1999)
Phil Patton, "Other Voices, Other Rooms: The Rise of the Alternative Space," *Art in America*, vol. 65, no. 4, July 1977

3 • Donald Judd, *100 Untitled works in mill aluminum*, 1982–6 (detail)
Permanent collection at the Chinati Foundation, Marfa, Texas

▲ 1984b ● 1969

▲ 2015

The "Pictures" exhibition identifies a group of young artists whose strategies of appropriation and critiques of originality advance the notion of "postmodernism" in art.

In early 1977 the critic Douglas Crimp was invited by Helene Winer, the director of Artists Space, to mount a show of artists relatively new to New York: Troy Brauntuch, Jack Goldstein, Sherrie Levine (born 1947), Robert Longo, and Philip Smith. Winer, who would later open the gallery Metro Pictures, steered Crimp toward young artists who, like others in their milieu—Cindy Sherman (born 1954), Barbara Kruger (born 1945), Louise Lawler (born 1947), and so on—were linked not by any one medium (they used photography, film, and performance, as well as traditional modes such as drawing) but by a new sense of the image as "picture"—that is, as a palimpsest of representations, often found or "appropriated," rarely original or unique, that complicated, even contradicted, the claims of authorship and authenticity so important to most modern aesthetics. "We are not in search of sources of origins," Crimp wrote, "but of structures of signification: underneath each picture there is always another picture." "Picture" was meant to transcend any given medium, delivering its message equally from the pages of magazines, books, billboards, and all other forms of mass culture. Further, it mocked the idea that a specific medium might serve as a resistant fact, a kind of bedrock of truth that might itself serve as an aesthetic origin in the modernist sense, whether by "truth to materials" or as revealed essence. "Pictures" have no specific medium, they are as transparent as beams of light, as flimsy as decals meant to dissolve in water.

The postmodernist "picture"

As this collective work developed over the next few years, it became clear that the challenge to authorship was most radical in Levine's practice. In 1980, with her series *Untitled, After Edward Weston*, she blatantly pirated a group of images from those Weston had taken in 1925 of his young son Neil posed nude and cropped to include no more than the boy's torso [1]. Absolutely fusing her own status as author with that of Weston's, Levine was seen as going beyond merely challenging his legal status as the creator, and therefore the holder of the copyright to his own work. Instead, her appropriation was taken as extending to Weston's very claim to originality, in the sense of being the origin of his images. For in framing his son's body in such a way as to yield a series of graceful

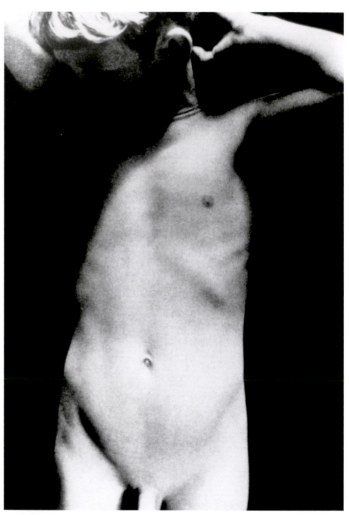

1 • Sherrie Levine, *Untitled, After Edward Weston I*, 1980
Photograph, 25.4 × 20.3 (10 × 8)

nude torsos, it could be argued that Weston was in fact helping himself to one of the most culturally disseminated visual tropes in Western culture: going back certainly to the male nude of Greek high classicism, itself the model for endless Roman copies, but filtered through the form in which these antiquities were received in the post-Renaissance world, namely as decapitated, armless fragments, the cut-off torso had come to symbolize the body's rhythmic wholeness. The "author" of this image is, therefore, dazzlingly multiple: from the nameless antique sculptors who

trafficked in copies, to the teams of archaeologists who excavated ruins, to the museum curators who put these bodies on display, to the modern advertisers who use versions of such images to promote their products. It is this perspective that Levine's violation of Weston's "authorship" opens onto his work, setting up a long line of claimants to this privilege and making a mockery of the very idea of Weston himself as the image's origin.

That Levine would have dramatized this appropriation with a photograph of another photograph was intended, moreover, to address the special role that photography itself had had in dispelling the mystique of "origin" that had settled onto the work of art. Belonging to a generation of artists for whom the lessons ▲ of Walter Benjamin's seminal 1936 essay "The Work of Art in the Age of Mechanical Reproduction" were now second nature, Levine thoroughly understood the condition of the photograph as a "multiple without an original." Thus the cult-value of the unique object, the artistic original whose aesthetic magic or "aura" would be voided by the invalidity of a copy or a fake, was held up to question by the very nature of photography. Benjamin: "From a photographic negative … one can make any number of prints; to ask for the 'authentic' print makes no sense." Indeed, one of the motives of the "Pictures" artists was to counter the growing market for fine photography, with its canceled negatives and vintage prints, with the lowly, derisive term "picture."

Building on this demystification of one type of origin (the aesthetic original), it was easy for Levine to transfer it to another (the author's originality). Photography, she implied, only made it technically easier and more transparent to do the kind of stealing—politely called "appropriation"—that has always been endemic to the "fine arts" whose fundamentally decorative status photography now reveals. As Benjamin's essay had already predicted: "Earlier much futile thought had been devoted to the question of whether photography is an art. The primary question—of whether the very invention of photography had not transformed the entire nature of art—was not raised." Levine and other appropriation artists were now raising it. One of the terms under which their critique sailed was "postmodernism."

Although not represented in the "Pictures" show, Louise Lawler most consistently took up this term to refer to her own production, as in show after show—"How Many Pictures," "It Could Be Elvis, and Other Pictures," "Paint, Walls, Pictures"—she integrated her work into the serialized world of mass production, injecting her photographs into the little domes of glass paperweights, projecting her images in the ephemeral form of slides, presenting her output as a kind of cultural detritus: matchbook covers, souvenir glasses, phonograph records. And in the grip of the same logic that had operated for Levine, Lawler extended the structure of multiplicity from the technical fact of copies generated from a matrix to the aesthetic domain of authorship, thereby dissolving herself as her work's point of origin into the bath of a diverse social continuum.

Many of her photographs bear titles like *Arranged by Barbara and Eugene Schwartz* [**2**]; *Desk Light by Ernesto Gismondi*, to

2 • Louise Lawler, *Arranged by Barbara and Eugene Schwartz*, 1982
Black-and-white photograph, 40.6 × 59.7 (16 × 23½)

signal the mutations in authorship they are documenting. The submission of works of art to the forces of the market has meant that they are not just integrated into the world of commodities, thereby taking on the personality of their owners, like the artfully ▲ arranged wall of August Sander portraits hanging in Mr. and Mrs. Schwartz's study. It has also meant that the form of commodity to which they are assimilated is one in which their exchange-value exists at the disembodied level of the sign, making them the equivalent of so many fashion logos worth far more than the incidental handbag or leather moccasin to which they might be attached.
• This status of art as nothing but "sign exchange value" is implied again and again by Lawler's images in which, in a work like *Pollock and Tureen* (1984), a dining room sideboard neatly splits our attention between a piece of eighteenth-century porcelain and the segment of the Jackson Pollock painting we can see on the wall above it; or in *Who Are You Close To?* (1990), where Andy Warhol's *S&H Green Stamps* hang on a magenta wall between symmetrically placed green Chinese horses, all of it a study in color coordination (magenta and green) worthy of *House and Gardens* magazine. By ceding her compositional privileges to the collectors of the works, by relinquishing her stylistic prerogatives to a whole range of mass-media vehicles—the photographic styles of fashion magazines, of high-end advertising, of brute documentation— and by sustaining the implied logical reciprocity through which "sign exchange value" will overtake not only Pollock's work but her own as well, Lawler suspends her own claims as author.

Readymade selves

All of these "pictures" issues generated by photography and affecting the fine-arts triumvirate—originality, original, origin— by leaching the autonomous world of the art object into the explosive domain of mass culture, found their way into the work of Cindy Sherman, a contemporary and colleague of Levine's and Lawler's. Elaborating the series she called *Untitled Film Stills* between 1977 and 1980 [**3, 4**], Sherman rang extraordinary changes on the idea of self-portraiture as she disappeared behind the guises

▲ 1935 ▲ 1929, 1935 ● 1980

of the movie stars she impersonated (Monica Vitti, Barbara Bel Geddes, Sophia Loren), the characters she implied (gun moll, battered wife, heiress), the directors whose styles she pastiched (Douglas Sirk, John Sturges, Alfred Hitchcock), and the film genres she dissimulated (film noir, suspense, melodrama).

Beyond jettisoning her selfhood as author and individual, however, the implication of these works is that the very condition of selfhood is built on representation: on the stories children are told or the books adolescents read; on the pictures the media provide through which social types are generated and internalized; on the resonance between filmic narratives and fantasy projections. Hence the transparency of the persona to the roles and situations that form in the public image-world, the one cannily projected first by film and then by television. If Sherman's work could be authored by so many Hollywood gambits, her pictures seem to be saying, this is because Sherman herself, standing in for all of us, is constructed by those same gambits. And in this form of the argument, not only does every author appropriate his or her images, but every author appropriates his or her "self."

By the mid-eighties and in the aftermath of feminist arguments
▲ such as Laura Mulvey's "Visual Pleasure and Narrative Cinema," however, it was no longer possible to see Sherman as standing in "for all of us," or to take the manipulations operated by Hollywood film as gender neutral. Not only was it obvious that the roles in

4 • Cindy Sherman, *Untitled Film Still #39*, 1979
Black-and-white photograph, 25.4 × 20.3 (10 × 8)

3 • Cindy Sherman, *Untitled Film Still #7*, 1978
Black-and-white photograph, 25.4 × 20.3 (10 × 8)

▲ 1975a

question in Sherman's *Film Stills* were feminine, but the feminist argument according to which those roles should be understood had shifted. Mulvey was no longer exhorting a kind of consciousness-raising by which women were asked to put aside the roles into which they had been cast, like a set of disguises they could change if only they would. She was making a far more structural argument according to which the division of labor under patriarchy could not be shifted: men were the actors in a world in which women were the passive objects; men were the speakers, the makers of meaning, while women—the spoken for—were the bearers of meaning. If Hollywood followed this pattern, producing female stars as somnolent visual fetishes and male ones as vigorous agents, this was because these assignments were hard-wired into the social psyche, unavoidable. Accordingly, Sherman's settings came to be analyzed less for their mass-cultural associations and more for their visual vectors: the traces of a male gaze trained on a waiting
▲ and defenseless female; the ways the female reacts to this gaze, entreating it, ignoring it, placating it.

As Mulvey's essay had also argued, the division of roles in terms of action and vision also apply to—or are structurally imbricated with—language. If she says that the woman is the bearer of

▲ 1975a, 1993a

5 • Barbara Kruger, *We Won't Play Nature to Your Culture*, 1983

confirms the sexual dynamics of vision as described by Mulvey: the young woman is the object, not the agent of vision.

Our bodies, ourselves

But working at cross purposes to this confirmation of the gender stereotypes is the text that mobilizes another aspect of the linguistic analysis proposed by the structuralists. This is the argument about the nature of pronouns put forward by the French linguist Émile Benveniste. Dividing language into two forms, narrative and discourse, the first the form of historical or objective accounts, the second the form of interactive dialogue (conversation), he pointed to another type of division of labor, that between the third person pronouns—he, they—joined to the (historical) past tense, and the first and second person pronouns—I, you, we—connected with the present tense. The former, he says, is the matrix through which purportedly objective, scientific fact is related and it is thus the medium of knowledge. The latter is the medium of active, lived experience, through which speakers assume their subjecthood, taking on the responsibility of entering the position "I." This is the dimension of language that the linguists would also call the "performative" and what it lacks in supposed truth-value it makes up in its assumption of power and agency. The two messages of Kruger's image are, then, decidedly "mixed," one playing to the narrative system in which the woman is the object of knowledge, her passivity constituting its very "truth," the other taking up the discursive system and, saying "I" (or in this case "we"), assuming a performative position. In doing so, the woman's voice aggressively returns the male gaze.

The work of these four women constituted an important part of what was identified as "critical postmodernism," a term that associated their critique with that of the theorists of mass culture who, from Adorno to Habermas, had denounced the "consciousness industry." This qualifier was necessary to differentiate the work from another form of postmodernism that was eagerly promoted by the very media the "Pictures" group was exposing. For an antimodernist postmodernism had declared war on "formalism" by returning to the classicist modes of painting in oil and sculpting in bronze (for example, the Italian Sandro Chia), as it waved goodbye to a progressive notion of history by eclectically assuming odd assortments of past pictorial styles, as though none of these had any historically fixed, internal meaning (for example, the American David Salle). The "Pictures" group, insofar as it declared that artistic mediums were no longer value neutral but had now, infected by the (communications) media, become part of the battle zone of modern culture, was itself an emblem of postmodernism understood as critique. **RK**

FURTHER READING
Douglas Crimp, *On the Museum's Ruins* (Cambridge, Mass.: MIT Press, 1993)
Hal Foster, "Postmodernism," *The Anti-Aesthetic* (Seattle: Bay Press, 1983) and
"The Crux of Minimalism," *The Return of the Real* (Cambridge, Mass.: MIT Press, 1998)
Craig Owens, *Beyond Recognition: Representation, Power, and Culture*
(Berkeley and Los Angeles: University of California Press, 1992)

meaning she is referring to the sense in which the woman's body is organized by what the French psychoanalyst Jacques Lacan called the signifier of difference, namely the phallus that she does not have but that—marked by castration and its threat—she is. Another way of describing this would be to say that her body— complete in its beauty but damaged in its phallic absence—is the fetish that marks the site of a lack. It is on this site and according to this lack that the difference that founds the very possibility of meaning, or language, is built.

The work of Barbara Kruger, another contemporary and colleague of the "Pictures" group, is constructed on acknowledging this linguistic division of labor only to suspend it. Like Sherman's, Lawler's, and Levine's, the basis of Kruger's work is appropriated mass-cultural imagery, here in the form of found photographs taken from magazines and other mass-circulation sources. But onto this visual foundation she collages trenchant verbal statements. In *We Won't Play Nature to Your Culture* [5], for example, these words ride atop the photograph of a young woman sunbathing with her eyes masked by leaves. Referring to the binaries that structure not only language but all cultural forms of meaning—the nature/cultural opposition being almost as fundamental as the male/female one—Kruger's young woman is indeed "playing" nature. As she lies prone on a barely visible field of grass, not only do the leaves covering her eyes encourage a sense of her as yielding to the natural conditions of her surroundings, like Roger Caillois's mimetic animals, but also this mask

1977 b

Harmony Hammond defends feminist abstraction in the newly founded journal *Heresies*.

▲ In the first number of the feminist journal *Heresies* (January 1977), an issue dedicated to "Feminism, Art and Politics," Harmony Hammond published an essay titled "Feminist Abstract Art: A Political Viewpoint." This text addressed what Hammond saw as a paradox since, at that time, it was widely presumed that if an artist were to address questions relating to women, her work should mimetically represent aspects of women's social conditions, pleasures, or crises. From this point of view, abstraction would constitute a flight from, or disavowal of politics—or even worse, the affirmation of a sexist status quo. In her essay, Hammond characterized this skeptical attitude by declaring, "They view abstract art as private expression which is not understandable or analyzable to the audience, and therefore irrelevant to feminist political goals."

● For indeed, despite the fact that modernist painting and sculpture of the early and mid-twentieth century fostered explicitly political ambitions in its efforts to create new social forms and modes of perception, by the 1970s, feminist analysis had indicted art history's nearly exclusive focus on the avant-garde accomplishments of men. From the perspective of identity politics then, abstraction was associated with masculinity and the patriarchal forces that oppress women. In the context of *Heresies*, of which she was a founding member of the publishing collective, Hammond's defense of abstraction called for some explanation. In fact, she admits, "Abstract art has become taboo for most artists who consider themselves political feminists."

In her own sculptures and paintings of the seventies, Hammond rethought abstraction in at least three ways: by relating its procedures to forms of creative labor traditionally performed by women, such as sewing and basket-weaving; by introducing qualities of ■ the body into geometric forms associated with Minimalism; and, finally, by widening the concept of criticism to embrace every audience member, no matter how unfamiliar she may be with contemporary art. With regard to the latter, Hammond advocated the use of one of seventies feminism's most important strategies: consciousness-raising, by which a group of women would share experiences and attitudes in order to produce a strong and politicized sense of community. As Hammond puts it, "This approach to art and to discussing art has developed from the consciousness-raising experience. It deals primarily with the work itself, what it

says, and how it says it—rather than with an imposed set of esthetic beliefs." In short, then, Hammond argues that the reception of art should be activated and democratized according to a set of values that dispenses with expertise as a criterion. A work like *Hug* (1979–80) [1] exemplifies the first two formal dimensions of feminine labor and embodiment outlined above. This piece is composed of two ladderlike structures, each wrapped, or bound, in cloth rags whose surfaces are subsequently given a coat—or skin—of acrylic medium: a smaller ladder leans against a larger one, which in turn leans against the wall. Together these two anthropomorphic figures stage an allegorical enactment of the titular "hug." Such hugging is given another dimension through the wrapping of fabric around the shapes, generating the folds and cushions of a voluptuous imagined anatomy. Hammond has associated these works with the weave and stitch of women's traditional basketwork and sewing, but the rags she applies also bring with them the history of their use by women. Such modes of embodiment, established through the raw materials in use, and their anthropomorphic (or perhaps "gynepomorphic") contours endow Hammond's sculpture with an affect reminiscent of artists like Eva Hesse who also animated geometric form through reference to skin and living bodies.

Breaking free of the norm

While the explicit development of queer theory did not occur until the nineties (and while seventies feminist art is often distinguished from later, more conceptually oriented feminist works), Hammond's art, and that of many other lesbian and gay artists working in the sixties and seventies may be productively understood from such a vantage point. The distinction that "queer theory" introduces beginning in the early nineties is fundamental: instead of departing from a type of difference that is rooted in the seemingly stable identities of "heterosexual" versus "lesbian" or "gay," the designation of queer indicates a more slippery form of *non-normativity*. The queer is that which perverts, travesties, caricatures, or desublimates norms and conventions. Queer is more a point of view than a stable identity. Consequently, heterosexual artists might make work that could be considered queer, while

▲ 1975a ● 1913, 1921b, 1923, 1928a, 1933, 1937a, 1937c, 1943, 1949b, 1957a, 1959c ■ 1965

1 • Harmony Hammond, *Hug*, 1979–80
Mixed media, 162.6 × 73.7 × 35.6 (64 × 29 × 14)

2 • **Kate Millett, *Terminal Piece*, 1972**
Wooden cage, wooden chairs, clothed mannequin with bag, dimensions variable

individual lesbians might not. Nonetheless, queer form-making has historically been a productive strategy for lesbians, gay men, and transgendered people. Hammond, along with other artists including Paul Thek and Kate Millett, could be said to have ▲ "queered" Minimalist and Postminimalist form, largely by introducing powerful modes of embodiment into conventions of geometric abstraction.

Kate Millett is best known as the author of the controversial and groundbreaking book *Sexual Politics* (1970), whose analysis of the Western literary canon in terms of gender inequities is one of the founding statements of women's studies, and which had an enormous influence on feminist politics of the seventies. Millett is also an artist whose sculptural installations persistently evoked geometries of entrapment that, as she suggested in a 1988 text about her art, allegorically describes the condition of women: "With women, I have always known. That was our life—confinement. Confinement within confinement, a Chinese nest of boxes; custom has even nominated child birth as 'confinement.'" Millett's most powerful installation works of the late sixties and seventies were often directly or indirectly inspired by her efforts to come to terms with the story of Sylvia Likens, a young girl who was starved, tortured, and imprisoned in a basement by her boarding house landlady, a single mother. As art historian Kathy O'Dell has declared, "The story of Sylvia Likens altered the course of Millett's life—what she wrote about, how she made art." Part of the force of the Likens tragedy, it seems, was its elision of physical and psychological entrapment. *Terminal Piece* (1972) [2] links such an experience of entrapment to Millett's own unexpected notoriety following the publication of *Sexual Politics*, which made her a high-profile representative, both for advocates and opponents of women's liberation. In *Terminal Piece*, a dressed mannequin resembling Millett is visible seated alone in a rank of forty-seven empty chairs arranged behind wooden bars, so that the artist-as-celebrity is gazed upon by an audience, which itself occupies the place of spectacle witnessed by the author's seated surrogate. As O'Dell puts it, "On display for all to see, but simultaneously caged, the figure's position is a visual analogue for the situation in which Millett found herself after *Sexual Politics*—the utterly public, yet profoundly alienated situation that is synonymous with stardom."

In Paul Thek's series of sculptures titled *Technological Reliquaries* dating from the mid-sixties, the dynamic of confinement in which mannequins are caged in Millett's work is enacted more viscerally through the encasement of brutally chopped chunks of flesh or severed limbs rendered in wax in cool, Minimalist "reliquaries" built from glass or Plexiglas. As Thek stated in an interview of 1981, "For me, it was absolutely obvious. Inside the glittery, swanky cases—the 'Modern Art' materials that were all the rage at the time, Formica and glass and plastic—was something very unpleasant, very frightening, and looking absolutely real." *Untitled* (1964), for instance, consists of a wall-mounted glass box, trimmed in metal and striated with yellow lines enclosing two squares of raw

▲ 1965, 1966b, 1969

Wax, metal, wood, paint, hair, cord,
resin, and glass, 61 × 61 × 19.1
(24 × 24 × 7½)

flesh made of wax—the smaller chunk centered on top of the larger one [**3**]. The nauseating effect of human or animal meat is enhanced by the presence of hair on the smaller slab. The irony here is that after one's initial shock at encountering the "absolutely real" within Thek's decorous boxes, one cannot help but recognize that the relic and its reliquary share a compositional logic—the flesh inside, after all, is carved into two squares, and this geometric composition, according to Thek, is reminiscent of the *Homage to the Square*
▲ for which the modernist painter Josef Albers—one of the great colorists of the twentieth century—is known.

In short, flesh, in these works, is as objectified as geometric form. In a 1966 interview with the critic G. R. Swenson, Thek hints at his attitude toward bodily objectification. In recounting his experience visiting catacombs in Sicily with his friend and lover, the photographer Peter Hujar, Thek states: "There are 8,000 corpses—not skeletons, corpses—decorating the walls, and the corridors are filled with windowed coffins. I opened one and picked up what I thought was a piece of paper; it was a piece of dried thigh. I felt strangely relieved and free. It delighted me that

bodies could be used to decorate a room, like flowers. We accept our thing-ness intellectually, but the emotional acceptance of it can be a joy." As gruesome as this anecdote may sound, it opens a perspective on Thek's reliquaries, which may assist us in compre-
▲ hending their "queerness." For if Minimalist art consisted of simple geometric forms intended to establish stimulating perceptual situations for viewers, which, according to the best criticism of the time, were meant to make such viewers conscious of their own subjective modes of perception, Thek asserts that we as spectators—as subjects composed of meat—are little more than objects ourselves. The difference between objective form and subjective perception that characterized Minimalism (what Thek meant by "'Modern Art' materials that were all the rage") is thus collapsed, causing a promiscuous mixture of human and thing. And indeed, Thek goes even further by insisting that there is a pleasure and liberation in this thingness, in such self-objectification. Here is where what might be called the "non-normative" enters Thek's work—in the pleasure humans might take in their own objectification.

▲ 1947a

▲ 1965

This pleasure, or eros, is explicitly associated with death in one of Thek's most important works, *The Tomb* exhibited at the Stable Gallery in New York in 1967. It consisted of a squat pink ziggurat, housing a hyperreal reclining corpse modeled on Thek himself, but typically referred to as the "Hippie." Like its mausoleum, the Hippie's skin and clothing were tinted entirely in pink, and he was encircled by various ritual objects reminiscent of ancient funerary practice, including three wine glasses, a covered bowl, blank sheets of paper, and on the wall behind his head, a personal letter, a few photographs, and the fingers severed from his right hand in a pouch. The Hippie's darkened tongue extends luridly from his mouth, while disks with psychedelic designs derived from the patterns of butterfly wings are placed on each cheek. A wall label elaborating on the construction of the tomb itself humorously alludes to Minimalism's reliance on workaday forms of construction and procedural transparency: "Welcome: You are in a replica of the tomb. It has been prefabricated at a cost of $950.00 of ½" and ¾" novaply by C and C Custom Woodwork…. It is 11½′ square at the base. Following an 85 degree angle it rises in three tiers to its 8½′ height." In this work the relation between a solemn monument and the unsettling corpse it houses—Thek's own alter ego—establishes an allegory of the artist's contradictory role (identical to the dynamic of the reliquaries), as both the subject and the object of his art. What's more, *The Tomb* calls to mind everything hippies represented in 1967, ranging from a highly visible countercultural lifestyle enhanced by ecstatic mind-altering drugs to vocal political opposition to the Vietnam War. What unites the diverse and even contradictory dimensions of The Tomb is the color pink. Pink is a hue strongly linked to a conventional understanding of femininity—even hyperfemininity—and it has the capacity to make anything—from tombs to corpses—look decorative, even cute. Through pink, things that should be deadly serious—the aesthetics of Minimalism and the social rituals of mortality—are queered, perverted, or diverted from normative meanings.

In his important review of *The Tomb*, Robert Pincus-Witten described the work as a form of "absolute fetishism." By this he meant the exacting care with which Thek simulated the dead Hippie's form and physiognomy: "Thek's long Genghis moustache, his lashes and lids, have been painstakingly fitted, hair by hair, into the wax mask. Absolute fetishism." In general, fetishism constitutes a surplus of emotional investment whose affect and significance differ depending upon what kind of object is at stake—whether, religious, erotic, or pop cultural. Karl Marx famously identified the commodity fetish (as an analogue to tribal representations of gods, often called "fetishes" by Europeans of Marx's time); and Sigmund Freud theorized the erotic fetish as a means of allaying masculine sexual anxiety—particularly with regard to fears of castration. In Thek's work, the fetish (as relic, or corpse, or as raw meat) is linked to an erotics of death—analogous to what he called, in his account of the catacombs in Sicily, the joy of thingness. In *Flaming Creatures* (1962–3), the best-known film of Thek's contemporary, Jack Smith, a different kind of excess is

performed—an exorbitant identification with B- or even C-movie Hollywood stars and the fantasy worlds they embody [4]. In his essay on the Dominican actress Maria Montez, known for her passionate performances in such Hollywood films as *Arabian Nights* (1942), *Ali Baba and the Forty Thieves* (1944), and *Cobra Woman* (1944), Smith introduces the concept of a "flaming image." In this text, "The Perfect Filmic Appositeness of Maria Montez," published in *Film Culture* in 1962–3, he writes: "Trash is true of Maria Montez flix but so are jewels." And indeed, for Smith, there was little difference between "trash" and jewels since both are equally capable of inspiring voluptuous fantasy. This sort of intense fascination with the marginalized, the outdated, and the trashy as conduits to the marvelous is often called "camp" and typically associated with the subcultural codes of gay men, especially before the Stonewall riots of 1969 began to make it easier for homosexuality to be acknowledged openly.

What erupts (or "ignites") in *Flaming Creatures*—which is closely linked to Smith's legendary but largely undocumented live performances in his downtown loft in New York—is everything that good acting and plot development seek to suppress in conventional Hollywood film. Namely, a flamboyant, erotic magic that blazes out through the wild antics of loosely rendered characters reminiscent of those that Montez might have played on screen, such as "Delicious Delores," "Our Lady of the Docks," and "The Spanish Girl." Shot on old-style black-and-white film stock, which gives the work a flickering, gauzy texture, and accompanied by an appropriated soundtrack including an excerpt from *Ali Baba and the Forty Thieves*, along with various nostalgia-inducing Pop songs, *Flaming Creatures* simultaneously erodes boundaries between genders (men are dressed as women, but make no effort to "pass"), as well as those between organs, the building blocks of individuals: complex and hieroglyphic human tableaux succeed one another, in which jiggling detumescent penises and breasts may be composed together with others' limbs and garments in a truly perverse rendering of a "social body." The queerness here enters not only through undermining gender and anatomy, but also in completely reinventing what can count as a community. These "flaming creatures" have invented a new social world with its own universe of feeling. But this, as Smith writes in the same essay, is also a self-consciously filmic world: "The primitive allure of movies is a thing of light and shadows. A bad film is one which doesn't flicker and shift and move through lights and shadows, contrasts, textures by way of light. If I have these I don't mind phoniness (or the sincerity of clever actors) simple minded plots (or novelistic "good" plots), nonsense or seriousness."

From flaming images to claiming communities

Flaming Creatures stages an orgy of images—one that finds its echoes in the mid-nineties paintings and drawings of Nicole Eisenman. Eisenman is one of several artists emerging at that time who approaches identity—in her case, lesbian identity—with

4 • Jack Smith, *Flaming Creatures*, 1962–3
16mm film, 43 mins

irreverence, bawdy humor, and explicit sexuality. This strategy might seem to run counter to the lesbian and gay art engaged in
▲ AIDS activism since the mid-eighties. But in fact, given that the crisis of AIDS put enormous pressure on queer people to assert their normalcy as a defense against homophobia, so-called sex-positivity was an equally important, if nonetheless controversial, activist agenda. It might be said that Eisenman, along with artists such as Catherine Opie and Lyle Ashton Harris acted on the free-doms claimed by *Flaming Creatures* at the dawn of the sixties "sexual revolution," just when, in the late eighties and nineties that

▲ 1987

revolution was under threat on many fronts—both from some gay and lesbian activists who counseled more conservative sexual practices (including, but often reaching beyond safer sex), but much more insidiously from conservative or fundamentalist Christians who effectively mobilized political power by orches-trating a panic against sexually explicit art in the so-called "culture" wars of this period.

Eisenman often created salon hangings composed of many works of diverse scales and subjects, which might combine biting commentary on art institutions, self-portraiture, portraits of

5 • Nicole Eisenman, *Drawing Installation*, 1994
Installation view, Jack Tilton Gallery, New York

others, and erotic scenarios [**5, 6**]. In the latter category, Eisenman explicitly engages homophobic attitudes regarding lesbians by wildly exaggerating stereotypes to the point of absurdity (a
▲ strategy also followed by Kara Walker with regard to myths of African-American sexuality). *Untitled (Lesbian Recruitment Booth)* of 1992, for instance, sends up the notion that gay people are trying to "recruit" hetereosexuals, while *Capture, Cut off Penis, Stuff Penis, Attach to Belt, Fitting* (1994) satirically embraces the myth that lesbians want to castrate men—a kind of inversion of Smith's detumescence in *Flaming Creatures*.

Eisenman's works in the nineties, often rendered in brushy monochrome, may teem, like Smith's tableaux, with crowds of impassioned characters (though they are often juxtaposed, in counterpoint, to portraits and self-portraits), but her brand of camp, or "flaming image," constitutes an unambiguous and spirited response to the marginalization of lesbians. The caged figures

of Millett's sculptures have clearly broken free in Eisenman's drawings and paintings, and have decided to wreak some havoc. The lesbian world she imagines is by no means invisible, meek, or victimized: it takes control of its own desires by establishing a community founded in mutual identification and pleasure.

The photographic portraits of Opie and Harris also establish scenarios of queer agency in association with queer kinship networks spanning family and friends. Among Opie's best-known works are two self-portraits produced by cutting words and images into the artist's skin, as part of a consensual form of cutting play. Both *Self-Portrait/Cutting* from 1993 [**7**] and *Self-Portrait/Pervert* of the following year show Opie formally posed in front of floral backdrops, in a dignified and even regal manner that the artist associates with the stately portraits of Hans Holbein. In *Self-Portrait/Cutting*, Opie photographs herself from behind; into her nude back is carved a scene of lesbian

▲ 1993c

6 • Nicole Eisenman, *Drawing Installation*, 1996
Installation view, Jack Tilton Gallery, New York

7 • Catherine Opie, *Self-Portrait / Cutting*, 1993
C-print, 101.6 × 76.2 (40 × 30)

domesticity that resembles a child's drawing—two explicitly female stick figures holding hands in front of a diminutive peaked-roof home. In *Self-Portrait / Pervert*, she photographs herself from the front, her head covered by a leather mask, but her chest carved with the word "pervert," rendered in elaborate script and underlined with a leaflike flourish, while her arms are pierced with orderly lines of needles. In a 1998 article on Opie's art, critic Suzanne Muchnic quotes the artist: "'I didn't like the way the leather community was being represented in the mainstream culture,' she says. 'They think we are child molesters…. Another big thing was that so many of my friends were dying of AIDS. I decided to do a body of work that was about being really out, and about being out about my sexuality, and being into S&M and leather and stuff like that…. I wanted to do a series of portraits of this community that were incredibly noble.'"

In a series of extraordinary photographs dating from 1994, Harris made use of an expanded community of friends and family members to create a series of staged, large-format Polaroid photographs in which qualities and antinomies of gender, ethnicity, and the intense stereotypes that accrue to them slip from one body to the next. The artist Renee Cox, for instance, is posed with exaggerated shiny black prosthetic breasts and

buttocks as *Venus Hottentot 2000* (1994). The so-called Hottentot Venus, whose real name was Saartjie Baartman, was brought from the Eastern Cape of South Africa to be exhibited in Britain and France as an exotic creature in the early nineteenth century. But Cox, like Eisenman's subjects, is anything but a demure model on exhibit; as in Thek's art, self-objectification is here exploited as a source of power.

Perhaps the most intense of Harris's works during this time are a series of three photographs he made with his brother, the filmmaker Thomas Allen Harris. In the first, *Brotherhood, Crossroads and Etcetera #1* (1994), the brothers, nude, but their faces enhanced with makeup, embrace one another, Lyle holding the apparently swooning Thomas from behind. In the second of the series, the brothers stand in three-quarter profile, again nude, face-to-face and kissing, but their lower bodies held apart by a gun that Thomas holds pressed into Lyle's rib cage [8]. The final image in the series shows the brothers still nude and face-to-face, and in profile, embracing each other closely if loosely, but with each man facing away from the other, to look out of the picture. In Lyle's left hand, loosely resting on Thomas's left shoulder, and in Thomas's right hand, posed symmetrically, are two guns pointing out at the spectator. In these works, as in all of the queer art mentioned here, the lines between kinship, love, sexuality, and violence are transgressed in order to redraw the dichotomous relations between body and gender, subject and object, abstraction and mimesis, while reimagining social bodies that transgress norms without losing the comforts and political claims of community. DJ

FURTHER READING

Jennifer Blessing, *Catherine Opie: American Photographer* (New York: Solomon R. Guggenheim Museum, 2008)

Samantha Topol (ed.), *Dear Nemesis, Nicole Eisenman* (St. Louis: Contemporary Art Museum; Verlag der Buchhandlung Walther König, 2014)

Harmony Hammond, *Lesbian Art in America: A Contemporary History* (New York: Rizzoli International Publications, 2000)

Cassandra Coblentz et al., *Lyle Ashton Harris: Selected Photographs—The First Decade* (Caracas, Venezuela: Centro de Arte Euroamericano; Coral Gables, Fla.: Ambrosino Gallery, in collaboration with Jack Tilton Gallery, 1996)

Edward Leffingwell, Carole Kismaric, and Marvin Heiferman (eds), *Flaming Creature: Jack Smith, His Amazing Life and Times* (London: Serpent's Tail; New York: Institute for Contemporary Art / P.S.1, 1997)

Kathy O'Dell, *Kate Millett, Sculptor: The First 38 Years* (Baltimore: Fine Arts Gallery, University of Maryland, Baltimore County, 1997)

Elisabeth Sussman and Lynn Zelevansky, *Paul Thek: Diver* (New York: Whitney Museum of American Art; Pittsburgh: Carnegie Museum of Art, 2010)

8 • **Lyle Ashton Harris in collaboration with Thomas Allen Harris**, *Brotherhood, Crossroads and Etcetera #2*, 1994
Unique polaroid, 76.2 × 61 (30 × 24)

1980–1989

1980

Metro Pictures opens in New York: a new group of galleries emerges in order to exhibit young artists involved in a questioning of the photographic image and its uses in news, advertising, and fashion.

"I don't think of myself as a photographer. I've engaged questions regarding photography's role in culture … but it is an engagement with a problem rather than a medium." With this statement Sarah Charlesworth (1947–2013) spoke for an entire group of young artists who, along with Cindy Sherman, Barbara Kruger, Sherrie Levine, and Louise Lawler, came to sudden prominence in the late seventies and early eighties—artists such as Richard Prince (born 1949), James Welling (born 1951), James Casebere (born 1953), and Laurie Simmons (born 1949), among others. Some were recent graduates of vanguard schools like the California Institute of the Arts (CalArts), where teachers such as John Baldesarri, Douglas Huebler, and Michael Asher had initiated them into the strategies of Conceptual art and institutional critique. But they were all marked by new developments of the time, such as an increased sophistication in feminist theory, which foregrounded the question of sexual difference in visual representation, and a qualitative transformation in the mass media, which changed the entire context of image production, distribution, and reception. If some of their predecessors contended with the divided "legacy of Jackson Pollock," some of these baby-boomers struggled with the ambiguous model of Andy Warhol, who appeared to collude with the spectacular image-world that he also exposed.

The serial and the simulacral

Most of these artists used photography along the lines described by Charlesworth: rather than reground the medium "in its area of competence" in a modernist manner as understood by formalist critics, they worked to problematize its usual claims to expressive abstraction or documentary referentiality in a postmodernist fashion. This problematizing operated on several fronts: on one side they were opposed to art photography that assumed the values of the unique image associated with painting; on another side they were suspicious of media photography that worked to produce effects of consensus in the news and of persuasion in advertising. Often made of purloined images, this photobased art was also positioned against neo-Expressionist painting and its forced reclamation of the auratic artist-genius. These postmodernists treated the photograph not only as a "serial" image, a multiple

without an original print, but also as a "simulacral" image, a representation without a guaranteed referent in the world. That is, they tended to regard the photograph less as a physical trace or indexical imprint of reality than a coded construction that produces "effects of the real," and with different accents they worked to investigate these effects. In this exploration of the rhetoric of the photograph Roland Barthes was a crucial guide, as were Jean Baudrillard, Michel Foucault, and Gilles Deleuze for their accounts of the simulacrum, a notion that Baudrillard used to understand recent transformations in the commodity, and Foucault and Deleuze used to challenge old Platonic conceptions of representation.

As an editor of the short-lived journal *The Fox*, Sarah Charlesworth was involved with the Conceptual art of Joseph Kosuth and Art & Language in the mid-seventies. Feminism prompted her to make her own art, and her first pieces adapted Pop as well as Conceptual idioms in an emergent critique of media representations of women (here she was aligned with Kruger, Silvia Kolbowski, and many others). In 1977 Charlesworth initiated a series that drew on the alterations of newspaper formats in early Warhol as well as in early Dan Graham. For the month of September she photocopied the front pages of the *International Herald Tribune* and whited out everything except the masthead and the photographs. At first glance this subtraction produced arbitrary montages, but the patriarchal structuring of the news soon became apparent, especially through the dominant representation of male heads of state. Charlesworth also applied this strategy to an array of North American newspapers, with similar effects of manifest randomness and latent patterning. For example, in all the papers surveyed on April 21, 1978, one figure appears: the Italian minister Aldo Moro kidnapped and killed by the Red Brigade [1]. Here, with the simple device of "the assisted readymade," Charlesworth exposed the first priority of dominant media: the maintenance of state authority. In part, this post-Watergate "hermeneutics of suspicion" concerning the news was also a critical reaction to the conservative turn in politics of the late seventies and early eighties.

Like some of her peers, Charlesworth proceeded to the patterning of images in advertising and fashion. In a series titled *Objects of Desire* she appropriated images from magazines, edited them further, then rephotographed them on saturated

▲ 1977a, 1993a ● 1968b, 1970, 1971, 1984a ■ 1949, 1960b, 1960c, 1964b ◆ 1977a, 1984b ▲ 1968b

fields of single colors. These fragments—of posed models and displayed accessories—pointed to a language of desire that is highly fetishistic, an effect that Charlesworth underscored with the fetishistic gloss of her own Cibachrome prints. Some of these works presented solitary traces of the female body such as a chic scarf, while others juxtaposed two images for critical comparison. In *Figures* (1983) a female torso wrapped in a dinner dress on a red ground is set next to a female body bound in fabric on a black ground; here, as the critic Abigail Solomon-Godeau wrote, "the (desirable) female body is bound not only by the gown, but by the cultural conventions of desirability, and the delimiting and defining convention of representation itself." Again like some of her peers, Charlesworth applied the strategy of a doubling of the stereotype in such a way as to expose its ideological or "mythical" ▲ operations (in the sense of Roland Barthes)—operations that work to naturalize the particular interests of one group, gender, or class.

Richard Prince also focused on the conventions of advertising and fashion images for what they reveal about subjective modeling. At stake in this patterning of images, Prince implies, is the patterning of identities, of identities *as* images, which are now shaped by media representation far more than was any older cultural form. In the mid-seventies he worked as a cataloguer in the periodical library of Time-Life Incorporated, where he collected images of models and products. He then arranged these images by type and rephotographed them, first in black and white, then in color, but always at the same scale in order to reveal the generic repetitions of poses and gestures, displays and effects [2].

1 • Sarah Charlesworth, *April 21, 1978*, 1978
One of forty-five black-and-white prints composing one work, varying sizes, each c. 55.9 × 40.6 (22 × 16)

▲ Introduction 3

Jean Baudrillard (1929–2007)

In the late sixties, French sociologist Jean Baudrillard led Marxian analysis into the structural-linguistic domain of the sign, arguing that it is signification that controls ideology. Beginning with *The System of Objects* (1968) and *The Society of Consumption* (1970), this project was developed in *For a Critique of the Political Economy of the Sign* (1972) and *The Mirror of Production* (1973). His most provocative formulation of this shift was the term "sign exchange value," which pointed to the displacement of exchange-value from commodities to their representatives, such as the logos of companies.

In order to think this displacement, Baudrillard focused on simulacra, in which reality is replaced by its representation. Disneyland was one of his favorite examples: "Disneyland is there to conceal the fact that it is the 'real' country, all of 'real' America, which *is* Disneyland (just as prisons are there to conceal the fact that it is the social in its entirety which is carceral)," he wrote in "The Precession of Simulacra."

It was Baudrillard's conviction that the commodity and the sign have become one, facilitated by the operations of a "code" through which meanings are exchanged in discourse. Baudrillard was not happy with the idea of "commodity fetishism," which imagines objects endowed with magical value; instead, he argued, objects are abstracted into signifiers in order to enter into the exchange of meaning governed by the "code."

The effacement of objects by signifiers that turn them into meaning and prepare them for "exchange" occurs everywhere, Baudrillard argued, even on the body, where signifiers proliferate and replace physiological substance. "Rewriting the cultural order on the body," tattoos, bound feet, eye shadow, mascara, bracelets, and jewelry, all show that "the erotic is the reinscription of the erogenous in a homogeneous system of signs."

Rather than the celebrity figures favored by Pop, Prince reframed anonymous subjects, and he did so less in a register of celebration or critique than in a mode of testing—a testing of our own ambivalent fascination with such models.

Like other postmodernist artists who use photography, Prince
▲ works in series, for only a serial structure can deliver the play of repetition and difference that interests him. In 1981 he began to rephotograph two genres of ads that traffic in semimythic lifestyles. The first involved the famous Malboro campaign with the Western cowboy, often on horseback, that associates cigarette smoking with macho masculinity. Prince developed a hyperbolic catalogue of this Western frontiersman in a manner that appeared equally suspicious of the legend and seduced by it. The second series concerned vacation ads of the beach, that utopia where sexual pleasure and family life are somehow made to coexist. In his version, however, the seaside vacationers, shot in grainy black-and-white against sunburst backgrounds, experience a holiday that looks like an atomic holocaust. Prince then turned to social subjects below the usual purview of the middle class. In *Entertainers* he

▲ 1964b, 1968a, 1968b

2 • Richard Prince, *Untitled (four women looking in the same direction) #1–#4*, 1977–9
Set of four Ektacolor prints, 50.8 × 61 (20 × 24)

rephotographed the murky photographs of nightclub performers used in newspaper ads, and floated them in black Plexiglas panels; frozen in lurid display, these blurry faces are offered up for our own obscure voyeurism. Later Prince grouped such images in formats that he called "gangs"—essentially slide sheets blown up to big grids that also capture a play of repetition and difference. Often the subjects are indeed gangs—motorcycle gangs and biker chicks, drag racers and surfers, and so on—"subcultures that operate outside the hegemony of high literacy," as the critic Jeffrey Rian has put it. Once again, as these figures "filter through the media and mutate in our minds," Prince offers up our own voyeurism for our inspection. Not as critical as the Barthesian analyses of Kruger or Charlesworth, his work is not as removed either; he admits to his own partial identification and ambivalent participation in the image-world on display.

Reality effects

The work of James Welling and James Casebere is more internal to photography, more committed to its traditions and techniques, but also more deconstructive of it as a result. Rather than challenge the referential dimension of the photograph, they insist on it, as the critic Walter Benn Michaels has argued, but in a nonrealist way that exploits the slight ambiguity of the photographic signifier. They are also less interested in simulation and seduction than in the differences between how we see and how the camera sees; in their photographs the "effects of the real" are all produced by staging and lighting, camera position, and image scale.

Welling opened this line of inquiry as early as 1974, while still a student at CalArts, with a videotape of scatterings of ash that resemble entire landscapes. In 1980, in New York, he photographed crinkled surfaces of aluminum foil in extreme close-up again with ambiguous effects—they could pass for semiabstract studies of rock formations by Minor White or of weathered doors by Aaron Siskind. A year later his photographs of pastry dough scattered on lush drapery also appeared equally representational and abstract, at once full of spatial depth and nothing but surface. With titles like *Wreckage*, *Island*, and *The Waterfall*, they evoke Romantic landscapes only enough to make us reflect on our own projections about photographic reality (here, as Barthes argued, "connotation" precedes "denotation," not vice versa as is usually thought). The very simplicity of means opens up these images to different readings: *In Search Of …* [3] suggests an alpine ridge or a glacial floe as well as flakes of dough caught in rifts of cloth. With Welling, the "search" for Romantic experience becomes a quest for elusive reference.

James Casebere has also played with the ambiguity of the photograph since the late seventies, but here the uncertainty is effected through quasi-architectural models, made of white mat board, plaster, and Styrofoam, which Casebere stages and lights like miniature movie sets. At once specific and generic, these tableaux only evoke their subjects, which, in his early work, tend to vernacular

scenes of the American West, the Civil War, the ante-Bellum South, and so on. Sometimes these scenes are entirely fictional, as in *Sutpen's Cave* [**4**], which alludes to a neoclassical mansion built out of the wilderness by a diabolical character in William Faulkner's novel *Absalom! Absalom!* (1936). Like Welling, Casebere creates his reality effects through his medium and titles alone. But again these effects are only partial or part-way: all his images are suspended in a no man's land between model and referent, fiction and document. His places have the uncanny consistency of dreams or myths; they are akin to phantasms in which representation rises up to replace reality.

In all this photo-based work the hierarchies of reality and representation and original and copy become somewhat unstable, and in this slight unfounding of the image is a subtle subverting of the viewer: the mastery that the photographs usually afford the subject—an empowered point of view and precision of vision—is partially withdrawn. Sometimes the viewer feels almost engulfed by these simulacra; as Deleuze writes, "the spectator is made part of the simulacrum, which is transformed and distorted according to his point of view." In this phantasmal disturbance the reality effects of the photograph are put into question, as are its conventional status as a "message without a code" (Barthes), as a document that renders things obvious and events natural. Twenty years ago this was still a critical insight, and challenges to the truth claims of photographic

4 • James Casebere, *Sutpen's Cave*, 1982
Silver-gelatin print, 40.6 × 50.8 (16 × 20)

representation—in the news and elsewhere—were urgent. But more and more in our contemporary image-world the simulacral triumphs over the referential; perhaps what we need today is less a critique of representation than a critique of simulation. HF

FURTHER READING

Roland Barthes, *Image-Music-Text*, trans. Stephen Heath (New York: Hill and Wang, 1977)
Jean Baudrillard, *Selected Writings*, ed. Mark Poster (Stanford: Stanford University Press, 1988)
Gilles Deleuze, *The Logic of Sense*, trans. Mark Lester (New York: Columbia University Press, 1990)
Louis Grachoes (ed.), *Sarah Charlesworth: A Retrospective* (Santa Fe: SITE Santa Fe, 1997)
Jacques Guillot (ed.), *Richard Prince* (Grenoble: Centre National d'Art Contemporaine, 1988)
Sarah Rogers (ed.), *James Welling: Photographs 1974–1999* (Columbus: Wexner Center for the Arts, 2000)
Abigail Solomon-Godeau, *Photography at the Dock: Essays on Photographic History, Institutions and Practices* (Minneapolis: University of Minnesota Press, 1991)

3 • James Welling, *In Search Of …*, 1981
Silver-gelatin print, 22.9 × 17.8 (9 × 7)

▲ 2009c

1984a

Victor Burgin delivers his lecture "The Absence of Presence: Conceptualism and Post-Modernisms": the publication of this and other essays by Allan Sekula and Martha Rosler signals a new approach to the legacies of Anglo-American photoconceptualism and to the writing of photographic history and theory.

It is important to realize that the founding concerns of Conceptual art—the focus on analytical propositions and on linguistic definitions—had a visual correlative in an increasingly analytical approach to the photographic image. If Postminimalist art had shifted the perception of language and of the body into the registers of performativity, photography's elementary indexicality had supplied the exacting medium with which these temporal and spatial dimensions could be recorded. Thus the photographic medium extended the Postminimalist concerns with the processes of production, specific locations, and the minute tracing of contingency and contextuality. Not surprisingly, photography's unique qualification to record the smallest spatio-temporal displacement and incremental or sequential performative changes made it also the ideal tool for Conceptualism's increasingly intense focus on the processes and the production of *signification* itself. British artist Victor Burgin's (born 1941) *Photopath* [1] demarcates that transition from contextual aesthetics to an analysis of photographic meaning at the very moment (1969) when Burgin was initiating the theorization of site-specificity in his crucial theoretical text "Situational Aesthetics," in the British journal *Studio International*.

Burgin's first book, *Work and Commentary: 1969–1973* from 1973, still adhered in its overall theoretical and artistic projects to the orthodoxies of late-sixties Anglo-American Conceptualism, in particular to the challenges posed by the late-modernist self-criticality of the Art & Language group and its journal *Art-Language*. But Burgin eventually became the first to systematically criticize that position in the pages of that very journal, arguing that "The optimum function of art is to modify institutionalized patterns of orientation towards the world and thus to serve as an agency of socialization. No art activity therefore is to be understood apart from the codes and practices of the society which contains it; art in use is bracketed ineluctably within ideology.... We must accept the responsibility of producing an art which has more than just Art as its content."

Clement Greenberg's American-type formalism had kept English artists (up to and including the members of the Art & Language group) in its spell for an astonishingly long time. It was the discovery of two theoretical legacies, introduced initially to an Anglophone audience of filmmakers, artists, and writers by

1 • Victor Burgin, *Photopath*, July 1969
Twenty-one photographs of twenty-one continuous sections of floor boards

the editors of *Screen* magazine, that accelerated the disintegration of formalist modernism. The first one would be the rediscovery of Russian and Soviet Formalist thought; and the second one, the encounter with French structuralist semiology and psychoanalytic theory from Freud to Lacan. Both discoveries provided a new theoretical foundation for artists such as Burgin and Mary Kelly in England and would motivate Burgin to finally sever his ties with modernism and Conceptualism, as manifested in his 1984 essay "The Absence of Presence." If Burgin's work was largely based on

▲ 1968b ● 1969 ■ 1960b

▲ 1915 ● Introduction 1, Introduction 3 ■ 1975a

semiology and the theories of the photographic image as they had been developed in several essays by Roland Barthes, the work of ▲ Michel Foucault would become Allan Sekula's (1951–2013) central theoretical focus, eventually leading to his groundbreaking essay "The Body and the Archive" (1986). And Mary Kelly's Lacanian feminism would find its counterpart in Martha Rosler's (born 1943) highly politicized critique of photographic representation as much as in an activist definition of feminist and artistic practices.

The photographic turn

The legacy of photography entered American art of the sixties in several contradictory ways. First of all there was the incorporation of "found" photography in the work of Robert Rauschenberg and subsequently in that of Andy Warhol through which a peculiar • transformation of the photomontage aesthetics of Europe of the twenties took place. Secondly, but in a much more complicated and at first unrecognizable way, there were the multiple references back to the specifically American traditions of photography from the twenties on: the great tradition of American straight photography from Paul Strand to Walker Evans; and that of the Farm ■ Security Administration (FSA) photographers and the documentary tradition as it had been programmatically formulated in the thirties. It was thus in a variety of ways that artists of the early sixties, after Warhol, contributed to the reemergence of the photographic image in the context of neo-avant-garde production.

One of the first figures in the rise of what could be seen as a specifically photographic aesthetic was Ed Ruscha, whose books from the ◆ early sixties onward, starting with *Twenty-six Gasoline Stations* (1962) and *Every Building on the Sunset Strip* (1966), introduced a peculiar type of photography. Inasmuch that one could characterize this as amateurish and popularist, it was involved in the principle of deskilling the photographic image; and indeed it is in the context of Pop art (with its own methods of deskilling the work of art) that Ruscha's books were first received. In the dialogue between Ruscha and Warhol, the latter's use of "found" photographs was translated into a principle of treating parts of the urban landscape as "found" material, to be recorded by Ruscha in the most banal way possible.

By the mid-sixties a different type of photographic production emerged in what could be called the protoconceptual photography of Dan Graham. While largely still dependent upon the work of Ruscha, Graham placed his work in a more manifest dialogue with the traditions of American documentary photographers, and specifically with the work of Walker Evans. Graham's deadpan photographic images of vernacular architecture in New Jersey—such as the suburban housing developments of his *Homes for America* (1966–7)—hark back directly to Evans's deadpan photographs of industrial architecture in Pittsburgh. But as much as it establishes a continuity with vernacular architectural imagery, Graham's work operates a kind of distancing from the high, ambitious quality of thirties and forties photography. Adding the idea of vernacular, popular, photographic practice to that of vernacular architecture as image, Graham exacerbated Ruscha's ▲ original project of deskilling the making of the photograph. His use of a cheap hand-held camera, of cheap color film, and of cheap commercial printing creates results that look as if they had been taken on the run by a tourist lost in New Jersey.

In the context of Conceptual art, photography assumed numerous functions beyond those established by Graham. First of all it addressed the problem of the form of distribution for the work of art. Starting with Ruscha, photography was embraced as a device for insisting on the mediatization, or mass distribution, of the work of art, a device that therefore contributes to the dismantling of the conception of the work of art as unique object. Although Warhol had already teased painting's condition as a unique original, he had ultimately returned to this very condition in all instances of his production. The result was that while his paintings were determined by the photographic image and by the silkscreen process, the end product of this process was inevitably a unique original object. With Ruscha, the end product was in fact the multiple object, the cheaply produced book, open to mass distribution, which therefore positioned itself in manifest contra- • diction to the Pop art painting with its "aura" paradoxically intact.

Secondly, photography entered the protoconceptual and conceptual context by introducing a whole range of previously unthinkable and invisible subject matter. It is with Ruscha that we can say that urbanism—questions of architecture, questions of vernacular urban space, questions of traffic circulation—reentered artistic practice by means of subjects that had not figured in anyone's work, either in Europe or the United States, for a good thirty years. Up to the moment of high modernism in the thirties it was, of course, fully understood that architecture and urbanism were subjects for avant-garde consideration. In the postwar period, however, all subjects concerning the conditions of collective, urban, public space had dramatically disappeared from artistic production. Only with Ruscha's work and with the subsequent practices of Graham and the Conceptual artists did the issues of public urban space, of architecture, of "publicness"—and how to conceive of it in the first place—reenter the field of avant-garde reflection.

From index to information

One of the American artists in whose Conceptual work these concerns became central was Douglas Huebler, who specifically linked the temporality and the spatiality of his activities to the photographic image and detached his practice of the medium from high-art iconography. In 1971 he initiated a project—*Variable Piece #70 (in process) Global*—to produce a universal collective portrait of everyone living on Earth, which in and of itself functions both as a critique of the genre of portraiture and as an attempt—in its vast spatial, temporal, and quantitative expansion —to radicalize the traditionally limited focus on representation and representational conventions [2].

2 • Douglas Huebler, *Variable Piece #70 (in process) Global*, 1971–97 (details)
Documentation photographs, text, dimensions variable

By the late sixties, however, in specific confrontation with the photographic practices of the Conceptualists, numerous artists repositioned themselves through a critique of Conceptualism on the one hand and, as is so often the case in the formation of a new artistic position, with a rediscovery and rereading of earlier legacies on the other: in this case that of the American documentary tradition. Beginning in California in the context of the group
▲ that studied with Allan Kaprow, John Baldessari, and the poet David Antin, these artists—primarily Sekula, Rosler, and Fred Lonidier—defined their work in opposition to the seeming neutrality of Conceptualism. One of the most important examples through which this historical turnabout can be recognized is Fred Lonidier's *29 Arrests* [**3**], which recapitulates the exact
● structure of Ruscha's books and the deadpan, almost campy neutrality with which seemingly random accumulations of found objects are made into their subjects. In his own project, Lonidier took photographs of people being arrested during an antiwar protest in San Diego harbor while military ships depart for Vietnam with new weaponry and new supplies of Army contingents. Thus Ruscha's seemingly neutral practice is critiqued by a sudden infusion of just those contingencies—political, contextual, historical—that Conceptualism had rejected.

One reason for this generation to oppose the Pop and Conceptualist mentality of artists such as Huebler, Baldessari, and Ruscha is precisely that at that time, belated as it might be, they rediscovered the legacies of the New York Film and Photo League of the twenties with its emphasis on Russian film. Thus, feeding into their work in the late sixties were not only the films of Sergei Eisenstein and Vsevolod Pudovkin but also the social documentary practices of the Film and Photo League, taken together with a
▲ serious reconsideration of figures such as John Heartfield. In some instances this occurred through the explicit mediation of the work of Hans Haacke. The latter's photographic work in 1970–1
● (such as the real-estate piece *Shapolski et al.*, which in its focus on architecture and its serializing format also parallels Ruscha's and Graham's practice) is another such turning-point where the Pop neutrality of an approach without either comment or contextualization is transformed into a model of activist intervention.

From Pop to photomontage

Artists such as Rosler and Sekula take the models of both photomontage and political documentary as historical points of departure. This first approach is visible in Rosler's late sixties work

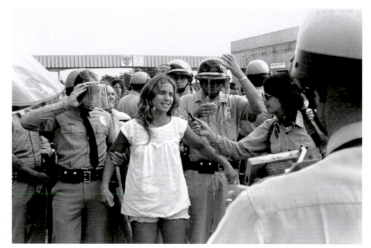

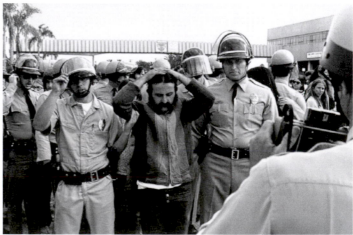

3 • Fred Lonidier, *29 Arrests*, (top) *#10: Headquarters of the 11th Naval District*; (bottom) *#18: Headquarters of the 11th Naval District*, May 4, 1972, San Diego
Thirty black-and-white photographs, 12.7 × 17.8 (5 × 7)

▲ 1961, 1968b ● 1967a, 1968b

▲ 1920, 1937c ● 1971, 1972b

Bringing the War Home: House Beautiful [**4**], which is a series of photomontages almost literally taken from the Heartfield model (although Rosler claims not to have known Heartfield at that time), in which images of the devastation in Vietnam are inserted into the slick imagery of advertising and fashion and home decoration magazines. Rosler attempted to produce this series of colored photomontages for mass distribution; although she failed to realize that goal, it was one of the first instances in which the politicization of the photomontage aesthetic reached its apogee in the American context.

The second approach, other than the rediscovery of photomontage, involved a complicated reconsideration of the legacy of American documentary traditions. In this group's orientation, there was a distinct desire to Americanize its practice, looking at local vernacular historical contexts and traditions rather than European ones alone. This interest in regional culture, which Pop art had already introduced to some degree by its persistent emphasis on the Americanness of its own project, is the background for the dialogue that Rosler and Sekula opened with ▲ the Film and Photo League as well as with the legacies of FSA photography in their effort to draw on existing traditions and cultures within American history.

The last element that is crucial to their work is the internal debate over the status of photography itself. Not only are both these artists prolific critics, theorists, and historians of photography, but it was largely as a result of their writings that the whole relationship between modernism and photography became increasingly problematized. It is important to recognize to what degree documentary photography entered the public awareness of American cultural history at that moment largely as a result of their contribution in their various essays, such as Rosler's "In, Around, and Afterthoughts on Documentary Photography" (1981) and Sekula's "Dismantling Modernism, Reinventing Documentary" (1984). Neither suggests a blind continuation of the documentary project. In fact the opposite is true; both are extremely critical and careful to point out the historical inadequacies of the legacy of FSA photography, for example.

First of all, what is clearly understood by these writer-artists is that, in the face of the political deployment of their work, the political neutrality of photographers like Walker Evans or Dorothea Lange was a severe shortcoming; for both of them were unaware of or disinterested in the actual political framework within which their work was going to be used under the auspices of Roy Stryker's FSA project. The conflict that both Rosler and Sekula continuously

4 • Martha Rosler, *First Lady (Pat Nixon)* from the series *Bringing the War Home: House Beautiful*, 1967–72
Photomontage printed as color photograph, 61 × 50.8 (24 × 20)

▲ 1936 ▲ 1936

5 • Allan Sekula, *Untitled Slide Sequence*, 1972

explore is the question of the degree to which photographic practices can take on an activist, interventionist, agitprop approach, or to what degree, as photographs, they are contained within the discursive conventions and institutional frameworks that prevent them from ultimately attaining political efficacy.

Between seriality and agency

This is one of the dilemmas that face photographers both in their writings and their practices. It is in projects such as Sekula's *Untitled Slide Sequence* [5] or Rosler's *The Bowery in Two Inadequate Descriptive Systems* [6] that one can see their efforts to go beyond the limitations of traditional documentary practice. Sekula's work, projected as slides in a continuously repeating cycle, is a series of eighty images of workers at the end of the day shift leaving the General Dynamics Convair Division aerospace factory in San Diego. It clearly responds to the California transformation

▲ of Conceptualism at the hands of someone like Huebler, as it also responds to images of the working-class movement in both the Weimar and American documentary traditions. The fact of its transformation from the static black-and-white photograph to a continuously running slide sequence, and its random shots of workers that point to the difficulty of identifying working-class subjects (as opposed to middle-class or white-collar workers) therefore gives us a much more accurate and complex image of the subject of the documentary photograph. On the one hand, then, the semiotic reflection on what the photograph is (its status as "indexical sign"), how it produces meaning, and how it is institutionally and discursively placed and disseminated, is crucial to this practice, which distances itself from a naive return to a political claim for photographic documentary. Yet at the same time, and in an opposite gesture, it goes beyond this purely semiotic critique by emphasizing the necessity and possibility for contextualization or historical specificity in the reflection of the subject matter. We could say, then, that the critique of a naive assumption about the political efficacy of American documentary joins the critique of the pure neutrality of Conceptualist photography.

Rosler's *The Bowery in Two Inadequate Descriptive Systems* is an exemplary project in this respect. It addresses documentary photography in its more debased forms—what Rosler calls "the find-a-bum school of photography"—in its gritty black-and-white imagery and the internal historical meaning that this type of work had acquired by the seventies. It also performs a critique of a certain type of New York street photography celebrated by MoMA's John Szarkowski at the time, especially in the work of Garry Winogrand, where, with a detached cynicism, the decrepitude and misery of everyday life are made the spectacular subject

• matter. In going back to the tradition of Walker Evans—many of the photographs function like quotations of Evans's work—Rosler positions herself in what she calls "the inadequacy of the photographic representation." Simultaneously, she constructs the manifest inadequacy of the linguistic system as a representation

▲ 1968b • 1936

sot

tippler

winebibber

elbow bender

overindulger

toper

lushington

6 • Martha Rosler, *The Bowery in Two Inadequate Descriptive Systems*, 1974–5
Forty-five black-and-white photos and three black panels, each 20.3 × 25.4 (8 × 10), edition of five

for drunkenness. Juxtaposed with the photographic images, the facing pages carry lists of terms for being inebriated—ranging from the most debased slang and the most archaic expressions to literary language. In their serial accumulation, these lists mimic the seriality of Pop repetitions even while they oppose, both by their subject matter and by their linguistic status, the claims of Conceptual art to have acquired a pure linguistic self-reflexivity. By linking language back into the sphere of the somatic—as into the sphere of the deranged, the digressive, the socially disqualified—a dimension of counterrationality is introduced into the rational project of Conceptual art that is typical for this moment of dialogue between these two generations. BB

FURTHER READING
Richard Bolton (ed.), *The Contest of Meaning* (Cambridge, Mass.: MIT Press, 1989)
Victor Burgin, *The End of Art Theory: Criticism and Postmodernity*
(Atlantic Highlands, N.J.: Humanities Press International, 1986)
David Campany (ed.), *Art and Photography* (London: Phaidon Press, 2003)
Martha Rosler, *Decoys and Disruptions: Selected Writings 1975–2001*
(Cambridge, Mass.: MIT Press, 2004)
Allan Sekula, *Photography Against the Grain: Essays and Photoworks 1973–1983*
(Halifax: The Press of the Nova Scotia College of Art and Design, 1984)
Abigail Solomon-Godeau, *Photography at the Dock: Essays on Photographic History, Institutions and Practices* (Minneapolis: University of Minnesota Press, 1991)

1984 b

Fredric Jameson publishes "Postmodernism, or the Cultural Logic of Late Capitalism," as the debate over postmodernism extends beyond art and architecture into cultural politics, and divides into two contrary positions.

No word in postwar criticism is more disputed than the term "postmodernism." This is so largely because it can be understood only in relation to other broad terms that are equally difficult to grasp, such as "modernism," "modernity," and "modernization." "Postmodernism" is also paradoxical in its own right. On the one hand, it suggests that "modernism"—whether understood as the refinement of each art form to its separate essence or, on the contrary, as the critique of all aesthetic separation—is somehow finished, and its death was indeed announced by many theorists. On the other hand, in the work of some artists and critics also associated with the term, postmodernism has provided new insights into modernism, especially into historical avant-gardes long scanted by dominant accounts ▲ (as Dada and Surrealism had been, for example, by Clement Greenberg and his followers). In this way, postmodernism has served as a way to revisit modernism as much as to declare it dead.

Like modernism, postmodernism does not designate any one style of art. Rather, its most ambitious theorists have used the term to mark a new cultural epoch in the West. For the American critic Fredric Jameson, whose "Postmodernism, or the Cultural Logic of Late Capitalism" is a classic Marxist analysis, the postmodern is less a clean break with the modern than an uneven development of old (or "residual") and new (or "emergent") elements. Nevertheless, it is distinct enough to "periodize" as a new moment in culture in relation to a new stage in capitalism, often called "consumer capitalism," which emerged after World War I. Thus ● for Jameson the spectacular images associated with postmodern culture—seductive simulations in magazines and movies, on TV and the Internet, that rarely represent anything real at all—reflect "the cultural logic" of an economy driven by consumerist desire. However, for the French philosopher Jean-François Lyotard, whose *The Postmodern Condition* (1979) inaugurated the philosophical debate over the term, the postmodern marked the end of any such Marxist narrative, indeed of all "grand narratives" of "modernity," whether told as a story of progress (such as the spread of enlightenment) or as a tale of decline (the enslavement of the proletariat). And yet, even as these two opponents in the debate about postmodernism disagree on its ramifications, they concur that its motive force remains "modernization," or the

ceaseless transformation of modes of production and consumption, transportation and communication, in the interest of profit. On this score there may be an end to the artistic formation that is called "modernism," perhaps even an end to the cultural epoch called "modernity," but no end to the socioeconomic process called "modernization" is in sight. On the contrary, the postmodern may only signal the near-global extent of this process.

Rival postmodernisms

But what did the term "postmodernism" signify in art and architecture at the height of this debate—that is, circa 1984, the year that Ronald Reagan was reelected president? (I include architecture because the debate first became public there.) In the United States this was the peak moment of neoconservativism in politics, which called for a return to original values of family, religion, and country—in short, of cultural tradition. But it was also, at least in the art and academic worlds, the peak moment of poststructuralism in theory, which put into question all such origins and returns. Hardly matched as antagonists—the first was a political force, the second an intellectual orientation—these two philosophies nonetheless governed the two basic positions on postmodernism at the time, and for convenience I will label them accordingly.

Then as now "neoconservative postmodernism" was the more familiar of the two. Defined mostly in terms of style, it reacted against modernism, which it reduced to abstract appearance alone—to the glass-and-steel International Style in architecture, to abstract painting in art, and to linguistic experimentation in fiction. It then countered this modernism with a return to ornament in architecture, to figuration in art, and to narrative in fiction. Neoconservative postmodernism justified these returns in terms of a heroic recovery not only of artistic individuality in opposition to the supposed anonymity of mass culture, but also of historical memory in opposition to the supposed amnesia of modernist culture. "Poststructuralist postmodernism," on the other hand, questioned both the originality of the artist and the authority of the tradition. Moreover, rather than a return to representation, ▲ this postmodernism advanced a critique of representation, in which representation was held to construct reality more than to

copy it, to subject us to stereotypes more than to reveal the truth about us. And yet, as we will see, these two contrary positions might now be seen to share a historical identity, one that neither could have foreseen.

In art and architecture neoconservative postmodernism favored an eclectic mix of archaic styles and contemporary structures. In ▲ architecture, as represented by Philip Johnson, Charles W. Moore, Robert Venturi, Michael Graves, Robert Stern, and others, this practice tended to use neoclassical elements like columns as so many popular symbols to dress up the usual modern building, rationalized in structure and space for efficiency and profit. And in art, as represented by Francesco Clemente (born 1952), Anselm ● Kiefer (born 1945), David Salle (born 1952), and Julian Schnabel (born 1951), it tended to use art-historical references as so many clichéd quotations to decorate the usual modern painting (the references differed with the national cultures of the artists—here Italian, German, and American, respectively [1]). So in what way was such work postmodernist? It did not argue with modernism seriously or exceed it formally. Rather it sought a reconciliation with the public (which is also to say with the marketplace) that was said to be alienated by the overly conceptual art and architecture of the sixties and seventies. Far from democratic (as was sometimes proclaimed), this reconciliation tended to be both elitist in its historical allusions and manipulative in its consumerist clichés. "Americans feel uncomfortable sitting in a square," Venturi once remarked, "they should be home with the family looking at television."

In this regard, neoconservative postmodernism was less postmodernist than antimodernist; and like the antimodernisms of the ▲ interwar period, it sought stability, even authority, through reference to official history. More than a stylistic program, then, this postmodernism was a cultural politics, the strategy of which was twofold: first to foreclose modernism, especially in its critical aspects (in the neoconservative scheme of things culture was to be only affirmative of the status quo), and then to impose old cultural traditions on a complex social present that was far beyond such stylistic solutions.

It was here that the great contradiction of this postmodernism began to surface, for even as it cited historical styles, its mix of ● quotations, often called "pastiche," tended to deprive these styles not only of context but also of sense. Ironically, then, rather than a return to tradition, this postmodernism pointed to its fragmentation, even its disintegration, at least as a coherent canon of styles. Indeed, "style," understood as the singular expression of a distinctive individual or period, and "history," understood as the basic ability to place cultural references at all, were undermined more than reinforced by this postmodernism. In this way, neoconservative postmodernism was exposed by the very cultural moment that it wanted to flee. For, as Jameson in particular has stressed, the eighties were marked not by a return of style but by its breakdown in pastiche, not by a recovery of historical consciousness but by its erosion in consumerist amnesia, and not by a rebirth of the artist as genius but by "the death of the author" (in the famous phrase of the French poststructuralist Roland Barthes), understood as the unique origin of all meaning.

1 • Julian Schnabel, *Exile*, 1980
Oil and antlers on wood,
228.6 × 304.8 (90 × 120)

▲ 1972c ● 1988 ▲ 1919, 1934a, 1937a ● 1919

Cultural studies

Insofar as semiology scanned the whole of the cultural horizon for examples of covert political speech, its field extended to advertising as well as television, packaging, and fashion. This semiological opening to the wider field of mass-cultural activity was contemporary with the attack mounted by Michel Foucault on the internal coherence of the various disciplines that make up the field of humanities: literature, history, art, etc. In England, at the University of Birmingham, scholars began to object to the idea that mass culture was simply a matter of manipulating passive consumers. Instead, argued cultural critics such as Stuart Hall there are strategies of consumption that slip over into forms of resistance. Rap would be one example of a reprogramming of music that turns it into a vehicle of aggression against middle-class values of decorum and obedience. It was even argued that the most degraded forms of popular storytelling, so-called "romance novels," could be a form of resistance that enabled lower-class women to carve out a space of privacy and fantasy.

That the divide between high art and mass entertainment would mirror class warfare was articulated by French sociologist Pierre Bourdieu (1931–2002), who, in *Distinction* (1979), argued that skill in the consumption of high art was tantamount to having "cultural capital," and thus translates in Western, industrialized societies into monetary advantage and power.

The other postmodernism, "poststructuralist postmodernism," differed in most respects. It differed, first of all, in its opposition to modernism. From the neoconservative point of view, modernism had to be overcome because it was too critical. From the poststructuralist point of view, it had to be overcome because it was no longer critical enough—it had become the official art of the museums, the favored architecture of the corporations, and so on. But it was on the question of representation that these two postmodernisms differed most clearly. As noted above, neoconservative postmodernism advocated a return to representation, and it took the truth of its representations for granted. Poststructuralist postmodernism, on the other hand, was driven by a critique of representation that questioned this truth, and it is this critique that aligned such postmodernist art most closely with poststructuralist theory.

Indeed, this art borrowed the poststructuralist notion of the fragmented "text" as a counter to the modernist model of the unitary "work." According to this argument, the modernist "work" suggested a work of art that was a symbolic whole, unique in its making and perfect in its form. The postmodernist "text" suggested a very different kind of entity: in the influential definition of Barthes, "a multidimensional space in which a variety of writings, none of them original, blend and clash." This notion of "textuality" seemed well suited to the strategy of appropriated images and/or anonymous writings, as used in the early phototexts of Barbara Kruger and poster-statements of Jenny Holzer (born 1950) [2], as well as in the early copied works of Sherrie Levine and photographic arrangements of Louise Lawler. In these practices postmodernist textuality was first brought to bear on the modernist ideas of "master" works and "master" artists, which were viewed as ideological "myths" to expose—to "demystify" or to "deconstruct." As these myths were seen to be gendered male, it was no accident that this critique was led by feminist artists.

Pastiche and textuality

As models of artmaking, then, the modernist "work" and the postmodernist "text" are distinct enough. But what about neoconservative "pastiche" and poststructuralist "textuality"—how different, finally, are they in effect? Consider, as an example of each practice, the work of two artists who were lionized circa 1984: the neo-Expressionist paintings of Julian Schnabel on the one hand and the multimedia performances of Laurie Anderson (born 1947) on the other [3]. Schnabel mixed high-art allusions (such as to Caravaggio in *Exile*) with low-culture materials (such as velvet and deer antlers), but not in order to question either set of terms. On the contrary, along with many other artists of the time, he turned the modernist techniques of collage and assemblage into contemporary devices dedicated to bolster the very medium that they once were used to break open: painting. Certainly some of his pictorial elements are fragmented (such as broken plates), but all are held together by the conventions of modern painting—such as expressive gestures, excessive frames, and heroic Abstract Expressionist posturings—that Schnabel attempted to resuscitate. Anderson, on the other hand, did play with art history and pop culture as clichés. In her performances, which tended to be allegories of disorientation in contemporary American life, she orchestrated a profusion of artistic media and cultural signs—projected images, taped narratives, electronically altered music and voice, and so on.

2 • Jenny Holzer, *Truisms*, 1977–9
Poster, 91.4 × 61 (36 × 24)

3 • Laurie Anderson, detail of the performance *United States*, 1978–82

This mélange rendered ambiguous the personal position as well as the social reference of her representations, and it did so outside of any one medium that might recontain them as high art.

Granted these great stylistic and political differences, did these respective practices of pastiche and textuality differ in any structural sense? Both tended to disrupt the idea of stable subjectivity and to shatter the notion of traditional representation —Anderson intentionally so, Schnabel inadvertently so. If this is the case, then the neoconservative "return" to individual style and historical tradition (as exemplified here by Schnabel) might be revealed, twenty years after its peak moment, to be similar in effect to the poststructuralist "critique" of these things (as exemplified here by Anderson). In short, pastiche and textuality might now be seen as complementary symptoms of the same crisis of subjectivity and narrative that comprised "the postmodern condition" for Lyotard, of the same process of fragmentation and disorientation that informed "the cultural logic of late capitalism" for Jameson.

But then what exactly were this subjectivity and that narrative that were supposed to be in crisis in the first place? They were presumed to be general, even universal; critics of "the postmodern condition" soon came to see them as more particular—as mostly white, middle-class, male, Western European and North American. For some, any threat to this subjectivity and that narrative, to the great modern tradition, was indeed grave, and it provoked both laments and disavowals concerning the end of art, history, the canon, the West. But for others, especially for people marked as "other," whether sexually, racially, and/or culturally, postmodernism did not signal an actual loss so much as a potential opening to other kinds of subjectivities and narratives altogether. HF

FURTHER READING

Roland Barthes, *Image-Music-Text*, trans. Stephen Heath (New York: Hill and Wang, 1977)

Hal Foster (ed.), *The Anti-Aesthetic: Essays on Postmodern Culture* (Seattle: Bay Press, 1983)

Fredric Jameson, *Postmodernism, or The Cultural Logic of Late Capitalism* (Durham, N.C.: Duke University Press, 1991)

Rosalind Krauss, *The Originality of the Avant-Garde and Other Modernist Myths* (Cambridge, Mass.: MIT Press, 1986)

Jean-François Lyotard, *The Postmodern Condition: A Report on Knowledge*, trans. Geoff Bennington and Brian Massumi (Minneapolis: University of Minnesota Press, 1984)

Craig Owens, *Beyond Recognition: Representation, Power, and Culture* (Berkeley and Los Angeles: University of California Press, 1992)

Brian Wallis (ed.), *Art after Modernism: Rethinking Representation* (Boston: David R. Godine, 1984)

▲ 1975a, 1977b, 1987, 1989, 1993c

1986

"Endgame: Reference and Simulation in Recent Painting and Sculpture" opens in Boston: as some artists play on the collapse of sculpture into commodities, others underscore the new prominence of design and display.

Like other movements in the sixties, Pop and Minimalism worked against traditional notions of artistic composition, and they did so partly through a serial mode of production: one image after another, as often in the silkscreened paintings of Andy Warhol; "one thing after another," as often in the sculptural units of ▲ Donald Judd. This serial ordering also oriented Pop and Minimalism to the everyday world of serial commodities more systematically than any previous art. In our world of consumer capitalism, the primary term of consumption is not necessarily the use of a given product so much as its difference as a sign from other such signs. According to
● the French sociologist Jean Baudrillard, it is often this "factitious, differential, encoded, systematized aspect of the object" that we consume more than the object as such; it is the brand name that
■ triggers our desire, the commodity-as-sign that becomes our fetish.

Codes of consumption

Once serial production and differential consumption penetrated art in this manner, distinctions between high and low forms became blurred in a way that exceeded any thematic borrowing of imagery or sharing of subject matter. Evident in Pop and Minimalism, this blurring became explicit in the early eighties when artists like Jeff Koons (born 1955) and Haim Steinbach (born 1944) equated art works with commodities directly; this work first came to broad attention in a 1986 show titled "Endgame" at the Institute of Contemporary Art in Boston. With his early basketballs half-submerged in aquarium tanks, Koons produced an almost Surrealist affect of ambivalence [1], yet his glossy ad campaigns and luxury objects thereafter seemed bent on little more than self-promotion, as Koons appeared to delight, nihilistically, in the commodity fetish and the media celebrity as the historical replacements of the auratic art work and the inspired artist.
◆ In effect he acted out what Walter Benjamin had predicted long ago for capitalist society: the cultural need to compensate for the lost aura of art and artist with "the phony spell" of the commodity and the star. Here his most famous precedent among artists was Andy Warhol. "Some company recently was interested in buying my 'aura,'" he wrote in *The Philosophy of Andy Warhol* (1975). "They didn't want my product." It was left to Koons to make this redefinition of aura as "phony spell" not only the subject but the operation of an art career.

1 • Jeff Koons, *Two Ball 50 / 50 Tank (Spalding Dr. J Silver Series, Wilson Supershot)*, 1985
Glass, steel, distilled water, and two basketballs, 159.4 × 93.3 × 33.7 (62¾ × 36¾ × 13¼)

And if Koons, a stockbroker-turned-artist, presented commercial hype as the contemporary substitute for artistic aura, then no-less-savvy ▲ artists like Damien Hirst (born 1965), the most notorious of the "Young British Artists" who emerged in the late eighties and early nineties and gained notoriety with the 1997 "Sensation" show at the Royal Academy in London, did much the same thing with media sensationalism. Koons had only placed kitschy products in his cases; Hirst went the whole hog and presented sectioned animals in his containers [2]. In this regard the outraged opponents of these artists played right into their hands, for together they produced a packaged simulacrum of artistic provocation.

Whereas Koons focused on the fetishistic aspect of the commodity-sign, Steinbach concentrated on its differential aspect.

A 1985 piece titled *related and different* displays a pair of Nike basketball shoes alongside five plastic goblets, as if to suggest that Air Jordans were a contemporary version of the Holy Grail. This is typical of his work: to set selected products on simple shelves or pedestals in clever juxtapositions of shape and color in a way that shows them to be "related and different"—related as commodities, different as signs. Steinbach frames art objects in these terms too: they are presented as signs to be appreciated—that is, consumed—as such. Like Koons he positions the viewer as shopper, the art connoisseur as commodity-sign fetishist, and celebrates the idea that our "passion for the consumerist code" (Baudrillard) seems to subsume all other values—use-value, aesthetic value, and so on. With Steinbach this code of consumption is first and foremost a matter of design and display, and its logic appears total, able to absorb any object, however bizarre, into any arrangement, however surreal. In his work such oppositions as functional and dysfunctional, rational and irrational, which structured the definition of the modern object since the Bauhaus and Surrealism, appear to be collapsed, which is indeed one "endgame" played out by this kind of "commodity sculpture."

These artists "pretend to engage in a critical annihilation of mass-cultural fetishization," Benjamin Buchloh has argued, but in doing so "they reinforce the fetishization of the high-cultural object even more: not a single discursive frame is undone, not a single aspect of the support systems is reflected, not one institutional device is touched upon." In this account they do not confront the contemporary status of the institution of art; rather, they perform (as one practitioner, Ashley Bickerton [born 1959], once boasted) a "strategic inversion of the deconstructive techniques" developed to critique this institution by such artists as Marcel Broodthaers, Michael Asher, and Hans Haacke in the sixties and seventies. If those older artists had expanded the presentational device of the readymade object in order to reflect on conditions of exhibition, these younger artists returned the readymade to its status as a product—indeed, they often transformed it into a luxury commodity on display.

Yet not all artists concerned with the commodification of art in the eighties succumbed to this cynical inversion of the old avant-garde device of the readymade. Allan McCollum (born 1944) demonstrated the same positioning of art—as object of desire and as vehicle of prestige—as did Koons and Steinbach, but he withheld the goods, so to speak, and so invited us to consider conventions of display as triggers of consumption. His *Surrogate Paintings* [3], which consist solely of minimal frame, mat, and rectangle in lieu of the usual image, are so many blank signs for easel painting (first painted in acrylic on wood, they were later cast in plaster); while his *Perfect Vehicles* (1985), urns cast in solid Hydrocal and painted in enamel bands of different colors, are equally generic tokens of sculptural objects. As with several subsequent series, both "the Surrogates" and "the Vehicles" come in various sizes and in extreme

▲ 1923, 1931a, 2007b

▲ 1970, 1971, 1972a, 1972b ● 1914

3 • Allan McCollum, *Surrogate Paintings*, 1978–80
Acrylics and enamels on wood and museum board, sizes vary

numbers: McCollum oversees a studio that functions, like a cottage industry, somewhere between a workshop and a factory, and he uses it to produce a superabundance of unique multiples that frustrates rather than satisfies our desire. In this way he calls up differences in production at the same time that he provokes reflections on consumption, and so carves out a place of critical distance on various kinds of making, showing, viewing, and owning from within an economy that works to foreclose awareness of alternative modes of production and distribution altogether.

John Knight (born 1945) has also worked to develop the deconstructive techniques of institution-critical art, with an eye not only to the increased commodification of art but also to its literal incor ▲ poration into big business, indeed *as* big business. This led him to mimic the forms of design and display in advertising and architecture that became pervasive during the Reagan-Thatcher years when corporate merging and culture marketing expanded exponentially. Thus for Documenta 7 (1982), the international exhibition in ● Kassel, West Germany, Knight made eight logotypes from his own initials abstracted in italicized Helvetica font (which he deemed "the ultimate mainstream corporate font"), mounted them in wood relief, and covered them with color reproductions of travel posters (in one piece he substituted an advertisement for a California bank). In this way he pointed to the historical recuperation of modernist forms of abstraction, relief, and collage "for the dissemination of the ideology

and the products of corporate postwar culture" (Buchloh). At the same time, positioned in the two main staircases in the principal hall of Documenta, his logotypes equivocated between art work and commercial logo, between private, individual signature and public, anonymous sign. In a sense Knight incorporated his own initials here, a rhetorical move that underscored the double condition that critical artists faced at this moment: not only the corporate domination of art-world institutions (along with the financial manipulation of art collectors like Charles Saatchi in England, whose first line of business is indeed advertising), but also the forced revival of ▲ Expressionist painting. His *Mirror* series [**4**] reflected on both developments, and suggested that the apparent subjectivity of the painting served as small compensation (and no little mystification) for the actual sovereignty of the corporation. According to Buchloh, Knight shaped his pseudocorporate logos in different geometric forms faced with mirrors so as to "remind us of the ultimate corporate reality that controls and determines the most secluded interior reflection. In the same manner, the trivial domesticity of the mirrors leaves no doubt that the aesthetic withdrawal from its public social function has no other place than that of the private framed reflex."

Other artists at the time also underscored the corporate designing of our identities. For example, Ken Lum (born 1956) has arranged standard modern furniture in bizarre positions—sofas standing, leaning, sometimes combining and coupling—as if they

4 • John Knight, *Mirror* series, 1986
Installation view

had taken on a life of their own and displaced their human owners. And Andrea Zittel (born 1965) has explored the modularization of our contemporary habitats in a series of mock models of stream-lined offices and homes. Still other artists have sought to reclaim a subjective dimension in this new order of everyday life under mega-corporations. Like Knight, Lum, and Zittel, Barbara Bloom (born 1951) has also mimicked cultural forms that shape social identity. Among other things, she has produced posters and advertisements, book jackets and film trailers, in a sly sort of deconstructive mimesis of these genres of the culture industry. "In all my work 'seeming' and 'appearing as if' play a large role," Bloom explains, "but this looking 'like,' this chameleonic means of achieving my purpose is, on the surface, a first impression. The images, often through irony, offer commentary upon the medium in which they are placed and cultural images (clichés) in general."

Bloom developed her early work out of feminist concerns of the late seventies and early eighties, which focused on questions of fetishism and spectatorship; in a 1985 installation titled *The Gaze*, which took the form of a showroom, she worked to catch our fasci-nation with designer shoes in the act. However, her later work is not so distanced; especially in her exhibitions staged as private collections Bloom has introduced fragments of stories, both fictional and (auto) biographical, through photographs and books, personal items and household objects, often redolent of the past [5]. Here rather than adopt the guise of the public curator, as many contemporary artists have done, she performs the role of the private collector. Other artists had taken up this part before her, or combined it with that of the curator (Broodthaers, for example), but Bloom is concerned less to critique the gallery–museum nexus than to transform it into an alternative theater to explore the secret lives of words and things. Like Walter Benjamin before her, Bloom sees the collector as a figure who resists the reduction of the object to either use-value or exchange-value, and who mobilizes a personal kind of fetishism—what she calls "the potency of detail"—against the abstract fetishism

of the commodity-sign. "Collectors are the physiognomists of the world of objects," Benjamin wrote in "Unpacking My Library" (1931); they elevate the commodity "to the status of allegory," finding hidden stories therein. Bloom performs a similar narrativ-ization with her objects: "I seem to spend an inordinate amount of time contemplating whether an object can be imbued with enough meaning to become a stand-in for a person or event."

In the eighties, artists responded to the market pressures and corporate interests in the art world (and beyond) in dialectically different ways. Some acted out these financial arrangements in their work, as if to exacerbate them might be to damage them somehow; while others attempted to reflect on these new forces critically, and to develop rather than to collapse the framing effects of the readymade device in order to do so. Although economic conditions shifted, temporarily, after the minicrash of the stock market in 1987, the mid-nineties saw another round of capitalist expansion, and some artists began to focus less on the commodifi-cation of art, which they considered a given by this time, than on the ubiquity of *design*, or the manner in which objects or practices are so often recoded, subsumed into a greater ensemble, turned into an element of decor or lifestyle. This shadowing, even doubling, of avant-garde art by "good design" is not a new story; it has haunted abstract art through much of its development. In this regard consider the trajectory of the Bauhaus, the most celebrated of modernist schools: if the Bauhaus did indeed transform the arts and crafts as they were traditionally taught, it also facilitated, as Baudrillard has argued, "the practical extension of the system of exchange-value to the whole domain of signs, forms and objects." This is one version of "the bad dream" of modernism—that its utopian transformations of art forms might be recouped as market advances in fashion and other commodity lines.

Some contemporary artists, such as Jorge Pardo (born 1963) and Karim Rashid (born 1960), appear to take this recuperation as a given, and to work within the parameters of a design logic. In this

5 • Barbara Bloom, *The Reign of Narcissism*, 1989
Mixed media, dimensions variable

space of design, categories and terms that a generation ago were held in productive contradiction—for example, "sculpture" versus ▲ "architecture" in site-specific art—appear as compounds without much generative tension, as in the many combinations of pictures, objects, and spaces in Installation art. In this state of reversion, site-specific art becomes a kind of ambient art, and the situational aesthetics developed by institution-critical artists like Michael ● Asher transmutes into a sort of design aesthetics. Indeed, artists like Pardo and Rashid use elements of decor—color-coded tile and wallpaper, super-sleek fixtures and furniture—to subsume the space of art into a total environment. In this sense, if some artists once pushed sculpture out into the realm of architecture, others now submit sculpture to the dictates of design.

Yet here too, as with the heightened commodification of art in the eighties, there are dialectically different responses to this pervasive design logic. The artist-architect Judith Barry (born 1949) has long appropriated aspects of this logic for critical purposes in her installations and exhibitions. And rather than exacerbate the implosive effects of this logic, some artists, such as Glenn Seator (1956–2002) and Sam Durant (born 1961), have sought to recover the "expanded field of sculpture" in the sixties, and to resist the totality of design through an explicit remotivation of site-specific practices. In the case of Durant, this has meant a recovery of the site/non-site ▲ dialectics of Robert Smithson, but now read through funky references to both subcultures and mass culture. In the case of Seator, it meant a ● recovery of the architectural cuts of Gordon Matta-Clark, but now performed in a manner in which the exposed architectural history becomes a systematic index of an exposed social history.　HF

FURTHER READING
Brooks Adams et al., *Sensation: Young British Artists from the Saatchi Collection* (London and New York: Thames & Hudson, 1998)
Benjamin H. D. Buchloh, *Neo-Avantgarde and Culture Industry* (Cambridge, Mass.: MIT Press, 2000)
David Joselit (ed.), *Endgame: Reference and Simulation in Recent American Painting and Sculpture* (Boston: Institute of Contemporary Art, 1986)
Lars Nittve (ed.), *Allan McCollum* (Malmo: Rooseum, 1990)
Peter Noever (ed.), *Barbara Bloom* (Vienna: Austrian Museum of Applied Arts, 1995)

▲ 1967a, 1970　　● 1970　　　　　　　　　▲ 1967a, 1970　　● 1967a

1987

The first ACT-UP action is staged: activism in art is reignited by the AIDS crisis, as collaborative groups and political interventions come to the fore, and a new kind of queer aesthetics is developed.

In response to conservative governments in the United States, the United Kingdom, and (then) West Germany, the early eighties witnessed a resurgence of art devoted to progressive politics, the most important since the height of the Vietnam War. Different events overlapped to provoke this resurgence: military interventions in Central America, corporate takeovers on Wall Street, the continued threat of nuclear holocaust, the phobic attacks of the religious Right, backlashes against civil rights and feminist gains, slashes in welfare and other social programs, and—most tragic of all for the art world—the AIDS epidemic, the indifference of most

governments to it, and the brutal scapegoating of gay men in particular on account of it. As the decade wore on, political art in the United States was also galvanized by a number of beatings and other violent events that were racially and/or sexually motivated, as well as by ideological conflicts that pitted the art world against the very governmental agencies founded in part to support it—above all the National Endowment for the Arts.

These responses were framed in two basic ways. The first tended to a "representation of politics," in which social identities and political positions were treated as given contents, to be communicated as

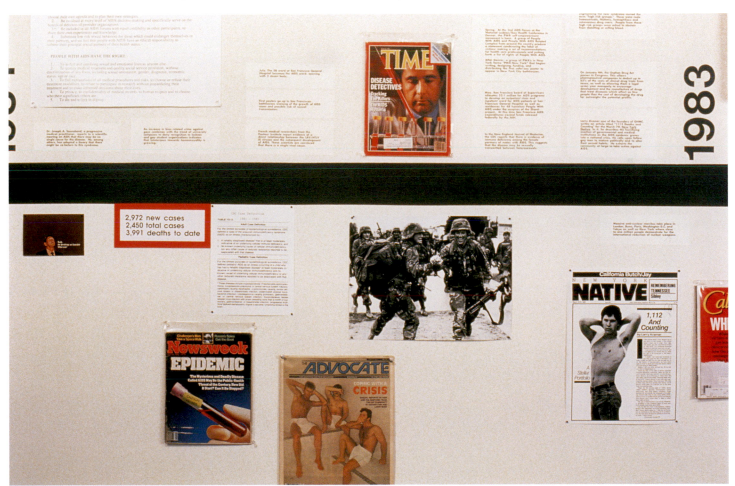

1 • Group Material, *AIDS Timeline*, 1989
Mixed-media installation

▲ Introduction 2, 1977b, 1984a

immediately as possible. The second tended to "a politics of representation," in which these identities and positions were treated as constructed representations, to be interrogated on formal as well as ▲ ideological levels. Thus, while some artists worked to present political problems in direct ways, others brought poststructuralist • critiques of representation to bear on them. One danger of the first approach was that it sometimes confirmed the stereotypes that it sought to challenge; and one danger of the second was that its very sophistication sometimes obscured its own critique.

The reactionary turn in politics was accompanied by one in aesthetics, as was manifest in the resurrection of old forms like oil painting and bronze sculpture; the common enemy here was the radical transformations in the sixties of politics and art alike. And yet, even as humanist myths of master art and artists were revived, the art world was given over to market forces like never before, especially to the financial manipulations of collector-investors (like the British advertising executive Charles Saatchi) who extended the rampant privatization of the public sphere under Reagan and ■ Thatcher to the institutions of art. Among other changes for the worse, this meant the trumping of curators and critics by collectors and dealers as arbiters of artistic importance and value.

In resistance to the ideological regression in art as well as the overt manipulation of its market, some artists pursued "collaborative, collective, cooperative, communal projects," as one New York group called COLAB put it. Often these collectives set up alternative spaces, sometimes for temporary exhibitions in abandoned storefronts, sometimes to engage communities not served by the art world and removed from its centers. One example of guerrilla exhibitions in New York was "The Real Estate Show" (1980), which combined ad hoc objects and installations by local artists with wall drawings and graffiti by neighborhood children in a derelict storefront in the East Village owned by the city. Almost immediately the show was closed by the authorities, who thereby only underscored the real-estate problems that the event sought to dramatize. One example of community spaces in New York was Fashion Moda, a storefront gallery in the South Bronx set up by Stefan Eins and Joe Lewis to connect various artists with local residents (some of whom were portrayed, in painted plaster busts, by John Ahearn and Rigoberto Torres). The activities of such collectives as Group Material in New York and Border Art Ensemble in San Diego also ranged from message shows and guerrilla interventions (such as illegal postering) to community

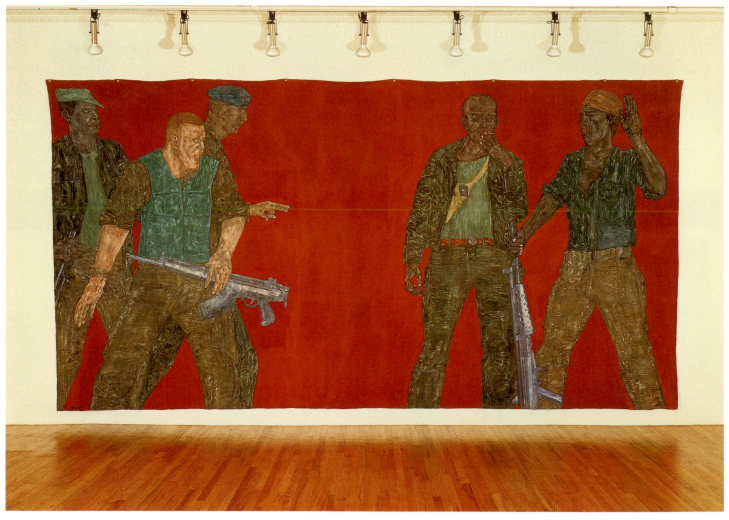

2 • Leon Golub, *Mercenaries (IV)*, 1980
Acrylic on canvas, 304.8 × 585.5 (120 × 230½)

▲ 1975a, 1977a, 1977b • 1977a, 1980, 1984b ■ 1976

projects [1]. The mission statement of Group Material—"to maintain control over our work, directing our energies to the demands of the social conditions as opposed to the demands of the art market"—captures the spirit of this movement of politically motivated artists who sought to be socially site-specific as well, a spirit that has lived on in other groups like RePo History.

The resurgence of political art associations in the eighties revived interest in such precursors as the Art Workers' Coalition, which was formed at the height of the Vietnam War in order to advance the cause of an artist union and to protest the absence of woman and minority artists in exhibitions and collections. The spotlight also fell again on engaged artists like Leon Golub, who updated his graphic paintings of the atrocities of American soldiers in Vietnam with the new subjects at hand, such as the mercenaries of the undeclared "dirty wars" of the eighties [2]. Intercut with this representation of politics, however, was a politics of representation, which led some artists to mimic Situationist strategies of ▲ *détournement* in particular—that is, the reworking of public symbols and media images with subversive kinds of social meanings and historical memories. Thus, from 1980 onward the Polish-born Krzysztof Wodiczko (born 1943) projected specific images at night, at first in guerrilla fashion, onto different monuments and buildings redolent of political and financial power: nuclear missiles on war memorials, presidential pledges of allegiance on corporate buildings, homeless people on heroic statues, and so on [3]. His goal was to counter the official languages and to expose the suppressed histories of these architectures, with the result that under his projections they often seemed to erupt, symptomatically, with repressed contents and connections. Others like Dennis Adams (born 1948) and Alfredo Jaar (born 1956) used similar strategies. In his site-specific bus shelters, Adams confronted passersby with photographs of political demons who still haunt the present, such as the anti-Communist demagogue Joseph McCarthy and the Nazi executioner Klaus Barbie. In a related set of substitutions, Jaar displaced the slick subway ads that glorify businesses and banks at home with graphic phototexts that detailed their real work of exploitation abroad.

Agitprop appropriations

The most effective of these neo-Situationist interventions were made by the numerous artist groups associated with ACT-UP, the acronym of AIDS Coalition To Unleash Power, founded in March 1987 "to undertake direct action to end the AIDS crisis." As sophisticated in poststructuralist critiques of representation as the aforementioned artists, these groups (among them Gran Fury, Little Elvis, Testing the Limits, DIVA TV, Gang, Fierce Pussy) deployed different mediums and techniques depending on the occasion: bold posters of appropriated images and invented texts for specific demonstrations, subversive reworkings of corporate ads and newspaper pages for general circulation, video cameras to counter police abuse and media misrepresentations of ACT-UP

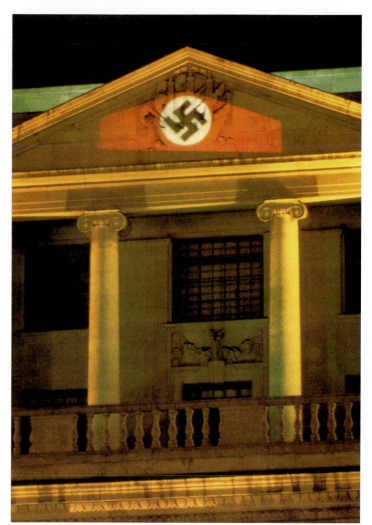

3 • Krzysztof Wodiczko, *Projection on South Africa House*, 1985
Trafalgar Square, London, dimensions variable

activities, and so on. In doing so, they drew on a wide range of art practices—the photomontages of John Heartfield, the graphics of Pop art, the outrageousness of Performance art, the reflexivity of institutional critique, the image-savvy of appropriation art, and the ▲ caustic wit of feminist artists like Barbara Kruger. "The aesthetic values of the traditional art world are of little consequence to AIDS activists," critic Douglas Crimp commented in 1990. "What counts in activist art is its propaganda effect; stealing the procedures of other artists is part of the plan—if it works, we use it." Or, as a 1988 poster by Gran Fury put it succinctly, "With 42,000 Dead Art Is Not Enough: Take Collective Direct Action To End The AIDS Crisis."

Some of these strategies were already at work in an anonymous poster that surfaced in downtown New York before the founding of ACT-UP: the mordant and mournful "Silence = Death" (1986). These two words were set in white type on a black ground with a pink triangle, the Nazi emblem for gays in the concentration camps. With the simple strength of its conviction, this sign indicted governmental inaction and public indifference regarding the AIDS epidemic (spelled out in a series of questions and exhortations in fine print at the bottom); indeed it equated this passivity with murder. At the same time, this sign turned the stigma of the

▲ 1957a

▲ 1920, 1937c, 1956, 1960c, 1964b, 1971, 1975a, 1977a, 1980, 1992

pink triangle into an emblem of proud identity—a characteristic transvaluation, in the political development of an oppressed group, of an abusive stereotype (a similar reversal was performed on the word "queer" during this time). Scores of signs followed. Many, like "Silence = Death," were made in various forms (posters, placards, T-shirts, buttons, and stickers), and all were used as tools for organizing and reporting, raising consciousness and support, surviving and fighting back.

ACT-UP groups knew that the ideological war over AIDS was fought through the media as well as in the streets, and with a membership of many artists, film- and videomakers, architects, and designers, they devised signs and events that not only critiqued and corrected the media but also played on its procedures and propensities. Some used graphic horror, such as a 1988 poster by Gran Fury that showed only a handprint in blood red, the sign of a murderer, with the texts "The Government Has Blood On Its Hands" above and "One AIDS Death Every Half Hour" below [**4**]. Others used campy humor, such as a 1989 poster, also by Gran Fury, that substituted the word RIOT for the old Pop icon of LOVE painted by Robert Indiana in 1966 (the poster also responded to a prior substitution, by the Canadian group General Idea, of AIDS for LOVE). Designed to commemorate the twentieth anniversary of the Stonewall Rebellion, the uprising after an abusive raid at a Greenwich Village gay bar that is often taken to mark the beginning of the gay-rights movement, this sign was at once a call to memory and a call to arms, with the captions "Stonewall '69" above and "AIDS Crisis '89" below. ACT-UP groups also targeted bureaucratic officials and reactionary politicians (from commissioners of health to presidents), as well as drug-company profiteers. The infamous 1988 election pledge of George Bush against new taxes—"Read My Lips"—became a different kind of promise altogether in announcements of gay and lesbian "kiss-ins." (When the group Gang substituted a beaver shot for the kissing couples, and added the words "Before They are Sealed," "Read My Lips" took on yet another meaning—an indictment of the Bush gag-order against the discussion of abortion at medical clinics.) Such edgy appropriations were practiced by other artist collectives too, feminist groups like the Guerrilla Girls and antiracist groups like Pest, both of which posted statistically terse condemnations of sexual and racial discrimination in the art world and beyond.

A queering of art

Empowered by ACT-UP, many gay and lesbian artists began to explore homosexuality as a subject of art in different ways—Robert ▲ Gober (born 1954), Donald Moffet (born 1955), Jack Pierson (born 1960), David Wojnarowicz (1954–92), Felix Gonzalez-Torres (1957–96), and Zoe Leonard (born 1961) prominent among them. (The death from AIDS of two of the six here is a small indication of the ghastly toll suffered by the gay and art communities.) In a sense these artists telescoped the different claims made by feminist artists ● of the first two generations, and "queered" them. That is, they

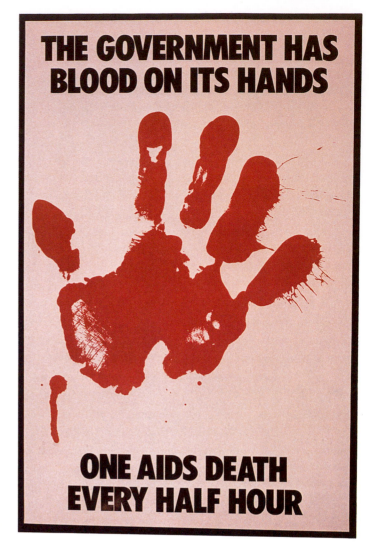

4 • Gran Fury, *The Government has Blood on its Hands*, 1988
Poster, offset lithography, 80.6 × 54.3 (31¾ × 21⅜)

explored homosexuality not only as a subjective experience that was essential in its nature (precisely what its enemies denied), but also as a social construction subject to cultural and historical variation.

More gentle than many of the ACT-UP appropriators urged on by Crimp, Felix Gonzalez-Torres, who was also a member of Group Material, performed a queering of other artistic forms of the sixties and seventies. "In our case," he once remarked, "we should not be afraid of using such formal references, since they represent authority and history. Why not take them?" And so Gonzalez-Torres did, with particular twists. He would arrange thousands of paper sheets, often lithographed with colors or images that bordered on kitsch (such as birds in the sky), in perfect ▲ stacks that recalled Minimalist volumes. Or he would spill thousands of gaily wrapped candies in the form (or antiform) of ● Postminimalist scatter pieces. Or he would paint an elliptical list of historical events in homosexual rights on public billboards in ■ the laconic manner of Conceptual art.

One such billboard appeared in 1989 at Sheridan Square in New York near the site of the Stonewall Rebellion. It consisted simply of a black ground captioned in white italics as follows:

▲ 1977b, 1994a ● 1975a ,1977b ▲ 1965 ● 1969 ■ 1968b

710 1987 | Activist art

The US Art Wars

In 1987 a US District Judge dismissed a lawsuit filed by Richard Serra to prevent the General Services Administration, a federal agency, from removing his sculpture *Tilted Arc* (above), which the same GSA had commissioned in 1981 for the Federal Plaza in downtown Manhattan. "To move it," Serra argued persuasively of his site-specific work, "is to destroy it." Nevertheless, two years later *Tilted Arc* was moved under the cover of night. This was hardly the first case of the seizure or outright destruction of an art work, nor would it be the last, but it did open a new era of marked intolerance toward the work of advanced artists.

Also in 1987 the artist Andres Serrano (born 1950) was awarded a $15,000 grant from the Southeastern Center for Contemporary Art (SECCA) in Winston-Salem, North Carolina, which was funded indirectly by the National Endowment for the Arts (NEA). During his grant period, Serrano produced a Cibachrome photograph that showed a small plastic crucifix submerged in a bubbly amber liquid.

Mostly on the basis of its title, *Piss Christ*, Serrano was accused of "religious bigotry" by the Reverend Donald Wildmon, director of the American Family Association. Again in 1987 the Philadelphia Institute of Contemporary Arts received $35,000 from the NEA to assist in a retrospective of the photographer Robert Mapplethorpe (1947–89), which contained five images of homosexual acts. Fearful of controversy, the Corcoran Gallery canceled the Washington version of the show. The exhibition then moved on to Cincinnati where Dennis Barrie, the director of the Cincinnati Museum of Contemporary Art, was charged with peddling obscenity. Led by Senator Jesse Helms, conservatives in Congress exploited the Serrano and Mapplethorpe controversies to call for the outright abolition of the NEA, an attack to which its supporters responded but meekly.

The greatest struggle concerning art since the Vietnam era was in full roar; and at least three lessons could be drawn from these events: public support for contemporary art had eroded drastically; the religious Right had exploited this failure for its own purposes; and a cultural politics of homophobia had gripped the United States. The work of other artists singled out by Congress also foregrounded homosexuality (for example, the performance artists Holly Hughes and Tim Miller). All such art was deemed antifamily, antireligion, and anti-American. A literalism dominated these battles from the start. Many thought of *Piss Christ* as an actual desecration of Jesus by urine. "The pictures are the state's case," the prosecutor declared of the Mapplethorpe images as if their crime was self-evident. For its part *Tilted Arc* was once likened to a terrorist device.

The immediate upshot of these cases was that *Tilted Arc* was destroyed, an antiobscenity clause was inserted into NEA contracts (unconstitutionally, it was argued), and the case against Dennis Barrie was dismissed. But there were other ramifications. Contemporary art became political fodder for the Right; when not associated with obscenity or scandal, it was ridiculed as hype, and so a waste of taxpayers' money in this respect too, with the result that many liberal supporters also turned away from art. An enormous pall was cast over public art in particular, with the NEA (and other institutions such as Public Broadcasting Stations and National Public Radio) under almost constant assault. And tolerance toward non-normative sexualities was met with murderous reaction at a time when AIDS therapies cried out for massive financing.

"People with AIDS Coalition 1985 Police Harassment 1969 Oscar Wilde 1895 Supreme Court 1986 Harvey Milk 1977 March on Washington 1987 Stonewall Rebellion 1969." Sooner or later one realized that all of the dates were landmark events—associations and demonstrations, trials and rulings, killings and uprisings—in the last century of gay life, but they were not in any order or sequence. The narrative was left to the viewer to construct, and the need to do so was underscored by the vacancy of the image, as if this history were always threatened by invisibility or illegibility.

The candy spills are ambiguous in another way. *Untitled (USA Today)* [5] consists of three hundred pounds of candies in gaudy red, blue, and silver wrappers heaped in a corner. The piece flies in the face of taboos in art against touching, let alone eating. It also brings together stylistic cues usually kept apart: a Postminimalist-like arrangement (Robert Morris and Richard Serra, among others, did corner pieces) with Pop-like materials (the glitziness reminds one of Andy Warhol in particular). It even seems to undo, if only for a moment, the old opposition between the avant-garde

▲ 1965, 1969, 1970 ● 1960c, 1964b

and kitsch. But these artistic allusions are complicated by more worldly ones. The subtitle points to the sugary news that the national paper *USA Today* delivers for our daily consumption, and consumption is literally foregrounded here, as a telling portrait of "USA Today" in another sense too. At the same time, the excess of the piece also conveys a sense of generosity, a spirit of offering so different from the cool cynicism of other uses of the readymade device by Jeff Koons, Damien Hirst, and others. Gonzalez-Torres solicits our participation in the register not only of consumption but of gift-exchange. Like his paper stacks, his candy spills are listed as "endless supply," which reminds us, in a utopian sense, that mass production once had democratic possibilities latent within it.

For all its spirit of offering, however, this art is also imbued with the pathos of loss. In *Untitled (March 5th) #2* (1991), for example, two light bulbs are suspended, supported by their own intertwined cords—a simple testament to love threatened by loss, as one light must burn out before the other. (March 5 was the birthday of his partner, who died of AIDS in 1991, five years before Gonzalez-Torres himself.) And in a 1992 billboard we see only a black-and-white photograph of an empty double bed, ruffled where two bodies recently lay—an elegy to absent lovers that also condemns antigay legislation criminalizing the bedroom [6].

Gender trouble

Like many of his generation, Gonzalez-Torres was influenced by poststructuralist critiques of the subject. Yet his art is concerned more with the making of a gay subjectivity than with its unmaking, for the simple reason that such a deconstruction would assume that gay identity is secure and central in a way that cannot be assumed in our heterosexist society. In his art, then, Gonzalez-Torres attempted to carve out of heterosexual space a lyrical-elegiac place for gay subjectivity and history. In her art Zoe Leonard finds such places in moments of "gender trouble" within straight society. In a 1992 poster made with the ACT-UP group Fierce Pussy, Leonard simply reframed a 1969 photograph of her second-grade class in Manhattan with the typewritten question "Are you a boy or a girl?" This is typical of her twofold tactic: to trouble gender, to expose what she calls the "the bizarreness" of its categories, and to construct a gay identity out of this trouble, to invent a lesbian history in the "place where expectations fall apart."

Leonard plays with this "bizarreness of gender" in her photographs of a *Preserved Head of a Bearded Woman* (1992) found in storage at the Musée Orfila in Paris. (She often searches the backrooms of medical and natural history museums for such "specimens.") Yet the true bizarreness here is not the woman's; for Leonard "it is her decapitation, the pedestal and the bell jar. What is disturbing is that someone or some group of people thought that was acceptable." And so Leonard photographs the "specimen" in such way that she seems to gaze back at her spectators, to put them on exhibit. A similar reversal occurs in the photograph *Male Fashion Doll #2* (1995), a toy that Leonard found in a flea market in Ohio. She describes him as "a little drag queen," with the face and body of a girl, as "usually rendered in plastic, completely sexless and pink," but with a little mustache drawn on him—a figure of gender trouble that Leonard reframes as a question for us.

"I wasn't interested in re-examining the male gaze," Leonard has remarked; "I wanted to understand my own gaze." But the objects of desire and / or identification of this gaze are not readily found in

5 • Felix Gonzalez-Torres, *Untitled (USA Today)***, 1990**
Red, silver, and blue wrapped sweets, dimensions variable

6 • Felix Gonzalez-Torres, *Billboard of Bed***, 1992**
Installed at a New York location

▲ 1986, 2007c ● 1977b

7 • Zoe Leonard, *Strange Fruit*, 1992–7 (detail)
295 banana, orange, grapefruit, and lemon peels, thread, zips, buttons, needles, wax, plastic, wire, and fabric, dimensions variable

heterosexual culture—a vacancy that she seems to figure in her photographs of mirrors that reflect an empty glare more often than any image. As with Gonzalez-Torres, then, Leonard responds to the need not only to critique what is given as identity or history but also to imagine other kinds of constructions. This mandate may lead to archival work, to historical invention, or to both. For example, in her *Fae Richards Photo Archive* (1996), made in conjunction with the 1996 film *The Watermelon Woman* by Cheryl Dunye, Leonard helped to construct, through different genres of photographs artificially aged in the darkroom, the documentary life history of an imaginary woman, a black lesbian of the early 1900s who performed in Hollywood "race films." "She is not real," Leonard attests of Fae Richards, "but she is true."

Along with her gender troublings and historical imaginings, Leonard has also worked toward an art of AIDS mourning, and in this project she is joined by such artists as Robert Gober and Gonzalez-Torres. Her *Strange Fruit* is a poignant instance of this coming to terms with loss: a community of hundreds of fruits whose peels she sewed back together once the fruit was extracted [7]. Inspired in part by her friend David Wojnarowicz, who once cut a loaf of bread in half, then stitched it back together with blood-red embroidery thread, *Strange Fruit* alludes not only to the old slang for homosexual but also to a Billie Holliday song about lynching—about hatred and violence, death and loss.

"It was sort of a way to sew myself back up," Leonard has commented; but the stitched peels attest more to holes than to healing, more to "the inevitability of a scarred life" than to the possibility of a redeemed one. In this regard they are pathetic in a profound sense, "repositories for our grief." This mnemonic model of art, this nonredemptive idea of beauty that allows for aesthetic sublimation but also works toward social change, is an important offering of artists like Gober, Gonzalez-Torres, and Leonard. HF

FURTHER READING
Anna Blume, *Zoe Leonard* (Vienna: Secession, 1997)
Judith Butler, *Gender Trouble: Feminism and the Subversion of Identity* (New York: Routledge, 1989)
Douglas Crimp (ed.), *AIDS: Cultural Analysis/Cultural Activism* (Cambridge, Mass.: MIT Press, 1988)
Douglas Crimp and Adam Rolston (eds), *AIDS DEMOgraphics* (Seattle: Bay Press, 1990)
Lucy R. Lippard, *Get the Message? A Decade of Social Change* (New York: Dutton, 1984)
Nancy Spector, *Felix Gonzalez-Torres* (New York: Guggenheim Museum, 1995)

▲ 1994a

1988

Gerhard Richter paints *October 18, 1977*: German artists contemplate the possibility of the renewal of history painting.

In depicting the impact of the Baader-Meinhof Group's violent attempts to overthrow capitalism, Gerhard Richter's 1988 cycle of paintings titled *October 18, 1977* [1, 2] concluded a long, complex succession of German artists' attempts to reposition painting as a critical reflection on German history. While most postwar visual art, certainly in Europe and the United States, had avoided references to the immediate past, whether the prewar years or the war experience itself, it was German painting from the sixties onward that specifically tried to oppose the elision of historical references that the artistic neo-avant-garde in general mandated.

Within the context of German postwar art there were attempts to relocate painting in relation to history from as early as 1963, with the exhibition of Georg Baselitz's *Die Grosse Nacht im Eimer* (and the subsequent scandal and censorship of the painting). First of all, with almost manifesto-like fervor, this type of work tried to reconstruct the site of a specifically German cultural tradition and to create some continuity for it by opposing all the standards that had been adopted in the first seven years of postwar visual culture— primarily the standards of *informel* painting and those imposed by the rise of American Pop art. Instead, Baselitz's work clamors to be seen as the result of a direct lineage linking it to pre-Weimar German painterly traditions, specifically to the legacies of Lovis Corinth and of German Expressionism. It thereby set out not only to skirt all postwar international avant-garde movements, but, typically and importantly, to avoid all photographically based practices that were specific to Weimar Dada, and to do so by reestablishing painting as the center of visual culture.

The problem of history

Like Baselitz, Gerhard Richter had arrived in West Germany from the East German Democratic Republic, and, also like him, Richter had confronted the question of whether and how recent German history could be made the subject of visual culture. This was also in direct opposition to the *informel* abstractionists such as Winter, Trier, Götz, Hoehme—who were the teachers of Richter, Baselitz, and their peers—and their attempt to internationalize postwar German art. As early as 1962, Richter explicitly addressed the repressed legacy of Germany from 1933 to 1945 by painting a

1 • Gerhard Richter, *October 18, 1977: Confrontation 1 (Gegenüberstellung 1)*, 1988
Oil on canvas, 111.8 × 102.2 (44 × 40¼)

portrait of Adolf Hitler (which he later destroyed). At the same time he began to collect the photographs that would form his huge *Atlas* project [3], in which images of private family narrative were increasingly juxtaposed with images of public German history. Over the years this resulted in the panels in which Richter collected photographs from Buchenwald and Bergen-Belsen.

It can therefore be argued that the project to make German painting assume the function of dismantling postwar historical repression could be credited to both Richter and Baselitz. However, the means with which those strategies were implemented were in fact very different; the difference culminated in the late sixties in the opposition between the work of Richter and Anselm Kiefer.

On the one hand, by continuously looking at Nouveau Réalisme and the work of Andy Warhol—the French and American examples who served as the two poles of reference for his early work—

2 • Gerhard Richter, *October 18, 1977: Funeral (Beerdigung)*, 1988
Oil on canvas, 200 × 320 (78¾ × 126)

Richter upheld the need to situate German painting in relation to all the other artistic practices that emerged in the early sixties. On the other, Baselitz almost programmatically denounced and denied both mass culture and photography, seeing them as conditions that painting had to counteract. Accordingly, the underlying argument (operative in work from Baselitz to the younger Kiefer)—that it was possible to establish an unbroken model of national identity and regional specificity right through from Corinth to Expressionism, to antimodernism, to Baselitz and Kiefer themselves—was refused by Richter, who insisted that all visual practices are determined both by their susceptibility to mass culture and by their entanglement in the postnational identity model of global cultural production.

Soon after 1962, Baselitz's work was seconded by numerous followers, among them Markus Lüpertz, all of whom tried to establish a specifically West German form of painting, to serve as the regional idiom of contemporary culture. At that time, links were already being made within painting between such a project and the problematic attempt to set up the foundations of a broader German cultural identity. Even so, Baselitz and his fellow neo-Expressionists avoided confronting the question of whether either of these two claims—for the continuity of national identity on the one hand or for the model of identity in cultural production on the other—were credible after fascism's destruction of any

model of national identity in cultural production (in particular the German one). Yet the establishment of this continuity— one that obscured the actual breakdown, the ruptures, the actual historical destruction that German fascism had brought about— was inherent in the project to renationalize and reregionalize cultural production. Thus, while painterly practices are not inherently reactionary, any attempt to project a continuity of experience outside the hiatus of fascism is necessarily both in and of itself a reactionary fiction.

It is along this axis of an opposition between the claim for a return to historical authenticity embedded in painting and the claim for a recognition of the various moments where that claim had been dismantled—by media culture, by political transformations, by the critique of the very idea that a model of national identity could be articulated by cultural production—that Richter and Kiefer can be situated. This opposition, as it reemerged in the eighties, when an international surge of interest in the fiction of a return to regional and national cultures made itself felt (specifically in the American reception of German neo-Expressionism) could be described as a question of mediation. First, since Kiefer's work explicitly addresses the legacy of German Nazi fascism, whereas Richter's focuses on events of German political life in the recent past (as in the *October 18, 1977* series), the issue of mediation occurs around the actual historical events the works address.

▲ 1908, 1925b, 1937a

3 • Gerhard Richter, *Atlas: Panel 9*, 1962–8
Black-and-white clippings and photograph, 51.7 × 66.7 (20⅜ × 26¼)

On that level, the question of the possibility of the representation of German history is already infinitely more complicated in Richter's work than in Kiefer's since, unlike Kiefer, Richter questions even painting's access to and capacity for representing historical experience. Secondly, mediation occurs at the level of painterly execution, since Kiefer's work claims access to German ▲ Expressionist painting as the means of executing his own project of historical representation. Richter, on the other hand, emphasizes both the degree to which history, if it is accessible at all, is mediated by photographic images, and also how not just the construction of historical memory but its very conception are dependent on photographic representation.

Richter's *October 18, 1977* cycle embodies a doubt, then, about the possibility of unmediated access to historical experience through the means of painting just as it asserts the possibility that painting could actually intervene in the process of critical, historical self-reflection. At the same time, the focus on the Baader-Meinhof Group as the subject of recent German history leads in a much more complicated way to a prolonged reflection on the questions of postwar Germany. Writers on the post-1968 student movement and the events leading to the formation of the Baader-Meinhof Group had made it clear that this rebellion against the neocapitalist German state was triggered largely by an underlying horror at both the complicity of the postwar generation's participation in the history of Nazi Germany and its insistent refusal to acknowledge this complicity. Richter's reflection on the fate of the Baader-Meinhof Group is thus part of a larger project of understanding the formation of postwar German identity by addressing the second and third generations of that historical trajectory rather than by returning to the actual events of the Nazi past as they were staged in Kiefer's work.

The staging of such events emerged in Kiefer's first work, his 1969 *Occupations* series [**4**], in which he placed himself in various majestic landscapes (reminiscent of German Romantic pictorial settings) or in monumental architectural complexes and, from a relatively great distance, had himself photographed making the "Heil Hitler!" salute. The fact that this series was accomplished

▲ 1908

photographically complicates the contradictions between Richter's and Kiefer's positions tremendously. First, Kiefer's work situates itself in an explicit dialogue with the photoconceptualist and ▲ performance practices of the sixties, but reorienting both of these within a tainted context of specific German historicity. That was the shock and the aesthetic interest of the project when it was first seen, primarily because it *attempted* to relocate European artistic ● practices—under the spell of either American Minimalism or Conceptualism in the late sixties—within the focus of addressing history in a specifically German context; and secondly, because the work tried to criticize the blind spots of the perpetual renovation of West German cultural practices in their approach to history. However, what is crucial in Kiefer's use of the photograph in this series is that unlike Conceptual art's approach to documentary photography at that time, Kiefer consistently treats the photograph as a hybrid, as a residue, as the one tool of representation that is just as discredited as painting. Thus there is a deeply antiphotographic impulse in Kiefer's collection of photographic remnants, as there is an antipainterly impulse in his use of nonpainterly materials such as straw, earth, and other matter in the construction of his paintings. Nonetheless, unlike Richter and artists of the Pop art generation, Kiefer never questions the authenticity or auratic ■ originality of the painting as a singular object, or that of painting as a craft that generates a unique aesthetic experience. Indeed, as far as the continuous visual trope of the *Occupations* series is a reference to Caspar David Friedrich's German Romantic imagery (such as his *Wanderer above the Mist* [c. 1818]), photography is asked to participate in the sublimity of experience to which painting presumably had access in the early nineteenth century and to which neo-Expressionism assumed it could once more connect.

In analyzing Kiefer, the cultural historian Eric Santner proposes that Kiefer's strategies should be seen as a "homeopathic" approach to the conditions of repression. He hails Kiefer's project of confronting the legacy of thirties and forties German history as a necessary attempt to dismantle the repressive apparatus, the almost phobic inhibition, that was established in postwar Germany. In addition to blanking out the Nazi past, this repression also blocked any attempt by the German people actually to articulate their historical experience, by barring their access to the culture of the late nineteenth and early twentieth centuries as well, since the principal figures who made up German culture in this period had been considerably tainted by their abrogation in Nazi ideology. In his portraits Kiefer provocatively mingled figures ranging from Heidegger to Hölderlin, from Moltke to Bismarck, paintings that are seen by Santner not as a project of resuscitating the heroicization of a tainted history but as necessary attempts to open up the repressive apparatus that German culture had internalized and imposed upon itself in the postwar period. Santner thereby follows a similar logic to the one that had been developed by Hans Jürgen Syberberg in his seventies film *Hitler: A Film from Germany*, which was a similar project to open up the question of how German cultural history could be reestablished across the historical hiatus.

Jürgen Habermas

The last of the major German philosophers to emerge from the so-called Frankfurt School of Critical Theory, Jürgen Habermas, was born in the year the Frankfurt Institute for Social Research was founded. At age the age of twenty-four, when still a doctoral candidate, he published a forceful critique of Martin Heidegger's infamous "Introduction to Metaphysics" (1935), which had announced that philosopher's conversion to Nazism, and which Heidegger had republished in 1953 without a single word of self-criticism, let alone an apology. In 1956 Theodor W. Adorno invited Habermas to join the recently reopened Institute for Social Research in Frankfurt. Under the tutelage of his mentor and the tradition of the Institute, Habermas would develop a synthesis of empirical social research and critical theory, addressing the particular conditions of postwar societies.

In his first groundbreaking work, *The Structural Transformation of the Public Sphere* (1962), Habermas developed a concept that would have important ramifications for an art-historical understanding of the museum and the functions of the avant-garde: the bourgeois public sphere, tracing it from its emancipatory beginnings in the eighteenth century to its imminent dissolution under the impact of late corporate capitalism. In *Knowledge and Human Interest* (1968), his second major work, and one that would bring him international recognition, he formulated the concepts of communicative reason and communicative action as normative models for the subjective and sociopolitical realization of a present-day enlightenment project founded in language itself.

Whether or not one finds the model of the "homeopathic" approach to repression an acceptable one, Richter's work, in contrast, seems to take the inextricability of postwar German culture and its repression as its point of departure rather than claiming that it can be remedied. It also seems to take the various layers of postwar German cultural involvement with certain forms of internationalization, and of Americanized consumer culture (e.g., an Americanized model of Pop art production) as a historical condition that cannot be undone. With this act of specifically disclaiming any possibility of access to German cultural history, Richter's project both criticizes and also perhaps—as some artists and critics would say—perpetuates false internationalization and its intrinsic intertwinement with the act of historical repression.

Richter's paintings of the Baader-Meinhof Group members, the various scenes, the arrest, and the members' funerals, are necessarily from the very recent past. They represent what one could call the conclusion of the utopian aspirations of the "moment of 1968," in its calamitous ending with the supposed suicides of Andreas Baader and Ulrike Meinhof in the Stammheim Prison in 1977. As a result of their iconography, the paintings have been widely recognized as an elegiac expression of German doubt and skepticism about the possibilities of utopian political transformation.

1980–1989

▲ 1962a, 1962b, 1968b ● 1965 ■ 1935, 1956, 1960c, 1962d, 1964b

4 • Anselm Kiefer, *Besetzungen (Montpellier)* (Occupations [Montpellier]), 1969
Eight photographs on cardboard

They have also been recognized as an allegory of the life and the history of the postwar German generation in its dual attempt to dissociate itself from and reassociate itself with German history, to overcome the repression of its fathers' generation and at the same time to develop countermodels and alternative political possibilities in the sixties radicalization and mobilization of leftist German thought. Richter himself has denied any aspect of these readings, refusing to be associated with any political interpretation of the paintings and claiming that if there is any connection between them and political thought, his aim was to articulate the problematic nature of *all* utopian projects. BB

FURTHER READING
Benjamin H. D. Buchloh, "A Note on Gerhard Richter's 18.October 1977," in Gerhard Storck (ed.), *Gerhard Richter: 18. Oktober 1977* (Cologne: Walther König; Krefeld: Kunstmuseum Krefeld; and London: Institute of Contemporary Arts, 1989)
Stefan Germer, "Unbidden Memories," in Gerhard Storck (ed.), *Gerhard Richter: 18. Oktober 1977* (Cologne: Walther König; Krefeld: Kunstmuseum Krefeld; and London: Institute of Contemporary Arts, 1989)
Andreas Huyssen, "Anselm Kiefer: The Terror of the History, the Temptation of Myth," in Andreas Huyssen, *Twilight Memories: Marking Time in a Culture of Amnesia* (Routledge, London, 1995)
Lisa Saltzman, *Anselm Kiefer and Art After Auschwitz* (Cambridge: Cambridge University Press, 1999)
Robert Storr, *Gerhard Richter: October 18, 1977* (New York: Museum of Modern Art; and London: Thames & Hudson, 2000)

1989

"Les Magiciens de la terre," a selection of art from several continents, opens in Paris: postcolonial discourse and multicultural debates affect the production as well as the presentation of contemporary art.

In the eighties two exhibitions at major museums in New York and Paris served as lightning rods for postcolonial debates about art, and also focused new attention on the old problem of the Western collection and exhibition of art from other cultures. The first show, "'Primitivism' in 20th Century Art: Affinities of the Modern and the Tribal" directed by William Rubin and Kirk Varnedoe at the Museum of Modern Art in 1984, consisted of brilliant juxtapositions of modern and tribal works that resembled one another in formal ways. For critics of the show, however, these juxtapositions only rehearsed the mostly abstract understanding of tribal art by European and American modernists, a noncontextual appropriation which the curators did not adequately question. To an extent the second exhibition, "Les Magiciens de la terre" (Magicians of the Earth), directed by Jean-Hubert Martin at the Centre Georges Pompidou in 1989, took such critiques into consideration. It included only contemporary practitioners, fifty from the West, fifty from elsewhere, many of whom made work specifically for the show. In this way "Magiciens" struggled against some of the formalist appropriations and museological abstractions of non-Western art that were replayed in "Primitivism." Yet for *its* critics "Magiciens" went too far in the opposite direction in its implicit claim of a special authenticity for non-Western art, a special aura of ritual or magic. "Who are the magicians of the earth?" Barbara Kruger countered in her skeptical contribution to the show. "Doctors? Politicians? Plumbers? Writers? Arms Merchants? Farmers? Movie Stars?"

The nomadic and the hybrid

The year 1989 was a time for reappraisal of rhetoric on several fronts. Not only had the opposition between the First and Third Worlds already fallen apart, along with the dichotomy between metropolitan centers and colonial peripheries that had structured the relation between modern and tribal art. But so, too, had the opposition between the First and Second Worlds broken down, as signaled by the fall of the Berlin Wall in November. A "new world order," as George Bush would dub it triumphally after the Gulf War in 1991, was emerging—a mostly American order of released multinational flows of capital, culture, and information for privileged people, but of reinforced local borders for many more others.

This mixed development affected many artists profoundly. "Hybridity" became a catchword for some, as postmodernist critiques of modernist values of artistic originality were extended by postcolonial critiques of Western notions of cultural purity. These postcolonial artists sought a third way between what the critic Peter Wollen has called "archaism and assimilation," or what the artist Rasheed Araeen has termed "academicism and modernism." Content to be neither illustrators of folklorish pasts nor imitators of international styles, they attempted to work out a reflexive dialogue between global trends and local traditions. Sometimes this postcolonial dialogue demanded an additional negotiation between the often nomadic life of the artist and the often site-specific positioning of the project that he or she was asked to produce. Indeed, in this new time of cosmopolitanism, artists were on the move as much as artifacts were in earlier moments of primitivism.

The search for a third way had precedents in art of the eighties. Some artists involved in political groups had already rejected institutions of art, while others involved, say, in graffiti art like Jean-Michel Basquiat (1960–88) had already played with signs of hybridity. This search was also supported by developments in theory, the most important of which were the critiques of Western self-fashioning and discipline-building in postcolonial discourse, which, after the Palestinian-American critic Edward Said (1935–2003) published his epochal study *Orientalism* in 1978, flourished in the work of theorists Gayatri Spivak, Homi Bhabha, and many others. Of course, postcolonial art and theory has assumed diverse forms depending on context and agenda; between the United States and the United Kingdom alone, for example, there is a difference of focus on the subject of racism, inflected historically by slavery in the States, and by colonialism in Britain. There are also conflictual demands on artists and critics alike, who are often torn between the call for positive images of given identities long subjected to negative stereotypes on the one hand, and the need for critical representations of what the critic Stuart Hall has called "new ethnicities" complicated by sexual and social differences on the other. Sometimes this very conflict between notions of identity—as given naturally or as constructed culturally—is foregrounded, as in some work by black British artists such as the filmmaker Isaac Julien (born 1960), the photographers Keith Piper (born 1960) and Yinka Shonibare (born 1962), and the

Aboriginal art

The most renowned form of Aboriginal art in Australia are the "Dreamtime" paintings produced in the northern and central regions (six Dreamtime artists from the Yuendumu community near Alice Springs were represented in "Les Magiciens de la terre"). In Aboriginal belief, Dreamtime was the period of Creation when ancestral beings shaped the land and its inhabitants, and Dreamtime paintings evoke these activities; the imaging of the creator-figures, which assume different forms (human, animal, and plant), tends to be more representational in the northern country, and more abstract, structured around vivid dots and lines, in the central area.

Dreamtime art is a good example of the third way between "archaism" and "assimilation" in contemporary global culture. On the one hand, its designs derive from motifs and patterns used in sacred ceremonies from archaic times (some paintings in rock shelters date back as far 20,000 years). On the other hand, the efflorescence of Dreamtime paintings on canvas is little more than three decades old, spurred technically by the assimilation of acrylic paints in the early seventies and commercially by the market for exotic images among Western collectors whose own culture appears ever more homogeneous. (The market for Maori art also boomed in the eighties, as did the demand for the arts of Africa, the Arctic, Bali, and so on.) Thus, even as Aboriginal art is still based in the ceremonial practices of specific communities—each painting is in part a reenactment of a cosmology passed on from generation to generation—it is also shot through with global forces of touristic taste, cultural commerce, and identity politics.

However, like similar forms of hybrid art in Africa and elsewhere, Dreamtime painting has seemed to thrive on its contradictions. Although it is often dismissed as a pidgin language, its mixing of indigenous idioms and foreign materials is part of its creativity. While its abstraction is attractive to elite tastes schooled in modern art, it also remains true to its own old traditions; and while it borrows such modern techniques as acrylic on canvas, it continues to elaborate ancient motifs otherwise applied to human bodies, tree bark, or the earth. In short, Dreamtime painting is an art that has remained authentic in its own terms even as it plays on the desire for "the authentic" on the part of outsiders. This use of forms is also not one-way: modern Australian artists have drawn on Aboriginal motifs too, and Qantas Airlines once painted one of its fleet in Aboriginal style. At work here then is a kind of exchange that, though hardly equal, must still be distinguished from prior episodes of exoticism in modern art, such as the use of African sculpture in the primitivist work of Picasso, Matisse, and others in the first decades of the century, as well as the projection of Native American art as primordial by some Abstract Expressionists, and the positing of an absolute *art brut*, or uncivilized "outsider art," by Jean Dubuffet and others, both at mid-century. In the case of Dreamtime painting and other forms like it, there is a borrowing from the West by "the other" as well.

"There is a very strong connection between the use of symmetry in Aboriginal art and the powerful commitment to the balance of reciprocity, exchange and equality in Aboriginal art," Peter Sutton, curator of the South Australian Museum, has remarked. At the same time we do well to remember that Aboriginal peoples of Australia, like other indigenous peoples on other continents, were long subject to forced resettlement and worse. To quote Frantz Fanon again: "The zone where the natives live is not complementary to the zone inhabited by the settlers."

painter Chris Ofili (born 1968). More often this conflict has led to divergent conceptions of the role of postcolonial art—to express and reinforce identity, or to complicate and critique its construction.

For Homi Bhabha the search for a third way in postcolonial art suggests a repositioning of the avant-garde—away from the pursuit of a utopian "beyond," a vision of a unitary social future, and toward an articulation of a hybrid "in-between," a negotiation between diverse cultural space-times. This theoretical notion has found its parallel development in the art of such diverse figures as Jimmie Durham (born 1940), David Hammons (born 1943), ▲ Gabriel Orozco (born 1962), and Rirkrit Tiravanija (born 1961).

Although different in generation and background, these artists have several things in common. All work with objects and in sites that are somehow hybrid and interstitial, not readily placed within the given discourses of sculpture or the commodity, or in the given spaces of museums or the street, but usually located somewhere in transit between these categories. To an extent photographs figure in this art, but like the other objects they are often residues of performative activities, or what Orozco calls "leftovers of specific situations." This work thus extends across performance and installation too,

without resting easily in either. To be sure, such an idiom of found objects, reclaimed debris, and documentary leftovers has precedents, especially in the sixties: one is reminded of the performance props of such artists as Piero Manzoni and Claes Oldenburg, the "social sculpture" of Joseph Beuys, the assemblages of archaic and technological materials in Arte Povera, and so on. (Importantly, Durham and Hammons, who were active by the early seventies, witnessed some of these practices, while Orozco and Tiravanija encountered them later in museum shows.) Nevertheless, all four contemporary artists are suspicious of the aestheticizing tendencies of such precursors. Although often lyrical as well, their aesthetic is even more provisional and ephemeral, in opposition not only to the old idea of timeless art but also to the new fixities of identity politics.

Subversive play

To different degrees all four artists work with what the critic Kobena Mercer has called "the stereotypical grotesque," and here they are joined by such African-American artists as Adrian Piper, ■ Carrie Mae Weems, Lorna Simpson, Renée Green, and Kara Walker.

Essentially this means that they play with ethnic clichés, sometimes with light, acerbic wit, sometimes with exaggerated, explosive absurdity. Thus Durham has fabricated "fake Indian artifacts," and Orozco, stereotypically Mexican skulls; Hammons has used loaded black symbols, and Tiravanija, stereotypically Thai cuisine. They have also engaged different models of the primitive object, such as the fetish and the gift, which they often juxtapose with "modern" products or debris. In some sense these subversively hybrid things are symbolic portraits of a similarly disruptive kind of complex identity.

Like the Performance artist James Luna (born 1950), who has acted out such stereotypes of the Indian as the warrior, the shaman, and the drunk, Jimmie Durham pressures primitivist clichés to the point of critical ridicule. This is most evident in *Self-Portrait* (1988), in which he summons up the smokeshop chief of American lore, only to tag this wooden figure with absurdist responses to racist projections about Native-American men. Durham first produced his fake Indian artifacts from old car parts and animal skulls; then he mixed in other kinds of commodity debris to produce "artifacts from the future" whose "physical histories … didn't want to go together." One such artifact juxtaposes, on a craggy board, a portable phone and an animal pelt, on top of which is inscribed this quotation from the anticolonial revolutionary and theorist Frantz Fanon: "The zone where the natives live is not complementary to the zone inhabited by the settlers" [1]. Such hybrid art, which reworks the Surrealist object to postcolonial ends, is wryly anticategorical in a way that resists any further "settlement" into separate "zones."

David Hammons also puts ethnic associations into subversive play. In the early seventies he did a series of images and objects with spades, at once a tool of manual labor and a slang word for African-American. One such object, *Spade with Chains* (1973), is especially provocative in its simultaneous suggestion of slavery and strength, bondage and resistance [2]. Hammons has since made many sculptures out of discarded or abject things that are culturally fraught, such as barbecue bones in bags, African-American hair wound into balls on wires and woven onto screens, chicken parts, elephant dung, and found bottles of cheap wine stuck on stripped branches or hung from trees. For some viewers these objects and installations evoke the desperation of the black urban underclass. Hammons, however, sees a sacred aspect in these profane things, a ritualistic power. "Outrageously magical things happen when you mess around with a symbol," he has remarked. "You've got tons of people's spirits in your hands when you work with that stuff." His contradictory contemporary fetishes return art to the street, and at once demystify and reritualize it there.

1 • Jimmie Durham, *Often Durham Employs …*, 1988
Mixed media, wood, squirrel skin, paint, and plastic, 30.5 × 40.6 × 12.7 (12 × 16 × 5)

▲ 1931a

2 • David Hammons, *Spade with Chains*, 1973
Spade, chains, 61 × 25.4 × 12.7 (24 × 10 × 5)

3 • David Hammons, *Bliz-aard Ball Sale*, 1983
Installation in Cooper Square, New York

Often indirect, the work of Hammons and Durham nonetheless possesses the edge of political commitment—Hammon's to the civil rights and Black Power movements, Durham's to the American Indian movement, in which he was an activist. Born of less confrontational times, the work of Orozco and Tiravanija is more lyrical. A 1983 performance piece by Hammons can help us track the directions that they take. In *Bliz-aard Ball Sale*, Hammons presented several rows of different-sized snowballs for sale, next to other vendors of disused things on the street, in front of Cooper Union in downtown Manhattan [3]. This piece cut across private and public spaces, and confounded valued and valueless things, in a way that suggested that these distinctions are often artificial and only afforded by the privileged—a demonstration made by Orozco as well. At the same time, the snowballs, like the rubber-doll shoes that Hammons has also offered on the street, exist in a pathetic and parodic relation to commodity exchange, and point to a system of resale, barter, and gifts that Tiravanija has also explored as a critical alternative to the capitalist network of art.

One instance of each practice must suffice here. In a 1993 project for the Museum of Modern Art, Orozco invited neighbors in the apartment building north of MoMA to place an orange in each window sill that fronted the museum [4]. Here was a sculpture, wittily titled *Home Run*, that exceeded the physical space of the museum ball park. At the same time it brought into ambiguous contact different kinds of objects (perishable fruit on the window sills, bronze sculpture in the museum garden), agents (semiprivate residents and semipublic curators), and spaces (homes and
▲ museums). This is institutional critique with a lyrical touch, which, as with Tiravanija, does not mean that it is inconsequential.

In a signal piece of 1992, Tiravanija also used the dislocating of space and the offering of food as a means to confuse the normal positions and conventional roles of art, artist, viewer, and
• intermediary (in this case the art dealer). At 303 Gallery in New York, he moved the private unseen rooms of the gallery, which contained the business office, the packing, and shipping areas, and all the other materials of its daily functioning, into its public viewing spaces [5]. The director and assistants at desks were on display in the central gallery, while Tiravanija worked over a stove in the back gallery where he cooked and served Thai curry vegetables over jasmine rice to interested gallery visitors, often with conversation added. In subsequent works he has often played on such reversals of physical space, substitutions of expected function, and displacements of object

▲ Introduction 4, 1971, 1992 ● 2009a

4 • Gabriel Orozco, *Home Run*, 1993
Installation in apartment building, view from
the Museum of Modern Art, New York

5 • Rirkrit Tiravanija, *Untitled (Free)*, 1992
Installation and performance at 303 Gallery, New York, tables,
stool, food, crockery, cooking utensils, dimensions variable

exchange that invite one to reflect on the enforced conventionality of all of these categories in the art world and beyond.

"Not the monument," Durham has remarked of his work in a way that relates to the other artists as well, "not the painting, not the picture." Rather, he seeks an "eccentric discourse of art" that might pose "investigatory questions about what sort of things it might be, but always within a political situation of the time." In this way the work of these artists constitutes the equivalent of the "minor literature" defined by the French critics Gilles Deleuze (1925–95) and Felix Guattari (1930–92) in their 1975 study of Franz Kafka: "The three characteristics of minor literature are the deterritorialization of language, the connection of the individual and the political, the collective arrangement of utterance. Which amounts to this: that 'minor' no longer characterizes certain literatures, but describes the revolutionary conditions of any literature within what we call the great (or established)." HF

FURTHER READING

Homi Bhabha, *The Location of Culture* (London: Routledge, 1994)

Tom Finkelpearl et al., *David Hammons* (Cambridge, Mass.: MIT Press, 1991)

Jean-Hubert Martin et al., *Les Magiciens de la terre* (Paris: Centre Georges Pompidou, 1989)

Laura Mulvey et al., *Jimmie Durham* (London: Phaidon Press, 1995)

Molly Nesbit et al., *Gabriel Orozco* (Los Angeles: Museum of Contemporary Art, 2000)

Peter Wollen, *Raiding the Icebox: Reflections on 20th Century Culture* (Bloomington: Indiana University Press, 1993)

Jennifer A. González, *Subject to Display: Reframing Race in Contemporary Installation Art* (Cambridge, Mass.: MIT Press, 2011)

1990—1999

1992

Fred Wilson presents *Mining the Museum* in Baltimore: institutional critique extends beyond the museum, and an anthropological model of project art based on fieldwork is adapted by a wide range of artists.

One way to understand some of the shifts in materials and methods over the last forty years of advanced art is to see them as a sequence of investigations: first into the constit-uent elements of a traditional medium like painting, as in the ▲ self-critical modernist painting advocated by Clement Greenberg; then into the perceptual conditions of an art object defined in ● terms less of a given medium than of a given space, as in Minimalist art; then into the material basis of such artmaking and perceiving, ■ as explored variously by Arte Povera, Process art, and Body art. Along the way, Conceptual art also shifted attention away from the specific conventions of painting and sculpture to the general ques-tions of "art as art" and "art as an institution."

At first the institution of art was understood mostly in physical terms, as the actual spaces of art studio, gallery, and museum, and artists worked to underscore these parameters and/or to expand them. One thinks of the systematic exposés of these art spaces by Michael Asher, Dan Graham, Marcel Broodthaers, and Daniel Buren, who also wrote an important set of critical texts on such ◆ subjects. Such "institutional critique" revealed that the institution of art was not only a physical space but also a network of discourses (including criticism, journalism, and publicity) that intersected with other discourses, indeed with other institutions (including the media and the corporation). It also suggested that the viewer of art could not be defined strictly in perceptual terms, for he or she was also a social subject marked by multiple differences of class, race, and gender—a point stressed by feminist artists above all others. Of course, this expansion of the definitions of art and institution, artist and viewer, was also driven by social developments (especially the civil rights and feminist movements early on, and postcolonial and queer politics later), as well as by theoretical critiques of the oppositions of high and low culture and modernist and mass art. Together these forces, both internal and external to art, prompted a wider engagement of the culture at large. Thus was the field of art and criticism expanded to "cultural studies," with culture under-stood in an almost anthropological sense.

This sequence of investigations can also be understood as a set of transformations involving the site of art: from the surface of painting and the armature of sculpture to the structure of the studio, gallery or museum, as well as to the alternative spaces of site-specific installations and the distant locations of Earthworks. Here, too, a gradual shift occurred from a literal, physical under-standing of site to a more abstract, discursive understanding—to the point where, in the late eighties and early nineties, artists and ▲ critics could treat desire or death, AIDS or homelessness, as so many sites for art projects. Along with this expanded notion of site came an expanded operation of "mapping," which also ranged from the literal to the discursive—for example, from the carto-graphic markings of (semi)natural sites by Robert Smithson ● and others to the sociological mappings of (sub)urban sites by Dan Graham and others (such as his *Homes for America* [1966–7], a magazine report of the "Minimalist" structures to be found in a tract-housing development in New Jersey).

An ethnographic turn

Sociological mapping became more programmatic in institutional critique during the seventies, especially in the work of Hans ■ Haacke. Haacke moved from profile polls of gallery and museum visitors and archival exposés of real-estate moguls in New York (1969–73), to detailed reports of the successive owners of partic-ular paintings by Manet and Seurat (1974–5), to continued investigations of the financial and ideological arrangements made by museums, corporations, and governments. Such work ques-tioned these social authorities incisively, but it did not often reflect on its own sociological authority, its own voice of truth. This reflexivity was more pronounced with artists, such as Martha Rosler, who were involved in a critique of documentary modes ◆ of representation as somehow transparent to the world. In her phototext work *The Bowery in Two Inadequate Descriptive Systems* (1974–5), Rosler mimicked documentary photographs as well as sociological descriptions of alcoholic destitution in order to show the "inadequacy" of both "descriptive systems" in the face of this recalcitrant social problem.

In feminist art the suspicion of documentary representation converged with an elaboration of institutional critique in the work of such artists as Louise Lawler and Silvia Kolbowski. This conver-gence was complicated by an interest in quasi-ethnographic modes of fieldwork, as some artists assumed the roles of both

▲ 1960b ● 1965 ■ 1967b, 1969, 1974 ◆ 1968b, 1970, 1971, 1972a ▲ 1984a, 1987 ● Introduction 2, 1968b, 1970 ■ 1971, 1972b ◆ Introduction 2, 1984a

ethnographer and native-informant in everyday life under patriarchy. (A few of these artists, like Susan Hiller [born 1942], were trained in anthropology.) It was in this manner that Mary Kelly reported on patriarchal conventions of language, schooling, artmaking, and aging in such projects as *Post-Partum Document* ▲ (1973–9) and *Interim* (1985–9). By the early nineties art based on personal reportage, fieldwork and/or archival research had become pervasive, as more and more artists were invited to do site-specific projects at museums and related institutions around
• the world. The combination of the nomadic condition of the artist and the project basis of the art made installation the preferred mode of this work.

There were several reasons for this ethnographic turn in some art of the nineties, such as an involvement in nonart forms of cultural representation that was also encouraged by the growth of cultural studies in the academy. Yet anthropology also possessed its own attractions for artists and critics alike. First, anthropology is the discipline that takes *culture* as its object, and this expanded
■ field of operations was desired by many postmodernist artists. Second, anthropology is *contextual* in nature, another attribute much valued in recent art and criticism. Third, it is seen as intrinsically *interdisciplinary*, a further characteristic prized in such practice. Fourth, it is a discipline that studies *otherness*, which has made anthropology, along with psychoanalysis, the common language of much recent art and criticism. And, finally, the *critique* of "ethnographic authority" launched in the eighties also rendered anthropology attractive, for it suggests a special self-awareness on the part of the ethnographic artist.

Such self-awareness was essential for artists who took up the model of fieldwork. Lothar Baumgarten (born 1944) was one of the first to do so in his mappings of indigenous cultures of North and South America, which were often based on his extensive travels. In several projects over the last two decades, Baumgarten has inscribed the names of native societies of both continents—names often imposed by explorers and ethnographers alike—onto various settings. These sites have ranged from Northern museums (such as the neoclassical dome of the Museum Fridericianum in Kassel, Germany, in 1982 [1] and the modernist spiral of the Guggenheim Museum in New York in 1993) to Southern settings (such as in Caracas, Venezuela) that Baumgarten has sometimes marked with the names of threatened local species and extracted raw materials as well. The names of the various native societies often appeared somewhat distorted in these installations, with letters placed upside down or reversed, as if to underscore the historical misrepresentation of these groups, but also to challenge this misrepresentation in the present. Thus in Kassel the mute Indian names seemed to suggest that the other side of Old World Enlightenment (as evoked by the neoclassical dome of the museum) was New World Conquest. Meanwhile in New York, these names seemed to suggest that some other mapping of the globe (as evoked by the spiral of the Frank Lloyd Wright building) was required, one without hierarchies of North and South or modern and primitive.

The last examples point to a potential problem with these quasi-ethnographic projects: they are often commissioned by the museums, and it can appear as if these institutions import this kind of critique as a substitute for an analysis that they might have undertaken internally. This complication has led some critics to declare institutional critique recuperated by the museums, and the flurry of international shows of commissioned site-specific projects in the mid-to-late nineties did not contradict this view (this trend culminated in the 1999 survey at the Museum of Modern Art with the telling title "The Museum as Muse"). On the other hand, this location within the museum is necessary if these

1 • Lothar Baumgarten, *Documenta installation project*, rotunda of the Museum Fridericianum, Kassel, 1982

▲ 1975a ● 2003 ■ 1977a, 1980, 1984b

projects are to remap its space or to reconfigure its audience in any way; indeed, this internal position is a premise of all work that purports to be deconstructive. And this argument held for the most incisive of these projects, such as *Mining the Museum* by Fred Wilson (born 1954).

The artist as curator

In *Mining the Museum*, sponsored by the Museum of Contemporary Art in Baltimore, Wilson took an ethnographic approach to the Maryland Historical Society. First he explored its collection of historical artifacts, especially ones deemed marginal and placed in storage; this excavating was a first meaning of the "mining" in the title. Then he reclaimed certain objects in the collection, most evocative of African-American experiences, which were not part of the official history on display; this repossessing was a second kind of "mining." Finally he reframed still other objects that were already part of the official history. For example, in an existing exhibit of exquisite goblets and pitchers captioned "Metalwork 1793–1880" [2], Wilson placed a rough pair of slave manacles found in storage; this third kind of "mining" wrenched the objects on view into a different context of meaning, from one kind of ownership to another. In this way Wilson served as an anthropologist not only of the Maryland Historical Society but also of the African-American communities not adequately represented there—a situation that the Society at least began to ameliorate through this very exhibition. Wilson had previously worked as a curator; as an artist he has continued this work, critically, by other means.

Andrea Fraser (born 1965) is best known for her barbed performances of various art-world types, including the curator, but she has also made several ethnographic probes into museum culture. In *Aren't They Lovely* (1992), for example, she reopened a private bequest to the art museum of the University of California at Berkeley in order to investigate how the heterogeneous domestic objects of a specific collector (from everyday eyeglasses to Renoir paintings) are transformed into the homogeneous public culture of a general art museum. Whereas Wilson has focused on the problem of institutional repression, here Fraser addressed the process of institutional sublimation; in both cases the artists play with museology in order first to expose and then to reframe the institutional codings of art and artifacts—how specific objects are translated into historical evidence and/or cultural exemplars by museums, invested as such with meaning and value, and for what constituencies this is done (or not done).

Renée Green (born 1959) has also adopted an ethnographic approach, in a way that often extends beyond the art museum. In her site-specific projects she has focused on the residues of ▲ racism, sexism, and colonialism that remain inscribed in various kinds of representations: popular movies and travel literature, domestic decor and institutional architecture, as well as private collections and museum displays. A few of her installations have sketched a critical genealogy of the principal figure of primitivist ● fantasy, the exotic and erotic female, from the "Hottentot Venus," a nineteenth-century European stereotype of an excessive African sexuality, to the American jazz dancer Josephine Baker, who ■ enthralled young modernists like Le Corbusier in the Paris of the

2 • Fred Wilson, *Mining the Museum*, 1992 (detail)
Slave manacles placed in metalwork display

METALWORK
1793-1880

▲ 1993c, 1997　● 1903, 1907　■ 1925a

Interdisciplinarity

Many positions in postwar art are articulated between or across the mediums and the disciplines: one thinks of the experiments at Black Mountain College, the aesthetics of John Cage and Robert Rauschenberg, the investigations of the Independent Group and the Situationists, the various practices of assemblage, happenings, and environments, as well as such disparate movements as Fluxus, Neoconcretism, Nouveau Réalisme, Minimalism, Process art, Performance art, video, and so on. Some of these practices recovered precedents from the prewar period that either attacked traditional art forms, like Dada and Surrealism, or sought to transform them utterly, like Constructivism. But they also reacted against a strong reading of modernist art that understood its mission to be the perceptual refinement of the specific mediums (e.g., the "opticality" of painting). "The concepts of quality and value—and to the extent that these are central to art, the concept of art itself—are meaningful, or wholly meaningful, only *within* the individual arts," Michael Fried insisted, famously, in his 1967 essay "Art and Objecthood." "What lies *between* the arts is theater." Clearly he had in mind some of the aforementioned practices, whose interdisciplinary methods and temporal involvements ("theatrical" in his lexicon) he deemed improper to visual art.

Yet this opposition overlooks several forces even more important to the general tendency toward interdisciplinary art over the last four decades. First, there was the inspiration of both the critique of political institutions and the expansion of cultural spaces in the social movements of the sixties and seventies—student, civil rights, antiwar, and feminist movements above all. Second, along with a crossing of mediums there was an erosion in hierarchies at this time—of high and low forms, elite and popular audiences, fine and media arts (we tend to forget, in the midst of our own technological retoolings, that the sixties and seventies experienced great transformations in this respect too). Third, there were, especially in the eighties, the interdisciplinary provocations of poststructuralist theory—a loose term that gathered together such disparate thinkers as Roland Barthes, Jacques Derrida, and Michel Foucault. However different their interests, all these figures practiced a critical suspicion of whatever appeared to be originary and authoritative, purely proper and simply present—a suspicion that was extended to artistic forms and institutional frames, and without which postmodernism could not have been theorized. Finally, there was, in the nineties, the effect of postcolonial discourse, which elaborated the poststructuralist deconstruction of conceptual oppositions in the political context of decolonialization—a deconstruction of such binaries as First World and Third World, center and periphery, and Occident and Orient. In related art, critiques of identity and notions of hybridity came to the fore.

The latter two developments are sometimes described, respectively, as a semiotic turn, in which the linguistic sign is the privileged term of analysis, and an ethnographic turn, in which cultural practice becomes the primary object of study. In the first instance, some artists, architects, filmmakers, and critics adapted semiotic models in order to rethink their work in textual terms. And in the second instance they did much the same thing with anthropological notions of culture. Sometimes, it must be admitted, these exchanges followed a used-car principle whereby, as one practice or discipline wore out a paradigm, it passed it on to another; but such exchanges also greatly expanded the fields of art and criticism alike. In the present, however, both fields show signs of a stalled relativism in which no one paradigm is strong enough to orient practice, or to make for relevant debate with any real purchase on the culture at large. Moreover, the inflation of design and spectacle in contemporary art and architecture sometimes appears as part of a greater revenge of advanced capitalism on the expanded fields of postmodernist culture—a recouping of its crossings of arts and disciplines, a routinization of its transgressions. Not long ago, when late modernism seemed to petrify into medium-specificity, postmodernism promised an interdisciplinary opening. What might renew postmodernism in turn?

twenties. In *Seen* [3] Green had the viewer stand on a special platform in order to see her images of these women, which in effect aligned the contemporary spectator with the historical voyeur of such figures—one could not assume a moral superiority with temporal distance. Green has also focused our gaze on aspects of primitivism closer to the present: in *Import/Export Funk Office* (1992), for example, she explored our urban legends concerning hip-hop culture music and black masculinity.

Mark Dion (born 1961) has taken the ethnographic approach even further afield: the "culture" that he studies is that of nature—how it is studied in science, represented in fiction, and staged in natural history museums. For Dion nature is "one of the most sophisticated arenas for the production of ideology," and his projects attempt to expose aspects of this production with techniques inspired by various artists and intellectuals—the wry fictional museums of Broodthaers, the site/non-site strategies of Smithson, the historical investigations of scientific discourses of Michel Foucault, and so on. For all its criticism of the ecological disasters precipitated by colonial history and postcolonial economics, his art is hardly one of disdainful critique: Dion is also an avid amateur, with his own collections of insects and other curiosities often on display; his work has drawn, too, on his many trips to the tropics and elsewhere. In this manner Dion plays the naturalist and the environmentalist in ways that are both straight and sardonic. Most often his installations have taken the form of works in progress, and they exist somewhere between a site in the field, the home office of a bizarre naturalist, and a finished museum display [4]. "I take raw materials out of the world and then act upon them in the space of the gallery," Dion has remarked. "When the collection is complete, when I've run out of space or raw material or time, the work is finished."

3 • Renée Green, *Seen*, 1990
Wood structure, height 207 × 207 × 136
(81½ × 81½ × 53½), lens, hologram, screen,
light, and audio system

SMALL SKULL WAS A SIGN OF STUPIDITY BASED ON "THAT

TO COME FROM HER BODY. FINALLY, SHE LEFT THE STAGE

CONDEMNED TO AN ETERNAL INFERIORITY THOSE RACES

HER HEAD, STIFF, REAR END IN THE AIR LOOK

S." SHE HAD ABOVE ALL A WAY OF POUTING HER LIPS.

RAFFE. IS IT A WOMAN? PEOPLE WONDERED. IS IT A MAN

4 • Mark Dion, *Flotsam and Jetsam (The End of the Game)*, 1994
Mixed-media installation

1990–1999

Each of these artists complicates the ethnographic approach with other models: Fraser is interested in the sociology of art pioneered by the French sociologist Pierre Bourdieu; Green, in the postcolonial discourse of critics like Homi Bhabha; Dion, in the study of disciplines developed by Foucault; and so on. But the ethnographic turn in recent art has also raised certain questions. The quasi-anthropological role set up for the artist can promote a presuming of ethnographic authority as much as a questioning of it. In some instances the artist might be asked to represent a neglected community, only to stand in for this community at the museum, and so confirm as much as contest its absence there. The curatorial role might also prompt an evading of institutional critique as much as an extending of it. In some instances the artist might become a curator for hire, an adviser in an educational program, or even a consultant in a public-relations campaign. Indeed, the nineties witnessed the rise not only of the artist-as-curator but of the complementary figure of the curator-as-artist, whose orchestration of a show or a set of site-specific projects often appeared to be the primary creative act. This development of curating as a pervasive "medium" of contemporary art suggests an uncertainty about the domains of artmaking and curating alike, just as the development of socially site-specific projects bespeaks an anxiety about the status of the public not only for art museums but for contemporary art in general.

There is a final question about this ethnographic turn that bears consideration. Such art is impressively inventive and smartly contingent: "We hold dear the belief," Dion has commented, "that our production can have many different forms of expression—making a film, teaching, writing, producing a public project, doing something for a newspaper, curating or presenting a discrete work in a gallery." But sometimes its very multiplicity might confuse its audience, or invite the charge that it is dilettantish. Moreover, with art conceived in terms of projects, and projects conceived in terms of discursive sites, these artists might be led to work horizontally, in a lateral movement from social issue to issue, or from political debate to debate, more than vertically, in a diachronic engagement with the historical forms of a genre, medium, or art. Granted, a strict focus on its own intrinsic problems can lead to an art that is involuted and detached, but a strict focus on extrinsic debates can lead art to forget its own repertoire of forms, its own memory of meanings—to relinquish the critical possibilities of its own semi-autonomous sites. HF

FURTHER READING
James Clifford, *The Predicament of Culture* (Cambridge, Mass.: Harvard University Press, 1988)
Lisa Corrin et al., *Mark Dion* (London: Phaidon Press, 1997)
Hal Foster, *The Return of the Real* (Cambridge, Mass.: MIT Press, 1996)
Andrea Fraser, "What's Intangible..."?, *October*, no. 80, Summer 1997
Miwon Kwon, *One Place After Another: Site-Specific Art and Locational Identity* (Cambridge, Mass.: MIT Press, 2002)
Arnd Schneider and Christopher Wright (eds), *Between Art and Anthropology: Contemporary Ethnographic Practice* (Oxford: Berg, 2010)

▲ 1989 ● 2003

1993_a



1993 a

Martin Jay publishes *Downcast Eyes*, a survey of the denigration of vision in modern philosophy: this critique of visuality is explored by a number of contemporary artists.

With a subtitle announcing his book as treating "The Denigration of Vision," the American historian Martin Jay's *Downcast Eyes* could easily have appeared as yet another theorization of postmodernism, joining the rising chorus of voices either producing or analyzing that challenge to vision familiar to the art world since the sixties. From Conceptual art's use of language to chase any experience of lush visuality from the visual arts, to the strategies of hiding, wrapping, or secreting that had been developed by certain kinds of Performance and Body art, the idea that aesthetic production should be geared to either optical display or ocular pleasure was opened to the severest attack.

And if this was happening in the domain of practice, at the level of criticism the break between modernism and postmodernism was being understood in terms of a transformation of the senses— here, the sense of sight—which were themselves no longer taken to be biological givens and thus transhistorical, but were seen to be specifically shaped by history. Thus, in order to analyze the onset of postmodernism, Fredric Jameson first describes the modernist experience of the visual, achieved by the time of Impressionism, as the constitution of a semiautonomous mode of perception. If Realism's drive was to express the experience of the world as a totality that therefore engages the sensory field of the whole body—touch, hearing, smell, balance, motion, as well as seeing— Impressionism breaks off this one perceptual channel from the whole and makes it instead into a quasi-abstract source of pleasure that could attain new heights of fullness and purity. In the postwar period, however, within the conditions of advanced capitalism, Jameson argues, this abstract but full visuality is transformed into a new and disorienting form of unreality, a generalized kind of seeing that Jameson names "the hysterical sublime." Still others would interpret this sense of an image-world divested of anything real behind it and thus become "simulacral" as a function of an ever-deepening effect of "spectacle."

But *Downcast Eyes* projects the attack on vision as more than a postwar or postmodern phenomenon; the book's full subtitle reads: "The Denigration of Vision in Twentieth-Century French Thought." Once regarded as the culture of En*light*enment thinking, in which vision's capacity to survey and order, to abstract and model the elements within a given field, had made it into the privileged vehicle of reason itself, France was now seen as covering vision with the utmost suspicion throughout the whole of the twentieth century. In Jay's account, this opens with Henri Bergson's repudiation of space as the dominant model of experience to which other orders, such as the temporal, are submitted. Contrasting the homogeneity of space—a matrix of repeatable equivalent units, each outside the other—to the heterogeneity of time, in which memory and projection are inextricably telescoped into the present, Bergson formulated the idea of duration—the *durée*—as radically unassimilable to space and thus also to vision. From Bergson, this opposition continues, in different terms, to the Surrealists and Georges Bataille, and thence to Jean-Paul Sartre's near paranoia, in his *Being and Nothingness*, about the other's "gaze," which, by trapping the subject in its beam like a deer caught in headlights, objectifies that subject and limits his or her freedom. As the roll call of French theorists suspicious of vision lengthens to include the psychoanalyst Jacques Lacan (with his idea of misrecognition), the Marxist Louis Althusser (with his concept of interpellation), the philosopher Jacques Derrida (with his formulation of "phallogocentrism"), the feminist Luce Irigaray (with her notion of the speculum), and the intellectual historian Michel Foucault (with his ideas of surveillance), Jay argues that "although the reasons are still uncertain, it is legitimate to talk of a discursive or paradigm shift in twentieth-century French thought in which the denigration of vision supplanted its previous celebration."

Precision optics

In the case of twentieth-century art, it may seem counterintuitive to characterize the period of high modernism as "antiocular." Wave after wave of modernist artists had followed Impressionism's move to establish a "purified" optical stratum as a semiautonomous field of experience. From Robert Delaunay's extrapolation of the optical blur of an airplane propeller into an abstract set of circular bands, to Giacomo Balla's Futurist search for the laws of pure iridescence, to Wassily Kandinsky's attempt to render the whole field of human emotion through symphonic surges of color, to the Bauhaus desire for a systematic exploration of color married to geometric form, conducted by Johannes Itten, Paul Klee, and Josef Albers, and

1990–1999

▲ 1968b ● 1974 ■ 1977a, 1980, 1984b ◆ 1957a, 1980 ▲ 1924, 1930b, 1931b, 1946, 1959c ● 1971 ■ 1908, 1909, 1913, 1923, 1947a

in the postwar period, to the phenomenon of "color-field painting" ▲ and Clement Greenberg's campaign for the idea of "opticality," which he also extended to sculpture, we feel the pressures of a strictly visual thinking.

Working counter to this opticalist euphoria, however, was quite another tradition, one given theoretical articulation in Bataille's
• concept of "formlessness." A generation of Surrealist artists embraced this attack on *form* and on the privilege it gave to the visual domination of experience—from Joan Miró's "antipainting" to Salvador Dalí and Luis Buñuel's *Un Chien d'Andalou* (with its razored eyeball). But they were not alone in this. The Dada artist
■ Hans Arp was also attacking the stability of form through the collages he was making of torn and crumpled paper, arranged by chance. Speaking of the way these works promoted a withering away of form through the devastating effects of entropy, Arp asked:

> *Why strive for accuracy and purity if they can never be attained? I now welcomed the decomposition that always sets in once a work is ended. A dirty man puts his dirty finger on a subtle detail in a painting to point it out. That place is now marked with sweat and grease. He bursts into enthusiasm and the painting is sprayed with saliva.… Moisture creates mildew. The work decomposes and dies. Now, the death of a painting no longer devastated me. I had come to terms with its ephemeralness and its death, and included them in the painting.*

For his part Marcel Duchamp had by now entered into the phase of his work he mockingly called "precision oculism," signaling its antiartistic nature by the fact that the oculist "machines" he was producing, from the sculpturelike *Rotary Demisphere* (1925) to the film *Anemic Cinema* (1925–6) to his visual phonograph records, the *Rotoreliefs* [1], was now the scientifico-commercial exploration
◆ conducted by his alter ego "Rrose Sélavy," who invariably defied the idea of art's inherent defense against reduplication by submitting such inventions either to copyright or patent. The ironic turn on opticality wrought by these oculist machines was the havoc they were able to wreak with form. For as the turning spirals of the "oculist charts" opened onto a pulsatile movement from concavity to convexity and back again, the throb of this motion dizzied and destabilized the field of vision, eroticizing and carnalizing it instead, by filling it with a suggestive play of "part-objects": now a breast, now an eye, now a uterus.

This idea of an attack on visuality itself continued and even intensified in the postwar period. On the one hand, as noted above, it involved the kind of inoculation of the work against the optical that occurred at the hands of Conceptual art, either by filling the field with the nonvisual substance of language as in the case of Lawrence Weiner or by so banalizing the image as to render it unexploitable by the mass-cultural forces of spectacle. On the other hand, it went beyond the negative strategy of an avoidance of the visual to the more positive one of an active aggression against the very prerogatives of vision.

1 • Marcel Duchamp, *Rotorelief No. 6: Escargot*, 1935
One of set of six cardboard discs printed on both sides, diameter 20 (7⅞)

One dimension of this strategy organized itself around a reprise of the pulsatile force of Duchamp's *Rotoreliefs*. Adopting both the medium of film and that of video in the late sixties, artists
▲ like Richard Serra and Bruce Nauman made works employing a repetitive rhythmic beat, in Serra's case the opening and closing of a fist in his film *Hand Catching Lead* [2], in Nauman's, the truncated image of an upside-down lower face and neck with the mouth saying "lip sync" over and over (although out of synchronization) in *Lip Sync* (1969). In both cases the body part performing the gesture becomes organlike (as in Duchamp's spirals), and the visual field, unstable. With Serra in particular, the example of contemporary cinematic practices in the field of avant-garde film was important, especially the phenomenon of the "flicker film," in which alternations of colored frames with more or less equal amounts of black leader produce rapid-fire flashing lights. While it might seem that the visual dazzle set up by the "flicker" is just another instance of "opticality," in fact the phenomenon sets off a strange bodily, or tactile, experience due to the way the light stimulates the viewer's production of an afterimage, which is then projected onto the empty field of the momentary stretch of blackness. So what we "see" in those interstitial spaces is not the material surface of the "frame" nor the abstract condition of the cinematic "field," but the bodily production of our own nervous systems, the rhythmic beat of the neural network's feedback, of its "retention" and "protention," as the nerve tissue retains and releases its impressions.
• This kind of beat is what James Coleman's (born 1941) *Box (ahhareturnabout)* [3] takes as its subject. Here, a filmed boxing match, cut into short bursts of between three and ten frames, interrupted by equally short spurts of black, is turned into a pulsing

2 • Richard Serra, *Hand Catching Lead*, 1968
Black-and-white 16mm film, silent, 210 minutes

with their repeated jabs and feints, and their always threatened dive into oblivion. Further, this field of visual representation is doubled aurally by a voiceover that emphasizes both the drive of repetition—"go on/go on," "again/again," "return/return"—and the ever-waiting possibility of the onset of nothingness—"break it/break it," "stop/s-t-o-p i-t," "regressive/to win/or to die."

The fact, however, that the viewer's own body, in the guise of its perceptual system and the projected afterimages it is automatically "contributing" to the film, is also being woven into the work, means that *Box*'s subject matter is somehow displaced away from the representational plane of the sporting event, and into the rhythmic field of two sets of beats or pulses: the viewer's and the boxers'. And it also means that the frequent projections of the sound of breathing—expressed in the track as "ah/ah," "aha/ah," "p-a-m/p-u-m"—is giving voice not just to the boxers' bodily rhythms but to those of the viewer as well.

In all these cases, then, the attack on modernism's notion of visual autonomy is thus staged in relation to the invasion of the body and its rhythms into the optical field now robbed of both its purity and its formal stability. But another strategy also developed in the following decade to assault the prerogatives of vision, one that could be called the "uncanny gaze," by which it was meant to return *against* the controlling system of the "gaze" itself by using its own power to overthrow it.

The theory of the controlling gaze emerged from various analyses of the operations of state power and the way modes of surveillance, for example, cause individual subjects to internalize systems of prohibition and thereby reproduce themselves as subjects of disciplinary force (the shopper who fears the closed-circuit television camera, for instance, and thus restrains him- or herself from stealing). Imported into the field of artistic practice as ▲ a theory of the "male gaze," visual control—now gendered as a function of patriarchy and therefore as masculine—froze women into the position of fetish-objects, rendered immobilized and mute by the force of male desire. Reorganized as the helpless body made intact in the unity of her own beauty, the object of this gaze is now coerced into functioning as a kind of "proof" that the male body is itself unthreatened, that there is no castrating power that can touch him. And if the theory of the male gaze was developed in relation to the mass-cultural construction of women—within advertising, films, pornography, etc.—it could easily be seen as applying to modernist painting, too, with its reciprocity between the visual object as autonomous unity and the individual viewer as independent subject.

• Cindy Sherman's early work *Untitled Film Stills* (1977–80) had taken on the mass-cultural construction of the woman's image, as the artist photographed herself convincingly posed in a variety of cinematic types (gun moll, dumb blonde), genres (film noir, melodrama), and styles (Douglas Sirk, Michelangelo Antonioni, Alfred Hitchcock). But as her work developed into the eighties the idea of a perspective that might fix the identity of the woman as a focal point controlled by the viewing point of the (male) spectator

movement that both breaks apart and flows together over those breaks, which is to say, emphasizes movement itself as a form of repetition, of beats that are separated by intervals of absolute extinction, even while the urgency of the rhythm promises the return of another beat and another. The gestures of the boxers, and thus of the representational field of the work—which is spun out of a few minutes of found footage documenting the historic Gene Tunney vs. Jack Dempsey fight of 1927—would seem to embody this rhythm,

▲ Introduction 1, 1975a ● 1977a

3 • James Coleman, *Box (ahhareturnabout)*, 1977
Black-and-white 16mm film, continuous projection with synchronized audio

mutated into a kind of shattered visual field. Sometimes this is the effect of a kind of backlighting that forces a glow to emerge from the ground of the image to advance outward at the viewer and thus to disrupt conditions of viewing, producing the figure herself as a kind of blindspot. In others this corrosive visual dispersal is the result of a kind of "wild light," the scattering of gleams around the otherwise darkened image as though refracting it through the facets of an elaborate jewel. This is the case in *Untitled #110* [4], where Sherman has concentrated on creating a sense of the completely aleatory quality of the illumination. For while the lighting plunges three quarters of the field in total blackness, it picks out the arm and draped edge of the figure's garment to create a glowing, knotted complex of near unintelligibility.

In opposition to the stability of traditional perspective in which the subject is fixed, its gaze taking in, capturing, controlling everything in its sight from a given point, this recourse to ricocheting light opens onto a very different idea of the "gaze," one that destabilizes its subject, making it the victim rather than the master of vision. This new gaze, theorized by Lacan as the gaze-as-*objet-a*,

or the uncanny gaze, is modeled on the idea of the light that surrounds each of us. Such an irradiation beaming at us from everywhere in space cannot be assimilated to the single focus of perspective. Instead, to describe this luminous gaze, Lacan turned ▲ to the model of animal camouflage, which Roger Caillois had described in the thirties as the effect of space at large on an organism that, yielding to the force of this space's generalized gaze, loses its own organic boundaries and merges with its surroundings in an almost psychotic act of imitation. Making itself into a kind of shapeless camouflage, this mimetic subject now becomes a formless part of the "picture" of space in general. "It becomes a stain," Lacan wrote, "it becomes a picture, it is inscribed in the picture."

Insofar as our body is the target of this luminous, uncanny gaze, its relation to the world establishes our perception not in the transparency of a conceptual grasp of space, but in the thickness and density of a being that simply intercepts the light. It is in this sense that to be "in the picture" is to feel dispersed, subject to a picture organized not by form but by formlessness. None of Sherman's works so captures this idea of entering the field as "stain," perhaps,

▲ 1930b

5 • Cindy Sherman, *Untitled #167*, **1986**
Color photograph, 152.4 × 228.6 (60 × 90)

as does *Untitled #167* [**5**], where the camouflage-effect of mimicry is in full flower. The figure, now absorbed and dispersed within the background, can be picked out only by a few remnants still visible, though only barely, in the mottled surface of the darkened detritus that fills the image. We make out the tip of a nose, the emergence of a finger with painted nail, the detached grimace of a set of teeth. Classical perspective sets two unities opposite one another: the viewing point and the vanishing point. Each reinforces the other's sense of focus and singularity. The unfocused, dispersed gaze gives the subject no support, nothing to identify with, unless it is dispersal itself. The fragmentation of the "point" of view here prevents the invisible, unlocatable gaze from being the site of coherence, meaning, unity. Desire is thus not mapped here as the desire for form, and thus for sublimation; desire is modeled in terms of a transgression against form. RK

FURTHER READING
George Baker (ed.), *James Coleman* (Cambridge, Mass.: MIT Press, 2003)
Douglas Crimp, *On the Museum's Ruins* (Cambridge, Mass.: MIT Press, 1993)
Hal Foster, "The Return of the Real," *The Return of the Real* (Cambridge, Mass.: MIT Press, 1996)
Martin Jay, *Downcast Eyes: The Denigration of Vision in Twentieth-Century French Thought* (Berkeley and Los Angeles: University of California Press, 1993)
Rosalind Krauss, "Cindy Sherman," *Bachelors* (Cambridge, Mass.: MIT Press, 1999)

4 • Cindy Sherman, *Untitled #110*, **1982**
Color photograph, 114.9 × 99.1 (45¼ × 39)

As Rachel Whiteread's *House*, a casting of a terrace house in east London, is demolished, an innovative group of women artists comes to the fore in Britain.

In the nineties many artists began to look back to the sixties and seventies for new points of departure—to Minimalist and Conceptual art, Performance and video art, Installation and site-specific art. The most provocative of these reconnections were made by young women in Britain such as Mona Hatoum (born 1952), Sarah Lucas (born 1962), Cornelia Parker (born 1956), Gillian Wearing (born 1963), and Rachel Whiteread (born 1963). The motives of these returns were various, but one factor in some was a discontent with a sensationalist art world that by the late eighties seemed dominated by marketing strategies and hyped scandals. More important, however, was the changed status of movements like Minimalism and Conceptualism by the nineties. On the one hand, the trajectories of such work seemed cut short in the eighties, pushed prematurely into the past. On the other hand, now that they were historical objects, these movements consti-tuted a new archive of forms and devices for different kinds of appropriation in the present. This liminal, almost paradoxical status—as both a vital beginning of postmodernist practice and an enshrined moment in art history—attracted young artists, critics, curators, and historians alike.

Minimalism was especially ambiguous in this regard. Some artists, like Whiteread and Hatoum, reworked its language of simple forms and serial orderings to new psychological and polit-ical ends. However, other artists, like the American Janine Antoni (born 1964), reacted against its apparent austerity, which they saw, reductively, as macho authority, and reintroduced what Minimalism had worked so hard to expunge—namely, a concep-tion of art as a matter of images, and a model of meaning dictated by iconographic referents and/or themes. Of course, Minimalism was hardly ignored in its own time. Already in the late sixties and early seventies it was developed in ways that artists like Whiteread and Hatoum would elaborate in the nineties. Thus, for example, its modular forms were repositioned in a social context by artists such as Dan Graham, whose *Homes for America* (1966–7) discov-ered Minimalist objects ready-made in the repetitive tract-houses of a New Jersey development. Other artists like Eva Hesse detected an irrational, even absurdist dimension in Minimalism, which they turned against its official position of extreme objectivity. Rather than a phobic reaction, however, this was an ambivalent

critique, as suggested by the strange compliment paid by Hesse to Carl Andre in 1970: "I feel, let's say, emotionally connected to his work. It does something to my insides. His metal plates were the concentration camp to me."

Minimalism with a twist

Artists like Hesse, Ree Morton (1936–77), Dorothea Rockburne (born 1932), Jackie Ferrara (born 1929), and Jackie Winsor (born 1941) were fluent with such Minimalist devices as the mono-chrome, the grid, and the cube. But they also twisted these devices in order to evoke structures of feeling more or less alien to Minimalism. For example, Ferrara constructed Minimalist forms like pyramids out of non-Minimalist materials like cardboard, rags, rope, fur, and flax. Her constructions were also just irregular enough to further undo the ideality of geometric forms. This is true, too, of Winsor, who gouged, burned, or otherwise marked her wood cubes in ways that registered the body through these fraught acts [1]. Like the irregularity of form in Ferrara, the intensity of process in Winsor intimated a psychology, even an irrationality,

1 • Jackie Winsor, *Burnt Piece*, 1977–8
Concrete, burnt wood, and wire, 36 × 36 × 36 (14⅛ × 14 x⅛ × 14⅛)

that Minimalism had seemed to expunge. These artists thus opened up Minimalist forms, only to turn them inward, as it were, to make of marked cubes and open boxes so many metaphors of the ▲ interiority not only of the body but of the psyche. At the same time, this Postminimalist art remained abstract or structured enough not to become reductively referential or personal. In this regard it did not reverse the most radical achievement of Minimalism—the ● opening of art onto the phenomenological field of the body— as is the case with recent treatments of Minimalism that tend to picture, pastiche, or otherwise package its forms as so many theatrical images. (This spectacularization is extended to Process and Performance art in the baroque installations and films of the American Matthew Barney [born 1967].)

Often fragile and ephemeral, much of this Postminimalist work is now neglected, when it is not lost altogether. Some practitioners such as Hesse and Morton died young, while others have fallen between the cracks of institutional categories of Minimalist,

▲ Process, and feminist art. However, in the late eighties and early nineties this line of working was picked up again by artists like Whiteread and Hatoum, who may have inadvertently benefited from the somewhat delayed reception of Minimalism in Britain. Although pledged to other purposes, their art also exists, enigmatically, between abstraction and figuration, structure and reference, the literal and the metaphorical.

Born in Beirut to Palestinian parents, Hatoum was stranded in London in 1975 when war broke out in Lebanon. This condition of displacement became a subtext of her art, as in a 1985 performance in which she walked barefoot through Brixton, a London community torn by racial strife, with Dr. Marten boots laced to her ankles like a ball and chain. Somewhat reminiscent of ● Vito Acconci, her early performances also tested taboos of the body (what is considered clean and unclean, fit and unfit), while her early videos focused on structures of surveillance. Hatoum continues to elaborate both of these interests in her installations,

2 • Mona Hatoum, *The Light at the End*, 1989
Angle iron frame, six electric heating elements, 166 × 162.4 × 5 (65⅜ × 63⅞ × 2)

1990–1999

which sometimes include abject residues of the human body like nails, skin, and hair. Indeed, her 1994 video *Corps étranger*, which explores the interior of her own body through a microscopic camera, takes surveillance of the body to an extreme. This tracing of boundaries (both corporeal and social) complements her tracking of displacements (both personal and political), and together they structure her art.

One installation in 1989, *The Light at the End* [2], signaled "a whole new way of working" for Hatoum. In a dark apex of a triangular gallery in London, she set six electrical rods in a vertical steel frame in a way that resembled an abstract cage. The viewer was attracted by the sheer beauty of the red-hot rods, only, on approach, to be repelled by the extreme heat: here the threat often projected onto Minimalist objects became actual. *Contra* the cliché, "the light at the end" of this particular tunnel brooked no escape or reprieve; as Hatoum commented, only "imprisonment, torture, and pain" were evoked. Positioned on the open side of the space, one might identify with the implied jailer. And yet, as one saw that there was just enough space under the rods to slip through, one might also identify with the implied prisoner. In this way Hatoum used a Minimalist aesthetic—the modular repetition ▲ of a Donald Judd, the spatial luminosity of a Dan Flavin—to produce a situation that was psychological as well as phenomeno-logical, a theater of ambivalence in which spatial positions became phantasmatic positions of power as well. In effect Hatoum reread ● Minimalism through the French philosopher Michel Foucault, in particular through his analysis of architectural surveillance in *Discipline and Punish* (1975). And she continued to explore these effects in such installations as *Light Sentence* (1992), a maze of wire-mesh lockers made fantastically carceral by the shadows cast by a single lightbulb slowly moving up and down at its center.

The social body

Bodies that are both fragile and porous, boundaries that are at once intractable and reversible, subjects that are both displaced and disciplined—these are experiences that Hatoum evokes through materials, structures, and spaces, more than themes that she illus-trates in images. (When she does picture her concerns in this way, it must be said, her work is less effective.) This is true too of Rachel Whiteread, who is also concerned with experiences of exposure, displacement, and homelessness. By the late eighties Whiteread began to cast objects associated with homes—bathtubs and mattresses, closets and rooms—in materials like rubber and resin, plaster and concrete. Often, as the objects are used as molds, the ■ castings are of the negative spaces of these things, the voids that they form. In this way they are at once obvious in production and ambiguous in reference. For example, although her sculptures are based on utilitarian objects and everyday sites, they negate function and harden space into mass. At the same time, although they appear whole and solid, they also seem fragmentary and spectral. More ambiguously still, these literal traces suggest symbolic traces

as well, especially memories of childhood and family. As the critic Jon Bird has argued, they conjure up "the cultural space of the home" as a place of beginnings and endings, departures and returns, as a place haunted by the actuality of loss and the presence of absence. The effect of these works is thus often associated with ▲ "the uncanny"—that is, with the return of familiar things made strange by repression. And indeed, as "death masks" of familial objects and maternal spaces cast in hard rubber and cold plaster, they do render the homey somewhat *unheimlich* (German for uncanny, literally "unhomelike"). But precisely as death masks they can also appear more melancholic than uncanny, suggestive less of the return of the repressed than of the persistence of the lost. Some of the objects, especially the tubs and the mattresses, evoke the body as emptied of desire, even as dead and calcified, and in fact Whiteread has also cast mortuary slabs.

The effects of these castings are not only psychological; they also "carry the marks of history written on the social body" (Bird). On the one hand, the hard pitted mattress of *Untitled (Amber Double Bed)* [3] suggests archetypal events of the bed—loving, birthing, and dying. On the other hand, it has a specific social reso-nance: slumped against the wall as if on the street, it recalls the stained bedding of a homeless person. And it is homelessness, as much as *Unheimlichkeit*, that Whiteread treats. This is especially true of her most-celebrated work to date, *House* [4], a concrete

3 • Rachel Whiteread, *Untitled (Amber Double Bed)*, 1991
Rubber and high-density foam, 106 × 136 × 121.5 (47 × 54 × 41)

▲ 1962c, 1965 ● 1971 ■ 1967a, 1974 ▲ 1924, 1931a

4 • Rachel Whiteread, *House*, 1993
Internal casting of 193 Grove Road, Bow, east London (destroyed)

Through different inversions of interiors and exteriors, Hatoum and Whiteread point to a social world in which private space often appears obscenely exposed and public space nearly collapsed; they also point to a melancholic culture fixed on traumatic events. And they make these comments count through a pertinent elaboration of postwar art. The particular antecedents differ in each case—besides various Minimalists, Hatoum draws on Piero Manzoni and Arte Povera with her charged materials, while Whiteread recalls

▲ Gordon Matta-Clark and Bruce Nauman with her architectural molds. But they adapt these different antecedents to similar ends—as psychological and mnemonic instruments. Again, Hatoum and Whiteread represent only two instances of a pervasive redeploy-
• ment of art of the recent past. Just as the "neo-avant-garde" of the fifties and sixties returned to the various devices of the "historical avant-garde" of the teens and twenties, so, too, it might be argued, have many artists in the nineties returned to the different paradigms of the sixties and seventies. And, as with the neo-avant-garde, some recoveries were opportunistic and reductive, and so spectacularized the past, while others were innovative and expansive, and so elaborated it critically and pertinently. It is crucial to distinguish between these returns, for at stake is the alternative, in a time of pervasive amnesia, between an artistic culture given over to a static consumerist recycling and an artistic culture that still seeks to reclaim different pasts to open up different futures. HF

FURTHER READING
Guy Brett et al., *Mona Hatoum* (London: Phaidon Press, 1997)
James Lingwood (ed.), *Rachel Whiteread: House* (London: Phaidon Press, 1993)
Susan L. Stoops (ed.), *More Than Minimal: Feminism and Abstraction in the '70s* (Waltham, Mass.: Rose Art Museum, 1996)
Chris Townsend (ed.), *The Art of Rachel Whiteread* (London: Thames & Hudson, 2004)
Catherine de Zegher (ed.), *Inside the Visible* (Cambridge, Mass.: MIT Press, 1996)
Lynne Zelevansky, *Sense and Sensibility: Woman Artists and Minimalism in the Nineties* (New York: Museum of Modern Art, 1994)

internal casting of a house (minus its roof) in an old working-class area of east London. In collaboration with the commissioning agency Artangel, Whiteread negotiated with the local council to cast a terrace house scheduled for demolition. This negative imprint of now-vanished rooms, inscribed not only with the faint outlines of window sills, door frames, and utility lines but also with the slight traces of past inhabitants, stood in a small park for a few months like the unrequited ghost of some social past. On the same evening that Whiteread won the Turner Prize, the most prestigious award for contemporary art in Britain, a vote to demolish *House* was passed by the local council, and a firestorm of controversy ensued. As Bird has suggested, the great provocation of *House* was to link the psychic and the social, "the lost spaces of childhood" and the lost working-class culture of east London, both threatened by rampant capitalist development. (The new business area Canary Wharf, the most egregious example of this development in London, was on a sight-line with *House*.) Perhaps its opponents grasped this connection subconsciously, or perhaps they simply refused a public sculpture that did not idealize social life or monumentalize historical memory. For *House* was indeed a public sculpture that, however abstract, was both specific and obdurate. It stood like an involuntary memorial, in a contemporary Pompeii, of catastrophic socioeconomic forces.

▲ 1959a, 1967a, 1967b, 1970, 1974 • 1960a

1993c

In New York, the Whitney Biennial foregrounds work focused on identity amid the emergence of a new form of politicized art by African-American artists.

In recent decades the different politics of identity—racial, multicultural, feminist, and queer—have sometimes followed similar trajectories, at least as they are taken up in art. In a first phase, an essential nature—of blackness, ethnicity, femininity, or homosexuality—is often claimed in the face of negative stereotypes, and positive images of this nature are put forward (that is, once minority artists have won access to art institutions at all). Then, in a second phase, this critique of stereotypes is pushed to the point where such identity is seen as a social construction more than an essential nature, and the assumption of simple categories is complicated by the fact of multiple differences (e.g., that one might be black, female, and/or gay at the same time). The undoing of stereotypes is an especially urgent task for artists concerned with the imaging of race, and they have developed a number of strategies to this end, including critiques of documentary forms of representation, testimonials of personal experience, and turns to alternative traditions of art.

Turning the tables

One of the most prominent artists involved in this project is Adrian Piper (born 1948). Already active in avant-garde circles in the late sixties and the early seventies, Piper adapted several devices of Performance and Conceptual art in her own investigation of the "visual pathology" of racism. In her "Mythic Being" series (1973–5), for example, she staged performances in public spaces that underscored the ideological construction or "mythic being" of the macho image of the African-American male, whom she impersonated. Later, in *My Calling (Card) #1* (1986), she used the Conceptualist technique of the written declaration, here in the guise of a business card that informed the recipient of the card, after he or she had made a racist remark, that its bearer (Piper) was black. Piper also turned techniques of Installation and video art to her own critical purposes. For instance, *Four Intruders Plus Alarm Systems* (1980) confronts its audience with four large photographs of "angry young black men"; as viewers process their own reactions to these images, they also hear a taped recitation of hypothetical reactions from (other) white viewers. *Cornered* [1] confronts its audience as well, here with an overturned table set in a corner that in turn "corners" viewers with a videotape in which Piper considers the likelihood

1 • Adrian Piper, *Cornered*, 1988
Video installation consisting of videotape, monitor, table, chairs, birth certificate, dimensions variable, 17 minutes

that the white people among them also have black ancestors: once again the myth of a simple or pure identity is challenged.

In the seventies Piper trained in Kantian philosophy, which she teaches to this day. Her dissertation adviser at Harvard was John Rawls, whose *A Theory of Justice* (1971) is a landmark in the field of political philosophy, and in her art Piper has consistently posed her specific arguments regarding racial inequity within the general framework of human rights issues. Other artists involved in the questioning of racial representations have tended in the opposite direction, toward a postmodernist suspicion about universal claims. Yet Piper is skeptical of any position that forgoes "the potent tools of rationality and objectivity," which she regards as necessary to the critique of the "pseudorationality" of racism, "the defenses we use to rationalize away the uniqueness of 'the other.'" "All you have to do," Piper argues, "is to echo or depict those defensive categorizations as they are, without too much aesthetic or literary embellishment, in order to generate a certain degree of self-awareness of how inadequate and simplistic they are." Piper sometimes renders this "echoing" concrete through photographic and documentary testimony of her own experience and history.

Carrie Mae Weems (born 1953) often employs personal images and stories as well. However, trained at the California Institute of the Arts and the University of California at San Diego—two

hotbeds of postmodernist art and theory—Weems is more inclined than Piper to question objective claims of truth-value. On the other hand, she draws less on avant-garde models of the sixties and seventies than on African-American precedents of the Harlem Renaissance in the forties, especially the writer Zora Neale Hurston and the photographer Roy DeCarava (his 1955 portrait of his ▲ Harlem neighborhood, *The Sweet Flypaper of Life*, is a particular touchstone for her). In her phototext work, Weems is content neither with strictly positive representations of African-American identity nor with merely negative demystifications.

Weems developed her signature combination of intimate photographs and narratives in *Family Pictures and Stories* (1978–84). Here, accompanied by texts and tapes, 35-millimeter snapshots tell the tale of four generations of her extended family in their various migrations from Mississippi. Even as the work reports on harsh conditions of racism, poverty, and violence, it also resists automatic assumptions about black victimization. As the critic Andrea Kirsh has argued, "*Family Pictures* takes two practices as points to resist:
• first, the imaging of black people as 'other' in the photo-documentary tradition (a tradition that is almost the exclusive property of white photographers); second, the official sociological studies commissioned by the US government in the 1960s (such as the famous Moynihan Report on "the black family"). Weems questions the objectifying often produced in the sociological tradition, with a nuanced account of black families drawn from her own stock of memories and experiences; and she questions the othering often produced in the documentary tradition through an alternative vision of black communities as developed in the work of DeCarava and others. (Informed in folklore—Weems also did graduate work in anthropology at UC Berkeley—she has since extended her gaze to black societies in the Sea Islands, Cuba, and elsewhere.)

In the "Kitchen Table" series [2], Weems refined her complex approach. This work consists of views of one or two black subjects (a man and a woman, two female friends, and so on) seated at a kitchen table under a stark light; beneath the images run narrative texts in a third-person voice (usually that of a woman, sometimes of a man) that mulls over the different demands of personal longings, romantic relationships, domestic arrangements, and workaday obligations. It is rare in American art, not to mention American culture at large, that such subjectivities are given such evocative expression.

Like Piper and Weems, Lorna Simpson (born 1960) also frames racial images for our critical reflection, yet her phototext works are neither as confrontational as those of Piper nor as intimate as those of Weems (her classmate at UCSD). Although also concerned with the alienation produced by stereotypes, Simpson concentrates on the use of photography as evidence, especially in the construction of pseudo-objective typologies of black identities. The manipulation of photos and texts for purposes of identification and surveillance was developed in the nineteenth century by the French criminologist

2 • Carrie Mae Weems, *Untitled (Man Reading Newspaper)*, from the *Kitchen Table* series, 1990
Three silver-gelatin prints, each 71.8 × 71.8 (28¼ × 28¼)

▲ 1943, 1959d ● 1936, 1959d, 1984a, 1997

Alphonse Bertillon and the English statistician Francis Galton, but clearly the deployment of "the body as archive" for reasons of discipline and punishment continues in the present, for instance in the "profiling" used (programmatically or not) by police, employers, and everyday people on the street. In her early work, Simpson was concerned to mirror this typological gaze—to catch it in the act, as it were—and to trouble its prejudicial classifications.

This work features simple photographs of black figures, most of them female, often with hairstyles and clothes that suggest a particular group or class identity (chignons or Afros, a white cotton servant shift or a black business suit). Rarely does Simpson show entire faces, and often her models are turned away from us: such partial or obscure views solicit our curiosity, but they also frustrate any desire to master the figures through either fetishistic details or holistic images. The short texts that accompany the photographs, often single words or simple phrases, further challenge any habit of reading that is either voyeuristic or sociological or both: although often elliptical, the texts can be cautionary, even accusatory. For example, *Guarded Conditions* (1989) consists of eighteen Polaroid prints of a black woman of unknown age in servant clothes, seen from behind with her arms crossed behind her back. Below the photos run two texts in block letters that alternate throughout the sequence: "SKIN ATTACKS … SEX ATTACKS … ". Here, with great economy and force, Simpson conveys the condition of many black women as double targets of racism and sexism. At the same time, like Weems, she does not indulge in victimology: the poses can be read as defensive or defiant or both, and the markings of "skin" and "sex" are underscored in a way that seems to strengthen rather than to debilitate the woman pictured.

Again like Weems, Simpson combines critique and beauty in her work, as if to refute advocates of either principle who deem the combination somehow impossible. For example, her exquisite early work *The Waterbearer* [3] presents a black girl, once again in a white cotton shift and with her back turned to us. In her right hand, the girl holds a plastic bottle by its neck and in her left a silver pitcher, and almost nonchalantly she lets water pour out of both. Underneath the image is this text in simple capitals: "She saw him disappear by the river. / They asked her to tell what happened. / Only to discount her memory." *The Waterbearer* "declares the existence of subjugated knowledge," as the critic bell hooks has argued, but it is a knowledge that appears resistant even when it is ignored, for the action of the girl indicates a small refusal, a slight subversion: spilling the water, releasing her burden, forgoing her task, she nonchalantly spites her implied deniers (she seems oblivious to her observers as well). Her pose is also subtly transformative: her unbalanced arms suggest a tilted scale of justice, and her *contrapposto* stance recalls any number of canonical figures in Western art—from ancient muses, through the maids of Vermeer, to paintings by Ingres, Seurat, and a host of others—only to redirect them toward a subject matter rarely represented in Western art at all. *The Waterbearer* thus recalls a classical tradition of beauty and grace in order to refashion it almost insouciantly. In her recent films and videos, Simpson has developed this aesthetic of subversive beauty further still.

The stereotypical grotesque

If Piper, Weems, and Simpson resist and redraw racial stereotypes, other artists exaggerate them to the point of critical explosion—a complementary strategy that the critic Kobena Mercer has termed "the stereotypical grotesque." Pioneered in the early seventies by artists in the States such as Betye Saar (born 1929), Faith Ringgold and David Hammons, this kind of parody was developed in the eighties and nineties by artists in Britain such as Rotimi Fani-Kayode (1955–89), Yinka Shonibare, and Chris Ofili, among others, in photography, painting, and other media. Influenced by the homoerotic portraits of Robert Mapplethorpe, the Nigerian-born Fani-Kayode (who delighted in his own outsider status as a gay African man in London) exaggerates the primitivist clichés of

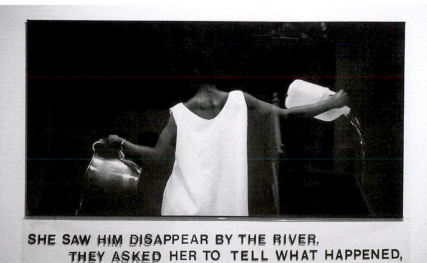

3 • Lorna Simpson, *The Waterbearer*, 1986
Silver-gelatin print with vinyl lettering,
114 × 194 × 4 (45 × 77 × 1½)

▲ 1975a ● 1989

African sexuality in his portraits of near-naked black men, who are shown painted, feathered, or otherwise costumed in exotic "tribal" garb [4]. Meanwhile, his compatriot Shonibare caricatures the other side of the primitivist fantasy: for example, in the three photos of his "Effnick" series [5] he assumes the sumptuous costume and haughty pose of a bewigged English gentleman of the late eighteenth century, a leisured man of letters (or perhaps a Victorian dandy who adopts this artificial style anachronistically). This fictional aristocrat, whose holdings might include colonial plantations worked by slaves, could well be the subject of a painting by Sir Joshua Reynolds—except for the fact that he is black. The imposture thus becomes a kind of travesty that renders the cultivation of the aristocrat more than suspect.

In Britain, of course, racist ideology is keyed to a complex history of colonialism more than to a traumatic legacy of slavery. One result is that "black" is a broader category in the Britain than in the United States, and its investigation involves many different subjects, cultures, and traditions. Indeed, British black art and film has explored a wide range of issues of the African diaspora and "the Black Atlantic." And in the eighties and nineties this great multiculturalism of multiple differences and hybrid states provoked an extraordinary efflorescence of painting, photography, and film-making by such different artists as Isaac Julien, Sonia Boyce, Steve McQueen, Keith Piper, and Ingrid Pollard, to name only several.

Of special relevance here is the work of Julien, which has spanned feature films, television documentaries, and film installations. From *Who Killed Colin Roach?*, a 1983 documentary about the suspicious death of a young black man while in police custody, through *Looking for Langston*, a luscious short film of 1988 evoking the gay life and aesthetics of the great poet Langston Hughes, ▲ a leader of the Harlem Renaissance, to his film installations with double and triple projections of the 1990s, such as *The Attendant* and *The Long Road to Mazatlán*, Julien has explored different representations of race, class, art, and homosexuality in British and American culture at large. Again and again he has used the force of desire to disrupt any rigidity in the definition of these categories, and he has doubled his thematic blurring of the edges between genders and sexualities with a formal blurring of the lines that divide genres and disciplines: fiction and nonfiction; imagistic and narrative; art and documentary; film and video. A cofounder of Sankofa Film and Video, a collective of young black British film-makers, in the early 1980s, Julien has long collaborated on projects in which politics and aesthetics are never pitted against each other; at the same time he has developed a cinematic style, rooted in gay black sensibility but not confined to any restrictive identity, that is distinctly his own.

Legibilities of race

The strategy of "the stereotypical grotesque" is also developed by young American artists such as Kara Walker (born 1969), whose tableaux and installations consist of postings and projections, on

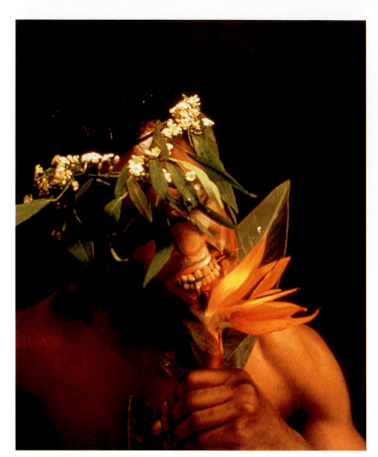

4 • Rotimi Fani-Kayode, *Nothing to Lose IV (Bodies of Experience)*, 1989

the white walls of galleries and museums, of black-paper cutouts [6]. Walker cites the genres of the cameo and the silhouette, but where one might expect the safe profiles of loved ones that are typical of these discreet forms, Walker restages ante-Bellum caricatures of Deep South slaves and slave-owners involved in wild scenes of sex and violence. In effect, she restages the myths of racist lore, but in a ribald fashion that undermines them at the same time. These fantasies persist outrageously in the American unconscious, Walker suggests; at the same time she subjects them to subversively excessive reimaginings.

The Walker silhouettes are both very visible and quite anonymous in a way that points to the ambiguous legibility of race in social relations today. This ambiguity is treated by some artists in the medium of painting, often through analogies of canvas with skin and paint with skin color. Ellen Gallagher (born 1965) has developed a language of tiny pictographs set on large fields of paper and canvas [7]. Often built up in shallow relief, her symbols look from a distance to be abstract forms; their combination of repetition and variation is sometimes associated with the rigor- ▲ ously nonobjective paintings of Agnes Martin. Only on closer examination are these forms revealed to be eyes, mouths, faces, hair styles, and the like—that is, physical attributes that are singled out for special significance in racist physiognomies. Even as Gallagher mimes this typological process, however, she breaks down its constituent parts, its loaded details, nearly to the point of their utter deconstruction.

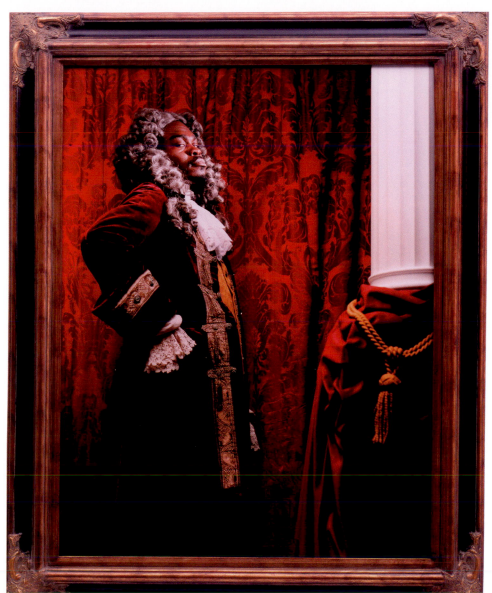

5 • Yinka Shonibare, *Untitled*,
from the "Effnick" series, 1997
C-print, reproduction Baroque frame,
edition two of five, 122 × 91.5 (48 × 36)

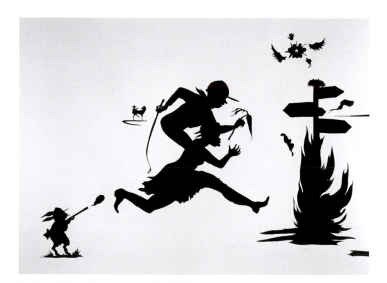

6 • Kara Walker, *Camptown Ladies*, 1998 (detail)
Cut paper and adhesive on wall, dimensions variable

7 • Ellen Gallagher, *Preserve (Yellow)*, **2001**
Oil, pencil, and paper on magazine page, 33.7 × 25.4 (13¼ × 10)

Glenn Ligon (born 1960) also plays with the legibility of race, here through the trope of paintings in black on white and white on black [**8**]. He has borrowed texts and images involving race, often drawn from writers like James Baldwin and critics like Frantz Fanon, setting them on canvas with various degrees of contrast between figure and ground, surface and depth. In effect, Ligon turns the formal issues of modernist painting into perceptual tests of racial readings, and vice versa. Here the structural questioning of abstraction and signification—from the early canvases of Jasper Johns through the continued investigations of Robert Ryman—takes on new social meaning and political valence. HF

FURTHER READING
Coco Fusco, *The Bodies That Were Not Ours* (New York: Routledge, 2001)
Thelma Golden, *Black Male: Representations of Masculinity in Contemporary Art*
(New York: Whitney Museum of American Art, 1994)
Stuart Hall and Mark Sealy, *Different: Contemporary Photography and Black Identity*
(London: Phaidon Press, 2001)
Kellie Jones et al., *Lorna Simpson* (London: Phaidon Press, 2002)
Kobena Mercer, *Welcome to the Jungle: New Positions in Cultural Studies* (Routledge, 1994)
Jennifer A. González, *Subject to Display: Reframing Race in Contemporary Installation Art*
(Cambridge, Mass.: MIT Press, 2011)

I FEEL MOST COLORED WHEN I AM THROWN AGAINST A SHARP WHITE BACKGROUND.

8 • Glenn Ligon, *Untitled (I Feel Most Colored …)*, **1990**
Oil on wood, 203.2 × 76.2 (80 × 30)

▲ 1957b, 1958, 1962d

1994 a

A mid-career exhibition of Mike Kelley highlights a pervasive concern with states of regression and abjection, while Robert Gober, Kiki Smith, and others use figures of the broken body to address questions of sexuality and mortality.

Although well known in the sixties and seventies, Louise Bourgeois and Eva Hesse became truly influential only in the eighties and nineties, as they had to await a context once again sympathetic to an exploration of body and space shaped psychologically by drives and fantasies. This reception was prepared by feminist artists such as Kiki Smith (born 1954), Rona Pondick (born 1952), and Jana Sterbak (born 1955), who wanted to return to the female image after its partial taboo in feminist art of the late seventies, but not necessarily in the "positive" manner of feminist art in the early seventies. It was also assisted by gay artists like Robert Gober, who, in response to the AIDS crisis, worked to transform Surrealist fetishes of heterosexual desire into enigmatic tokens of homosexual mourning and melancholy. Like Bourgeois, these artists have developed a model of art as "the re-experiencing of a trauma," which they understand sometimes as a symptomatic acting-out of a traumatic event, in which the art work becomes a site where memory or fantasy can be attempted, as it were, and sometimes as a symbolic working-through of such an event, in which the work becomes a place where "treatment" or "exorcism" can be attempted (Bourgeois).

Fantasies objectified

As the critic Mignon Nixon has argued, some of these artists appear to objectify the fantasies of a child. For example, in her installations Rona Pondick has set up a quasi-infantile theater of oral-sadistic drives, not only in *Mouth* [1], an array of dirty mouths with nasty teeth, but also in *Milk Milk* (1993), a landscape of mammarian mounds with multiple nipples. Meanwhile other artists have focused on the imagined effects of such fantasies, especially the effects on mother and child. Like Bourgeois, Kiki Smith evokes both subjects, but in a way that is more literal than Bourgeois. Smith has often cast organs and bones like hearts, wombs, pelvises, and ribs in various materials like wax, plaster, porcelain, and bronze. In *Intestine* (1992) we see a clotted line in bronze, as long as an actual intestine (thirty feet), that stretches out, inert, on the floor. "Materials are also sexy things," Smith has remarked, "that have either life in them or death in them." Here it is mostly death, and if there is a primary drive evoked in her work, it is the death

1 • Rona Pondick, *Mouth*, 1993 (detail)
Rubber, plastic, and flax, six hundred parts, dimensions variable

drive. Smith imagines the insides of the body not as animated by aggression, as they are in Bourgeois, so much as evacuated by it; all that remains are the hardened scraps of viscera, bare bones, and flayed skin.

Smith has spoken of this loss of "insides" as a loss of self, as intimated in *Intestine*. But more often this anxiety about loss seems to center on the maternal body, as suggested by *Tale* (1992), a naked female figure on her hands and knees who trails a long straight tail of spilled entrails. This figure recalls the maternal body as conceived, according to the psychoanalyst Melanie Klein, as the medium of the ambivalent child who imagines it damaged and

2 • Kiki Smith, *Blood Pool*, 1992
Painted bronze 35.6 × 99.1 × 55.9 (14 × 39 × 22). Cast two of an edition of two

hallucinatory dimension of such displays. They place us in an ambiguous space—as in a dream we seem to be both inside and outside the scenes—that is also an ambiguous time—"memories filtered through my current experiences." In this way we are like sudden voyeurs of forgotten events, as if from our own lives. The result is an uncanny experience that seems both past and present, imagined and real.

But unlike Bourgeois, Smith, and Pondick, Gober stages adult desires more than infantile drives. Thus with his enigmatic female breast (1990) presented in relief as a part-object, Gober seems to ask: "What is a sexual object, and for whom?" And with his strange hermaphrodite torso (1990), one side coded male, the other female, he seems to wonder: "What is a sexual subject, and how do we know which kind we are?" Even as he questions the origins of desire, Gober also considers the nature of loss. In effect he reworks the Surrealist aesthetic of desire, tilted strongly to the heterosexual, into an art of melancholy and mourning, here tinged gay—an art of loss and survival in the age of AIDS. "For me," Gober remarked in 1991, "death has temporarily overtaken life in New York City."

Abject states

When we look back on such art of the early nineties, and wonder at its many figures of damaged psyches and wounded bodies, we must remember that this was a time of great anger and despair about a persistent AIDS crisis and a routed welfare state, about invasive disease and pervasive poverty. In this grim period many artists staged regression as an expression of protest and defiance, often in the form of performances, videos, and installations. This regression was especially aggressive in the work of Paul McCarthy (born 1945) and Mike Kelley (1954–2012), both based in Los Angeles with continuous ties to Performance art there, whether focused on the pathos of failure, as with Bruce Nauman, or on the pathologies of transgression, as with Chris Burden. McCarthy and Kelley combined both modes of Performance and took them to new extremes.

In the mid-sixties, unaware of the precedent of Yves Klein, Paul McCarthy torched his canvases, and called the charred remains "black paintings." In the early seventies he developed these antiaesthetic actions into outright performances in which his own body became the brush, with food products like ketchup as paint: a portrait of the artist as infant or madman or both. In his performances thereafter, many of which were filmed or videotaped, McCarthy attacked conventional figures of male authority, with the aid of grotesque masks and bizarre costumes sometimes based on deranged pop-cultural icons. Some of these characters performed roles or functions entirely alien to them—in *My Doctor* (1978) the male protagonist gave bloody birth to a doll out of his head like some horror-movie Zeus—while others (fathers and grandfathers, a sea captain, *Mad* magazine's Alfred E. Newman) are pushed beyond stereotype to grotesquerie. McCarthy reserved his nastiest ridicule for the figure of the artist, especially the expressionistic painter, whom he presented as a monster of regression.

restored in turn. In the plaster *Trough* (1990) this body lies cut in half, an empty vessel long dead and hollowed out, while in the bronze *Womb* (1986) it appears intact, even impervious. Smith echoes this ambivalent imagining of the mother in her representation of the child. In one untitled figure in wax with white pigment (1992), a girl crouches low, her submissive head tucked down, her elongated arms extended with palms upward in a gesture of extreme supplication. Smith also presents the child in a manner as abused as the mother: in the grisly *Blood Pool* [2], a malformed female child, painted a viscous red, is posed in a fetal position, her spine a double row of extruded bones like teeth. It is as if the oral sadism of the child evoked by Pondick in *Mouth* had returned, now to attack the child. As often with Bourgeois, Smith suggests an assault on patriarchy, but whereas Bourgeois imagines the man destroyed, Smith focuses on the woman violated and / or mourned.

Mourning of another kind is evoked by Robert Gober, who also casts body parts like male legs and buttocks in wax and other materials, set alone on the floor or in spare settings with strange decor. Often these parts, nearly all male, appear truncated by the wall, and they are clad, with boots, trousers or underpants, only enough to seem all the more exposed. Even more oddly, they are sometimes tattooed with bars of music or planted with candles or drains [3]. Like Bourgeois, Smith, and Pondick, Gober presents these body parts in order to query the intricate relations among aesthetic experience, sexual desire, and death. His art is also involved with memory and trauma: "Most of my sculptures," he has remarked, "have been memories remade, recombined, and filtered through my current experiences." Often his tableaux do not evoke actual events so much as enigmatic fantasies, and in this respect Gober is both more realistic and less literal than Smith. Indeed, he has called his installations "natural history dioramas about contemporary human beings," and sometimes they do possess the hyperreal, almost

▲ 1966b ● 1924, 1931a, 1987 ■ 1974 ◆ 1960a, 1967c

3 • Robert Gober, *Untitled*, 1991
Wood, beeswax, leather, and fabric 38.7 × 42 × 114.3
(15¼ × 16½ × 45) (shown with *Forest*, silkscreen on paper)

In the eighties and nineties McCarthy often displayed the props of his performances as installations—such things as stuffed animals, dolls, and artificial body parts found on the street or in junk shops. Some of these installations turned into contraptions that staged outrageous actions, such as couplings of figures that defy all lines of difference—young and old, human and animal, person and thing [4]. In his own account McCarthy uses his props "as a child might use them, to manipulate a world through toys, to create a fantasy." Yet, even when comic, these fantasies are usually obscene, darker than any precedent in American Gothic art or fiction, for again and again McCarthy shows the orders of both natural and cultural worlds in disarray, and all structures of identity—especially the family—in dissolution.

On several points Mike Kelley was close to McCarthy, with whom he collaborated on several performances and videos (their *Heidi* [1992] recasts the Swiss family tear-jerker as an American horror home-movie). Kelley also deployed carnivalesque reversals

of character and inversions of role, but in a way that was more specific in its social references and cultural targets. Often he drew on aspects of his Roman Catholic, working-class childhood as well as his rock-and-roll, subcultural adolescence; and like his long-time associates John Miller (born 1954) and Jim Shaw (born 1952), he was very alert to connections between social oppression and artistic sublimation, between hierarchies in class and values in culture (Shaw, for example, has curated shows of found amateur paintings, placing marginal works in central galleries). If McCarthy assaults the symbolic order with performances of infantile regression, Kelley revealed this order to be already cracked in installations that often track the deviant interests of the adolescent male. Kelley used this persona, whom he called "the dysfunctional adult," to dramatize failures (or refusals) of accepted socialization, and in this respect he was drawn more to "the abject" than to the grotesque. Indeed, his work favored found things that, even if reclaimed, cannot be quite redeemed—things like worn stuffed animals and

4 • Paul McCarthy, *Tomato Heads*, 1994
Sixty-two objects, fiberglass, urethane, rubber, and metal clothing, 213.3 × 139.7 × 111.7 (84 × 55 × 44)

dirty throw rugs from the Salvation Army, things that have dropped out of use, let alone exchange, things that Kelley rendered even more pathetic through juxtaposition and combination.

The notion of the abject took on great currency in art and criticism of the early nineties. According to the canonical definition of the psychoanalytical theorist Julia Kristeva, the abject is a psychically charged substance, often imagined, which exists somewhere between a subject (or person) and an object (or thing). At once alien to us and intimate with us, it exposes the fragility of our boundaries, of the distinctions between what is inside and what is outside. Abjection is thus a condition in which subjecthood is troubled, "where meaning collapses" (Kristeva)—hence its attraction for artists like Kelley, McCarthy, and Miller, who often figure it through social detritus and bodily remains (which are sometimes equated). Indeed, art of the early nineties often seems pervaded by the dejected and the rejected, mess and scatter, dirt and shit (or shit-substitute). Of course, these are states and substances resistant to social order; in fact, in *Civilization and its Discontents* (1930)

Freud argues that civilization was founded on the repressing of the lowly body, of the anal region and the olfactory sense, and the privileging of the erect body, of the genital region and the visual sense. In this light it is as if abject art sought to reverse this first step into civilization, to undo repression and sublimation, especially through a flaunting of the anal and the fecal. Such defiance is a strong subcurrent in twentieth-century art, from the coffee grinders of Duchamp, through the cans of shit of Piero Manzoni, to the messy practices of Kelley, McCarthy, and Miller, with whom it is often self-conscious, even self-parodic. "Let's Talk About Disobeying" reads one home-made banner by Kelley that is emblazoned with an image of a big cookie jar. "Pants-shitter and Proud of It" reads another.

However pathetic, this defiance can also be perverse, a twisting of laws of sexual difference, a staging of regression to an anal universe where difference as such is obscured. This is the fictive space that artists like Kelley, McCarthy, and Miller set up for transgressive play. For example, in *Dick / Jane* (1991) Miller stained a blonde, blue-eyed

▲ 1959a

5 • Mike Kelley, *Dialogue #1 (An Excerpt from "Theory, Garbage, Stuffed Animals, Christ")*, **1991**
Blanket, stuffed animals, and cassette player, 30 × 118 × 108 (11¾ × 46½ × 42½)

doll brown and buried her neck-deep in shit-substitute. Familiar characters in old school primers, "Dick" and "Jane" taught several generations of North American children how to read—and how to read sexual difference. In the Miller version, however, Jane is turned into a phallic composite and plunged into a fecal mound. Like the stroke between the names in the title, the difference between male and female here is both erased and underscored, as is the difference between white and black. In this way Miller creates an anal world that tests the conventional terms of difference—sexual and racial, symbolic and social.

Kelley also often placed his creatures in an anal universe. "We interconnect everything, set up a field," Kelley has the bunny say to the teddy bear in *Theory, Garbage, Stuffed Animals, Christ* [**5**], "so there is no longer any differentiation." Like McCarthy and Miller, Kelley explored this space where symbols mix, where "the concepts *faeces* (money, gift), *baby* and *penis* are ill-distinguished from one another," as Freud wrote of the anal stage. Like the others, Kelley did so less to celebrate material indistinction than to trouble symbolic difference. *Lumpen*, the German word for "rag" that gives us *Lumpenproletariat* ("the scum, the leavings, the refuse of all classes" that so interested Karl Marx), is a crucial

term in the Kelley lexicon, a kind of cognate of the abject. And his art is indeed one of lumpen forms (dingy toy animals stitched together in ugly masses, dirty throw rugs laid over nasty shapes), lumpen themes (pictures of dirt and trash), and lumpen personae (dysfunctional men who build weird devices ordered from obscure catalogues in basements and backyards)—an art of degraded things that resist formal shaping, let alone cultural sublimating or social redeeming. HF

FURTHER READING
Russell Ferguson (ed.), *Robert Gober* (Los Angeles: Museum of Contemporary Art, 1997)
John Miller, *The Price Club* (Geneva / Dijon: JRP Editions, 2000)
Mignon Nixon, "Bad Enough Mother," *October*, no. 71, Winter 1995
Helaine Posner (ed.), *Corporal Politics* (Cambridge, Mass.: MIT List Visual Arts Center, 1992)
Ralph Rugoff et al., *Paul McCarthy* (London: Phaidon Press, 1996)
Linda Shearer (ed.), *Kiki Smith* (Columbus: Wexner Center for the Arts, 1992)
Elisabeth Sussman et al., *Mike Kelley: Catholic Tastes* (New York: Whitney Museum of American Art, 1993)

1994 b

William Kentridge completes *Felix in Exile*, joining Raymond Pettibon and others in demonstrating the renewed importance of drawing.

In the Renaissance, artistic self-consciousness split the pictorial arts in two, associating each half of the enterprise with the city that seemed to stand for the workshop of its most intense practice. These were Rome and Venice, the former the center of drawing (*disegno*), the latter the headquarters of color (*colore*). Raphael and Michelangelo were the great exemplars of *disegno*, demonstrating the conceptual powers of this art of contour and composition. In Venice, the leading practitioners of *colore* were Bellini, Giorgione, Titian, Tintoretto, and Veronese, whose great altarpieces and multipanel installations showed how painting could dissolve away the solidity of plaster and stone to fill interior spaces with a disembodied radiance.

In France, the Académie des Beaux-Arts institutionalized the Renaissance division of painting in the competition for the prestigious Prix de Rome, the prize being to work at a State-sponsored studio at the Medici Palace in Rome. The prize required mastery of figure drawing in the production of an "academy," or study of the male nude, and of multifigure composition in the execution of a complex history painting. Jacques-Louis David (1748–1825) won the Prix in the late eighteenth century, followed soon by J.-A.-D. Ingres (1780–1867). The privileging of *disegno* was not challenged until Eugène Delacroix (1798–1863) emerged not only as a great colorist but as an ardent "Orientalist," his imagination fired by the patterns and palette of the Middle East: its mosques, its harems, its opiates. Encouraged by Delacroix's success, the landscape painters who emerged in the 1870s and became known as Impressionists hunted down the effects of color through *plein air* (out-of-doors) painting in which they discovered how the actual color of shadows cast by the golden sun is violet. Stroking such complementary colors onto the surfaces of their figures in short, fragile traces, the brushwork they practiced dissolved drawing into a shimmer of colored light. By the 1880s, Claude Monet and Auguste Renoir, the leading Impressionists, worried about the dissolution of line and thus of form that was a consequence of their attention to color. The emergence of neo-Impressionism, in the work of Georges Seurat and Paul Signac, was the acknowledgment of this resurgence of the rights of drawing.

The split between color and drawing seemed to continue, ▲ unabated, into the twentieth century as Cubism came to dominate avant-garde practice with an art of monochrome shading ▲ (chiaroscuro); only Matisse mounted a serious challenge in the name of color. Yet, as Yve-Alain Bois has shown, Matisse himself spoke of "color by design," or "color by drawing," a formulation that collapses the centuries-old distinction that had formed the logic of the pictorial arts. When Mondrian began to draw in colored line, weaving the florid masking tapes he discovered in ● New York into the late canvases for *New York* and *Victory Boogie Woogie*, he joined Matisse in imploding the difference between line and color and discovered a form of abstraction that synthesized the oppositions that occur within the visual experience of reality: color vs. contour; figure vs. ground; light vs. shadow, etc.

Perhaps the most spectacular such synthesis was achieved by the ■ major "drip pictures" Jackson Pollock executed in 1950 and 1951, immense canvases filled with nothing but huge skeins of dripped and thrown liquid paint, weaving colored lines into one another in such a way as never to permit the bounding of an individual shape and thus the formation of a contour. The effect, as the critic Michael Fried expressed it, was to bound or delimit "nothing except, in a sense, eyesight." Once again, then, line emerged as the master-resource, a component of painting that was capable of generating the experience of light and color without surrendering its own abstractness.

This paradoxical deployment of line (the ultimate resource of representation) in the service of abstraction reflects the development of the two major aspects of drawing within the twentieth century. As Benjamin Buchloh has argued, drawing was essentialized as either a form of matrix or a form of grapheme. The first was the flattened and abstracted representation of the spatial ambience, as when the Cubists' grid simplified the geometricized lattice of Renaissance perspective, generalizing it into the description of the infrastructure of the woven canvas; the second was the expressive mark, as when some ◆ Abstract Expressionists exploited the bodily trace, or Cy Twombly used a graffiti-like scrawl, in order to effect the indexical registration of neuromotor and psychosexual impulses. According to Buchloh, if the matrix model of drawing delivers an abstract form of the object, the grapheme model performs an abstract version of the subject.

In the sixties Sol LeWitt developed a species of wall drawing that repeated Pollock's act of synthesis as it similarly dissolved recognizable form within a luminous matrix of line, one capable of generating the experience of color and light as well. But LeWitt's

work, executed by assistants following formulaic instructions (for example, *Ten thousand one-inch long lines evenly spaced on each of six walls* [1]), acknowledges the incursion into handicraft of industrialized and technologized forms of drawing such as commercial rendering and computer graphics. This demonstration of the obsolescence of drawing continued in the practice of ▲ Pop artists Andy Warhol and Roy Lichtenstein, in whose hands drawing was once again placed in the service of representation rather than abstraction. Indeed, the industrialization of represen-

tation by mass-cultural forces, which have exploited drawing for magazine advertisements and comic-book narrative, has withdrawn graphic expression from the sphere of the private and the expressive, from which it had always seemed to have issued, and forced it into the domain of the commercial and the public.

The Californian artist Raymond Pettibon (born 1957) takes up drawing exactly at that intersection between public and private by situating it within the culture of the comic books and "zines" that developed on the ruins of the West Coast counterculture of the

1 • Sol LeWitt, *Wall Drawing #150, Ten thousand one-inch (2.5cm) lines evenly spaced on each of six walls*, 1972 (detail)
Black pencil, dimensions variable

▲ 1960c, 1964b

late sixties. Basing his style on the linear simplifications that Francisco Goya and Honoré Daumier adopted in order to make their work available to replication techniques such as lithography, Pettibon sets his art within a domain from which individual subjective life has been removed, having been replaced by the most impersonal, stereotypified, caricatures of individuality. Batman becomes the man-at-large in a series of "zines" set in Gotham City. The grip of mass-cultural practice at work on Pettibon's graphic expression not only displays the flattened character of subjective life within the world of what the Frankfurt School calls the "consciousness industry," but it also manifests the opacity of the forms of social communication within the sphere of developed consumer culture. But Pettibon works as well to pay homage to his modernist prede-

▲ cessors: from the great draftsmen such as Matisse to the commercial stylists such as Roy Lichtenstein. His drawing *No Title (I think the pencil)* [2], recalls Lichtenstein's imitation of comic-book auditory bursts such as "BLAM, BRATATATATA! TAKA TAKA"; it also restricts the contours of the figure to the uninflected lines of a deskilled illustrator. This mechanical quality, given the human body part, reflects ironically on the promise of expressive gesture bodied forth by the pencil in the hand, as well as by the effusive "SNAP."

The South African artist William Kentridge (born 1955) takes a different tack with regard to drawing, making pictures in charcoal whose minute erasures and corrections are individually filmed in a stop-shoot technique that causes the finished drawing to appear "animated" once the run-on film is projected. The world of animated films (cartoons) is not far from that of "zines"; thus Kentridge's art inhabits a sphere, somewhere between the subcultural and the mass-cultural, which abuts that of Pettibon. Kentridge's cartoon world takes the form of a serialized "story" about the lives of a restricted set of characters: the mine-owner Soho Ekstein and his wife; and the artist Felix Teitelbaum, erotically involved with Mrs. Ekstein. But Kentridge's "story" is also about the form he practices, and it dares to focus on the resources and possibilities of drawing. That these resources are now threatened by a technological fluency that will soon render them obsolete is communicated by the mechanical metamorphoses that animation effects. But it is that very fluency that allows Kentridge to depict his own process, as when the motion of windshield wipers mimics the action of his own erasures, necessary to his work's production.

In *Felix in Exile*, Felix Teitelbaum is in a hotel in Paris looking through a suitcase of drawings, all of which represent slaughtered bodies of black protesters as they lie, fallen in the fields around Johannesburg. The author of these drawings is Nandi, a black woman surveyor whose activity seems to be forensic since she not only makes representations of the bodies but also draws lines around their contours as an index of where they have fallen in the

● fields. This is a regression back along the history of drawing toward a "deskilled" graphic mark that is nothing but the mechanical trace of an object. Nandi's drawings also record the rivulets of blood that

■ ooze from the wounds on the bodies, drippings which inevitably recall Pollock's development of line and are an ironic manifestation

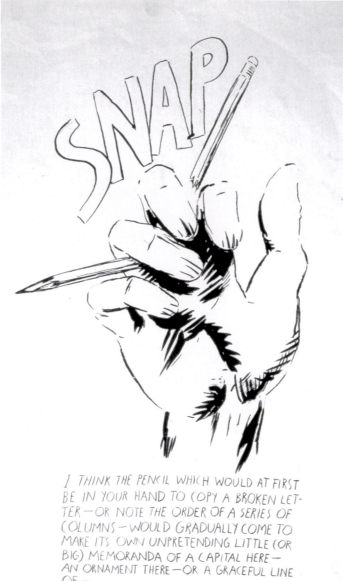

2 • Raymond Pettibon, *No Title (I think the pencil)*, 1995
Pen and ink on paper, 61 × 34.3 (24 × 13½)

of the tradition of the grapheme. Nandi's optical instrument (the theodolite) allows her, as a surveyor, to objectify her view of the mutilated human flesh she must record. It is the theodolite that then forms a bridge between Felix, standing at his hotel-room mirror to shave [3] and Nandi, looking back at him from faraway Africa, and allows Felix to observe the murder of Nandi, shot down as she draws [4]. Kentridge is thus determined that subjectivity and, indeed, extreme forms of emotion, can enter and develop within the field of mass-cultural entertainment that his medium occupies.

Kentridge's approach to drawing is neither matrix nor grapheme but a form of erasure, in which the traces of erased lines remain on the page, forming a faint charcoal mist. This type of linear overlay has the technical name "palimpsest" and attaches to the oldest forms of human graphic activity. In the paleolithic renderings of the caves, such as those at Ruffignac, we find animals layered one over

▲ 1903, 1906, 1910, 1944b, 1960c ● 1968b ■ 1949a, 1960b

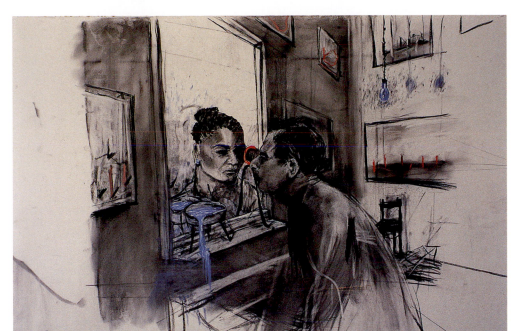

3 • William Kentridge, *Felix in Exile*, 1994 (detail)
Charcoal on paper, 120 × 160 (47¼ × 63)

4 • William Kentridge, *Felix in Exile*, 1994 (detail)
Charcoal on paper 45 × 54 (17¾ × 21¼)

the other, bison covering up and canceling groups of mammoths. Palimpsest does for time what matrix had done for the object and grapheme for the subject: it renders it abstract. Rather than a narrative or history composition, we are given erasure and layering.

If the indexical outlines of the bodies is a way of acknowledging the outmoding of drawing, as hand work is made obsolescent by mechanized graphic forms, Kentridge's practice of animation is a meditation on the fate of the arts under the pressures of advanced ▲ technologies. Walter Benjamin has written that various artistic media have sometimes faced their superannuation at the hands of technology by summoning up the earliest history of the medium, a history within which is inscribed the utopian promise of the

medium itself. In the case of Kentridge, this is to recall the earliest forms of film in which the little drawings pasted onto the drum of the zootrope or the phanokistoscope made possible a collective experience, thereby transforming the private consumer into the collective ensemble of the audience. RK

FURTHER READING
Benjamin H. D. Buchloh, "Raymond Pettibon: Return to Disorder and Disfiguration," *October,* no. 92, Spring 2000
Carolyn Christov-Bakargiev, *William Kentridge* (Brussels: Palais des Beaux Arts, 1998)
Rosalind Krauss, "The Rock: William Kentridge's Drawings for Projection," *October,* no. 92, Spring 2000
Raymond Pettibon, *Plots Laid Thick* (Barcelona: Museu d'Art Contemporani, 2002)
Benjamin H. D. Buchloh, *Raymond Pettibon: Here's Your Irony Back* (Göttingen: Steidl, 2011)

▲ 1935

1997

Santu Mofokeng exhibits *The Black Photo Album / Look at Me: 1890–1950* in the 2nd Johannesburg Biennale.

I n 1997, Santu Mofokeng (born 1960) exhibited a work titled *The Black Photo Album / Look at Me: 1890–1950* in the controversial second (and final) Johannesburg Biennale. As its title suggests, *The Black Photo Album* is structured as an archive, reproducing a collection of historic studio portraits of black South Africans that the artist had discovered while he was an affiliate in the oral-history project of the African Studies Institute, University of Witwatersrand, from 1988 to 1998. Resembling the products of commercial photographic studios anywhere in the world, the portraits appear unremarkable at first glance: subjects are posed in European dress, and face the camera with the formality characteristic of such occasions [1]. What drew Mofokeng to these pictures is suggested by one of the text panels that punctuate the series (in addition to more specific descriptive "captions" that give what little information is available on each sitter). This text poses a question that undoubtedly troubled both the artist and also many viewers of the work: "Are these images evidence of mental colonization or did they serve to challenge prevailing images of 'The African' in the western world?" In other words, do these studio portraits in Western dress inevitably force their African subjects to conform to the norms of white European society? And if so, why would one of South Africa's most important black artists want to recover and present such images?

Documenting struggle

Mofokeng began his career as an untrained street photographer, and subsequently worked as a darkroom assistant, before becoming a freelance photographer in 1985. He was a member of the influential collective Afrapix, founded in 1982 by Omar Badsha (born 1945), Paul Weinberg (born 1956), and a group of professional and amateur photographers to supply activist images to the alternative and independent media of South Africa documenting the intense struggles against apartheid taking place at that time—a strategy that was politically effective both domestically and internationally. In addition to functioning as an active photographic agency, Afrapix also published a number of important books, such as *South Africa: The Cordoned Heart* (1986) and *Beyond the Barricades: Popular Resistance in South Africa* (1989), before it disbanded

in 1991. Mofokeng's practice as a photojournalist—as part of what is often called "struggle photography" in South Africa—helps to give a context for *The Black Photo Album*. Underlying his journalism, his archival research, and his photo essays is one of the fundamental issues at stake in South African apartheid: the relationship between black Africans and urbanism.

After the election of the Afrikaner National Party in 1948, apartheid (an Afrikaans word meaning "apart-hood" or the "state of being apart") emerged as a legal framework wherein black Africans were geographically isolated in what were called *bantustans* (later renamed "homelands") and also segregated outer suburbs known as "townships." These areas represented a small percentage of South African land overall and provided their residents with substandard services and infrastructure. Whereas apartheid ideology suggested that this living arrangement created "separate but equal" communities for black Africans, known as "natives," and those of European descent, in reality blacks had been dispossessed of their land, denied educational or other social services of the caliber available to whites, and forced into low-paying labor in enterprises such as gold and diamond mining—the cornerstones of the nineteenth- and twentieth-century South African economy—and domestic service in white parts of the country. Despite long and difficult commutes being a consequent necessity, mobility for blacks in South Africa was severely limited and closely regulated through a despised internal pass system. Policies of apartheid thus forcibly and violently established a displaced, urban, industrial, and service-related black labor force that was segregated in residential areas remote from their workplaces. And yet during the same period, the dominant visual representation of black South Africans by the white elites (as well as to international tourists) was an idealized ethnographic image of a tribal Africa. One of the best-known instances of this photographic discourse in South Africa is the work of Alfred Duggan-Cronin (1874–1954), who came to the country in the late 1890s as a guard at the De Beers diamond mines, and in 1904 began an ambitious photographic documentation of tribal cultures that was eventually published as *The Bantu Tribes of South Africa* in four volumes between 1928 and 1954.

While the industrialization and ethnic segregation begun in the colonial era, and later intensified by apartheid, created a modern

1 • Santu Mofokeng, *The Black Photo Album / Look at Me: 1890–1950*, 1997 (details)
Black-and-white slide projection, edition of 5; clockwise from top left: slides 4/80, 8/80, 10/80, 51/80

black urban workforce, the draconian exploitation at the heart of this system was masked through representations of black South Africans as the denizens of a timeless tribal Africa; in other words, their territorial displacement was mirrored, and in fact abetted, by a kind of visual displacement from urban modernity. This is why *The Black Photo Album* was important, for it recovered a cultural—and visual—reality that had been eclipsed by ethnographic images in the tradition of Duggan-Cronin. In response, then, to the question posed by Mofokeng of whether studio portraits of black Africans in European dress are "evidence of mental colonization," the answer must be "no": African identity and modernity are not in opposition, as is suggested, for instance, in the primitivizing images of ethnographic and tourist photography. In fact, redressing the absence of images of black urban life in South Africa has characterized much of the photography produced in the country since the fifties, with the emergence of *Drum* magazine as an important vehicle of black modernity's visual culture. The publication was founded in 1951 in Cape Town as *The African Drum*—with the subtitle "A Magazine of Africa for Africa"—but soon moved to Johannesburg and abbreviated its name. While owned by white South Africans, *Drum* employed many significant black writers and photographers who covered the vibrant social and political life among blacks in neighborhoods like Sophiatown in Johannesburg. After a few early unsuccessful issues in which, as outlined by Darren Newbury in his book *Defiant Images: Photography and Apartheid South Africa*, *The African Drum* pursued an editorial policy in line with the tribal fantasies of white South Africa, it shifted gears, publishing a heady mix of photographs and photo essays on music, popular culture, nightlife, and politics that directly represented modern black urbanity. Perhaps more importantly, *Drum* was an incubator for the emerging documentary tendency of struggle photography. One of the early watersheds in this regard was Peter Magubane's (born 1932) photographs of the funeral following the Sharpeville Massacre on March 21, 1960, when police fired on peaceful demonstrators protesting pass laws, killing some two hundred unarmed people. Magubane's published photographs include a now famous picture of a line of coffins, stretching far into the distance, encircled by an enormous crowd of solemn mourners [2]. Photographs like this one, and the equally iconic and wrenching image by Sam Nzima of a dying twelve-year-old Hector Pieterson being carried away after being shot by police during a peaceful demonstration in Soweto, were essential weapons in the international war against apartheid. Such pictures became icons of struggle whose emotional key ranged from deeply tragic, as in Magubane's image of the Sharpeville funeral, to aggressively confrontational, as in the work of the so-called Bang Bang Club—which included the photographers Kevin Carter (1960–94), Greg Marinovich (born 1962), Ken Oosterbroek (1963–94), and João Silva (born 1966)—whose images shared a visceral power and frank shock value meant to convey the horror of apartheid's violence.

2 • Peter Magubane, Sharpeville Funeral, March 21, 1960

3 • David Goldblatt, "Lashing shovels retrieved from underground, Central Salvage Yard, Randfontein Estates, Randfontein," 1966 (left); "Greaser, No. 2 North Winder, Randfontein Estates," 1965; "Gang on surface work, Rustenburg Platinum Mine, Rustenburg," 1971; all from the book *On the Mines*, 1973

Rediscovering the ordinary

As important as this documentary tradition is—spanning the years between 1960 and the end of apartheid in 1994, and contributing significantly to its downfall—many South African photographers (as well as writers and artists in other media) sought an alternative to its violent and often simplistic account of life under apartheid. The novelist and literary theorist Njabulo S. Ndebele crystallized this attitude by identifying what he called the spectacularization of everyday life in South Africa. In an influential lecture of 1984, subsequently published as an essay in 1991, he declared: "Everything in South Africa has been mind-bogglingly spectacular: the monstrous war machine developed over the years; the random massive pass raids; mass shootings and killings; mass economic exploitation the ultimate symbol of which is the mining industry…. It could be said, therefore, that the most outstanding feature of South African oppression is its brazen, exhibitionist openness." Against such a spectacular point of view that, like apartheid, sees everything in black and white, Ndebele recommended redirecting attention to the everyday, or what he called in the title to his lecture the "rediscovery of the ordinary."

In many ways, David Goldblatt (born 1930), considered the father of documentary photography in South Africa, pursued such a project, of "rediscovering the ordinary." Goldblatt grew up in Randfontein, a mining town, as the son of a white businessman. He began working as a commercial photographer in 1963, before producing a series of important photo essays documenting South African life. His first book, *On the Mines* (1973), which includes an essay by the anti-apartheid activist and Nobel Prize-winning South African writer Nadine Gordimer, represents a particular kind of "ordinary" experience: the everyday contacts that bridged official barriers between "races" under apartheid. As Gordimer movingly writes of black and white mineworkers, "The colour bar kept them separated. Below, at work, there was life-and-death dependency between them. It was codified in something called Safety Regulations. Such a code is the recognition of a final faith necessary between man and man, for survival." And indeed Goldblatt's photographs establish proximities between white and black men engaged in the enterprise of mining, while nonetheless maintaining the significant and violent social distance that separated them.

His richly toned black-and-white prints often convey a geometric weight and balance, as in a 1966 image of a mound of "lashing" shovels (used by miners to dispose of debris) piled neatly in a kind of pyramid at a salvage yard in Randfontein as an ad hoc monument to the grueling labor underground [3]. Goldblatt's pictures of both black and white miners—not only groups, but also individual portraits—express an analogous emotional gravity. Such human proximities are matched in *On the Mines* by Goldblatt's implied socioeconomic map of mining's economic cycles and effects: the book begins with photographs of mines abandoned, presumably because of exhaustion or unprofitability, and proceeds to a few images of urban Johannesburg, including a particularly

4 • Santu Mofokeng, "Hands in Worship, Johannesburg–Soweto Line," from *Train Church*, 1986
Silver print, edition of 5

unsettling image of a courtyard fountain at the headquarters of the General Mining and Finance Company that includes three dark-bronze (but presumably ethnically white) figures, two reclining, as though fallen. The middle section of Goldblatt's *On the Mines* is devoted to the dangerous procedures of shaft-sinking, and the last includes a sequence of individual and group portraits. The book, then, tracks the complex world of mining, as both a social configuration structured by apartheid—as exemplified in the picture of a funeral for fifty-eight Basotho shaft-sinkers in Buffelsfontein from 1969, where white mourners seen from behind in the foreground are greatly outnumbered by a vast circle of blacks—and an economic system, South African capital emerging out of the ground as raw commodities and becoming urban flourishes of prosperity such as the corporation's fountain.

As Ndebele later recommended in his lecture of 1984, Goldblatt resisted spectacularizing apartheid in *On the Mines*, choosing instead to represent the texture of its everyday interactions—the points of contact where proximity and collaboration must be prevented from leading to intimacy or equality between blacks and whites. In an affecting photo essay of 1986, *Train Church*, Mofokeng pictured another type of everyday response to apartheid,

which unlike Goldblatt's was internal to black communities [4]. As outlined above, the segregation of black Africans in homelands or townships far from urban centers required significant commutes to work—as long as three hours each way. One response to this arduous situation was the rise of the train church. As Mofokeng describes it in a 2011 catalogue: "Early morning, late-afternoon and evening commuters preach the gospel in trains en route to and from work. The train ride is no longer a means to an end, but an end in itself as people from different townships congregate in coaches—to sing to the accompaniment of improvised drums (banging the sides of the train) and bells." Mofokeng's photographs of the train churches develop a very different sense of intimacy from those of Goldblatt's mines: on crowded trains, the photographer shoots from within the action of spirited prayer and laying on of hands. Whereas Goldblatt traced a line from the mine to the metropolis, showing how the accumulation of capital through extraction of primary commodities moves from the ground to the city, Mofokeng aims at a different set of connections: between everyday forms of drudgery, like the commute, and a "world beyond" where a spiritual salve might be found for demoralizing earthly conditions. In seeking what Ndebele called

the rediscovery of the ordinary, both artists demonstrate something fundamental, if not spectacular, about apartheid: the means by which its violent dichotomies were paradoxically both performed and potentially transgressed through the everyday interactions that relentlessly inscribed its values in the psyches of both black and white South Africans.

Beyond his personal photographic projects, Goldblatt played an important role in the history of photography in South Africa as founder of the Market Photo Workshop in 1989, a multiethnic photography school that was one of the few places that black South Africans could learn their trade (recall that Mofokeng, for example, received no formal education as a photographer). The credo of the workshop, which continues to this day, was to make "visual literacy and photographic craft available to people of all races, especially those to whom apartheid had largely denied the possibility of acquiring those skills." The importance of such access to education cannot be overestimated. For instance, the only way Zwelethu Mthethwa (born 1960), now one of South Africa's best-known artists among a generation that came of age in the waning years of apartheid, could study at a "white" institution, the University of Cape Town, was to, as he put it, "take a course that wasn't offered at a black university. So I chose photography." The Market Photo

Workshop has had a major impact on contemporary South African photography: Zanele Muholi (born 1972) and Nontsikelelo Veleko (born 1977), for example, two younger photographers whose careers have flourished since 1994, the year that apartheid was dismantled and a democratic constitution was adopted by South Africa, both studied there.

Mthethwa and his younger colleagues working in the post-apartheid era share a shift in emphasis away from explicit political struggle characteristic of documentary photography and toward investigations of complex, and sometimes even embattled, identities, which characterized not only art in South Africa in the nineties, but also many identity-oriented aesthetic practices worldwide during that decade. For Mthethwa, one of the most effective means of making this switch was through color: his series *Interiors* (1995–2005), for instance, includes portraits of residents at home in informal settlements in the Cape Flats region outside of Cape Town. While these domestic spaces are modest and improvised, they are visually individualized and sometimes even flamboyant. The subject of one photograph, for instance, reclines in his boxer shorts amidst a series of large advertisements of glowing gold French brandy, enclosing him as though in a pavilion of intoxication [5]. In a 1998 interview with Rory Bester,

6 • Zwelethu Mthethwa, "Untitled," from the *Interiors* series, 2003
Digital C-print, 96.5 × 122.5 (38 × 48¼)

6 • Nontsikelelo Veleko, *Beauty is in the Eye of the Beholder: Thobeka II*, 2003 / 6
Pigment ink on cotton rag paper, image 29.6 × 19.7 (11⅝ × 7¾); paper 36 × 24.7 (14³⁄₁₆ × 9¾)

7 • Nontsikelelo Veleko, *Beauty is in the Eye of the Beholder: Kepi I*, 2003 / 6
Pigment ink on cotton rag paper, image 29.6 × 19.7 (11⅝ × 7¾); paper 36 × 24.7 (14³⁄₁₆ × 9¾)

Mthethwa explains his attitude toward color, which is as ethical as it is visual: "Photographs of informal settlements prior to the elections in 1994 were mostly black-and-white images. The photographers weren't shooting for themselves, they were on assignment and black and white was used to suit political agendas of the time. For me, these images missed a lot of the colour of informal settlements. I wanted to give some dignity back to the sitters. I wanted them to have a sense of pride, and for me colour is a dignifying vehicle."

According to Mthethwa's formulation, color dignifies because it individualizes, which is also the effect of Nontsikelelo Veleko's extraordinary series of photographs *Beauty is in the Eye of the Beholder*, capturing South African street style. These pictures exemplify a moment in South African history that Sarah Nuttall, director of the Wits Institute for Social and Economic Research at the University of the Witwatersrand, described in 2008 as "the immense coincidence, so tangible in Johannesburg at present, between the end of apartheid and the rise of new media culture and cultures of consumption." The youth culture to which Nuttall

refers is evident in Veleko's pictures through extraordinary combinations of color and garments—a kind of sartorial remix [6, 7]. Her subjects typically address the camera with a confident posture and gaze that verges on challenging—an effect amplified by their frequent positioning in or beside an empty street, or against a brightly colored wall as though claiming the city as their stage. A statement of Mthethwa's in a 2011 interview illuminates the particular kind of self-assertion represented in these pictures: "In South Africa the gaze is a political thing. In South Africa, where black people were seen as non-citizens, they were not allowed to return the gaze, but for me, when they stare back it's like they are saying, 'I am here, I have the power to look at you. You are looking at me, but I am also looking at you.'"

Returning the gaze takes on great poignancy in Zanele Muholi's series of photographs of black lesbians, *Faces and Phases*, which she began in 2006 [8, 9]. In making classically composed, tonally rich portraits of her community, Muholi sees herself as a visual activist whose representations of lesbian South Africans helps to fight homophobia by making them both visible and powerful in their

self-assertion. This particular series (though not all of Muholi's work) is in black and white. Perhaps, as art historian Tamar Garb has suggested, it is in the urgency to document these lives, to create an archive of contemporary black South African lesbians not unlike the one that Mofokeng made of studio portraits in *The Black Photo Album*, that Muholi strategically makes use of the codes of documentary, which are so intimately tied with black-and-white photography. Indeed, the struggle against apartheid was a struggle over who is granted the power to document whom—from the literal form of documentation involved in compelling black South Africans to carry passes to the realm of spectacle in which various condescending or primitivizing photographic representations of black life contended with images of urbanity. The collapse of apartheid did not end economic inequality or racism in South Africa. Interwoven traditions of documentary and art photography now address new struggles, including assertions of dissident identities, the problem of poverty, and South Africa's relation to the continent that once shunned it, and within which it now embraces a role of leadership. DJ

FURTHER READING

Corinne Diserens (ed.), *Chasing Shadows: Santu Mofokeng—Thirty Years of Photographic Essays* (Munich: Prestel, 2011)

Okwui Enwezor and Rory Bester (eds), *Rise and Fall of Apartheid: Photography and the Bureaucracy of Everyday Life* (New York: International Center of Photography; Munich: DelMonico Books / Prestel, 2013)

Tamar Garb, *Figures & Fictions: Contemporary South African Photography* (London: V & A Publishing; Göttingen: Steidl, 2011)

Njabulo S. Ndebele, *Rediscovery of the Ordinary: Essays on South African Literature and Culture* (Scottsville, South Africa: University of KwaZulu-Natal Press, 2006 [originally published by COSAW, 1991])

Darren Newbury, *Defiant Images: Photography and Apartheid South Africa* (Pretoria: Unisa Press, 2009)

Sarah Nuttall and Achille Mbembe (eds), *Johannesburg: The Elusive Metropolis* (Durham, N.C.: Duke University Press, 2008)

John Peffer, *Art and the End of Apartheid* (Minneapolis: University of Minnesota Press, 2009)

8 • Zanele Muholi, *Ziyanda Majozi Sandton Johannesburg*, 2013
Silver gelatin print, image 76.5 × 50.5 (30⅛ × 19⅞); paper 86.5 × 60.5 (34 × 23¹³/₁₆)

9 • Zanele Muholi, *Vuyelwa Vuvu Makubetse Daveyton Johannesburg*, 2013
Silver gelatin print, image 76.5 × 50.5 (30⅛ × 19⅞); paper 86.5 × 60.5 (34 × 23¹³/₁₆)

▲ 1916b, 1929, 1930a, 1935, 1936, 1959d, 1993

1998

An exhibition of large video projections by Bill Viola tours several museums: the projected image becomes a pervasive format in contemporary art.

Perception in all its complexity is the principal concern of the philosophy of phenomenology, and, as such, it was of special interest to Minimalist artists like Robert Morris who moved to "take relationships out of the work and make them a function of space, light, and the viewer's field of vision." Phenomenology cast particular doubt on ideal geometries such as cubes, spheres, and regular polyhedrons, arguing that the body of the viewer interrupts the field of vision and so complicates any reading of such forms. "Even the most unalterable property, shape, does not remain constant," Morris claimed, "for with each shift in position the viewer also constantly changes the apparent shape of the work." Foregrounding the seeming variability of simple forms in their installations, the Minimalists made explicit Marcel Duchamp's notion that it is the viewer who completes the work.

The art of suture

If Minimalist art acknowledged the conditions of both the ambient space and the viewing subject, it did so strictly in physical and perceptual terms. For this reason its phenomenological basis was called into question in the seventies and eighties by some artists and critics who claimed that the space of art is never so neutral and that the viewer considered in an abstractly phenomenological way is likely to be male, white, and heterosexual. Practitioners informed by feminist, postcolonial, and queer theories moved to undercut these assumptions and to set up other kinds of spectatorship; this work on representation vis-à-vis identity often took the form of a critical manipulation of given images, usually in photographs. Yet other practices—Performance, video, and Installation art in particular—continued the opening to the body and its spaces inaugurated by Minimalism, thus elaborating on its phenomenological concerns. Performance and video engaged the viewer directly, but restrictions of staging in the former and dependence on monitors in the latter often kept the spectator at a distance. It was Installation that threw everything onto the experience of the viewer, and nowhere more clearly than in the work of James Turrell (born 1943), who sets up enormous fields of colored light [1]. Often these fields are produced through a slight opening in a gallery wall backed by an oblique plane that is brilliantly illuminated but

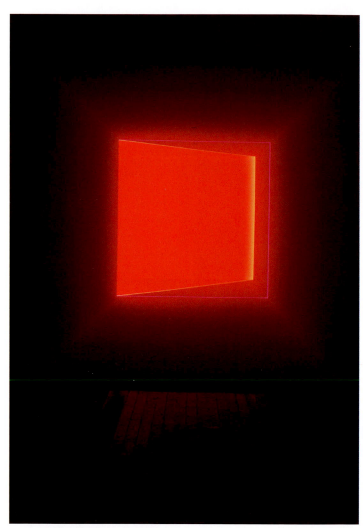

1 • James Turrell, *Milk Run III*, 2002
Light into space

whose exact location is almost impossible to determine for that very reason. A Turrell installation seems to exist as a spatial after-image, appearing as a phantom shape projected by our own retinal activity and nervous system rather than as a fixed object in its own right. Instead of the reflexive viewers and delineated spaces of Minimalism, such art tends to effect a kind of sublime experience in which the spectator is overwhelmed by an apparition that he or she seems to project into being. For many viewers this free-floating

▲ 1965, 1969　● 1975a, 1977b, 1987, 1989, 1994a　■ 1977a, 1980　◆ 1973, 1974

aestheticism is exhilarating; for some, however, it bears a disturbing relation to dazzling forms of technological spectacle.

▲ Installation artists such as Turrell complemented video artists such Peter Campus and Bruce Nauman who used the video camera to draw the viewer directly into the field of the work, often folding the time of perception onto the time of the video through its capacity for immediate transmission and rapid replay. It was left to subsequent video artists like Bill Viola and Gary Hill to combine the different effects of such Installation and video art, with viewers drawn into darkened spaces punctuated by luminous projections. Prompted by advances in projection devices in the eighties, Viola and Hill transcended the limited scale of the video monitor, sometimes making the field of display the size of a museum wall, and so creating an image-space that was immense yet mysterious, thoroughly mediated yet seemingly immediate. In some respects these video projections, which often include color and sound as well, partake equally of the fixity of grand painting and the temporality of narrative cinema. This reformatting of video transforms the terms of its space and its viewer alike: the former is literally obscure, and the latter is positioned somewhere between the contemplative and the awestruck. Yet the phenomenological effects of Minimalist installations do not disappear altogether; in some respects they are heightened, but in a manner that often confounds bodily perception and technological mediation.

Of course, seductive luminosity and immense projection were already combined in Hollywood cinema, which also activates another kind of projection, a psychically charged identification of the audience with the figures presented to it as visual models or ego ideals. Film theory has analyzed the experience of such cinema as a matter of projective identification through "suture," the process by which the audience is woven into the matrix of the filmic event through its alignment with the point of view of the camera; as the camera turns to a figure within its visual field, the audience imagines itself entering the field of the narrative, thereby joining the actors and their shifting points of view as well. In this way cinema doubles psychological projection with imagistic projection. For the most part this doubling is adapted rather than rejected in large video installations by Viola, Hill, and others, for though they are far less narrative than movies, less suturing of the viewer through camera and story, they are sometimes even more enveloping, more immersive of the viewer in a total image-sound space. Even when the video screens are arrayed in different configurations, sometimes confronting the viewer and sometimes surrounding them, the space often seems even more virtualized, the medium even more derealized, than in cinema. To what ends are these effects produced?

In his video installations Viola has consistently sought to represent, indeed to reproduce, different bodily experiences. Tranquil and agitated states often collide in the same work: in *The Sleep of Reason* (1988) a video monitor shows a close-up of a sleeping person; randomly, as if in a dreaming fit, the room darkens and violent images appear on the walls as roaring sounds fill the room; then the space returns to normal. Further, these bodily states frequently evoke extreme mental conditions: in *Reasons for Knocking at an Empty House* (1982) a monitor shows a man periodically struck from behind (again to the accompaniment of sound bursts), while the viewer sits in a wood chair listening via headphones to chattering voices telling of a horrible head injury. Moreover, these mental conditions are often analogues of spiritual experiences: in *Room for St. John of the Cross* (1982) images of mountain peaks are accompanied by sounds of a violent storm while turbulent poems by the sixteenth-century Spanish mystic are recited. Again and again, Viola foregrounds ritual passages and visionary states: from the baptismal *Reflecting Pool* (1977–9), in which a man leaps above a pool only to vanish, to *Nantes Triptych* (1992), which juxtaposes a young woman giving birth, a clothed man suspended under water, and an old woman dying, to *The Crossing* [2], which shows a figure consumed by fire on one side of the screen and a figure inundated with water on the other. In his most elaborate work to date, *Going Forth by Day* (the title is derived from the Egyptian *Book of the Dead*), the viewer is surrounded by five vast videos projected in slow motion. Inspired in part by the Giotto frescoes at the Scrovegni Chapel in Padua (c. 1303–5), the different parts of this "cinematic fresco" are titled *Fire Birth*—another baptism, here in waters of fire and blood; *The Path*—a parade of people along a forest path; *The Deluge*—the flooding of an apartment house; *The Voyage*—the dying of an old man by a riverside; and *First Light*—the witnessing

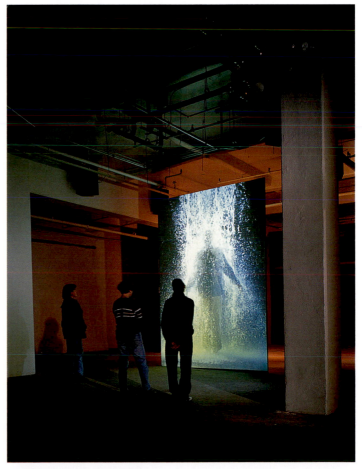

2 • Bill Viola, *The Crossing*, 1996
Video and sound installation at the Grand Central Market, Los Angeles

The spectacularization of art

In the nineties architecture and design acquired a new importance in culture at large. Although this prominence stemmed from the initial debates about postmodernism, which centered on architecture, it was confirmed by the inflation of design and display in many aspects of consumerist life—in fashion and retail, in corporate branding and urban redevelopment, and so on. This economic emphasis on design and display has affected both curatorial practice and museum architecture as well: every large exhibition seems to be conceived as an installation piece in itself, and every new museum as a spectacular *Gesamtkunstwerk* or "total work of art." To take two prominent examples, the Guggenheim Museum (1991–7) designed by Frank Gehry in the Basque city of Bilbao, and Tate Modern (1995–2000) renovated by Herzog and de Meuron along the Thames in London, are now tourist attractions themselves. Like other mega-museums, they were designed to accommodate the expanded field of postwar art, but in some ways they also trump this art: they use its great scale, which was first posed as a challenge to the modern museum, as a pretext to inflate the contemporary museum into a gigantic space-event that can swallow any art, let alone any viewer, whole. In part the new significance granted architecture has a compensatory dimension: in some respects the celebrity architect is the latest figure of the artist-genius of old, a mythic creator endowed with magisterial vision and worldly agency that the rest of us in a mass society cannot possess.

In *The Society of the Spectacle* (1967) Guy Debord defined spectacle as "capital accumulated to such a degree that it becomes an image." This process has become more intensive in the last four decades, to the point where media-communications-and-entertainment conglomerates are the dominant ideological institutions in Western society. In this way the corollary of the Debordian definition has become true as well: spectacle is "an image accumulated to such a degree that it becomes capital." Such is the logic of many museums and cultural centers, as they are designed, alongside theme parks and sports complexes, to assist in the postindustrial refashioning of the old industrial city—that is, in its being made safe for shopping and spectating, which often involves the displacing of working and unemployed classes and the furthering of "brand equity" for global corporations (including museums like the Guggenheim).

of a saved person by a group of exhausted rescue workers. The *New York Times* described the piece as "an ambitious meditation on the epic themes of human existence—individuality, society, death and rebirth." This ambition suggests why Viola works to virtualize his space and to derealize his medium: so that his ahistorical vision of spiritual transcendence can be effected—that ▲ is, it can come across as an effect. From the start, video art was prone to a technological kind of mysticism (with Nam June Paik it is more Zen Buddhist in flavor; here it is more Christian).

Of course, cinema has long been similarly inclined, and it continues to strive for ever more intense effects of immediacy through ever ▲ more elaborate forms of mediation. (As Walter Benjamin remarked long ago of film in "The Work of Art in the Age of Mechanical Reproduction" (1936): "the equipment-free aspect of reality here has become the height of artifice; the sight of immediate reality has become a blue flower in the land of technology.") As with Turrell, how one feels about such illusion will guide how one feels about such work: for many, this mystical experience is a genuine effect of much great art; for some, it is just that—mystification.

The traumatic sublime

Much contemporary art of the projected image recalls the two-part movement of the Sublime, as discussed by German philosopher Immanuel Kant, with a first moment in which the viewer is almost overwhelmed, even shattered, by an awesome sight and/or sound, followed by a second moment in which he or she comprehends the experience and so recoups it intellectually, and feels a rush of power, not of loss, for doing so. Viola privileges the second, redemptive moment. A partial list of other artists involved with video and film projections who favor the first, traumatic moment might include Matthew Buckingham (born 1963), Janet Cardiff (born 1957), Stan Douglas (born 1960), Douglas Gordon (born 1966), Pierre Huyghe (born 1962), Steve McQueen (born 1969), Tony Oursler (born 1957), Paul Pfeiffer (born 1966), Pipilotti Rist (born 1962), ● Rosemarie Trockel (born 1952), and Gillian Wearing. Sometimes these artists (who are of many different nationalities, interests, and commitments) project images of both beauty and violence. For example, in her video diptych *Ever is Over All* (1997), Pipilotti Rist shows a luscious field of red and yellow flowers on one screen, and a young woman in a blue dress strolling down a city street on the other, gaily smashing car windows as she does so. For his part Douglas Gordon focuses more strictly on the traumatic; indeed, he seems obsessed with splittings of many sorts—imagistic, formal, thematic, and psychological. Often Gordon uses split screens to project his appropriated films (he has favored Hollywood *auteurs* from Alfred Hitchcock to Martin Scorsese), sometimes mirroring the extracted scenes on the two halves; usually he deploys these devices to highlight a divided subjectivity. One video projection, *Confessions of a Justified Sinner* (1996), contains all these elements: extracts of *Dr. Jekyll and Mr. Hyde* are projected on two screens, the one image in positive, the other in negative, as if the split personality of the protagonist had penetrated everything, including its re-representation here. Gordon appears to identify with this division: *Monster* (1996–7) includes a double self-portrait with one photograph of his face expressionless and the other of his face Scotch-taped into a grotesque mask. (Perhaps there is a religious dimension here as well: he grew up in Glasgow in a Calvinist family with a Manichean view of good and evil in the world.) His most famous work appropriates the most famous movie about schizophrenia, *Psycho*;

▲ 1973

▲ 1935 ● 1993b, 2003, 2009a

however, Gordon slows the Hitchcock film to a hypnotic, almost catatonic pace—hence his title, *24 Hour Psycho* [3].

Sometimes Gordon interrupts his appropriated films in a manner that produces a hysterical effect of fitful starts and stops. Hysteria is a common interest of several of these artists, especially Martin Arnold and Paul Pfeiffer, both of whom also use found footage (Arnold tends to old Hollywood films, Pfeiffer to recent commercial spectacles), which they subject to compulsive repetitions. These concerns suggest particular precedents: if one model (for Gordon in particular) is the cinema of Andy Warhol, with its often fixed camera, prolonged shots, and split screens, another model is the "flicker" films pioneered by Peter Kubelka in Vienna and developed by Hollis Frampton, Paul Sharits, and others in New York in the sixties and seventies. The flicker effect is produced through a rapid-fire alternation between clear frames of film and opaque ones; this visual stutter allows the viewer actually to see the separate integers that make up the cinematic medium in the very course of its projection. On the one hand, this visual attack interrupts any identification based on suture; on the other, it stimulates the nervous system in specific ways. As the clear light triggers the retina to project its shapes onto the visual field as afterimages in the complementary color, purple rectangles begin to dance on the field of black, as projections of the clear frames join the experience of the opaque ones; the body thus seems propelled into the field of the screen. Inspired by modernist investigations of the medium (for example, those of Sergei Eisenstein and Dziga Vertov), the flicker-filmmakers were interested in revealing not only the reflexes of the body but also the materiality of the celluloid, the apparatus of the camera and the projector, the space of screening, and so on. Some contemporary artists develop these materialist interests; most, however, do not. Unlike their modernist predecessors, they use flicker and related effects in order to induce an experience of bodily shock, of traumatized subjectivity. And unlike their postmodernist predecessors as well, they seem concerned to produce image-spaces of psychological intensity more than critical reflections on given representations.

Film as archive

Along with recent advances in image technologies has come an increased appreciation of outmoded devices; renewed interest in flicker films is only one instance of this concern. Not long ago film was considered the medium of the future; now it appears as a privileged index of the recent past (perhaps it will enter the art museums as it becomes outmoded elsewhere). Early cinema in particular has emerged as an archive of historical experience, a repository of old sensations, private fantasies, and collective hopes, and it is often treated in these terms by Buckingham, Cardiff, Tacita Dean (born 1965), Douglas, Huyghe, McQueen, and others. "Both in terms of presentation and the subject matter of my work,"

3 • Douglas Gordon, *24 Hour Psycho*, 1993
Video projection installation

▲ 1973, 1993a ▲ 1925d ● 2003, 2009a

Stan Douglas has remarked (in a comment that might represent the others as well), "I have been preoccupied with failed utopias and obsolete technologies. To a large degree, my concern is not to redeem these past events but to reconsider them: to understand why these utopian moments did not fulfill themselves, what larger forces kept a local moment a minor moment: and what was valuable there—what might still be useful today." To cite only one instance of this collective concern, *Overture* [4] is a film installation by Douglas that combines archival footage from the Edison Company from 1899 and 1901 with audio text from Marcel Proust's *Remembrance of Things Past* (1913–22). The old film was shot from a camera mounted on a train engine as it passed along cliffs and through tunnels in British Columbia; the Proust is a meditation on the state of semiconsciousness that exists between sleeping and waking. There are six extracts from Proust and three sections of film (with tunnel passages extended by leader film), so that when the footage recurs it is matched with a different text, in a way that tests our sense of repetition and difference, memory and displacement. *Overture* is concerned not only with the transition from sleeping to waking, with the rebirth of consciousness that is also a return to mortality, but also with the shift in dominance from one kind of narrative medium (the novel) to another kind (the film). It juxtaposes moments of rift—in subjective experience as well as in cultural history—when other versions of self and society are glimpsed, lost, and glimpsed again. "Obsolete forms of communication," Douglas has commented, "become an index of an understanding of the world lost to us." To recover these forms is to "address moments when history could have gone one way or another. We live in the residue of such moments, and for better or worse their potential is not yet spent."

In this way recent projections of video and film suggest a dialectic ▲ of advanced and outmoded techniques, of future and past possibilities in media. On the one hand, more and more contemporary art seems to be reworked in cinematic terms, a development aided by the ready availability of digital cameras and editing programs since the mid-nineties (the trajectory of a prominent artist like Matthew Barney—from elaborate installation-performances to a mammoth film cycle titled *Cremaster*—is telling in this regard). On the other hand, there is a counterimpulse to complicate media history as never before, to find new avenues of expression in surpassed modes. Why this turn to the cinematic in art? No doubt one reason is the sheer legibility of movies: "I try to use film as a common denominator," Douglas Gordon has remarked. "They [movies] are the icons of a common currency." Perhaps, too, these artists see the medium as best suited to treat fundamental transformations in experience and subjectivity in contemporary society—that is, experience that is so often routed through imaging devices, and subjectivity that has learned not only to survive but even to thrive on technological shocks. RK/HF

McLuhan, Kittler, and new media

Canadian anthropologist Marshall McLuhan's *Understanding Media* (1964) was a breakthrough in the theorization of culture, generating terms such as "Gutenberg galaxy" and "the medium is the message." For him, all media were "extensions of man" modifying or amputating some other, former extension. The military development of gunpowder and firearms, which led to the loss of archery skills, is one example of how new technology makes older skills obsolete. The telephone extends the voice, even while it "amputates" penmanship. Gutenberg's invention of movable type produced the new medium of the book, which resulted in a reduction of communal relations since it is consumed in private. It was only television, a mass-consumed electronic medium, that reinstated what McLuhan termed the "global village." The "galaxy" half of "Gutenberg galaxy" reveals McLuhan's ambitions to conceive of distinct historical periods, or paradigms, much like Walter Benjamin's "Age" in "The Work of Art in the Age of Mechanical Reproduction." McLuhan's 1951 book *The Mechanical Bride*'s concentration on advertising's incitement of commodity desire situates media within the orbit of Marcel Duchamp's *Bride Stripped Bare by her Bachelors, Even*, whose Bride incites the Bachelors' intense longing for her nudity. The most famous of McLuhan's aphoristic phrases, "The medium is the message," does not refer to modernism's self-critical analysis of an aesthetic medium—its self-reflexive "message" being the nature of the medium itself: painting "about" painting, etc. Instead, his medium is not an aesthetic tradition, but rather the condition of a given stage of media. The "message" here understands the content of every new medium—or form of media—as being "about" an older one; for McLuhan, the content of writing is speech, just as the written word is the content of print, and print is the content of the telegraph.

Friedrich Kittler, professor of aesthetics and history of media at Humboldt-University, Berlin, goes further, seeing the military as the motor of new media, as in his *Gramophone, Film, Typewriter* (1986). A nuclear explosion's release of high-intensity electromagnetic pulses that would immobilize communications networks drove the military, he said, to develop the fiber-optic channel that supports the cyber-spatial web. A product of the Bomb, then, the Internet joins the repeating rifle's enabling of the film projector, and consequently the desire for cinema.

FURTHER READING
Russell Ferguson et al., *Douglas Gordon* (Los Angeles: Museum of Contemporary Art, 2001)
Lynne M. Herbert et al., *James Turrell: Space and Light* (Houston: Contemporary Arts Museum, 1990)
Chrissie Iles et al., *Into the Light: The Projected Image in American Art, 1964–1977* (New York: Whitney Museum of American Art, 2001)
David Ross et al., *Bill Viola* (New York: Whitney Museum of American Art, 1998)
Chris Townsend (ed.), *The Art of Bill Viola* (London: Thames & Hudson, 2004)
Scott Watson et al., *Stan Douglas* (London: Phaidon Press, 1998)

▲ 2003

4 • Stan Douglas, *Overture*, 1986
Black-and-white 16mm film with looping device and mono optical soundtrack, each rotation seven minutes

2000–2015

2001

A mid-career exhibition of Andreas Gursky at the Museum of Modern Art in New York signals the new dominance of a pictorial photography, which is often effected through digital means.

The photograph appears distant from the digital image. With its chemical registration of continuous gradients of ambient light on chemically treated paper, the photograph might be taken to exemplify the analogical image: the photograph as a direct imprint of things in the world in opposition to the digital image as a manipulated screen of information scanned with a computer. Slowly but surely, however, digital techniques have penetrated photographic image-production in various forms of media—and, in some instances, displaced it altogether. Many artists have explored the uneasy commingling of the photographic and the digital—Jeff Wall (born 1946) and Andreas Gursky most prominent among them—and sometimes they have done so in ways that exploit our uncertainty about the physical status, even the ontological nature, of the resultant image. At least for the time being, the traits long associated with photography—monocular perspective, realistic detail, and, above all, documentary referentiality—remain natural enough to us so that any digital alteration of these terms still appears disruptive, but perhaps this will soon change. (Of course, there are other kinds of digital art too, as well as different experiments in web or Internet art, but the practical terms of such work, let alone the critical terms of its evaluation, are not yet in place; this too might soon change.)

Ersatz unities

The last decade has witnessed a transformation in image technologies as dramatic as those changes registered by the photography debates in the late twenties and early thirties and by the various Pop manifestations in the late fifties and early sixties. As Wall observed as early as 1989, "The historical consciousness of the medium [of photography] is altered": rather than a direct "message without a code" (as Roland Barthes defined it in "The Photographic Message" [1961]), the photograph might now be shot through with complicated codes of various sorts (including the computer sense of "code"). This new status of the photograph not only qualifies its presumed referentiality but also revises its possible applications in art. Consider photocollage and photomontage: the uses of these devices in modernism were diverse, but they all depended on the explicit juxtaposition of referential photographs

for their effects, whether these were aesthetically subversive as in Dada, psychically charged as in Surrealism, or politically agitational as in Constructivism (and indeed in much Dada also). However, with digital manipulation—that is, of images taken with a digital camera or of photographic negatives scanned into digital files that can then be revised or changed utterly, with entirely new negatives printed as a result—the old logic not only of documentary photographs but also of montaged ones is transformed. Proportions can be adjusted, perspectives corrected, color changed (Gursky, for example, makes all these alterations routinely); and, for that matter, novel images can be synthesized. In the process montage becomes not only hidden but also internal to the single image, almost intrinsic to it: more a seamless join than a physical cut, more a morphing than a montaging, the digital composite exists somewhere between a photographic document and an electronic puzzle.

At the same time that digital photography signals technological advance, in the hands of practitioners like Wall and Gursky it often evokes historical art (a related dialectic is active in art involving projected images). Quite apart from its frequently grand scale and sometimes explicit references, this work tends to pictorial composition, even to narrative themes, in ways that often align it with figurative painting or classical cinema more closely than with unmanipulated or straight photography. If the pictorial image was under assault in advanced art after Minimalism (especially in Process, Body, and Installation art)—in large part because it seemed to promise a virtual space that a private consciousness or a unitary subject might enter and inhabit—the pictorial image now returns triumphant in digital photography (and much other art besides). Moreover, if "pictorialism" dominated painting and photography *before* modernist art, it now seems to reign supreme *after* it as well. This has led some critics to decry artists like Wall and Gursky as conservative, but they might also be understood to recover a semiotically hybrid and temporally heterogeneous type of image that was pervasive before abstract painting and straight photography became dominant—to recover (as the curator Peter Galassi has put it vis-à-vis Gursky) a "long tradition of fluid mendacity."

Wall is explicit about the restorative dimension of his practice. In his view the avant-garde aesthetic of the fragment—of collage and montage—has become almost rote, as has the privilege given

1 • Jeff Wall, *The Storyteller*, 1986
Color transparency in lightbox, 229 × 437 (90⅛ × 172)

any rupture with art history; for Wall this is a misbegotten celebration of discontinuity that overlooks the greater continuity "which is that of capitalism itself." "The rhetorics of critique have had to make an 'other' out of the pictorial," he has charged; "this truth has been totalized, and transformed into what [Theodor] Adorno called 'identity'. I am struggling with that identity." According to this argument, the fragmentation of both the art work and the viewing subject is now normative, "our orthodox form of cultural lucidity," in a way that renders a return to the unified picture and the centered viewer a critical move, a "transgression against the institution of transgression" (Wall).

For some critics of Wall this argument is sophistry, yet it is not all, or not precisely, that Wall performs with his large color transparencies set in luminous light boxes. Even as his format mimics advertisement display, his images often suggest historical painting, and sometimes they are composed in a manner that specifically recalls the neoclassical tableau—that is, a staged ensemble of painted figures captured in a significant action or pregnant moment. *Diatribe* (1985), which shows two welfare mothers, one with a child on her hip, in the vague terrain of a working-class backlot, is calculated to resonate—in difference as much as in similarity—with such Old Master paintings as *Landscape with Diogenes* (1648) by Nicolas Poussin. And *The Destroyed Room* (1978), which stages the violent trashing of the apparent apartment of a prostitute, with clothes strewn and mattress slashed, is meant to evoke *The Death of Sardanapalus* (1827) by Eugène Delacroix, his Romantic (indeed Orientalist) vision of an entire harem put to the sword. Yet Wall

focuses his art-historical gaze not only on traditional painting but also on modernist painting at its very birth. As the critic Thierry de Duve has written, "It is as though Wall had gone back to the fork in the roadway of history, to that very moment when, around Manet, painting was registering the shock of photography; and as though he had then followed the route that had not been taken by modern painting, and had incarnated the painter of modern life as a photographer." In this way, even as Wall seeks to reinscribe "the painting of modern life" in contemporary photography, he also wants to redeploy its social critique—to expose new myths of capitalist society, as Manet often did with old myths, at the same time that he stages them. Wall has cited Manet a number of times. *Woman and Her Doctor* (1980–1), which shows these two affluent figures seated together at a cocktail party, updates the ambiguous rendezvous of a bourgeois couple depicted by Manet in *In the Conservatory* (1879); and *The Storyteller* [1] resituates his famous *Le Déjeuner sur l'herbe* (1863) in a wasteland under a highway bridge, where Wall replaces the leisurely Parisian bohemians of Manet with the homeless native Canadians of his home town Vancouver.

For some critics the unities of this art are forced; for others it is its very lack of consistency, its pastiche of references, that is problematic. For his part Wall seems to intend both effects: to produce a pictorial order that reflects (on) a social order, and to suggest that both are in decay, with the former a symptom of the latter. This is the principal lesson that he takes from Manet, who, according to Wall, inherited a traditional painting (again, the tableau) that was in crisis, a crisis that the spread of photography only exacerbated.

What once seemed organic and composed in traditional painting had become mechanistic and fragmented in Manet, who opposed the "ersatz unity" of contemporary Salon pictures with what Wall terms a "negative, almost memorializing unification of the image around a ruined, or even a dead concept of the picture." Wall seeks to recover and to advance this dialectic of "unity and fragmentation" ("I feel that my work is in fact both classical and grotesque"), and to make it the instrument of "profane illuminations" of his own social world.

Delirious spaces

Sam Taylor-Wood (born 1967) also cites historical paintings in some of her work, which includes video and sound installations as well as large photographs; her *Wrecked* (1996), for example, is a contemporary version of *The Last Supper* of Leonardo. "These allusions and quotations are a self-discipline that I impose on my history," Taylor-Wood has remarked; but as with Wall there are contemporary social insights to be gleaned here as well. Her series *Five Revolutionary Seconds* (1995–8), for instance, presents a panoramic frieze of mostly bored subjects in mostly affluent homes, connected only by intermittent acts or gestures of violence. Like many of her peers who use projected images, Taylor-Wood is concerned with extreme states (this is evident from her titles alone): "I have an interest, both personal and social, in ungluing the setting." In her *Soliloquy* series [2], she presents large portraits of a figure above with smaller panoramas of various scenes below, on the model of the Renaissance altarpiece with its underlying "predella" pictures. Here an Old Master format, developed to convey different orders of existence (heavenly and earthly) in the scenes of a saintly life, is updated to evoke different orders of experience, objective and subjective, public and private, perhaps conscious and unconscious.

2 • Sam Taylor-Wood, *Soliloquy I*, 1998
C-type color print (framed), 211 × 257 (83⅛ × 101⅛)

3 • Andreas Gursky, *Hong Kong and Shanghai Bank***, 1994**
Chromogenic color print, 226 × 176 (89 × 69¼)

Influenced by James Coleman, Taylor-Wood draws on precedents in cinema, theatre, and the *tableau vivant* as much as in painting and photography, and like her peers (such as Tacita Dean) she moves back and forth between mediums in an attempt "to offer a 'provocation' of meanings." Andreas Gursky is far more focused on traditions of photography; but he too produces a kind of pictorial tension, here produced in part through digital montage. In the early eighties, along with Thomas Struth, Thomas Ruff, and Candida Höfer, Gursky studied with Hilla and Bernd Becher at the Düsseldorf Art Academy, where he was schooled in the distinctive Becher approach: photograph a single subject as uniformly and objectively as possible, usually in black and white; then display the results typologically, usually in grids or series. His early photographs of security guards and Sunday activities adapted these principles. However, unlike the Bechers, Gursky worked in color (his is the first generation of German photographers to use it extensively), and soon he experimented with digital splicing as well (at first to create sleek urban panoramas). By the nineties most of his prints had become large and pictorial, though he was never as concerned with art-historical allusions as Wall (whom Gursky nonetheless acknowledges as an important influence at this time). Gursky does produce the occasional "Romantic" landscape (e.g., *Aletsch Glacier* [1993]), but his primary interest lies in a different sort of contemporary "sublime"—in the intense spaces of detailed commodity production (*Siemens* [1991]), furious financial exchange (*Tokyo Stock Exchange* [1990]), spectacular professional sports (*EM, Arena, Amsterdam I* [2000]), rave youth culture (*May Day IV* [2000]), excessive product display (*99 Cent* [1999]), and other such "hyperspaces" characteristic of global capitalism both at work and at play [3].

Many of these spaces are already spectacular, with people and products alike arranged in total designs or as "mass ornaments" (to use the term of the critic Siegfried Kracauer, who first pointed to this phenomenon in industrial culture); yet Gursky also manipulates his panoramic images to further heighten photogenic patterns of repeated forms and colors. Sometimes his digital stretching of the photograph—spliced images with two or three perspectives and the like—seems driven by a desire to image spaces that might not otherwise be given to sight or to representation, that test our "cognitive map" of the postmodern world (to borrow a term from the critic Fredric Jameson). For example, *Salerno* (1990) is a vast panorama of color-coded vehicles, containers, cranes, and freighters, a "second nature" of commercial distribution that has overwhelmed the ancient landscape of this Mediterranean port, and still it is the merest fragment of the contemporary network of maritime transport. Other spaces pictured by Gursky appear almost abstract (the tarmac in *Schipol* [1994], the warehouses in *Toys "R" Us* [1999], the river banks in *Rhine II* [1999], and so on); they attest to a deterritorializing of space that is also characteristic of advanced capitalism, a stripping-down that Gursky underscores with further digital edits.

For Jameson, delirious spaces are a distinctive attribute of post-modern culture, and his prime example are the vast atriums of John Portmann hotels, which Gursky has attempted to image, again through digital edits, more than once. In *Times Square* (1997), for example, he montaged two views of one such atrium, seen in opposite directions along a single line of sight, to convey its vertiginous extent. Again, one stake of his photography is the very representability of a post-Fordist order where capital seems in ceaseless flux, and architecture and urban space seem overwhelmed by images—indeed where the "photographic face" of the modern world described by Kracauer in 1928 seems outdone by "the communicational signifier" of a postmodern world in which media and environment are often difficult to distinguish. Perhaps this world cannot be imaged by the old means of painting and photography, which still tend to locate viewers punctually, in one place. Perhaps this can be done only by the kind of "computer vision" that Gursky and others affect—precisely because this vision seems to exceed any human perspective, any physical placement. But the danger is that such vision might also render this world natural, even beautiful or again sublime, all in a fetishistic manner that fully delivers on the appearances of the image but otherwise obscures the reality of labor. (I echo here the famous critique that Walter Benjamin made of Neue Sachlichkeit photographers like Albert Renger-Patzsch in 1931—that they beautified the industrial world.) In other words, these beautiful images might help to reconcile us to a world without qualities where the human subject has little place. In this regard Gursky might take away too finally what Wall seems to restore too quickly—the authority of a unified subjectivity. HF

Hubertus von Amelunxen (ed.), *Photography After Photography* (Amsterdam: G&B Arts, 1996)
Michael Bracewell et al., *Sam Taylor-Wood* (London: Hayward Gallery; and Göttingen: Steidl, 2002)
Thierry de Duve et al., *Jeff Wall* (London: Phaidon Press, 1996)
Peter Galassi, *Andreas Gursky* (New York: Museum of Modern Art, 2001)
Charlotte Cotton, *The Photograph as Contemporary Art* (London: Thames & Hudson, 2009)

▲ 1993a, 2007a ● 1998, 2003 ■ 1968a ◆ 1968a, 1984b ▲ 1929, 1935

2003

With exhibits such as "Utopia Station" and "Zone of Urgency," the Venice Biennale exemplifies the informal and discursive nature of much recent artmaking and curating.

In a gallery over the last decade you might have happened on one of the following: a room empty except for a mound of identical candies wrapped in brilliant foils, the candies free for the taking. Or, space where the office contents are dumped into the exhibition area, and a couple of pots of Thai food are on offer to visitors, who might be puzzled enough to linger, eat, and talk. Or an array of abstract bulletin boards, drawing tables, and discussion platforms, some concerning a role player of the near past (such as Robert McNamara, Secretary of Defense under Presidents Kennedy and Johnson), as though a documentary script were in the making or a history seminar had just let out [1]. Or, finally, a makeshift altar, monument, or kiosk, cobbled together out of plastic, cardboard, and tape, and filled, like a homemade study-shrine, with images and texts devoted to a particular artist, writer, or philosopher (e.g., Piet Mondrian, Raymond Carver, or Georges Bataille) [2]. Such works, which exist somewhere between a public installation,

1 • Liam Gillick, _McNamara_, 1994
Brionvega Algol TVC 11R, 35mm film transferred onto appropriate format, Florence Knoll table (optional), copies of various drafts of the film _McNamara_, dimensions variable

▲ 1987 ● 1989, 2009a ▲ 1913, 1917a, 1930b, 1931b, 1944a

2 • Thomas Hirschhorn, *Raymond Carver Altar,* **1998–9**
Mixed-media installation at The Galleries at Moore, Philadelphia

an obscure performance, and a private archive, can also be found in nonart spaces, which might render them even more difficult to decipher in aesthetic terms; nonetheless, they can be taken to indicate a distinctive turn in recent art. In play in the first two examples—works by the Cuban-American Felix Gonzalez-Torres ▲ and the Thai Rirkrit Tiravanija respectively—is a notion of art as an ephemeral offering, a precarious gift; and in the second two instances—works by the English Liam Gillick (born 1964) and the Swiss Thomas Hirschhorn (born 1957) respectively—a notion of art as an informal probing into a specific figure or event in history or politics, fiction or philosophy. There is also a utopian dimension in the first approach and an archival impulse in the second.

This way of working includes other prominent practitioners
• such as the Mexican Gabriel Orozco, the Scot Douglas Gordon, the French Pierre Huyghe, Philippe Parreno (born 1964), and Dominique Gonzalez-Foerster (born 1965), the Americans Renée
■ Green, Mark Dion, and Sam Durant, and the English Tacita Dean. They draw on a wide range of artistic precedents such as the performative objects of Fluxus, the humble materials of Arte Povera, and the site-specific strategies of institution-critical artists like Marcel
◆ Broodthaers, Michael Asher, and Hans Haacke. Yet the current generation has also transformed the familiar devices of the ready-

made, collaboration, and installation. For example, some of these artists treat television shows and Hollywood films as found images: in *The Third Memory* (2000) Huyghe reshot parts of the 1975 Al Pacino movie *Dog Day Afternoon* with the real-life protagonist (a reluctant bank robber) returned to the lead role [3], and Gordon ▲ has adapted a couple of Hitchcock films in drastic ways. For Gordon such pieces are "time readymades," given narratives to be sampled in large image-projections (a pervasive medium in contemporary art), while the French critic Nicolas Bourriaud has championed such work under the rubric of "post-production." This term underscores the secondary manipulations (editing, special effects, and the like) that are almost as pronounced in this art as in film; it also suggests a changed status of "the work" of art in an age of information. However one regards this age (if it exists as a distinct epoch at all), "information" does often appear as a kind of ultimate readymade, as data to be reprocessed and sent on, and some of these artists work accordingly "to inventory and select, to use and download" (Bourriaud), to revise not only found images and texts but also given forms of exhibition and distribution.

One upshot of this way of working is a "promiscuity of collaborations" (Gordon) in which the postmodernist complications of
• artistic originality and authorship are pushed to the limit. Consider

▲ 1987, 1989, 2009a, 2009c ● 1989, 1998 ■ 1992, 1993c, 1998 ◆ 1962a, 1967b, 1970, 1971, 1972a ▲ 1998 ● 1977a, 1980, 1984b

3 • Pierre Huyghe, *The Third Memory*, 1999
Double projection, Beta digital, 4 minutes 46 seconds

a collaborative work like *No Ghost Just a Shell* (1999–2002) led by Huyghe and Parreno. After they learned that a Japanese animation company wanted to sell some of its minor characters, they bought one such person-sign, a girl named "AnnLee," and invited other artists to deploy her in their own work. Here the art piece becomes a "chain" of pieces: for Huyghe and Parreno, *No Ghost Just a Shell* is "a dynamic structure that produces forms that are part of it"; it is also "the story of a community that finds itself in an image." Or consider another group project that also adapts a ready-made product to unusual ends. Here Gonzalez-Foerster, Gillick, Tiravanija, and others detail how to customize a coffin out of cheap furniture from IKEA; the work is titled *How to Kill Yourself Anywhere in the World for Under $399*.

 The tradition of ready-made objects, from Marcel Duchamp to ▲ Damien Hirst, often mocks high art or mass culture or both; in these examples it is mordant about global capitalism as well. Nevertheless, the prevalent sensibility of the new work tends to be expansive, even ludic—again an offering to other people and/or an opening to other discourses. At times a benign image of globaliza-

tion is also advanced (this international group of artists finds one of its preconditions there), and again there are utopian moments ▲ as well: for example, Tiravanija has spearheaded a "massive-scale artist-run space" called "The Land" in rural Thailand that is designed as a collective "for social engagement." More modestly, these artists aim to fashion passive viewers into temporary communities of active discussants. In this regard Hirschhorn, who once worked in a communist collective of graphic designers, sees his makeshift structures dedicated to artists, writers, and philosophers as a species of passionate pedagogy, and they do partake a little of • the agitprop kiosks of the Constructivist Gustav Klutsis as well as of the obsessive constructions of the Dadaist Kurt Schwitters. With these works Hirschhorn seeks to "distribute ideas," "radiate energy," and "liberate activity" all at once: he wants not only to familiarize his audience with an alternative public culture but also to charge this relationship with affect. Other figures, some of whom were trained as scientists or architects (such as the Belgian Carsten Höller [born 1961] and the Italian Stefano Boeri [born 1956] ■ respectively), adapt a model of collaborative research and experi-

▲ 1914, 1986, 2007c ▲ 1989, 2009a ● 1920, 1926 ■ 1992

ment closer to the science laboratory or the design firm than the traditional artist studio. "I take the word 'studio' literally," Orozco remarks, "not as a space of production but as a time of knowledge."

"A promiscuity of collaborations" has also meant a promiscuity of installations: installation is the default format, and exhibition the common medium, of much contemporary art. (In some measure this tendency is driven by the increased importance of huge shows in the art world: there are now biennials and triennials in Venice, Saõ Paulo, Istanbul, Gwangju, Seoul, Yokohama). Often entire exhibitions are given over to messy juxtapositions of projects—photos and texts, images and objects, videos and screens—and occasionally the effects are more chaotic than communicative: in these instances legibility as art is sacrificed without great gains in other kinds of literacy. Nonetheless, discursivity and sociability are central concerns of the new work, both in its making and in its viewing. "Discussion has become an important moment in the constitution of a project," Huyghe comments, while Tiravanija aligns his art, as "a place of socialization," with a village market or a dance floor.

Interactive aesthetics

In this time of mega-exhibitions the artist often doubles as a curator. "I am the head of a team, a coach, a producer, an organizer, a representative, a cheerleader, a host of the party, a captain of the boat," Orozco comments, "in short, an activist, an activator, an incubator." This rise of the artist-as-curator is complemented by the rise of the curator-as-artist; maestros of large shows have become very prominent over the last decade. Often the two groups share models of working as well as terms of description. For example, several years ago Tiravanija, Orozco, and other artists
▲ began to speak of projects as "platforms" and "stations," as "places that gather and then disperse," in order to underscore the casual communities that they sought to create. In 2002, Documenta 11, curated by an international team led by the Nigerian Okwui Enwezor (born 1963), was also conceived in terms of "platforms" of discussion, scattered around the world, on such topics as "Democracy Unrealized," "Processes of Truth and Reconciliation," "Creolité and Creolization," and "Four African Cities"; the actual exhibition in Kassel, Germany, was only the final such "platform." And in 2003 the Venice Biennale, curated by another international group headed by the Italian Francesco Bonami (born 1955), featured sections titled "Utopia Station" and "Zone of Urgency," both of which exemplified the informal discursivity of much recent artmaking and curating. Like "kiosk," the terms "platform" and "station" call up the old modernist ambition to modernize
● culture in accordance with industrial society (El Lissitzky spoke of his *Proun* designs as "way-stations between art and architecture"). Yet, these terms also evoke the electronic network, and many artists and curators do use the Internet rhetoric of "interactivity," though the means applied to this end are usually far funkier and more face-to-face than any chat room on the web.

Along with the emphasis on discursivity and sociability, a concern with the ethical and the everyday is often voiced: art
▲ is "a way to explore other possibilities of exchange" (Huyghe), a model of "living well" (Tiravanija), a means of being "together in the everyday" (Orozco). "Henceforth," Bourriaud declares, "the group is pitted against the mass, neighborliness against propaganda, low tech against high tech, and the tactile against the visual. And above all, the everyday now turns out to be a much more fertile terrain than pop culture." The possibilities of such interactive aesthetics seem clear enough, but there are problems here as well. Sometimes radical politics are ascribed to the art by a shaky analogy between an open work and an inclusive society, as if a desultory form might evoke a democratic community, or a non-hierarchical installation predict an egalitarian world. Hirschhorn sees his projects as "never-ending construction sites," while Tiravanija rejects "the need to fix a moment where everything is complete." But one service that art can still render is to make a stop, take a stand, in a concrete register that constellates the aesthetic, the cognitive, and the critical. Moreover, formlessness in society might be a condition to contest rather than to celebrate in art—a condition to make over into form for purposes of reflection and resistance (as some modernist painters attempted to do).
● The artists in question frequently cite the Situationists as a model of critique, but the Situationists valued precise intervention and rigorous organization above all other things.

"The question," Huyghe argues, "is less 'what?' than 'to whom?' It becomes a question of address." Bourriaud also sees art as "an ensemble of units to be reactivated by the beholder–manipulator." In many ways this approach is another legacy of the Duchampian provocation, but when is such "reactivation" too great a burden to place on the viewer? As with previous attempts to
■ involve the audience directly (as in some Conceptual art), there is a risk of illegibility, which might return the artist as the principal figure and the primary interpreter of the work. At times, it must be admitted, "the death of the author" has meant not "the birth of the reader," as Roland Barthes speculated in his 1968 essay of that title, so much as the befuddlement of the viewer. Moreover, when has art *not* involved discursivity and sociability, at least since the Renaissance? Such an emphasis might risk a strange situation of discussion and interaction pursued for their own sakes. Collaboration, too, is often regarded as a good in itself: "Collaboration is the answer," the peripatetic curator Hans Ulrich Obrist has remarked wryly, "but what is the question?"

Perhaps discursivity and sociability are foregrounded in art today because they appear scarce in other spheres (at least in the United States), and the same might hold true for the ethical and the everyday: it is as if the very idea of community has taken on a utopian inflection. Even art audiences cannot be taken for granted but must be conjured up every time, which might be one reason why contemporary exhibitions sometimes feel like remedial work in socialization ("come play, talk, learn with us"). Yet if participation appears threatened in other areas of life, its privileging in art

must function in part as a compensatory substitute. At one point Bourriaud almost suggests as much: "Through little services rendered, the artists fill in the cracks in the social bond." And only when he is most grim is he most revealing: "The society of spectacle is thus followed by the society of extras, where everyone finds the illusion of an interactive democracy in more or less truncated channels of communication." The situation in the global art world would seem to be no different.

An archival impulse

Yet there are hopeful signs here as well, not only in the utopian aspiration of this art, but also in its archival impulse, which might be taken as a tacit paradigm in contemporary practice. This impulse, which has many precedents in postwar art, is manifest in a will to make historical information, often lost, marginal, or suppressed, physical and spatial, indeed interactive, usually through found images, objects, and texts arranged in installations. Like any archive, the materials of this art are found but also constructed, public but also private, factual but also fictive, and often they are put together simply for the occasion. Frequently this work also manifests a kind of archival architecture, a physical complex of information (as in the kiosks of Hirschhorn or the platforms of Gillick), as well as a kind of archival logic, a conceptual matrix of citation and juxtaposition. Hirschhorn speaks of his process as one of "ramification," and much of this art does branch out like a tree or, rather, like a weed or a "rhizome" (a term drawn from the philosopher Gilles Deleuze that others like Gillick and Durant also use). Perhaps the life of any archive is a matter of mutative growth of this sort, through connection and disconnection, which this art also reveals. "Laboratory, storage, studio space, yes," Hirschhorn has remarked, "I want to use these forms in my work to make spaces for the movement and endlessness of thinking...."

The archival impulse is strong in Tacita Dean, who works in a variety of mediums in photography, drawing, and sound, but primarily in short films and videos accompanied by texts that she calls "asides." Dean is drawn to people, things, and places that have become lost somehow, sidelined or stranded. Typically she begins with one such event and traces it as it ramifies into an archive as if of its own accord. Consider *Girl Stowaway* (1994) an 8-minute, 16-millimeter film in color and black and white with a narrative aside. Here Dean happened on a photograph of a young stowaway named Jean Jeinnie who, in 1928, sneaked onto a ship named *Herzogin Cecilie,* bound from Australia to England. Several years later the ship was towed to Starehole Bay on the South Devon Coast, where it eventually broke up.

The archive of *Girl Stowaway* forms as a tissue of coincidences. First Dean loses the photograph in a bag mishandled at Heathrow, another "stowaway" that turns up later in Dublin. Then, as she researches Jean Jeinnie, she hears echoes of her name everywhere—from the author Jean Genet to David Bowie's song *Jean Genie.* When Dean travels to Starehole Bay to inquire about

the ship, a girl is murdered on the cliffs above the harbor on the very night that Dean also spends there. *Girl Stowaway* is thus an archive that includes the artist-as-archivist within it. "Her voyage was from Port Lincoln to Falmouth," Dean writes. "It had a beginning and an end, and exists as a recorded passage of time. My own journey follows no such linear narrative. It started at the moment I found the photograph but has meandered ever since, through uncharted research and to no obvious destination. It has become a passage into history along the line that divides fact from fiction, and is more like a journey through an underworld of chance intervention and epic encounter than any place I recognize. My story is about coincidence, and about what is invited and what is not." In this way archival work is also an allegory of archival work.

In another film-and-text piece Dean tells the story of another lost-and-found figure. In 1968 one Donald Crowhurst, a failed businessman from Teignmouth, a coastal town in England hungry for tourist recognition, was driven to enter the Golden Globe Race to be the first to sail solo nonstop around the world. Yet neither sailor not boat, a trimaran christened *Teignmouth Electron*, was prepared, and Crowhurst soon faltered: he faked his logs, then broke off all radio contact. He began to suffer from time-madness, with incoherent log entries that amounted to a private discourse on God and the Universe. Eventually Crowhurst jumped overboard with his chronometer, just a few hundred miles from the coast of Britain.

Dean treats this event obliquely in three short films. The first two, *Disappearance at Sea I* and *II* (1996, 1997) were shot at different lighthouses: in the first, filmed near Berwick, images of the lighthouse bulbs alternate with blank views out to the horizon as darkness slowly descends; in the second, filmed in Northumberland the camera mounted on the lighthouse apparatus provides a continuous panorama of a sea bereft of human life. In the third film, *Teignmouth Electron* (2000) Dean travels to Cayman Brac in the Caribbean to document the remains of the trimaran. It has "the look of a tank or the carcass of an animal or an exoskeleton left by an arrant creature now extinct," she writes. "Whichever way, it is at odds with its function, forgotten by its generation and abandoned by its time." In this extended work, then, "Crowhurst" is a term that implicates others in an archive that reveals an ambitious town, a misbegotten race, a metaphysical seasickness, and an enigmatic remnant.

And Dean lets this archive ramify further. While on Cayman Brac she happens on another derelict structure dubbed "the Bubble House" by locals [4], and documents this "perfect companion" to the *Teignmouth Electron* in another short film and text (1999). Designed by a Frenchman jailed for embezzlement, the Bubble House was "a vision for perfect hurricane housing, egg-shaped and resistant to wind, extravagant and daring, with its Cinemascope-proportioned windows that look out onto the sea." Never completed and long deserted, it now sits in ruin "like a statement from another age." "I like these strange monoliths that sit in this no place," Dean remarks of another "failed futuristic vision" that she has reclaimed as an archival object, fully aware that a

▲ 2009a ● 2009b ■ 1998

4 • Tacita Dean, _Bubble House_, 1999
R-type photograph, 99 × 147 (39 × 57⅞)

"no place" is the literal meaning of "utopia" and that it conjures up a "no time" as well. In a sense all her objects serve as arks of uncertain temporalities, in which the here-and-now of the work functions as a crux between an unfinished past and a reopened future. And herein lies the most extraordinary aspect of such archival art: its desire to turn failed visions of the past into scenarios of alternative futures—in short, to turn the no-place of archival remains into the no-place of utopian possibility. HF

FURTHER READING

Claire Bishop, "Antagonism and Relational Aesthetics," _October_, no. 110, Fall 2004

Laurence Bossé et al., _Tacita Dean: 7 Books_ (Paris: Musée d'Art Moderne de la Ville de Paris, 2003)

Nicolas Bourriaud, _Postproduction_ (New York: Lukas & Sternberg, 2002) and _Relational Aesthetics_ (Dijon: Les Presses du Réel, 1998)

Okwui Enwezor (ed.), _Documenta 11: Platform 5_ (Kassel: Hatje Cantz Verlag, 2002)

Tom McDonough, "No Ghost," _October_, no. 110, Fall 2004

Hans Ulrich Obrist, _Interviews, Volume I_ (Milan: Edizioni Charta, 2003)

2007 a

With a large retrospective at the Cité de la Musique, Paris acknowledges the importance of American artist Christian Marclay for the future of avant-garde art; the French foreign ministry expresses its own belief in this future by sending Sophie Calle to represent France at the Venice Biennale; while the Brooklyn Academy of Music commissions the South African William Kentridge to design the sets for their production of *The Magic Flute*.

▲ n "Modernist Painting," published in 1960, Clement Greenberg argued that the authentic self-reflexive—or, as he called it, "self-critical"—avant-garde artist is the one who tests the work of art against the logic of its own specific conditions, and who acknowledges the tradition of his medium by referring to its history, at least implicitly. "The self-criticism of modernism grows out of, but is not the same thing as the criticism of the Enlightenment. The Enlightenment criticized from the outside, the way criticism in its accepted sense does; modernism criticizes from the inside, through the procedures themselves of that which is being criticized," procedures Greenberg called a specific medium's "area of competence." (Accordingly, he wrote, "I cannot insist enough that Modernism has never meant anything like a break with the past. It may mean a devolution, an unraveling of anterior tradition, but it also means its further evolution. Modernist art develops out of the past without gap or break, and wherever it ends up, it will never stop being intelligible in terms of the past.")

Early modernist art can be said to have thus "figured forth" the work's support—summoning it up to the surface as a reflexive image of the work's very ground—as when the Cubist grid not only represents the flatness and lateral spread of its surface, as well as the shape of that painting's rectangular frame, but also imitates—or "figures forth"—the interwoven mesh of its canvas. These strategies might be called the "rules" of the grid. Similarly, in his 1916 series ▲ *Pier and Ocean*, Piet Mondrian turned notations of the cresting waves into cross-axial glyphs so that the sea would simultaneously "figure forth" the perspective of visual space (its horizon line crossed by the trajectory of visual penetration of the space) *and* the flatness and weave of the canvas. Fulfilling this aesthetic obligation placed the Cubists and Mondrian squarely within Greenberg's authentic avant-garde. In the opposite camp, Greenberg placed "kitsch," which he had attacked in his earlier essay "Avant-Garde • and Kitsch" as the simulacrum of art rather than the real thing, adding that it had become the polluted atmosphere of the very culture we breathe. Kitsch's identity, he maintained, derives from its feckless indifference to the very idea of a medium, thereby enforcing the corruption of taste by the substitution of simulated effects—as in formica imitations of wood or marble—in place of "self-criticism." If the avant-garde has an authentic vocation, it is, he wrote, to mount a crusade against the pervasive spread of kitsch.

1 • Christian Marclay, *Video Quartet*, 2002
Four-channel DVD projection with sound, running time 14 minutes, each screen 243.8 × 304.8 (96 × 120), overall installation 243.8 × 1219.2 (96 × 480)

▲ 1960b ▲ 1917a ● 1960b

By the seventies, however, three developments seemed to have consigned this view of the modernist avant-garde and medium-specificity to the junk-heap of history: the "dematerialization" of the aesthetic object; the advent of conceptualism; and the ascendancy of Duchamp over Picasso as the century's most important artist. In her *Six Years: The Dematerialization of the Art Object* (1973), Lucy Lippard demonstrated how contemporary art (as ▲ represented for her by Postminimalism) condemned the crass market status of the Minimalists' commodified works of art—considered logical products of Greenberg's medium-specificity—a situation only remedied by the ephemeral condition of site-specific interventions, such as Sol LeWitt's wall drawings, and that of evanescent ● Performance art, as in the work of Chris Burden and Vito Acconci.

Another form of dematerialization alongside these manifestations was the transformation of object into "idea." This was the route taken by Joseph Kosuth in his manifesto "Art after Philosophy" of 1968. Pointing to the way that, after Ludwig Wittgenstein, Willard Quine, and A. J. Ayer, Western transcendental philosophy had been displaced by the (mostly British) analysis of language, Kosuth developed a parallel between this transformation in philosophy and that wrought by Marcel Duchamp when, with his readymades, he demanded of the serially produced, commercial object that it be understood merely as the proposition "This is art." Insisting that Duchamp's transposition dematerializes the object into mere idea or aesthetic definition, Kosuth concluded that to define art, as such, is to leave the modernist doctrine of the specific medium behind:

> *Being an artist now means to question the nature of art. If one is questioning the nature of painting, one cannot be questioning the nature of art. If an artist accepts painting (or sculpture), he is accepting the tradition that goes with it. That's because if you make paintings you are already accepting (not questioning) the nature of art.*

The ascendancy of Duchamp in "Art after Philosophy" over the seemingly unassailable dominance of Picasso already signals the decline of the specific medium, as when Kosuth dismisses the importance of modernism's demand for "self-critical" reflection on the nature of painting or sculpture by saying that Duchamp's transformation of object into statement had already cashiered the necessity ▲ of specific mediums. With "Ceci n'est pas une pipe," René Magritte had earlier submitted representation to language; and Marcel ● Broodthaers, with his repeated labels "this is not a work of art," in his *Eagles Department, Catalogues Section*, joined him in considering the work as statement. Kosuth's own demonstration of conceptualism, *One and Three Chairs*, backed an ordinary, readymade chair with a photograph of the same chair. On the wall was a textual panel displaying the dictionary definition of the word *chair*. With this Duchampian flood of language into art, the paradigms invented by Picasso now appeared to have been washed away. What was ■ left of collage, on the one hand, had contracted to the practice of "*décollage*" or photomontage, while the Cubist grid, on the other, was maintained merely in variations on the monochrome.

Art in the age of the postmedium condition

Installation art, the mixed-media presentations of tableaux inside museums and galleries, with its disdain for the specific medium, may be interpreted as the contemporary heir to the attack on medium-specificity mounted by the dematerialization of the art object, conceptualism, and Duchamp. As such, it is the herald of what we name the "postmedium condition," which, following ◆ Walter Benjamin when he spoke of "Art in the Age of Mechanical Reproduction," we might see as the hallmark of our own age of artistic production. And yet while installation art may appear to have been pervasive in recent years, not all contemporary artists bow to this condition. Some have developed new mediums as the ground or support for their representations and often invoke

2 • Christian Marclay, *Telephones*, 1995
Video, running time 7 minutes 30 seconds

year," he says, "and I began to feel that there was so much wasteland between L.A. and Oklahoma that somebody had to bring the news to the city. Then I had this idea for a book title—*Twenty-six Gasoline Stations*—and it became like a fantasy rule in my mind that I knew I had to follow." He photographed his *Parking Lots* from an airplane, making each print a demonstrably flat page, with the empty slots for the cars a grid of white, painted lines. Like the modernist grid, the repeated compartments secure the idea of the car as a multiple, produced in series, just like the little pamphlets themselves—a homage to Benjamin's conviction that we inhabit the "age of mechanical reproduction." Ruscha's consistent references to the car and to car culture suggests that his "technical support" is the very automobile itself, which in turn generates the "rules" of his medium—guaranteeing its specificity the way the Cubist grid had proposed the "rules" for modernist painting. Puddles of motor oil stain the tarmac of the *Lots*, the trace of the cars that had parked there. From this, Ruscha may have derived the rule for a subsequent series of books, which he called *Stains*. Explaining that the traditional medium of oil on canvas no longer interested him, he turned instead to eccentric materials to supply him the color with which to stain the fabric covers of his books (silk moiré, taffeta): substances such as blueberry extract, curry, chocolate syrup, and caviar. In this way, Ruscha's *Stains* gesture toward the previous development of modernist art into "stain painting," also called "color field."

As with Ruscha and the automobile, American artist Christian Marclay (born 1955) consistently refers to the history and culture of music, and of sound more generally, in his work. In *Video Quartet*, his masterpiece of 2002, Marclay places four DVD screens in a horizontal row, each screen displaying a compilation of clips from famous movies. Janet Leigh's open-mouthed scream in the shower of *Psycho* on one screen, competes with Ingrid Bergman's meditative singing of "You Must Remember This" from *Casablanca* on the next. These simultaneous passages, each an example of the commercial, cinematic medium of synchronous sound, are timed by Marclay to appear in conjunction with one another, in a cacophony that is both distracting and exciting. Here, synch sound can be said to be Marclay's "technical support," constituting a cinema-derived medium that he works to "figure forth." One instance is the frame from *West Side Story* where the five members of the gang snap their fingers in percussive unison. Another instance pairs the clip of Marilyn Monroe from *Gentlemen Prefer Blondes* snapping shut her fan with a resounding click at the exact moment that a geisha on the neighboring screen furls her own fan shut. A third, electrifying example juxtaposes an image of the mute Harpo Marx with a frame of cockroaches spilling onto a piano keyboard, which they frantically and soundlessly scurry over [1]. Both frames propel the viewer back down the history of film to silent cinema in 1929 with the momentous invention of synchronous sound. We could say that in letting us *see* the almost impossible image of the edge of audio tape running along the side of the celluloid strip, Marclay is using silence to "figure forth" sound.

the history of these mediums, even if they are newly wrought for art. In doing so, they are in effect returning to a form of medium-specificity, although in ways that depart from Greenberg's original modernist doctrine. Artists today who assume the mantle of the true avant-garde and resist the postmedium condition's kitsch do so by developing the rules of their new, individual mediums, and conceive ways to "figure forth" these supports (which, in distinction to traditional, historical mediums, we shall call "technical supports")—themselves drawn from commercial object-types, such as journalism, film, animation, or PowerPoint presentations.

Figuring forth the support

An early influence for dissenters from the postmedium condition ▲ was Ed Ruscha, whose work in the sixties was often published in small, inexpensive pamphlets of the photographs he took of stereotypical Los Angeles subjects: palm trees, swimming pools, parking lots, gas stations. Ruscha explains this latter choice: "I used to drive back [to Oklahoma, his birthplace] four or five times a

▲ 1960c, 1967a, 1968b

In *Video Quartet*, Ingrid Bergman sings her song meditatively while she watches herself in a mirror, as does Doris Day in another clip. Even though both singer and reflection are in the same frame, they constitute a "figuring forth" of the cinematic editing technique of angle/reverse angle. Another example of this trope is found in Marclay's video *Telephones* of 1995, where angle/reverse angle manages the exchange between two interlocutors as we concentrate on the face of one, then jump to the face of the other's reaction, and finally return to the first to see his or her response [2]. This swiveling back and forth is one way of establishing the continuity and density of the space of the film. Nothing could display angle/reverse angle better than the ringing of a telephone interrupted and received with the inevitable "Hello." Cut to the caller: "Darling it's me …"; Cut to: "What?" The entire plot of Hitchcock's *Dial M for Murder* could be said to be generated from the angle/reverse angle of the telephone call.

Like *Telephones*, James Coleman's masterly *I.N.I.T.I.A.L.S.*, a work made from a sequence of slides married to an audio tape (as in a PowerPoint presentation), evokes the same trope. Choreographing an image with two of his interlocutors facing directly out of the frame instead of toward one another, he "figures forth" the still photograph's immobility and thus the unavailability of angle/reverse angle to the single slide [3]. Roy Lichtenstein had
▲ demonstrated the same limitation for the comic book frame, as lovers exchange intimacies with one another, even while both undercut this by facing directly outward at the viewer. Coleman's self-critical acknowledgment of this "rule" of his technical support surges forth in the sound track of *I.N.I.T.I.A.L.S.* in a quote from W. B. Yeats's play *The Dreaming of the Bones*, when the narrator asks, "Why do you gaze, one on the other, and then turn away?" in a perfect acknowledgment of the limitations of the slide-tape.

The French artist Sophie Calle (born 1953) began her career as a conceptual photographer, marrying text to image. Quickly, however, she turned to a new "technical support" for the development of her medium. Adapting investigative journalism (think *Washington Post* and Watergate), Calle turned herself into a

4 • Sophie Calle, *Take Care of Yourself*, 2007 (detail with Miranda Richardson)
Fine art print dry-mounted on aluminum, wooden frame, glass, 98 × 78.5 (38½ × 31)

reporter on the track of the unknown. The 1983 work *Address Book* developed from the little telephone register someone had lost in a café in Paris. Calle grabbed the abandoned object and called every number in the book, so as to interview the entry's subject about the absent owner of the telephone list, her project being to build an idea of the man who had lost it from the network of his acquaintances. Driving home investigative journalism as the work's "technical support," these interviews and Calle's conclusions about the owner's character were published daily in the French newspaper *Libération*.

The later work *A Woman Vanishes* focuses on the newspaper account of Benedicte, a guard for Calle's 2003 retrospective at the Centre Pompidou "M'a tu vue?" Fascinated by Calle's working process, the guard followed visitors of the exhibition and furtively snapped their pictures. Later, a mysterious fire on the Île Saint-Louis, where Benedicte's Paris apartment was located, reduced her home to ashes. The police found burned negatives of the pictures there, but Benedicte herself had disappeared. The daily reports of the police investigation—dredging the Seine River, interviewing residents of Benedicte's neighborhood—photographed from the newspapers and made into the work, allows *A Woman Vanishes* to "figure forth" Calle's very journalistic support.

In 2007, when she was selected to represent her country at the Venice Biennale, Calle acted on her peculiar sense of humor, advertising in newspapers for a curator for her show. When
▲ Daniel Buren answered the ad, she picked him. The work featured, *Take Care of Yourself*, took as its subject an e-mail sent to Calle by a lover to terminate their affair absolutely and abruptly. The height of hypocrisy, the letter ended "take care of yourself." On the work's multiple video screens, many women, all professionals in their specific fields, including the actresses Catherine Deneuve, Jeanne Moreau, and Miranda Richardson [4], read the letter aloud, performing its cruelty. Others sing it; still another

3 • James Coleman, *I.N.I.T.I.A.L.S.*, 1993–4
Projected images with audio narration

▲ 1960c

▲ 1971

Brian O'Doherty and the "white cube"

In the early sixties, as Abstract Expressionism gave way to Minimalism, the center of the New York art world shifted. The studios that had populated 8th Street and Greenwich Village were displaced southward to a district of cast-iron buildings formerly given over to light industry that provided the large open floors of what came to be called "lofts." Major art dealers followed suit, and the production and display of art now occupied the urban space called Soho. Painted white and filled with light, the lofts encouraged larger and larger art works, just as the former employment of the spaces suggested industrial materials. The work of Donald Judd or Robert Morris was unimaginable without the new form of space, which the Irish critic and artist Brian O'Doherty called the "white cube."

Originally published as a series of essays in *Artforum* from 1976, O'Doherty's *Inside the White Cube: The Ideology of the Gallery Space* spread the radical refusal of modernist doctrine. Reaffirming the importance of ephemeral art and conceptualism as the replacement of Minimalist objects, the sobriquet "white cube" caught on as a way of sneering at that modernist protocol of the self-critical obligation for a medium to proclaim its own "area of competence." According to O'Doherty, the "ideology" of the new galleries stemmed from the homology of the space of commerce and the space of creation, like a Moebius strip in which the one could not be distinguished from the other. The goal of modernism had been to enforce the *autonomy* of the work of art, its absolute enclosure within its frame, its *self-reference* through which nothing from the outside could penetrate within. Self-reference was another way to say self-representation—itself the foundational condition of abstraction. In his *Critique of Judgment*, Immanuel Kant had declared this autonomous "disinterest" as a condition of beauty—such disinterest grounded on the work's eschewal of everything outside itself, whether the object of representation or any other "concept." Derived from the white exhibition galleries of palatial museums, the white cube was thought to be the basis of the work's "purity"—another term for autonomy. But once the

synonymy of the gallery and the loft became undeniable, "purity" vanished behind a screen of financial gain. The demise of modernist autonomy gave important permission to installation art's development of the postmedium condition. Video projections ate away at the impermeable fact of painting's surface to mimic the dreamlike condition of mist or cloud. As the "white cube" collapsed, the tension between the wall's objectivity and the viewer's subjective experience left no space for the resistant support of the medium.

O'Doherty's activity extended beyond his writing. In 1967, he edited *Aspen 5 + 6*, a magazine sponsored by an artist colony in Colorado's Red Mountain. The "magazine" was an eight-inch-square, three-inch-deep snow-white box containing phonograph records (Alain Robbe-Grillet reciting from *Jealousy*), reels of film (Robert Morris's dance piece *Site*), and the initial publication of Roland Barthes's "The Death of the Author"). O'Doherty also convinced Marcel Duchamp to read "The Creative Act" for the edition. It was not their first encounter. Trained in Dublin as a doctor, O'Doherty had persuaded Duchamp in 1966 to submit to an EKG recording of his heartbeat, from which he created his 'portrait' in the form of moving light on an oscilloscope. In exhibits of this Dada lifeline, the viewer is left puzzled whether it should be seen as a readymade or a work of creation.

O'Doherty also practices as an artist, questioning artistic conventions and the assumptions on which we base aesthetic judgments with work that is heavily influenced by Duchamp. It ranges from conceptual works to "Rope Pieces," ironically dependent on the purity of the white cube. Stretching interlaced across the corner of the gallery or museum space, the colored ropes fuse visually into the illusion of a suspended plane—an optical gestalt that cancels the physical dimension of the box itself.

In 1972, O'Doherty began signing his works "Patrick Ireland" in protest at the Bloody Sunday killings perpetrated by the British army in Derry, Northern Ireland. In 2007, New York University's Grey Art Gallery organized a retrospective of O'Doherty/Ireland's work, the year before O'Doherty ceremoniously "buried" his alter ego in the grounds of the Irish Museum of Modern Art in Dublin in recognition of the continued success of the Irish peace process.

renders it in "sign." Like *Address Book*, the work is intended to build an image of its writer. Separating this work from others like it, however, is the delicate question of whether or not Calle herself is the letter's author. Thus, paradoxically, an artist whose whole oeuvre turns on the matter of documenting the unknown Other, might end up making a sentimentally "confessional" object, to be performed by strangers. In summer 2008, *Take Care of Yourself* opened as an exhibition at the former Bibliothèque Nationale in Paris. At the entrance to the magnificent Labrouste cast-iron reading room, the visitor was given a copy of the letter, which was being projected from video monitors scattered on the long reading tables, as the various female participants read the letter for their unseen audiences. By staging the work in the reading room lined with shelves of leather-bound volumes, the library display intensified the work's own effect as a series of textual recitations.

If Christian Marclay adopts the synchronous sound of movies as his "technical support," and James Coleman and Sophie Calle employ the techniques of Powerpoint and investigative journalism and writing respectively, the South African artist William ▲ Kentridge chooses animated film as his own. Elaborating on the commercial artform of animation, he makes a charcoal drawing, photographs it, erases it slightly, and exposes another frame of film to record the newly altered image: a process that fills the entire cinematic strip. In 2000, he made *Medicine Chest*, the frontal image of some shelves holding bottles, tubes, and brushes, all faced with a mirror, which he rear-projected inside a real medicine cabinet [5]. The film opens with Kentridge's own reflection, turning the image into an ambiguous experience of space: is the face *behind* the frontal plane, as in most paintings; or is it resting *on* that surface? This is the ambiguity that centuries of painters have explored,

▲ 1994b

2000–2015

from Jan van Eyck's *Arnolfini Wedding* to Parmigianino's *Self-Portrait in a Convex Mirror*.

At the film's end, a series of crows take flight behind the artist's head, their black wings churning the air, as though mimicking Kentridge's animation procedure by producing the ghostly phantom-shapes of a sequence of pale erasures. The smeared wings of flying birds also filled the backdrop for Kentridge's 2007 interpretation of *The Magic Flute* for the Brooklyn Academy of Music. This "figuring forth" of his own technique had already been explored in the 1996 *History of the Main Complaint*. As its hero drives his car through the rain, the windshield's wipers rhythmically blur the glass in a figure of erasure itself [6]. The smears of Kentridge's erasures join, technically, with the blur of Ruscha's stains, both of them referring to the history of the modernist fight against the hardness of conventional contours. Kentridge, born in South Africa to a father who was a famous lawyer supporting the African National Congress (Nelson Mandela's party), left South Africa for Paris, where he joined a theatrical company devoted to modernist drama, such as Samuel Beckett. Returning to South Africa, Kentridge addressed the aesthetic paradox raised by political art. "These two elements—our history and the moral imperative arising from that—are the factors for making that personal beacon rise into the immovable rock of apartheid. To escape this rock is the job of the artist. These two constitute the tyranny of our history. And escape is necessary, for as I stated, the rock is possessive, and inimical to good work. I am not saying that apartheid or, indeed, redemption are not worthy of representation, description or exploration. I am saying that the scale and weight with which this rock presents itself is inimical to that task. You cannot face the rock head on; the rock always wins." Kentridge's determination to "figure forth" the erasure on which his medium is based is the hallmark of his own resistance to the "rock." RK

FURTHER READING

Clement Greenberg, "Avant-garde and Kitsch" (1939) "Modernist Painting" (1960), in *The Collected Essays and Criticism*, vols 1 and 4, ed. John O'Brian (Chicago: University of Chicago Press, 1986 and 1993)

Ed Ruscha, *Leave Any Information at the Signal: Writings, Interviews, Bits, Pages* (Cambridge, Mass.: MIT Press, 2002)

Jean-Pierre Criqui (ed.), *Christian Marclay: Replay* (Zurich: JRP|Ringier, 2007)

George Baker (ed.), *James Coleman* (Cambridge, Mass.: MIT Press, 2003)

Sophie Calle, *Take Care of Yourself* (Paris: Dis Voir / Actes Sud, 2007)

Rosalind Krauss, "The Rock: William Kentridge's Drawings for Projection," *October*, vol. 92, Spring 2000, pp. 3–35

Rosalind Krauss, *Perpetual Inventory* (Cambridge, Mass.: MIT Press, 2010)

"Unmonumental: The Object in the 21st Century" opens at New York's New Museum: the show marks a new focus on assemblage and accumulations among a younger generation of sculptors.

Since the late eighties and early nineties, a generation of sculptors has defined its work in manifest opposition to the grand legacies of Minimalism (such as Donald Judd and Carl Andre), Postminimalism (Eva Hesse, Bruce Nauman, and Richard Serra), and the explicitly antisculptural propositions issued by Conceptual artists who claimed to have displaced the material practices of modeling, cutting, carving, and constructing once and for all (Hans Haacke, Douglas Huebler, and Lawrence Weiner). These legacies had governed the perception of sculpture throughout the sixties and seventies, but by the eighties sculptural practice had begun to explore different paradigms, initiated by artists such as Isa Genzken (born 1948), Thomas Hirschhorn, John Miller, and Gabriel Orozco. Reaching a climax in the later work of these artists, these developments in turn triggered responses from younger sculptors such as Carol Bove (born 1971), Tom Burr (born 1963), and Rachel Harrison (born 1966).

New motivations, new paradigms, new strategies

Undoubtedly, a number of heterogeneous forces had necessitated this radical generational shift and its paradigmatic changes. An almost masochistic embrace of cheap commercial commodities could be identified as the first of these forces. The commodity is the very object type that sculpture—with the exception of the readymade—had opposed in the history of modernism, claiming either monumental endurance or utopian construction against the commodity's immanent obsolescence. In distinct opposition, the current work combines easily available objects of mass consumption; conjures cheap, ephemeral, and tacky materials into the sculptural body (such as styrofoam, Parex, duct tape, aluminum, found industrial detritus); and mimes the common object's perpetually renewed cycles from innovation and planned obsolescence, to trash and ecological disaster. As had been the case with Duchamp's readymade, the decision to make sculpture simulate the common object's universal presence and obsolescence not only seems to negate the transhistorical aspirations of sculpture, but ultimately threatens the endurance of aesthetic autonomy altogether. But it was not only Duchamp's readymade that had prepared the ground for what Hal Foster has identified as the rise

of *commodity sculpture*. Rather, a variety of sources in the mid- to late fifties and early sixties had renewed the readymade's epistemic radicality. These ranged from Robert Rauschenberg's *Combines*, through Arman's accumulations and Martial Raysse's sublime constellations of plastic parts [1], to Andy Warhol's *Brillo Box* and the critical semiological constructions of Hans Haacke. That this legacy seemed to threaten sculpture itself would become explicit in the incongruity between the iconography of Pop art and the almost simultaneously emerging phenomenological positions of the Minimalists, polemically stated in the sixties when Carl Andre attacked Pop artists for having been corrupted by their simulacral relationships to consumer culture.

This conflict between sculpture's presumed continuity of discursive autonomy and a programmatic annihilation of its Constructivist, Minimalist, or phenomenological aspirations is one of the crucial dialectics of sculpture throughout the twentieth century, and it regained a new urgency with the artists emerging in the eighties. Beyond their fixation on the mass-cultural object, the new sculptors share a second historical determination: precisely their decision to exchange the conventions of sculptural plasticity for a broad spectrum of textualities, ranging from the simulacra of advertisement and product propaganda to photographically mediated myths and mass-culturally constructed icons (such as "the celebrity"). As a direct result of admitting the mediated image within the sculptural body, traditional monolithic forms (Minimalism's nearly universal cubes and squares, for example) and morphologies (such as the purified self-referential, even if technologically produced, surfaces) are dislodged by foregrounding almost infinite combinations and contiguities of objects, textures, and images in space. All of these signal that sculptural perception is now primarily mediated by those forces that control public and private spaces in actuality: advertisement, commodity production, media design, and technological displays.

A third and related set of motivations shared by these artists challenges sculpture's traditional assumptions about its function in defining the experience of public space. While twentieth-century sculptural objects still aspired to be perceived as being situated within the public sphere, and even to contribute to its construction (evident in sculpture's eternal desire to cross over

1 • Martial Raysse, *Étalage: Hygiène de la Vision*, 1960
Collection of objects, 210 × 70 (82¹¹⁄₁₆ × 27⁹⁄₁₆)

2 • Isa Genzken, *Spielautomat*, 1999–2000
Various materials, 160 × 65 × 50 (63 × 25⁹/₁₆ × 19⁹/₁₆)

from object to monument and into architecture), in actuality the perception of publicness had long since been controlled by regimes of media technologies and commodity production. Camera images, from photography to film and television, rather than sculpture had become the means for disseminating the representations that would become integral to spectacular or ideological forms of collective identity.

To cope with the pervasiveness of the photographic mediation of spectacle has therefore become one of the sculptural orders of the epoch. Consequently, all of these artists now deploy photographic images within their sculptural constructs. Some incorporate photography directly, as Hirschhorn does most intensely in what one could call his monumentally spatialized collages: his massive and riotous image accumulations appear nowadays like the historically necessary negations of what had once been the utopian aspirations of the large-scale photomurals and exhibition designs by the Soviet, French, and Spanish artists of

▲ the twenties and thirties. Other artists deliver extensive photographic records that run parallel to, yet are equivalent to, their object production (as in the work of Genzken [2], Harrison, Miller,

and Orozco). These compounds of plasticity and photography do not simply signal the fact that different forms of representation determine the subject's situatedness in the public sphere, but also challenge the claims that material constructs alone could actually generate credible conditions of simultaneous public perception, traditionally one of the foundational aspirations of plasticity and the demands of sculptural experience.

Post-Surrealist assemblages—in particular the boxes of Joseph Cornell and the assemblages of Robert Rauschenberg and Bruce

▲ Conner—had already provided a sculptural license to the deployment of photographs as counterfigures to that theory of plasticity. Yet while these artists incorporated photographs primarily as mnemonic devices, photography as a medium condition had still been rigorously excluded from the discourses of postwar sculpture until the work of Nauman and the Conceptualists. Thus it is not surprising that the paradigms of collage, montage, and assemblage, and the spatial and quantitative expansion of these paradigms in

● Pop art and Nouveau Réalisme, would have become a foundational reference for these younger artists since the eighties. Combinatory permutations of spatial and discursive frames, found objects,

▲ 1921b, 1926, 1937a, 1937c

▲ 1931a, 1959b ● 1960a, 1964b, 1980

and a multitude of seemingly random photographic images emphasize that the formation of social identities and spaces of self-constitution in the past and present result to an equal—if not higher—degree from design and media, rather than from the traditionally defined spatiality and plasticity of sculpture.

Design, display, and decoration

The initially delayed reception of the work of this new generation of sculptors suggests that our expectations of the sculptural, in spite of a century of readymades and assemblages, have not yet been sufficiently revised. Otherwise we would have recognized sooner that sculpture in the present might have to be confined to the metonymic representations of infinitely expanded and pervasive discourses of spectacularized object consumption. These conditions determine present-day sculptural experience just as deeply as the horizons of industrial production and utopian construction had defined sculpture until the latter part of the twentieth century. To speak of sculpture as production, a concept that had been essential to the traditonal definition of sculpture at least up to Minimalism and beyond to Serra, would no longer be appropriate, ▲ since the classical quartet of carving, cutting, casting, and construction, which had mimicked artisanal and industrial processes, now has been programmatically dismantled. In explicit opposition to a masculinist mythology of industrial labor and construction, the work of these younger artists recalibrates sculptural bodies and

3 • Tom Burr, *Movie Theater Seat in a Box*, 1997
Wood, silver perspex mirror, carpet, seat, chewing gum, 107 × 91.5 × 91.5 (42⅛ × 36 × 36)

spaces with surprising propositions far removed from what Minimalism and Postminimalism might have taught us to expect.

The new sculptors often organize objects as mere arrangements, and simulate object relations and spatial situations as though they were the outcome of chance encounters, found constellations that are haphazardly assembled at best. They home in on precisely those procedures that had been traditionally disqualified as fey or feminine: arranging, displaying, and decorating, thereby unfurling hidden and different tactilities of everyday life, and pointing to alternate interactions with the world of materials and objects. Sculpture is thus, once again, unexpectedly opened up to those spheres of experience that had been previously considered as undesirable and unthinkable in the perimeters of plasticity: fashion, design, domesticity, and the architecture of vernacular spaces.

In the work of Bove, Burr, and Miller, for example, we could recognize an almost melancholic evacuation of the traditional sculptural claims, whereas Genzken, Harrison, and Hirschhorn initiate more psychotically aggressive, or polemically derisive travesties of sculptural traditions, violent denials of the very promise that sculpture as public material construction and rational or allegorical critique could still alter the perception of the social structures and spaces that contain us. Tom Burr's conception of public space (partially derived from his early comprehension of the work of Dan Graham, Hans Haacke, and Dara Birnbaum) clearly opposes any transhistorical definition of phenomenological spatiality, and his structures show spatial experience itself as always already controlled by social interests and ideological investments. At the same time, the allegorical dimensions of his work resist and *détourne*—or divert—these innate conditions of regulation and control and suggest alternate social and spatial configurations of subversive dissent and desire.

His *Movie Theater Seat in a Box* of 1997 embodies these complex strategies perfectly [**3**]. At first sight appearing in the guise of yet another Minimalist cube, the box is fitted with both the plywood and the mirror surfaces that had become Judd's and Morris's ▲ hallmark materials. Yet, as in a cube by Eva Hesse, it is now not solely the shell of the classic cube but its inside that matters, just as much if not more. The cubicle, its ground covered in carpet, houses an actual seat taken from a somewhat decrepit movie theater. This relic, ripped from the ruined spaces of mass-cultural rituals, is upholstered with the typical red velvet fabric on its recto, and carries on the seat's verso a spectator's surreptitiously deposited chewing gum—almost like Brassaï's *sculptures involontaires* or Hannah Wilke's extreme microcosmic parody of plasticity. Thus the classic cube of sculptural neutrality is permeated by a vulgar vernacular of erotically charged bodily textures, surfaces, and materials. In an instantaneous, almost universal flashback of mass-cultural experience, the seat not only offers an uncanny intimacy and memories of cheap enchantment, but the body appears also as a historically mediated fragment controlled by an incredibly powerful mass-cultural institution of the past that

has now lost almost all of its appeals. And this nostalgic dimension turns quickly into a critical revelation when one recognizes that the cube and the seat confront each other exactly as that unresolvable historical conflict between plasticity and sculptural utopianism on the one hand, and the actuality of the mass-media sphere on the other, a sphere within which all aspirations for a newly emerging simultaneous collective communication had already been buried from the start.

Carol Bove does not pursue an explicitly subversive agenda criticizing the normative social and ideological inscriptions operative in given architectural formations. Yet her suggestions that sculpture could also be defined as a sequence of objects arranged in the manner of an interior designer, a homemaker, or a museum curator ▲ (and here Bove has transferred Louise Lawler's photographic strategies into sculptural structures) certainly insinuate a feminist critique of long-prevailing assumptions about gendered role behavior in the sculptural reordering of space. Bove—like Burr—allegorizes sculpture, matching seemingly incompatible objects (driftwood, black-and-white photographs of nudes and models, cast-concrete cubes, peacock feathers, designer furniture, etc.) in

4 • Carol Bove, *Utopia or Oblivion*, 2002
Knoll tables, wood and string object, five books, 114 × 46 × 46 (45 × 18 × 18)

combinations whose logic at first seems utterly implausible to rational comprehension or phenomenological perception. Yet—as had always been the case with Cornell's work—the logic of these arrangements appears instantly evident to the orders of unconscious desire. Like her peers among the sculptural allegorists, Bove has internalized the object's condition of universal exchangeability and of spectacularized consumption as latent regimes of her work. And since the permeation of all objects with the irreversible instantaneity of obsolescence has made even the mythical stability and solidity of sculpture a farce, Bove seems to choose her objects from the reversed perspective of their final destiny, not from their promises for the future. Inevitably then, even the obsolescence of the medium itself enters Bove's displays of the outdated, and sculpture figures in her arrangements without privilege at the intersections of various plastic and discursive formations. The outlived radicality of a sculptor's initial aspirations (evident, for example, in the citation of a Kenneth Snelson tension-wire model in the almost programmatically titled *Utopia or Oblivion* of 2002 [4]) is literally contained in what appears to be sculpture's inevitable decline into design: two small wood-and-chrome Knoll tables, stacked in the manner of Minimalism, form two cubic registers of display, the cubes' interiors and exteriors now serving simultaneously as base and frame of display for the Snelson model, but also as a bookshelf and tabletop for a stack of books. Displayed in the upper register of the structure, an open page of one of the volumes serves as a photographic readymade and calls up a female nude as an allegory of the origins of sculptural desire. Or in *The Sky over Berlin: March 2* of 2006, the base of the sculptural display has now been fully mapped onto the place, and the function of an architecturally embedded shelf (in other works the sculptural base is simply defined as a wooden tabletop for the display of a variety of incongruent objects). Yet this containment is countered by the citation of yet another lost moment of radical utopian thinking, hovering like ▲ a kinetic ceiling over the display: a citation of Jesús-Rafael Soto's once euphorically technocratic dissolution of the sculptural body into perceptual and phenomenological units from the late fifties.

Rachel Harrison's work by contrast engages in a sly and comical subversion of the grandiloquent claims with which massive material constructs (like Richard Serra's later work) or gigantic object accumulations (like the work of the late Jason Rhoades) have pretended to act as oppositional forces in the public sphere, when in reality they merely replicate the spaces of control, surveillance, and spectacularization, or the blind violence of the object, to which we are all subjected in everyday life. In fact, one could argue that Harrison's hilarious combines border on travesties of the very idea that allegorical constellations might sustain the critical potential with which an artist like Haacke—or Burr in his wake—had combined the elements of their assemblages for an enlightening, if not pedagogical, confrontation with the public. In fact, Harrison's *Nice Rack* of 2006 [5] even explicitly quotes one of Haacke's works with a photographic detail from his installation *Hommage à Marcel Broodthaers* (1986). The citation is complemented by an equally

▲ 1977a

▲ 1955b

5 • Rachel Harrison, *Nice Rack,* **2006**
Wood, polystyrene, cement, Parex, acrylic, digital print, dolly, card rack, snow shovel, fake peaches, bejeweled barrettes, and rotary phone, 251.5 × 160 × 71.1 (99 × 63 × 28)

underhand homage to Duchamp's *In Advance of the Broken Arm*, and a number of cheap fashion attributes on a Hallmark card rack, topped by a sign calling out "Big Time Greetings." Yet it remains obscure whether the function of the citation is a mere travesty of the critical aspirations of Haacke's type of assemblage, or whether it is in fact a melancholic acknowledgment of the loss of any critical aspiration for sculpture in the present.

If Enlightenment reason and dialectical critique had still motivated Haacke's combinations, he had also presumed an audience that would receive his work in a disposition of dialogic attention and response. Harrison's structures, in contrast, anticipate the derision with which contemporary audiences will meet the project of critical enlightenment, and she makes their contempt and indifference an integral part of her own object constellations. Yet by siding with cynical reason alone, Harrison annihilates sculpture's mnemonic potential as much as its critical and utopian dimensions. And since all sculptural work, production, or citation inevitably declares its affinities, even solidarities, with objects, materials, and spaces, Harrison's sculpture confronts us with the inevitable query about the type of solidarity it pronounces. After all, the grotesque and the comical enunciated in these constructs not only serve ultimately as palliative forms of reconciliation with the unacceptable. Like all jokes, they are always on somebody, and it is not evident whether the jokes are on us as spectators of sculpture, on the legacies of sculpture, or on the artist's own despair to have to continue her citational sculptural crafts. In fact one might wonder whether it is not precisely the subject's suffocating deprivation of transcendentality, confined to the privacy of object experience and the universal condition of consumption at the center of these sculptures, that reduces sculpture's metaphysical horizons from Serra's sublime and mnemonic invocation of sculpture's lost utopian dimensions, or the melancholic criticality of Broodthaers's and Haacke's allegorical constellations, to the affirmative structure of the one-liner joke as the last reprieve from total affirmation.

Figurines and the cabinet of dummies

A fifth phenomenon, eery and unexpected at first, has by now acquired the condition of a shared stylistic feature. It is the peculiar presence of mannequins in many structures and sets by Genzken, Hirschhorn, Harrison, and Miller. While tailor's dummies and shop-window figures have a complex iconographic history in the twentieth century after their appearance in
▲ Giorgio de Chirico's metaphysical paintings and their impact on Dada and Surrealist representations of the reified body, their deployment in contemporary sculpture differs dramatically from these initial displays. Until recently, our common conception of the readymade would never have included anthropomorphic figuration and physiognomic iconicity (except in its photographic versions). Yet in their contemporary return from the dead, these figurines simply mingle as just another readymade among a sheer

infinity of industrial relics and refuse. They spawn the sudden and uncanny intensity of hybrids, however: suspended between indexicality and iconicity, these figures as objects are now comparable to the photographic image, and they gain an intensely discomforting presence precisely from that suspension. Furthermore, the uncanny presence of these industrial statues destabilizes the boundaries of display genres and exhibition conventions. After all, their primary affiliation (and our first association) is not with an exhibition of sculpture, but with a commodity display, thus they disintegrate the firm disciplinary divisions between the shop window and the museum, between a fashion display and sculptural production. That the destruction of these distinctions might be imminent had already been prophesied in one of
▲ Duchamp's most consequential works, his design of the "Exposition Surréaliste" in Paris in 1938, a work that seems to have been neglected and might even have remained illegible were it not for its resuscitation in the practices of the present. Duchamp's redefinition of the readymade as a potentially iconic object originated in a state of exception. Nothing could have denounced the pernicious pretenses of a return to order under the aegis of Fascism more decisively than Duchamp's dummies in the 1938 exhibition (after all, German marching band music was pumped into the installation while the coal sacks slowly released their dust from the ceiling). Yet the artist did not merely articulate his polemical response to the humanist *rappels à l'ordre* that had echoed the emergence of Fascism in Europe. Rather, the sudden figuration of the readymade signaled a heretofore unimaginable condition of universal reification: the decisive inability to sustain a foundational difference between subject and object. Subjecthood, in late capitalism and its wartimes, had now been totally constituted within the simultaneous acts of consumption and destruction; and objecthood had been driven to an unimaginable climax of ideologically simulated subjectivity. As with Duchamp's collection of mad mannequins (each of them had been designed by a different artist, each of them decomposed the subject's artificial composure of fashioned identities), the figurines might at first appear uncannily as the last representations of the intact human figure, however discombobulated by the individual accumulation of fashion and household objects inflicted on their bodies and surrounding spatial containers. In Genzken's recent work, especially since her series *Empire/Vampire: Who Kills Death* (2006) and her installation *OIL* for the Venice Biennale in 2007, and even more so in Hirschhorn's recent installations, the quantitative and qualitative expansion of the assemblage into a new typology of totally deranged or decentered stage sets systematically sabotages the spectator's demand for a minimum of cohesion, or at least a minimal orientation through the labyrinthine spaces and cumulative quantities of objects, images, textures, and surfaces on display.

These expectations for cohesion are deeply frustrated by the sheer size, discontinuity, and heterogeneity of the displays. The actual collapse of the boundaries that had traditionally separated

▲ 1909, 1916a, 1920, 1924, 1942b, 1966a

▲ 1942b

From composition to compulsion

It is productive to consider the differences between Bove's and Burr's work and that of Genzken and Hirschhorn. It is an opposition between allegorical, yet intentional gestures of selections and arrangement and a seeming absence of intention in massive accumulations and willful combinations (with Harrison and Miller situated halfway between these two extreme poles). In other words, these sculptors perform the differences between traditional claims for a formal control of morphology and materials and the subject's ostentatious loss of intention and control in response to the ceaseless destruction of use value and material specificity, simulating an externally imposed formlessness. After all, how could criteria of material selection and formal discrimination be sustained against the perpetual onslaught of equivalences of objects, structures, and materials?

What collage had done to painting—namely to dissolve its formal, procedural, and material unity—assemblage would inflict now on the cast, cut, and carved holistic sculptural body. Yet for a long period in the twentieth century, the concepts of chance accumulation and aleatory constellations seemed fundamentally inconceivable in sculpture. Only with Arman, Rauschenberg, and Raysse had it become obvious that the ceaseless expansion of objects and qualities in social production had to find its correspondences in the sheer size and quantity of the randomly assembled representations of the objects' battlefields. And the intimacy of a carefully composed Cornell box had to be exchanged for Arman's iterative collections and accumulations, generating a manifest conflict between the structures of collection and composing and the structures of compulsion and repetition as the alternative ordering principles of sculpture. Once it became obvious that an infinity of repetitions and processes, a perpetual proliferation of the same, and a deluge of devalorized matter and detritus, would become the new regimes of object experience, sculpture could no longer deny these parameters a central role among its formal and procedural principles. BB

FURTHER READING

Richard Flood, Laura Hoptman, Massimiliano Gioni, and Trevor Smith, *Unmonumental: The Object in the 21st Century* (London: Phaidon Press, 2007)

Julia Robinson (ed.), *New Realisms, 1957–1962: Object Strategies Between Readymade and Spectacle* (Madrid: Museo Nacional Centro de Arte Reina Sofía; and Cambridge, Mass.: MIT Press, 2010)

Tom Eccles, David Joselit, and Iwona Blazwick, *Rachel Harrison: Museum without Walls* (New York: Bard College Publications, 2010)

Iwona Blazwick, Kasper König, and Yve-Alain Bois, *Isa Genzken: Open Sesame!* (Cologne: Walther König, 2009)

Benjamin H. D. Buchloh and David Bussel, *Isa Genzken: Ground Zero* (Göttingen: Steidl, 2008)

Florence Derieux, *Tom Burr: Extrospective: Works 1994–2006* (Zurich: JRP Editions, 2006)

6 • John Miller, *Glad Hand*, 1998
Mixed media, 160 × 81.3 × 38.1 (63 × 32 × 15)

private life and publicness is mimetically inscribed within these derangements, and they register the universal permeation of each and every sphere of experience by the demands of spectacularization. Once again, as already before in Duchamp's exhibition design, in both Genzken's and Hirschhorn's work these seemingly intact holistic figurines are plausibly positioned at the intersection between fashion and a perpetually intensified condition of consumption whose function it is to repress an apparently permanent state of war. Miller's figurines (or his frequent displays of luscious plastic fruit as another iconic readymade, also employed by Harrison) often appear against amorphous backdrops of entropic matter, golden or scatologically colored mounds of waste, of unidentifiable origins and destinations (acknowledging the generally unrecognized impact of Dieter Roth) that signal imminent ecological apocalypse [**6**]. To dismantle the imaginary security of a sustainable separation between the sphere of consumption on the one hand and everyday ecological destruction and the practice of perpetual war on the other, and to present both dimensions as the Janus faces of our age, is one of the great insights that these works facilitate.

2007 c

As Damien Hirst exhibits *For the Love of God*, a platinum cast of a human skull studded with diamonds costing £14 million and for sale for £50 million, some art is explicitly positioned as a media sensation and a market investment.

In the postmodern condition, we are told, the grand narratives of modern history are no longer credible, including any story about the progress of art, and the sheer heterogeneity of the contemporary art scene would seem to support this view. Yet already in 1975 Andy Warhol saw one clear path to the future: "Business art is the step that comes after Art," he wrote in *The Philosophy of Andy Warhol*. Not only might an artist aim to make money, but "making money is art" and "good business is the best art." Among the implications here are that artistic production could be based on business models (Warhol had established "Andy Warhol Enterprises" as early as 1957, and books, films, TV programs, and *Interview* magazine followed over the years), and that any avant-garde opposition to the economic order was quixotic or quaint. Also implicit, however, was that at least one narrative of postwar art might still make sense, one that charts its gradual commingling with the operations of fashion, media, marketing, and investment. Certainly in the 2000s, in the widespread dismissal of other modes of judgment, artistic value was often equated with name recognition and financial success.

Neoliberal patrons

Production for the marketplace has been a fundamental condition of art since the Renaissance, one that promoted its characteristic forms of portable painting and sculpture. However, the art market as we have come to know it is a far more recent creation, the effect of an international bourgeoisie that, reconstructed after World War II, emerged in the boom years of the sixties with money to burn on art, particularly American Pop, that brand which, as the art historian Thomas Crow has put it, "looked like products being sold like products." At that time, too, the network of commercial galleries expanded greatly, as did the influence of dealers and collectors. That contemporary art might be viewed in the first instance as an investment was soon made clear by the rise of high-return auctions, the most notorious being the 1973 sale of the Robert and Ethel Scull collection centered on Pop (enraged artists saw none of the profits).

After the recessionary seventies, the antiregulatory policies of Reagan and Thatcher promoted a new class of the super-rich, some of whom became very visible collectors, and, naturally enough, they favored market-proven painting and sculpture over critical forms of Conceptual, performative, and site-specific art. A telling figure in the eighties boom was Charles Saatchi, the head of a London-based advertising empire, who was alert not only to the new investment potential of contemporary art but also to the publicity value of its more notorious players (Saatchi was an early backer of Young British Artists such as Damien Hirst and Tracey Emin). The art market fell dramatically in 1990, three years after the stock crash of 1987 (art and financial markets are connected but not synchronized); however, later in the decade, a fully neoliberal economy produced personal fortunes in excess of those of the eighties, and an irrationally exuberant art market roared to life.

If the standard-bearer of the eighties boom was an advertising executive like Saatchi, then his counterpart in the last upswing was a hedge-fund manager like Steven Cohen, who has used his enormous profits as founder of SAC Capital to build an extensive collection of postwar art in a short time. According to Amy Cappellazzo, deputy chairman of Christie's auction house, the new type of collector understood contemporary art as "an asset one can borrow against, or trade on and defer capital gains taxes on," and regarded the art market essentially as a branch of the securities markets. An added attraction was that insider trading and price fixing, illegal in other areas of investment, remained standard practices in the art world. In language that became common in art circles, Cappellazzo summed up the situation in spring 2008 as follows: "Art's recent financial appeal stems from the idea that high-quality works of art were undervalued, and that as the market became more truly global in the past five years, their worth would increase in value as a result of (a) heightened demand for scarce objects, (b) an enormous roll up of private wealth that remains unprecedented, and (c) the market necessity for a new asset class that could trade among individuals globally."

In the wake of the financial crisis in fall 2008, these conditions changed—but not as dramatically as one might have expected—and in any case the extent of art-market activity up to that point was most impressive, especially as petrodollar plutocrats from Russia and the Middle East, as well as new collectors from Asia and India, joined ad execs and financiers from Western Europe and

1 • Damien Hirst,
***For the Love of God*, 2007**
Platinum, diamonds, human teeth,
17.1 × 12.7 × 19.1 (6¾ × 5 × 7½)

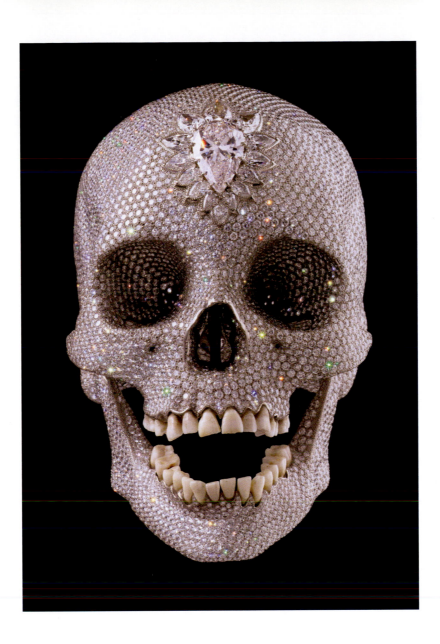

North America as movers and shakers. The intensity of this activity was indicated by the fact that turnover at contemporary art auctions more than quadrupled between 2002 and 2006, with sales at each of the two major houses, Christie's and Sotheby's, approaching $1.5 billion in 2007 alone. (Incidentally, Christie's is controlled by François Pinault, who operates his own museum in the Palazzo Grassi in Venice and formerly, through Christie's, his own gallery, Haunch of Venison, in London, Berlin, and New York; for this prominent collector, who also owns Gucci among other brands, buying, validating, and selling art can all be done in-house, as it were.) However, even in bubbly times contemporary art is not a sure-fire investment, and investment cannot fully explain its allure in any case. "These buyers have a tremendous surplus of economic capital and an equally large deficit of social and cultural capital," writes Olav Velthuis, an expert on the art market. "By buying contemporary art, they buy access to a social world." In this account, the motive of collectors remained the old one of prestige, position, and "pleasure of participation" (as Crow phrases it)—

"luxury travel on the art-fair circuit, the opening dinners, the right parties, deference from lesser players, access to the artists, etc."

What makes this of more than sociological interest is its effect on the production as well as the reception of much contemporary art. For instance, the desire for display brought a demand for scale and spectacle, which raised the costs of both making and exhibiting, whether the works in question are the massive sculptures of Richard Serra, the lavish performances, films, and installations of Matthew Barney, or the extravagant environments of Olafur Eliasson. The expense of such projects is enormous, and so, however international, the clientele of much contemporary art remains exclusive. In fact, a tight system of grand patronage returned, with the most coveted work often bespoken before it is produced. This development led the public to view art, even more than previously, as a private affair, regardless of the nature of its content or the mode of its address; and the profusion of private museums in the United States, Europe, and elsewhere reinforced this suspicion (how long some will be able to survive, financially, is unclear).

Of course, there is a long history of collections becoming museums, but the current phenomenon amounts to a partial privatizing of public culture as much as the reverse. A case in point is the "venture philanthropy" of the real-estate billionaire Eli Broad, who has effectively established his own collection, indeed his own museum, within the tax-supported complex of the Los Angeles County Museum of Art, with no commitment for the future. A trustee of an institution acting in his own interest is hardly a unique event, yet it is symptomatic of a situation that has led many museum directors and curators to behave as servants of a patron class first and custodians of a collective patrimony second. There is little *noblesse* in this arrangement, and even less *oblige*, but then the beneficiaries of a global economy are not likely to feel very loyal to merely local institutions.

The commingling of much contemporary art with the media and the market has affected it in other ways as well. Critic Julian Stallabrass highlights these parallels with corporate mass culture: "an emphasis on the image of youth, the prevalence of work that reproduces well on magazine pages, and the rise of celebrity artist; work that cosies up to commodity culture and the fashion industry, and serves as accessible honey pots to sponsors; and a lack of critique, except in defined and controlled circumstances." Such connections are significant, but others might be even more structural. For example, once seen as a bohemian outsider, the artist is now often regarded as a model of the innovative worker in a post-Fordist economy. According to the sociologists Luc Boltanski and Eve Chiapello, managerial discourse over the last two decades has promoted attitudes and attributes once associated with the artistic personality: "autonomy, spontaneity, rhizomorphous capacity, multitasking (in contrast to the narrow specialization of the old division of labor), conviviality, openness to others and novelty, availability, creativity, visionary intuition, sensitivity to differences, listening to lived experience and receptiveness to a whole range of experience, being attracted to informality and the search for interpersonal contacts."

Even as managerial discourse has assimilated artistic qualities in this manner, so too have some artists embraced business models with a rigor that puts Warhol to shame. Hirst multitasks like mad: he has owned his own publishing house, clothing line, and restaurant; and his "Murderme" collection of art and curiosities is slated to be on view in his Victorian Gothic manor in the Cotswolds area of rural west England. He also has an army of assistants, as do his peers in Business Art, Jeff Koons and Takashi Murakami. Prior to the 2008 crash, Koons oversaw a studio factory with ninety employees in Chelsea, while Murakami ran a corporation with a hundred employees based near Tokyo and in Brooklyn; the work signed "Koons" or "Murakami" is largely designed on computers by assistants and then executed by fabricators. At times underscoring the collapse between museum art and mass culture, at other times reinscribing the differences to their own benefit, these two artists exemplify the developments at issue here. In each case, the market structures the practice; in a sense, it is the very medium of the art.

The market is the medium

▲ As noted in a previous entry, Koons played on the convergence of art exhibition and commodity display in early works in the eighties that introduced a slight ambiguity into the equation: why stack immaculate vacuum cleaners in well-lit Plexiglas cases, for example, or submerge brand-new basketballs in water-filled glass tanks? Also foreign to art-world taste were subsequent series that refashioned tokens of suburban leisure, such as bar accessories, in stainless steel, and figurines of small-town hominess, such as cute pets and farmyard animals, in polychrome wood. With objects ranging from a bust of Louis XIV to a statuette of Bob Hope, from the folk figure of Kiepenkerl (a traveling pedlar in medieval Germany) to the pop figure of Michael Jackson and his pet chimp Bubbles, Koons showed a canny sense of the capacious nature of kitsch. Yet the social unease produced by a conscious display of bad taste was not the point for Koons, who, in Warholian fashion, insisted on the sincerity of his message. "I don't see a Hummel figurine as tasteless," he has commented of this brand of faux-folk art. "I see it as beautiful. I see it and respond to the sentimentality in the work." If the avant-garde was once defined in opposition to kitsch, then its embrace might still carry a modicum of surprise, but there is little vanguard challenge here—just the opposite in fact: "I have always tried to create work which does not alienate any part of my audience," Koons states. "Through my work, I tell people to embrace their past, to embrace who they are." According to Koons, this past, this identity, is constituted by the symbols of "mass cultural history," which we are encouraged to deem "perfect just the way it was."

Most pertinent here is his "Celebration" series (1994–2006), which includes twenty large sculptures of balloon figures, Valentine hearts, diamond rings, and cracked-open eggs, cast in high-chromium stainless steel, coated with transparent color, and polished to a brilliant shine in a manner evocative of luxury-gift packaging. The series did not begin well, with production difficulties leading to cost overruns that pushed Koons to the point of bankruptcy. Yet when his auction prices rose sharply, one of his dealers, Jeffrey Deitch, was able to assemble a consortium of gallerists and patrons to buy some of the pieces in advance, sight unseen. (Tellingly, Deitch has since become director of the Los Angeles Museum of Contemporary Art.) It turned out to be a smart investment: one such work, *Hanging Heart (Magenta / Gold)*, sold in 2007 at Sotheby's for $23.6 million. What makes these objects apparently so attractive to patron and public alike? Consider *Balloon Dog* (1994–2000), which comes in luscious yellow, orange, or magenta [2]. It offers the slight *frisson* of a small, fragile, and ephemeral toy made monumental, hard, and permanent, produced at a great cost and sold at an even greater price; it also presents a seductive mix of populism of image and exclusivity of ownership. For some commentators, this formula renders a Koons sculpture the ideal public art, and his advocates speak of "a panorama of society" addressed in his work. Yet critic Peter Schjeldahl captures well what this "panorama" consists of: Koons

▲ 1986

2 • Jeff Koons, *Balloon Dog (Magenta),* 1994–2000, installed in the Château de Versailles, France, 2008
High-chromium stainless steel with transparent color coating, 307.3 × 363.2 × 114.3 (121 × 143 × 45)

3 • Damien Hirst's *The Dream* (2008) shown at the "Beautiful Inside My Head Forever" auction exhibition at Sotheby's, London, September 2008

"apostrophizes our present era of plutocratic democracy, sinking scads of money in a gesture of solidarity with lower-class taste." Appropriately, in fall 2008 Koons staged a show of his recent production at that tourist Mecca, the royal palace at Versailles.

Two years later, Murakami caused great controversy with his own exhibition at the same venue. The Japanese artist has exploited the convergence of art, media, and market even more thoroughly than Koons has. If the latter operates with smart selections from the repertoire of Western kitsch, the former develops figures of his own branding inspired by the Japanese subcultures of *otaku* (often translated as "geek") and *kawaii* ("cuteness"). *Otaku* fans tend to be male adolescents obsessed with particular characters in *manga* (comic books) and *anime* (television programs and films); some are action figures to identify with, while others are submissive girls to fantasize about. An early attempt by Murakami in the *otaku* vein was *Miss Ko²* (1997), a combination of a pixie blonde girl with her hair in a ribbon and a buxom porn star in a skimpy waitress costume. *Miss Ko²* was not a hit among *otaku* fans—apparently she did not appear submissive enough—but Murakami has proved more successful with motifs that play on the female-oriented subculture of *kawaii*, such as his

zesty mushrooms, smiley flowers, toddlers called "Kaikai" and "Kiki" (his corporation is titled in their honor), and, above all, "Mr DOB." Named after a *manga* character, DOB closely resembles a Mickey Mouse whose head (that is all he is) spells out his name (D and B appear on his ears, and his face is an O). Toothy and sinister in his first incarnation, DOB was quickly refashioned as infantile and cute; as it happens, Mickey evolved in similar fashion, and the branding of DOB does seem based on that of the Disney star.

Although Japan does not hold to the separation between high and low culture that once marked the modern West, Murakami still spans socioeconomic registers in a way that might be unprecedented. His bright mutants like DOB appear both in the costliest paintings and sculptures and in the cheapest merchandise (stickers, buttons, key chains, dolls, etc.); they can be found in major museums as well as in convenience stores. The graffiti artist Keith Haring had some of this market range in the eighties; his signature figures of "the radiant baby" and "the barking dog" also extended from T-shirts to art work. Yet his "Pop Shop" was small beer compared to the Murakami corporation, which offers such services as advertising, packaging, animation, exhibition development, and website production. At one point, the multitasking Murakami also

managed the careers of seven young Japanese artists, ran an art fair, hosted a radio show, wrote a newspaper column, served as a brand consultant for a television station and for billionaire Minoru Mori, and worked on his own animation features. Perhaps his biggest splash in the West came in 2002 when Marc Jacobs commissioned Murakami to design a version of the Louis Vuitton monogram; the sale of handbags with the rebranded symbol, which also include his "jellyfish eye" and cherry blossom motifs, exceeded $300 million in their first year of production. That Murakami considers such activity fully in line with his art practice was made clear by the presence of a Louis Vuitton boutique smack in the middle of his 2007–8 retrospective at MoCA in Los Angeles, which was titled "©Murakami," as though it were just another sales space among others.

▲ Arguably, with Warhol there was still an element of disturbance in this confusion of positions and values—of artistic and commercial, high and low, rare and mass, expensive and cheap, and so on. There is little tension, and not much insight, now that these pairs have imploded—just a giddy delight, a weary despair, or a manic-depressive cocktail of the two. "Anytime we do the honest thing," Murakami once said in an instructive turn of language, "we get the win. People find it very difficult to find their honest desire. Andy Warhol did that." Yet beyond the apparent straight talk of Murakami or the quasi-medicated cheeriness of Koons one can sometimes catch a sinister and/or perverse note (as indeed exists in Warhol). However innocent at first glance, *Balloon Dog* also intimates a polymorphous sexuality, with the bulbous parts of the poodle morphing into breast and penis, and the initial DOB betrays more than a trace of the sadomasochistic nastiness some

● times sensed in Mickey Mouse or Donald Duck. Walter Benjamin once speculated that the early Disney films were so popular because "the public recognizes its own life" in the trials that Mickey and Donald are made to endure, and that their primary lesson is to teach us how "to survive [a] civilization" become barbaric. There is an element of this odd appeal in the cute degradation that Koons and Murakami figures embody. Certainly, Murakami understands the infantile aspects of *otaku* and *kawaii* subcultures in a related way, referring them to the traumatic effects of nuclear holocaust and postwar subjection in Japan.

This dark side is most evident in the work of Hirst, who, with his courting of controversy, is the champion of converting media attention into financial reward. Yet even before he floated his famous shark in a tank of formaldehyde or left his cow's head to rot in a vitrine, Hirst recognized that "being sensational isn't sensational any more," that anesthesia was the flip side of shock, and that deadness was his true theme. In this respect, his *pièce de résistance* came in 2007 when Hirst exhibited a platinum cast of a human skull studded with diamonds worth £14 million [1]. Some interpreted this pirate treasure *cum* crown jewel as a *vanitas* or a *memento mori*, but, if this is so, it is a very glamorous one and a jackpot to boot: it came into the world valued at £50 million. Hirst himself is the the majority shareholder, owning two-thirds of the work; the remaining

third is owned by a consortium. Hirst also made headlines on September 15–16, 2008, when he bypassed his two major dealers and auctioned a large lot of new work directly at Sotheby's (there were 223 pieces in all), beating the sky-high estimates by a substantial margin [3]. Sales totaled $200.7 million, ten times the old record for a single-artist auction set by Picasso with eighty-eight works in 1993. As it happened, Wall Street melted down during those same days, with storied financial institutions bought in fire sales, vanishing into thin air, or bailed out at enormous cost to taxpayers. Perhaps the diamond skull will come to serve as a memorial to this moment.

Deep into the Depression of the thirties, Benjamin speculated that the antisocial behavior of the bohemian artist (he had Baudelaire in mind) might not be as subversive as some of us like to think, and with an eye to the embittered realisms and bankrupt surrealisms of his time he remarked: "It was left to the bourgeoisie of the twentieth century to incorporate nihilism into its apparatus of domination." To reflect on this nihilism, but also to update it and to further it, is part of the ambiguous achievement of the Warholian line of Koons, Murakami, and Hirst.

Recessional aesthetics?

The 2008 crash rendered uncertain some of these developments, so it might be appropriate to end with a few questions that cannot be answered definitively at present. What are the effects of the recent recession on the role of the artist? Has it relieved any of the expectations associated with art as entertainment or spectacle? Might some dimension of a public sphere be reclaimed for contemporary art? Is the art museum of the neoliberal era sustainable, or might the (near) failure of several institutions (such as MoCA in Los Angeles) lead to different modes of organization? Might the crisis present an opportunity for the undercapitalized, or, on the contrary, will neoliberal patrons consolidate further power? Since contemporary art appeared to flourish alongside hedge funds and mega-banks, often by creating products with some of the same derivative strategies for dissemination as those that created the virtual wealth of those financial entities, what is its complicity with this system? Is the economic model of local development and international commerce that sustained art biennials still tenable? Might emphasis be placed on other features of globalization, or will there be a withdrawal to the local—a sort of art-world protectionism? Finally, might art criticism, long irrelevant to an art market driven by powerful dealers and collectors, regain some currency? HF

FURTHER READING

Artforum, vol. XLVI, no. 8, April 2008 (special issue on "Art and its Markets")

Luc Boltanski and Eve Chiapello, *The New Spirit of Capitalism*, trans. Gregory Elliot (London: Verso, 2005)

Isabelle Graw, *High Price: Art Between the Market and Celebrity Culture* (Berlin and New York: Sternberg Press, 2009)

Julian Stallabrass, *Art Incorporated* (London: Verso, 2004)

Olav Velthius, *Talking Prices: Symbolic Meanings for Prices on the Market for Contemporary Art* (Princeton: Princeton University Press, 2005)

2009ₐ

Tania Bruguera presents *Generic Capitalism* at the multimedia conference "Our Literal Speed," a performance that visualizes the assumed bonds and networks of trust and likemindedness among its art-world audience by transgressing those very bonds.

n 2009, the Cuban artist Tania Bruguera (born 1968) presented *Generic Capitalism* as her contribution to the second installment of an experimental multiyear academic conference-cum-festival titled "Our Literal Speed." Some members of the audience at the weekend-long event, held at the University of Chicago and the Art Institute of Chicago, as well as other locations around the city, were surprised to see Bruguera merely attending the work instead of participating directly, since she had become known in the eighties and nineties for incorporating her body into her art. Notable

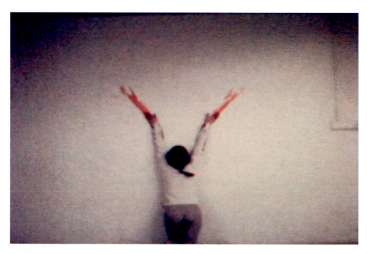

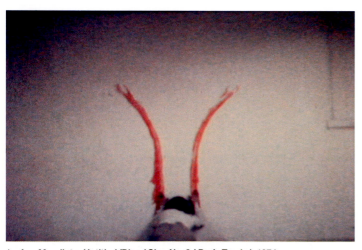

1 • Ana Mendieta, *Untitled (Blood Sign No. 2 / Body Tracks)*, 1974
Super-8 color, silent film

among these early works were a series of reenactments initiated in 1986 of actions by the important feminist artist Ana Mendieta, also of Cuban descent, who lived in the United States from 1961 until ▲ her death in 1985. Mendieta's oeuvre ranged from implicitly traumatic pieces such as *Untitled (Body Tracks)* of 1974 [1], where she dragged her arms and hands, dipped in blood or paint, onto surfaces like paper, fabric, or the wall itself, to her quasi-ritualistic *Siluetas*, a series of anthropomorphic silhouettes, often set aflame, that became markers in the landscape. Bruguera, who splits her time between Cuba and the United States, sought to reinsert Mendieta into Cuban art history by "revivifying" her actions—thus staging a return of the older "exiled" artist to her birthplace. This was the first of Bruguera's many efforts to explore how the ephemeral effects of Performance art may be remembered and represented both in the minds of individual audience members and even in museum collections through the purchase of archives and instructions for reenactment.

Generic Capitalism [2] was another kind of work altogether—one more consistent with what Bruguera calls Arte de Conducta, or "Behavior Art," a practice to which she devoted a collaborative study center in Havana from 2003 to 2009 called the Cátedra Arte de Conducta. The purpose of Arte de Conducta is to rupture the membrane between art and life in aesthetic actions that have direct social impact. As the artist stated in an interview with performance historian and curator RoseLee Goldberg in 2004, "I want to work with reality. Not the representation of reality. I don't want my work to represent something. I want people not to look at it but to be in it, sometimes without even knowing it is art." In *Generic Capitalism*, spectators were indeed incorporated into the work as witnesses of a panel discussion featuring the married sixties Weather Underground activists Bernadine Dohrn and Bill Ayers, who in 2008 had again grown notorious due to the Republican Party's efforts to discredit Barack Obama during the presidential campaign by stressing his ties with Ayers, who was characterized as a dangerous radical. Inviting these charismatic and deeply ethical figures to address a largely politically progressive audience (which was drawn from the conference attendees as well as members of the general public) made for an exciting event, but it hardly posed a challenge to the political preconceptions of most people in the

▲ 1975a

2 • Tania Bruguera, *Generic Capitalism*, performance at "Our Literal Speed" conference, Chicago, 2009

room. Dohrn is now a law professor and director of the Children and Family Justice Center at Northwestern University, and her husband Ayers is a distinguished education professor. Such complacency was ruptured, however, when a few audience members began to make aggressive challenges to both Dohrn and Ayers, and by extension to the presumed political consensus that held in the auditorium. The one-time radicals were accused by some of not being radical enough, and by others of being out of touch. This atypical eruption of real dissent and impassioned discussion at an art event was highly bracing and it led to one of the most stimulating and lively discussions that many in the audience could remember—a true instance of democratic debate in action.

It later came to light that Bruguera had planted the most outspoken questioners unbeknownst to Dohrn and Ayers, who were themselves visibly taken aback by the vehemence of their interlocutors. What had felt like a spontaneous and explosive conversation had therefore been manipulated, which led to another, unmanipulated but equally impassioned discussion at the symposium the next day, where several participants expressed their feelings of betrayal that the dicussion had been fixed. In *Generic Capitalism*, Bruguera successfully brought art into life not by introducing some external political content into the framework of art, as she seemed to be doing by inviting Dohrn and Ayers to participate as her guest "performers," but rather by confronting an "insider" audience with two sorts of assumptions that implicitly tied them together: first, a presumed agreement on basic political positions; and second, the trust that public interchange will be free and disinterested rather than manipulated by the artist (or anyone else). In other words, Bruguera was not "preaching to the converted" by reconfirming the liberal assumptions of an audience presumed to be liberal. Instead, she was making these unconscious assumptions painfully visible, while simultaneously introducing manipulation into an occasion putatively governed by free speech. Perhaps this presence of manipulation amidst an "imagined community" (the term is political scientist Benedict

Anderson's) is why Bruguera titled the work *Generic Capitalism*, for in a market economy where, for instance, "air time" on radio, television, and even often space on the Internet must be paid for, speech is vulnerable to manipulation by those with the means to purchase it.

"A bundle of relations"

In short, Bruguera's "Behavior Art" is much more specific than a generalized participation or interactivity between the audience and a work of art. It delineates *the ties that bind* particular audience members together rather than their simultaneous, but nonetheless individual connections to an image, object, or event (the latter functioning in this work as a pretext for clarifying the interpersonal relationships of the audience rather than as an end in itself). In other words, Bruguera's work explores the nature of social ties or associations; in effect, it is this web of connections that constitutes her medium. In this regard, though it has not been explicitly categorized in this way, Arte de Conducta might be understood in light of what Nicolas Bourriaud has influentially identified as "relational aesthetics." Bourriaud has elaborated his position in a series of important exhibitions and most directly in his book *Relational Aesthetics*, which was published in French in 1998 and translated into English in 2002. In a statement that resonates with Bruguera's work, Bourriaud writes, "Each particular artwork is a proposal to live in a shared world, and the work of every artist is a bundle of relations with the world, giving rise to other relations, and so on and so forth, ad infinitum." Bourriaud's phrase "bundle of relations" is particularly apt and helpful in exploring the distinction between the artists based in Europe and North America who have been associated with relational aesthetics since the mid-nineties—including Pierre Huyghe, Philippe Parreno, Liam Gillick, Dominique Gonzalez-Foerster, Rirkrit Tiravanija, and several others—and the pioneers of performance and installation art earlier in the twentieth century.

▲ 2003 ● 1916a, 1961, 1962a, 1962b, 1973, 1974, 1987, 1989, 1998, 2003

3 • Rirkrit Tiravanija, _Untitled (Free)_, 1992
Installation and performance at 303 Gallery,
New York, tables, stool, food, crockery,
cooking utensils, dimensions variable

It is important to acknowledge that participatory art works, including installations that incorporate viewers within an immersive environment and actions that stage a heightened encounter with the body of an artist and / or delegated performers, have been
▲ part of modern art since at least 1916, when Dada's Cabaret Voltaire opened its doors in Zurich. But aesthetic formats of installation and performance were only consolidated as _mediums_ during the period spanning Allan Kaprow's invention of "happenings" in 1959 and
● the widespread practice of body art in Europe, Latin America, and the United States during the seventies. Both types of practice sought to shift the viewer's perceptions away from objects and toward environments and relationships. Installation-based work replaced paintings or discrete sculptures with spaces that ultimately opened out to a wide range of so-called post-studio practices such as land
■ art where artists sought to sensitize visitors to various kinds of surroundings sometimes as unremarkable as ordinary suburban sprawl, and sometimes as sublime as a wide-open desert landscapes. Typically, happenings and installations orchestrated one or many interconnected settings often embracing the audience, but physical interaction, when it occurred, was usually limited to manipulating preconceived devices or otherwise following specified rules or scores laid down by the artist. In body art, as in the works of Ana Mendieta, viewers are made vividly aware both of the performer's person as an object—and particularly a gendered object, as in much
◆ significant feminist performance since the seventies—and to the ethical relationship between oneself and the performer, especially in those works where an artist places her- or himself at physical or psychological risk in the presence of spectators as witnesses.

By contrast, pieces that are classified as relational aesthetics tend to be less scripted—and indeed, one of the forms favored by artists such as Gillick, Parreno, and Huyghe is what they call scenarios: in other words, textual, cinematic, or spatial frameworks that remain open to a wide range of interactions and interpretations. Consequently, an art work's center of gravity shifts from the viewer's unilateral relationship with installation or performer to a multilateral network of relationships _among_ viewers as in Bruguera's _Generic Capitalism_. Many artists championed by Bourriaud have developed such structures through acts of hospitality, where an artist _hosts_ situations without attempting to occupy center stage either through the objects s / he produces or through her or his person. Cooking and serving meals, for
▲ example, is a central dimension of Rirkrit Tiravanija's art. In _Untitled (Free)_ from 1992, an early exhibition in New York, he moved all of the contents of the back room of the small 303 Gallery (including the gallery director and her workspace) into the front room and set up shop in the back cooking curries for those who dropped by [**3**]. One of the most intriguing aspects of Tiravanija's practice is what he calls their "coming out of action"—when, for instance, no cooking is taking place but the remnants of the activity nonetheless remain present. Dirty utensils and scraps of food are left to crust up or decay in what might be read as an allegory of a public sphere fallen into ruin.

Tiravanija's hospitable gesture was further literalized in _Untitled (Tomorrow is Another Day)_ of 1997, which consisted of a full-scale plywood replica of the artist's New York tenement apartment, complete with working appliances in both kitchen and bathroom.

▲ 1916a ● 1961, 1973, 1974 ■ 1967a, 1970 ◆ 1974, 1975a ▲ 1989, 2003

4 • Rirkrit Tiravanija, *Secession*, 2002
Installation and performance at the Vienna Secession

Guests were invited to occupy this "home away from home" in any way they wished, twenty-four hours a day, six days a week, for the duration of its exhibition at the Kölnischer Kunstverein in Cologne. In other words, the art work was offered to visitors as a *facility* rather than as an object of contemplation. But what exactly is being facilitated? The casual or uninitiated museumgoer faced a dilemma: s/he had to decide whether to invade the "privacy" of the work and set up camp—an act that could easily seem transgressive or embarrassing—while, on the other hand, art-world insiders who were aware of Tiravanija's intentions might feel more at home, but only at the risk of collapsing the work's public ambitions into an inside joke. This dilemma, centering on how entitled one feels to inhabit the artist's facilities and how spontaneous this mode of association can or should be, is addressed in later pieces such as Tiravanija's *Secession* at the Vienna Secession in 2002 [**4**]. Like many works of the nineties and since, *Secession* included a navigable architectural fragment installed amidst a program of live activities. Indeed, several works by Tiravanija have incorporated nearly life-size models of iconic designs by modernist architects such as Le Corbusier, Jean Prouvé, and Philip Johnson, in what function as citations of the modernist "open plan"—a historical and spatial "predecessor" of the open scenario dear to proponents of relational aesthetics. In Vienna, Tiravanija included a chromesheathed reproduction of a portion of Viennese émigré architect Rudolf Schindler's 1922 home in Los Angeles, famously designed as a cluster of open pavilions of indeterminate program. Accom-

panying activities during the course of the exhibition ranged from a barbecue and DJ sessions to Thai massage and film screenings. Tiravanija, like several of his colleagues, often contains citations of architecture with media presentations, perhaps because this conjunction brings together the two species of space that everyone now must navigate: the actual and the virtual. Huyghe and Parreno, for example, are especially interested in how cinematic space may become a space of *association*, as when Huyghe had the "real" protagonists upon which the film *Dog Day Afternoon* (1975) was based reenact scenes from the movie in his own two-channel video installation *The Third Memory* (2000), confounding the fictional and documentary, the act and its reenactment in a multitude of ways. As he declared in an interview with the art historian George Baker published in 2004, "a film is a public space, a common place. It is not a monument but a space of discussion and action. It's an ecology."

Tiravanija and Huyghe stage occasions. Tiravanija's cooking, for instance, is paralleled by the events Huyghe organizes, such as Streamside Day, an inaugural celebration for a subdivision in upstate New York, complete with parade, costumes, and entertainment. By inventing a holiday for a fairly generic upscale neighborhood, Huyghe attempted, perhaps ironically, to build a sense of community or symbolic identity for a brand new place carved out of the surrounding countryside. For his related gallery installation, *Streamside Day Follies* of 2003 [**5**], a film and video transfer "document" of the live event was projected in a nomadic

▲ 1998, 2003

5 • Pierre Huyghe, *Streamside Day Follies*, 2003
Digital video projection from Super-16 film and video transfers, color, surround sound, 26 minutes

screening pavilion—a set of five mobile walls, originally quite distant from one another, and placed flush against the rooms' perimeter, slowly moved together via ceiling tracks to form a temporary enclosure in the center of one large gallery. The ethos of hospitality and celebration that Tiravanija and Huyghe embody, and which is typical of artists identified with relational aesthetics, thus seems the converse of Bruguera's Arte de Conducta. If the former exhibits an optimistic conviction that new and meaningful communal associations can be built through art, the latter pivots on visualizing the bias and unexamined forms of class solidarity ▲ that haunt more utopian forms of association.

Hosting connections

All of these works share an emphasis on *hosting*—whether a panel discussion, a meal, or a parade—but each takes place in an *actual space*. In the age of online social networking, there is another type of location available to artists: the virtual space utilized by Anton Vidokle (born 1965) and Julieta Aranda (born 1975) to facilitate e-flux, their collaboratively run e-mail information service. E-flux *hosts* in the manner that a computer or website does: it typically distributes four e-mail announcements per day [6], informing thousands of international subscribers about exhibitions, events, competitions, and job openings occurring all over the world. Through fees charged to its "clients," the venture nets sufficient funds to support a variety of other e-flux activities, including a gallery space in the Lower East Side of Manhattan and an electronic

journal sent to all subscribers, as well as various special projects. Although Vidokle and Aranda resolutely regard themselves as artists in all of their activities, there has been some controversy over designating the e-flux announcement service as *art*, in part because it "merely" redistributes existing press releases (albeit often in serious and even experimental form), and second because it yields a profit directly, like an ordinary business, rather than buffering artists from commerce through the mediation of a ▲ gallery. In this regard, it is worth recalling Conceptual art's fundamental insight: that information is fungible, constantly changing shape in different instances of communication, and that art, by exploring its status as a special kind of self-reflexive information, may articulate these "shapes," ranging from bureaucratic rationality (or pseudo-rationality) to the breakdowns that occur through interference or "noise."

As an art-world information bureau, free to subscribers and thus devoted to broadening access to a wide range of far-flung events, e-flux, like Bruguera's Arte de Conducta, *immerses* users in a situation—namely, information overload—rather than representing it back to them. In an era when the proliferation of large international exhibitions, dubbed "biennial fever," makes it doubly implausible for anyone to comprehend the full scope of contemporary art—first, because it is physically and financially impractical to travel everywhere, and second, because each major international exhibition is now so vast as to require several days for an adequate visit—e-flux gives subscribers the tools necessary to develop what the cultural theorist Fredric Jameson might call a

"cognitive map" of the art world as a multifocal database. In short, e-flux offers a "search algorithm" for current art based on Vidokle and Aranda's choices of inclusion from the submissions they receive every day. Even with this reduced database, the subscriber herself must sort through what's available in order to derive meaning or value from art's information overload. In other words, e-flux makes visible one of the dominant structural principles of contemporary art: its migration toward a "survey" or database structure quite different from the history of modernism in which styles or movements were typically used exclusively to organize aesthetic meaning. In demonstrating contemporary art's "informational unconscious" of data production, storage, and retrieval, e-flux takes its place in the tradition of Conceptual art, and especially those artists associated with institutional critique, such as
▲ Hans Haacke or even Hanne Darboven, who demonstrated how the meaning and value of art are deeply conditioned by its institutional frameworks of display, exchange, and publication.

In its economic structure, e-flux raises a further set of questions regarding the artist's economic (and artistic) autonomy during a period when the art market has expanded enormously. For certain artists the massive growth of galleries and collectors in the
● nineteen and 2000s opened unprecedented opportunities, while for many others who did not have (or wish to acquire) the "right" market appeal, it has been severely limiting and even demoralizing. Somewhat paradoxically, Vidokle and Aranda and their various collaborators literally *earned* their independence from the art market by inventing, albeit unintentionally, a profitable business platform with their e-flux announcement service. As Vidokle declared in a statement of 2009: "An artist today aspires to a certain sovereignty, which implies that in addition to producing art one also has to produce the conditions that enable such production and its channels of circulation. Consequently the production of these conditions can become so critical to the production of work that it assumes the shape of the work itself." Vidokle's insight that the work of art is itself the *social production* of its conditions of existence returns us to the questions of social interaction, or association, raised by Arte de Conducta and relational aesthetics. It is clear that the fundamental issue in all of this work is not merely the isolation and/or enactment of a relation among viewers or "users" *qua* relation, but rather the investigation *aesthetically* of the nature, value, and quality of different sorts of social connection. For Bruguera, it is a question of the good or bad faith of association between citizens—their assumptions about collective identity and the mechanisms of participatory democracy. For Tiravanija or Huyghe, it is a question of consolidating a group—sometimes an in-group and not always a public—through contemporary celebrations, rituals, or holidays. Finally, for Vidokle, Aranda, and e-flux, it is a question of understanding the different degrees of informational association—from the entrepreneurial to the pedagogical, as a spectrum of databases that range from virtual e-mails to face-to-face encounters. In each case, the work of art defines itself not as an object, but as a network or framework for association within which a particular shape of communication may appear. DJ

FURTHER READING

Carrie Lambert-Beatty, "Political People: Notes on Arte de Conducta," in *Tania Bruguera: On the Political Imaginary* (Milan: Edizioni Charta; Purchase, NY: Neuberger Museum of Art, 2009)

Tania Bruguera (Venice: La Biennale di Venezia, 2005)

Nicolas Bourriaud, *Relational Aesthetics*, trans. Simon Pleasance and Fronza Woods with the participation of Mathieu Copeland (Les Presses du Réel, 2002)

George Baker, "An Interview with Pierre Huyghe," *October*, no. 110, Fall 2004, pp. 80–106

Anton Vidokle, *Produce, Distribute, Discuss, Repeat* (New York: Lukas & Sternberg, 2009)

Anton Vidokle, Response to "A Questionnaire on 'The Contemporary,'" *October*, no. 130, Fall 2009, pp. 41–3

e-flux

Clients Archive Projects Journal About Subscribe Contact RSS [Search]

Mary Kelly

Moderna Museet / Iaspis

By showing Mary Kelly's major projects from the 1970s together with works from the past decade, the exhibition seeks to engage us in a visual dialogue across generations that have been shaped by different cultural circumstances, but subject to the same historical events.

Continue reading

Mary Kelly and Ray Barrie, "Habitus" 2010.
© Mary Kelly/Ray Barrie.

18 8th Shanghai Biennale • Rehearsal
Queensland Art Gallery | Gallery of Modern Art • 21st Century: Art in the First Decade
MAK Gallery • David Zink Yi
Moderna Museet / Iaspis • Mary Kelly

17 **ZKM | Center for Art and Media Karlsruhe** • The Digital Oblivion - International symposium
Frederick Kiesler Prize for Architecture and the Arts • Awarded to an Austrian artist, Heimo Zobernig
Marres, centre for contemporary culture • Hygiene, the story of a museum at Marres

16 **If I Can't Dance, I Don't Want To Be Part Of Your Revolution** • Iglu by Guy de Cointet
Bidoun • Browser, beware: # 22: LIBRARY
Behring Institute • Call for: Placebos for Art
Kunst- und Ausstellungshalle der Bundesrepublik Deutschland • Vibracion

e-flux journal

issue #18
10 / 2010

view all issues ➞

Julieta Aranda, Brian Kuan Wood, Anton Vidokle,
Editorial

Svetlana Boym, **The Off-Modern Mirror**

Diedrich Diederichsen,
People of Intensity, People of Power: The Nietzsche Economy

Boris Groys, **Marx After Duchamp, or The Artist's Two Bodies**

6 • e-flux announcement, October 2010

Website screenshot

2009 _b

Jutta Koether shows "Lux Interior" at Reena Spaulings Gallery in New York, an exhibition that introduces performance and installation into the heart of painting's meaning: the impact of networks on even the most traditional of aesthetic mediums—painting—is widespread among artists in Europe and the United States.

With a characteristic flourish of perversity linking painting to pasta, the German artist Martin Kippenberger (1953–97) identified in an interview from 1990–1 the most important painterly problem to arise since Warhol's silkscreens of the sixties: "Simply to hang a painting on the wall and say that it's art is dreadful. The whole network is important! Even spaghettini…. When you say art, then everything possible belongs to it. In a gallery that is also the floor, the architecture, the color of the walls." In Kippenberger's work, which included painting and sculpture as well as many hybrid practices in between, the limits of an individual object were consistently challenged. Already in his first painting project of 1976–7, *One of You, a German in Florence* [1], Kippenberger displaced attention from singular works by rapidly executing one hundred canvases in grisaille, all the same size, that reproduced snapshots or newspaper clippings. His intention was to make enough paintings so that when piled up they would be as tall as him. Here painting enters several types of network at once: each individual canvas belonged to a "family grouping"; all were assimilated to the fluid economy of photographic information, referencing the personal snapshot or the journalistic document; and the scale of the series was indexed to the physical characteristics of the artist—namely, his height—as well as his everyday activities, as marked by the choice of motifs that might be recorded by any avid, though eccentric, German resident in Florence.

If we take Kippenberger at his word, then, a significant question arises: How can painting incorporate the multiple networks that frame it? This late-twentieth-century problem, whose relevance has only increased with the turn of the twenty-first century and the growing ubiquity of digital networks, joins a sequence of modernist challenges to painting. Early in the last century, ▲ Cubism pushed the limits of what a coherent painterly mark could be by demonstrating the minimum requirements for visual coherence. Mid-twentieth-century gestural abstraction, epitomized by ● Abstract Expressionism, raised the issue of how representation may approach the status of pure matter—consisting of nothing but raw paint applied to canvas. And finally, during the sixties a ■ whole range of photomechanical procedures pioneered by Pop and

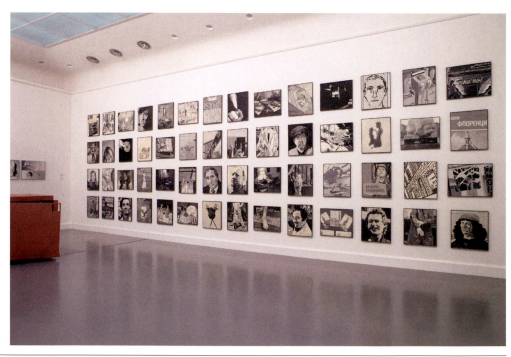

1 • Martin Kippenberger, *Untitled* (from the series *One of You, a German in Florence*), 1976–7
Oil on canvas, each 50 × 60 (19¹¹⁄₁₆ × 23⅝)

▲ 1911, 1913, 1921a ● 1947b, 1949, 1951 ■ 1960c, 1964b, 1967c

2 • Jutta Koether, "Lux Interior," Reena Spaulings Gallery, New York, 2009
Installation view

related artists in the United States and Europe explored the relationship between the painted image and mechanical reproduction (more recently encompassing both video and digital photography). None of these questions, which have structured the history of twentieth-century art, exists in isolation or ever disappears; instead there are shifts in emphasis in which earlier aesthetic challenges or preoccupations are reformulated through newer ones.

The passage of painting

Certainly, painting has always belonged to networks of distribution and exhibition, but Kippenberger claims something more: that, by the early nineties, an individual painting should explicitly *visualize* and *incorporate* such networks in its form as an object. And indeed, Kippenberger's studio assistants and close associates (some might call them collaborators) like Michael Krebber (born 1954), Merlin Carpenter (born 1967), and his interviewer of 1990–1, Jutta Koether (born 1958), have developed practices in which painting links the world of images within a canvas to an external network composed of human actors. In Koether's 2009 exhibition "Lux Interior" at Reena Spaulings Gallery in New York, for instance, painting functioned as a crossroads of performance, installation, and painted canvas [2]. The exhibition centered on a

single work mounted on an angled floating wall—much like a screen—which, as Koether put it, had one foot on and one foot off the raised platform that delineates the gallery's exhibition area, as though caught in the act of stepping on stage. This effect was enhanced by a vintage scoop light trained on the painting, which had been salvaged from The Saint, a famous gay nightclub that officially closed its doors in 1988 largely as a consequence of the AIDS crisis. The canvas itself, *Hot Rod (after Poussin)*, is a nearly monochromatic reworking of Poussin's *Landscape with Pyramus and Thisbe* (1651) representing a Roman tale centered on the extinction of love—and life—caused by the misreading of visual cues (Pyramus sees Thisbe's ruined veil and assumes she has been murdered by a lioness, leading to his suicide, and then, upon finding him dead, Thisbe's own). The painting is predominantly red—the color of blood and anger (and by extension AIDS)—and it centers on a scaled-up motif—a giant bolt of lightning that had played a much less prominent role in Poussin's canvas. This jagged form divides the composition like a scar, around which brushstrokes collect like metal filings drawn to a magnet. The marks are by turns tentative and assertive, something like the caress before a slap. Indeed, inspired by art historian T. J. Clark's extended reading of Poussin in his 2006 book *The Sight of Death*, Koether developed a gesture that is deeply ambivalent: equally composed

3 • Stephen Prina, *Exquisite Corpse: The Complete Paintings of Manet, 207 of 556. Chemin de Fer (The Railway), 1873*, National Gallery, Washington, January 20, 2004
Left panel: ink wash on rag barrier paper, 93 × 112 (36⅝ × 44³⁄₃₂); right panel: offset lithograph on paper, 66 × 83 (25¹⁵⁄₁₆ × 32⁹⁄₁₆)

of self-assertion and interpretation, her marks seem to be hollowed out by the elapsed time between Poussin's work of 1651 and her own reenactment of it in 2009. Three lecture performances accompanied the exhibition, in which Koether moved around and even under the wall that supported her canvas—her body and the bright anger of her recitation of collaged text furnished a frame for the canvas. The painting's own presence as a personage—or interlocutor—was further enhanced by strobe light flashing onto it in different configurations during these live events as if painting and painter had hooked up at a dance club.

"Lux Interior" offers a sophisticated response to the question of how painting visualizes and incorporates networks. It is worth pausing to consider how difficult it is to represent networks, which, in their incomprehensible scale, ranging from the impossibly small microchip to the impossibly vast global Internet, truly embody the contemporary sublime. One need only google "Internet maps" to turn up Star Trek-inspired images of interconnected solar systems that do little to enhance one's understanding of the traffic in information but do much to tie digital worlds to ancient traditions of stargazing. Koether approaches the problem in a different way. Instead of attempting to visualize the overall contours of a network, she actualizes the *behavior of objects within networks* by demonstrating what might be called their transitivity.

The Oxford English Dictionary gives one definition of *transitive* as "expressing an action which passes over to an object." The term *passage* is well suited to capture the status of objects within networks—which are defined by their circulation from place to place and their subsequent translation into new contexts. In "Lux Interior," Koether established two different kinds of passage. First, each brush-stroke of her reenactment of Poussin's *Landscape with Pyramus and Thisbe* embodies the passage of time between the Poussin that serves as her model and her own contemporary painting. This temporal axis of painting is joined to a second kind of spatial passage that moves out from the painting into various social networks surrounding it, as indicated by *Hot Rod*'s behavior as a personage (it "steps" on stage, and is lit by disco lamps, etc.), as well as by the artist's performance as the painting's interlocutor in her three lecture events.

What defines transitive painting, of which Koether represents only one "mood," is therefore the capacity to hold two kinds of *passage* in suspension: one sort that is internal to a canvas, and another that is external to it. In this regard, painting since the nineties has absorbed into itself so-called "institutional critique"—the practice of incorporating the art world's conventional values and systems of presentation into the art work itself. Stephen Prina (born 1954) has developed a number of painterly projects that,

more explicitly than Koether, integrate such themes of institutional critique, and consequently epitomize a cooler "mood" of transitive painting. In 1988 Prina initiated an ongoing project titled *Exquisite Corpse: The Complete Paintings of Manet*, in which an offset lithograph representing a visual index of Édouard Manet's corpus of 556 works (arranged to scale in a grid of "blanks" based on the contour and dimensions of each painting or drawing) was exhibited next to every monochrome sepia ink drawing made by Prina to the exact size and format of corresponding works in Manet's oeuvre [3]. While on casual examination these drawings might appear empty, the artist rightly insists on their positive visual affect. In an interview of 1988, he stated:

They may be the lowest common denominator of expressivity. The surfaces are sponged with a diluted sepia ink wash. Some people see them as being vacant or empty images. They are subtle, but they aren't empty. In some ways they're as full as they could be. There's pigment edge to edge. Every square inch has been mapped out, plotted and occupied. They are quite clearly hand-made.

If, for Koether, painting functions as the nodal point of performance, installation, and a figurative style of free gestural "reenactment," for Prina it marks the intersection of an artist's complete oeuvre (as represented by Manet's inventory), the single object's format (its size and contour), and a simple, deskilled method of applying a single hue of paint on paper. The tone of *Exquisite Corpse* is thus dramatically different from "Lux Interior," but Koether and Prina share the same project: to visualize painting within an integrated social network—an expanded field of personal, aesthetic, critical, and historical conditions. As Prina declares in the same 1988 interview, "I entitled the Manet project *The Exquisite Corpse* because it seemed necessary to see a complete body of work, in relation to his body and to my body."

Transitive painting arises, therefore, as a dynamic equilibrium between two types of passage: those that are internal to a canvas, including mark-making and the delineation of motifs; and those that are external to it, encompassing the work's location in space, its position within a particular constellation of institutions, its relationship to art history, and the social connections established between author and spectators. In other words, for artists like Kippenberger, Koether, and Prina, the structure of a painting is profoundly affected by the external conditions of display and reception that frame it. In this regard, it is possible to link these transitive strategies to an earlier innovation in mid-twentieth-century art, where external pressure is brought to bear on a painterly image. Frank Stella's black stripe paintings, begun in 1958, epitomize what Yve-Alain Bois has called noncompositionality through *deduction*: instead of either inventing painterly motifs from his imagination or causing them to arise through intuitive acts of dripping, staining, or pouring paint onto canvas, Stella generated a geometric pattern based on the size and contour

▲ 1958

of the canvas support, and a simple set of rules according to which he applied commercial enamel paint with a housepainter's brush. His stripes seem to move from the circumference of a canvas to its interior as a kind of internal echo of this external boundary, thus implicitly signaling the fact that no painting may be fully extracted from its surroundings. But in Stella's case the demonstration of an external pressure on internal composition ended at the physical limits of the canvas—which functioned as a stable boundary between picture and world. Many of the younger artists currently exploring painting's transitive behavior have adopted both the look and the procedures of deductive noncompositionality while nonetheless either conceptually or literally transgressing the physical limits of the canvas. In these works, the "inner echo" of the physical limit of the canvas is paired with an "outer echo" in which qualities and allusions from outside enter the interior of the work.

Spectacular blankness

In two exhibitions of 2009, "Robert Macaire Chromachromes" at Andrew Kreps in New York and "Pedestals, Bias-cut / Robert Macaire / Chronochromes" at Galerie Daniel Buchholz in Berlin [4, 5], for example, Cheyney Thompson (born 1975) presented two related series of works whose abstract surface pattern was derived

4 • Cheyney Thompson, *Pedestal IV*, 2009
Resopal, MDF, paper, 94.3 × 96.5 × 122 (37⅛ × 38 × 48)

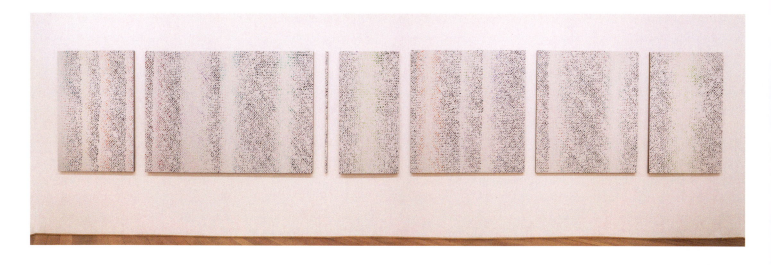

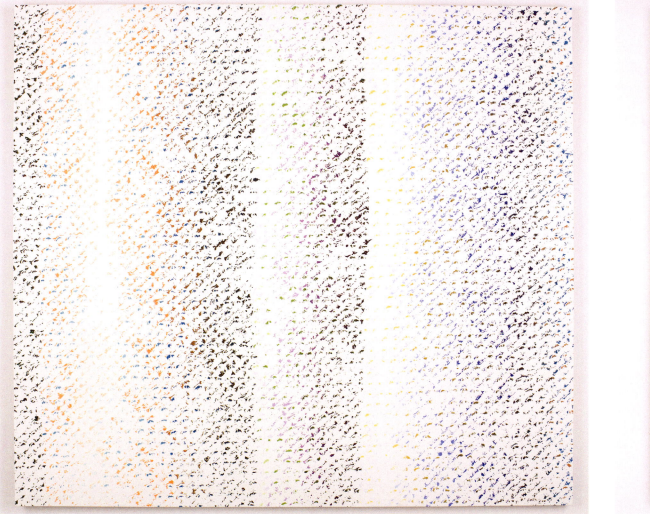

5 • Cheyney Thompson, from the exhibition "Pedestals, Bias-cut / Robert Macaire / Chronochromes,"
Galerie Daniel Buchholz, Berlin, 2009
(top) Installation view
(above left) *Chronochrome V*, 2009, oil on canvas, 140 × 158 (55⅛ × 62³⁄₁₆)
(above right) *Chronochrome X*, 2009, oil on canvas, 140 × 4 (55⅛ × 1⁹⁄₁₆)

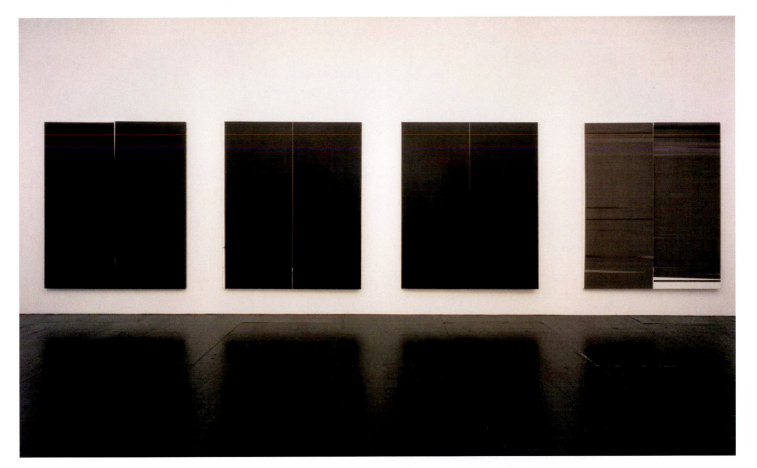

from an enlarged digital scan of the paintings' linen support (in New York, the orientation of the weave was true, but in Berlin, it was "on the bias"). Unlike Stella, whose deductive composition was generated by the physical limits of the canvas, Thompson inserts an intermediary step of digital reproduction in which the *ground* of the painting is transposed as its figure—or put slightly differently, the support for an image (the linen) becomes the image itself. Such a spectacularization of blankness (or the insinuation that everything, even the most neutral format, has now become an image) was accomplished in a different manner in Wade Guyton's (born 1972) exhibition at Friedrich Petzel Gallery in 2007 by his use of a ready-made computer format—namely, a rectangle drawn and filled in using Photoshop—as the source for a series of black monochrome paintings generated by ink-jet printer [6]. For both artists, whose works look fully nonobjective and rigorously deductive at first glance, external forces associated with economies of labor ultimately reframed their spectacular blank formats. For Thompson, the hue and value of his Berlin motifs self-reflexively index the length of time and hour of the day in which he made them, giving his paintings the quality of time cards; while Guyton's work requires an entire external apparatus of computer, software, and printer in order to generate the images as though they were products of a networked corporate office. While these artists are indeed the heirs of Stella's deductive tactics, they also participate in Koether's and Prina's effort to incorporate social networks into the body of painting, though in a much less confrontational way.

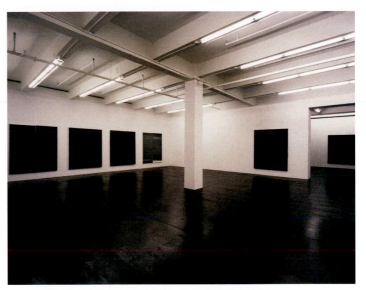

6 • Wade Guyton, exhibition at Friedrich Petzel Gallery, New York, 2007
Installation views

7 • R. H. Quaytman, from the exhibition "From One O to the Other," Orchard, New York, 2008
Installation view showing painting rack

The archive as medium

The literal introduction of contemporary social conditions within painting, as opposed to Koether's and Prina's historicization of networks, or Thompson's and Guyton's aestheticization of labor, was made explicit in an exhibition titled "From One O to the Other," at the New York collective Orchard in 2008. The show was a collaboration between critic and historian Rhea Anastas (born 1969) and artists R. H. Quaytman (born 1961) and Amy Sillman (born 1954). Like many of the projects at Orchard—which was itself a kind of collaborative art work—this multilayered installation reflected directly on the context of the gallery, including its largely inadvertent effect as a gentrifying force in its Lower East Side neighborhood. As her contribution to the exhibition, Anastas presented a selection of press clippings on Orchard in vitrines, while Sillman made slyly sophisticated gouache-and-ink portraits on paper (face only) of Orchard participants and friends. Rather than hanging on the wall, Sillman's drawings were available for anyone to leaf through and rearrange on a long table that doubled as a desk occupying the center of the narrow front section of the gallery. Quaytman's contribution came in three parts. The most prominent was a series of paintings on wood collectively titled *Chapter 10: Ark*, which was made during the years that the artist served as director of Orchard. Some panels from the series were hung on the walls in the usual manner, while others were held *in potential*—stored in a shelving unit resembling those in museums' or galleries' storage rooms [7]. Visitors were invited by gallery attendants to explore this open storage by propping paintings on top of the shelf for a quick look, or by hanging them up in a few spots on the adjacent wall reserved for this purpose. Quaytman also made a new version of *Orchard Spreadsheet*, which outlines in financial terms the life of the organization, and a beautiful catalogue, *Allegorical Decoys*, designed by Geoff Kaplan to function inside out: the dust cover expands into a large poster including an archive of the book's illustrations, while the pages themselves carry only text.

This exhibition was devoted to the ethical problem of how and for whom archives are constructed and how such archives serve as the "medium" of painting's social networks. It seems significant for instance, that both Sillman and Quaytman solicit *handling*: visitors were called upon to think with the eye and the hand simultaneously. And in both artists' work it was the "matter" of the institution that was to be handled: the faces of those who made and consumed Orchard's programs in Sillman's drawings; the Orchard space itself in Quaytman's silkscreen paintings, as represented in motifs derived from Polaroid photographs of the gallery's architecture, either empty (typically photographed from skewed perspectives) or inhabited by visitors who might be members of the collective or their friends. Onto such photographically derived source material, Quaytman often silkscreened a tight raster of horizontal lines inducing an optical burn that bordered on pain. Suffice it to say that the connection established between seeing and handling, as well as the fusion of disorienting optical sensation, and a strong consciousness of literal emplacement in a particular site in a particular city, made it necessary for the viewer to position herself in optical experience *and* in a network of institutional association at once: the internal passages of the paintings were in dynamic equilibrium with the external impact of the gallery phenomenologically as a space and sociologically as a neighborhood institution, in a potent instance of transitive painting. Quaytman's and Sillman's works trigger an actual connection on the part of the viewer from the inside of the painting to its framing conditions—from supposedly self-possessed vision to the dispossession of a neighborhood undergoing gentrification.

Paintings may function as archives of such actual connections between the eye (the person) and the world. The philosopher and historian Bruno Latour has an apt quasi-museological term to describe what, in his view, sociologists should do: collecting the social, or better, in the title of his 2005 book, *Reassembling the Social*. It is the responsibility of those who work with archives (including artists, critics, and art historians) to construct them with care because in doing so, they are indeed reassembling the social. Here are four conditions that come together in Quaytman's painterly archive: (1) vision causes pain (optical burning); (2) paintings are accumulated (as wealth, in storage shelves); (3) viewers look because they wish to place themselves meaningfully in architectural and urban space; and (4) no arrangement of pictures is final. These archival conditions offer a toolkit—one of many that Orchard provided over its short lifetime—for rethinking the *forms and responsibilities* of *association*—for reassembling the social.

The various transitive practices under discussion here have gained currency because they offer a way out of a particularly enduring critical dead end in writing about contemporary art. As the most collectible type of art, which combines maximum prestige with maximum convenience of display (both for private and institutional collectors), painting is the medium most frequently condemned for its intimate relation to commodification. Needless to say, this is an accurate diagnosis, but the problem with the term commodification is that it connotes the permanent arrest of an object's circulation within a network: it is halted, paid for, put on a wall, or sent to storage, therefore permanently crystallizing a particular social relation. Transitive painting, on the other hand, invents forms and structures whose purpose is to demonstrate that once an object enters a network, it can never be fully stilled but only subjected to different material states and speeds of circulation ranging from the geologically slow (cold storage) to the infinitely fast. A Poussin might land in the hands of Jutta Koether, or Stephen Prina might seize the entire oeuvre of Manet. DJ

FURTHER READING
Yve-Alain Bois, *Painting as Model* (Cambridge, Mass.: MIT Press, 1990)
Johanna Burton, "Rites of Silence: On the Art of Wade Guyton," *Artforum*, vol. XLVI, no. 10, Summer 2008, pp. 364–73, p. 464
T. J. Clark, *The Sight of Death: An Experiment in Art Writing* (New Haven and London: Yale University Press, 2006)
Ann Goldstein, *Martin Kippenberger: The Problem Perspective* (Los Angeles: Museum of Contemporary Art; Cambridge, Mass.: MIT Press, 2008)
Texte zur Kunst, "The [Not] Painting Issue," March 2010

▲ 2003

▲ 1986, 2007c

2009 c

Harun Farocki exhibits a range of works on the subject of war and vision at the Ludwig Museum in Cologne and Raven Row in London that demonstrate the relationship between popular forms of new-media entertainment such as video games and the conduct of modern war.

2000–2015

The strangest televised image from the 2003 American invasion of Iraq was also the most banal: a virtually unchanging view of a Baghdad streetscape recorded from the hotel where most Western journalists were headquartered. As an image of war, this bland prospect could hardly compete with the pyrotechnic graphics and rousing martial music that opened network news reports back in the US. And yet, like a surveillance camera, its fixed point of view was strangely riveting, in part because it arose from a paradox: that representatives (albeit unofficial) of an invading force could check in to a hotel in a city under siege in order to monitor its bombardment. When the bombardment did come, its coverage—from the distanced perspective of the hotel—resembled nothing so much as a festive fireworks display. The reporters in Baghdad, then, like their colleagues on the battlefield who were assigned to accompany specific combat units once the ground war began, were, to use the official military term, *embedded*. And indeed, given that journalists in the field were not allowed to disclose their positions or anything at all about the substance of "their" units' activities, what they, like their counterparts peering from the windows of a Baghdad hotel, could communicate back home was largely constrained by the military's point of view.

Perhaps more than any armed conflict in history, the Iraq War was scripted for domestic consumption. Since it was widely assumed that the erosion of consensus for the Vietnam War—the United States' last sustained conflict abroad—was due to its events being televised on the evening news, the strategists for Iraq sought to narrowly control its image in at least two ways: first, by distancing or sanitizing the invasion's violence through an emphasis on high-tech weapons presented as tools as precise and salutary as those of a doctor (hence the frequently repeated term "surgical strike" to describe the initial air war); and second, by strictly controlling the access given to reporters. By assigning journalists to a particular combat unit, for example, it was virtually assured that narratives of the war would emerge from the heroic perspective of sympathetic soldiers with whom "embedded" reporters would naturally establish an esprit de corps. Each of these strategies was structurally linked to familiar entertainment genres in the West: the "surgical strike," accomplished by high-tech bombs with built-in cameras, transposed real war into the virtual aesthetic of video games that have

themselves been adapted to train military pilots; and first-person accounts of the war from the combatant's point of view echoed the narrative conventions of Hollywood film (an association made literal by the frequent projection of rousing advertisements for the National Guard, which emphasized the heroism of military service, screened before features in many American cinemas).

The power of the image / the image of power

The official representation of the Iraq War thus offers one of the most poignant, and one of the most tragic, early twenty-first-century instances of how images wield power by asserting a point of view that marginalizes other perspectives. Artists responded to this situation in a variety of ways: by emphasizing how pictures alternately establish or dissolve associations among citizens; by showing how new technologies of vision migrate from the realm of entertainment to that of war; and finally by demonstrating how the art world can offer a relatively free space for political speech. Despite very different visual strategies, the artists under consideration here all explore how images position viewers vis-à-vis the controversial and traumatic events of the Iraq War: by establishing a sense of shared belonging (or, conversely, of alienation); by sorting citizens and their reactions into types; and by representing how individual war trauma is mediated. The first of these procedures was evident in two conceptually linked exhibitions by Thomas Hirschhorn, "Utopia, Utopia = One World, One War, One Army, One Dress" (2005) at the Boston Institute of Contemporary Art (ICA) and "Superficial Engagement" (2006) at the ▲ Barbara Gladstone Gallery in New York. Hirschhorn's art is known for the kiosks, vitrines, monuments, and immersive installations he builds, which are typically composed of overwhelming accretions of images drawn from various media, ranging from books to the Internet, and usually held together with modest materials like cardboard and packing tape. His works are committed to what might be called an ethics of images, through exploring and demonstrating how pictures may fashion our relation to one another and establish the experience of a shared world. Within this general project, Hirschhorn's exhibitions in Boston and New York pursued two distinct yet complementary approaches.

▲ 2003, 2007b

1 • Thomas Hirschhorn, "Utopia, Utopia = One World, One War, One Army, One Dress," Institute of Contemporary Art, Boston, 2005
Installation views

"Utopia, Utopia," whose theme was the worldwide proliferation of camouflage as a ubiquitous decorative motif, proposed the thesis that in displaying a particular abstract pattern like camouflage (by wearing it or by buying products emblazoned with it), one joins the "one world" and "one war" of a global society. Put crudely, Hirschhorn suggests that fashionistas and pop stars the world over are sartorially—if unconsciously—"signing up" for the "one war" exemplified by the conflict in Iraq when they wear camouflage on the streets of Paris, Los Angeles, or Tokyo. "Utopia, Utopia" included so many items decorated with camouflage designs, ranging from cigarette lighters to underwear, that the motif began to lose its specificity as a symbol or attribute of modern warfare [1]: on the contrary, its obsessive repetition sanitized it, draining it of any direct association with violence. If the shared display of a particular type of sign creates a "community," Hirschhorn suggests, it is a community of consumers in which popular culture and military aggression are seamlessly (albeit quasi unconsciously) woven together into a world where fashion models wear military drag and suburban executives drive

Hummers. Such a widespread recoding of war as a commercial fashion statement helps to build consensus for actual conflict by glamorizing it, even during peacetime.

In "Superficial Engagement," on the other hand, the ethical bond between citizens, as established through collective spectatorship, was posed through a stark contrast between unbearable photographs representing the shattered bodies of war casualties, many of which Hirschhorn downloaded from the Internet, and the "redemptive" power of art. The former were collaged and jumbled together as a kind of topographical base in the life-size dioramas that filled the gallery [2], while the latter was represented by reproductions of abstractions mounted on cardboard, several by the mystic artist Emma Kunz, either descending or ascending, depending upon one's perspective, from the landscape of carnage in formations reminiscent of birds in flight or Berniniesque bursts of divine light. "Superficial Engagement" thus staged a clear opposition between the capacity of images to injure, sicken, or enrage and the pretensions of art (particularly abstraction) to heal. As difficult as it was to look at the spilled intestines and blasted skulls

2 • Thomas Hirschhorn, "Superficial Engagement," Barbara Gladstone Gallery, New York, 2006
Installation views

that Hirschhorn presented, it was enormously courageous that the artist had brought forward images that were purposely omitted from the official scenarios of the Iraq War in which devastating bombardments could be euphemistically referred to as "surgical strikes." While there is of course a great difference between wearing camouflage as a fashion statement and confronting such explicit representations of war casualties, the near simultaneity of "Utopia, Utopia" and "Superficial Engagement" suggests that they are linked. Indeed, domesticating war through popular culture helps to obscure its real consequences and hence make it morally bearable for citizens to condone.

In both "Utopia, Utopia," and "Superficial Engagement," Hirschhorn made use of a compositional strategy that vividly embodies the potential malignancy of pictures: what might be called the "image swarm." Each of these installations established a claustrophobic landscape enveloping spectators in a disorienting atmosphere of pictures. Indeed, image swarms brilliantly manifest both how pictures circulate in a networked world, and how their excesses can lead to an atmosphere of interference or "noise" that is difficult to navigate. Swarms *saturate* spaces with representations

and this can lead to either benign or tragic effects: in "Utopia, Utopia," saturation represents the tipping point for a fashion or style—namely the craze for camouflage. In "Superficial Engagement," on the other hand, it is the irrepressibility of painful images of war that is performed in a kind of "return of the repressed." Such a saturation of scandal was exemplified in the most notorious unplanned representation of the Iraq War: once the humiliating photographs of prisoners taken by a group of American soldiers stationed at Abu Ghraib came to light, they took on a life of their own in the media, and could not be suppressed by any public-relations effort at damage control.

A proliferation of truths

Hirschhorn's installations enact a specific model of how images (or information) circulate within a densely integrated media ecology operating nonstop, twenty-four hours a day, seven days a week. Whether it is the sudden eruption of a fashion trend (like camouflage) or a scandal (like Abu Ghraib), images accrue power through their capacity to saturate many media channels at once:

3 • Andrea Geyer, Sharon Hayes, Ashley Hunt, Katya Sander, and David Thorne, *9 Scripts from a Nation at War*, Documenta 12, Kassel, Germany, 2007
Installation views

they are *virulent* if they attract enough individual consumers and/or spectators to establish communal identification. In a manner of speaking, Hirschhorn allows images to behave "naturally," expanding exponentially in physical space as they expand within the virtual networks of the Internet. A ten-channel video installation, *9 Scripts from a Nation at War* (2007), produced by a group of artists—Andrea Geyer, Sharon Hayes, Ashley Hunt, Katya Sander, and David Thorne—and first exhibited at Documenta 12 in Kassel, Germany, occupies the opposite end of the spectrum. Rather than focusing, as Hirschhorn does, on the ways in which images *swarm* or *saturate*, *9 Scripts* demonstrates how different types of person, each of whom experiences and represents the Iraq War from a different point of view, filter their images of the war. The "scripts," each of which centers on a different type of person—Citizen, Blogger, Correspondent, Veteran, Student, Actor, Interviewer, Lawyer, Detainee, and Source—all respond, according to the artists' project description, to a central question: "How does war construct specific positions for individuals to fill, enact, speak from, or resist?" In other words, *9 Scripts* matches a proliferation of persons to Hirschhorn's proliferation of images.

In the first version of *9 Scripts* at Documenta 12, its ten channels were presented on monitors embedded individually or in groups in desks resembling study carrels [**3**]. These "carrels" were set out in a public area adjacent to the galleries where admission was free. The use of small monitors, headphones for audio, and individualized seating arrangements encouraged—indeed required—an intimate form of concentrated spectatorship—like reading in a library— that belied the lively foot traffic of the surrounding lobby. This quasi-pedagogical mode of display, which was offered *in passing* to spectators who might be on their way to a busy café adjacent to the lobby, corresponded to an equally pedagogical narrative structure in the individual tapes. The scripts devoted to nine of the ten types of person included in the work were filmed to call attention to the presence or absence of an audience. The Veteran(s) give a short speech based on her/his own experiences to a large empty auditorium; the Citizen(s) write a series of predictions of what they will do when democracy finally arrives on a classroom blackboard as though for an invisible group of students (each of the 248 predictions is erased to make way for the next), and the Lawyer speaks to an audience that comes in and out of view according to the camera's tracking shots. These scenes force the question at the core of *9 Scripts from a Nation at War*: How can the fact of the Iraq War—its *image*—ever be honestly and accurately communicated?

9 Scripts explores this important question by using its several hours of videotaped "testimony" to create doubt about the authority of any individual's statements—and particularly to suggest that personal opinion is regulated by public roles, as exemplified by the work's ten types. This doubt is represented in the piece by dividing speakers from their speech in at least three ways. First, as the titles of each channel indicate, individuals are grouped according to types that "share" an ongoing narration (that is, several different people successively speak the same monologue, and roles like interviewer vs. interviewed may seamlessly change or reverse). This suggests that what is called a "subject position," or a particular social or psychological point of view based on identity characteristics like profession, nationality, race, gender, or sexuality, determines the perspective of individuals who merely "read the lines" of a part they have been given to play. Second, as I have already suggested, a gap is introduced between audience and speaker by staging performers in empty auditoria, or alternately including or excluding a view of the audience via the camera's frame as it zooms in or out. In either case, speech is shown to fall short of reaching its anticipated or desired auditors. Finally, authentic speech (in which a person gives an account from her or his own life experience) is divorced from whoever *enunciates* this speech in several of the tapes. In the "Lawyer" script, for example,

4 • Harun Farocki, *Serious Games 1: Immersion*, 2009
Two-channel video installation, video 20 minutes

2000–2015

an actress performs a monologue based on an interview with a US lawyer representing Yemeni detainees at Guantanamo Bay; in the "Actor" script, actors attempt to learn their lines based on various accounts from people involved in the war; and even in the "Veteran" tape, an interview transcript is edited to become a formal lecture that, although spoken by the veterans themselves, changes the genre, and thus the emotional urgency, of individual testimony. In these three ways—inhabiting a collective type, showing the absence or presence of an audience, and demonstrating how testimony may be recoded or even fictionalized—individual voices narrating the war in Iraq are denaturalized, divorced from particular individuals, and filtered instead through situations and types.

While Hirschhorn demonstrates that images attain power quantitatively through *saturation* (either as a commercial trend capturing markets or as a scandal burning through media channels), *9 Scripts* pivots on how images accrue a different kind of power—namely by attaining documentary truth-value. Such power arises through association with a guarantor of authority: for example, a lawyer's statements are credited differently from a detainee's, or a journalist's differently from her source, to mention just two complementary pairs from the many permutations generated in *9 Scripts*. No single event in the history of the Iraq War better exemplifies the centrality of such procedures of *authorization* than Colin Powell's projection of a grainy and patently inconclusive intelligence photograph in his 2002 presentation to the United Nations as "proof" that Iraq possessed hidden weapons of mass destruction. This "evidence" (which later proved to be illusory) was fully backed by Powell's integrity as a former general, the status of his office as secretary of state, and the vast intelligence resources of the United States to which he had special access. In the absence of this authoritative backing, Powell's *document* would have appeared in 2002 as the *fictions* we now know them to be. It is precisely such mechanisms of *authorization*, of assigning different truth-values, ranging from fact to fiction, to *the very same* image or experience that *9 Scripts* demonstrates by recounting the Iraq War in a plurality of voices, none of which is definitively attached to any secure position.

Immersing the spectator

From the late sixties the German filmmaker and artist Harun Farocki (1944–2014) addressed the same slippage between fact and fiction in the management of war. And like Hirschhorn, he was acutely aware of how the ostensibly benign consumption of martial values—as style or, more frequently in his case, as entertainment—is always at work culturally to justify conflicts once they erupt. For Farocki, what might be called the military-entertainment complex often pivots on digital gaming, where entertainment and war are intimately linked.

In "Utopia, Utopia" and "Superficial Engagement," Hirschhorn demonstrates the power that images accrue by *saturating* virtual and physical space, while *9 Scripts from a Nation at War* reveals how images gain influence through their *authorization* by extra-aesthetic powers. Farocki's *Immersion*, from his *Serious Games 1* series, as its title suggests, explores a third kind of power wielded by images: their capacity to enclose spectators in virtual worlds—to *immerse* them [4]. Video games are now the most common vernacular form of image immersion and Farocki's late work explores how this mode of entertainment can migrate to the realm of war. *Immersion* is a two-channel video projection drawn from footage that the artist recorded at a workshop demonstrating a new therapy for Iraq War veterans suffering from post-traumatic stress disorder (PTSD), sponsored by the Institute of Creative Technologies at the University of Southern California. In this therapy, soldiers recount traumatic war experiences, particularly involving casualties among comrades, while "reliving" them via software meant to simulate the events fed into virtual-reality goggles. In a rhythmic alternation punctuated by blank screens, soldiers in their goggles are shown on the right screen recounting their experiences, while the left screen alternately shows the stylized digital simulation that can never capture the vivid detail of the oral accounts they are meant to represent and therapist/technicians manipulating the software program to match these accounts. When a male "soldier" nearly breaks down recounting a horrific story of his superior being killed by a mine (it is unclear to the viewer whether this is the soldier's *own* story or one that he "performs," which is actually the case, as the filmed session is one in which civilian therapists train military therapists by putting them in the place of patients), the therapist working with him ends the session with the declaration, "I was having trouble keeping him in the image."

This declaration goes to the heart of the ethics of images in wartime: the managers of conflict work hard to keep civilians and soldiers alike *in the image* (one might even say, *embedded in it*). Whether through seduction, coercion, discipline or therapy, consensus requires that a sufficiently positive mental picture of the war be maintained. One of the ways artists have challenged this *saturation, authorization,* and *immersion* of war images is to bring little-known or difficult-to-access information about the Iraq conflict into the relatively free public sphere of the art world. One component of each exhibition of *9 Scripts from a Nation at War*, for instance, was a live reading of detainee transcripts lasting some four hours. Similarly, Jenny Holzer's redaction paintings from 2005–6 reproduce documents related to the war in Iraq as legible paintings that spectacularize the regulation—or censorship—of information. These represented documents are almost as shocking for their copious deletion of names, phrases, and passages as they are for recounting atrocities in the bland idiom of bureaucratic forms: to see these pockmarked pages on public view (and *as paintings*) is a powerful reminder that a major front in any modern war must be informational. The most interesting of Holzer's paintings are those whose deletions are so uncompromising that entire pages/canvases are covered in blocks of black [5]. Here information meets the history of the monochrome (in what looks like a bastardized work by Mark Rothko or Ad Reinhardt) in a provocative dialectic of abstraction and discourse. Should Holzer's proposition that abstraction may arise as the by-product of censorship be understood as a condemnation of modern painting, or is her transfer of obscure and harrowing documents into works of art a way of restoring their status as public speech? These questions, and the more general problem of how images participate in consolidating political consensus, are essential to understanding how art can resist the prosecution of war on the home front by challenging its tactics of misinformation. DJ

FURTHER READING

Giovanna Borradori, *Philosophy in a Time of Terror: Dialogues with Jürgen Habermas and Jacques Derrida* (Chicago: University of Chicago Press, 2003)

Antje Ehmann and Kodwo Eshun (eds), *Harun Farocki: Against What? Against Whom?* (London: Koenig Books, 2009)

Alison M. Gingeras, Benjamin H. D. Buchloh, and Carlos Basualdo, *Thomas Hirschhorn* (London: Phaidon Press, 2004)

http://www.9scripts.info

Robert Storr, *Jenny Holzer: Redaction Paintings* (New York: Cheim & Reid, 2006)

5 • Jenny Holzer, *Colin Powell Green White*, 2006
Oil on linen, four panels, each panel 83.8 × 64.8 × 3.8 (33 × 25½ × 1½), installed 83.8 × 259.1 × 3.8 (33 × 102 × 1½)

▲ 1947b, 1957b

2010ₐ

Ai Weiwei's large-scale installation *Sunflower Seeds* opens in the Turbine Hall of London's Tate Modern: Chinese artists respond to China's rapid modernization and economic growth with works that both engage with the country's abundant labor market and morph into social and mass-employment projects in their own right.

Ai Weiwei's (born 1957) contribution to Documenta 12 in 2007, the international exhibition of contemporary art held every five years in Kassel, Germany, was aptly titled *Fairytale* [**1**]. As part of the work, 1001 Chinese citizens, most traveling abroad for the first time, were brought to Kassel as "tourists." As in a fairytale, these travelers were transported to a different world—an *art world*—at minimal cost to themselves and with the technical assistance of Ai's substantial staff all along the way. No doubt this was a fairytale tailor-made to an era of globalization: invitations to participate were published on Ai's blog and within three days there were over three thousand responses, leading the artist to close applications to avoid disappointing even more prospective participants. The trip to Kassel, which occurred in five waves over the summer, was given its own visual "identity" or branding: Ai designed accommodations, luggage, cupboards, and T-shirts for the travelers in a simulation of the mass tourism that has made travel accessible to ever greater numbers of people, especially in the developed world. But like the sinister fairytales of the Brothers Grimm, who are native to Kassel and who are said to have inspired Ai's project for Documenta, *Fairytale* also hints at the darker side of global mobility.

While travel is habitually taken for granted among the affluent of the developed world, financial and political mobility is far from equally accessible to all. As Ai made clear in a 2007 interview, one of the objectives of *Fairytale* was to call attention to—and to overcome—the administrative hurdles involved in traveling abroad from China: "This process made people realize what it means to be a man or woman as an identity and with a Nation: you have to go through the system, and the system can be simple or more complicated.… The participants started thinking about getting a visa, and the visa is a matter of foreign affairs." It is paradoxical that a prerequisite for the right to travel internationally is to possess a secure *national* identity, which must be politically authorized and widely, if not universally, recognized. The fact that national identity is neither natural nor attainable by everyone who inhabits a particular territory (such as illegal immigrants) was implicit in the difficulties encountered by many of Ai's tourists in obtaining visas—some of whom were in fact denied. Even before any of the Chinese travelers set foot in Kassel, *Fairytale* thus gave a real-life snapshot of the realities beneath globalization's glib surface of easy mobility. And indeed, the manner in which Ai's travelers were *managed* as a population in *Fairytale*, as well as the scale of their "migration," which at 1001 travelers well exceeded the average packaged tour, suggest the movements of migrant laborers and refugees as much as "tourists": moreover, in housing his guests in dormitory settings that, despite their festive design, inevitably suggested camps [**2**], Ai insinuated the kind of travel undertaken not for pleasure, but out of economic or political necessity.

What unites all travelers, from business executives to refugees, is how governments, as well as supra-national non-governmental organizations, attempt to manage groups of individuals as populations by tracking personal documents like passports on the one hand, and compiling generalized statistical data on travel and migration on the other. In *Fairytale*, Ai established such an intimate association between citizenship and information on both micro- and macroscopic levels by gathering two types of data from his "tourists": first, before departure, they responded to a questionnaire of ninety-nine questions; and second, extensive documentation was made before, during, and after the journeys. Once again, Ai's strategies have a double edge, for if his information-gathering tends to aggregate the tourists as a group, his project is also aimed at furnishing each individual participant with their own singular experience. As Ai stated in a 2007 interview, "What we really want to emphasize is the '1,' not the '1001.' Each participant is a single person.… In this project 1001 is not represented by one project, but by 1001 projects, as each individual will have his or her own independent experience." Indeed, Ai's juxtaposition of the "mass" (the 1001) with the "individual" (the 1) accords with the concept of the "multitude" that has come to prominence in discussions of globalization since the publication of Michael Hardt and Antonio Negri's highly influential book *Empire* in 2000. As Hardt and Negri write: "The mobility of commodities, and thus of that special commodity that is labor-power, has been presented by capitalism ever since its birth as the fundamental condition of accumulation. The kinds of movements of individuals, groups, and populations that we find today … cannot be completely subjugated to the laws of capitalist accumulation.… The movements of the multitude designate new spaces, and its journeys establish new residences."

▲ 1972b

▲ Introduction 5

1 • Ai Weiwei, *Fairytale*, project for Documenta 12, Kassel, Germany, 2007
1001 Chinese visitors

2 • Ai Weiwei, *Fairytale*, project for Documenta 12, Kassel, Germany, 2007
Gottschalk-Hallen: Ladies' Dormitory No. 9

There are two important points to be drawn from this passage from *Empire*. First, Hardt and Negri distinguish between the creative power of groups of people in motion, and their status as workers—or commodified units of labor. There is a residual freedom that the multitude possesses that may lead to "new spaces" or "new residences" (such as the experiences of 1001 Chinese transported to Kassel). The international division of labor fundamental to globalization, where factories are set up in the developing world—in places such as China—in order to reduce production costs for Western multinational corporations is, on the other hand, devoted to what the authors call "accumulation"— that is, to the brute extraction of profit. Second, Hardt and Negri hope to use the concept of the multitude to invert negative and often frankly tragic images of the refugee or migrant laborer (the traveler who is outside the protection of the nation state per se) by insisting on the creative potential for liberation possessed by such populations. From this perspective, Ai has not only "represented" but actually constituted a multitude by bringing together his tourists in what he hoped would be a transformative experience.

The "multitude," and its implication of a jump in scale between the "one" and the "many," which is fundamental to any discussion of globalization, is expressed even more explicitly in terms of labor in Ai's *Sunflower Seeds* [3], which is composed of some 100 million actual-size porcelain sunflower seeds laid on the floor of Tate Modern's massive Turbine Hall in London like sand or gravel (and indeed, until health risks due to fine porcelain dust were discovered, the public was invited to walk on this carpet of crunching seeds). Each piece was handmade over a period of years by workers in Jingdezhen, which had once provided porcelain for the Chinese imperial court. If the unimaginably large number of 100 million is, like the "globe," beyond individual conception—a kind of populational "sublime"—this sea composed of millions of skillfully wrought miniature objects functions as a physical trace of the massive reserves of labor which, more than any other factor, have fuelled China's economic boom.

As in many other important projects of the 2000s, *Fairytale*, as well as *Sunflower Seeds* in its original state as a carpet of tiny objects to be walked on, are "compositions" of human relationships. But the 1001 tourists who traveled from China to Germany are only one part of the work: its *social* composition was complemented by a composition of *objects* analogous to the seeds on the Turbine Hall's floor. Throughout the far-flung exhibition venues of Documenta, Ai arranged 1001 chairs dating from the late Ming and Qing dynasties in various flexible configurations that beckoned visitors to rest for a moment and perhaps to converse with one another, in the midst of the vast exhibition [4]. Ai has frequently repurposed Chinese antiques in startling ways that call attention to the endangerment of China's traditional material culture under the pressure of its rapid development. Perhaps the most notorious example of this strategy is his 1995 act of dropping a Han Dynasty urn from his hands, allowing it to shatter on the ground—a small drama of loss and destruction that is recorded in a series of three photographs. Ai has also repainted antique ceramics, emblazoning one pot with the Coca-Cola logo and encasing a Tang Dynasty courtesan figure in an empty bottle of Absolut vodka. He has used wooden antiques as the building blocks for spidery new sculptures, some of which fill entire rooms with a complex network of interconnected branches. In repurposing ancient objects, Ai not only calls attention to the masses of antiques of questionable provenance that have flooded Chinese markets, but he also gives a highly visceral demonstration of the disappearance of the urban fabric of cities like Beijing.

In other words, Ai's use—one might even say his destruction—of antiques calls attention to a global economy of cultural property at just the moment when the government of China has fostered policies making it a giant manufacturing workshop to the world. The 1001 people and the 1001 chairs that visited Kassel under Ai's aegis thus beg one of the most important structural questions related to globalization: how flows of objects (both venerable cultural properties and brand new commodities) are articulated with flows of humans (including human labor). It is certainly not coincidental

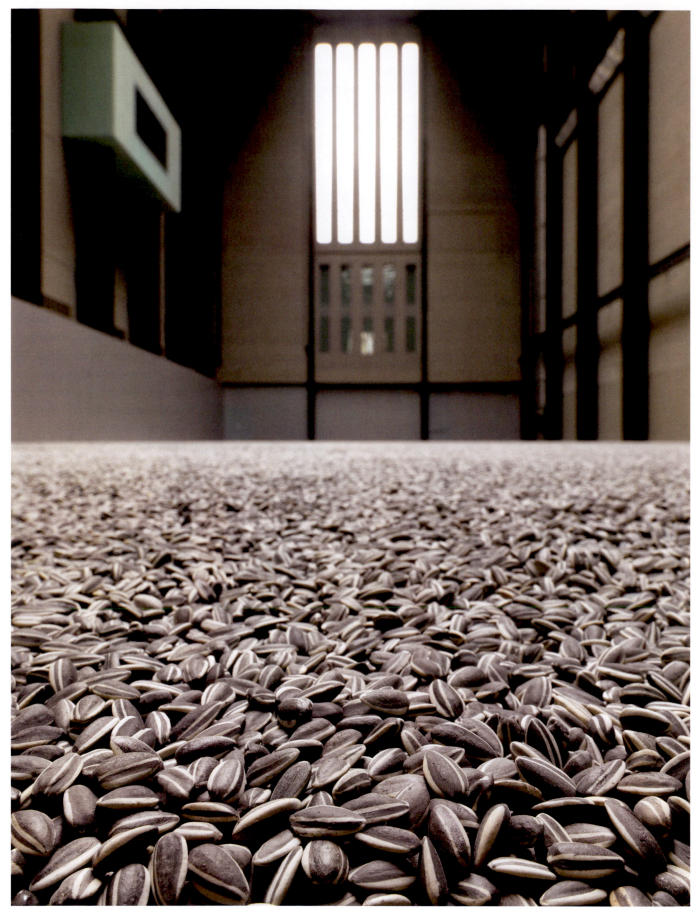

3 • Ai Weiwei, *Sunflower Seeds***, Turbine Hall, Tate Modern, London, 2010**
Installation view

4 • Ai Weiwei, *Fairytale*, project for Documenta 12, Kassel, Germany, 2007
Qing Dynasty wooden chairs (1644–1911)

that despite the much greater complexity of transporting 1001 people to Kassel as opposed to shipping 1001 chairs there, it is very likely that the average Documenta visitor had no contact whatsoever with, and perhaps no awareness of, the Chinese tourists of *Fairytale*, while every visitor would have noticed the presence of 1001 chairs that connote traditional "Chinese identity." Part of Ai's *fairytale* concerns how objects communicate as envoys of persons or nations—and what better image for such stand-ins than empty chairs? *Fairytale*, then, juxtaposed two different publics that were in danger of completely missing one another: a public composed of Chinese citizens discovering a European city for the first time, and a public composed of largely European and American art enthusiasts discovering a set of Chinese artifacts. Each group no doubt brought their own preconceptions and expectations to the experience and therefore inevitably took away meanings that had as much to do with themselves as with their encounter with the foreign. In other words, *Fairytale* provides a highly nuanced and

▲ multilevel enactment of globalization, not as a small, unified world, but as a world of people and things that travel at different speeds in which connections are missed as often as they are made.

In his understanding of the work of art as a composition of different publics—particularly of a Chinese public encountering the West, and a Western public encountering Chinese material culture—Ai provides an apt introduction to contemporary art in China, which since the mid-nineties has been an object of fascination and financial speculation in the West. The art historian Wu Hung has argued that *exhibitions* are central to an understanding of contemporary Chinese art through their capacity to open small, temporary, but often virulent public spheres where an intellectual and artistic vanguard can incrementally broaden the scope of artistic freedom as well as political speech in China. The first watershed exhibition after the end of Mao Tse-Tung's Cultural Revolution in 1976—a decade during which open intellectual and cultural life was severely suppressed and artistic production was narrowly channeled into official Socialist Realist representations in service to the state—was organized by a group called the "Stars" in 1979. This

was the same year that China's leader Deng Xiaoping initiated the market reforms that were to set off China's massive economic growth in the ensuing decades. The members of the Stars (which included Ai Weiwei) worked in diverse styles, but what historians identify as their most significant accomplishment as a group was their invention of the "unofficial exhibition" in China, typically presented alongside official presentations as a kind of "parasite." The "Stars" show in 1979, for instance, was installed outside the east gate of the National Art Gallery in Beijing during the National Art Exhibition for the thirtieth anniversary of the founding of the People's Republic of China; it was closed down by the police, leading to a demonstration convened at Beijing's famous Democracy Wall, and it ultimately garnered a front-page story in the *New York Times*, as well as the consternation of the highest ranks of the Chinese government.

Ten years later, in 1989, just months before the Democracy Movement (known in China as the June Fourth Movement) was brutally suppressed by the army in Tiananmen Square, another important exhibition "China / Avant-Garde" was closed down twice during its two-week run. This exhibition surveyed a lively range of artists' groups and experimental activities that occurred between 1985 and 1989 as part of what was called the New Wave, and it encompassed experiments in several media, including performance and installation. This efflorescence of art activity arose partly in response to new flows of information about modern art and crit-ical theory from abroad during the eighties, and partly due to a domestic infrastructure of unofficial art journals, including the Beijing-based weekly *Fine Arts in China* and the Wuhan quarterly *The Trend of Art Thought*, which tied together diverse practices

5 • Wang Guangyi, *Great Criticism: Marlboro*, 1992
Oil on canvas, 175 × 175 (68⅞ × 68⅞)

across China into an emerging art world. These specifically aesthetic debates occurred in parallel to, and partly as an expression of, growing demands for political democratization, whose tragic denouement were the events in Tiananmen Square. It is, perhaps paradoxically, after 1989 and the government's attempts to extinguish the Democracy Movement, that the kind of public sphere pioneered in unofficial art exhibitions began to gain commercial support—first from abroad and eventually from domestic sources as well. The first generation of artists who gained wide exposure internationally were known as "Cynical Realists" or "Political Pop" artists. Their works, as epitomized by Wang Guangyi (born 1957), often took the codes of Socialist Realist political propaganda and made them sarcastic or ironic, and/or blended them with the signs of a growing commercialism, such as corporate logos, that had gripped China [5].

Indeed, Wu Hung has argued that the period encompassing the 1979 "Stars" exhibition, the 1989 "China/Avant-Garde" show, and the rise of new forms of iconoclastic realism aimed against official propaganda as a kind of kitsch was a sort of "exorcism" of the deprivations and restrictions of the Cultural Revolution. If the unofficial exhibition, the journal, and the artists' group were the preferred tools for expanding the Chinese art world as a nascent public sphere, beginning in the nineties these functions were taken over by commerce, which had definitively consolidated its power by the time of the New York Sotheby's sale of contemporary Chinese art in 2006. This brief survey can hardly do justice to the history of Chinese contemporary art, let alone the wide range of interesting and important artists active in China or in the Chinese diaspora abroad, but what it can do is to put Ai Weiwei's *Fairytale* into a different light. For, since 1979, Chinese contemporary art has been closely aligned with political liberalization through public exhibition—a practice Ai has adapted to the Internet through his important blog, which has done brave and revelatory research into the tragic deaths of schoolchildren in poorly built schools in the great Sichuan earthquake of 2008. It may seem that the Chinese art world's enthusiastic embrace of the art market disqualifies it as a political force, but in his important book *The Party and the Arty in China: The New Politics of Culture* (2004), the political scientist Richard Curt Kraus argues the opposite. Kraus asserts that the success of Chinese artists in the international art market has led to reduced restrictions in the cultural realm and consequently greater political openness overall. As he declares, "Despite the violence of the 1989 Beijing Massacre, political reform in China has been more profound than is commonly recognized: artists (and other intellectuals) have established a new more autonomous relationship with the state. The price of this growing independence is financial insecurity, commercial vulgarization, and the specter of unemployment."

The commercial public sphere Kraus identifies is closely related to a thematic shift in Chinese art. If the legacy of the Cultural Revolution had been largely overcome by the time Chinese contemporary art began to achieve international prominence in the mid-1990s, a new set of historical challenges had already

presented themselves. Artists now confronted China's extraordinary modernization, which rapidly transformed the nation's urban landscape and dramatically affected the lifestyles of a significant proportion of its population. Few figures better demonstrate the changing status of artists and their greatly enhanced opportunities under these conditions than Zhang Huan (born 1965), who in the mid-nineties came to prominence for his edgy performances, but who, by the 2000s, had become an international art star capable of producing large-scale paintings and sculptures with the help of an impressive cadre of assistants. What unites these different moments in his career is Zhang's consistent attention to economic development on the one hand and commemoration on the other. *12M²* of 1994 is probably the most widely discussed of Zhang's early performances [6]. In it, he sat nude for one hour, covered in honey and fish oil in a filthy public toilet in his eastern Beijing neighborhood, known as the East Village as a tribute by its artist residents to New York's East Village. During this hour, despite being covered by flies and gawked at by neighbors arriving to relieve themselves, Zhang maintained the concentration and equanimity associated with endurance-based performances by

6 • **Zhang Huan,** *12 M²*, **1994**
Performance, detail showing artist covered in honey, fish oil, and flies

▲ artists such as Chris Burden or Marina Abramovic. After sixty minutes, Zhang walked calmly into a nearby pond until he was submerged in its dirty water, and the flies had floated off his body.

12M² demonstrated the uneven development of Chinese cities where primitive, unimproved facilities may exist cheek by jowl with newly constructed skyscrapers served by a thoroughly up-to-date urban infrastructure. Photographed and videotaped during his performance, Zhang openly displayed what modernization attempts to veil or sanitize: the insistent needs and abject materiality of the body. The management of *waste* in modern cities—its consignment to various invisible technological systems—here experiences a return of the repressed. But Zhang's work also serves as an allegory for the relationship between physical and emotional presence and retrospective memory. As he reflected in a 2008 statement: "During the whole process, I tried my best to forget reality and separate my mind from my body. But I was pulled back to reality again and again. Only after the performance did I understand what I'd just experienced."

More recently, Zhang has made highly spectacular paintings and sculptures, such as his 2008 hybrid of those two media titled *Canal Building* [7]. All that was initially visible of *Canal Building* when one entered the cavernous Pace Gallery in New York where it was exhibited was an enormous gray block over five feet tall, nearly sixty feet long, and almost twenty feet wide, spanned by a metal bridge. Once one climbed the steep stairs onto the narrow span of the suspended walkway, it became clear that the large block, made of compressed ash, was the ground for a vast reproduction of a fifties press photograph documenting a large-scale construction project during China's Great Leap Forward, rendered in ash of different tones of gray. This icon of industrial construction, visible only from the suspended gangway, is also clearly the product of contemporary cultural production on a grand scale: during the course of the exhibition the enormously intricate and time-consuming work was completed by assistants suspended on a

low scaffold, moving across the image like human scanners. Zhang also used the labor of his assistants to sort various tones of gray from incense ash that he had acquired from temples in Shanghai that had burned it ceremonially. In other words, the residue or waste of a traditional Chinese religious ceremony—which Zhang realized would have been thrown out—was recycled to create an image of industrial construction within a project that belongs to the postindustrial economy of global contemporary art. Zhang's emphasis on waste and recycling, as well as his establishment of a chain of memories and residues in this work—the Great Leap Forward, temple ceremonies, and contemporary art production—links it to his earlier performance. And yet he, like so many artists in China—including Ai Weiwei in projects such as *Sunflower Seeds*—opted to work *with* rather than *against* the abundant labor market that has fuelled China's boom, almost like a small factory proprietor. And indeed, one of the distinctive qualities of China's aesthetic response to its rapid modernization is through scale. In the hands of artists like Ai and Zhang, the work of art becomes a truly social project: the unofficial public spheres pioneered by artists in the eighties and early nineties have morphed into a new kind of Chinese culture industry that can manage actual populations—of "tourists," assistants, and art world audiences alike.　DJ

FURTHER READING

Jochen Noth et al., *China Avant-Garde: Counter-currents in Art and Culture* (Oxford: Oxford University Press, 1994)

Yilmaz Dziewior et al., *Zhang Huan* (London: Phaidon Press, 2009)

Michael Hardt and Antonio Negri, *Empire* (Cambridge, Mass.: Harvard University Press, 2000)

Richard Curt Kraus, *The Party and the Art in China: The New Politics of Culture* (Lanham: Rowman & Littlefield Publishers, 2004)

Charles Merewether, *Ai Weiwei: Under Construction* (Sydney: University of New South Wales Press, 2008)

Wu Hung, *Transience: Chinese Experimental Art at the End of the Twentieth Century*, revised edition (Chicago: The David and Alfred Smart Museum of Art; University of Chicago Press, 2005)

Gao Minglu, *Total Modernity and the Avant-Garde in Twentieth-Century Chinese Art* (Cambridge, Mass.: MIT Press, 2011)

▲ 1974

2010_b

French artist Claire Fontaine, whose "operation" by two human assistants is itself an explicit division of labor, dramatizes the economies of art in a major retrospective at the Museum of Contemporary Art in North Miami, Florida: the show marks the emergence of the avatar as a new form of artistic subjecthood.

Since Marcel Duchamp invented the first readymades in the teens of the twentieth century, using found and often mass-produced commodities in works of art has become as widespread as figure drawing once was for painters. There are ▲ two justifications most frequently given for presenting commodities in the place of art. First, based on often-quoted statements by Duchamp, it is said that the artist's *choice* of an object is what matters in making a thing into an art work—that, by definition, artists are authorized to legitimize virtually anything as art, ranging from a bicycle wheel to a snow shovel, to take two examples from Duchamp's oeuvre, merely by calling it so. A second justification supplements this first: commodities themselves carry powerful visual messages that may be manipulated—even "spoken"—as a ready-made symbolic language, as when Robert Rauschenberg or ● Andy Warhol appropriated the Coca-Cola logo as an American icon. Since the late seventies, when the question of gender's social codes began to emerge among artists such as Cindy Sherman or ■ Barbara Kruger, a third understanding of the readymade emerged: stereotypes were identified and re-presented as expressions of what might be called the "human readymade." Sherman, for instance, embodied stereotypes of feminine Hollywood protagonists or supporting actresses in her *Film Stills*, while Kruger appropriated such stereotypes by utilizing found photographs as the ground for trenchant graphic texts that operated as disarming "captions." Both artists reframed the "human readymade" in order to challenge the presumption that femininity is constituted from a menu of biologically determined attributes.

In the United States, the struggles and controversies around identity politics that characterized a good deal of art during the late eighties and nineties, and which were greatly indebted to the strategies of impersonation and appropriation pioneered by artists such as Sherman and Kruger, ultimately resulted in an effort to possess and recode such stereotypes, or alternately to express the discomfort or rage at being misrepresented, or ◆ *dispossessed*, by them. Hence the work of Adrian Piper or Lorna Simpson confronted viewers with their presumed stereotypical preconceptions about African-Americans in an effort to move beyond such ready-made characterizations. In other words, like Duchamp's so-called nominalism, where a commodity was consti-

tuted as a work of art by being named such, much of the art associated with identity politics pivoted on the authorization to *name*—in this case, to name an identity, rather than a work of art. More recently, a distinctly different strategy pertaining to personhood has emerged among artists who introduce fictional characters as readymades—or *avatars*—into a variety of real and virtual environments. Like the surrogate actors in video games also known as avatars, these artist-built characters have no essential link to an existing person or identity per se. Instead, they are remote-controlled avatars who, like their virtual cousins in the game world, may travel to places or articulate meanings that would be inaccessible to any flesh-and-blood individual. In other words, avatars "free" artists from identity, allowing them to propose forms of selfhood, or subjectivity, that may be collective, imaginary, or utopian.

Artist Inc.

The term *corporate* is typically associated with business enterprises, but it can signify any organized group endeavor. Under the conditions of contemporary media society, corporations of every type distinguish themselves aesthetically through the adoption of "visual identities" (that is, coordinated design campaigns encompassing logos, merchandising display, and advertising), and empathically through representation by a leader or paid spokesperson. Artists who wish to de-emphasize their own individuality—and the powerful myth of artistic creativity it entails—have also formed corporate entities that function as a kind of anthropomorphic brand, or avatar. The Bernadette Corporation, for instance, is an artists' group founded in 1994 and known for its forays into fashion, art dealing, and activism, whose flexible model of the "holding company" allows it to shuttle between the art world and politics like other collectives established in the ▲ eighties, such as ACT-UP or the Guerrilla Girls. In 2004, the Bernadette Corporation published a novel titled *Reena Spaulings*, which serves as a kind of manifesto or a general theory of avatars [1]. In it, the fictional adventures of the title character, Reena Spaulings, indicate two forms of image power: first, the capacity of images to absorb human beings into pictures through *identification*, and

1 • (above) Bernadette Corporation, cover of *Reena Spaulings*, 2004

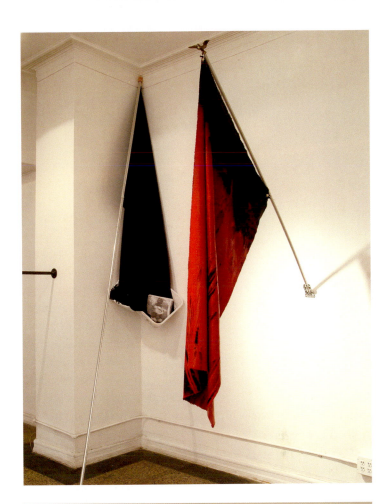

2 • (right, top and bottom) Reena Spaulings, "The One and Only",
Sutton Lane Gallery, London, 2005
Installation view

second, the *projection* of powerful representations into real situations in order to manipulate events.

In the opening chapter of *Reena Spaulings*, Reena, working as a guard at the Metropolitan Museum of Art, falls into an extended meditation on Édouard Manet's famous painting *Woman with a Parrot* (1866) hanging in the gallery where she's on duty. Over and over again, the book narrates encounters between persons and pictures where the differences between them begin to blur: "She stood up a little straighter and fixed her eyes on a Manet on the opposite wall. The woman in the painting had Reena's blank pallor and below-the-radar presence. Reena could be a Manet, one of these thinking pictures you can't see through, no matter how long you stare at them." Reena becomes precisely such a "thinking picture" when Maris Parings, a flamboyant entrepreneur, recognizes her particular brand of bohemian chic and transforms her into an underwear model, giving her new social mobility as a celebrity (that is, a human picture or avatar) and allowing her to build new communities through a delirious sequence of live and mediated representations. If Reena meets and recognizes herself as a picture in her encounter with the Manet, and *becomes* a picture in her metamorphosis into fashion model, in the third paradigm

explored by *Reena Spaulings*, such personified pictures begin to operate as agents. This shift into image-agency—or the realm of the avatar—occurs most explicitly in a staged riot produced by Parings' company, Vive la Corpse, and titled *Cinema of the Damned* (or a Battle on Broadway), in which a performance starring Reena and a full cast of insurgents in the street shades into an actual riot. When images act, *Reena Spaulings* seems to assert, the fictional has real consequences as a kind of catalyst, and art attains the potential to function as politics—in other words, as an avatar.

Indeed, in 2004, the same year the novel was published, the fictional character Reena Spaulings began to operate as an avatar in the world—both as an art dealer, running Reena Spaulings Gallery in downtown New York (founded by the writer John Kelsey and the artist Emily Sundblad), and as an artist who has contributed works to group exhibitions, staged her own one-person shows, and even entered the collection of the Museum of Modern Art in New York. Spaulings' art objects are sometimes produced in collaboration with gallery artists, and sometimes composed of materials drawn from the ordinary gallery "artifacts," such as guest books or tablecloths from opening dinners. In her first solo show, "The One and Only" in 2005, she introduced a powerfully iconic genre of objects: various types of flags mounted on ordinary household flagpoles [2]. The flag is of course a special kind of representation whose purpose is to assert sovereignty. By posing as a flag, the work of art reveals its unconscious imperialist drive: to claim space and demand recognition. This gesture is echoed by the flag's equally "imperializing" absorption of art's two classic media—painting as a colored surface, and sculpture as a three-dimensional object (these works even give a nod to time-based media, since the point of a flag is to move with changing currents of air). In short, Reena Spaulings began her public career as an artist by planting a flag: she would occupy space in the physical and informational circuits of the art world, and she would embrace as many media as possible in what Rosalind Krauss has called the "postmedium condition." A third impulse supplemented these first two: Reena's insistence on being *both* artist and art dealer. Instead of entering *into* an art world, one might say that Reena Spaulings *became* an art world.

Breaking the division

Since the sixties a vast number of new galleries, art fairs, biennial exhibitions, and museums—often designed by celebrity architects—has emerged, causing the art world to grow so large and so spectacular that it functions as a branch of the entertainment and tourist industries. Such are the general conditions that Bernadette Corporation, as well as other avatars like the Paris-based Claire Fontaine (whose name is drawn from the well-known French notebook company Clairefontaine, and who is "operated" by her human assistants, Fulvia Carnevale and James Thornhill) responds to. It is no longer enough for an artist to make objects in a studio and wait passively for these works to enter the public sphere—rather, as Reena Spaulings implies, the entire system of

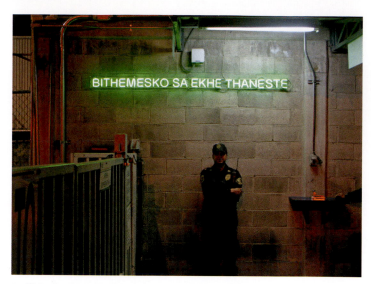

3 • Claire Fontaine, *Foreigners Everywhere (Romany)*, 2010
Emerald-green argon glass, framework, electronic transformer and cables, 10 × 228 × 5 (3⅞ × 89¾ × 1¹⁵⁄₁₆)

production, distribution, sales, display, and critical reception that constitutes an art world must be, as economists put it, vertically integrated. Indeed, Claire Fontaine, whose work often echoes that of other artists—as when she makes flags recalling the work of Reena Spaulings—is profoundly concerned with questions of labor. As she states in a 2006 interview with John Kelsey, "The division of labor is *the* fundamental problematic of our work. Claire Fontaine grew out of the impossibility of accepting the division between intellectual and manual work; the art world is best adapted for fleeing this sort of hierarchy." Claire Fontaine understands herself as a ready-made artist, but more profoundly, she explores a division of labor that increasingly characterizes globalized economic systems: the separation between manual production, which may take place in locations and cultures very remote from the intellectual labor that commands it from metropolitan centers. Indeed, her projects often acknowledge the wider geopolitical conditions of global labor, which habitually crosses national borders through migration—legal and illegal—and corporate outsourcing. In *Foreigners Everywhere* [3], for example, which was exhibited in a window in East Jerusalem in 2008, such ethnic/national division is directly enunciated, as Claire Fontaine recounts in a 2008 interview: "The Hebrew and Arabic translations of St Paul's sentence 'Divide the division,' or 'Divide the divided,' flash on and off in the two languages alternatively, [on neon signs] one on top of the other…. Of course, the violence of the translation is the core of our gesture: in Arabic the sentence sounds more like 'Break the division.'"

Since artists are among those few persons left (corporate or otherwise) who habitually span manual and intellectual labor in a single individual, their "mode of production" may serve as a laboratory for questioning the division of labor that characterizes global economics more broadly. Indeed, as the philosopher Bruno Latour has argued, in a networked world, the local and the global

are always directly connected, usually existing side-by-side (he gives train lines as an example of how even a remote station in the countryside is directly linked to a vast transportation infrastructure). Bernadette Corporation and Claire Fontaine resist displacing the mechanisms of globalization onto forces or conditions external to them: art does not *reflect* global division of labor, but rather the artist herself is formed by those divisions. It is therefore not surprising that Claire Fontaine's major 2010 retrospective at the Museum of Contemporary Art in North Miami, Florida, was titled "Economies" and included work that explicitly mined the financial relationship between the artist and her gallery. Like many specialized markets based on highly customized products, such as fashion or graphic design, the art world's economy is largely based on trust (despite the open secret that artists are often exploited economically by their galleries and that collectors are frequently slow in paying for works of art). "Economies" included a series of framed blank checks—each titled "*Trust*" with the name of its signatory in parentheses—issued by several of Claire Fontaine's galleries from around the world. If a collector "breaks the glass" and fills in the check, s/he destroys Fontaine's work, while simultaneously profiting from it, and perhaps bankrupting the gallery in question. Of course there is a parallel dilemma for the art dealer who would have to decide whether or not to honor the check.

The success of an avatar lies in its capacity to operate within a particular world (it would, after all, be impossible to "see" the global operations of a multinational corporation all at once, but it is easy to understand Claire Fontaine's allegory of *carte blanche*). Making a successful avatar thus entails inhabiting a particular world, by mastering and exhibiting its rules of behavior.

Enter the picture

The Chinese artist Cao Fei (born 1978), for instance, has constructed a three-dimensional simulation of contemporary China—her RMB City—in Second Life, a "community" launched by the Linden Lab in 2003 that allows users (known as residents) to build and inhabit a wide range of invented environments. There is a great aesthetic difference between Bernadette Corporation and Claire Fontaine's Conceptual art–inspired techniques and the lush animations of Cao's elegiac videos set in Second Life, which recall Japanese *anime* and the worldwide culture of graphic literature and cartoons [4]. What most distinguishes Cao's art, however, is the viewer's *immersion* in her image of RMB City. The allure of Second Life, after all, is for participants to *collectively enter into a picture*: the game itself is a social experiment in how a group of "residents" drawn from all over the world may together inhabit the same virtual space. Although the prevailing atmosphere of Second Life is one of pleasurable escape—as though its residents are enjoying an island vacation—businesses, art events, and political actions have all taken root there, and a genuine economy is facilitated by the

4 • Cao Fei, *The Birth of RMB City*, 2009
Second Life environment

Plate 69
Renault
5
White
March 25, 1986
10:04
Sin El Fil, Beirut
8 killed
80 injured
75 kg. of TNT
Hexogen
2.4 m. x 0.8 to 1.25 m. crater

№ 69

№ 70

Plate 70
BMW
320
White
April 8, 1986
13:04
Jounieh
11 killed
90 injured
75 kg. of TNT
Hexogen

ABLF v38 p69
Original 12.6 x 21.3 cm
Paper / Ink / Photograph
1975–1991
Courtesy of The Atlas Group

ABLF v38 p70
Original 12.8 x 21.3 cm
Paper / Ink / Photograph
1975–1991
Courtesy of The Atlas Group

5 • The Atlas Group / Walid Raad, *Notebook Volume 38: Already Been in a Lake of Fire [cat.A]_Fakhouri_Notebooks_38_055-071,* 1999 / 2003
Detail, from a set of nine plates, each 31.3 × 43.3 (12⁵⁄₁₆ × 17), edition of 7 + 1AP

game's currency, the Linden Dollar. Cao's RMB City includes several of the signature "icons" of China, ranging from a floating panda to a suspended model of Rem Koolhaas's design for the Beijing headquarters of CCTV. But here the ready-made stereotype, unlike those proffered by the artists of appropriation and identity politics, is literally inhabitable: one can navigate within it as *an environment* and Cao's avatar, China Tracy, does so, as if physically leading her viewers through an allegory of the recent history of China, whose physical face seems to change daily and whose citizens' identities are under massive reconstruction as well.

The videos that lead us through RMB City are very beautiful, and the avatars one sees along the way are exotic: sometimes humanoid, sometimes not, sometimes dancing alone in elegant spasms, sometimes conversing intently in intimate pairs. But perhaps the most significant aspect of Cao's RMB City project is how it represents two kinds of movement indigenous to virtual worlds: first, a smooth gliding locomotion and, second, jump cuts from one location to another. Each type of motion offers a distinct
▲ alternative for navigating within pictures—either total absorption corresponding to the fantasy of frictionless Internet surfing and

immersive gaming; or instantaneous mobility banishing gravity and space to allow for sudden movement from one unrelated site to another. In both cases, virtual space suggests a world of sovereign privilege that, in Cao's RMB City, seems intimately related to the conditions of manic real-estate development in contemporary urban China—a condition marked by the frequent presence of rotating signs proclaiming Second Life "land" for sale.

The authority of visual information

As familiar as these two types of virtual locomotion are, it is important to explore and understand them, for as our everyday world begins to consist more and more of digital environments of various sorts, the question of how to *cohabit an image* becomes a pressing civic duty—thus giving new meaning to art history's traditional project of interpreting visual codes. Indeed, one of the most significant contemporary tasks in an era when photographs may be presented as evidence to justify the declaration of war (as Colin Powell did at the United Nations in 2002 in his capacity as the US secretary of state), and scientists make discoveries through simu-

▲ 2009c

lated visual models, is to interpret the meaning and veracity of pictures—to develop what is called "visual literacy." The art historian Carrie Lambert-Beatty has used the term "parafiction" to describe various artistic projects that address this situation by playing with the often highly charged dividing line between fantasy and documentary. Among the best known of these are projects of the Lebanese artist Walid Raad (born 1967), operating under the guise of The Atlas Group, an entity invented by Raad devoted to documenting Lebanon's recent history.

The Atlas Group has produced three types of documents, as catalogued in their online archive: "Type A—for files that contain documents that we produced and that we attribute to named imaginary individuals or organizations. Type FD—for files that contain documents that we produced and we attribute to anonymous individuals or organizations. Type AGP—for files that contain documents that we produced and that we attribute to The Atlas Group." In other words, The Atlas Group produced an imaginary archive that pertains to real historical events. The Fakhouri File, for instance is a series of 226 notebooks and 2 films bequeathed to The Atlas Group in 1994 by Dr. Fadi Fakhouri, "the foremost historian of the Lebanese wars." These documents give with one hand what they take away with the other, as in "Already Been in a Lake of Fire_Notebook Volume 38," which includes elegant collages including cut-outs of every model of car used as a car bomb between 1975 and 1991, as well as details of the explosion and its casualties [5]. These pieces are delirious and beautiful—the cars are arrayed at different angles in what seems like a vicious parody of their imminent explosion. But while the fact of car bombings is very real, this whimsical "document" is utterly imaginary—and thus proper authorization is *taken away*. History is shown as an aesthetic folly that leads viewers to examine—somewhat queasily—their assumptions about archival truth. And the fact that images must be authorized in order to claim truth-value is made abundantly clear.

The question of authorization is even more potently at play in the work of the Yes Men, a pair of artist-activists who have successfully posed as corporate spokesmen by creating websites that look official in order to attract actual invitations to speak at business conferences or as press representatives. Their most spectacular project to date was the announcement of "Jude Finisterra" (one of the Yes Men posing as a representative of the Dow Chemical Corporation) on BBC Television, that Dow would take responsibility for the devastating Union Carbide chemical spill in Bhopal, India, in 1984, for which the company had refused responsibility since buying Union Carbide in 2001 [6]. For a few hours, the world thought that a major corporation was to do the right thing: in Bhopal victims of the disaster rejoiced in (well-founded) disbelief, and in the West, Dow's stock price plunged, the market instantly assuming the news to be accurate. In an integrated media circuit, where news reports are drawn from other news outlets and infinitely recirculated, even a few hours were enough for the story to circle the world—and of course when the deception emerged,

6 • The Yes Men, *Dow Does the Right Thing*, 2004
Performance

the backlash was equally swift and decisive. As avatars, the Yes Men not only literally reshaped the speech of a corporate giant (if only for a brief moment in time), but they demonstrated the manic circulation and recirculation of information that characterizes contemporary media. Both operations pivoted on how surprisingly easy it was to *authorize* information.

The avatars under discussion here fall into three categories: the *corporate*, whose purpose is to explore how artists reorganize their labor as a "vertically integrated" art world in microcosm; the *fantastic*, in which virtual spaces offer mythic forms of freedom of movement and association; and the *interventionist*, where parafictional "counterfeits," either archives or characters, impinge on actual events. In each case, the question of an artist's given identity is set aside in order to imagine forms of agency that no single person, acting alone, could affect. DJ

FURTHER READING
The Atlas Group, *The Truth Will Be Known When the Last Witness is Dead: Documents from the Fakhouri File in The Atlas Group Archive* (Cologne: Walther König, 2004)
Bernadette Corporation, *Reena Spaulings* (New York: Semiotext(e), 2004)
Eleanor Heartney, "Life Like," *Art in America*, vol. 96, no. 5, May 2008, pp. 164–5, p. 208
Ruba Katrib and Tom McDonough, *Claire Fontaine: Economies* (North Miami: Museum of Contemporary Art, 2010)
Carrie Lambert-Beatty, "Make-Believe: Parafiction and Plausibility," *October*, no. 129, Summer 2009, pp. 51–84

2015

As Tate Modern, the Museum of Modern Art, and the Metropolitan Museum of Art plan further expansions, the Whitney Museum of American Art opens its new building, capping a period of international growth in exhibition space for modern and contemporary art including performance and dance.

When the new Whitney Museum, conceived by the Italian architect Renzo Piano, opened its doors on the Hudson River in New York City in May 2015, the press likened its stepped levels with outdoor decks to an ocean liner [1]. Meanwhile, on the Thames River in London, Tate Modern 2, designed by the Swiss team Jacques Herzog and Pierre de Meuron, wedged its way into position alongside Tate Modern, an old power station converted into a museum by the same office in 2000 [2].

Guided by the American firm Diller Scofidio + Renfro, the Museum of Modern Art (MoMA) in midtown Manhattan plans another expansion (the last one was completed only in 2004), and the Metropolitan Museum uptown envisions a new wing for modern and contemporary art, conceived by the English architect David Chipperfield, who, like the others, is a veteran of museum design. These examples are drawn from London and New York alone, and so skip over the museum boom underway in Europe,

1 • Renzo Piano Workshop, Whitney Museum of American Art, New York, 2007–15
Situated between the Hudson River and the High Line, the building includes 50,000 square feet of indoor galleries and 13,000 square feet of outdoor exhibition space and terraces.

the Middle East, China, and elsewhere. Yet all institutions that aim to encompass modern and contemporary art face similar problems, and not all of these are political or economic in nature.

After the white cube

The first dilemma faced by such museums is the different scales of modern and contemporary art and the different spaces needed to exhibit it. The initial setting of modern painting and sculpture, produced as they primarily were for the market, was the nineteenth-century interior, usually the bourgeois apartment, and so the first museums for this art were scaled accordingly, often in refurbished rooms of a similar sort. Gradually, in the twentieth century this model of exhibition was displaced by another type: as modern art became more abstract and more autonomous, it
▲ called out for a space that mirrored this homeless condition, a space that came to be known as "the white cube," which some viewed as austere and others as exalted. In turn, this model was pressured by the expanded size of ambitious work, especially after World War II, from the vast canvases of Jackson Pollock, Barnett Newman, and others to the serial objects of Minimalists
● like Carl Andre, Donald Judd, and Dan Flavin, and on to the site-specific and postmedium installations of subsequent artists.

To hold together the large halls required for contemporary production with the limited galleries suitable for modernist painting and sculpture is no easy task, as any visit to Tate Modern or MoMA attests. And this problem is complicated by the fact that some recent art demands yet another space: an enclosed area
■ darkened for image projection (whether film, video, or digital) that is termed "the black box." Finally, with the new interest in performance and dance presented at museums, these institutions plan for still other galleries, which the initial proposal for the MoMA expansion called "gray boxes" and "art bays"; the former is a cross between a white cube and a black box, while the latter suggests a hybrid of a performance area and an event space. Any museum that intends to show a representative array of modern and contemporary art must somehow allow for all these settings, and do so in the same building. (Of course, an institution might opt for multiple sites, but that brings challenges of its own.)

Two factors were central to the recent expansion of modern and contemporary art museums. In the sixties, as industry began to collapse in New York and other cities, manufacturing lofts were turned into inexpensive studios by artists such as the Minimalists, in part so that they could produce work that might test the limits of the white cube. Eventually, however, industrial structures were refashioned as galleries and museums in order to cope with the increased size of this art (the power station that became Tate Modern is only one example). A circularity emerged here, as is evident at institutions such as Dia:Beacon (2003), a mecca for Minimalist and Postminimalist art in upstate New York, which was an old biscuit-box factory transformed into an ensemble of
◆ cavernous halls to encompass gigantic sculptures by Richard Serra

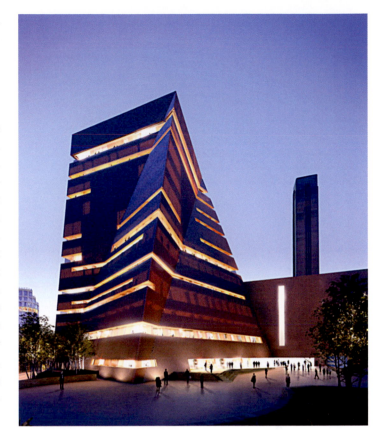

2 • Herzog & de Meuron, Tate Modern 2, London, 2005–16
The underground oil tanks of the old power station form the foundation of the new building as its volume rises out of these clover-shaped structures below, doubling the museum's gallery space and creating subterranean performance areas.

and others. The second road to this expansion was more direct: the building of altogether new museums as vast containers for
▲ huge art work, as is exemplified by the Guggenheim Bilbao (1997) designed by Frank Gehry. In some respects, this bigness is the outcome of a space race between architects like Gehry and artists like Serra, and by now it seems almost natural. Yet there is nothing definitive about it; well-regarded artists who emerged over the last
● two decades, such as Pierre Huyghe, Rirkrit Tiravanija, and Tino Sehgal among many others, do not require such room, and in many ways they refuse it. (Bigness has also led to bad by-products like immense atria, which are deadly as exhibition spaces.)

The Guggenheim Bilbao remains the best example of a third problem: the museum as icon. Leaders of a depressed city or an overlooked region want to retool for a new economy of cultural tourism, and believe an architectural symbol that also serves as a media emblem can help them toward this goal. To achieve this iconicity, however, the chosen architect is allowed, even encouraged, to shape idiosyncratic volumes at urban scale, and often in or near poor neighborhoods that are thereby disrupted, if not displaced altogether (MACBA, or the Museu d'Art Contemporani de Barcelona, designed in 1995 by the American Richard Meier, can be taken to exemplify this disruption). Some museums are so sculpturally expressive that the art can only arrive

▲ 1926, 2007a ● 1947b, 1949a, 1951, 1960b, 1962c, 1965, 1966b, 1969, 1970 ■ 1973, 1998 ◆ 1969, 1970 ▲ 1976 ● 1989, 1998, 2003, 2009a

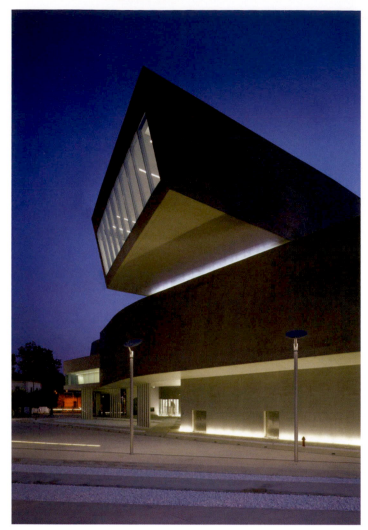

3 • Zaha Hadid Architects, MAXXI Museum of XXI Century Arts, Rome, 1998–2009
Italy's first public museum devoted to contemporary creativity, MAXXI was, in the words of the architects, "not only an arena in which to exhibit art, but a research 'hothouse'—a space where contemporary languages of design, fashion, cinema, art and architecture can meet in new dialogue."

not really know and cannot truly anticipate? As a result of this uncertainty, we have seen the rise of "cultural sheds" that have little apparent program; one such structure, designed by Diller Scofidio + Renfro and Rockwell Group, with great canopies that open and close for different events, is slated for the Hudson Yards area on the West Side of Manhattan and scheduled to open in 2019 [5]. The logic of these sheds seems to be build a container and then leave it for artists to respond. The result on the artistic side is likely to be a default form of installation work, while on the architectural side the projection of new spaces like "gray boxes" and "art bays" might constrain the very art that they aim to present. What seems like flexibility can end up as the opposite; witness the very tall galleries at the New Museum on the Lower East Side in New York, or indeed at MoMA, which tend to overbear the art shown there.

A fifth problem, somewhat outside our purview here, might be noted briefly, and that is the rise of private museums that house the art collections of the super-wealthy. Contemporary art is a beautiful thing for these collectors, who have profited enormously from a neoliberal economy of deregulation and financialization, for it is at once auratic as an object and fungible as an asset. Although the American version of this international class benefits from tax breaks (because the collections are nominally open to visitors who can arrange the pilgrimage), they do not pretend to any real connection to the public sphere. Often at a remove from urban centers, they are largely museums of equity display, equal parts prestige and portfolio, and they compete for the best art works with institutions that are at least semipublic, driving up prices as they do so. Perhaps some of these collections will be folded back to civic museums eventually, but why, then, the self-aggrandizing detour in the first place?

after the fact as a second-bill act; this is often the case at the MAXXI Museum of XXI Century Arts in Rome, a neo-Futurist plaiting of low-slung volumes created by the Iraqi-British architect Zaha Hadid [3]. Meanwhile, other museums are so visually smart that the artists have to respond to the architecture in the first instance; this is sometimes the case at the Institute of Contemporary Art, designed by Diller Scofidio + Renfro for the Boston harbor front, so ingenious is it as a machine for seeing and spectating [4]. Still other museums make such a claim on our interest that they stand as the dominant work on display, and so upstage the art they are meant to present; this might be the impression left by Tate Modern 2. Of course, architects operate in the visual arena too, and can hardly be questioned for doing so, but sometimes emphasis on the imagistic power of the design can distract from attention to fundamental matters of function and context.

The question of program points to a fourth problem, which is a pervasive uncertainty about what contemporary art is and what spaces might be suited to it. How can one design for what one does

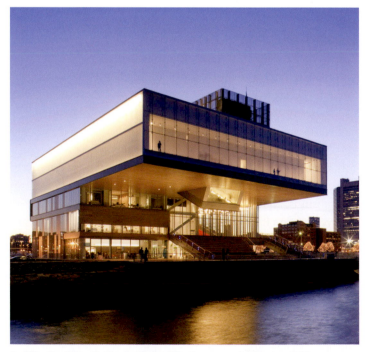

4 • Diller Scofidio + Renfro, Institute of Contemporary Art, Boston, 2006
The galleries are located on the building's upper level, which is dramatically cantilevered over the Harbor Walk, a 47-mile public walkway along the waterfront.

5 • Diller Scofidio + Renfro and Rockwell Group, Culture Shed, New York City, 2015–19
Located in the Hudson Yards area of New York's Chelsea district, the six-story building will host "art, performance, film, design, food, fashion, and new combinations of cultural content."

Experience or interpretation?

Despite appearances, many new and renovated museums do have a program, a mega-program that usually goes unstated: entertainment. Most of us still live in a spectacle society (our financial reliance on information has not much altered our cultural investment in images), or, to use the anodyne phrase, we live in an "experience economy." What relation do these museums have to a culture that so prizes entertainment? Already in 1997, Tate director Nicholas Serota framed "the dilemma of museums of modern art" as a stark option—"experience or interpretation"—which might be rephrased as entertainment and spectacle on the one side or aesthetic contemplation and historical understanding on the other. More than twenty years later, however, this either/or should no longer stymie us. Spectacle is here to stay, at least as long as capitalism is, and museums are part of it; that is a given, but for that very reason it need not be a goal.

However, for many museums, even ones that do not depend on ticket sales, it does seem to be a goal. This is evident from all the space these institutions give over to event rooms, big stores, and fancy restaurants, but it is also suggested by recent trends in programming. Consider the turn to performance and dance, and the restaging of historical examples of both, in art museums over the last decade and more. The 2010 retrospective of Marina Abramovic at MoMA titled "The Artist is Present," which included a ten-week spectacle in which she stared down anyone who sat opposite her, is a good example of the first tendency; Judson Dance Theater (Yvonne Rainer, Steve Paxton, Trisha Brown, and others) figures prominently in the second. In the sixties and seventies, performances tended to be one-time only, and this you-had-to-be-there-ness (also implicit in the earlier term "happening") was deemed a signal feature of the practice (it was one thing that differentiated it from theater). As dance is usually scored, and so intrinsically iterative, it avoids this problem; and yet when dance is restaged in museums, it tends to appear as performance too—that is, as a visual event, an art piece.

This institutionalization of experimental performance and dance can be seen negatively as the recuperation of once alternative practices or positively as the recovery of otherwise lost events; like independent film, performance and dance have come to museums in part because their own venues have fallen on hard times economically. Yet this alone does not explain the embrace of live events in institutions otherwise dedicated to inanimate art. During the first boom in museums in "the new Europe" after 1989, the Dutch architect Rem Koolhaas remarked that, since there is not enough past to go around, its tokens can only rise in value. Today, it seems, there is not enough present to go around; for reasons that are obvious enough in a hypermediated age, it is in great demand too, as is anything that feels like presence.

Some institutions have restaged historical art exhibitions too, and tellingly one focus has fallen on shows of art that foreground presence and process, such as "Primary Structures" (1966) and

▲ 1973, 1974

▲ 1961, 1974 ● 1965

▲ "When Attitudes Become Form" (1969), which were among the
● inaugural presentations of Minimalism and Postminimalism
respectively. A perfect reconstruction of a past show is impossible,
but no such thing is attempted here: often the original works are
represented by enlarged photographs on the wall or forensic
outlines on the floor. This treatment cannot help but derealize the
art, and the derealization works on the viewer as well. As with
some restagings of performance and dance, we enter into a gray
zone, not quite present or past, even a zombie condition, not quite
alive or dead, and this odd temporality is hardly the owlish twilight
of historical understanding made famous by Hegel; in fact it might
get in the way of such coming to terms with the past.

An important counter here is the reenactment practice of such
artists as Jeremy Deller (born 1966), Sharon Hayes (born 1970),
and Mark Tribe (born 1966), who often call up past events of a
political nature otherwise threatened with historical oblivion. "I've
always described it as digging up a corpse and giving it a proper
post-mortem," Deller remarked of *The Battle of Orgreave* (2001),
his filmed restaging of a 1984 confrontation between police and
striking miners in South Yorkshire, England, a key moment in
Thatcherite neoliberalism [**6**]. For Deller, historical reenactment
does not lay the past to rest but instead puts it into play again; it is a
kind of preposterous history—"preposterous" because it conjures
both a before (pre) and an after (post) in a way that aims to open
up possibilities for the now. For her part, Hayes often "respeaks"
political actions in the civil rights, feminist, and other movements,
as she does in her work *In the Near Future* (2009) [**7**]. In thus
probing this past, she also aims to examine "the speech act and the
political sign and the contemporary constriction of public space
and public speech."

The promiscuity of the art work

There is another reason why performance is embraced by
museums today: like art that foregrounds process, it is said to
"activate" the viewer, especially so when the two are combined,
that is, when a process—an action or a gesture—is performed.
The assumption here is that to leave a work undone is to prompt
the viewer to complete it, and yet this attitude can easily become
an excuse of the artist not to execute a work fully. A piece that
appears unfinished hardly ensures that the viewer will be engaged;
indifference is as likely a result, perhaps a more likely one.
In any case, such informality tends to discourage sustained
attention, both aesthetic and critical: we are likely to pass over the
work quickly because its maker appears to have done the same
prior to us, or because quick effect seems to be what was intended
in the first place. Two further assumptions are no less dubious.
The first is that the viewer is somehow passive to begin with,
which need not be the case at all, and the second is that a finished
work in the traditional sense cannot activate the viewer as effec-
tively, which is also false.

Lately museums cannot seem to leave us alone, prompting us
as parents often do children. And often this activation has become
an end, not a means: as in the culture at large, communication and
connectivity are promoted for their own sake, with little interest in
the quality of subjectivity and sociality thus effected. This activa-
tion helps to validate the museum, to overseers and onlookers
alike, as relevant, vital, or simply busy—yet, more than the viewer,
it is the museum that the museum seeks to activate. Weirdly,
however, this only confirms the negative image that detractors
have long had of it: not simply that aesthetic contemplation is

6 • Jeremy Deller, *The Battle of Orgreave*, 2001
Two-day reenactment involving 800 participants,
including historical reenactors, former miners,
and former policemen. Commissioned and
produced by Artangel, London.

7 • Sharon Hayes, *In the Near Future*, 2009 (detail)
35mm multiple-slide-projection installation, 13 projections, edition of 3 + 1 AP

boring and historical understanding is elitist, but that the museum is a dead place, a mausoleum.

"Museum and mausoleum are connected by more than phonetic association," the German philosopher Theodor Adorno wrote in his classic essay "The Valéry Proust Museum" (1953). "Museums are like the family sepulchres of works of art. They testify to the neutralization of culture." For Adorno, this is the view of the artist in the studio who can only regard the museum as a place of "reification" and "chaos," a view that he ascribes to the French poet Paul Valéry. Adorno assigns the alternative position to the French novelist Marcel Proust, who in this account begins where Valéry stops, with "the afterlife of the work," which Proust sees from the vantage point of the spectator in the museum. For the idealist viewer à la Proust, the museum perfects the studio: it is a spiritual realm where the material messiness of artistic production is distilled away, where, in his own words, "the rooms, in their sober abstinence from all decorative detail, symbolize the inner spaces into which the artist withdraws to create the work." Rather than a site of reification, then, the museum for Proust is a medium of animation.

However opposed the two terms appear, "reification" and "animation" call out for one another: just as the viewer must be posited as passive in order to be activated, the art work must be deemed dead so that it can be resuscitated. Central to the modern discourse on the art museum, this ideology is basic to "art history as a humanistic discipline," the mission of which, the art historian Erwin Panofsky wrote over seven decades ago, is to "enliven what otherwise would remain dead." Here the proper retort in our time comes from the medieval art historian Amy Knight Powell: "Neither institution nor individual can restore life to an object that never had it. The promiscuity of the work of art—its return, reiteration, and perpetuation beyond its original moment—is the surest sign it never lived."

The upshot is this: viewers are not so passive that they have to be activated, and art works not so dead that they have to be animated, and, if designed and programmed intelligently, museums can allow for both entertainment and contemplation, and promote understanding along the way. That is, they can allow for spaces where art works reveal their "promiscuity" with other moments of production and reception. A central role of the museum is to operate as a space-time machine in this way, to transport us to different periods and cultures—diverse ways of perceiving, thinking, depicting, and being—so that we might test them in relation to our own and vice versa, and perhaps be transformed a little in the process. This access to various thens and nows is especially urgent during an era of consumerist presentism, political parochialism, and curtailed citizenship. In the end, if museums are not places where different constellations of past and present are crystallized, why have them? HF

FURTHER READING

Bruce Altshuler, *Salon to Biennial: Exhibitions that Made Art History, Volume I: 1863–1959*
(London: Phaidon, 2008)
Bruce Altshuler, *Biennials and Beyond: Exhibitions that Made Art History, Volume II: 1962–2002*
(London: Phaidon, 2013)
Hal Foster, *The Art-Architecture Complex* (London and New York: Verso Press, 2011)
Brian O'Doherty, *Inside the White Cube: The Ideology of the Gallery Space*
(Berkeley and Los Angeles: University of California Press, 1976)
Nicholas Serota, *Experience or Interpretation: The Dilemma of Museums of Modern Art*
(London: Thames & Hudson, 1997)

roundtable

The predicament of contemporary art

RK: We've structured our entries on twentieth-century art through the analytical perspectives that each one of us tends to favor: Hal's is a psychoanalytic view; Benjamin's, a social-historical view; Yve-Alain's, a formalist and structuralist view; and mine, a poststructuralist view. One way to look back on the development of postwar art is to consider what happened to those methodological tools—how their relevance grew or diminished.

YAB: None of us is married to a particular method.

HF: Right: my commitment to psychoanalysis is not as strong as you suggest; frequently the art led me somewhere else, methodologically, altogether. But your question is really about the *fate* of these different methods in postwar art and criticism. On that score, as far as psychoanalysis is concerned, the Surrealist concern with the unconscious continues after World War II, but in a register more private than political. Many artists from

▲ Abstract Expressionism to Cobra attempt to open up this private unconscious to a more collective dimension; there's a turn, for example, from a Freudian focus on desire to a Jungian interest in archetypes. Yet that move is soon stunted, at least in the United States, by the rise of ego psychology, and another reaction sets in. An aversion to the private ego as the source of artmaking is palpable in milieux from John Cage, Robert Rauschenberg, and

● Jasper Johns to the Minimalists: to different degrees they all try to de-psychologize art, and, in the face of much pathos-laden work in the fifties, one can understand why.

One irony of Minimalism is that, despite its making art more public in its meaning, more objective in its situation, it also puts the subject back into play in a phenomenological form, embodied

■ in space. And as Postminimalists like Eva Hesse moved to complicate this general subject, and to reveal it to be marked differently by fantasy, desire, and death, psychoanalysis returns. This is explicit in the seventies when feminist artists and theorists question how the subject is riven by sexual difference, and how such difference informs both the making and the viewing of art.

Psychoanalysis is extremely productive for many feminists, even as they also critique its presuppositions, and the same holds for some queer artists and theorists thereafter, as well as some postcolonial critics.

On a more abstract level, psychoanalysis has provided insights into artistic forms that other models don't grasp well—for example, the persistent evocation of the "part-object" from Duchamp, through Johns, Louise Bourgeois, Hesse, and Yayoi Kusama, to many artists today. However, psychoanalysis is not consistently important in the postwar period: its presence waxes and wanes as questions of subjectivity and sexuality advance and recede.

YAB: The postwar fate of the methodological tools of formalism and structuralism is partly discussed in my introduction. There I trace the transformation of a morphological conception of formalism (à la Roger Fry in the prewar period, but revived by

▲ Clement Greenberg in the postwar era) into a structuralist one, and then the transformation of the structuralist position into the "poststructuralist" one, which Rosalind in turn explains in her introduction. She discusses how many artists in the middle seventies and early eighties found in "poststructuralism" a powerful theoretical ally that helped them sort out issues in their own production. (By the way, if, as I do with "postmodernism," I put "poststructuralism" in quotation marks, it is because, as far as I know, it was never used by the authors designated by that label.) Here I want to stress that structuralism also left a mark on the artistic production of the sixties. We know that a number of artists in New York were reading Roland Barthes and Claude Lévi-Strauss

● (for example, their books were in Robert Smithson's library) and, perhaps more importantly, the novels of the French Nouveau Roman (such as Alain Robbe-Grillet's), which were written in a structuralist context (Barthes was the biggest champion of Robbe-Grillet's early novels). In many ways the antisubjectivism that is an essential element of structuralism was parallel to the de-psychologizing tendency, just mentioned by Hal, of many

▲ 1947b, 1949a, 1957a, 1960b ● 1953, 1958, 1962d, 1965 ■ 1966b, 1969 ▲ 1906, 1960b ● 1967a, 1970

artists opposing the pathos of Abstract Expressionism in the
▲ US or *art informel* in Europe. The anticompositional impulse
that characterizes so much of the art produced from the
mid-fifties through Minimalism—the serial attitude, the interest
● in indexical procedures, the monochrome, the grid, chance,
etc.—goes hand in hand with the rebellion of structuralism
against existentialism.

This brings me to the other methodology alluded to by Hal, which
does not appear in our official quartet: phenomenology. It's very
interesting that Maurice Merleau-Ponty's *Phenomenology of
Perception* became a bedside book for many American artists
■ (e.g., Robert Morris) as well as critics (e.g., Michael Fried) soon
after it was published in English in 1962. Merleau-Ponty's
theoretical formation was identical to that of Sartre and his
existentialism (the founding text for both was the philosophical
work of Edmund Husserl), but Sartre had a limited appeal to artists
(mainly in Europe, and just for a short while). I wonder if it's not
because, unlike Merleau-Ponty, who wrote beautifully about
Ferdinand de Saussure, Sartre remained hostile to the structuralist
position (not to mention his awkward position with regard to
psychoanalysis). In other words, Sartre continued to presuppose
a "free subject," and so in part remained a prisoner of the classical
philosophy of consciousness inherited from Descartes. As such,
he was out of touch with what many artists were dealing with after
Abstract Expressionism (his champion in the US art world was
Harold Rosenberg, himself identified with a "pathos" formulation of
the Abstract Expressionist aesthetic). By contrast, Merleau-Ponty,
even though he had little knowledge of the artistic avant-garde of
his time (his best pages on art concern Cézanne), was touching on
points that resonated with the concerns of artists of the sixties.

RK: Hal, when Yve-Alain and I curated the exhibition "L'Informe:
Mode d'Emploi" at the Centre Pompidou in 1996, we foregrounded
the operation of "the formless" in a great range of artistic
production from Duchamp to Mike Kelley; in order to understand
this formlessness, it was important for us to think through the
problem of "desublimation," and psychoanalysis was still fresh,
still urgent, for that investigation.

YAB: It's a question of different uses of the same model. This is
something we also learned from Georges Bataille, from whom
we borrowed the anticoncept of the *informe* or "formless."
◆ Bataille opposed the literary way in which André Breton had
applied psychoanalysis in his Surrealism, reducing Freud's dynamic
discourse to a treasure trove of myths and symbols. For Bataille
symbols and myths were to be contested; they were illusions,
on the side of the dominant ideology of representation, and
psychoanalysis was a means of dissecting and dissipating them.

His work forced us to rethink what aspects of psychoanalysis
might speak to the art practices that interested us, how it might be
used to configure a different constellation of objects and concepts
that were not addressed in other sorts of readings—in part
because they were involved in an operation of desublimation.
Maybe that is the project of each of us in this book: to suggest
different kinds of reconfigurations.

For Bataille the same model could be used in a conservative way
and in a revolutionary way (I guess we wouldn't use that term
today); that's a constant in all his writings concerning not only
psychoanalysis but also Marxism, Nietzsche, de Sade, and
almost every other philosophical system or mode of interpretation
he discussed. And I think this is linked to our mode of approach
here. For example, Hal wrote an essay in the early eighties
▲ stressing that there were two kinds of "postmodernism" in art,
an authoritarian one and a progressive one, and he also wrote
in a similar way about the divergent legacies of Russian
Constructivism and Minimalism. This goes hand in hand with
what I mentioned about the two kinds of formalisms, a
morphological one and a structural one.

HF: Perhaps "desublimation" is a way to raise the question of
social art history in the postwar period. The attack on reified forms
and codified meanings à la Bataille is one version of the process,
but there is also the spectre of "repressive desublimation" in the
Marxist sense of Herbert Marcuse. What are the social effects
when artistic forms and cultural institutions are desublimated—
i.e., when they are cracked open by libidinal energies? It's not
always a liberatory event: it can also open up those spheres to
a depoliticized rechanneling of desire by "the culture industry."

BB: As I develop in my introduction, the dialectic of sublimation
and desublimation plays an enormously important role in the
history of postwar art. Perhaps it is even one of the central
dynamics of the period, certainly more so than in the history
of the prewar avant-gardes. It is defined differently by different
theoreticians, both as an avant-garde strategy of subversion
and as a strategy of the cultural industry to achieve incorporation
and subjection. One axis on which this dialectic is played out
more programmatically in the postwar period than ever before is
the relationship of the neo-avant-garde to the ever-expanding
apparatus of cultural industrial domination: as of the fifties, in the
● context of the Independent Group in England, for example, or in
■ early Pop art activities in the United States, appropriating imagery
and structures of industrial production became one of the
methods with which artists tried to reposition themselves between
a bankrupt humanist model of avant-garde aspirations and an
emerging apparatus whose totalitarian potential might not have

▲ 1946, 1947b, 1949a, 1960b ● 1957b ■ 1965 ◆ 1924, 1930b, 1931a, 1931b ▲ 1984b ● 1956 ■ 1960c, 1964b

been visible at first. Desublimation in England served as a radical strategy simultaneously to popularize cultural practice and to recognize the conditions of collective mass-cultural experience as governing. Desublimation in Andy Warhol, by contrast, operated more within the project of a final annihilation of whatever political and cultural aspirations the artists of the immediate postwar period might still have harbored.

As schematic as this might sound, my own work is situated, methodologically, between two texts: one from 1947, *The Dialectic of Enlightenment* by Theodor Adorno and Max Horkheimer, the chapter on "The Culture Industry" in particular, and the other ▲ from 1967, *The Society of the Spectacle* by Guy Debord. The more I think about those texts the more they seem to historicize the last fifty years of artistic production, for they demonstrate how the autonomous spaces of cultural representation—spaces of subversion, resistance, critique, utopian aspiration—are gradually eroded, assimilated, or simply annihilated. This is what occurred in the postwar period with the transformation of liberal democracies in the United States and in Europe: from my perspective not only has the prognosis of Adorno and Horkheimer in 1947 been bitterly fulfilled, but so too has the even more nihilistic prognosis of Debord in 1967—exceeded even. The postwar situation can be described as a negative teleology: a steady dismantling of the autonomous practices, spaces, and spheres of culture, and a perpetual intensification of assimilation and homogenization, to the point today where we witness what Debord called "the integrated spectacle." Where does that leave artistic practices in the present, and how can we, as art historians and critics, address them? Are there still spaces situated outside that homogenizing apparatus? Or do we have to recognize that many artists themselves don't want to be situated outside it?

HF: Are you content with the finality of that narrative?

YAB: It's a dire diagnostic (after all, Debord committed suicide), but one I think we all share to some extent.

HF: Yes, but if you agree entirely with Adorno and / or Debord, little more can be said.

BB: I take the last statement I made seriously: I'm not concluding that every artist in the present defines her or his work as inextricably integrated and affirmative. The artistic capacity still might exist not only to reflect on the position that the art work assumes within the wider system of infinitely differentiated representations (fashion, advertisement, entertainment, etc.), but also to recognize its susceptibility to becoming integrated into those subsets of ideological control. And yet, if there are artistic practices that still stand apart from this process of

homogenization, I'm less convinced than ever that they can survive, and that we as critics and historians are able to support and sustain them in a substantial and efficient manner, to prevent their total marginalization.

DJ: There is a methodological approach that accepts the structure of the spectacle as a new visual environment in which to act, where works of art are recognized as one type of images among many, ranging from cinema and television to the Internet and cell phones. Influenced on the one hand by figures in media studies such as Lev Manovich and on the other by Bruno Latour's actor-network theory, this approach focuses less on critique per se, which implies negation, and more on new configurations of association that ▲ are *productive* of new networks, or—in a nod to Debord—new *situations*. Latour uses a wonderful expression reminiscent of the museum—"reassembling the social." By this phrase he insists that no unified stable version of the "social" exists waiting to be discovered and subverted—that there is no ready-made community at all, but only configurations of association, of relationships that may be assembled or "collected." This perspective is helpful in addressing a wide range of tendencies and works in contemporary art. Many artists throughout the twentieth century, but especially from the sixties onward, have attempted to forge alternative communities through art. This is ● clear in the early history of video art, which not only sought alternatives to commercial television, and new phenomenological experiences for the viewer, but also often involved communal living arrangements and working structures—a kind of cellular organization that is structurally analogous to media networks. More recently, the many collective and experiential art practices that are sometimes categorized as "relational aesthetics" focus on *association* as an aesthetic act.

So-called new media, and especially the capacity to replicate and reformat images digitally, offer an opportunity to rethink our assumptions about the value of art as emerging from its rarity or scarcity. As competitors in the culture industry, figures like Warhol—or Matthew Barney—learned to deploy images at a scale that approaches that of popular culture. Today, under conditions where artists must build a kind of "brand" that will be recognizable in a globalized art world, distribution and "saturation" of markets matters in new ways.

HF: Let's look back over the last few decades to instances where critical alternatives were proposed. Indicating some "incomplete projects" might help us look ahead as well.

BB: Yes: what place does neo-avant-garde practice have in the present compared to the one it held in the moment of 1968, for example? Or even in seventies, when the relative autonomy of such

practice had a role in the liberal bourgeois public sphere as a site of differentiating experience and subjectivity? It was supported then, or at least taken seriously, by the state, the museums, and the universities. As of the eighties, artistic production was subsumed into the larger practice of the culture industry, where it now functions as commodity production, investment portfolio, and entertainment. Consider Matthew Barney in this regard: even

▲ more than Jeff Koons, he has articulated, that is to say exploited, those tendencies. In that sense he is a proto-totalitarian artist for me, a small-time American Richard Wagner who mythifies the catastrophic conditions of existence under late capitalism.

HF: Again, can't we complicate the Adornian position that the totalitarian cultural sphere is simply continued in the American culture industry, and that that industry has entirely subsumed art?

YAB: There were energetic expressions of artistic freedom in the aftermath of 1968—and before as well …

BB: Of course there's an important artistic culture in the postwar United States—from Abstract Expressionism, through

● Pop and Minimalism, to Conceptualism at least. That has to be taken into account. Why was it possible? Because the United States was a liberal democracy at its highest level of differentiation. But no more.

HF: Other possibilities also opened up in other parts of the globe, especially in various encounters with different modernisms. For example, Yve-Alain discusses the elaboration of Constructivism

■ among the Neoconcretists in Brazil, as well as of performance after Pollock with the Gutai artists in Japan. Those practices alone complicate the old story of a simple shift from Europe to North America or, even more reductively, from Paris to New York. It's an alternative narrative of cultural *différance*—of avant-garde practices in other place-times.

YAB: At first, though, the usual paradigm isn't changed much: for at least two decades those avant-garde activities on various continents still define themselves in relation to the old centers. For example, the Brazilians still look to Paris, and for Gutai it's all New York, Pollock especially, whom they read through the photographs of Hans Namuth. It's only later, once they have had some history in their own way of working, that they give up the competitive relation to the old centers. On this level 1968 marks a very important date: there's an extraordinary internationalization not only of political rebellion but of its artistic offspring, with social unrest all over Europe, the States, and elsewhere (the Prague Spring and its crushing by the Soviet Union; the Chicago Democratic convention followed by violent riots, and so on), all in the context of the Vietnam War. That was a strong political unifier for progressive

minds around the world, let us not forget; and certain aspects of the present and recent political situations are reminiscent of that period—notably the fact that the Bush administration unified much of the world against American imperialism. It remains to be seen, of course, if this "negative internationalism" will have any direct consequences in the cultural sphere.

DJ: The so-called globalization of the art world has made the "directionality" of influence in contemporary art rather different. On the one hand, I think a strong case can be made that there is now an international style, which may be called "Global

▲ Conceptualism" after an important exhibition of that name organized by the Queens Museum in New York in 1999. On the one hand, one could be cynical and argue that the materials of Conceptual art—text, photography, and video—travel more easily (and cheaply) than the traditional media of painting and sculpture, as of course the important curator and Conceptual art "entrepreneur" Seth Siegelaub recognized early on. But it is equally important that this shared "language" be suffused with clear local inflections (or accents). As James H. Gilmore and B. Joseph Pine II argue in their 2007 book *Authenticity: What Consumers Really Want*, the relentless standardization that the culture industry imposes also generates a kind of compensatory demand for "customization"—for "authenticity." I believe we've seen these effects in the contemporary art world. For instance, as the great "socialist" powers, the USSR and China began to enter into global capitalist markets—the newly reborn Russia in the early 1990s, and China in the late 1990s and 2000s—there was a huge fascination with this work and a corresponding boom in the markets for them. On the one hand we could condemn this as merely another instance where the work of art serves as an economic vanguard—creating new cultural markets for emerging economic superpowers—but the fascination that these works (and those from many other places) inspire in the West is also a form of good-faith curiosity. I like to think of these works as ambassadors of sorts. They form an avant-garde of cultural translation that helps to introduce unfamiliar systems of value and signification through the familiar rhetoric of Conceptual art.

HF: And long before 1968, too, the postwar period witnessed an international resurrection of some movements—like Dada,

● Surrealism, and Constructivism—that were international in ambition in the first instance. The Bauhaus alone had several afterlives in different sites after World War II. This is further complicated by a centrifugal move outward from Paris and New York. Cobra, for instance, initiates a partial shift away from Paris to other European cities; and later, to take another

■ example, Arte Povera emerges in Italy. So there's a remapping of Europe, a relativizing of Paris as art capital, which is slight

▲ 1986, 2007c ● 1947b, 1949a, 1951, 1960c, 1962d, 1964b, 1965, 1968b ■ 1921b, 1928a, 1955a, 1959e ▲ Introduction 5 ● 1916a, 1920, 1921b, 1924, 1928a, 1930b, 1931a ■ 1949b, 1957a, 1967b

but significant. There's also a remapping of the United States, with a similar relativizing of New York, especially by artists in California—beat performance and assemblage artists in San

▲ Francisco and in Los Angeles, and later California Pop and abstract artists as well.

BB: Yes, but then if we turn back to the present, what do we see? Look at Michael Asher, in many ways the most radical of the figures involved in institutional critique from the late sixties onward, and long based in Los Angeles: his work is now mostly neglected; the very radicality of its contestation appears forgotten. Clearly the complexity of Asher's work seems to pose, now more than ever, insurmountable obstacles to its reception within the present parameters of the art world. So, as with social repression at large, the way to respond to the work is simply to eradicate it from historical memory and to isolate its producer as an outsider. And Daniel Buren, another radical artist of institutional critique, is the pendant on the European side, only Buren has now transformed himself, willingly, into an affirmative state artist in order to avoid

● the fate that has befallen Asher.

HF: Once again, can't your narrative be complicated? It carries a teleology of its own that is reductive, indeed defeatist.

RK: Perhaps a different narrative will help, though it might be no less dire. In my view postmodernism, understood through the prism of poststructuralism, constituted a great critique of essentialist thinking—of what is proper to a given category or activity. It annihilated the very idea of the self-same, and launched an especially strong attack on the idea of the medium (this is explicit in Jacques Derrida's essay "The Law of Genre"). So the medium came under a concerted assault from the most sophisticated thinkers of the sixties and seventies, and that critique joined a similar attack in Conceptual art on medium-specificity in art (that painting be only about the forms of painting, etc.); this was supported in turn by the reception of Duchamp at the time, which only underscored the Conceptualist contempt for the medium. And then video entered the field of aesthetic practice, which also disturbed the idea of the medium (it's very hard to find the specificity of video). So poststructuralism, Conceptual art,

■ Duchamp reception, video art: together they effectively dismembered the concept of the medium.

The problem is that this dismemberment then became a kind of official position (the pervasiveness of installation art is one sign of this state of affairs), and now it's a commonplace among artists and critics alike: it's understood as given. And if I as a critic have any responsibility now, it is to dissociate myself from this attack on the medium, and to speak for its importance, which is to say for the continuance of modernism. I don't know if poststructuralism will

help me do this, and thus I don't know if I can maintain my earlier commitment to this methodological option.

HF: That's a strange position for the author of "Sculpture in the Expanded Field"—among other essays that theorized the intermedial and interdisciplinary dimensions of postmodernism—to take. What do you intend by "medium" now? Surely not medium-specificity in a Greenbergian sense.

RK: No: I mean the technical support for the work. It needn't be a traditional support—like canvas, which is the support of oil painting, or metal armature, which is the support of modeled sculpture. A medium grounds an artistic production, and provides a set of rules for that production. It can be complicated even when it appears simple; a good example is Ed Ruscha's use of the automobile as a kind of medium—it's a consistent support of

▲ his work. His early book of photographs *Twenty-Six Gasoline Stations* (1962) documents a number of gas stops on his drives from Oklahoma City to Los Angeles and back; that idea gave him a rule for making his book. Again, a medium is a source of rules that prompts production but also limits it, and returns the work to a consideration of the rules themselves.

HF: This notion of medium still seems a little arbitrary to me, almost free of historical motivation, let alone of social convention. In that respect it's not clear how much of a corrective it could be to the relativistic condition of contemporary art. Surely a medium is a social contract with an audience as well as a private protocol for form-making.

RK: Sometimes it only appears arbitrary. At one point in his work Ruscha could use almost anything as a support for color—like blueberry extract, chocolate sauce, axel grease, and caviar. What he did with this comestible mess was to do a portfolio of prints (actually they're dirtied sheets of paper) titled "Stains," and those works hooked back into the history of stained painting—from

● Pollock through Helen Frankenthaler and color-field painting. It got him away from the arbitrary back into the history of recent art.

YAB: If I understand you, it's a question not of the materiality of the medium so much as of the concept of the medium. The medium can fluctuate from one series of work to another, but the artist has to have a set of rules to work.

RK: The idea of a coherent set of rules means that the structure of the work will be recursive, that it will generate analogues for the medium itself.

HF: Now your definition of medium sounds formalistic as well as arbitrary.

RK: Without the logic of a medium, art is in danger of descending

▲ 1959b, 1960c ● 1970, 1971 ■ 1966a, 1968a, 1968b, 1970, 1972b, 1973, ▲ 1968b ● 1949a, 1960b

into kitsch. Attention to medium is one way modernism tried to defend against itself against kitsch.

HF: Now that really is Greenberg come again.

YAB: As a concept, kitsch seems very dated—it has been replaced by spectacle.

RK: I don't think it's dated at all. Kitsch is the meretricious, and we see that everywhere. On the other hand, Greenberg's was a blanket condemnation of kitsch, and, as Yve-Alain has argued elsewhere, some kitsch practices, such as Lucio Fontana's use

▲ of ceramics or Jean Fautrier's use of color, take on the presumption that "advanced" art, such as Cubist-compositions or elegant monochromes, is the epitome of good taste. The late paintings of Francis Picabia are another case of the mobilization of kitsch.

● And how can we speak of an artist like Jeff Koons without recourse to the concept of kitsch?

BB: I disagree with many of the statements you've made. I'd like to support your demand for a continuation of modernism—rather than look back at its demise with a melancholic attitude—but whether one can preserve its practices is not a matter of voluntaristic decisions within the cultural sphere. What is aesthetically achievable is not in the control of critics or historians or even artists, unless artistic practice is to become a mere preserve, a space of self-protection. And there are problems even there. One might argue that Brice Marden, for example, or Gerhard Richter retains a space of exemption for painting in a relatively credible way, as does

■ Richard Serra in sculpture. But the moment they formalize that position they border on a conservative position that contradicts their initial project. And the question becomes whether preserving modernism is desirable, even if it were possible.

HF: I'm also not happy with this story of a modernism of medium-specificity, followed by a postmedium condition, which is then recouped somehow by a renewal of the medium, even if in an extended sense. There are multiple ruptures in the postwar period that can't be sutured so easily. One transformation has to do with the eclipse of the very tension between avant-garde and kitsch that Rosalind still insists upon. Many artists—perhaps most under fifty—assume that that dialectic is now overwhelmed, that they have to work within a condition of spectacle. That's not to say they capitulate to it, although we see extravagant examples of that embrace too. (Spectacle is the very logic of a Matthew Barney, his "medium" if you like, and for many people he turns it to his advantage.) Some artists also find productive cracks within this condition; it's not as seamless as Benjamin makes it out to be.

BB: Give us an example.

◆ **YAB**: There was Warhol earlier. That's one reason why he became

so important to subsequent artists: they understood how he worked with spectacle.

BB: Yes, he was the oracle of things to come.

HF: I hope you don't mean that Warhol was *only* an agent of spectacle. To take but one instance from his work, is there a more critical exposé of the dark side of spectacle than his 1963 images of consumerist "death in America"—of car wrecks and botulism victims? Or another instance already mentioned, the photobooks of Ruscha from the sixties: I don't see them as affirmative of the car-commodity landscape (as is so often claimed); they show its null aspect, or document its space as so much gridded real estate, or both. Another example is Dan Graham, who has also become

▲ important to younger artists: his *Homes for America* (1966–7), for instance, indicates how the serial logic in play in Minimalism and Pop was already at work in capitalist society at large, specifically in the development of suburban tract-homes. There, in the very similarity in production-logic between avant-garde art and capitalist development, Graham was able to point to the possibility of both critical insight and artistic innovation. And many other examples

● could be cited here—in Fluxus, for instance, and work closer to the present too. Cindy Sherman has generated her art out of an ambivalent play with the restrictive types of women offered up by spectacle. Mike Kelley has produced his out of a fascinated exploration of the wayward subcultures of "dysfunctional adults" that spectacle cannot always conceal. And, with his tacky installations of kitsch items, fan photos, and tin foil, Thomas

■ Hirschhorn does all he can (in that great old line of Marx's) to make "life's reified conditions dance once again" by "playing them their own tune." And so on. So we can't say that artists haven't diagnosed the problem and produced work that addresses it.

YAB: Yet perhaps conditions have changed again now, and, instead of a polar opposition à la Adorno between resistant high art and mass-cultural trash, both have become, in the context of global media, so many bits in the planetary web. The paradigm isn't resistance versus dissolution any more: resistance is immediately dissolved in the new situation. Young artists are not necessarily suicidal about it (there I agree); they want to do something with it.

DJ: Perhaps instead of subverting the system, artists can *game* the system or *leverage* it in some way. In fact, many contemporary performative strategies result in few if any commodities at all, but they do cause a disruption in the ethical assumptions held both by institutions and spectators. For example, in the work of Tania

◆ Bruguera or of Tino Sehgal, who has taken the position that his "situations," which are often based on semi-scripted, semi-impromptu confrontations between spectators and figures in the

▲ 1946, 1959a ● 1986, 2007c ■ 1962d, 1969, 1970, 1988 ◆ 1960c, 1962d, 1964b ▲ Introduction 2, 1968b ● 1962a ■ 2003, 2007b, 2009c ◆ 2009a

gallery (sometimes museum employees like guards and sometimes "performers"), should not be documented in any way. He has gone so far as to sell works to collections like the Museum of Modern Art purely through oral contracts. These strategies focus on the ethical and legal dimension of association that I mentioned before through an art devoted entirely to connectivity, to use a term drawn from the Internet. I can't think of any gesture that more fully calls into question the good or bad faith of a museum than compelling it to buy something it wants with hardly any legal protection!

There was a lot of anger among artists in response to the Marina Abramovic retrospective at MoMA in 2010 where several of her canonical performances were reenacted and others documented. I puzzled over why this exhibition inspired two such different types of reactions: on the one hand, fascination bordering on adulation among a very large general public, and on the other serious rancor among more specialized viewers. I came to the conclusion that museum visitors were very moved by Abramovic being physically present in MoMA's atrium at all times when the museum was open, ready to sit with anyone who had the time to wait in line. But the fact that she has developed a very high-profile gallery career out of her performance work may have felt like a kind of betrayal or hypocrisy to those who are more deeply involved in the art world.

I think it *is* possible, nonetheless, for artists to create "events" within the spectacle, as when ACT-UP invented the inverted pink triangle, or the Yes Men introduce false information into media circuits in order to demonstrate the hypocrisy and cravenness of corporate double speak. These images have the capacity to go viral (as Warhol's art did for that matter).

BB: Certainly, artists as diverse as Allan Sekula, Mark Lombardi, and Hirschhorn address the condition of artistic production under the rule of an intensely expansionist form of late-capitalist and corporate imperialism, now generally identified with the anodyne and meaningless term "globalization." All of them have succeeded to articulate the fact that nation-state ideology and traditional models of conventional identity-construction are no longer available to relevant cultural production, since the internationalization of corporate culture would desire nothing more than a cultural retreat into mythical models of compensatory identity-formations. At the same time such artists have made it one of their priorities to *work through* the intensely complicated networks of political, ideological, and economic intersections that make up the supposedly liberating forms of globalization. Thereby they achieve a critical analysis of phenomena that are generally presented by the media, but also by cultural organizers and functionaries, as an emancipatory and almost utopian achievement.

But globalization is only one of the driving factors. There are at least two others. One is technological development, which confronts artists, historians, and critics today with problems that none of us really foresaw in the sixties or seventies. The second factor is more complicated, and it's difficult not to sound conspiratorial about it: the very construct of an oppositional sphere of artists and intellectuals appears to have been eliminated; certainly this is true in the realm of cultural production. That production is now homogenized as an economic field of investment and speculation in its own right. The antinomy between artists and intellectuals on the one hand and capitalist production on the other has been annihilated or has disappeared by attrition. Today we are in a political and ideological situation that, while it is not quite yet totalitarian, points toward the elimination of contradiction and conflict, and this necessitates a rethinking of what cultural practice can be under the totalizing conditions of fully advanced capitalist organization.

HF: The postwar acceleration of new technologies was already evident in the early sixties, and it was addressed not only by media gurus like Marshall McLuhan but also by artists involved in Minimalism, Pop, and other movements. These artists treated new and/or nonartistic materials and techniques (e.g., Plexiglas in Donald Judd, fluorescent lights in Dan Flavin, silkscreen seriality in Warhol) within the formats of sculpture and painting the better to register their effects there. These examples (to say nothing of video) suggest that "new media" already has a complicated history within postwar art—indeed all history is littered with "new media." So are the consequences of "new media" really so total today? For example, isn't there a dialectic here, however feeble it might appear, whereby "new media" also produce outmoded forms as a by-product—outmoded forms that then stand as ciphers of surpassed or suppressed aesthetic and social experiences that contemporary artists can recover critically? Alongside the embrace of "new media" there is a recovery of displaced modes, which can be mined as an archive of past subjectivities and socialities.

I grant that these attempts to open up cultural history through old media are humble, and certainly they appear overwhelmed by the institutional attention given to "new media." Here I have in mind such technophiliac extravaganzas as the recent video installations of Bill Viola, who seems to want to deliver what Walter Benjamin once called, in the thirties in relation to film, "the blue flower in the land of technology"—that is, the effect of spiritual immediacy through the means of intensive mediation. This effect is a kind of techno-sublime that overwhelms body and space alike, but which today goes well beyond simple distraction (Benjamin's concern in the thirties) to outright immersion. An immersive, even mesmeric experience seems to be the desired effect of much art today (you

roundtable

see it in much digital photography too), and it's very popular, in part because it aestheticizes, or "artifies," an already-familiar experience—the mind-blowing intensities produced by media culture at large. In this art we get the rush of special effects along with the surplus-value of the aesthetic.

DJ: As someone who is very interested in media, including some that are habitually called "new," I want to agree with Hal about the facile and exaggerated claims for novelty that are often made on behalf of new media. In working on television, I realized that the histories of radio, television (including early cable) and the Internet followed similar patterns: the development of a technology for military purposes with no existing consumer market; the gradual popularization of these technologies through hobbyist or amateur use, which leads to a threshold of saturation when the network created by the technology becomes so dense, so essential for anyone who wants to stay in communication, that it compels a mass public. The homology of these developments has made me interested in processes of saturation (as opposed to the scarcity that is usually associated with art) as well as what I like to call *formats* in place of media: in other words configurations of association instead of material substrates, or Rosalind's more sophisticated definition of medium as a recursive body of rules. As in software, any content may be conveyed in many different formats. It's important to remember that certain aesthetic capacities that are very venerable and have been practiced since the beginning of modernism, such as collage, have now been *accelerated* and *disseminated* so that everyone who owns a computer can make a collage in a matter of minutes. These qualities of saturation, quantity, and speed introduce different conditions into what are largely similar impulses to communicate and represent.

HF: Nevertheless, there are also artists who sketch a different project, again a sort of archaeology of outmoded forms, and, interestingly, they do so often in film, now that film is no longer the medium of the future or even the present but is already touched with archaism …

BB: Artists such as?

▲ **HF**: Stan Douglas, Tacita Dean, Matthew Buckingham, to name just a few.

● **RK**: Another artist engaged with the outmoded is William Kentridge.

■ **HF**: Right. And one reason why James Coleman is so interesting to younger artists is that he has consistently explored the social spaces of outmoded media. One might argue that the separateness of these spaces is illusory, that the culture industry is always there to recolonize them, but we shouldn't say they never existed in the first place.

BB: We've seen that recuperation already with Surrealism and advertising.

HF: Absolutely, but we shouldn't declare the dialectic foreclosed for ever.

YAB: The outmoded is resistant only to a certain point and only for a certain time. I was struck to hear that the radical filmmakers Jean-Marie Straub and Danièle Huillet refuse video and DVD: they only want their films to be projected on the screen. How long can they sustain that position, and not be forgotten? In this regard they're the equivalent of Asher in the universe of film.

RK: Yet the way the outmoded works is that new technologies— maybe even DVD—will fail, or at least be surpassed, rendered outmoded, too. What will Coleman do, for example, when Kodak no longer makes slide projectors? They're being outmoded by digital projection and PowerPoint.

YAB: The digitization of images is going to be the Esperanto of globalization. There's a becoming-uniform of format at the level of production and distribution alike. Young artists want to address that frame.

BB: To return for a moment to the opposition of Bill Viola and James Coleman: they reveal two tendencies that are very complicated in their interrelationship. One is the intensification for the desire of myth—that's the secret of Viola's success. He succeeds in reinvesting technological representation with mythological imagery, even religious experience …

HF: One sees that kind of cultic reenchantment through new media everywhere. Benjamin saw a fascistic dimension to this manipulated immediacy, and maybe that's still accurate.

RK: Viola produces the video monitor as a black box meant as an analogue of the viewer's own head: the psychic space externalized as the physical surround. Once physical space is converted to psychological space in this way (notice I'm not saying phenomenological space), all connection to the reality of his artistic means is dissolved.

HF: Right: it's a "faux-phenomenological" experience: experience reworked, keyed up, given back to us in a very mediated fashion— as immediate, spiritual, absolute.

RK: In that respect the concept of kitsch is relevant again.

BB: That's the treacherous tendency. In opposition to it Coleman succeeds in bringing together two things that seem mutually exclusive—namely, the mnemonic dimension of art and a technological format of representation. That's extraordinarily important in the present; and yet, as we've just remarked, the

▲ 1998, 2003 ● 1994b, 2007a ■ 1993a, 2007a

potential of tapping the mnemonic through the outmoded is extremely fragile. There's no more innate resistance in the mnemonic than there is in the outmoded: both are very precarious. We know that the mnemonic dimension in art (intrinsic to modernism since Baudelaire) is the most susceptible to fetishization and spectacularization, as such work as Anselm ▲Kiefer's has amply proven. On the one hand, the effort to retain or to reconstruct the capacity to remember, to think historically, is one of the few acts that can oppose the almost totalitarian implementation of the universal laws of consumption. On the other hand, as artists such as Viola and Barney demonstrate, to deliver the aesthetic capacity to construct memory images to the voracious demands of an apparatus that entirely lacks the ability to remember and to reflect historically, and to do so in the form of resuscitated myth, is an almost guaranteed route to success in the present art world, especially with its newly added wing of "the memory industry."

HF: There's a further danger there. As you suggest, the mnemonic easily tips into the memorializing, that is to say, into a demand that the historical be monumentalized, and often today what is monumentalized is the traumatic. The chief example here, among countless others, is the World Trade Center design by Daniel Libeskind, with its vast memorial preserve and immense glass spire: historical trauma is here made not only monumental but spectacular and triumphal as well. Paradoxically enough, then, there might be no contradiction between a blinding fixation on historical trauma and a culture industry that produces historical amnesia as a precondition of ever-renewed consumption (next to the memorial there'll be the usual Gap, Starbucks, etc.). This condition is in stark contrast to the utopian dimension of so much modernist art and architecture of the early twentieth century that also experienced great trauma: we seem to live in a culture fixed on horrific pasts, not in a culture desirous of transfigured futures. From my perspective its political effects are disastrous: we live under the repressive dread of antidemocratic blackmails ("9/11," "the war on terrorism," etc.).

RK: By the nineties the question of trauma becomes a kind of intellectual fashion. Essentially it is a way of reinserting the subject into the discourses of history and culture. Trauma discourse effectively reconstitutes the subject—even if it is a subject absented somehow, by definition not alert to the traumatic event. This way of privileging the subject again slips into a reconstitution of the biographical subject, and that project is very suspect from a poststructuralist perspective.

HF: Yet in one sense the poststructuralist critique of the biographical subject is continued in the psychoanalytic understanding of the traumatized subject, even as, from another angle, it is also recouped there. I don't think the two discourses are as opposed as you suggest: both fix on slippages and breakdowns—on aporias—in a way that sometimes suggests another contemporary version of the sublime.

BB: But why hold out for a poststructuralist critique of the subject now, or even then? Hasn't it become evident that such a critique prevents not only a reflection on the historical foundations of postwar culture but also an understanding of their traumatic conditions?

▲**YAB**: Why do you say that? How would Michel Foucault, for example, prevent such an understanding?

BB: As far as I know, Foucault did not reflect on those conditions of postwar culture in the way that Adorno, for example, did from the forties onward. Adorno's critique is always directed at both cultural practice and the subject in post-Holocaust European and American society.

YAB: Foucault's critique of subjectivity doesn't imply any disjunction from historical struggles. He was very politically engaged, as you know, especially at the time he was writing *Discipline and Punish* and reflecting on the nature of power. And through his political engagement, notably at the side of prisoners struggling for their rights, he became very attentive to the way in which collective memory—especially what he called "popular memory"—is violently erased by the state and by the media. This is probably why, unlike Adorno, he was reluctant to single out the Holocaust as a kind of absolute limit of evil. And that is probably what prevented him, contrary to Adorno, from being deaf to the student uprising in 1968.

HF: I agree, but the poststructuralist critique of the subject was questioned in other ways as well. It was seen to concern a particular kind of subject only: this was a critique initiated by feminist theory and advanced in postcolonial discourse. Both argued that many groups had not yet acceded to the very privileges that the poststructuralist critique wanted to throw into doubt or to dispense with altogether. Why critique a subjecthood, these groups argued, that was denied one in the first place?

BB: That was a very important argument.

HF: Yes, and another problem with the poststructuralist critique of the subject was that it was sometimes turned into a cliché about the construction of the subject—that we are all fashioned, top to bottom, socially—and this reductive version of the poststructuralist critique was not resistant enough to the consumerist modeling of the subject: that we can be made and remade continually in terms of new clothes, cars, and cuisines too—and art as well. For many people "postmodernism" is not much more than hip, knowing consumerism.

▲ 1988

▲ 1971

DJ: Of course, Foucault was incredibly important for artists of color and feminists—even if they didn't agree with many of his specific arguments—because he elaborated a model of *productive* subjectivity. In other words, through his work one can theorize a person who is not only passively *subject* to discipline, but who possesses a corresponding agency of regulating behavior—by exaggerating it (one sees this in artists as diverse as Kara Walker ▲ and Cindy Sherman) or redirecting it. Foucault's insight that discipline—or repression—is constantly reenacted, for instance, that social discourses must always be *reiterated* in order to survive, and that in this regard they exhibit a certain kind of vulnerability between one moment of enunciation and the next, is given full articulation by Judith Butler's highly influential model of performativity. The danger has been—as Butler recognized and cautioned—to imagine that identity was little more than a "costume" that could be adopted at will. Instead, the profound point she and Foucault make is that even the most coercive norms must be embodied and enacted by the objects of control *themselves* and this gives us a space in which to operate efficaciously. I think this is why psychoanalytic perspectives have been "reinvented" in the ways that Hal is speaking of. It also explains why we see so many strategies of reenactment and reframing since the first great moment of this strategy in appropriation of the late sixties and eighties.

BB: The reception of Cindy Sherman, for example, supports that account.

HF: As I see it, the interest in the nineties in a traumatic subject—a
● subject fixed by trauma, stuck in abjection—was in part a reaction to that consumerist version of the constructed subject. It called into question the idea that we just float along as so many combinations of signs and commodities. So, however reductive it might seem now, and however grim then, trauma discourse did have a certain point, even perhaps a certain politics, and Cindy Sherman was important there as well (it's not as though she was blind to how her work was being taken up).

BB: Your first argument concerning the postcolonial caution about the poststructuralist critique provides a way to return to the
■ question of globalization. There was a move to open up the focus of practices and institutions in Western Europe and the United States—to recognize that cultural representation can also be a form of political representation. With an almost missionary zeal the art world responded to the aspiration that all cultures, all countries, at whatever stage, might have access to contemporary artistic practices. That is politically progressive, even radical, but it is also naive, and sometimes problematic, because one problem in the globalization of culture is a failure to recognize the dialectics of

dissemination—that inherent in this dissemination is the possibility of new forms of commodification and blockage as well as of new forms of self-constitution and self-representation. That contradiction is not well understood in the avid globalizing of current curatorial enterprises.

HF: To make this point more specific, we might consider what occurred between the moment of the "Les Magiciens de la terre"
▲ show at the Centre Pompidou in 1989 and the present flourishing of international biennials, where the formats of work seem both fairly restricted and generally available (prominent models include installation art, the projected image or video, the vast pictorial photograph or photographic sequence, the chat-room filled with all sorts of texts, documents, images …). "Magiciens" was an emphatic attempt to open up the center to the peripheries, even if it came at a time when the two couldn't be opposed in that manner any more. There was a great diversity of work and a concerted attention to local traditions. That was as recent as 1989, and yet today international exhibitions—Documenta, the biennials in Venice, Johannesburg, Gwangju, Istanbul, and so on—feel very different.

YAB: The model of "Les Magiciens de la terre" was not so dissimilar to any colonial show. Things are different now in part because the market is two-way. Work flows in from South Africa, for example, but part of the art world also goes there, and its net can pick up anything. It's not exoticism any more; it's feeding the network of markets.

BB: A curator like Okwui Enwezor might say that we're looking at this phenomenon only from a hegemonic Western perspective, and that we don't see that the development of cultural activities within these countries has tremendous consequences for producers and receivers alike. They develop forms of representation, communication, and interrelation that might not have been so readily established without the globalization of cultural practices.

● **YAB**: In South Africa there has been a great surge in artistic practice since the end of apartheid, and alternative spaces of art have mushroomed. So has the number of artists.

BB: But we don't know yet at this moment whether a quantitative expansion is a desirable effect in and of itself. From the perspective of an art world that is more crowded than ever before, marked by extraordinary overproduction, the simple multiplication of artistic practices and alternative spaces might not be desirable if it's not linked to an actual agenda of new forms of political articulation through cultural means.

YAB: It's too early to say. But we can say now that there's an

roundtable

▲ 1977a, 1993a ● 1994a ■ Introduction 5 ▲ Introduction 5, 1989 ● 1997

unbelievably sharp acceleration in artistic production and reception in many countries as a result of globalization.

DJ: I think we have to remember that a rigorous definition of globalization involves not just an undifferentiated consciousness of other parts of the world and a kind of postcolonial awareness:
▲ It denotes a distribution of labor that has become absolutely global. In other words, with sophisticated computing and rationalized forms of container shipping, the capitals of global finance can become informational command stations that coordinate production in several far-flung regions of the world. This is no longer true exclusively in manufacturing either; globalization has allowed a worldwide decentralization of the service economy as well. Take for instance, the now common experience of speaking with operators in India when calling for customer service from the United States or Europe. Likewise, Indian software engineers have been sought after for work in Silicon Valley, and the Chinese have financed the American deficit. The art world, too, operates through "mass customization" made possible by global decentralization and distribution. This doesn't mean that art works are now more or less commodified than they have been since the eighties—or the sixties for that matter. The difference is that, as I asserted earlier,
● the "international style" of Conceptual art languages is now regionally customized for global circulation. I think this kind of explosion in access calls for new critical tools rather than pure pessimism.

RK: One possible positive of globalization is the internationalism of the art world today. This was very important in the early aspirations of the avant-garde—to turn away from nationalist culture and to move into a set of international connections.

HF: But, as we discussed in the first roundtable, that aspiration was often driven by faith in socialist revolution. What social projects guide the present internationalism?

BB: Corporate culture.

HF: OK, what *other* social project? There are counters to corporate culture, to American Empire, even if at this point those counters often seem rather romantic (as those are articulated, for example, by Toni Negri and Michael Hardt). But then none of us is in a position to comment on what projects might be emerging in other parts of the globe. There is much interest, for instance, in contemporary art in China: what role might it assume internationally? Or art produced in the Indian subcontinent, which has its own modern history of national forms and international responses? Or in contemporary Islam? And so on. Postcolonial discourse gave us some conceptual tools with which to address these formations—to do with hybrid spaces and complicated temporalities—but how are those practices to be articulated with

ones more familiar to us, in a manner that is neither restrictively particular nor glibly synthetic?

This opens up a question we haven't confronted, but it goes to the heart not only of our own double status as modernist art historians and contemporary art critics, but also of the latter part of this book. Are there plausible ways to narrate the now myriad practices of contemporary art over the last twenty years at least? I don't point to this period of time arbitrarily: in the last several years the two primary models we've used to articulate different aspects of postwar art have become dysfunctional. I mean, on the one hand, the model of a medium-specific modernism challenged by an interdisciplinary postmodernism, and, on the other, the model of a historical avant-garde (i.e., ones critical of the old bourgeois
▲ institution of art such as Dada and Constructivism) and a neo-avant-garde that elaborates on this critique (we discussed both models in the first roundtable). Today the recursive strategy of the "neo" appears as attenuated as the oppositional logic of the "post" seems tired: neither suffices as a strong paradigm for artistic or cultural practice, and no other model stands in their stead; or, put differently, many local models compete, but none can hope to be paradigmatic. And we should note too that the methods discussed again here—psychoanalysis, Marxian social history, structuralism, and poststructuralism—are hardly thriving. For many, this condition is a good thing: it permits artistic freedom and critical diversity. But our paradigm of no-paradigm has also abetted a flat indifference, a stagnant incommensurability, a consumerist-touristic culture of art sampling—and in the end is this posthistorical default in contemporary art any great improvement on the old historicist determinism of modernist art à la Greenberg and company? And then we have to compound this problem with the question of the narrativity of art in a global context.

The problem is not abstract: it's there in the museum galleries (but not, interestingly, in the auction halls). It's evident in the proliferation
● of single-artist and single-period museums—the Dia:Beacon shrine to Minimalism and Postminimalism is just one instance. It's also apparent in the mix-and-match thematics of the Tate Modern, for example, with works from across the century clustered under iconographic headings like "Nude / Action / Body" or "Still Life / Object / Real Life." And this sense of *post-histoire* is, paradoxically enough, a common institutional effect today: we wander through museum spaces as if after the end of time.

BB: For the most part participants in the contemporary art world (and that includes ourselves) have not yet developed a systematic understanding of how that once integral element of the bourgeois public sphere (represented by the institution of the avant-garde as much as by the institution of the museum) has irretrievably disappeared. It has been replaced by social and institutional

▲ 2010a ● Introduction 5, 1968a, 1968b, 1970, 1971, 1972a, 1972b, 1975b, 1984a ▲ 1916a, 1920, 1921b, 1925c, 1926, 1928a ● 1965, 1966b, 1969

formations for which we not only do not have any concepts and terms yet, but whose modus operandi remains profoundly opaque and incomprehensible to most of us. For example, we have more artists, galleries and exhibition organizers than ever before in the postwar period, yet none of these operate in any way comparable to the way they functioned from the 1940s to the 1990s. We have

▲ ever larger and evermore imposing museum buildings and institutions emerging all around us, but their social function, once comparable to the sphere of public education or the university, for example, has become completely diffuse. These new functions range from those of a bank—which holds, if not the gold standard, at least the quality and value warranties for investors and speculators in the art market—to those of a congregational space, semi-public at that, in which rites are enacted that promise to compensate for, if not to obliterate, the actual loss of our sense of a once given desire and demand for political and social self-determination.

YAB: But couldn't we say that such a current amnesia is in great part what motivated us to write this book? I don't think we should delude ourselves into thinking that we are going to change the global colonization of the cultural sphere by spectacle, but I don't think we should whine either. After all, we've been united in our desire to reshuffle the cards, not only to revisit canonical moments of modernism and "postmodernism," but also to retrieve from oblivion many aspects of the cultural production of these past hundred-plus years that had been ignored or deliberately repressed. In doing so, I think, we have presented a much more complex tableau than the one served to us when we were students. Who knows, it might have some liberatory effect.

This roundtable discussion originally took place in December 2003.
The participants were Yve-Alain Bois, Benjamin H. D. Buchloh, Hal Foster, and Rosalind Krauss. David Joselit contributed further thoughts in September 2010.

▲ 2015

glossary

CAPITALS indicate other glossary terms

affirmative culture

The concept of an affirmative culture was initially coined by the philosopher Herbert Marcuse in his essay "On the Affirmative Character of Culture," where he argued that cultural production inherently supported existing political, economical, and ideological power structures by the very fact of its innately legitimizing character. This means that cultural production not only provides presumably compelling evidence of social and subjective autonomy to any given political system, but also prohibits contestation and change since it corroborates the *status quo* as valid and productive by its very existence; or as T. W. Adorno once said, "culture by the mere fact of its existence prohibits the sociopolitical change that it promises." Artists since the sixties in particular have attempted to overcome Marcuse's pessimistic totalization (represented best by Andy Warhol's universal affirmation), and have responded by developing a variety of specific critiques and contestations. And in fact it could be argued that the momentary successes of artistic practices such as institutional critique of the seventies, feminist interventions of the eighties, and gay activism of the nineties have proven that forms of cultural opposition can raise public and political consciousness successfully. This does not imply, however, that the continuously expanding arsenal of instant recuperation that transforms cultural opposition into mere market—and museum—goods does not pose a permanent challenge to artists and requires a perpetual change of strategies.

Alexandrianism

The avant-garde assumed different positions in its lifetime: opposed to academic art, engaged in political critique, turned inward toward its given materials, or outward toward mass culture, and so on. Yet common to all these positions was the imperative of *advance*—"to keep culture *moving*," as Clement Greenberg put it in "Avant-Garde and KITSCH" (1939), "in the midst of ideological confusion and violence" (note the date of the essay, on the brink of World War II). Paradoxically, in a society in transformation or turmoil when the "verities" of tradition are thrown into question, "a motionless *Alexandrianism*" can take over cultural practice: "an academicism in which the really important issues are left untouched because they involve controversy, and in which creative activity dwindles to virtuosity in the small details of form, all larger questions being decided by the precedents of the old masters." According to Greenberg, the avant-garde first emerged in the middle of the nineteenth century to challenge this stalled state of affairs; but such Alexandrianism is hardly a one-time event. The illusion of great movement that conceals the reality of oppressive stasis might well be the rule more than the exception in capitalist society; and if this is the case—if the problem of Alexandrianism has not disappeared—then perhaps the need for an avant-garde has not either.

alogism

This term, coined by Kazimir Malevich around 1913–14, refers to a body of works that he realized at the same time as he was transforming the idiom of Synthetic Cubism into his own particular brand of abstraction, Suprematism, which came to light in 1915. By superposing onto his alogic canvases unrelated figures, represented as they would be in an illustrated dictionary and sharply contrasting in terms of scale, that could not possibly belong to the same scene, Malevich sought to create the pictorial equivalent of the "transrational" (or ZAUM) poetry of his friends Aleksei Kruchenikh and Velemir Khlebnikov.

alterity

Etymologically, "alterity" is the condition of "otherness," a longtime goal of many modernists (note the statement of the young French poet Arthur Rimbaud in 1871: "Je est un autre"). Often this otherness was projected onto faraway cultures; the most famous instance is Paul Gauguin, who traveled to Tahiti in search of a new way not only to make art but to live life. But it could also be sought in places closer to home—in native traditions, folk art, peasant culture, and so on. Sometimes, too, this alterity was seen to exist even more intimately, if no less strangely, in the unconscious—the otherness of obscure dreams and vague desires explored by Surrealists like Max Ernst above all. In short, many modernists pursued alterity for its disruptive potential, but it never had a fixed location. In the wake of feminist theory and postcolonial discourse, the term has taken on a renewed valence, wherein alterity is privileged as a position of radical critique of the dominant culture—of what it cannot think or address or permit at all—more than as a place of romantic escape from it.

anomie / anomic

This term, first defined by Émile Durkheim in 1894, has been generally deployed in social history and theory in order to describe particular historical formations of social deregulation, periods in which the fundamental contracts of social ethics that had traditionally regulated the interaction among subjects, and between subjects and the state, have been canceled. In the present time, typical examples of the expansion of social anomie could be found in the overall attitudes of capitalist neo-liberalism that has systematically dismantled fundamental social institutions such as education, healthcare, and the elementary political processes of participation and representation (e.g., unionization). Transferred into aesthetic and art-historical debates, the term anomic identifies the working conditions of cultural producers for whom utopian avant-garde aspirations, or even the desire for a minimum of sociopolitical relevance, have become extinct. The absence of a sociopolitical dimension within artistic production inevitably leads to anomic conditions in culture at large (e.g., Jeff Koons, Matthew Barney) where the neo-liberal principles of speculation and investment opportunities driven by the promise of profit maximization govern the politics of artists, collectors, and institutions alike. Culture under the conditions of anomie acquires at best the features of a SIMULACRUM of legitimation and prestige, and at worst those of a closed-circuit system of specialized investment expertise.

aporia / aporetic

Originating in philosophy and rhetorics, the terms aporia and aporetic describe what seems to be an almost inextricably necessary condition of the work of art: that it generates intrinsically unresolvable structures of paradoxical contradiction. For example, to be at once representational yet self-referential; to claim autonomy status while being totally subjected to ideological interests; or to claim freedom from instrumentalization, yet be determined by mass-cultural frameworks and massive economic interests—these are just some of the more obvious cases of artistic aporias in the present. More subtle aporetic structures would be the claims of the aesthetic to be universally legible, yet to be always confined to privileged situations of reading and reception. Aporetic is also the work's desire to expand its audiences to disseminate critical reflection, only to end up in the mass-cultural formations of a voraciously recuperative spectacle culture. Thus one could argue that the aporetic has become in fact *one* of the fundamental rhetorical TROPES of the aesthetic at this moment. It remains unclear whether it is reactive, in the sense that that every work of art has to face unresolvable contradictions, or whether it is proactive in the sense that it is precisely the function of the work of art to subvert and implode fixities and certainties in the behavioral and perceptual structures of everyday life by confronting them with an incessant barrage of unresolvable contradictions.

art autre

Meaning "a different art," or, more literally, "an art that is other," this expression was launched in 1952 by the French critic Michel Tapié to group together the art of Jean Dubuffet, Jean Fautrier, and Wols (who had died in 1951), as well as that of their imitators and of an eclectic compendium of Abstract Expressionist and neo-Surrealist artists, under a single banner. Tapié soon replaced it, and with more lasting success, with the phrase *art informel* (although Dubuffet and Fautrier reviled that just as much as *art autre*). SEE ART INFORMEL

art informel

When in 1962 French writer Jean Paulhan published his book *L'Art informel*, the phrase, coined by Michel Tapié a decade earlier, had not gained much in clarity. By then it designated a post-Cubist pictorial (or eventually sculptural) mode in which the figures, abstract or not, were not readily legible but would gradually emerge from a tangle of gestures or accumulation of matter before the consciousness of the spectator. Most of the painters satisfied with this label were also to be called TACHISTES.

atavism

From the Latin for "great-grandparent," "atavism" signifies the tendency to resemble, in a given trait, an ancestor more than a parent. In the nineteenth century, largely under the influence of racialist biology, "atavism" took on a pathological shading, whereby such resemblance was taken to suggest a reversion to a diseased state that had passed into remission for a generation or two. Used in this way, the term connoted a regression to a primitive or

degenerate condition, ambiguously physical, psychological, or both, and this negative connotation still echoes in its use in art criticism and cultural discourse today.

avatar

While originally denoting a Hindu deity, the term "avatar" is now most commonly associated with graphical representations of surrogate identities in online games and chatrooms. What is most significant about an avatar in the context of contemporary art is that like the surrogate actors in video games, which are also known as avatars, these artist-built characters have no essential ties to an existing person or identity per se. Instead, they are remote-controlled surrogates who, like their virtual cousins in the game world, may travel to places or articulate meanings that would be inaccessible to any flesh-and-blood individual. In other words, avatars "free" artists from "having" to exhibit a particular identity, thus allowing them to propose forms of selfhood, or subjectivity, that may be collective, imaginary, or utopian.

biographism

With the eclipse of modernism in the seventies, the formal logic of abstract art began to fade, making way for a new conviction that the meaning of avant-garde works was to be found in the artist's life, for which the art objects could be seen to serve as an emblem. This was the same period during which biographism came under fierce attack, as in Roland Barthes's essay "The Death of the Author" (1968) and Michel Foucault's truculent "What matter who's speaking?" ("What is an author?"[1969]). Following Freud's *Leonardo da Vinci* and a *Memory of his Childhood* (1910), art historians and critics searched within the biographical information for a symptomatic detail that would "unlock" the work. Picasso's habit of signing his paintings and drawings not only with his name but with the precise dates and even hours of their execution lent credibility to this belief. Jaume Sabartés, Picasso's secretary, predicted that once this trail of clues was followed, "We would discover in his works his spiritual vicissitudes, the blows of fate, the satisfactions and annoyances, his joys and delight, the pain suffered on a certain day or at a certain time of a given year."

calligramme / calligram / calligrammatic

In 1918, Guillaume Apollinaire published a volume of his *calligrammes*, composed while he was sequestered in the trenches during World War I. *Calligrammes* are poems fashioned so that the words take the shape of the object named by the poem. One example is "Il pleut" (It is raining), with the letters descending in vertical channels to imitate rain; another is "The necktie and the pocket watch," with both objects represented by the words of the poem. The similar combination of language and image, as in Cubist collages or the paintings of Jasper Johns and Ed Ruscha, are therefore designated "calligrammatic."

Concrete poetry

As a historical term, Concrete poetry identifies the postwar resurrection and academicization of the linguistic and poetical experiments of the radical avant-gardes of the teens and twenties that had been conducted in the context of Russian Futurism, and the practices of international Dadaism in Berlin, Zurich, Hanover, and Paris. If the Dada painters and poets (such as Hugo Ball and Raoul Hausmann) were engaged in a radical opposition to traditional painterly and poetical languages (e.g., Berlin sound poetry as a travesty of the German cult of the poet Rainer Maria Rilke or of German Expressionism), the Russian and Soviet sound poets (e.g., the ZAUM poetry of Velemir Khlebnikov) developed a theoretical understanding of poetical processes and functions that would correspond to the new theoretical analysis of linguistic functions in Russian and Soviet Formalism. The Concrete poets of the postwar period typically emerged in areas that had been both remote and protected from the cataclysms of World War II, both privileged and disadvantaged with regard to the naivety of their early rediscovery of these avant-garde projects. Thus we find early resuscitations named Concrete poetry in the context of Latin American countries and in Switzerland in the forties, often working in tandem with the academicization of abstraction (for example, Eugen Gomringer and Max Bill). Here the celebration of a newfound ludic irrelevance and of typographical gamesmanship displaced both the political, the graphic, and the semiological radicality of the originary figures.

condensation

Sigmund Freud developed this term in his interpretation of dreams, but it also signified a basic process of the unconscious in general, whereby a single idea—image and / or word—comes to represent multiple meanings through association.

This idea attracts different lines of associated meanings, "condenses" them, and so takes on a special intensity (as well as a particular obscurity) through them. In this light one can understand its function in dreams, the "manifest content" of which (the narrative that we seem to see) is more concentrated and confused than its "latent meaning" (the sense that we might decode); yet condensation is also in play in the formation of symptoms, which can also combine different desires into one trait or action. To the limited extent that images are analogous to dreams or symptoms, "condensation" has some use-value in art criticism as well. Its complement in psychoanalysis, as a fundamental process of the unconscious, is DISPLACEMENT, and its parallel in linguistics, as a layering of associated meanings, is metaphor (*see* METONYMY).

décollage

Décollage was initially envisioned by the late Surrealist writer Léo Malet, who in 1936 predicted that in the future the process of collage would be transferred from the small scale and intimate collections of found and glued remnants of the everyday (e.g., Kurt Schwitters) via an aggressive expansion to the large-scale frameworks of advertisement billboards, then increasingly taking control of what were once public urban spaces. It is only in the immediate postwar period in Paris that Malet's prognosis would be fulfilled by a group of young artists who were equally disenchanted with Surrealism as with *art brut* or ART AUTRE. Jacques de la Villeglé and Raymond Hains initiated *décollage* in 1946 by collecting lacerated billboards and transferring the remnants into pictorial formats, identifying their work as deliberate acts of collaboration with anonymous vandals who oppose the power of product propaganda. This collaborative dimension, as much as the totally aleatory nature of the found lacerations, was an important aspect of the process. *Décollage* positioned itself in a complex dialogic relationship with the cult of Pollock's *painterly allover* by replacing it with an *allover structure of textuality*. It was also the first postwar activity to resituate artistic production at the intersection of urban architectural space, advertisement, and the conditions of textuality and reading under the newly emerging regimes of advanced forms of consumer culture.

deductive structure

The Cubist grid is, perhaps, the first instance of the kind of pictorial composition that would later in the twentieth century come to comprise the whole of Frank Stella's paintings. Derived from the shape of the canvas and repeating its vertical and horizontal edges in a series of parallel lines, the grid is an instance of drawing that does not seem to delimit a representational object, but, mirroring the surface on which it is drawn, "represents" nothing but that surface itself. Stella would make this "mirroring" much more emphatic by casting his paintings into eccentric shapes, such as Vs or Us. With his drawing paralleling these edges, to create a series of concentric stripes, there was not only no question that anything but the shape itself was being represented, but also no possibility of reading "depth" or illusionistic space into the surface, which was stretched as tight as a drum-head by the constant representation of itself. Writing about Stella's work, the critic Michael Fried called this procedure "deductive structure."

desublimation

The concept of desublimation figures in contradictory ways within criticism and psychoanalytically informed writing on art history. In its obvious response to Freud's model of SUBLIMATION as the presumed precondition for any type of cultural production, the countermodel describes first of all the social conditions that foil the subject's capacities to sublimate libidinal demands and to differentiate experience within increasingly complex forms of social relations, knowledge, and production. Adorno's critique of the "desublimation" of musical listening, arising with the technologies of musical reproduction such the radio and the gramophone, would be a case in point. Here desublimation is identified as a socially and historically determining factor of cultural decline caused by mass-cultural formations. But in its opposite definition, desublimation has taken on the meaning of a strategy to foreground the conflicting impulses within the aesthetic object itself. The social enforcement of sublimation is counteracted in antiaesthetic gestures, processes, or materials that discredit the sublimatory triumphalism made by the work of high art. Desublimation is played out in the dialectics of high art versus mass culture, performed throughout the twentieth century as a counteridentification with the iconographies and the technologies of mass culture in order to debase the false autonomy claims with which modernism had propped up its myths. At the same time, these antiaesthetic gestures underline that all acts of sublimation are always also acts of libidinal repression, and that the work of art is the sole site to make these contradictions manifest by its emphatic invocation of the somatic origins of artistic production.

détournement

The French word for deflection, diversion, rerouting, distortion, misuse, misappropriation, hijacking, or otherwise turning something aside from its normal course or purpose, *détournement* is a technique developed in the 1950s by the Situationists. As defined in the third issue of the *Internationale Situationniste* (1959), "*détournement* is … first of all a negation of the value of the previous organization of expression." In general, it is where an artistic or nonartistic production—whether it be a work of art, a film, a news photograph, a poster, an advertisement, a text, a speech, or some other form of visual or verbal expression—is reworked so that the new version has a meaning that is antagonistic or antithetical to the original. In an early theorization of the concept, *A User's Guide to Détournement* (1956), Guy Debord and Gil J. Wolman categorized *détournements* into two types: minor *détournements* and deceptive *détournements*. "Minor *détournement* is the *détournement* of an element which has no importance in itself and which thus draws all its meaning from the new context in which it has been placed. For example, a press clipping, a neutral phrase, a commonplace photograph. Deceptive *détournement* … is in contrast the *détournement* of an intrinsically significant element, which derives a different scope from the new context. A slogan of Saint-Just, for example, or a film sequence from Eisenstein." The Situationists acknowledged their development of the *détournement* technique had had a number of precursors and influences, among them the Surrealists' use of collage and practice of placing incongruous objects beside one another. "*Détournement*, the reuse of preexisting artistic elements in a new ensemble, has been a constantly present tendency of the contemporary avant-garde, both before and since the formation of the SI," they wrote in the 1959 issue of *Internationale Situationniste*. But they went on to demonstrate how their own use of the technique extended into daily life: "Examples of our use of detourned expression include Jorn's altered paintings; Debord and Jorn's book *Mémoires*, 'composed entirely of prefabricated elements,' in which the writing on each page runs in all directions and the reciprocal relations of the phrases are invariably uncompleted; Constant's projects for detourned sculptures; and Debord's detourned documentary film *On the Passage of a Few Persons Through a Rather Brief Unity of Time*. At the stage of what the 'User's Guide' calls 'ultra-*détournement*, that is, the tendencies for *détournement* to operate in everyday social life' (e.g., passwords or the wearing of disguises, belonging to the sphere of play), we might mention, at different levels, Gallizio's industrial painting; Wyckaert's 'orchestral' project for assembly-line painting with a division of labor based on color; and numerous *détournements* of buildings that were at the origin of unitary urbanism. But we should also mention in this context the SI's very forms of 'organization' and propaganda." The last examples point to the Situationists' belief in the revolutionary potential of *détournement*, which consists of turning expressions of the capitalist system against itself. According to the *User's Guide*, "*détournement* not only leads to the discovery of new aspects of talent; in addition, clashing head-on with all social and legal conventions, it cannot fail to be a powerful cultural weapon in the service of a real class struggle. The cheapness of its products is the heavy artillery that breaks through all the Chinese walls of understanding. It is a real means of proletarian artistic education, the first step toward a literary communism."

diachronic

Although this term, derived from the Greek language, existed before the Swiss linguist Ferdinand de Saussure, its modern acceptation was forged in his *Course of General Linguistics*, posthumously published in 1916, where it is used in direct opposition to SYNCHRONIC. Meaning "lasting through time," diachronic designates any process observed from the point of view of its historical development. The diachronic study of a language deals exclusively with its evolution (for example, from Old English to present-day English).

dialogism / dialogical

The writings of Mikhail Bakhtin entered the world of structuralism in the sixties, when a group of Eastern Europeans—Tzvetan Todorov and Julia Kristeva among them—emigrated to France, bringing with them knowledge of Russian linguistic work that had previously been unknown in the West. *Discourse in the Novel* (1934) and *Problems of Dostoevsky's Poetics* (1929) were important sources of Bakhtin's notion of dialogism, or the dialogical principle. Dostoevsky's novels, Bakhtin observed, are polyphonic, which means that "a plurality of independent and unmerged voices and consciousnesses" takes up existence there. "What unfolds in his work," Bakhtin writes, "is not a multitude of characters and fates in a single objective world, illuminated by a single authorial consciousness; rather a plurality of consciousnesses, with equal rights and each with its own world, combine but are not merged in the unity of the event." The conventional novel, to which this technique is opposed, attempts to synthesize these voices within the vision of a single consciousness—that of the author—creating, thus, a monological universe. The dialogical principle carries over to Bakhtin's understanding of the linguistic utterance, which structuralism pictured as a coded message sent between a sender and a receiver. Instead, Bakhtin's dialogism assumed that any such message would already take the receiver's position into account and thus be conditioned by that position: supplicating it, refuting it, placating it, seducing it.

displacement

The complement of CONDENSATION in psychoanalysis, "displacement" is the other essential process at work in dreams, or the DREAM-WORK, according to Freud. Rather than a layering of meanings in a vertical (or metaphorical) association as in condensation, displacement signifies a slippage of meanings in a horizontal (or METONYMIC) connection. In the case of displacement, then, one idea—a word and / or an image "cathected" or invested with special energy or significance—passes on some of this charge to an adjacent idea, which, as in condensation, gains in intensity as well as obscurity. As in condensation, too, displacement is often at work in the formation of symptoms and other unconscious productions, and it might also be applied, with caution, to a reading of art—in terms of the unconscious processes involved in both making and viewing a work.

dream-work

In psychoanalysis this term encompasses all the operations of the dream as it transforms its various materials (bodily stimuli while asleep, traces of the events of the day, old memories, and so on) into visual narratives. The two essential operations are CONDENSATION and DISPLACEMENT; yet two other mechanisms are important as well: "considerations of representability" and "secondary revision." The first mechanism selects the dream-thoughts that can be represented by images and reformats them (as it were) accordingly. The second mechanism then arranges these dream-images so that they might form a scenario fluid enough to stage a dream in the first instance. In some sense both operations—"representability" and "revision"—already suggest activities of picture-making, and so they might appear to be of rather direct use in matters of art. But this proximity is also a danger: a painting that takes the dream as its model—as Paul Gauguin, say, or the young Jackson Pollock sometimes did implicitly, or as some Surrealists did explicitly—risks a reductive circularity whereby the painting illustrates the dream, which in turn delivers the key to its meaning.

durée

The French philosopher Henri Bergson, whose work was highly valued by the Italian Futurists, opposed "objective time" and "subjective time," which he called *durée* (duration). While "objective time" is space in disguise, argued Bergson (thus the spatial means used to measure or represent it: the clock, the arrow), the subjective time of experience flows indivisibly, and its intuitive apprehension is one of the means by which human consciousness accedes to its central unity. Bergson's views, enormously successful in the teens and twenties (he was awarded the Nobel Prize for literature in 1927) were eclipsed by psychoanalysis, for which the human psyche is a field divided by conflicting forces, but they have been regaining some currency from the sixties on, in a large measure thanks to the work of the French philosopher Gilles Deleuze.

entropy

The law of entropy, which is the second law of thermodynamics, a branch of physics founded in the nineteenth century, predicts the inevitability of the deperdition of energy in any given system, thus the future and irreversible dissolution of any organization and return to a state of indifferentiation. The concept of entropy had an immediate and enormous effect on the popular imagination, especially because the example chosen by Sadi Carnot, one of its creators, was the fact that the solar system would inevitably cool down. It was soon imported into many fields of knowledge, not only in hard sciences but also in the humanities, drawing the interest of authors as different as Sigmund Freud in psychology, Claude Lévi-Strauss in anthropology, and Umberto Eco in aesthetics. While the way in which words become clichés and gradually lose their meaning—a topic of immense concern for modernist writers, starting with Stéphane Mallarmé—can be characterized as an entropic process, it is only with the adoption of the concept of entropy by the theoreticians of information Claude Shannon and Norbert Wiener in the late forties that it was directly applied to the field of communication. In their definition, the less informational content a message carries the more entropic it is: were all American presidents assassinated, for example, the announcement of their death would be highly entropic; conversely, since American presidents are very rarely assassinated, the murder of John F. Kennedy was of exceptional informational value for the media. Until Robert Smithson's choice of entropy for

his main motto in the sixties, however, it had always been understood as a kind of dark inevitable doom. Fascinated by the strength and inevitability of entropy in any process, Smithson viewed it, positively, as performing in itself a kind of critique of humankind and its pretenses that it is the only universal condition of all things and beings.

epistemology

Derived from the Greek words *episteme* (science, knowledge) and *logos* (study, discourse), this term first meant the theory of knowledge or of science. At the beginning of the twentieth century, however, a major crisis in the foundations of mathematics and physics led epistemological inquiries—that is, critical analyses of the general principles and methods of sciences—into the realm of pure logic, a current that still dominates in Anglo-Saxon epistemology. Another trend, particularly active in France in the immediate postwar period(with Gaston Bachelard, Alexandre Koyre, and Georges Canguilhem) and represented in the United States by Thomas Kuhn, focuses on the formation of scientific disciplines and the internal evolution of scientific theories. It from this branch of epistemology that derives Michel Foucault's use of the concept of episteme, in *The Order of Things*, as the specific way knowledge is articulated in various sciences, or rather discursive practices, during any specific period, determining what is thinkable at any given time. While the historical shift from one episteme to another is always marked by a rupture, each episteme is characterized by a specific grouping of several dominant discursive practices that all conform to the same cohesive model. In *The Order of Things*, Foucault identified and discussed three successive epistemes in Western thought, that of the Renaissance, obsessed by resemblance, that of the Classical Age, for whom representation was crucial, and that of modernity, which presided over the advent of human sciences.

estrangement

This term, often mistranslated from the German or Russian as "alienation," originated in Russian Formalist theories of literature and it became a central concept in the practice and theory of the theatre of Bertolt Brecht. The Russian Formalists conceived of *ostranenie* (the devices and processes of "making strange") as one of the quintessential tasks of aesthetic operations. The aim of this artificial estrangement was primarily to alert the spectator / reader to a different perception of the world, to rupture the rote repetitions of everyday speech, and to renew the senses by estranging them from their conventional representations. But estrangement also meant to alert the spectator / reader to the formal devices and material tools of language as integral elements in the processes of meaning production. Following their own principles and inherent logic, they might even supersede meaning's more traditional elements such as narratives, semantics, or referents in the world of objects. Brecht's *theory or effect of estrangement* transfers the concept from linguistic analysis to the social and political situation of the subject. Throughout his work, Brecht attempted to define viewer participation as active transformations of those cognitive and behavioral structures that have become *naturalized*, as Roland Barthes would later say, and that are invisible to the subject. Estrangement in Brecht therefore means in fact the exact opposite of *alienation*, since one of the tasks of *estrangement* is precisely to resituate the subject in a comprehension of the social and political determinism that suddenly appears as "made" rather than as "fate" and therefore encourages the spectators of Brecht's plays to take the matter of political change directly into their own hands.

facture / faktura

These two terms are intricately related, yet they demarcate a significant shift in the evaluation of artisanal competence and artistic skills in the execution of painting and sculpture. While *facture* played a great role in judgments concerning painterly techniques until the end of the nineteenth (already challenged by Seurat's mechanical facture in divisionism), if not until the beginning of the twentieth century, its status as criterion vanished with the rise of collage aesthetics in Cubism. But even during the time of its validity, *facture* underwent dramatic changes: from the conception of painting as an act of manual bravura, and a display of virtuosity and skills, to the modernist insistence (beginning with Cézanne and culminating in Cubism) on the almost molecular clarity in making every detail and passage of painterly execution transparent in terms of its procedure of production and placement. With the rise of collage aesthetics, a painting became an object, rather than a substratum of illusionistic and perspectival conventions, and to the degree that it aspired to become an object of contemporaneity, it subjected itself to an aesthetic that mimicked manufacturing and industrial montage, all the way denigrating the supposedly hallow grounds of artisanal painting. Thus *facture* now came to mean the degree with which the painterly or sculptural object foregrounded its status

and condition of having been *fabricated*, self-reflexively revealing the principles of its own making, and the processes of its production (rather than pretending to have emerged from transcendental inspiration or supernatural talents). The artists emphasizing *facture* in this way is engaged in demythifying the creative process and the artistic object itself, as much as *facture* makes the object itself transparently contingent, rather than autonomous, let alone transcendental.

fetish / fetishism

In the anthropological sense of the word, a fetish is any object endowed with a cultic value or autonomous power of its own, often construed as a magical or divine force, which, rationally speaking, it does not possess. A term with a complex etymology— it was originally used by Portuguese and Dutch traders to designate things that Africans tribes exempted from trade (irrationally, according to the Europeans)—the fetish came to stand for the lowest form of spirituality in various accounts of religion (e.g., in Hegel); that is, to represent the superstitious vulgarity of a mere thing taken to be a sacred entity. It is this notion of the fetish—of an object overvalued by its producers in a manner that subjugates them in turn to it—that Karl Marx and Sigmund Freud turned to critical advantage. In a famous passage in *Capital* (volume 1, 1867), Marx argued that the division of labor in capitalist production leads us to forget how commodities are made, with the result that we "fetishize" them—endow them with a magical power of their own. And, some decades later, Freud suggested that all erotic life involves some fetishism, some investment of inanimate objects with libidinal energy. In short, both Marx and Freud implied that we enlightened moderns are also, at times, superstitious fetishists. In all three definitions—the anthropological, the Marxist, and the Freudian—fetishism has become a central concept in cultural criticism. It is also a multivalent category of the object that modernists have evoked, again and again, in order to test the given parameters—cultural, economic, and sexual —of the work of art.

Gesamtkunstwerk

A German term, translated as "total work of art," the *Gesamtkunstwerk* was vaunted by the nineteenth-century composer Richard Wagner in order to designate the aesthetic ambition of his grand operas—to subsume all the arts within one musical theater, to make an aesthetic experience so awesome that it might be, if not redemptive, at least ritualistic in its power. Thereafter the notion took on a life of its own (in this sense it became an artistic FETISH), soon central to most projects that claimed a transcendental or totalistic dimension for art, with different arts nominated at different times as the master form that would gather all others under it. Thus, for example, in Art Nouveau, design functioned as this dominant term; in De Stijl, it was the painted panel; in the Bauhaus, it was building (the founding program of the Bauhaus carried on its cover a woodcut of a Gothic cathedral under which all arts and crafts were, allegorically speaking, sheltered). However, because it subsumed all the arts, the *Gesamtkunstwerk* became the enemy of another imperative within modernism, that of "medium-specificity," which defined each art precisely in its difference from all the others. Although the notion of the *Gesamtkunstwerk* now seems archaic, it has hardly disappeared: reborn in happenings and other performances after World War II, it lived on in some spectacles of Nouveau Réalisme and Pop art, and has found a resurgence in much Installation art today.

Gestalt psychology

Emerging in the thirties in the work of Wolfgang Köhler and Kurt Koffka, Gestalt psychology was born as a refutation of Behaviorism, then the reigning theory of human mental development. Behaviorists pictured human and animal behavior as a series of learned, automatic responses to repeated stimuli (such as the bell accompanying the food provided a dog, then triggering salivation in the dog [stimulus / response] even when no food accompanies it). This view of the human condition as entirely passive and, worse, as entirely open to vicious training, worried the Gestaltists, who theorized activity within the human subject—the activity necessary to understanding and responding creatively to its environment. Focusing on the perceptual apparatus with which every human subject is endowed, the Gestaltists refused to grant a merely empiricist view of perception, in which the human eye forms a picture of the world by passively internalizing the visual stimuli that fall onto its retinal field. Instead, the Gestaltists argued that even from infancy the human observer is mastering that field by making inferences in which elements of the retinal pattern are associated with one another to form a "figure," everything around that figure being constituted as a "ground" or background. This actively constituted figure was called a gestalt, or form, which means, in addition, a force of hanging together, for which the Gestaltists' term was "praegnanz." Given the period when Gestalt psychology developed, it is clear that the rise of fascism lent urgency to its teaching.

grapheme

In normal usage, a grapheme is the smallest unit of written language, an element of writing that cannot be decomposed into smaller, meaningful units. Even before it gets down to the job of depicting anything, every linear deposit associates itself to another world of drawing or meaning, whether that be the wooden line of the mechanical draftsman, or the flowing mark of the comic-book illustrator, or the simpering contours of the advertisement illustrator. This associative identification is the work of the grapheme, or the cursive mark within which all drawing is formed.

Hegelianism

This shorthand is intended to signal some of the ideas of Georg Wilhelm Friedrich Hegel (1770–1831), the greatest philosopher of the early nineteenth century. Still important to many artists and critics a century later, Hegel argued that history proceeds in dialectical stages, through contradiction, in a steady progress of *thesis*, *antithesis*, and *synthesis* toward the self-consciousness of *Geist* (Mind or Spirit). For Hegel all aspects of society and culture participate in this march of Spirit toward freedom, and are to be judged according to their contributions to its development. In his scheme, then, there is a natural hierarchy in the arts, from the most material to the most spiritual, from architecture through sculpture and painting (equally based and refined), to poetry and music, all of which culminate in the pure reflections of philosophy. This idealism, with its assurance of artistic refinement and cultural progress, influenced many modernists, especially abstract painters such as Kazimir Malevich and Piet Mondrian, who harbored transcendental aspirations.

hegemony/hegemonic

A term in that appears in the writings of both Lenin and Mao, hegemony is most associated with the thought of the Italian Marxist Antonio Gramsci. In his *Prison Notebooks*, written while jailed by the Fascists, Gramsci argued that modern power is not limited to direct political rule but also operates through an indirect system of social institutions and cultural discourses that promote the ideology of the ruling classes as natural, normal, commonsensical, everyday. Such discursive power might seem more benign than direct subjugation, but it is also more subtle, and opposition to it must be rethought accordingly: "revolution" consists, then, not only in the transfer of control over politics and economics, but also in the transformation of forms of consciousness and experience. In this redefinition of politics as a struggle for hegemony, art and culture gain in importance; they are no longer seen as "superstructural" effects of the economy alone. The revision implies—at times romantically—that political change can be effected through critical interventions into art and culture.

hermeneutics

Derived from the Greek word meaning "to interpret," hermeneutics referred at first to the exegesis of The Bible considered as a historically sedimented text that is not to be read literally. By extension, hermeneutics has come to designate any method of interpretation that seeks the meaning of a text beyond its letter. We owe to the German philosopher Wilhelm Dilthey, at the end of the nineteenth century, the first investigation of the relationship between history as a scholarly practice and hermeneutics. Arguing that there is a radical difference between the human sciences, whose facts can be apprehended only through interpretation, and the natural sciences, whose facts can be empirically verified, he directly contradicted the positivist view according to which the ideal model of knowledge is physics. Dilthey's investigation of history, his analysis of how facts are deemed historical and are causally linked, led him to the formulation of what he called the "hermeneutic circle": in order to interpret a document we need to have a prior understanding not only of its whole but also of the culture to which it belongs (or of the genre of which it is only an example, or of the intention of its author), yet our understanding of this larger context depends upon our knowledge of similar documents.

iconic

The American philosopher Charles Sanders Peirce, anxious to analyze the activity of signs, felt the need to separate the profusion of signs into a manageable number of related types. The three kinds he isolated for this purpose were: symbols, icons, and indexes. Arguing that each of these types bore a different relation to its referent (or the thing for which it stood), he taught that symbols have a purely conventional (or agreed upon) relation, for which an example would be the words of a language; indexes, on the other hand, have a causal relationship, since they are the precipitates or traces of an engendering cause, the way footprints in the sand or broken branches in the forest are traces of the being that passed by; thirdly, the icon's relation is neither causal nor conventional but resemblant; it looks like its referent either by sharing its shape (the way figures on a map do) or registering its image (the way photographs do). The problem for this tidy semiology (or study of sign-types) is that signs can be mixed rather than pure; photographs are both icons and indexes; and pronouns are both symbols and indexes (the referent of the pronoun "I" being caused by the source of utterance—the speaker —within the flow of speech).

iconography

This approach to the study of images and objects focuses on questions of *meaning* (more than, say, matters of form, style, etc.), for which it often refers to source texts found outside the art work. The term is most associated with the work of the German-born art historian Erwin Panofsky (1892–1968), who proposed iconography as the basic operation of art history soon after his departure from Nazi Germany for the United States in the early thirties. (In those initial years of the academic discipline, iconography offered the advantage of a technique that could be taught and reproduced—professionalized.) Panofsky proposed three levels of meaning within art: "primary or natural subject matter," which can be treated by "a pre-iconographical description" of the work; "secondary or conventional subject matter," which can be related to known themes in the culture at large (this is the work of iconography proper); and "intrinsic meaning or content," which involves "the basic attitude of a nation, a period, a class, a religious or philosophical persuasion—qualified by one personality and condensed into one work" (Panofsky called this level, which recalls the notion of Kunstwollen, "iconology"). Iconographic analysis is suited to ancient, medieval, and Renaissance art and architecture, informed as they are by classical mythology and Christian doctrine, more than to modern practices, which often challenged the presumption of an illustrational relation between image and text in different ways (e.g., through abstraction, chance, found or readymade objects).

ideograph

Discarded by most contemporary linguists, who deem it improper, this term was coined in the nineteenth century to designate a symbol directly representing an idea rather than its name (the Chinese characters and Egyptian hieroglyphs were long thought to be pure ideographs, or ideograms, or even pictograms, but we know now that their complex formation is far from entailing the simple one-to-one connection between an idea and its figurative expression). The word ideograph was appropriated by Barnett Newman in 1947 as a means to elucidate the mode of signification that he and fellow artists such as Mark Rothko or Clyfford Still wanted to implement in their art. Opposed to both the model provided by Surrealism (and its symbology derived from Freud) and that offered by abstract art (which he discarded as formalist exercise), Newman looked instead toward the art of Northwest Coast Indians, which he characterized as "ideographic pictures." For the Kwakiutl artist, wrote Newman, "a shape was a living thing, a vehicle for an abstract thought-complex, a carrier of the awesome feelings he felt before the terror of the unknowable." Although ideograph continued to be used by some critics with regard to the pseudo-glyphic marks that filled the canvases of his friend Adolph Gottlieb until the mid-fifties, it disappeared from Newman's vocabulary almost as soon as he had celebrated it. Not only did he realize that a truly ideographic mode of communication would require the elaboration of a code shared by producers and receivers of messages, but by 1948 he no longer wished to represent "pure ideas" in his art, nor did he think it possible.

informe

Georges Bataille, the challenger to André Breton's hold over the Surrealist group of artists and writers, formed his own journal during the twenties and thirties, which he called *Documents*. This journal published a dictionary of definitions for terms such as "spit," "eye," and *informe* (or formless). *Informe*, he wrote, could not have a definition; it could only have a job, since its work is to destroy the universe of classifications by "declassing" language, or bringing it down in the world. In this way, he said, words would no longer resemble anything but would, formless, operate like a spider or spit. Alberto Giacometti, operating in the mode of formlessness, would blur the differences between male and female (on which the concept of gender depends) in a work like *Suspended Ball*.

intertext

In the definition for DIALOGISM, Bakhtin's concept of dialogue was shown to have modified the picture of the structuralist utterance to show how the sender's message is always already affected by the receiver's imagined response. A further modification of that diagram concerns the channel of emission and reception, which the structuralists labeled "contact," as though it were the telegraph wire

opened by the utterance. Bakhtin relabeled this channel "intertext" since it is not the neutral connection of "contact" but the universe of associational relationships figured forth by the sender him / herself.

isotropic
Used in physics, this term means "exhibiting the same physical properties in all directions." A body of pure water, for example, is isotropic. The notion has often been used by modernist architects, from the twenties on, to express their conception of space as nonhierarchical, and their desire to create buildings that would have no center nor privileged point (they often drew in isometric projection, a mode of representation in which each of the three directions of space are equally foreshortened). It has also been applied to Jackson Pollock's allover drip paintings.

kitsch
Kitsch is a form of dissembling the nature of the material of which an object is made, a form that is largely a result of industrial production. Thus when the silversmith no longer works his metal by hand into the extrusions and relief that his technique suggests, and the metal is merely stamped by a "die" cut to imprint it, those forms are no longer conceived as respecting the metal's natural resistance to stress, but are made to mimic other patterns, such as floral motifs or the grooves of Ionic columns. It is this aping that came to be called kitsch and that Clement Greenberg named as the natural enemy of the avant-garde, in his "Avant-Garde and Kitsch" (1939). A more violent definition was proposed by Milan Kundera in his novel *The Unbearable Lightness of Being*, when he spoke of kitsch's transformation of disgust into universal approval and thus its dissimulation of the presence, in human life, of shit. Kitsch is thus the witless embrace of cliché as a defense against the weight of human reality. Because of this defense, he writes, "human existence loses its dimensions and becomes unbearably light."

Kunstwollen
A concept developed by the Viennese art historian Alois Riegl, *Kunstwollen* is usually translated as "artistic volition" or "artistic will," and it proposes, in Hegelian fashion, that a distinctive will-to-form, at once spiritual and aesthetic in nature, permeates all aspects of a given culture and / or period—from "low" crafts like textiles (Riegl worked as a curator in the Austrian Museum of Applied Arts) to "high" arts like easel painting. Unlike Hegel, however, Riegl argued that none of these forms or epochs should be denigrated, and his own work concentrated on practices and periods that were long undervalued, such as Baroque group portraiture and "the late Roman art industry." Pitched against the theories of architect Gottfried Semper (1803–79), who privileged the positive roles of material, technique, and function, the idealism of *Kunstwollen*—the implication that one will-to-form animates all products of a period—was attractive to some artists in the early twentieth century, especially ones involved in the Viennese Secession, whose motto encapsulated the *Kunstwollen* idea: "To each Age its Art, to Art its Freedom."

logocentrism / logocentric
In his doctoral dissertation, published as *Speech and Phenomena* (1973), the French philosopher Jacques Derrida examined Edmund Husserl's theory of language, which privileges speech over all other secondary transmission of meaning, such as writing or even memory. Husserl insisted that meaning must be immediate to the speaker, resonating inside his brain even as he or she produces and utters it. All secondary forms drive a wedge into this immediacy, either forcing the meaning to come after its conception—a temporal distancing that Derrida called "deferral,"—or traducing the meaning by differing from it. Derrida's term for this double betrayal is *différance* (spelled with an "a" to make its written form necessary to its reception). Husserl's refusal of writing in the name of speech, or *logos* (here meaning the "living presence" of the word), Derrida termed logocentrism, the ideology of *logos* and the condemnation of the GRAPHEME.

matrix
The gestalt, or figure, depends on its distinctness from its ground. This distinction brings with it the assumption that every figure is separate both from its neighbor and the space in which it exists. In thinking about this order of the visual, the philosopher Jean-François Lyotard constructed a third possibility, which he called "matrix", to describe a spatiality that is not consistent with the coordinates of external space, and from which the intervals and differences that make the external world recognizable and observable as objects are excluded. As with Freud's conception of the unconscious, the matrix contains incompatible figures that all occupy the same place at the same time, at war both with each other and with conscious experience. The matrix could, thus, be an avatar of Georges Bataille's concept of the INFORME, or formless.

medium-specificity
With the migration of the Surrealists to the United States at the outbreak of World War II, their work, which the critic Clement Greenberg found frivolously literary, threatened, he said, "to [assimilate] the arts to entertainment pure and simple." To escape this dire fate, the arts had to emulate the Enlightenment philosophy of Immanuel Kant, "because he was the first to criticize the means itself of criticism." As this "self-criticism" became the task of painters and sculptors, each was set the duty of revealing what was "specific" to a given aesthetic medium: "What had to be exhibited," Greenberg wrote in "Modernist Painting," "was not only that which was unique and irreducible in art in general, but also that which was unique and irreducible in each particular art. According to Greenberg, the essence of modernism lies "in the use of characteristic methods of a discipline to criticize the discipline itself, not in order to subvert it but in order to entrench it more firmly in its area of competence…. Each art had to determine, through its own operations and works, the effects exclusive to itself. By doing so it would, to be sure, narrow its area of competence, but at the same time it would make its possession of that area all the more certain. It quickly emerged that the unique and proper area of competence of each art coincided with all that was unique in the nature of its medium. The task of self-criticism became to eliminate from the specific effects of each art any and every effect that might conceivably be borrowed from or by the medium of any other art. Thus would each art be rendered 'pure,' and in its purity find the guarantee of its standards of quality as well as of its independence…. Modernism used art to call attention to art. The limitations that constitute the medium of painting—the flat surface, the shape of the support, the properties of the pigment." For the Old Masters, these were limitations to be dissembled, but for modernism they became positive factors to be acknowledged, for they were specific to the medium of painting, and painting alone.

metonym / metonymy / metonymic
A figure of speech by which a concept is expressed through a term referring to another concept that is existentially related to it. The most common form of metonymy is synecdoche, where a part stands for the whole (as in "sail" standing for "ship"), or the whole for a part (as in "China is losing" standing for "the Chinese soccer team is losing"). It was the Russian linguist and poetician Roman Jakobson who established metonymy as one of the two main axes of language (the other being metaphor), which he aligned to Ferdinand de Saussure's opposition of SYNTAGM and PARADIGM, as well as to Freud's opposition of DISPLACEMENT and CONDENSATION. Although he later admitted that the line of demarcation between metonymy and metaphor is sometime loose, Jakobson had recourse to these two concepts throughout his oeuvre about a vast array of phenomena (identifying Surrealism with metaphor and Cubist or Dadaist collage with metonymy, for example). His most explicit elaboration of the opposition between these two axes figures in his study of aphasia (or the incapacity to communicate linguistically), in which he distinguished two kinds of troubles: a patient whose metonymic function is affected cannot combine linguistic terms and construct propositions, while a patient whose metaphoric function is affected cannot choose between words nor relate any homonyms or synonyms.

mimesis / mimetic
The Greek word for "imitation," mimesis comes from the assumption that the imitative double must reproduce a single or simple object that comes before it, which is then duplicated by imitation. In his important essay "The Double Session" (1981), Jacques Derrida questions this traditional concept of representation as imitation by introducing Stéphane Mallarmé's reverie called "Mimique," in which "the false appearance of the present" is used to refer to a mime's performance of ideas that refer to no possible object, such as "she died laughing": a commonplace expression that names something impossible. In this way the mime does not imitate but rather initiates something. As Mallarmé expresses, "The scene illustrates but the idea, not any actual action, in a hymen tainted with vice yet sacred, between desire and fulfillment, perpetration and remembrance: here anticipating, there recalling, in the future, in the past, under the false appearance of a present."

objet trouvé
Along with the readymade, the construction, and the assemblage, the *objet trouvé* or "found object" is a critical alternative to traditional sculpture based in the idealist modeling of the human figure. As practiced by such Surrealists as André Breton and Salvador Dalí, the found object is best defined in contradistinction to the device closest to it in character, the readymade. First proposed by Marcel Duchamp, the readymade is an everyday product of industrial manufacture—a bicycle wheel, a bottlerack, a urinal—that, repositioned as art, questions basic assumptions about art and artist; the readymade tends to be anonymous,

detached from subjectivity and sexuality, with little or no sign of human labor. Not so the found object, at least in the hands of the Surrealists, who were drawn to old and odd things, often found in marginal stalls or flea markets, that spoke to a repressed desire within the artist and / or a surpassed mode of production within the society at large. One such object that constellated both kinds of enigmatic impulse was "the slipper-spoon" that Breton found one day in a flea market on the Paris outskirts (he recounts the anecdote in *Mad Love* [1937]). A wooden utensil, of peasant craft, carved with a little boot as its base, the spoon was an outmoded thing that Breton took as a sign of past desire and future love.

Oedipus complex

A fundamental concept in Freudian psychoanalysis, the Oedipus complex is the web of longings, fears, and prohibitions that captivates the psychological life of the young child, male and female. Named after the Sophocles tragedy *Oedipus Rex*, the complex involves a sexual desire for the parent of the opposite sex and a death wish for the parent of the same sex. The complex is most intense from ages three to five, but returns, after the period of sexual latency, at puberty, when it is usually resolved by the choice of a sexual object beyond the family (though this choice can also carry forward the preferences developed within the complex—that is, a man who seeks his mother, a woman her father—in another guise). According to Freud, the son is forced out of the Oedipus complex through the threat of the father—often, literally or figuratively, the threat of castration. The daughter does not face this same threat, and so, for Freud, the Oedipus complex is not so definitively terminated for the girl. As one might expect, this notion interested the Surrealists, and it continues to provoke feminist artists and theorists.

ontology / ontological

Derived from the Greek words *ontos* ("being," as present participle of the verb "to be") and *logos* (study, discourse), ontology is a term invented in the seventeenth century to designate that part of philosophy pertaining to "being qua being," or to the "essence of being," which had constituted the most important part of metaphysics since Aristotle. By extension, the adjective "ontological" means "that which concerns the essence." Clement Greenberg's conception of the history of each art as a quest for its own essence is both a TELEOLOGICAL and an ontological argument.

paradigm / paradigmatic

Although Ferdinand de Saussure used only the adjective form "paradigmatic," the opposition between paradigm and SYNTAGM is central to his linguistics and by extension to SEMIOLOGY as well as to structuralism. Having established that in language "everything is based on relations," Saussure distinguished between two kinds or relations: syntagmatic relations concern the association of discrete linguistic units resulting in elements of discourse (a word like "reread" is a syntagm made of two semantic units, "re," meaning repetition, and "read"; a sentence like "God is good" is a syntagm made of three units); paradigmatic relations concern the associations that are made *in absentia* between each unit of the syntagm and other units belonging to the same system. The word "revolution," for example, "will unconsciously call to mind a host of other words": revolutionary and revolutionize, but also gyration, rotation, turnover, reorganization, as well as evolution, or even any other word ending with the suffix "tion," such as population or argumentation, or beginning with the prefix re, such as reread. The group of these possible associations, which are governed by specific rules (phonetic and / or semantic) but whose number is indeterminate and which can appear in any order (as opposed to the succession of units in a syntagm) is called a paradigm. In recent years, the term has acquired a new meaning in the field of history of sciences, where it was introduced by Thomas Kuhn in *The Structure of Scientific Revolutions*. Almost a synonym of Michel Foucault's concept of *episteme*, it designates the intellectual horizon of a science during a certain period, determining a threshold beyond which it cannot go unless it fundamentally shifts its tenets and methods (the Newtonian paradigm of physics, for example, was definitively superseded by the Einsteinian one).

performative / performativity

In his book *How to Do Things with Words*, the British philosopher John Langshaw Austin (1911–60) divides language into two modes: the constative and the performative, the first a description of things that the structural linguist Émile Benveniste called "narrative" (which uses, he reminds us, the third person and the historical past tense); the second, an enactment of things, as when a judge says "I sentence you to five years in jail," or a person says either "I do" (in a marriage ceremony) or "I promise," Benveniste calling this "discourse" (which uses the first and second person pronouns and the present tense).

phallogocentrism

This feminist coinage complicates the concept of LOGOCENTRISM, developed by the philosopher Jacques Derrida, with the concept of "the phallus," developed by the psychoanalyst Jacques Lacan. If "logocentrism" signifies the persistent privilege given in Western culture to speech, to the "self-presence" of the spoken word (as in the Word, or *logos*, of God), the prefix "phal" suggests that this privilege is supported by the symbolic power accorded, within this same tradition, to the phallus as the prime signifier of all difference—prime because it is taken to signify the fundamental difference of them all, the difference between the sexes. For feminist artists and theorists this privilege is an ideology, however ingrained it might be in subjective and cultural formation, and as such is subject to radical deconstruction.

phenomenology

In the sixties, translation made Maurice Merleau-Ponty's *Phenomenology of Perception* (1945) available to English-speaking artists, and produced a collective meditation on the way the spatial coordinates of vision determine the meaning of objects. Because the individual's body is lived in its orientation to space—its head above, its feet below, its front fundamentally different from a reverse side it cannot even see—that body effectuates a "preobjective" meaning that determines the gestalts the individual must form. Preobjective meaning is, of course, another way of naming abstraction; thus phenomenology was seen as a support for the idea of abstract art.

phoneme

A phoneme is the smallest distinctive unit of articulated speech, an atom of language. Phonemes are vocal sounds that cannot be decomposed into smaller units, but not every such vocal sound, even in articulated speech, is a phoneme. The aspirated sound that necessarily follows the "p" or the "t" in English, for example, is not a phoneme because it has no distinctive (differential) function. The same sound at the beginning of the word "hair" is a phoneme in that it differentiate this word from "heir," from which it is absent.

polysemy / polysemous / polysemic

The polysemy of a word (and by extension of any other kind of signs, including visual ones) is its quality of having several distinct significations. Polysemy is often substituted for *ambiguity,* whose connotation of vagueness it does not share. Many more words are polysemous or polysemic than one is usually aware of (as the consultation of any good dictionary reveals), a fact on which most puns are based.

positivism

It was the French philosopher Auguste Comte (1798–1857) who first used this term, or that of "positive philosophy," to characterize his doctrine as radically opposed to metaphysics. Instead of attempting to discover the essence of things, thought Comte, philosophy should repel all a priori principles and seek to provide a systematic synthesis of all observable (positive) facts. Based on sense-experience, Comte's empirical theory of knowledge stressed that there was no difference in principle between the methods of the social sciences and the physical sciences, a idea that was directly contradicted by Wilhelm Dilthey's discussion of the HERMENEUTIC circle. Although the philosophers and mathematicians of the Vienna Circle grouped around Rudolf Carnap (1891–1970) and Otto Neurath (1882–1945) in the wake of Ludwig Wittgenstein gave a sounder philosophical base to Comte's argument in their logical positivism, the general tenets of positivism have been decried by most thinkers—and certainly all art historians—valued by each of the writers of the present book.

postcolonial discourse

This interdisciplinary form of critique aims to deconstruct the colonial legacy embedded within Western representations, verbal, visual, and other. Eclectic in its theoretical sources, it draws on Marxist and Freudian methods, especially as inflected by Michel Foucault, Jacques Derrida, and Jacques Lacan; it also elaborates on modes of thought more anthropological in character, such as "subaltern studies" in India and "cultural studies" in Britain. Even as postcolonial discourse works over the cultural-political residues of colonialism, it also seeks to come to conceptual terms with a present in which the old markers of the colonial world—of centers and peripheries, metropoles and hinterlands, within a globe divided up into First, Second, and Third Worlds— are no longer so relevant. Postcolonial discourse was all but inaugurated by Edward Said with his *Orientalism* (1978), a critique of "the imaginary geography" of the Near East, and it was thereafter developed by Gayatri Spivak, Homi Bhabha, and many others.

postmedium condition

In the sixties and seventies, five separate yet connected phenomena seemed to consign the MEDIUM-SPECIFICITY that had been so central to modernism to history. The first was postminimalism, which saw the concerted dematerialization of the art object into penciled lines on walls, photographic records of walks in the English landscape, and flows of asphalt poured down hillsides. The second was Conceptual art, related to the first in its dependence on photography and its disdain for the material object, since, as one of its founders Joseph Kosuth maintained, its only interest was a naked, and verbal, definition of the word "art." The third phenomenon was the rise of Marcel Duchamp, who seemed to eclipse Pablo Picasso as the most influential artist of the century. The fourth was postmodernism, a movement in painting, sculpture, and architecture that sought to void everything that modernist art had fought for. If the modernist architecture of the Bauhaus and Mies van der Rohe had followed the dictum "form follows function," it was to produce spatial volume that would articulate the principles of its construction in a move toward abstraction. Spurning such abstraction, however, postmodern architects such as Michael Graves and Charles W. Moore made architecture into a species of decoration, imitating the fluted colonnades of classical banks or the lattices of eighteenth-century garden pavilions or "follies." In the domains of painting and sculpture, Italian artists collected under the rubric "trans-avant-garde" abandoned constructed sculpture to return to casting in bronze, and jettisoned the monochrome and other forms of abstraction by importing the classical nudes of fascist realism. The fifth element in the mix was "deconstruction," the intellectual vogue of the late sixties and seventies, centered on the work of French philosopher Jacques Derrida. MEDIUM-SPECIFICITY, as Clement Greenberg had defined it, demanded that the self-reflexive—or "self-critical"—modernist artist determine "the unique and proper area of competence of each art [which] coincided with all that was unique in the nature of its medium." The task of this "self-criticism" was to eliminate from the specific effects of each art any and every effect that might conceivably be borrowed from or by the medium of any other art. Thus "would each art be rendered 'pure,' and in its *purity* find the guarantee of its standards of quality as well as of its independence" (italics added). However, the notions of "proper" and "purity" were linked to the meaning of *propre*, French for both "pure" and "selfhood," concepts that were considered illusory by deconstructionists. Selfhood is consolidated around the consciousness of the subject reflecting on its presence to itself in a grasp of the uniqueness of its specific being, which Derrida derided as the "metaphysics of presence." These concerted attacks on everything that had guaranteed the "specificity" of the medium brought about what some art critics began to refer to as "the postmedium condition," in which contemporary painters and sculptors felt a strong inhibition against reverting to practices that had been voided in the avalanche of postmodernist criticism.

referent

Within structural linguistics it was important to differentiate the idea to which a sign refers from the object it might name. This is because, as its founder, Ferdinand de Saussure, taught, "meaning is oppositive, relative, and negative." This means that meaning forms around oppositions, which the structuralists call "binaries" or "PARADIGMS," with the meaning of something depending on its contrast to what it is not; "high," for example, differentiating itself out from "low," or "black" from "white." The referent is this "relative and negative" result of opposition—not an object, but a concept.

relational aesthetics

Relational aesthetics is a critical term popularized by the French curator and critic Nicolas Bourriaud through several exhibitions and essays, many of which were collected in his influential book *Relational Aesthetics*, published in French in 1998 and translated into English in 2002. The term identifies a kind of art that establishes spaces, situations, or "platforms" designed to host a variety of social activities—often very ordinary ones, such as eating or watching movies, and sometimes more celebratory occasions, such as a parade or music performance. Some of the core artists associated with relational aesthetics, including Pierre Huyghe, Philippe Parreno, Liam Gillick, Dominique Gonzalez-Foerster, and Rirkrit Tiravanija, have described their objective as establishing "open scenarios," which may or may not be entered into by others, thus causing social relations to appear as aesthetic acts—as relational aesthetics. Sometimes these activities occur live as part of the life of the exhibition; at other times they are presented through some form of documentation such as film or video.

semiology / semiotics

In his *Course in General Linguistics*, posthumously published in 1916, Ferdinand de Saussure envisioned a "science that studies the life of signs within society," which he called semiology (from the Greek *semeion*, sign). It would "show what constitutes signs, what laws govern them," and these laws would be applicable to linguistics, which it would include as the science of only one particular system of signs, language. At around the same time, and independently, the American philosopher Charles Sanders Peirce developed his own science of signs, which he called semiotics. "Semiology" and "semiotics" are often used interchangeably, though there are major differences between Saussure's enterprise and that of Peirce. Paradoxically, although Saussure stressed that linguistics was only a part of the future semiology, albeit a privileged one, this discipline modeled itself on linguistics when it developed in the postwar period, to the point that the structuralist author Roland Barthes was led in his *Elements of Semiology* (1964) to reverse Saussure's proposal and state that semiology was in fact depending upon linguistics. This assertion fueled, in turn, Jacques Derrida's criticism of semiology as a LOGOCENTRIC discipline. By contrast, Peirce's semiotics, which consists largely of a TAXONOMY of signs from the point of view of their mode of reference, remained much less dependent upon the linguistic model. Peirce distinguished three categories of signs: the *symbol*, in which the relation between the sign and its referent is arbitrary; the *index*, in which this relation is determined by contiguity or co-presence (a footprint in the sand is an *indexical sign* of a foot, smoke an *indexical sign* of fire, etc.); the *icon*, in which this relation is characterized by resemblance (a painted portrait). These categories are somewhat porous (a photograph is both an index and an icon, for example), and although most linguistic signs are *symbols*, certain categories of words are *indexical signs* (the signification of these words, called *deictics,* change according to their context: "I," "you," "now," "here," etc.), while others, such as onomatopoeias (the moo of a cow, the cock-a-doodle-do of a rooster) are *iconic signs*.

signified / signifier

In his desire to stress the immateriality of the referent, Saussure divided the sign into two parts, one the conceptual domain of the signified, or meaning, the other the material domain of the signifier, or signifying deposit, whether written or auditory.

simulacrum / a

A term in ancient philosophy, a simulacrum is a representation that is not necessarily tied to an object in the world. As a copy without an "original"—in the double sense of both a physical referent and a first version—the simulacrum is often used, in cultural criticism, to describe the status of the image in a society of SPECTACLE, of mass-mediated consumerism. So too, in poststructuralist theory, the simulacrum is called upon to question the Platonic order of representation that adjudicates between "good" and "bad" copies according to their relative truth, or apparent verisimilitude, to models in (or, in Plato, *beyond*) the world. One finds this challenge intermittently posed in twentieth-century art, for example, in the fantastic paintings of René Magritte and in the serial silkscreens of Andy Warhol—images that, even as they appear to be representations, dissolve the truth-claims of most representations. Indeed, the simulacrum is a crucial concept in the understanding of both Surrealist and Pop art, as attested by important texts on these subjects by Gilles Deleuze, Michel Foucault, Roland Barthes, and Jean Baudrillard.

spectacle

Developed in critical debates within the radical European movement the Situationist International (1957–72), "the spectacle" is used to signal a new stage of advanced capitalism, especially evident in the reconstruction period after World II, in which consumption, leisure, and the image (or SIMULACRUM) became more important than ever before in the economies of social and political life. For the lead figure of Situationism, Guy Debord, "the spectacle" is the terrain of new forms of power but, as such, of new strategies of subversion as well, which the Situationists worked both to theorize and to practice. Taken with Marxist notions of "FETISHISM" and "reification," Debord argued in *The Society of the Spectacle* (1967) that the commodity and the image had become structurally one ("the spectacle is capital," he wrote in a famous line, "accumulated to the point where it becomes image"), and that, as a result, a qualitative leap in control had occurred, one that, through consumption, renders its subjects politically passive and socially isolated. The Situationist hope remains that, if power continues to live by the spectacle, it might still be challenged there as well.

sublimation

Within psychoanalysis sublimation remains an elusive concept, never precisely defined by Freud or any of his followers. It concerns the diversion of instincts from sexual to nonsexual aims; these drives are "sublimated"—at once refined and rechanneled—in the pursuit of goals that are more valued, or at least less disruptive, than sexual activity in the society at large: goals of intellect and art (the ones underscored by Freud) but also of law, sport, entertainment, and so on. The energy for this work remains sexual, but the aims are social; indeed, for Freud there is no civilization without sublimation (not to mention repression). However, no firm line exists between the erotic and the aesthetic; and some artists in the twentieth century—Duchamp most famously—liked to point to overlaps between the two. Other artists (e.g., other Dadaists) sought, more aggressively, to reverse the process of sublimation altogether, to break open aesthetic forms to libidinal energies—a strategy sometimes discussed as "DESUBLIMATION."

Symbolic, the

This term has a specific meaning in the psychoanalytic thought of Jacques Lacan that must be distinguished from its general use. In his controversial thought "the Symbolic" represents all phenomena of the psyche that are structured like a language, not, say, formed as images (he terms this adjacent realm of experience "the Imaginary"); such phenomena include, in part, dreams and symptoms (see CONDENSATION and DISPLACEMENT). In effect, Lacan reread the Freudian conception of the unconscious through the structural linguistics of Ferdinand de Saussure and Roman Jakobson (neither of whom Freud could have known). At the same time Lacan conveyed, through the term "the Symbolic," that these linguistic operations of the unconscious are also at work in the social order at large (here he was influenced by his contemporary, the anthropologist Claude Lévi-Strauss): the human subject is inserted into society as into language, and vice versa. In this sense "the Symbolic" also stands for an entire system of identifications and prohibitions—of laws—that each of us must internalize to become functional social beings at all. According to Lacan, our difficulties with this order are often expressed through neuroses; any outright denial of this order is tantamount to psychosis. Suggestive as this model is to some artists and many theorists, it can also project a profoundly conservative attitude to the social order, which is made to appear absolute.

synchronic

Trained as a comparativist historian of language, the founder of structural linguistics Ferdinand de Saussure realized that in order to study the essential structure of language (at least that common to all Indo-European languages), he had to ignore historical developments and examine the cross-section of a language at any given time, past or present, much as a biologist looks at some tissue under a microscope in order to study its cellular structure. This hypothetical cross-section is called synchronic because all its elements are frozen in time. The opposite of synchronic, in Saussure's terminology, is DIACHRONIC.

syncretism

Derived from a Greek word meaning "union of all Cretans," this term was first coined to characterize the work of Proclus (CE 410–485), the last major philosopher of ancient Greece, who attempted a synthesis of all past philosophies and scientific doctrines. Although it did not have any negative connotations at first, and it can still be used in a positive sense, this word is now most commonly used to describe any incoherent combination of contradictory doctrines or systems.

synecdoche

Speech is understood either as literal or figurative, the figures of speech swerving away from the literal names into imagistic relations for things. In *The New Science* (1725), the Italian philosopher Giambattista Vico wondered how knowledge might be acquired if it were not revealed to man by God. Imagining a caveman, he assumed that his only means to understanding was a comparison of the unknown with the known, which is the savage's own body. Hearing thunder, the savage likens it to what he knows and decides it is a loud voice, this act of likening constituting the poetic form of metaphor. Next the savage wonders about its cause and imagines a very large body producing the voice, this body being, he thinks, that of a god, the notion of cause then constituting the poetic form of METONYMY. Finally the savage wonders why the god should emit the noise and decides this is because the god is angry, the cause or conceptual foundation, constituting for Vico the poetic form of synecdoche. Unsurprisingly, Vico called this progression from the unknown to the known "poetic knowledge." It is poetic knowledge that in turn structures Michel Foucault's influential study of periods of Western historical

development, *The Order of Things* (1970), which he identified as separate epistemes. The Renaissance, he taught, imagines knowledge as based on resemblance, or metaphor. The seventeenth and eighteenth centuries, which he called the Classical period, imagines it as identity and difference, or metonymy; while the nineteenth century, during which the modern disciplines are born, imagines it as analogy and succession, or synecdoche.

syntagm / syntagmatic

First defined by Ferdinand de Saussure as constituting one of the most important elements of language, a syntagm is any succession in the spoken chain of a minimum of two semantic units that cannot be replaced or whose order cannot be changed without changing the meaning or the intelligibility of the utterance. Syntagms can be words ("reread" is made of two units, "re" and "read"), phrases ("human life") or whole sentences ("God is good"). Syntagmatic relations, which he opposed to PARADIGMATIC ones, were particularly important for Saussure, whose primary interest was language as a social fact, in that in them the distinction between the collective and the individual use of language is particularly difficult to distinguish. The case is rather simple when it concerns colloquial syntagms (they belong to common use and thus cannot be changed), but the formation of new words (neologisms) is also governed by rules transmitted by tradition, and thus by common use. After Saussure, Roman Jakobson related METONYMY and metaphor, which he saw as the two main axes of language, respectively to Saussure's conception of syntagmatic and paradigmatic relations.

tachisme

A European toned-down version of Abstract Expressionism, *tachisme* (from the French *tache*, meaning "stain," "splash," or "mark") was also referred to as "lyrical abstraction." The main difference between *tachiste* works and their American counterparts is their modest scale and reliance upon the figurative tradition of landscape. Despite the interest expressed by several *tachiste* artists for the automatic method favored by Pollock, their art remained highly composed and as such dependent upon a Cubist conception of the picture as a harmonious totality. SEE ART INFORMEL

taxonomy

From the Greek word *taxis*, meaning "arrangement," taxonomy is the practice or principle of classification or grouping. When the eighteenth-century Swedish botanist Linnaeus drew up a graph as a way of sorting out the orders of living beings, he set the large categories (such as "animal") down one side of the table and called them *genus*, and the smaller ones (such as "dog," "cat," etc.) across the horizontal axis, calling them *species*. Such an inclusive graph is a taxonomy.

telos / teleology / teleological

Telos means "goal" or "end" in Greek, and initially *teleology* designated the study of finality. The first major teleological argument, concluding from the regularities in the operations of nature that all things had a purpose in the universe, was elaborated in the Middle Ages as a proof of God's existence. It was then staunchly refuted during the Enlightenment, first by David Hume in his *Dialogues Concerning Natural Religion* of 1779, then by Immanuel Kant in his *Critique of Pure Reason* of 1781. Today the word teleology is used to characterize any theory presupposing or predicting that a process has an end (in both senses of ending and of purpose), or retroactively interpreting a process as geared toward its end. Darwin's theory of evolution, though attacked by the Church upon its inception, is today commonly recognized as teleological, as is Marx's conception of history.

trope

A trope is a figure of speech—a word, phrase, or expression that is used in a figurative way—usually for rhetorical effect. Giambattista Vico's "poetic knowledge" (see SYNECDOCHE) depends on language's figurative potential, its swerve away from the literal into a set of comparisons and contrasts. This swerve is an example of a "trope," the most common of which is metaphor.

zaum

An abbreviation of the Russian word *zaumnoe* (transrational), the term was coined in 1913 by the futurists Aleksei Kruchenikh and Velemir Khlebnikov to refer to the new poetic language they were inventing, replete with new, nonsensical words and nonrepresentational sounds or, in its written form, groups of letters. Arguing that the word-as-such directly affects our senses and has a meaning independently of its ascribed signification, they sought to bypass the rational use of language and underscored the phonetic materiality of linguistic utterances.

further reading

GENERAL: SURVEY AND SOURCE BOOKS

William C. Agee, *Modern Art in America 1908–1968* (London and New York: Phaidon, 2016)

Michael Archer, *Art Since 1960* (London and New York: Thames & Hudson, 1997; third edition, 2014)

Iwona Blazwick and Magnus Af Petersens (eds), *Adventures of the Black Square: Abstract Art and Society 1915–2015* (New York and London: Prestel and Whitechapel Gallery, 2015)

Herschel Chipp, *Theories of Modern Art: A Source Book by Artists and Critics* (Berkeley: University of California Press, 1968)

Francis Frascina and Jonathan Harris (eds), *Art in Modern Culture: An Anthology of Critical Texts* (London: Phaidon, 1992)

Francis Frascina and Jonathan Harris (eds), *Modern Art and Modernism: A Critical Anthology* (New York: Harper and Row, 1982)

Jason Gaiger and Paul Wood (eds), *Art of the Twentieth Century: A Reader* (New Haven and London: Yale University Press, 2003)

George Heard Hamilton, *Painting and Sculpture in Europe, 1880–1940* (New Haven and London: Yale University Press, 1993)

Charles Harrison, Francis Frascina, and Gill Perry, *Primitivism, Cubism, Abstraction: The Early Twentieth Century* (New Haven and London: Yale University Press, 1993)

Charles Harrison and Paul Wood (eds), *Art in Theory, 1900–2000: An Anthology of Changing Ideas* (Cambridge: Blackwell, 2003)

Robert Hughes, *The Shock of the New* (London: Thames & Hudson, 1991)

David Joselit, *American Art Since 1945* (London: Thames & Hudson, 2003)

Rosalind Krauss, *Passages in Modern Sculpture* (New York: Viking Press, 1977; reprint Cambridge, Mass.: MIT Press, 1981)

Christopher Phillips, *Photography in the Modern Era: European Documents and Critical Writings, 1913–1940* (New York: Metropolitan Museum of Art/Aperture, 1989)

Alex Potts, *The Sculptural Imagination: Figurative, Modernist, Minimalist* (New Haven and London: Yale University Press, 2000)

Kristin Stiles and Peter Selz (eds), *Theories and Documents of Contemporary Art* (Berkeley: University of California Press, 1996)

Paul Wood et al., *Modernism in Dispute: Art Since the Forties* (New Haven and London: Yale University Press, 1993)

Paul Wood et al., *Realism, Rationalism, Surrealism: Art Between the Wars* (New Haven and London: Yale University Press, 1993)

GENERAL: AVANT-GARDE, MODERNISM, POSTMODERNISM

Marcia Brennan, *Modernism's Masculine Subjects: Matisse, the New York School, and Post-Painterly Abstraction* (Cambridge, Mass.: MIT Press, 2004)

Peter Bürger, *Theory of the Avant-Garde* (1974), trans. Michael Shaw (Minneapolis: University of Minnesota Press, 1984)

Douglas Crimp, "Pictures," *October*, no. 8, Spring 1979

Thierry de Duve, *Sewn in the Sweatshops of Marx: Beuys, Warhol, Klein, Duchamp*, trans. Rosalind Krauss (Chicago: University of Chicago Press, 2012)

Hal Foster (ed.), *Discussions in Contemporary Culture* (Seattle: Bay Press, 1987)

Hal Foster (ed.), *The Anti-Aesthetic: Essays on Postmodern Culture* (Seattle: Bay Press, 1983)

Serge Guilbaut (ed.), *Reconstructing Modernism* (Cambridge, Mass.: MIT Press, 1990)

Serge Guilbaut, Benjamin H. D. Buchloh, and David Solkin (eds), *Modernism and Modernity* (Halifax: The Press of the Nova Scotia College of Art and Design, 1983)

Andreas Huyssen, *After the Great Divide: Modernism, Mass Culture, Postmodernism* (Bloomington: Indiana University Press, 1986)

Rosalind Krauss, *"A Voyage on the North Sea": Art in the Age of the Post-Medium Condition* (London: Thames & Hudson, 1999)

Craig Owens, "The Allegorical Impulse: Towards a Theory of Postmodernism," *October*, nos 12 and 13, Spring and Summer 1980

Brian Wallis (ed.), *Art After Modernism: Rethinking Representation* (New York: New Museum of Contemporary Art, 1994)

GENERAL: COLLECTED ESSAYS

Yve-Alain Bois, *Painting as Model* (Cambridge, Mass.: MIT Press, 1991)

Yve-Alain Bois and Rosalind Krauss, *Formless: A User's Guide* (New York: Zone Books, 1997)

Benjamin H. D. Buchloh, *Neo-Avantgarde and Culture Industry: Essays on European and American Art from 1955 to 1975* (Cambridge, Mass.: MIT Press, 2000)

T. J. Clark, *Farewell to an Idea: Episodes from a History of Modernism* (New Haven and London: Yale University Press, 1999)

Thomas Crow, *Modern Art in the Common Culture* (New Haven and London: Yale University Press, 1996)

Thierry de Duve, *Kant after Duchamp* (Cambridge, Mass.: MIT Press, 1996)

Briony Fer, *On Abstract Art* (New Haven and London: Yale University Press, 1997)

Hal Foster, *Prosthetic Gods* (Cambridge, Mass.: MIT Press, 2004)

Hal Foster, *The Return of the Real: The Avant-Garde at the End of the Century* (Cambridge, Mass.: MIT Press, 1996)

Michael Fried, *Art and Objecthood* (Chicago: University of Chicago Press, 1998)

Clement Greenberg, *Art and Culture: Critical Essays* (Boston: Beacon Press, 1961)

Clement Greenberg, *The Collected Essays and Criticism*, vols 1 and 4, ed. John O'Brian (Chicago: University of Chicago Press, 1986 and 1993)

Clement Greenberg, *Homemade Esthetics: Observations on Art and Taste* (Oxford: Oxford University Press, 1999)

Rosalind Krauss, *Bachelors* (Cambridge, Mass.: MIT Press, 1999)

Rosalind Krauss, *The Optical Unconscious* (Cambridge, Mass.: MIT Press, 1993)

Rosalind Krauss, *The Originality of the Avant-Garde and Other Modernist Myths* (Cambridge, Mass.: MIT Press, 1985)

Rosalind E. Krauss, *Perpetual Inventory* (Cambridge, Mass.: MIT Press, 2010)

Meyer Schapiro, *Modern Art: 19th and 20th Century, Selected Papers, Vol. 2* (New York: George Braziller, 1978)

Leo Steinberg, "Rodin," *Other Criteria: Confrontations with Twentieth-Century Art* (London, Oxford, and New York: Oxford University Press, 1972)

Anne M. Wagner, *Three Artists (Three Women): Georgia O'Keeffe, Lee Krasner, Eva Hesse* (Berkeley and Los Angeles: University of California Press, 1997)

Peter Wollen, *Raiding the Ice Box: Reflections on Twentieth-Century Culture* (London: Verso, 1993)

GENERAL: THEORY AND METHODOLOGY

Frederick Antal, *Classicism and Romanticism* (London: Routledge & Kegan Paul, 1966)

Roland Barthes, *Critical Essays*, trans. Richard Howard (Evanston: Northwestern University Press, 1972)

Roland Barthes, *Image, Music, Text*, trans. Stephen Heath (New York: Hill and Wang, 1977)

Roland Barthes, *Mythologies* (1957), trans. Annette Lavers (New York: Noonday Press, 1972)

Leo Bersani, *The Freudian Body: Psychoanalysis and Art* (New York: Columbia University Press, 1986)

Walter Benjamin, *Selected Writings*, four volumes, ed. Michael Jennings (Cambridge, Mass.: Harvard University Press, 1999, 2004, and 2006)

Benjamin H. D. Buchloh, *Formalism and Historicity: Models and Methods in Twentieth-Century Art* (Cambridge, Mass.: MIT Press, 2015)

T. J. Clark, *Image of the People: Gustave Courbet and the 1848 Revolution* (London: Thames & Hudson, 1973)

T. J. Clark, *The Absolute Bourgeois: Artists and Politics in France 1848–1851* (London: Thames & Hudson, 1973)

T. J. Clark, *The Painting of Modern Life: Paris in the Art of Manet and his Followers* (London: Thames & Hudson, 1984)

T. J. Clark, *The Sight of Death: An Experiment in Art Writing* (New Haven and London: Yale University Press, 2006)

Thomas Crow, *Painters and Public Life in 18th-Century Paris* (New Haven and London: Yale University Press, 1985).

Thomas Crow, *The Intelligence of Art* (Chapel Hill, N.C.: University of North Carolina Press, 1999)

Whitney Davis, *A General Theory of Visual Culture* (Princeton: Princeton University Press, 2011)

Jacques Derrida, *Of Grammatology*, trans. Gayatri Spivak (Baltimore: The Johns Hopkins University Press, 1976)

Jacques Derrida, "Parergon," *The Truth in Painting*, trans. Geoff Bennington (Chicago and London: University of Chicago Press, 1987)

Jacques Derrida, "The Double Session," *Dissemination*, trans. Barbara Johnson (Chicago and London: University of Chicago Press, 1981)

Michel Foucault, *The Archaeology of Knowledge* (Paris: Gallimard, 1969; translation London: Tavistock Publications; and New York: Pantheon, 1972)

Michel Foucault, "What is an Author?", *Language, Counter-Memory, Practice*, trans. D. Bouchard and S. Simon (Ithaca, N.Y.: Cornell University Press, 1977)

Sigmund Freud, *Art and Literature*, trans. James Strachey (London: Penguin, 1985)

Nicos Hadjinicolaou, *Art History and Class Struggle* (London: Pluto Press, 1978)

Arnold Hauser, *The Social History of Art* (1951), four volumes (London: Routledge, 1999)

Fredric Jameson, *The Prison-House of Language: A Critical Account of Structuralism and Russian Formalism* (Princeton: Princeton University Press, 1972)

Fredric Jameson (ed.), *Aesthetics and Politics* (London: New Left Books, 1977)

Richard Kearney and David Rasmussen, *Continental Aesthetics—Romanticism to Postmodernism: An Anthology* (Malden, Mass. and Oxford: Blackwell, 2001)

Francis Klingender, *Art and the Industrial Revolution* (1947) (London: Paladin Press, 1975)

Sarah Kofman, *The Childhood of Art: An Interpretation of Freud's Aesthetics*, trans. Winifred Woodhull (New York: Columbia University Press, 1988)

Jean Laplanche and J.-B. Pontalis, *The Language of Psychoanalysis*, trans. Donald Nicholson-Smith (New York: W. W. Norton, 1973)

Thomas Levin, "Walter Benjamin and the Theory of Art History," *October*, no. 47, Winter 1988

Jacqueline Rose, *Sexuality in the Field of Vision* (London: Verso, 1986)

Ferdinand de Saussure, *Course in General Linguistics*, trans. Wade Baskin (New York: McGraw-Hill, 1966)

Meyer Schapiro, *Theory and Philosophy of Art: Style, Artist, and Society, Selected Papers, Vol. 4* (New York: George Braziller, 1994)

Richard Shone and John-Paul Stonard (eds), *The Books that Shaped Art History: From Gombrich and Greenberg to Alpers and Krauss* (London and New York: Thames & Hudson, 2013)

VIENNESE AVANT-GARDE

Walter Benjamin, "The Paris of the Second Empire in Baudelaire," in *Charles Baudelaire: A Lyric Poet in the Era of High Capitalism* (London: New Left Books, 1973)

Gemma Blackshaw, *Facing the Modern: The Portrait in Vienna 1900* (London: National Gallery, 2013)

Gemma Blackshaw and Leslie Topp (eds), *Madness and Modernity: Mental Illness and the Visual Arts in Vienna 1900* (London: Lund Humphries, 2009)

Allan Janik and Stephen Toulmin, *Wittgenstein's Vienna* (New York: Simon and Schuster, 1973)

Adolf Loos, "Ornament and Crime," in Ulrich Conrads (ed.), *Programs and Manifestoes on 20th-Century Architecture* (Cambridge, Mass.: MIT Press, 1975)

Carl E. Schorske, *Fin-de-Siècle Vienna: Politics and Culture* (New York: Vintage Books, 1980)

Kirk Varnedoe, *Vienna 1900: Art, Architecture, and Design* (New York: Museum of Modern Art, 1985)

MATISSE AND FAUVISM

Alfred H. Barr, Jr., *Matisse: His Art and His Public* (New York: Museum of Modern Art, 1951)

Roger Benjamin, *Matisse's "Notes of a Painter": Criticism, Theory, and Context, 1891–1908* (Ann Arbor: UMI Research Press, 1987)

Yve-Alain Bois, "Matisse and Arche-drawing," *Painting as Model* (Cambridge, Mass.: MIT Press, 1990)

Yve-Alain Bois, *Matisse and Picasso* (New York: Flammarion Press, 1998)

Yve-Alain Bois, "On Matisse: The Blinding," *October*, no. 68, Spring 1994

Marcia Brennan, *Modernism's Masculine Subjects: Matisse, the New York School, and Post-Painterly Abstraction* (Cambridge, Mass.: MIT Press, 2004)

John Elderfield, "Describing Matisse," *Henri Matisse: A Retrospective* (New York: Museum of Modern Art, 1992)

John Elderfield, *The "Wild Beasts": Fauvism and its Affinities* (New York: Museum of Modern Art, 1976)

Jack D. Flam, (ed.), *Matisse on Art* (Berkeley and Los Angeles: University of California Press, 1995)

Jack D. Flam, *Matisse: The Man and His Art, 1869–1918* (Ithaca, N.Y. and London: Cornell University Press, 1986)

Judi Freeman (ed.), *The Fauve Landscape* (New York: Abbeville Press, 1990)

Lawrence Gowing, *Matisse* (London: Thames & Hudson, 1976)

James D. Herbert, *Fauve Painting: The Making of Cultural Politics* (New Haven and London: Yale University Press, 1992)

John Klein, *Matisse Portraits* (New Haven and London: Yale University Press, 2001)

John O'Brian, *Ruthless Hedonism: The American Reception of Matisse* (Chicago and London: Chicago University Press, 1999)

Margaret Werth, *The Joy of Life: The Idyllic in French Art, Circa 1900* (Berkeley: University of California Press, 2002)

Alastair Wright, *Matisse and the Subject of Modernism* (Princeton: Princeton University Press, 2004)

Yve-Alain Bois (ed.), *Matisse in the Barnes Foundation* (London and New York: Thames & Hudson, 2016)

PRIMITIVISM

James Clifford, "Histories of the Tribal and the Modern," *The Predicament of Culture* (Cambridge, Mass.: Harvard University Press, 1988)

Hal Foster, "The 'Primitive' Unconscious of Modern Art," *October*, no. 34, Fall 1985

Jack D. Flam (ed.), *Primitivism and Twentieth-Century Art: A Documentary History* (Berkeley: University of California Press, 2003)

Robert Goldberg, *Primitivism in Modern Art* (1938) (New York: Vintage Books, 1967)

Colin Rhodes, *Primitivism and Modern Art* (London: Thames & Hudson, 1994)

William Rubin (ed.), *"Primitivism" in 20th Century Art: Affinity of the Tribal and the Modern* (New York: Museum of Modern Art, 1984)

EXPRESSIONISM

Aesthetics and Politics: Debates between Ernst Bloch, Georg Lukács, Bertolt Brecht, Walter Benjamin, Theodor Adorno (London: New Left Review Books, 1977)

Vivian Endicott Barnett, Michael Baumgartner, Annegret Hoberg, and Christine Hopfengart, *Klee and Kandinsky: Neighbors, Friends, Rivals* (London and New York: Prestel, 2015)

Stephanie Barron, *German Expressionism: Art and Society* (New York: Rizzoli, 1997)

Timothy O. Benson (ed.), *Expressionism in Germany and France: From Van Gogh to Kandinsky* (Los Angeles and New York: Los Angeles County Museum of Art and Prestel, 2014)

Lisa Florman, *Concerning the Spiritual—and the Concrete—in Kandinsky's Art* (Palo Alto: Stanford University Press, 2014)

Donald Gordon, *Expressionism: Art and Idea* (New Haven and London: Yale, 1987)

Donald Gordon, "On the Origin of the Word 'Expressionism'," *Journal of the Warburg and Courtauld Institutes*, vol. 29, 1966

Charles Haxthausen, "'A New Beauty': Ernst Ludwig Kirchner's Images of Berlin," in Charles Haxthausen and Heidrun Suhr (eds), *Berlin: Culture and Metropolis* (Minneapolis: University of Minnesota Press, 1990)

Yule Heibel, "They Danced on Volcanoes: Kandinsky's Breakthrough to Abstraction, the German Avant-Garde and the Eve of the First World War," *Art History*, 12, September 1989

Siegfried Kracauer, *From Caligari to Hitler: A Psychological History of German Film* (Princeton: Princeton University Press, 1947)

Wassily Kandinsky, *Concerning the Spiritual in Art* (1912) (New York: Dover Publications, 1977)

Wassily Kandinsky and Franz Marc (eds), *The Blaue Reiter Almanac* (London: Thames & Hudson, 1974)

Angela Lampe and Brady Roberts (eds), *Kandinsky: A Retrospective* (Paris: Centre Georges Pompidou and Milwaukee Art Museum, 2014)

Carolyn Lanchner (ed.), *Paul Klee* (New York: Museum of Modern Art, 1987)

Jill Lloyd, *German Expressionism: Primitivism and Modernity* (New Haven and London: Yale University Press, 1991)

Bibiana K. Obler, *Intimate Collaborations: Kandinsky and Münter, Arp and Taeuber* (New Haven: Yale University Press, 2014)

Rose-Carol Washton Long, *German Expressionism: Documents from the End of the Wilhelmine Empire to the Rise of National Socialism* (New York: Macmillan International, 1993)

Joan Weinstein, *The End of Expressionism: Art and the November Revolution in Germany, 1918–1919* (Chicago: University of Chicago Press, 1990)

O. K. Werckmeister, *The Making of Paul Klee's Career 1914–1920* (Chicago and London: Chicago University Press, 1988)

CUBISM AND PICASSO

Mark Antliff and Patricia Leighten, *Cubism and Culture* (London: Thames & Hudson, 2001)

Alfred H. Barr, Jr., *Cubism and Abstract Art* (New York: Museum of Modern Art, 1936)

Yve-Alain Bois, "Kahnweiler's Lesson", *Painting as Model* (Cambridge, Mass.: MIT Press, 1990)

Yve-Alain Bois, "The Semiology of Cubism," in Lynn Zelevansky (ed.), *Picasso and Braque: A Symposium* (New York: Museum of Modern Art, 1992)

T. J. Clark, *Picasso and Truth: From Cubism to Guernica* (Princeton: Princeton University Press, 2013)

David Cottington, *Cubism in the Shadow of War: The Avant-Garde and Politics in Paris 1905–1914* (New Haven and London: Yale University Press, 1998)

Lisa Florman, *Myth and Metamorphosis: Picasso's Classical Prints of the 1930s* (Cambridge, Mass.: MIT Press, 2000)

Edward Fry, *Cubism* (London: Thames & Hudson, 1966)

John Golding, *Cubism: A History and an Analysis, 1907–1914* (New York: G. Wittenborn, 1959)

Christopher Green, *Juan Gris* (New Haven and London: Yale University Press, 1992)

Christopher Green (ed.), *Picasso's Les Demoiselles d'Avignon* (Cambridge: Cambridge University Press, 2001)

Clement Greenberg, "The Pasted Paper Revolution" (1958), *The Collected Essays and Criticism*, vols 1 and 4, ed. John O'Brian (Chicago: University of Chicago Press, 1986 and 1993)

Daniel-Henry Kahnweiler, *The Rise of Cubism*, trans. Henry Aronson (New York: Wittenborn, Schultz, 1949)

Rosalind Krauss, "In the Name of Picasso," *The Originality of the Avant-Garde and Other Modernist Myths* (Cambridge, Mass.: MIT Press, 1985)

Rosalind Krauss, "Re-Presenting Picasso," *Art in America*, vol. 67, no. 10, December 1980

Rosalind Krauss, "The Motivation of the Sign," in Lynn Zelevansky (ed.), *Picasso and Braque: A Symposium* (New York: Museum of Modern Art, 1992)

Rosalind Krauss, *The Picasso Papers* (New York: Farrar, Straus & Giroux, 1998)

Fernand Léger, *Functions of Painting*, ed. Edward Fry (London: Thames & Hudson, 1973)

Patricia Leighten, *Re-Ordering the Universe: Picasso and Anarchism, 1897–1914* (Princeton: Princeton University Press, 1989)

Marilyn McCully (ed.), *A Picasso Anthology: Documents, Criticism, Reminiscences* (Princeton: Princeton University Press, 1982)

Christine Poggi, *In Defiance of Painting: Cubism, Futurism, and the Invention of Collage* (New Haven and London: Yale University Press, 1992)

Robert Rosenblum, *Cubism and Twentieth-Century Art* (New York: Harry N. Abrams, 1960, revised 1977)

William Rubin, "Cezannism and the Beginnings of Cubism," *Cezanne: The Late Work* (New York: Museum of Modern Art, 1977)

William Rubin, "From Narrative to Iconic: The Buried Allegory in *Bread and Fruitdish on a Table* and the Role of *Les Demoiselles d'Avignon*," *Art Bulletin*, vol. 65, December 1983

William Rubin, "Pablo and Georges and Leo and Bill," *Art in America*, vol. 67, March–April 1979

William Rubin, *Picasso and Braque: Pioneering Cubism* (New York: Museum of Modern Art, 1989)

William Rubin, "The Genesis of *Les Demoiselles d'Avignon*," *Studies in Modern Art* (special *Les Demoiselles d'Avignon* issue), Museum of Modern Art, New York, no. 3, 1994 (chronology by Judith Cousins and Hélène Seckel, critical anthology of early commentaries by Hélène Seckel)

Leo Steinberg, "Resisting Cezanne: Picasso's Three Women," *Art in America*, vol. 66, no. 6, November–December 1978

Leo Steinberg, "The Algerian Women and Picasso at Large," *Other Criteria: Confrontations with Twentieth-Century Art* (London, Oxford, and New York: Oxford University Press, 1972)

Leo Steinberg, "The Philosophical Brothel" (1972), *October*, no. 44, Spring 1988

Leo Steinberg, "The Polemical Part," *Art in America*, vol. 67, March–April 1979

Ann Temkin and Anne Umland (eds), *Picasso Sculpture* (New York: Museum of Modern Art, 2015)

Jeffrey Weiss (ed.), *Picasso: The Cubist Portraits of Fernande Olivier* (Washington, D.C.: National Gallery of Art; and Princeton: Princeton University Press, 2003)

Lynn Zelevansky (ed.), *Picasso and Braque: A Symposium* (New York: Museum of Modern Art, 1992)

FUTURISM AND VORTICISM

Mark Antliff and Scott Klein (eds), *Vorticism: New Perspectives* (Oxford: Oxford University Press, 2013)

Germano Celant, *Futurism and the International Avant-Garde* (Philadelphia: Philadelphia Museum of Art, 1980)

Hal Foster, *Prosthetic Gods* (Cambridge, Mass.: MIT Press, 2004)

Anne Coffin Hanson, *The Futurist Imagination* (New Haven and London: Yale University Press, 1983)

Pontus Hulten (ed.), *Futurism and Futurisms* (New York: Abbeville Press; and London: Thames & Hudson, 1986)

Wyndham Lewis (ed.), *Blast* (London: Thames & Hudson, 2009)

Marianne W. Martin, *Futurist Art and Theory 1909–1915* (Oxford: Clarendon Press, 1968)

Marjorie Perloff, *The Futurist Moment: Avant-Garde, Avant Guerre, and the Language of Rupture* (Chicago: University of Chicago Press, 1986)

Apollonio Umbro (ed.), *Futurist Manifestoes* (London: Thames & Hudson, 1973)

DADA

Dawn Ades (ed.), *Dada and Surrealism Reviewed* (London: Arts Council of Great Britain, 1978)

Jenny Anger, *Paul Klee and the Decorative in Modern Art* (Cambridge and New York: Cambridge University Press, 2004)

George Baker, *The Artwork Caught by the Tail: Francis Picabia and Dada in Paris* (Cambridge, Mass.: MIT Press, 2007)

Hugo Ball, *Flight Out of Time: A Dada Diary* (New York: Viking Press, 1974)

Timothy Benton (ed.), *Hans Richter: Encounters* (Los Angeles: LACMA, 2013)

Annie Bourneuf, *Paul Klee: The Visible and the Legible* (Chicago: University of Chicago Press, 2015)

William Camfield, *Francis Picabia: His Art, Life, and Times* (Princeton: Princeton University Press, 1979)

Leah Dickerman (ed.), *Dada* (Washington: National Gallery of Art, 2005)

Brigid Doherty, *Montage: The Body and the Work of Art in Dada, Brecht, and Benjamin* (Berkeley: University of California Press, 2004)

John Elderfield, *Kurt Schwitters* (London: Thames & Hudson, 1985)

Hal Foster, *Prosthetic Gods* (Cambridge, Mass.: MIT Press, 2004)

Maud Lavin, *Cut with the Kitchen Knife: The Weimar Photomontages of Hannah Höch* (New Haven and London: Yale University Press, 1993)

Andreas Marti (ed.), *Paul Klee: Hand Puppets* (Bern: Zentrum Paul Klee, 2006)

Robert Motherwell, *The Dada Painters and Poets: An Anthology* (New York: Wittenborn, Schultz, 1951)

Francis Naumann, *New York Dada, 1915–1923* (New York: Abrams, 1994)

Anson Rabinbach, *In the Shadow of Catastrophe: German Intellectuals Between Apocalypse and Enlightenment* (Berkeley: University of California Press, 1997)

Ruth Hemus, *Dada's Women* (New Haven and London: Yale University Press, 2009)

Hans Richter, *Dada: Art and Anti-Art* (New York: McGraw-Hill, 1965)

William Rubin, *Dada, Surrealism, and Their Heritage* (New York: Museum of Modern Art, 1968)

Isabel Schulz (ed.), *Kurt Schwitters: Color and Collage* (New Haven and London: Yale University Press, 2010)

Richard Sheppard, *Modernism—Dada—Postmodernism* (Chicago: Northwestern University Press, 1999)

Anne Umland and Adrian Sudhalter (eds), *Dada in the Collection of the Museum of Modern Art* (New York: Museum of Modern Art, 2008)

Michael White, *Generation Dada: The Berlin Avant-Garde and the First World War* (New Haven: Yale University Press, 2013)

DUCHAMP

Dawn Ades, Neil Cox, and David Hopkins, *Marcel Duchamp* (London: Thames & Hudson, 1999)

Martha Buskirk and Mignon Nixon (eds), *The Duchamp Effect* (Cambridge, Mass.: MIT Press, 1998)

Pierre Cabanne, *Dialogues with Duchamp* (New York: Da Capo Press, 1979)

T. J. Demos, *The Exiles of Marcel Duchamp* (Cambridge, Mass.: MIT Press, 2007)

Thierry de Duve, *Kant After Duchamp* (Cambridge, Mass.: MIT Press, 1996)

Thierry de Duve, *Pictorial Nominalism: On Marcel Duchamp's Passage from Painting to the Readymade* Minneapolis: University of Minnesota Press, 1991)

Thierry de Duve (ed.), *The Definitively Unfinished Marcel Duchamp* (Halifax: The Press of the Nova Scotia College of Art and Design, 1991)

Linda Dalrymple Henderson, *Duchamp in Context: Science and Technology in the Large Glass and Related Works* (Princeton: Princeton University Press, 1998)

David Joselit, *Infinite Regress: Marcel Duchamp, 1910–1914* (Cambridge, Mass.: MIT Press, 1998)

Rudolf Kuenzli and Francis M. Naumann (eds), *Marcel Duchamp: Artist of the Century* (Cambridge, Mass.: MIT Press, 1989)

Robert Lebel, *Marcel Duchamp*, trans. George Heard Hamilton (New York: Grove Press, 1959)

Francis M. Naumann and Hector Obalk (eds), *Affect t | Marcel.: The Selected Correspondence of Marcel Duchamp* (London: Thames & Hudson, 2000)

Molly Nesbit, *Their Common Sense* (London: Black Dog Publishing, 2001)

Arturo Schwarz, *Complete Works of Marcel Duchamp* (New York: Delano Greenridge Editions, 2000)

MONDRIAN AND DE STIJL

Carel Blotkamp, *Mondrian: The Art of Destruction* (New York: Harry N. Abrams, 1994)

Carel Blotkamp et al., *De Stijl: The Formative Years* (Cambridge, Mass.: MIT Press, 1986)

Yve-Alain Bois, "Mondrian and the Theory of Architecture," *Assemblage*, 4, October 1987)

Yve-Alain Bois, "The De Stijl Idea" and "Piet Mondrian: *New York City*," *Painting as Model* (Cambridge, Mass.: MIT Press, 1990)

Yve-Alain Bois, Joop Joosten, and Angelica Rudenstine, *Piet Mondrian* (Washington, D.C.: National Gallery of Art, 1994)

Harry Cooper, *Mondrian: The Transatlantic Paintings* (Cambridge, Mass.: Harvard University Art Museums, 2001)

Gladys Fabre and Doris Wintgens Hötte (eds), *Van Doesburg and the International Avant-Garde* (London: Tate Publishing, 2009)

Hans L. C. Jaffé (ed.), *De Stijl* (London: Thames & Hudson, 1970)

Joop Joosten, "Mondrian: Between Cubism and Abstraction," *Piet Mondrian Centennial Exhibition* (New York: Guggenheim, 1971)

Joop Joosten and Robert P. Welsh, *Piet Mondrian*, catalogue raisonné, two volumes (New York: Harry N. Abrams, 1998)

Francesco Manacorda and Michael White (eds), *Mondrian and His Studios: Colour in Space* (London: Tate Publishing, 2015)

Annette Michelson, "De Stijl, It's Other Face: Abstraction and Cacophony, Or What Was the Matter with Hegel?," *October*, no. 22, Fall 1982

Piet Mondrian, *The New Art—The New Life: The Collected Works of Piet Mondrian*, ed. and trans. Harry Holtzman and Martin S. James (Boston: G. K. Hall and Co., 1986)

Nancy Troy, *The De Stijl Environment* (Cambridge, Mass.: MIT Press, 1983)

Nancy Troy, *The Afterlife of Piet Mondrian* (Chicago: University of Chicago Press, 2014)

Michael White, *De Stijl and Dutch Modernism* (Manchester and New York: Manchester University Press, 2003)

RUSSIAN AVANT-GARDE, SUPREMATISM, AND CONSTRUCTIVISM

Troels Andersen, *Malevich* (Amsterdam: Stedelijk Museum, 1970)

Richard Andrews and Milena Kalinovska (eds), *Art into Life: Russian Constructivism 1914–32* (Seattle: Henry Art Gallery; and New York: Rizzoli, 1990)

Stephen Bann (ed.), *The Tradition of Constructivism* (London: Thames & Hudson, 1974)

Yve-Alain Bois, "El Lissitzky: Radical Reversibility," *Art in America*, vol. 76, no. 4, April 1988

Yve-Alain Bois, Aleksandra Shatskikh, and Magdalena Dabrowski, *Malevich and the American Legacy* (London and New York: Prestel, 2011)

Achim Borchardt-Hume (ed.), *Kazimir Malevich* (London: Tate Publishing, 2013)

John Bowlt (ed.), *Russian Art of the Avant-Garde: Theory and Criticism* (London: Thames & Hudson, 1988)

Benjamin H. D. Buchloh, "Cold War Constructivism" in Serge Guibaut (ed.), *Reconstructing Modernism* (Cambridge, Mass.: MIT Press, 1990)

Benjamin H. D. Buchloh, "From Faktura to Factography," *October*, no. 30, Fall 1984

Rainer Crone and David Moos, *Kazemir Malevich: The Climax of Disclosure* (Chicago: University of Chicago Press, 2015)

Magdalena Dabrowski, Leah Dickerman, and Peter Galassi, *Aleksandr Rodchenko* (New York: Museum of Modern Art, 1998)

Charlotte Douglas, "Birth of a 'Royal Infant': Malevich and 'Victory Over the Sun'," *Art in America*, vol. 62, no. 2, March/April 1974

Matthew Drutt (ed.), *Kasimir Malevich: Suprematism* (New York: Guggenheim Museum, 2003)

Hal Foster, "Some Uses and Abuses of Russian Constructivism," *Art into Life: Russian Constructivism, 1914–1932* (Seattle: Henry Art Gallery; and New York: Rizzoli, 1990)

Hubertus Gassner, "Analytical Sequences," in David Elliot (ed.), *Rodchenko and the Arts of Revolutionary Russia* (New York: Pantheon, 1979)

Hubertus Gassner, "John Heartfield in the USSR," *John Heartfield* (New York: Museum of Modern Art, 1992)

Hubertus Gassner, "The Constructivists: Modernism on the Way to Modernization," *The Great Utopia* (New York: Guggenheim Museum, 1992)

Maria Gough, "In the Laboratory of Constructivism: Karl Ioganson's Cold Structures," *October*, no. 84, Spring 1998

Maria Gough, "Tarabukin, Spengler, and the Art of Production," *October*, no. 93, Summer 2000

Camilla Gray, *The Great Experiment: Russian Art 1863–1922* (1962), republished as *The Russian Experiment in Art 1863–1922* (London: Thames & Hudson, 1986)

Selim O. Khan-Magomedov, *Rodchenko: The Complete Work* (Cambridge, Mass.: MIT Press, 1987)

Christina Kiaer, "Rodchenko in Paris," *October*, no. 75, Winter 1996

Christina Kiaer, *Imagine No Possessions: The Socialist Objects of Russian Constructivism* (Cambridge, Mass.: MIT Press, 2005)

Alexei Kruchenykh, "Victory over the Sun," *Drama Review*, no. 15, Fall 1971

El Lissitzky, *El Lissitzky: Life, Letters, Texts*, ed. Sophie Lissitzky-Kuppers (London: Thames & Hudson, 1968)

Sophie Lissitzky-Küppers, *El Lissitzky: Life-Letters-Texts* (London: Thames & Hudson, 1968)

Christina Lodder, *Russian Constructivism* (New Haven and London: Yale University Press, 1983)

Nancy Perloff and Brian Reed (eds), *Situating El Lissitzky: Vitebsk, Berlin, Moscow* (Los Angeles: Getty Research Institute, 2003)

Margit Rowell, "Vladimir Tatlin: Form/Faktura," *October*, no. 7, Winter 1978

Margit Rowell and Deborah Wye (eds), *The Russian Avant-Garde Book 1910–1934* (New York: Museum of Modern Art, 2002)

Herbert Spencer, *Pioneers of Modern Typography*, revised edition (Cambridge, Mass: MIT Press, 2004)

Margarita Tupitsyn, "From the Politics of Montage to the Montage of Politics: Soviet Practice, 1919 through 1937," in Matthew Teitelbaum (ed.), *Montage and Modern Life, 1919–1942* (Cambridge, Mass.: MIT Press, 1992)

Margarita Tupitsyn et al., *El Lissitzky—Beyond the Abstract Cabinet: Photography, Design, Collaboration* (New Haven and London: Yale University Press, 1999)

Larisa Zhadova, *Malevich: Suprematism and Revolution in Russian Art 1910–1930* (New York: Thames & Hudson, 1982)

Larisa Zhadova (ed.), *Tatlin* (New York: Rizzoli, 1988)

PURISM, NEUE SACHLICHKEIT, AND THE RETURN TO ORDER

Stephanie Barron and Sabine Eckmann (eds), *New Objectivity: Modern German Art in the Weimar Republic 1919–1933* (New York: Prestel, DelMonico Books, and LACMA, 2015)

Gottfried Boehm, Ulrich Mosch, and Katharina Schmidt (eds), *Canto d'Amore: Classicism in Modern Art and Music, 1914–1945* (Basel: Kunstmuseum, 1996)

Benjamin H. D. Buchloh, "Figures of Authority, Ciphers of Regression: Notes on the Return of Representation in European Painting," *October*, no. 16, Spring 1981

Carol S. Eliel, *L'Esprit Nouveau: Purism in Paris 1918–1925* (Los Angeles and New York: Los Angeles County Museum of Art and Abrams, 2001)

Romy Golan, *Modernity and Nostalgia: Art and Politics in France Between the Wars* (New Haven and London: Yale University Press, 1995)

Christopher Green, *Cubism and its Enemies: Modern Movements and Reaction in French Art, 1916–1928* (New Haven and London: Yale University Press, 1987)

Jeffrey Herf, *Reactionary Modernism: Technology, Culture, and Politics in Weimar and the Third Reich* (Cambridge, Mass.: MIT Press, 1990)

Anton Kaes, Martin Jay, and Edward Dimendberg (eds), *Weimar Republic Sourcebook* (Berkeley: University of California Press, 1994)

Nina Rosenblatt, "Empathy and Anaesthesia: On the Origins of a French Machine Aesthetic," *Grey Room*, no. 2, Winter 2001

Kenneth Silver, *Esprit de Corps* (Princeton: Princeton University Press, 1989)

BAUHAUS AND PREWAR GERMAN MODERNISM

Herbert Bayer, Walter Gropius, and Ise Gropius, *Bauhaus 1919–1928* (New York: Museum of Modern Art, 1938)

Christopher Burke, *Active Literature: Jan Tschichold and New Typography* (London: Hyphen Press, 2007)

Arthur A. Cohen, *Herbert Bayer: The Complete Work* (Cambridge, Mass: MIT Press, 1984)

Éva Forgács, *The Bauhaus Idea and Bauhaus Politics* (Budapest: Central European University Press, 1995)

Margaret Kentgens-Craig, *The Bauhuas and America: First Contacts 1919–1936* (Cambridge, Mass.: MIT Press, 1996)

Mary Emma Harris, *The Arts at Black Mountain College* (Cambridge, Mass.: MIT Press, 1987)

Margret Kentgens-Craig, *The Bauhaus and America: First Contacts 1919–1936*, trans. Lynette Widder (Cambridge, Mass.: MIT Press, 1999)

Richard Kostelanetz (ed.), *Moholy-Nagy* (London: Allen Lane, 1971)

Ruari McLean, *Jan Tschichold: Typographer* (Boston: David R. Godine, 1975)

László Moholy-Nagy, *An Anthology*, ed. Richard Kostelanetz (New York: Da Capo Press, 1970)

László Moholy-Nagy, *Painting, Photography, Film* (1927), trans. Janet Seligman (Cambridge, Mass.: MIT Press, 1969)

László Moholy-Nagy, *The New Vision* (New York: Wittenborn, Schultz, 1947)

Herbert Spencer, *Pioneers of Modern Typography*, revised edition (Cambridge, Mass: MIT Press, 2004)

Frank Whitford, *Bauhaus* (New York: Thames & Hudson, 1984)

Frank Whitford (ed.), *The Bauhaus: Masters and Students by Themselves* (Woodstock, N.Y.: The Overlook Press, 1992)

Hans Wingler, *The Bauhaus: Weimar, Dessau, Berlin, Chicago* (Cambridge, Mass.: MIT Press, 1969)

EARLY AMERICAN MODERNISM

Allan Antliff, *Anarchist Modernism: Art, Politics, and the First American Avant-Garde* (Chicago: University of Chicago Press, 2007)

Stephanie Barron and Lisa Mark (eds), *Calder and Abstraction: From Avant-Garde to Iconic* (New York: Del Monico Books, 2013)

Achim Borchardt-Hume (ed.), *Alexander Calder: Performing Sculpture* (New Haven: Yale University Press, 2016)

Marcia Brennan, *Painting Gender, Constructing Theory: The Alfred Stieglitz Circle and American Formalist Aesthetics* (Cambridge, Mass.: MIT Press, 2001)

Erin B. Coe, Bruce Robertson, and Gwendolyn Owens, *Modern Nature: Georgia O'Keeffe and Lake George* (London and New York: Thames & Hudson, 2013)

Helen Molesworth, *Leap Before You Look: Black Mountain College 1933–1957* (New Haven: Yale University Press, 2015)

Mark Rawlinson, *Charles Sheeler: Modernism, Precisionism and the Borders of Abstraction* (London: I. B. Tauris, 2007)

Terry Smith, *Making the Modern: Industry, Art, and Design in America* (Chicago: University of Chicago Press, 1993)

SURREALISM

Dawn Ades (ed.), *Dada and Surrealism Reviewed* (London: Arts Council of Great Britain, 1978)

Dawn Ades and Simon Baker, *Undercover Surrealism: Georges Bataille and Documents* (Cambridge, Mass.: MIT Press, 2006)

Dawn Ades, Michael Richardson, and Krzysztof Fijalkowski (eds), *The Surrealism Reader: An Anthology of Ideas* (Chicago: University of Chicago Press, 2016)

Matthew Affron, and Sylvie Ramond (eds), *Joseph Cornell and Surrealism* (University Park, Penn.: Penn State University Press, 2015)

Anna Balakian, *Surrealism: The Road to the Absolute* (Cambridge: Cambridge University Press, 1986)

Yve-Alain Bois and Rosalind Krauss, *Formless: A User's Guide* (New York: Zone Books, 1997)

André Breton, "Introduction to the Discourse on the Paucity of Reality," *October*, no. 69, Summer 1994

André Breton, *Mad Love*, trans. Mary Ann Caws (Lincoln: University of Nebraska Press, 1980)

André Breton, *Manifestoes of Surrealism*, trans. Richard Seaver and Helen R. Lane (Ann Arbor: University of Michigan Press, 1972)

André Breton, *Nadja*, trans. Richard Howard (New York: Grove Weidenfeld, 1960)

André Breton, *What is Surrealism?*, trans. David Gascoyne (New York: Haskell House Publishers,1974)

William Camfield, *Max Ernst: Dada and the Dawn of Surrealism* (Munich: Prestel, 1993)

Mary Ann Caws (ed.), *Surrealist Painters and Poets: An Anthology* (Cambridge, Mass.: MIT Press, 2001)

Jacqueline Chenieux-Gendron, *Surrealism* (New York: Columbia University Press, 1990)

Herschel B. Chipp, *Picasso's Guernica: History, Transformations, Meaning* (Berkeley and Los Angeles: University of California Press, 1988)

Hal Foster, *Compulsive Beauty* (Cambridge, Mass.: MIT Press, 1993)

Michel Foucault, *This is Not a Pipe* (Berkeley: University of California Press, 1982)

Francis Frascina, "Picasso, Surrealism and Politics in 1937," in Silvano Levy (ed.), *Surrealism: Surrealist Visuality* (New York: New York University Press, 1997)

Carlo Ginzburg, "The Sword and the Lightbulb: A Reading of *Guernica*," in Michael S. Roth and Charles G. Salas (eds), *Disturbing Remains: Memory, History, and Crisis in the Twentieth Century* (Los Angeles: Getty Research Institute, 2001)

Jutta Held, "How do the political effects of pictures come about? The case of Picasso's *Guernica*," *Oxford Art Journal*, vol. 11, no. 1, 1988, pp. 38–9

Gijs van Hensbergen, *Guernica: The Biography of a Twentieth-Century Icon* (London and New York: Bloomsbury, 2004)

Denis Hollier, *Against Architecture: The Writings of Georges Bataille*, trans. Betsy Wing (Cambridge, Mass.: MIT Press, 1989)

Denis Hollier, *Absent Without Leave: French Literature Under the Threat of War*, trans. Catherine Porter (Cambridge, Mass.: Harvard University Press, 1997)

Rosalind Krauss, *The Optical Unconscious* (Cambridge, Mass.: MIT Press, 1993)

Rosalind Krauss and Jane Livingston, *L'Amour fou: Surrealism and Photography* (New York: Abbeville Press, 1986)

Alyce Mahon, *Surrealism and the Politics of Eros 1938–1968* (London: Thames & Hudson, 2005)

Jennifer Mundy (ed.), *Surrealism: Desire Unbound* (London: Tate Publishing, 2001)

Maurice Nadeau, *History of Surrealism* (New York: Macmillan, 1965)

Sidra Stich, "Picasso's Art and Politics in 1936," *Arts Magazine*, vol. 58, October 1983, pp. 113–18

Dickran Tashjian, *A Boatload of Madmen: Surrealism and the American Avant-Garde 1920–1950* (London: Thames & Hudson, 2002)

Lynne Warren, *Alexander Calder and Contemporary Art: Form, Balance, Joy* (London: Thames & Hudson, 2010)

MEXICAN MURALISTS

Alejandro Anreus, *Orozco in Gringoland: The Years in New York* (Albuquerque: University of New Mexico Press, 2001)

Jacqueline Barnitz, *Twentieth-Century Art of Latin America* (Austin, Texas: University of Texas Press, 2001)

Linda Downs, *Diego Rivera: A Retrospective* (New York and London: Founders Society, Detroit Institute of Arts in association with W. W. Norton & Company, 1986)

Desmond Rochfort, *Mexican Muralists* (London: Laurence King Publishing, 1993)

Antonio Rodriguez, *A History of Mexican Mural Painting* (London: Thames & Hudson, 1969)

SOCIALIST REALISM

Matthew Cullerne Bown, *Socialist Realist Painting* (London and New Haven: Yale University Press, 1998)

Leah Dickerman, "Camera Obscura: Socialist Realism in the Shadow of Photography," *October*, no. 93, Summer 2000

David Elliott (ed.), *Engineers of the Human Soul: Soviet Socialist Realist Painting 1930s–1960s* (Oxford: Museum of Modern Art, 1992)

Hans Guenther (ed.), *The Culture of the Stalin Period* (New York and London: St. Martin's Press, 1990)

Thomas Lahusen and Evgeny Dobrenko (eds), *Socialist Realism without Shores* (Durham, N.C. and London: Duke University Press, 1997)

Brandon Taylor, "Photo Power: Painting and Iconicity in the First Five Year Plan," in Dawn Ades and Tim Benton (eds), *Art and Power: Europe Under the Dictators 1939–1945* (London: Thames & Hudson, 1995)

Andrei Zhdanov, "Speech to the Congress of Soviet Writers" (1934), translated and reprinted in Charles Harrison and Paul Wood (eds), *Art in Theory 1900–1990* (Oxford and Cambridge, Mass.: Blackwell, 1992)

HARLEM RENAISSANCE

Mary Ann Calo, *Distinction and Denial: Race, Nation, and the Critical Construction of the African-American Artist, 1920–40* (Ann Arbor: University of Michigan Press, 2007)

M. S. Campbell et al., *Harlem Renaissance: Art of Black America* (New York: Studio Museum in Harlem and Harry N. Abrams, 1987)

David C. Driskell, *Two Centuries of Black American Art* (New York: Alfred A. Knopf and Los Angeles County Museum of Art, 1976)

Patricia Hills, *Painting Harlem Modern: The Art of Jacob Lawrence* (Berkeley: University of California Press, 2010)

Alain Locke (ed.), *The New Negro: An Interpretation* (first published 1925; New York: Atheneum, 1968)

Guy C. McElroy, Richard J. Powell, and Sharon F. Patton, *African-American Artists 1880–1987: Selections from the Evans-Tibbs Collection* (Washington, D.C.: Smithsonian Institution Traveling Exhibition Service, 1989)

James A. Porter, *Modern Negro Art* (first published 1943; Washington, D.C.: Howard University Press, 1992)

Joanna Skipworth (ed.), *Rhapsodies in Black: Art of the Harlem Renaissance* (London: Hayward Gallery, 1997)

ABSTRACT EXPRESSIONISM

David Anfam, *Abstract Expressionism*, second edition (London and New York: Thames & Hudson, 2015)

David Anfam, *Jackson Pollock's Mural: Energy Made Visible* (London and New York: Thames & Hudson, 2015)

David Anfam (ed.), *Mark Rothko: The Works on Canvas*, catalogue raisonné (New Haven and London: Yale University Press, 1998)

Marcia Brennan, *Modernism's Masculine Subjects: Matisse, the New York School, and Post-Painterly Abstraction* (Cambridge, Mass.: MIT Press, 2004)

T. J. Clark, "The Unhappy Consciousness" and "In Defense of Abstract Expressionism," *Farewell to an Idea* (New Haven and London: Yale University Press, 1999)

Harry Cooper, *Mark Rothko: An Essential Reader* (Houston: Museum of Fine Arts, 2015)

John Elderfield (ed.), *De Kooning: A Retrospective* (New York: Museum of Modern Art, 2011)

Francis Frascina (ed.), *Pollock and After: The Critical Debate* (New York: Harper & Row, 1985)

Serge Guilbaut, *How New York Stole the Idea of Modern Art: Abstract Expressionism, Freedom, and the Cold War* (Chicago: University of Chicago Press, 1983)

Melissa Ho, *Reconsidering Barnett Newman* (New Haven and London: Yale University Press, 2005)

Rosalind Krauss, *Willem de Kooning Nonstop: Cherchez La Femme* (Chicago: University of Chicago Press, 2015)

Ellen G. Landau, *Reading Abstract Expressionism: Context and Critique* (New Haven and London: Yale University Press, 2005)

Michael Leja, *Reframing Abstract Expressionism: Subjectivity and Painting in the 1940s* (New Haven and London: Yale University Press, 1993)

Barnett Newman, *Selected Writings and Interviews*, ed. John O'Neill (Berkeley: University of California Press, 1992)

Francis O'Connor and Eugene Thaw (eds), *Jackson Pollock: A Catalogue Raisonné of Paintings, Drawings, and Other Works* (New Haven and London: Yale University Press, 1977)

Ad Reinhardt, *Art as Art: Selcted Writings of Ad Reinhardt*, ed. Barbara Rose (Berkeley: University of California Press, 1991)

Harold Rosenberg, *The Tradition of the New* (New York: Horizon Press, 1959)

Irving Sandler, *Abstract Expressionism: The Triumph of American Painting* (London: Pall Mall, 1970)

David Shapiro and Cecile Shapiro, *Abstract Expressionism: A Critical Record* (Cambridge: Cambridge University Press, 1990)

Kirk Varnedoe with Pepe Karmel, *Jackson Pollock* (New York: Museum of Modern Art, 1998)

DUBUFFET, FAUTRIER, KLEIN, AND NOUVEAU RÉALISME

Jean-Paul Ameline, *Les Nouveaux Réalistes* (Paris: Centre Georges Pompidou, 1992)

Nuit Banai, *Yves Klein* (Chicago: University of Chicago Press, 2015)

Benjamin H. D. Buchloh, "From Detail to Fragment: Décollage/Affichiste," *Décollage: Les Affichistes* (New York and Paris: Virginia Zabriske Gallery, 1990)

Curtis L. Carter and Karen L. Butler (eds), *Jean Fautrier* (New Haven and London: Yale University Press, 2002)

Bernadette Contensou (ed.), *1960: Les Nouveaux Réalistes* (Paris: Musée d'Art Moderne de la Ville de Paris, 1986)

Hubert Damisch, "The Real Robinson," *October*, no. 85, Summer 1998

Jean Dubuffet, *Prospectus et tous écrits suivants*, four volumes, ed. Hubert Damisch (Paris: Gallimard, 1967–91) and "Notes for the well read" (1945), trans. in M. Glimcher, *Jean Dubuffet: Towards an Alternative Reality* (New York: Pace Publications and Abbeville Press, 1987)

Catherine Francblin, *Les Nouveaux Réalistes* (Paris: Editions du Regard, 1997)

Thomas F. McDonough, *"The Beautiful Language of My Century": Reinventing the Language of Contestation in Postwar France, 1945–1968* (Cambridge, Mass.: MIT Press, 2007)

Rachel Perry, "Jean Fautrier's *Jolies Juives*," *October*, no. 108, Spring 2004

Francis Ponge, *L'Atelier contemporain* (Paris: Gallimard, 1977)

Jean-Paul Sartre, "Fingers and Non-Fingers," translated in Werner Haftmann (ed.), *Wols* (New York: Harry N. Abrams, 1965)

RAUSCHENBERG, JOHNS, AND OTHERS

Yve-Alain Bois, *Ellsworth Kelly: Catalogue Raisonné of Paintings, Reliefs, and Sculpture Vol. 1, 1940–1953* (London and New York: Thames & Hudson, 2015)

Yve-Alain Bois, *Ellsworth Kelly: The Early Drawings, 1948–1955* (Cambridge, Mass.: Harvard University Press, 1999)

Russell Ferguson (ed.), *Hand-Painted Pop: American Art in Transition, 1955–62* (Los Angeles: Museum of Contemporary Art, 1993)

Walter Hopps, Susan Davidson et al., *Robert Rauschenberg: A Retrospective* (New York: Guggenheim Museum, 1997)

Walter Hopps, *Robert Rauschenberg: The Early 1950s* (Houston: Menil Collection, 1991)

Hiroko Ikegami, *The Great Migrator: Robert Rauschenberg and the Global Rise of American Art* (Cambridge, Mass.: MIT Press, 2010)

Jasper Johns, *Writings, Sketchbook Notes, Interviews* (New York: Museum of Modern Art/ Harry N. Abrams, 1996)

Branden W. Joseph (ed.), *Robert Rauschenberg*, October Files 4 (Cambridge, Mass.: MIT Press, 2002)

Branden W. Joseph, *Random Order: Robert Rauschenberg and the Neo-Avant-Garde* (Cambridge, Mass.: MIT Press, 2003)

Fred Orton, *Figuring Jasper Johns* (Cambridge: Harvard University Press, 1994)

James Rondeau, *Jasper Johns: Gray* (Chicago: Art Institute of Chicago, 2007)

Leo Steinberg, *Other Criteria: Confrontations with Twentieth-Century Art* (London, Oxford, and New York: Oxford University Press, 1972)

Kirk Varnedoe, *Jasper Johns: A Retrospective* (New York: Museum of Modern Art, 1996)

Jeffrey Weiss, *Jasper Johns: An Allegory of Painting, 1955–1965* (New Haven and London: Yale University Press, 2007)

FONTANA, MANZONI, AND ARTE POVERA

Yve-Alain Bois, "Fontana's Base Materialism," *Art in America*, vol. 77, no. 4, April 1989

Germano Celant, *Arte Povera* (Milan: Gabriele Mazzotta; New York: Praeger; London: Studio Vista, 1969)

Germano Celant, *The Knot: Arte Povera* (New York: P.S.1; Turin: Umberto Allemandi, 1985)

Germano Celant (ed.), *Piero Manzoni* (London: Serpentine Gallery, 1998)

Carolyn Christov-Bakargiev (ed.), *Arte Povera* (London: Phaidon, 1999)

Richard Flood and Frances Morris (eds), *Zero to Infinity: Arte Povera 1962–1972* (Minneapolis: Walker Art Gallery; London: Tate Gallery, 2002)

Jaleh Mansoor, "Piero Manzoni: 'We Want to Organicize Disintegration'," *October*, no. 95, Winter 2001

Jon Thompson (ed.), *Gravity and Grace: Arte Povera/Post Minimalism* (London: Hayward Gallery, 1993)

Anthony White, *Lucio Fontana: Between Utopia and Kitsch*, October Books (Cambridge, Mass.: MIT Press, 2012)

Sarah Whitfield, *Lucio Fontana* (London: Hayward Gallery, 1999)

COBRA AND SITUATIONISM

Iwona Blazwick (ed.), *An Endless Adventure—An Endless Passion—An Endless Banquet: A Situationist Scrapbook* (London: Verso, 1989)

Guy Debord, *The Society of the Spectacle* (1967), trans. Donald Nicholson-Smith (Cambridge, Mass.: MIT Press, 2002)

Ken Knabb (ed.), *Situationist International Anthology* (Berkeley: Bureau of Public Secrets, 1981)

Karen Kurczynski, *The Art and Politics of Asger Jorn: The Avant-Garde Won't Give Up* (London: Ashgate, 2014)

Thomas F. McDonough (ed.), *Guy Debord and the Situationist International* (Cambridge, Mass.: MIT Press, 2002)

Willemijn Stokvis, *Cobra: The Last Avant-Garde Movement of the Twentieth Century* (Aldershot: Lund Humphries, 2004)

Elisabeth Sussman (ed.), *On the Passage of a Few People Through a Rather Brief Moment in Time: The Situationist International 1957–1972* (Cambridge, Mass.: MIT Press, 1989)

GUTAI, NEOCONCRETISM, AND NONWESTERN MODERNISM

Barbara von Bertozzi and Klaus Wolbert (eds), *Gutai: Japanese Avant-Garde 1954–1965* (Darmstadt: Mathildenhöhe, 1991)

Guy Brett et al., *Hélio Oiticica* (Minneapolis: Walker Art Center, 1994)

Guy Brett et al., *Lygia Clark* (Barcelona: Fundació Antoni Tàpies, 1997)

Guy Brett et al., *Lygia Pape: Magnetized Space* (London: Serpentine Gallery, 2011)

Cornelia Butler and Luis Pérez-Oramas, *Lygia Clark: The Abandonment of Art 1948–1988* (New York: Museum of Modern Art, 2014)

Luciano Figueiredo et al., *Hélio Oiticica: The Body of Color* (Houston: Museum of Fine Arts, 2007)

Gutai magazine, facsimile edition (with complete English translation) (Ashiya: Ashiya City Museum of Art and History, 2010)

Sergio Martins, *Constructing an Avant-Garde: Art in Brazil 1949–1979* (Cambridge, Mass.: MIT Press, 2013)

Tetsuya Oshima, "'Dear Mr. Jackson Pollock': A Letter from Gutai," in Ming Tiampo (ed.), *"Under Each Other's Spell": Gutai and New York* (East Hampton: Pollock-Krasner House, 2009)

Ming Tiampo, *Gutai: Decentering Modernism* (Chicago: Chicago University Press, 2011)

Ming Tiampo and Alexandra Munroe, *Gutai: Splendid Playground* (New York: Guggenheim Museum, 2013)

Paulo Venancio Filho, *Reinventing the Modern: Brazil* (Paris: Gagosian Gallery, 2011)

POP

Darsie Alexander and Bartholomew Ryan (eds), *International Pop* (Minneapolis: Walker Art Center, 2015)

Lawrence Alloway, *American Pop Art* (New York: Collier Books, 1974)

Graham Bader, *Roy Lichtenstein*, October Files 7 (Cambridge, Mass.: MIT Press, 2009)

Graham Bader, *Hall of Mirrors: Roy Lichtenstein and the Face of Painting in the 1960s* (Cambridge, Mass.: MIT Press, 2010)

Yve-Alain Bois, *Edward Ruscha: Romance with Liquids* (New York: Gagosian Gallery, 1993)

Benjamin H. D. Buchloh, *Andy Warhol: Shadows and Other Signs of Life* (Cologne: Walther König, 2008)

Thomas Crow, *The Long March of Pop: Art, Music, and Design, 1930–1995* (New Haven: Yale University Press, 2014)

Thomas Crow, *The Rise of the Sixties: American and European Art in the Era of Dissent* (New York: Abrams, 1996)

Hal Foster, *The First Pop Age: Painting and Subjectivity in the Art of Hamilton, Lichtenstein, Warhol, Richter, and Ruscha* (Princeton: Princeton University Press, 2014)

Hal Foster (ed.), *Richard Hamilton*, October Files 10 (Cambridge, Mass.: MIT Press, 2010)

Hal Foster and Mark Francis, *Pop Art* (London: Phaidon, 2005)

Lucy Lippard, *Pop Art* (London: Thames & Hudson, 1966)

Marco Livingstone, *Pop Art: A Continuing History* (London: Thames & Hudson, 2000)

Michael Lobel, *Image Duplicator: Roy Lichtenstein and the Emergence of Pop Art* (New Haven: Yale University Press, 2002)

Michael Lobel, *James Rosenquist: Pop Art, Politics, and History in the 1960s* (Berkeley: University of California Press, 2009)

Steven Henry Madoff, *Pop Art: A Critical History* (Berkeley: University of California Press, 1997)

Kynaston McShine (ed.), *Andy Warhol: A Retrospective* (New York: Museum of Modern Art, 1989)

Annette Michelson (ed.), *Andy Warhol*, October Files 2 (Cambridge, Mass.: MIT Press, 2001)

Jessica Morgan and Flavia Frigeri (eds), *The World Goes Pop* (New Haven and London: Yale University Press, 2015)

David Robbins (ed.), *The Independent Group: Postwar Britain and the Aesthetics of Plenty* (Cambridge, Mass.: MIT Press, 1990)

James Rondeau and Sheena Wagstaff, *Roy Lichtenstein: A Retrospective* (Chicago: Art Institute of Chicago, 2012)

Nadja Rottner (ed.), *Claes Oldenburg*, October Files 13 (Cambridge, Mass.: MIT Press, 2012)

Ed Ruscha, *Leave Any Information at the Signal: Writings, Interviews, Bits, Pages* (Cambridge, Mass.: MIT Press, 2002)

John Russell and Suzi Gablik, *Pop Art Redefined* (New York: Praeger, 1969)

Alexandra Schwartz, *Ed Ruscha's Los Angeles* (Cambridge, Mass.: MIT Press, 2010)

Paul Taylor, *Post-Pop Art* (Cambridge, Mass.: MIT Press, 1989)

Cecile Whiting, *A Taste for Pop: Pop Art, Gender, and Consumer Culture* (Cambridge: Cambridge University Press, 1997)

CAGE, KAPROW, AND FLUXUS

Elizabeth Armstrong, *In the Spirit of Fluxus* (Minneapolis: Walker Art Center, 1993)

Benjamin H. D. Buchloh, and Judith Rodenbeck (eds), *Experiments in the Everyday: Allan Kaprow and Robert Watts—Events, Objects, Documents* (New York: Wallach Gallery, Columbia University, 1999)

John Cage, *Silence* (Hanover, N.H.: Weslyan University Press, 1939)

Rudolf Frieling and Boris Groys, *The Art of Participation: 1950 to Now* (London: Thames & Hudson, 2008)

Jon Hendricks (ed.), *Fluxus Codex* (Detroit: Gilbert and Lila Silverman Fluxus Collection, 1988)

Branden W. Joseph, *Beyond the Dream Syndicate: Tony Conrad and the Arts After Cage* (New York: Zone Books, 2008)

Allan Kaprow, *Assemblage, Environments & Happenings* (New York: Abrams, 1966)

Allan Kaprow, *Essays on the Blurring of Art and Life* (Berkeley: University of California Press, 1993)

Liz Kotz, "Post-Cagean Aesthetics and the 'Event' Score," *October*, no. 95, Winter 2001

Julia Robinson (ed.), *John Cage*, October Files 12 (Cambridge, Mass.: MIT Press, 2011)

POSTWAR GERMAN ART

Dan Adler, *Hanne Darboven: Cultural History 1880–1983* (Cambridge, Mass.: MIT Press, 2009)

Danielle Arasse, *Anselm Kiefer* (New York and London: Thames & Hudson, 2015)

Georg Baselitz and Eugen Schönebeck, *Pandämonium Manifestoes*, excerpts in English translation in Andreas Papadakis (ed.), *German Art Now*, vol. 5, no. 9–10, 1989

Joseph Beuys, *Where Would I Have Got If I Had Been Intelligent!* (New York: Dia Center for the Arts, 1994)

Benjamin H. D. Buchloh, *Gerhard Richter, 18 Oktober 1977* (London: Institute of Contemporary Arts, 1989)

Benjamin H. D. Buchloh, "Gerhard Richter's Atlas: The Anomic Archive," *October*, no. 88, Spring 1999

Benjamin H. D. Buchloh, "Joseph Beuys at the Guggenheim," *October*, no. 12, Spring 1980

Benjamin H. D. Buchloh (ed.), *Gerhard Richter*, October Files 8 (Cambridge, Mass.: MIT Press, 2009)

Lynne Cooke, Karen Kelly, and Barbara Schröde (eds), *Blinky Palermo: Retrospective 1964–77* (New Haven and London: Yale University Press, 2010)

Stefan Germer, "Die Wiederkehr des Verdrängten. Zum Umgang mit deutscher Geschichte bei Baselitz, Kiefer, Immendorf und Richter," in Julia Bernard (ed.), *Germeriana: Unveröffentlichte oder übersetzte Schriften von Stefan Germer* (Cologne: Oktagon Verlag, 1999)

Siegfried Gohr, "In the Absence of Heroes: The Early Work of Georg Baselitz," *Artforum*, vol. 20, no. 10, Summer 1982

Tom Holert, "Bei Sich, über allem: Der symptomatische Baselitz," *Texte zur Kunst*, vol. 3, no. 9, March 1993

Andreas Huyssen, "Anselm Kiefer: The Terror of History, the Temptation of Myth," *October*, no. 48, Spring 1989

Kevin Power, "Existential Ornament," in Maria Corral (ed.), *Georg Baselitz* (Madrid: Fundacion Caja de Pensiones, 1990)

Gerhard Richter, *The Daily Practice of Painting: Writings 1960–1993* (London: Thames & Hudson, 1995)

Gerhard Richter, *Text: Writings, Interviews and Letters 1961–2007*, ed. Dietmar Elger and Hans Ulrich Obrist (London: Thames & Hudson, 2009)

Margit Rowell, *Sigmar Polke: Works on Paper, 1963–1974* (New York: Museum of Modern Art, 1999)

Caroline Tisdall, *Joseph Beuys: Coyote* (London: Thames & Hudson, 2008)

MINIMALISM, POSTMINIMALISM, AND POSTWAR SCULPTURE

Carl Andre, *Cuts: Texts 1959–2004*, ed. James Meyer (Cambridge, Mass.: MIT Press, 2005)

Carl Andre and Hollis Frampton, *12 Dialogues, 1962–1963*. Halifax: The Press of the Nova Scotia College of Art and Design, 1981)

Jo Applin, *Eccentric Objects: Rethinking Sculpture in 1960s America* (New Haven: Yale University Press, 2012)

Gregory Battcock, *Minimal Art: A Critical Anthology* (New York: E. P. Dutton, 1968)

Tiffany Bell and Frances Morris (eds), *Agnes Martin* (London: Tate, 2015)

Maurice Berger, *Labyrinths: Robert Morris, Minimalism and the 1960s* (New York: Harper & Row, 1989)

Julia Bryan-Wilson (ed.), *Robert Morris*, October Files 15 (Cambridge, Mass.: MIT Press, 2013)

Lynne Cooke and Karen Kelly (eds), *Agnes Martin* (New Haven and London: Yale University Press, 2011)

Hal Foster (ed.), *Richard Serra*, October Files 1 (Cambridge, Mass.: MIT Press, 2000)

Carmen Gimenez, Hal Foster, et al., *Richard Serra: The Matter of Time* (Göttingen: Steidl, 2005)

Ann Goldstein (ed.), *A Minimal Future? Art as Object 1958–1968* (Los Angeles: Museum of Contemporary Art, 2004)

Suzanne P. Hudson, *Robert Ryman: Used Paint* (Cambridge, Mass.: MIT Press, 2009)

Donald Judd, *Donald Judd, Complete Writings, 1959–1975* (Halifax: The Press of the Nova Scotia College of Art and Design, 1975)

Rosalind Krauss, *Passages in Modern Sculpture* (New York: Viking Press, 1977

Rosalind Krauss, *The Sculpture of David Smith: A Catalogue Raisonné* (New York: Garland Publishing, 1977)

Lucy Lippard, *Eva Hesse* (New York: Da Capo Press, 1992)

James Meyer, *Minimalism: Art and Polemics in the Sixties* (New Haven and London: Yale University Press, 2001)

Robert Morris, *Continuous Project Altered Daily: The Writings of Robert Morris* (Cambridge, Mass.: MIT Press, 1993)

Mignon Nixon (ed.), *Eva Hesse*, October Files 3 (Cambridge, Mass.: MIT Press, 2002)

Mignon Nixon, *Fantastic Reality: Louise Bourgeois and a Story of Modern Art* (Cambridge, Mass.: MIT Press, 2005)

Nancy Princenthal, *Agnes Martin: Her Life and Art* (London and New York: Thames & Hudson, 2015)

Julia Robinson, (ed.), *New Realisms, 1957–1962: Object Strategies Between Readymade and Spectacle* (Madrid: Museo Nacional Centro De Arte Reina Sofía; And Cambridge, Mass.: MIT Press, 2010)

Corinna Thierolf and Johannes Vogt, *Dan Flavin: Icons* (London: Thames & Hudson, 2009)

Clara Weyergraf-Serra and Martha Buskirk (eds), *The Destruction of Tilted Arc: Documents* (Cambridge, Mass.: MIT Press, 1991)

EARTHWORKS, PROCESS ART, AND ENTROPY

Suzaan Boettger, *Earthworks: Art and the Landscape of the Sixties* (Berkeley: University of California Press, 2003)

Thomas Crow et al., *Gordon Matta-Clark* (London: Phaidon, 2003)

Robert Hobbs, *Robert Smithson: Sculpture* (Ithaca, N.Y.: Cornell University Press, 1981)

Bruce Jenkins, *Gordon Matta-Clark: Conical Intersect* (Cambridge, Mass.: MIT Press, 2011)

Philipp Kaiser and Miwon Kwon, *Ends of the Earth: Land Art to 1974* (Los Angeles and New York: Museum of Contemporary Art, Los Angeles in association with Prestel, 2012)

Pamela Lee, *Chronophobia* (Cambridge, Mass.: MIT Press, 2004)

Pamela Lee, *Object to be Destroyed: The Work of Gordon Matta-Clark* (Cambridge, Mass.: MIT Press, 2000)

James Nisbet, *Ecologies, Environments, and Energy Systems in Art of the 1960s and 1970s* (Cambridge, Mass.: MIT Press, 2014)

Ann Reynolds, *Robert Smithson: Learning from New Jersey and Elsewhere* (Cambridge, Mass.: MIT Press, 2003)

Jennifer L. Roberts, *Mirror-Travels: Robert Smithson and History* (New Haven: Yale University Press, 2004)

Robert Smithson, *The Collected Writings*, ed. Jack Flam (Berkeley: University of California Press, 1996)

Eugenie Tsai (ed.), *Robert Smithson* (Berkeley: University of California Press, 2004)

CONCEPTUAL ART

Alexander Alberro and Sabeth Buchmann (eds), *Art After Conceptual Art* (Cambridge, Mass.: MIT Press, 2007)

Alexander Alberro and Blake Stimson (eds), *Conceptual Art and the Politics of Publicity* (Cambridge, Mass.: MIT Press, 2003)

Mel Bochner, *Solar System & Rest Rooms: Writings and Interviews, 1965–2007*, foreword by Yve-Alain Bois (Cambridge, Mass.: MIT Press, 2008)

Benjamin H. D. Buchloh, "Conceptual Art 1962–69: From an Aesthetics of Administration to the Critique of Institutions," *October*, no. 55, Winter 1990

Ann Goldstein (ed.), *Reconsidering the Object of Art: 1965–1975* (Los Angeles, Museum of Contemporary Art, 1995)

Boris Groys, *History Becomes Form: Moscow Conceptualism* (Cambridge, Mass.: MIT Press, 2010)

Boris Groys (ed.), *Total Enlightenment: Conceptual Art in Moscow 1960–1990* (Frankfurt: Schirn Kunsthalle and Ostfildern: Hatje Cantz, 2008)

Joseph Kosuth, *Art After Philosophy and After: Collected Writing 1966–1990* (Cambridge, Mass.: MIT Press, 1991)

Liz Kotz, *Words to Be Looked At: Language in 1960s Art* (Cambridge, Mass.: MIT Press, 2007)

Lucy Lippard, *Six Years: The Dematerialization of the Art Object 1966–1972* (Berkeley: University of California Press, 1973)

Ursula Meyer, *Conceptual Art* (New York: Dutton, 1972)

Kynaston McShine, *Information* (New York: MoMA, 1970)

Anne Rorimer, *New Art in the 60s and 70s: Redefining Reality* (New York: Thames & Hudson, 2001)

Blake Stimson and Alexander Alberro (eds), *Conceptual Art : An Anthology of Critical Writings and Documents* (Cambridge, Mass.: MIT Press, 2000)

Margarita Tupitsyn, "About Early Moscow Conceptualism," in Luis Camnitzer, Jane Farver, and Rachel Weiss (eds), *Global Conceptualism: Points of Origin 1950s–1980s* (New York: Queens Museum of Art, 1999)

INSTALLATION, INSTITUTIONAL CRITIQUE, AND SITE-SPECIFICITY

Alexander Alberro (ed.), *Museum Highlights: The Writings of Andrea Fraser* (Cambridge, Mass.: MIT Press, 2005)

Alexander Alberro and Blake Stimson (eds), *Institutional Critique: An Anthology of Artists' Writings* (Cambridge, Mass.: MIT Press, 2009)

Michael Asher, *Writings 1973–1983 on Works 1969–1979* (Halifax: The Press of the Nova Scotia College of Art and Design, 1983)

Claire Bishop, *Installation Art: A Critical History* (New York: Routledge, 2005)

Marcel Broodthaers, *Broodthaers: Writings, Interviews, Photographs* (Cambridge, Mass.: MIT Press, 1987)

Julia Bryan-Wilson, *Art Workers: Radical Practice in the Vietnam War Era* (Berkeley: University of California Press, 2009)

Daniel Buren, *Daniel Buren: Les Couleurs, Sculptures, Les Formes, Peintures* (Paris: Centre Georges Pompidou, 1981)

Victor Burgin, "Situational Aesthetics," *Studio International*, vol. 178, no. 915, October 1969

Rachel Churner (ed.), *Hans Haacke*, October Files 18 (Cambridge, Mass.: MIT Press, 2015)

Rosalyn Deutsche, *Evictions: Art and Spatial Politics* (Cambridge, Mass.: MIT Press, 1996)

Dan Graham, *Two-Way Mirror Power: Selected Writings by Dan Graham on His Art* (Cambridge, Mass.: MIT Press, 1999)

Dan Graham, *Video, Architecture, Television: Writings on Video and Video Works, 1970–1978* (Halifax: The Press of the Nova Scotia College of Art and Design, 1979)

Hans Haacke, *Unfinished Business* (Cambridge, Mass.: 1986)

Rachel Haidu, *The Absence of Work: Marcel Broodthaers, 1964–1976* (Cambridge, Mass.: MIT Press, 2011)

Jennifer King (ed.), *Michael Asher*, October Files 19 (Cambridge, Mass.: MIT Press, 2016)

Alex Kitnick (ed.), *Dan Graham*, October Files 11 (Cambridge, Mass.: MIT Press, 2011)

Rosalind Krauss, "The Cultural Logic of the Late Capitalist Museum," *October*, no. 54, Fall 1990

Miwon Kwon, *One Place After Another: Site-Specific Art and Locational Identity* (Cambridge, Mass.: MIT Press, 2002)

Jennifer Licht, *Spaces* (New York: Museum of Modern Art, 1969)

Brian O'Doherty, *Inside the White Cube: The Ideology of the Gallery Space* (Berkeley and Los Angeles: University of California Press, 1999)

Spyros Papapetros and Julian Rose (eds), *Retracing the Expanded Field: Encounters between Art and Architecture* (Cambridge, Mass.: MIT Press, 2014)

Kirsi Peltomäki, *Situation Aesthetics: The Work of Michael Asher* (Cambridge, Mass.: MIT Press, 2010)

Birgit Pelzer, Mark Francis, and Beatriz Colomina, *Dan Graham* (London: Phaidon, 2001)

Erica Suderburg (ed.), *Space, Site, Intervention: Situating Installation Art* (Minneapolis: University of Minnesota Press, 2000)

Marsha Tucker, *Anti-Illusion: Procedures/Materials* (New York: Whitney Museum of American Art, 1969)

Fred Wilson, *Mining the Museum* (Baltimore: Museum of Contemporary Art, 1994)

PERFORMANCE AND BODY ART

Sally Banes, *Democracy's Body: Judson Dance Theater, 1962–1964* (Durham, N.C.: Duke University Press, 1993)

Stephen Barber, *Performance Projections: Film and the Body in Action* (London: Reaktion Books, 2015)

Sabine Breitwieser (ed.), *Simone Forti: Thinking with the Body* (Chicago: Hirmer, 2015)

Julia Bryan-Wilson, *Art Workers: Radical Practice in the Vietnam War Era* (Berkeley: University of California Press, 2009)

Rudolf Frieling and Boris Groys, *The Art of Participation: 1950 to Now* (London: Thames & Hudson, 2008)

RoseLee Goldberg, *Performance Art: From Futurism to the Present* (London and New York: Thames & Hudson, 2001)

RoseLee Goldberg, *Performance: Live Art Since the 60s* (London: Thames & Hudson, 2004)

Adrian Heathfield and Tehching Hsieh, *Out of Now: The Lifeworks of Tehching Hsieh* (Cambridge, Mass.: MIT Press, 2009)

Fred Hoffman et al., *Chris Burden* (London: Thames & Hudson, 2007)

Amelia Jones, *Body Art: Performing the Subject* (Minneapolis: University of Minnesota Press, 1998)

Amelia Jones and Andrew Stephenson (eds), *Performing the Body/Performing the Text* (London and New York: Routledge, 1999)

Carrie Lambert-Beatty, *Being Watched: Yvonne Rainer and the 1960s* (Cambridge, Mass.: MIT Press, 2008)

Sally O'Reilly, *The Body in Contemporary Art* (London: Thames & Hudson, 2009)

Paul Schimmel and Russell Ferguson (eds), *Out of Actions: Between Performance and the Object: 1949–1979* (Los Angeles: Museum of Contemporary Art, New York, 1998)

Kristine Stiles, "Uncorrupted Joy: International Art Actions," in Paul Schimmel and Russell Ferguson (eds), *Out of Actions: Between Performance and the Object 1949–1979* (London: Thames & Hudson, 1998)

Frazer Ward, "Some Relations Between Conceptual and Performance Art." *Art Journal*, vol. 56, no. 4, Winter 1997

Anne Wagner, "Performance, Video, and the Rhetoric of Presence," *October*, no. 91, Winter 2000

FEMINISM, POSTCOLONIAL ART, IDENTITY ART, AND POLITICIZED ART

Carol Armstrong and Catherine de Zegher (eds), *Women Artists at the Millennium* (Cambridge, Mass.: MIT Press, 2006)

Homi Bhabha, *The Location of Culture* (London: Routledge, 1994)

Gregg Bordowitz, *General Idea: Imagevirus (The AIDS Project)* (Cambridge, Mass.: MIT Press, 2010)

John P. Bowles, *Adrian Piper: Race, Gender, and Embodiment* (Durham, N.C.: Duke University Press, 2011)

Julia Bryan-Wilson, *Art Workers: Radical Practice in the Vietnam War Era* (Berkeley: University of California Press, 2009)

Cornelia H. Butler and Lisa Gabrielle Mark (eds), *WACK!: Art and the Feminist Revolution* (Cambridge, Mass.: MIT Press, 2007)

Judith Butler, *Gender Trouble: Feminism and the Subversion of Identity* (New York: Routledge, 1989)

Gavin Butt, *Between You and Me: Queer Disclosures in the New York Art World, 1948–1963* (Durham, N.C.: Duke University Press, 2005)

Judy Chicago, *Beyond the Flower: The Autobiography of a Feminist Artist* (New York: Viking, 1996)

Judy Chicago, *The Dinner Party: Restoring Women to History* (New York: Monacelli Press, 2014)

Douglas Crimp (ed.), *AIDS: Cultural Analysis/Cultural Activism* (Cambridge, Mass.: MIT Press, 1988)

Douglas Crimp and Adam Rolston (eds), *AIDS DEMOgraphics* (Seattle: Bay Press, 1990)

Olivier Debroise (ed.), *The Age of Discrepancies: Art and Visual Culture in Mexico 1968–1997* (Mexico City: Universidad Nacional Autónoma de México; Madrid: Turner, 2006)

Darby English, *How to See a Work of Art in Total Darkness* (Cambridge, Mass.: MIT Press, 2007)

Ales Erjavac (ed.), *Postmodernism and the Postsocialist Condition: Politicized Art under Late Socialism* (Berkeley: University of California Press, 2003)

Sujatha Fernandes, *Cuba Represented: Cuban Arts, State Power, and the Making of New Revolutionary Cultures* (Durham, N.C.: Duke University Press, 2006)

Joanna Frueh, Cassandra L. Langer, and Arlene Raven (eds), *New Feminist Art Criticism: Art, Identity, Action* (New York: HarperCollins, 1994)

Coco Fusco, *The Bodies That Were Not Ours* (New York: Routledge, 2001)

Thelma Golden, *Black Male: Representations of Masculinity in Contemporary Art* (New York: Whitney Museum of American Art, 1994)

Jennifer A. González, *Subject to Display: Reframing Race in Contemporary Installation Art* (Cambridge, Mass.: MIT Press, 2008)

Stuart Hall and Mark Sealy, *Different: Contemporary Photography and Black Identity* (London: Phaidon, 2001)

Harmony Hammond, *Lesbian Art in America: A Contemporary History* (New York: Rizzoli International Publications, 2000)

Amelia Jones and Erin Silver, *Otherwise: Imagining Queer Feminist Art Histories* (Manchester: Manchester University Press, 2016)

Jonathan David Katz and Rock Hushka, *Art AIDS America* (Seattle: University of Washington Press, 2015)

Mary Kelly, *Imaging Desire* (Cambridge, Mass.: MIT Press, 1997)

Zoya Kocur (ed.), *Global Visual Cultures: An Anthology* (Chichester: Wiley-Blackwell, 2011)

Lucy R. Lippard, *Get the Message? A Decade of Social Change* (New York: Dutton, 1984)

Lucy R. Lippard, *The Pink Glass Swan: Selected Essays in Feminist Art* (New York: New Press, 1995)

Jean-Hubert Martin et al., *Les Magiciens de la terre* (Paris: Centre Georges Pompidou, 1989)

Kobena Mercer, *Welcome to the Jungle: New Positions in Cultural Studies* (New York: Routledge, 1994)

Gerardo Mosquera and Jean Fisher, *Over Here: International Perspectives on Art and Culture* (Cambridge, Mass.: MIT Press, 2005)

Lisa Ryan Musgrave (ed.), *Feminist Aesthetics and Philosophy of Art: The Power of Critical Visions and Creative Engagement* (New York: Springer, 2014)

Linda Nochlin, *Women, Art and Power: And Other Essays* (New York: Harper & Row, 1988; and London: Thames & Hudson, 1989)

Linda Nochlin, *Women Artists: The Linda Nochlin Reader*, ed. Maura Reilly (London and New York: Thames & Hudson, 2015)

Roszika Parker and Griselda Pollock, *Framing Feminism: Art and the Women's Movement 1970–85* (London: Pandora, 1987)

Griselda Pollock, *Vision and Difference: Femininity, Feminism, and Histories of Art* (New York: Routledge, 1988)

Helaine Posner (ed.), *Corporal Politics* (Cambridge, Mass.: MIT List Visual Arts Center, 1992)

Maura Reilly and Linda Nochlin (eds), *Global Feminisms: New Directions in Contemporary Art* (New York: Brooklyn Museum and Merrell Publishers, 2007)

Blake Stimson and Gregory Sholette (eds), *The Art of Social Imagination after 1945* (Minneapolis: University of Minnesota Press, 2007)

Catherine de Zegher (ed.), *Inside the Visible: An Elliptical Traverse of 20th-Century Art* (Cambridge, Mass.: MIT Press, 1994)

PHOTOGRAPHY, FILM, VIDEO, AND THE PROJECTED IMAGE

Dawn Ades, *Photomontage* (London: Thames & Hudson, 1976)

Carol Armstrong, *Scenes in a Library: Reading the Photograph in the Book* (Cambridge, Mass.: MIT Press, 1998)

George Baker (ed.), *James Coleman*, October Files 5 (Cambridge, Mass.: MIT Press, 2003)

Béla Balázs, *Theory of the Film: Character and Growth of a New Art* (London: D. Dobson, 1952)

Peter Barberie, *Paul Strand: Master of Modern Photography* (New Haven: Philadelphia Museum of Art, Fundacion Mapfre, and Yale University Press, 2014)

Roland Barthes, *Camera Lucida: Reflections on Photography*, trans. Richard Howard (New York: Hill and Wang, 1981)

Roland Barthes, "The Photographic Message" and "The Rhetoric of the Image," *Image/Music/Text* (New York: Hill and Wang, 1977)

Geoffrey Batchen, *Photography Degree Zero* (Cambridge, Mass.: MIT Press, 2009)

André Bazin, *What is Cinema?*, vol. 1, trans. Hugh Gray (Berkeley: University of California Press, 1967)

John Berger, *Another Way of Telling* (New York: Pantheon, 1982)

Jennifer Blessing, *Catherine Opie: American Photographer* (New York: Solomon R. Guggenheim Museum, 2008)

Jay Bochner, *An American Lens: Scenes from Alfred Stieglitz's New York Secession* (Cambridge, Mass.: MIT Press, 2005)

Stan Brakhage, *The Essential Brakhage* (Kingston, N.Y.: McPherson & Company, 2001)

Benjamin H. D. Buchloh, "Allegorical Procedures: Appropriation and Montage in Contemporary Art," *Artforum*, vol. 21, no. 1, September 1982

Johanna Burton (ed.), *Cindy Sherman*, October Files 6 (Cambridge, Mass.: MIT Press, 2006)

Noel Burch, *Theory of Film Practice*, trans. Helen R. Lane (New York: Praeger, 1973)

Stanley Cavell, *The World Viewed: Reflections on the Ontology of Film* (Cambridge: Harvard University Press, 1971)

Diarmuid Costello and Margaret Iversen (eds), *Photography After Conceptual Art* (*Art History* Special Issues) (Chichester: Wiley-Blackwell, 2010)

Charlotte Cotton, *The Photograph as Contemporary Art* (London: Thames & Hudson, 2009)

Malcolm Daniel, *Stieglitz, Steichen, Strand* (New Haven and London: Yale University Press, 2010)

Corinne Diserens (ed.), *Chasing Shadows: Santu Mofokeng—Thirty Years of Photographic Essays* (Munich: Prestel, 2011)

Mary Ann Doane, "Information, Crisis, Catastrophe" in Patricia Mellencamp (ed.), *Logics of Television: Essays in Cultural Criticism* (Bloomington: Indiana University Press, 1990)

Sergei Eisenstein, *Film Form: Essays in Film Theory* (San Diego: Harvest Books, 1969)

Okwui Enwezor and Rory Bester (eds), *Rise and Fall of Apartheid: Photography and the Bureaucracy of Everyday Life* (New York: International Center of Photography; Munich: DelMonico Books/Prestel, 2013)

Tamar Garb, *Figures & Fictions: Contemporary South African Photography* (London: V & A Publishing; Göttingen: Steidl, 2011)

Robert Hirsch, *Seizing the Light: A History of Photography* (Boston: McGraw-Hill, 2000)

Chrissie Iles, *Into the Light: The Projected Image in American Art, 1964–1977* (New York: Whitney Museum of American Art, 2001)

Gabrielle Jennings and Kate Mondloch (eds), *Abstract Video: The Moving Image in Contemporary Art* (Oakland: University of California Press, 2015)

Omar Kholeif (ed.), *Moving Image*, Documents of Contemporary Art (London and Cambridge, Mass.: Whitechapel Gallery and MIT Press, 2015)

David Joselit, *Feedback: Television Against Democracy* (Cambridge, Mass.: MIT Press, 2007)

Friedrich Kittler, *Gramophone, Film, Typewriter* (Stanford: Stanford University Press, 1999)

Elizabeth Ann McCauley, *Industrial Madness: Commercial Photography in Paris 1848–1871* (New Haven and London: Yale University Press, 1994)

Darren Newbury, *Defiant Images: Photography and Apartheid South Africa* (Pretoria: Unisa Press, 2009)

Beaumont Newhall, *The History of Photography: From 1839 to the Present* (Boston: Little, Brown and Company, 1999)

Erwin Panofsky, "Style and Medium in the Motion Pictures" (1974), in Gerald Mast and Marshall Cohen (eds), *Film Theory and Criticism: Introductory Readings* (London: Oxford University Press, 1974)

John Peffer, *Art and the End of Apartheid* (Minneapolis: University of Minnesota Press, 2009)

John Peffer and Elisabeth L. Cameron (eds), *Portraiture and Photography in Africa. African Expressive Cultures* (Bloomington: Indiana University Press, 2013)

Kira Perov (ed.), *Bill Viola* (London: Thames & Hudson, 2015)

Christopher Phillips, *Photography in the Modern Era: European Documents and Critical Writings, 1913–1940* (New York: Metropolitan Museum of Art, 1989)

Eva Respini, *Cindy Sherman* (New York: Museum of Modern Art, 2012)

Naomi Rosenblum, *A World History of Photography* (New York: Abbeville Press, 1984)

"Round Table: Independence in the Cinema," *October*, no. 91, Winter 2000

"Round Table: The Projected Image in Contemporary Art," *October*, no. 104, Spring 2003

Michael Rush, *Video Art* (London: Thames & Hudson, 2007)

Allan Sekula, "On the Invention of Photographic Meaning," *Artforum*, vol. 13, no. 5, January 1975

Allan Sekula, "The Traffic in Photographs." *Art Journal*, vol. 41, no. 1, Spring 1981

P. Adams Sitney, *Modernist Montage: The Obscurity of Vision in Cinema and Literature* (New York: Columbia University Press, 1990)

P. Adams Sitney, *The Avant-Garde Film: A Reader of Theory and Criticism* (New York: New York University Press, 1978)

P. Adams Sitney, *Visionary Film: The American Avant-Garde, 1943–2000* (Oxford: Oxford University Press, 2002)

Abigail Solomon-Godeau, *Photography at the Dock: Essays on Photographic History, Institutions, and Practices* (Minneapolis: University of Minnesota Press, 1991)

Susan Sontag, *On Photography* (New York: Farrar, Straus, Giroux, 1977)

Yvonne Spielmann, *Video: The Reflexive Medium* (Cambridge, Mass.: MIT Press, 2008)

Edward Steichen (ed.), *The Family of Man*, 60th anniversary edition (New York: Museum of Modern Art, 2015)

John Tagg, *The Burden of Representation: Essays on Photographies and Histories* (Amherst, Mass.: University of Massachusetts Press, 1988)

Matthew Teitelbaum (ed.), *Montage and Modern Life: 1919–1942* (Cambridge, Mass.: MIT Press, 1992)

Chris Townsend (ed.), *The Art of Bill Viola* (London: Thames & Hudson, 2004)

Alan Trachtenberg (ed.), *Classic Essays on Photography* (New Haven: Leete's Island Books, 1980)

Malcolm Turvey, "Jean Epstein's Cinema of Immanence: The Rehabilitation of the Corporeal Eye," *October*, no. 83 (Winter 1998)

Malcolm Turvey, *The Filming of Modern Life: European Avant-Garde Film of the 1920s* (Cambridge, Mass.: MIT Press, 2011)

Andrew V. Uroskie, *Between the Black Box and the White Cube: Expanded Cinema and Postwar Art* (Chicago: University of Chicago Press, 2014)

Dziga Vertov, *Kino-Eye: The Writings of Dziga Vertov* (Berkeley: University of California Press, 1984)

Jonathan Walley, "The Material of Film and the Idea of Cinema: Contrasting Practices in Sixties and Seventies Avant-Garde Film," *October*, no. 103, Winter 2003

CONTEMPORARY ART AND ARTIST MONOGRAPHS

Ernst van Alphen, *Staging the Archive: Art and Photography in the Age of New Media* (London: Reaktion Books, 2015)

The Atlas Group, *The Truth Will Be Known When the Last Witness is Dead: Documents from the Fakhouri File in The Atlas Group Archive* (Cologne: Walther König, 2004)

George Baker, "An Interview with Pierre Huyghe," *October*, no. 110, Fall 2004, pp. 80–106

George Baker (ed.), *James Coleman* (Cambridge, Mass.: MIT Press, 2003)

Bernadette Corporation, *Reena Spaulings* (New York: Semiotext(e), 2004)

Claire Bishop, *Artificial Hells: Participatory Art and the Politics of Spectatorship* (London: Verso, 2012)

Joline Blais and Jon Ippolito, *At the Edge of Art* (London: Thames & Hudson, 2006)

Iwona Blazwick, Kasper König, and Yve-Alain Bois, *Isa Genzken: Open Sesame!* (Cologne: Walther König, 2009)

Yve-Alain Bois (ed.), *Gabriel Orozco*, October Files 9 (Cambridge, Mass.: MIT Press, 2009)

Yve-Alain Bois and Benjamin H. D. Buchloh, *Gabriel Orozco* (London: Thames & Hudson, 2007)

Sabine Breitwieser, Laura Hoptman, Michael Darling, Jeffrey Grove, and Lisa Lee, *Isa Genzken: Retrospective* (New York: Museum of Modern Art, 2013)

Tania Bruguera et al., *Tania Bruguera* (Venice: La Biennale di Venezia, 2005)

Nicolas Bourriaud, *Relational Aesthetics*, trans. Simon Pleasance and Fronza Woods with the participation of Mathieu Copeland (Dijon: Les Presses du Réel, 2002)

Benjamin H. D. Buchloh, *Raymond Pettibon: Here's Your Irony Back* (Göttingen: Steidl, 2011)

Benjamin H. D. Buchloh and David Bussel, *Isa Genzken: Ground Zero* (Göttingen: Steidl, 2008)

Johanna Burton, "Rites of Silence: On the Art of Wade Guyton," *Artforum*, vol. XLVI, no. 10, Summer 2008, pp. 364–73, p. 464

Sophie Calle, *Take Care of Yourself* (Paris: Dis Voir/Actes Sud, 2007)

Melissa Chiu and Benjamin Genocchio, *Contemporary Asian Art* (London: Thames & Hudson, 2009)

Charlotte Cotton, *The Photograph as Contemporary Art* (London: Thames & Hudson, 2009)

Jean-Pierre Criqui (ed.), *Christian Marclay: Replay* (Zurich: JRP|Ringier, 2007)

Florence Derieux, *Tom Burr: Extrospective: Works 1994–2006* (Zurich: JRP Editions, 2006)

Anna Dezeuze, *Thomas Hirschhorn: Deleuze Monument* (London: Afterall Books, 2014)

Yilmaz Dziewior et al, *Zhang Huan* (London: Phaidon, 2009)

Tom Eccles, David Joselit, and Iwona Blazwick, *Rachel Harrison: Museum Without Walls* (New York: Bard College Publications, 2010)

Antje Ehmann and Kodwo Eshun (eds), *Harun Farocki: Against What? Against Whom?* (London: König Books, 2009)

Richard Flood, Laura Hoptman, Massimiliano Gioni, and Trevor Smith, *Unmonumental: The Object in the 21st Century* (London: Phaidon, 2007)

Ruba Katrib and Thomas F. McDonough, *Claire Fontaine: Economies* (North Miami: Museum of Contemporary Art, 2010)

Gao Minglu, *Total Modernity and the Avant-Garde in Twentieth-Century Chinese Art* (Cambridge, Mass.: MIT Press, 2011)

Alison M. Gingeras, Benjamin H. D. Buchloh, and Carlos Basualdo, *Thomas Hirschhorn* (London: Phaidon, 2004)

RoseLee Goldberg, *Performance: Live Art Since the 60s* (London: Thames & Hudson, 2004)

Ann Goldstein, *Martin Kippenberger: The Problem Perspective* (Los Angeles: Museum of Contemporary Art; Cambridge, Mass.: MIT Press, 2008)

Rachel Greene, *Internet Art* (London: Thames & Hudson, 2004)

Kelly Grovier, *Art Since 1989* (London: Thames & Hudson, 2015)

Eleanor Heartney, "Life Like," *Art in America*, vol. 96, no. 5, May 2008, pp. 164–5, p. 208

David Joselit, *After Art* (Princeton: Princeton University Press, 2012)

Rosalind Krauss, "The Rock: William Kentridge's Drawings for Projection," *October*, vol. 92, Spring 2000, pp. 3–35

Carrie Lambert-Beatty, "Political People: Notes on Arte de Conducta," in *Tania Bruguera: On the Political Imaginary* (Milan: Edizioni Charta; Purchase, N.Y.: Neuberger Museum of Art, 2009)

Carrie Lambert-Beatty, "Make-Believe: Parafiction and Plausibility," *October*, no. 129, Summer 2009, pp. 51–84

Lars Bang Larsen (ed.), *Networks*, Documents of Contemporary Art (London and Cambridge, Mass.: Whitechapel Gallery and MIT Press, 2014)

Lisa Lee (ed.), *Isa Genzken*, October Files 17 (Cambridge, Mass.: MIT Press, 2015)

Charles Merewether, *Ai Weiwei: Under Construction* (Sydney: University of New South Wales Press, 2008)

Richard Meyer, *What Was Contemporary Art?* (Cambridge, Mass.: MIT Press, 2014)

Helen Molesworth (ed.), *Louise Lawler*, October Files 18 (Cambridge, Mass.: MIT Press, 2013)

Jochen Noth et al., *China Avant-Garde: Counter-Currents in Art and Culture* (Oxford: Oxford University Press, 1994)

Sally O'Reilly, *The Body in Contemporary Art* (London: Thames & Hudson, 2009)

Christiane Paul, *Digital Art* (London: Thames & Hudson, 2008)

Michael Rush, *New Media in Art* (London: Thames & Hudson, 2005)

Michael Rush, *Video Art* (London: Thames & Hudson, 2007)

Edward A. Shanken (ed.), *Systems*, Documents of Contemporary Art (London and Cambridge, Mass.: Whitechapel Gallery and MIT Press, 2015)

Terry Smith, *What is Contemporary Art?* (Chicago: The University of Chicago Press, 2009)

Robert Storr, *Jenny Holzer: Redaction Paintings* (New York: Cheim & Reid, 2006)

Texte zur Kunst, "The [Not] Painting Issue," March 2010

Samantha Topol (ed.), *Dear Nemesis, Nicole Eisenman* (St. Louis: Contemporary Art Museum; Verlag der Buchhandlung Walther König, 2014)

Chris Townsend (ed.), *The Art of Rachel Whiteread* (London: Thames & Hudson, 2004)

Chris Townsend (ed.), *The Art of Bill Viola* (London: Thames & Hudson, 2004)

Anton Vidokle, *Produce, Distribute, Discuss, Repeat* (New York: Lukas & Sternberg, 2009)

Anton Vidokle, Response to "A Questionnaire on 'The Contemporary,'" *October*, no. 130, Fall 2009, pp. 41–3

Wu Hung, *Transience: Chinese Experimental Art at the End of the Twentieth Century*, revised edition (Chicago: David and Alfred Smart Museum of Art; University of Chicago Press, 2005)

Wu Hung (ed.), *Contemporary Chinese Art: Primary Documents*, with the assistance of Peggy Wang (New York: Museum of Modern Art; Durham, N.C.: Duke University Press, 2010)

RELATED ISSUES

Walter L. Adamson, *Embattled Avant-Gardes: Modernism's Resistance to Commodity Culture in Europe* (Berkeley and Los Angeles: University of California Press, 2006)

Giorgio Agamben, *The Open: Man and Animal* (Palo Alto: Stanford University Press, 2003)

Gwen Allen, *Artists' Magazines: An Alternative Space for Art* (Cambridge, Mass.: MIT Press, 2011)

Philip Armstrong, Laura Lisbon and Stephen Melville (eds), *As Painting: Division and Displacement* (Cambridge, Mass.: MIT Press, 2001)

Artforum, vol. XLVI, no. 8, April 2008 (special issue on "Art and its Markets")

Hans Belting, Andrea Buddensieg, and Peter Weibel (eds), *The Global Contemporary and the Rise of New Art Worlds* (Cambridge, Mass.: MIT Press, 2013)

Luc Boltanski and Eve Chiapello, *The New Spirit of Capitalism*, trans. Gregory Elliot (London: Verso, 2005)

Giovanna Borradori, *Philosophy in a Time of Terror: Dialogues with Jürgen Habermas and Jacques Derrida* (Chicago: University of Chicago Press, 2003)

Nestor Garcia Canclini, *Consumers and Citizens: Globalization and Multicultural Conflicts* (Minneapolis: University of Minnesota Press, 2001)

T. J. Demos, *The Migrant Image: The Art and Politics of Documentary during Global Crisis* (Durham, N.C.: Duke University Press, 2013)

Romy Golan, *Muralnomads: The Paradox of Wall Painting Europe 1927–1957* (New Haven and London: Yale University Press, 2009)

Isabelle Graw, *High Price: Art Between the Market and Celebrity Culture* (Berlin and New York: Sternberg Press, 2009)

Boris Groys, *Art Power* (Cambridge, Mass.: MIT Press, 2008)

Boris Groys, *History Becomes Form: Moscow Conceptualism* (Cambridge, Mass.: MIT Press, 2010)

Michael Hardt and Antonio Negri, *Empire* (Cambridge, Mass.: Harvard University Press, 2000)

Juliet Koss, *Modernism After Wagner* (Minneapolis: University of Minnesota Press, 2010)

Richard Curt Kraus, *The Party and the Arty in China: The New Politics of Culture* (Lanham: Rowman & Littlefield Publishers, 2004)

Claude Lichtenstein and Thomas Schregenberger (eds), *As Found: The Discovery of the Ordinary* (Zurich: Lars Müller Publishers, 2001)

Alexander Nagel, *Medieval Modern: Art Out of Time* (London: Thames & Hudson, 2013)

Gabriel Pérez-Barreiro (ed.), *The Geometry of Hope: Latin American Abstract Art from the Patricia Phelps Cisneros Collection* (Austin: Blanton Museum of Art and Fundación Cisneros, 2006)

Martin Puchner, *Poetry of the Revolution: Marx, Manifestos, and the Avant-Gardes (Translation/Transnation)* (Princeton: Princeton University Press, 2005)

Eric S. Santner, *On Creaturely Life: Rilke, Benjamin, Sebald* (Chicago: University of Chicago Press, 2006)

Arnd Schneider and Christopher Wright (eds), *Between Art and Anthropology: Contemporary Ethnographic Practice* (Oxford: Berg, 2010)

Edward A. Shanken (ed.), *Art and Electronic Media* (London: Phaidon, 2009)

Julian Stallabrass, *Art Incorporated* (London: Verso, 2004)

Barbara Vanderlinden and Elena Filipovic, *The Manifesta Decade: Debates on Contemporary Art Exhibitions and Biennials in Post-Wall Europe* (Cambridge, Mass.: MIT Press, 2006)

Olav Velthius, *Talking Prices: Symbolic Meanings for Prices on the Market for Contemporary Art* (Princeton: Princeton University Press, 2005)

Anne M. Wagner, *Mother Stone: The Vitality of Modern British Sculpture* (New Haven and London: Yale University Press, 2005)

selected useful websites

Listed below is a small selection of the many websites devoted to modern and contemporary art. Many contain links to other related websites for those wishing to continue their study and research.

GENERAL INFORMATION, RESEARCH PORTALS, AND LINKS

http://www.aaa.si.edu The Archives of American Art, the world's largest and most widely used resource on the visual arts in America

http://www.abcgallery.com "Olga's Gallery"—brief histories of movements, artists' biographies, images of art works, with extensive links to other websites

http://americanhistory.si.edu/archives/ac-i.htm Largest source in the United States of primary documentation on the visual arts

http://artcyclopedia.com Links to websites by artist and movement

http://arthist.net Information, links, and news for art historians

http://the-artists.org Links to art works, essays, artists' biographies, portraits, and websites, and museums

http://www.artnet.com An online resource about artists and the art market

http://www.theartstory.org Extensive information about the key styles, movements, artists, critics, curators, galleries, schools, and ideas in modern art

http://www.askart.com AskART is an online database containing close to 300,000 artists, with information ranging from biographies to auction records

http://www.bc.edu/bc_org/avp/cas/fnart/links/art_19th20th.html Links to websites on nineteenth- and twentieth-century art, by movement, period, and artist

http://www.biennialfoundation.org Information and links about contemporary art biennials and triennials worldwide

https://www.ebscohost.com/academic/art-source Art Source, an online resource for art and architecture research

http://getty.edu/research/tools/portal/index.html The Getty Research Portal is a free online search platform providing worldwide access to an extensive collection of digitized art history texts from a range of institutions

http://www.jstor.org JSTOR, a digital library of academic journals, books, and primary sources

http://www.moma.org/learn/moma_learning Museum of Modern Art Learning, an online information resource about themes and movements in modern art

http://www.nyarc.org The New York Art Resources Consortium (NYARC) consists of the research libraries of three leading art museums in New York City: Brooklyn Museum, Frick Collection, and Museum of Modern Art

http://witcombe.sbc.edu/ARTH20thcentury.html Links to art works, essays, artists' biographies and websites, and museums

IMAGE BANKS

http://www.artstor.org Non-profit initiative, founded by the Andrew W. Mellon Foundation—archive of hundreds of thousands of digital images and related data

https://www.google.com/culturalinstitute/project/art-project The Google Cultural Institute's Art Project, providing links to and images from a variety of worldwide collections

http://www.photo.rmn.fr Visual archive of the French national holdings of modern and contemporary art

http://www.videomuseum.fr Visual archive of modern and contemporary art held in public collections in France

MUSEUMS AND INSTITUTIONS OF ART

http://www.artic.edu Art Institute of Chicago

http://www.berlinbiennale.de Berlin Biennial for Contemporary Art

http://www.bienalhabana.cult.cu Havana Biennial

http://www.biennaleofsydney.com.au Sydney Biennial of Contemporary Art

http://www.brandeis.edu/rose Rose Art Museum, Brandeis University

http://www.cmoa.org/ Carnegie Museum of Art, Pittsburgh

http://www.cnac-gp.fr Centre Georges Pompidou, Paris

http://commonpracticeny.org Network of small-scale arts organizations in New York City, including Anthology Film Archives, Artists Space, The Kitchen Center, Printed Matter, and others

http://www.diaart.org Dia Art Foundation, New York

http://www.documenta.de Documenta

http://www.guggenheim.org Solomon R. Guggenheim Museum, New York

https://hammer.ucla.edu Hammer Museum, Los Angeles

http://hirshhorn.si.edu/collection/home/#collection=home Hirshhorn Museum and Sculpture Garden, Washington, D.C.

http://www.icaboston.org Institute of Contemporary Art, Boston

http://www.icp.org International Center of Photography, New York

http://www.istanbulmodern.org Istanbul Museum of Modern Art, Istanbul

http://www.labiennale.org Venice Biennale

http://www.lacma.org Los Angeles County Museum of Art

http://www.maaala.org Museum of African American Art, Los Angeles

http://mam.org.br Museu de Arte Moderna, São Paulo

http://www.manifesta.org Manifesta, the European Biennial of Contemporary Art

http://www.metmuseum.org Metropolitan Museum of Art, New York

http://www.mcachicago.org Museum of Contemporary Art, Chicago

http://moma.org Museum of Modern Art, New York

http://www.newmuseum.org New Museum of Contemporary Art, New York

http://www.nga.gov/content/ngaweb.html National Gallery of Art, Washington, D.C.

http://njpac-en.ggcf.kr Nam June Paik Center, Yongin, South Korea

http://on1.zkm.de/zkm/e ZKM, Center for Art and Media Karlsruhe

http://performa-arts.org Performa, biennial of visual art performance, New York

http://www.philamuseum.org Philadelphia Museum of Art

http://www.secession.at Vienna Secession, forum for experimental art

http://www.sfmoma.org San Francisco Museum of Modern Art

http://www.stedelijk.nl Stedelijk Museum, Amsterdam

http://www.studiomuseum.org Studio Museum, Harlem, New York

http://www.tate.org.uk Tate, London

http://ucca.org.cn/en Ullens Center for Contemporary Art, Beijing

http://www.whitney.org Whitney Museum of American Art, New York
(also see "General information, research portals, and links")

ARTISTS' AND MOVEMENTS' WEBSITES

http://www.albersfoundation.org Josef and Anni Albers Foundation, Bethany, Connecticut

http://www.artsmia.org/modernism "Milestones in Modernism 1880–1940"

http://www.bauhaus.de/en Bauhaus Archive and Collection, Berlin

http://www.cia.edu/library/artists-books The Cleveland Institute of Art's important international collection of artists' books, containing more than 1700 books and multiples from the 1960s to the present

http://www.dekooning.org Willem de Kooning Foundation, New York

http://www.fundaciomiro-bcn.org Joan Miró Foundation, Barcelona

http://www.iniva.org/harlem Institute of International Visual Arts—Harlem Renaissance archive

http://sdrc.lib.uiowa.edu/dada/index.html International Dada Archive

http://www.luxonline.org.uk Online resource and archive devoted to British-based film and video artists

http://www.moma.org/brucke Museum of Modern Art, New York—Die Brücke archive

http://www.mondriantrust.com Mondrian Trust

http://www.musee-picasso.fr Musée National Picasso, Paris

http://www.museupicasso.bcn.es/en Picasso Museum, Barcelona

https://www.okeeffemuseum.org Georgia O'Keeffe Museum

http://www.paikstudios.com The Nam June Paik Estate

https://picasso.shsu.edu Online Picasso Project—extensive archive of works

http://www.pkf.org The Pollock-Krasner Foundation, New York

http://www.rauschenbergfoundation.org Robert Rauschenberg Foundation, New York

http://rhizome.org An online resource on new media art, the intersection of new technologies and contemporary art

http://sdrc.lib.uiowa.edu/dada/index.html The International Dada Archive, part of the Dada Archive and Research Center

http://www.surrealismcentre.ac.uk The Centre for the Study of Surrealism and its Legacies

http://www.theviennasecession.com An online museum devoted to the Vienna Secession

http://www.usc.edu/dept/architecture/slide/babcock Cubism archive

www.warhol.org The Andy Warhol Museum, Pittsburgh
(also see "General information, research portals, and links")

ONLINE DICTIONARIES AND GLOSSARIES

http://www.artlex.com Basic dictionary of terms

http://www.cia.edu/files/resources/14ciaglossaryofartterms.pdf Cleveland Institute of Art glossary of art terms

http://www.dictionaryofarthistorians.org Online biographical dictionary of historic scholars, museum professionals, and academic historians of art

http://www.moma.org/learn/moma_learning/glossary Museum of Modern Art glossary of art terms

http://www.tate.org.uk/learn/online-resources/glossary Tate glossary of art terms

http://www.oxfordartonline.com/public Home of Grove Art Online, the online version of *The Dictionary of Art*, the authoritative dictionary of art and artists; over 45,000 articles on the fine arts, decorative arts, and architecture; written by over 6,000 international scholars; over 130,000 art images, with links to museums and galleries around the world; access to full text of *The Encyclopedia of Aesthetics*, *The Oxford Companion to Western Art*, and *The Concise Oxford Dictionary of Art Terms* (subscription)

ONLINE JOURNALS, BLOGS, AND ART PUBLISHERS

http://artcritical.com Online magazine of art and ideas

http://www.artfagcity.com Online art news, reviews, and culture commentary blog; links to modern and contemporary art galleries

http://www.artforum.com *Artforum* magazine—international news digest, features, and selected articles from past issues; links to modern and contemporary art galleries

http://www.artinamericamagazine.com Online version of *Art in America Art* magazine—archive of past issues

http://www.artinfo.com Online news magazine about international art and culture

http://artlog.com Online magazine and art guide

http://www.artmonthly.co.uk Online version of *Art Monthly* magazine—archive of past issues

http://www.artnews.com Online version of *ArtNews* magazine—archive of past issues

http://www.artsjournal.com Online aggregator of international news reports and features on art, culture, and ideas

https://www.artsy.net Artsy, an online resource for art collecting and education

http://www.caareviews.org College Art Association—extensive archive of reviews of books and catalogues

http://canopycanopycanopy.com Online magazine, workspace, and platform for editorial and curatorial activities

http://www.contemporaryartdaily.com *Contemporary Art Daily*, a daily journal of international exhibitions

http://www.e-flux.com International network that reaches more than 50,000 visual art professionals on a daily basis through its website, e-mail list and special projects. Its news digest – e-flux announcements – distributes information on some of the world's most important contemporary art exhibitions, publications and symposia.

http://www.flashartonline.com Online version of *Flash Art* magazine—archive of past issues

http://www.frieze.com/magazine Online version of *Frieze* magazine—archive of past issues

http://www.mitpressjournals.org/loi/octo *October* journal —selected articles from past issues

http://newsgrist.typepad.com NEWSgrist "where spin is art"—blog that gathers short profiles, exhibition reviews, op-ed pieces, and commentary

http://www.textezurkunst.de *Texte zur kunst* journal—archive of past issues; links to modern and contemporary art galleries

http://www.thamesandhudson.com and http://www.thamesandhudsonusa.com Extensive range of books on modern and contemporary art; links to related websites

http://www.theartnewspaper.com Online version of the monthly newspaper; links to modern and contemporary art galleries

http://www.twocoatsofpaint.com Online articles, reviews and writing on painting

http://www.uchicago.edu/research/jnl-crit-inq *Critical Inquiry* journal—selected articles from past issues; links to websites of critical interest

http://universes-in-universe.org/eng Online magazine about the global art world

picture credits

Measurements are given in centimeters, followed by inches, height before width before depth, unless otherwise stated.

p.5 (top) Ernst Ludwig Kirchner, *The Street, Dresden*, 1908. Oil on canvas, 150.5 × 200 (59¼ × 78⅞). Museum of Modern Art, New York. © Dr. Wolfgang & Ingeborg Henze-Ketterer, Wichtrach/Bern; (second top) František Kupka, *Amorpha, Fugue in Two Colors*, 1912. Oil on canvas, 211.8 × 220 (83⅜ × 86⅝). Národní Galerie, Prague. © ADAGP, Paris and DACS, London 2004; (center) Franz Marc, *The Fate of the Animals*, 1913. Oil on canvas, 194.3 × 261.6 (76½ × 103). Kunstmuseum, Basle; (second bottom) Kazimir Malevich, *Warrior of the First Division*, 1914. Oil and collage on canvas, 53.6 × 44.8 (21⅛ × 17⅝). Museum of Modern Art, New York; (bottom) Marcel Duchamp, *Fountain*, 1917 (1964 replica). Readymade: porcelain, 36 × 48 × 61 (14⅛ × 18⅞ × 24). Photo Tate, London 2004. © Succession Marcel Duchamp/ADAGP, Paris and DACS, London 2004; p.6 (top) Fernand Léger, *The City*, 1919. Oil on canvas, 231.1 × 298.4 (91 × 117½). ADAGP, Paris and DACS, London 2016; (second top) Gustav Klutsis, *Let us Fulfill the Plan of our Great Projects*, 1930. Photomontage. Russian State Library, Moscow; (center) Barbara Hepworth, *Large and Small Form*, 1934. Alabaster, 23 × 37 × 18 (9 × 14 × 7). The Pier Gallery Collection, Stromness. © Bowness, Hepworth Estate; (second bottom) Karl Blossfeldt, *Impatiens Glandulifera; Balsamine, Springkraut*, 1927. Silver salts print. Courtesy Galerie Wilde, Cologne; (bottom) Wolfgang Paalen, *Ciel de Pieuvre*, 1938. Fumage and oil on canvas, 97 × 130 (38¼ × 51⅛). Private Collection, Courtesy Paalen Archiv, Berlin; p.9 (top) Morris Louis, *Beta Kappa*, 1961. Acrylic resin on canvas, 262.3 × 429.4 (103¼ × 173). National Gallery of Art, Washington, D.C. © 1961 Morris Louis; (second top) Ellsworth Kelly, *Colors for a Large Wall*, 1951. Oil on canvas, mounted on 64 joined panels 243.8 × 243.8 (96 × 96). Museum of Modern Art, New York. © Ellsworth Kelly; (center) Mario Merz, *Objet Cache Toi*, 1968–77. Metal tubes, glass, clamps, wire mesh, neon, 185 × 365 (72⅞ × 143¾). Courtesy Archivo Merz, Turin; (second bottom) Chris Burden, *Trans-fixed*, 1974. Performance, Venice, California. Courtesy the artist; (bottom) Bernd and Hilla Becher, *8 Views of a House*, 1962–71. Black-and-white photographs. Courtesy Sonnabend Gallery, New York; p.10 (top) Gerhard Richter, *October 18, 1977: Confrontation 1 (Gegenüberstellung 1)*, 1988. Oil on canvas, 111.8 × 102.2 (44 × 40¼). Museum of Modern Art, New York. Photo Axel Schneider, Frankfurt/Main. © Gerhard Richter; (second top) Barbara Bloom, *The Reign of Narcissism*, 1989. Mixed media, dimensions variable. © Barbara Bloom, 1989. Courtesy Gorney, Bravin + Lee, New York; (center) Rachel Whiteread, *(Untitled) House*, 1993. Destroyed. Commissioned by Artangel. Sponsored by Beck's. Photo Sue

Ormera. Courtesy Rachel Whiteread and Gagosian Gallery, London; (second bottom) Kiki Smith, *Blood Pool*, 1992. Painted bronze 35.6 × 99.1 × 55.9 (14 × 39 × 22). Cast two of an edition of two. Collection of the artist. Photo Ellen Page Wilson, courtesy Pace Wildenstein, New York. © Kiki Smith; (bottom) Kara Walker, *Camptown Ladies*, 1998 (detail). Cut paper and adhesive on wall, dimensions variable. Courtesy the artist and Brent Sikkema, NYC; p.11 (top) Douglas Gordon, *24 Hour Psycho*, 1993. Video projection installation. Courtesy Lisson Gallery, London; (second top) Rirkrit Tiravanija, *Secession*, 2002. Installation and performance at the Vienna Secession. Courtesy Gavin Brown Enterprise © Rirkrit Tiravanija; (center) John Miller, *Glad Hand*, 1998. Mixed media, 160 × 81.3 × 38.1 (63 × 32 × 15). Courtesy the Artist and Metro Pictures; (second bottom) Thomas Hirschhorn, "Utopia, Utopia = One World, One War, One Army, One Dress," Institute of Contemporary Art, Boston, 2005. Installation view. Courtesy Gladstone Gallery, New York; (bottom) Sharon Hayes, *In the Near Future*, 2009 (detail). 35mm multiple-slide-projection installation, 13 projections, edition of 3 + 1 AP. Courtesy Sharon Hayes; Introduction 1: 1 • Museum Folkwang, Essen; 2 • Museum of Modern Art, New York. © DACS 2004; 3 • Collection William Rubin, Bronxville, New York. © ADAGP, Paris and DACS, London 2004; 4 • Galerie Krikhaar, Amsterdam. © Karel Appel Foundation/DACS, London 2004; 5 • Courtesy Ydessa Hendeles Art Foundation, Toronto; 6 • © DACS, London/VAGA, New York 2004; 7 • © Lee Miller Archives, Chiddingly, England, 2004. All rights reserved; Introduction 2: 1 • Photo Akademie der Künste der DDR, Berlin. © The Heartfield Community of Heirs/VG Bild-Kunst, Bonn and DACS, London 2004; 2 • From Szymon Bojko, *New Graphic Designs in Revolutionary Russia*, Lund Humphries, London, 1972. Lissitzky: © DACS 2004; 4 • Martha Rosler, © Martha Rosler, 1969–72. Courtesy the artist and Gorney Bravin & Lee, New York; 5 • Photo Dave Morgan, London. Courtesy Lisson Gallery, London; 6 • Courtesy the artist. © DACS 2004; 7 • Photo Reiner Ruthenbeck. Courtesy Konrad Fischer Galerie. © Gerhard Richter; Introduction 3: 1 • Kunstmuseum, Basel. Gift of Raoul La Roche, 1952. © ADAGP, Paris and DACS, London 2004; 2 • Musée Picasso, Paris. © Succession Picasso/DACS 2004; 3 • Pablo Picasso, Museum of Modern Art, New York. Gift of the artist. © Succession Picasso/DACS 2004; 4 • Haags Gemeentemuseum. © 2004 Mondrian/Holtzman Trust. c/o hcr@hcrinternational.com; Introduction 4: 1 • Städtische Kunsthalle, Düsseldorf. Photo © Gilissen. © DACS 2004; 2 • © ADAGP, Paris and DACS, London 2004; 3 • Museum of Contemporary Art, Chicago, gift of Susan and Lewis Manilow. © Estate of Robert Smithson/VAGA, New York/DACS, London 2004; 4 • © the artist; 5 • © 1981 by The University of Chicago; © 1981 by Continuum.; 6 • Courtesy the artist

and Metro Pictures; Introduction 5: 3 • *Gutai* journal, no. 11, November 1960, p. 13; 4 • Courtesy Kwon Ohyup; 5 • Third Havana Biennial 1989; 6 • Photo Archivo Aldo Menéndez; 7 • Courtesy Queens Museum, New York; 8 • Photo courtesy Secession/Oliver Ottenschläger 9 • Revolver Verlag/Secession, 2012; 1900: 1 • Photo Dr F. Stoedther; 4 • Leopold Museum, Vienna; 5 • Photo Jörg P. Anders. Nationalgalerie Staatliche Museen Preussischer Kulturbesitz, Berlin. © DACS 2004; 1900b: 1 • Baltimore Museum of Art, The Cone Collection – formed by Dr. Claribel Cone and Miss Etta Cone of Baltimore, Maryland. 50.422. © Succession H. Matisse/DACS 2004; 2 • Iris & B. Gerald Cantor Collection, Beverly Hills, California; 3 • Musuem of Modern Art, New York. Lillie P. Bliss Bequest. Photo Soichi Sunami. © Succession H. Matisse/DACS 2004; 4 • Museum of Modern Art, New York. Gift of Stephen C. Clark. © ADAGP, Paris and DACS, London 2004; 5 • Museum of Modern Art, New York. Gift of Mrs. Simon Guggenheim Fund. © Succession H. Matisse/DACS 2004; 6 • Museum of Modern Art, New York. Gift of Mrs. Simon Guggenheim Fund. © Succession H. Matisse/DACS 2004; 7 • Museum of Modern Art, New York. Gift of Mrs. Simon Guggenheim Fund. © Succession H. Matisse/DACS 2004; 8 • Museum of Modern Art, New York. Gift of Mrs. Simon Guggenheim Fund. © Succession H. Matisse/DACS 2004; 9 • Museum of Modern Art, New York. Gift of Mrs. Simon Guggenheim Fund. © Succession H. Matisse/DACS 2004; 10 • Baltimore Museum of Art, The Cone Collection. © Succession H. Matisse/DACS 2004; 1903: 1 • Private Collection. © ADAGP, Paris and DACS, London 2004; 2 • Private Collection; 3 • Albright Knox Art Gallery, Buffalo, New York, A. Conger Goodyear Collection, 1965; 4 • Kunstsammlung Nordrhein-Westfalen, Dusseldorf. © Dr. Wolfgang & Ingeborg Henze-Ketterer, Wichtrach/Bern; 5 • The Baltimore Museum of Art, The Cone Collection, formed by Dr Claribel Cone and Miss Etta Cone. © Succession H. Matisse/DACS 2004; 1906: 1 • Musée d'Orsay, Paris. © Succession H. Matisse/DACS 2004; box Roger Fry, *Self-Portrait*, 1918. Oil on canvas, 79.8 x 59.3 (31⅜ x 23⅜). By permission of the Provost and Fellows of King's College, Cambridge. Photo Fine Art Photography; 2 • San Francisco Museum of Modern Art. Bequest of Elise S. Haas. © 2004 Succession H. Matisse/DACS 2004; 3 • Musée Matisse, Nice. © Succession H. Matisse/DACS 2007; 4 • National Gallery of Art, Washington D.C. © Succession H. Matisse/DACS 2004; 5 • The Barnes Foundation, Merion, Pennsylvania / The Bridgeman Art Library, London. © Succession H. Matisse/DACS 2004; 1907: 1 • Museum of Modern Art, New York, Lillie P. Bliss Bequest. © Succession Picasso/DACS 2004; 2 • Metropolitan Museum of Art. Bequest of Gertrude Stein, 1946. © Succession Picasso/DACS 2004; 3 • Offentliche Kunstsammlung, Kunstmuseum, Basel. ©

Succession Picasso/DACS 2004; 4 • Photographed for Gelett Burgess, 1908; 5 • Musée Picasso, Paris. © Succession Picasso/DACS 2004; 6 • Sergei Pankejeff, sketch from *The Wolf-Man & Sigmund Freud*, ed. Murial Gardiner, Hogarth Press, 1972, p.174; 7 • The State Hermitage Museum, St. Petersburg. © Succession Picasso/DACS 2004; **1908: 1** • Städtische Galeries im Lenbachhaus, Munich. © ADAGP, Paris and DACS, London 2004; 2 • Städtische Galeries im Lenbachhaus, Munich. GMS 153. © ADAGP, Paris and DACS, London 2004; 3 • Museum of Modern Art, New York. © Dr. Wolfgang & Ingeborg Henze-Ketterer, Wichtrach/Bern; 4 • Kunstmuseum, Basel; 5 • © Wyndham Lewis and the Estate of the late Mrs G. A. Wyndham Lewis by kind permission of the Wyndham Lewis Memorial Trust (a registered charity); **1909: 2** • Civica Galleria d'Arte Moderna, Milan. © DACS 2004; 3 • Albright-Knox Art Gallery, Buffalo, New York, Bequest of A. Conger Goodyear and Gift of George F. Goodyear, 1964. © DACS 2004; 4 • Museum of Modern Art, New York. Acquired through the Lillie P. Bliss Bequest; **box** Edward Muybridge, *Movement Phases of a Galloping Horse*, 1884–5. Collotype print; Étienne-Jules Marey, *Investigation into Walking*, c. 1884. Geometric chronograph (from original photograph). Collège de France Archives, Paris; 5 • Peggy Guggenheim Collection, Venice; 6 • Mattioli Collection, Milan. © DACS 2004; 7 • Galleria Nazionale d'Arte Moderna, Rome. Isabella Pakszwer de Chirico Donation. © DACS 2004; 8 • Pinacoteca di Brera, Milan. Photo © Scala, Florence/Courtesy of the Ministero Beni e Att. Culturali 1990. © DACS 2004; **1910: 1** • The State Hermitage Museum, St. Petersburg. © Succession H. Matisse/DACS 2004; 2 • The State Hermitage Museum, St. Petersburg. © Succession H. Matisse/DACS 2004; 3 • The State Hermitage Museum, St. Petersburg. © Succession H. Matisse/DACS 2004; 4 • St. Louis Art Museum, Gift of Mr & Mrs Joseph Pulitzer. © Succession H. Matisse/DACS 2004; 5 • The State Hermitage Museum, St. Petersburg. © Succession H. Matisse/DACS 2004; 6 • Musée de Grenoble. Gift of the artist, in the name of his family. © Succession H. Matisse/DACS 2004; Pablo Picasso, *Apollinaire blessé (Apollinaire Wounded)*, 1916. Pencil on paper, 48.8 x 30.5 (19¼ x 12). © Succession Picasso/DACS 2004; **1911: 1** • Art Institute of Chicago. Gift of Mrs. Gilbert W. Chapman in memory of Charles B. Goodspeed. © Succession Picasso/DACS 2004; 2 • Kunstmuseum, Basel. Donation Raoul La Roche. © ADAGP, Paris and DACS, London 2004; 3 • Museum of Modern Art, New York. Nelson A. Rockefeller Bequest. © Succession Picasso/DACS 2004; 4 • Museum of Modern Art, New York. Nelson A. Rockefeller Bequest. © Succession Picasso/DACS 2004; 5 • Musée Picasso, Paris. Photo © RMN – R. G. Ojeda. © Succession Picasso/DACS 2004; **1912: 1** • Private Collection. © ADAGP, Paris and DACS, London 2004; 2 • Musée National d'Art Moderne, Centre Georges Pompidou, Paris. Gift of Henri Laugier. © Succession Picasso/DACS 2004; 3 • Musée National d'Art Moderne, Centre

Georges Pompidou, Paris. Gift of Henri Laugier. © Succession Picasso/DACS 2004; 4 • Mildred Lane Kemper Art Museum, Washington University in St. Louis. University Purchase, Kende Sale Fund, 1946. © Succession Picasso/DACS 2004; 5 • Musée National d'Art Moderne, Centre Georges Pompidou, Paris. Gift of Henri Laugier. © Succession Picasso/DACS 2004; 6 • Marion Koogler McNay Art Museum, San Antonio. © Succession Picasso/DACS 2004; 7 • Photo Pablo Picasso. © Succession Picasso/DACS 2004; 8 • Guillaume Apollinaire, 'La Cravate et la Montre', 1914. From *Calligrammes: Poèmes de la paix et de la guerre, 1913–16, Part I: Ondes*. Paris: Éditions Gallimard, 1925; **1913: 1** • Private Collection. © DACS 2004; 2 • Národní Galerie, Prague. © ADAGP, Paris and DACS, London 2004; 3 • Philadelphia Museum of Art, The Louise and Walter Arensberg Collection. © ADAGP, Paris and DACS, London 2004; 4 • Solomon R. Guggenheim Museum, New York. © 2004 Mondrian/Holtzman Trust. c/o hcr@hcrinternational.com; 5 • © L & M Services B.V. Amsterdam 20040801; 6 • © L & M Services B.V. Amsterdam 20040801; 7 • © L & M Services B.V. Amsterdam 20040801; 8 • Museum of Theatrical and Musical Arts, St Petersburg; **1914: 1** • Philadelphia Museum of Art, The Louise and Walter Arensberg Collection. © Succession Marcel Duchamp/ADAGP, Paris and DACS, London 2004; 2 • Whereabouts unknown. © DACS 2004; 3 • Photo State Film, Photographic and Sound Archive, St Petersburg. © DACS 2004; 4 • Hessisches Landesmuseum, Darmstadt. © Succession Marcel Duchamp/ADAGP, Paris and DACS, London 2004; 5 • Photo Tate, London 2004. © Succession Marcel Duchamp/ADAGP, Paris and DACS, London 2004; **1915: 1** • Museum of Modern Art, New York; 3 • State Russian Museum, St Petersburg; 4 • Stedelijk Museum, Amsterdam; 5 • Museum of Modern Art, New York; **1916a: 2** • Musée National d'Art Moderne, Centre Georges Pompidou, Paris. © ADAGP, Paris and DACS, London 2004; 3 • Private Collection. © DACS 2004; 4 • bpk/Nationalgalerie, Staatliche Museen zu Berlin/Jörg P. Anders. © DACS, 2016; 5 • Stiftung Arp e.V., Berlin/Rolandswerth. © DACS, 2016; **1916b: 1** • Metropolitan Museum of Art, New York. © ADAGP, Paris and DACS, London 2004; 2 • Museum of Modern Art, New York. © ARS, NY and DACS, London 2004; 3 • Museum of Modern Art, New York. Reprinted with permission of Joanna T. Steichen; 4 • Museum of Modern Art, New York. © ARS, NY and DACS, London 2004; 5 • © 1971 Aperture Foundation Inc., Paul Strand Archive; 6 • Philadelphia Museum of Art, The Alfred Stieglitz Collection. © ARS, NY and DACS, London 2004; **1917a: 1** • Rijksmuseum Kröller-Müller, Otterlo, The Netherlands. © 2011 Mondrian/Holtzman Trust c/o HCR International Virginia; 2 • Rijksmuseum Kröller-Müller, Otterlo, The Netherlands. © 2011 Mondrian/Holtzman Trust c/o HCR International Virginia; 3 • Gemeentemuseum Den Haag. © 2011 Mondrian/Holtzman Trust c/o HCR International Virginia; 4 • Stedelijk Museum, Amsterdam. © 2011 Mondrian/Holtzman Trust c/o HCR

International Virginia; 5 • Stedelijk Museum, Amsterdam. © 2011 Mondrian/Holtzman Trust c/o HCR International Virginia; **1917b: 1** • Rijksdienst voor Beeldende Kunst, L'Aia/Gemeentemuseum, L'Aia. © DACS 2011; 2 • Gemeentemuseum Den Haag; 3 • Nederlands Architectuurinstituut, Rotterdam-Amsterdam; 4 • British Architectural Library, RIBA. © DACS, London 2004; 6 • Stedelijk Museum, Amsterdam. © DACS 2011; **1918: 1** • Philadelphia Museum of Art, Walter and Louise Arensberg Collection. © Succession Marcel Duchamp/ADAGP, Paris and DACS, London 2004; 2 • Museum of Modern Art, New York. Katherine S. Dreier Bequest. © Succession Marcel Duchamp/ADAGP, Paris and DACS, London 2004; 3 • Museum of Modern Art, New York. © DACS 2004; 4 • Yale University Art Gallery, New Haven, Connecticut. Gift of Katherine S. Dreier. © Succession Marcel Duchamp/ADAGP, Paris and DACS, London 2004; 5 • Private Collection, Paris. © Succession Marcel Duchamp/ADAGP, Paris and DACS, London 2004. © Man Ray Trust/ADAGP, Paris and DACS, London 2004; **box** Man Ray, *Rrose Sélavy*, c. 1920–1. Silver-gelatin print, 21 x 17.3 (8¼ x 6¾). Philadelphia Museum of Art. The Samuel S. White 3rd and Vera White Collection. © Man Ray Trust /ADAGP, Paris and DACS, London 2004. © Succession Marcel Duchamp/ADAGP, Paris and DACS, London 2004; **1919: 1** • Musée Picasso, Paris. © Succession Picasso/DACS 2004; **box** Pablo Picasso, *Portrait of Sergei Diaghilev and Alfred Seligsberg*, 1919. Charcoal and black pencil, 65 x 55 (25⅝ x 21⅝). Musée Picasso, Paris. © Succession Picasso/DACS 2004; 2 • Private Collection. © Succession Picasso/DACS 2004; 3 • ADAGP, Paris and DACS, London 2004; 4 • Musée Picasso, Paris. © Succession Picasso/DACS 2004; 5 • Yale University Art Gallery, New Haven, Connecticut. Gift of Collection Société Anonyme; **1920: 2** • Staatliche Museen, Berlin. © DACS 2004; 3 • Musée National d'Art Moderne, Centre Georges Pompidou, Paris. © ADAGP, Paris and DACS, London 2004; 4 • Photo Akademie der Künste der DDR, Berlin. Grosz © DACS, 2004. Heartfield © The Heartfield Community of Heirs/VG Bild-Kunst, Bonn and DACS, London 2004; 5 • Musée National d'Art Moderne, Centre Georges Pompidou, Paris. © ADAGP, Paris and DACS, London 2004; 6 • Akademie der Kunst, Berlin. © The Heartfield Community of Heirs/VG Bild-Kunst, Bonn and DACS, London 2004; 7 • Russian State Library, Moscow; **1921a: 1** • © Succession Picasso/DACS, London 2016; 2 • © Succession Picasso/DACS, London 2016; 3 • © Succession Picasso/DACS, London 2016; 4 • Photo Courtesy Sotheby's, Inc. © 2016. © ADAGP, Paris and DACS, London 2016; 6 • © ADAGP, Paris and DACS, London 2016; **1921b: 1** • National Museum, Stockholm. © DACS 2004; 4 • Museum of Modern Art, New York. © DACS 2004; 5 • A. Rodchenko and V. Stepanova Archive, Moscow. © DACS 2004; **1922: 1** • © DACS 2004; 2 • Paul Klee-Stiftung, Kunstmuseum, Berne (inv. G62). © DACS 2004; 3 • Private Collection. © ADAGP, Paris and DACS, London 2004; 4 • Sammlung Prinzhorn

der Psychiatrischen Universitätsklinik Heidelbert; 5 • Lindy and Edwin Bergman Collection. © ADAGP, Paris and DACS, London 2004; **1923:** 2 • Bauhaus-Archiv, Museum für Gestaltung, Berlin. © DACS 2004; 3 • President and Fellows, Harvard College, Harvard University Art Museums, Gift of Sibyl Moholy-Nagy. © DACS 2004; 4 • Bauhaus-Archiv, Museum für Gestaltung, Berlin. © DACS 2004; 5 • © Dr Franz Stoedtner, Düsseldorf; 6 • Barry Friedman Ltd, New York; 7 • Bauhaus-Archiv, Museum für Gestaltung, Berlin. Brandt © DACS 2004; **1924:** 1 • Photo Per-Anders Allsten, Moderna Museet, Stockholm. © DACS 2004; 2 • Museum of Modern Art, New York. © ADAGP, Paris and DACS, London 2004; 3 • Museum of Modern Art, New York. Given anonymously. © Salvador Dalí, Gala-Salvador Dalí Foundation. DACS, London 2004; 4 • Collection Jose Mugrabi. © Successió Miró – ADAGP, Paris, DACS, London 2004; 5 • © Man Ray Trust/ADAGP, Paris and DACS, London 2004; **box** Man Ray, cover of *La Révolution surréaliste*. Black-and-white photograph. © Man Ray Trust/ADAGP, Paris and DACS, London 2004; 6 • © Man Ray Trust/ADAGP, Paris and DACS, London 2004; 7 • Private collection, Paris. © ADAGP, Paris and DACS, London 2004; **1925a:** 1 • © FLC/ADAGP, Paris and DACS, London 2004; 2 • Musée National d'Art Moderne, Centre Georges Pompidou, Paris. Photo © CNAC/MNAM Dist. RMN/ © Jacqueline Hyde. © FLC/ADAGP, Paris and DACS, London 2004; 3 • Museum of Modern Art, New York. Mrs Simon Guggenheim Fund, 1942. © ADAGP, Paris and DACS, London 2004; 4 • Museum of Modern Art, New York. © ADAGP, Paris and DACS, London 2004; 5 • © ADAGP, Paris and DACS, London 2004; 7 • © DACS 2004; **1925b:** 1 • Nationalgalerie, Berlin. © DACS 2004; 2 • Kunstsammlung Nordrhein-Westfalen, Düsseldorf. © DACS 2004; 3 • Private Collection. © Christian Schad Stiftung Aschaffenburg/ VG Bild-Kunst, Bonn and DACS, London 2004; 4 • Musée National d'Art Moderne, Centre Georges Pompidou, Paris. © DACS 2004; 5 • Museum of Modern Art, New York, Purchase 49.52. © DACS 2004; **1925c:** 2 • © DACS 2011; 3 • © DACS 2011; 4 • © DACS 2011; 5 • Sammlung des Landes Rheinland-Pfalz für das Arp Museum, Rolandseck. © DACS 2011; 6 • Zentrum Paul Klee, Livia Klee Donation; 7 • Harvard University Art Museums. Photo Archive C. Raman Schlemmer, 28824 Oggebbio (VB), Italy. © 2011 The Oskar Schlemmer Theatre Estate and Archive, Bühnen Archiv Oskar Schlemmer, Secretariat: 28824 Oggebbio, Italy, www.schlemmer.org; **1925d:** 1 • © ADAGP, Paris and DACS, London 2016; 3 • © Hans Richter Estate; 4 • © ADAGP, Paris and DACS, London 2016; **1926:** 1 • Ronald S. Lauder. © DACS 2004; 2 • Stadtbibliothek Hannover, Schwitters Archive. © DACS 2004; 3 • Stedelijk Van Abbe Museum, Eindhoven, The Netherlands. © DACS 2004; 4 • Stedelijk Van Abbe Museum, Eindhoven, The Netherlands. © DACS 2004; 5 • © DACS 2004; **1927a:** 1 • Los Angeles County Museum of Art, purchased with funds provided by the Mr and Mrs William Harrison Collection. © ADAGP, Paris and DACS,

London 2004; 2 • Musée National d'Art Moderne, Centre Georges Pompidou, Paris. © ADAGP, Paris and DACS, London 2004; 3 • Private Collection. © ADAGP, Paris and DACS, London 2004; **1927b:** 1 • Philadelphia Museum of Art. © ADAGP, Paris and DACS, London 2004; 2 • Musée National d'Art Moderne, Centre Georges Pompidou, Paris. © ADAGP, Paris and DACS, London 2004; 3 • The Musée National d'Art Moderne, Centre Georges Pompidou, Paris. © ADAGP, Paris and DACS, London 2004; 4 • National Gallery of Art, Washington D.C. Given in loving memory of her husband, Taft Schreiber, by Rita Schreiber, 1989. © ADAGP, Paris and DACS, London 2004; 5 • Musée National d'Art Moderne, Centre Georges Pompidou, Paris. © ADAGP, Paris and DACS, London 2004; **1927c:** 1 • Mildred Lane Kemper Art Museum, Washington University in St Louis. University Purchase, Bixby Fund, 1952; **box** Alfred Barr 'The Development of Abstract Art' chart prepared for the jacket of the catalogue *Cubism and Abstract Art* published by the Museum of Modern Art New York, 1936; 2 • The Newark Museum, Newark, NJ; 3 • Whitney Museum of American Art, New York; 4 • Museum of Modern Art, New York; 5 • Whitney Museum of American Art, New York, Purchase 41.3. © Estate of Stuart Davis/VAGA, New York/DACS, London 2004; 6 • Metropolitan Museum of Art, New York, Alfred Stieglitz Collection 1969 (69.278.1). © ARS, NY and DACS, London 2004; **1928a:** 1 • © DACS 2004; 3 • Kunsthandel Wolfgang Werner KG, Bremen; 4 • Sprengel Museum, Hanover. © DACS 2004; 5 • Muzeum Sztuki, Lódz, Poland. Photo Mariusz Lukawski; 6 • Muzeum Sztuki, Lódz, Poland. Photo Piotr Tomczyk; **1928b:** 1 • © DACS 2011; 2 • © DACS 2011; 3 • © Hattula Moholy-Nagy/DACS 2011; 4 • © DACS 2011; 5 • © DACS 2011; 6 • © DACS 2011; **1929:** 2 • Photo © The Lane Collection; 3 • Kunstbibliothek Preussischer Kulturbesitz, Berlin; 5 • © Albert Renger-Patzsch-Archiv/Ann und Jürgen Wilde, Köln/VG Bild-Kunst, Bonn and DACS, London 2004; 6 • Bauhaus-Archiv, Museum für Gestaltung, Berlin. © DACS 2004; 7 • Courtesy Galerie Wilde, Cologne; **1930a:** 1 • Sammlung Ann und Jürgen Wilde, Zülpich, Köln/ Zülpich. Estate Germaine Krull, Museum Folkwang, Fotografische Sammlung, Essen; 2 • Lotte Jacobi Collection, University of New Hampshire; 3 • Museum Folkwang, Essen; 4 • Museum für Moderne Kunst, Frankfurt am Main. © Gisèle Freund/Agency Nina Beskow; 5 • Lotte Jacobi Collection, University of New Hampshire; **1930b:** 1 • Museum of Modern Art, New York. Purchase. © Succession Miró, DACS, 2004; 2 • Alberto Giacometti Foundation, Zurich. © ADAGP, Paris and DACS, London 2004; 3 • Private Collection, Paris. © Man Ray Trust/ADAGP, Paris and DACS, London 2004; 4 • Musée National d'Art Moderne, Centre Georges Pompidou, Paris. ESTATE BRASSAÏ – R.M.N. – © CNAC/Mnam. Dist RMN-Jacques Faujour; 5 • Manoukian Collection, Paris. © Salvador Dalí, Gala-Salvador Dalí Foundation, DACS, London 2004; **1931a:** 1 • Collection Lucien Treillard, Paris. © Man Ray Trust/ADAGP, Paris and DACS, London 2004; 3 • Photo Per-Anders Allsten, Moderna Museet,

Stockholm. © DACS 2004; 4 • National Gallery of Art Washington, D.C. © ADAGP, Paris and DACS, London 2004; 5 • Collection Robert Lehrman, Washington, D.C. © The Joseph and Robert Cornell Memorial Foundation/VAGA, New York/DACS, London 2004; **1931b:** 1 • Private Collection. © Succession Miró/ADAGP, Paris and DACS, London 2011; 2 • National Gallery of Art, Washington, D.C. Gift of the Collection Committee, 1981. © Succession Miró/ADAGP, Paris and DACS, London 2011; 3 • Museum of Modern Art, New York. © Succession Miró/ADAGP, Paris and DACS, London 2011; 4 • Museum of Modern Art, New York. Gift of the Pierre Matisse Gallery. © Succession Miró/ADAGP, Paris and DACS, London 2011; 5 • Designed for Spanish Pavillion, Paris World Fair, July 1937. Courtesy Art Resource, New York. © 2011 Calder Foundation, New York/DACS London; 6 • Private Collection. Courtesy Art Resource, New York. © 2011 Calder Foundation, New York/DACS London; 7 • Calder Plaza, Vandenberg Center, Grand Rapids, Michigan. Photo © Joel Zatz/Alamy. © 2011 Calder Foundation, New York/DACS London; 8 • Tate, London. Photo Tate, London, 2010. © Succession Picasso/DACS, London 2011; **1933:** 1 • © DACS 2004; 2 • Photo Bob Schalkwijk, Mexico City. © 2004 Banco de México, Diego Rivera & Frida Kahlo Museums Trust. Av. Cinco de Mayo No. 2, Col. Centro, Del. Cuauhtémoc 06059, México, D.F.; 3 • Mexican Electricians' Syndicate, Mexico City. Courtesy of Laurence P. Hurlbert, Middleton, Wisconsin. © DACS 2004; 4 • © 2004 Banco de México Diego Rivera & Frida Kahlo Museums Trust. Av. Cinco de Mayo No.2, Col. Centro, Del. Cuauhtémoc 06059, México, D.F.; **1934a:** 1 • © DACS 2004; 2 • Historical Museum, Moscow. © DACS 2004; 3 • Tretyakov Gallery, Moscow. © DACS 2004; 4 • Tretyakov Gallery, Moscow; **1934b:** 1 • Père Lachaise Cemetery, Paris. Frantisek Staud/www. phototravels.net. © Tate, London 2004; 2 • Birmingham Museums & Art Gallery. © Tate, London 2004; 3 • Photo Tate, London 2004. Photo David Quinn; 4 • Photo Tate, London 2004. Reproduced by permission of the Henry Moore Foundation; 5 • The Pier Gallery Collection, Stromness. © Bowness, Hepworth Estate; **1935:** 1 • Museum of Modern Art, New York. Mr. and Mrs. John Spencer Fund. © DACS 2004; 2 • Die Photographische Sammlung/SK Stiftung Kultur – August Sander Archiv, Köln/VG Bild-Kunst, Bonn and DACS, London 2004; 3 • Die Photographische Sammlung/SK Stiftung Kultur – August Sander Archiv, Köln/VG Bild-Kunst, Bonn and DACS, London 2004; 5 • Philadelphia Museum of Art, Walter and Louise Arensberg Collection. © Succession Marcel Duchamp/ADAGP, Paris and DACS, London 2004; **1936:** 1 • Courtesy the Dorothea Lange Collection, Oakland Museum of California; 2 • Library of Congress, Washington, D.C., LC-USF342-T01-008057; 3 • Library of Congress, Washington, D.C., LC-USZ62-103098; 4 • Archives Photographiques, Paris; 5 • Library of Congress, Washington, D.C., LC-USZ62-34372; **1937a:** 1 • Photo Bildarchiv Preussischer Kulturbesitz, Berlin; 2 • The Merrill

C. Berman Collection. © Schawinsky Family; 3 • Nuremberg, Grounds of the Reichsparteitag, Breker Museum/Marco-VG; 5 • Museo Nacional Centro de Arte Reina Sophia, Madrid. On permanent loan from the Museo Nacional del Prado, Madrid. © Succession Picasso/DACS 2004; **1937b:** 1 • Photo Tate, London 2004. © Angela Verren-Taunt 2004. All Rights Reserved, DACS; 2 • Hamburg Kunsthalle/bpk, Berlin. Photo Elke Walford. © ADAGP, Paris and DACS, London 2004; 3 • Felix Witzinger, Switzerland/ The Bridgeman Art Library, London; **1937c:** 1 • Private Collection. © Succession Picasso/DACS, London 2011; 2 • © Fundacio Josep Renau; 3 • © 2010 Calder Foundation, New York/DACS London and © Succession Picasso/DACS, London 2011; 4 • Museum of Modern Art, New York. © Succession Picasso/DACS, London 2011; 5 • © The Heartfield Community of Heirs/ VG Bild-Kunst, Bonn and DACS, London 2011; 6 • Private collection. © The Estate of Roy Lichtenstein/DACS 2011; **1942a:** 1 • Private Collection, Courtesy Paalen Archiv, Berlin; 2 • Estate of William Baziotes, Collection Mary Jane Kamrowski. Pollock: © ARS, NY and DACS, London 2004; 3 • Formerly collection Simone Collinet, Paris. © ADAGP, Paris and DACS, London 2004; 4 • The Solomon R. Guggenheim Museum, New York. © ADAGP, Paris and DACS, London 2004; 5 • Albright-Knox Art Gallery, Buffalo, New York. Gift of Seymour H. Knox, 1956. © ADAGP, Paris and DACS, London 2004; 6 • Collection Seattle Art Museum. Gift of Mr. and Mrs. Bagley Wright. © ADAGP, Paris and DACS, London 2004; **1942b:** 2 • Morton Neumann Collection, Chicago. © ADAGP, Paris and DACS, London 2004; 3 • © Succession Marcel Duchamp/ADAGP, Paris and DACS, London 2004; 4 • Courtesy Mrs Frederick Kiesler, New York; 5 • Philadelphia Museum of Art, Gift of Jacqueline, Paul and Peter Matisse in memory of their mother Alexina Duchamp. © Succession Marcel Duchamp/ADAGP, Paris and DACS, London 2004; **1943:** 1 • Collection Schomburg Center for Research in Black Culture, The NY Public Library, The Astor, Lenox and Tilden Foundations, New York. Courtesy of the Meta V. W. Fuller Trust; 2 • © Donna Mussenden VanDerZee; 3 • The Gallery of Art, Howard University, Washington D.C. Courtesy of the Aaron and Alta Sawyer Douglas Foundation; 4 • National Museum of American Art, Smithsonian Institution. Museum purchase made possible by Mrs N. H. Green, Dr R. Harlan and Francis Musgrave. © Lois Mailou Jones Pierre-Noel Trust; 5 • The Metropolitan Museum of Art, Arthur Hoppock Hearn Fund, 1942, 42.167. © ARS, NY and DACS, London 2004; 6 • The Estate of Reginald Lewis. Courtesy of Iandor Fine Arts, Newark, New Jersey. Photo Frank Stewart; 7 • The Gallery of Art, Howard University, Washington D.C. © DACS, London/VAGA, New York 2004; **1944a:** 1 • Private Collection. Photo Instituut Collectie Nederland. © 2011 Mondrian/ Holtzman Trust c/o HCR International Virginia; 2 • Private Collection, Basel. © 2011 Mondrian/ Holtzman Trust c/o HCR International Virginia; 3 • Phillips Collection, Washington D.C. © 2011 Mondrian/Holtzman Trust c/o HCR International

Virginia; 4 • Kunstsammlung Nordrhein-Westfalen, Dusseldorf. © 2011 Mondrian/ Holtzman Trust c/o HCR International Virginia; **1944b:** 1 • Musée National d'Art Moderne, Centres Georges Pompidou, Paris. © Succession H. Matisse/DACS 2004; 2 • Musée National d'Art Moderne, Centre Georges Pompidou, Paris. © Succession H. Matisse/ DACS 2004; 3 • UCLA Art Galleries, LA. © Succession H. Matisse/DACS 2004; 4 • Private Collection. © Succession Picasso/DACS 2004; 5 • Musée National d'Art Moderne, Centre Georges Pompidou, Paris. © ADAGP, Paris and DACS, London 2004; 6 • Musée National d'Art Moderne, Centre Georges Pompidou, Paris. © ADAGP, Paris and DACS, London 2004; 7 • Private Collection. © DACS 2004; **1945:** 1 • Indiana University Art Museum, Bloomington, Indiana Photo Michael Cavanagh, Kevin Montague, IUAM #69.151. © Estate of David Smith/VAGA, New York/DACS, London 2004; 2 • Museum of Modern Art, New York. Mrs Solomon Guggenheim Fund. © ADAGP, Paris and DACS, London 2004; 3 • Musée Picasso, Paris. Photo © RMN Béatrice Hatala. © Succession Picasso/DACS 2004; 4 • Private Collection. Photo David Smith. © Estate of David Smith/VAGA, New York/DACS, London 2004; 5 • Private Collection. Photo Robert Lorenzson. © Estate of David Smith/VAGA, New York/DACS, London 2004; 6 • Photo Shigeo Anzai. © Sir Anthony Caro; 7 • Whitney Museum of American Art, New York Gift of the Albert A. List Family 70.1579a–b. © ARS, NY and DACS, London 2004; **1946:** 1 • Solomon R. Guggenheim Museum, New York. © ADAGP, Paris and DACS, London 2004; 2 • The Menil Collection, Houston; 3 • Galerie Limmer, Friburg im Breisgau. © ADAGP, Paris and DACS, London 2004; 4 • Musée d'Art Moderne de la Ville de Paris. © ADAGP, Paris and DACS, London 2004; 5 • Musée National d'Art Moderne, Centre Georges Pompidou, Paris. Photo Jacques Faujour. © ADAGP, Paris and DACS, London 2004; **1947a:** 1 • © DACS 2004; 2 • © The Josef and Anni Albers Foundation/VG Bild-Kunst, Bonn and DACS, London 2004; 3 • Photo Tim Nighswander. © The Josef and Anni Albers Foundation/VG Bild-Kunst, Bonn and DACS, London 2004; **1947b:** 1 • Nina Leen/Getty Images; 2 • Art Institute of Chicago, Mary and Earle Ludgin Collection. © Willem de Kooning Revocable Trust/ARS, NY and DACS, London 2004; 3 • Private Collection. © Dedalus Foundation, Inc/VAGA, New York/DACS, London 2004; 4 • Museum of Modern Art, new York. Bequest of Mrs. Mark Rothko through The Mark Rothko Foundation Inc. 428.81. © 1998 Kate Rothko Prizel & Christopher Rothko/DACS 2004; 5 • Private Collection. © ARS, NY and DACS, London 2004; **1949a:** 1 • Museum of Modern Art, New York. Sidney and Harriet Janis Collection Fund (by exchange). Photo Scala, Florence/The Museum of Modern Art, New York. © ARS, NY and DACS, London 2004; 2 • Photo Tate, London 2004. © ARS, NY and DACS, London 2004; 3 • Photo Musée National d'Art Moderne, Centre Georges Pompidou, Paris. © ARS, NY and DACS, London 2000; 4 • Museum

of Modern Art, New York. © ARS, NY and DACS, London 2004; 5 • Metropolitan Museum of Art, George A. Hearn Fund, 1957 (57.92). © ARS, NY and DACS, London 2004; **1949b:** 1 • Karel Appel Foundation; 2 • Photo Tom Haartsen. © Constant Nieuwenhuys, c/o Pictoright Amsterdam; 4 • Collection Colin St John Wilson. © The Estate of Nigel Henderson; 5 • © The Estate of Nigel Henderson; 6 • Pallant House Gallery, Chichester, UK. Wilson Gift through The Art Fund/The Bridgeman Art Library. © Trustees of the Paolozzi Foundation, licensed by DACS 2011; **1951:** 1 • Museum of Modern Art, New York. Courtesy of The Barnett Newman Foundation. © ARS, NY and DACS, London 2004; 2 • Museum of Modern Art, New York. Courtesy of The Barnett Newman Foundation. © ARS, NY and DACS, London 2004; 3 • Courtesy of The Barnett Newman Foundation. Photo Hans Namuth. © Hans Namuth Ltd. Pollock © ARS, NY and DACS, London 2004; 4 • Courtesy of The Barnett Newman Foundation. © ARS, NY and DACS, London 2004; 5 • Collection of David Geffen, Los Angeles. Courtesy of The Barnett Newman Foundation. © ARS, NY and DACS, London 2004; **1953:** 1 • San Francisco Museum of Modern Art, purchased through a gift of Phyllis Wattis. © Robert Rauschenberg/VAGA, New York/DACS, London 2004; 2 • Collection of the artist. © Robert Rauschenberg/VAGA, New York/ DACS, London 2004; 3 • Private Collection. © Ellsworth Kelly; 4 • Museum of Modern Art, New York. © Ellsworth Kelly; 5 • Marx Collection, Berlin; **1955a:** 1 • Photo Hans Namuth. © Hans Namuth Ltd. Pollock © ARS, NY and DACS, London 2004; 2 • Hyogo Prefectural Museum of Modern Art, Kobe. Courtesy Matsumoto Co. Ltd; 3 • Courtesy Matsumoto Co. Ltd; 4 • © Makiko Murakami; 5 • © Kanayama Akira and Tanaka Atsuko Association; 6 • © Kanayama Akira and Tanaka Atsuko Association; **1955b:** 1 • Photo Galerie Denise René, Paris; 2 • Photo Tate, London 2004. The works of Naum Gabo © Nina Williams.; 3 • Private Collection. © ARS, NY and DACS, London 2004; 5 • Collection the artist. Photo Clay Perry; **1956:** 1 • Photo Tate, London 2004. © Eduardo Paolozzi 2004. All Rights Reserved, DACS; 2 • Private Collection. © Richard Hamilton 2004. All Rights Reserved, DACS; 3 • © The Estate of Nigel Henderson, courtesy of the Mayor Gallery, London; 4 • © The Estate of Nigel Henderson. Courtesy of the Mayor Gallery, London; 5 • Courtesy of Richard Hamilton. © Richard Hamilton 2004. All Rights Reserved, DACS; 6 • Kunsthalle, Tübingen. Prof. Dr. Georg Zundel Collection. © Richard Hamilton 2004. All Rights Reserved, DACS; **1957a:** 1 • Musée Nationale d'Art Moderne, Paris, Centres Georges Pompidou, Paris. Jorn © Asger Jorn/ DACS 2004; 2 • Musée d'Art Moderne et Contemporain de Strasbourg, Cabinet d'Art Graphique. Photo A. Plisson. © Alice Debord, 2004; 3 • Installation at Historisch Museum, Amsterdam. Photo Richard Kasiewicz. © documenta Archiv; 4 • Courtesy Archivio Gallizio, Turin; 5 • Courtesy Archivio Gallizio, Turin; 6 • Collection Pierre Alechinsky, Bougival. Photo André Morain, Paris. © Asger Jorn/DACS 2004; 7 • Collection Pierre Alechinsky, Bougival. Photo

André Morain, Paris. © Asger Jorn/DACS 2004; **1957b: 1** • Photo Tate, London 2004. © ARS, NY and DACS, London 2004; **2** • Modern Art Museum of Fort Worth, Texas, Museum Purchase, Sid W. Richardson Foundation Endowment Fund. © Agnes Martin; **3** • The Greenwich Collection Ltd. © Robert Ryman; **4** • Stedelijk Museum, Amsterdam. © Robert Ryman; **1958: 1** • Museum of Modern Art, New York. Gift of Mr & Mrs Robert C. Scull. Photo Scala, Florence/Museum of Modern Art, New York 2003. © Jasper Johns/VAGA, New York/DACS, London 2004; **2** • Museum of Modern Art, New York. Gift of Philip Johnson in honour of Alfred Barr. © Jasper Johns/VAGA, New York/DACS, London 2004; **3** • Collection the artist. © Jasper Johns/VAGA, New York/DACS, London 2004; **4** • Whitney Museum of American Art, New York. Gift of Mr and Mrs Eugene M. Schwartz. © ARS, NY and DACS, London 2004; **5** • Menil Foundation Collection, Houston. © ARS, NY and DACS, London 2004; **1959a: 1** • Galerie Bruno Bischofberger, Zurich. © Fondazione Lucio Fontana, Milan; **2** • Musée National d'Art Moderne, Centre Georges Pompidou, Paris. © Fondazione Lucio Fontana, Milan; **3** • Private Collection, Milan. © Fondazione Lucio Fontana, Milan; **4** • Archivio Opera Piero Manzoni, Milan. © DACS 2004; **5** • Herning Kunstmuseum, Denmark. © DACS 2004; **1959b: 1** • Photo Charles Brittin. © The Wallace Berman Estate; **2** • Photo of *CHILD* courtesy of Bruce Conner. Museum of Modern Art, New York, gift of Philip Johnson; **3** • Photo MUMOK, Museum Moderner Kunst Stiftung Ludwig, Vienna; **4** • Museum Moderner Kunst, Vienna. © Nancy Reddin Kienholz; **5** • Museum Ludwig, Cologne. © Nancy Reddin Kienholz; **1959c: 1** • Private Collection. © ADAGP, Paris and DACS, London 2004; **2** • Kunsthaus Zürich. Alberto Giacometti Foundation. © ADAGP, Paris and DACS, London 2004; **3** • Purchased with funds from the Coffin Fine Arts Trust; Nathan Emory Coffin Collection of the Des Moines Art Center, 1980. Photo Michael Tropea, Chicago. © Estate of Francis Bacon 2004. All rights reserved, DACS; **4** • Hirshhorn Museum and Sculpture Garden, Smithsonian Institution, Gift of Joseph H. Hirschhorn, 1966. © Willem de Kooning Revocable Trust/ARS, NY and DACS, London 2004; **1959d: 1** • Courtesy Michel Brodovitch; **2** • Courtesy Laurence Miller Gallery, New York. © Helen Levitt; **3** • Courtesy Baudoin Lebon, Paris; **4** • © Weegee (Arthur Fellig)/International Centre of Photography/Getty Images; **5** • Museum of Modern Art, New York. © 1971 The Estate of Diane Arbus; **6** • Courtesy Pace/MacGill Gallery, New York. © Robert Frank; **1959e: 1** • Photo Guy Brett. © Cultural Association 'The World of Lygia Clark'. © ADAGP, Paris and DACS, London 2004; **2** • Clark Family Collection. Photo Marcelo Correa. Courtesy Cultural Association 'The World of Lygia Clark'. © ADAGP, Paris and DACS, London 2004; **3** • Clark Family Collection. Photo Marcelo Correa. Courtesy Cultural Assosiation 'The World of Lygia Clark'. © ADAGP, Paris and DACS, London 2004; **4** • Photo César Oiticica Filho; **5** • Courtesy Associação Cultural "O Mundo de Lygia Clark"; **6** • Photo Claudio

Oiticica; **7** • Photo Andreas Valentin; **8** • © Lygia Pape; **1960a: 1** • Photograph © David Gahr, 1960. © DACS 2004; **2** • Photo Jean-Dominique Lajoux. Copyright Christo 1962; **3** • Photo Andre Morain. Collection Musée National d'Art Moderne, Centre Georges Pompidou, Paris. Courtesy Ginette Dufrêne, Paris. © ADAGP, Paris and DACS, London 2004; **4** • Musée National d'Art Moderne, Centre Georges Pompidou, Paris. Villeglé © ADAGP, Paris and DACS, London 2004. Hains © ADAGP, Paris and DACS, London 2004; **5** • Museum of Modern Art, New York. Photo Scala, Florence. The Museum of Modern Art, New York 2003. © DACS 2004; **6** • © ADAGP, Paris and DACS, London 2004; **1960b: 1** • Yale University Art Gallery, New Haven. Richard Brown Baker bequest. © ARS, NY and DACS, London 2004; **2** • The Solomon R. Guggenheim Museum, New York. © 1959 Morris Louis; **3** • National Gallery of Art, Washington, D.C., Gift of Marcella Louis Brenner. © 1961 Morris Louis; **4** • Des Moines Art Center, purchased with funds from the Coffin Fine Arts Trust, Nathan Emory Coffin Collection of the Des Moines Art Center, 1974. © Kenneth Noland/VAGA, New York/DACS, London 2004; **5** • Collection the artist, on loan to the National Gallery of Art, Washington D.C. © Helen Frankenthaler; **1960c: 1** • Private Collection. © The Estate of Roy Lichtenstein/DACS 2004; **2** • Scottish National Gallery of Modern Art, Edinburgh. © The Estate of Roy Lichtenstein/DACS 2004; **3** • Musée National d'Art Moderne, Centre Georges Pompidou, Paris. © James Rosenquist/VAGA, New York/DACS, London 2004; **4** • The Eli and Edythe L. Broad Collection. © Ed Ruscha; **5** • Whitney Museum of American Art, New York, Purchase, with funds from the Mrs Percy Uris Purchase Fund 85.41. © Ed Ruscha; **6** • Private Collection. © The Estate of Roy Lichtenstein/DACS 2004; **1961: 1** • Photo © Robert R. McElroy/VAGA, New York/DACS, London 2004. © Claes Oldenberg and Coosje van Bruggen; **2** • Research Library, Getty Research Institute, Los Angeles (980063). Photo © Robert R. McElroy/VAGA, New York/DACS, London 2004. ; **3** • Courtesy Research Library, Getty Research Institute, Los Angeles (980063). Photo © Sol Goldberg; **4** • Photo Martha Holmes. © Claes Oldenburg and Coosje van Bruggen; **5** • Whitney Museum of American Art, New York. 50th Anniversary Gift of Mr. and Mrs. Victor W. Ganz 79.83a–b. Photo Jerry L. Thompson, New York. © Claes Oldenburg and Coosje van Bruggen; **1962a: 1** • Courtesy the Gilbert and Lila Silverman Fluxus Collection, Detroit. Photo George Maciunas; **2** • Courtesy the artist; **3a** • Photo © dpa. © Nam June Paik; **3b** • Courtesy Museum Wiesbaden. © Nam June Paik; **4** • Courtesy Gilbert and Lila Silverman Fluxus Collection, Detroit. Photo George Maciunas; **5** • Courtesy Gilbert and Lila Silverman Fluxus Collection, Detroit. Photo Paul Silverman; **6** • Courtesy Robert Watts Studio Archive, New York. Photo Larry Miller; **7** • Courtesy Gilbert and Lila Silverman Fluxus Collection, Detroit. Photo R. H. Hensleigh; **8** • Courtesy Gilbert and Lila Silverman Fluxus Collection, Detroit. Photo R. H. Hensleigh;

1962b: 1 • Courtesy Gallery Kranzinger, Vienna; **2** • Courtesy Hermann Nitsch. Photo L. Hoffenreich. © DACS 2004; **3** • Scottish National Gallery of Modern Art, Edinburgh. © the artist; **4** • © The artist; **5** • Courtesy the artist. Photo Werner Schulz. © DACS 2004; **1962c: 1** • Photo Cathy Carver © Dia Art Foundation. Estate of Dan Flavin. © ARS, NY and DACS, London 2004; **2** • Formally Saatchi Collection, London. © ARS, NY and DACS, London 2004; **3** • Courtesy Paula Cooper Gallery, New York. © Carl Andre/VAGA, New York/DACS, London 2004; **4** • Photo Tate, London 2004. © Carl Andre/VAGA, New York/DACS, London 2004; **5** • © Sol LeWitt. © ARS, NY and DACS, London 2004; **6** • Collection Neues Museum Weimar. © Sol LeWitt. © ARS, NY and DACS, London 2004; **1962d: 1** • Collection of the Artist. © Jasper Johns/VAGA, New York/DACS, London 2011; **2** • Collection Sally Ganz, New York. © Jasper Johns/VAGA, New York/DACS, London 2011; **3** • Museum of Modern Art, New York. © ARS, NY and DACS, London 2011; **4** • Richmond Hall, The Menil Collection, Houston, 1987–8. © The Andy Warhol Foundation for the Visual Arts/Artists Rights Society (ARS), New York/DACS, London 2011; **5** • Thomas Ammann, Zurich. © The Andy Warhol Foundation for the Visual Arts/Artists Rights Society (ARS), New York/DACS, London 2011; **6** • Private collection. © ADAGP, Paris and DACS, London 2011; **1963: 1** • Museum Ludwig, Cologne. © Georg Baselitz; **2** • Collection Verlag Gachnang und Springer, Bern-Berlin. © DACS 2004; **3** • Sammlung Ludwig, Museum of Modern Art, Vienna. © Georg Baselitz; **1964a: 1** • Photo Heinrich Riebeshl. © DACS 2004; **2** • Photo Heinrich Riebesehl. © DACS 2004; **3** • Museum Schloss Moyland, Bedburg-Hau. Collection van der Grinten, MSM 03087. © DACS 2004; **4** • Photo Walter Klein, Düsseldorf. Museum Schloss Moyland, Bedburg-Hau. © DACS 2004; **5** • Hessisches Landesmuseum, Darmstadt. © DACS 2004; **1964b: 1** • Dia Art Foundation, New York. The Menil Collection, Houston. © The Andy Warhol Foundation for the Visual Arts, Inc./ARS, NY and DACS, London 2004; **2** • Photo Tate, London 2004. © The Andy Warhol Foundation for the Visual Arts, Inc./ARS, NY and DACS, London 2004; **3** • The Menil Collection, Houston. © The Andy Warhol Foundation for the Visual Arts, Inc./ARS, NY and DACS, London 2004; **4** • © The Andy Warhol Foundation for the Visual Arts, Inc./ARS, NY and DACS, London 2004; **1965: 1** • Art © Judd Foundation. Licensed by VAGA, New York/DACS, London 2004; **2** • © ARS, NY and DACS, London 2004; 3. © ARS, NY and DACS, London 2004; **1966a: 1** • Collection Hirshhorn Museum and Sculpture Garden, Smithsonian Institution, Washington D.C., Joseph H. Hirshhorn Purchase Fund, Holenia Purchase Fund, and Museum Purchase, 1993. Courtesy Sperone Westwater, New York. © ARS, NY and DACS, London 2004; **2** • Collection Jasper Johns, New York. © Succession Marcel Duchamp/ADAGP, Paris and DACS, London 2004; **3** • Philadelphia Museum of Art. Gift of the Cassandra Foundation. © Succession Marcel Duchamp/

ADAGP, Paris and DACS, London 2004; **4** • Philadelphia Museum of Art. Gift of the Cassandra Foundation. © Succession Marcel Duchamp/ADAGP, Paris and DACS, London 2004; **1966b: 1** • Museum of Modern Art, New York. Photo © Estate of Peter Moore/VAGA, New York/DACS, London 2004. © Louise Bourgeois/VAGA, New York/DACS, London 2004; **2** • Courtesy Cheim & Read, New York. Photo Rafael Lobato. © Louise Bourgeois/VAGA, New York/DACS, London 2004; **3** • Courtesy the artist; **4** • National Gallery of Australia, Canberra, 1974. © The Estate of Eva Hesse. Hauser & Wirth Zürich and London; **5** • Daros Collection, Switzerland. © The Estate of Eva Hesse. Hauser & Wirth; **1967a: 1** • © Estate of Robert Smithson/VAGA, New York/DACS, London 2004; **2** • Collection of Geertjan Visser. Courtesy Sperone Westwater, New York. © ARS, NY and DACS, London 2004; **3** • Courtesy Gagosian Gallery, London. © Ed Ruscha; **4** • Private Collection. © ARS, NY and DACS, London 2004; **5** • Courtesy the Estate of Gordon Matta-Clark and David Zwirner, New York. © ARS, NY and DACS, London 2004; **1967b: 1** • Courtesy Archivio Merz, Turin; **2** • Photo Claudio Abate. Courtesy the artist; **3** • © the artist; **4** • Installation of 12 Piedi at Centre Georges Pompidou, Paris, 1972. Photo © Giorgio Colombo, Milan; **5** • Courtesy the artist; **6** • Galleria Civica d'Arte Moderna e Contemporanea di Torino – Fondazione De' Fornaris. Courtesy Fondazione Torino Musei – Archivio Fotografico, Turin; **7** • Photo the artist; **8** • Collection Annemarie Sauzeau Boetti, Paris. © DACS 2004; **1967c: 1** • No 58005/1–4, Collection Manfred Wandel, Stiftung für Konkrete Kunst, Reutlingen, Germany; Courtesy François Morellet. © ADAGP, Paris and DACS, London 2004; **2** • Photo Moderna Museet, Stockholm. © ADAGP, Paris and DACS, London 2004; **3** • Private Collection. Photo André Morain. © ADAGP, Paris and DACS, London 2004; **4** • © Photo CNAC/MNAM Dist. RMN; **5** • © D.B. © ADAGP, Paris and DACS, London 2004; **1968a: 1** • Courtesy Sonnabend Gallery, New York; **2** • Courtesy Sonnabend Gallery, New York; **3** • Courtesy the artist and Marian Goodman Gallery, New York; **4** • Museum of Modern Art, New York. The Fellows of Photography Fund. © DACS 2004; **5** • © DACS 2004; **6** • Courtesy Monika Sprueth Gallery/Philomene Magers. © DACS, London 2004; **1968b: 1** • Courtesy Gagosian Gallery, London. © Ed Ruscha; **2** • Museum Ludwig, Cologne. Courtesy Rheinisches Bildarchiv Cologne. © Sol LeWitt. © ARS, NY and DACS, London 2004; **3** • Museum of Modern Art, New York. © ARS, NY and DACS, London 2004; **4** • Musée Nationale d'Art Moderne, Centre Georges Pompidou, Paris. © ARS, NY and DACS, London 2004; **5** • © ARS, NY and DACS, London 2004; **6** • Courtesy Lisson Gallery, London; **7** • Collection Van Abbe Museum, Eindhoven, The Netherlands. © ARS, NY and DACS, London 2004; **8** • Courtesy of John Baldessari; **1969: 1** • Formerly Saatchi Collection, London. © ARS, NY and DACS, London 2004; **2** • Courtesy the artist. Photo ©

Estate of Peter Moore/VAGA, New York/DACS, London 2004; **3** • Museum of Modern Art, New York. Courtesy the artist. Photo © Estate of Peter Moore/VAGA, New York/DACS, London 2004; **4** • Art Institue of Chicago, through prior gifts of Arthur Keating and Mr. and Mrs. Edward Morris. © The Estate of Eva Hesse. Hauser & Wirth Zürich and London; **1970: 1** • Photo © Estate of Peter Moore/VAGA, New York/DACS, London 2004; **2** • Drawing by Lawrence Kenny. Courtesy the artist; **2** • Photo Frank Thomas. Courtesy the artist; **2** • Photo Frank Thomas. Courtesy the artist; **3** • Solomon R. Guggenheim Museum, New York (Panza Collection). Courtesy the artist. Photo © Estate of Peter Moore/VAGA, New York/DACS, London 2004; **4** • Estate of Robert Smithson/VAGA, New York/DACS, London 2004; **1971: 1** • Musée National d'Art Moderne, Centre Georges Pompidou, Paris. Courtesy the artist. © DACS 2004; **2** • D.B. © ADAGP, Paris and DACS, London 2004; **3** • Collection Daled, Brussels. Courtesy of the artist. © DACS 2004; **1972a: 1** • Collection Benjamin Katz. © DACS 2004; **1** • Collection Benjamin Katz. © DACS 2004; **2** • Collection Anne-Marie and Stéphane Rona. © DACS 2004; **3** • Galerie Michael Werner, Cologne. © DACS 2004; **4** • Ruth Kaiser, Courtesy Johannes Cadders. © DACS 2004; **5** • Municipal Van Abbe Museum, Eindhoven. © DACS 2004; **6** • © DACS 2004; **7** • © DACS 2004; **1972b: 1** • Museum Ludwig, Köln. Courtesy Rheinisches Bildarchiv, Köln (Cologne) ; **2** • Courtesy the artist. © DACS 2004; **3** • Art Institute of Chicago, Barbara Neff Smith Memorial Fund, Barbara Neff Smith & Solomon H. Smith Purchase Fund, 1977.600a-h. Courtesy Sperone Westwater, New York; **4** • Courtesy the artist. © DACS 2004; **5** • Collection Kunstmuseum, Bonn. © DACS 2004; **6** • Collection Speck, Cologne. Copyright the artist; **1972c: 1** • Archigram Archives 2016. © Archigram 1964; **2** • Venturi, Scott Brown and Associates, Inc.; **3** • Dorling Kindersley Ltd/Alamy Stock Photo; **4** • Courtesy Superstudio; **5** • Photo Diane Andrews Hall. © Ant Farm (Lord, Michels, Shreier), 1975. All rights reserved; **6** • Photo Arnaud Chicurel/Getty Images; **7** • Nikreates/Alamy Stock Photo; **1973: 1** • Photo © Estate of Peter Moore/VAGA, New York/DACS, London 2004. © Nam June Paik; **2** • Courtesy Electronic Arts Intermix (EAI), New York; **3** • Courtesy Electronic Arts Intermix (EAI), New York; **4** • © ARS, NY and DACS, London 2004; **5** • Courtesy Electronic Arts Intermix (EAI), New York; **1974: 1** • Photo Erró. Collection the artist. © ARS, NY and DACS, London 2004; **2** • Photo by Minoru Niizuma. © Yoko Ono; **3** • Photo Bill Beckley. Courtesy the artist; **3** • Photo Bill Beckley. Courtesy the artist; **4** • Photo Kathy Dillon. Courtesy the artist; **5** • Courtesy the artist; **6** • San Francisco Museum of Modern Art. © ARS, NY and DACS, London 2004; **1975a: 1** • © Judy Chicago 1972. © ARS, NY and DACS, London 2004; **2** • Philip Morris Companies, Inc. Faith Ringgold © 1980. ; **3** • The Brooklyn Museum of Art, Gift of The Elizabeth A. Sackler Foundation. Photo © Donald Woodman. © Judy

Chicago 1979. © ARS, NY and DACS, London 2004; **4** • Photo David Reynolds. Courtesy the artist; **5** • Courtesy of the Estate of Ana Mendieta and Galerie Lelong, New York; **6** • Arts Council of Great Britain. Courtesy the artist; **1975b: 3** • Photo Vlad Burykin. Courtesy of Museum of Avant-Garde Mastery and Knigi WAM, Moscow; **4** • Photo Hermann Feldhaus. Courtesy of Ronald Feldman Fine Arts, New York. © 2016 Komar and Melamid; **5** • Courtesy Andrei Monastyrski; **6** • Courtesy Garage Museum of Contemporary Art, Moscow. © Inspection Medical Hermeneutics; **1976: 1** • Photo E. Lee White, NYC, 1978. Courtesy the artist and The Kitchen, New York; **2** • Photo © Christopher Reenie/Robert Harding; **3** • Permanent collection the Chinati Foundation, Marfa, Texas. Photo Florian Holzherr. Art © Judd Foundation. Licensed by VAGA, New York/DACS, London 2004; **1977a: 1** • Courtesy the artist; **2** • Courtesy the artist and Metro Pictures; **3** • Courtesy the artist and Metro Pictures; **4** • Courtesy the artist and Metro Pictures; **5** • Courtesy Ydessa Hendeles Art Foundation, Toronto; **1977b: 1** • © Harmony Hammond/DACS, London/VAGA, NY 2016; **2** • Photo Chie Nishio; **3** • Courtesy Alexander and Bonin, New York. © The Estate of George Paul Thek; **4** • Courtesy Gladstone Gallery, New York and Brussels. © Jack Smith Archive; **5** • Photo Ellen Page Wilson. Courtesy the artist and Koenig & Clinton, New York; **6** • Photo Ellen Page Wilson. Courtesy the artist and Koenig & Clinton, New York; **7** • Courtesy Regen Projects, Los Angeles. © Catherine Opie; **8** • Courtesy of the artist; **1980: 1** • Courtesy the artist and Gorney Bravin and Lee, New York. © Sarah Charlesworth, 1978; **2** • Courtesy Barbara Gladstone Gallery, New York; **2** • Courtesy Barbara Gladstone Gallery, New York; **2** • Courtesy Barbara Gladstone Gallery, New York; **3** • Courtesy the artist; **4** • Courtesy Sean Kelly Gallery, New York; **1984a: 1** • Courtesy the artist; **2** • © ARS, NY and DACS, London 2004; **2** • © ARS, NY and DACS, London 2004; **3** • Collection the artist. Fred Lonidier, Visual Arts Department, University of California, San Diego; **3** • Collection the artist. Fred Lonidier, Visual Arts Department, University of California, San Diego; **4** • Courtesy the artist and Gorney Bravin & Lee, New York. © Martha Rosler, 1967–72; **5** • Courtesy the artist and Christopher Grimes Gallery, Santa Monica, CA; **6** • © Martha Rosler, 1974–5. Courtesy the artist and Gorney Bravin & Lee, New York; **6** • © Martha Rosler, 1974–5. Courtesy the artist and Gorney Bravin & Lee, New York; **1984b: 1** • Collection Mrs. Barbara Schwartz. Photo courtesy Gagosian Gallery, New York; **2** • Photo Jenny Holzer. © ARS, NY and DACS, London 2004; **3** • Courtesy Canal St. Communications; **1986: 1** • © Jeff Koons; **2** • Courtesy the artist and Jay Jopling/White Cube (London). © the artist; **3** • Courtesy the artist; **4** • Courtesy the artist; **5** • © Barbara Bloom, 1989. Courtesy Gorney, Bravin + Lee, New York; **1987: 1** • Courtesy of Group Material; **2** • Collection of Ulrich and Harriet Meyer. Photo James Dee. © DACS, London/VAGA, New York 2004; **3** • © Krzysztof Wodiczko. Courtesy Galerie Lelong, New York; **4** • The New York Public Library;

box Richard Serra, *Tilted Arc*, 1981 (destroyed). Cor-ten steel, 365.8 x 3657. 6 x 6.4 (144 x 1440 x 2½). Federal Plaza, New York. Photo Ann Chauvet, Paris; **5** • The Werner and Elaine Dannheisser Foundation, New York. © The Felix Gonzalez-Torres Foundation. Courtesy of Andrea Rosen Gallery, New York; **6** • The Werner and Elaine Dannheisser Foundation, New York. On long term loan to the Museum of Modern Art, New York. © The Felix Gonzalez-Torres Foundation. Courtesy of Andrea Rosen Gallery, New York; **7** • Philadelphia Museum of Art. Courtesy the artist; **1988: 1** • Museum of Modern Art, New York. Photo Axel Schneider, Frankfurt/Main. © Gerhard Richter; **2** • Museum of Modern Art, New York. Photo Friedrich Rosenstiel, Cologne. © Gerhard Richter; **3** • Städtische Galerie im Lenbachhaus, Munich. © Gerhard Richter; **4** • Courtesy the artist; **1989: 1** • Courtesy the artist; **2** • Photo Dawoud Bey. Courtesy Jack Tilton/Anna Kustera Gallery, New York; **3** • Courtesy Jack Tilton Gallery, New York; **4** • Courtesy Marian Goodman Gallery, New York; **5** • Courtesy Gavin Brown's Enterprise, New York; **1992: 1** • Courtesy of Documenta Archiv. © DACS 2004; **2** • Courtesy the artist and Metro Pictures Gallery, New York; **3** • Courtesy Galleria Emi Fontana, Milan. Photo Roberto Marossi, Milan; **4** • Courtesy the artist. Photo Nina Möntmann; **4** • Photo courtesy De Vleeshal, Middelberg, American Fine Arts, Co., New York and Tanya Bonakdar Gallery, New York; **1993a: 1** • Collection Alexina Duchamp, France. © Succession Marcel Duchamp/ADAGP, Paris and DACS, London 2004; **2** • Courtesy the artist. © ARS, NY and DACS, London 2004; **3** • Courtesy James Coleman and Marian Goodman Gallery, New York. © James Coleman; **4** • Courtesy the artist and Metro Pictures Gallery, New York; **5** • Courtesy the artist and Metro Pictures Gallery, New York; **1993b: 1** • Private Collection. Courtesy of the Paula Cooper Gallery, New York; **2** • Arts Council of England, London. Photo Edward Woodman. Courtesy the artist and Jay Jopling/White Cube (London). © the artist; **3** • Courtesy the artist; **4** • Commissioned by Artangel. Sponsored by Beck's. Courtesy Rachel Whiteread and Gagosian Gallery, London. Photo Sue Ormera; **1993c: 1** • Courtesy the Paula Cooper Gallery, New York; **2** • Courtesy the artist and P.P.O.W. Gallery, N.Y.; **3** • Courtesy Sean Kelly Gallery, New York; **4** • Photograph. © Rotimi Fani-Kayode/Autograph ABP; **5** • Courtesy Stephen Friedman Gallery, London; **6** • Courtesy the artist and Brent Sikkema, NYC; **7** • Courtesy the artist and Hauser & Wirth. Photo courtesy Gagosian Gallery, New York; **8** • © 2004 Glenn Ligon; **1994a: 1** • Courtesy Sonnabend Gallery, New York; **2** • Collection of the artist. Photo Ellen Page Wilson, courtesy Pace Wildenstein, New York. © Kiki Smith; **3** • Courtesy the artist and Matthew Marks Gallery. Photo K. Ignatiadis for Jeu de Paume; **4** • Courtesy the artist; **5** • Private Collection/Courtesy Jablonka Galerie, Cologne. Photo Nic Tenwiggenhorn, Düsseldorf; **1994b: 1** • Solomon R. Guggenheim Museum, New York. © Sol LeWitt. © ARS, NY and DACS, London 2004; **2** • Courtesy Regen Projects, Los Angeles; **3** • Courtesy the artist; **4** • Courtesy the artist; **1997: 1** • Courtesy Lunetta Batz, Maker, Johannesburg.

© Santu Mofokeng; **2** • © Peter Magubane; **3** • © David Goldblatt; **4** • Courtesy Lunetta Batz, Maker, Johannesburg. © Santu Mofokeng; **5** • Courtesy the artist and Jack Shainman Gallery, New York. © Zwelethu Mthethwa; **6** • Courtesy Goodman Gallery, Cape Town. © Nontsikelelo Veleko; **7** • Courtesy Stevenson, Cape Town and Johannesburg. © Zanele Muholi; **1998: 1** • Photo Florian Holzherr. © James Turrell; **2** • Courtesy the artist. Photo © 1997 Fotoworks Benny Chan; **3** • Courtesy Lisson Gallery, London; **4** • Courtesy David Zwirner, New York; **1999: 1** • Courtesy the artist and Marian Goodman Gallery, New York; **2** • Courtesy the artist and Jay Jopling/White Cube (London). © the artist; **3** • Collection the artist. Courtesy Monika Sprueth Gallery/Philomene Magers. © DACS, London 2004; **2003: 1** • Courtesy the artist and Corvi-Mora, London; **2** • Courtesy the artist and Stephen Friedman Gallery, London; **3** • Courtesy Marian Goodman Gallery, New York; **4** • Courtesy the artist, Frith Street Gallery, London and Marian Goodman Galleries, New York and Paris; **2007a: 1** • Courtesy Paula Cooper Gallery, New York. © Christian Marclay; **2** • Courtesy Paula Cooper Gallery, New York. © Christian Marclay; **3** • Photo courtesy the Artist and Marian Goodman Gallery, New York. © James Coleman; **4** • Courtesy Paula Cooper Gallery, New York. © ADAGP, Paris and DACS, London 2011; **5** • Photo courtesy the Artist and Marian Goodman Gallery, New York. © William Kentridge; **6** • Photo courtesy the Artist and Marian Goodman Gallery, New York. © William Kentridge; **2007b: 1** • © ADAGP, Paris and DACS, London 2011; **2** • Courtesy the Artist and Galerie Daniel Buchholz, Cologne/Berlin; **3** • Courtesy Stuart Shave/Modern Art, London. © Tom Burr; **4** • Image courtesy the Artist and Kimmerich Gallery, New York; **5** • Courtesy the Artist and Greene Naftali Gallery, New York; **6** • Courtesy the Artist and Metro Pictures; **2007c: 1** • © Hirst Holdings Limited and Damien Hirst. All rights reserved, DACS 2011; **2** • Photo Laurent Lecat. © Jeff Koons; **3** • Photo © Andy Rain/epa/Corbis. © Hirst Holdings Limited and Damien Hirst. All rights reserved, DACS 2011; **2009a: 1** • Courtesy Galerie Lelong, New York. © The Estate of Ana Mendieta Collection; **2** • Courtesy Studio Tania Bruguera; **3** • Courtesy Gavin Brown Enterprise © Rirkrit Tiravanija; **4** • Courtesy Gavin Brown Enterprise © Rirkrit Tiravanija; **5** • Courtesy Marian Goodman Gallery, Paris / New York. © ADAGP, Paris and DACS, London 2011; **6** • Courtesy Anton Vidokle; **2009b: 1** • Installation view "Martin Kippenberger", Van Abbe Museum, Eindhoven, 2003. © Estate Martin Kippenberger, Galerie Gisela Capitain, Cologne; **2** • Courtesy the Artist, Reena Spaulins, New York and Galerie Daniel Buchholz, Cologne/Berlin; **3** • National Gallery of Art, Washington, D.C., January 20, 2004. Image courtesy Friedrich Petzel Gallery, New York. Photo Lammy Photo; **4** • Courtesy the Artist and Galerie Daniel Buchholz, Cologne/Berlin; **5** • Courtesy the Artist and Galerie Daniel Buchholz, Cologne/Berlin; **6** • Image courtesy Friedrich Petzel Gallery, New York. Photo Thomas Mueller; **7** • Photo Jeffrey Sturges; **2009c: 1** • Courtesy Gladstone Gallery, New York; **2** • Courtesy Gladstone Gallery, New York; **3** • Courtesy

Andrea Geyer; **4** • © Harun Farocki 2009; **5** • Courtesy Cheim & Read Gallery, New York / © ARS, NY and DACS, London 2011; **2010a: 1** • Courtesy the Artist; Leister Foundation, Switzerland; Erlenmeyer Stiftung, Switzerland and Galerie Urs Meile, Beijing-Lucerne; **2** • Courtesy the Artist; Leister Foundation, Switzerland; Erlenmeyer Stiftung, Switzerland and Galerie Urs Meile, Beijing-Lucerne; **3** • Photo Tate, London, 2011. © Ai Weiwei; **4** • Courtesy the Artist; Leister Foundation, Switzerland; Erlenmeyer Stiftung, Switzerland and Galerie Urs Meile, Beijing-Lucerne. Photograph by Frank Schinski; **5** • © Wang Guangyi; **6** • © Zhang Huan; **7** • Courtesy Pace Gallery, New York. © Zhang Huan; **2010b: 1** • Courtesy Bernadette Corporation; **2** • Courtesy John Kelsey; **3** • Images from the Jumex traveling show curated by Adriano Pedrosa "Intruders (Foreigners Everywhere, 2004–10)", 2010, Courtesy the Artist and Gaga Arte Contemporanea, Mexico D.F. and Metro Pictures, New York; **4** • © 2010 Cao Fei, courtesy Lombard Fried Projects, New York; **5** • Courtesy Anthony Reynolds Gallery, London. © the Artist; **6** • Courtesy www.theyesmen.org; **2015: 1** • Photo Ed Lederman; **2** • Courtesy Herzog & de Meuron; **3** • Photo Roland Halbe; **4** • age fotostock/Alamy Stock Photo; **5** • Diller Scofidio + Renfro; **6** • Courtesy Jeremy Deller; **7** • Courtesy Sharon Hayes

index